Greek Art and Aesthetics

in the Fourth Century B.C.

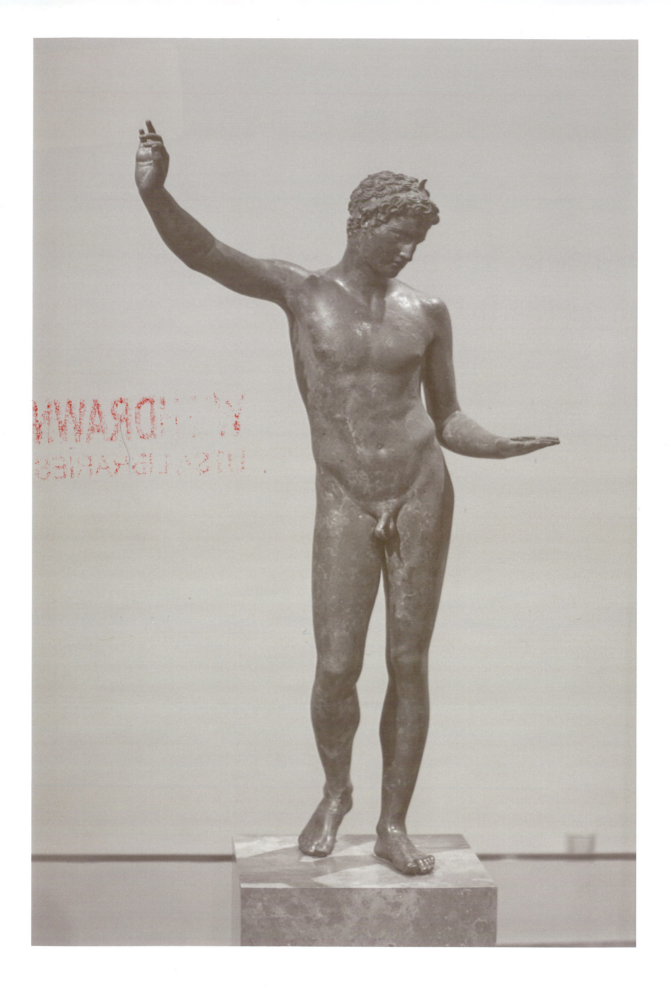

Greek Art and Aesthetics
in the Fourth Century B.C.

William A. P. Childs

DEPARTMENT OF ART AND ARCHAEOLOGY
PRINCETON UNIVERSITY

in association with

PRINCETON UNIVERSITY PRESS
Princeton and Oxford

Published by the Department of Art and Archaeology,
Princeton University, Princeton, New Jersey 08544-1018
in association with Princeton University Press

Distributed by Princeton University Press,
41 William Street, Princeton, New Jersey 08540-5237
press.princeton.edu

Library of Congress Control Number 2017935852

ISBN 978-0-691-17646-8

British Library Cataloging-in-Publication Data is available

Designer: Pamela Schnitter

Typesetter: Kerri Cox Sullivan

This book was typeset in Whitman and KadmosU

Print-on-demand edition printed by Acme Bookbinding, Charlestown, Massachusetts

Printed on acid-free paper. ∞

Cover illustrations: (front) Artemis of Gabii, Musée du Louvre Ma 529 (detail),
photographer: Marie-Lan Nguyen/Wikimedia Commons; (back) Derveni bronze krater,
Thessaloniki, Archaeological Museum Derveni B1, photo: © Beryl Barr-Sharrar

Frontispiece: Marathon boy, Athens, National Archaeological Museum X 15118,
photographer: Erin Babnik

Contents

List of Illustrations

173. Diskobolos attributed to Naukydes. Frankfurt am Main, Liebieghaus Skulpturen-sammlung 2608 (photo: Liebieghaus Skulpturensammlung)

174. Hermes, Richelieu type. Paris, Musée du Louvre Ma 573 (photo: Musée du Louvre/Art Resource)

175. Eros, Centocelle type, much restored. Naples, Museo Archeologico Nazionale 6335 (photo: DAI Rom neg. 66.1827; photographer: G. Singer)

176. Herakles, Lansdowne type. Malibu, J. Paul Getty Museum 70.AA.109 (photo: J. Paul Getty Museum)

177. Herakles, Copenhagen-Dresden type, front. Copenhagen, Ny Carlsberg Glyptotek 1720 (photo: author)

178. Herakles, Copenhagen-Dresden type, three-quarter right view. Copenhagen, Ny Carlsberg Glyptotek 1720 (photo: author)

179. Youth. Berlin, Staatliche Museen zu Berlin-Preußischer Kulturbesitz (Pergamon Museum) Sk 471 (photo: Staatliche Museen zu Berlin-Preußischer Kulturbesitz/Art Resource)

180. Resting satyr. Munich, Glyptothek 228 (photo: Staatliche Antikensammlungen und Glyptothek München; photographer: Renate Kuehling)

181. Apollo Sauroktonos. Paris, Musée du Louvre Ma 441 (photo: Musée du Louvre/Art Resource)

182. Bronze Apollo Sauroktonos. Cleveland Museum of Art 2004.30.c (photo: Cleveland Museum of Art)

183. Herakles, Farnese type. Naples, Museo Archeologico Nazionale 6001 (photo: DAI Rom neg. 85.486; photographer: H. Schwanke)

184. Conservatori girl. Rome, Palazzo dei Conservatori, Centrale Montemartini (ACEA) MC 1107 (photo: DAI Rom neg. 67.2; photographer: G. Singer)

185. Grave stele of Ktesileos and Theano. Athens, National Archaeological Museum 3472 (photo: Erin Babnik)

186. Hera from Ephesos. Vienna, Gemäldegalerie der Akademie der bildenden Künste Wien, Glyptothek (photo: Gemäldegalerie der Akademie der bildenden Künste Wien, Glyptothek)

187. Grave stele, from the Piraeus. Athens, National Archaeological Museum 726 (photo: Erin Babnik)

188. Sandal-binding Hermes, front. Copenhagen, Ny Carlsberg Glyptotek 2798 (photo: author)

189. Sandal-binding Hermes, right side. Copenhagen, Ny Carlsberg Glyptotek 2798 (photo: author)

190. Raving mainad attributed to Skopas. Dresden, Staatliche Kunstsammlungen, Skulpturensammlung, Herrmann 133 (ZV 1941) (photo: Staatliche Kunstsammlungen Dresden)

191. Themis signed by Chairestratos, from Rhamnous. Athens, National Archaeological Museum 231 (photo: Erin Babnik)

192. Attic white-ground lekythos, unattributed, detail of male head. Athens, Kerameikos Museum 3146 (photo: U. Koch-Brinkmann)

193. Attic white-ground lekythos, Group of the Huge Lekythoi, scene at grave, detail. Berlin, Staatliche Museen zu Berlin-Preußischer Kulturbesitz F 2685 (photo: Staatliche Museen zu Berlin-Preußischer Kulturbesitz/Art Resource)

Foreword

This study began with a most appreciated semester at the Institute for Advanced Study in Princeton in the autumn of 1988. An original version of this book was completed in 2002; its rejection by a publisher led to revisions carried out over the next few years. Health problems intervened and delayed further work. The fifteen years intervening between the original completion of the manuscript and the present publication resulted in only sporadic updating of the bibliography. This may be irritating to those who wish the very last word on various issues, but the aim of the book is to present an interpretation of the art of the fourth century which is largely unaffected by adjustments of details. Indeed, I hope that this book sheds light on the underlying meaning of the art of the fourth century and clarifies the relationship of primarily the Athenian intelligentsia to the contemporary art. I have been unable to follow the late-nineteenth-century negative reaction, particularly to Plato. Instead I see a vibrant dialogue beginning at least with Gorgias and running down through Aristotle, and preoccupying all the usual suspects in the fields of philosophy and literature. The fourth century is hardly a period of artistic or intellectual decline. To the contrary, it is a natural and creative successor to the fifth century's abstract idealism.

I owe a debt of thanks to many people who have been supportive of the project, particularly to three readers whose comments have been important in the final form of the book. Many museums, institutions, and collections of antiquities have been extremely kind in providing excellent images. It would be unfair on the one hand to give only a partial list and, on the other hand, extremely boring to give a full list; it will be obvious from the illustrations where my debts lie. There are also many people to whom I owe thanks for encouragement, advice, and help on various aspects of this study. Principal of these is Michael Padgett of the Princeton University Art Museum and Christopher Moss, who has painstakingly worked over every aspect of the manuscript. Of course, without the support of Thomas Leisten and Michael Koortbojian, past and present chairs of the Department of Art and Archaeology at Princeton University, this book would not exist. This is equally true of Susan Lehre, manager of the department, whose kindness and persistence have kept everything on track and the vast cost of illustrations paid for.

Princeton
February 2017

Bibliographic Abbreviations

Abbreviations of periodicals and series are those recommended by the *American Journal of Archaeology* (www.ajaonline.org/submissions/abbreviations). The following abbreviations are also used.

ABL—Haspels, C. H. E., *Attic Black-Figured Lekythoi* (Paris 1936).

ABV—Beazley, J. D., *Attic Black-Figure Vase-Painters* (Oxford 1956).

AcadBelg-BCBA—*Académie royale des sciences, des lettres et des beaux-arts de Belgique, Bulletin de la Classe des beaux-arts*

Adam, *Technique*—Adam, S., *The Technique of Greek Sculpture in the Archaic and Classical Periods*, British School of Archaeology at Athens Supplementary Volume 3 (London 1966).

AErgoMak—*To archaiologiko ergo ste Makedonia kai Thrake*

AGD—*Antike Gemmen in deutschen Sammlungen*

Amandry and Hansen, *FdD* 2.C.14—Amandry, P., and E. Hansen, *Fouilles de Delphes*, vol. 2, *Topographie et architecture*, pt. C, *Divers*, fasc. 14, *Le temple d'Apollon du IVe siècle*, 3 vols. (Paris 2010).

Andronikos, *Royal Tombs*—Andronikos, M., *Vergina: The Royal Tombs* (Athens 1987).

Arnold, *Polykletnachfolge*—Arnold, D., *Die Polykletnachfolge: Untersuchungen zur Kunst von Argos und Sikyon zwischen Polyklet und Lysipp*, *JdI-EH* 25 (Berlin 1969).

ARV²—Beazley, J. D., *Attic Red-Figure Vase-Painters*, 2nd ed. (Oxford 1963).

Aupert, *FdD* 2.C.3—Aupert, P., *Fouilles de Delphes*, vol. 2, *Topographie et architecture*, pt. C, *Divers*, fasc. 3, *Le stade*, 2 vols. (Paris 1979).

Barr-Sharrar, *Derveni Krater*—Barr-Sharrar, B., *The Derveni Krater: Masterpiece of Classical Greek Metalwork*, Ancient Art and Architecture in Context 1 (Princeton 2008).

Barr-Sharrar and Borza, *Macedonia*—Barr-Sharrar, B., and E. N. Borza, eds., *Macedonia and Greece in Late Classical and Early Hellenistic Times*, Studies in the History of Art 10, Symposium Series 1 (Washington, DC, 1982).

Baumer, *Vorbilder*—Baumer, L. E., *Vorbilder und Vorlagen: Studien zu klassischen Frauenstatuen und ihrer Verwendung für Reliefs und Statuetten des 5. und 4. Jahrhunderts vor Christus*, Acta Bernensia 12 (Bern 1997).

Beazley Addenda²—Carpenter, T. H., et al., *Beazley Addenda: Additional References to ABV, ARV² and Paralipomena*, 2nd ed. (Oxford 1989).

Beck, Bol, and Bückling, *Polyklet*—Beck, H., P. C. Bol, and M. Bückling, eds., *Polyklet: Der Bildhauer der griechischen Klassik; Ausstellung im Liebieghaus, Museum alter Plastik, Frankfurt am Main*, exh. cat. (Mainz 1990).

Bentz, *Preisamphoren*—Bentz, M., *Panathenaische Preisamphoren*, *AntK-BH* 18 (Basel 1998).

Bergemann, *Demos und Thanatos*—Bergemann, J., *Demos und Thanatos: Untersuchungen zum Wertsystem der Polis im Spiegel der attischen Grabreliefs des 4. Jahrhunderts v. Chr. und zur Funktion der gleichzeitigen Grabbauten* (Munich 1997).

Bieber, *Ancient Copies*—Bieber, M., *Ancient Copies: Contributions to the History of Greek and Roman Art* (New York 1977).

Blümel, *Hermes*—Blümel, C., *Der Hermes eines Praxiteles* (Baden-Baden 1948).

Blümel, *Klassisch Skulpturen Berlin*—Blümel, C., *Die klassisch griechischen Skulpturen der Staatlichen Museen zu Berlin*, AbhBerl, Klasse für Sprachen, Literatur und Kunst, Jarhg. 1966, no. 2 (Berlin 1966).

Boardman, *ARFV-CP*—Boardman, J., *Athenian Red Figure Vases: The Classical Period* (London 1989).

Boardman, *GS-AP*—Boardman, J., *Greek Sculpture: The Archaic Period* (London 1978).

Boardman, *GS-CP*—Boardman, J., *Greek Sculpture: The Classical Period* (London 1985).

Boardman, *GS-LCP*—Boardman, J., *Greek Sculpture: The Late Classical Period* (London 1995).

Bol, *Amazones Volneratae*—Bol, R., *Amazones Volneratae: Untersuchungen zu den Ephesischen Amazonenstatuen* (Mainz 1998).

Bol, *Antretende Diskobol*—Bol, P. C., *Der antretende Diskobol*, Liebieghaus Monographie 17 (Mainz 1996).

Bol, *Bildhauerkunst*—Bol, P. C., et al., *Die Geschichte der antiken Bildhauerkunst*, vol. 2, *Klassische Plastik*, Schriften des Liebieghauses (Mainz 2004).

Bol, *Villa Albani*—Bol, P. C., et al., *Forschungen zur Villa Albani: Katalog der antiken Bildwerke*, vol. 1, *Bildwerke im Treppenaufgang und im Piano nobile des Casino* (Berlin 1989); vol. 4, *Bildwerke im Kaffeehaus* (Berlin 1994).

Bommelaer and Laroche, *Delphes: Le site*—Bommelaer, J.-F., and D. Laroche, *Guide de Delphes: Le site*, École française d'Athènes, Sites et monuments 7 (Paris 1991).

Borchhardt, *Limyra*—Borchhardt, J., *Die Bauskulptur des Heroons von Limyra: Das Grabmal des lykischen Königs Perikles*, IstForsch 32 (Berlin 1976).

Bourguet, *FdD 3.1*—Bourguet, É., *Fouilles de Delphes*, vol. 3, *Épigraphie*, fasc. 1, *Inscriptions de l'entrée du sanctuaire au trésor d'Athènes*, 2 vols. (Paris 1911–29).

BrBr—Brunn, H., *Denkmäler griechischer und römischer Sculptur in historischer Anordnung* (Munich 1888–1904 [text: 1902–47]).

Brecoulaki, *Peinture funéraire*—Brecoulaki, H., *La peinture funéraire de Macédoine: Emplois et fonctions de la couleur, IVe–IIe s. av. J.-C.*, Centre de Recherches de l'Antiquité Grecque et Romaine (Athènes), Meletemata 48 (Athens 2006).

Brinkmann and Wünsche, *Bunte Götter*—Brinkmann, V., and R. Wünsche, eds., *Bunte Götter: Die Farbigkeit antiker Skulptur; Eine Ausstellung der Staatlichen Antikensammlungen und Glyptothek München in Zusammenarbeit mit der Ny Carlsberg Glyptotek Kopenhagen und den Vatikanischen Museen, Rom*, exh. cat., 2nd ed. (Munich 2004).

Brommer, *Giebel*—Brommer, F., *Die Giebel des Parthenon: Eine Einführung* (Mainz 1959).

Brouskari, *Acropolis Museum*—Brouskari, M. S., *The Acropolis Museum: A Descriptive Catalog*, trans. J. Binder (Athens 1974).

Bruno, *Form and Color*—Bruno, V. J., *Form and Color in Greek Painting* (New York 1977).

Burford, *Temple Builders*—Burford, A., *The Greek Temple Builders at Epidauros: A Social and Economic Study of Building in the Asklepian Sanctuary, during the Fourth and Early Third Centuries B.C.*, Liverpool Monographs in Archaeology and Oriental Studies (Liverpool 1969).

Burn, *Meidias Painter*—Burn, L., *The Meidias Painter*, Oxford Monographs on Classical Archaeology (Oxford 1987).

*CAH*²—*Cambridge Ancient History*, 2nd ed. (1961–).

Charbonneaux, *FdD* 2.B.4.2—Charbonneaux, J., *Fouilles de Delphes*, vol. 2, *Topographie et architecture*, pt. B, *Le sanctuaire d'Athèna Pronaia*, fasc. 4.2, *La Tholos* (Paris 1925).

Childs, "Stil als Inhalt"—Childs, W. A. P., "Stil als Inhalt statt als Künstlersignatur," in *Meisterwerke: Internationales Symposion anläßlich des 150. Geburtstages von Adolf Furtwängler, Freiburg im Breisgau, 30. Juni–3. Juli 2003*, ed. V. M. Strocka (Munich 2005) 235–41.

Clairmont, *CAT*—Clairmont, C. W., *Classical Attic Tombstones*, 8 vols. (Kilchberg 1993).

Cohen, *Colors of Clay*—Cohen, B., *The Colors of Clay: Special Techniques in Athenian Vases*, exh. cat. (Los Angeles 2006).

Comstock and Vermeule, *Sculpture in Stone*—Comstock, M. B., and C. C. Vermeule, *Sculpture in Stone: The Greek, Roman and Etruscan Collections of the Museum of Fine Arts, Boston* (Boston 1976).

Cook, *Relief Sculpture of the Mausoleum*—Cook, B. F., *Relief Sculpture of the Mausoleum at Halicarnassus*, Oxford Monographs on Classical Archaeology (Oxford 2005).

Courby, *FdD* 2.A.2—Courby, F., *Fouilles de Delphes*, vol. 2, *Topographie et architecture*, pt. A, *Le Sanctuaire d'Apollon*, fasc. 2, *La terrasse du temple* (Paris 1927).

Croissant, *FdD* 4.7—Croissant, F., *Fouilles de Delphes*, vol. 4, *Monuments figurés: Sculpture*, pt. 7, *Les frontons du temple du IVe siècle* (Paris 2003).

Daehner and Lapatin, *Power and Pathos*—Daehner, J. M., and K. Lapatin, eds., *Power and Pathos: Bronze Sculpture of the Hellenistic World*, exh. cat. (Los Angeles 2015).

Danner, *Griechische Akrotere*—Danner, P., *Griechische Akrotere der archaischen und klassischen Zeit*, RdA suppl. 5 (Rome 1989).

Davies, *APF*—J. K. Davies, *Athenian Propertied Families, 600–300 B.C.* (Oxford 1971).

DialHistAnc—*Dialogues d'histoire ancienne*

Diels-Kranz, *Vorsokr.*—H. Diels and W. Kranz, *Die Fragmente der Vorsokratiker*, 9th ed. (Berlin 1959).

Diepolder, *Grabreliefs*—Diepolder, H., *Die attischen Grabreliefs des 5. und 4. Jahrhunderts v. Chr.* (Berlin 1931; repr. Darmstadt 1965).

Dugas, Berchmans, and Clemmensen, *Sanctuaire d'Aléa Athéna*—Dugas, C., J. Berchmans, and M. Clemmensen, *Le sanctuaire d'Aléa Athéna à Tégée au IVe siècle* (Paris 1924).

EA—Arndt, P., and W. Amelung, *Photographische Einzelaufnahmen antiker Skulpturen* (Munich 1893–1940).

Edwards, "Votive Reliefs to Pan"—Edwards, C. M., "Greek Votive Reliefs to Pan and the Nymphs" (Ph.D. diss., New York University, 1985).

Favaretto et al., *Museo Archeologico Nazionale di Venezia*—Favaretto, I., M. De Poli, and M. C. Dossi, eds., *Museo Archeologico Nazionale di Venezia* (Milan 2004).

FdX—*Fouilles de Xanthos*

FGrHist—Jacoby, F., *Fragmente der griechischen Historiker* (Berlin 1923–).

Fittschen, *Griechische Porträts*—*Griechische Porträts*, ed. K. Fittschen (Darmstadt 1988).

Flashar, *Apollon Kitharodos*—Flashar, M., *Apollon Kitharodos: Statuarische Typen des musischen Apollon*, Arbeiten zur Archäologie (Cologne 1992).

Ford, *Origins of Criticism*—Ford, A. L., *The Origins of Criticism: Literary Culture and Poetic Theory in Classical Greece* (Princeton 2002).

Furtwängler, *Masterpieces*—Furtwängler, A., *Masterpieces of Greek Sculpture: A Series of Essays on the History of Art*, trans. E. Sellers (New York 1895); repr. with omissions, ed. A. N. Oikonomides (Chicago 1964).

Furtwängler, *Meisterwerke*—Furtwängler, A., *Meisterwerke der griechischen Plastik* (Leipzig 1893).

Gazda, *Emulation*—*The Ancient Art of Emulation: Studies in Artistic Originality and Tradition from the Present to Classical Antiquity*, ed. E. K. Gazda (Ann Arbor 2002).

Geominy, "Daochos Monument"—Geominy, W., "The Daochos Monument at Delphi: The Style and Setting of a Family Portrait in Historic Dress," in *Early Hellenistic Portraiture: Image, Style, Context*, ed. P. Schultz and R. von den Hoff (Cambridge 2007) 84–98.

Geominy, *Niobiden*—Geominy, W., *Die florentiner Niobiden*, 2 vols. (Bonn 1984).

Gercke and Zimmermann-Elseify, *Bestandskatalog Kassel*—Gercke, P., and N. Zimmermann-Elseify, *Antike Steinskulpturen und neuzeitliche Nachbildungen in Kassel: Bestandskatalog* (Mainz 2007).

Ginouvès, *Balaneutikè*—Ginouvès, R., *Balaneutikè: Recherche sur le bain dans l'antiquité grecque*, BÉFAR 200 (Paris 1962).

Giuliano, *MNR*—Giuliano, A., ed., *Museo Nazionale Romano: Le sculture*, 13 vols. (Rome 1979–95).

Gschwantler, *Zeuxis und Parrhasios*—Gschwantler, K., *Zeuxis und Parrhasios: Ein Beitrag zur antiken Künstlerbiographie*, Dissertationen der Universität Graz 29 (Vienna 1975).

Gulaki, *Nikedarstellungen*—Gulaki, A., *Klassische und klassizistische Nikedarstellungen: Untersuchungen zur Typologie und zum Bedeutungswandel* (Bonn 1981).

Güntner, *Göttervereine*—Güntner, G., *Göttervereine und Götterversammlungen auf attischer Weihreliefs: Untersuchung zur Typologie und Bedeutung*, Beiträge zur Archäologie 21 (Würzburg 1994).

Hamdy Bey and Reinach, *Nécropole royale*—Hamdy Bey, O., and T. Reinach, *Une nécropole royale à Sidon: Fouilles de Hamdy Bey* (Paris 1892).

Hamiaux, *Sculptures grecques*—Hamiaux, M., *Les sculptures grecques*, vol. 1, *Des origines à la fin du IVe siècle avant J.-C.*, Musée du Louvre, Départment des antiquités grecques, étrusques et romaines (Paris 1992).

Havelock, *Aphrodite of Knidos*—Havelock, C. M., *The Aphrodite of Knidos and Her Successors: A Historical Review of the Female Nude in Greek Art* (Ann Arbor 1995).

Helbig[4]—Helbig, W., *Führer durch die öffentlichen Sammlungen klassischer Altertümer in Rom*, 4th ed. (Tübingen 1963–72).

Himmelmann, *Ausruhende Herakles*—Himmelmann, N., *Der ausruhende Herakles*, Nordrhein-Westfälische Akademie der Wissenschaften und der Künste, Geisteswissenschaften, Vorträge G 420 (Paderborn 2009).

Himmelmann, *Reading Greek Art*—Himmelmann, N., *Reading Greek Art: Essays by Nikolaus Himmelmann*, ed. W. A. P. Childs and H. Meyer (Princeton 1998).

Himmelmann, *Realistische Themen*—Himmelmann, N., *Realistische Themen in der griechischen Kunst der archaischen und klassischen Zeit*, JdI-EH 28 (Berlin 1994).

Hofkes-Brukker and Mallwitz, *Bassai-Fries*—Hofkes-Brukker, C., and A. Mallwitz, *Der Bassai-Fries* (Munich 1975).

Houser, *Bronze Sculpture*—Houser, C., *Greek Monumental Bronze Sculpture of the Fifth and Fourth Centuries B.C.* (New York 1987).

IG—*Inscriptiones Graecae* (Berlin 1873–).

Kaltsas, *SNAMA*—Kaltsas, N., *Sculpture in the National Archaeological Museum, Athens*, trans. D. Hardy (Los Angeles 2002).

Knell, *Athen im 4. Jahrhundert*—Knell, H., *Athen im 4. Jahrhundert v. Chr., eine Stadt verändert ihr Gesicht: Archäologisch-kulturgeschichtliche Betrachtungen* (Darmstadt 2000).

Knittlmayer and Heilmeyer, *Antikensammlung Berlin*[2]—Knittlmayer, B., and W.-D. Heilmeyer, *Die Antikensammlung: Altes Museum, Pergamonmuseum*, Staatliche Museen zu Berlin, 2nd ed. (Mainz 1998).

Knoll, Vorster, and Woelk, *Katalog Dresden*—Knoll, K., C. Vorster, and M. Woelk, *Staatliche Kunstsammlungen Dresden, Skulpturensammlung: Katalog der antiken Bildwerke*, vol. 2, *Idealskulptur der römischen Kaiserzeit* (Munich 2011).

Knoll et al., *Antiken im Albertinum*—Knoll, K., et al., *Die Antiken im Albertinum: Staatliche Kunstsammlungen Dresden; Skulpturensammlung*, Zaberns Bildbände zur Archäologie 13 (Mainz 1993).

Koch-Brinkmann, *Polychrome Bilder*—Koch-Brinkmann, U., *Polychrome Bilder griechischen Malerei*, Studien zur antiken Malerei und Farbgebung 4 (Munich 1999).

Kosmopoulou, *Statue Bases*—Kosmopoulou, A., *The Iconography of Sculptured Statue Bases in the Archaic and Classical Periods*, Wisconsin Studies in Classics (Madison, WI, 2002).

Landwehr, *Gipsabgüsse*—Landwehr, C., *Die antiken Gipsabgüsse aus Baiae: Griechische Bronzestatuen in Abgüssen römischer Zeit*, AF 14 (Berlin 1985).

Lawton, *Document Reliefs*—Lawton, C. L., *Attic Document Reliefs: Art and Politics in Ancient Athens*, Oxford Monographs on Classical Archaeology (Oxford 1995).

LIMC—*Lexicon Iconographicum Mythologiae Classicae* (Zurich 1981–99).

Lippold, *Griechische Plastik*—Lippold, G., *Die griechische Plastik*, Handbuch der Archäologie, vol. 3, pt. 1 (Munich 1950).

Löhr, *Familienweihungen*—Löhr, C., *Griechische Familienweihungen: Untersuchungen einer Repräsentationsform von ihren Anfängen bis zum Ende des 4. Jhs. v. Chr.*, Internationale Archäologie 54 (Rahden, Westphalia, 2000).

Lullies and Hirmer, *Greek Sculpture*[2]—Lullies, R., and M. Hirmer, *Greek Sculpture*, 2nd ed. (New York 1960).

Lygkopoulos, *Untersuchungen*—Lygkopoulos, T., *Untersuchungen zur Chronologie der Plastik des 4. Jhs. v. Chr.*, Dissertation, Rheinische-Friedrich-Wilhelms-Universität zu Bonn, 1982 (Bonn 1983).

Madigan, *Apollo Bassitas*—Madigan, B. C., *The Temple of Apollo Bassitas*, vol. 2, *The Sculpture*, ed. F. A. Cooper (Princeton 1992).

Mansuelli, *Uffizi*—Mansuelli, G. A., *Galleria degli Uffizi: Le sculture*, vol. 1, Cataloghi dei musei e gallerie d'Italia (Rome 1958).

Metzger, *Répresentations*—Metzger, H., *Les représentations dans la céramique attique du IVe siècle*, BÉFAR 172 (Paris 1951).

Meyer, *Urkundenreliefs*—Meyer, M., *Die griechischen Urkundenreliefs*, AM-BH 13 (Berlin 1989).

Mitropoulou, *Votive Reliefs*—Mitropoulou, E., *Corpus I, Attic Votive Reliefs of the 6th and 5th Centuries B.C.* (Athens 1977).

Moltesen, *Classical Period*—Moltesen, M., et al., *Greece in the Classical Period: Ny Carlsberg Glyptotek* (Copenhagen 1995).

Moreno, *Lisippo*—Moreno, P., *Lisippo: L'arte e la fortuna*, exh. cat. (Rome 1995).

Neumann, *Weihreliefs*—Neumann, G., *Probleme des griechischen Weihreliefs*, Tübinger Studien zur Archäologie und Kunstgeschichte 3 (Tübingen 1979).

Oberleitner, *Heroon von Trysa*—Oberleitner, W., *Das Heroon von Trysa: Ein lykisches Fürstengrab des 4. Jahrhunderts v. Chr.*, AntW 25, Sondernummer (Mainz 1994).

Overbeck, *Schriftquellen*—Overbeck, J., *Die antiken Schriftquellen zur Geschichte der bildenden Künste bei den Griechen* (Leipzig 1868; repr. Hildesheim 1971).

Palagia, *Euphranor*—Palagia, O., *Euphranor*, Monumenta Graeca et Romana 3 (Leiden 1980).

Palagia and Pollitt, *Personal Styles*—Palagia, O., and J. J. Pollitt, eds., *Personal Styles in Greek Sculpture*, YCS 30 (Cambridge 1996).

Paralipomena—Beazley, J. D., *Paralipomena: Additions to Attic Black-Figure Vase-Painters and to Attic Red-Figure Vase-Painters* (Oxford 1971).

Pasquier and Martinez, *Praxitèle*—*Praxitèle*, exh. cat., ed. A. Pasquier and J.-L. Martinez (Paris 2007).

Paul-Zinserling, *Jena-Maler*—Paul-Zinserling, V., *Der Jena-Maler und sein Kreis: Zur Ikonologie einer attischen Schalenwerkstatt um 400 v. Chr.* (Mainz 1994).

Picard, *Delphes: Le musée*—Picard, O., ed., *Guide de Delphes: Le musée*, École française d'Athènes, Sites et monuments 6 (Paris 1991).

Picard, *Manuel*—Picard, C., *Manuel d'archéologie grecque: La sculpture*, vol. 3, *Période classique, IVe siècle*, pt. 1 (Paris 1948); vol. 4, *Période classique, IVe siècle*, pt. 2 (Paris 1954–63).

Pollitt, *Ancient View*—Pollitt, J. J., *The Ancient View of Greek Art: Criticism, History, and Terminology* (New Haven, CT, 1974).

Pollitt, *Art of Greece*—Pollitt, J. J., *The Art of Greece, 1400–31 B.C.*, Sources and Documents in the History of Art (Englewood Cliffs, NJ, 1965).

Pouilloux, *FdD 2.C.2*—Pouilloux, J., *Fouilles de Delphes*, vol. 2, *Topographie et architecture*, pt. C, *Divers*, fasc. 2, *La région nord du sanctuaire, de l'époque archaïque à la fin du sanctuaire* (Paris 1960).

Pouilloux, *FdD 3.4*—Pouilloux, J., *Fouilles de Delphes*, vol. 3, *Épigraphie*, fasc. 4, *Les inscriptions de la terrasse du temple et de la région nord du sanctuaire: Nos. 351 à 516* (Paris 1976).

Poulsen, *Catalogue*—Poulsen, F., *Catalogue of Ancient Sculpture in the Ny Carlsberg Glyptotek* (Copenhagen 1951).

Rausa, *Vincitore*—Rausa, F., *L'immagine del vincitore: L'atleta nella statuaria greca dall'età arcaica all'ellenismo*, Ludica 2 (Treviso and Rome 1994).

Rhodes and Osborne, *Greek Historical Inscriptions*—Rhodes, P. J., and R. Osborne, *Greek Historical Inscriptions: 404–323 BC* (Oxford 2003).

Richter, *Catalogue*—Richter, G. M. A., *Catalogue of Greek Sculptures (Metropolitan Museum of Art)* (Cambridge, MA, 1954).

Richter, *Portraits*—Richter, G. M. A., *The Portraits of the Greeks*, 3 vols. (London 1965–72).

Richter and Smith, *Portraits*—Richter, G. M. A., and R. R. R. Smith, *The Portraits of the Greeks* (Ithaca, NY, 1984).

Ridgway, *Fifth Century Styles*—Ridgway, B. S., *Fifth Century Styles in Greek Sculpture* (Princeton 1981).

Ridgway, *Fourth-Century Styles*—Ridgway, B. S., *Fourth-Century Styles in Greek Sculpture*, Wisconsin Studies in Classics (Madison, WI, 1997).

Ridgway, *Hellenistic Sculpture*—Ridgway, B. S., *Hellenistic Sculpture*, Wisconsin Studies in Classics: vol. 1, *The Styles of ca. 331–200 B.C.* (Madison, WI, 1990); vol. 2, *The Styles of ca. 200–100 B.C.* (Madison, WI, 2000); vol. 3, *The Styles of ca. 100–31 B.C.* (Madison, WI, 2002).

Ridgway, *Roman Copies*—Ridgway, B. S., *Roman Copies of Greek Sculpture: The Problem of the Originals*, Jerome Lectures, 15th series (Ann Arbor 1984).

Robertson, *Vase-Painting*—Robertson, M., *The Art of Vase-Painting in Classical Athens* (Cambridge 1992).

Rodenwaldt, *Θεοὶ ῥεῖα*—Rodenwaldt, G., *Θεοὶ ῥεῖα ζώοντες*, AbhBerl 1943, no. 13 (Berlin 1943).

Rolley, *Sculpture grecque*—Rolley, C., *La sculpture grecque*, vol. 2, *La période classique* (Paris 1999).

Rouveret, *Histoire et imaginaire*—Rouveret, A., *Histoire et imaginaire de la peinture ancienne: Ve siècle av. J.C.–Ier siècle ap. J.C.*, BÉFAR 274 (Rome 1989).

Rügler, *Columnae caelatae*—Rügler, A., *Die Columnae caelatae des jüngeren Artemisions von Ephesos*, IstMitt-BH 34 (Tübingen 1988).

Saatsoglou-Paliadeli, *Τάφος του Φιλίππου*—Saatsoglou-Paliadeli, C., *Βεργίνα· Ο τάφος του Φιλίππου· Η τοιχογραφία με το κυνήγι*, Bibliothiki tis en Athenais Archaiologikis Hetaireias 231 (Athens 2004).

Salzmann, *Kieselmosaiken*—Salzmann, D., *Untersuchungen zu den antiken Kieselmosaiken: Von den Anfängen bis zum Beginn der Tesseratechnik*, AF 10 (Berlin 1982).

SBFrankfurt—*Sitzungsberichte der Wissenschaftlichen Gesellschaft an der Johann-Wolfgang-Goethe-Universität Frankfurt am Main*

Scanlon, *Eros and Greek Athletics*—Scanlon, T. F., *Eros and Greek Athletics* (Oxford 2002).

Scheer, *Gottheit*—Scheer, T. S., *Die Gottheit und ihr Bild: Untersuchungen zur Funktion griechischer Kultbilder in Religion und Politik*, Zetemata 105 (Munich 2000).

Schefold, *KV*—Schefold, K., *Kertscher Vasen*, Bilder griechischer Vasen 3 (Berlin 1930).

Schefold, *UKV*—Schefold, K., *Untersuchungen zu den kertscher Vasen*, Archäologische Mitteilungen aus russischen Sammlungen 4 (Berlin and Leipzig 1934).

Scheibler, *Griechische Malerei*—Scheibler, I., *Griechische Malerei der Antike* (Munich 1994).

Schlörb, *Timotheos*—Schlörb, B., *Timotheos*, JdI-EH 22 (Berlin 1965).

Schmaltz, *Griechische Grabreliefs*—Schmaltz, B., *Griechische Grabreliefs*, Erträge der Forschung 192 (Darmstadt 1983).

Schultz, "Argead Portraits"—Schultz, P., "Leochares' Argead Portraits in the Philippeion," in *Early Hellenistic Portraiture: Image, Style, Context*, ed. P. Schultz and R. von den Hoff (Cambridge 2007) 205–33.

SIG—Dittenberger, W., *Sylloge Inscriptionum Graecarum* (Leipzig 1883–).

Sjöqvist, "Lysippus"—Sjöqvist, E., "Lysippus: I, Lysippus' Career Reconsidered; II, Some Aspects of Lysippus' Art," in *Lectures in Memory of Louise Taft Semple, Second Series*, ed. C. G. Boulter et al., University of Cincinnati Classical Studies 2 (Norman, OK, 1973) 1–50.

Smith, *Polis and Personification*— Smith, A. C., *Polis and Personification in Classical Athenian Art*, Monumenta Graeca et Romana 19 (Leiden 2011).

Stafford, *Worshipping Virtues*—Stafford, E., *Worshipping Virtues: Personification and the Divine in Ancient Greece* (London 2000).

StConserv—*Studies in Conservation = Études de conservation*

Steiner, *Images in Mind*—Steiner, D. T., *Images in Mind: Statues in Archaic and Classical Greek Literature and Thought* (Princeton 2001).

Steinhauer, *Μουσείο Πειραιώς*—Steinhauer, G., *Το Αρχαιλοκιγικό Μουσείο Πειραιώς* (Athens 2001).

Stewart, *Greek Sculpture*—Stewart, A. F., *Greek Sculpture: An Exploration* (New Haven, CT, 1990).

Stewart, *Skopas*—Stewart, A. F., *Skopas of Paros* (Park Ridge, NJ, 1977).

Stucky, *Tribune d'Echmoun*—Stucky, R. A., *Tribune d'Echmoun: Ein griechischer Relief-zyklus des 4. Jahrhunderts v. Chr. in Sidon, AntK-BH* 13 (Basel 1984).

Süsserott, *Griechische Plastik*—Süsserott, H. K., *Griechische Plastik des 4. Jahrhunderts vor Christus: Untersuchungen und Zeitbestimmung* (Frankfurt 1938).

Thompson and Wycherley, *Athenian Agora* 14—Thompson, H. A., and R. E. Wycherley, *The Athenian Agora*, vol. 14, *The Agora of Athens: The History, Shape and Uses of an Ancient City Center* (Princeton 1972).

Todisco, *Scultura greca*—Todisco, L., *Scultura greca del IV secolo: Maestri e scuole di statuaria tra classicità ed ellenismo*, Repertori fotografici Longanesi 8 (Milan 1993).

Traversari, *Sculture del V°–IV° secolo*—Traversari, G., *Sculture del V°–IV° secolo A.C. del Museo archeologico di Venezia*, Collezioni e musei archeologici del Veneto (Venice 1973).

Travlos, *Pictorial Dictionary*—Travlos, J., *Pictorial Dictionary of Ancient Athens* (London 1971).

Valavanis, *Παναθηναϊκοί αμφορείς*—Valavanis, P., *Παναθηναϊκοί αμφορείς από την Ερέτρια· Συμβολή στην Αττική αγγειογραφία του 4ου π.Χ. αι.*, Bibliothiki tis en Athenais Archaiologikis Hetaireias 122 (Athens 1991).

van Straten, "Gifts for the Gods"—van Straten, F. T., "Gifts for the Gods," in *Faith, Hope and Worship: Aspects of Religious Mentality in the Ancient World*, ed. H. S. Versnel (Leiden 1981) 65–151.

van Straten, *Hierà Kalá*—van Straten, F. T., *Hierà Kalá: Images of Animal Sacrifice in Archaic and Classical Greece*, Religions in the Graeco-Roman World 127 (Leiden 1995).

Vierneisel-Schlörb, *Klassische Skulpturen*—Vierneisel-Schlörb, B., *Glyptothek München, Katalog der Skulpturen*, vol. 2, *Klassische Skulpturen* (Munich 1979).

Waywell, *Free-Standing Sculptures*—Waywell, G. B., *The Free-Standing Sculptures of the Mausoleum at Halicarnassus in the British Museum* (London 1978).

Webster, *Art and Literature*—Webster, T. B. L., *Art and Literature in Fourth-Century Athens* (London 1956).

Wilson, *Khoregia*—Wilson, P., *The Athenian Institution of the Khoregia: The Chorus, the City and the Stage* (Cambridge 2000).

Worman, *Cast of Character*—Worman, N. B., *The Cast of Character: Style in Greek Literature* (Austin, TX, 2002).

Zanker, *Klassizistische Statuen*—Zanker, P., *Klassizistische Statuen: Studien zur Veränderung des Kunstgeschmacks in der römischen Kaiserzeit* (Mainz 1974).

Museum Abbreviations

Athens, Acrop.—Athens, Acropolis Museum

Athens, Agora—Athens, Agora Museum

Athens, EM—Athens, Epigraphical Museum

Athens, Kerameikos—Athens, Kerameikos Museum

Athens, NAM—Athens, National Archaeological Museum

Basel, Antikensammlung—Basel, Antikensammlung und Sammlung Ludwig

Berlin, Staatl. Mus.—Berlin, Staatliche Museen zu Berlin-Preußischer Kulturbesitz, Antikensammlung

Bonn, AKM—Bonn, Akademische Kunstmuseum, Universität Bonn

Boston, MFA—Boston, Museum of Fine Arts

Copenhagen, NCG—Copenhagen, Ny Carlsberg Glyptotek

Dresden, SKD—Dresden, Staatliche Kunstsammlungen Dresden, Skulpturensammlung

Florence, MAN—Florence, Museo Archeologico Nazionale

Frankfurt, Liebieghaus—Frankfurt am Main, Liebieghaus Skulpturensammlung

Kassel, MHK—Kassel, Museumslandschaft Hessen Kassel, Antikensammlung

London, BM—London, British Museum

Malibu, Getty—Malibu, J. Paul Getty Museum

Munich, Glyptothek—Munich, Glyptothek und Staatliche Antikensammlungen München

Naples, MAN—Naples, Museo Archeologico Nazionale

New York, MMA—New York, Metropolitan Museum of Art

Oxford, Ashmolean—Oxford, Ashmolean Museum of Art and Archaeology, University of Oxford

Paris, Louvre—Paris, Musée du Louvre

Rome, MNR—Rome, Museo Nazionale Romano

Rome, Villa Giulia—Rome, Museo Nazionale Etrusco di Villa Giulia

Ruvo, MAN Jatta—Ruvo, Museo Archeologico Nazionale Jatta

Toronto, ROM—Toronto, Royal Ontario Museum

Vatican—Rome, Musei Vaticani

Venice, MAN—Venice, Museo Archeologico Nazionale

Vienna, KHM—Vienna, Kunsthistorisches Museum, Antikensammlung

Würzburg—Würzburg, Martin von Wagner Museum der Universität Würzburg

Greek Art and Aesthetics

in the Fourth Century B.C.

1 Introduction

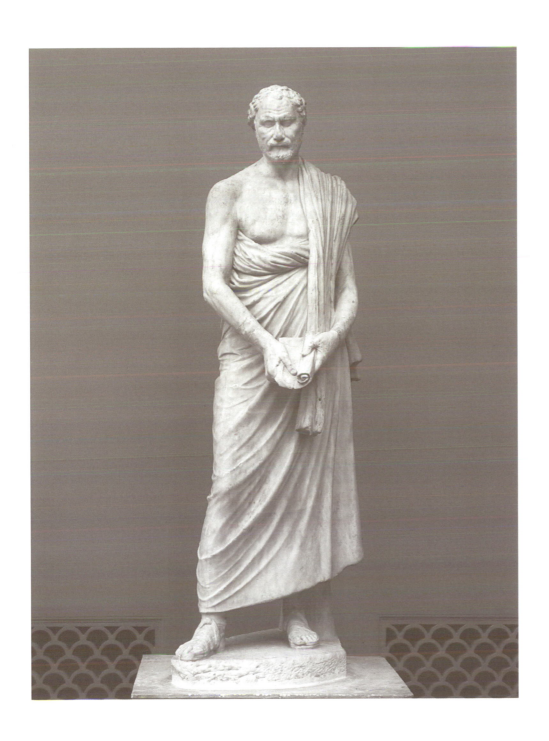

Social unrest and even revolution, war, new foreign cults, exports and travel on a larger scale than ever before, prosperity in general and conspicuous wealth of a few—these describe Greece in the fourth century B.C., and they are, coincidentally, not unfamiliar characteristics of the recent past of western European history. The appearance of a plethora of studies of Greece of the fourth century B.C. over the last few decades can only reflect our familiarity with and sympathy for the issues of that century, which not a hundred years ago, and sometimes still today, was considered to mark the beginning of the end of classical Greek civilization, which had reached its apogee with the completion of the Parthenon in 432 B.C. Although such a value judgment may seem insensitive, the contemporary sympathy for the fourth century and the recent past's condemnation of it may actually not be mutually exclusive. In 1943, Gerhard Rodenwaldt had already identified one of the principal difficulties in dealing with the art of the fourth century: it appears ambiguous and open to too great a range of subjective responses to fit neatly into the structures of modern scholarship.[1] Rodenwaldt chronicled briefly the great swings between appreciation and denigration of fourth-century sculpture from the late nineteenth century to his time. We can add that it is not only the art of the fourth century that has experienced such strong vicissitudes, but the fourth century in all its aspects—literature, politics, trade, war, even philosophy, for the word "sophistry" has become a modern term for erudite nonsense, and the fourth century B.C. is the century of the sophist. The negative cast of so much of modern interpretation is fostered by the Greeks of the fourth century themselves. One can hardly read a text of the period that does not contrast the greatness of the fifth century with the dismal present,[2] and Plato and Aristotle have nothing but contempt for their contemporary colleagues.[3] The impression these observations give is misleading because each writer, particularly the orators speaking before a jury, had a particular axe to grind.[4] Even a casual reading of the speeches gives the impression that the orators use the fifth century in a manner similar to Pindar's use of heroic mythology in his epinician odes, which makes one wary of accepting the pessimistic rhetoric at face value.[5]

[1] G. Rodenwaldt, Θεοὶ ῥεῖα ζώοντες, AbhBerl 1943, no. 13 (Berlin 1943). L. Burn, *The Meidias Painter* (Oxford 1987) 1–3, describes the vicissitudes of Attic vase painting, particularly the condemnation by J. D. Beazley and others in the first half of the twentieth century of the flamboyant style of the Meidias Painter and his associates. See generally J. de Romilly, *La modernité d'Euripide* (Paris 1986).

[2] K. Jost, *Das Beispiel und Vorbild der Vorfahren bei den attischen Rednern und Geschichtschreibern bis Demosthenes* (Paderborn 1936); G. Schmitz-Kahlmann, *Das Beispiel der Geschichte im politischen Denken des Isokrates*, *Philologus* suppl. 31.4 (Leipzig 1939); M. Nouhaud, *L'utilisation de l'histoire par les orateurs attiques* (Paris 1982).

[3] E.g., Plato, *Politikos* 299b: ἀδολέσχην τινὰ σοφιστὴν; Aristotle, *Nikomachean Ethics* 1.9.20. Plato, *Gorgias* 503b–c, 516d–e, has Kallikles denigrate contemporary politicians in favor of those of the fifth century, but Sokrates rejects his assessment of the past.

[4] S. Todd, "The Use and Abuse of Attic Orators," *GaR* 37 (1990) 158–78.

[5] Aischines, *On the Embassy* (II) 74, even remarks on this use of the past by "popular" speakers to sway the Athenian *demos*.

Arnold von Salis, in his general study of Greek art, suggested that the Medusa Rondanini might serve as an appropriate head-of-chapter vignette for his treatment of the late fifth and fourth centuries.[6] This is particularly the case for my own inquiry, since a reasonable interpretation of the Medusa Rondanini is that it is a Roman classicistic work based on the development of the beautiful Medusa in the second half of the fifth century. As a possible Roman work, the Medusa reflects the fact that so many of the statues of the fourth century are known only in Roman copies, which are increasingly considered less and less to be copies, and more and more to be Roman ideal sculpture. The very idea of the beautiful Medusa is also symptomatic of the period because it runs contrary to the normal interpretation of the figure as a horrible, death-bringing monster. The impassive face, the little wings, and the luxuriant hair convey the extraordinary ambivalence of the art and culture of what I shall loosely term the Late Classical period, from roughly 420 to 300 B.C.

There is, of course, definitely some truth to the impression of a crisis as the fourth century proceeds. After all, the conquest of Greece by Philip of Macedon and the eventual formation of the Hellenistic monarchies bring to an end the experiments with democracy.[7] Yet the structure of the Greek city-state can be considered vastly less important than the achievements of perspective it had fostered, which endured. Indeed, I shall argue, along with many recent historians, that the fourth century does not represent a period of decline or a sharp break with the hallowed golden age of the fifth century;[8] rather, the century develops earlier patterns into new configurations of importance. It is for that reason that the upper boundary of my study encompasses the last quarter of the fifth century and at times requires still earlier excurses. It is also difficult to establish a terminal date; the patterns on which I focus led to a world defined by the eastern conquests of Alexander the Great and the Hellenistic monarchies. Yet it is worth reflecting at the outset on the longstanding and intimate relations of the Greeks with their eastern neighbors. Greek culture had developed out of the eastern cultures, and the two shared a basic matrix of values and perspectives in the Late Bronze Age and again from the ninth through the seventh century B.C. In the two hundred years between 600 and 400 B.C., the Greeks developed their own distinctive culture, which we generally call classical civilization. Contact with and fertilization from the East had, in fact, never ceased, neither in the Early Iron Age, from 1000 to 900 B.C., nor later in the Archaic and Classical periods, from 600 to 400. On initial view, what is most distinctive of the fourth century is the export to the east, and indeed throughout the Mediterranean, of a cultural perspective that is most clearly visible in the concrete representation of the human form in sculpture and painting, but is equally discernible in thought and politics. Although the city-state was the vehicle of this cultural revolution of the world, it could not have sustained it.

This book does not attempt to document the eastern adventure of the fourth century, nor to present studies of all aspects of Greek culture in the period, though both play a

[6] A. von Salis, *Die Kunst der Griechen* (Zurich 1953) 156–57. Munich, Glyptothek 252: B. Vierneisel-Schlörb, *Glyptothek München, Katalog der Skulpturen*, vol. 2, *Klassische Skulpturen* (Munich 1979) 62–67, no. 7, figs. 31–35; Boardman, *GS-CP*, fig. 241.

[7] J. Pečírka, "The Crisis of the Athenian Polis in the Fourth Century B.C.," *Eirene* 9 (1976) 5–29. A. W. Gomme, "The End of the City-State," in *Essays in Greek History and Literature* (Oxford 1937) 204–27, points out that the Greek city-state really lasted until Roman dominion. But this begs the point that the city-state had become a bit player in the shadow of the monarchies. See also R. L. Fox, "Aeschines and Athenian Democracy," in *Ritual, Finance, Politics: Athenian Democratic Accounts Presented to David Lewis*, ed. R. Osborne and S. Hornblower (Oxford 1994) 154–55.

[8] Pečírka, *Eirene* 9 (1976) 5–29, is perhaps the most lucid on the subject; see also P. J. Rhodes, in *CAH*[2], vol. 6 (1994) 589–91; J. K. Davies, "The Fourth Century Crisis: What Crisis?" in *Die athenische Demokratie im 4. Jahrhundert v. Chr.: Vollendung oder Verfall einer Verfassungsform? Akten eines Symposiums, 3.–7. August 1992, Bellagio*, ed. W. Eder (Stuttgart 1995) 29–36.

role to varying degrees almost throughout the period. The center of my focus is plastic form and the general principles to be derived from the study of sculpture and painting. A central issue is that of aesthetics. The human form as depicted by Greek art has since the Renaissance been so thoroughly integrated into the modern western European sensibility that it has been considered a standard. The gradual broadening of western European knowledge of earlier Mediterranean and non-Mediterranean cultures has only recently begun to render the Greek standard precarious.

The word "aesthetics" was invented by a German, Alexander Gottlieb Baumgarten, in the early eighteenth century to isolate the formal qualities of an object from its content.[9] It is a commonplace to assert that it was the Greeks who first discovered the aesthetic function of objects and thus invented "art," and this occurred in the fourth century B.C. As with all commonplace observations, there is an element of truth in this proposition despite its obviously nonsensical general purport. Clearly, any plastic form has an aesthetic quality, through which in part the content is molded. What the Greeks appear to have done is to have recognized the role of form in expression and thereafter to have manipulated form to express ever more varied or subtle levels of content.[10] That this first happened in the fourth century is debatable, but aesthetic manipulation is, I shall argue, a primary characteristic of the period, even if the principles were recognized and developed earlier, as seems probable.

The aesthetic function of a Greek sculpture or painting must not blind us to the fact that almost all preserved sculptures—as well as most painting, whether on walls or pots—served a cultural-religious function not dissimilar to the role of "art" in earlier societies. Any reader of Pausanias, the author of a Greek guidebook of the later second century A.D., who tries to create a mental image of the great Greek sanctuaries he described must be impressed by the vast quantity, variety, and chaotic disposition of the votives Pausanias saw. Take, for example, the purportedly original statue of Prokne and Itys on the Acropolis of Athens, which Pausanias may have seen (1.24.3).[11] To the best of my knowledge, the statue (group) is depicted in modern studies only as an isolated, single "work of art."[12] Yet it stood in a sanctuary crammed with other statues, record stelai, and varied votives of pottery, metal, etc. The aesthetic isolation in which the modern viewer ideally contemplates the object was absent in antiquity.[13] An inscription regulating activity in the Asklepieion of Rhodes in the third century B.C. gives a vivid picture of how a Greek sanctuary was experienced at the time: "No one is permitted to request that an image be raised or some other votive offering set up in the lower part of the sanctuary... or in any other spot where votive offerings prevent people walking past."[14]

[9] *Meditationes Philosophicae de Nonnullis ad Poema Pertinentibus quas Amplissimi Philosophorum Ordinis* (Halle 1735), ed. and trans. K. Aschenbrenner and W. B. Holther as *Reflections on Poetry* (Berkeley 1954) § 116–17, with the explanatory observations of the editors on pp. 5–7, 30–31.

[10] J. J. Pollitt, *The Ancient View of Greek Art: Criticism, History, and Terminology* (New Haven, CT, 1974) 28–31.

[11] Athens, Acrop. 1358 + 2789: M. S. Brouskari, *The Acropolis Museum: A Descriptive Catalog*, trans. J. Binder (Athens 1974) 165–66, fig. 351; R. E. Wycherley, "Pausanias and Praxiteles," in *Studies in Athenian Architecture, Sculpture, and Topography Presented to Homer A. Thompson*, Hesperia suppl. 20 (Princeton 1982) 190 and note 12.

[12] E.g., most recently, J. M. Hurwit, *The Athenian Acropolis* (Cambridge 1999) fig. 178 on p. 207.

[13] D. Harris, "Bronze Statues on the Athenian Acropolis: The Evidence of a Lycurgan Inventory," *AJA* 96 (1992) 637–52; see also N. Himmelmann, *Utopische Vergangenheit: Archäologie und Moderne Kultur* (Berlin 1976), selections of which were published in an English translation by D. Dietrich, "The Utopian Past: Archaeology and Modern Culture," in N. Himmelmann, *Reading Greek Art: Essays by Nikolaus Himmelmann*, ed. W. A. P. Childs and H. Meyer (Princeton 1998) 237–98.

[14] F. Sokolowski, *Lois sacrées des cités grecques: Supplément* (Paris 1962) 175–76, no. 107, lines 10–18; translation by F. T. van Straten in "Gifts for the Gods," in *Faith, Hope and Worship: Aspects of Religious Mentality in the Ancient World*, ed. H. S. Versnel (Leiden 1981) 78.

One might compare the contemporary hordes of visitors to the old Acropolis Museum, should they be turned into bronze and marble, to the distracting chaos of the ancient sanctuary. An initial attempt to control the context of statues is evident in the fourth century, when enclosures for statue groups become frequent, but it is only in the Roman period that sculpture is arranged in great visual compositions in which the individual work becomes an aesthetic unit, though generally not in the pristine isolation of a modern photograph but as part of a conscious structure with a determined content.[15] The appreciation of Greek art in the modern world has definitely been skewed by the use to which it was put by the Romans because, more often than not, a work is preserved only in the form of a Roman copy in a Roman context. The problem has been compounded by the development in the nineteenth century of the concept of "art for art's sake." The study of Greek art, particularly as seen through Roman commentaries and Roman contexts, was all too easily interpreted in this romantic manner. But "art for art's sake" is not an ancient concept, neither Greek nor Roman. The very ambivalence of fourth-century objects—which served the traditional religious-social function of all art until the nineteenth century, but now clothed in an aesthetic expressive form—easily beguiled the modern eye into seeing what it expected or desired.

The baby must not be thrown out with the bathwater. The Greeks, particularly in the fourth century, do recognize and try to understand the function of aesthetics in the plastic forms of art. The earliest evidence of the conscious expressive function of aesthetics is found in the *Frogs* of Aristophanes[16] and the fragments of the sophist Gorgias.[17] Then the works of Plato wrestle with aesthetics over and over again, though again the disparaging criticism of Plato's apparent philistine attitude is an opinion of the early twentieth century.[18] It is no surprise that proponents of "art for art's sake" could not understand the effort Plato made to describe the function of aesthetics in art (plastic and literary) because they saw it as the sole function of art.[19] Plato's student, Aristotle, develops ideas first broached by Plato in a number of treatises that clearly define the importance given to expression in the fourth century. Here pride of place belongs to the *Poetics* and the *Rhetoric,* but also of great importance are the Aristotelian *Physiognomika* and Theophrastos's *Characters.* It is no exaggeration to say that the principles of representation are a central intellectual concern of the fourth century, and they are accordingly the focus of this study.

In keeping with the general modern impression of the period as an unappealing amorphousness, it is frequently claimed that the lack of a well-defined chronology for the monuments of the fourth century thwarts closer analysis of the art of the period.[20] Although more precision in dating has been gained in recent years for some monuments,

[15] P. Zanker, "Zur Funktion und Bedeutung griechischer Skulptur in der Römerzeit," in *Le classicisme à Rome aux 1ers siècles avant et après J.-C.,* Fondation Hardt, Entretiens sur l'antiquité classique 25, ed. H. Flashar (Geneva 1979) 283–316; Zanker, "Nachahmen als kulturelles Schicksal," in *Probleme der Kopie von der Antike bis zum 19. Jahrhundert: Vier Vorträge* (Munich 1992) 9–24; E. K. Gazda, "Roman Sculpture and the Ethos of Emulation: Reconsidering Repetition," *HSCP* 97 (1997) 131–33.

[16] B. Snell, "Aristophanes und die Ästhetik," chap. 7 of *Die Entdeckung des Geistes,* 3rd ed. (Hamburg 1955) 161–83; G. M. A. Grube, *The Greek and Roman Critics* (Toronto 1965) 22–32; E. A. Havelock, *The Literate Revolution in Greece and Its Cultural Consequences* (Princeton 1982) 268–92; N. O'Sullivan, *Alcidamas, Aristophanes, and the Beginnings of Greek Stylistic Theory* (Stuttgart 1992).

[17] Diels-Kranz, *Vorsokr.,* no. 82, II, pp. 271–307.

[18] R. Jenkyns, *The Victorians and Ancient Greece* (Cambridge, MA, 1980) 227–63.

[19] O. Wilde, "Lecture to Art Students," in *Art and Decoration: Being Extracts from Reviews and Miscellanies* (London 1920) 39–52.

[20] E.g., K. Fittschen, "Griechische Porträts: Zum Stand der Forschung," in *Griechische Porträts,* ed. K. Fittschen (Darmstadt 1988) 21.

such as the sarcophagi from the royal cemetery of Sidon,[21] very few significant changes have been made to earlier systems. Yet it is largely fallacious to claim that there is a greater lack of precision in the chronology of the fourth century than in earlier periods of Greek art. On the one hand, the number of securely dated works, contrary to common opinion, is quite large;[22] on the other hand, the chronology of monuments of earlier periods is far less secure than consensus maintains. My study will not, however, address the issue of chronology in its finer details; I shall content myself with sketching dates with a broad brush.

While the lack of a precise chronology of fourth-century monuments is a spurious reason for avoiding study of the period, there are some real problems that are largely, if not exclusively, new in the fourth century. For example, the role of the individual is conspicuously greater in the production of sculpture. This is true both for the commissioner and the artist. From about 430 on, there is an explosion of private monuments in the form of grave stelai, votive reliefs, and choregic monuments. These represent both the greater prosperity and the increasing importance of the individual as opposed to the community.[23] This is perhaps illustrated most graphically by the new practice in Athens of decreeing honorific statues of living men for service to the state, and in the proliferation of naturalistic statues as private votives. The fact that the names of individual masters dominate the literature on Greek art of the fourth century B.C. reflects the greater role of the varied expressive function of the monuments, again a shift from a common, communal perspective to a fragmented, subjective one. Yet I shall argue that the emphasis on the individual artist may have been exaggerated both in the ancient sources and in modern scholarship. Indeed, the role of the individual, both as commissioner and artist, is nothing new: signatures of artists appear as early as the late eighth century, as do inscriptions proclaiming dedications by individuals; these increase greatly in the seventh century and become common thereafter.[24] It is not even the range and quality of the fourth-century private monuments that distinguish them from their predecessors, since inexpensive dedications—pottery, small terracotta figurines, and miscellaneous minor items of daily life or trade—had always constituted the majority of dedications in sanctuaries. The principal change is the far greater use of stone in general and of bronze for portrait statues. This does reflect the greater value of even modest dedications in comparison to terracotta votives, but the difference in quality (and cost) between a small and poorly carved grave stele and a large and beautifully carved stele is probably no greater than the range that existed earlier. Part of the problem lies in the modern prejudice in favor of the material considered to be more noble (and expensive). But the modern prejudice appears also to have been shared by the people of the fourth century, as is amply documented by literary references to conspicuous private ostentation in the fourth century (e.g., Demosthenes, *Against Meidias* 158).

The role of the famous master is analogous to the role of the private commissioner. The number of master artists of the fourth century listed by Overbeck is more than double the number for the second half of the fifth century (86 sculptors versus 40, 58 painters versus 10); the number of passages is also greater, although not by the same proportion, at least

[21] O. Hamdy Bey and T. Reinach, *Une nécropole royale à Sidon: Fouilles de Hamdy Bey* (Paris 1892); J. C. Assmann, "Zur Baugeschichte des Königsgruft von Sidon," *AA*, 1963, cols. 690–716; H. Gabelmann, "Zur Chronologie der Königsnekropole von Sidon," *AA*, 1979, 163–77.

[22] See chap. 2, pp. 26–31 below.

[23] M. M. Austin, in *CAH²*, vol. 6 (1994) 557–58.

[24] M. L. Lang, "The Alphabetic Impact on Archaic Greece," in *New Perspectives in Early Greek Art*, Studies in the History of Art 32, ed. D. Buitron-Oliver (Washington, DC, 1991) 65–79.

for sculptors (504 passages on sculptors versus 424, but 304 passages on painters versus 95).[25] There is also a greater amount of detail in the citations: lists of works and, on occasion, some characterization of style. To be sure, part of the reason for this phenomenon lies in the fact that it was the Greek writers of the later fourth century, such as Xenokrates of Athens,[26] who produced the first commentaries on art and devoted the lion's share of their work to the artists of their time or of the immediately preceding period. Since hardly any of the original statues and none of the paintings are preserved, some scholars, such as Brunilde S. Ridgway, have argued quite reasonably against creating ephemeral corpora of works by named artists.[27] Yet the tradition, begun in the nineteenth century, has been too strong and too central to the manner of viewing the fourth century to be resisted.[28] It is also the oeuvres of named artists that have filled the void of chronological sequences in giving structure to the study of the fourth century.[29]

The ancient belief in the importance of individual masters in the art of the fourth century is so strong that it cannot be ignored completely. Yet the preserved monuments of sculpture do not provide sufficient evidence to confirm this belief; for the painters the issue is moot, since nothing at all is preserved. Perhaps a slightly different approach may help us understand the ancient emphasis on the role of the individual artist. On the one hand, it appears highly likely that the Roman desire to collect works of Greek art inspired many false attributions to great, known artists to enhance the market value of the works.[30] On the other hand, several of the central problems of the study of the fourth century mentioned above point to a more positive and constructive conclusion. The lack of an internally cohesive chronological framework for art in the fourth century points to the multiplicity of styles. From the Archaic period through the Rich Style, that is, from 600 to 380 B.C., style evolves in a Darwinian progression. Individual style is subordinate to period style, yet the identification of hands of sculptors in the Archaic period is usually accepted,[31] just as it is in Corinthian and Attic vase painting. Already in the later fifth century this system appears to break down.[32] The best explanation of the change is the increasing importance of style as a conscious expressive tool, as discussed above. Aesthetic quality is recognized as a tool

[25] J. Overbeck, *Die antiken Schriftquellen zur Geschichte der bildenden Künste bei den Griechen* (Leipzig 1868; repr. Hildesheim 1971) lists 40 sculptors, through Polykleitos the Younger, and 10 painters; 86 sculptors for the whole fourth century, through the followers of Lysippos, and 58 painters. The number of entries for each period is: classical sculptors: 424 [618–1041]; classical painting: 95 [1042–1136]; Late Classical sculptors: 504 [1137–1640]; Late Classical painting: 304 [1641–1980]. It is useful to note that Overbeck's great collection is in many respects an abbreviation of Franciscus Junius's seventeenth-century original: *The Literature of Classical Art*, vol. 1, *The Painting of the Ancients: De Pictura Veterum Libri Tres*, ed. K. Aldrich, P. Fehl, and R. Fehl (Berkeley 1991) lxxix–lxxx with note 129.

[26] B. Schweitzer, *Xenokrates von Athen: Beiträge zur Geschichte der antiken Kunstforschung und Kunstanschauung* (Halle 1932); repr. in Schweitzer, *Zur Kunst der Antike: Ausgewählte Schriften*, ed. U. Hausmann and H.-V. Herrmann (Tübingen 1963) vol. 1, 105–64.

[27] See principally B. S. Ridgway, *Roman Copies of Greek Sculpture: The Problem of the Originals* (Ann Arbor 1984), but her other books stress the same theme.

[28] O. Palagia and J. J. Pollitt, eds., *Personal Styles in Greek Sculpture* (Cambridge 1996). See the excellent assessment of the issues by M. D. Fullerton in his review in *BMCR* 97.9.22.

[29] Cf. comments by B. Schmaltz, *Griechische Grabreliefs*, 2nd ed. (Darmstadt 1993) 192–93, on critiques of the chronology of H. Diepolder, *Die attischen Grabreliefs des 5. und 4. Jahrhunderts v. Chr.* (Berlin 1931; repr. Darmstadt 1965).

[30] Bergmann, *HSCP* 97 (1995) 90–92; Ridgway, *Roman Copies*, 22–23; B. S. Ridgway, *Fourth-Century Styles in Greek Sculpture* (Madison, WI, 1997); E. Perry, "Forgery in the Early Roman Empire," *AJA* 99 (1995) 346 (paper abstract).

[31] For example, the groupings by H. Payne, *Archaic Marble Sculpture from the Acropolis* (London 1936; repr. New York 1950); C. Tsirivaku-Neumann, "Zum Meister der Peploskore," *AM* 79 (1964) 114–26; and W. Deyhle, "Meisterfragen der archaischen Plastik Attikas," *AM* 84 (1969) 1–64.

[32] A. Leibundgut, *Künstlerische Form und konservative Tendenzen nach Perikles: Ein Stilpluralismus im 5. Jahrhundert v. Chr.?* (Mainz 1989); B. S. Ridgway, *Fifth Century Styles in Greek Sculpture* (Princeton 1981).

of expression that allows a whole new range of subtle interpretations of a subject. This is made amply clear by Aristotle (*Rhetoric* 3.7.1–2):

> Propriety of style will be obtained by the expression of emotion and character, and by proportion to the subject matter. Style is proportionate to the subject matter when neither weighty matters are treated offhand, nor trifling matters with dignity, and no embellishment is attached to an ordinary word. (Trans. J. H. Freese, Loeb edition)

It is precisely the interpretive element of contemporary art that informs Plato's examination of poetry and the plastic arts—the triumph of the subjective over the communal vision, to exaggerate slightly. This is the essential phenomenon that altered the structure of the city-state, as Jan Pečírka proposed many years ago,[33] and the effect of reading written texts as opposed to public performances, as presented by Eric Havelock.[34] In the realm of sculpture, I shall argue that the role of the individual master lies in the choice of one of a number of possible expressive styles as the preponderant personal mode of interpreting and therefore rendering.[35] A style may accordingly become a characteristic of the oeuvre of an artist, but one shared with numerous other artists. When the Romans and probably even the later Hellenistic collectors built their collections, the market forces found it expedient to attribute any work in a given style to an artist who actually favored or excelled in the use of the style in question.

The fact that style was imbued with content is clearly illustrated by the use of archaistic motifs from the late fifth century on. Indeed, the vast influence of the style of the Parthenon sculptures on almost all works, large and small, during and after its construction demonstrates beyond a shadow of a doubt that the Greeks of the late fifth century and thereafter were, as Oscar Wilde pointed out, nascent art critics with an excellent sense of taste.[36] The aesthetic appeal of a work and the importance of an artist's commissions clearly guided the production of contemporary imitations. This has been recognized since the early work by Adolf Furtwängler on copies of Greek sculpture.[37] Though much of *Kopienkritik* has focused on the Roman propensity to vary known types to suit a variety of tastes and functions, it is clear that the Greeks of the later fifth and fourth centuries already reproduced famous works and styles with gay abandon.[38] The recognition of this is implicit in the numerous modern attributions of works to the schools of the great artists on no other basis than a general resemblance of a more or less "securely attributed" work to others that are unencumbered by any possible mention in the ancient sources, and it is explicit in the identification of more or less contemporary famous statues in the record reliefs and on vases, particularly the Panathenaic amphoras.[39]

[33] Note 7 above.

[34] Havelock, *Literate Revolution* (note 16 above) 266–67.

[35] W. A. P. Childs, "Stil als Inhalt statt als Künstlersignatur," in *Meisterwerke: Internationales Symposion anläßlich des 150. Geburtstages von Adolf Furtwängler, Freiburg im Breisgau, 30. Juni–3. Juli 2003*, ed. V. M. Strocka (Munich 2005) 235–41.

[36] O. Wilde, "The Critic as Artist: Part One," in *The Complete Works of Oscar Wilde* (London 1966; repr. London 1989) 1015ff.

[37] A. Furtwängler, *Meisterwerke der griechischen Plastik* (Leipzig 1893) (= A. Furtwängler, *Masterpieces of Greek Sculpture: A Series of Essays on the History of Art*, trans. E. Sellers [New York 1895]).

[38] F. Brommer, "Vorhellenistische Kopien und Wiederholungen von Statuen," in *Studies Presented to David Moore Robinson on His Seventieth Birthday*, ed. G. E. Mylonas (St. Louis, MO, 1951) vol. 1, 674–82; V. M. Strocka, "Variante, Wiederholung und Serie in der griechischen Bildhauerei," *JdI* 94 (1979) 143–73; S. Schmidt, "Über den Umgang mit Vorbildern: Bildhauerarbeit im 4. Jahrhundert v. Chr.," *AM* 111 (1997) 191–223; M. Gaifman, "Statue, Cult and Reproduction," *ArtH* 29 (2006) 258–79.

[39] N. Eschbach, *Statuen auf panathenäischen Preisamphoren des 4. Jhs. v. Chr.* (Mainz 1986); L. E. Baumer, *Vorbilder und Vorlagen: Studien zu klassischen Frauenstatuen und ihrer Verwendung für Reliefs und Statuetten des 5. und 4. Jahrhunderts vor Christus* (Bern 1997).

So much of our knowledge of the sculpture of the fourth century is, as just discussed, due to the great appreciation of the period in the Late Hellenistic and Roman periods. As has become evident in the preceding remarks, the Hellenistic and Roman copies must be treated as faithful reflections of the purported originals with some caution.[40] Yet this caution should not be taken to suggest a rejection of such copies as valuable evidence for my study. It is an undeniable fact that the Romans commissioned copies and adaptations principally of the sculpture produced between 480 and 300 B.C., the range of the works represented in the fragments of plaster casts found at Baiae.[41] The strong classical and classicistic revival of the Late Hellenistic period is boldly underscored by the Hellenistic Greek source for Pliny's comment (*NH* 34.19.51–52) that after Olympiad 121 (295–292 B.C.) "cessavit deinde ars ac rursus olympiade CLVI [156–153 B.C.] revixit."[42] The modern perception of a major change between High Classic and Late Classic does not appear to have been part of the Roman or even the Greek experience: Aristotle's *Poetics* makes no sharp break between the fifth and fourth centuries. Indeed, Plato's sole ideal is Egyptian art (*Laws* 2.656c–657a), which may be considered commensurate with the archaic style of Greek art.

Perhaps an important insight lies in the tacit Greek and Roman assessment of classical Greek sculpture as a continuous phenomenon worthy of being copied and adapted from beginning to end, without obvious predilection. The modern historian of classical art distinguishes not just two major stylistic phases between 450 and 300 B.C., but three and even four: High Classical, Rich Style, Late Classical, and often the beginning of the Hellenistic. The Rich Style is generally considered an aberrant phenomenon and sometimes as a psychological reaction to the horrors of the Peloponnesian War.[43] This is not the case, as I shall argue in detail. Rather, if we view Greek classical art as a continuous phenomenon, as it seems the Greeks themselves and the Romans did, the art of the fourth century becomes an integral part of a single expressive vocabulary.

In the sense proposed here, the word "classic" bears the meaning "worthy of admiration." It is an altogether different issue whether the content of the style remains constant or explores different views of human experience. The late commentaries on the classical masters give us some valuable information on the subjects they represented. In addition, the waning art of vase painting, at least on the Greek mainland and at Athens in particular, is invaluable in delineating both changing subject matter and new interpretations of old themes. Most noticeable and, I shall argue, characteristic of the fourth century is the clear movement away from depicting heroic myths, and particularly heroic battles, in favor of domestic scenes or at least apparently domestic scenes. This shift also affects the representation of the mythical heroes and gods in sculpture: Herakles stands pensively (**Fig. 176**), Aphrodite bathes (**Figs. 147–49**), Apollo kills a lizard (**Fig. 181**), satyrs rest (**Fig. 180**) or pour wine (**Fig. 68**) to no obvious end. As Rodenwaldt observed, we are more often than not in a quandary when confronting these statues and their ambiguous content. In the official public sphere, we can only speculate (and shall) on why an Amazon, evidently triumphant, occupies the center of the west pediment of the Temple of

[40] My position is essentially that of C. H. Hallett, "*Kopienkritik* and the Works of Polykleitos," in *Polykleitos, the Doryphoros, and Tradition*, ed. W. G. Moon (Madison, WI, 1995) 121–27.

[41] C. Landwehr, *Die antiken Gipsabgüsse aus Baiae: Griechische Bronzestatuen in Abgüssen römischer Zeit*, AF 14 (Berlin 1985). Cf. Ridgway, *Roman Copies*, 32–33.

[42] Cf. Pollitt, *Ancient View*, 27–28; A. A. Donohue, "Winckelmann's History of Art and Polyclitus," in Moon, *Polykleitos* (note 40 above) 343–44.

[43] J. J. Pollitt, *Art and Experience in Classical Greece* (Cambridge 1972) 111–14; A. F. Stewart, *Greek Sculpture: An Exploration* (New Haven, CT, 1990) chap. 14, "The Peloponnesian War and Its Legacy" (p. 114).

Asklepios at Epidauros (**Fig. 28**) or why the grave relief of Dexileos at Athens depicts the triumphant (but dead) Dexileos fully clothed on his horse rearing over a fallen and naked enemy (**Fig. 4**). In the earlier fifth century, Amazons were the stand-ins for the Persians and thus the implacable and barbarian enemy to be conquered; the epithets "triumphant" and "heroic" seem inappropriate. Male nudity had usually been reserved for the athlete and hero, whether in myth or contemporary life; again, it seems inappropriate to represent a fallen enemy nude.

These few examples give a tiny glimpse of the novelty of art in the fourth century. But there is also a change in the very types of monuments or, rather, a signal shift or development of earlier forms, such as the explosion of grave monuments in grand displays of family pride and wealth (**Figs. 86–89**). Marble votive reliefs also multiply from the last third of the fifth century and are sometimes mounted on high and massive pillars to enhance their display (**Figs. 91, 92**); the iconography more often than not is bewildering. Despite the grandeur of both the grave reliefs and the marble votive reliefs, the scenes depicted are of a thoroughly private, even domestic, character, contrasting the very public display with the intimate world of the family. These contrast with the semiprivate dedications of large and at times complex choregic monuments, that is, monuments to celebrate victory in one of the public dithyrambic contests, a tremendous vogue that gave its name to the Street of the Tripods in Athens. These again contrast with a new emphasis on the elaboration of what we traditionally call the minor arts: metal vessels and terracotta figurines, which become exquisite works of art (**Figs. 105, 107–11**). In short, there is much that is new, much that is a radical development of the old, and a general transformation of the patterns and nature of everything. It is, of course, no coincidence that political and social historians have come to a very similar evaluation of the fourth century, and it is greatly to our advantage to review ever so briefly their views.

THE BACKGROUND

In the simplest terms, our period begins with the completion of the Parthenon (432 B.C.) and the beginning of the Peloponnesian War (431 B.C.) between Athens and Sparta that ends in 404 with the ignominious defeat of Athens and the dismemberment of her empire. The salient character of the next one hundred years is more of the same: war, shifting alliances, ephemeral hegemonies, and inadequate treaties. At first Sparta exercised a general hegemony over Greece. Several peace treaties were concocted with the active participation of Persia; the first, indeed, formally recognized Persia's role in its name, the King's Peace of 387/6, which was periodically renewed on slightly different terms.[44] Thebes finally ended Sparta's dominance at the battle of Leuktra in 371 and was herself defeated nine years later at the battle of Mantineia in 362. Athens remained largely on the sidelines until the creation of her second league or federation in 378/7; this only faintly resembled the Delian League which had become her empire in the fifth century, since the relationship of the participating states was explicitly formulated to prevent the domination of Athens, as had occurred in the earlier league.[45] Nonetheless, the new league led in-

[44] R. Urban, *Der Königsfrieden von 387/86 v. Chr.: Vorgeschichte, Zustandekommen, Ergebnis und politische Umsetzung*, *Historia* Einzelschriften 68 (Stuttgart 1991); M. Jehne, *Koine Eirene: Untersuchungen zu den Befriedungs- und Stabilisierungsbemühungen in der griechischen Poliswelt des 4. Jahrhunderts v. Chr.*, *Hermes* Einzelschriften 63 (Stuttgart 1994).

[45] M. Dreher, *Hegemon und Symmachoi: Untersuchungen zum zweiten athenischen Seebund* (Berlin 1995).

evitably to an assertive hegemony, which came to an end with the Social War of 357–355, a most confusing Latinized name for the "War of the Allies."

After the battle of Mantineia there was something of a brief respite: Thebes had not been crippled, the Peloponnesos was settled for the most part, and Athens had not yet lost her second league. The Sacred War (356–346), which was fought in fits and starts to dislodge the Phokaians from Delphi, around which they had created an ephemeral hegemony over central Greece, ended bloodlessly with the general Peace of Philokrates under the aegis of Philip II of Macedon.[46] Thessaly had briefly succeeded in establishing itself as a power in north-central Greece, but Philip also brought this to an end. Indeed, all attempts to create a local or a general hegemony were in the end nullified by internecine bickering and finally by Philip, who came to power in 360. It is worth noting that Macedon was not quite the barbarian backwater that Demosthenes describes in his speeches, though it is true that she had never before played an important role in the political events of the Greek heartland. In the late fifth century, Euripides had left war-torn Athens for the new royal court of Archelaos at Pella, where he died in 407/6, and Aristotle's connection with the royal Macedonian family went back to his father, Nichomachos, who had been physician to Amyntas II.

The Persian Empire hardly enjoyed a better situation than Greece in the fourth century, at least in its western provinces of Asia Minor. Cyrus the Younger revolted against his brother, who had become Artaxerxes II, in 401 with the use of Greek mercenaries (the "Ten Thousand") but was defeated and killed. Evagoras of Cyprus was in revolt in the 390s at the same time that the Spartan king Agesilaos tried unsuccessfully to free the Greek cities of western Asia Minor from Persian rule. There was then peace for twenty years until the Satrap's Revolt in the 360s.[47] Finally, Macedon entered the picture in 334 under Alexander, Philip's son, who inherited his father's project of invading the Persian Empire.

Although the last decades of the fourth century are usually included in the Hellenistic period—because the battle of Chaironeia ended the independence of the Greek city-states and subjected them first to the monarchy of Macedon and later to the monarchies of the Diadochoi, the followers of Alexander—the distinction seems to me inconsequential in the area of art, and I shall aim at the totally arbitrary date of 300 B.C. to end my inquiry.[48]

The details of the political-military course of events are rarely of direct importance to the study of the art of the fourth century, with several notable exceptions. My purpose here is, however, to describe the atmosphere in which the art was produced by singling out developments that give the human context understandable contours. Rather than paraphrase the ancient sources or modern commentaries on the principal issues of the fourth century, I shall allow the contemporary texts to speak for themselves as much as possible.

As already indicated, the main occupation of the fourth century was war and political strife, whereas a balance of power between Sparta and Athens had existed from after the Persian Wars (479) to the end of the Peloponnesian War (404). Isokrates states the case bluntly through the mouth of the Spartan king Archidamos (*Archidamos* 64–67):

[46] J. Buckler, *Philip II and the Sacred War*, Mnemosyne suppl. 109 (Leiden 1989).

[47] M. Weiskopf, *The So-called "Great Satraps' Revolt", 366–360 B.C.: Concerning Local Instability in the Achaemenid Far West*, Historia Einzelschriften 63 (Stuttgart 1989).

[48] Gomme, "End of the City-State" (note 7 above) 204, notes that both Grote and the first edition of the *Cambridge Ancient History*, volume 6 (1927), took the position that I follow here. He notes that 338 or 323 B.C. was a more popular point to end discussion of the century. The second edition of the *Cambridge Ancient History* (1994) has chosen 322 as the end of its historical account, but 300 for the art (table on pp. 900–1), as has A. H. Borbein, "Die griechische Statue des 4. Jahrhunderts v. Chr.," *JdI* 88 (1973) 46.

I believe that the whole population of the Peloponnese, and even the common people, whom we imagine to be most hostile to us, are now regretting the days of our over-lordship. For since their revolt, none of their expectations has been realized: instead of freedom they have found the opposite; they have lost their best citizens and fallen at the mercy of the worst. Instead of autonomy, they have been plunged into lawlessness of many terrible kinds. Previously they were used to march with us against other peoples, but now they see others campaigning against them, and the civil dissensions which formerly they knew of only from hearsay and abroad, are now an almost daily occurrence with them. They have been so leveled by disasters that no one can say who is the worst off among them. None of their cities has remained intact, none is free from enemies on its borders; hence the land has been ravaged, cities sacked, private dwellings destroyed, constitutions subverted and laws abolished, which used to make them the best governed and the happiest of the Greeks. Their mutual relations are based on such distrust and hostility, that they are more afraid of their fellow-citizens than of the enemies. In place of the harmony which prevailed in our time and the abundance they enjoyed among each other, they have reached such a peak of mutual hatred that those who own property would prefer to throw their possessions into the sea than to give help to the needy, while those in poorer circumstances would rather seize by force the wealth of the rich than merely come across it fortuitously. (Trans. M. M. Austin[49])

Over the course of the fourth century this situation was familiar in all parts of Greece. An immediate and pressing problem was paying for the incessant wars.[50] Our information is, as always, best for Athens. In the fifth century she was enriched by the tribute of her empire to the point that Thucydides has Perikles list the vast sums available on the eve of the Peloponnesian War (Thuc. 2.13.3–5). In the fourth century she had to rely on a complex system of direct and indirect taxation, which Xenophon has Sokrates review for his interlocutor, Kritoboulos, around 360 B.C. (*Oeconomicus* 2.5–6):

In the first place I see you are compelled to offer many lavish sacrifices, otherwise you would be on bad terms with gods and men. Then it is your duty to entertain many strangers, and to do this in grand style. Then you must invite your fellow-citizens to dinner and shower benefits on them, or you would be destitute of allies. Furthermore I notice that the city is already laying heavy expenses on you, for keeping horses, acting as *choregos*, gymnasiarch or undertaking some important function, and should war break out, I know that they will impose on you the trierarchy, the soldiers' pay and contributions, so great that you will not find it easy to bear them. And if ever you are thought to have fallen short in the performance of these duties, I know that the Athenians will punish you just as much as if they had caught you stealing their own property. (Trans. M. M. Austin[51])

[49] M. M. Austin and P. Vidal-Naquet, *Economic and Social History of Ancient Greece: An Introduction* (Berkeley 1977) 340, text no. 109.

[50] On the known costs of war, see M. L. Cook, "Timokrates' 50 Talents and the Cost of Ancient Warfare," *Eranos* 88 (1990) 69–97; V. Gabrielsen, *Financing the Athenian Fleet* (Baltimore 1994).

[51] Austin and Vidal-Naquet, *Economic and Social History* (note 49 above) 320, text no. 97. On liturgies and taxes in general, see M. Hakkarainen, "Private Wealth in the Athenian Public Sphere during the Late Classical and Early Hellenistic Period," in *Early Hellenistic Athens: Symptoms of a Change*, Papers and Monographs of the Finnish Institute at Athens 6, ed. J. Frösén (Helsinki 1997) 1–32; J. Ober, *Mass and Elite in Democratic Athens: Rhetoric, Ideology, and the Power of the People* (Princeton 1989) 199–202; Austin, in *CAH*², vol. 6 (1994) 541–51.

The burdens of the liturgies and taxes were great even with restructuring to ease the pain; J. K. Davies has estimated that there were ninety-seven annual or festival liturgies in the fourth century, which were hardly as oppressive as the military liturgies.[52] Demosthenes records how unpopular the latter had become in 341, when Philip complained to Athens about the disturbances caused by the Athenian general Diopeithes in the Chersonesos not long before Chaironeia (*On the Chersonese* 21–23):

> We refuse to pay war-taxes or to serve in person; we cannot keep our hands off the public funds; we will not pay Diopithes the allowances agreed upon, nor sanction the sums that he raises for himself; but we grumble and criticize his methods, and ask what he intends to do, and all that sort of thing; and yet, while maintaining that attitude, we refuse to perform our own tasks; with our lips we praise those whose speeches are worthy of our city, but our actions serve only to encourage their opponents. Now, you have a habit of asking a speaker on every occasion, "What then must be done?"; but I prefer to ask you, "What then must be said?" Because, if you are not going to pay your contributions, nor serve in person, nor keep your hands off the public funds, nor grant Diopithes his allowances, nor sanction the sums that he raises for himself, nor consent to perform your own tasks, I have nothing to say. (Trans. J. H. Vince, Loeb edition)

In this vein pseudo-Aristotle relates three anecdotes about the cash-starved Athenian general Timotheos, the most famous of which was a ruse he used to forestall his men's demands for pay, which he could not meet during the campaign off Kerkyra in 375 B.C. (*Oikonomika* 2.1350a–b):

> Timotheus was reduced to sore straits. His men demanded their pay, refused to obey his orders, and declared they would desert to the enemy. Accordingly he summoned a meeting and told them that the stormy weather was delaying the arrival of the silver he expected; meanwhile, as he had on hand such abundance of provisions, he would charge them nothing for the three months' ration of grain already advanced. The men, unable to believe that Timotheus would have sacrificed so large a sum to them unless he was in truth expecting the money, made no further claim for pay until he had completed his dispositions. (Trans. G. C. Armstrong, Loeb edition)

Warfare itself had changed since the fifth century, as Demosthenes relates (*Third Philippic* 47–50):

> But for my own part, while practically all the arts have made a great advance and we are living today in a very different world from the old one, I consider that nothing has been more revolutionized and improved than the art of war. For in the first place I am informed that in those days the Lacedaemonians, like everyone else, would spend the four or five months of the summer "season" in invading and laying waste the enemy's territory with heavy infantry and levies of citizens, and would then retire home again; and they were so old-fashioned, or rather such good citizens, that they never used money to buy an advantage from anyone, but their fighting was of the fair and open kind. But now you must surely see that most disasters are due to traitors, and none are the result of a regular pitched battle. On the other hand you hear of Philip

[52] J. K. Davies, "Demosthenes on Liturgies: A Note," *JHS* 87 (1967) 33–40; Davies, *APF*, xx–xxiii; Davies, *Wealth and the Power of Wealth in Classical Athens* (New York 1981) 27–37.

marching unchecked, not because he leads a phalanx of heavy infantry, but because he is accompanied by skirmishers, cavalry, archers, mercenaries, and similar troops. When, relying on this force, he attacks some people that is at variance with itself, and when through distrust no one goes forth to fight for his country, then he brings up his artillery and lays siege. I need hardly tell you that he makes no difference between summer and winter and has no season set apart for inaction. (Trans. J. H. Vince, Loeb edition)

Not only was continuous war in itself expensive, but the increasing use of mercenaries made it even more so.[53] A secondary problem in the use of mercenaries was that they became an uncontrollable horde when not managed strictly and paid well. Isokrates decries the situation thus (*On the Peace* 44–46):

Although we seek to rule over all men, we are not willing to take the field ourselves, and although we undertake to wage war upon, one might almost say, the whole world, we do not train ourselves for war but employ instead vagabonds, deserters, and fugitives who have thronged together here in consequence of other misdemeanors, who, whenever others offer them higher pay, will follow their leadership against us. But, for all that, we are so enamored of these mercenaries that while we would not willingly assume the responsibility for the acts of our own children if they offended against anyone, yet for the brigandage, the violence, and the lawlessness of these men, the blame for which is bound to be laid at our door, not only do we feel no regret, but we actually rejoice whenever we hear that they have perpetrated any such atrocity. (Trans. G. Norlin, Loeb edition[54])

To war and the consequent financial and social strains was added another serious problem: the need to import significant amounts of grain just to survive.[55] This had always been the case but became more acute in the fourth century. Athens was particularly dependent and thus cultivated foreign rulers to ensure the supply, on many occasions awarding them honors to cement relations or to recognize particular acts of generosity. The main source was the Black Sea, but Cyprus, Libya, and Egypt were also important.[56] Maintaining the supply of grain thus required far-flung diplomatic relations, making it clear that there was a heightened cosmopolitanism in fourth-century Greece. In the fifth century, Greece had prided itself not only on the defeat of the Persian invasions but on a continuing and successful hostility to Persia. This remains a major motif in the fourth century, but tempered by an ambiguity typical of the century. Already in the last years of the Peloponnesian War, the Spartan victory over Athens was funded by Persia (Xenophon, *Hellenika* 1.4.1–7, 5.1–9; 2.1.10–32). And Athens's recovery in the first decade of the fourth century was marked by her premier general, Konon, serving in the Persian fleet and defeating Sparta at the battle of Knidos in 394 (Xenophon, *Hellenika* 4.3.10–12). Xenophon is quick to point out how complex and absurd some of these relationships became, since at that same time Athens was sending ships to support Evagoras of Salamis

[53] L. P. Marinovich, *Le mercenariat grec au IVe siècle avant notre ère et la crise de la polis*, Centre de recherches d'histoire ancienne 80 (Paris 1988); D. Whitehead, "Who Equipped Mercenary Troops in Classical Greece?" *Historia* 40 (1991) 105–13; P. McKechnie, *Outsiders in the Greek Cities of the Fourth Century B.C.* (London 1989) 79–93.

[54] Austin and Vidal-Naquet, *Economic and Social History* (note 49 above) 338–39, text no. 108B (excerpt).

[55] Austin, in *CAH*[2], vol. 6 (1994) 558–62; cf. Xenophon, *Oikonomikos* 20.27–28.

[56] J. McK. Camp II, "Drought and Famine in the 4th Century B.C.," in *Studies in Athenian Architecture, Sculpture, and Topography Presented to Homer A. Thompson*, *Hesperia* suppl. 20 (Princeton 1982) 14–15.

in Cyprus against Persia (*Hellenika* 4.8.24). In the 370s or 360s, special honors and economic rewards were given to Strato, king of Sidon, for assistance with an embassy to the Great King.[57] Later, in 343 B.C., Demosthenes had read in court an inscription of the fifth century that cited Arthmios of Zelea for treason because he conveyed "gold from barbarians to Greeks" (*De falsa legatione* 271), which he repeats in 341 (*Third Philippic* 41–44), yet he himself appears to suggest at the end of the latter speech (§ 71) that the Athenians should approach the Persian king for support against Philip.[58]

Persian gold seems to have been accepted by any Greek or any Greek state that was offered it, yet Persia remained the barbarian enemy.[59] The inconsistency is both glaring and yet typical of the extreme volatility of all Greek interstate relations in the fourth century. The conquest of Persia by Alexander is seen by many modern commentators as the culminating event of the century which brings the Classical period to an end, but on closer examination it seems to be a minor footnote in an age of so many conflicts. The idea of founding a Greek state in Asia Minor had even flickered across the mind of Xenophon when he brought the "Ten Thousand" down to the Black Sea in the spring of 400 B.C. (*Anabasis* 5.6.15–33). In 408, Gorgias of Leontinoi had addressed the Olympic games with the proposal of establishing harmony among the Greeks by attacking Persia,[60] and Lysias apparently brought up the same idea in his address to the same body in 388 or 384.[61] Isokrates was a student of Gorgias, and it may have been from him that Isokrates developed his theme, first propounded in the *Panegyrikos* around 380 B.C. The reality is that Greece had become so intertwined with Persia at all levels of public and private life that the unification of East and West was not a deeply dramatic turn of events but almost the recognition of a pre-existing situation.

The cosmopolitanism of fourth-century Greece is everywhere evident, but it is a natural continuation of trends in the fifth century, particularly in Athens, which was the undisputed center of Aegean and even Mediterranean trade. Cults from other Greek areas were introduced into Athens, for example, the cult of Asklepios that took up its home on the south slope of the Acropolis in 420/19.[62] One of the earliest truly foreign gods in Attica was Bendis, whose cult took place in the Bendideion in the Piraeus and was officially organized as a state cult as early as 429.[63] Other foreign cults, such as those of Adonis and

[57] Rhodes and Osborne, *Greek Historical Inscriptions*, 86–87, no. 21; Austin and Vidal-Naquet, *Economic and Social History* (note 49 above) text no. 71.

[58] The passage is included only in the margins of the best manuscript. J. R. Ellis, in *CAH*[2], vol. 6 (1994) 774, clearly accepts the genuineness of the tradition, which is elaborated in the *Fourth Philippic* [10] 31–34, sometimes considered spurious.

[59] Lysias, *Olympiakos* 5: ". . . you are aware that empire is for those who command the sea, that the King has control of the money, that the Greeks are in thrall to those who are able to spend it. . . ." (trans. W. R. M. Lamb, Loeb edition).

[60] Philostratos, *Lives of the Philosophers* 493. On the date, see Diels-Kranz, *Vorsokr.*, 287, with reference to U. von Wilamowitz-Moellendorf, *Aristoteles und Athen* (Berlin 1893; repr. Berlin 1966) vol. 1, n. 75 on pp. 172–73. The passage from Philostratos is given in full by Diels-Kranz, p. 272 (A1). See generally M. Flower, "Alexander the Great and Panhellenism," in *Alexander the Great in Fact and Fiction*, ed. A. B. Bosworth and E. J. Baynham (Oxford 2000) 96–135.

[61] W. R. M. Lamb, in *Lysias* (Cambridge, MA, 1930) 681 (Loeb edition).

[62] R. Garland, *Introducing New Gods: The Politics of Athenian Religion* (London 1992) 116–35; R. Parker, *Athenian Religion: A History* (Oxford 1996) 175–87; H. Knell, *Athen im 4. Jahrhundert v. Chr., eine Stadt verändert ihr Gesicht: Archäologisch-kulturgeschichtliche Betrachtungen* (Darmstadt 2000) 15–25.

[63] R. R. Simms, "The Cult of the Thracian Goddess Bendis in Athens and Attica," *AncW* 1 (1988) 59–76; Garland, *Introducing New Gods* (note 62 above) 111–14; Parker, *Athenian Religion* (note 62 above) 160–61, 170–75. See also D. Tsiafakis, "The Allure and Repulsion of Thracians in the Art of Classical Athens," in *Not the Classical Ideal: Athens and the Construction of the Other in Greek Art*, ed. B. Cohen (Leiden 2000) 386–88.

Sebazios, appear to have existed without official recognition and to have flourished in the fourth century.[64] A cult of Ammon was recognized at an unknown time, at least by the 370s,[65] and in the second half of the fourth century followers of Isis were allowed to buy land for a sanctuary sometime before 333, when the same permission was granted to the merchants of Kition for their cult of Aphrodite.[66] These foreign cults certainly reflect and probably officially served the widespread economic and political interests of Athens.[67] Xenophon points out that Athens had a large and very mixed population of non-Greek foreigners, as all major Greek cities presumably had; he cites Lydians, Phrygians, and Syrians (*Ways and Means* 2.3).[68] In the accounts of the completion of the Erechtheion on the Athenian Acropolis in the last decade of the fifth century, the lists reveal a greater number of *metics* (resident foreigners) at work than Athenian citizens,[69] and around the middle of the fourth century Xenophon advocates a concerted effort on the part of Athens to increase the *metic* population to improve government finances (*Ways and Means* 2.3).[70] Although these resident foreigners had some security under the law, it was not great, and the burden of taxes and obligations was not small.[71]

There has been much debate about the relative roles of *metics* and citizens in all aspects of Athenian trade; certainly *metics* were very important, but current scholarly opinion appears to allow greater citizen involvement than was formerly thought.[72] The debate tends to obscure the point that *metics* followed many callings. The Erechtheion inscriptions underscore what is otherwise never questioned: many prominent sculptors and painters who worked in Athens in the fifth and fourth centuries were not Athenians. Some may have been simply visiting foreigners, but others were certainly *metics*.[73] But it always comes as a surprise to recall that Aristotle was a *metic*;[74] so were the orators Lysias, Isaeus, and Dinarchos. Admittedly, all of these men were Greeks and not from far-off, exotic, or barbarian lands, yet they were just as much *metics* as a Syrian or a Phrygian. Although the reckoning of the number of inhabitants of Attica at any given time must of necessity be very imprecise, a recent suggestion proposed that in 360 B.C. there

[64] Parker, *Athenian Religion* (note 62 above) 160, 194, 198. See also L. E. Roller, "Foreign Cults in Greek Vase Painting," in *Proceedings of the 3rd Symposium on Ancient Greek and Related Pottery, Copenhagen, August 31–September 4, 1987,* ed. J. Christiansen and T. Melander (Copenhagen 1988) 506–13.

[65] Parker, *Athenian Religion* (note 62 above) 195–96.

[66] *IG* II² 337: Rhodes and Osborne, *Greek Historical Inscriptions,* 462–66, no. 91, lines 42–45; Austin and Vidal-Naquet, *Economic and Social History* (note 49 above) 274–75, no. 72; R. R. Simms, "Isis in Classical Athens," *CJ* 84 (1989) 216–21.

[67] Simms, *CJ* 84 (1989) 219–21; Parker, *Athenian Religion* (note 62 above) 174–75, 197, 198, 243.

[68] McKechnie, *Outsiders in the Greek Cities* (note 53 above) 178–88, gives a sketchy picture of the actual traders who carried cargo from port to port. E. Erxleben, "Das Verhältnis des Handels zum Produktionsaufkommen in Attika im 5. und 4. Jahrhundert v. u. Z.," *Klio* 57 (1975) 365–98, gives a lively account of Attic imports and exports in the Classical period.

[69] R. H. Randall, "The Erechtheion Workmen," *AJA* 57 (1953) 199–210, partially reproduced in Austin and Vidal-Naquet, *Economic and Social History* (note 49 above) 276–82, text no. 73.

[70] Austin and Vidal-Naquet, *Economic and Social History* (note 49 above) 362–68, text no. 122.

[71] D. Whitehead, *The Ideology of the Athenian Metic,* Proceedings of the Cambridge Philological Society, Supplementary Volume 4 (Cambridge 1977).

[72] S. C. Humphreys, "Economy and Society in Classical Athens," *AnnPisa* 39 (1970) 1–26; E. E. Cohen, *Athenian Economy and Society: A Banking Perspective* (Princeton 1992); and particularly I. Morris's review of the latter, in *CP* 89 (1994) 351–66, which strikes a balanced view similar to that of Humphreys.

[73] McKechnie, *Outsiders in the Greek Cities* (note 53 above) 142–60, reviews the situation of the "mobile skilled workers." However, these became *metics* not only in Athens but elsewhere after a very brief stay, usually of a month, except under special circumstances: Whitehead, *Athenian Metic* (note 71 above) 7–11.

[74] D. Whitehead, "Aristotle the Metic," *PCPS* 21 (1975) 94–99.

were 29,000 male citizens and 35,000 *metics*.[75] If this is even vaguely correct, whatever the disadvantages of being a *metic* in Athens (or elsewhere) were, it clearly had its advantages, too. It is equally clear that *metics* did not simply occupy the middle ground between citizen and slave, though there are enough slighting comments preserved in the texts to indicate that they could easily be a subject of criticism and/or derision.[76] The fact that a number of Attic terracotta figurines and vases depict travelers suggests that the cosmopolitan tenor of the age even crept into the domestic world.[77]

A third and particularly modern aspect of the fourth century is the development of professionalism in almost all walks of life and endeavor. One important aspect of this trend is the writing of treatises on "How to Do" something or "The History of" something. This is not an invention of the fourth century, since we hear of various works of this type in the second half of the fifth century, such as Polykleitos's work on the canon (Galen, *De placitis Hippocratis et Platonis* 5),[78] writings on perspective by Demokritos (Vitruvius 7 praef. 11), the beginning of the *Corpus Hippocraticum*,[79] and the earliest treatises on rhetoric by Gorgias and perhaps his teacher, Teisias.[80] But many new types appear in the fourth century, ranging from the various "Constitution of..." by Aristotle and others to Xenophon's many works (such as his *Ways and Means, Oikonomikos, On the Art of Horsemanship,* and *On Hunting*), Aeneas Tacticus's manual *On the Defense of Fortified Positions*, Theophrastos's *Characters*, and, not least important for the present study, Xenokrates of Athens's *On Bronze Working* and *On Painting*.[81] These manuals and treatises are, of course, all written in prose, which was certainly not a new invention but one coupled with the habit of writing rather than with oral composition, and this arguably led to a major change in patterns of thought.[82] "Athens was becoming more 'document-minded,' and the state was in fact demanding more written documentation," as Rosalind Thomas has put it.[83] The laws of Athens were completely reviewed between 410 and 399 to provide a recognized basic platform for the structure of the state after the oligarchic upheavals.[84] As the fourth century progressed, the development of an increasingly rigorous and professional administration of the government became a simple necessity as society became more complex and financial needs had to be

[75] P. J. Rhodes, in *CAH*[2], vol. 6 (1994) 567. M. H. Hansen, *Demography and Democracy: The Number of Athenian Citizens in the Fourth Century B.C.* (Herning, Denmark, 1985), proposes a figure of ca. 30,000 in the second half of the fourth century; A. W. Gomme, *The Population of Athens in the Fifth and Fourth Centuries B.C.* (Oxford 1933) 47, proposed that in 430 there were 60,000 citizens, 25,000 *metics*, and 70,000 slaves; in 330 there may have been 50,000 citizens, 36,000 *metics*, and 82,000 slaves. Cf. Whitehead, *Athenian Metic* (note 71 above) 97–98.

[76] Whitehead, *Athenian Metic* (note 71 above) 34–61. Whitehead tries to make a case for a general disparagement of *metics* in Athens but is unable to come up with texts that really confirm this. The two that come closest (Demosthenes 22.54 and 52.3; pp. 47–48, 49–50) do not carry much conviction beyond a moderate antipathy for noncitizens.

[77] W. R. Biers and J. R. Green, "Carrying Baggage," *AntK* 41 (1998) 87–93.

[78] Overbeck, *Schriftquellen*, no. 959; J. J. Pollitt, *The Art of Greece, 1400–31 B.C.* (Englewood Cliffs, NJ, 1965) 89.

[79] A. Krug, *Heilkunst und Heilkult: Medizin in der Antike* (Munich 1985) 43–44.

[80] W. K. C. Guthrie, *A History of Greek Philosophy*, vol. 3, *The Fifth-Century Enlightenment* (Cambridge 1969) 192.

[81] See note 26 above. Aristotle, *Politics* 1.7.7, comments on the usefulness of such manuals.

[82] Havelock, *Literate Revolution* (note 16 above) 261–312.

[83] *Literacy and Orality in Ancient Greece* (Cambridge 1992) 148. C. W. Hedrick, "Writing, Reading, and Democracy," in Osborne and Hornblower, *Ritual, Finance, Politics* (note 7 above) 157–74, draws attention to the ambiguous function of writing, especially epigraphy, in classical Athens.

[84] M. Ostwald, *From Popular Sovereignty to the Sovereignty of Law: Law, Society, and Politics in Fifth-Century Athens* (Berkeley 1986) 369–72, 409–11, 414–20, 509–24; P. J. Rhodes, in *CAH*[2], vol. 6 (1994) 567–68; J. P. Sickinger, *Public Records and Archives in Classical Athens* (Chapel Hill, NC, 1999) 94–105.

met.[85] In the public sector, the name of Euboulos stands out, and, after him, that of Lykourgos.[86] Although the evidence is not absolutely clear, the tendency in fourth-century Athens was to create boards or magistracies, such as the *theorikon*, that were neither chosen by lot nor served only one year, providing both expertise and continuity of administration.[87] These developments represent a slight movement away from the radical democratic selection by lot and a term limit of just one year.[88] Perhaps unrelated is the fact that the Athenian citizens most engaged in the government were not, as one might suppose, purely or even largely from the general *dēmos* but were often men of wealth and from reputed families.[89] The most visible sign of all these changes to a professional government was the construction or reconstruction of buildings in the Agora[90] and the massive expansion of the public meeting place, the Pnyx.[91]

The new professionalism became all pervasive and extended to the great festival games, though the wholly negative assessment of this development fostered by E. Norman Gardiner at the beginning of the twentieth century has little basis in fact.[92] In the fifth century, probably early in the century, the trend to special diet and single-purpose training had begun, which led to contemporary criticism.[93] But the evidence for the repute of athletes and the games is ambiguous. Hans-Volkmar Herrmann states that in the fourth century Olympia experienced a building boom as never before or after,[94] and Pausanias records more statues of athletic victors of that century than for any other period.[95] Yet the games appear to have suffered something of an eclipse, too: the West Greeks no longer participated, and the fame of athletic victors appears to have been not as great in the fourth century.[96] At Delphi the surviving gymnasium was built in the fourth century,[97]

[85] P. J. Rhodes, in *CAH*[2], vol. 6 (1994) 565–72; Rhodes, "Athenian Democracy after 403 B.C.," *CJ* 75 (1979/80) 309–15.

[86] B. Hintzen-Bohlen, *Die Kulturpolitik des Eubulos und des Lykurg: Die Denkmäler- und Bauprojekte in Athen zwischen 355 und 322 v. Chr.* (Berlin 1997); Austin, in *CAH*[2], vol. 6 (1994) 541–51; G. Cawkwell, "Eubulus," *JHS* 83 (1963) 47–67; F. W. Mitchel, "Lykourgan Athens: 338–322," in *Lectures in Memory of Louise Taft Semple, Second Series, 1966–1970*, ed. C. G. Boulter et al. (Norman, OK, 1973) 190–214; S. C. Humphreys, "Lycurgos of Butadae: An Athenian Aristocrat," in *The Craft of the Ancient Historian: Essays in Honor of Chester G. Starr*, ed. J. W. Eadie and J. Ober (Lanham, MD, 1985) 199–252. The life and deeds of Lykourgos are largely based on pseudo-Plutarch, *Lives of the Ten Orators*, in *Moralia* 841a–844a.

[87] H. Leppin, "Zur Entwicklung der Verwaltung öffentlicher Gelder im Athen des 4. Jahrhunderts v. Chr.," in Eder, *Athenische Demokratie* (note 8 above) 557–71.

[88] P. J. Rhodes, in *CAH*[2], vol. 6 (1994) 572.

[89] Pečírka, *Eirene* 9 (1976) 9–10; Davies, *APF*, xxv–xxxi; C. Mossé, "La classe politique à Athènes au IVème siècle," in Eder, *Athenische Demokratie* (note 8 above) 67–77.

[90] H. A. Thompson and R. E. Wycherley, *The Athenian Agora*, vol. 14, *The Agora of Athens: The History, Shape and Uses of an Ancient City Center* (Princeton 1972) 21 and passim; Knell, *Athen im 4. Jahrhundert*, 63–114; J. Travlos, *Pictorial Dictionary of Ancient Athens* (London 1971) 1–27.

[91] Thompson and Wycherley, *Athenian Agora* 14 (note 90 above) 48–52; Knell, *Athen im 4. Jahrhundert*, 55–62; Travlos, *Pictorial Dictionary*, 466–76.

[92] E. N. Gardiner, *Greek Athletic Sports and Festivals* (London 1910); cf. F. Rausa, *L'immagine del vincitore: L'atleta nella statuaria greca dall'età arcaica all'ellenismo* (Treviso and Rome 1994) 111–12; D. C. Young, "How the Amateurs Won the Olympics," in *The Archaeology of the Olympic Games: The Olympics and Other Festivals in Antiquity*, ed. W. J. Raschke (Madison, WI, 1988) 69–71; S. G. Miller, *Ancient Greek Athletics* (New Haven, CT, 2004) 207–15 ("Professionals and Amateurs").

[93] N. Serwint, "Greek Athletic Sculpture from the Fifth and Fourth Centuries B.C.: An Iconographic Study" (Ph.D. diss., Princeton University, 1987) 24–38; cf. Aristotle, *Politics* 7.16.12; 8.4.7–9.

[94] H.-V. Herrmann, *Olympia: Heiligtum und Wettkampfstätte* (Munich 1972); 161; A. Mallwitz, *Olympia und seine Bauten* (Darmstadt 1972) 96–100.

[95] Rausa, *Vincitore*, 113–14.

[96] Herrmann, *Olympia* (note 94 above) 161.

[97] J.-F. Bommelaer and D. Laroche, *Guide de Delphes: Le site* (Paris 1991) 73–79. Aupert, *FdD* 2.C.3, 45–54, 164–65, dates the current stadium above the sanctuary to the early third century B.C.

and a stadium and palaestra were built at Athens under Lykourgos.[98] The great Temple of Zeus at Nemea was built in the second half of the fourth century,[99] and rebuilding at Isthmia is also known.[100] It seems clear, therefore, that whatever status the Panhellenic games may have enjoyed in the fourth century, their physical setting was greatly enhanced with major stone buildings and facilities, and major dedications of sculpture, both of victors and others, continued to fill the sanctuaries associated with the games.

To balance the prominence of instability and change in the fourth century there is the constant sense of the past and the desire to live up to it.[101] The increased concern with documentation and recordkeeping has already been mentioned. Two significant and related aspects of this trend were the regular restaging of fifth-century tragedies beginning in 387/6 (*IG* II[2] 2318, lines 201–3) and of comedies from 340/39 on (*IG* II[2] 2318, lines 316–18).[102] Under Lykourgos the texts of the tragedies were standardized,[103] and the Theater of Dionysos was rebuilt in stone and decorated with statues of the great fifth-century tragedians.[104] Lykourgos is thus of interest not only as a great administrator but also as a promoter not just of the political and military glories of earlier times but the poetry, too. His sole surviving speech, *Against Leokrates*, contains a long quotation from Euripides' otherwise largely lost play *Erechtheus* (§ 100),[105] as well as quotations from the *Iliad* (§ 103), Tyrtaios (§ 107), the epigram of the Spartans at Thermopylai (§ 109), the ephebic oath (§ 77), the oath of Plataia (§ 81), unattributable verses (§ 92, 132), and a string of earlier decrees, including a Spartan law (§ 129). The first lines invoke justice and reverence for the gods that recall the invocations of Pindaric odes and Aischylos's tragedies (*Against Leokrates* § 1):

> Justice towards you, Athenians, and reverence for the gods, shall mark the opening of my speech against Leokrates, now here on trial; so may Athena and those other gods and heroes whose statues are erected in our city and the country round receive this prayer. (Trans. J. O. Burt, Loeb edition)

The religious tone, which recurs in the speech, probably derives from the fact that Lykourgos was a member of the Eteobutadai, a family to which the ancient and important priesthoods of Athena Polias and Erechtheus belonged.[106] But the theme of reverence

[98] Knell, *Athen im 4. Jahrhundert*, 167–95; Hintzen-Bohlen, *Kulturpolitik des Eubulos* (note 86 above) 38–39; Travlos, *Pictorial Dictionary*, 498; Mitchel, "Lykourgan Athens" (note 86 above) 199–201; R. E. Wycherley, *The Stones of Athens* (Princeton 1978) 222–26; pseudo-Plutarch, *Lives of the Ten Orators*, in *Moralia* 841C–D.

[99] B. H. Hill, L. T. Lands, and C. K. Williams, *The Temple of Zeus at Nemea* (Princeton 1966) 44–46; D. Birge, in *Nemea: A Guide to the Site and Museum*, ed. S. G. Miller (Berkeley 1990) 130–48; Miller, *Ancient Greek Athletics* (note 92 above) 106–10.

[100] O. Broneer, *Isthmia: Excavations by the University of Chicago under the Auspices of the American School of Classical Studies at Athens*, vol. 2, *Topography and Architecture* (Princeton 1973) 46–66. The "earlier" stadium was apparently rebuilt around 390 B.C., and the "later" stadium may have been built in the last third of the fourth century.

[101] See note 2 above.

[102] P. Wilson, *The Athenian Institution of the Khoregia: The Chorus, the City and the Stage* (Cambridge 2000) 22–23.

[103] Pseudo-Plutarch, *Lives of the Ten Orators*, in *Moralia* 841F; Mitchel, "Lykourgan Athens" (note 86 above) 209; A. Lesky, *A History of Greek Literature*, trans. J. Willis and C. de Heer (New York 1966) 267–68.

[104] Knell, *Athen im 4. Jahrhundert*, 126–47; Hintzen-Bohlen, *Kulturpolitik des Eubulos* (note 86 above) 21–31; Travlos, *Pictorial Dictionary*, 537–52; P. Zanker, *Die Maske des Sokrates: Das Bild des Intellektuellen in der antiken Kunst* (Munich 1995) 49–61.

[105] Euripides, *Selected Fragmentary Plays*, 2nd ed., vol. 1, ed. C. Collard, M. J. Cropp, and K. H. Lee (Warminster 2009) 158, no. 360.

[106] Parker, *Athenian Religion* (note 62 above) 290–93. H. Montgomery, "Piety and Persuasion: Mythology and Religion in Fourth-Century Athenian Oratory," in *Religion and Power in the Ancient Greek World: Proceedings of the Uppsala Symposium 1993*, Acta Universitatis Upsaliensis, Boreas 24, ed. P. Hellström and B. Alroth (Uppsala 1996) 125–32, remarks on the infrequent use of religion and mythology in forensic speeches and little use even in epideictic works.

for the gods as a patriotic quality is sufficiently frequent in speeches by other orators to indicate that it was expected by the jury as one of the qualities that defined the good citizen,[107] and my assumption is that religious reverence is undiminished in the fourth century outside of small groups of intellectuals who had already begun to question the inherited beliefs in the sixth century.[108] It should be remembered that the vast majority of the liturgies in Athens were for the sacred festivals, and these numbered some ninety-seven, apart from the special quadrennial Panathenaics.[109] Equally, in times of constant war, the pressing need of many states for money might have led many Greek states to despoil the enormous treasure stored in the sanctuaries to fund their armies, but most states rejected this tactic (Xenophon, *Hellenika* 7.4.33–34), with the notable exception of the Phokaians during their brief control of the sanctuary of Apollo at Delphi during the Third Sacred War (Diodorus 16.56–57).[110] Athens had used the sacred treasures in the waning years of the Peloponnesian War, and suggestions were made to do this again in the fourth century, though they were apparently not carried out.[111] This restraint before the gods does not mean there were not ugly incidents, such as the pitched battle that took place in the sanctuary of Zeus at Olympia in the 104th Olympiad (364 B.C.) (Xenophon, *Hellenika* 7.4.28–32). But this was the exception, not the rule, and we can in general agree with A. W. Gomme that the fourth century does not represent a spiritual decline from the fifth century.[112]

It must be clear at this point that Greece in the fourth century manifests undiluted ambiguities as a political, social, and economic entity. It was, after all, a period of change. For the most part this was gradual and not as wrenching as might first appear to be the case. For example, the social opposition of oligarch and democrat that played a major role in the turmoil of the fourth century did not play itself out in violence in Athens after the tyranny of 404–403. That there were oligarchic sympathizers cannot be doubted; both Plato and Aristotle are clearly such.[113] Yet in the political, rather than the philosophic, arena the acceptance of the democracy in Athens appears to have been broad and profound.[114] This does not mean that there was not a wealthy elite that functioned as a class and asserted its status, but the assertiveness was integrated into the balanced functioning of the city-state through the system of liturgies, which the wealthy themselves viewed as a means

[107] K. J. Dover, *Greek Popular Morality in the Time of Plato and Aristotle*, 2nd ed. (Indianapolis, IN, 1994) 246–54, cites many relevant passages; W. R. Connor, "'Sacred' and 'Secular': Ἱερὰ καὶ ὅσια and the Classical Athenian Concept of the State," *Ancient Society* 19 (1988) 161–88.

[108] Cf. B. Snell, "Der Glaube an die Olympischen Götter," in *Das neue Bild der Antike*, ed. H. Berve (Leipzig 1942) vol. 1, 124–26, who says (p. 125): "Die olympischen Götter sind gestorben an der Philosophie." Cf. C. Auffarth, "Aufnahme und Zurückweisung 'Neuer Götter' im spätklassischen Athen: Religion gegen die Krise, Religion in der Krise?" in Eder, *Athenische Demokratie* (note 8 above) 337–65. See further chap. 6, pp. 259–60, and chap. 8, pp. 317–18 below.

[109] See note 52 above.

[110] See also Rhodes and Osborne, *Greek Historical Inscriptions*, 336–42, no. 67, on the repayment of the stolen treasure, which helped to pay for the completion of the Temple of Apollo damaged or destroyed in 373: G. Roux, *L'amphictionie, Delphes et le temple d'Apollon au IVe siècle* (Lyon and Paris 1979) 164–72.

[111] On the whole topic, see Austin, in *CAH*², vol. 6 (1994) 555–56; Demosthenes, *Against Androtion* (22) 48, and Dinarchos, *Against Demosthenes* (1) 69, criticize such proposals.

[112] "End of the City-State" (note 7 above) 233–48. Gomme compares the inefficiency and corruption of British administration and military in the seventeenth to nineteenth centuries with the situation in Athens of the fourth century. The same comparison could doubtless be made with the contemporary United States of America.

[113] J. Ober, "How to Criticize Democracy in Late Fifth-Century and Fourth-Century Athens," in *The Athenian Revolution: Essays on Ancient Greek Democracy and Political Theory* (Princeton 1996) 142–60; C. Mossé, *Athens in Decline, 404–86 B.C.*, trans. J. Stewart (London 1973) 60–67.

[114] Ober, *Mass and Elite* (note 51 above).

to curry favor (*charis*) with the *demos*.[115] Such sublimation in the polity of elitist feelings can be concretely experienced in the building of grand choregic monuments, a notable public-private demonstration of wealth, since the *chorēgos* performed a public liturgy.[116] Equally, Nikolaus Himmelmann has convincingly pointed to nondemocratic overtones in the iconography of Attic funerary reliefs.[117] But if one needs evidence of the stability of the Athenian democracy, the fact that it did not disappear after Chaironeia nor suffer greatly or long under Demetrios of Phaleron (317–307) should suffice.[118] In fact, the oligarchy made hardly any particular difference to the daily life of Athenians; Aristotle had remarked earlier that there were democracies that were run like oligarchies and vice versa (*Politics* 4.5.3).

Despite the ravages of the Peloponnesian War, Athens managed to assuage the horrors of political strife, to engage in foreign ventures, and especially to rebuild her economy.[119] The Piraeus again became the major center of trade in the Aegean, as it had been under the Athenian empire of the fifth century.[120] Admittedly, trade was not a highly regarded activity for the old landed families; Aristotle contrasts the wealth of agricultural self-sufficiency with pure money-making, which he deplores (*Politics* 1.8–11). But the father of Demosthenes, one of the richest men in Athens at the beginning of the fourth century, had no land and made his money from factories and lending money (Demosthenes, *Against Aphobos I* 9–11).[121] Although *metics* may have been a major force in the promotion and success of Athens's trade, citizens clearly participated and profited well.[122] General assessments point to a broad prosperity of the Athenian population, in contrast to the almost constant woes of the city's finances.[123] The latter were, however, largely a result of the costs of war and abated or disappeared under Euboulos's administration, during which war was largely avoided. The new professionalism in government administration, based on some restraints on the principles of radical democracy coupled with the growth of a wealthy class of citizens who did not hold land, suggests that Athenian and almost certainly Greek society as a whole was moving toward a new configuration in which cosmopolitanism and urbanism were displacing aristocratic clan and landed ideals.

An important gauge of the situation is the notable wealth amassed by sculptors and painters during the fourth century. We know close to nothing about artists and craftsmen prior to the late fifth century, though a general social antipathy toward them is

[115] Ober, *Mass and Elite* (note 51 above) 192–269; F. Vannier, *Finances publiques et richesses privées dans le discours athénien aux Ve et IVe siècles*, Centre de Recherches d'Histoire Ancienne, Université de Besançon 75 (Paris 1988). The word *charis* deserves special attention: Ober, *Mass and Elite*, 226–33; see further chap. 6, p. 236, and chap. 7, pp. 281–82 below.

[116] See chap. 2, pp. 41–42, chap. 5A, pp. 196–97, and chap. 5B, pp. 211–212 below.

[117] N. Himmelmann, *Attische Grabreliefs* (Opladen 1999) 82–94.

[118] Ober, *Mass and Elite* (note 51 above) 334. On this period, see Mossé, *Athens in Decline* (note 113 above) 102–8.

[119] B. S. Strauss, *Athens after the Peloponnesian War: Class, Faction, and Policy, 403–386 B.C.* (Ithaca, NY, 1986).

[120] Austin, in *CAH*², vol. 6 (1994) 543–44.

[121] His total assets came to about 14 talents: Austin and Vidal-Naquet, *Economic and Social History* (note 49 above) 358–59, no. 120; Davies, *Power of Wealth* (note 52 above) 71.

[122] Cf. C. Mossé, "The 'World of the Emporium' in the Private Speeches of Demosthenes," in *Trade in the Ancient Economy*, ed. P. Garnsey, K. Hopkins, and C. R. Whittaker (Berkeley 1983) 53–63, who emphasizes that the actual traders, that is, those who travelled on the ships, were generally poor and not part of the "political class"; but those who loaned the money and controlled the merchandise did do well (p. 54). W. R. Connor, *The New Politicians of Fifth-Century Athens* (Princeton 1971) 151–68, shows that the new moneyed politicians of late-fifth-century Athens were already from families that owned no land or at least made their money from manufacturing, etc.

[123] Pečírka, *Eirene* 9 (1976) 13–15; A. French, "Economic Conditions in Fourth-Century Athens," *GaR* 38 (1991) 24–40. A. Fuks, "Isokrates and the Social-Economic Situation in Greece," *Ancient Society* 3 (1972) 17–44, dwells on the undeniable negatives as emphasized by Isokrates.

clear.[124] In the late fifth century, the painters Zeuxis and Parrhasios were both particularly noted for their conspicuous display of wealth,[125] and Lysippos is said by Pliny to have made 1,500 statues (*NH* 34.17.37). Although wages did rise during the fourth century, it has been difficult to understand how artists could become wealthy, since the recorded rates of pay are so small: one drachma a day in the late fifth and early fourth century and, later, only two drachmas a day.[126] A logical assumption must be that successful artists followed the trend toward developing workshops that at times employed sizeable numbers of slaves,[127] who may have made up about 35 percent of the total Athenian population of 210,000 in 360 B.C.[128] Slaves were apparently paid the same wage as free workmen, but the owner must have received the wage and been able to retain a portion as profit.[129] The artists could thus have multiplied their productivity and earning power, and the profit could have been invested for further profit, in accordance with general practice. J. K. Davies has proposed that the family that produced Kephisodotos and Praxiteles was immensely wealthy in the fourth century,[130] though this proposal must be treated with some caution, since it assumes that the names in the ancient sources are the same as those of the famous sculptors of the fourth century and a blood relationship that is so far only hypothesis.[131] Whatever the case, artists belonged to the swelling crowd of people making money with notable success from sources other than land.

The world of the fourth century looked back consciously to the glories of the fifth century in social, political, and artistic terms. Given the significant changes in all these areas, this is not difficult to understand. To clarify Rodenwaldt's remark on the ambiguous nature of the art of the century,[132] we can see that the fourth century in all respects looked both backward and forward; every sword has two edges, and in the fourth century both were particularly sharp. The sophists might be attacked for their professional, immoral, or amoral attitudes to the task of persuasion, yet Sokrates, Plato, Aristotle, and many others struggled to organize and understand the elements of the ever more complex worlds

[124] See most recently N. Himmelmann, *Realistische Themen in der griechischen Kunst der archaischen und klassischen Zeit, JdI-EH* 28 (Berlin 1994) 23–48 ("Banausen").

[125] K. Gschwantler, *Zeuxis und Parrhasios: Ein Beitrag zur antiken Künstlerbiographie* (Vienna 1975) 119–20. For Parrhasios, Gschwantler cites Athenaeus 12.543c–f and Aelian, *VH* 9.11; for Zeuxis, Pliny, *NH* 35.62.

[126] Cook, *Eranos* 88 (1990) 83–87; A. Burford, *Craftsmen in Greek and Roman Society* (Ithaca, NY, 1972) 138–44. Both stress that the evidence is difficult to interpret precisely, but, given that we know the sums paid to Athenians for military service, jury duty, and for attending the assembly, these figures seem accurate. E. E. Cohen, "'Whoring under Contract': The Legal Context of Prostitutes in Fourth-Century Athens," in *Law and Social Status in Classical Athens*, ed. V. Hunter and J. E. Edmondson (Oxford 2000) 125, points to evidence that salaries could and did in fact vary with the nature of the work.

[127] Cohen, *Banking Perspective* (note 72 above) 92–93. The negative effect of slavery on the social and economic fabric of ancient Greece appears to have been mitigated by the lack of a massive use of slaves in any area except mining: Humphreys, *AnnPisa* 39 (1970) 14–16, 21; Mossé, *Athens in Decline* (note 113 above) 43–46. Although Aristotle indicates that there were some who opposed the institution (*Politics* 1.3.4), he did not, nor did ancient society to its end: the sacking and total destruction of cities was followed by the selling of their populations into slavery as a matter of course.

[128] Note 75 above.

[129] Randall, *AJA* 57 (1953) 203–4 (Erechtheion accounts). As W. T. Loomis, *Wages, Welfare Costs, and Inflation in Classical Athens* (Ann Arbor 1998) 232–39, points out, however, the Erechtheion accounts are unusual in specifying a single wage for all participants in the building.

[130] Davies, *APF*, 286–90, no. 8334; H. Lauter, "Zur wirtschaftlichen Position der Praxiteles-Familie im spätklassischen Athen," *AA*, 1980, 525–31; A. Corso, *The Art of Praxiteles*, vol. 1, *The Development of Praxiteles' Workshop and Its Cultural Tradition until the Sculptor's Acme (364–1 BC)*, Studia Archaeologica 133 (Rome 2004) 111–14.

[131] V. C. Goodlett, *Collaboration in Greek Sculpture: The Literary and Epigraphical Evidence* (New York 1989) 170–76.

[132] Note 1 above.

of politics, society, and art. Indeed, we can say without hesitation that the old, small, and clannish world of the sixth and fifth centuries was gradually turning into an urbane and cosmopolitan world in which the Greeks were becoming the leaders and no longer the followers. To bemoan this development is as curious as it is to bemoan the creation of the centralized states of Egypt and Mesopotamia in the early third millennium. The Greek world was growing up and flexing its muscles. To be sure, the initial impression is one of relative chaos and decline, yet the subsequent domination of Greek culture—that is, political, social, intellectual, and artistic criteria for judging anything and everything down to the present day—belies such a simple impression. Greece was headed toward a new and important role as leader of the eastern Mediterranean. Even when the Romans came on the scene with such vigor a mere century later, the defeat of Philip V of Macedon at Kynokephale in 197 paralleled the defeat of Athens and her allies at Chaironeia (338); Flamininus's announcement of the liberation of Greece at the Isthmian games of 196 paralleled the spirit of the Corinthian League and merely marked a new change, not a totally new dispensation.

2 The Evidence, Part 1

Originals and Chronology

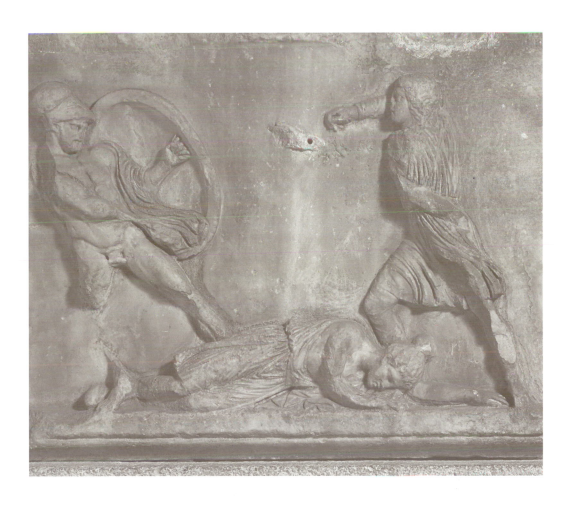

The chronology of the art of the fourth century B.C. has few objectively fixed points, and there remains much dispute over the date of specific monuments, large and small. In broad terms, the monuments under discussion begin to attain a recognizable stylistic character between 430 and 420 B.C. This is the beginning of the Rich Style, which continues to around 370 B.C. The name accurately describes the flamboyant calligraphy seen in both sculpture and vase painting. There follows the Plain Style, which has no easily identifiable terminal point but blends imperceptibly into the Hellenistic period in the last quarter of the fourth century. The name suggests a blandness that is anything but accurate; a more appropriate term would be the Opulent Style, though other names have been suggested.[1] For the record, it must be noted that Attic pottery has a slightly different period nomenclature: the Kerch Style is approximately the equivalent of the Plain Style in sculpture; the name is derived from vases found near the modern town of Kerch (ancient Pantikapaion), in the Crimea, that largely date after 370.[2] Attic vases of the first third of the century are grouped simply by their date or are occasionally referred to as of the "First [fourth-century] Style."[3] Arguments against this terminology have been raised,[4] but I shall retain the traditional names because introducing new ones can only be confusing.

The beginning date for our study has some objective foundation: the completion of the Parthenon is dated to 433/2 B.C. by firm epigraphic evidence (*IG* I³ 450 [I² 353]).[5] The building of the Temple of Athena Nike on the bastion at the entrance to the Athenian Acropolis must fall after this date on archaeological grounds: the foundations of the temple were built at the same time as the Propylaia.[6] It seems probable that the actual temple and its sculptured frieze (**Fig. 1**) were completed after 425, though there is no firm proof of this. It is the frieze of this temple that clearly marks the beginning of the Rich Style: figures lunge at steep angles to the horizontal, and drapery regularly begins to fan out in arcs and twists to heighten the sense of vigorous action.[7] Still in the fifth century,

[1] E. B. Harrison, "Early Classical Sculpture: The Bold Style," in *Greek Art: Archaic into Classical*, ed. C. G. Boulter (Leiden 1985) 42; Harrison, "Style Phases in Greek Sculpture from 450 to 370 B.C.," in *Proceedings of the 12th International Congress of Classical Archaeology, Athens, 4–10 September 1983*, vol. 3 (Athens 1988) 99–105; W. Childs, review of Ridgway, *Fourth-Century Styles*, in *AJA* 103 (1999) 156.

[2] Schefold, *KV*; Schefold, *UKV*; H. Metzger, *Les représentations dans la céramique attique du IVe siècle*, BÉFAR 172 (Paris 1951).

[3] Metzger, *Représentations*, 9.

[4] Boardman, *ARFV-CP*, 144, 190, titles his chapters "Later Classical I" and "Later Classical II."

[5] W. B. Dinsmoor, "Attic Building Accounts, V: Supplemental Notes," *AJA* 25 (1921) 233–47.

[6] M. M. Miles, "The Date of the Temple on the Ilissos," *Hesperia* 49 (1980) 323–25; B. Wesenberg, "Zur Baugeschichte des Niketempels," *JdI* 96 (1981) 28–54; I. S. Mark, *The Sanctuary of Athena Nike in Athens: Architectural Stages and Chronology*, AIA Monograph New Series 2, *Hesperia* suppl. 26 (Princeton 1993); M. Lippman, D. Scahill, and P. Schultz, "Knights 843–59, the Nike Temple Bastion, and Cleon's Shields from Pylos," *AJA* 110 (2006) 558–59.

[7] W. A. P. Childs, "In Defense of an Early Date for the Frieze of the Temple on the Ilissos," *AM* 100 (1985) 226–30. The new and excellent color photographs published by I. Trianti, *Το Μουσείο Ακροπόλεως* (Athens 1998) figs.

the sculpture of the Erechtheion is dated with some precision on epigraphic evidence (**Figs. 2, 3**): it is certain that the caryatids[8] were carved before construction of the temple was resumed in 409/8 after a hiatus of unknown length (*IG* I³ 474, lines 83–89 [I² 372]), though the disastrous Sicilian expedition of 413 is usually cited as its cause.[9] The frieze of the temple was certainly carved between 409/8 and 408/7.[10] How early the caryatids may have been made is uncertain, but they cannot be earlier than the 420s.

In the early fourth century, two dated grave reliefs describe the continuation of the Rich Style in the 390s: the stele of Dexileos (*IG* II² 6217) (**Fig. 4**) and the state grave stele for the fallen in the battles around Corinth in 394/3 (*IG* II² 5221).[11] In both, the most significant characteristic is the drapery that flutters around the figures even more vigorously than on the frieze of the Temple of Athena Nike.

The terminal date for the Rich Style is difficult to pinpoint. Evidence is gleaned primarily from Athenian record reliefs which are datable by the introductory formulas of the inscriptions.[12] Their small size and somewhat hasty execution do not, however, make them very reliable chronological benchmarks. Nonetheless, they do indicate unequivocally that by the end of the 370s the Rich Style was no longer in vogue (**Fig. 102**).[13]

It is only around 350 that the next monument with a relatively certain date, the Maussolleion at Halikarnassos, helps organize monumental sculpture (**Figs. 5–10**).[14] Its date is based on the date given by the ancient sources for the death of Maussollos of Karia (353 B.C.) and of his wife Artemisia very shortly after.[15] Unfortunately, the sources are not at all precise about the period in which the tomb was constructed, but the evidence does suggest it was begun by Maussollos and continued at least by Artemisia and perhaps by

386–400, show the heavy weathering of the frieze slabs that remained on the building until recently, which makes the old photographs and particularly the casts in Berlin so valuable: C. Picard, *L'Acropole, l'enceinte, l'entrée, le bastion d'Athéna Niké, les propylées* (Paris 1929) pls. 36–40; F. Felten, *Griechische tektonische Friese archaischer und klassischer Zeit* (Waldsassen 1984) pls. 33–37, 39, 47.

[8] H. Lauter, "Die Koren des Erechtheions," *AntP* 16 (1976) 16–17, 40–45.

[9] G. P. Stevens, L. D. Caskey, H. N. Fowler, and J. M. Paton, *The Erechtheum* (Cambridge, MA, 1927) 288–89, 301, 326–27, 345, 413–16.

[10] *IG* I³ 474, lines 40–43; *IG* I³ 475, restored first three lines before line 1; *IG* I³ 476, lines 136–37, 150–57, 159–84 [*IG* I² 372; 373; 374, lines 38–40]). For a detailed commentary and translation of the inscriptions, see L. D. Caskey, "The Inscriptions," in *The Erechtheum* (Cambridge, MA, 1927) 277–422; P. N. Boulter, "The Frieze of the Erechtheion," *AntP* 10 (1970) 7–24, pls. 1–30.

[11] Dexileos: Athens, Kerameikos P 1130: Clairmont, *CAT*, 2.209; S. Ensoli, *L'heróon di Dexileos nel Ceramico di Atene: Problematica architettonica e artistica attica degli inizi del IV secolo A.C.*, *MemLinc*, ser. 8, 29, fasc. 2 (Rome 1987); P. C. Bol et al., *Die Geschichte der antiken Bildhauerkunst*, vol. 2, *Klassische Plastik* (Mainz 2004) 260–61, fig. 194 (W. Geominy). State relief: Athens, NAM 2744: Kaltsas, *SNAMA*, 314, no. 313*; Travlos, *Pictorial Dictionary* figs. 421, 422.

[12] M. Meyer, *Die griechischen Urkundenreliefs*, *AM-BH* 13 (Berlin 1989); C. L. Lawton, *Attic Document Reliefs: Art and Politics in Ancient Athens* (Oxford 1995).

[13] Meyer, *Urkundenreliefs*, 49–52; Lawton, *Document Reliefs*, 69–71. The relief marking a treaty between Athens and Korkyra (Athens, NAM 1467) lacks the names of officials, which would provide the precise date, though on historical grounds the relief must fall between 376 and 374, with the consensus being 376/5: Meyer, *Urkundenreliefs*, 47–48, no. A 51; Lawton, *Document Reliefs*, 126–27, no. 96 (here **Fig. 101**).

[14] S. Hornblower, *Mausolus* (Oxford 1982) 223–74, gives a good review of the evidence for the building, including the recent work by the Danish under Kristian Jeppesen; K. Jeppesen, "Tot operum opus: Ergebnisse der dänischen Forschungen zum Maussolleion von Halikarnass seit 1966," *JdI* 107 (1992) 59–102.

[15] K. Jeppesen, in K. Jeppesen and A. Luttrell, *The Maussolleion at Halikarnassos: Reports of the Danish Archaeological Expedition to Bodrum*, vol. 2, *The Written Sources and Their Archaeological Background* (Aarhus 1986) 13–113, collects all the sources with detailed commentary and text criticism; the two principal ones are Pliny, *NH* 36.30–31, and Vitruvius 7 praef. 12–13. See also F. Højlund, in K. Jeppesen, F. Højlund, and K. Aaris-Sørensen, *The Maussolleion at Halikarnassos: Reports of the Danish Archaeological Expedition to Bodrum*, vol. 1, *The Sacrificial Deposit* (Copenhagen 1981) 82–83.

her successors Ada and Idrieos in the early 340s.[16] Here the Rich Style is gone: drapery has real mass and even texture, though it may flutter behind a figure, demonstrating a memory of its Rich Style antecedents (**Figs. 7–10**).

A statue in good condition was found in 1982 in the sanctuary of Eukleia at Vergina (**Fig. 11**); the inscription on the fully preserved base indicates that it was a dedication by Eurydike, the daughter of Sirras, who was the wife of the Macedonian king Amyntas III and therefore the mother of Philip II, father of Alexander the Great.[17] Manolis Andronikos suggested a date for the sanctuary after Chaironeia (338 B.C.),[18] but the statue cannot be that late. Although it has been compared to the Eirene attributed to Kephisodotos (**Fig. 12**), this is not very convincing.[19] The regular tubular folds over the standing leg resemble those of the Athena Ince Blundell type (**Fig. 268**)[20] and one of the statuettes in Venice thought to come from Crete,[21] both of which must be dated around 400 B.C. or slightly after. Another similarity is the manner in which the drapery is pulled taught around the ankle of the free leg. Eurydike married Amyntas III in the late 390s, so it is likely that the statue dates after that event. It is therefore old-fashioned and as such cannot help in establishing a stylistic chronology for the first half of the fourth century.[22]

Slightly later, the Daochos Monument was set up at Delphi by the Thessalian tetrarch Daochos II, who served as *hieromnēmon* for Thessaly approximately between the years 338/7–337/6 and 334/3–343/2 B.C.[23] His monument consisted of nine statues, eight of

[16] Hornblower, *Mausolus* (note 14 above) 237–44, 266–67; K. Jeppesen, "Nisi absoluto iam: Observations on the Building of the Mausoleum at Halicarnassus," in *Mansel'e Armağan/Mélanges Mansel* (Ankara 1974) vol. 2, 735–48; Jeppesen, "Zur Gründung und Baugeschichte des Maussolleions von Halikarnassos," *IstMitt* 27–28 (1977–78) 206–8.

[17] C. Saatsoglou-Paliadeli, "Ευρυδίκα Σίρρα Ευκλείαι" (A Dedication of Eurydice, Daughter of Sirras, to Eukleia at Vergina), in *Αμητός· Τιμητικὸς τόμος για τον καθηγητή Μανόλις Ανδρόνικο* (Thessaloniki 1987) 733–43, pl. 144 (English summary on p. 744); Saatsoglou-Paliadeli, "Βεργίνα 1990· Ανασκαφή στο ιερό της Εύκλειας" (Vergina 1990: The Sanctuary of Eukleia), *AErgoMak* 4 (1990) 21–28; figs. 1–12 on pp. 31–34 (English summary on p. 29); M. Andronikos, *Ergon*, 1990, 83–84, figs. 116–18; S. Drougou and C. Saatsoglou-Paliadeli, *Vergina: Wandering through the Archaeological Site*, 2nd ed., trans. A. Doumas (Athens 2000) 347; P. Schultz, "Leochares' Argead Portraits in the Philippeion," in *Early Hellenistic Portraiture: Image, Style, Context*, ed. P. Schultz and R. von den Hoff (Cambridge 2007) 216–17, figs. 140, 141; Schultz, "Divine Images and Royal Ideology in the Philippeion at Olympia," in *Aspects of Ancient Greek Cult: Context, Ritual and Iconography*, ed. J. T. Jensen, G. Hinge, P. Schultz, and B. Wickkiser, Aarhus Studies in Mediterranean Antiquity 8 (Aarhus 2009) 144–45, figs. 17a–c.

[18] M. Andronikos, *Vergina: The Royal Tombs* (Athens 1987) 49–51.

[19] Saatsoglou-Paliadeli, *AErgoMak* 4 (1990) 27, 29; Ridgway, *Fourth-Century Styles*, 347. The statue does have a series of stacked catenary folds down the middle of her back, similar to the Eirene: Andronikos, *Ergon*, 1990, 84, fig. 117; A. Pariente, "Chronique des fouilles et découvertes archéologiques en Grèce en 1990," *BCH* 115 (1991) 901, fig. 92. For a certainly late (very late-fourth or early-third-century) reflection of the Eirene, see the peplophoros from the Dionysion on Thasos: P. Bernard and F. Salviat, "Nouvelles découvertes au Dionysion de Thasos," *BCH* 83 (1959) 302–15, figs. 13, 14, pls. XII–XVII.

[20] Liverpool, World Museum, Ince Blundell Collection 8: L. Todisco, *Scultura greca del IV secolo: Maestri e scuole di statuaria tra classicità ed ellenismo* (Milan 1993) no. 9.

[21] Ibid., no. 23; I. Favaretto, M. De Poli, and M. C. Dossi, *Museo Archeologico Nazionale di Venezia* (Milan 2004) 26, fig. 1.1a, no. 15.

[22] Schultz, "Argead Portraits," dates the statue to the mid-fourth century and also considers it old-fashioned.

[23] A. Jacquemin and D. Laroche, "Le monument de Daochos ou le trésor des Thessaliens," *BCH* 125 (2001) 305–32. The date is given by inscriptions from Delphi (often restored), but at least some are sufficiently certain to warrant respect: É. Bourguet, *Fouilles de Delphes*, vol. 3, *Épigraphie*, fasc. 5, *Les comptes du IVe siècle* (Paris 1932); J. Bousquet, *Corpus des inscriptions de Delphes*, vol. 2, *Les comptes du quatrième et du troisième siècle* (Paris 1989). The numbers of the *Corpus* (CID) are followed in brackets by the numbers of the *Fouilles* (FdD): CID 74, col. I, 2; 74, col. II, 22, 75 [FdD 47, 2] (archonship of Palaios); CID 75, col. II, 10, 26 [FdD 49] (archonship of Dion); CID 76, col. I, 17 [FdD 50.1] (archonship of Dion); CID 79 A, col. I, 5 [FdD 48 + 63, 1, 17]; CID 79 A, col. II, 7, 36 [FdD 48, col. 2, 8] (archonship of Damochares); CID 80, 6 [FdD 51, 7]; CID 82, 18 [FdD 52, 18] (archonship of Damokrates). Bourguet dates Palaios to 339/8 (pp. 25, 33) and Damochares 338/7 (pp. 25–26). P. de la Coste-Messelière, "Listes amphictioniques du IVe siècle," *BCH* 73 (1949) 229–30, 233–36, 239–40, 242, redated Palaios to 337/6, Dion to 336/5, Damochares to 334/3, and Damokrates to 333/2, and was followed by: Pouilloux, *FdD* 3.4, 136 (no. 460); J. Bousquet, *Études sur*

which are preserved to varying degrees, set on a rectangular base in a building to the east of the Temple of Apollo, where it was excavated by the French in 1894 (**Figs. 13–18**).[24] It has been argued convincingly that the monument must have been set up during the period in which Daochos held office at Delphi; signs of rapid building—such as the backs of blocks not being smoothed, the lack of a strong foundation, and some missing clamps—point in this direction.[25] The better-preserved statues of the group present a medley of styles.

Almost contemporary with the Daochos Monument is the choregic monument of Lysikrates in Athens, dated to 334 B.C. or slightly later by the inscription on its three-fascia architrave (*IG* II[2] 3042) (**Figs. 19, 20**).[26] The monument commemorates the victory of youths of the tribe Akamantis in a dithyramb singing competition in the archonship of Euainetos (335/4). It is likely that Lysikrates was trierarch ten years later, in 325/4 (*IG* II[2] 1629, line 43),[27] and was therefore quite understandably one of the richest Athenians of the day. The building is round and stands on a high square basement that is almost completely preserved and still in situ on the Street of the Tripods. It has six pseudo-engaged Corinthian columns, above which is a frieze representing events related in the *Homeric Hymn to Dionysos*: the transformation into dolphins of the pirates who had abducted the god. Many of the figures move vigorously and gesture dramatically, with wide open spaces between them. According to Heinrich Bauer, the building was planned to be open on all sides, but during its construction walls were erected between all but the eastern intercolumniation for reasons of stability.[28] A bronze tripod was placed on the elaborate acanthus finial.[29] The monument has stood in the open since its construction and has suffered badly

les comptes de Delphes, BÉFAR 267 (Athens 1988) 48, 51, 61, 67; Bousquet, *CID*, vol. 2, 145, 147, 150, 160, 172, 179; and A. H. Borbein, "Die bildende Kunst Athens im 5. und 4. Jahrhundert v. Chr.," in *Die athenische Demokratie im 4. Jahrhundert v. Chr.: Vollendung oder Verfall einer Verfassungsform? Akten eines Symposiums, 3.–7. August 1992, Bellagio*, ed. W. Eder (Stuttgart 1995) 451, note 134. Note, however, that P. Marchetti, "En reliant les comptes de Delphes autour de l'archonte Palaios," *BCH* 126 (2002) 67–70, rejects the restoration of Daochos in *CID* no. 64. Pouilloux, *FdD* 2.C.2, 77, and O. Picard, ed., *Guide de Delphes: Le musée* (Paris 1991) 91, cite the date of 338–334. G. Roux, *L'amphictionie, Delphes et le temple d'Apollon au IVe siècle* (Lyon and Paris 1979) 25, gives the date of Daochos as 339/8–333/2 without argument or explanation. The differences are too slight to matter in the discussion of the sculpture: Daochos was *hieromnēmon* from the mid- to late 330s. The evidence does, however, strongly suggest that Daochos was *hieromnēmon* from the spring of 336 (*CID* 74 [*FdD* 47]) to the autumn of 333 (*CID* 82 [*FdD* 52]), as La Coste-Messelière originally proposed: *BCH* 73 (1949) 229–30.

[24] Jacquemin and Laroche, *BCH* 125 (2001) 305–32, argue that the dedication was set up in a completely enclosed and roofed building of slightly earlier date. On the earlier reconstruction, see T. Homolle, "Découvertes de Delphes," *GBA*, ser. 3, 12 (1894) 452; Homolle, "Lysippe et l'ex-voto de Daochos," *BCH* 23 (1899) 421–85; Bommelaer and Laroche, *Delphes: Le site*, 200–201, no. 511. On the sculpture: Picard, *Delphes: Le musée*, 91–98; T. Dohrn, "Die Marmor-Standbilder des Daochos-Weihgeschenks in Delphi," *AntP* 8 (1968) 33–53, pls. 10–37; and further chap. 5A, pp. 171–74, and chap. 7, pp. 276–78 below.

[25] Pouilloux, *FdD* 3.4, p. 136; Pouilloux, *FdD* 2.C.2, 70–76. However, W. Geominy, "Zum Daochos-Weihgeschenk," *Klio* 80 (1998) 369–402, and "The Daochos Monument at Delphi: The Style and Setting of a Family Portrait in Historic Dress," in *Early Hellenistic Portraiture: Image, Style, Context*, ed. P. Schultz and R. von den Hoff (Cambridge 2007) 84–98, has argued for a date in the early third century on the basis of prosopography and the historical situation. His arguments are based on so many possible variant interpretations that it is difficult to draw the momentous conclusions he proposes; see H. von Steuben, "Zur Komposition des Daochos-Monumentes," in *Antike Porträts: Zum Gedächtnis von Helga von Heintze*, ed. H. von Steuben (Möhnesee 1999) 35–38. Jacquemin and Laroche, *BCH* 125 (2001) 323–25, 329–30, suggest that the building was destroyed by a mudslide before the dedication was even completed, and that the Column of the Dancers, dated circa 330 (see further below), is the terminus ante quem for the disaster. Geominy, "Daochos Monument," 85–88, raises serious questions about this reconstruction of events.

[26] H. Riemann, *RE*, suppl. 8 (Stuttgart 1956), s.v. "Lysikratesmonument," cols. 266–348; Travlos, *Pictorial Dictionary*, 348–51, 566–67; H. Bauer, "Lysikratesdenkmal: Baubestand und Rekonstruktion," *AM* 92 (1977) 197–227; W. Ehrhardt, "Der Fries des Lysikratesmonument," *AntP* 22 (1993) 7–67; Wilson, *Khoregia*, 219–26.

[27] Riemann, *RE*, suppl. 8, col. 267.

[28] Bauer, *AM* 92 (1977) 204–5.

[29] P. Amandry, "Monuments chorégiques d'Athènes," *BCH* 121 (1997) 463–70.

from weathering, as can be seen from casts in the British Museum made for Lord Elgin and casts in various European collections stemming from an original set of the early nineteenth century in Paris.[30]

The last securely dated building of the fourth century with sculptural decoration is the Temple of Apollo at Delphi (330s–327).[31] The date, based on very fragmentary inscriptions, has been much disputed, but an intelligible consensus has at last been reached. The sculptured pediments are very fragmentary but provide valuable evidence as we near the end of the century (**Figs. 21, 22**).[32]

All of the dates for other monumental sculpture are based on stylistic comparisons with these firmly dated examples. New buildings with sculptural decoration in the period of 430 to 300 are relatively plentiful. From the fourth century proper there are a number of temples with sculptural decoration that is more or less well preserved: the Argive Heraion (ca. 400),[33] the Temple of Apollo Epikourios at Bassai (Phigalia) (400–390) (**Figs. 23–25**),[34] the tholos of the Marmaria at Delphi (ca. 380) (**Figs. 26, 27**),[35] a temple of Athena at Mazi[36] and a similar temple with marble pedimental sculpture near Patras (both ca. 390–370),[37] the Temple of Asklepios at Epidauros (370s) (**Figs. 28–33**),[38] the Temple of Athena Alea at Tegea (340s) (**Figs. 34–38**),[39] the Temple of Artemis at Ephesos (330s) (**Figs. 39, 40**),[40] the Temple of Athena Polias at Priene (330s?).[41] At the very end of the century or possibly just beyond are two buildings with sculptural

[30] Ehrhardt, *AntP* 22 (1993), reproduces both sets of casts with new and quite excellent photographs of the frieze made in 1975 by Gösta Hellner.

[31] Picard, *Delphes: Le musée*, 77–84, figs. 38–45; J.-F. Bommelaer, "La construction du temple classique de Delphes," *BCH* 107 (1983) 191–215; Amandry and Hansen, *FdD* 2.C.14, 474–90. On the epigraphic evidence, see J. Bousquet, "Inscriptions de Delphes," *BCH* 108 (1984) 695–98 (A: Les sculptures tympanales du temple delphique d'Apollon [IVe s.] et les comptes des trésoriers); Bousquet, *Comptes de Delphes* (note 23 above) 51–57, 80–81; Bousquet, *CID*, vol. 2, commentaries on pp. 193, 200, 206, 215, 224, who rejects the arguments of Roux, *Amphictionie* (note 23 above). For the general background, see F. Croissant, "Les Athéniens à Delphes avant et après Chéronée," in *Le IVe siècle av. J.-C.: Approches historiographiques*, ed. P. Carlier (Nancy 1996) 127–39.

[32] Croissant, *FdD* 4.7; Ridgway, *Hellenistic Sculpture*, 17–21, pls. 2a, 2b, 3; M. Flashar, *Apollon Kitharodos: Statuarische Typen des musischen Apollon* (Cologne 1992) 60–70, 115, 117, 143–47, 153, figs. 30, 31, 36, 88, 89; Todisco, *Scultura greca*, nos. 212, 243; Bol, *Bildhauerkunst*, 370, figs. 336a–c (C. Maderna).

[33] C. A. Pfaff, *The Argive Heraion: Results of Excavations Conducted by the American School of Classical Studies at Athens*, vol. 1, *The Architecture of the Classical Temple of Hera* (Princeton 2003) 191–96; P. Amandry, "A propos de Polyclète: Statues d'olympioniques et carrière de sculpteurs," in *Charites: Studien zur Altertumswissenschaft*, ed. K. Schauenburg (Bonn 1957) 79–82; C. Waldstein, *The Argive Heraeum* (Boston 1902–5); F. Eichler, "Die Skulpturen des Heraions bei Argos," *ÖJh* 19 (1919) 15–153.

[34] U. Liepmann, *Das Datierungsproblem und die Kompositionsgesetze am Fries des Apollontempels zu Bassae-Phigalia* (Hannover 1970); B. C. Madigan, *The Temple of Apollo Bassitas*, vol. 2, *The Sculpture* (Princeton 1992) 35–37, 95–98, prefers a slightly earlier date, in the last decade of the fifth century.

[35] C. Picard, *Manuel d'archéologie grecque: La sculpture*, vol. 3, *Période classique, IVe siècle*, pt. 1 (Paris 1948) 178–89; J. Marcadé, "A propos du décor en marbre des monuments de Marmaria," in *Delphes: Centenaire de la "grande fouille" réalisée par l'École française d'Athènes (1892–1903)* (Leiden 1992) 251–62; Picard, *Delphes: Le musée*, 66–76.

[36] I. Trianti, *Ο γλυπτός διάκοσμος του ναού στο Μάζι της Ηλείας* (Thessaloniki 1985); Trianti, "Ο γλυπτός διάκοσμος του ναού στο Μάζι της Ηλείας," in *Archaische und klassische griechische Plastik: Akten des internationalen Kolloquiums vom 22.–25. April 1985 in Athen*, ed. H. Kyrieleis (Mainz 1986), vol. 2, 155–68, pls. 136–43; Ridgway, *Fourth-Century Styles*, 30–34, ills. 3, 4; Boardman, *GS-LCP*, fig. 8.

[37] Trianti, "*Γλυπτός διάκοσμος*" (note 36 above) 164, pls. 143.1–4, 144.1, 144.2; Ridgway, *Fourth-Century Styles*, 32–33.

[38] N. Yalouris, "Die Skulpturen des Asklepiostempels in Epidauros," *AntP* 21 (1992).

[39] N. J. Norman, "The Temple of Athena Alea at Tegea," *AJA* 88 (1984) 169–94; C. Dugas, J. Berchmans, and M. Clemmensen, *Le sanctuaire d'Aléa Athéna à Tégée au IVe siècle* (Paris 1924).

[40] Ephesos: A. Rügler, *Die Columnae caelatae des jüngeren Artemisions von Ephesos, IstMitt-BH* 34 (Tübingen 1988).

[41] J. C. Carter, *The Sculpture of the Sanctuary of Athena Polias at Priene*, Reports of the Research Committee of the Society of Antiquaries of London 42 (London 1983) 38–40, 99–103.

decoration, the Temple of Artemis at Epidauros (**Fig. 47**)[42] and the Monument of the Bulls on Delos.[43]

There is another body of indubitably original marble statues of the highest quality that must have once been associated with buildings that cannot be identified with certainty. These include several figures of roughly the first quarter of the fourth century, which must have been acroteria, now in the Agora Museum in Athens (**Fig. 41**), and a Nereid on a dolphin in the National Museum (part of which was found in the Agora) (**Fig. 42**).[44] Of about the same date is the beautiful statue in the Palatine Museum usually recognized as an Aura; she is certainly an original and, from the weathering, must have been an acroterion (**Fig. 43**).[45] Her counterpart was discovered in 1995 in the villa of Herodes Atticus near Loukou.[46] Also here belong the two running women in the Louvre that at one time were thought to be acroteria of the Temple of Apollo at Bassai.[47] One is largely preserved, while the other has a modern upper torso.

A small (0.76 m) headless statue of a female figure in clinging, wet drapery in Burlington House, London, is probably an original and may have belonged to a building, since the front side is weathered, but the back is not (**Fig. 44**).[48] It belongs in the early fourth century, since it has close stylistic associations with the sculptures of the Temple of Asklepios at Epidauros.[49]

A fragmentary figure of an Amazon on a rampant horse, apparently found in the vicinity of Rome and now in Boston, must have come from a pediment, though a votive group has also been suggested.[50] The workmanship is excellent; the date must be very close to

[42] G. Roux, *L'architecture de l'Argolide aux IVe et IIIe siècles avant J.-C.* (Paris 1961) 211–22; A. Burford, *The Greek Temple Builders at Epidauros: A Social and Economic Study of Building in the Asklepian Sanctuary, during the Fourth and Early Third Centuries B.C.* (Liverpool 1969) 70–73; N. Yalouris, "Τὰ ἀκρωτήρια τοῦ ναοῦ τῆς Αρτέμιδος," *ArchDelt* 22 (1967) Mel. 25–37, pls. 22–38.

[43] J. Marcadé, "Les sculptures décoratives du monument des taureaux à Délos," *BCH* 75 (1951) 55–89, pls. VI–XVII; Marcadé, *Au musée de Délos*, BÉFAR 215 (Paris 1969) 361–62, reviews the slight evidence for the date of the building, which appears to be connected with Demetrios Poliorketes' victory at Cypriot Salamis in 306; Ridgway, *Hellenistic Sculpture*, 172–76, pls. 77–80.

[44] Athens, Agora S 182, S 312; Athens, NAM 3397 + 4320 + 4798 + Agora S 2091: A. Delivorrias, *Attische Giebelskulpturen und Akrotere des fünften Jahrhunderts* (Tübingen 1974) pls. 16, 43–53; Naples, MAN, without number: fragment of a female torso, joins Athens, NAM 4798 + Agora S 2091: W. Fuchs, "Aus den Museumsnotizen einer Stipendiatenreise des Jahres 1954," *Boreas* 2 (1979) 59–60, pls. 3, 4, 5.1, 5.2; Delivorrias, *Giebelskulpturen*, 129, note 561, with pls. 46, 47, 51a.

[45] Rome, MNR (Museo Palatino) 124697: A. Giuliano, ed., *Museo Nazionale Romano: Le sculture*, vol. 1, pt. 1 (Rome 1979) 204–6, no. 27 (J. Papadopoulos); C. Picón, "The Oxford Maenad," *AntP* 22 (1993) 91–92, figs. 15, 16; Bol, *Bildhauerkunst*, 201, fig. 131 (D. Kreikenbom).

[46] Astros 356a: G. Spyropoulos, *Drei Meisterwerke der griechischen Plastik aus der Villa des Herodes Atticus zu Eva/Loukou* (Frankfurt am Main 2001) 61–128, pls. 1, 2, 13–17; G. Despinis, "Sculture architettoniche greche a Roma," *BullCom* 97 (1996) 256.

[47] C. Hofkes-Brukker, "Die Akrotere des Bassaetempels," *BABesch* 40 (1965) 51–71; A. Delivorrias, "*Disiecta Membra*: The Remarkable History of Some Sculptures from an Unknown Temple," in *Marble: Art Historical and Scientific Perspectives on Ancient Sculpture*, ed. M. True and J. Podany (Malibu, CA, 1990) 11–46; Bol, *Bildhauerkunst*, 201–2, figs. 132a, 132b (D. Kreikenbom); M. Hamiaux, *Les sculptures grecques*, vol. 1, *Des origines à la fin du IVe siècle avant J.-C.*, Musée du Louvre, Départment des antiquités grecques, étrusques et romaines (Paris 1992) vol. 1, 236–39, nos. 251*, 252* (Louvre Ma 3072, Ma 3516).

[48] BrBr 747, 748 (B. Ashmole) (Munich 1932); H. K. Süsserott, *Griechische Plastik des 4. Jahrhunderts vor Christus: Untersuchungen und Zeitbestimmung* (Frankfurt 1938) 134–35; B. Schlörb, *Timotheos*, JdI-EH 22 (Berlin 1965) 64–66, fig. 53; E. Bielefeld, "Drei Akroter-Statuen Reichen Stils," *AntP* 9 (1969) 59; Todisco, *Scultura greca*, no. 83; Boardman, *GS-LCP*, fig. 12.

[49] Yalouris, *AntP* 21 (1992) pls. 15a (cat. 14), 27 (cat. 26); less close is the Nike, pl. 3 (cat. 2).

[50] Boston, MFA 03.751: M. B. Comstock and C. C. Vermeule, *Sculpture in Stone: The Greek, Roman and Etruscan Collections of the Museum of Fine Arts, Boston* (Boston 1976) 32, no. 42*; Yalouris, *AntP* 21 (1992) 39, figs. 9, 10.

the Temple of Asklepios at Epidauros, as the statue resembles very closely the central figure of the west pediment (**Fig. 28**).[51]

Erwin Bielefeld has dated a pair of Nereids on hippocamps from Formia, now in Naples, to the early fourth century;[52] they must have served as acroteria. Their date, however, is uncertain: Heinrich Fuhrmann dated them in the Hellenistic period,[53] followed by Barbara Schlörb,[54] but the torsos are not slim shouldered, and the figures closely resemble a Nereid, British Museum no. 909, from the Nereid Monument in Xanthos, which dates around 390–380 B.C. (**Fig. 50**).[55] The figures from Formia, however, make a very baroque impression, with a lot of busy work, unlike the more austere Nereids from Xanthos (**Figs. 50, 51**). Still, a date in the later first quarter of the fourth century is possible. Bielefeld connected the Nereids from Formia with a statue, possibly of Aura, in the Ny Carlsberg Glyptotek (**Fig. 45**).[56] Georg Lippold associated this statue closely with the pedimental sculpture of the Temple of Asklepios at Epidauros;[57] Schlörb put it in the circle of Timotheos at or after the end of his career, that is, near the middle of the fourth century.[58] Frederik Poulsen—correctly, to my mind—considered the statue to be later; he says Hellenistic, but the end of the fourth century is possible.[59]

A controversial set of statues considered to be Niobids may have formed part of a pedimental group of the first half of the fourth century in Greece.[60] These are scattered over several museums—one in Copenhagen is thought to be an original and, from its plinth, very probably does come from a pediment; the rest are copies. There is no clear indication that any of the figures are actually Niobids nor that the statues might once have belonged together or are even of the same date. The original statue in Copenhagen could be a generic warrior. But it is very close in size to the group of Niobids generally believed to date

[51] Yalouris, *AntP* 21 (1992) 35–38, no. 34, pls. 40, 41, 42c.

[52] Naples, MAN 145070, 145080: Bielefeld, *AntP* 9 (1969) 47–64, pls. 25–36; Bielefeld, "Zu den Nereiden aus Formia," *RM* 76 (1969) 93–102, pls. 41–43; P. Danner, *Griechische Akrotere der archaischen und klassischen Zeit* (Rome 1989) 32, no. 256, pl. 31.

[53] H. Fuhrmann, "Archäologische Grabungen und Funde in Italien und Libyen," *AA*, 1941, 573–75, figs. 100, 101.

[54] Schlörb, *Timotheos*, 80.

[55] W. A. P. Childs and P. Demargne, *Fouilles de Xanthos*, vol. 8, *Le monument des Néréides: Le décor sculpté* (Paris 1989) pl. 89; Bol, *Bildhauerkunst*, fig. 134.

[56] Copenhagen, NCG 2432: F. Poulsen, *Catalogue of Ancient Sculpture in the Ny Carlsberg Glyptotek* (Copenhagen 1951) 266–67, no. 397a; M. Moltesen et al., *Greece in the Classical Period: Ny Carlsberg Glyptotek* (Copenhagen 1995) 60–61, no. 9*; Bielefeld, *AntP* 9 (1969) 56–59, pls. 37–39; Schlörb, *Timotheos*, 79–80, fig. 57; BrBr 664 and 665 (G. Lippold) (Munich 1926). A statue of Apollo Kitharoidos also in the Ny Carlsberg (inv. 497; Poulsen, *Catalogue*, no. 63) is probably a Roman work: Moltesen, *Classical Period*, 58–59, no. 8*. A. Gulaki, *Klassische und klassizistische Nikedarstellungen: Untersuchungen zur Typologie und zum Bedeutungswandel* (Bonn 1981) 183, figs. 139, 140, 142; and Flashar, *Apollon Kitharodos*, 215–16, note 123, argue strongly that the statue is Roman, but E. Simon, in *LIMC*, s.v. Apollon/Apollo no. 42, considers the statue an original of the early fourth century.

[57] BrBr 664, 665.

[58] Schlörb, *Timotheos*, 79–80.

[59] Poulsen, *Catalogue*, 267; so also Picón, *AntP* 22 (1993) 93. The very low relief of the folds is remarkable and contrasts both with the Nereids of the Nereid Monument and the pediments and acroteria of Epidauros. See further chap. 4, p. 133 below.

[60] *LIMC*, s.v. Niobidai nos. 55, 56, 59, 61, with commentary (vol. 6, p. 926) by W. Geominy, who also rejects the grouping. The statues are: Copenhagen, NCG 1668: Poulsen, *Catalogue*, no. 400; A. F. Stewart, *Skopas of Paros* (Park Ridge, NJ, 1977) 101–2 (on p. 151 it is stated that tests of the marble suggest it is Greek, and Peloponnesian in particular); Moltesen, *Classical Period*, 62–63, no. 10*; Basel, Antikensammlung BS 229: K. Schefold, *Meisterwerke der griechischen Kunst* (Basel 1960) 78, 242*, 250, no. 311; Munich, Glyptothek 270 ("Ilioneus"): B. Vierneisel-Schlörb, *Glyptothek München, Katalog der Skulpturen*, vol. 2, *Klassische Skulpturen* (Munich 1979) 431–34, no. 39, figs. 210–15; and Rome, MNR (Palazzo Massimo) 1075 (from Subiaco; here **Fig. 235**): Giuliano, *MNR*, vol. 1, pt. 1, 168–71, no. 114* (L. de Lachenal).

just after the middle of the fifth century,[61] and I see no reason not to attribute the statue to that group and remove it completely from the fourth century.

Right at the end of our period and probably just beyond is an original marble statue in Oxford that Carlos Picón has suggested served as an acroterion of an unknown building (**Fig. 46**).[62] The marble is possibly Pentelic, though Susan Walker has suggested Greek island marble, probably Parian.[63] The statue is flamboyant; Picón understandably found no direct stylistic parallels for the statue in the fourth century, though he draws comparisons with the acroteria from the Temple of Athena Alea at Tegea (**Figs. 36, 37**).[64] However, a comparison that he rejects, with the small acroteria of the Temple of Artemis at Epidauros, from the end of the fourth or the early third century (**Fig. 47**), appears to me more convincing and will be discussed further in a later chapter.[65]

The tradition in the eastern Mediterranean of large and richly decorated tombs, of which the Maussolleion is the most famous, is preserved in a series of local dynastic structures richly embellished with sculpture: the Nereid Monument of Xanthos (ca. 380) (**Figs. 48–55**),[66] the heroon of Trysa (370) (**Figs. 56–58**),[67] and the heroon of Limyra (360) (**Figs. 59, 60**).[68] To be classified in a parallel track are four elaborate sarcophagi with extensive sculptural decoration from the royal cemetery at Sidon: the Lykian Sarcophagus (390), the Satrap Sarcophagus (380–370), the Mourning Women Sarcophagus (370–360) (**Figs. 61, 62**), and the so-called Sarcophagus of Alexander (320–310).[69] The Fuggischer Sarcophagus in Vienna (320–300), long thought to have come from Thessaloniki, actually comes from Soloi on Cyprus (**Figs. 63, 64**).[70] A curious monument, the so-called Tribune of Eshmoun (**Figs. 271, 272**), also from Sidon, may belong to our period.[71]

[61] NCG 1668 (see note 60 above), a kneeling warrior without head, measures 0.80 m; NCG 520 (Poulsen, *Catalogue*, no. 398), from the purportedly earlier group, a running girl with head, measures 1.40 m; and NCG 1682 (Poulsen, no. 304), a girl without head and feet, measures 0.69 m. On the earlier group, see Ridgway, *Fifth Century Styles*, 55–59, who gives a list of all possible members of the group; Delivorrias, *Giebelskulpturen* (note 44 above) 86–90; Moltesen, *Classical Period*, 41–53, nos. 1–5.

[62] Oxford, Ashmolean AN1928.530: Picón, *AntP* 22 (1993) 84–104, pls. 28–33.

[63] Ibid., p. 89, note 2.

[64] Tegea 59 and 2288: ibid., p. 92, figs. 8–11.

[65] Ibid., p. 92, figs. 12–14. See chap. 4, p. 134, and chap. 5B, p. 210, below.

[66] P. Demargne and P. Coupel, *Fouilles de Xanthos*, vol. 3, *Le monument des Néréides: L'architecture* (Paris 1969); Childs and Demargne, *FdX* 8 (note 55 above). Whether the fragmentary pediment discovered at Sardis in 1969 and 1977 is as early (430–420) as its publishers believe is open to question because I have not seen the piece, except in photographs, but it certainly belongs among the early monuments of the type: G. M. A. Hanfmann and P. Erhart, "Pedimental Reliefs from a Mausoleum of the Persian Era at Sardis: A Funerary Meal," in *Studies in Ancient Egypt, the Aegean, and the Sudan: Essays in Honor of Dows Dunham on the Occasion of His 90th Birthday, June 1, 1980* (Boston 1981) 82–90, with earlier bibliography.

[67] F. Eichler, *Die Reliefs des Heroon von Gjölbaschi-Trysa* (Vienna 1950); W. Oberleitner, *Das Heroon von Trysa: Ein lykisches Fürstengrab des 4. Jahrhunderts v. Chr.*, AntW 25, Sondernummer (Mainz 1994); T. Marksteiner, *Trysa, eine zentrallykische Niederlassung im Wandel der Zeit: Siedlungs-, architektur- und kunstgeschichtliche Studien zur Kulturlandschaft Lykiens*, Wiener Forschungen zur Archäologie 5 (Vienna 2002) 160–89.

[68] J. Borchhardt, *Die Bauskulptur des Heroons von Limyra: Das Grabmal des lykischen Königs Perikles*, IstForsch 32 (Berlin 1976).

[69] Hamdy Bey and Reinach, *Nécropole royale*; J. C. Assmann, "Zur Baugeschichte des Königsgruft von Sidon," *AA*, 1963, 690–716; H. Gabelmann, "Zur Chronologie der Königsnekropole von Sidon," *AA*, 1979, 163–77; J. Ferron, *Sarcophages de Phénicie: Sarcophages à scènes en relief* (Paris 1993) 107–58, pls. XXV–LXVII, color pls. LXXX–LXXXIX, citing the extensive bibliography on each sarcophagus as it is discussed.

[70] A. Hermary, "Le sarcophage d'un prince de Soloi," *RDAC* (1987) 231–33; Ferron, *Sarcophages de Phénicie* (note 69 above) 319–44, pls. LXVIII–LXXV; R. Fleischer et al., "Der Wiener Amazonensarkophag," *AntP* 26 (1998) 7–54.

[71] R. A. Stucky, *Tribune d'Echmoun: Ein griechischer Reliefzyklus des 4. Jahrhunderts v. Chr. in Sidon*, AntK-BH 13 (Basel 1984); Stucky, *Die Skulpturen aus dem Eschmun-Heiligtum bei Sidon: Griechische, römische, kyprische und*

Its relief friezes are difficult to date convincingly and will be treated in detail below.[72] Perhaps the most interesting aspect of all the buildings—whether temple, monument, or tomb—is the wide geographic spread. It is probable, as the dates given in parentheses suggest, that they cover the whole fourth century.

Original freestanding sculpture is rarely preserved, and the criteria for distinguishing originals of the fourth century have increasingly been thrown into doubt in recent years.[73] This applies to statues in marble as well as in bronze. The function of the statues is more often than not also in doubt, since few, if any, have been found in situ. The majority certainly served as votives dedicated by private citizens, though this distinction is not as clear as the modern mind might wish. For example, some statues were certainly set up by individuals in their capacity as public officials, such as manager of a festival liturgy in Athens.[74] However, even statues set up to honor private citizens, such as statues of victors in athletic contests, could and did have public connotations.[75]

Perhaps the most important distinction made by modern scholars is between purportedly major works that could conceivably be attributed to a sculptor known from the ancient texts, and works of lesser aspirations that are generally small and of modest craft. The list of works of the first category that are or *might* be originals is short: marble Persephone in Eleusis (400);[76] marble youth from the Piraeus (390);[77] marble statue of Hygieia from Epidauros (380);[78] seated statue of Kybele from the Athenian suburb Moschato (ca. 350);[79] bronze boy from Marathon Bay (350) (**Figs. 65–67**);[80] bronze youth from Antikythera (340) (**Figs. 69, 70**);[81] bronze apoxyomenos or strigil-cleaner from Ephesos in Vienna (360–330) (**Figs. 71, 72**);[82] the statue of Apollo Patroos, probably by Euphranor, in the Athenian Agora (ca. 330) (**Figs. 73, 74**);[83] the statues of the Daochos Monument

phönizische Statuen und Reliefs vom 6. Jahrhundert vor Chr. bis zum 3. Jahrhundert nach Chr., AntK-BH 17 (Basel 1993) 109–10, no. 247, pls. 58–61.

[72] See chap. 7, pp. 274–76 below.

[73] Ridgway, *Fourth-Century Styles*, passim.

[74] On liturgies as a public-private responsibility, see chap. 1, pp. 20–21 above.

[75] Amandry, "A propos de Polyclète" (note 33 above) 63–75; H.-V. Herrmann, "Die Siegerstatuen von Olympia," *Nikephoros* 1 (1988) 119–83; Rausa, *Vincitore*, 13–73. Alice Donohue has pointed out that the neat compartmentalization of modern categories do not obviously apply to ancient statues: a votive could be the object of a cult and could change its function depending on circumstances: A. A. Donohue, "The Greek Images of the Gods: Considerations on Terminology and Methodology," *Hephaistos* 15 (1997) 31–45; see also S. G. Miller, *Ancient Greek Athletics* (New Haven, CT, 2004) 160–65. T. S. Scheer, *Die Gottheit und ihr Bild: Untersuchungen zur Funktion griechischer Kultbilder in Religion und Politik* (Munich 2000) 3–34, reviews the various Greek words for statue and finds only limited consistency in their application, in contrast to modern usage; on p. 135 she comes to the conclusion that "Die einzige Frage, die sich stellt, ist die, ob die Gemeinde das Bild für einen passenden Sitz der Gottheit hält." See generally ibid., 130–46.

[76] Eleusis 5076 (64); for the bibliography, see chap. 4, p. 106, note 27 below.

[77] Piraeus 430: G. Steinhauer, *Το Αρχαιολογικό Μουσείο Πειραιώς* (Athens 2001) no. 332; Ridgway, *Fifth Century Styles*, 117–19, fig. 92; Lullies and Hirmer, *Greek Sculpture*², pl. 198.

[78] Athens, NAM 299: Kaltsas, *SNAMA*, 178, no. 353*; Todisco, *Scultura greca*, no. 82

[79] Piraeus 3851: G. Steinhauer, *Τα μνημεία και το Αρχαιολογικό Μουσείο Πειραιά* (Athens 1998) 57–59, fig. on p. 56; Steinhauer, *Μουσείο Πειραιώς*, 229 and fig. 319; I. Papachristodoulou, "Άγαλμα καὶ ναὸς Κυβέλης ἐν Μοσχάτῳ Ἀττικῆς," *ArchEph* (1973) 189–217, pls. 89–93, 95a; F. Naumann, *Die Ikonographie der Kybele in der phrygischen und der griechischen Kunst*, IstMitt-BH 28 (Tübingen 1983) 162, 310, no. 123, pl. 22.1; *LIMC*, s.v. Kybele no. 47b* (E. Simon).

[80] Athens, NAM X 15118: Kaltsas, *SNAMA*, 242–43, no. 509*; see chap. 4, pp. 112–13, and chap. 5A, pp. 192–94 below.

[81] Athens, NAM X 13396: Kaltsas, *SNAMA*, 248–49, no. 518*; see chap. 4, pp. 112–13, and chap. 5A, pp. 191–92 below.

[82] Vienna, KHM, Ephesos Museum VI 3168; for bibliography and discussion, see chap. 3, p. 88 with note 257, and chap. 4, p. 118 below.

[83] Athens, Agora S 2154: O. Palagia, *Euphranor* (Leiden 1980); Todisco, *Scultura greca*, no. 210; Knell, *Athen im 4. Jahrhundert*, 89–91; Bol, *Bildhauerkunst*, 369, fig. 335 (C. Maderna). See chap. 3, pp. 75–76 and note 84 below for discussion and fuller bibliography.

(330s; **Figs. 14–18**);[84] the bronze Athena in the Piraeus (330s) (**Figs. 75, 77, 78**);[85] and sundry statues of women/goddesses in Athens, Berlin, New York, Paris, and elsewhere.[86]

There are rather more originals of the last quarter of the century than from the earlier part of the century: the Tyche or Themis in the Athenian Agora (**Fig. 80**);[87] the seated statue of Demeter from Knidos now in London (**Fig. 81**);[88] a statue of Asklepios in Eleusis dedicated by Epikrates son of Pamphilos;[89] and a colossal seated figure at Delphi, whether male or female is uncertain, perhaps still of the fourth century.[90] A statue of Nike from Megara now in Athens may well fall beyond our artificial boundary of 300, but if so, not by much.[91] A very fragmentary gilded bronze portrait statue in the Agora of Athens said to represent Demetrios Poliorketes and dated to the last years of the fourth century is unfortunately still not published in detail.[92] The bronze so-called praying boy or orant in Berlin (*Betender Knabe*) probably falls just after our lower limit of 300 B.C.[93]

Three new bronze statues appeared while this book was in progress. The first is a fragmentary bronze example of the Apollo Sauroktonos now in the Cleveland Museum of Art

[84] Picard, *Delphes: Le musée*, 91–98.

[85] For a discussion of the statue and bibliography, see chap. 3, pp. 75–76 below.

[86] Athens, Agora S 1882: Todisco, *Scultura greca*, no. 19. Athens, Agora S 37: *LIMC*, s.v. Aphrodite no. 242*. Athens, Agora S 210: B. Schlörb, *Untersuchungen zur Bildhauergeneration nach Phidias* (Waldsassen 1964) 53, pl. 9.2. Athens, Agora S 339: T. L. Shear, "Excavations in the Athenian Agora: The Sculpture Found in 1933," *Hesperia* 4 (1935) 371–74, figs. 1–3. Berlin, Staatl. Mus. Sk 586 (leaning woman) and Sk 286 (Triton): Blümel, *Klassisch Skulpturen Berlin*, 85–86, no. 103, figs. 142–45, 98–99, no. 117, figs. 192–95; B. Knittlmayer and W.-D. Heilmeyer, *Die Antikensammlung: Altes Museum Pergamonmuseum*, Staatliche Museen zu Berlin, 2nd ed. (Mainz 1998) nos. 33*, 88*. New York, MMA 03.12.17: G. M. A. Richter, *Catalogue of Greek Sculptures (Metropolitan Museum of Art)* (Cambridge, MA, 1954) no. 126, pl. 96. Paris, Louvre Ma 2838: Hamiaux, *Sculptures grecques*, vol. 1, 272–73, no. 299*.

[87] Athens, Agora S 2370: T. L. Shear, Jr., "The Athenian Agora: Excavations of 1970," *Hesperia* 40 (1971) 270–71, pl. 56; O. Palagia, "A Colossal Statue of a Personification from the Agora of Athens," *Hesperia* 51 (1982) 99–113, identified the statue as a personification of Demokratia but later returned to Shear's original suggestion: Palagia, "No Demokratia," in *The Archaeology of Athens and Attica under the Democracy*, ed. W. D. E. Coulson, O. Palagia, et al. (Oxford 1994) 113–22, fig. 1. H. A. Thompson, *The Athenian Agora: A Guide to the Excavation and Museum*, 3rd ed. (Athens 1976) 204–5, fig. 37 (on p. 86), and E. B. Harrison, "The Shoulder-Cord of Themis," in *Festschrift für Frank Brommer*, ed. U. Höckmann and A. Krug (Mainz 1977) 155–61, favor the identification as Themis. See also Todisco, *Scultura greca*, no. 304; Bol, *Bildhauerkunst*, 370, fig. 337 (C. Maderna).

[88] London, BM 1300: B. Ashmole, "Demeter of Cnidus," *JHS* 71 (1951) 13–28; Todisco, *Scultura greca*, no. 221; Bol, *Bildhauerkunst*, 358–59, figs. 324a–c (C. Maderna).

[89] Eleusis 50: S. Adam, *The Technique of Greek Sculpture in the Archaic and Classical Periods* (London 1966) 101–4, pls. 50, 51; Boardman, *GS-LCP*, fig. 59.

[90] Delphi 10950: Picard, *Delphes: Le musée*, 98–100, figs. 57, 58; Flashar, *Apollon Kitharodos*, 116–21, figs. 81, 85–87. The statue of Dionysos in the British Museum (no. 432) from the choregic monument of Thrasyllos and Thrasykles above the Theater of Dionysos in Athens may not originally have belonged to the monument: Ridgway, *Hellenistic Sculpture*, vol. 1, 212–13, pl. 97; Flashar, *Apollon Kitharodos*, 119–20, figs. 83, 84; Travlos, *Pictorial Dictionary*, 562. The statue may nonetheless date to the end of the fourth century; Amandry, *BCH* 121 (1997) 460 and note 30, cites Marcadé's preference for the earlier date.

[91] Athens, NAM 225: Gulaki, *Nikedarstellungen* (note 56 above) 79–88, fig. 36; L. Alscher, *Griechische Plastik*, vol. 3 (Berlin 1956) 123–25, fig. 44.

[92] T. L. Shear, Jr., "The Athenian Agora: Excavations of 1971," *Hesperia* 42 (1973) 165–68; C. Houser, "Alexander's Influence on Greek Sculpture as Seen in a Portrait in Athens," in B. Barr-Sharrar and E. N. Borza, eds., *Macedonia and Greece in Late Classical and Early Hellenistic Times* (Washington, DC, 1982) 229–38, figs. 3–7, 9; Houser, *Greek Monumental Bronze Sculpture of the Fifth and Fourth Centuries B.C.* (New York 1987) 255–81, ills. 16.1–6; J. McK. Camp, *The Athenian Agora* (London 1986) 162–65; C. C. Mattusch, *Classical Bronzes: The Art and Craft of Greek and Roman Statuary* (Ithaca, NY, 1996) 127–28, fig. 4.11.

[93] Berlin, Staatl. Mus. Sk 2: A. Conze, "Der betende Knabe in den königlichen Museen zu Berlin," *JdI* 1 (1886) 1–13; R. Kabus-Preisshofen, "Der 'betende Knabe' in Berlin," *AA*, 1988, 679–99; G. Zimmer and N. Hacklander, *Der betende Knabe: Original und Experiment* (Frankfurt am Main 1997); S. Gerlach, *Der betende Knabe: Ein Werk aus dem Alten Museum* (Berlin 2002). S. Lehmann, "Der 'Betende Knabe': Zur kunsthistorischen Einordnung und Deutung eines frühhellenistischen Siegerbildes," *ÖJh* 66 (1997) 117–28, dates the statue (p. 125) to the 320s; while P. Zanker, *Klassizistische Statuen: Studien zur Veränderung des Kunstgeschmacks in der römischen Kaiserzeit* (Mainz 1974) 66–67, dates it to the first century B.C.

and said by some to be the original (**Fig. 182**).[94] The second is a statue similar to both the Cleveland Sauroktonos and the bronze boy from Marathon Bay (**Fig. 65**) that is said to have been retrieved from smugglers and was placed on exhibition in the National Museum in Athens in August 2004 (inv. X 26087). The third is the stunning statue of a raving satyr found in the sea between Sicily and Tunisia in 1997 and 1998 and now extensively published and on display in the museum in Mazara del Vallo, Sicily.[95] Assessment of the statue by major scholars has resulted in identifications ranging from an original of the fourth century to a Hellenistic creation and even a Roman classicistic creation.[96] The detailed studies of the motif of a satyr *mainomenos* from the late fifth or early fourth century to late antiquity by Paolo Moreno and Bernard Andreae suggest a single model.[97] The earliest reflections of the statue are gems of the second and first centuries B.C.[98] and a hemispherical relief bowl from the agora of Pella dated no earlier than the second century,[99] though aspects of the pose do appear ca. 400 B.C.[100] Andreae has argued that the Mazara statue is an original work and not a copy on the basis of the imprint of rushes inside the torso,[101] though these have also been interpreted as the concave lines of a tool either on a clay core or on the inside surface of the wax layer in the indirect casting process.[102] On the basis of this evidence, it is possible that the Mazara statue is the model for all the later representations and is a Late Classical creation, but it could just as easily be

[94] M. Bennett, "Une nouvelle réplique de l'Apollon Sauroctone au musée de Cleveland," in *Praxitèle*, ed. A. Pasquier and J.-L. Martinez (Paris 2007) 206–8, figs. 126a–c; P. Moreno, "Satiro in estasi di Praxiteles," in *Il Satiro danzante di Mazara del Vallo: Il restauro e l'immagine; Atti del convegno, Roma, 3–4 giugno 2003*, ed. R. Petriaggi (Naples 2005) 211, figs. 17, 20; C. Vogel, "Ohio Museum Attributes a Purchase to Praxiteles," *New York Times*, Tuesday, 22 June 2004, section E ("The Arts"), p. 1.

[95] Martinez, *Praxitèle*, 284–91, no. 72; B. Andreae, *Der tanzende Satyr von Mazara del Vallo und Praxiteles*, Abh.Mainz, Jahrg. 2009, no. 2 (Mainz 2009); P. Moreno, "Satiro di Prassitele," in *Il Satiro danzante*, ed. R. Petriaggi (Milan 2003) 102–13; R. Petriaggi, ed., *Il Satiro danzante di Mazara del Vallo: Il restauro e l'immagine: Atti del convegno, Roma, 3–4 giugno 2003* (Naples 2005); D. Ekserdjian and C. Treves, eds., *Bronze* (London 2012) 126–27, 258, no. 28: C. Wolf, "Der tanzende Satyr aus Mazara del Vallo," *MemLinc*, ser. 9, vol. 30.4 (Rome 2013).

[96] Andreae, *Tanzende Satyr* (note 95 above) 7, with notes 2, 4, and 5, citing both published and verbal opinions of scholars.

[97] Moreno, "Satiro in estasi" (note 94 above) 198–227; Andreae, *Tanzende Satyr* (note 95 above) 9–21.

[98] Gems: E. Brandt, *AGD* I, *Staatliche Münzsammlung München*, pt. 1, *Griechische Gemmen von minoischer Zeit bis zum späten Hellenismus* (Munich 1968) 103–4, nos. 607–9, pl. 62 (second to first centuries B.C.); E. Schmidt, *AGD* I, pt. 2, *Italische Glaspasten vorkaiserzeitlich* (Munich 1970) 89, nos. 1078–80, pl. 120 ("vor kaiserzeitlich"); P. Zazoff, *Die antiken Gemmen*, Handbuch der Archäologie (Munich 1983) 292, note 151, pl. 83.2; Moreno, "Satiro in estasi" (note 94 above) 220, fig. 26; Andreae, *Tanzende Satyr* (note 95 above) fig. 15; a similar gem is in Naples: Moreno, "Satiro di Prassitele" (note 95 above) 105, fig. 7.

[99] Moreno, "Satiro in estasi" (note 94 above) 208, 220, fig. 27; G. M. Akamantes, Πήλινες μήτρες ἀγγειών απο την Πέλλα· Συμβολή στη μελέτη της ἑλληνιστικῆς κεραμικῆς, Ἐπιστημονική ἐπετηρίδα τῆς Φιλοσοφικῆς Σχολῆς, Παράρτημα 61 (Ph.D. diss., Aristotle University of Thessaloniki) (Thessaloniki 1985) 200–201 no. 315, 459–60, 500, pl. 212; later published under the same title as *ArchDelt* suppl. 51 (Athens 1993) 135–36, no. 316, pls. 13, 26; see also nos. 315 and 318, pls. 25 and 27, and the raving mainad with head thrown back on a fragment of Pergamene relief ware once in Berlin: B. Barr-Sharrar, *The Derveni Krater: Masterpiece of Classical Greek Metalwork* (Princeton 2008) fig. 138.

[100] On the Maikop bronze vessel in Berlin, Staatl. Mus. 30622: W. Züchner, *Der Berliner Mänadenkrater*, BWPr 98 (Berlin 1938) pls. 1, 3, 6; E. Giouri (Youri), Ὁ κρατήρας τοῦ Δερβενίου (Athens 1978) pls. 105, 106; Barr-Sharrar, *Derveni Krater*, fig. 137. On the Derveni krater: Giouri, pls. 15, 19, 22; Barr-Sharrar, figs. 126, 133; on the Ortiz rhyton: L. Summerer, "Achämenidische Silberfunde aus der Umgebung von Sinope," *Ancient Civilizations from Scythia to Siberia* 9 (2003) 33–34, fig. 11. There is also an early-fourth-century mold for a relief vase from the Athenian Agora (MC 12229) with a dancing satyr in a pose similar to the Mazara figure: Barr-Sharrar, 107, fig. 93.

[101] B. Andreae, "Il Satiro danzante di Mazara del Vallo, copie o originale?" in Petriaggi, *Satiro danzante di Mazara del Vallo* (note 95 above) 141–44, fig. 1; Andreae, *Tanzende Satyr* (note 95 above) 30–37, figs. 28–30. See also S. Tusa, "Il Satiro danzante di Mazara del Vallo nel quadro della ricerca archeologica in acque extraterritoriali del Canale di Sicilia," *SicArch* 36 (2003) 12, 15.

[102] R. Petriaggi and P. Donati, "Il restauro del Satiro danzante: Considerazioni sul degrado e sugli aspetti tecnici," in Petriaggi, *Satiro danzante di Mazara del Vallo* (note 95 above) 115, fig. 8.

a Hellenistic original. A further deduction is impossible to test: according to our textual sources, Praxiteles made a famous statue of a satyr, and the Mazara statue might be this statue.[103] But there are two factors against the Mazara statue being an original of the later fourth century. First, the lead content of the bronze is high (from 14% to 21%[104]); second, the incredibly twisted pose and sweeping gesture of the arms and legs are difficult to parallel in the later fourth century, as I shall argue in a later chapter. But even the suggestion that the Mazara statue is by Praxiteles indicates that the rather facile reconstruction of the style of Praxiteles (and, obviously, of other sculptors too) may need revision.

There are a number of statues that were almost certainly carved for funerary monuments. A mildly controversial piece is a statue of a seated woman in Chalkis,[105] to which a head now in Berlin may belong.[106] Although the statue has been dated as late as 330,[107] the date of ca. 380 proposed by Ioanna Konstantinou is surely correct.[108] The figure sits twisted somewhat awkwardly to create the principal point of view from the figure's left side,[109] which led Werner Fuchs to suggest that it belonged to a grave monument[110] and was perhaps set in a naiskos. Quite a number of statues that must have belonged to grave monuments are dated in the late fourth century, such as those in Athens,[111] Berlin,[112] New York,[113] Boston,[114] and Paris.[115] Some are life-size, yet it seems probable that they were actually set up in naiskoi and thus parallel the late deep stelai, so they do not really qualify as freestanding statues.[116] A group of such statues recently published by Giorgos Despinis is particularly impressive; they may have decorated large tomb complexes, such as that of Kallithea, though the only other preserved example of such a very elaborate funerary

[103] Moreno, "Satiro in estasi" (note 94 above); Andreae, *Tanzende Satyr* (note 95 above) 22–30.

[104] Martinez, *Praxitèle*, 72; G. Guida et al., "Analisi di EDXRF," in *Il Satiro danzante*, ed. R. Petriaggi (Milan 2003) 66–69; G. Guida, "Indagini non distruttive per il restauro del Satiro di Mazara del Vallo," in Petriaggi, *Satiro danzante di Mazara del Vallo* (note 95 above) 80, 88, tables 2–5 on pp. 89–90. Admittedly, the use of increased quantities of lead in bronze is difficult to date securely, but is most frequently believed to be a Hellenistic or early Roman phenomenon: P. C. Bol, *Antike Bronzetechnik: Kunst und Handwerk antiker Erzbildner* (Munich 1985) 17. D. E. L. Haynes, *The Technique of Greek Bronze Statuary* (Mainz 1992) 86–88 with table 2; C. C. Mattusch, *Greek Bronze Statuary from the Beginnings through the Fifth Century B.C.* (Ithaca, NY, 1988) 14, note 15, and Mattusch, *Classical Bronzes: The Art and Craft of Greek and Roman Statuary* (Ithaca, NY, 1996) 124, 125, note 68, 137, 213, give percentages of lead in a variety of statues, which does indicate that low lead content tends to be early and high lead content tends to be late, with exceptions that make a definite conclusion on the date of a statue by its lead content uncertain.

[105] Chalkis MX 33: I. K. Konstantinou, "Ἄγαλμα καθημένος θεᾶς," *ArchEph* (1953/54, pt. 2 [1958]) 30–40, pls. 1, 2; W. Fuchs, "Zur Rekonstruktion einer weiblichen Sitzstatue in Chalkis," *JBerlMus* 8 (1966) 32–49; E. Sapouna-Sakellaraki, *Chalkis: History, Topography, and Museum* (Athens 1995) 51, fig. 18.

[106] Berlin, Staatl. Mus. K 43: Blümel, *Klassisch Skulpturen Berlin*, 22, no. 12, figs. 19, 20. The statue in Chalkis is illustrated in fig. 21.

[107] Fuchs, *JBerlMus* 8 (1966) 44–47, followed by Dohrn, *AntP* 8 (1968) 47.

[108] Konstantinou, *ArchEph* (1953/54, pt. 2 [1958]) 38–39, followed by Sapouna-Sakellaraki, *Chalkis* (note 105 above) 51.

[109] Fuchs, *JBerlMus* 8 (1966) figs. 3, 13, 15.

[110] Ibid., 48.

[111] Athens, NAM 709: Kaltsas, *SNAMA*, 207, no. 420*.

[112] Berlin, Staatl. Mus. Sk 498 and Sk 499: Blümel, *Klasssisch Skulpturen Berlin*, 44–45, no. 45, K 13a and K 13b, figs. 64–69 (mourning servants).

[113] Inv. 44.11.2–3: Richter, *Catalogue*, 62–64, no. 94, pls. 76, 77.

[114] Boston, MFA 04.283: Comstock and Vermeule, *Sculpture in Stone*, 42, no. 59*; C. Blümel, *Der Hermes eines Praxiteles* (Baden-Baden 1948) 24, fig. 14 (back).

[115] Hamiaux, *Sculptures grecques*, vol. 1, nos. 210–14.

[116] Ridgway, *Fourth-Century Styles*, 348–50. Whether such statues stood in naiskoi or in the open in not clear: O. Alexandris, "Περίβολος οἰκογενειακῶν τάφων παρὰ τὴν ὁδὸν πρὸς Ἀκαδημείαν," *AAA* 2 (1969) 257–64 (English summary, "Burial Terrace near the Road to Academy," 265–68) figs. 2–5 on pp. 260–61; G. Touchais, "Chronique des fouilles et découvertes archéologiques en Grèce en 1978," *BCH* 103 (1979) 547, figs. 57–59; B. C. Petrakos, "Ἀνασκαφὴ Ῥαμνοῦντος," *Prakt* 1976, 26, pls. 11, 12.

structure is one relief block of an Amazonomachy in the National Archaeological Museum in Athens.[117]

There is hardly a museum in Greece without one or even several examples of the second modern category, that is, statues of small size or modest craft. I cite for the record just a few of these: in Athens,[118] Delphi,[119] Sparti,[120] and Thessaloniki.[121] The "little bears" dedicated in the cult of Artemis Brauronia,[122] the group of statuettes in Venice thought to be from Crete (**Figs. 82–85, 274**),[123] and the related statuettes from Kos (**Figs. 269, 270**)[124] belong to this category. The statuette of Aphrodite riding a goose, now in Boston, also belongs here.[125]

Finally, there are a large number of heads that are certainly or probably originals.[126] Two marble heads—one on the Athenian Acropolis,[127] the other in the National Archaeological Museum[128]—have been published not only as originals but as by the hand of Praxiteles himself.

[117] G. I. Despinis, "Αττικοί επιτύμβιοι ναΐσκοι του 4ου αι. Π.Χ.· Μια πρώτη προσέγγιση," in *Αρχαία Ελληνική γλυπτική· Αφιέρωμα στη μνήμη του γλύπτη Στέλιου Τριάντη*, ed. D. Damaskos (Athens 2002) 209–31. A. Scholl, "Πολυτάλαντα μνημεῖα: Zur literarischen und monumentalen Überlieferung aufwendiger Grabmäler im spätklassischen Athen," *JdI* 109 (1994) 239–71, reviews the literary evidence for unusually large tomb monuments with statues and reliefs, particularly the tomb of Isokrates (pp. 240–52). Relief slab with Amazonomachy in Athens, NAM 3614: Kaltsas, *SNAMA*, 254, no. 531*; *LIMC*, s.v. Amazones no. 429b; Ridgway, *Hellenistic Sculpture*, vol. 1, 32–33. E. Tsirivakos, "Kallithea: Ergebnisse der Ausgrabung," *AAA* 4 (1971) 110, says that the slab comes from behind the Syngrou prison and originally proposed that it might belong to a tomb building similar to that of Kallithea; see further chap. 5B, pp. 224–25 below.

[118] Rapidly scanning Kaltsas's recent catalogue of the sculptures in the National Archaeological Museum reveals a large number of candidates; I cite here just one as an example: Athens, NAM 230: Kaltsas, *SNAMA*, 271, no. 567*; J. Marcadé, "Apollon 'Mitréphoros,'" in *Études Delphiques*, *BCH* suppl. 4 (Paris 1977) figs. 5 and 6 on pp. 394–95; Flashar, *Apollon Kitharodos*, 85–86, figs. 47, 48.

[119] Marcadé, "Apollon 'mitréphoros'" (note 118 above) figs. 7 and 8 on pp. 396 and 397.

[120] A. Delivorrias, "Η σημασία τῶν γλυπτῶν τῆς Σπάρτης καί ἡ ἀνγκή τὶς ἐκδοσεως ἑνος νέο κατάλογου," in *Πρακτικά του Δ΄ Διεθνοῦς Συνεδρίου Πελοποννησιακῶν Σπουδῶν* (Corinth, 9–16 September 1990) (Athens 1992–93) 299–300, figs. 5, 6.

[121] G. Despinis, T. Stefanidou-Tiveriou, and E. Voutiras, *Catalogue of Sculpture in the Archaeological Museum of Thessaloniki*, vol. 1, *Catalogue of Sculptures Nos. 1–148* (Thessaloniki 1997) 51–53, nos. 31 (inv. 1129), 32 (inv. 1069), 33 (inv. 1083), figs. 65–74, 86–89.

[122] Ridgway, *Hellenistic Sculpture*, vol. 1, 338 and n. 39, pls. 175, 176; Palagia, *Hesperia* 51 (1982) 103 and n. 2, pls. 32d, 32e, 33a. See also statuettes of a boy and two girls in the National Archaeological Museum, Athens: Kaltsas, *SNAMA*, 270–71, nos. 564*–566*.

[123] R. Kabus-Jahn, "Die grimanische Figurengruppe in Venedig," *AntP* 11 (1972) 7–97.

[124] R. Kabus-Preisshofen, "Statuettengruppe aus dem Demeterheiligtum bei Kyparissi auf Kos," *AntP* 15 (1975) 31–65, pls. 11–28.

[125] Boston, MFA 03.752: Comstock and Vermeule, *Sculpture in Stone*, 32–33, no. 43*.

[126] E.g., Athens, NAM 182 (head of "Ariadne") from the Theater of Dionysos: Kaltsas, *SNAMA*, 260, no. 542*; S. Karouzou, *National Archaeological Museum: Collection of Sculpture; A Catalogue* (Athens 1968) 165, pl. 53. Olympia boxer head, Athens, NAM X6439: Kaltsas, *SNAMA*, 248, no. 517*; P. C. Bol, *Großplastik aus Bronze in Olympia*, Ol-Forsch 9 (Berlin 1978) 40–43, 114–15, no. 159, pls. 30–32; E. Voutiras, *Studien zu Interpretation und Stil griechischer Porträts des 5. und frühen 4. Jahrhunderts* (Bonn 1980) 161–67; S. Lehmann, "Zum Bronzekopf eines Olympioniken im Nationalmuseum Athen," *Stadion* 21–22 (1995–96) 1–29; Mattusch, *Classical Bronzes* (note 92 above) 84–87, figs. 3.5a–c; Lullies and Hirmer, *Greek Sculpture*², pls. 238, 239. African (bronze) from Cyrene, London, BM Br 628: Mattusch, *Classical Bronzes*, 80–83, fig. 3.4; Lullies and Hirmer, pl. 210. "Hygieia" from Tegea, Athens, NAM 3602: Kaltsas, *SNAMA*, 257, no. 538*; Lullies and Hirmer, pl. 205; Todisco, *Scultura greca*, no. 303. Aberdeen Head, London, BM 1600: R. M. Cook, "The Aberdeen Head and the Hermes of Olympia," in Hockmann and Krug, *Festschrift für Frank Brommer* (note 87 above) 77, pl. 23; Todisco, *Scultura greca*, no. 128. Heads from Priene in London and Berlin: S. T. Schipporeit, "Das alte und das neue Priene: Das Heiligtum der Demeter und die Gründung Prienes," *IstMitt* 48 (1998) 220–25, pls. 19–21.

[127] G. Despinis, "Neues zu einem alten Fund," *AM* 109 (1994) 173–98, pls. 31–36.

[128] H. Lauter, "Der praxitelischer Kopf Athen Nationalmuseum 1762," *AntP* 19 (1988) 21–29, pls. 14–19. Cf. Kaltsas, *SNAMA*, 244, no. 510*; Kaltsas, in A. Lazaridou, ed., *Transition to Christianity: Art of Late Antiquity, 3rd–7th Century AD* (New York 2011) 148, no. 115*.

This is certainly not a long list, but original statues of the Early and High Classical periods of the fifth century are not more numerous. Indeed, most statues of the Classical period (480–300) are known mainly from Roman copies or adaptations, and the reliability of these as accurate reflections of the purported classical originals is a thorny issue which we shall examine in the next chapter.

It is the vast number of grave reliefs, whether stelai or stone vases with reliefs, that constitute the core of original sculpture of the fourth century.[129] The majority of these, but by no means all, are Attic. The Attic reliefs provide only a secure date near the beginning of the sequence, as has already been mentioned: the relief for the cenotaph of Dexileos (**Fig. 4**) and the state relief for those fallen in the Corinthian War of 394/3.[130] They cease in Athens sometime between 317 and 307 B.C., when Demetrios of Phaleron is said to have passed a sumptuary law forbidding excessive luxury in grave monuments (Cicero, *Leges* 2.26.64).[131] On the basis of the very precise excavation of the Kerameikos cemetery over the last 130 years, there is at least some archaeological evidence for the intervening chronology of the stelai. Lykourgos reports in his oration *Against Leokrates* (44) that the Athenians, in a panic after the defeat by Philip at Chaironeia, dismantled grave plots to strengthen the walls of the city, in the false expectation that Philip would immediately attack Athens.[132] Certain grave monuments and plots in the Kerameikos can indeed be dated before 338 because of the quite distinctive robbing of stone and, for the most part, subsequent rebuilding. Perhaps the best-dated plot is that of Dionysios of Kollytos (no. 23).[133] Dionysios is known to have served as treasurer of Hera on Samos in 346/5; his grave plot in the Kerameikos was robbed for its stone in 338, so he must have died in the eight years between those two events. Unfortunately, his plot did not contain a characteristic carved stele that would serve as a chronological benchmark for other monuments. The plot of Agathon from Herakleia, in the Pontos (no. 22), is not dated quite as closely but must fall between 364 and 338, and its carved stele of Korallion, Agathon's wife, is characteristic and serves as a midcentury benchmark (**Fig. 86**).[134] In the case of the two stelai of Demetria and Pamphile, the earlier one, now in the National Archaeological Museum,

[129] The standard old publications are A. Conze, *Die attischen Grabreliefs* (Berlin 1893–1922); and H. Diepolder, *Die attischen Grabreliefs des 5. und 4. Jahrhunderts v. Chr.* (Berlin 1931; repr. Darmstadt 1965). These have largely been replaced by C. Clairmont, *Classical Attic Tombstones* (Kilchberg 1993), who lists some 3,500 Attic grave monuments; B. Schmaltz, *Griechische Grabreliefs* (Darmstadt 1983); and N. Himmelmann, *Attische Grabreliefs* (Opladen 1999). The Dyabola database of grave stelai (www.db.dyabola.de) contains 2,759 individual monuments.

[130] See note 11 above.

[131] W. W. Fortenbaugh and E. Schütrumpf, eds., *Demetrius of Phalerum: Text, Translation, and Discussion*, Rutgers University Studies in Classical Humanities 9 (New Brunswick, NJ, 2000) 100–103, no. 53, 350 (M. Gagarin); R. H. W. Stichel, "Columella–Mensa–Labellum: Zur Form der attischen Grabmäler im Luxusgesetz des Demetrios von Phaleron," *AA*, 1992, 433–40; K. Friis Johansen, *The Attic Grave-Reliefs of the Classical Period: An Essay in Interpretation* (Copenhagen 1951) 13. As Friis Johansen points out, the date for the laws of Demetrios is derived from the Marmor Parium (F. Jacoby, *Das Marmor Parium* [Berlin 1904; repr. Chicago 1980] 22), but Süsserott, *Griechische Plastik*, 120, note 136, and G. M. A. Richter, "Archaeological Notes: Two Greek Statues," *AJA* 48 (1944) 239, note 16, point out that the date of the funerary law is not at all sure, though it must fall between 317 and 307. J. Bergemann, *Demos und Thanatos: Untersuchungen zum Wertsystem der Polis im Spiegel der attischen Grabreliefs des 4. Jahrhunderts v. Chr. und zur Funktion der gleichzeitigen Grabbauten* (Munich 1997) 156, stresses that both the beginning and the end of the classical Attic grave reliefs have a broad significance beyond the useful chronological benchmarks they provide.

[132] D. Ohly, "Kerameikos-Grabung: Tätigkeitsbericht 1956–1961," *AA*, 1965, cols. 341–42.

[133] U. Knigge, *Der Kerameikos von Athen: Führung durch Ausgrabungen und Geschichte* (Athens 1988) 123–25, figs. 119, 120 (plot no. 23); Ohly, *AA*, 1965, cols. 345–47; A. Brueckner, *Der Friedhof am Eridanos bei der Hagia Triada zu Athen* (Berlin 1909) 74–83.

[134] Athens, Kerameikos P 688: Ohly, *AA*, 1965, cols. 342–45, fig. 38; Knigge, *Kerameikos* (note 133 above) 121; Brueckner, *Friedhof am Eridanos* (note 133 above) 64–74. For the stele of Korallion, see Clairmont, *CAT*, 4.415; Diepolder, *Grabreliefs*, 49–50, pl. 45.2; Bol, *Bildhauerkunst*, 380–81, fig. 346 (C. Maderna).

can be dated before 338,[135] and the later one close to the end of the century, both on archaeological grounds (**Fig. 87**).[136] Indeed, on the basis of the relationship of the grave plots, the earlier stele must be dated close to the middle of the century. At times, however, the archaeological evidence can be misleading; the stele of Eukoline was thought to be certainly after 338,[137] but Franz Willemsen was able to demonstrate that this is in fact not the case.[138] Likewise, the interesting relief depicting a funeral banquet together with a boat and a man long thought to be Charon was found associated with the grave plot of Lysimachides (no. 24), who died after 338, but the relief appears to have been reused in his plot.[139] In the end, the main guide for distributing the grave monuments over the late fifth and fourth centuries is style and the evolution of the naiskos form of the stelai. The stele of Hegeso, although in a plot (no. 34) that was largely rebuilt after 338,[140] is usually dated at the very end of the fifth century or the beginning of the fourth.[141] The relief is low, and the framing architecture is very shallow. Near the end of the fourth century, the stele of Aristonautes presents the deceased frontally and almost in the round in a deep naiskos (**Fig. 88**);[142] this contrasts with the early stelai depicting soldiers in battle, which represent the soldier in profile in a shallow field.[143] By coupling this evolution with stylistic and iconographic analysis, the grave stelai can be distributed over the late fifth and fourth centuries with some confidence.[144]

It should be noted that these stelai were frequently set up in family plots to create impressive displays along the roads leading into Athens, as any visitor to the Kerameikos today can still witness.[145] Since this was also the case at Rhamnous (**Fig. 89**),[146] there is ample reason not to consider the grave monuments—whether figured stelai, plain stelai

[135] Athens, NAM 2708: Clairmont, *CAT*, 2.426; Knigge, *Kerameikos* (note 133 above) 118, fig. 114; W. Kovacsovics, *Kerameikos: Ergebnisse der Ausgrabungen*, vol. 14, *Die Eckterrasse im Grabbezirk des Kerameikos* (Berlin 1990) 79, pl. 16; Himmelmann, *Attische Grabreliefs*, 39, 59, note 80, fig. 13.

[136] Athens, Kerameikos P 687: Clairmont, *CAT*, 2.464; Kovacsovics, *Kerameikos* 14 (note 135 above) 73–77, 79–81, pl. 17; Bol, *Bildhauerkunst*, 378, fig. 347 (C. Maderna).

[137] Athens, Kerameikos P 388: Clairmont, *CAT*, 4.420; Diepolder, *Grabreliefs*, 47. B. Vierneisel-Schlörb, "Eridanos Nekropole I: Gräber und Opferstellen hS 1–204," *AM* 81 (1966) 77–79, 83–84, nos. 141, 142, Beil. 63.1–2, proposed the certain date after 338 on archaeological grounds.

[138] F. Willemsen, "Mitteilungen aus dem Kerameikos: Stelen," *AM* 85 (1970) 41–44, Beil. 3. As he points out, the date of ca. 350 given by Diepolder, *Grabreliefs*, 47, is thus not in opposition to the archaeological evidence.

[139] Athens, Kerameikos P 692: A. Conze, *Grabreliefs*, vol. 2 (Berlin 1900) no. 1173, pl. 251; F. Brommer, "Ein Lekythos in Madrid," *MM* 10 (1969) 171, no. 7; J.-M. Dentzer, *Le motif du banquet couché dans le proche orient et le monde grec du VIIe au IVe siècle avant J.-C.*, BÉFAR 246 (Paris 1982) 352–53, 590, no. R 199, pl. 76, fig. 457; *LIMC*, s.v. Charon no. 57* (C. Sourvinou-Inwood); Knigge, *Kerameikos* (note 133 above) 126. On the new interpretation of the relief as the grave stele of *metic* traders, see A. Scholl, "Das 'Charonrelief' im Kerameikos," *JdI* 108 (1993) 353–73, pls. 1–3; Clairmont, *CAT, Supplement*, 70–72, no. 5.470, photo on p. 160.

[140] Knigge, *Kerameikos* (note 133 above) 131–34, figs. 127, 128; Athens, NAM 3624: Kaltsas, *SNAMA*, 156, no. 309*; Clairmont, *CAT*, 2.150; Diepolder, *Grabreliefs*, 27, pl. 20.

[141] Athens, NAM 3624: Clairmont, *CAT*, 2.150; Ridgway, *Fifth Century Styles*, 146–48, and note on p. 157.

[142] Athens, NAM 738: Kaltsas, *SNAMA*, 204, no. 410*; Diepolder, *Grabreliefs*, 52–53, pl. 50; Clairmont, *CAT*, 1.360; A. von Salis, *Das Grabmal des Aristonautes*, BWPr 84 (Berlin 1926); B. S. Ridgway, "Aristonautes' Stele, Athens Nat. Mus. 738," in *Kotinos: Festschrift für Erika Simon*, ed. H. Froning, T. Hölscher, and H. Mielsch (Mainz 1992) 270–275.

[143] E.g., stele of Lysias Tegeatas (now lost): Clairmont, *CAT*, 1.194; Paris, Louvre Ma 3382: Clairmont, *CAT*, 1.277; Diepolder, *Grabreliefs*, 33, pl. 28.1; Athens, storeroom of the Ephorate of the Acropolis (Silanion Aristodemou): Clairmont, *CAT*, 1.361; N. Himmelmann, *Ideale Nacktheit in der griechischen Kunst*, JdI-EH 26 (Berlin 1990) 63, fig. 31.

[144] For problems and disputes, see Clairmont, *CAT*, vol. 1, 12–18.

[145] Bergemann, *Demos und Thanatos*, 7–11, pls. 1–3; Knell, *Athen im 4. Jahrhundert*, 23–46; Travlos, *Pictorial Dictionary*, 299–322; Knigge, *Kerameikos* (note 133 above) 94–165.

[146] V. C. Petrakos, Ο δῆμος τοῦ Ῥαμνοῦντος· Σύνοψη των ανασκαφών και των ἐρευνων (1813–1998) (Athens 1999) vol. 2, 343–413; Petrakos, "Νέες ἔρευνες στὸν Ῥαμνόντα," *ArchEph* (1979) 3–10, 17–41, figs. 17, 18, 40, 41; Petrakos, "Οἱ ἀνασκαφές τοῦ Ῥαμνοῦντος (1813–1987)," *ArchEph* (1987) 283–92, figs. 15–18.

with anthemia and inscriptions, or stone vases—as independent works, but primarily as parts of unified monuments that glorified a family as much as its individual members. Indeed, on many stelai some of the figures represent still-living members of the family. The first stele of Demetria and Pamphile, for example, presents the living Pamphile bidding farewell to Demetria, the seated deceased; on the later stele, the deceased Demetria stands beside the equally deceased Pamphile (**Fig. 87**). The magnificence of such plots, with multiple stelai, marble lekythoi, etc., cannot compete with the even grander tomb of Nikeratos and Polyxenos from Istria (**Fig. 247**) found at Kallithea, between Athens and Piraeus, which resembled the magnificent dynastic tombs of Asia Minor, such as the Nereid Monument (**Fig. 49**).[147]

Another large body of original relief sculpture is the votive reliefs. They are known sporadically throughout Greece prior to the last third of the fifth century, but, as with the grave reliefs, they become more numerous toward the end of the fifth century, particularly in Attica, and then become common in the fourth century.[148] Several have datable inscriptions. One of the earliest, in the first decade of the fourth century, is also among the more elaborate, with a relief of Telemachos celebrating the foundation of the sanctuary of Asklepios on the south slope of the Athenian Acropolis (**Fig. 90**).[149] The majority are relatively small, on the order of 0.40 meters to 1.0 meter wide and the same range in height. Although we have little evidence for the manner in which they were displayed, a notable characteristic of several late-fifth-century or fourth-century reliefs is a tall, massive pillar on which they were set, which turned relatively small reliefs into prominent monuments. Such are the reliefs of Telemachos just cited and the reliefs of Echelos and Basile[150] and of Xenokrateia (**Figs. 91, 92**),[151] though the last two have rarely been published in photographs showing their high stands.[152] Both come from the same sanctuary near New Phaleron. Such pillars were also discovered in the Pythion of the Attic deme of Ikaria, with their votive reliefs nearby.[153] A slighter but more elaborate pillar for a votive relief was found in the Athenian Agora, a dedication by a shoemaker.[154] Although the relief supported by the inscribed pillar is missing, the cutting at the top clearly shows that it was intended to hold a separate relief slab. In addition, the top of the pillar bears a small

[147] Steinhauer, *Μουσείο Πειραιώς*, figs. 458–65; E. Tsirivakos, "Ειδήσεις ἐκ Καλλιθεάς," *AAA* 1 (1968) 35–36; Tsirivakos, "Kallithea: Ergebnisse der Ausgrabung," *AAA* 4 (1971) 108–10; Schmaltz, *Griechische Grabreliefs*, 141–42. See further chap. 5B, pp. 224–25 below.

[148] G. Neumann, *Probleme des griechischen Weihreliefs* (Tübingen 1979); E. Mitropoulou, *Corpus I, Attic Votive Reliefs of the 6th and 5th Centuries B.C.* (Athens 1977); E. Vikela, "Attische Weihreliefs und die Kult-Topographie Attikas," *AM* 112 (1997) 167–246, pls. 20–31.

[149] L. Beschi, "Il monumento di Telemachos, fondatore dell'Asklepieion ateniese," *ASAtene* 45–46 (n.s., 29–30) (1967–68) 381–436; Beschi, "Il rilievo di Telemachos ricompletato," *AAA* 15 (1982) 31–43; *LIMC*, s.v. Asklepios no. 394* (B. Holzmann); E. Stafford, *Worshipping Virtues: Personification and the Divine in Ancient Greece* (London 2000) 153–56, 159.

[150] Athens, NAM 1783: Kaltsas, *SNAMA*, 258, no. 134*; Mitropoulou, *Votive Reliefs*, no. 128, figs. 185, 186.

[151] Athens, NAM 2756: Kaltsas, *SNAMA*, 257, no. 133*; Mitropoulou, *Votive Reliefs*, no. 65, fig. 103.

[152] J. N. Svoronos, *Das athener Nationalmuseum* (Athens 1908–11) pl. 182. Two votive reliefs to the nymphs from the sanctuary on Mount Pentelikon were also mounted on bases: Athens NM 4465, 4466: Kaltsas, *SNAMA*, 213, no. 434*, 221, no. 459, neither illustrated with their bases; for the former, see H. W. Catling, "Archaeology in Greece, 1979–80," *ArchRep* 26 (1980) 14, fig. 23. The base of 4465 is low and round; the base for 4466 is tall and rectangular; both are roughhewn.

[153] E. Voutiras, "A Dedication of the *Hebdomastai* to the Pythian Apollo," *AJA* 86 (1982) 230. Reliefs on such pillars in the Amphiareion of Rhamnous are illustrated by Petrakos, *ArchEph* (1987) p. 295, fig. 20; Petrakos, *Δήμος τοῦ Ραμνοῦντος* (note 146 above) vol. 2, 309, fig. 217.

[154] Agora I 7396: J. McK. Camp, *The Athenian Agora: A Guide to the Excavation and Museum*, 4th ed. (Athens 1990) 211–13, fig. 134; Himmelmann, *Realistische Themen*, 29, fig. 14 on p. 31.

rectangular field carved with a scene from the shoemaker's workshop, further enhancing the rich dedication and its prominence. That such reliefs mounted on pillars were not unusual is demonstrated by a fragmentary votive relief to Asklepios and Hygieia, found in Metropolis Square in Athens, with Hygieia depicted leaning casually against precisely such a relief on a pillar (**Fig. 93**).[155]

A signal characteristic of votive reliefs is the frequent inclusion of setting. This can range from low-relief and schematic views of columns joined by architraves (**Fig. 221**)[156] to elaborate and fully three-dimensional buildings,[157] to landscapes with goats and divine figures (**Fig. 94**),[158] though sometimes in the later fourth century this amounts only to a simplified and almost abstract rendition of the cave.[159] All of this is rare or unheard of in other categories of Greek reliefs of the fourth century. Also, the figure types on reliefs can occasionally be identified as statues of the pertinent god(s) and/or goddess(es).[160] These provide invaluable evidence, as we shall see, for the existence in the fourth century B.C. of figure types otherwise known only in Roman statues which are often suspect as accurate reflections of Greek originals. Equally important is the evidence the votive reliefs provide of the breadth and depth of Greek religion, all too often passed over in the search for a pure and somewhat abstract beauty. The recent refurbishment of the rooms containing votive reliefs in the National Archaeological Museum in Athens emphasizes two salient impressions: the tedious repetitiousness of the massed reliefs and their exhilarating variety in comparison with almost all other classes of classical Greek relief sculpture. The now bright and attractive rooms will inevitably draw more visitors and will stimulate greater scholarly interest in these under-studied original (in many senses) monuments.

A subclass of votive reliefs are liturgical monuments, taken in the original sense of the word, that is, dedications for victory in the various festival contests held both by the tribes and the polis. Several surviving examples take the form of marble bases with relief decoration, on which bronze tripods were set. Most are undistinguished in either form or quality of sculpting, for example, the base from the Athenian Agora signed by Bryaxis.[161] But a particularly elegant example, found near the Lysikrates Monument in Athens, is a three-sided marble base with two Nikai and a figure of Dionysos in relief on its sides.[162]

[155] Athens, NAM 2557: Kaltsas, *SNAMA*, 223, no. 465; *LIMC*, s.v. Hygieia no. 29*. A similar pillar and relief are depicted on relief 1383: ibid., no. 28*.

[156] E.g., votive reliefs to Herakles: Athens, NAM 1404, 2723: Kaltsas, *SNAMA*, 139, no. 266*; *LIMC*, s.v. Herakles no. 760*.

[157] Votive relief to Asklepios: Athens, NAM 1377: Neumann, *Weihreliefs*, 51, fig. 29.

[158] Athens, NAM 2011: Kaltsas, *SNAMA*, 218, no. 450*. Such elements of landscape are particularly, but not exclusively, found on reliefs dedicated to the nymphs: W. Fuchs, "Attische Nymphenreliefs," *AM* 77 (1962) 242–49. See generally Ridgway, *Fourth-Century Styles*, 195–204.

[159] Athens, NAM 1859: Kaltsas, *SNAMA*, 221, no. 460; Svoronos, *Nationalmuseum* (note 152 above) 575–76, no. 228, pl. 96; R. Feubel, *Die attischen Nymphenreliefs und ihre Vorbilder* (Heidelberg 1935) 42–43, no. 26; Fuchs, *AM* 77 (1962) 243, pl. 69.1; C. M. Edwards, "Greek Votive Reliefs to Pan and the Nymphs" (Ph.D. diss., New York University, 1985) 503–9, no. 26, pl. 13; G. Güntner, *Göttervereine und Götterversammlungen auf attischer Weihreliefs: Untersuchung zur Typologie und Bedeutung* (Würzburg 1994) 125, no. A 42. Edwards (pp. 505–7) dates the relief 330–320, but Feubel, Fuchs, Güntner, and Kaltsas prefer a date close to the end of the century; the difference is immaterial for my point.

[160] Baumer, *Vorbilder*, 81–88; Palagia, *Euphranor*, p. 19, no. 1, fig. 18; G. Lippold, *Die griechische Plastik, Handbuch der Archäologie*, vol. 3, pt. 1 (Munich 1950) 278; C. Picard, *Manuel d'archéologie grecque: La sculpture*, vol. 4.1 *Période classique, IVe siècle (deuxième partie, fasc. 1)* (Paris 1954) 378–80; L. J. Roccos, "Athena from a House on the Areopagus," *Hesperia* 60 (1991) 398.

[161] Athens, NAM 1733: Kaltsas, *SNAMA*, 254, no. 530*; Ridgway, *Fourth-Century Styles*, 250, 274 n. 41; Boardman, *GS-LCP*, fig. 31; Todisco, *Scultura greca*, no. 156. On the original location of the base, see chap. 5A, p. 198 below.

[162] Athens, NAM 1463: Kaltsas, *SNAMA*, 244, no. 511*; O. Benndorf, "Dreifussbasis in Athen," *ÖJh* 2 (1899) 255–69, pls. V–VII; Süsserott, *Griechische Plastik*, 115, pl. 19.1, 19.3.

Its height is 1.30 meters, though the top is damaged. The discovery of a copy of this base occasioned questions about its date, leading to the suggestion that it is a Hellenistic or Roman copy.[163] The arguments in favor of a Late Hellenistic creation are mostly technical: the size and shape of the kantharos and oinochoe held by Dionysos and one of the Nikai, and the manner in which the feathers are rendered. But equally telling is the fine sense of linear detail in the drapery, as well as the curious relationship of the figures to the ground that makes each seem a slightly awkward quotation from some other context. Accordingly, the arguments in favor of it being a Neo-Attic creation appear very strong.[164]

The Lysikrates Monument itself is certainly the most elaborate choregic monument preserved, but it was not exceptional (**Figs. 19, 20** [details]). The foundations of several others are known, and Pausanias describes them thus (1.20.1):[165]

> Leading from the Prytaneion is a road called Tripods. The place takes its name from the shrines, large enough to hold the tripods which stand upon them, of bronze, but containing very remarkable works of art, including a satyr, of which Praxiteles is said to have been very proud. (Trans. W. H. S. Jones, Loeb edition)

The choregic monument dedicated by Atarbos on the Athenian Acropolis supported statues rather than a tripod (**Figs. 223, 224**),[166] so the range of size, complexity, and artistic interest of these monuments must have varied considerably.

Closely related to the votive reliefs, and particularly to the choregic and other liturgical monuments, are statue bases, some with reliefs and some even associated with known artists. The value of those bases without relief decoration, some of which are signed by sculptors known from texts, is primarily that they reveal the stance of the statues that once stood on them, which is often the only certain, original evidence we have for the style of the sculptor who signed the base. The numerous bases with reliefs rarely have great artistic merit in their own right, yet they contribute an invaluable addition to our understanding of the appearance of ancient statues, which we experience without exception isolated both from their original context in sanctuary or other public space and from the narrative and visual embellishment that bases display. Particularly tantalizing in the latter respect is the base found at Olympia dedicated to honor Poulydamas (**Fig. 95**);[167] Pausanias saw it and attributed it to Lysippos (6.1.4–5). In our mind's eye we must place on the base a statue of an athlete, such as the Apoxyomenos in the Vatican (**Figs. 150–53**)[168] or any other familiar statue, and realize how much of the original monument is missing. Even grander is a base consisting of three slabs with reliefs, found at Mantineia reused as paving

[163] E. Berger, "Dreiseitiges Relief mit Dionysos und Niken," *AntK* 26 (1983) 114–16, pls. 22–26; H. Jung, "Die Reliefbasis Athen Nationalmuseum 1463: Spätklassisch oder neuattisch?" *MarbWPr*, 1986, 3–38.

[164] Kaltsas, *SNAMA*, 254, and Boardman, *GS-LCP*, 133, figs. 152.1, 151.2, accept a date in the second half of the fourth century; Ridgway, *Fourth-Century Styles*, 232–33, is uncertain; A. Kosmopoulou, *The Iconography of Sculptured Statue Bases in the Archaic and Classical Periods* (Madison, WI, 2002) 211–13, no. 44, figs. 65–67, is tentatively in favor of the Hellenistic date proposed by Berger, "Dreiseitiges Relief" (note 163 above), and Jung, "Reliefbasis" (note 163 above).

[165] Knell, *Athen im 4. Jahrhundert*, 148–66; Travlos, *Pictorial Dictionary*, illustrates many (list in index); Wilson, *Khoregia*, 198–262.

[166] Athens, Acrop. 1338: Brouskari, *Acropolis Museum*, 20, fig. 5; Kosmopoulou, *Statue Bases*, 204–5, no. 39, fig. 60; Boardman, *GS-LCP*, 133, fig. 153. See further chap. 5A, p. 171 below.

[167] Olympia Λ 45: J. Marcadé, "A propos de la base de Poulydamas à Olympie," in *Lysippe et son influence*, ed. J. Chamay and L.-L. Maier (Geneva 1987) 113–24; P. Moreno, *Lisippo: L'arte e la fortuna*, exh. cat. (Rome 1995) 92–93, cat. no. 4.12.1; Kosmopoulou, *Statue Bases*, 200–2, no. 36, figs. 55–57; Todisco, *Scultura greca*, no. 246; Bol, *Bildhauerkunst*, vol. 2, 372–73, fig. 339 (C. Maderna).

[168] Vatican, Museo Pio-Clementino 1185: Stewart, *Greek Sculpture*, fig. 554; Todisco, *Scultura greca*, no. 274; Bol, *Bildhauerkunst*, 351–53, figs. 319a–i (C. Maderna).

stones in a Byzantine church, which must be associated with a description of a monument by Pausanias (8.9.1):

> The Mantineans possess a temple composed of two parts, being divided almost exactly at the middle by a wall. In one part of the temple is an image of Asklepios, made by Alkamenes; the other part is a sanctuary of Leto and her children, and their images were made by Praxiteles two generations after Alkamenes. On the pedestal of these are figures of Muses together with Marsyas playing the flute. (Trans. W. H. S. Jones, Loeb edition)

This description, however brief, fits the three slabs, now in the National Archaeological Museum in Athens (**Figs. 96–98**). Nonetheless, as with the bases of Bryaxis and Lysippos, few scholars are willing to conclude that these reliefs are indeed from the hand of Praxiteles[169] because they are not brilliant works and because it is assumed that the artists may have turned over such menial tasks to sculptors in their workshops.[170] Nevertheless, the bases do instruct us on the complexity of production and the iconographic elements missing from otherwise undefined statues, and they underscore that the "artistic" or aesthetic element of an ancient work was not indissolubly linked to the genius of a named "artist." Students of western European art, for example, of Rubens, can perhaps grasp the point best.

A final group of original monuments closely related to the preceding but in many respects more substantial are the public monuments set up in sanctuaries to commemorate and give thanks for some historical event. The most famous is the Lysander dedication at Delphi that commemorated the Spartan victory over Athens in the Peloponnesian War and must date to the last years of the fifth century.[171] Only some of the bases are preserved, but they suggest the composition of the thirty-seven statues listed by Pausanias (10.9.7–12) that made up the monument, which was complex in its distribution of figures in depth, as opposed to a paratactic alignment of statues in a simple row. Another such major monument, this time largely preserved, is the Acanthus Column, also known as the Column of the Dancers, at Delphi (**Figs. 99, 100**).[172] From a very fragmentary inscription it is certain that it was a dedication of the Athenians. Claude Vatin believed that some time ago he was able to read much more of this and other inscriptions on the base, but examination by other commentators has been unable to confirm these readings.[173] The tall column with elaborate acanthus decoration was surmounted by three women in thin

[169] Athens, NAM 215–17: Kaltsas, *SNAMA*, 246–47, no. 513*; Kosmopoulou, *Statue Bases*, 248–51, no. 63, figs. 105–7; Ridgway, *Fourth-Century Styles*, 206–9; Boardman, *GS-LCP*, 55, figs. 28.1–3; Bol, *Bildhauerkunst*, 375–76, figs. 341a–c (C. Maderna). Blümel, *Hermes*, 47, is the exception insofar as he makes the logical observation that the workshop will have worked in the same manner and to the same standards as the master. See further chap. 4, pp. 120–21 and 124–25 below.

[170] Ridgway, *Fourth-Century Styles*, 250, 287. For the suggestion that artists probably had large workshops, see chap. 1, p. 22 above.

[171] Bommelaer and Laroche, *Delphes: Le site*, 108–10, no. 109; J.-F. Bommelaer, "Les navarques et les successeurs de Polyclète à Delphes," *BCH* 95 (1971) 45–64; J. Pouilloux and G. Roux, *Énigmes à Delphes* (Paris 1963) 16–36; D. Arnold, *Die Polykletnachfolge: Untersuchungen zur Kunst von Argos und Sikyon zwischen Polyklet und Lysipp*, JdI-EH 25 (Berlin 1969) 97–109. C. Vatin, *Monuments votifs de Delphes* (Rome 1991) 103–38, proposes a more precise reconstruction of the monument on the basis of twenty-seven new blocks, several with inscriptions, that he attributes to the monument. See further chap. 5A, pp. 165–69 below.

[172] Picard, *Delphes: Le musée*, 84–90, figs. 46–48; Pouilloux and Roux, *Énigmes à Delphes* (note 171 above) 123–49 (chap. 5, "Les danseuses de Delphes et la base de Pankratès"); J.-L. Martinez, "La colonne des danseuses de Delphes," *CRAI*, 1997, 53–46; Bol, *Bildhauerkunst*, 371, figs. 338a–f (C. Maderna).

[173] C. Vatin, "Les danseuses de Delphes," *CRAI*, 1983, 26–40. For the most explicit rejection of Vatin's reading of the inscriptions, see Martinez, *CRAI*, 1997, 44, note 27, though J. de Waele, review of C. Vatin, *Monuments votifs de Delphes*, in *RA*, 1993, 127, supports A. Corso's acceptance of the readings: *Prassitele: Fonti epigrafiche e letterarie, vita e opere*, vol. 1, *Fonti epigrafiche: Fonti litterarie dall'età dello scultore al medio impero (IV sec. a.C.–circa 175 d.C.)* (Rome 1988) 34.

chitons who supported a tripod. The date is by consensus around 330 B.C.[174] A number of other monuments of the type will be discussed later, though detailed evidence for their reconstruction is largely lacking.[175]

Record reliefs are a purely Attic phenomenon (**Figs. 101, 102, 163**). The reliefs are attached to official inscriptions of the polis which are associated with the development of the democracy and sometimes preserve the name of the archon of the year in which the decree was promulgated and can thus be dated precisely. The earliest firmly dated relief is from 426/5, though the type may have begun as early as the middle of the fifth century.[176] Although the record reliefs continue down into the Hellenistic period, their number diminishes greatly toward the end of the fourth century. They are, however, small, and their quality varies, so for the purpose of establishing chronology they do not provide as sure a comparison to larger monuments as one might wish.[177] They also appear on occasion to reflect older, famous, or popular iconographic and perhaps stylistic types, so they may even be misleading when used as chronological benchmarks.[178]

Although I shall not deal extensively with works categorized as belonging to the "minor arts," these constitute an important and large body of original material. Two main types are directly related to the major categories of sculpture and painting: terracotta figurines and metal vases, both with and without figural decoration. The terracotta figurines are important both for themselves and because they adapt monumental types, which allows us to assert with certainty that a statue type existed even though it is otherwise known only in Roman copies. One such example is the terracotta group of Leda and the swan that clearly resembles the Roman stone examples of the same subject, the original of which is often attributed to the sculptor Timotheos (**Figs. 103, 104**).[179] In this function the figurines parallel the votive and record reliefs discussed above. As works of art in their own right, terracotta figurines extend the picture of the subjects of Greek art, particularly after the end of the fifth century. There are some exquisite works prior to that date, but they are rare and more frequent in the sixth century than in the fifth. Although it would be tidy if terracotta figurines could be made to fit the pattern of grave and votive reliefs, which experienced a gradual revival in the last third of the fifth century and blossomed in the fourth, the terracottas seem to lag this development slightly, though a number of figurines do begin to reflect the style of monumental sculpture around the turn of the fifth to the fourth century.[180] But it is only toward the middle

[174] J. Bousquet, "Delphes et les Aglaurides d'Athènes," *BCH* 88 (1964) 655–75; Bousquet, "Inscriptions de Delphes," *BCH* 108 (1984) 696; Boardman, *GS-LCP*, caption to fig. 15. See also G. Roux, "Problèmes delphiques d'architecture et d'épigraphie," *RA*, 1969, 45–46.

[175] See chap. 5A, pp. 169–85 below.

[176] Meyer, *Urkundenreliefs*, 264, no. A1, pl. 1.1, and, generally, 246–50; Lawton, *Document Reliefs*, 81, no. 1, pl. 1; see generally pp. 19–22.

[177] Meyer, *Urkundenreliefs*, 215–17; Lawton, *Document Reliefs*, 73–77.

[178] Meyer, *Urkundenreliefs*, 223–46; Baumer, *Vorbilder*, 82–84.

[179] London, BM 1865.7-20.44: R. A. Higgins, *Catalogue of the Terracottas in the Department of Greek and Roman Antiquities, British Museum*, vol. 1 (London 1954) 235, no. 880, pl. 128; Paris, Louvre CA 2570: S. Mollard-Besques, *Musée du Louvre: Catalogue raisonné des figurines et reliefs en terre-cuite grecs, étrusques et romains*, vol. 1, *Époques préhellénique, géométrique, archaïque et classique* (Paris 1954) 119, no. C227, pl. LXXXV; Berlin, Staatl. Mus. 8822: G. Kleiner, *Tanagrafiguren: Untersuchungen zur hellenistichen Kunst und Geschichte*, JdI-EH 15 (Berlin 1942) 132, pl. 29b. For the Roman marbles, see A. Rieche, "Die Kopien des 'Leda des Timotheos,'" *AntP* 17 (1978) 21–55, pls. 10–34.

[180] London, BM 42.12-3.1: Higgins, *Catalogue of the Terracottas* (note 179 above) 190–91, pl. 94. See generally R. A. Higgins, *Greek Terracottas* (London 1967). The best impression of the change can be gained by perusing the catalogue of the exhibition in Munich: *Hauch des Prometheus: Meisterwerke in Ton*, ed. F. W. Hamdorf (Munich 1996), with excellent color illustrations, or the great catalogues of terracotta figurines, such those cited in notes 179 above and 181 below.

of the fourth century that terracotta figurines wholeheartedly express the lively trends of major sculpture. Perhaps typical of the fourth century is that all regions of Greece share in this development. Indeed, I have not yet mentioned the issue of regionalism, despite its often prominent place in the scholarly literature, quite simply because it appears to me to be far less emphatic from the late fifth century on. Formally, this also becomes true of the terracottas from the middle of the fourth century on, though fabric allows the expert to place most figurines in their geographic centers with some assurance. In the last third of the fourth century begins the extraordinary sequence of figurines known as Tanagras (**Fig. 105**).[181] These must rank as some of the most beautiful and finely worked figurines ever made. Their subject is often of an intimate or personal nature; the women, who figure prominently in the repertory of the Tanagras, are dressed in rich and fashion-conscious clothes and stand, sit, or kneel in elegant poses. The figurines continue, of course, to appear in sanctuaries as votive offerings, but they were also to be found in the increasingly substantial houses, where they would have served private cult.[182] They also occur in tombs. It is certainly significant that the vast majority of the Tanagras represent women[183] and, as we shall see in a later chapter, underscore a fourth-century fascination with the complexities of women's dress. Indeed, the prominent role of women in the art of the fourth century of all varieties is noteworthy.

Small bronze figures constitute an important class of object from the eighth century B.C. on.[184] They are frequently associated with utilitarian objects; in the Archaic and Classical periods mirror handles in human and animal form are immensely popular and are of the highest quality of workmanship.[185] The decline in such plastic figured handles in the later fifth century and the development in the early fourth century of mirror cases with figural decoration in relief, often very elaborate, marks a break with the past.[186] Another change in the later fifth and fourth centuries is the rarity of freestanding bronze figurines,[187] which had been quite popular in the sixth and the first half of the fifth century. There are a number of examples in the Louvre that Claude Rolley has dated to the fourth century (**Fig. 106**),[188] but only scattered examples in other museums and private collections.[189] It may

[181] Boston, MFA 01.7843: J. P. Uhlenbrock, ed., *The Coroplast's Art: Greek Terracottas of the Hellenistic World*, exh. cat. (New Paltz, NY, 1991) 112, no. 5* (J. J. Herrmann); Bol, *Bildhauerkunst*, 430, 450, 456, fig. 432 (U. Mandel). See generally Kleiner, *Tanagrafiguren* (note 179 above); D. B. Thompson, "Three Centuries of Hellenistic Terracottas," *Hesperia* 21 (1952) 116–64; Thompson, "The Origin of Tanagras," *AJA* 70 (1966) 51–66, pls. 17–20; H. A. Thompson, D. B. Thompson, and S. Rotroff, *Hellenistic Pottery and Terracottas* (Princeton 1986); R. Higgins, *Tanagra and the Figurines* (Princeton 1986); J. P. Uhlenbrock, "The Hellenistic Terracottas of Athens and the Tanagra Style," in Uhlenbrock, *Coroplast's Art*, 48–53.

[182] Higgins, *Greek Terracottas* (note 180 above) xlix–l.

[183] D. B. Thompson, *AJA* 70 (1966) 52.

[184] C. Rolley, *Greek Bronzes*, trans. R. Howell (London 1986); D. G. Mitten and S. F. Doeringer, *Master Bronzes from the Classical World*, exh. cat. (Greenwich, CT, n.d. [1968]); W. Lamb, *Ancient Greek and Roman Bronzes* (London 1929; repr. Chicago 1969).

[185] F. Schaller, *Stützfiguren in der griechischen Kunst*, Dissertationen der Universität Wien 87 (Vienna 1973) 101–38.

[186] L. O. K. Congdon, *Caryatid Mirrors of Ancient Greece* (Mainz 1981) 104–7; A. Schwarzmaier, *Griechische Klappspiegel: Untersuchungen zu Typologie und Stil*, AM-BH 18 (Berlin 1997) 224–25; W. Züchner, *Griechische Klappspiegel*, JdI-EH 14 (Berlin 1942) 119–20.

[187] D. G. Mitten, introduction to *The Gods Delight: The Human Figure in Classical Bronze*, exh. cat. (Bloomington, IN, 1988) 10.

[188] Rolley, *Greek Bronzes* (note 184 above): wrestler (Louvre MND 1895), 164, fig. 145; Herakles (Louvre Br 387), 244, cat. no. 277; from the end of the century or the early third century, a stunning youthful Pan (Louvre Br 4359), 204, fig. 176.

[189] E.g., a nude male divinity in Berlin, Staatl. Mus. 30835: K. A. Neugebauer, *Katalog der statuarischen Bronzen im Antiquarium*, vol. 2, *Die griechischen Bronzen der klassischen Zeit und des Hellenismus* (Berlin 1951) 18–19, no. 10, pl. 12; an apoxyomenos in Heidelberg, F 161: B. Borell, *Katalog der Sammlung antiker Kleinkunst des archäologischen Instituts der Universität Heidelberg*, vol. 3, pt. 1, *Statuetten, Gefässe und andere Gegenstände aus Metall* (Mainz 1989) 9–10, no.

be mere coincidence, but the small freestanding bronzes disappear just as marble votive reliefs rise in popularity; the same coincidence marks the end of the fourth century, when marble votive reliefs decline in popularity and small bronzes become frequent again. Of course, these patterns may be no more than the result of an arbitrary archaeological record of preservation, though this seems to gratuitously depreciate the double coincidence.

Another important change comes near the end of the fifth century with the increase in the private as opposed to official or "ritual" use of metal vases, particularly silver plate.[190] Michael Vickers and David Gill have argued convincingly for a much greater use of metal vases and utensils by wealthy Greeks before the fourth century than has usually been thought,[191] but both the archaeological evidence of preservation and the literary evidence point to a great increase in bronze, silver, and (much more rarely) gold vases in the fourth century and thereafter (**Figs. 107, 108**).[192] Both Aristophanes and Demosthenes cite luxury vessels in a manner that implies familiarity (and disdain).[193] Almost all the preserved examples come from tombs in the area of Macedon and farther north, presumably the graves of the local aristocracies which still took pride in providing the dead with real wealth.[194] Many are metal counterparts to contemporary ceramic vessels,[195] though a number are richly decorated.

9, pl. 5; a nude Aphrodite in London, BM 1084: Rolley, *Greek Bronzes* (note 184 above) 166, fig. 147; a similar nude Aphrodite in Berlin, Staatl. Mus. 1701: C. Rolley, *Greek Minor Arts*, fasc. 1, *The Bronzes*, Monumenta Graeca et Romana 5 (Leiden 1967) no. 90*; an athlete in the Musée Royal de Mariemont, B 32: Rolley, *Greek Minor Arts*, no. 89*; two examples in anonymous private collections and one in the George Ortiz collection: Schefold, *Meisterwerke* (note 60 above) 262, nos. 340a, 343, 346, with illustrations on p. 255.

[190] D. E. Strong, *Greek and Roman Gold and Silver Plate* (Ithaca, NY, 1966) xxvi–xxvii, 78–89.

[191] D. W. J. Gill, "Classical Greek Fictile Imitations of Precious Metal Vases," in *Pots and Pans: A Colloquium on Precious Metals and Ceramics in the Muslim, Chinese and Graeco-Roman Worlds, Oxford, 1985*, ed. M. Vickers (Oxford 1986) 9–30; M. Vickers and D. W. J. Gill, *Artful Crafts: Ancient Greek Silverware and Pottery* (Oxford 1994). H. Hoffmann, "Why Did the Greeks Need Imagery?" *Hephaistos* 9 (1988) 150–60; Hoffmann, "*Dulce et decorum est pro patria mori:* The Imagery of Heroic Immortality on Athenian Painted Vases," in *Art and Text in Ancient Greek Culture*, ed. S. Goldhill and R. Osborne (Cambridge 1994) 29–32, actually makes the most forceful statement of the case. An interesting parallel is raised by Dorothy Thompson's suggestion that the elegant Tanagra figurines reflect contemporary bronze and silver figurines that have almost totally disappeared from the archaeological record: *AJA* 70 (1966) 54–55. The controversy engendered by some of the views of Vickers and Gill, particularly on the relative merits of metal versus ceramic vases, is not relevant to the issues under consideration here. Their position seems to me in any case to be illogical, since the social prominence of metal does not a priori exclude the artistic quality of vase painting; see M. Robertson, "Beazley and Attic Vase Painting," in *Beazley and Oxford: Lectures Delivered at Wolfson College, Oxford, 28 June 1985*, ed. D. C. Kurtz (Oxford 1985) 19–30; J. Boardman, "Silver Is White," *RA*, 1987, 279–95; Boardman, "Trade in Greek Decorated Pottery," *OJA* 7 (1988) 27–33.

[192] Silver kantharos, Thessaloniki B 5: B. Barr-Sharrar, "Macedonian Metal Vases in Perspective: Some Observations on Context and Tradition," in Barr-Sharrar and Borza, *Macedonia*, 126, fig. 5; see also K. Rhomiopoulou, A. Herrmann, and C. C. Vermeule, eds., *The Search for Alexander: An Exhibition*, exh. cat. (Boston 1980) 181, no. 156*. Silver rhyton, partly gilt, Ruse, District Museum of History II-358: I. Marazov, ed., *Ancient Gold: The Wealth of the Thracians; Treasures from the Republic of Bulgaria* (New York 1998) 224, no. 175*; S. Ebbinghaus, "Between Greece and Persia: Rhyta in Thrace from the Late 5th to the Early 3rd Centuries B.C.," in *Ancient Greeks West and East*, ed. G. R. Tsetskhladze (Leiden 1999) 391, fig. 1c on p. 393. For a wealth of bronze vessels, see A. Andriomenou, "Vases et lampes de bronze dans les collections privées d'Athènes," *BCH* 99 (1975) 335–59; J. Vokotopoulou, "Le trésor de vases de bronze de Votonosi," *BCH* 99 (1975) 729–88. The most famous gold vessels are those from the hoard found at Panagyurishte in Bulgaria: D. Končev, "Der Goldschatz von Panagjurište," in B. Svoboda, *Neue Denkmäler antiker Toreutik* (Prague 1956) 117–64; E. Simon, "Der Goldschatz von Panagurište—Eine Schöpfung der Alexanderzeit," *AntK* 3 (1960) 3–29.

[193] Aristophanes, *Ploutos* 802–14; Demosthenes, *Against Meidias* 158.

[194] I. Venedikov and T. Gerasimov, *Thracian Art Treasures*, 2nd ed. (Sofia 1979); A. Fol, ed., *Der thrakische Silberschatz aus Rogozen Bulgarien*, exh. cat. (Sofia 1988); Marazov, *Ancient Gold* (note 192 above).

[195] See particularly B. B. Shefton, "Persian Gold and Attic Black-Glaze: Achaemenid Influences on Attic Pottery of the 5th and 4th Centuries," in *Orient, Grèce et Rome: XIème Congrès international d'archéologie classique, Damas, 11–20 octobre 1969* = *AAS* 21 (1971) 109–11, pls. 20–22; Rhomaiopoulou, Herrmann, and Vermeule, *Search for Alexander* (note 192 above) 156–69, nos. 106–34; C. Rolley, "Objets de métal," in *Médéon de Phocide*, vol. 5, *Tombes hellénistiques, objets de métal, monnaies* (Paris 1976) 95–107. For a general discussion, see B. A. Sparkes and L. Talcott, *The Athenian Agora*, vol. 12, *Black and Plain Pottery of the 6th, 5th, and 4th Centuries B.C.* (Princeton 1970) 20–30 (decoration), 121–22 (the kantharos).

Noteworthy among the latter are a small number of silver vases with incised figures covered in gold foil that closely resemble red-figure ceramic vase painting (**Fig. 108**).[196] The earliest date to the middle of the fifth century. A janiform gilt silver head rhyton in the British Museum has a representation of the Judgment of Paris on the neck.[197] The figures are inscribed in Lykian. Donald Strong suggests that the vase was made by an Athenian craftsman in Lykia around 400 B.C. or shortly after. Other silver rhytons, occasionally with elaborate figural decoration, are known.[198] There are also bronze situlas with relief decoration; a simple one found near Plovdiv in Bulgaria dates from the turn of the fifth to the fourth century;[199] a far more elaborate though poorly preserved example in Boston is said to come from South Italy and is ascribed to workshops in Taras (Tarentum).[200] Of quite a different type are the impressive fragments of a bronze calyx-krater in Berlin depicting a Bacchic revel (**Fig. 109**)[201] and the huge and richly decorated volute-krater from Derveni tomb B, now in Thessaloniki, with a similar subject (**Figs. 110, 111**).[202] The date of the vase in Berlin is uniformly placed around 400; the date of the Derveni krater is widely held to be around 330–320, though its style is closest to that of the early fourth century.[203] The issue of the krater's style and date is thus of great importance in our assessment of the artistic climate of the fourth century and will be

[196] Plovdiv, Regional Museum of Archaeology 1515: Marazov, *Ancient Gold* (note 192 above) 138–39, no. 64*; Vickers and Gill, *Artful Crafts* (note 191 above) 41, fig. 2.2; Strong, *Gold and Silver Plate* (note 190 above) 80, pl. 15b. See generally B. Pharmakowsky, "Archäologische Funde im Jahre 1909: Rußland," *AA*, 1910, 219–20, figs. 18, 19; K. S. Gorbunova, "Engraved Silver Kylikes from the Semibratny Barrows," in *Kultura e iskusstvo antichnogo mira* (Leningrad 1971) 18–38 (in Russian), 123 (English summary); Gill, "Classical Greek Fictile Imitations" (note 191 above) 111–12, figs. 3–6; M. Vickers, "Artful Crafts: The Influence of Metalwork on Athenian Painted Pottery," *JHS* 105 (1985) 110–11, pl. IVc; Vickers, "The Metrology of Gold and Silver Plate in Classical Greece," in *Economics of Cult in the Ancient Greek World: Proceedings of the Uppsala Symposium 1990*, ed. T. Linders and B. Alroth (Uppsala 1992) 54, figs. 1, 2; Vickers and Gill, *Artful Crafts*, 130–36, figs. 5.20, 5.22–5:24; Marazov, *Ancient Gold*, nos. 64, 77, 116; Hoffmann, *Hephaistos* 9 (1988) 150, figs. 11, 12.

[197] London, BM 1962.12-12.1: D. E. Strong, "A Greek Silver Head-Vase," *BMQ* 28 (1964) 95–102, pls. XVI–XVIII; R. D. Barnett, "A Silver Head-Vase with Lycian Inscriptions," in *Mansel'e Armağan/Mélanges Mansel* (Ankara 1974) vol. 2, 893–903, pls. 319, 320; E. Simon, "Boreas und Oreithyia auf dem silbernen Rhyton in Triest," *AuA* 13 (1967) 124–26, fig. 14.

[198] Ortiz collection: G. Ortiz, *In Pursuit of the Absolute: Art of the Ancient World; The George Ortiz Collection* (Bern 1996) no. 152*; Rhomaiopoulou, Herrmann, and Vermeule, *Search for Alexander* (note 192 above) 128–29, cat. 53*, color pl. 6. On rhytons in general, see Ebbinghaus, in *Ancient Greeks West and East* (note 192 above) 385–425.

[199] Plovdiv, Regional Archaeological Museum 1847: D. Zontschew, "Ein neuer Bronzeeimer aus Thrakien," *AA*, 1936, cols. 411–19, figs. 4–6; I. Venedikov, "Les situles de bronze en Thrace," *Thracia* 4 (1977) 87, 100, no. 17, figs. 34–36; Venedikov and Gerasimov, *Thracian Art Treasures* (note 194 above) 356, figs. 105–7. A related but far less well-preserved situla with two figures in relief, one of which may be Dionysos, was found at Vasiljovo: Venedikov, *Thracia* 4 (1977) 87, 100, no. 18, figs. 37, 38.

[200] Boston, MFA 03.1001: M. B. Comstock and C. C. Vermeule, *Greek, Etruscan and Roman Bronzes in the Museum of Fine Arts, Boston* (Boston 1971) 302–3, no. 428*; E. Pernice, "Tarentiner Bronzegefässe," *JdI* 35 (1920) 91–92, fig. 6; Pernice, *Gefässe und Geräte aus Bronze*, Die hellenistische Kunst in Pompeji 4 (Berlin 1925) 26, pl. V.

[201] Berlin, Staatl. Mus. 30622: Züchner, "Berliner Mänadenkrater" (note 100 above); W.-D. Heilmeyer, L. Giuliani, G. Platz, and G. Zimmer, *Antikenmuseum Berlin: Die ausgestellten Werke* (Berlin 1988) 136–37*; Schwarzmaier, *Klappspiegel* (note 186 above) 64–65.

[202] Barr-Sharrar, *Derveni Krater*; Giouri, Κρατήρας τοῦ Δερβενίου (note 100 above); Rhomaiopoulou, Herrmann, and Vermeule, *Search for Alexander* (note 192 above) 164–65, cat. no. 127*, color pls. 20, 21; Rolley, *Greek Bronzes* (note 184 above) 178–83, figs. 158–60; C. Rolley, *La sculpture grecque*, vol. 2, *La période classique* (Paris 1999) 370–71, figs. 9 (color), 387–89; T. H. Carpenter, "Images and Beliefs: Thoughts on the Derveni Krater," in *Periplous: Papers on Classical Art and Archaeology Presented to Sir John Boardman*, ed. G. R. Tsetskhladze, A. J. N. W. Prag, and A. M. Snodgrass (London 2000) 51–59.

[203] Some early commentators recognized this and dated the vase accordingly: M. Robertson, "Monocrepis," *GRBS* 13 (1972) 39 ("fourth century and not late"); K. Schefold, "Der Basler Pan und der Krater von Derveni," *AntK* 22 (1979) 112–18 (around 360). In the most recent publication of the krater, by Barr-Sharrar, *Derveni Krater*, 44–46, 112–14, the date of around 370 is proposed, based on a detailed study of the shape of the vase and the style of its decoration. The late date for the vase is argued by Giouri, Κρατήρας τοῦ Δερβενίου (note 100 above) 66–73, and Schwarzmaier, *Klappspiegel* (note 186 above) 77–82.

treated in a later chapter.[204] All in all, one can speak of a refined elegance permeating Greek society in the fourth century, which implies a personal realm, as opposed to the official.

There is another class of monument that is also either in origin or at least strongly influenced from the east: mosaics. Patterned pebble mosaics occur in Asia Minor and Syria in the eighth and seventh centuries; at Gordion in Phrygia they continue to be made down into the fifth century.[205] It is probable that these influenced the beginning of mosaics in Greece near the end of the fifth century.[206] Mosaics first occur sporadically around Greece in Corinth, Sikyon, Eretria (**Figs. 112, 113**), and, most prominently, at Olynthos in the Chalkidike (**Fig. 114**).[207] The only certain date for the first appearance of decorative and figured mosaics in Greece is the destruction of Olynthos in 348 B.C.[208] The most accomplished mosaics are those from the last third of the fourth century found at Pella (**Fig. 115**).[209] All are accurately described as pebble mosaics, that is, the patterns are created by using small unworked stones of different colors, at first just black and white; later, red and yellow are added. Over the little more than the century of concern here, there is a noticeable development of technique from graphic to plastic patterns. Particularly at Pella there are clear gradations of the size of the stones, and metal strips are used to emphasize the perimeter of shapes, which are also given volume by gradations of color. To some extent the mosaics convey an idea of the accomplishments of monumental painting,[210] but their most important contribution is to document the extraordinary enlargement of pictorial vocabulary in the private sphere and to emphasize once again the broad private wealth and decorative sensibilities of the fourth century,[211] paralleling the use of richly decorated pottery, architectural moldings, metal vessels, and cloth of elaborate design.[212]

PAINTING AND POTTERY

Monumental painting appears relatively late in our period and far to the north, in Macedonia and Bulgaria, on the walls of tombs. However, painted grave stelai occur much earlier, perhaps at the end of the fifth century or close to the beginning of the fourth. Two stelai from excavations in the city of Athens have been dated by Semni Karouzou as early

[204] Chap. 7, p. 274 below.

[205] D. Salzmann, *Untersuchungen zu den antiken Kieselmosaiken: Von den Anfängen bis zum Beginn der Tesseratechnik* (Berlin 1982) 4–8.

[206] Ibid., 21–22, 55–56. P. Bruneau, *La mosaïque antique* (Paris 1987) 35–39, argues for an independent Greek invention unrelated to the earlier traditions. Admittedly, Salzmann's insistence on citing Bronze Age Aegean precedents and simple undecorated pebble pavements in the Archaic period in Greece appears irrelevant, but his arguments in favor of influence from more or less contemporary Asia Minor are persuasive.

[207] Salzmann, *Kieselmosaiken*, 11–30, and 140–41 for a chronological chart of the dates Salzmann argues in the text, which are in general slightly later than the dates proposed by the various excavators and earlier commentators; M. Robertson, "Early Greek Mosaics," in Barr-Sharrar and Borza, *Macedonia*, 241–49. P. Ducrey, *Eretria*, vol. 8, *Le quartier de la Maison aux mosaïques* (Lausanne 1993) 96, compromises on the date of the mosaics from the House of the Mosaics at Eretria, accepting a date around 360. His earlier arguments for a date in the first third of the fourth century, based on the date of the fill beneath the house, are given in his article "L'habitat classique à Érétrie: Le cas de la Maison aux mosaïques," in *Proceedings of the 12th International Congress of Classical Archaeology, Athens, 4–10 September 1983*, vol. 4 (Athens 1985) 54–56.

[208] Salzmann, *Kieselmosaiken*, 11, 25.

[209] Ibid., 12, 27–30.

[210] Ibid., 57–58; Bruneau, *Mosaïque antique* (note 206 above) 51–54.

[211] Salzmann, *Kieselmosaiken*, 14–20, 57.

[212] F. von Lorentz, "Βαρβάρων ὑφάσματα," *RM* 52 (1937) 165–222, followed by Bruneau, *Mosaïque antique* (note 206 above) 48–49. Salzmann, *Kieselmosaiken*, 8, 56–57, is more persuasive in seeing fabric and perhaps carpets simply as parallel phenomena rather than the source for the development of mosaics.

as 430, but they are probably no earlier than the end of the century.[213] They depict the standard scenes of the deceased known from the relief stelai, as do several other painted stelai from the Kerameikos.[214] A rather unorthodox stele from the Kerameikos was apparently raised for an athlete.[215] An aryballos and strigil, as well as a pair of shoes, are depicted hanging from a painted fillet at its broken top, while below a dog appears to have knocked over a lekythos placed on the base of the depicted monument. A later example, probably dating around 340, is the stele of Hermon, also in the Kerameikos (**Fig. 116**).[216] Several painted stelai recovered from the great tumulus at Vergina in the 1970s[217] begin to resemble the earliest painted stelai from Demetrias (Pagasai) generally believed to date after the foundation of Demetrias in 293 B.C.[218] Most recently, the painting on carved fourth-century grave stelai from Athens has been reconstructed.[219]

The number of excavated painted tombs in northern Greece and adjacent areas has increased greatly over the last decades, though few are published in detail.[220] Among the earliest discovered and best published are the great tombs at Kazanlăk in Bulgaria[221] and at Lefkadia in Macedonia.[222] The latter is particularly impressive, with large figures in an architectural framework on the facade (**Figs. 117, 118**). Here the subtle coloristic effects are quite remarkably well preserved. Above are a row of painted metopes, and above that a monochrome battle frieze, all of which attest the extraordinary ability of fourth-century painters. The excavator dated the tomb to the Early Hellenistic period, after 300 B.C.,[223] though most recent commentators place it in the late fourth century.[224]

[213] S. Papaspyridi-Karusu, "Bemalte attische Stele," *AM* 71 (1956) 124–39, pls. A, B (color), Beil. 69–73.

[214] R. Posamentir, "Drei 'neue' bemalte Grabstelen aus dem Kerameikos-Museum," *AM* 114 (1999) 127–38, pls. 15–19, with a list on p. 127, note 1. A sculpted and painted marble lekythos is briefly described by U. Koch-Brinkmann, *Polychrome Bilder griechischen Malerei* (Munich 1999) 120, note 195.

[215] Athens, Kerameikos P 863: M. Robertson, *Greek Painting* (Geneva 1959; repr. 1979) 153, 156, fig. on p. 157; Robertson, *History of Greek Art* (London 1975) 422.

[216] E. Walter-Karydi, "Der Naiskos des Hermon: Ein spätklassisches Grabgemälde," in *Kanon: Festschrift Ernst Berger zum 60. Geburtstag am 26. Februar 1988 gewidmet*, ed. M. Schmidt (Basel 1988) 331–38, pls. 93–95; V. von Graeve, "Der Naiskos des Hermon: Zur Rekonstruktion des Gemäldes," in ibid., 339–43, pls. 93–95.

[217] H. Brecoulaki, *La peinture funéraire de Macédoine: Emplois et fonctions de la couleur, IVe–IIe s. av. J.-C.* (Athens 2006) 149–59, pls. 54–57; C. Saatsoglou-Paliadeli, *Τὰ ἐπιτάφια μνημεῖα ἀπὸ τὴ Μεγάλη Τούμπα τῆς Βεργίνας* (Thessaloniki 1984); the best-preserved is cat. no. 20, pp. 152–59, pls. 42, 43; Andronikos, *Royal Tombs*, 85, fig. 45; R. Ginouvès and M. B. Hatzopoulos, eds., *Macedonia: From Philip II to the Roman Conquest* (Princeton 1994) 230, fig. 200.

[218] V. von Graeve, "Zum Zeugniswert der bemalten Grabstelen von Demetrias für die griechische Malerei," in *La Thessalie: Actes de la table-ronde, 21–24 juillet 1975, Lyon*, ed. B. Helly (Lyon 1979) 111–31; A. S. Arvanitopoulos, *Γραπταὶ στῆλαι Δημητριάδος-Παγασῶν* (Athens 1928).

[219] U. Koch-Brinkmann and R. Posamentir, "Der Grabstele der Paramython," in V. Brinkmann and R. Wünsche, eds., *Bunte Götter: Die Farbigkeit antiker Skulptur; Eine Ausstellung der Staatlichen Antikensammlungen und Glyptothek München in Zusammenarbeit mit der Ny Carlsberg Glyptotek Kopenhagen und den Vatikanischen Museen, Rom*, exh. cat., 2nd ed. (Munich 2004) 149–65.

[220] Brecoulaki, *Peinture funéraire*; S. G. Miller, "Macedonian Painting: Discovery and Research," in *International Congress Alexander the Great: From Macedonia to the Oikoumene, Veria, 27–31/5/1998*, ed. A. Vlazakis (Veroia 1999) 75–88.

[221] V. Mĭkov, *Le tombeau antique près de Kazanlăk* (Sofia 1954); A. Vasiliev, *Das antike Grabmal bei Kasanlak* (Sofia 1959); G. Kitov, "A Newly Found Thracian Tomb with Frescoes," *Archaeologia Bulgarica* 5 (2001) 15–29; V. Todorov, "The Thracian Tomb at Alexandrovo, SE Bulgaria: Preliminary Observations on Its Painting Technique," in *Interdisziplinäre Forschungen zum Kulturerbe auf der Balkanhalbinsel*, ed. V. Nikolov, K. Bacvarov, and H. Popov (Sofia 2011) 323–34; H. M. Franks, *Hunters, Heroes, Kings: The Frieze of Tomb II at Vergina* (Princeton 2012) 50–52, figs. 42–44.

[222] P. M. Petsas, *Ὁ τάφος τῶν Λευκαδίων* (Athens 1966); Brecoulaki, *Peinture funéraire*, 204–17, pls. 74–76; V. J. Bruno, *Form and Color in Greek Painting* (New York 1977) 34–30, figs. 5b–9; Bruno, "The Painted Metopes at Lefkadia and the Problem of Color in Doric Sculptured Metopes," *AJA* 85 (1981) 3–11; A. Rouveret, *Histoire et imaginaire de la peinture ancienne: Ve siècle av. J.C.–Ier siècle ap. J.C.* (Rome 1989) 174–78, 221–23.

[223] Petsas, *Τάφος τῶν Λευκαδίων* (note 222 above) 179–82.

[224] Bruno, *Form and Color*, 23, note 1; K. Rhomiopoulou, *Lefkadia: Ancient Mieza* (Athens 1997) 29.

Equally remarkable paintings come from the great tumulus at Vergina (ancient Aigai), the original capital of Macedonia. Here there is a badly damaged frieze of a series of hunts above the entrance of the "Tomb of Philip" (**Fig. 119**).[225] In a neighboring small tomb is a painted scene of Hades carrying off Persephone, which was fully published by Manolis Andronikos (**Fig. 120**).[226] Another richly painted tomb of the end of the fourth century was discovered in 1994 at Aghios Athanasios near Thessaloniki; a well-preserved narrow (0.35 meters high) painted frieze 3.75 meters long depicts a procession and a banquet.[227]

Since our textual records have much to say about the development of painting in the fourth century, the lack of any but the skimpiest physical remains is much to be lamented.[228] Scholars have frequently tried to identify Greek panel paintings in the preserved wall decoration of Roman, particularly Pompeian, houses, but this issue is just as controversial, if not moreso, than the identification of Roman sculptures as reflections of classical statues.[229] The practice of using Attic red-figure vases to reconstruct panel or wall-paintings recorded by later (Roman) writers, though widely accepted for the fifth century, has not been applied equally to the fourth century because vase painting is generally thought to diverge strongly from monumental painting in the late fifth century.[230] According to the ancient texts on painting, the artists of the late fifth and fourth centuries developed both illusionistic and impressionistic techniques that are antithetical to the almost purely linear draftsmanship of vase painting. Although this appears to be true, there are nevertheless several characteristics of fourth-century Attic vases that must reflect developments in contemporary monumental painting, as we shall see in a later chapter. Equally important, as Henri Metzger has pointed out, is that there are several vase painters who are remarkable artists and whose works may shed more light on monumental painting than is often thought.[231]

The special category of Attic Panathenaic vases deserves particular attention.[232] These are painted in the archaic black-figure style that had its heyday in the sixth century B.C. and in the course of the first half of the fifth century gradually disappeared from all vases

[225] Andronikos, *Royal Tombs*, 97–119; C. Saatsoglou-Paliadeli, Βεργίνα· Ο τάφος του Φιλίππου· Η τοιχογραφία με το κυνήγι (Athens 2004): Brecoulaki, *Peinture funéraire*, 103–36, pls. 27–43; Franks, *Hunters, Heroes, Kings* (note 221 above); A. Pekridou-Gorecki, "Zum Jagdfries des sogenannten Philipp-Grabes in Vergina," in *Fremde Zeiten: Festschrift für Jürgen Borchhardt zum sechzigsten Geburtstag am 25. Februar 1996 dargebracht von Kollegen, Schülern und Freunden*, ed. F. Blakolmer et al. (Vienna 1996) vol. 2, 89–103; Rouveret, *Histoire et imaginaire*, 223–35.

[226] Andronikos, *Royal Tombs*, 86–95; M. Andronikos, *Vergina*, vol. 2, *The Tomb of Persephone* (Athens 1994); Brecoulaki, *Peinture funéraire*, 77–100, pls. 11–25; Rouveret, *Histoire et imaginaire*, 235–44.

[227] M. Tsimbidou-Avloniti, Μακεδονικοί τάφοι στον Φοίνικα και στον Άγιο Αθανάσιο Θεσσαλονίκης· Συμβολή στη μελετή της εικονογραφίας των ταφικών μνημείων τη Μακεδονίας (Athens 2005); Tsimbidou-Avloniti, "Η ζωφόρος του νέου Μακεδονικού τάφου στον Αγιο Αθανάσιου Θεσσαλονίκης· Εικονογραφικά στοιχεία," *Archaia Makedonia* 6 (1999) 1247–59; Tsimbidou-Avloniti, "Revealing a Painted Macedonian Tomb," in *La pittura parietale in Macedonia e Magna Grecia, Atti del convegno internazionale di studi in ricordo di Mario Napoli, Salerno-Paestum, 1996*, ed. A. Pontrandolfo (Paestum 2002) 37–42; Brecoulaki, *Peinture funéraire*, 263–303, pls. 90–102; M. Tsimbidou-Avloniti, "The Macedonian Tomb at Aghios Athanasios, Thessaloniki," in *Alexander the Great: Treasures from an Epic Era of Hellenism*, ed. D. Pandermalis (New York 2004) 149–51.

[228] Overbeck, *Schriftquellen*, 310–70, nos. 1641–80; Pollitt, *Art of Greece*, 154–82; A. Reinach, *Recueil Milliet: Textes grecs et latins relatifs à l'histoire de la peinture ancienne* (Paris 1921; repr. Paris 1985) 184–393, nos. 193–520.

[229] Bergmann, *HSCP* 97 (1995) 79–120; J. F. Trimble, "Greek Myths, Gender, and Social Structure in a Roman House," in *The Ancient Art of Emulation: Studies in Artistic Originality and Tradition from the Present to Classical Antiquity*, ed. E. K. Gazda (Ann Arbor 2002) 225–48.

[230] The observations of Koch-Brinkmann, *Polychrome Bilder*, 83–84, on the end of the painting of white-ground lekythoi are particularly noteworthy in this regard.

[231] Metzger, *Représentations*, 379–82, stresses the relationship of subject matter of vases and monumental painting, in which composition is implicit but not explicit. Boardman, *ARFV-CP*, 167, notes some possible relationships without being explicit.

[232] M. Bentz, *Panathenaische Preisamphoren*, AntK-BH 18 (Basel 1998); P. Valavanis, Παναθηναϊκοί αμφορείς από την Ερέτρια· Συμβολή στην Αττική αγγειογραφία του 4ου π.Χ. αι. (Athens 1991).

except those connected with the Great Panathenaia, the celebration of Athena held every four years in Athens.[233] Like the record reliefs, some of these vases bear the name of the archon of the year of the event for which they were painted, and these names can usually be dated with precision, so the scenes on the vases can be used to gauge stylistic development (**Fig. 121**).[234] A second signal characteristic of these vases is that the pair of columns that flank Athena sometimes carry small figures that can on occasion be identified as reflections of contemporary or near contemporary sculptures (**Fig. 122**).[235] Consequently, some of the Panathenaic vases can serve as chronological benchmarks for monumental sculpture, even though the small figures on the columns are mere sketches.

All the preserved material evidence reflects an extraordinary blossoming of aesthetically impressive artifacts in the fourth century, and, although we may lack much of the original stone and bronze sculptures and monumental paintings, we must acknowledge from the outset that we are inundated with original material of very diverse types which defines a culture far more fully than in any earlier period of Greek history. This is also true of literature: the works of Plato, Aristotle, Xenophon, and Demosthenes fill twenty-five volumes of Oxford Classical Texts, while all the preserved texts from Homer through Euripides fill only nineteen volumes. This count is actually biased in favor of the earlier works, since many of the volumes of collected fragments have much that is late, and I have left out Aristophanes and Lysias, because they bridge the two periods, and Isokrates, because there is no Oxford Classical Text yet.

The vast number of monuments speaks to a prosperity of individuals that is unparalleled at any prior time anywhere. The late fifth and the fourth century are, after all, the period of the apogee of Athenian democracy. Despite the incessant wars and shifting dominance of various city-states throughout the fourth century, and the long struggle against Macedon, prosperity exudes from the number and quality of the monuments. Athens and Attica remain the focus of the archaeological record, but it appears from the texts that the prosperity was widespread in Greece. It should be noted that there is quite respectable Corinthian and even Boiotian red-figure pottery.[236] The center of monumental painting is shared by Athens and Sikyon, but painters and sculptors come from all over and work throughout Greece. Athens is perhaps particularly marked by the ostentation of a prosperous democracy, whereas other cities remained more conservative socially.[237]

A final characteristic of the fourth century is an extraordinary cosmopolitanism, discussed in the preceding chapter. So far, my comments have dealt almost exclusively with metropolitan Greece. Yet many of the original monuments of sculpture come from non-Greek Asia Minor and the royal cemetery at Sidon in the Levant (**Figs. 61, 62**).[238] These

[233] J. Neils, *Goddess and Polis: The Panathenaic Festival in Ancient Athens*, exh. cat. (Princeton 1992); *Worshipping Athena: Panathenaia and Parthenon*, ed. J. Neils (Madison, WI, 1996).

[234] Cambridge, MA, Harvard Art Museums 1925.30.124 (side A): Bentz, *Preisamphoren*, 176, no. 4.081, pls. 119, 120 (archonship of Theophrastos, 340/39 B.C.).

[235] Athens, NAM 14814: Bentz, *Preisamphoren*, 172, no. 4.052, pls. 112, 113; Valavanis, Παναθηναϊκοί αμφορείς, 30–34, no. 4, pls. 4, 20, 21; N. Eschbach, *Statuen auf panathenäischen Preisamphoren des 4. Jhs. v. Chr.* (Mainz 1986) 59, no. 38, ills. 36, 37 (on p. 62), pl. 16.1–2 (archonship of Kallimedes, 360/59 B.C.).

[236] S. Herbert, *Corinth*, vol. 7, pt. 4, *The Red-Figure Pottery* (Princeton 1977); I. McPhee, "Local Red-Figure from Corinth, 1973–1980," *Hesperia* 52 (1983) 137–53; I. McPhee and A. D. Trendall, "Six Corinthian Red-Figure Vases," in *Corinthiaca: Studies in Honor of Darrell A. Amyx*, ed. M. A. Del Chiaro and W. R. Biers (Columbia, MO, 1986) 160–67; I. McPhee, "A Corinthian Red-Figured Calyx-Krater and the Dombrena Painter," *OJA* 10 (1991) 325–34.

[237] Himmelmann, *Ideale Nacktheit*, 60, remarks on the fact that Attic grave reliefs almost never show deceased citizen soldiers nude, while in other areas of Greece the earlier tradition of ideal nudity continues.

[238] See chap. 1, p. 33 above.

prefigure the spread of Hellenic culture eastward in the aftermath of the conquests of Alexander the Great. At the same time, there is a reverse current of influences from the east to Greece that is evident in the forms of luxury items, particularly metalwork, cloth, and the related mosaics. Equally important is the number of foreign cults that thrive in metropolitan Greece in this period. These have left only minimal artistic traces, but the epigraphic evidence is clear and strong.[239] Perhaps for the first time since the end of the Bronze Age, there is a sense of communal culture, but now it is Greece that is the dominant partner rather than the Orient.

Many readers will notice that another area is absent from the above remarks: West Greece. From the seventh century on, West Greece, that is, Sicily and the southern boot of Italy, had a flourishing Greek population that closely paralleled the cultural developments of metropolitan Greece in architecture, sculpture, painting, and literature.[240] For reasons that are not quite clear, these monuments are rarely integrated into a unified treatment of Greek culture, whereas the parallel development of East Greece, that is, the west coast of Asia Minor, is more frequently than not considered an integral part of Greek culture.[241] It is not my intention here to argue the merits or demerits of this modern dilemma, but simply to note that in the following discussions West Greece will figure only rarely.

[239] See chap. 1, pp. 15–16 above.

[240] E. Lippolis, *I greci in Occidente: Arte e artigianato in Magna Grecia,* exh. cat. (Naples 1996); G. Pugliese Carratelli, ed., *The Western Greeks* ([Milan] 1996); L. Cerchial, L. Janelli, and F. Longo, *The Greek Cities of Magna Graecia and Sicily* (Malibu, CA, 2004).

[241] S. Hornblower, in *CAH*[2], vol. 6 (1994) 22, may give a part of the reason: the first Greek history to include the west was that of Timaeus (a Sicilian) in the late fourth and early third centuries.

3 The Evidence, Part 2

Copies

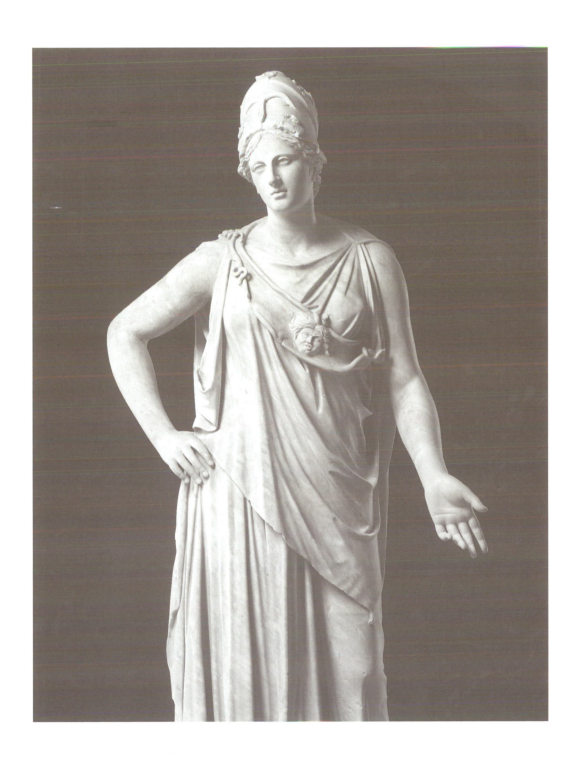

SCULPTURE

Since so many statues of the fourth century are preserved only in the form of Roman copies, some attempt must be made to evaluate these copies as reflections of the Greek originals. This also applies to painting, though the issue has never been advanced with equal passion as it has for sculpture, to which I turn first. The realization that the ancient statues collected assiduously from the Renaissance on were copies was rarely recognized explicitly or considered to be of importance until the early eighteenth century.[1] Casts in bronze and plaster were avidly collected by kings and by princes of the church and were deemed almost as prestigious possessions as the works from which they were cast. Indeed, the attitude toward the manufacture of casts and the production of drawings and engravings for dissemination was remarkably lax, allowing more or less important changes without concern.[2] Clearly the western European world was in the thrall of antiquity, and vast sums of money were paid for actual ancient statues, casts of them, and for forgeries more or less well disguised. No distinction was made between Greek and Roman works, even though the difference might have been assumed from the identification of the subjects, such as portraits of historical Romans versus works identified as the products of famous Greek sculptors. The evidence was simply ignored, and the textual tradition, well known since the commentary of Franciscus Junius, *De Pictura Veterum* (Amsterdam 1637), which he translated into English as *The Painting of the Ancients* (London 1638), and his compilation of ancient texts, *Catalogus Architectorum, Mechanicorum, sed Praecipue Pictorum, Statuariorum, Caelatorum, Tonatorum, Aliorumque Artificum, & Operum quae Fecerunt, Quorum Index Separatim Praemittitur, Secundem Seriem Litterarum Digestus, Nunquam antehac Editus* (Rotterdam 1694),[3] was used indiscriminately and selectively to enhance the importance and value of certain statues. Equally interesting for the present inquiry is that formal qualities were largely or completely ignored in published accounts of the ancient sculptures. To be sure, Junius addresses the issue of copies at the end of his commentary and in a disparaging vein, basing his remarks on such ancient authorities as Dionysios of Halikarnassos (*Dinarchos* 7), but he does not proceed to recognize that the ancient works that surrounded him

[1] F. Haskell and N. Penny, *Taste and the Antique: The Lure of Classical Sculpture, 1500–1900* (New Haven, CT, 1981); M. Koortbojian, "Pliny's Laocoön," in *Antiquity and Its Interpreters*, ed. A. Payne, A. Kuttner, and R. Smick (Cambridge 2000) 204–5, 206–7, notes that the existence of copies was recognized in Renaissance Italy, though little attention was paid to the issue.

[2] N. H. Ramage, "Restorer and Collector: Notes on Eighteenth-Century Recreations of Roman Statues," in Gazda, *Emulation*, 61–77. On the history of casts, see H. Lavagne and F. Queyrel, eds., *Les moulages de sculptures antiques et l'histoire de l'archéologie: Actes du colloque international, Paris, 24 Octobre 1997*, École Pratique des Hautes Études, IVe section, Sciences Historiques et Philologiques, III: Hautes Études du monde gréco-romain 29 (Geneva 2000).

[3] The English edition of *The Painting of the Ancients* of 1638 and the first (1694) edition of the *Catalogus* have been reedited by K. Aldrich, P. Fehl, and R. Fehl under the title *The Literature of Classical Art* (Berkeley 1991).

at Arundel House were copies.[4] However, just a little later, in 1722, Jonathan Richardson, father and son, published a terse account of the sculpture and paintings in many European collections in which the numerous copies of the Venus de Medici and the Hercules Farnese are noticed with no sense that the existence of multiple copies was unusual.[5] Nevertheless, the first real attempt to deal with the ancient sculptures themselves and to organize them into a historical framework did not occur until Johann Joachim Winckelmann published his *Geschichte der Kunst des Altertums* (Dresden 1764).[6] Yet the issue of the nature and status of the ancient sculptures in European and American collections was not systematically broached until the late nineteenth century, by Adolf Furtwängler.[7]

The issue is very simple: there exist multiple examples of a statue. Complexity begins with the fact that many ancient statues were found in more or less fragmentary condition, and restorations were carried out according to the taste of the time and the whim of sculptor or commissioner.[8] The early restoration of the mislaid proper right arm of Laokoön is an excellent example;[9] but total reworking of statues, as well as additions that greatly changed the figures, are not uncommon. Examples of this practice are the Artemis in Munich that became a Tyche (and is on exhibit with the old, incorrect restorations to demonstrate the practice)[10] and the Persephone in Vienna restored as a Muse.[11] The difficulty of detecting modern restorations can, on occasion, tax the most observant scholar, as Wilfred Geominy has demonstrated for the Florentine statues of Niobids.[12] The realization that a genuinely ancient, unrestored statue type may exist in examples with significant variations of stance and/or gesture is, at first, more perplexing. In certain cases the answer is simple: the Romans sometimes used statues in pairs and adjusted one example of a statue to serve as a symmetrical pendant to another.[13] In other cases, paired and even multiple examples of a single figure type are varied in style and compositional details with the probable intent of drawing attention to the aesthetic effect of such variations.[14] In the case of the Piraeus bronze statue of Athena (**Fig. 75**), which I consider to be an original, the adaptation in Paris, the so-called Mattei Athena (**Fig. 76**), varies in composition

[4] *The Painting of the Ancients*, III, 7.9–12: Aldrich, Fehl, and Fehl, *Literature of Classical Art* (note 3 above) vol. 1, 304–10.

[5] Jonathan Richardson Sr. and Jonathan Richardson Jr., *An Account of Some of the Statues, Bas-Reliefs, Drawings and Pictures in Italy, France, &c with Remarks* (London 1722; 2nd ed., 1754) 55–56, 66–67, 127, 128, 131–32, 166–67, 185; Haskel and Penny, *Taste and the Antique* (note 1 above) 60–61, 99–100.

[6] See Franciscus Junius, *The Literature of Classical Art*, vol. 1, *The Painting of the Ancients: De Pictura Veterum Libri Tres*, ed. K. Aldrich, P. Fehl, and R. Fehl (Berkeley 1991) vol. 1, lxxi–lxxx, for a succinct commentary on the fate of Junius's work after Winckelmann. E. K. Gazda, "Roman Sculpture and the Ethos of Emulation: Reconsidering Repetition," *HSCP* 97 (1995) 125–26 and note 11, notes that Winckelmann recognized that many statues he studied in Rome, such as the Sauroktonos, were Roman copies, but made nothing of his observations.

[7] Furtwängler, *Meisterwerke*; A. Furtwängler, "Über Statuenkopien im Altertum," *Abhandlungen der Königlichen Bayerischen Akademie der Wissenschaften, München, Philosophisch-historische Klasse* 20.3 (1896) 525–88.

[8] See, for example, the articles in J. Fejfer, T. Fischer-Hansen, and A. Rathje, eds., *The Rediscovery of Antiquity: The Role of the Artist*, Acta Hyperborea 10 (Copenhagen 2003): B. P. Venetucci, "Pirro Ligorio and the Rediscovery of Antiquity," 63–88; M. G. Picozzi, "Orfeo Boselli and the Interpretation of the Antique," 89–122; and S. Pieper, "The Artist's Contribution to the Rediscovery of the Caesar Iconography," 123–45.

[9] Haskel and Penny, *Taste and the Antique* (note 1 above) 246–47.

[10] Vierneisel-Schlörb, *Klassische Skulpturen*, 293–301, no. 28; Todisco, *Scultura greca*, no. 107.

[11] Lippold, *Griechische Plastik*, 290, pl. 86.3; *LIMC* VIII (1997), s.v. Persephone no. 10*; Todisco, *Scultura greca*, 290.

[12] W. Geominy, *Die florentiner Niobiden* (Bonn 1984) 160–64.

[13] C. C. Vermeule, *Greek Sculpture and Roman Taste: The Purpose and Setting of Graeco-Roman Art in Italy and the Greek Imperial East*, Jerome Lectures, 12th series (Ann Arbor 1977) 27–35.

[14] E. Bartman, "Decor et Duplicatio: Pendants in Roman Sculptural Display," *AJA* 92 (1988) 211–25; Bartman, "Sculptural Display and Collecting in the Private Realm," in *Roman Art in the Private Sphere: New Perspectives on the Architecture and Decor of the Domus, Villa, and Insula*, ed. E. K. Gazda (Ann Arbor 1991) 75, 80–82.

principally in the position of the proper left arm.[15] The reasons for this change are not self-evident, and numerous similar changes have led to the belief that the Romans did not demand an accurate copy but were primarily concerned with the expression of a specific content imbued with the cultural authority of Greek art that need not exclude moderate changes from the prototype or even a totally new creation in the Hellenic mode.[16] The Augustus of Prima Porta is a good example of a reflection of a Greek statue, the Doryphoros of Polykleitos, that was changed significantly to suit a Roman ideal in which the reflection of the Greek prototype is but a part.[17] Cicero's letters to Atticus, who served as his art dealer, are also good examples of this attitude, since he specifies a subject and not a style or artist as his primary concern in a purchase.[18] The very similar attitude of Renaissance to early modern collectors briefly alluded to above tends to confirm this interpretation of the ancient evidence.

Modern scholarship has built up a whole discipline of analyzing the preserved statues—principally of late Roman Republican and imperial date, though Late Hellenistic Greek works are also included—and categorizing them according to subtle standards as copies, adaptations, variants, or reflections of Greek originals.[19] The subtlety goes so far as to propose that a work may be a Roman copy of a Hellenistic adaptation of a classical Greek statue, as has been proposed for a Roman statue of Athena in Argos that reflects at some distance the Athena Parthenos by Pheidias.[20] Yet there is a large number of statues that may be considered accurate copies if only because multiple examples are very close to each other in details and particularly in size. For example, the type known as the Hera Borghese exists in multiple examples, all of approximately the same size, plus or minus 2 meters tall (**Fig. 123**).[21] Incidentally, the explicit eroticism of the statue strongly suggests that it represents Aphrodite, not Hera.

In addition to the fact that multiple copies of a single statue exist, there is the extraordinary evidence for the nature of Roman copying of Greek statues provided by the plaster casts of statues found at Baiae on the Bay of Naples in 1954.[22] Although extremely fragmentary, these plaster casts leave no room for doubt that they served as the means of producing multiple examples of a statue. Indeed, among the Baiae casts are identifiable

[15] Piraeus 4646; Paris, Louvre Ma 530: M. Fuchs, *In Hoc etiam Genere Graeciae Nihil Cedamus: Studien zur Romanisierung der späthellenistischen Kunst im 1. Jh. v. Chr.* (Mainz 1999) 12–14, pls. 1–3; discussed further below, pp. 75–76.

[16] See most recently essays in Gazda, *Emulation*: E. E. Perry, "Rhetoric, Literary Criticism, and the Roman Aesthetics of Artistic Imitation," 153–71; M. Koortbojian, "Forms of Attention: Four Notes on Replication and Variation," 173–204; L. J. Roccos, "The Citharode Apollo in Villa Contexts: A Roman Theme with Variations," 273–93.

[17] Gazda, *HSCP* 97 (1995) 140–41, fig. 6.

[18] M. Marvin, "Copying in Roman Sculpture: The Replica Series," in *Retaining the Original: Multiple Originals, Copies, and Reproductions*, Studies in the History of Art 20, ed. K. Preciado (Washington, DC, 1989) 29–33, 41–43.

[19] The bibliography is extensive; perhaps the most influential work after Furtwängler's original essays is G. Lippold, *Kopien und Umbildungen griechischer Statuen* (Munich 1923). The more recent wealth of studies begins with H. Lauter's *Zur Chronologie römischer Kopien nach Originalen des V. Jahrhundert* (Erlangen 1966) and runs up to the present, best represented by the conference organized by Elaine Gazda and published as *The Ancient Art of Emulation*, cited repeatedly in the preceding notes. Perhaps the most pessimistic evaluation of Roman sculptures as reflections of Greek originals is E. Langlotz's essay "Zur richtigen Wertung römischer Kopien," in the collection of his essays *Griechische Kunst in heutiger Sicht* (Frankfurt am Main 1973) 74–82. Furtwängler's thesis was strongly criticized right at the beginning by R. Kekulé in his review of *Meisterwerke* in *GGA*, 1895, 625–41.

[20] J. Marcadé and E. Raftopoulou, "Sculptures argiennes (II)," *BCH* 87 (1963) 57–60, fig. 22; *LIMC*, s.v. Athena no. 233* (P. Demargne).

[21] Landwehr, *Gipsabgüsse*, 88–94, no. 53, pls. 54, 55; A. Delivorrias, "Der statuarische Typus der sogenannten Hera Borghese," in *Polykletforschungen*, ed. H. Beck and P. C. Bol (Berlin 1993) 221–52. Landwehr (88–89, note 420) notes that the heights at the shoulder vary between 1.68 and 1.78 m.

[22] Landwehr, *Gipsabgüsse*.

fragments of twelve preserved Roman copies of Greek statues, including the head of Aristogeiton from the Tyrannicides group attributed to Kritios and Nesiotes that stood in the Agora of Athens, the Athena Velletri, the three Ephesian Amazon types, the Hera/Aphrodite Borghese, the Westmacott Ephebe, the so-called Narkissos, the Ploutos of the Eirene group by Kephisodotos, and one or two small fragments perhaps of the Apollo Belvedere, along with many other, unidentified, statue types.[23] Comparison of the plaster casts from Baiae with the preserved marble copies is enlightening:[24] the overall appearance of the marble statues is altered in favor of slightly heavier forms, which may be the result of translating bronze statues into marble. Though details may be accurate, they frequently vary, though not consistently. Finally, the Augustan copies tend to be more accurate than later imperial statues.[25]

Although the variations in detail between the Baiae plaster casts and the preserved Roman copies reveal that exact copies were generally not made in the Roman period, it is nonetheless clear that the preserved copies remain sufficiently faithful to the originals to allow immediate recognition, so it is probable that works attributed to the great Greek masters of the fifth and fourth centuries B.C. could be recognized, and this recognition was important. This is made clear by ancient literary criticism. Dionysios of Halikarnassos, who lived in Rome in the first century B.C., is an invaluable source because he lived in just the period when, and the place where, copies of Greek statues became highly popular. He discusses the idiosyncrasies of style on several occasions with a view to establishing criteria to judge whether a composition is by a particular author. Although his interest is specifically in the orators of the fourth century B.C., he occasionally throws in a reference to sculptors and painters. The most revealing commentary is the following (*Demosthenes* 50):

> Now I promised to show further how one can recognize the characteristics of Demosthenes' style of composition, and what indications one can use to distinguish it from those of other authors. There is in fact no single clear distinguishing mark which one should rely on to the exclusion of others, but the concentration and amplification which he brings to his examination of every subject and every person amount to a special characteristic of his style. To illustrate my point, I shall draw an obvious comparison from the human body. Every man has stature, color, shape, limbs, and a certain rhythm to his limbs and other qualities of this kind. Now if anyone expects to detect the general character of the whole from one of these, he will not obtain accurate knowledge; for he might find in many other physical forms another instance of what he took to be a token of the one form. But if he puts together all, or the majority, or the most important of the attributes of this form, he will quickly come to understand its nature completely, and not stop short in his examination of similarities. I should recommend all those who wish to understand the style of Demosthenes to do this: to form their judgment from several of its properties, that is to say the most important and significant of them. He should first consider its melody, of which the most reliable test is the instinctive feeling; but this requires much practice and prolonged instruction. Sculptors and painters without long experience in training the eye by studying the works of the old masters would not be able to identify them readily, and would

[23] Ibid., 187–88.

[24] Ibid., 184–86.

[25] P. Zanker, "Nachahmen als kulturelles Schicksal," in *Probleme der Kopie von der Antike bis zum 19. Jahrhundert: Vier Vorträge* (Munich 1992) 21; see also J. J. Pollitt, "The Impact of Greek Art on Rome," *TAPA* 108 (1978) 155–74; Gazda, *HSCP* 97 (1995) 129–38; Himmelmann, *Reading Greek Art*, 246.

not be able to say with confidence that this piece of sculpture is by Polykleitos, this by Pheidias, this by Alkamenes; and that this painting is by Polygnotos, this by Timanthes, and this by Parrhasios. So with literature: is anyone going to understand in detail the nature of melodious composition after learning a few rules of thumb and attending a brief intensive course? Impossible! This, then, is the first subject that I think they should study, learning about it and becoming familiar with it; and after it the right use of rhythm. (Trans. S. Usher, Loeb edition)

I doubt that there is today a more sophisticated analysis of how to evaluate a personal artistic style.[26] Consequently, we must accept that some Romans had a highly developed sense of earlier artistic styles and could recognize works by specific classical Greek sculptors and painters, just as the preserved copies and the Baiae casts would indicate. The value of modern scholarly criticism of the copy tradition is that it underscores the complexity of the Roman attitude to earlier Greek works, for clearly Greek statues were widely adapted, changed, and recomposed to suit new tastes, desires, needs, situations. These are not mutually exclusive attitudes, though not as neat as modern scholarship generally prefers. A rarely noticed fact is, however, that the Romans selected the Greek statues they chose to copy very narrowly; Elizabeth Bartman estimates that the number is not greater than one hundred, though very few of these are among the statues mentioned by Pliny as being in Rome.[27]

The primary issue for the present study is the ability to distinguish a true copy from a work with various shades of adaptation and reflection of a purported Greek original. The consequence of modern scholarly attention to this problem has been to demote many statues that were formerly considered true copies to the lower status of variant, reflection, etc.[28] The basic procedure is simple and logical: take a statue and examine whether it reflects in a coherent manner a stylistic phase of Greek art. As Dionysios of Halikarnassos stresses, no single element or characteristic can be decisive; the real test is to examine many elements and the total configuration. One relatively objective, if limited, criterion for determining that a statue is an adaptation or reflection is some confusion or mistake in rendering an element of dress, for example, which shows that the sculptor had no personal familiarity with the object and misunderstood the purported Greek prototype. This approach is advocated by Margarete Bieber, whose knowledge of ancient dress was second to none.[29] An equally straightforward criterion is the mixing of chronologically different styles in a single statue, that is, eclecticism, as expounded by Paul Zanker and Brunilde Ridgway.[30] This argument must be treated with some caution because we know, and shall discuss later, that there was a revival of archaic stylistic traits in Greek art at the end of the fifth century B.C. that continued through the whole fourth century and into the Hellenistic period. Apart from archaisms, however, the use of multiple styles in a single figure is not known in classical Greek art, and both Zanker and Ridgway point to the incongruent juxtaposition in a single figure of stylistic characteristics of different periods as

[26] See also *On Literary Composition* 21; *Dinarchos* 7; and E. Perry, *The Aesthetics of Emulation in the Visual Arts of Ancient Rome* (Cambridge 2005) 181–84.

[27] Bartman, "Sculptural Display" (note 14 above) 78. Pollitt, *TAPA* 108 (1978) 170–72, lists 71 statues or groups of original Greek sculpture in Rome, the dates of which range from the Archaic to the Late Hellenistic period, though the majority fall in the Early to Late Classical periods.

[28] For recent literature, see note 19 above.

[29] Bieber, *Ancient Copies.*

[30] Zanker, *Klassizistische Statuen;* Ridgway, *Fourth-Century Styles;* B. S. Ridgway, "*Paene ad Exemplum:* Polykleitos' Other Works," in *Polykleitos, the Doryphoros, and Tradition,* ed. W. G. Moon (Madison, WI, 1995) 177–99.

casting doubt on the authenticity of a statue as a true copy or even any sort of copy.[31] One of the clearest examples of this approach is the study by Raymond Wünsche of the bronze youth from Magdalensberg, which on occasion had been thought to be a Greek original or at least a Roman copy of a Greek original.[32] Wünsche demonstrates convincingly that the statue is a Roman eclectic creation of the Late Republican or Early Imperial period.

Other cases are far more difficult to judge, such as the statues of Amazons that have been connected with a passage in Pliny (*NH* 34.19.53) which relates that there was a contest between the great masters of the mid-fifth century to create a statue of an Amazon for the sanctuary of Artemis at Ephesos:

> The most celebrated [sculptors] have also come into competition with each other, although born at different periods, because they had made statues of Amazons; when these were dedicated in the Temple of Artemis of Ephesus, it was agreed that the best one should be selected by the vote of the artists themselves who were present; and it then became evident that the best was the one which all the artists judged to be the next best after their own: this is the Amazon by Polykleitos, while next to it came that of Pheidias, third Kresilas's, fourth Kydon's, and fifth Phradmon's. (Trans. H. Rackham, Loeb edition)

Since several statues of Amazons are preserved in Roman copies, attributing them to the sculptors Pliny names has been a major industry over the past century. At the same time, some scholars have doubted that there ever was such a contest, and the preserved statues, variously reckoned from three to six types, are sometimes given widely divergent dates.[33] Certainly the Roman literary tradition is full of anecdotes that are widely held to be spurious,[34] so there is no a priori reason to accept this one. Kurt Gschwantler notes, however, that the inscription of the Nike of Paionios in Olympia indicates that there had been a contest for the making of the acroteria of the Temple of Zeus.[35] Herodotos (8.123) relates that a solution similar to that in Pliny's account of the Ephesian contest was employed after the battle of Salamis in 480 B.C. for choosing the most valorous of those who fought there. This parallel can be interpreted either as meaning that this was not an unusual way for the contentious Greeks of the fifth century to determine the most worthy person in various situations or to mean that Pliny, or his source, borrowed the passage from Herodotos to give credence to a made-up contest among the sculptors. Of course, contests were an integral part of Greek poetic performance probably even before Hesiod's victory on Euboia in the seventh century (*Works and Days* 651–59) and continuing with archaic dithyrambic performances and, of course, Athenian drama.[36]

[31] Ridgway, however, has used the adjective "lingering" to designate the continued use of a style after it has ceased to be the uniform mode of expression, and a work may therefore show "lingering" traits of the archaic style together with elements of the new classical style: B. S. Ridgway, *The Severe Style in Greek Sculpture* (Princeton 1970) 93–105; Ridgway, *Fifth Century Styles*, 225–26.

[32] R. Wünsche, "Der Jüngling vom Magdalensberg: Studie zur römischen Idealplastik," in *Festschrift Luitpold Dussler: 28 Studien zur Archäologie und Kunstgeschichte*, ed. J. A. Schmoll, M. Restle, and H. Weiermann (Munich 1972) 45–80. See also the lengthy discussion by Himmelmann, *Ideale Nacktheit*, 90–95, of small bronze figurines of nude "strategoi" that are often taken to be accurate reflections of classical statues.

[33] The history of the issue and all the ancient sources are succinctly discussed by R. Bol, *Amazones Volneratae: Untersuchungen zu den Ephesischen Amazonenstatuen* (Mainz 1998) 5–19.

[34] V. L. Brüschweiler-Mooser, *Ausgewählte Künstleranekdoten: Eine Quellenuntersuchung* (Bern 1969) 142–50, discusses the anecdotal contest of Pheidias and Alkamenes with references to the Ephesian Amazons.

[35] Gschwantler, *Zeuxis und Parrhasios*, 129; on pages 130–31 he casts doubt on the Ephesian contest.

[36] A. Ford, *Homer: Poetry of the Past* (Ithaca, NY, 1992) 114–18; Ford, *The Origins of Criticism: Literary Culture and Poetic Theory in Classical Greece* (Princeton 2002) 272–93.

The most serious recent doubt about the contest at Ephesos has been voiced by Ridgway, who has argued that three of the Amazons commonly connected with Pliny's anecdote are late creations and another two are not contemporary.[37] Evelyn Harrison modified Ridgway's conclusions by adding to the list of different types the Amazon found in Herodes Atticus's villa near Loukou[38] and rejecting the Amazon in the Palazzo Doria Pamphilj.[39] She accepted that two statues were roughly contemporary and dated ca. 440 (Sosikles/Capitoline and Loukou types), with one of about 430–415 (Ephesos type), one of the late fifth century (Sciarra/Lansdowne type), and one of the early fourth century (Mattei type).[40] The most recent and comprehensive study of the Amazon statues, by Renate Bol, accepts only three types as genuine reflections of classical Greek originals: the Sciarra/Lansdowne, the Sosikles/Capitoline, and the Mattei. Bol considers the Doria Pamphilj statue a variant of the Sciarra/Lansdowne type,[41] the Loukou caryatid a variant of the Mattei type,[42] and the Ephesos Amazon an adaptation of the Sosikles/Capitoline type.[43] She accepts the probable reality of the contest and attributes her three types to Polykleitos, Pheidias, and Kresilas, and simply states that no examples of the statues of the other two contestants are known.[44]

The fact that fragments of three of the Amazon statues (Sciarra/Lansdowne, Sosikles/Capitoline, and Mattei types) were found among the Baiae casts strongly suggests that these types had good classical Greek prototypes.[45] In addition, three very fragmentary and battered figures generally thought to be Amazons were used at Ephesos itself as high reliefs decorating piers that are probably associated with the theater.[46] They were originally interpreted as somewhat free versions of the Sosikles/Capitoline and Sciarra/Lansdowne types, but Fritz Eichler, in the first publication of the battered figures, concluded that one represented a new type altogether, which became known as the Ephesos type.[47] Finally, this same figure has been reinterpreted by Kim J. Hartswick as a personification of the city of Ephesos; he thinks that the fragment thought to represent the Sciarra/Lansdowne type may be a figure of Dionysos.[48] Hartswick's arguments are not completely convincing, since the figures are at best free variants of the Amazon types, but he at least leaves one figure, Vienna, Kunsthistorisches Museum 1615, as an Amazon. Another Amazon, this time clearly a free version of the Sciarra/Lansdowne type, appears on a small relief from

[37] B. S. Ridgway, "The Five Ephesian Amazons," in *Proceedings of the Xth International Congress of Classical Archaeology* (Ankara 1973) vol. 2, 761–70; Ridgway, "A Story of Five Amazons," *AJA* 78 (1974) 1–17; Ridgway, *Fifth Century Styles*, 244–45.

[38] E. Harrison, "Two Pheidian Heads: Nike and Amazon," in *The Eye of Greece: Studies in the Art of Athens*, ed. D. Kurtz and B. Sparkes (Cambridge 1982) 65–70.

[39] See also Bol, *Amazones Volneratae*, 81, note 154.

[40] Ibid., 65–81.

[41] Ibid., 41, 47, 170, 180 (I.11).

[42] Ibid., 29–30, 63–64, 67–68, 69, 173, 211 (III.8), pls. 123–25, 138f. See also Perry, *Aesthetics of Emulation* (note 26 above) 99–108, figs. 21, 22.

[43] Bol, *Amazones Volneratae*, 57, 172, 194 (II.13), pls. 67b, 69, 103d.

[44] Ibid., 5, note 25. Harrison, "Two Pheidian Heads" (note 38 above) 81–85, argues at some length that the Amazon of Kresilas is not preserved in the Roman copies, based on her belief that he was older and his style incompatible with any of the preserved statues.

[45] Landwehr, *Gipsabgüsse*, nos. 29–33, 34–39, 40, 41; Bol, *Amazones Volneratae*, 173 (I.1), 187–88 (II.1), 206 (III.1), pls. 1, 70d, 70e, 106, 107.

[46] Vienna, KHM I 1615, I 1616 + BM 1239, I 1617: F. Eichler, "Eine neue Amazone und andere Skulpturen aus dem Theater von Ephesos," *ÖJh* 43 (1958) 7–13, figs. 1–4; Bol, *Amazones Volneratae*, 52, 182 (I.14), 193–94 (II.12, II.13), pls. 67–69, 103b–d.

[47] Vienna, KHM I 1616: Eichler, *ÖJh* 43 (1958) 8–12. This was accepted by Harrison, "Two Pheidian Heads" (note 38 above) 79–81.

[48] K. J. Hartswick, "The So-called Ephesos Amazon: A New Identification," *JdI* 101 (1986) 127–36.

Ephesos in Vienna,[49] which at least confirms that there was an interest in the types of the Roman statues in the purported location of the originals.

Some time ago, Martin Robertson made the cogent observation that, in light of the passage in Pliny, which indicates contemporaneity of the types, the stylistic differences between the three main types of Amazon statues are not sufficiently great to warrant greatly divergent dates within the High and Late Classical periods, as discussed above.[50] In the final analysis, Bol's solution to the thorny issue of the many Roman statues of Amazons is probably correct: there are three types which reflect classical prototypes that can be dated to around 430 B.C.,[51] with a number of free variant types created in the Roman period.

A similarly controversial set of statues is the type known as the oil-pourer. Adolf Furtwängler originally argued that there were three main types—Petworth, Munich, and Dresden—and that all three represented Greek originals of the fifth and fourth centuries.[52] Recently, Dorothea Arnold has followed Furtwängler in part but discerns five main types.[53] One of the best attested types is that in Munich (**Figs. 124, 125**), which is variously dated from the early fourth century to as late as the second half of the century.[54] There are at least three fragmentary copies of the type: a torso in Side,[55] a torso in Dresden (Herrmann 66),[56] and a fine, probably Late Hellenistic, fragment of the head in Boston,[57] to which two more torsos are added by Arnold.[58] A second, perhaps earlier, type[59] is represented by statues in the Palazzo Pitti in Florence (**Fig. 126**),[60] the Museo Nuovo Capitolino in Rome,[61] and the Museo Torlonia in Rome (no. 476).[62] Another Dresden statue (Herrmann

[49] Vienna, KHM I 811: Bol, *Amazones Vulneratae*, 181–82 (I.13), pls. 15b, 46b, 46c, 134c.

[50] M. Robertson, *Between Archaeology and Art History* (Oxford 1963) 20.

[51] For recent similar opinions, see T. Hölscher, "Die Amazonen von Ephesos: Ein Moment der Selbstbehauptung," in Ἀγαθὸς δαίμων: *Mythes et cultes; Études d'iconographie en l'honneur de Lilly Kahil*, BCH suppl. 38, ed. L. de Bellefonds and J. Balty (Athens 2000) 207–8; H. H. Wimmer, "Die Amazonen von Ephesos," *NumAntCl* 28 (1999) 147–50, 158.

[52] Furtwängler, *Meisterwerke*, 464–70 (= Furtwängler, *Masterpieces*, 257–62).

[53] Arnold, *Polykletnachfolge*, 146–48, 268, group H; 168–71, 271–73, group L.I–IV; plus the Petworth type that she ascribes to Polykleitos himself (168). She makes the more complete statue in Dresden (Herrmann 67) a minor variant of the Munich type: 272–73, L.III.

[54] Munich, Glyptothek 302: Vierneisel-Schlörb, *Klassische Skulpturen*, 304–8, no. 29, figs. 144–53; Todisco, *Scultura greca*, no. 63; Bol, *Bildhauerkunst*, 288–90, figs. 246a, 246b (W. Geominy). Vierneisel-Schlörb dates the statue type just before the middle of the fourth century (pp. 305–6). Arnold, *Polykletnachfolge*, 243, and A. F. Stewart, "Lysippan Studies 2: Agias and Oilpourer," *AJA* 82 (1978) 302–13, date the statue late in the century, in the circle of Lysippos.

[55] J. Inan, *Roman Sculpture in Side* (Ankara 1975) 72–74, no. 20, pls. XXXII, XXXIII.

[56] P. Herrmann, *Verzeichnis der antiken Originalbildwerke der Staatlichen Skulpturensammlung zu Dresden* (Berlin 1925) 24–25, no. 66; K. Knoll, C. Vorster, and M. Woelk, *Staatliche Kunstsammlungen Dresden, Skulpturensammlung: Katalog der antiken Bildwerke*, vol. 2, *Idealskulptur der römischen Kaiserzeit* (Munich 2011) 716–18*, no. 166 (J. Raeder).

[57] Boston, MFA 04.11: BrBr 557; Comstock and Vermeule, *Sculpture in Stone*, 100, no. 154*.

[58] Arnold, *Polykletnachfolge*, 272, L.II, nos. 5, 6. She includes a torso in the Palazzo Mattei in Rome, but it probably does not belong to the group, though it is difficult to tell because the torso has been given a head of Nero and restored proper right arm (now fallen off) and legs. However, the torso does pull the proper right shoulder back, as does the Munich statue but not the other types: EA 2068; F. Carinci, "Sculture di Palazzo Mattei: Le statue del cortile," *Studi miscellanei* 20 (1972) 38–39, no. 8, pls. XLVIII, XLIX; L. Guerrini, ed., *Palazzo Mattei di Giove: Le antichità* (Rome 1982) 115–17, no. 7, pl. XXXIII (F. Carinci).

[59] Furtwängler, *Meisterwerke*, 467–78 (= Furtwängler, *Masterpieces*, 259–60); Arnold, *Polykletnachfolge*, 168–71; Vierneisel-Schlörb, *Klassische Skulpturen*, 306.

[60] Palazzo Pitti 128 (Dütschke 22); EA 222–24; Lippold, *Griechische Plastik*, 218, pl. 78.1.

[61] Rome, Museo Nuovo Capitolino 1861: D. Mustilli, *Il Museo Mussolini* (Rome 1939) 132, sala VIII/IX, no. 2, pl. 82.308; A. Linfert, "Die Schule des Polyklets," in H. Beck, P. C. Bol, and M. Bückling, eds., *Polyklet: Der Bildhauer der griechischen Klassik; Ausstellung im Liebieghaus, Museum alter Plastik, Frankfurt am Main*, exh. cat. (Mainz 1990) 278–80, fig. 158; Todisco, *Scultura greca*, no. 49.

[62] C. L. Visconti, *Les monuments de sculpture antique du Musée Torlonia* (Rome 1894) 358–60, no. 476, pl. 122.

67) probably also belongs to this type.[63] The most important difference is that the statues of the latter type are broad of build and stand four-square, while the Munich statue is slim and pulls his right shoulder back as he raises his right arm to pour the presumed oil into his left hand. This causes the torso to tilt slightly to the figure's proper left side. In the case of the Petworth statue, considered by Furtwängler and Arnold to be a copy of an early work by Polykleitos,[64] Paul Zanker and Barbara Vierneisel-Schlörb are surely right that it is a late creation based on the popular classical motif.[65] Although Zanker dates the creation of the new figure to the second century A.D., the Gnaios gem in Baltimore[66] and at least one Myrina terracotta figurine[67] indicate that a date in the first century B.C. is more plausible. I would, along with others, assign the various other versions in the Vatican, Museo Torlonia, and elsewhere to the Roman period.[68] These statues are accordingly late creations in the manner of some earlier Greek statue or merely in a Greek style and based on no particular original at all.[69]

Within the realm of the true copy there are variations in the carving that are easily noticeable on close inspection. When a statue type exists in numerous examples, the study of these variations can be classified: first, there is very simply the quality of the copyist;[70] second, there is the period in which the copy was made.[71] The decision to prefer one rendering over another is mostly subjective, but there are a few cases in which the existence of both the original and copies of it give some guidance. This analysis was done long ago for the caryatids of the Erechtheion by Hans Lauter and Erika Schmidt[72] and for

[63] Dresden, SKD Herrmann 67; *EA* 133; J. Dörig, "Ein Jugendwerk Lysipps," *AntP* 4 (1965) figs. 1, 2; Stewart, *AJA* 82 (1978) 301–13; figs. 2, 4, 6, 8; Beck, Bol, and Bückling, *Polyklet* (note 61 above) 619–20, no. 146*; K. Knoll et al., *Die Antiken im Albertinum: Staatliche Kunstsammlungen Dresden; Skulpturensammlung* (Mainz 1993) 23, no. 8*; Bol, *Bildhauerkunst*, 289, figs. 247a, 247b (W. Geominy); Knoll, Vorster, and Woelk, *Katalog Dresden*, 719–25*, no. 167 (J. Raeder). Stewart and Geominy consider the Dresden example to be the superior type; they correctly see it as a good bit earlier than the Munich type.

[64] Furtwängler, *Meisterwerke*, 464–66, fig. 77 (= Furtwängler, *Masterpieces*, 257–59, fig. 107); Arnold, *Polykletnachfolge*, 168.

[65] Zanker, *Klassizistische Statuen*, 40 (no. 39); Vierneisel-Schlörb, *Klassische Skulpturen*, 306.

[66] G. Platz-Horster, "Der 'Ölgießer' des Gnaios Granat in der Walters Art Gallery," *JWalt* 51 (1993) 11–21.

[67] S. Besques, *Catalogue raisonné des figurines et reliefs en terre-cuite grecs, étrusques et romains*, vol. 2, *Myrina: Musée du Louvre et collections des universités de France* (Paris 1963) 124, pl. 150e.

[68] To the Petworth statue I would add Arnold's group H: Vatican, Museo Pio-Clementino 164 (Lippold, *Griechische Plastik*, no. 598); Rome, Museo Torlonia 480; and her group L.IV (p. 273): Turin, Dütschke 82; Vatican, Braccio Nuovo 99, 103; Kassel, MHK Sk 9 (P. Gercke and N. Zimmermann-Elseify, *Antike Skulpturen und neuzeitliche Nachbildungen in Kassel: Bestandskatalog* [Mainz 2007] 170–72, no. 49*); Bonn, AKM B 56; and Copenhagen, National Museum of Denmark 179. So also generally Furtwängler, *Meisterwerke*, 468, note 1 (= Furtwängler, *Masterpieces*, 260 and note 3) (except for the Petworth statue); A. Greifenhagen, in *EA* 4233; and Vierneisel-Schlörb, *Klassische Skulpturen*, 306. Rausa, *Vincitore*, 122–25, 198–99, no. 12, claims that the statues have been wrongly restored and probably depict runners or jumpers.

[69] Wünsche, "Jüngling vom Magdalensberg" (note 32 above) 64–65, gives a good assessment of the Roman attitude to Greek prototypes; see also W. Trillmich, "Bemerkungen zur Erforschung der römischen Idealplastik," *JdI* 88 (1973) 248–82; M. Fuchs, *Glyptothek München, Katalog der Skulpturen*, vol. 6, *Römische Idealplastik* (Munich 1992).

[70] M. Bieber, *Die antiken Skulpturen und Bronzen des Königlichen Museum Fridericianum in Cassel* (Marburg 1915) 19, suggests that the three examples of the Dresden Artemis type in Kassel (pl. XXIa–c) came from a single sculptor's workshop excavated by Jenkins or Gavin Hamilton in the eighteenth century; on these statues see most recently Gercke and Zimmermann-Elseify, *Bestandskatalog Kassel*, 85–91, nos. 16–18*. Another statue of the type was sold by Hamilton to the British Museum (= cat. no. 1638); Bieber suggests further that each statue was done by a different sculptor in the workshop, since the details vary.

[71] Zanker, *Klassizistische Statuen*, XVI–XVII. Some of the criticisms of this approach by C. H. Hallett, "Kopienkritik and the Works of Polykleitos," in Moon, *Polykleitos, the Doryphoros, and Tradition* (note 30 above) 125–27, are valid, but hardly respond to the full force of the varied arguments used to date Roman statues. See also Hallett's review of the issues: "Emulation versus Replication: Redefining Roman Copying," *JRS* 18 (2005) 419–35.

[72] Lauter, *Chronologie römischer Kopien* (note 19 above) 8–36; H. Lauter, *AntP* 16 (1976); E. E. Schmidt, "Die Kopien der Erechtheionkoren," *AntP* 13 (1973). As Lauter, *Chronologie römischer Kopien*, 10–14, points out, the two

the Great Eleusinian Relief in Athens and New York by Lambert Schneider.[73] The copies of the caryatids in the Forum of Augustus in Rome share with the New York copy of the Great Eleusinian Relief very accurate duplication of measurements and fold patterns, to which they add a lively *interpretation* of the folds, both in terms of deeper cutting and an elaboration of the original patterns. There are, however, many adaptations and variants of the Erechtheion caryatids that cannot claim great fidelity to the originals.[74] The terracotta fragments of a copy of the Eleusis relief in Rome are not only 15 percent smaller than the original, presumably due to the shrinkage of the clay, but they present a simplified and somewhat coarse reflection of it, insofar as the small fragments allow any judgment.[75]

A shoulder fragment of the seated Aphrodite-Olympias type was discovered by Angelos Delivorrias in the storerooms of the National Archaeological Museum in Athens.[76] The original fragment is precisely the same size as a copy in Verona long considered to be the best example of the type. However, the carving of the drapery of the Verona copy, though precisely accurate in pattern, is shallower and almost lifeless in comparison to the original. As Delivorrias points out, only the side and back of the proper right shoulder of the original statue are preserved, so the remarkable contrast of the precision of pattern with the shallow carving of the copy may be a result of the common neglect of sides and backs of copies because of their frequent placement in niches or against walls, where the neglected parts would never be seen.[77]

A fragmentary statue now in the Acropolis Museum, but of unknown provenance in Athens, has a precise copy from Hadrian's Villa at Tivoli, now in the Vatican.[78] The figure is covered by a very unusual pattern in the form of a coarse net, probably a ritual garment indicating a priest. The original may be of the late fifth century. Unfortunately, the two fragments in Athens do not preserve enough of the figure to allow a general comparison of the style.

Although fragments of the statue of Nemesis at Rhamnous were known from the early excavations of the site by the Dilettanti in 1812–13, they were long overlooked and eventually lost, only to be rediscovered by Georgios Despinis in the 1960s.[79] After an exhaustive study of the numerous preserved fragments of the statue, Despinis recognized that the type was well known in Roman statues. However, he calculated that the original statue was 3.55 meters tall, while the "copies" measure only slightly under 2 meters, though without the head in the case of the two best examples, one in Copenhagen (**Fig. 127**)

copies from the Forum of Augustus and Hadrian's villa at Tivoli (Schmidt nos. 3 and 4) copy only caryatids C and D of the Erechtheion, probably because the copies were made from plaster casts brought to Rome for the purpose.

[73] L. Schneider, "Das grosse Eleusinische Relief und seine Kopien," *AntP* 12 (1973) 103–24.

[74] Schmidt, *AntP* 13 (1973) 7.

[75] Rome, MNR 4368, 4371, and 4372: Schneider, *AntP* 12 (1973) 117–18, pl. 40. Schneider considers the adaptation of the relief in New York (MMA 24.97.99) to be very probably modern (pp. 118–20, pl. 41).

[76] A. Delivorrias, "Das Original der sitzenden 'Aphrodite-Olympias,'" *AM* 93 (1978) 1–23. Ridgway, *Fifth Century Styles*, 235–37, rejects the classical date of the original in favor of it being a Roman creation.

[77] Delivorrias, *AM* 93 (1978) 4–5; see also Lauter's comments on the Augustan copies of the Erechtheion caryatids, *Chronologie römischer Kopien* (note 19 above) 14. P. C. Bol, *Großplastik aus Bronze in Olympia*, OlForsch 9 (Berlin 1978) 37, notes that a fragment (no. 144) of hair of a male figure that is similar to the hair of the Doryphoros is far more plastic than the copy.

[78] Athens, Acrop. 6889, 6890; Vatican, Museo Pio-Clementino 934: M. Flashar and A. Mantis, "Ein wiedergewonnenes attisches Original: Zum Typus Vatikan, Museo Pio Clementino Inv. 934," *AntP* 22 (1993) 75–87, pls. 24–27; B. Andreae, ed., *Bildkatalog der Skulpturen des Vatikanischen Museums*, vol. 2, *Museo Pio Clementino, Cortile Ottagono* (Berlin and New York 1998) pls. 11–15, with bibliography on pp. 5*–6*.

[79] G. I. Despinis, "Discovery of the Scattered Fragments and Recognition of the Type of Agorakritos' Statue of Nemesis," *AAA* 3 (1970) 407–13; Despinis, Συμβολή στη μελέτη του έργου του Αγορακρίτου (Athens 1971); Ridgway, *Roman Copies*, 74–75.

and the other in Athens (**Fig. 128**).[80] Indeed, his detailed analysis revealed that the "copies" differ in significant elements of the rendering of the drapery and somewhat in the stance.[81] Despinis judged the example in Copenhagen to be the more lively and better worked, the copy in Athens to be rigid and dry.[82] An interesting divergence of the copies from the original is the incision of a line in the carving of the fold furrows.[83] Given that the preserved statues are much reduced in size compared to the original, it is not surprising that they differ among themselves and can only be said to be reflections of the original. But they serve an important purpose, both in the evidence they provide for the general appearance and style of the original and in their variations from strictly precise rendition of the details of the original.

One of the few cases in which a statue mentioned in an ancient text has been found is the Apollo Patroos in the Athenian Agora: Pausanias (1.3.4) mentions the statue in his account of his tour of the Agora and says that it is by Euphranor (**Figs. 73, 74**).[84] Unfortunately, there is only one smaller, rather inaccurate copy in the Vatican,[85] though the type was used on roughly contemporary votive reliefs. The original statue is preserved only from the mid-torso down and is 2.54 meters high; the example of the type in the Vatican is preserved with its head and is only 1.93 meters high, so comparisons between the two can be of only the most general nature.[86] An important contrast between the Roman statue and the original is that the original has a particular type of openwork sandal that the Roman statue does not; that sandal type, however, reappears on another kitharoid Apollo, the Apollo Barberini in Munich.[87]

A fragment of the upper torso of a female figure draped in a thin chiton falling off the proper right breast and a mantle slung around her proper left shoulder comes from Daphni, just outside Athens, and is preserved in the National Archaeological Museum.[88] A careful study of the fragment by Delivorrias has shown that the figure does not conform closely to the types of leaning Aphrodites preserved in Roman copies and thus must represent a third or even fourth variant of the type, all made in a relatively short span of time, between ca. 430 and 410.[89]

In each case the comparison of original and copy reveals something slightly different. Exact copies were clearly made, but it is only in the age of machines that the word "exact" has taken on the meaning of precise in every respect. Even so, the modern conception of an exact copy is certainly misleading, since even the most precise machine will not

[80] Copenhagen, NCG 2086: Poulsen, *Catalogue*, no. 304a; Despinis, Συμβολή στη μελέτη (note 79 above) 28, no. 1, pls. 35–40. Athens, NAM 2949: Despinis, 28–29, no. 2, pls. 41, 42.2.

[81] Despinis, Συμβολή στη μελέτη (note 79 above) 33–36.

[82] Ibid., 35.

[83] Ibid., pls. 13.1, 13.2, 16.1, 33.1; cf. Harrison, "Two Pheidian Heads" (note 38 above) 73.

[84] Athens, Agora S 2154: H. A. Thompson, "The Apollo Patroos of Euphranor," *ArchEph* (1953–54 [1961]) III, 30–44, pls. I, II; Adam, *Technique*, 94–97, pls. 42, 43; Palagia, *Euphranor*; C. W. Hedrick, "The Temple and Cult of Apollo Patroos in Athens," *AJA* 92 (1988) 198–200; Flashar, *Apollon Kitharodos*, 50–60, figs. 37–39; Knell, *Athen im 4. Jahrhundert*, 89–91; Bol, *Bildhauerkunst*, 369, fig. 335 (C. Maderna).

[85] Vatican, Museo Chiaramonti, Sala a Croce Greca 229: Helbig⁴, vol. 1, no. 23 (W. Fuchs); Thompson, *ArchEph* (1953–54 [1961]) III, 33, figs. 3a, 3b; Palagia, *Euphranor*, 20, no. 8, fig. 19; Todisco, *Scultura greca*, no. 211. A miniature example of the type was also found at Delphi: Delphi 1876: Picard, *Delphes: Le musée*, 114, no. 1, fig. 70.

[86] A. H. Borbein, review of O. Palagia, *Euphranor*, in *Gnomon* 59 (1987) 47.

[87] Munich, Glyptothek 211: Palagia, *Euphranor*, 17, fig. 26; *LIMC*, s.v. Apollon no. 146*; Flashar, *Apollon Kitharodos*, 206–12, figs. 180, 181.

[88] Athens, NAM 1604: Kaltsas, *SNAMA*, 122, no. 224; A. Delivorrias, "Die Kultstatue der Aphrodite von Daphni," *AntP* 8 (1968) 19–31; Bol, *Bildhauerkunst*, figs. 122a, b.

[89] Delivorrias, *AntP* 8 (1968) 26–27, 30–31; Delivorrias, *LIMC*, vol. 2 (Zurich 1984) pp. 29–32, s.v. Aphrodite nos. 185–201.

reproduce the feeling of surfaces that have been worked by hand. Accordingly, the slight variations between the Eleusis and New York versions of the Great Eleusinian Relief or the Athenian and Roman versions of the Erechtheion caryatids are well within the tolerances of a meaningful use of the word "exact," whereas the Roman version of the Apollo Patroos is simply a reflection of the type. The Baiae casts provide, as discussed above, another useful insight into the issue of the meaning of exact copy: the variations between the casts and the preserved Roman marble statues are sufficiently great to exclude the description "exact," but the size and general features are on the whole close enough to justify the description "accurate."

A further enhancement of the study of copies has been the observation of the techniques evident in the manufacture of indubitable originals. A major new technique was the use of the running drill, introduced in the first half of the fourth century.[90] The idea is simple: instead of using the drill to bore holes perpendicularly into the surface of stone, the drill is held at an angle and run along the surface to create a narrow furrow. The advantage of this technique for creating long, narrow, and deep cuttings is obvious for deep fold furrows, the undercutting of drapery, or just the marking of a clear border between two surfaces. The old technique for making deep and narrow cuttings was to drill a series of holes perpendicular to the surface close to each other, then clear away the remaining stone between the holes with a chisel, and finally smooth the surface with abrasives.[91] Even in the best work the bottoms of such contiguous holes were rarely completely hidden for the obvious reason that no tool could actually be used efficiently in the tight space. An uncertain and early example of the use of the running drill is the so-called Aura Palatina in Rome, usually dated around 400 B.C. (**Fig. 43**).[92] Andrew Stewart has claimed that the statue represents a very early example of use of the running drill,[93] but autopsy suggests that the vertical, honeycombed method of cutting the deep channels was probably used: there are slight dimple-like depressions in the deep furrows of the drapery and where the drapery is parted over the proper right leg. Sheila Adam, however, points out that the running drill can leave similar marks.[94] The presence of clear traces of a rasp on the proper right thigh and elsewhere suggests that the surface may have been cleaned when the statue was brought to Rome.[95] The use of the running drill is securely attested slightly later on the pedimental sculpture of the Temple of Asklepios at Epidauros, early in the second quarter of the fourth century.[96] It is worth noting that the ancient masters, both Greek and Roman, were not always quite as fussy as many modern critics: on a fragment of the original Nemesis from Rhamnous the gap behind the lower hem of the chiton was drilled with parallel,

[90] Adam, *Technique*, 61–64; M. Pfanner, "Vom 'laufenden Bohrer' bis zum 'bohrlosen Stil': Überlegungen zur Bohrtechnik in der Antike," *AA*, 1988, 667–76.

[91] Adam, *Technique*, 42.

[92] See chap. 2, p. 31, note 45 above.

[93] A. F. Stewart, "Some Early Evidence for the Use of the Running Drill," *BSA* 70 (1975) 199–200, pl. 26a–c. G. Spyropoulos, *Drei Meisterwerke der griechischen Plastik aus der Villa des Herodes Atticus zu Eva/Loukou* (Frankfurt am Main 2001) notes drillwork on the Loukou twin of the "Aura," while pointing out that the furrows were cleaned up with a chisel. I have not seen the statue. Stewart (p. 200, pl. 27) also notes traces of the running drill on the "Aura" in Burlington House, London.

[94] Adam, *Technique*, 63 with fig. 8.

[95] E. B. Harrison, "Repair, Reuse, and Reworking of Ancient Greek Sculpture," in *Marble: Art Historical and Scientific Perspectives on Ancient Sculpture*, ed. M. True and J. Podany (Malibu, CA, 1990) 179. The twin of the "Aura" in Loukou, however, also shows very similar rough rasping: Spyropoulos, *Drei Meisterwerke* (note 93 above) 70, pl. 18.

[96] Stewart, *BSA* 70 (1975) 200; Yalouris, *AntP* 21 (1992) 14, notes the use of both drill and running drill, but in the descriptions of the individual statues only a drill is mentioned, presumably often a running drill. I have not been close enough to the sculptures to note such details.

perpendicular holes which were hardly cleaned up at all.[97] Adam argues that the date of the change to the running drill falls between 370 and 350;[98] Stewart would push the date back some thirty years. An original statue made before that point almost always reveals its originality by the so-called honeycombing method of drilling.

It is, however, important to point out that the evidence of drillwork is not as clear as is sometimes assumed.[99] A case in point is the statue of Athena in the Acropolis Museum, 1336 (**Fig. 129**). Renate Kabus-Jahn noted the sporadic presence of the slight depressions created by drills and accordingly pronounced the statue an original of the late fifth century.[100] My own inspection of the statue indeed revealed traces of the depressions of drill-work in the proper left armpit, around both feet, and a single example at the top of a deep fold furrow along the proper left leg. Both Maria Brouskari and Pavlina Karanastassis, however, date the statue much later, to the Late Hellenistic and the Roman imperial period, respectively.[101] Similar traces of depressions that appear similar to vertical drilling can be found on two of the assuredly Roman copies of the Artemis of the Dresden type in Kassel (Sk 16 and Sk 17), in the deep and narrow fold furrow on the proper right side.[102] The evidence is even clearer on the Hellenistic statue of a Nike in Basel (**Figs. 130, 131**).[103] Here the back edge of the long and deep furrow behind the figure's proper left leg shows a series of at least five parallel vertical drill marks. Below the lower hem of the garment and in the ends of the folds there are also numerous traces of the vertical use of a drill to undercut and hollow out. Also visible on many Roman statues is the round depression of a drill at the end of a narrow space, whether a fold furrow, the separation of the toes, or other narrow cutting. So the vertical use of a drill, either in close sequence in deep and narrow furrows or in the ends of folds, provides no evidence of date. However, comparison of the surface of Acropolis Museum 1336 with an indubitable original, for example, the "Sandal-binder" of the parapet of the Temple of Athena Nike on the Acropolis (**Fig. 160**),[104] reveals no appreciable difference. Also in favor of an early date for Acropolis 1336 is the slightly irregular shape of the tight fold loops at the belt, which in Roman copies tend to be evenly broad and blunt at the end, a shape derived from the facile use of the running drill. But I am not prepared to assert with any conviction that the statue is an original.

Another change in technique is even more difficult to evaluate: the treatment of the surface of stone sculptures. Archaic and classical Greek stone sculptures were painted, and traces of paint are occasionally preserved.[105] In the later fifth century and in the course of the fourth century, there is sporadic evidence of polishing, or at least fine smoothing, of

[97] Despinis, Συμβολή στη μελέτη (note 79 above) pls. 18, 19.1, 19.2. Adam, *Technique*, 63–64, agrees with earlier studies that the vertical drill was used for primary work long after the introduction of the running drill.

[98] Adam, *Technique*, 46, 61–66; she points out (p. 64) that no honeycombing appears anywhere on the so-called statue of Maussollos from Halikarnassos, or the Demeter of Knidos, or the grave stele Athens, NAM 870. Cf. R. E. Wycherley, "Pausanias and Praxiteles," in *Studies in Athenian Architecture, Sculpture, and Topography Presented to Homer A. Thompson*, Hesperia suppl. 20 (Princeton 1982) 187.

[99] Adam, *Technique*, 63.

[100] Kabus-Jahn, *AntP* 11 (1972) 93–94.

[101] Brouskari, *Acropolis Museum*, 21–22; P. Karanastassis, "Untersuchungen zur kaiserzeitlichen Plastik in Griechenland, II: Kopien, Varianten und Umbildungen nach Athena-Typen des 5. Jhs. v. Chr.," *AM* 102 (1987) 361–69, 422 (B.IV.1).

[102] Gercke and Zimmermann-Elseify, *Bestandskatalog Kassel*, 87–91, nos. 17, 18*; Bieber, *Ancient Copies*, figs. 338–43, but there are no details of the drapery.

[103] Basel, Antikensammlung BS 299: P. Blome, *Basel Museum of Ancient Art and Ludwig Collection* (Basel 1999) 99, fig. 136.

[104] Athens, Acrop. 973: Lullies and Hirmer, *Greek Sculpture*², pl. 191.

[105] P. Reuterswärd, *Studien zur Polychromie der Plastik*, vol. 2, *Griechenland und Rom* (Stockholm 1960); V. Brinkmann, *Die Polychromie der archaischen und frühklassischen Skulptur* (Munich 2003); Brinkmann and Wünsche, *Bunte*

the flesh parts of statues.[106] This finish is preserved on protected areas of the Helios and "Ilissos" figures of the Parthenon pediments[107] and on the so-called cat stele from Salamis or Aigina,[108] also of the fifth century. In works of the fourth century, it is visible in good light on the statues of the Daochos group in Delphi from the 330s[109] and on the exposed proper left foot of the Apollo Patroos in the Athenian Agora, which is distinctly more lustrous than the adjoining lightly rasped surfaces of his clothing (**Fig. 74**), though Homer Thompson is correctly at pains to say that this does not constitute lustrous polishing.[110] The distinction is not unusual on well-preserved grave stelai; one of the best examples is the Ilissos stele (**Fig. 132**).[111] Finally, a particularly fine and well-preserved example is a Hellenistic statuette in Dresden that preserves well the contrast of polished flesh and painted drapery.[112] This conveys the effect that was certainly sought in the fourth century. Since the preserved evidence indicates that even the flesh of statues was painted,[113] the fine smoothing and/or polishing of the flesh surfaces at first seems peculiar. However, it is probable that the effect was to be visible through the painting, and thus in certain cases the color applied to the skin surfaces may have been transparent, so that the smooth texture of the surface would still contrast with the rougher and, I presume, more opaque coloring of a garment. In at least one case, the Augustus of Prima Porta, analysis indicates that the skin was not colored at all but was covered with a transparent coat of casein, a protein found in milk, which may have given the marble a warmer tone.[114] In the case of bronze statues, it appears that the dull green-black oxidized patina so highly cherished today was not appreciated in antiquity. Some treatments of the surface provided a color that approximated the favored skin color of men, a reddish tan.[115] An Early Hellenistic inscription from Delos details the accounts for the treatment of statues that included application of wax, oil, and perfume.[116] So a statue really was an ἄγαλμα, a gleaming pleasure for the gods. The opaque, matt finish adopted for the reconstruction of painted sculptures in the Munich-Copenhagen-Rome exhibition is therefore a little misleading.[117]

Götter. Landwehr, *Gipsabgüsse*, 183, discusses painted marble statues and that casts of them were not made because the process damaged the surface and the valuable paint jobs.

[106] G. Despinis, "Neues zu einem alten Fund," *AM* 109 (1994) 186–87, discusses the polished surface of the head Athens, Acrop. 1352.

[107] D. E. L. Haynes, "A Question of Polish," in *Wandlungen: Studien zur antiken und neueren Kunst: Ernst Homann-Wedeking gewidmet* (Munich 1975) 131, pl. 28; O. Palagia, "Marble Carving Techniques," in *Greek Sculpture: Function, Materials, and Techniques in the Archaic and Classical Periods*, ed. O. Palagia (Cambridge 2006) 261. See also Boardman, *GS-CP*, 11, and C. M. Havelock, *The Aphrodite of Knidos and Her Successors: A Historical Review of the Female Nude in Greek Art* (Ann Arbor 1995) 15–16.

[108] Athens, NAM 715: Kaltsas, *SNAMA*, 148, no. 287; Clairmont, *CAT*, 1.550*; C. Blümel, *Griechische Bildhauerarbeit*, *JdI-EH* 11 (Berlin 1927) 40; A. Kreuzer, "Der Hermes von Olympia," *JdI* 58 (1943) 138.

[109] T. Dohrn, "Die Marmor-Standbilder des Daochos-Weihgeschenks in Delphi," *AntP* 8 (1968) 34 (Agias: "Oberfläche fein geglättet"), 37 (Aknonios), 38 (Daochos I), 41 (Sisyphos II: "Der Körper ist fein geglättet"); K. E. Evans, "The Daochos Monument" (Ph.D. diss., Princeton University, 1996) 8–9 (Aknonios), 13 (Agias), 27 (Daochos I), 32 (Sisyphos I), 52, 59; Adam, *Technique*, 78, 126.

[110] Thompson, *ArchEph* (1953–54 [1961]) III, 32; see also Palagia, *Euphranor*, 14.

[111] Athens, NAM 869: Kaltsas, *SNAMA*, 193, no. 382; Clairmont, *CAT*, 2.950*; Blümel, *Griechische Bildhauerarbeit* (note 108 above) 40; C. Blümel, *Der Hermes eines Praxiteles* (Baden-Baden 1948) 32.

[112] Dresden, SKD Herrmann 215 (ZV 966): H. Protzmann, *Griechische Skulpturen und Fragmente: Staatliche Kunstsammlungen Dresden, Skulpturensammlung* (Dresden 1989) 88–89, no. 39*; Knoll et al., *Antiken im Albertinum*, 37, no. 18* (color).

[113] Reuterswärd, *Polychromie der Plastik* (note 105 above) 67–74; Brinkmann, *Polychromie* (note 105 above) 43–45.

[114] P. Liverani, "Der Augustus von Prima Porta," in Brinkmann and Wünsche, *Bunte Götter*, 189, 190.

[115] Brinkmann and Wünsche, *Bunte Götter*, 142–43.

[116] T. Homolle, "Comptes et inventaires des temples Déliens en l'année 279," *BCH* 14 (1890) 497–500; Reuterswärd, *Polychromie der Plastik* (note 105 above) 70–74.

[117] See note 105 above.

The evidence for the polishing of stone sculpture remains, of course, ambiguous. But there is not a single provably Greek original marble statue of the Classical period that has a high polish. The only possible exception is the Hermes of Olympia (**Figs. 133, 134**). This statue has taken on a very important position in every discussion of Greek sculpture of the fourth century because Pausanias (5.17.3) saw it in precisely the place where it was found by the German excavators of Olympia in 1877, and Pausanias notes that it was by Praxiteles.[118] After listing a number of very old dedications in the Heraion, Pausanias states: "at a later time other dedications were made in the Heraion; the stone Hermes carrying the child Dionysos is a work of Praxiteles. . . ." (χρόνῳ δὲ ὕστερον καὶ ἄλλα ἀνέθεσαν ἐς τὸ Ἡραῖον· Ἑρμῆν λίθου, Διόνυσον δὲ φέρει νήπιον, τέχνη δέ ἐστι Πραξιτέλους. . . .). Although objections to the attribution to Praxiteles were raised immediately by Gustav Hirschfeld, then director of the excavations,[119] and by Otto Benndorf,[120] the attribution was widely accepted until 1927, when Carl Blümel published the first serious criticism of it based on his study of the techniques of Greek sculpture.[121] His arguments, briefly, are as follows: (1) The very unfinished state of the back of the tree stump and the chlamys lying on it contradicts normal classical Greek sculptural practice, which was to complete each stage of carving over the whole work, whereas this part of the statue group was left at an early stage of carving, while the rest of the statue was carried through two or three further steps.[122] (2) The horizontal strut between the left hip of Hermes and the tree stump is unknown in classical Greek sculpture and only appears in the later Hellenistic period.[123] (3) The coarse recutting of the upper back of the statue resembles similar Late Hellenistic work, and the tools employed are also only known late.[124] (4) The high degree of polish of the front of the statue is unknown until the later Hellenistic period. (5) The use of the rounded chisel on the tree stump is again known only late. (6) The modeling of the chlamys as a series of masses instead of lines is late. (7) The use of the drill in the hair is the same.[125] A further observation was made by William Bell Dinsmoor: the uninscribed base on which the Hermes stood in the Heraion is demonstrably of the later Hellenistic period.[126] Since it is extremely improbable that the Hermes was made to be set up in the temple, the base could have been made for the statue when it was moved there. Two of the statues from the Philippeion stood in the temple, as Pausanias (8.17.4) remarks, and the temple seems to have served as a treasury or museum in the second century A.D.[127]

Evaluating whether the statue of Hermes at Olympia is an original or a copy provides one of the best cases for an examination of the issues involved in such a deter-

[118] G. Treu, *Hermes mit dem Dionysosknaben: Ein Originalwerk des Praxiteles gefunden im Heraion zu Olympia* (Berlin 1878); Treu, *Olympia: Die Ergebnisse der von dem Deutschen Reich veranstalteten Ausgrabung*, vol. 3, *Die Bildwerke von Olympia in Stein und Thon* (Berlin 1897) 194–206, pls. 49–53; *LIMC*, s.v. Dionysos no. 675* (C. Gasparri), s.v. Hermes no. 394* (G. Siebert); Bol, *Bildhauerkunst*, 326–28, figs. 296a–d (C. Maderna); Todisco, *Scultura greca*, no. 129. The bibliography of the statue is so immense that it is impractical to list it here, but an excellent and sensitive review of the issues is given by Alain Pasquier, "L'Hermès d'Olympie," in *Olympie: Cycle de huit conférences organisé au Musée du Louvre par le Service culturel du 18 janvier au 15 mars 1999*, ed. A. Pasquier (Paris 2001) 241–71.

[119] Cited by Blümel, *Hermes*, 7–8.

[120] O. Benndorf, "Der Hermes des Praxiteles," *Kunstchronik* 13, no. 49 (1878) cols. 777–85.

[121] Blümel, *Griechische Bildhauerarbeit* (note 108 above) 37–48. His arguments are repeated and elaborated in *Hermes*, 11–46, which I cite alone below for simplicity's sake.

[122] Blümel, *Hermes*, 11–17.

[123] Ibid., 17–22.

[124] Ibid., 23–30.

[125] Ibid., 30–46.

[126] W. B. Dinsmoor, "Architectural Note," *AJA* 35 (1931) 296–97.

[127] K. W. Arafat, "Pausanias and the Temple of Hera at Olympia," *BSA* 90 (1995) 466–71.

mination. Two of Blümel's arguments for a late date for the Hermes have been refuted convincingly by Sheila Adam: the use and sequence of specific tools, such as the flat and rounded chisel, were known to Greek sculptors as early as the Archaic period.[128] Although these were important considerations for Blümel, their elimination does not directly affect his other arguments, and a new observation in support of a late date was added by Mary Wallace, who claimed that the shape of Hermes' sandal is known only later in the Hellenistic period,[129] an opinion supported more recently by Katherine D. Morrow.[130] A more subtle interpretation of the form of Hermes' sandal is offered by Michael Pfrommer, who puts forward convincing arguments that the sandal form need be no later than the early third century B.C.[131] This certainly weakens the evidence of the footwear. Blümel's other arguments have not been totally convincing to numerous eminent scholars, partly because there are so few original stone statues preserved from the fourth century with which the Hermes of Olympia can be compared. A brief review of some of the arguments is helpful.

Although it has been observed that Greek sculptors did not avoid struts where they were absolutely necessary,[132] horizontal struts related in any manner to that of the Hermes at Olympia remain unknown before the later Hellenistic period. This is the only observation not yet called into question by anyone. Of debatable consequence are the following issues. First, the unfinished back of the tree stump and chlamys is coarser than most other examples of the fourth century cited by Sheila Adam, though she does note that a grave relief of the late fourth century is coarsely worked in a similar manner.[133] The recutting of the back of the torso is another matter altogether. It is quite clear that the torso was completely finished front and back, head to foot; only then was the back of the torso recut. The surface of the cutting is deeper than the surrounding finished parts of the back. Treu, Blümel, and Adam believe that the sculptor who created the statue was responsible for the recutting.[134] Although this is certainly possible—the recutting could have taken place directly after the statue was finished in all other respects—there is equally no reason that it could not have taken place much later. Albert Kreuzer remarked on the fact, otherwise ignored or neglected, that there are five concave cuttings on the proper right buttock of the Hermes, right in the middle of the otherwise finished surface.[135] This is particularly peculiar for any sculptor—Praxiteles, copyist, or Hellenistic creator. It is also apparent that the recutting of the back of the torso as carried out would have entailed a complete recutting of the whole back of the statue. Since many scholars judge the craft of the statue to be consummate, it is difficult to attribute the recutting to the master creator. It is also clear that the recutting is certainly not the equivalent of the unfinished backs of other

[128] Adam, *Technique*, 8–39, especially 8 and 29. See also A. Corso, "The Hermes of Praxiteles," *NumAntCl* 25 (1996) 134–37, and D. Boschung and M. Pfanner, "Antike Bildhauertechnik: Vier Untersuchungen an Beispielen in der Münchner Glyptothek," *MüJb* 39 (1988) 9–10.

[129] M. Wallace, "Sutor supra Crepidam," *AJA* 44 (1940) 217–21.

[130] K. D. Morrow, *Greek Footwear and the Dating of Sculpture* (Madison, WI, 1985) 83–84.

[131] M. Pfrommer, "Leochares? Die hellenistischen Schuhe der Artemis Versailles," *IstMitt* 34 (1984) 176; see also Corso, *NumAntCl* 25 (1996) 142; Landwehr, *Gipsabgüsse*, 109, 144–45. Morrow, *Greek Footwear* (note 130 above) 113–14, rejected Landwehr's arguments, but this does not address the later observations of Pfrommer.

[132] Adam, *Technique*, 126–27; M. B. Hollinshead, "Extending the Reach of Marble: Struts in Greek and Roman Sculpture," in Gazda, *Emulation*, 122–26. Corso, *NumAntCl* 25 (1996) 138–39, disagrees without citing a convincing example to the contrary.

[133] Athens, NAM 2885: Adam, *Technique*, 126; Clairmont, *CAT*, 3.453*. Adam (pp. 15, 37) does, however, draw attention to the frequency of statues with unfinished backs in the fourth century.

[134] Treu, *Bildwerke von Olympia* (note 118 above) 203; Blümel, *Hermes*, 23–24; Adam, *Technique*, 126.

[135] Kreuzer, *JdI* 58 (1943) 137–38.

statues cited by Blümel, since those were quite simply never finished.[136] Brunilde Ridgway has drawn attention to a Late Hellenistic statue in the Elis museum as a plausible parallel for the Hermes of Olympia and confirmation of its late date.[137] That statue, however, has only a modest sheen, visible principally on the shoulders, and, though the back is roughly worked—with horizontal striations of a claw chisel mainly on the proper left buttock, half of the right, and extending down the thighs—the statue, like the examples cited by Blümel, is simply unfinished. However, the manner of the unfinished carving of the back of the statue in Elis and the examples cited by Blümel do resemble the back of the Hermes in Olympia, so it is reasonable to deduce that the recutting of the Hermes took place in the later Hellenistic period. This does not, however, imply a date when the statue itself was made.

Another difficult technical issue was raised by Blümel: the impressionistic treatment of the hair of the Hermes.[138] Adam remarks on the unusual use of the running drill in the hair,[139] a tool that was also used on the hair of the "Maussollos" from Halikarnassos (**Fig. 6**), but in a different manner.[140] The impressionistic, tufted hair of the Hermes is, however, not so very different from the hair of the bronze youth from Antikythera (**Figs. 69, 70**)[141] or the youth of the Ilissos stele (**Fig. 132**),[142] though it consists more of complex masses and has less linear detail. The hair therefore does not present a strong case for a date.

The same is true of the plastic rendering of the chlamys Hermes has laid over the tree trunk to his left. Blümel and others have cited the statue of "Germanicus" in the Louvre, a statue of the first century B.C., as the only known parallel.[143] Ironically, perhaps, this statue is, as Blümel states, a free copy of a fifth-century statue with an added portrait head. The usual manner of rendering drapery in Greek sculpture of the fifth and fourth centuries is to treat folds and furrows as linear patterns that articulate surfaces and model plastic shapes.[144] The chlamys of Hermes alters this practice by focusing on plastic masses with modulated surfaces that convey the heavy texture of the material. Fold lines and deep furrows are subservient to the modulated surfaces, as seen both from the front and from the viewer's right, where the drapery falls against the tree trunk. The proposition that this is unique or even unusual is strange because Rhys Carpenter many years ago pointed to the carved column drum from the fourth-century Temple of Artemis at Ephesos and

[136] Blümel, *Hermes*, 24–30.

[137] E. Andreou, "Ὁ Ἑρμῆς τῆς Ἔλιδος," *ArchDelt* 31.1 (1976 [1980]) 260–64, pls. 58, 59a, with French summary on p. 365; N. Yalouris, "Elis, die Wiege der Olympischen Spiele, im Lichte neuer Ausgrabungsergebnisse," in *Olympia 1875–2000: 125 Jahre deutsche Ausgrabungen; Internationales Symposion, Berlin 9.–11. November*, ed. H. Kyrieleis (Mainz 2002) 350, fig. 21 on p. 355. Ridgway, *Roman Copies*, 85, 93, note 30; Ridgway, *Fourth-Century Styles*, 261–62, 281–82, note 67.

[138] Blümel, *Hermes*, 36–37. Benndorf, *Kunstchronik* 13, no. 49 (1878) col. 784, was the first to raise objections based on the treatment of the hair; he considered it more Lysippan.

[139] Adam, *Technique*, 125.

[140] G. B. Waywell, *The Free-Standing Sculptures of the Mausoleum at Halicarnassus in the British Museum: A Catalogue* (London 1978) 97–98, no. 26, pl. 14. See also Corso, *NumAntCl* 25 (1996) 138.

[141] Athens, NAM X 13396: Kaltsas, *SNAMA*, 248–49, no. 518*; for discussion and bibliography, see chap. 4, p. 112 with note 85, and chap. 5A, pp. 191–92 below.

[142] Athens, NAM 869: Kaltsas, *SNAMA*, 193–94, no. 382*; N. Himmelmann-Wildschütz, *Studien zum Ilissos-Relief* (Munich 1956) fig. 19; Blümel, *Hermes*, fig. 21.

[143] Paris, Louvre 1207: K. de Kersauson, *Catalogue des portraits romains, Musée du Louvre*, vol. 1, *Portraits de la République et d'époque julio-claudienne* (Paris 1986) 46–47, no. 18* (Marcellus); Blümel, *Griechische Bildhauerarbeit* (note 108 above) 42–43, fig. 10; Blümel, *Hermes*, 37–42, fig. 28; H. Jucker, *Vom Verhältnis der Römer zur bildenden Kunst der Griechen* (Frankfurt am Main 1950) 13; Adam, *Technique*, 128, pl. 71a, 71b.

[144] R. Carpenter, *Greek Sculpture: A Critical Review* (Chicago 1960) 132.

noted exactly the same interests in the carving of the mantel of "Alkestis" (**Fig. 39**).[145] But there are a number of examples that span the second half of the fourth century. A small statue of a seated man wearing a heavy garment in the Ny Carlsberg Glyptotek was dated around 430–420 by Frederik Poulsen,[146] but Schuchhardt correctly saw that it must be much later, though he almost certainly placed the piece too far down, dating it in the Hellenistic period, contemporary with the Gauls and frieze of the Great Altar of Pergamon.[147] The same interest is clearly visible in the chlamys of Aknonios of the Daochos group at Delphi (**Fig. 16**)[148] and, somewhat less forcefully, in the drapery of the Artemis from Gabii in Paris (**Figs. 137, 138**)[149] and the Large and Small Herculaneum Women in their various manifestations.[150] The emphasis on plasticity in the drapery is closely allied to the treatment of the hair of the Hermes at Olympia and constitutes a harmonious stylistic character. But the plasticity of drapery and hair is in direct contrast with the lustrous, gleaming surface of the front side of Hermes' body. As already pointed out, this would be unique for an original statue of the fourth century; the high polish of marble sculpture appears to begin only in the first century B.C.

The very shiny polished surface of the Hermes of Olympia does have many parallels in Roman sculpture, but it is certainly not universal. Good examples are the ephebe of Westmacott type in Dresden[151] and the relief of a nymph with two satyrs recently discovered in the Insula Occidentalis at Herculaneum.[152] In the latter piece, even the garments of the nymph and one satyr are highly polished, though perhaps not quite as lustrous as the figures' flesh. Casual examination of many other Roman sculptures in European collections indicates that the high lustrous polish is the exception, not the rule. This may be because weathering has effectively removed it, though traces would then frequently remain in protected areas, but this does not often seem to be the case. However, the Westmacott Ephebe in Dresden is shiny on the front but not the back, while the Dresden youth[153] is shiny on the back but not the front, though on the latter statue the shine is more a light sheen. Another curiosity of the Hermes in Olympia is that the lustrous polish is only on the front of Hermes; his back, where the surface is preserved, has simply a bright sheen. The child Dionysos barely has this surface finish, the workmanship being much less precise and careful.

An equally unusual trait is the carving of the front of the tree trunk with roughly parallel concave furrows. The few trees that survive on statues of the fourth century are usually

[145] London, BM 1206: Rügler, *Columnae caelatae*, 151–55, pl. 13.2; Carpenter, *Greek Sculpture*, 176, pl. 33; Lullies and Hirmer, *Greek Sculpture*², pl. 223. See also V. Müller, "Some Notes on the Drapery of the Hermes," *AJA* 35 (1931) 291–95; and C. H. Morgan, "The Drapery of the Hermes of Praxiteles," *ArchEph* (1937) 63–68.

[146] Copenhagen, NCG 1185; Poulsen, *Catalogue*, no. 325; Moltesen, *Classical Period*, 54–55, no. 6*.

[147] W.-H. Schuchhardt, "Relief mit Pferd und Negerknaben im National-Museum in Athen, N.M. 4464," *AntP* 17 (1978) 89, note 40, fig. 20.

[148] Adam, *Technique*, pls. 44, 45; Dohrn, *AntP* 8 (1968) pl. 26; see also the statue in Chalkis, pl. 36.

[149] Paris, Louvre Ma 529: Rolley, *Sculpture grecque*, 262, fig. 265; Ridgway, *Fourth-Century Styles*, 329, pl. 77; Corso, *NumAntCl* 25 (1996) 137–38; Todisco, *Scultura greca*, no. 116; Boardman, *GS-LCP*, figs. 86.1, 86.2; Bol, *Bildhauerkunst*, 364–65, figs. 327a–h (C. Maderna).

[150] Bieber, *Ancient Copies*, 148–57, figs. 664–712.

[151] Dresden, SKD Herrmann 84: Knoll et al., *Antiken im Albertinum*, 21, no. 6*; Knoll, Vorster, and Woelk, *Katalog Dresden*, 694–98*, no. 161 (C. Vorster).

[152] Herculaneum, Antiquarium, magazine, Soprintendenza Archeologica di Pompei 79613: J. Mühlenbrock and D. Richter, eds., *Verschüttet vom Vesuv: Die letzten Stunden von Herculaneum* (Mainz 2005) 302, no. 8.13*.

[153] Dresden, SKD Herrmann 88 and 84: Knoll et al., *Antiken im Albertinum*, 18–19, 21, nos. 4 and 6 (the excellent color plates unfortunately show only the fronts of the statues); Bol, *Bildhauerkunst*, 243–48, fig. 180 (D. Kreikenbom); Knoll, Vorster, and Woelk, *Katalog Dresden*, 704–11*, no. 164 (C. Vorster), and 694–98*, no. 161 (C. Vorster).

smooth or, in the case of the tree support of Sisyphos I of the Daochos group at Delphi (**Fig. 17**), treated with a claw chisel, which is noticeable only at close range, though the surface contrasts with the smooth sheen of the leg next to the tree trunk.[154] However, it is open to question that the pattern of the trunk of the Olympia Hermes becomes common only in the later Hellenistic period, as some have claimed.[155] First, the pattern of the Late Hellenistic period is usually far more emphatic, as, for example, on the trunk of the Doryphoros from Pompeii in Naples.[156] On a fourth-century votive relief to Herakles in Venice the three trees, upper trunks, and branches are rendered in precisely the manner of the tree next to Hermes at Olympia (**Figs. 139, 140**).[157] I have not located any certainly late statue or relief with a tree rendered in a similar pattern.

An evaluation of all the evidence presented above gives at best ambiguous results. The number of questionable elements of the statue certainly suggests the possibility that Blümel's analysis was correct and that the Hermes at Olympia was carved in the first century B.C. or, less probably, in the early Empire. For me, the most critical factor is the horizontal strut between the hip of Hermes and the tree trunk. The very lustrous polish of only the front of the statue certainly must give one pause, but the curious rough recutting of the back of the torso and the chisel marks on the buttocks strongly suggest a reworking long after the statue was completed. In view of Dinsmoor's observation that the base on which the statue stood in the Heraion is Late Hellenistic and the fact that the statue cannot have been originally dedicated in the temple but was moved there at some time before Pausanias's day, the polishing and recutting more than likely occurred late in the life of the statue. The other principal issues raised against the originality of the statue are the manner in which the running drill is used in the hair and the form of the sandal, but neither has unambiguous value. There is, however, enough room for doubt to make a certain judgment impossible. I am, however, not willing to go as far as Ridgway, who rejected the statue as an original and identified it as a copy of a fourth-century statue possibly by Praxiteles.

While many scholars and artists, such as Aristide Maillol, have not reacted positively to the statue,[158] this appears to me more a matter of personal preference than a fair evaluation of its qualities. There is no reason to reject the general manner in which either the hair or the chlamys are rendered as being reliable fourth-century forms. The softly

[154] Blümel, *Hermes*, 42–44; F. Muthmann, *Statuenstützen und dekoratives Beiwerk an griechischen und römischen Bildwerken*, AbhHeid, Jarhg. 1950, no. 3 (Heidelberg 1951) 23, 33–34, no. 3; Adam, *Technique*, 126, pl. 47a, 47b.

[155] Morgan, *ArchEph* (1937) 62; Corso, *NumAntCl* 25 (1996) 136.

[156] D. Kreikenbom, *Bildwerke nach Polyklet: Kopienkritische Untersuchungen zu den männlichen statuarischen Typen nach polykletischen Vorbildern; 'Diskophoros,' Hermes, Doryphoros, Herakles, Diadumenos* (Berlin 1990) no. III.2, pls. 108, 109. It should be noted, however, that the Hellenistic and Roman examples of horizontally grooved tree trunks are both cut more deeply and are more regular than that of the Hermes in Olympia; the irregularity of the pattern adds a definite touch of naturalism which the comparable pieces do not share. In this respect the surface of the tree trunk corresponds well with the treatment of the hair and the chlamys.

[157] Venice, MAN 100: G. Traversari, *Sculture del V°–IV°secolo A.C. del Museo Archeologico di Venezia* (Venice 1973) no. 9; *LIMC*, s.v. Herakles no. 1375* (J. Boardman et al.); E. Tagalidou, *Weihreliefs an Herakles aus klassischer Zeit*, SIMA-PB 99 (Jonsered 1993) 239–42, cat. no. 39, pl. 16; Favaretto et al., *Museo Archeologico Nazionale di Venezia*, 74, no. III.2*; P. C. Bol, "Zum Heros des Weihreliefs in Venedig," *AA*, 1971, 194–98. A. Linfert, "Zu zwei Reliefs: Herakles und Kybele," *AA*, 1966, 496–501, noticed that the background of the top third of the relief above the bull, including the trees and the columns, had been recut in the Renaissance. He points out further that the bottom of the tree trunk below the bull's head is smooth, as is common for trees in the fourth century. I find it difficult to believe that the modulated surface of the upper parts of the trees was a gratuitous addition of the Renaissance and not part of the original, recut along the original pattern to suit the new depth of the background. The treatment is not easily visible in any of the published photographs but is absolutely clear in the museum.

[158] Conveniently collected by Blümel, *Hermes*, 59–62.

modulated body of Hermes and his pose are both sufficiently well represented in statues widely believed to be copies of fourth-century works, such as the Apollo Sauroktonos (**Fig. 181**) or even the Marathon boy (**Fig. 65**), though the pose does raise questions that will be discussed later.[159] The most cautious position is that the statue is an excellent copy of a fourth-century work that was carried off, whether to Rome or elsewhere.[160] The fact that Pausanias does not mention this can hardly be considered proof that it is not possible.[161] Equally, the fact that the statue does not figure in any account by Pliny or other late commentators carries no weight, since this is true of many statues. Why there are no copies of the statue in the Roman tradition is more perplexing.[162] Even if one accepts that the statue is a Late Hellenistic creation, it is a work of extraordinary quality that must have had admirers. This is perhaps the best argument that it is indeed a Late Hellenistic creation that was protected from copying by its location in the sanctuary at Olympia.[163] It is, however, difficult or impossible to find another statue of the period, whether copy or original creation, that matches the technical skill of the Hermes. Indeed, the composition and iconography of the Hermes and Dionysos at Olympia, as I shall discuss in a later chapter, are generally at home in the second half of the fourth century, and for this reason I accept the statue as a brilliant copy of the Late Hellenistic period.[164] My principal reason for this, however, is the strut. Further speculation by me is fruitless.

Another controversial statue is the bronze Athena found in the Piraeus (**Figs. 75, 77**). Although widely believed to be an original statue of the fourth century B.C., the date and originality of the statue, discovered in 1959 and still not adequately published, have, like the Hermes and Dionysos of Olympia, gradually come into question.[165] There is a generally accurate copy of the statue in the Louvre, known as the Mattei Athena after the Italian

[159] Ridgway, *Fourth-Century Styles*, 265–66, 343–44, does reject both of these as probably Late Hellenistic or Roman.

[160] Blümel, *Bildhauerarbeit*, 47; but he later changed his mind and considered the statue a Late Hellenistic creation: *Hermes*, 54–58, following Morgan, *ArchEph* (1937) 61–68.

[161] Wycherley, "Pausanias and Praxiteles" (note 98 above) 182–91, defends Pausanias and assembles the amusing conflicts of opinions about the Hermes.

[162] Corso, *NumAntCl* 25 (1996) 132–34, figs. 3, 4, 7, 8, 15, does mention the various statuettes and even a painting that resemble the Hermes and Dionysos, but most interesting is the fragment of a tree trunk with an end of drapery in Verona, Museo Archeologico al Teatro Romano, which is similar to the Olympia statue and is inscribed Πραξιτέλης ἐπόει: ibid., 144–45, figs. 20, 21; A. Corso, "Praxiteles and the Parian Marble," in *Paria Lithos: Parian Quarries, Marble and Workshops of Sculpture: Proceedings of the First International Conference on the Archaeology of Paros and the Cyclades, Paros, 2–5 October 1997*, ed. D. U. Schilardi (Paroikia 2000) 234, figs. 18, 19. M. Donderer, "Nicht Praxiteles, sondern Pasiteles: Eine signierte Statuenstütze in Verona," *ZPE* 73 (1988) 63–68, has argued unconvincingly that the name is Pasiteles. Unfortunately, the tree trunk and bit of drapery do not appear to be close enough to any preserved statue type to lead further.

[163] See pp. 77–78 below on restrictions on copying works in Greek sanctuaries.

[164] Also the opinion of Rolley, *Sculpture grecque*, 250–54. Benndorf, *Kunstchronik* 13, no. 49 (1878) col. 784, and Stewart, *Greek Sculpture*, 177, consider the statue an Early Hellenistic original by an imitator of Praxiteles, perhaps one of his sons or grandsons. The most recent voice in favor of it being an original is Maderna, in Bol, *Bildhauerkunst*, 326.

[165] Piraeus 4646: Steinhauer, Μουσειό Πειραιώς, figs. 300–14; K. Schefold, "Die Athena des Piräus," *AntK* 14 (1971) 37–42, 133; O. Palagia, "Εὐφράνορος τέχνη," *AAA* 6 (1973) 323–29; A. Steinberg, "Joining Methods on Large Bronze Statues: Some Experiments in Ancient Technology," in *Application of Science in Examination of Works of Art: Proceedings of the Seminar, June 15–19, 1970, Conducted by the Research Laboratory, Museum of Fine Arts, Boston, Mass.*, ed. W. J. Young (Boston 1973) 106–14; Palagia, *Euphranor*, 21–23, figs. 32, 33; *LIMC*, s.v. Athena no. 254* (P. Demargne); C. Houser and D. Finn, *Greek Monumental Bronze Sculpture* (New York 1983) 58–61*; Houser, *Bronze Sculpture*, 212–35, no. 13, figs. 13.1–7, 13.12; Stewart, *Greek Sculpture*, 179, fig. 511; Todisco, *Scultura greca*, no. 214; Ridgway, *Fourth-Century Styles*, 322–24, pls. 74a–c; Rolley, *Sculpture grecque*, 286–88, fig. 293; Fuchs, *In Hoc etiam Genere* (note 15 above) 11–14, pls. 1–3.2, 4; J. M. Daehner and K. Lapatin, eds., *Power and Pathos: Bronze Sculpture of the Hellenistic World*, exh. cat. (Los Angeles 2015) 29, fig. 1.9. On the discovery, see E. Vanderpool, "Newsletter from Greece," *AJA* 64 (1960) 265–66, pls. 65, 68, 69; A. A. Papagiannopoulou-Palaiou, "Πειραϊκὴ Ἀρχαιολογία," *Polemon* 7 (1958/59) 26–64.

collection in which it long resided (**Figs. 76, 79**).[166] The accuracy of the folds of the cloth is remarkable, though the depth of carving is shallower in some places, for example, on the large triangular fold end of the overfold at the back on the viewer's right (**Figs. 78, 79**). On the other hand, even the folds deep in the furrow of cloth over Athena's proper right foot are accurately replicated. The left forearm and hand of the Mattei Athena are modern restorations;[167] the position of the ancient arm is the same as that of the Piraeus Athena. The Mattei Athena appears to lean forward slightly, while the Piraeus bronze stands more vertically; her neck also angles forward more. The main difference, however, is the position of the proper right arm: the Piraeus Athena extends her right arm forward and held something in her hand; the Mattei Athena rests her right hand on her hip, with her arm held akimbo. There is also an iconographic difference: the Piraeus Athena has a pair of owls flanking the nosepiece of her Corinthian helmet, while the Mattei Athena has the more traditional pair of ram's heads. A variant head, the Stroganoff head in Basel,[168] is the same size as the Piraeus and Mattei heads and has the traditional pair of ram's heads on the helmet, which Michaela Fuchs thinks makes the Piraeus example a variant.[169] The shift of iconography on the helmet and the inclusion of some object held in the outstretched proper right hand of the Piraeus Athena further suggest an agglomeration of iconographic elements that appears more common in the later Hellenistic period.[170]

None of the above observations approaches convincing proof that the Piraeus Athena is a Late Hellenistic variant of a hypothetical Mattei type original. In general form and in the details of her drapery she is obviously a type from the middle of the fourth century; it is perfectly possible that she is a fourth-century original, even if one can argue that the Mattei Athena also reflects in detail a fourth-century original, since all the sculptor had to do was change one arm and the devices on the front of the helmet, while using the same molds for everything else.[171] Scientific analysis is still either not fully completed or not published: a primary issue is whether there is any evidence of lead around the feet, which might be expected had the statue been set up and affixed to a pedestal and then removed to be shipped elsewhere.[172] It is worth pointing out, though, that there is a lump of lead in Athena's proper left hand which must have served to fix the spear and shield that she held at her side,[173] and this seems somewhat anachronistic if the statue was a new creation made for export. My conclusion is that the Piraeus Athena is an original of the fourth century B.C.

In her provocative book on Roman copies, Brunilde Ridgway has expressed strong doubt that there are many Roman statues that are true copies of Greek originals. She bases this view on the undeniable fact that there are very few certainly identifiable Roman copies of statues that are mentioned in the ancient texts. For example, despite the many Greek statues of the fifth and fourth centuries B.C. that are mentioned in the texts as

[166] Paris, Louvre Ma 530: Palagia, *Euphranor*, 22, figs. 36–40; Fuchs, *In Hoc etiam Genere* (note 15 above) 12–14, pls. 3.3, 3.4, 4.1, 5; *LIMC*, s.v. Athena no. 255* (P. Demargne); Todisco, *Scultura greca*, no. 215.

[167] W. Fröhner, *Notice de la sculpture antique du Musée nationale du Louvre* (Paris 1884) 150–51, no. 121.

[168] Basel, Antikensammlung: M. Guggisberg, "Athena 'Stroganoff,'" in *Antike Kunstwerke aus der Sammlung Ludwig in Basel*, ed. E. Berger, vol. 3 (Mainz 1990) 177–82, no. 232*.

[169] Fuchs, *In Hoc etiam Genere* (note 15 above) 13.

[170] Ibid., 13–14. The lack of specific attributes in the Classical period and the inclusion of them in the later Hellenistic period is a broadly recognized phenomenon: Stucky, *Tribune d'Echmoun*, 29.

[171] There exists the possibility that the Piraeus statue is a recasting of a statue; the theoretical position is that a cast could be made of an original from which a new, precise, bronze copy could be made. However, the evidence for such recastings is dubious to nonexistent: Landwehr, *Gipsabgüsse*, 185–86 and note 708.

[172] Houser, *Bronze Sculpture*, 215, says there is, while Fuchs, *In Hoc etiam Genere* (note 15 above) 11, says there is not.

[173] Houser and Finn, *Monumental Bronze Sculpture* (note 165 above) 58; Houser, *Bronze Sculpture*, 213.

being in the city of Rome, securely identifiable copies of them are very few or possibly nonexistent.[174] If we expand the search to encompass certainly identifiable copies of statues mentioned in Pliny alone, wherever they may have been located (often unknown), the number is small: Harmodios and Aristogeiton by Kritios and Nesiotes in the Athenian Agora (*NH* 34.70), the Diskobolos of Myron (34.57), the Diadoumenos and Doryphoros by Polykleitos (34.55), the Amazons of Ephesos (34.53), the Nemesis of Rhamnous by Agorakritos (36.17), the Knidian Aphrodite (36.20–21) and the Apollo Sauroktonos (34.70) by Praxiteles, perhaps the Apoxyomenos by Lysippos (34.62), and perhaps the dying Niobids (36.28). As Ridgway points out, the situation is rather better for Hellenistic statues, which the Romans also admired greatly. Of course, many scholars would expand this list to include works that are possibly correctly identified as copies of statues mentioned by Pliny, but my list is confined to just those that are agreed on by many.[175]

If we turn to statues known to have remained in Greece, the evidence of copying is ambiguous. Ridgway, extending the observations of Georg Lippold[176] and several other scholars,[177] asserts that "no classical statue from Delphi and Olympia, or from other major Greek sanctuaries, was ever mechanically duplicated."[178] Her arguments are difficult to judge. From the foregoing discussion it is clear that the existence of "exact" copies of any kind and from any source cannot be proved and appears quite unlikely. Equally problematic, as we shall see below, is the fact that it is rarely possible to prove beyond a shadow of a doubt that a Roman copy is a specific statue known from texts, in this case principally Pausanias, because the texts generally lack sufficient detail. Yet the evidence of the accurate, but not exact, copies of preserved originals is indisputable. These originals come from the Acropolis and Agora of Athens and the Temple of Nemesis at Rhamnous. There is the additional evidence of the votive reliefs: several reliefs of the fourth century B.C., notably one from Eleusis (**Fig. 141**)[179] and one other found in Italy,[180] portray a figure of Persephone that agrees in detail with a Roman statue now in the Uffizi

[174] Ridgway, *Roman Copies*, 23–24. G. Daltrop, *Il gruppo mironiano di Athena e Marsia nei Musei Vaticani* (Vatican City 1980) 14–15, points out that P. Visconti, "Relazione delli ritrovamenti di antiche cose seguiti in Roma, e ne' suoi dintorni dal principio dell'anno 1823, letta nell'Accademia di Archeologia nell'adunanza del 3 Luglio nel medesimo anno," *Dissertazioni della Pontifica Accademia romana di archeologia* 2 (1825) 643–53, relates that Ignazio Vescovali apparently found a sculptor's workshop of the second century A.D. on the Esquiline in Rome, in which the Lateran Marsyas, among other statues, was found. One can easily imagine that such a workshop might produce copies of original statues that stood in Rome, but no such evidence is forthcoming. For a list of original statues in Rome mentioned by Pliny, see Pollitt, *TAPA* 108 (1978) 170–72.

[175] Cf. Ridgway, *Roman Copies*, 23.

[176] Lippold, *Kopien und Umbildungen* (note 19 above) 68–70.

[177] F. Eckstein, Αναθηματα: *Studien zu den Weihgeschenken strengen Stils im Heiligtum von Olympia* (Berlin 1969) 112, note 31; U. Kron, *Die zehn attischen Phylenheroen*, AM-BH 5 (Berlin 1976) 222, 223; Bol, *Großplastik aus Bronze* (note 77 above) 37; A. Linfert, *BJb* 181 (1981) 611–12.

[178] Ridgway, *Roman Copies*, 23; Ridgway, "*Paene ad Exemplum*" (note 30 above) 178. Cf. H.-V. Herrmann, "Die Siegerstatuen von Olympia," *Nikephoros* 1 (1988) 131 and notes 66, 67. Harrison, "Two Pheidian Heads" (note 38 above) 60–61, agrees with the assertion that there was no access to the sanctuaries of Olympia and Delphi for making copies, but that was not true for Athens. Vierneisel-Schlörb, *Klassische Skulpturen*, 4, alone questions the whole premise.

[179] Eleusis 5069 (11): Baumer, *Vorbilder*, 139–40, cat. R 40, pl. 33.6; G. E. Rizzo, *Prassitele* (Milan and Rome 1932) 101, pl. 152; Picard, *Manuel*, vol. 4.1, 380, fig. 164 on p. 375; Lippold, *Griechische Plastik*, 237, pl. 85.4. See also the relief in Paris, Louvre 752: Baumer, *Vorbilder*, 148–49, cat. R 54, pl. 36.3; F. T. van Straten, *Hierà Kalá: Images of Animal Sacrifice in Archaic and Classical Greece* (Leiden 1995) fig. 81 (R67); and two reliefs from the Piraeus now in Athens, NAM 1461: Kaltsas, *SNAMA*, 224, no. 471; Baumer, *Vorbilder*, 129–30, cat. R 22, pl. 29.2; Picard, *Manuel*, vol. 4.1, 380, fig. 167 on p. 381; Athens, NAM 3608 (1016): Baumer, *Vorbilder*, 133–34, cat. R 28, pl. 31.1; van Straten, *Hierà Kalá*, fig. 82 (R68).

[180] Naples, MAN (without inv. no.): P. Mingazzini, "Mondragone—Rilievo eleusinio rinvenuto in territorio di Mondragone (Sinuessa)," *NSc* 52 (1927) 309–15; *LIMC*, s.v. Demeter no. 412* (L. Beschi); Baumer, *Vorbilder*, 147–48, cat. R 52, pl. 36.1; Picard, *Manuel*, vol. 4.1, 378, fig. 165 on p. 377; H. Metzger, *Imagerie athénienne* (Paris 1965) 36, no. 14; I. Leventi, "The Mondragone Relief Revisited: Eleusinian Cult Iconography in Campania," *Hesperia* 76 (2007) 107–41.

(**Fig. 142**).[181] Equally, the type known as the Asklepios Giustini, of which several examples exist,[182] appears on fourth-century votive reliefs.[183] It is not a controversial assumption that the figures on the votive reliefs depict statues of the goddess and god which the Roman statues copy with some fidelity to detail. Finally, there are many over-life-size statues that were probably cult statues, such as the Athena Velletri and the Hera/Aphrodite Borghese (**Fig. 123**), both known in multiple examples, many of approximately the same size. As already indicated, the correspondence of size between multiple examples of the same type strongly suggests an original from which all were made. In the case of the Athena Velletri, there is also a fragment among the Baiae casts.[184] Evelyn Harrison has argued that this type is the Athena Hephaisteia in Athens.[185] The evidence, therefore, is that there was no general prohibition of making copies in Greek sanctuaries, and Ridgway has tempered her earlier assertion with the admission that there must have been occasions when particular circumstances intervened, such as the reconstruction of a temple.[186]

The evidence, if not absolutely clear, suggests that both accurate and variant copies of Greek statues were made. Given the very fragmentary nature of the material remains—whether in Italy, Greece, or the Hellenistic-Roman East—it is probably not peculiar that the various sources of our knowledge of Graeco-Roman sculpture overlap only slightly. A visit to any museum of Graeco-Roman sculpture can only impress on the visitor how much sculpture was produced in the Roman period to adorn every conceivable public and private space. If the number of Greek types copied across the Roman Empire is only around 100, that figure must be contrasted with the vast number of sculptures actually preserved in museums today. To take a single, though admittedly conspicuously large, example, the fourth edition of Wolfgang Helbig's *Führer durch die öffentlichen Sammlungen klassischer Altertümer in Rom* catalogues 3,338 works (many of which are inscriptions) in the main museums of Rome plus a large number in an appendix titled "Nicht aufgenommene Nummern."[187] There are a few to quite a large number of examples of each copy of a Greek statue, some of which are reflections and variants. Some have been found only in the west, such as the statues of Harmodios and Aristogeiton[188] and the caryatids of the

[181] Florence, Uffizi 120: G. A. Mansuelli, *Galleria degli Uffizi: Le sculture*, vol. 1 (Rome 1958) 60–61, no. 37*; *LIMC*, suppl. vol. 8, s.v. Persephone no. 11* (G. Güntner); Baumer, *Vorbilder*, 31–34, 96–97, cat. G6/1, pl. 8.1; A. Filges, *Standbilder jugendlicher Göttinnen: Klassische und frühhellenistische Gewandstatuen mit Brustwulst und ihre kaiserzeitliche Rezeption* (Cologne 1997) 257, no. 71*; R. Kabus-Jahn, *Studien zu Frauenfiguren des vierten Jahrhunderts vor Christus* (Darmstadt 1963) 2–5, pl. 1; T. Lygkopoulos, *Untersuchungen zur Chronologie der Plastik des 4. Jhs. v. Chr.* (Bonn 1983) 148–49, fig. 124; Picard, *Manuel*, vol. 4.1, fig. 166 on. p. 379; Todisco, *Scultura greca*, no. 286; Boardman, *GS-LCP*, fig. 90.

[182] *LIMC*, s.v. Asklepios nos. 154–96 (B. Holtzmann); M. Meyer, "Erfindung und Wirkung: Zum Asklepios Giustini," *AM* 103 (1988) 119–59; Meyer, "Zwei Asklepiostypen des 4. Jahrhunderts v. Chr.: Asklepios Giustini und Asklepios Athen-Macerata," *AntP* 23 (1992) 7–55; E. Berger, "Zwei neue Skulpturenfragmente im Basler Ludwig-Museum: Zum Problem des 'Asklepios Giustini,'" in *Praestant Interna: Festschrift für Ulrich Hausmann zum 65. Geburtstag am 13. August 1982*, ed. B. von Freytag gen. Löringhoff, D. Mannsperger, and F. Prayon (Tübingen 1982) 63–71, pls. 7–11.

[183] *LIMC*, s.v. Asklepios nos. 200–10 (B. Holtzmann), to which add Athens, NAM 1402: Kaltsas, *SNAMA*, 210, no. 428*; Knell, *Athen im 4. Jahrhundert*, 121–23, fig. 87.

[184] Landwehr, *Gipsabgüsse*, 76–88, nos. 42–52, pls. 44–53.

[185] E. B. Harrison, "Alkamenes' Sculptures for the Hephaisteion: Part I, the Cult Statues," *AJA* 81 (1977) 150–55; cf. Ridgway, *Roman Copies*, 69.

[186] *Roman Copies*, 52, 74; see also her comments in Moon, *Polykleitos, the Doryphoros, and Tradition* (note 30 above) 178. P. C. Bol, *Der antretende Diskobol* (Mainz 1996) 44, suggests that plaster casts, from which both marble and bronze copies could be made, might have been made in sanctuaries.

[187] Helbig⁴, vol. 4, pp. 438–59.

[188] S. Brunnsåker, *The Tyrant Slayers of Kritios and Nesiotes: A Critical Study of the Sources and Restorations*, 2nd ed., Skrifter Utgivna av Svenska Institutet i Athen, 4°, 17 (Stockholm 1971) 47–73. The provenance of several of the copies now outside Italy appears very probably to be Italy.

Erechtheion.[189] Copies of the Apollo Sauroktonos (**Figs. 181, 182**) and the Athena Vescovali (**Figs. 145, 146**) have so far been found only in the west and in Greece.[190] Other statue types have been found both in the west and the east, e.g., statue types attributed to Polykleitos[191] and the Eros stringing his bow commonly attributed to Lysippos (**Figs. 143, 144**).[192]

An arbitrary sample of a few types and the form in which they have come down to us is instructive. Of the three Ephesian Amazon types, the Sciarra type is represented by one cast from Baiae, nine statues (plus three statuettes), five heads, and three variants; of the Sosikles type, there are one Baiae cast, nine statues, twelve heads, and one variant; of the Mattei type, there are one Baiae cast, five statues (plus two statuettes), and two variants.[193] Of the Doryphoros, there are twenty-six statues (plus three statuettes) and twenty-five heads;[194] of the Hera/Aphrodite Borghese, there are fifteen statues, three heads, and a statuette;[195] of the Apollo Sauroktonos, there are fourteen statues (**Fig. 181**) (plus eleven possibles/missing and four statuettes), thirteen heads, and six variants.[196] Of the Eros stringing his bow attributed to Lysippos there are forty-four statues (**Fig. 143**), and fifteen heads;[197] of the Athena Vescovali (**Fig. 145**), there are twenty statues (plus three statuettes) and six heads.[198] Finally, of the Apollo Lykeios, there are fourteen statues, eleven heads, and six variants (plus four variant heads).[199] Though arbitrary, these are probably quite representative examples of statues considered to have classical Greek prototypes. Clearly, they represent an infinitesimally small percentage of marble sculpture produced during the Roman imperial period; of bronze sculpture we can say nothing. Our inability to connect more than an infinitesimal part of this enormous production with mentions of well-known statues in the texts does seem a bit strange and in need of some explanation.

There is one further factor that complicates the study of Roman copies of Greek sculpture: the growing realization that the Greeks also copied and adapted their own sculpture, both at the time the works were made and thereafter, a point already made by Furtwängler over one hundred years ago.[200] More recently, Frank Brommer, Volker Michael Strocka, Gerhild Hübner, and Stefan Schmidt have demonstrated this unequivocally for preserved originals and approximately contemporary copies.[201] The number of such actual copies of

[189] E. E. Schmidt, "Die Kopien der Erechtheionkoren," *AntP* 13 (1973); only the head in Paris (Louvre Ma 693) has no provenance: 35–37, pl. 50a–c.

[190] Only a few examples of each statue type have no known provenance, and in each case there are only two or three examples from Greece (including Crete): R. Preisshofen, "Der Apollon Sauroktonos des Praxiteles," *AntP* 28 (2002) 41–115; W. Schürmann, "Der Typus der Athena Vescovali und seine Umbildungen," *AntP* 27 (2000) 37–90.

[191] Kreikenbom, *Bildwerke nach Polyklet* (note 156 above), catalogue of replicas on pp. 143–203.

[192] H. Döhl, *Der Eros des Lysipp: Frühhellenistische Eroten* (Göttingen 1968) 51–59.

[193] Bol, *Amazones Volneratae*, 171–73.

[194] Kreikenbom, *Bildwerke nach Polyklet* (note 156 above) 163–80.

[195] Landwehr, *Gipsabgüsse*, 88–89 and note 422. Only two come from outside Italy (Crete and Cyrene).

[196] Preisshofen, *AntP* 28 (2002) 56.

[197] Döhl, *Eros des Lysipp* (note 192 above) 51–59.

[198] Schürmann, *AntP* 27 (2000) 37–70.

[199] E. J. Milleker, "The Statue of Apollo Lykeios in Athens" (Ph.D. diss., New York University, 1986) 197–318.

[200] *Meisterwerke*, 127 (= Furtwängler, *Masterpieces*, 94). C. Robert, *Bild und Lied: Archäologische Beiträge zur Geschichte der griechischen Heldensage* (Berlin 1881; repr. New York 1975) 4–6, also stresses the formal tradition of images in Greek art, as opposed to independent, novel creations.

[201] F. Brommer, "Vorhellenistische Kopien und Wiederholungen von Statuen," in *Studies Presented to David Moore Robinson on His Seventieth Birthday*, ed. G. E. Mylonas (St. Louis, MO, 1951) vol. 1, 674–82; V. M. Strocka, "Variante, Wiederholung und Serie in der griechischen Bildhauerei," *JdI* 94 (1979) 143–73; G. Hübner, "Ein archaisches Relief aus Paros," *AA*, 1994, 335–48; S. Schmidt, "Über den Umgang mit Vorbildern: Bildhauerarbeit im 4. Jahrhundert v. Chr.," *AM* 111 (1997) 191–223, pls. 33–44. Since bronze statues were produced with piece molds, the creation of several exact replicas or similar statues was possible: C. Mattusch, "In Search of the Greek Bronze Original," in Gazda, *Emulation*, 99–115; D. E. L. Haynes, *The Technique of Greek Bronze Statuary* (Mainz 1992); P. C. Bol, *Antike Bronzetechnik: Kunst und Handwerk antiker Erzbildner*, Beck's Archäologische Bibliothek (Munich 1985) 119–21.

reliefs preserved from the end of the fifth century into the fourth century is quite large: the Acropolis (Lenormant) trireme relief,[202] the Telemachos relief (**Fig. 90**),[203] and a nymph relief in Berlin and Rome,[204] among others. There is, accordingly, an additional complexity in studying copies: all may not be Roman copies or adaptations of a single Greek original; some Roman statues may be copies of Greek copies or adaptations. This has already been proposed above to explain the differences between the Piraeus and the Mattei Athenas.

Distinguishing the Roman copy from a purported Greek variant is difficult or impossible. It has long been recognized that the sculptures of the Parthenon inspired many reflections in more or less contemporary monuments. It seems likely that this was also true of the cult statue created by Pheidias, since many statues of Athena reflect aspects thought to stem from his statue of the Parthenos. This has been posited for the Athena of the Ince Blundell type (**Fig. 268**), which is known in various examples.[205] The veiled and veil-less statues of the leaning Aphrodite type have led Angelos Delivorrias to posit two main original fifth-century types and several nearly contemporary variations of both.[206] There are less obvious examples of multiple variants of a statue type: the youths known as oil-pourers come to mind first (**Fig. 124**), since, beyond the multiple versions already discussed, there also exists a satyr pouring in a similar pose (**Fig. 68**).[207] Such briefly popular subjects are also known in vase painting: scenes of Meleager or Marsyas have short periods of popularity, for unknown reasons, around and soon after 400 B.C.[208] The interest in more or less contemporary statues as particularly noteworthy also shows up, as we have seen, on votive reliefs and Panathenaic amphoras (**Fig. 122**),[209] but also, though less clearly, on record reliefs.[210] Typological comparisons have also been made between the pedimental figures of the Temple of Apollo at Delphi and Attic votive reliefs.[211] The idea of emulation of a figure type to convey a specific content, in fact, goes back well into the fifth century, when the poses of the statues of Harmodios and Aristogeiton were used for figures of Theseus both on painted vases and on the friezes of the temple generally known

[202] Athens, Acrop. 1339: L. Beschi, "Rilievi votivi attici ricomposti," *ASAtene* 47–48 (n.s., 31–32) (1969–70) 117–32; Brouskari, *Acropolis Museum*, 176–77, fig. 379; Ridgway, *Fifth Century Styles*, 136.

[203] Beschi, *ASAtene* 45–46 (1967–68) 382–436; E. Mitropoulou, *A New Interpretation of the Telemachos Monument* (Athens 1975); Ridgway, *Fifth Century Styles*, 136.

[204] Mitropoulou, *Votive Reliefs*, nos. 104, 105: Vatican, Saletta degli Originali Greci 1345: Helbig⁴, vol. 1, no. 863 (W. Fuchs); Berlin, Staatl. Mus. 709a (K 83): Blümel, *Skulpturen Berlin*, 60–61, no. 69, fig. 101.

[205] Karanastassis, *AM* 102 (1987) 360–69, pl. 54.2; M. Mangold, *Athenatypen auf attischen Weihreliefs des 5. und 4. Jhs. v. Chr.* (Bern 1993) 14–19, pl. 1; Todisco, *Scultura greca*, no. 9. See generally M. Gaifman, "Statue, Cult and Reproduction," *ArtH* 29 (2006) 258–79.

[206] Delivorrias, *AntP* 8 (1968) 20–26; *LIMC*, s.v. Aphrodite nos. 185–224 (A. Delivorrias et al.)

[207] Four copies come from the cavea of the theater at Castel Gandolfo: Dresden, SKD Herrmann 100 and 102; London, BM 1648; and Malibu, Getty 2002.34 (formerly Dresden, SKD Herrmann 101, but returned to a private owner in 1999, having been confiscated by the DDR, and acquired by the J. Paul Getty Museum in 2002): R. Neudecker, *Die Skulpturenausstattung römischer Villen in Italien* (Mainz 1988) 49–50, 133–34, 141, nos. 9.2a–d, pl. 5; Koortbojian, "Forms of Attention" (note 16 above) 195, fig. 8.15; Bol, *Bildhauerkunst*, 291–92, fig. 252 (W. Geominy); Knoll, Vorster, and Woelk, *Katalog Dresden*, 863–69*, no. 207 (C. Vorster), 870–75, no. 208 (W. Geominy). Other examples: Palermo, Museo Archeologico Regionale 1556: Todisco, *Scultura greca*, no. 102; Bol, *Bildhauerkunst*, fig. 251; Rome, MNR, Palazzo Altemps (Terme) 8597: Giuliano, *MNR*, vol. 1, pt. 5, 137–40, no. 59* (B. Palma); Berlin, Staatl. Mus. Sk 257 (K 225): Knittlmayer and Heilmeyer, *Antikensammlung Berlin*², 179, no. 104*; Paris, Louvre Ma 2333: Hollinshead, "Struts in Greek and Roman Sculpture" (note 132 above) 129 and note 41, 144–45.

[208] Meleager: Metzger, *Représentations*, 312–18; *LIMC*, s.v. Meleagros nos. 25, 26*, 27, 37*, 38*–42 (S. Woodford). Marsyas: Metzger, *Représentations*, 158–68; *LIMC*, s.v. Marsyas nos. 19, 20*, 21, 23, 24*, 31*, 37* (A. Weis).

[209] See chap. 1, p. 8, chap. 2, pp. 51–52, and pp. 77–78 above.

[210] Lawton, *Document Reliefs*, 40–41, 43–44 (Athena), 49 (Asklepios); Meyer, *Urkundenreliefs*, 223–46.

[211] Picard, *Delphes: Le musée*, 79–80; Voutiras, *AJA* 86 (1982) 229–33, pls. 30–32.

as the Hephaisteion.[212] Accordingly, the Greeks may have praised artists for inventing new and more convincing means of representation or a particularly successful image, but once the invention was made it was copied and imitated with no sense of diminished value, presumably since the content of the invention was objectively admirable.

One prosaic explanation of the difficulty of coordinating the textual accounts of sculpture and the preserved wealth of Roman statuary is that the textual accounts are usually so brief and dwell on aspects of sculpture that do not aid in convincing identifications. It is worthwhile to look briefly at a few test cases of the relationship between text and statue, taking, of course, examples from the fourth century B.C. In doing this, we can also test the thorny issue of attributing copies to a particular sculptor.

ATTRIBUTIONS TO SCULPTORS: THE LITERARY SOURCES

A somewhat facetious but not totally inaccurate assessment of the methodology of attributing Roman statues to Greek sculptors has recently been given by Hartswick: "Number of replicas, popularity, Greek prototype, famous sculptor, literary mention."[213] We have already seen that this is wildly inaccurate, since even the most popular Greek statue preserved in multiple Roman copies is barely more than a footnote in the huge production of statues in the Roman period. The example of the statue type of Eros stringing his bow is particularly elucidating (**Figs. 143, 144**).[214] Several types exist: the one considered to represent a Greek original of the fourth century is preserved in some forty examples and is most often attributed to Lysippos, though there is no literary source for the identification other than a casual reference in Pausanias (9.27.3) to the fact that Lysippos made a bronze statue of Eros for Thespiai.[215] The fact that Pliny (*NH* 36.22) praises to the sky a marble Eros by Praxiteles, also in Thespiai—about which Pausanias (1.21.1–2, 9.27.3) tells the amusing story that Phryne tricked Praxiteles into admitting that it, together with a satyr, was his favorite statue—has received scant attention because the style of the preserved type (**Figs. 143, 144**) is not thought to be close to the modern construct of Praxiteles' style. One element of the argument is that the original is judged by scholars to have been bronze, the reported medium of Lysippos's statue, while Praxiteles' was in marble. Accordingly, it is not only textual accounts that are the foundation of modern attributions of Roman statues to Greek sculptors but also more or less subjective stylistic analysis. This is the case for the widely reproduced statue of Leda and the swan (**Fig. 104**) which is frequently attributed to Timotheos, though there is no textual source of any kind for such an attribution—it is made on the basis of style alone.[216] The attribution of statue types to classical Greek sculptors is a somewhat arcane discipline frequently based on assumptions that are difficult or impossible to test, as Hartswick has stressed.

One body of information reveals how uncertain our knowledge is: preserved bases of statues inscribed with the signature of the sculptor. Although many bases signed by sculptors named in the ancient literary sources have been found, many more are signed by otherwise totally unknown sculptors. In 1885, Emmanuel Loewy compiled a useful list, now

[212] C. H. Morgan, "The Sculptures of the Hephaisteion, II: The Friezes," *Hesperia* 31 (1962) 226; W. R. Connor, "Theseus in Classical Athens," in *The Quest for Theseus*, ed. A. G. Ward (New York 1970) 153–55.

[213] K. J. Hartswick, "The Ares Borghese Reconsidered," *RA*, 1990, 228.

[214] Moreno, *Lisippo*, 111–29.

[215] Döhl, *Eros des Lysipp* (note 192 above) 5–14, 29–43.

[216] A. Rieche, "Die Kopien des 'Leda des Timotheos,'" *AntP* 17 (1978) 21–55, pls. 10–34; Schlörb, *Timotheos*, 51–56, pl. 16. See further chap. 5B, p. 215 below.

sadly out of date, of bases with inscribed signatures of sculptors and compared these with sculptors known from literary sources.[217] In the fifth and fourth centuries, the number of sculptors known only from inscribed bases is less than in other periods; nonetheless, there are many sculptors about whom we otherwise know nothing:

	6th cent.	5th cent.	4th cent.	4th/3rd cent.	3rd/2nd cent.	2nd/1st cent.
Literature and inscribed base	2	14	16	10	7	9
Inscribed base only	11	8	8	19	25	55

Conversely, a rapid perusal of Overbeck's *Schriftquellen* indicates that there is also a very large number of sculptors mentioned in texts about whom we otherwise know nothing.

Part of the problem derives from the purposes of the literary sources at our disposal. One of the primary sources for the art of attributing statues to a given sculptor is the work already frequently cited, the *Natural History* of Pliny the Elder, dedicated to Titus in A.D. 77, though not published in its entirety until after Pliny's death in 79.[218] It generally comes as something of a surprise, if not a shock, to learn that Pliny gives us our most authoritative ancient history of art as a series of digressions on studies of the materials from which objects were made: stone, metal, minerals. He cites Greek authors in the bibliographies attached to the detailed table of contents in book 1 as the sources for his observations, and he occasionally cites them in his commentaries on specific points. From these references scholars have been able to sketch out some of the Greek historians of art on whom Pliny relied, though he may have known them only or principally through the earlier and now lost Latin treatise of Varro.[219] Essentially, Pliny's work is a list of the names of various artists and their works, arranged more or less chronologically in each category, with an absolute minimum of description of, or commentary on, formal aspects of their works. But he occasionally waxes more loquacious and provides some understandable characteristics of the style of an artist. In some respects, Pliny is a special case, as well as a representative one: he was immensely industrious both in public affairs right up to his death in A.D. 79 and in his scholarly pursuits. The passages on sculpture and painting in the *Natural History* reflect this incredible industry but also a certain mechanical attitude that is explicit in this comment (36.27):

> At Rome, indeed, the great number of works of art and again their consequent efface-
> ment from our memory, and, even more, the multitude of official functions and busi-

[217] E. Loewy, *Inschriften griechischer Bildhauer* (Leipzig 1885; repr. Chicago 1976) xvi.

[218] To select from the vast number of major works on the subject is perhaps unfair, but the following are perhaps the most representative: Lippold, *Kopien und Umbildungen* (note 19 above); Lauter, *Chronologie römischer Kopien* (note 19 above); Zanker, "Nachamen als kulturelles Schicksal" (note 25 above) 9–24.

[219] A succinct review of Pliny's methods and sources and the modern controversies is given by J. W. Duff, *A Literary History of Rome in the Silver Age: From Tiberius to Hadrian*, 3rd ed. (London 1964) 283–92, 294; see also E. Sjöqvist, "Lysippus, I: Lysippus' Career Reconsidered," in *Lectures in Memory of Louise Taft Semple, Second Series*, ed. C. G. Boulter et al. (Norman, OK, 1973) 4–9; and W. D. E. Coulson, "The Reliability of Pliny's Chapters on Greek and Roman Sculpture," *CW* 69 (1976) 361–72. The literature on the art-historical chapters is immense: Pollitt, *Ancient View*, 73–81; K. Jex-Blake and E. Sellers, eds., *The Elder Pliny's Chapters on the History of Art* (New York 1896) remains very useful, particularly with the new preface supplied by R. V. Schoder in the reprint (Chicago, 1968; 2nd ed. 1976) pp. A–K, who brings the bibliography up to that date, with commentary. It should be noted that Schoder disagrees with the view expressed here on Pliny's reliance on Varro, which follows that of Eugénie Sellers (p. xiii); cf. Pollitt, *Ancient View*, 81; S. Carey, *Pliny's Catalogue of Culture: Art and Empire in the Natural History* (Oxford 2003) 18; I. Scheibler, *Griechische Malerei der Antike* (Munich 1994) 38.

ness activities must, after all, deter anyone from serious study, since the appreciation involved needs leisure and deep silence in our surroundings. Hence we do not know the maker even of the Venus dedicated by the emperor Vespasian in the precincts of his Temple of Peace, although it deserves to rank with the old masters. (Trans. D. E. Eichholz, Loeb edition)

As has been emphasized in recent studies, the issue for Pliny was not just cataloguing the uses to which the various materials were put (sculpture and painting) but also defining the total dominion of the Roman Empire.[220] Pliny is particularly concerned to enumerate the works of famous Greek sculptors and painters that were in Rome and to contrast them with the lesser number of such works in Greek sanctuaries. Accordingly, a name of a sculptor with a list of works but with no or minimal description fulfilled Pliny's aims. It is therefore no surprise that Pliny neither had the skill of Dionysios of Halikarnassos, discussed above, nor was he really interested in his art-historical digressions, for that is what they are, beyond their contribution to his full treatment of stones, metals, and minerals, which, after all, are his professed subjects. Their brevity and very limited usefulness must be emphasized.[221]

We do not have to rely on Pliny alone, as has already been indicated. Lucian, active in the middle of the second century A.D., is an interesting source from whom we gain further information that has the ring of accuracy. He describes a house with copies of Greek statues thus (*Philopseudes* 18–19):

> "Have you not observed on coming in," said he, "a very fine statue set up in the hall, the work of Demetrios, the maker of portrait-statues?" "Do you mean the discus-thrower," said I, "the one bent over in the position of the throw, with his head turned back toward the hand that holds the discus, with one leg slightly bent, looking as if he would spring up all at once with the cast?" "Not that one," said he, "for that is one of Myron's works, the discus-thrower you speak of. Neither do I mean the one beside it, the one binding his head with the fillet, the handsome lad, for that is Polykleitos' work. Never mind those to the right as you come in, among which stand the tyrant-slayers, modeled by Kritios and Nesiotes; but if you noticed one beside the fountain, pot-bellied, bald on the forehead, half bared by the hang of his cloak, with some of the hairs of his beard windblown and his veins prominent, the image of a real man, that is the one I mean; he is thought to be Pellichos, the Corinthian general." (Trans. A. M. Harmon, Loeb edition)

Despite the chatty narrative, typical of Lucian, the descriptions of the statues in the house are about as full and accurate as we possess in any ancient text.

More sober and sometimes more informative is Pausanias, the periegete whose testimony has been cited above on several occasions. He wrote his great description of Greece between about A.D. 150 and 180[222] and is the most obvious heir of Pliny. Ostensibly Pausanias wrote for the educated traveler, though recent study suggests a far more complex and sophisticated goal. Although he lived about 500 years after the monuments we are inves-

[220] Carey, *Pliny's Catalogue* (note 219 above) 79–84.

[221] The misattribution of the statues of Harmodios and Aristogeiton to Praxiteles (34.69–71) is probably just a passage misplaced by carelessness, but the sequence of Pheidias, Polykleitos, Myron, in 36.54–60, seems a little different. See, however, Pollitt, *Ancient View*, 75, and Jex-Blake and Sellers, *Elder Pliny's Chapters* (note 219 above) xiii, in general, and xx–xxi, on possible reasons for the peculiar, nonchronological sequence of sculptors.

[222] C. Habicht, *Pausanias' Guide to Ancient Greece*, 2nd ed. (Berkeley 1998) 8–12; E. Bowie, "Inspiration and Aspiration: Date, Genre, and Readership," in S. E. Alcock, J. Cherry, and J. Elsner, eds., *Pausanias: Travel and Memory in Roman Greece* (Oxford 2001) 21–23.

tigating were made, his testimony is one of first-hand experience: he saw and described buildings, monuments, and individual statues, most of which have since disappeared. Also of great importance is that he sometimes attributes works to artists so that we have some, though uncertain, evidence for the oeuvre of an artist or, as in the case of the Poulydamas base (**Fig. 95**) and the Mantineia base (**Figs. 96–98**),[223] actual works of an artist or workshop for which no other original evidence exists. Pausanias is, of course, not necessarily accurate in every observation he makes, and modern scholarship continues to struggle with unclear passages, such as his path through the Athenian Agora (1.3–17.3)[224] and his identification of the sculptor of the Hermes and Dionysos group in Olympia, which has been questioned earlier in this chapter. But in some cases where Pausanias's testimony has been doubted, he has eventually been proven correct, such as in the location of the Spartan victory monument at the entrance to the sanctuary of Apollo at Delphi (10.9.3–11).[225] Needless to say, Pausanias's accounts leave much to be desired from the modern art-historical point of view, despite the fact that they often provide a rudimentary statement of the subject of a work in terms that allow us to identify the original (as in the case of the two bases and the Apollo Patroos already cited) or plausibly a copy. Such is the statue of Eirene and the child Ploutos by Kephisodotos (1.8.2), which Pausanias saw in the Athenian Agora (**Fig. 12**).[226]

The fact that Pausanias is selective in his mention of sculpture and painting has long been recognized, though the reasons are elusive.[227] Perhaps most important is the recognition that his account is not arbitrary but reflects conscious criteria. Jaś Elsner has stressed Pausanias's desire to present the ancient and sacred character of Greece.[228] Inscriptions are often transcribed with painstaking accuracy,[229] but monuments and statues very infrequently receive more than a bare identification of the subject and name of the creator. Two notable exceptions are the chest of Kypselos at Olympia, of the seventh or early sixth century,[230] and the painting of Polygnotos in the Lesche of the Knidians at Delphi.[231] Pausanias's detailed description of the east pediment of the Temple of Athena Alea at Tegea, which contrasts with his bare mention of the west pediment (8.45.4–7; quoted in full on page 216 below), is similarly uncharacteristic, though to a lesser extent.[232] The three monuments have in common a very complex imagery and references to the earliest history of Greece, and both the chest and the paintings were intricately inscribed with the names of the figures depicted. Pausanias goes to great lengths to decipher the archaic Corinthian script on the chest of Kypselos (5.17.6) and comments on the

[223] Poulydamas base, Olympia Λ 45: Moreno, *Lisippo*, 91–93, no. 4.12*; Kosmopoulou, *Statue Bases*, 200–202, no. 36, figs. 55–57. Mantineia base, Athens, NAM 215, 216, and 217: Kaltsas, *SNAMA*, 246–47, no. 513*.

[224] H. A. Thompson and R. E. Wycherley, *The Athenian Agora*, vol. 14, *The Agora of Athens: The History, Shape and Uses of an Ancient City Center* (Princeton 1972) 204–7.

[225] Habicht, *Pausanias' Guide* (note 222 above) 71–77; Bommelaer and Laroche, *Delphes: Le site*, 108–10.

[226] Thompson and Wycherley, *Athenian Agora* 14, 168, 205; see further chap. 4, pp. 109–10 below. See generally Ridgway, *Roman Copies*, 67–69, on copies of works seen by Pausanias in Athens.

[227] U. Kreilinger, "Τὰ ἀξιολογώτατα τοῦ Παυσανίου: Die Kunstauswahlkriterien des Pausanias," *Hermes* 125 (1997) 470–91.

[228] J. Elsner, "Structuring 'Greece': Pausanias's *Periegesis* as a Literary Construct," in Alcock, Cherry, and Elsner, *Pausanias: Travel and Memory* (note 222 above) 3–20.

[229] C. Habicht, "Pausanias and the Evidence of Inscriptions," *ClAnt* 3 (1984) 40–56; Habicht, *Pausanias' Guide* (note 222 above) 64–94.

[230] Pausanias 5.17.5–19.10; A. S. Snodgrass, "Pausanias and the Chest of Kypselos," in Alcock, Cherry, and Elsner, *Pausanias: Travel and Memory* (note 222 above) 127–41.

[231] Pausanias 10.25.1–27.4; most recently M. D. Stansbury-O'Donnell, *Pictorial Narrative in Ancient Greek Art* (Cambridge 1999) 178–87, with earlier bibliography.

[232] See chap. 5B, pp. 215–16 below.

invented names of the figures in the painting of the Iliupersis (10.25.3). It seems likely that two factors stimulated Pausanias's response to these three monuments: the subjects represent the most important and earliest Greek myths, and the monuments themselves are from the "golden age" of early Greece.[233] Certainly Pausanias is clear about why he cites specific statues at Olympia and omits others (6.1.2): "Those only will be mentioned who themselves gained some distinction, or whose statues happen to be better made than others" (ὁπόσοις δὲ ἢ αὐτοῖς τι εἶχεν ἐς δόξαη ἢ καὶ τοῖς ἀνδριᾶσιν ὑπῆρχεν ἄμεινον ἑτέρων πεποιῆσθαι, τοσαῦτα καὶ αὐτος μνησθήσομαι).

But it is not my purpose to give a full critical account of the sources on Greek sculpture, which can be gained by a perusal of Overbeck's great compendium[234] and J. J. Pollitt's study of the ancient view of Greek art.[235] It is, however, important to stress that the sources we have are of very varied date and have very different purposes—none of which is art history as we understand it. Indeed, the issues raised by the nature of the commentaries in the ancient texts reveals as clearly as one could wish that the ancient view of art was not that of the modern art historian. It is nonetheless worth pointing out that for both Pliny and Pausanias there was a certain aura of the original, since they never address the issue of copies, with which they both were surrounded. Clearly, to reiterate, Dionysios of Halikarnassos shows that some people in the Roman period were interested in accurate assessment of sculpture and painting, and had the tools to make informed judgments. Pliny, one of our main sources, admits that he is not one of them. Pausanias also has other interests.

The identification of specific works in the Roman copies with named sculptors is obviously fraught with difficulty. I choose for examples the Aphrodite of Knidos and the Apollo Sauroktonos of Praxiteles, and the Apoxyomenos of Lysippos, all of which are major examples from the fourth century B.C. Pliny has the following to say about the Aphrodite of Knidos (**Figs. 147–49**)[236] (*NH* 36.4.20–21):

> Praxiteles is an artist whose date I have mentioned [34.69–70] among those of the makers of bronze statues, but in the fame of his work in marble he surpassed even himself. There are works by him at Athens in the Kerameikos; and yet superior to anything not merely by Praxiteles, but in the whole world, is the Venus, which many people have sailed to Knidos to see. He had made two figures, which he put up for sale together. One of them was draped and for this reason was preferred by the people of Kos, who had an option on the sale, although he offered it at the same price as the other. This they considered to be the only decent and dignified course of action. The statue which they refused was purchased by the people of Knidos and achieved an immeasurably greater reputation. Later King Nikomedes was anxious to buy it from them, promising so to discharge all the state's vast debts. The Knidians, however, preferred to suffer anything but this, and rightly so; for with this statue Praxiteles made Knidos a famous city. The shrine in which it stands is entirely open so as to allow the image of the goddess to be viewed from every side, and it is believed to have been made in this way with the blessing of the goddess herself. The statue is equally admirable from every angle. There is a story that a man once fell in love with it and hiding by night embraced it, and that a stain betrays this lustful act. (Trans. D. E. Eichholz, Loeb edition)

[233] Kreilinger, *Hermes* 125 (1997) 479, 482, suggests that the poor preservation may have been part of the motivation for the detailed descriptions of the chest and the paintings, but this does not apply to the pediment of Tegea.

[234] Overbeck, *Schriftquellen.*

[235] Pollitt, *Ancient View.*

[236] For selected bibliography, see the discussion below.

Sometimes Pliny is not our only source. In the case of the Knidian Aphrodite, Lucian (already mentioned above), writing in the middle of the second century A.D., is more loquacious, but his description is only marginally more evocative of the actual appearance of the statue (*Amores* 13–15):[237]

> When the plants had given us pleasure enough, we entered the temple. In the midst thereof sits (καθίσματα) the goddess—she's a most beautiful statue of Parian marble—arrogantly smiling a little as a grin parts her lips. Draped by no garment, all her beauty is uncovered and revealed, except insofar as she unobtrusively uses one hand to hide her private parts. So great was the power of the craftsman's art that the hard unyielding marble did justice to every limb. . . .
>
> The temple had a door on both sides for the benefit of those also who wish to have a good view of the goddess from behind, so that no part of her be left unadmired. It's easy therefore for people to enter by the other door and survey the beauty of her back. {14} . . . [W]e were filled with an immediate wonder for the beauty we beheld. The Athenian who had been so impassive an observer a minute before, upon inspecting those parts of the goddess which recommend a boy, suddenly raised a shout far more frenzied than that of Charikles. "Herakles!" he exclaimed, "what a well-proportioned back! What generous flanks she has! How satisfying an armful to embrace! How delicately molded the flesh on the buttocks, neither too thin and close to the bone, nor yet revealing too great an expanse of fat! And as for those precious parts sealed in on either side by the hips, how inexpressibly sweetly they smile! How perfect the proportions of the thighs and the shins as they stretch down in a straight line to the feet!" (Trans. M. D. Macleod, Loeb edition)

The statue of Aphrodite in the Vatican known as the Colonna type (**Fig. 147**) has generally been accepted as a reasonably good copy of the Knidian,[238] although the Belvedere type (**Fig. 148**), also in the Vatican, though relegated to the storerooms, has also had supporters.[239] A recent exhibition in the Louvre brought the two statues together side by side, making it possible for the first time in my memory to see them well and from all sides. One serious reservation about the authority of the Colonna type is that its head, though

[237] Overbeck, *Schriftquellen*, lists twenty-two mentions of the Knidia (nos. 1227–48).

[238] Vatican, Museo Pio-Clementino 812. A. Pasquier, "Les Aphrodites de Praxitèle," in Pasquier and Martinez, *Praxitèle*, 139–46, 175–77, no. 36*, and other replicas, 172–95, nos. 34–46; C. S. Blinkenberg, *Knidia: Beiträge zur Kenntnis der Praxitelischen Aphrodite* (Copenhagen 1933); Havelock, *Aphrodite of Knidos;* and K. Seaman, "Retrieving the Original Aphrodite of Knidos," *RendLinc*, ser. 9, 15 (2004) 531–69, are the four essential monographic studies of the statue and its various adaptations; the long and rambling treatment by Picard, *Manuel*, vol. 3.2, 559–609, is particularly well illustrated, albeit with somewhat fuzzy, dark images. A selection of important briefer assessments includes: Rizzo, *Prassitele*, 45–59, pls. 70–88; Helbig[4], vol. 1, no. 207 (H. von Steuben); M. Pfrommer, "Zur Venus Colonna: Ein späthellenistische Redaktion der knidischen Aphrodite," *IstMitt* 35 (1985) 173–80; H. von Steuben, U. Mandel, C. Reinsberg, and E. Kelpari, "Belauschte oder unbelauschte Göttin? Zum Motiv der Knidischen Aphrodite," *IstMitt* 39 (1989) 535–60; K. Stemmer, ed., *Standorte: Kontext und Funktion antiker Skulptur* (Berlin 1995) 241–43, no. B79 (D. Damaskos); A. Ajootian, "Praxiteles," in *Personal Styles in Greek Sculpture*, YCS 30, ed. O. Palagia and J. J. Pollitt (Cambridge 1996) 99–101; A. Stewart, *Art, Desire, and the Body in Ancient Greece* (Cambridge and New York 1997) 97–106; Todisco, *Scultura greca*, no. 113; Bol, *Bildhauerkunst*, 328–30, figs. 297a, 297b, 298 (C. Maderna).

[239] Vatican, magazzino 4260: G. von Kaschnitz-Weinberg, *Sculture del magazzino del Museo Vaticano* (Vatican City 1936–37) 116–19, no. 256, pls. 46–50; Blinkenberg, *Knidia* (note 238 above) 131–41, no. I.3, pl. 4; Pasquier and Martinez, *Praxitèle*, 139–46, 172–73, no. 34*. Arguments that this statue is closer to the original Knidia have been proposed by Rizzo, *Prassitele*, 48–51, pls. 71–75; Pfrommer, *IstMitt* 35 (1985) 180; A. Corso, "The Hermes of Praxiteles," *NumAntCl* 25 (1996) 144, 145, note 32; Corso, "The Cnidian Aphrodite," in *Sculptors and Sculpture of Caria and the Dodecanese*, ed. I. Jenkins and G. B. Waywell (London 1997) 93–94; Corso, "Praxiteles and the Parian Marble" (note 162 above) 228; and Seaman, *RendLinc*, ser. 9, 15 (2004) 538–50, fig. 2.

ancient, does not belong. Indeed, it is impossible to say which version of several types of more or less closely related heads may come closest to the original. The most famous is the Kaufmann head in the Louvre, but it is now generally thought to be a somewhat sweet variant of the Late Hellenistic period.[240] Alain Pasquier, following Charles Picard, suggests another head in the Louvre as a more convincing reflection of the original.[241] But the question must remain open concerning both the type of head and its precise position, though all agree that it was turned, probably only slightly, to the statue's proper left. Caution is equally required because of the numerous restorations of the Colonna statue (lower right arm and hand, left arm from the armband to the fingers of the hand, lower right and left legs, both feet, the rectangular support of the hydria) and the coarse cleaning of the whole surface.[242]

The Belvedere statue is, in contrast, relatively complete: the only major restoration is the lower right leg with the added tree stump.[243] Christoph Blinkenberg's preference for the Colonna version was based on the nature of the pose, and his argument was taken up and strengthened by Rodenwaldt.[244] Briefly, their argument is that the Colonna type appears to ignore the viewer, while the Belvedere type quite explicitly seems to respond to an intruder both in the position of her head and in the gesture of her left hand, which appears to pull the drapery toward her instead of letting it drop onto the hydria, a gesture particularly pronounced in the Braschi type in Munich (**Fig. 149**).[245] Certainly the desire to show nude Aphrodites covering their nudity is dominant in the Hellenistic period,[246] which favors the Colonna type as being closer to a fourth-century original. The preference for the Belvedere type is based on an inverted interpretation summarized most recently by Michael Pfrommer and Kristin Seaman:[247] the difficulty of the pose of the goddess, undressing for her bath and apparently looking at an indeterminate point off to her left, is best explained as a reaction to an intruder, which is the usual interpretation of the Belvedere version in the Vatican and its variants. In addition, the form and decoration of the hydria of the Colonna version and its sister in the Vatican storeroom can be dated no earlier than the second century B.C.[248] Finally, the base on which the hydria sits is unmotivated and must be part of the creative adaptation of the original statue to a new, Late Hellenistic sensitivity. Christine Havelock cut through these knotty problems by arguing that all

[240] Paris, Louvre Ma 3518: Pasquier and Martinez, *Praxitèle*, 178–79, no. 37*; *LIMC*, s.v. Aphrodite no. 395* (A. Delivorrias).

[241] Paris, Louvre Ma 421: Pasquier and Martinez, *Praxitèle*, 188–89, no. 42*; *LIMC*, s.v. Aphrodite no. 394* (A. Delivorrias); Picard, *Manuel*, vol. 3.2, 584–85, figs. 250, 251.

[242] Blinkenberg, *Knidia* (note 238 above) 123–24. A further but fragmentary example of the Colonna type in the storerooms of the Vatican preserves the whole left arm and the legs: ibid., 125–31, no. I.2, pl. 3; Kaschnitz-Weinberg, *Sculture del magazzino* (note 239 above) 119–21, no. 257, pls. 51–53; Rizzo, *Prassitele*, 53, pl. 81.

[243] Blinkenberg, *Knidia* (note 238 above) 137–39; Kaschnitz-Weinberg, *Sculture del magazzino* (note 239 above) 116–17; Rizzo, *Prassitele*, 49.

[244] Rodenwaldt, Θεοὶ ῥεῖα, 14–16.

[245] Munich, Glyptothek 258: Vierneisel-Schlörb, *Klassische Skulpturen*, 323–48, no. 31, figs. 158–64. Rolley, *Sculpture grecque*, 258–60, reverses and mixes up the two types. On the two types, see most recently A. Delivorrias, *LIMC*, vol. 2 (1984), s.v. Aphrodite, p. 50.

[246] Havelock, *Aphrodite of Knidos*, 55–101.

[247] Pfrommer, *IstMitt* 35 (1985) 173–80; Seaman, *RendLinc*, ser. 9, 15 (2004) 531–69. Cf. W. Neumer-Pfau, *Studien zur Ikonographie und gesellschaftlichen Funktion hellenistischer Aphroditestatuen*, Habelts Dissertationsdrucke, Reihe klassische Archäologie 18 (Bonn 1982) 75–82.

[248] The formal and iconographic objections to the Colonna type are largely refuted by studies appended to Hans von Steuben's article, "Belauschte oder unbelauschte Göttin? Zum Motiv der Knidischen Aphrodite," *IstMitt* 39 (1989): U. Mandel, "Zum Fransentuch des Typus Colonna," pp. 547–54; C. Reinsberg, "Zur Hydria des Typus Colonna," pp. 555–57; and E. Kelpari, "Zum Armreif des Typus Colonna," pp. 558–60.

the preserved versions were created after 150 B.C. and probably only reflect aspects of the original.[249] But the excellent display of both statues in the recent Louvre exhibition suggests strongly that the detailed analyses do not do justice to the quite different composition of the two statues. The Colonna version has a rhythm that is totally lacking in the Belvedere statue: she pulls back her proper left shoulder commensurate with the gesture of her arm dropping the garment on the hydria; her proper right shoulder is forward and down as she turns slightly to her proper left; the torso is bent slightly forward; the legs suggest an incipient crouching motion. The Belvedere version is stiffly upright; the position of the legs is awkward; the shoulders are rigid; the figure is totally frontal and static; the head position is most awkward. The Colonna version reflects the frontal emphasis of statues of the fourth century while maintaining a fluid, rhythmical stance that convincingly suggests the third dimension. The essence of the Colonna version is the celebration of Aphrodite as goddess of fertility, in contrast to the Belvedere version, which appears to find nudity embarrassing.[250]

But the attribution of the statue type to Praxiteles is largely based on the extraordinary popularity of the type and its infinite reflections in later Hellenistic and Roman statues. The revolutionary depiction of Aphrodite nude, so strongly stressed by the later texts and most modern commentaries, is only partly justified. A comment of Pliny is mostly ignored in the recent literature: that Skopas made a statue of Aphrodite nude either before or better than (depending on the translation of *antecedens*) that of Praxiteles (*NH* 36.4.26).[251] It is, of course, possible that the statue was by Skopas II, a sculptor of the second century B.C., as Jacob Isager has suggested,[252] but Pliny gives no indication of this. Indeed, in citing the comparison with Praxiteles' statue he appears from the text, rightly or wrongly, to mean explicitly Skopas of the fourth century. As we shall see later, this could make one wonder whether the statue in the Vatican reflects Praxiteles' or Skopas's work, since there are numerous nude Aphrodites of very similar appearance.

The lack of absolute clarity in the identification of the Knidian Aphrodite by Praxiteles is not very disturbing because the identification of a statue type that corresponds to the ancient descriptions is unambiguous. The fact that Skopas most likely made a nude Aphrodite before Praxiteles' statue is of primarily iconographic importance, and this is not as

[249] Havelock, *Aphrodite of Knidos*, 6 and passim; also supported by Seaman, *RendLinc*, ser. 9, 15 (2004) 550.

[250] Seaman, *RendLinc*, ser. 9, 15 (2004) 550, argues on the basis of the far greater frequency of the "embarrassed type" that it is closer to the original, but that is very misleading; since "embarrassed" Aphrodites are popular in the Hellenistic period, the alteration of the "original" Knidia could just as easily be a product of contemporary (later Hellenistic) taste. The textual evidence Seaman cites for her interpretation (pp. 561–68) of Aphrodite's *aidos* is hardly evidence that the goddess is dressing rather than undressing.

[251] "[Scopas] . . . praeterea Venus in eodem loco [temple built by Brutus Callaecus in the Circus Flaminius] nuda, Praxiteliam illam antecedens et quemcumque alium locum nobilitatura." "Antecedo" can mean either to precede in time or, secondarily, to surpass. Jex-Blake, in *Elder Pliny's Chapters* (note 219 above) ad loc.; Rackham, in the Loeb edition; and Stewart, *Skopas*, appendix 1, p. 127, no. 5, all choose the second meaning. Stewart gives a brief commentary on the passage, pp. 110–11, no. 1, with earlier bibliography. Pollitt, *Art of Greece*, 141, translates "precedes." It should be noted that Pliny says of Praxiteles (36.20): "qui marmoris gloria superavit etiam semet. . . . sed ante omnia est non solum Praxiteles, verum in toto orbe terrarum Venus, quam et videret, multi navigaverunt Cnidum." It is probably not justifiable to compare these two passages and to conclude that Pliny *must* have used "antecedens" to mean "precede" in the former because he has eliminated the meaning "surpass" in the latter. However, the commentary of Carey, *Pliny's Catalogue* (note 219 above) 81, gives more weight to the translation "surpass" in the general interpretation of Pliny's exultation of the primacy of Rome, where the best and most of everything is to be found.

[252] J. Isager, *Pliny on Art and Society: The Elder Pliny's Chapters on the History of Art* (New York 1991) 155 and note 545 on p. 154, with reference to F. Coarelli, "L'ara di Domizio Ahenobarbo' e la cultura artistica in Roma nel II secolo a.C.," *DialArch* 2 (1968) 325–27.

problematic a possibility as modern scholarship's extolling Praxiteles' purported innovation might lead one to believe, as I shall show in a later chapter.

Another statue in Pliny's compendium is open to more serious questioning. He relates an anecdote about the statue of an "apoxyomenos" by Lysippos which has almost uniformly been identified with another statue in the Vatican, of which there are very few copies (**Figs. 150–53**).[253] Scholarly opinion on this identification was not particularly shaken when another type of apoxyomenos was found by the Austrian excavators at Ephesos in 1896 (**Figs. 71, 72**),[254] of which several copies were already known.[255] Pliny records the following (*NH* 34.19.62):[256]

> Lysippus as we have said was a most prolific artist and made more statues than any other sculptor, among them the man using a body-scraper (*destringentem se*) which Marcus Agrippa gave to be set up in front of his Warm Baths and of which the emperor Tiberius was remarkably fond. Tiberius, although at the beginning of his principate he kept some control of himself, in this case could not resist the temptation, and had the statue removed to his bedchamber, putting another one in its place at the baths; but the public were so obstinately opposed to this that they raised an outcry at the theater, shouting "Give us back the 'Apoxyomenos'" and the Emperor, although he had fallen quite in love with the statue, had to restore it. (Trans. H. Rackham, Loeb edition)

[253] Vatican, Museo Pio-Clementino 1185: Andreae, *Bildkatalog* (note 78 above) pls. 43–49, with bibliography on pp. 7*–8*; Helbig⁴, vol. 1, no. 254 (W. Fuchs); K. Moser von Filseck, *Der Apoxyomenos des Lysipp und das Phänomen von Zeit und Raum in der Plastik des 5. und 4. Jhs. v. Chr.* (Bonn 1988); Süsserott, *Griechische Plastik*, 180–84, pl. 36.3; Lippold, *Griechische Plastik*, 279, pl. 100.1; Borbein, *JdI* 88 (1973) 147, figs. 69–72; Ridgway, *Hellenistic Sculpture*, vol. 1, 74–75, pls. 34, 35; M. Weber, "Zum griechischen Athletenbilde: Zum Typus und zur Gattung des Originals der Apoxyomenosstatue im Vatikan," *RM* 103 (1996) 31–49; Todisco, *Scultura greca*, no. 274; Bol, *Bildhauerkunst*, 351–53, figs. 319a–i (C. Maderna). On other copies, see K. Schauenburg, "Athletenbilder des vierten Jahrhunderts v. Chr.," *AntP* 2.5 (1963) 78–79, pls. 60–62 (statuette in Fiesole), pls. 63–71, figs. 6, 7 (Vatican Apoxyomenos); H. Lauter, "Eine seitenverkehrte Kopie des Apoxyomenos," *BJbb* 167 (1967) 119–28, figs. 1, 4 (battered torso in the Terme gardens); J. Inan, "Roman Copies of Some Famous Greek Statues from Side," *AntP* 12 (1973) 77–79, no. 3, pls. 19, 20; Inan, *Roman Sculpture in Side* (note 55 above) 83–85, no. 28, pls. 38, 39. A rather fine copy is on loan to the Antikensammlungen Basel, no. S 385, but it has not been published nor even noted in the literature, and the museum has provided no information on it.

[254] Vienna, KHM, Ephesos Museum VI 3168: O. Benndorf, *Forschungen in Ephesos* 1 (Vienna 1906) 181–204, figs. 127–35, pls. 6–9, frontispiece; BrBr 682–85 rechts; Süsserott, *Griechische Plastik*, 159–61; Lippold, *Griechische Plastik*, 218, pl. 78.3; S. Lattimore, "The Bronze Apoxyomenos from Ephesos," *AJA* 76 (1972) 13–16; Moser von Filseck, *Apoxyomenos des Lysipp* (note 253 above) 111–20; E. Pochmarski, "Zur kunstgeschichtlichen Stellung des Schabers von Ephesos," in *Griechische und römische Statuetten und Grossbronzen*, ed. G. Gschwantler and A. Bernhardt-Walcher (Vienna 1988) 74–81; Weber, *RM* 103 (1996) 45; three articles in *100 Jahre Österreichische Forschungen in Ephesos: Akten des Symposions Wien 1995*, Denkschriften der Österreichischen Akademie der Wissenschaften, Philosophisch-Historische Klasse 260, ed. H. Friesinger and F. Krinzinger (Vienna 1999): C. Pavese, "L'atleta di Ephesos," 579–84, E. Pochmarski, "Neues zum schaber von Ephesos," 585–92, and M. Weber, "Zur Gattung des Strigilisreinigers," 593–96; K. Gschwantler, "Der Schaber von Ephesos: Bronzeguss; Zerstörung und Rekonstruktion," in *Die griechische Klassik: Idee oder Wirklichkeit*, ed. W.-D. Heilmeyer (Mainz 2002) 506–8, no. 381; Linfert, "Schule des Polyklets" (note 61 above) 273, fig. 143 on p. 271; Ridgway, *Hellenistic Sculpture*, vol. 1, 77–78, pl. 38a, b; Todisco, *Scultura greca*, no. 58; Bol, *Bildhauerkunst*, 286–88, figs. 243a–g (W. Geominy). A bronze replica was discovered off the Dalmatian coast in the 1990s: M. Michelucci, ed., *Apoxyomenos: The Athlete of Croatia* (Florence 2006); M. Sanader, "Der Meergeborenen: Die Entdeckung einer Bronzestatue in Kroatien," *AntW* 30 (1999) 357–59, figs. 2–5; I. Karnis, "Statue of an Athlete from under the Sea, Island of Losinj, Croatia: Conservation and Restoration Works," in *The Antique Bronzes: Typology, Chronology, Authenticity; The Acta of the 16th International Congress of Antique Bronzes, Organized by the Romanian National History Museum, Bucharest, May 26th–31st, 2003*, ed. C. Mușeteanu (Bucharest 2004) 243–48; I. Jenkins et al., *Defining Beauty: The Body in Greek Art* (London 2015) 66–67; Daehner and Lapatin, *Power and Pathos*, 274–75, no. 41*.

[255] Florence, Uffizi 100: Mansuelli, *Uffizi*, 59–60, no. 36; L. Bloch, "Eine Athletenstatue der Uffiziengallerie," *RM* 7 (1982) 81–105; V. Saladino, "The Uffizi Athlete," in Michelucci, *Apoxyomenos* (note 254 above) 52–53, figs. 32, 33; Todisco, *Scultura greca*, no. 59; Bol, *Bildhauerkunst*, 287, figs. 242a, b (W. Geominy); Daehner and Lapatin, *Power and Pathos*, 278–79, no. 43*.

[256] Overbeck, *Schriftquellen*, no. 1502; this is the only mention of the statue.

There is obviously very little of value in this account except the anecdote about Tiberi-us's fondness for the statue. Therefore the identification of the statue in the Vatican as a copy of this work by Lysippos is founded on very little. Indeed, several scholars have argued that the Ephesos Apoxyomenos, or more accurately, strigil-cleaner, is a copy of Lysippos's statue, in part because it exists in several examples, though all of these are adaptations.[257]

It is something of a relief to turn to the Apollo "Sauroktonos" (**Figs. 181, 182**).[258] Pliny's account runs thus (*NH* 34.19.70): "Praxiteles also made a youthful Apollo called in Greek the Lizard-Slayer because he is waiting with an arrow for a lizard creeping towards him" (trans. H. Rackham, Loeb edition). There is really no statue type that fits this description other than the full-size marble statues in the Louvre and the Vatican and the recently acquired bronze in Cleveland.[259] So we can consider the identification relatively secure.

The fact that we can feel absolutely certain about the identification of only one of three major pieces by Praxiteles cited by Pliny does make me hesitant to rely very much on the attribution of preserved Roman copies to the oeuvres of Greek sculptors. In the last analy-sis, the criterion of judgment comes down to a particular composition or simply a subject of which there are few, or, better, only one example in the preserved material.

PAINTING

As already mentioned, a similar problem exists for panel painting. The discovery of the painted wall panels depicting Greek myths in the houses of Pompeii and Herculaneum (and elsewhere, notably Rome itself) suggested to early commentators that they might be copies of famous Greek works cited by Pliny and others. Parallel to the study of sculp-tural copies, a whole scholarly industry grew up around the distinction of Greek versus

[257] A. Maviglia, *L'attività artistica di Lisippo ricostruita su nuova base* (Rome 1914) 9–18, reviews the history of the attribution of the Vatican statue to Lysippos and questions it; on pp. 18–30 she argues that the Ephesos type reflects the Lysippan statue; on pp. 23–24 she lists six full-size examples of the Ephesos type, three small versions, and two gems; see also Moser von Filseck, *Apoxyomenos des Lysipp* (note 253 above) 111–20. To the earlier known works should be added a black schist example in Castel Gandolfo: P. Liverani, *L'Antiquarium di Villa Barberini a Castel Gan-dolfo* (Vatican City 1989) 59–60, no. 22, figs. 22.1–4; and the bronze found in the Adriatic in 1999, cited in note 254 above. Maviglia's thesis was picked up by C. H. Morgan, "The Style of Lysippos," in *Commemorative Studies in Honor of Theodore Leslie Shear*, *Hesperia* suppl. 8 (Baltimore 1949) 228–34, pls. 24, 25; Comstock and Vermeule, *Sculpture in Stone*, 100–101, no. 155*; Vermeule, *Greek Sculpture and Roman Taste* (note 13 above) 28. Vermeule's opinion is also cited in a Sotheby's sale catalogue on a bronze head of the Ephesos Apoxyomenos type: *Antiquities: New York, Wednesday, June 14, 2000*, 58–65, no. 60 (reference kindly provided by Michael Padgett); this was eventually acquired by the Kimbell Art Museum in Fort Worth, Texas: *Calendar, Kimbell Art Museum, Fort Worth*, September 2000 through February 2001, pp. 14–15; most recently, Daehner and Lapatin, *Power and Pathos*, 276–77, no. 42*.

[258] J.-L. Martinez, " L'Apollon sauroctone," in Pasquier and Martinez, *Praxitèle*, 202–6, 209–35; Preisshofen, *AntP* 28 (2002) 41–115, pls. 21–64; *LIMC*, s.v. Apollon/Apollo nos. 53* and 53a* (E. Simon); Stewart, *Greek Sculpture*, 178–79, fig. 509; Todisco, *Scultura greca*, nos. 126 and 127; Bol, *Bildhauerkunst*, 294–95 (W. Geominy), 322–23 (C. Maderna), figs. 258–61.

[259] Paris, Louvre Ma 441, and Vatican, Museo Pio-Clementino 750: Martinez, "Apollon sauroctone" (note 258 above) 216–20, nos. 50, 51*; and Preisshofen, *AntP* 28 (2002) 56–64, nos. S1 and S2, pls. 21–29. See the citations in the previous note and Ajootian, "Praxiteles" (note 238 above) 116–22. There is a large number of fragmentary copies scattered through European museums (Preisshofen's count is: 12 statues, 1 tree with lizard, 4 statuettes, and 13 heads, to which she adds 10 lost or questionable examples and 6 variants). Perhaps most noteworthy is the small bronze example in the Villa Albani, 952: Bol, *Villa Albani*, vol. 1, 188–91, no. 58, pls. 106–9 (P. C. Bol); Preisshofen, 91–93, no. St. 1, figs. 24, 25, pls. 56, 57. Only a brief commentary on the full-sized bronze Sauroctonos acquired by the Cleveland Museum of Art in 2004 has been published: M. Bennett, "Une nouvelle réplique de l'Apollon Sauroctone au musée de Cleveland," in *Praxitèle*, ed. A. Pasquier and J.-L. Martinez (Paris 2007) 206–8, figs. 126a–c; see also Daehner and Lapatin, *Power and Pathos*, 25, fig. 1.6; P. Moreno, "Satiro in estasi di Praxitele," in *Il Satiro danzante di Mazara del Vallo: Il restauro e l'immagine; Atti del convegno, Roma, 3–4 giugno 2003*, ed. R. Petriaggi (Naples 2005) 211, 209, fig. 17, 210, fig. 20.

Roman painting.[260] Painted panels depicting Greek mythological subject matter with relatively large figures in relation to the picture frame and minimal context or spatial depth to the scene were considered copies or adaptations of Greek works, while paintings with relatively small figures in elaborate contexts of landscape or cityscape were considered Roman or primarily so. The evidence of actual Greek painting from the Macedonian and Thracian tombs suggests that it is generally correct to suppose that the Greeks of the fifth and fourth centuries did depict scenes with relatively large figures in at most schematic contexts.[261] Even the hunt frieze on the facade of "Philip's Tomb" at Vergina does not contradict this observation (**Fig. 119**).[262]

Although Attic red-figure vase painting of the fourth century is generally considered to have diverged from monumental painting and to be in decline, eventually to disappear near the end of the century, the actual characteristics of composition sometimes reflect patterns known from the large-figure Roman panel paintings. An unambiguous example is the seated figure of Achilles in a painting from Pompeii that appears in precisely the same manner on a Kerch vase depicting Herakles seated in the Garden of the Hesperides.[263] The issue of overall composition is more difficult. Take, for example, the various scenes of Perseus rescuing Andromeda (**Fig. 154**).[264] Pliny (*NH* 35.132) mentions a famous painting with the title *Andromeda* by Nikias the younger, an Athenian who lived at the end of the fourth century. Since he does not describe the picture, it is impossible to know whether any of the preserved Roman paintings is a copy or even a general reflection of Nikias's work. If one applies the same reasoning used to analyze variants of statue types, at least a hypothetical prototype may be deduced for the variant pictures. There is indeed clearly an internal relationship between the various subsets of the Roman paintings and some relationship to the iconography of the subject developed in South Italian red-figure vases of the fourth century.[265] Basically, the stance and gestures of Perseus and Andromeda are repeated in the examples that show the two on a rocky outcrop, even though the setting changes and extra figures appear.[266] The similarities are, however, strong enough to persuade us that a single model is reflected in the stances and relative positions of the two principal figures, but all the rest is open to variation.[267] The large figures and the spare background of some

[260] A critical review of arguments pro and con Pompeian paintings being primarily copies of lost Greek works is given by G. Lippold, "Antike Gemäldekopien," *AbhMünch*, N.F., 33 (1951) 5–9; P. H. von Blanckenhagen, "Painting in the Time of Alexander and Later," in Barr-Sharrar and Borza, *Macedonia*, 251–60; R. Ling, *Roman Painting* (Cambridge 1991) 112–35.

[261] The most recent and thorough study is Brecoulaki, *Peinture funéraire*.

[262] Andronikos, *Royal Tombs*, 106–19, figs. 55–71; Saatsoglou-Paliadeli, *Τάφος του Φιλίππου*; H. M. Franks, *Hunters, Heroes, Kings: The Frieze of Tomb II at Vergina* (Princeton 2012). J. P. Small, "Time in Space: Narrative in Classical Art," *ArtB* 81 (1999) 568, agrees with the view; but see the contrary views of von Blanckenhagen, "Painting in the Time of Alexander" (note 260 above) 257–58, and Scheibler, *Griechische Malerei*, 120.

[263] I. Scheibler, "Zum Koloritstil der griechischen Malerei," *Pantheon* 36 (1978) 300, figs. 6 (Naples, MAN 9020), 8 (London, BM E 227: *CVA*, London 6 [Great Britain 8], pl. 93.2 [368] dated 370–360).

[264] K. M. Phillips, "Perseus and Andromeda," *AJA* 72 (1968) 1–23; H. Lauter-Bufe, *Zur Stilgeschichte der figürlichen pompejanischen Fresken* (Erlangen 1969) 20–29; B. Neutsch, *Der Maler Nikias von Athen: Ein Beitrag zur griechischen Künstlergeschichte und zur pompejanischen Wandmalerei* (Borna 1940) 2–14; K. Schefold, "Die Andromeda des Nikias," in *Studies in Honour of Arthur Dale Trendall*, ed. A. Cambitoglou (Sydney 1979) 155–58; B. Schmaltz, "Andromeda: Ein campanisches Wandbild," *JdI* 104 (1989) 259–81; Scheibler, *Griechische Malerei*, 66–67, fig. 24.

[265] Phillips, *AJA* 72 (1968) 6–15, pls. 2, 6–13.

[266] *LIMC*, s.v. Andromeda I, nos. 67*–71* (K. Schauenburg); Phillips, *AJA* 72 (1968) 5–6, pl. 4, fig. 7; Schmaltz, *JdI* 104 (1989) figs. 2, 3.

[267] Phillips, *AJA* 72 (1968) 14, posits a Hellenistic prototype; Scheibler, *Pantheon* 36 (1978) 299, 302, 304, and Scheibler, *Griechische Malerei*, 66–67, cautiously accepts a Late Classical model for the type represented by the painting in the House of Dioscuri, while Lauter-Bufe, *Stilgeschichte der Pompejanischen Fresken* (note 264 above) 22–23,

of the pictures clearly suggest a very different artistic vision from that of paintings of Perseus flying in to rescue Andromeda in a full and complex landscape.[268] Whether an actual Late Classical Greek model, such as Nikias's painting of the scene, was used for the large figure scenes depends on how one judges the actual figures and their relationship. Neither Attic nor South Italian vases of the fourth century depict the figure types, though an Attic krater in Berlin demonstrates that the idea of the Roman paintings has Greek roots.[269] Objections to the drapery of Andromeda as inappropriate to the fourth century are not very convincing,[270] since the Artemis from Gabii (**Figs. 137, 138**) and even the Herculaneum Women are generally comparable.[271] An even better comparison for both the stances and clothing of the figures is the small frieze of the painted tomb of Aghios Athanasios, at Thessaloniki, of the end of the fourth or the first half of the third century B.C.[272] Just as with statues, it is impossible to attribute the painting to a particular artist, but the picture does share some characteristics of Late Classical and Early Hellenistic painting. It is also possible, though less likely, that it was a Roman creation in the Greek manner.[273]

Perhaps one of the best examples of the range of variation in a Roman painting and a purported Greek prototype is the painting of the sacrifice of Iphigeneia from the House of the Tragic Poet at Pompeii.[274] Although it was at first held to be a reflection of the painting by Timanthes described by Pliny (*NH* 35.73), most commentators have recognized that little more than the subject is the same. The representations of the subject in vase painting of the fifth and fourth centuries have no relationship to the wall painting.[275]

Since no original Greek panel painting has survived, what criteria might be used to identify plausible Greek prototypes among the numerous preserved Roman wall paintings? Obviously, size of figure alone is not reliable. There is one case in which the circumstantial evidence is strong, though hardly conclusive: the scene of the rape of Persephone. The subject is painted on one of the long sides of the cist tomb of the same name in the large tumulus at Vergina (**Fig. 120**).[276] The scene is also known in closely similar form in a Roman mosaic.[277] Pliny (*NH* 35.108) states that there was a painting of the subject by Nikomachos in Rome. Since Nikomachos is known to have worked for the Macedonian court in the second half of the fourth century, it is not too difficult to accept the conclusion that the painting in Vergina and the mosaic in Rome both reflect the painting men-

prefers her type III, best represented by a mosaic from Antioch: *LIMC*, s.v. Andromeda I, no. 73*; D. Levi, *Antioch Mosaic Pavements* (Princeton 1947) 150–54, pl. 29c; Levi, in *Antioch-on-the-Orontes*, vol. 3, *The Excavations of 1937–1939*, ed. R. Stillwell (Princeton 1941) 205–6, no. 163, pl. 79.

[268] *LIMC*, s.v. Andromeda I, nos. 32*, 38, 40* (K. Schauenburg); Small, *ArtB* 81 (1999) 568, fig. 8; C. M. Dawson, *Romano-Campanian Mythological Landscape Painting*, YCS 9 (New Haven, CT, 1944) 122–23, pls. 16, 17 (no. 40); Phillips, *AJA* 72 (1968) 15, 22, pl. 1, figs. 2, 3, suggests a Hellenistic, Alexandrian origin for the model.

[269] Berlin, Staatl. Mus. 3732: Phillips, *AJA* 72 (1968) pls. 6, 7, figs. 16, 17.

[270] L. Curtius, *Die Wandmalerei Pompejis* (Cologne 1929; repr. Darmstadt 1960) 256–57; Phillips, *AJA* 72 (1968) 5–6; Schmaltz, *JdI* 104 (1989) 260.

[271] Bieber, *Ancient Copies*, pls. 46, 112–14.

[272] Brecoulaki, *Peinture funéraire*, 263–303, pls. 91–94; see further bibliography below, chap. 4, note 345.

[273] Schmaltz, *JdI* 104 (1989) 278–81, and von Blanckenhagen, "Painting in the Time of Alexander" (note 260 above) 252, conclude that the paintings are Campanian classicizing works.

[274] Naples, MAN 9112: Ling, *Roman Painting* (note 260 above) 134, fig. 139; Scheibler, *Griechische Malerei*, 67–68, fig. 26; Bergmann, *HSCP* 97 (1995) 84–85.

[275] *LIMC*, s.v. Iphigeneia nos. 1*, 3*, 11* (L. Kahil); the last is an Apulian krater of ca. 370–355.

[276] See chap. 4, p. 147 below with note 314.

[277] R. Lindner, *Der Raub der Persephone in der antiken Kunst* (Würzburg 1984) 58, no. 50, pl. 14.1, with extensive commentary under no. 21 (Persephone tomb), 30–34; P. Moreno, "La pittura tra classicità e ellenismo," in *La crisi della polis*, vol. 2, *Arte, religione, musica*, Storia e civiltà dei Greci, ed. R. Bianchi Bandinelli, vol. 6 (Milan 1979) 712–13, pl. 74b; Scheibler, *Griechische Malerei*, 69–70, fig. 27.

tioned by Pliny. Some scholars are even willing to go further and suggest that the painting in Vergina was produced by the workshop of Nikomachos because of its very impressionistic style, for which Nikomachos was famous.[278] In this case the copy does not of itself provide any new insight into Greek art except to confirm that Roman pictures did at times reproduce Greek prototypes more or less accurately.

An example of a Roman mosaic that is more helpful for the study of earlier Greek painting is the Alexander Mosaic from the House of the Faun at Pompeii (**Fig. 155**), dated on archaeological grounds to the late second century B.C.[279] Pliny (*NH* 35.110) once again provides the hook on which to hang the mosaic: Philoxenos of Eretria painted the battle of Alexander against Darius for King Kassander of Macedon (ruled 306–297 B.C.). Although the mosaic is widely considered to be an accurate copy of a Late Classical or Early Hellenistic painting, the early commentators were careful to note the relatively extensive damage to the mosaic caused by the earthquake of A.D. 63 and awkwardnesses in the composition, which they attributed to the mosaicist adding to the original to better fit the space the mosaic had to occupy.[280] But in general the details of Persian armor and dress accurately reflect late Achaemenid forms.[281] A further, and the most important, point is the close resemblance of the figures of Darius and his charioteer to those of Hades carrying off Persephone in the tomb painting at Vergina (**Fig. 120**).[282] The color scheme of the mosaic is also that reported in the texts for classical painting of four colors: red, yellow, black, and white.[283] Finally, there is the shared concept of space, particularly the dramatic foreshortenings coupled with superimposed bands of recession that together create an illusion of space without establishing a coherent system of a spatial continuum.[284] The rider seen from the back in the deer hunt on the left of the facade painting of "Philip's Tomb" at Vergina is a good Late Classical parallel (**Fig. 119**).[285]

There is, however, a problem with the attribution of the painting to Philoxenos of Eretria: his style is described in the ancient texts as particularly rapid and is thus widely believed to be impressionistic, similar to the renderings of Hades and Persephone in the Tomb of Persephone at Vergina.[286] This clearly does not apply to the style of the Alexander Mosaic. The

[278] Andronikos, *Vergina*, vol. 2, 126–30. E. Thomas, "Nikomachos in Vergina?" *AA*, 1989, 219–26, and Rouveret, *Histoire et imaginaire*, 235, reject the proposal.

[279] Naples, MAN 10020: B. Andreae, *Der Alexandermosaik aus Pompeji* (Recklinghausen 1977), with excellent color plates; A. Cohen, *The Alexander Mosaic: Stories of Victory and Defeat* (Cambridge 1997); Rouveret, *Histoire et imaginaire,* 290–98, pls. 19.2–20; Scheibler, *Griechische Malerei*, 63, 102, 156, fig. 56, pl. V; Bergmann, *HSCP* 97 (1995) 81–82.

[280] F. Winter, *Das Alexandermosaik aus Pompeji* (Strassburg 1909) 5; H. Fuhrmann, *Philoxenos von Eretria: Archäologische Untersuchungen über zwei Alexandermosaike* (Göttingen 1931) chap. 5 (Schäden, Ausbesserungen und Technik des pompejanischen Alexandermosaik), 93–126; Andreae, *Alexandermosaik* (note 279 above) 9–12. M. Bieber and G. Rodenwaldt, "Die Mosaiken des Dioskurides von Samos," *JdI* 26 (1911) 10–14, argue that the blank bottom border within the frame is a common feature of Hellenistic Greek (votive) pictures; Fuhrmann (pp. 129–30) agrees.

[281] C. Nylander, "The Standard of the Great King: A Problem in the Alexander Mosaic," *OpRom* 14 (1983) 19–37; Cohen, *Alexander Mosaic* (note 279 above) 53.

[282] Moreno, "Pittura tra classicità e ellenismo" (note 277 above) 713–15, figs. 4, 5; Rouveret, *Histoire et imaginaire*, 226–27, 234–35, fig. 17.

[283] Pliny, *NH* 35.50; Bruno, *Form and Color*, 74–77; I. Scheibler, "Die 'Vier Farben' der griechischen Malerei," *AntK* 17 (1974) 92–102; Scheibler, *Griechische Malerei*, 102; Rouveret, *Histoire et imaginaire*, 235.

[284] Andreae, *Alexandermosaik* (note 279 above) 27–28; Rouveret, *Histoire et imaginaire*, 242, 290–93; Cohen, *Alexander Mosaic* (note 279 above) 57–58.

[285] Andronikos, *Royal Tombs*, figs. 58–60; Saatsoglou-Paliadeli, *Τάφος του Φιλίππου*, pls. 4a, 8.1, 8.2, 11a; Brecoulaki, *Peinture funéraire*, pls. 27, 29.

[286] A. Rumpf, "Zur Alexander-Mosaik," *AM* 77 (1962) 240; Andreae, *Alexandermosaik* (note 279 above) 24–26; C. Saatsoglou-Paliadeli, "Compendaria," in *La pittura parietale in Macedonia e Magna Grecia: Atti del Convegno internazionale di studi in ricordo di Mario Napoli (Salerno-Paestum, 21–23 novembre, 1996)*, ed. A. Pontrandolfo (Paestum 2002) 52.

impressionistic style does appear, though rarely, in Roman wall paintings; the most famous example is the Alexander Keraunophoros in the House of the Vettii at Pompeii (**Fig. 156**).[287] It is immediately apparent that in translating such a style into mosaic it must lose the diffuse quality of rapid brushstrokes that are not confined by a linear contour. Since other battles of Alexander were certainly painted, there is no firm ground on which to attribute the Pompeian mosaic to Philoxenos, and moderately good grounds not to do so.[288]

On the basis of the qualities of spatial construction and the palette of four colors, several Roman paintings can be considered to reflect Greek prototypes more or less accurately. The paintings of Io and Argos follow a pattern similar to that of Perseus and Andromeda, and it is difficult to isolate a convincing image of a fourth-century prototype.[289] Indeed, one version of the Io and Argos painting from Pompeii that is limited to just the two figures (**Fig. 157**) is so close to the similarly tightly framed version of Perseus and Andromeda that both could be either fairly good reflections of Greek prototypes or classicistic creations.[290] A variant form of the scene, found in the House of Livia on the Palatine in Rome, adds the figure of Hermes arriving on the left to the pair of Io and Argos, who have precisely the same poses and relationship as in the Pompeian painting.[291] Bernhard Neutsch has argued that this is the more believable reflection of the original because the addition of Hermes changes the picture from a static to a narrative scene that points to the momentous freeing of Io from under Argos's watchful eyes.[292] As such, it is similar to the Perseus and Andromeda scene in which Perseus helps Andromeda down from her perch, which points to the further unraveling of the story.[293] Needless to say, these good arguments have no strong supporting evidence.

More convincing are the painting of Briseis being led away from Achilles, from the House of the Tragic Poet (**Fig. 158**)[294], and of the discovery by Odysseus of Achilles hiding among the daughters of Lykomedes on Skyros, known in nearly fifty examples.[295] Both paintings share with the Alexander Mosaic the radical views of individual figures and the clear sense of superimposed bands of figures, creating the sense of depth. In the picture of Briseis, Achilles sits in three-quarter frontal view, while Patroklos stands with his back to the viewer in the foreground at center right, just like the hunter (no. 3) on the left of the

[287] P. Mingazzini, "Una copia dell'Alexandros Keraunophoros di Apelle," *JBerlMus* 3 (1961) 6–17; J. Charbonneaux, R. Martin, and F. Villard, *Hellenistic Art (330–50 B.C.)* (New York 1973) 115, fig. 114; Rouveret, *Histoire et imaginaire*, 225.

[288] Fuhrmann, *Philoxenos* (note 280 above) 72–92, reviews the possible attribution to a painter Aristeides, and (pp. 51–71) to an Alexandrian painter, Helena.

[289] *LIMC*, s.v. Io I, nos. 47*, 48* (N. Yalouris); B. Wesenberg, "Zur Io des Nikias in den pompejanischen Wandbildern," in *Kanon: Festschrift Ernst Berger zum 60. Geburtstag am 26. Februar 1988 gewidmet*, ed. M. Schmidt (Basel 1988) 344–50, pl. 96.

[290] Curtius, *Wandmalerei Pompejis* (note 270 above) 258–63; Scheibler, *Griechische Malerei*, 65–67, figs. 23, 24. Ling, *Roman Painting* (note 260 above) 129–30, figs. 133, 134; Lippold, "Antike Gemäldekopien" (note 260 above) 94; and H. Mielsch, *Römische Wandmalerei* (Darmstadt 2001) 141–42, accept both as good copies of Late Classical originals. Von Blanckenhagen, "Painting in the Time of Alexander" (note 260 above) 252, rejects both as classicistic.

[291] Wesenberg, "Zur Io des Nikias" (note 289 above) pl. 96.1.

[292] Neutsch, *Nikias von Athen* (note 264 above) 56–57.

[293] Rejected as a late elaboration for the same reasons by Ling, *Roman Painting* (note 260 above) 129–30, fig. 35 (on p. 37).

[294] Naples, MAN 9105: Charbonneaux, Martin, and Villard, *Hellenistic Art* (note 287 above) 124, fig. 123 (color); Scheibler, *Pantheon* 36 (1978) 299–300, fig. 2; B. Bergmann, "The Roman House as Memory Theater: The House of the Tragic Poet in Pompeii," *ArtB* 76 (1994) 232, fig. 16 (on p. 235).

[295] Scheibler, *Griechische Malerei*, 68–69, color pls. VIb, VII; Charbonneaux, Martin, and Villard, *Hellenistic Art* (note 287 above) 126–27, figs. 124, 125 (color); V. M. Strocka, *Die Wandmalerei der Hanghäuser in Ephesos*, Ephesos 8.1 (Vienna 1977) 107–8; in note 380 Strocka lists forty-eight monuments with the scene, of which twelve are paintings; Ling, *Roman Painting* (note 260 above) 133–34.

boar hunt in the painting on the facade of "Philip's Tomb" at Vergina (**Fig. 119**).[296] Behind the main group of Achilles, Patroklos, and Briseis, the soldiers form a second, slightly raised, band of figures. Above and behind them is some rudimentary architecture, with a view of sky at the top left, possibly paralleled on the painted stele of Hermon, of about 340, in the Athenian Kerameikos (**Fig. 116**).[297] In the painting of Achilles on Skyros, the daughter of Lykomedes in the left foreground runs in distress to the left with her back to the viewer, and the principal actors in the foreground are in a band separate from the figures behind. Again, a trace of architecture fills the top of the picture.[298]

The basic characteristics of all the paintings discussed thus far are the large figures, limited spatial recession defined by separate bands of figures or setting, dramatic foreshortenings, and a dramatic moment in the mythological story. Ingeborg Scheibler has emphasized a useful additional criterion: color.[299] Both Pliny (*NH* 35.50) and Cicero (*Brutus* 18.70) relate that classical Greek paintings were confined to four colors, which Pliny lists as red, yellow, black, and white. Since the primary color blue—which is necessary to mix with yellow and red to create the whole spectrum of colors—is missing from this list, it is difficult to see how classical Greek painters proceeded. Preserved paintings in the Macedonian tombs and on Athenian grave stelai both give a partial answer: blue was used for specific purposes but usually only in a subsidiary role for shading or special objects.[300] This is also the case in the Alexander Mosaic.[301] But the lack of blue in the list of colors may also be explained by the meaning of the Greek word for black, "μέλας," which frequently means just "dark."[302] Since one substance used to make the "dark" color was burnt wine lees, which have a blue-purple tint, this could explain the lack of a "real" blue in Pliny's list of the four colors that constituted the classical palette. However, the existence and use of a "real" blue in the Macedonian tombs suggest a far simpler answer: color has an iconographic function, that is, it is the carrier of meaning,[303] and blue was not appropriate as a principal color either in panel painting or, better, some classes of panel painting. The range of reds, browns, and yellows is the color of people, and scenes that focus on people have little need for a more generous palette.[304] There is now sufficient evidence to indicate that in fact the use of the four-color palette was only one option, and a full palette of colors was used either where the subject was appropriate or where the function required it.[305] Thus the divine and heroic mythological scenes discussed above lack blue and green except in subsidiary roles, while Hermes on the facade of the tomb at Lefkadia (**Fig. 117**) wears a bright blue chlamys, and a man in the

[296] Andronikos, *Royal Tombs*, figs. 58–61; Saatsoglou-Paliadeli, *Τάφος του Φιλίππου*, pls. 4a, 8.1, 8.2; Brecoulaki, *Peinture funéraire*, pl. 27.

[297] V. von Graeve, "Der Naiskos des Hermon: Zur Rekonstruktion des Gemäldes," in Schmidt, *Kanon: Festschrift Ernst Berger* (note 289 above) 340, pl. 93:2.

[298] Strocka, *Wandmalerei der Hanghäuser* (note 295 above) 108, argues that the version under discussion here is a Hellenistic creation, while the slightly different version in Ephesos is the more widely known type and "classical."

[299] Scheibler, *AntK* 17 (1974) 92–102; Scheibler, *Pantheon* 36 (1978) 299–307.

[300] Bruno, *Form and Color*, 79–87; Rouveret, *Histoire et imaginaire*, 260. It is used in the face of Hermes in the tomb of Persephone at Vergina: H. Brecoulaki, "Eléments de style et de technique sur les peintures funéraires de Macédoine (IVe–IIIème s. av. J.-C.)," in Pontrandolfo, *Pittura parietale in Macedonia* (note 286 above) 27, pl. II.1.

[301] Bruno, *Form and Color*, 76–77.

[302] M. Platnauer, "Greek Colour-Perception," *CQ* 15 (1921) 153–54; Rouveret, *Histoire et imaginaire*, 245–46. See generally E. Irwin, *Colour Terms in Greek Poetry* (Toronto 1974) 22–27.

[303] Scheibler, *Pantheon* 36 (1978) 303–5.

[304] E. Walter-Karydi, "Color in Classical Painting," in *Color in Ancient Greece: The Role of Color in Ancient Greek Art and Architecture, 700–31 B.C., Proceedings of the Conference Held in Thessaloniki, 12th–16th April, 2000*, ed. M. A. Tiverios and D. S. Tsiafakis (Thessaloniki 2002) 86.

[305] Rouveret, *Histoire et imaginaire*, 264; Walter-Karydi, "Color in Classical Painting" (note 304 above) 82–87; Koch-Brinkmann, *Polychrome Bilder*, 96–98; Brecoulaki, *Peinture funéraire*, 444–50.

procession of the tomb at Kazanlăk carries a bright blue cloth.[306] Equally, it is likely that the important areas of blue and green in the Theseus, Briseis, and other Pompeian paintings are additions of the wall painters.

Clearly the issue of copies is far more complex for paintings than for statues because it is not only iconographic or formal but also resides in the use of color and even the manner of its application. A further complication, and one that is a parallel to sculpture, is that paintings could be and were copied long before the Romans produced their elaborate wall decorations: on the so-called Alexander sarcophagus from Sidon the inner surface of a shield was painted with a faithful copy of an Achaemenid audience scene.[307] Equally, when famous paintings were carried off to Rome, copies were sometimes left in their place.[308]

THE USE OF COPIES IN THIS STUDY

This review of Roman copies and textual sources for the study of Greek sculpture and painting indicates that a great deal of caution is advised. Yet the wholesale dismissal of these sources for our inquiry is not a reasonable response. The issue of copies is clearly different for the study of painting than for sculpture: there are no original panel paintings of any sort against which to set the purported copies; the tomb paintings and vases operate on a different level than the famous panel paintings recorded in the sources; and even the detailed descriptions of the large classical wall paintings allow us only a dim insight into their appearance. To distinguish between a painting in the Greek style and an accurate copy of a Greek painting is simply not possible on the basis of the preserved evidence. In the case of sculpture, the situation is different: some originals are preserved against which to test the copies of them. Other originals allow some judgment of style and composition in the broadest sense. But it is the sheer number of Roman examples of a statue type that are closely similar in size and share broad characteristics in a coherent classical Greek style that argues strongly that the type is a copy rather than a new, classicizing creation. This is not to say that Roman creations of ideal sculpture were not copied, but these are generally identifiable as such, though surely mistakes are made, as is evident in the difference of opinion about the Ares Borghese type.[309] The statues judged to be true copies may vary significantly among themselves in details, but they can nonetheless be demonstrated to belong to a single type. This is equally true of Roman wall paintings.

The positive identification of a statue from textual sources and its attribution to a sculptor is more difficult and more often than not unconvincing. The exceptions are few; these are largely works that can be identified by their unique subject matter, such as the Sauroktonos of Praxiteles[310] and the Eirene and Ploutos of Kephisodotos.[311] Beyond such relatively secure identifications there is a larger realm of probably identifiable statues, such as the Aphrodite of Knidos. Here the problem lies in establishing which of the numerous variations of stance, gesture, and head type might reasonably follow the original.

[306] Bruno, Form and Color, figs. 6, 11, 13a.

[307] V. von Graeve, Der Alexandersarkophag und seine Werkstatt, IstForsch 28 (Berlin 1970) 102–11, pls. 69–71; von Graeve, "Eine Miszelle zur griechischen Malerei," IstMitt 37 (1987) 131–44, figs. 3, 7, pls. 40.1–3.

[308] Bergmann, HSCP 97 (1995) 91–92.

[309] Hartswick, RA, 1990, 227–83; Ridgway, Fourth-Century Styles, 244; Ridgway, Roman Copies, 68–69, 85; versus Vierneisel-Schlörb, Klassische Skulpturen, 178–81; Linfert, "Schule des Polyklets" (note 61 above) 268, 271; Bol, Bildhauerkunst, 242–43, figs. 174a, b (D. Kreikenbom).

[310] Which Ridgway, Fourth-Century Styles, 265, suggests is a later Hellenistic creation.

[311] Chap. 4, pp. 109–10 below.

If one wishes to construct an oeuvre of Praxiteles, these details become very important; if, however, one seeks only to describe the possibilities of the art of the fourth century B.C., they are less important. Similarly, variations in the examples of the Resting Satyr type can be glossed over in favor of simply using the general stance as an indication of the formal qualities of fourth-century sculpture (**Fig. 180**).[312] It is this latter path that I shall follow in subsequent chapters. However, some of the variations in statue types become more interesting in my discussion because of the great emphasis in studies of the fourth century on the importance of the personal styles of the great masters: Praxiteles, Skopas, Leochares, Timotheos, Lysippos, to name only the most frequently cited.

The inability to identify with conviction the vast majority of Roman statues that look as though they could be copies or adaptations of Greek originals must be based in part on the Romans' penchant for Greek-like art, that is, they are original Roman creations in the Greek manner, Roman "ideal sculpture."[313] This must be equally true for painting. But we must also consider that the lack of correspondence between the textual lists of Greek sculpture and paintings and the preserved statues and paintings is simply the fortuitous result of very fragmentary traditions. Hans-Volkmar Herrmann has correlated Pausanias's account of victors' statues at Olympia with the preserved bases.[314] The results show that Pausanias lists far more statues from the High and Late Classical periods, while a preponderance of the preserved bases date to the later Hellenistic and Roman imperial periods. As Herrmann points out, the criteria that Pausanias states for his citing works are the notable achievements of the athletes and the quality of the statues.[315] Since he says almost nothing about the latter except to give the name of the sculptor, we are left in the dark on this point. Finally, a number of the older bases recovered by the German excavations of Olympia belonged to statues Pausanias did not mention, and many are by artists otherwise unknown to us.[316] Since many statues mentioned by Pausanias are by sculptors considered of the first rank—Ageladas, Onatas, Kalamis, Pythagoras, Myron, Pheidias, Polykleitos[317]—we simply have to admit that the material evidence preserved to us is an arbitrary selection, and the identification of the preserved Roman copies of statues need have little to do with the importance of the originals from which they were copied.

It seems to me extremely likely that the situation is not so bleak as may at first appear. In the vast number of Roman sculptures and paintings we probably possess copies, variants, adaptations, and reflections of numerous anonymous Greek works that never made it into the preserved (or any!) texts. Consider the remark of Pliny about the volume of sculpture in Rome and Greece at about his time (*NH* 34.35–37):

> What was the first origin of representing likenesses in the round will be more suitably discussed when we are dealing with the art for which the Greek term is 'plasticē,' *plastic*, as that was earlier than the art of bronze statuary. But the latter has flourished to an extent passing all limit and offers a subject that would occupy many volumes if

[312] See the excellent discussion of the typological variations by J.-L. Martinez, "Les satyrs de Praxitèle," in Pasquier and Martinez, *Praxitèle*, 236–45. For the bibliography of the type, see p. 194, note 275 below.

[313] Gazda, *HSCP* 97 (1995) 121–56; Gazda, *Emulation*. R. M. Kousser, *Hellenistic and Roman Ideal Sculpture: The Allure of the Classical* (Cambridge and New York 2008), stresses the ready recognizability and consequent authoritative form of the Greek copies and Greek-inspired images in much the vein suggested here.

[314] Herrmann, *Nikephoros* 1 (1988) 123–24, 128–29; see also his lists (Anhang I and II) with statement on p. 136.

[315] Ibid., 126–28.

[316] Ibid., 136–37.

[317] Ibid., 129.

one wanted to give a rather extensive account of it—for as for a completely exhaustive account, who could achieve that? {36} In the aedileship of Marcus Scaurus there were 3,000 statues on the stage in what was only a temporary theater. Mummius after conquering Achaia filled the city with statues, though destined not to leave enough at his death to provide a dowry for his daughter—for why not mention this as well as the fact that excuses it? A great many were also imported by the Luculli. Yet it is stated by Mucianus who was three times consul that there are still 3,000 statues at Rhodes, and no smaller number are believed still to exist at Athens, Olympia, and Delphi. {37} What mortal man could recapitulate them all, or what value can be felt in such information? Still it may give pleasure just to allude to the most remarkable and to name the artists of celebrity, though it would be impossible to enumerate the total number of the works of each, inasmuch as Lysippus is said to have executed 1,500 works of art, all of them so skillful that each of them by itself might have made him famous. . . . (Trans. H. Rackham, Loeb edition)

Pausanias too says at the beginning of his tour of the sanctuary of Apollo at Delphi that there is simply too much to record (10.9.1–2):

The city of Delphi, both the sacred enclosure of Apollo and the city generally, lies altogether on sloping ground. The enclosure is very large, and is on the highest part of the city. Passages run through it, close to one another. I will mention which of the votive offerings seemed to me most worthy of notice. {2} The athletes and competitors in music that the majority of mankind have neglected, are, I think, scarcely worthy of serious attention; and the athletes who have left a reputation behind them I have set forth in my account of Elis. (Trans. W. H. S. Jones, Loeb edition)

All manner of objects were dedicated and set up side by side in Greek sanctuaries; the pile of iron obeloi dedicated by the courtesan Rhodopis mentioned by Herodotos (2.135) must have stood cheek by jowl with statues.[318] Although we may set up statues in our museums as discreet "objets d'art," this was certainly not their original function; they were more akin to a modern machine than to museum pieces.[319] The Romans almost certainly made dedications in a similar manner, though the vast majority of the preserved statues do not come from sanctuaries but from public and private buildings in which the choice of statues was apparently guided by a unified program. Let us take as an example Building M at Side in Pamphylia, of the second century A.D. Of the nineteen relatively well-preserved statues, eleven are copies or recognizable adaptations of well-known Greek prototypes.[320] These include the following: the Diskobolos of Myron, the Kassel Apollo, Polykleitos's Diadoumenos, the Ares Borghese, the Hera Ephesia, the Munich Oil-Pourer, the Hermes Richelieu, the Apoxyomenos attributed to Lysippos (Vatican type), the Sandal-binder also attributed to Lysippos, the Small Herculaneum Woman, and a Marsyas.[321] The function of Building M has not been determined, though part of it may have been a

[318] Bommelaer and Laroche, *Delphes: Le site,* 160–61.

[319] E. Langlotz's essay "Griechische Plastik im Blickfeld der modernen Kunst," in a volume of his collected essays, *Griechische Kunst in heutiger Sicht* (Frankfurt am Main 1973) 30–57, emphasizes this point.

[320] Inan, *Roman Sculpture in Side* (note 55 above). She gives a list (p. 265) of the catalogue numbers of all the sculpture catalogued from Building M, of which 19 are relatively well-preserved statues and 112 are small fragments that do not allow any identification.

[321] Ibid., cat. nos. 2, 4, 7, 10, 12, 20, 22, 28, 32, 54, 55.

library attached to a gymnasium.[322] A more limited repertory of sculpture was recovered from the theater in Lecce (ancient Lupiae) in southern Italy: an Athena Giustiniani, an Ares probably adapted from the Diskophoros of Polykleitos, a torso either of Polykleitos's Doryphoros or his Herakles, and the Copenhagen Herakles.[323] Precisely how either set of statues is to be interpreted is, for my purposes, secondary to the extensive quotations from classical Greek prototypes. At least among the educated these must all have been recognizable, as indicated by the passage from Lucian's *Philopseudes* cited above, which describes a house with several copies of Greek sculpture near its entrance. The description may be fictive, but clearly Lucian expected the reader to recognize the genre of the house and its owner, and it is therefore a convincing sketch.[324] The statues do not so much constitute a program as an advertisement of the house owner's culture. Both culture and program probably determined the choice of the paintings in the House of the Tragic Poet at Pompeii.

A point that cannot be stressed enough is that there must have been a whole spectrum of different attitudes toward art, and Greek art in particular, for which the modern analogy is probably not a bad guide. There were clearly two worlds, the official and public, and the private or domestic. In the official world, art was propaganda, and the objects it employed were probably more malleable. Certainly the Augustus of Prima Porta can only be described as a vague reflection of the Doryphoros, an almost subliminal message beneath the cuirass and gesture of the Roman imperator.[325] The inscription on the Herakles of the Farnese type in the Palazzo Pitti in Florence reads: ἐργόν τοῦ Λυσίππου (work of Lysippos),[326] yet the statue bears the portrait head of the emperor Commodus, and to my mind the type is an overly muscle-bound reflection of a statue by the late-fourth-century sculptor Lysippos.[327] Today similar situations arise, for example, where a piece of furniture in the Chippendale style becomes a Chippendale piece. Even if recognizably not an antique original, the piece carries connotations of taste and wealth.

In the private realm there must have been a great deal of variation in the perception of art. In the preserved texts there is no author who parallels the scholarly expertise of Dionysios of Halikarnassos in his analysis of the style of Demosthenes, though clearly Pausanias had a great store of knowledge and was intensely interested in the monuments he saw. Perhaps Maecenas and Sallust were real connoisseurs as well as collectors. Pliny represents the educated high government official who was curious but certainly not a passionate connoisseur.[328] Cicero probably belongs in the same category. Below him were the *philopseudes*, the collectors who are frequently criticized and lampooned in literature. There were also probably a large number of people who just liked the stuff but were indifferent to fine points of criticism. These various categories of collectors must have had

[322] A. M. Mansel, *Die Ruinen von Side* (Berlin 1963) 109–21.

[323] M. Fuchs, *Untersuchungen zur Ausstattung römischer Theater in Italien und den Westprovinzen des Imperium Romanum* (Mainz 1987) 51–54.

[324] The Iliac tablets must fit into this picture of Roman assertions of culture, since they appear really to be a cross between a "Classic Comic" and a coffee-table book, carefully set out to be seen: A. Sadurska, *Les tables iliaques* (Warsaw 1964); D. Petrain, *Homer in Stone: The Tabulae Iliacae in Their Roman Context* (Cambridge and New York 2014).

[325] Gazda, *HSCP* 97 (1995) 140–41, fig. 6.

[326] D. Krull, *Der Herakles vom Typ Farnese: Kopienkritische Untersuchungen einer Schöpfung des Lysipp* (Frankfurt am Main 1985) 22–27, no. 2; Todisco, *Scultura greca*, no. 273.

[327] See further chap. 6, pp. 109–10 below.

[328] Pollitt, *TAPA* 108 (1978) 168–69, suggests that Pliny's attitude to art and Greek art in particular was at least in part a reflection of Titus's policy.

quite different demands of the objects they bought, and very different budgets too. In this light, what is preserved to us is therefore not a select group of masterpieces but probably a good cross-section of sculptural production—good, mediocre, and bad. Within the sphere of the copy the same must be true: some are accurate, some are mild adaptations, some are distant reflections of Greek works that themselves represented a wide repertory of types and artists.

4 General Issues of Style in Sculpture and Painting

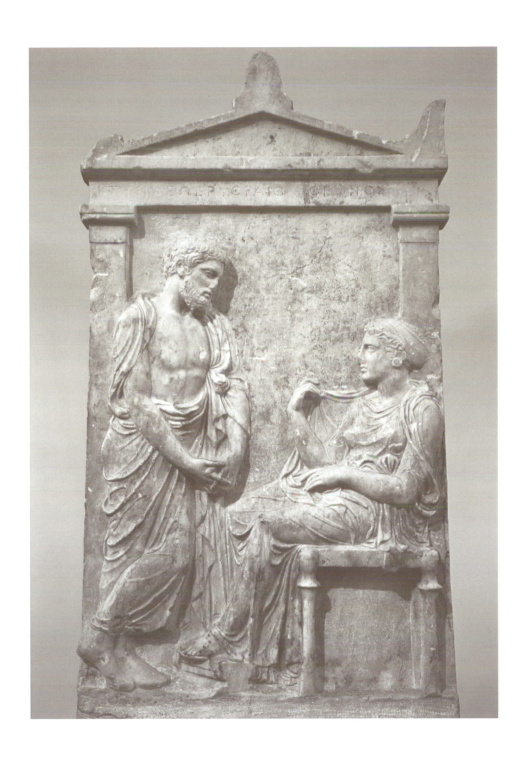

The art of the fourth century is confusing because on the casual perusal of any of the general books on the period there are so many different characteristics that leap out: the poles are a quiet simplicity (**Fig. 174**) and a contrasting turbulent complexity (**Fig. 159**). But there are also soft, erotic male figures (**Fig. 181**) and muscle-bound hulks (**Fig. 183**), neither of which fits easily into the simple or turbulent temperament. It is tempting to propose right at the outset that the different stylistic manifestations are dependent on the general class of monument[1]—such as grave relief, funerary relief, or architectural sculpture, or even a specific deity, hero, or type of mortal—but this is mostly not the case. In part, the distinctions are chronological, but just as important appears to be the interpretation of the subject. For example, Herakles may be young (without beard) or old (with beard), static or active (**Figs. 176, 177, 159**). There is also a clear sense that on occasion older figure types and styles are quoted and even revived to serve specific functions. At the same time, there is an influx of influences from the east, both in iconography and style, which also appear to convey special content. The next three chapters aim at describing this complexity; the chapters following these will investigate plausible interpretations.

SCULPTURE

The Rich Style, ca. 425–375

Although the fourth century as an arbitrary chronological unit begins with momentous events—the defeat of Athens by Sparta and the breakup of her first empire in 404 B.C., and the condemnation of Sokrates in 399—art has a different rhythm. The High Classical style had already begun to dissolve in the 420s. Though citations of the style, derived particularly from the sculptures of the Parthenon, are frequent for decades afterward, by 400 a highly mannered style dominated the Greek mainland and was spreading out to the east and west. Aptly called the Rich Style, its turbulent mannerisms continue through the first quarter of the new century and constitute a period as long in years (425–375 B.C.) as the Early Classical and High Classical periods together (480–425 B.C.).

Although the Rich Style permeates all forms of art, its most obvious trait is the treatment of drapery, which is first apparent on the frieze of the little Ionic Temple of Athena Nike at the west end of the Athenian Acropolis (**Fig. 1**). As already remarked, the temple's foundations were laid at the same time as the building of the Propylaia,[2] but it is probable that the temple and its frieze were erected just after 425 and may mark the spectacular victories of Demosthenes at Olpai in Argeia in 426/5 (Thucydides 3.106–14) or

[1] The German concept of *Gattungsstil* was very popular a few decades ago and still has some validity: U. Hausmann, *Allgemeine Grundlagen der Archäologie*, Handbuch der Archäologie (Munich 1969) 176–80.
[2] See chap. 2, p. 26 above.

of Demosthenes and Kleon over the Lakedaimonians at Sphakteria in the following year (Thucydides 4.37–40).[3] The frieze runs around all four sides of the prostyle temple and is only 0.45 meters high.[4] On the east was a now badly damaged assembly of the gods, until recently still in situ; on the south, a battle between nude Greeks and rather buxom Persians, whom one might first take to be Amazons, but the presence of a beard proves they are not. On the west and north sides are battles between Greeks.[5]

The new function of drapery as an expressive element of the composition is seen best in the battle friezes, where chlamydes arc out behind advancing or lunging figures in sympathy with the movement of the figure. Although the earliest and indeed a most impressive example of such a use of drapery occurs on the central block of the west frieze of the Parthenon (block VIII),[6] the Nike temple frieze begins to develop a real vocabulary of flying drapery. The effect is strongest on the west side, blocks i (**Fig. 1**) and k (British Museum 421 and 422);[7] on the badly damaged blocks of the south side, blocks l and e (Athens, Acropolis Museum),[8] the effect must have been similar, while on block g (British Museum 424) it is more restrained.[9] On the east frieze there is just one figure—near the north side and appearing to move swiftly to the south, or center, of the facade—whose drapery emphasizes the movement.[10] All the other figures in the divine assembly are more or less at rest, yet the characteristics of the Rich Style are just as apparent: the drapery clings to the bodies and is dominated by sharp, sinuous lines that emphasize the shape of the bodies beneath.[11] The novelty and importance of the effect can best be judged in comparison with the east frieze of the building formerly known as the Theseion and now generally recognized as the Hephaisteion.[12] Here the drapery plays no role in the battle segments of the frieze, while on the seated divinities it is far heavier and less decorative. The date of the frieze is uncertain, but it probably belongs in the 430s.[13]

[3] Furtwängler, *Meisterwerke*, 209–11 (= Furtwängler, *Masterpieces*, 443–44), favored the first of these alternatives on the basis of a later fourth-century inscription recording the restoration of the statue of Athena Nike that had been dedicated from the spoils of the battle at Olpai and others: *IG* II² 403; U. Köhler, "Zur Geschichte des amphilochischen Krieges," *Hermes* 26 (1891) 43–50; I. S. Mark, *The Sanctuary of Athena Nike in Athens: Architectural Stages and Chronology*, AIA Monograph New Series 2, *Hesperia* suppl. 26 (Princeton 1993) 79, 97, 113–14, 123.

[4] F. Felten, *Griechische tektonische Friese archaischer und klassischer Zeit* (Waldsassen 1984) 118–31.

[5] T. Hölscher, *Griechische Historienbilder des 5. und 4. Jahrhunderts v. Chr.* (Würzburg 1973) 91–98; K. Stähler, *Griechische Geschichtsbilder klassischer Zeit* (Münster 1992) 75–84.

[6] F. Brommer, *Der Parthenonfries: Katalog und Untersuchung* (Mainz 1977) pl. 23.

[7] C. Picard, *L'Acropole, l'enceinte, l'entrée, le bastion d'Athéna Niké, les propylées* (Paris 1929) pl. 41; Travlos, *Pictorial Dictionary*, figs. 207, 208; Felten, *Tektonische Friese* (note 4 above) pl. 36; C. Blümel, *Der Fries des Tempels der Athena Nike* (Berlin 1923) pls. I–III, below; Blümel, "Der Fries des Tempels der Athena Nike in der attischen Kunst des fünften Jahrhunderts vor Christus," *JdI* 65–66 (1950–51) figs. 28, 29 (p. 165).

[8] I. Trianti, *Το Μουσείο Ακροπόλεως* (Athens 1998) figs. 398, 400; Picard, *Acropole* (note 7 above) pl. 40; E. Harrison, "The South Frieze of the Nike Temple and the Marathon Painting in the Painted Stoa," *AJA* 76 (1972) pl. 76, fig. 12 (block l); Felten, *Tektonische Friese* (note 4 above) pl. 35 (block e); Blümel, *Fries des Tempels der Athena Nike* (note 7 above) pls. IV–VI, above; Blümel, *JdI* 65–66 (1950–51) figs. 22, 20 (pp. 162, 161).

[9] Picard, *Acropole* (note 7 above) pls. 40, 41; Travlos, *Pictorial Dictionary*, fig. 209; Felten, *Tektonische Friese* (note 4 above) pl. 34; Blümel, *Fries des Tempels der Athena Nike* (note 7 above) pls. IV–VI, above right; Blümel, *JdI* 65–66 (1950–51) fig. 26 (p. 164).

[10] Trianti, *Μουσείο Ακροπόλεως* (note 8 above) figs. 389, 390; Picard, *Acropole* (note 7 above) pl. 39; Blümel, *Fries des Tempels der Athena Nike* (note 7 above) pls. I–III, above right; Blümel, *JdI* 65–66 (1950–51) figs. 2 and 15 (pp. 137, 159).

[11] Trianti, *Μουσείο Ακροπόλεως* (note 8 above) figs. 386–93; Picard, *Acropole* (note 7 above) pls. 38, 39; Felten, *Tektonische Friese* (note 4 above) pl. 39; Blümel, *Fries des Tempels der Athena Nike* (note 7 above) pls. I–III, above, VII; Blümel, *JdI* 65–66 (1950–51) figs. 15–18 (pp. 159–60).

[12] S. von Bockelberg, "Die Friese des Hephaisteion," *AntP* 18 (1979) pls. 10–32; J. Dörig, *Le frise est de l'Héphaisteion* (Mainz 1985).

[13] W. A. P. Childs, "In Defense of an Early Date for the Frieze of the Temple on the Ilissos," *AM* 100 (1985) 236–39.

The mannerisms of the Rich Style characterize some of the most sensitive and beautiful works of Greek art, notably the "Sandal-binder" of the parapet of the Temple of Athena Nike (**Fig. 160**).[14] There is no external evidence for the date of the parapet, though it must be later than the temple that it encloses; opinions mostly divide between a date close to that of the construction of the temple[15] and one in the last decade of the fifth century.[16] The disagreement may be resolved by positing an interruption of work on the parapet at the time of the disastrous Sicilian expedition of 413, similar to the hiatus documented for the Erechtheion. A final, south, section, to which the "Sandal-binder" belongs, is most easily dated shortly before the final defeat of Athens in 404 B.C.[17] Comparison of the "Sandal-binder" with any of the metopes of the Parthenon delineates the salient characteristics of the style and the dramatic change of mood from the High Classic. The Nike stands on one foot while she bends forward and to the left to touch her raised right foot, probably to adjust her sandal.[18] Despite the gesture, the torso is held over the standing leg, and she holds her mantle out to the right. The composition is essentially a vertical oval defined by the great folds of the mantle across the legs below and the line of the torso, right arm, and wings above. The oval, by nature hardly a stable form, is actually not even complete here; it is broken at the upper left between the raised proper right thigh of the Nike and her head and the front edge of her wing. The sculptor has nonetheless achieved a precarious balance in both mass and line. Compare this composition to that of one of the most famous of the preserved metopes of the Parthenon, south 27 (**Fig. 161**).[19] That highly active scene is frozen by the balance of equal masses and vectors of force, which are resolved into a circle that rotates around the center of the metope, which is covered by the only drapery in the scene, the mantle of the Lapith. Here too the figures touch the ground only in a limited space off-center to the right, where the leg of the Lapith crosses the rear legs of the centaur. Yet the contrast of the metope with the "Sandal-binder" is between solid body masses frozen in counterbalanced action and a static pose in which fluid masses precariously balance linear drapery patterns.

Comparison of another slab of the Nike parapet with the Parthenon sculpture reinforces the impression of continuity and change. The two Nikai bringing a bull to sacrifice on

[14] Athens, Acrop. 973: Brouskari, *Acropolis Museum*, 158, no. 973, fig. 333; Trianti, Μουσείο Ακροπόλεως (note 8 above) 382–83, figs. 403, 404; Boardman, *GS-CP*, fig. 130.4; R. Carpenter, *The Sculpture of the Nike Temple Parapet* (Cambridge, MA, 1929) 63, pl. XXVII; E. Simon, "Zur Sandalenlöserin der Nikebalustrade," in *Kanon: Festschrift Ernst Berger zum 60. Geburtstag am 26. Februar 1988 gewidmet*, ed. M. Schmidt (Basel 1988) 69–73.

[15] Most fully argued on stylistic grounds by M. Brouskari, "Το θωράκιο τοῦ ναοῦ τῆς Αθήνας Νίκης," *ArchEph* 137 (1999) 16–55, and G. Spyropoulos, *Drei Meisterwerke der griechischen Plastik aus der Villa des Herodes Atticus zu Eva/Loukou* (Frankfurt am Main 2001) 61–128. P. Schultz, "The Date of the Nike Temple Parapet," *AJA* 106 (2002) 294–95, and M. Lippman, D. Scahill, and P. Schultz, "Knights 843–59, the Nike Temple Bastion, and Cleon's Shields from Pylos," *AJA* 110 (2006) 559, also argue for a date close to 420 because provision for the parapet was made in the rebate carved into the crown molding of the bastion, which had to have been set before the temple itself was built. This is certainly correct, but provides only a terminus post quem. The further argument that δρύφακτον in *IG* I³ 64A, refers to the parapet is an interesting hypothesis but is not compelling.

[16] Ridgway, *Fifth Century Styles*, 98; A. Delivorrias, "*Disiecta Membra*: The Remarkable History of Some Sculptures from an Unknown Temple," in *Marble: Art Historical and Scientific Perspectives on Ancient Sculpture*, ed. M. True and J. Podany (Malibu, CA, 1990) 11–46.

[17] E. Harrison, "Style Phases in Greek Sculpture from 450 to 370 B.C.," in *Proceedings of the 12th International Congress of Classical Archaeology, Athens, 4–10 September 1983*, vol. 3 (Athens 1988) 103–4, suggests that a very last phase (Master F) should be dated to the first decade of the fourth century and the completion of the parapet sculpture should be associated with the naval victories of Konon. This seems to me possible.

[18] The basic elements of this figure appear in mirror image on the east frieze of the Temple of Athena Nike; the differences emphasize the swift stylistic development: Trianti, Μουσείο Ακροπόλεως (note 8 above) 360–61, figs. 386, 387; Picard, *Acropole* (note 7 above) pl. 38; Blümel, *Fries des Tempels der Athena Nike* (note 7 above) pl. VIII, above; Blümel, *JdI* 65–66 (1950–51) figs. 13 and 18 (pp. 153, 160).

[19] F. Brommer, *Die Metopen des Parthenon* (Mainz 1967) pls. 216–20.

the north side of the parapet are set in a V pattern with the bull between.[20] The figures of Athena and Poseidon on the west pediment of the Parthenon were similarly arranged, as the drawing by Jacques Carrey shows.[21] The closer juxtaposition of the statues of the pediment and their solid mass contrast with the more distant placement of the two Nikai and the linear swirls of their drapery. In addition, the diagonal placement of the bull between them and the twist of its neck heighten the sense of space and movement in the scene. Precisely what occupied the center of the west pediment of the Parthenon is unknown, but the sacred olive tree, which is variously reconstructed, probably created a static central axis bisecting the V-shaped arrangement of the two divinities on either side.[22]

Typical of the Rich Style, a major trait of the reliefs of the Nike parapet is the treatment of the drapery. The dominance of linear pattern is particularly clear in the pair of Nikai with the bull. Similar patterns are found in the work of the Meidias Painter at the end of the fifth century (**Fig. 201**).[23] The "Sandal-binder" adds to this a sense of texture: her chiton clings transparently to her torso, while at her feet the hem is depicted in a more traditional opaque crinkle pattern. Her mantle contrasts with both textures of the chiton and seems a viscous dough. A similar though less pronounced example of drapery that is both transparent and opaque occurs at the end of the fifth century on the frieze of the Erechtheion (**Fig. 3**) together with heavy, doughy drapery that is sometimes bunched in the crotch.[24] The development of this manneristic treatment of drapery is visible in sculpture of the High Classical period. From the metopes and east frieze of the Parthenon to the pediments, drapery becomes progressively more linear and molded to the body. The most famous examples of the latter style are the three figures of the east pediment known by the letters K, L, and M; figure M is identified as Aphrodite.[25] The generally heavy drapery of her himation is twisted around her legs yet reveals their form clearly; above, her mildly swelling belly is modeled by a few folds caused by the pinching of the soft cloth of her chiton by her belt; finally, her chiton changes texture and becomes clinging and viscous over her breasts, clearly to emphasize their swelling forms. Already the manneristic transformation of a single garment into multiple textures and patterns prefigures the "Sandal-binder" of the Nike temple's parapet. Just as stunning is the fragmentary torso of Athena (figure L) from the west pediment, with her narrow aegis running between her breasts, from which folds hang as though trickles of water over the moist and clinging cloth.[26] This development can also be traced in freestanding statues,

[20] Brouskari, *Acropolis Museum*, 160–61, nos. 972 and 2680, fig. 342; Trianti, *Μουσείο Ακροπόλεως* (note 8 above) 389, fig. 410; Carpenter, *Nike Temple Parapet* (note 14 above) 19, 23, no. 11, pls. V, VII; Boardman, *GS-CP*, fig. 130.1.

[21] T. Bowie and D. Thimme, *The Carrey Drawings of the Parthenon Sculptures* (Bloomington, IN, 1971) pl. 1 (figures L and M); a model of the pediment in the state seen by Carrey is in Basel: E. Berger, "Bauwerk und Plastik des Parthenon: Stationen des Verfalls und der Wiederherstellung," *AntK* 23 (1970) pl. 17.

[22] E. Simon, "Die Mittelgruppe im Westgiebel des Parthenon," in *Tainia: Roland Hampe zum 70. Geburtstag am 2. Dezember 1978*, ed. H. A. Cahn and E. Simon (Mainz 1980) 239–55.

[23] Burn, *Meidias Painter*, pls. 3–7a (hydria, London, BM E 224), 19a (pyxis lid, London, BM E 775).

[24] Brouskari, *Acropolis Museum*, 156, 154–55, nos. 1071, 1073, figs. 331, 324; Boulter, *AntP* 10 (1970) pls. 11, 26. Note Harrison's chronology in "Style Phases in Greek Sculpture" (note 17 above) 103–5, where she dates Master E of the Nike parapet parallel with the Erechtheion frieze (last decade of the fifth century) and the last phase (Master F) to the 390s; this comparison supports her suggestion.

[25] F. Brommer, *Die Giebel des Parthenon: Eine Einführung* (Mainz 1959) pls. 45–49; Boardman, *GS-CP*, fig. 80.3.

[26] Brommer, *Giebel*, pls. 87–101. See the commentary of L. Llewellyn-Jones, "Sexy Athena: The Dress and Erotic Representation of a Virgin War-Goddess," in *Athena in the Classical World*, ed. S. Deacy and A. Villing (Leiden, Boston, and Cologne 2001) 254–57, on the Athena of the east frieze of the Parthenon, and J. G. Younger, "Gender and Sexuality in the Parthenon Frieze," in *Naked Truths: Women, Sexuality, and Gender in Classical Art and Archaeology*, ed. A. O. Koloski-Ostrow and C. L. Lyons (London and New York 1997) 134.

from the Kore Albani (**Fig. 162**) to the Nemesis of Rhamnous (**Figs. 127, 128**) to a statue of Persephone in Eleusis.[27] The first of these statues is known only in a Roman copy, the second in the form of a copy and some fragments of the original; the third is very probably an original. To justify the conclusions drawn from this comparison, only the Kore Albani needs to be defended as a reasonably accurate copy rather than an adaptation or Roman ideal statue. The fragmentary female torso of south metope 19 of the Parthenon performs this duty quite adequately,[28] as does the small statuette replica of the Kore Albani in Venice (**Fig. 82**).[29]

In the Rich Style, drapery is a many-textured thing, an adjunct to rather than a covering of the body. In the first years of the fourth century, drapery achieves new levels of expression on the frieze of the Temple of Apollo Epikourios at Bassai (**Figs. 23–25**).[30] The folds of the warriors' short skirts stretch between their knees in emphatic horizontal bands, like motion lines in modern comic strips.[31] The twists and swirls of chlamydes around arms express the complex gestures of rotation and lunging (**Fig. 23**),[32] a motif already employed on the frieze of the Temple of Athena Nike in the depiction of a horse rearing, rotating, and collapsing.[33] The even more violent swirls of the Bassai frieze (**Fig. 23**) contrast with the limp drapery of a fallen and a falling Amazon (**Fig. 24**),[34] which express with astonishing clarity the differing situations of the figures. The patterns of drapery may become more tortuous, culminating in the Nereid and Nike acroteria in the Athenian Agora (**Figs. 41, 42**), but the expressive vocabulary has achieved its apogee at Bassai.[35]

The Plain Style, ca. 380–300 B.C.

The excesses of the last phase of the Rich Style are abandoned somewhat after 380, as seen in the ambivalent sculptures of the Temple of Asklepios at Epidauros (**Figs. 28–33**).[36] There is no secure date for the temple, but a consensus has gradually developed that places it in the decade 380–370.[37] The temple is noteworthy not only because its sculpture is relatively well preserved, but also because the building accounts inscribed on a marble

[27] Kore Albani: Rome, Villa Albani 749: Bol, *Villa Albani*, vol. 4, 205–22, no. 460, pls. 125–31 (C. Maderna-Lauter); *LIMC*, s.v. Aphrodite no. 149* (A. Delivorrias); Boardman, *GS-CP*, fig. 210. Nemesis: G. I. Despinis, Συμβολή στη μελέτη του έργου του Αγορακρίτου (Athens 1971); *LIMC*, s.v. Nemesis nos. 1*, 2* (P. Karanastassis); Boardman, *GS-CP*, fig. 122; Bol, *Bildhauerkunst*, vol. 2, 213, fig. 137 (D. Kreikenbom). Persephone: Eleusis 5076 (64): L. E. Baumer, "Betrachtungen zur 'Demeter von Eleusis,'" *AntK* 38 (1995) 11–25, pls. 6–8.1; *LIMC*, s.v. Demeter no. 50 (the accompanying photograph is not of this statue) (L. Beschi); Boardman, *GS-CP*, fig. 137; Bol, *Bildhauerkunst*, vol. 2, 222–23, fig. 157 (W. Geominy). The grave stele Athens, NAM 1822, also represents the end phase of this development: Kaltsas, *SNAMA*, no. 296, p. 152*; Diepolder, *Grabreliefs*, pl. 21; Clairmont, *CAT*, 2.151.

[28] Brommer, *Metopen* (note 19 above) pl. 207; cf. Maderna-Lauter, in Bol, *Villa Albani*, vol. 4, 211–12, 215.

[29] R. Kabus-Jahn, "Die Grimanische Figurengruppe in Venedig," *AntP* 11 (1972) 13–20, pl. 1; Boardman, *GS-CP*, fig. 196.1.

[30] C. Hofkes-Brukker and A. Mallwitz, *Der Bassai-Fries* (Munich 1975); Madigan, *Apollo Bassitas*.

[31] Hofkes-Brukker and Mallwitz, *Bassai-Fries*, 76–77, 86–87 (blocks 534, 535, 538, 533); Madigan, *Apollo Bassitas*, pls. 46–48.

[32] Hofkes-Brukker and Mallwitz, *Bassai-Fries*, 58–59, 73, 79, 85 (blocks 530, 531, 540, 538); Madigan, *Apollo Bassitas*, pls. 45, 47, 48.

[33] Picard, *Acropole* (note 7 above) pl. 41.1; Harrison, *AJA* 76 (1972) 354–55, pl. 56, fig. 12; Stähler, *Griechische Geschichtsbilder*, 77, pl. 7.3.

[34] Hofkes-Brukker and Mallwitz, *Bassai-Fries*, 73, 87; Madigan, *Apollo Bassitas*, pls. 45, 46.

[35] A. Delivorrias, *Attische Giebelskulpturen und Akrotere des fünften Jahrhunderts* (Tübingen 1970) pls. 44, 45, 48–51; Boardman, *GS-CP*, figs. 118, 119.

[36] N. Yalouris, "Die Skulpturen des Asklepiostempels in Epidauros," *AntP* 21 (1992), with earlier bibliography; Bol, *Bildhauerkunst*, vol. 2, 272–77, figs. 214–25 (W. Geominy).

[37] Yalouris, *AntP* 21 (1992) 82–83.

stele are largely preserved.[38] These indicate a very brief duration of only four and a half years plus seventy days, or roughly four years and eight months, for the completion of all elements of the building, including the sculpture.[39] The inscription also includes the full names of two sculptors, Hektoridas and Timotheos, the unrecognizably damaged name of another sculptor, and one more that is completely lost. Hektoridas is otherwise known only from one inscribed base from Epidauros.[40] Timotheos is cited four times in later texts—once by Vitruvius, twice by Pliny, and once by Pausanias.[41] As we have seen already, defining his or any other sculptor's personal style is difficult at best. For the moment, the importance of the sculptures of the Temple of Asklepios is that they share characteristics of the preceding Rich Style and the succeeding Plain Style. Yalouris has argued that Timotheos was the designer of all the sculptures of the temple,[42] which, if true, would suggest that the new style did not spring full-blown from the head of a revolutionary artist, but evolved slowly. This is also suggested by the combination of Rich and Plain Styles in the record relief marking a treaty between Athens and Kerkyra, unfortunately without dating formula but usually assigned to the period around 375 or just slightly later (**Fig. 101**).[43] Certainly the seated Erechtheus or Kekrops on the relief precisely dated to 377/6 (**Fig. 163**) is very close to the seated Zeus of the Kerkyra relief.[44] The signal characteristic of these reliefs is that the drapery does not cling to the body but forms large smooth areas that contrast with the sharp, sinuous folds. Although the record reliefs never embrace the full force of the Rich Style's mannerisms, the reliefs of 403/2, 400/399, and 397/6 demonstrate well the contrast with the reliefs of the 370s.[45] The transition to the new style is complete in the record relief of 362/1 (**Fig. 102**).[46] Here the drapery of the standing figures has become a real covering of the body and is no longer an adjunct to it. The vertical folds over the standing legs have a variety of fold patterns combining long, narrow, straight ridges with broad, flat ones.

To return to the Temple of Asklepios at Epidauros, it is one of the smallest of Greek classical temples, measuring 12.03 × 23.28 meters, with six by eleven columns.[47] The pedimental sculptures and the acroteria are correspondingly small: all are less than one meter high. The one relatively well-preserved Nike acroterion (**Fig. 31**), which Yalouris attributes to the east facade of the temple,[48] and one of the two well-preserved women (Aurai) riding rampant horses that must be the corner acroteria of the west end of the building (**Fig.**

[38] *IG* IV², I, 102: G. Roux, *L'architecture de l'Argolide aux IVe et IIIe siècles avant J.-C.* (Paris 1961) 84–89, 424–32 (translation); Burford, *Temple Builders*, 54–59, 207, 212–20 (translation).

[39] The figure is derived from the fact that the architect received two payments of 353 drachmas, two of 350 drachmas, one of 175 drachmas, and a final payment of 70 drachmas: *IG* IV², I, 102: face A, col. I, 9, 31–32, 54; face B, col. I, 104–5, 110–11.

[40] *IG* IV², I, 695; Yalouris, *AntP* 21 (1992) 68–69.

[41] Vitruvius 2.8.11; Pliny, *NH* 34.91, 36.32; Pausanias 2.32.4; Yalouris, *AntP* 21 (1992) 69. The three later passages are in Overbeck, *Schriftquellen*, nos. 1328–30.

[42] Yalouris, *AntP* 21 (1992) 70–74.

[43] Athens, NAM 1467: Lawton, *Document Reliefs*, 70, 126–27, no. 96, pl. 50; Meyer, *Urkundenreliefs*, 47–48, 280, no. A 51, pl. 16.2; Bol, *Bildhauerkunst*, vol. 2, 359–60, fig. 192 (W. Geominy). Rhodes and Osborne, *Greek Historical Inscriptions*, 112 (no. 24) date the inscription later, 372/1.

[44] Athens, EM 7859: Lawton, *Document Reliefs*, 92–93, no. 20, pl. 11; Meyer, *Urkundenreliefs*, 51, 279, no. A 49, pl. 16.1.

[45] Athens, Acrop. 1333; Athens, EM 7862; Athens, NAM 1479: Lawton, *Document Reliefs*, 88–90, nos. 12–14, pls. 7, 8; Meyer, *Urkundenreliefs*, 273–74, 275–76, nos. A 26, A 27, A 36, pls. 10.1, 10.2, 11.1.

[46] Athens, NAM 1481: Lawton, *Document Reliefs*, 94, no. 24, pl. 13; Meyer, *Urkundenreliefs*, 282, no. A 58, pl. 17.2; Bol, *Bildhauerkunst*, vol. 2, 259–60, fig. 193 (W. Geominy).

[47] Roux, *Architecture de l'Argolide* (note 38 above) 83–130.

[48] Yalouris, *AntP* 21 (1992) 19, no. 2, pls. 3–5.

33), present the exaggerated mannerisms of the late Rich Style.[49] The contrast of smooth drapery and sharp, sinuous fold ridges together with the turbulent bunch of cloth on the thighs of the horse-riding figure are characteristics of many of the fragmentary figures from the east pediment.[50] The other two acroteria attributed to the west end of the temple share many of these traits, but moderated at least in part by a thicker rendition of cloth that, particularly in the case of the central acroterion figure of a Nike holding a bird (**Fig. 32**),[51] begins to be cloth instead of an independent pattern over the body or adjacent to it. This new concept of cloth as actual clothing is clearest in the Amazon on a rampant horse in the center of the west pediment (**Fig. 28**);[52] the contrast with the horse-riding acroterion figures of the same side of the building is stark. The drapery appears to cover the body; the breasts of the Amazon, though the cloth clings to them, are less emphasized by the patterns than those of the figures of Aphrodite and Athena in the pediments of the Parthenon. The hem of her garment does twist up into a series of small loops, but how quiet they are in view of the vigorous pose! The same sense of cloth as material and as an independent mass rather than an expressive pattern is found in most of the fragmentary figures of the west pediment, though there is also ample evidence that the Rich Style is not distant.[53]

This interest in texture remains an important characteristic of drapery throughout the fourth century. The Amazon's garment is quite distinct from the body that it actually clothes; that is, the body and its garment are two separate but related entities, and the cloth has a coherent and realistic texture. I am, however, not certain that one can speak of realistic drapery at any point in this period, though the violent mannerisms of the Rich Style are first moderated and then largely eliminated. The name given to the new style after 380–375 is the "Plain Style." It is perhaps useless to quibble about nomenclature, but few figures in this style, and far fewer drapery patterns, can be accurately described as "plain." Indeed, opulent drapery is the norm. Comparison of any number of female figures throughout the course of the fourth century with High Classical counterparts reveals how lively the drapery of the so-called Plain Style is: the woman ("Hera") from Samos in Berlin (**Fig. 164**)[54] versus the Kore Albani (**Fig. 162**);[55] the Artemis Colonna (**Figs. 165, 166**)[56] versus figure G (Iris or Artemis) in the east pediment of the Parthenon (**Fig. 167**);[57] the Athena Vescovali (**Figs. 145, 146**)[58] or Rospigliosi (**Figs. 168, 169**)[59] versus the Athena

[49] Ibid., 31–33, no. 26, pls. 27, 28.

[50] Ibid., 21–22, no. 7, pl. 9; 25, no. 14, pl. 15; 28, no. 19, pls. 18, 19; 29, no. 22, pl. 22.

[51] Ibid., 30–31, no. 25, pls. 24–26; 32–33, no. 27, pls. 29–31.

[52] Ibid., 35–38, no. 34, pls. 40–42. A larger but closely similar statue of an Amazon on a rampant horse is in Boston, MFA 03.751: Comstock and Vermeule, *Sculpture in Stone*, 32, no. 42*; Yalouris, *AntP* 21 (1992) 39, figs. 9, 10.

[53] Yalouris, *AntP* 21 (1992) no. 37 (Amazon falling off horse), pl. 46.

[54] Berlin, Staatl. Mus. Sk 1775: R. Horn, *Samos*, vol. 12, *Hellenistische Bildwerke auf Samos* (Bonn 1972) 1–5, 77–79, no. 1, pls. 1–4, 10.1; Knittlmayer and Heilmeyer, *Antikensammlung Berlin*², 193–94, no. 115*; Boardman, *GS-LCP*, fig. 50. Horn (pp. 2–3) argues that the statue must be earlier, though only slightly, than the expulsion of the Athenians in 322/1. Compare the peplophoros from the Dionysion on Thasos, which may even date in the early third century: P. Bernard and F. Salviat, "Nouvelles découvertes au Dionysion de Thasos," *BCH* 83 (1959) 302–15, figs. 13, 14, pls. XIII–XVII.

[55] See note 27 above.

[56] Berlin, Staatl. Mus. Sk 59: C. Blümel, *Staatliche Museen zu Berlin: Katalog der Sammlung antiker Skulpturen*, vol. 5, *Römische Kopien griechischer Skulpturen des vierten Jahrhunderts v. Chr.* (Berlin 1938) 27–28, K 243, pls. 59–61; Bieber, *Ancient Copies*, 88–89, figs. 366–71; Beck, Bol, and Bückling, *Polyklet*, nos. 137–41; Todisco, *Scultura greca*, no. 64; Boardman, *GS-LCP*, fig. 85.

[57] Brommer, *Giebel*, pl. 39; Boardman, *GS-CP*, fig. 80.2.

[58] W. Schürmann, "Der Typus der Athena Vescovali und seine Umbildungen," *AntP* 27 (2000). See pp. 130–31 below.

[59] I. E. Altripp, "Zu den Athenatypen Rospigliosi und Vescovali: Die Geschichte einer Verwechslung," *AA*, 1996, 83–94. See pp. 131–32 below.

Velletri.[60] I shall return to consider these in greater detail below, but a single comparison serves my purpose best: the caryatids of the Erechtheion (**Fig. 2**)[61] versus the statue group of Eirene and Ploutos (**Fig. 12**), a Roman copy known in several examples and thought to reflect a group set up by the Athenians at the altar of Peace (Eirene) in the Agora, either to commemorate a victory or negotiations for peace with Sparta between 375 and 371.[62] Despite the fact that the Eirene is known only in Roman copies, it is certain that a group of this form existed in the second quarter of the fourth century from its representation in miniature on the columns flanking Athena on the Panathenaic vases of the archonship of Kallimedes in 360/59 (**Fig. 122**).[63] In addition, a fragment of the Ploutos was found among the plaster casts at Baiae.[64] Despite all the differences in function—architectural support versus purported cult statue—the Eirene clearly reflects the basic patterns of the caryatids. The stance and garments are indeed the same; the contrast of smooth drapery over the forward-set proper right leg with the vertical fluting of the drapery over the proper left (standing) leg is also very close. Even the fold pattern of Eirene's overfold is close to that of one of the caryatids (C, in London [**Fig. 2**]).[65] There are differences in detail, to be sure: the rendering of the hair in a bound-up braid versus open strands over the shoulder; the pose and turn of the head; the presence of Ploutos, etc. The important differences, however, are the broad rendition of the folds over the standing leg of Eirene, in contrast to the narrow, linear, and busier folds over the caryatid's standing legs, to which are added slightly curved folds running parallel to the free leg. On the Eirene the torso appears broader and flatter, an effect heightened by the spreading out of the drapery behind her arms. She is stockier, more matronly. The effect is indeed plainer; the cloth is heavier and more concealing. The spreading out of the himation behind her arms does convey depth, since there is a real distance between the front plane of the overfold and the folds of the himation, but the plastic, curved surfaces of the caryatids convey a more convincing sense of volume. Since they function as columns, the plastic mass of the caryatids has a purpose, both real and apparent: they must support the roof of the south porch and appear to do so convincingly. If the Eirene is correctly identified as the copy of a cult statue, the emphasis on a frontal plane may also have functional significance: the isolation of the epiphany for the viewer, almost like the mandorla of Early Christian art.[66] The emphasis on a relatively flat frontal plane is discernible in many statues of goddesses from the High Classical period,[67] but the Eirene adds a new characteristic: both real depth and

[60] *LIMC*, s.v. Athena no. 247* (P. Demargne); Harrison, *AJA* 81 (1977) 150–55, figs. 8–17; Todisco, *Scultura greca*, no. 5; Boardman, *GS-CP*, fig. 202.

[61] H. Lauter, "Die Koren des Erechtheions," *AntP* 16 (1976).

[62] N. Agnoli, "L'Eirene di Kephisodotos nella replica da Palombara Sabina," *Xenia* 7 (1998) 5–24; E. Simon, "Eirene und Pax: Friedensgöttinnen in der Antike," *SBFrankfurt* 24, no. 3 (1988) 62–66, pl. 4; Vierneisel-Schlörb, *Klassische Skulpturen*, 255–73, no. 25, figs. 119–27; H. Jung, "Zur Eirene des Kephisodot," *JdI* 91 (1976) 97–134; E. La Rocca, "Eirene e Ploutos," *JdI* 89 (1974) 112–36; *LIMC*, s.v. Eirene no. 8* (E. Simon); A. C. Smith, *Polis and Personification in Classical Athenian Art* (Leiden 2011) 110–12, 146–47, no. S 4; Stafford, *Worshipping Virtues*, 173–84; Todisco, *Scultura greca*, no. 96; Bol, *Bildhauerkunst*, vol. 2, 284–85, figs. 240a, b (W. Geominy).

[63] N. Eschbach, *Statuen auf panathenäischen Preisamphoren des 4. Jhs. v. Chr.* (Mainz 1986) 58–70, figs. 36–48, pls. 16–18; Valavanis, Παναθηναϊκοί αμφορείς, 110–12, pls. 40–42, 51, 57; Bentz, *Preisamphoren*, 172–73, pls. 112–14.

[64] Landwehr, *Gipsabgüsse*, 103–4, no. 63, pl. 60.

[65] London, BM 407: Lauter, *AntP* 16 (1976) pls. 23–31; Boardman, *GS-CP*, fig. 125.

[66] Eschbach, *Preisamphoren* (note 63 above) 68, notes, however, that the depictions of the group on the Panathenaics of 360/59 show the group seen slightly off center from the proper right side, rather than directly from the front.

[67] E.g., in the fifth century the Athena Medici: *LIMC*, s.v. Athena/Minerva no. 144* (F. Canciani); Boardman, *GS-CP*, fig. 200; Rolley, *Sculpture grecque*, 132–33, fig. 118; and the Athena Veletri: *LIMC*, s.v. Athena no. 247* (P. Demargne); Harrison, *AJA* 81 (1977) 151–55, figs. 8–10; Rolley, *Sculpture grecque*, 138–39, fig. 123; Todisco, *Scultura greca*, no. 5; Boardman, *GS-CP*, fig. 202.

an illusionistic sense of depth, as described by Adolf Borbein.[68] The fifth-century trait of developing modeling lines that lead the viewer's eye around a figure to emphasize the real but invisible depth of the sculpture[69] is replaced by the build-up of real depth achieved by stacking elements of the side and/or back views at the sides of the figure so that they could be seen from the front. As is evident in this comparison of the caryatids and the Eirene, the fifth-century pattern allows the real volume of the statue to be seen from divergent points of view, while the fourth-century pattern places far greater emphasis on a rather strict frontal point of view.[70] The use of the mantle hanging from both shoulders and projecting at either side of a figure is the simplest version of this technique, and it is seen on the Aphrodite of the Louvre (Fréjus)-Naples type, perhaps of the last decade of the fifth century, and the Eirene under discussion.[71]

The heavy, realistic cloth folds of the peplos of the statue of Eirene parallel in a different mode the change in style evident in the opaque crinkle folds of the Amazon at the center of the west pediment of the Temple of Asklepios at Epidauros. Although the absolute date of neither is certain (and the Eirene is in any case a Roman copy), the probable date of the Eirene and Ploutos agrees with the evidence cited above derived from the Athenian record reliefs. The circumstantial evidence for the date of the Temple of Asklepios at Epidauros (after 380) and for the original of the statue of Eirene and Ploutos (after 375, before 360) is in broad terms confirmed.

Statues of Males

Another index of the shift from the style of the High Classic to the sculpture of the fourth century is the development of stance. The statue of the Diadoumenos, attributed to the great master Polykleitos, has broken with the self-contained rhythms of the earlier, High Classical, Doryphoros. The act of tying a fillet around the head is combined with a movemented position of the legs, creating an apparent conflict of gesture and stance.[72] It is, however, the altogether heightened sense of movement in the statue that is most striking and introduces a series of new poses, all of which suggest a more active image of the human form than the one prevalent in freestanding sculpture of the High Classical style. Variations on that theme are numerous in the late fifth century and are used to express a wholly new view of the human condition. The Westmacott boy raises one arm to his head while the other hangs limply at his side; his head is turned down as though in contemplation,[73] yet the stance of the legs again suggests conflicting motions.[74] A further variation on the theme is the so-called Narkissos

[68] A. H. Borbein, "Die griechische Statue des 4. Jahrhunderts v. Chr.," *JdI* 88 (1973) 108–31.

[69] R. Carpenter, *Greek Sculpture: A Critical Review* (Chicago 1960) 129–51.

[70] A. H. Borbein, "Kanon und Ideal: Kritische Aspekte der Hochklassik," *AM* 100 (1985) 254.

[71] M. Brinke, "Die Aphrodite Louvre-Neapel," *AntP* 25 (1996) 7–64; Rolley, *Sculpture grecque*, 142–43, fig. 127. L. J. Roccos, "The Shoulder-Pinned Back Mantle in Greek and Roman Sculpture" (Ph.D. diss., New York University, 1986) dates the introduction of the back-pinned mantle, a garment which aids greatly the effect of depth and volume in sculpture, to the last quarter of the fifth century.

[72] N. Himmelmann, "The Stance of the Polykleitan Diadoumenos," in Himmelmann, *Reading Greek Art*, originally published as "Die 'Schrittstellung' des polykletischen Diadumenos," *MarbWPr*, 1967, 27–39.

[73] Borbein, *AM* 100 (1985) 264, 265–68; Stewart, *Greek Sculpture*, 80. Cf. Himmelmann, *Attische Grabreliefs*, 112, n. 137; Bol, *Bildhauerkunst*, vol. 2, 243–48, fig. 180 (D. Kreikenbom).

[74] Zanker, *Klassizistische Statuen*, pls. 21–23. H. Meyer, "A Roman Masterpiece: The Minneapolis Doryphoros," in *Polykleitos, the Doryphoros, and Tradition*, ed. W. G. Moon (Madison, WI, 1995) 108–11, figs. 6.89–96, describes these characteristics with particular clarity.

(**Fig. 171**).[75] His legs are less movemented than those of the preceding statues, but, while he leans relatively solidly on his proper left arm, which rested on an object that came to mid-thigh, he places his proper right arm behind his back in a pose that will become particularly popular thereafter. This pose creates a series of contrasting forward and backward movements of the body: proper left shoulder forward, proper left leg back; proper right shoulder back, proper right leg forward. The motif again emphasizes the opposition of a clearly static pose or situation with a distinctly contrasting motion in the body. Less clearly related to this motif is the leaning Aphrodite type, yet it too reflects the same ambiance as the preceding examples.[76] The compositional frame of the figures is a right triangle, with the body forming the hypotenuse.[77] Here the novelty is the introduction of an unstable pose which is brought into balance by an object distinct from the human figure—pillar, tree, etc.—again a compositional structure that becomes popular in the fourth century. The idea is already implicit in the wounded Amazon and the "Narkissos" types, but the truly leaning Aphrodite type finally leans with greater vigor, creating a lively interaction of stasis and internal tension. The popularity of the new composition is demonstrated by its use on a grave stele of the end of the fifth century in Athens.[78]

A notably different but related stance is found in the diskobolos attributed to Naukydes (**Figs. 172, 173**)[79] and the Ares Borghese.[80] Both stand with their feet solidly planted on the ground; the body is carried over the rear standing leg, creating a vertical axis, while the free leg is set forward at an angle. The result is a triangular composition, but now in depth; the body appears to recoil slightly from the viewer.[81] The diskobolos is the more complex of the two statues. There is no real frontal plane, even though there is a logical position from which to view the statue, which is a bit difficult to describe. The frontal plane of the statue is determined approximately by the toes of the two feet; the center point of the statue is approximately the groin. Looking at the statue from a position perpendicular to the plane of the toes, all elements of the statue—legs, torso, head—are seen obliquely. The effect creates a spiral turning from the viewer's right to left: from the viewer's point of view the leg on the right is back, the leg on the left is forward; the right side of the torso is forward, the left is back; the head is turned even more to the left. Here is a consummately subtle rendition of the action of a diskobolos's twirling motion, even though he is

[75] Paris, Louvre Ma 457: Beck, Bol, and Bückling, *Polyklet*, 599–600, no. 123 (A. Linfert); Rolley, *Sculpture grecque*, 48, fig. 34; Todisco, *Scultura greca*, no. 34; Bol, *Bildhauerkunst*, vol. 2, 245–48, figs. 182a, b (D. Kreikenbom). See also Zanker, *Klassizistischen Statuen*, pl. 29.1; Arnold, *Polykletnachfolge*, 54–64, pls. 3a, 4a; Landwehr, *Gipsabgüsse*, 100–102, nos. 59–62, pls. 58, 59.

[76] A. Delivorrias, "Die Kultstatue der Aphrodite von Daphni," *AntP* 8 (1968) 19–31; *LIMC*, s.v. Aphrodite nos. 185*–203* (A. Delivorrias et al.); Rolley, *Sculpture grecque*, 140–41, fig. 124.

[77] W. Drost, "Strukturwandel der griechischen Kunst im Zeitalter des Euripides," *Gymnasium* 77 (1970) 375–91.

[78] Athens, NAM 3891: Kaltsas, *SNAMA*, 154, no. 301*; Clairmont, *CAT*, 1.182.

[79] Frankfurt, Liebieghaus 2608: Bol, *Antretende Diskobol*; Arnold, *Polykletnachfolge*, 110–23, pls. 11b, 12, 13b; A. Linfert, "Die Schule des Polyklets," in Beck, Bol, and Bückling, *Polyklet*, 268, 271, figs. 133, 139, 603–5*, no. 128; Stewart, *Greek Sculpture*, 169, fig. 442; Rausa, *Vincitore*, 120–21, 199–202, no. 13, figs. 20–22; Todisco, *Scultura greca*, no. 47; Boardman, *GS-CP*, fig. 233.

[80] Paris, Louvre Ma 866: W.-H. Schuchhardt, *Alkamenes*, BWPr 126 (Berlin 1977) 33–37; Vierneisel-Schlörb, *Klassische Skulpturen*, 178–85, no. 16, figs. 80–84; K. J. Hartswick, "The Ares Borghese Reconsidered," *RA*, 1990, 227–83; Linfert, "Schule des Polyklets" (note 79 above) 271–73, fig. 134; Todisco, *Scultura greca*, no. 4; Boardman, *GS-CP*, fig. 223; Bol, *Bildhauerkunst*, vol. 2, 242–43 figs. 174a, b (D. Kreikenbom).

[81] The left-hand statue that once stood on the Atarbos base on the Athenian Acropolis was depicted in this stance, assuring us that the various Roman copies and adaptations are based on good prototypes: Brouskari, *Acropolis Museum*, 20, fig. 5; A. L. Boegehold, "Group and Single Competitions at the Panathenaia," in *Worshipping Athena: Panathenaia and Parthenon*, ed. J. Neils (Madison, WI, 1996) 101–3, figs. 4.1, 4.2. See further chap. 5A, p. 171 below.

at rest. This impression is enhanced by the position of the feet of the Frankfurt example (**Figs. 172, 173**), particularly the right foot, whose toes grip the ground in anticipation of the throw.[82] The compositional structure is not profoundly different from that of the various leaning statues discussed above, but the internal movement is new. Here, though, the balance of the figure is established within itself: the downward-turned glance and the horizontal gesture of the arm counterbalance the apparent shift of the torso backward.

There are differences, and important ones, between the diskobolos and the Ares Borghese: the knees of the Ares are not bent, while those of the diskobolos are slightly; the torso of the Ares forms the frontal plane of the statue. The Ares is at rest and contemplative; the diskobolos too is reflecting, but at the same time he is flexing his joints and about to move; his purpose is clear, while Ares' is not.[83] Brunilde Ridgway's suggestion that the Ares is a Roman classicistic work is convincing.[84] The diskobolos follows the principle of tenuous balance seen in of all the statues just discussed. In addition, the stance of all these statues has become more specific, or, perhaps more accurately, less generalized. The balanced motion and stasis of the Doryphoros has been replaced by an uneasy and only partial equilibrium, much like the "Sandal-binder" in comparison to south metope 27 of the Parthenon (**Figs. 160, 161**).

Despite the number of names of important sculptors known from later texts to have worked during the fourth century, attributions are most difficult unless the subject is rare or unique, as discussed in chapters 2 and 3 above. In lieu of attributions to specific sculptors, it may be possible to group works by the general school—the Peloponnesian or Polykleitan school, and the Attic or Praxitelian school. In broad terms, the former represents males as broad and muscular; the latter as slim and lithe. These differences are well illustrated by a comparison of two original bronzes, the youth from Antikythera (**Figs. 69, 70**)[85] and the boy from Marathon Bay (**Figs. 65–67**).[86] The general scholarly consensus is that they both belong at or just after the middle of the fourth century, although Nikolaus Himmelmann has argued for a date earlier in the century.[87] There are common features: both stand frontally and both raise their proper right arm forward and slightly to the viewer's left. The contrasts are obvious: the statue from Antikythera represents a young male with pubic hair and a powerful, muscular body; the boy from Marathon Bay is an adolescent with slim, unmuscular body and limbs. Each sets the proper right leg well back, but the Antikythera statue's right foot is set a good bit farther back and farther out to the side. This stance conveys a slightly greater sense of motion, but the vertical, broad, and powerful chest offsets this motion. It also stabilizes the emphasis of the head

[82] Bol, *Antetrende Diskobol*, 28.

[83] Arnold, *Polykletnachfolge*, 112–13, stresses the ambiguity of the pose, which does not allow a precise moment in the throwing of a discus to be specified; rather, action is blended with a "geistige Tätigkeit" (p. 113). See further chap. 5A, pp. 193–94 below.

[84] Ridgway, *Roman Copies*, 68–69, 85, pl. 80, and *Fourth-Century Styles*, 243–44, pls. 56, 57; Hartswick, *RA*, 1990, 227–83; the statue is accepted by D. Kreikenbom, in Bol, *Bildhauerkunst*, vol. 2, 242–43.

[85] Athens, NAM X 13396 (6758): J. N. Svoronos, *Das athener Nationalmuseum* (Athens 1908–11) 18–28, no. 1, pls. 1, 2; Kaltsas, *SNAMA*, 248–49, no. 518*; Houser, *Bronze Sculpture*, 179–96, ills. 11.1–13, with photographs of restoration in progress (ills. 11.12a–d); *LIMC*, s.v. Perseus no. 65* (L. J. Roccos); Arnold, *Polykletnachfolge*, 207–10, pl. 27c; Ridgway, *Fourth-Century Styles*, 340–42, pls. 83a–d; Rolley, *Sculpture grecque*, 294, figs. 304, 305; Todisco, *Scultura greca*, no. 202; Boardman, *GS-LCP*, 70, fig. 43; Bol, *Bildhauerkunst*, vol. 2, 320–21, figs. 293a–c (C. Maderna).

[86] Athens, NAM X 15118: Kaltsas, *SNAMA*, 242–43, no. 509*; W.-H. Schuchhardt, "Der Jüngling von Marathon," *Die Antike* 6 (1930) 332–53; Houser, *Bronze Sculpture*, 236–43, ills. 14.1–9; Ridgway, *Fourth-Century Styles*, 343–44, pl. 84a–c; Rolley, *Sculpture grecque*, 248, fig. 241; Todisco, *Scultura greca*, no. 298; Bol, *Bildhauerkunst*, 368, figs. 331a–c (C. Maderna).

[87] N. Himmelmann, *Der ausruhende Herakles* (Paderborn 2009) 186, dates the Antikythera youth no later than 360.

looking in the direction of the raised proper right hand. In the case of the Marathon boy, instability predominates even though the head looks down at the object once carried in the proper left hand, on the side of the standing leg, which I expect would create a fully static composition. But this is exactly not the case: the strong curvature of the torso to the viewer's left and the raised arm on that side pull the statue to the viewer's left, a tendency that is not counterbalanced by the turn of the head to the viewer's right or the arm held horizontally on this side. Perhaps whatever the proper left hand held corrected the strong impression of imbalance of the statue in its current incomplete state. Although there is no trace of the proper right hand having rested against an object such as a tree, the pose of the Marathon boy does recall that of Hygieia on votive reliefs of the period (**Figs. 93, 242**).[88]

Within the "Praxitelean" group of statues, the pouring satyr (**Fig. 68**)[89] has been compared to the boy from Marathon Bay.[90] It is, however, the contrast of the two that is striking: the pouring satyr is a closed and stable composition, while the boy from Marathon Bay is open and eminently unstable. Of course both represent young and slim figures, but the pouring satyr has real muscles, which are particularly prominent in the copy in Baltimore.[91] Chronological differences may play a role here, though there are few convincing grounds on which to build such a chronology, and the uncertainty of what the Marathon boy held in his proper left hand recommends caution. Another comparison is useful: the "Polykleitan" Hermes Richelieu (**Fig. 174**)[92] with the "Praxitelean" Eros of Centocelle (**Fig. 175**).[93] Again the two figures differ in age: the Hermes is mature, Eros adolescent. Hermes has his feet planted flat-footed on the ground; Eros has his proper right leg back in Polykleitan stance. Hermes has his arms at his sides; Eros's arms are held splaying out slightly. Both figures look down and to the side, but Hermes looks toward his standing leg, Eros to his free leg. Since Eros appears to be in motion, his stance is more open, while Hermes appears caught in quiet contemplation. Hermes' stance is very nearly strictly frontal, while the stance of Eros invites a variety of viewing angles over an arc just short of 180 degrees.

[88] E.g., Athens, NAM 2557, 1330, and 1333: Kaltsas, *SNAMA*, 223, nos. 465 and 466*, 226, no. 475*. For a photographic detail of the hand, see Houser, *Bronze Sculpture*, ills. 14.6, 14.7.

[89] Many copies exist, all of roughly the same size; the three principal examples are: Dresden, SKD Herrmann 100; Palermo, Museo Archeologico Regionale 1556; and Rome, MNR, Palazzo Altemps (Terme) 8597. For the bibliography, see chap. 3, p. 80, note 207 above.

[90] Most recently by Rolley, *Sculpture grecque*, 246–47.

[91] Baltimore, Walters Art Museum 23.22: E. D. Reeder, *Hellenistic Art in the Walters Art Gallery* (Baltimore 1988) 76–77, no. 6*; F. Weege, *Der einschenkende Satyr aus Sammlung Mengarini*, BWPr 89 (Berlin 1929); Rizzo, *Prassitele*, 17–20, pl. 24; P. Gercke, *Satyrn des Praxiteles* (Hamburg 1968) 1–2, no. St. 1; C. C. Vermeule, *Greek and Roman Sculpture in America: Masterpieces in Public Collections in the United States and Canada* (Malibu, CA, and Berkeley, 1981) 63, no. 35*.

[92] Paris, Louvre Ma 573: Arnold, *Polykletnachfolge*, 276–77, no. 15, pl. 13c; Beck, Bol, and Bückling, *Polyklet*, 609–10, no. 134* (A. Linfert); Todisco, *Scultura greca*, no. 53.

[93] The name piece is Vatican, Museo Chiaramonti 769: Helbig⁴, vol. 1, no. 116 (H. von Steuben); *LIMC*, s.v. Eros no. 79 (A. Hermary); Zanker, *Klassizistische Statuen*, 108–9, no. 4, pl. 81.2; Boardman, *GS-LCP*, fig. 72; Bol, *Bildhauerkunst*, vol. 2, 295–97, figs. 263a, 263b, 264 (W. Geominy). Zanker considers it an inferior version of Naples, MAN 6335 (*Klassizistische Statuen*, no. 1, pl. 81.1; *LIMC*, s.v. Eros no. 79* [A. Hermary]; Martinez, *Praxitèle*, 354–56, no. 94*), and Saint Petersburg, Hermitage A 278 (O. F. Waldhauer, *Die antiken Skulpturen der Ermitage*, vol. 2 [Berlin and Leipzig 1931] no. 123, pls. 25, 26; X. Gorbunova and I. Saverkina, *Greek and Roman Antiquities in the Hermitage* [Leningrad 1975] fig. 78). Waldhauer's list does not include Boston, MFA 1979.477: Vermeule, *Greek and Roman Sculpture in America* (note 91 above) 64, no. 36*; C. C. Vermeule and M. B. Comstock, *Sculpture in Stone and Bronze: Additions to the Collections of Greek, Etruscan and Roman Art, 1971–1988* (Boston 1988) 32–33, no. 20*. Hans von Steuben, in Helbig⁴, considers the statue an early-fourth-century Peloponnesian work; Zanker considers the type to be Praxitelean but sees Polykleitan elements which, however, he ascribes to the copyist.

On the basis of the preceding observations it seems possible that a distinction between the "Polykleitan" and "Praxitelean" school—or, more properly, styles—is that the former favors mature, robust, and balanced nude males, the latter adolescent, lithe, and imbalanced figures. This initial impression is strengthened by another comparison: the Lansdowne Herakles (**Fig. 176**)[94] and the Apollo Lykeios.[95] The Lansdowne type of Herakles is closely related to a stock pose going back perhaps to the fifth century;[96] the statues are all appropriately broad-chested and muscular; they stand flat-footed with club lowered, but the contrapposto, the turn of the head, and the position of the arms create a sense of vigor and potential action. The Lansdowne type is somewhat uneasily planted on his feet; the torso is erect without curvature; the proper right arm hangs at the side grasping the lion skin; and the proper left hand holds the club shouldered with only a hint of immanent action. Since Herakles is beardless, the moment portrayed could be the direct aftermath of his first labor, the killing of the Nemean lion. If the statue is compared to the earlier figures of the diskobolos attributed to Naukydes (**Figs. 172, 173**), the Lansdowne Herakles has less complex shifting planes of the legs, torso, and head. There is just a slight turning motion from the viewer's left to right. Herakles is clearly at rest and, with head held up, he looks quietly into the distant future rather than contemplating an immanent action.

How different is the Apollo Lykeios![97] His feet are relatively close together and flat on the ground; the hips swing out to the viewer's left; the torso curves up to the shoulders. His proper right arm is thrown up over his head, and his proper left arm was extended slightly forward and to the viewer's right. According to the description of the statue by Lucian (*Anacharsis* 7), Apollo held his bow in this hand. Despite the relatively muscular torso, he has no pubic hair. His hair is quite feminine, with the added elegance of a central braid associated with prepubescent children.[98] At one level the gesture of the arm certainly indicates lassitude (the reason for the gesture cited by Lucian), but it may also suggest a powerful epiphany—the god witnessing his own power.[99] The stance ripples with nervous ambiguity. The attribution of the original sculpture to Praxiteles himself is based only on stylistic analysis,[100] but this is precisely the point here.

Several observations are in order: (1) The two different styles just described under the rubrics "Polykleitan" and "Praxitelean" seem to be applied here to figures of quite different types. (2) All the statues just described are Roman copies; their chance preservation is due to the Roman interest in the statues, and the two divergent styles may simply reflect the Roman attitude to the subjects. (3) The choice of statues for the above discussion

[94] Malibu, Getty 70.AA.109: S. Lattimore, "Two Statues of Herakles," *GettyMusJ* 2 (1975) 24–26, figs. 6–10; S. Howard, *The Lansdowne Herakles*, rev. ed. (Malibu, CA, 1978); S. Kansteiner, *Herakles: Die Darstellungen in der Großplastik der Antike* (Cologne 2000) 3–24, 113, cat. La 1, figs. 1, 2, 7, 17, 21; Himmelmann, *Ausruhende Herakles*, 135, fig. 58, 184, and Exkurs II, 193–95; BrBr 691; Süsserott, *Griechische Plastik*, 147–48, pl. 31.3; Lippold, *Griechische Plastik*, 251, pl. 91.1; Todisco, *Scultura greca*, no. 201; Boardman, *GS-LCP*, 75, fig. 76.

[95] E. J. Milleker, "The Statue of Apollo Lykeios in Athens" (Ph.D. diss., New York University, 1987); *LIMC*, s.v. Apollon no. 39 (V. Lambrinoudakis); Bol, *Bildhauerkunst*, vol. 2, 368, figs. 331a–c (C. Maderna).

[96] Boardman, *GS-CP*, fig. 72; Boardman, *GS-LCP*, 75, figs. 74, 75. An example closer to the Lansdowne type is in Rome, MNR (Palazzo Massimo) 29: Giuliano, *MNR*, vol. 1, pt. 2 (Rome 1981) 339–40, no. 42*; *LIMC*, s.v. Herakles no. 289* (J. Boardman et al.).

[97] See note 95 above.

[98] Milleker, "Apollo Lykeios" (note 95 above) 49–50.

[99] N. Himmelmann-Wildschütz, *Zur Eigenart des klassischen Götterbildes* (Munich 1959) 17, English translation in Himmlemann, *Reading Greek Art*, 112; Milleker, "Apollo Lykeios" (note 95 above) 58–69, esp. 64–66 on Dionysos.

[100] A. Ajootian, "Praxiteles," in *Personal Styles in Greek Sculpture*, YCS 30, ed. O. Palagia and J. J. Pollitt (Cambridge 1996) 126–27.

is derived simply from earlier analyses and could be extended almost infinitely. (4) The chronology of the statues discussed above is largely open to debate, though they tend to cluster around the middle of the fourth century. Statues frequently dated to the second half of the fourth century add some new characteristics without displacing the "Polykleitan" and "Praxitelean" styles.

One of the clearest presentations of the divergent styles of the fourth century are the reliefs of the Maussolleion at Halikarnassos (**Figs. 7–10**). Pliny (*NH* 36.30–31) describes the building and the sculptors thus:

> The contemporaries and rivals of Scopas were Bryaxis, Timotheus, and Leochares, whom we must discuss along with him because together with him they worked on the carvings of the Mausoleum. This is the tomb that was built by Artemisia for her husband Maussollos, the viceroy of Karia, who died in the second year of the 107th Olympiad [351 B.C.].[101] These artists were chiefly responsible for making the structure one of the seven wonders of the world. On the north and south sides it extends for 63 feet, but the length of the facades is less, the total length of the facades and sides being 440 feet. The building rises to a height of 25 cubits and is enclosed by 36 columns. The Greek word for the surrounding colonnade is 'pteron,' 'a wing.' The east side was carved by Scopas, the north by Bryaxis, the south by Timotheus, and the west by Leochares; and before they completed their task, the queen died. (Trans. D. E. Eichholz, Loeb edition)

The attempts to assign various preserved relief slabs of the friezes of the Maussolleion to the four sculptors have failed,[102] but quite distinct interpretations of the composition of the Amazonomachy were recognized early in the study of the monument. Heinrich Brunn, followed by Paul Wolters and Johannes Sieveking, discerned two principal groups of slabs, each subdivided into two groups.[103] In the briefest terms, one group has lots of open space around rather slim figures and a minimum of overlapping (**Figs. 7, 8**). The other group of slabs has little free space around the figures, heavy, plastic bodies, and lots of overlapping (**Figs. 9, 10**). The principal interest is that the composition of all the slabs of the Amazonomachy is relatively coherent: triangular three-figure groups are distributed among fanlike compositions in which, from a central point, figures lean to left and right at increasing angles. Clearly the individual sculptors had a large degree of freedom in the interpretation of the details but not in the overall composition. The one group of slabs with slim figures and much open space around them has compositions resembling those of the Temple of Asklepios at Epidauros, while the massive, tightly composed figures suggest connections with developments of the second half of the fourth century, with which the names of Skopas and Lysippos are most frequently associated.

Pausanias (8.45.4–7) states that Skopas was the architect of the Temple of Athena Alea at Tegea:

[101] Diodorus 16.36.2 notes the death of Maussollos in the year 353/2 (16.32.1: when Thudemos was archon in Athens) and adds that Artemisia, his wife, reigned for only two years after his death. As Simon Hornblower, *Mausolus* (Oxford 1982) 38–39, notes, Diodorus's date is to be preferred; Pliny gives the date of Artemisia's death erroneously.

[102] B. F. Cook, "The Sculptors of the Mausoleum Friezes," in *Architecture and Society in Hecatomnid Caria: Proceedings of the Uppsala Symposium 1987*, ed. T. Linders and P. Hellström (Uppsala 1989) 31–42; B. F. Cook, *Relief Sculpture of the Mausoleum at Halicarnassus* (Oxford 2005) 19–22. S. G. Schmid, "The Twisted Amazon: A Small Mistake with a Big Effect at the Maussolleion of Halikarnassos," in *Skopas of Paros and His World: Proceedings of the Third International Conference on the Archaeology of Paros and the Cyclades, Paroikia, Paros, 11–14 June 2010*, ed. D. Katsonopoulou and A. F. Stewart (Athens 2013) 303–15. There is the added confusion that Vitruvius (7 praef. 13) adds Praxiteles to the group.

[103] H. Brunn, "Studien über den Amazonenfries des Mausoleums," *SBMünch* (1882) 114–38; P. Wolters and J. Sieveking, "Der Amazonenfries des Mausoleums," *JdI* 24 (1909) 171–91.

The modern temple is far superior to all other temples in the Peloponnesus on many grounds, especially for its size. Its first row of columns is Doric, and the next to it Corinthian; also, outside the temple, stand columns of the Ionic order. I discovered that its architect was Scopas the Parian, who made images in many places of ancient Greece, and some besides in Ionia and Caria. On the front gable is the hunting of the Calydonian boar. The boar stands right in the centre. On one side are Atalanta, Meleager, Theseus, Telamon, Peleus, Polydeuces, Iolaüs, the partner in most of the labors of Heracles, and also the sons of Thestius, the brothers of Althaea, Prothoüs, and Cometes. On the other side of the boar is Epochus supporting Ancaeüs who is now wounded and has dropped his axe; by his side is Castor, with Amphiaraüs, the son of Oïcles, next to whom is Hippothoüs, the son of Cercyon, son of Agamedes, son of Stymphalus. The last figure is Peirithoüs. On the gable at the back is a representation of Telephus fighting Achilles on the plain of the Caïcus. (Trans. W. H. S. Jones, Loeb edition)

The temple had Doric columns on the outside and semidetached Corinthian columns on the inside; since there are no Ionic columns associated with the temple, Pausanias's mention of them is obscure.[104] A distinctive feature of the carved architectural ornament of the temple, beyond the new design of the Corinthian capitals, was the lateral sima with elaborate carved rinceaux. Unfortunately, the pedimental sculptures are preserved only in fragments, though the impressive heads with almost cubic proportions and deep-set eyes are quite distinctive (**Figs. 34, 35**).[105] Pausanias does not say that Skopas was responsible for the pedimental sculpture, but that has often been assumed. Ridgway, however, goes so far as to say that architectural sculpture was carried out by workshops rather than masters, so it does not reveal anything significant about the master.[106] This is probably too skeptical an approach; the elaborate plastic architectural ornament of the Temple of Athena Alea and the development of the Corinthian capitals certainly indicate an architect with a strong sense of plastic mass and forceful patterns, patterns which can easily be compared to the heavy, plastic bodies and the tight composition of the second group of slabs of the Maussolleion.

The blocklike form of the male heads combined with their expressive gaze suggests comparison with a number of male statues, though all are Roman copies. A few examples suffice. A statue of Herakles leaning on his club, of which the best copies are in Copenhagen (**Figs. 177, 178**) and Dresden,[107] differs totally from the Lansdowne Herakles, dis-

[104] N. J. Norman, "The Temple of Athena Alea at Tegea," *AJA* 88 (1984) 179–80, ills. 4, 8. Cf. J. Pakkanen, "The Height and Reconstruction of the Interior Corinthian Columns in Greek Classical Buildings," *Arctos* 30 (1996) 153–64, fig. 8 on p. 160; and O. Palagia, "Skopas of Paros and the 'Pothos,'" in *Paria Lithos: Parian Quarries, Marble, and Workshops of Sculpture; Proceedings of the First International Conference on the Archaeology of Paros and the Cyclades, Paros, 2–5 October 1997*, ed. D. U. Schilardi and D. Katsonopoulou (Athens 2000) 219–20.

[105] Athens, NAM 179, 180; Tegea 60, 61: Dugas, Berchmans, and Clemmensen, *Sanctuaire d'Aléa Athéna*, 87–88, no. 7 (Tegea 60), pls. 99A, 100A–C, 89–90, no. 9 (Athens, NAM 180), pl. 102A; 91–92, no. 17 (Athens, NAM 179), pl. 102B; Stewart, *Skopas*, 16–18, no. 9, pls. 7, 8a, 8b, 38c, 38d, 52b.1, 52c.1; 22–23, no. 16, pls. 13, 14a, 14b, 52b.2, 52c.2; 23–24, no. 17, pls. 14c, 14d, 15, 35c, 35d, 52a.1, 52b.3, 52c.3; Bol, *Bildhauerkunst*, vol. 2, 331–33, figs. 301, 302, 304 (C. Maderna).

[106] B. S. Ridgway, "The Study of Greek Sculpture in the Twenty-First Century," *PAPS* 149 (2005) 64–65, 70.

[107] Copenhagen, NCG 1720: Poulsen, *Catalogue*, no. 250; W.-H. Schuchhardt, "Der junge Lysipp," in *Neue Beiträge zur klassischen Altertumswissenschaft: Festschrift zum 60. Geburtstag von Bernhard Schweitzer*, ed. R. Lullies (Stuttgart 1954) 223–24; V. H. Poulsen, "Some Early Fourth Century Sculptures," *ActaArch* 15 (1944) 63–67, figs. 1–4; K. Schauenburg, "Athletenbilder des vierten Jahrhunderts v. Chr.," *AntP* 2 (1963) 77–78; Arnold, *Polykletnachfolge*, 34–35, pl. 29a; R. Wünsche, "Staatliche Antikensammlungen und Glyptothek," *MüJb*, n.s. 3, 51 (2000) 266–67; Himmelmann, *Ausruhende Herakles*, 140–41, figs. 60, 61; Todisco, *Scultura greca*, no. 139; Bol, *Bildhauerkunst*, vol. 2, 365–66, figs. 328a–f (C. Maderna). Dresden, SKD Herrmann 92 (ZV 1094): Beck, Bol, and Bückling, *Polyklet*, 620–21, no.

cussed above. Unfortunately, the lower legs of neither copy survive, but the lower legs of the Dresden copy are restored on the basis of the London Diadoumenos: the proper left leg is pulled well back in Polykleitan stance. Certainly the preserved proper left knee indicates a strong bend; both legs are turned slightly to the viewer's right when the torso is viewed frontally. Herakles, bearded and with deep-set eyes, also looks in this direction; his head is blocklike and the hair a wooly covering of heavy tufts. His proper right hand is on the back of his hip, while he leans with slightly inclined torso on his club, which is jammed into his proper left armpit. The club must have rested on something rising above the ground, since it is much too short to reach the level of the figure's feet. The torso is muscular but lean; the head, seen from the front, is blocklike and in this way resembles the heads from the pediment at Tegea.[108] The solid, balanced, and essentially frontal pose of the Lansdowne Herakles is here a fluid pose, partly frontal and partly in three-quarter view. The youthful Lansdowne Herakles rests in himself. The aging Copenhagen-Dresden Herakles is bent forward, with back arched and proper right shoulder pulled back; he stares out to the viewer's right with a fixed look; his hand on his hip suggests tired repose, but the axes of his legs, torso, and head suggest restlessness and far greater spatial complexity than the Lansdowne statue.[109]

The contrast of stasis and motion is more explicit in the Vatican Apoxyomenos (**Figs. 150–53**).[110] He is, of course, caught in the activity of scraping himself. He stands frontally, stretching his proper right arm straight out, while his proper left arm applies the scraper to his right elbow, forming an intermediate plane in front of his chest and thereby incorporating a substantial volume of space in the composition which had only been implied in earlier statues, from the diskobolos attributed to Naukydes to the Copenhagen-Dresden Herakles. Despite the plasticity of the pose, the figure is relatively slim and stands with feet apart but not completely flat on the ground. The very slight swing of the hips over the proper left, standing, leg is countered by a slight inclination of the torso to the viewer's left. The pronounced gestures of the arms cause the line of the shoulders to slope down from the viewer's left to right, which stabilizes the pose without any noticeable curvature of the torso so often seen in so-called Praxitelean statues. The athlete seems to be rocking to one side and the other while he scrapes himself. At least as it is now set up in the Vatican, on a moderately high base, the statue can be appreciated from a broad arc of vantage points; even from the left (**Fig. 151**) the gesture of the extended right arm of the Apoxyomenos remains fully intelligible, and even the proper left arm and its gesture is clear.[111] Perhaps most remarkable is that the gestures of the arms remain clear from the back (**Fig. 153**), giving the statue a full, plastic three-dimensionality not seen since the fifth century. However, the rhythmic motion that pervades the whole figure and its space

147* (H. Protzmann); Todisco, *Scultura greca*, no. 140; Bol, *Bildhauerkunst*, vol. 2, 365–66, figs. 329a, 329b (C. Maderna); Knoll, Vorster, and Woelk, *Katalog Dresden*, 631–34, no. 144 (C. Vorster); and in general P. Moreno, "Il Farnese ritrovato ed altri tipi di Eracle in riposo," *MÉFRA* 94 (1982) 406–9, 486–89 (group A.1) figs. 12, 14, 15, 121, 122; Kansteiner, *Herakles* (note 94 above) 98–99; *LIMC*, s.v. Herakles nos. 663–81 (vol. 5, p. 762).

[108] See also the "Scopaic" head of the second half of the fourth century found in the agora of Thasos: C. Picard, "Fouilles de Thasos (1914 et 1928)," *BCH* 45 (1921) 134–35, figs. 18, 19; P. Devambez, " Sculptures thasiennes," *BCH* 66/67 (1942–43) 204–9, figs. 2, 3, pl. X; *Guide de Thasos* (Paris 1968) 130, nos. 24, 25, figs. 66, 67.

[109] Poulsen, Schuchhardt, Wünsche, and Himmelmann (note 107 above) date the type ca. 370, before the Lansdowne Herakles, while Schauenburg and I prefer a date after the latter, somewhere in the earlier second half of the fourth century.

[110] For the bibliography see chap. 3, p. 89, note 253 above.

[111] C. Maderna, in Bol, *Bildhauerkunst*, vol. 2, 352, states on the contrary that the figure is strongly frontal, which even the photographs appear to me to contradict.

exceeds by far the still graphic and frozen pose of even the Diadoumenos attributed to Polykleitos. Whoever the creator of the original statue was, the Vatican Apoxyomenos is one of the great statues of the second half of the fourth century.

How different is the bronze Apoxyomenos, or, more appropriately, the athlete cleaning his strigil from Ephesos, now in Vienna (**Figs. 71, 72**).[112] The figure appears to be squatter and more powerful, though his face is elongated and so appears youthful. His hair is shaggy and apparently plastered down above the forehead, one assumes from his previous exertions. The position of his feet is reversed from that of the Vatican Apoxyomenos: the foot of his free leg is set forward with the heel raised; the standing leg is set back. Though both hands are held in front of the body, they are at the level of the groin and therefore do not project as far from the torso as the Vatican Apoxyomenos's hands, and the lateral views are more static than those of the Vatican statue. Still, the arms together enclose a space in front of the statue, and the sense of that space is enhanced by the downturned head that focuses the athlete's glance on the activity of his hands. This space is closed, as the three-quarter and side views show; the action is obviously less emphatic, and the motion of the figure is internalized. Yet the stance, arm positions, and sharply downturned head create a more nervous impression than the statues discussed above. Indeed, Bernard Andreae has pointed out that the direction of the gaze of many fourth-century figures is a broadly popular trait.[113] Like the Ephesos strigil-cleaner who looks down at his hands, the baby Dionysos looks at the grapes that Hermes holds up (**Figs. 33, 34**), Apollo looks at the lizard on the tree (**Fig. 181**), Aphrodite appears to look at the implied basin for her bath (**Fig. 147**), etc. The focused gaze is a powerful tool to enhance the impression of space and aliveness.

The best parallels to the nervous impression of the Ephesos strigil-cleaner are the Agias of the Daochos group at Delphi (at last an original) (**Fig. 14**)[114] and a marble copy of a youth in Berlin (**Fig. 179**).[115] The Daochos Monument is dated on historical grounds to the 330s.[116] In both statues the feet are flat on the ground, the free leg is set forward, the torso is only slightly curved, and the arms are held slightly bent at the elbow and a little away from the sides. Agias's head is turned to his proper left side; the statue in Berlin turns the head minimally to the same side. Erik Sjöqvist said of Agias that he "seems to shiver in a restless idleness. There is an inner tension in the seemingly quiet pose which points into the third dimension. . . ."[117] The same can be said of the statue in Berlin. These two statues are emblematic of the style of nude male statues in the second half of the fourth century. The small heads and tousled hair are signs of their late date within the fourth century, but otherwise they represent characteristics similar to those we saw in the statues of the early part of the century, such as the diskobolos attributed to Naukydes (**Fig. 172**).

[112] For bibliography, see chap. 3, p. 89, note 254 above.

[113] B. Andreae, *Der tanzende Satyr von Mazara del Vallo und Praxiteles*, AbhMainz, Jahrg. 2009, no. 2 (Mainz 2009) 18–20.

[114] Delphi 1875: P. de la Coste-Messelière and G. de Miré, *Delphes* (Paris 1943) pls. 184–87; Dohrn, *AntP* 8 (1968) 34–35, pls. 10–20, figs. 1, 2; Lippold, *Griechische Plastik*, 287, pl. 102.3; E. Sjöqvist, "The Early Style of Lysippus," *OpAth* 1 (1953) 93–97, pls. I.1, I.2, II.1; Sjöqvist, "Lysippus," 15–16, figs. 3–5; Adam, *Technique*, 97–102, pls. 44–49; Todisco, *Scultura greca*, no. 241.

[115] Berlin, Staatl. Mus. Sk 471: C. Blümel, *Staatliche Museen zu Berlin: Katalog der Sammlung antiker Skulpturen*, vol. 4, *Römische Kopien griechischer Skulpturen des fünften Jahrhunderts v. Chr.* (Berlin 1931) 21, no. K 233, pls. 45, 46; Rausa, *Vincitore*, 136–37, 206–7, no. 21, figs. 34–37; Moreno, *Lisippo*, 226–27, no. 4.34.1*; Knittlmayer and Heilmeyer, *Antikensammlung Berlin*², 56–57, no. 24*; Todisco, *Scultura greca*, no. 309. The pubic hair was carved away in an early restoration when a fig leaf was added.

[116] See chap. 2, pp. 28–29 above.

[117] Sjöqvist, "Lysippus," 15.

Perhaps the clearest characteristics of the changes over the period of a century are the increasingly convincing depiction of motion within the standing figure and the more effective portrayal of an inner life that parallels the nervous outer one. Both characteristics bring the statues alive in a manner that Pheidias and Polykleitos could not have thought relevant. It is precisely here that the statue of Hermes holding the child Dionysos belongs (**Figs. 133–36**).[118] But if its stance is compared to that of other statues generally accepted as respectable copies of fourth-century originals, the Hermes is unusual. At first glance this does not seem to be the case. Hermes shares with the Resting Satyr (**Fig. 180**) and the Sauroktonos (**Figs. 181, 182**) the placement of the free leg on the side of the external support. He also shares with them the exaggerated swing of the hip away from the support, but that is as far as the similarities go. Although the Sauroktonos and the Resting Satyr are relatively slim, and neither has pubic hair, the satyr is stockier and less elegant. Hermes is a young man with a broad, powerful torso. The awkwardness of his legs is perhaps the most jarring aspect of the statue. From a frontal position both his legs appear to be straight, as opposed to the curvature of the free legs of the other two statues. It is only from a three-quarter position that the viewer really gets a clear view of the position of the legs, while the other statues retain an understandable and essentially harmonious view of the legs over a wide arc of vantage points. The pronounced curvature of the upper torso of the other statues agrees well with the legs, as opposed to the conflict in the Hermes. Finally, the outstretched proper right arm of Hermes—plausibly holding up grapes as a treat for the child Dionysos during a rest stop on the journey to the nymphs of Nyssa—may be similar to the arm of the Sauroktonos resting against the tree, but there all the focus is in the direction of the upraised arm. But Hermes looks away from his upraised arm and at the child Dionysos on his left; the statue group thus has two focuses—the grapes and Dionysos. Of all the sculpture attributed to the fourth century this statue group is by far the most complex, and it has no obvious sequel. The Herakles Farnese type (**Fig. 183**)[119] and the Papposilenos holding the child Dionysos in the Vatican and Munich[120] both have a single focus and a far less jarring composition.

Only the Marathon boy (**Fig. 65**) has a similarly complex and indeed peculiar stance closely resembling that of the Hermes of Olympia (**Fig. 133**).[121] Not only does he raise his proper right arm in a manner very similar to that of Hermes, but he looks down at his proper left hand, and whatever it once held, creating precisely the same dual focus. As suggested above, the arc of the Marathon boy's torso does not even bring his shoulders back over his hips, and thus his center of gravity calls out for a support on the side of his upraised proper right arm, though there is no trace of one, suggesting that he held something quite substantial in his left hand. Whatever the case, both statues are clearly meant to be seen primarily from the front, and both convey an awkward instability.

It could easily be argued that the complex composition of the Hermes and Dionysos in Olympia is so different from the other statues of the fourth century that it should simply be considered a Late Hellenistic creation in the mode of the fourth century, which indeed is the conclusion of Carl Blümel and Brunilde Ridgway, as discussed in the previous chapter. The Marathon boy weakens this proposition. An equally or even more attractive hypothesis is that the Hermes represents the characteristics of statuary of the fourth century

[118] See chap. 3, pp. 70–75 above.

[119] For bibliography, see chap. 6, p. 250, note 160 below.

[120] Munich, Glyptothek 238: Vierneisel-Schlörb, *Klassische Skulpturen*, 446–52, no. 41, figs. 219–26. Vatican, Braccio Nuovo 2292: Moreno, *Lisippo*, 255, no. 4.37.3; Helbig[4], vol. 1, no. 410 (W. Fuchs).

[121] For bibliography, see note 86 above.

described above in the most impressive manner: a restless stasis, like the Agias (**Fig. 14**), surrounded by a real space, like the Vatican Apoxyomenos (**Fig. 150**); an implied setting in a narrative, like the Sauroktonos (**Fig. 181**); and a powerful divine epiphany. Some of the spatial complexity and awkwardness can be seen in the slightly later statues of the Tyche of Antioch,[122] the Anzio girl,[123] and the Conservatori girl (**Fig. 184**).[124]

A compelling comparison with the statue of Hermes is the Mantineia base (**Figs. 96–98**), which was surmounted, Pausanias remarked (8.9.1), by statues by Praxiteles. As noted above, most scholars consider that the reliefs of the base must have been made by the workshop, not the master.[125] This may be a logical contemporary deduction, but it does not address the significance of the style. My own deduction is that the workshop produced works which Praxiteles thought to be good, and therefore the base must indicate something of Praxiteles' style, unless one also rejects the base as an erroneous attribution by Pausanias.[126] The panels of the base are 0.98 meters high. On the panel depicting the contest of Apollo and Marsyas (**Fig. 96**), the god sits in profile on the left with his kithara and faces to the right, where Marsyas is grouped with the Skythian servant. These two figures are standing and are taller than Apollo; together they occupy almost exactly half of the panel (from the right edge to the toe of the proper right foot of the Skythian). There is much space both behind and in front of Apollo, so the impression that he is subsidiary is underscored by the composition. Indeed, it is Marsyas who is playing his flutes in a pose of vigorous activity. The Skythian stands calmly, with his proper right foot slightly drawn back, his left arm akimbo with the hand turned over and the knuckles resting on his hip. His proper right arm hangs at his side holding the knife with which he will eventually flay Marsyas; the vertical arm occupies the central axis of the relief panel. The arm is actually not quite precisely vertical but bends slightly to the viewer's right, and the knife blade is held in front of his proper right thigh. He appears to be tapping the blade against his thigh with impatience. Indeed, everything in the relief seems to emphasize the temporal sequence of the event: Apollo has played and is a little withdrawn; Marsyas plays most vigorously; and the Skythian impatiently bides his time. This is a brilliant narrative, most of which—both Apollo's and the Skythian's part in the event—is communicated by implication; only Marsyas vainly acts.

Both of the other two panels of the Mantineia base depict three Muses standing frontally or nearly so; whether there was a fourth relief is unknown, but its existence is usually assumed. The composition of both reliefs is not precisely symmetrical: panel 216 (**Fig. 97**) has more open space on the right than on the left, while on panel 217 (**Fig. 98**) the

[122] See generally Ridgway, *Hellenistic Sculpture*, vol. 1, 133–37, figs. 115, 116.a, 116.b.

[123] Rome, MNR (Palazzo Massimo) 50170: Giuliano, *MNR*, vol. 1, pt. 1 (Rome 1979) 186–92, no. 121* (L. de Lachenal); Borbein, *JdI* 88 (1973) 133, 134, figs. 53, 54.

[124] Rome, Musei Capitolini, Centrale Montemartini (ACEA) MC 1107: Helbig⁴, vol. 2, no. 1480 (H. von Steuben); Ridgway, *Hellenistic Sculpture*, vol. 1, 136–37, fig. 120.

[125] Athens, NAM 215–17: Kaltsas, *SNAMA*, 246–47, no. 513*. See the discussion in chap. 2, pp. 44–45 above, with additional bibliography. W. Amelung, *Die Basis des Praxiteles aus Mantineia: Archaeologische Studien* (Munich 1895); I. Linfert-Reich, *Musen- und Dichterinnenfiguren des vierten und frühen dritten Jahrhunderts* (Cologne 1971) 32–42; Ridgway, *Fourth-Century Styles*, 206–9; Todisco, *Scultura greca*, no. 289; Boardman, *GS-LCP*, fig. 28; Bol, *Bildhauerkunst*, vol. 2, 375–76, figs. 341a–c (C. Maderna). W.-H. Schuchhardt, "Das 'badende Mädchen' im Münchner Antiquarium," *Die Antike* 12 (1936) 105, dates the reliefs to around 300 B.C. and is followed by R. Kabus-Jahn, *Studien zu Frauenfiguren des vierten Jahrhunderts vor Christus* (Darmstadt 1963) 12. Ridgway, *Fourth-Century Styles*, 208, however, correctly makes a close comparison with the frieze of the Lysikrates choregic monument, which clearly places the Mantineia reliefs in the decade 330–320.

[126] Ridgway, *Fourth-Century Styles*, 208, considers the possibility that the base was reused from some other monument when Pausanias saw it.

situation is reversed. The central Muse of panel 216 is shifted slightly to the left of center, while the equivalent Muse of panel 217 is precisely on its central axis. None of this can be fortuitous and suggests a dynamic composition, despite the simple vertical notations of the individual figures. The curiosity is that the Muses are basically inactive. Only on panel 217 does the right-hand Muse raise a kithara high in the air, and the left-hand Muse appears to open a scroll and is turned in three-quarter position toward the center. There is no obvious way to relate all three slabs so that they form a consistent composition, but the unusual elements do make one reflect on the unconventionality of original sculptures versus the expectations of the modern scholarly commentaries.

Given the peculiar characteristics of the Hermes of Olympia and the novel elements of the Mantineia base, it is very difficult to see how either represents the style of Praxiteles in the terms defined by modern scholarship, which is basically an elegant fastidiousness. Admittedly, this evaluation of Praxiteles' style is based on competent copies of statues attributed by modern scholars to the master, but in the form we have them they hardly explain the extraordinary praise heaped on Praxiteles in the later texts. It is here that the satyr *mainomenos* in Mazara might possibly find its place. Although the extraordinary twisting motion of the statue has nothing in common with the style of Praxiteles as reconstructed by modern scholarship, it does relate to the nervous and contradictory poses of the statues just discussed, which have been attributed to Praxiteles. Until a signed original by Praxiteles is discovered, any judgment of the Mazara satyr and especially of the Hermes and Dionysos of Olympia remains subjective, but it is not out of place to suggest that Praxiteles may well have created more inventive and interesting works than the standard copies associated with his name today.

Statues of Females

Similar qualities and ambiguities are evident in statues of female figures. One of the few originals is the statue of "Artemisia" from the Maussolleion (**Fig. 5**).[127] It must be said from the outset that we do not know who the woman represented is. She is either a member of Maussollos's family or an ancestor, and the name Artemisia is used simply for convenience. The date of the statue must be plus or minus 350 B.C. Her hairdo is elaborate: a triple arc of snail curls frames her face.[128] She is dressed in a chiton and himation, the latter thrown over her shoulders and brought across her front to hang over her extended proper left arm. The garment has faint traces of creases from having been folded before wearing. She has rather full breasts, and their shape is emphasized by the parallel folds descending from the pins over her shoulders, but there is no sense of transparency of the cloth nor voluptuousness. Perhaps, like the Eirene, the emphasis is on the character of a matron. She stands with proper right leg free and set slightly forward; the himation is pulled tight over her calf and thigh just enough to reveal the shape of the limb and hint at the folds of the chiton beneath.[129]

[127] London, BM 1001: Waywell, *Free-Standing Sculptures*, 103–5, no. 27, pl. 13; Kabus-Jahn, *Frauenfiguren* (note 125 above) 23–27; Stewart, *Greek Sculpture*, 181, fig. 535; Bol, *Bildhauerkunst*, vol. 2, 305–7, figs. 280a, b (C. Maderna); Todisco, *Scultura greca*, no. 163; Boardman, *GS-LCP*, fig. 19.

[128] The pattern of the hair can best be appreciated in another, even more elaborate, head from the Maussolleion, BM 1051: Waywell, *Free-Standing Sculptures*, 106–7, pl. 16; B. Ashmole, "Solvitur Disputando," in *Festschrift für Frank Brommer*, ed. U. Höckmann and A. Krug (Mainz 1977) 19, pl. 5.4; Todisco, *Scultura greca*, no. 164.

[129] The heaviness and proportions of the statue are well described by Lygkopoulos, *Untersuchungen*, 138–39.

As a general type the statue of "Artemisia" is related to a large group of Roman statues believed to reflect fourth-century originals.[130] She shares with many statues of this group the opulent drapery with the himation in a roll across the torso just under the breasts, though she is notably heavier set than all the others. This may be because, as Axel Filges argues, the Roman copies primarily depict Kore/Persephone and a few other young goddesses such as the Muses, Artemis, and Hygieia.[131] The drapery pattern is also widely represented on Attic grave stelai, so in itself it does not bear a precise meaning.[132] However, "Artemisia" shares with some of the statues of this large group the gesture of her arms, with both forearms held out to the front. The position of the forearms suggests that the proper right hand held an offering or a phiale for the pouring of a libation, an act of reverence.[133] Her gesture has nothing to do with the slightly earlier figures of mourning women on the sarcophagus from the royal cemetery at Sidon (**Fig. 61**), all of whom clearly mourn.[134] Accordingly, it seems likely that the Artemisia is not just a generic image of a matron, but a reverent matron.[135] The stacked curls over her forehead, an archaic conceit, strengthens this impression, though they may just as well represent an elegant eastern fashion.[136]

The Artemisia of the Maussolleion is a subtle image of a lively, reverent, and aristocratic matron. In the Rich Style it is the calligraphy of drapery folds that most obviously characterizes the style, and, as we saw, was used to emphasize the particular situation of the figure represented, as on the frieze of the Temple of Apollo Epikourios at Bassai (**Figs. 23, 24**). This is clearest in cases of figures in movement. What, though, is the function of drapery on figures at rest? In the case of the "Sandal-binder," I have already shown that the drapery creates an intensely lively aura around the figure, both in terms of the calligraphic patterns and of the fluid textural metamorphoses (**Fig. 160**). In the case of the two examples on the Bassai frieze cited above, the drapery serves as a foil to the physical state of the wounded and collapsing figures, a function that conveys an interpretation of the inner life of the figures in objectively defined situations. On grave stelai such as the elaborate monument of Ktesileos and Theano this effect is not as clear (**Fig. 185**).[137] The bodies of both standing man and seated woman are equally substantial and evenly overlaid with the linear patterns of their drapery. On a simple level, the patterns create an ambience of delicate movement over the surface of the figures. Can this effect be read as a more profound suggestion of a living quality of the figures, in contrast to the fundamental

[130] A. Filges, *Standbilder jugendlicher Göttinnen: Klassische und frühhellenistische Gewandstatuen mit Brustwulst und ihre kaiserzeitliche Rezeption* (Cologne 1997).

[131] Ibid., 145–55.

[132] Lygkopoulos, *Untersuchungen*, compares the statue to the woman on the left on the stele of Mnesistrate, Athens, NAM 826: Kaltsas, *SNAMA*, no. 374, p. 189* (illustration reversed); Clairemont, *CAT*, 2.430 (who notes that the stele does not come from Salamis but was found in Attica in 1837); Diepolder, *Grabreliefs*, 45, pl. 43.1. I find far closer in detail the earlier of the reliefs of Demetria and Pamphile, Clairmont, *CAT*, 2.426. The style of dress, however begins at least around the end of the fifth century: Kaltsas, *SNAMA*, 146–47, no. 280* (Athens, NAM 712), 153, no. 299* (Athens, NAM 716); Diepolder, *Grabreliefs*, pls. 10, 11, 14 (Boston, MFA 04.16; Athens, NAM 2670, 716).

[133] On this gesture for divinities, see N. Himmelmann, "Some Characteristics of the Representation of Gods in Classical Art," in Himmelmann, *Reading Greek Art*, 103–38, translated and revised by the author from *Zur Eigenart des klassischen Götterbildes* (Munich 1959).

[134] Istanbul 368: R. Fleischer, *Der Klagefrauensarkophag aus Sidon*, IstForsch 34 (Tübingen 1983); cf. Kabus-Jahn, *Frauenfiguren* (note 125 above) 25–26.

[135] Ridgway, *Fourth-Century Styles*, 339, observes of the Themis in the Athenian Agora (S 2370, here **Fig. 80**) "how anonymous female statuary could be, in the absence of proper attributes."

[136] G. Rodenwaldt, "Griechische Reliefs in Lykien," *SBBerl* 27 (1933) 1038, note 6; Ashmole, "Solvitur Disputando" (note 128 above) 19 and note 34.

[137] Athens, NAM 3472: Kaltsas, *SNAMA*, 158, no. 310*; Clairmont, *CAT*, 2.206; Diepolder, *Grabreliefs*, 28, pl. 22; Boardman, *GS-CP*, fig. 157.

message of death implicit in the monument? This interpretation has a great deal in its favor, and the sheer delicacy of the style may carry even more profound connotations, as I shall suggest in a later chapter.[138]

Comparison of these Rich Style figures with the Artemisia, however, does reveal how much the later statue owes to the earlier style: the use of surfaces and lines to depict an active aliveness; the use of surfaces to emphasize the corporeality of the figure.[139] In neither case is realism an obvious goal; rather, the goal appears to be an expressive representation of real, living people of a certain rank and standing. In the case of the statue of Artemisia, the subtle definition of the body in motion and the gesture of the arms, coupled with the manner of dress and the hair, all suggest a similar sense of the aliveness and reality of the subject. Since she too decorated a tomb and may have stood between framing columns similar to the naiskos of Attic stelai, the aim may have been the same: to represent the dead as alive. However, because other statues, principally of women, use similar patterns of drapery, the phenomenon appears to be more general and not limited to grave monuments.

The only other certain original female statue of the fourth century is the seated Demeter from Knidos in the British Museum (**Fig. 81**).[140] The identification of the figure is based on where she was found: in the sanctuary of Demeter and Persephone at Knidos.[141] Generally dated near the end of the century, or at least around 330, the statue has several interesting characteristics. Most important is the apparent polish of the face. According to Bernard Ashmole, this is a result of cleaning in the nineteenth century,[142] yet its smoothness contrasts with the stringy character of the drapery enveloping the body and is comparable to the slight polish of the skin areas of the statues of the Daochos group at Delphi of about the same time.[143] The body of the figure is slight and yet despite the strong pattern of folds is not obscured. Although Ashmole feels that the figure is to be seen from slightly off to the left, the full frontal view seems to me more advantageous; her head is turned slightly to the viewer's right, though the neck is tilted to the viewer's left, breaking the rigidity of the frontal position.[144] Although occasionally attributed to a prominent sculptor (Ashmole argues for Leochares), the statue is rather bland.[145]

The two reasonably well-preserved acroteria of the Temple of Athena Alea at Tegea represent women wearing a wind-blown peplos (**Figs. 36, 37**).[146] The drapery is rendered principally as thick and opaque, though it becomes thinner over the breast and thigh, where the wind presumably plasters it against the body. In each case the drapery falls from

[138] See chap. 7, pp. 281–82, chap. 8, p. 310 below.

[139] See particularly the description of both the Maussollos and Artemisia by Ridgway, *Fourth-Century Styles*, 132–33.

[140] London, BM 1300: B. Ashmole, "Demeter of Cnidus," *JHS* 71 (1951) 13–28; Ashmole, "Solvitur Disputando" (note 128 above) 13–20, pl. 5.1, 5.2; Stewart, *Greek Sculpture*, 189, 191, figs. 571–72; Ridgway, *Fourth-Century Styles*, 332–33, pls. 79a–c; Rolley, *Sculpture grecque*, 289–90, figs. 296, 298a; Boardman, *GS-LCP*, fig. 49; Bol, *Bildhauerkunst*, vol. 2, 358–59, figs. 324a–c (C. Maderna).

[141] C. T. Newton and R. P. Pullan, *A History of Discoveries at Halicarnassus, Cnidus, and Branchidae*, vol. 2, pt. 2 (London 1863) 375–77, 381–82, pls. LIII, LV.

[142] Ashmole, "Solvitur Disputando" (note 128 above) 15.

[143] See further chap. 3, p. 69 above.

[144] On frontality in sculpture of the fourth century, see A. H. Borbein, "Die Athena Rospigliosi," *MarbWPr*, 1970, 29, 31–34.

[145] Very much the same assessment as Ridgway, *Fourth-Century Styles*, 333.

[146] Tegea 59 and 2288: Dugas, Berchmans, and Clemmensen, *Sanctuaire d'Aléa Athéna*, 80–84, no. 1, pls. 96–98; Stewart, *Skopas*, 9–14 (nos. 1–4), 49–50, 59–60, 76–77, pls. 1–4; Gulaki, *Nikedarstellungen*, 74–78, figs. 28, 29; Danner, *Griechische Akrotere*, 27, no. 168, pl. 29; 20, no. 120, pl. 13; Bol, *Bildhauerkunst*, vol. 2, 333–35, figs. 305a–c (C. Maderna).

the proper right shoulder and uncovers one breast. Because the figures are badly battered, the heavy parts of the drapery currently give the impression of a series of masses defined by straight lines,[147] a style which is clearly very different from representations of Nikai, such as the acroteria of the Temple of Asklepios at Epidauros (**Figs. 31, 32**) or the later Temple of Artemis at Epidauros (**Fig. 47**).[148] Although the drapery of the Nikai from the Temple of Artemis is heavy and opaque, it is defined by the traditional sinuous patterns that began with the Nike of Paionios at Olympia in the 420s.[149] One of the acroteria at Tegea (inv. 59; **Fig. 36**) appears to be striding forward and possibly holding a wreath in her hand; Andrew Stewart identifies her tentatively as a local Arkadian nymph and attributes her to the east pediment, above the Kaledonian boar hunt.[150] The other acroterion can have had wings, perhaps added in some material other than marble, and she wears a himation held diagonally behind her back, which resembles just slightly one of the Nereids from Xanthos, London, British Museum 910 (**Fig. 51**).[151] The figure at Tegea, however, appears to hold up one corner of the himation with her proper right hand while allowing it to fall down behind her thighs, where it is held somewhat loosely by her proper left hand.[152] Seen from the proper left side, this figure has a curious structure: the belt of her peplos is close under her breasts, and the apoptygma wafts out slightly below it. Her belly swells out strongly under the apoptygma and then slopes down gradually to her groin. Both the belly and the hip back to the buttock have the garment plastered against them; as preserved, she appears very deep at the hip and much thinner at the level of the breasts.

As far as I can tell, there are no good stylistic parallels for the acroteria of the Temple of Athena Alea at Tegea. The high belt just below the breasts speaks in favor of a date after the 350s; the one small fragment of the hip portion of a female figure from the pediments[153] and the upper torso of another[154] have nothing in common with the style of the acroteria and appear, insofar as the small fragments allow any judgment, to be quite conventional. The fact that the backs of the acroteria were left rough, with marks of point and claw and heavy use of the running drill, may suggest a local workshop hastening to complete the temple as money ran out.[155]

Although not statues, the Muses of the Mantineia base in Athens should be mentioned again here (**Figs. 97, 98**).[156] Although I have discussed the composition of the relief panels above in conjunction with the Hermes of Olympia, their stylistic characteristics deserve more attention here. As already mentioned, Pausanias (8.9.1) saw the base, and although

[147] Ridgway, *Fourth-Century Styles*, 51.

[148] Photographs of the latter set next to the Tegea acroteria are published by Picón, *AntP* 22 (1993) figs. 8–14.

[149] Borbein, *JdI* 88 (1973) 165–69, figs. 89, 90; T. Hölscher, "Die Nike der Messenier und Naupaktier in Olympia: Kunst und Geschichte im späten 5. Jahrhundert v. Chr.," *JdI* 89 (1974) 70–111; Rolley, *Sculpture grecque*, 124–25, figs. 113, 114; Bol, *Bildhauerkunst*, vol. 2, 198–99, figs. 125a, b; Lullies and Hirmer, *Greek Sculpture*², pl. 178; Boardman, *GS-CP*, fig. 139.

[150] Stewart, *Skopas*, 60.

[151] W. A. P. Childs and P. Demargne, *Fouilles de Xanthos*, vol. 8, *Le monument des Néréides: Le décor sculpté* (Paris 1989) pt. 2, pl. 96.

[152] Stewart, *Skopas*, pl. 3d. Stewart (pp. 12, 60) compares the figure to a Nike found in Cyrene: E. Paribeni, *Catalogo delle sculture di Cirene: Statue e rilievi di carattere religioso* (Rome 1959) 28, no. 38, pl. 41, which Paribeni dates far too early, at the beginning of the fourth century.

[153] Tegea 194: Dugas, Berchmans, and Clemmensen, *Sanctuaire d'Aléa Athéna*, 90, fig. 34, pl. 107:C, D; Picard, *Manuel*, vol. 4.1, 190–91, fig. 84; Stewart, *Skopas*, 26, no. 20, pl. 17b; A. A. Stavridou, *Τα γλύπτα του Μουσείου Τεγέας* (Athens 1996) 69, fig. 26.

[154] Stewart, *Skopas*, 16, no. 8, pl. 6b, 6c.

[155] Ibid., 9, 11, 12, 68–69.

[156] See p. 120 above with note 125.

most scholars reject his testimony, I cannot follow such reasoning and am happy to consider the Mantineia base to be at the very least from the workshop of Praxiteles. In any case, the six Muses preserved on two slabs of the base are variously dressed in chiton and/or peplos and himation, three of them in the general manner of Artemisia and related types, with a roll of cloth across the chest just beneath the breasts (slab 217; **Fig. 98**). In each case the himation covers a different amount of the lower body. The Muse on the left of this slab is seen in three-quarter view, the middle figure rests the back of her proper right hand on her hip, and the figure on the right has her proper left hand enveloped in drapery while she holds up a kithara with her right hand. The arrangement of the hand seen in the last two figures is well known from Roman copies of statues attributed to the fourth century. The hand on the hip is best illustrated by the Athena Vescovali type (**Figs. 145, 146**),[157] and the hand enveloped in drapery is found on the Athena Rospigliosi (**Figs. 168, 169**)[158] and the Herculaneum Women.[159] On slab 216 (**Fig. 97**) the right Muse is seated with her himation loosely arranged on her lap, the center figure holds the upper roll of the himation almost above her breast, while on the left the third Muse wears the himation rather tightly wrapped around the body, passing under her proper right breast, and then up and over her proper left shoulder. This last pattern was much beloved in the late fourth century and is seen on the statue of Persephone in Florence (**Fig. 142**), the votive reliefs in Eleusis and Naples, and the figure C on Kos (**Fig. 270**).[160] In each case, insofar as is visible, the pattern of the chiton or peplos over the standing leg is quite similar to that of a small statue in the Louvre from Halikarnassos which probably had no direct association with the Maussolleion.[161]

What becomes evident in reviewing the original stone sculptures of women from the fourth century is that the main focus of the sculptures is the representation of drapery; poses and attributes are mere accessories to an expression of opulence.[162] Despite the fact that there are clearly discernible patterns of drapery that enjoy more or less extended periods of popularity, it seems that the variations of how to wear a himation, for example, are almost infinite.[163]

Copies add appreciably to the repertory of statues of women, particularly goddesses, in the fourth century. A popular figure is Artemis. Perhaps the earliest type is that in Berlin, from the Colonna collection, after which it is named (**Figs. 165, 166**).[164] The date is controversial but is probably just after the shift from the Rich to the Plain Style, that is, about

[157] See pp. 130–31 below.

[158] See pp. 131–32 below.

[159] Kaltsas, *SNAMA*, 242, 268–69, nos. 508*, 561*, 562*; S. Karusu, "Der Hermes von Andros und seine Gefährtin," *AM* 84 (1969) 148–52, pls. 69, 70; Todisco, *Scultura greca*, nos. 291, 292. The Attic grave relief of the end of the fourth century, Athens, NAM 1005 (Kaltsas, 205–6, no. 414*), reflects the same type and pose.

[160] See chap. 3, pp. 77–78 above with notes 179–81, and chap. 7, p. 273 below.

[161] Paris, Louvre Ma 2838: Hamiaux, *Sculptures grecques*, vol. 1, 272–73, no. 299*; Bieber, *Ancient Copies*, 105, figs. 463–65; Schuchhardt, *Alkamenes* (note 80 above) 45–46; Kabus-Jahn, *AntP* 11 (1972) 56, figs. 8, 9; R. Kabus-Preisshofen, *Die hellenistische Plastik der Insel Kos*, AM-BH 14 (Berlin 1989) 83. The preserved height is 1.30 m. As Palagia, *Hesperia* 51 (1982) 102, note 16, remarks, the statue was not included in Waywell's catalogue of the freestanding sculpture of the Maussolleion because it must be later. Where in Halikarnassos the statue was found in 1829 is unknown.

[162] Compare the comments of Linfert-Reich, *Musen- und Dichterinnenfiguren* (note 125 above) 42, on the figures of the Mantineia base.

[163] M. Bieber, *Griechische Kleidung* (Berlin and Leipzig 1928) 22.

[164] Berlin, Staatl. Mus. Sk 59: Blümel, *Katalog Skulpturen Berlin*, vol. 5 (note 56 above) 27–28, Sk 59, no. K 243, pls. 59–61; Bieber, *Ancient Copies*, 88–89, figs. 356, 357; *LIMC*, s.v. Artemis no. 163* (L. Kahil); Beck, Bol, and Bückling, *Polyklet*, 611–12, no. 137* (H. Heres); Todisco, *Scultura greca*, no. 64; Boardman, *GS-LCP*, fig. 85.

380–370.[165] The manner in which the drapery is both opaque and semitransparent, particularly over and around the legs, strongly suggests the early date.[166] The emphasis on the linearity of the folds as opposed to a milder, textured surface also points to the earlier date. The Hera from Ephesos now in Vienna presents a similar sense of line, volume, and partial transparency of drapery (**Fig. 186**).[167] Other good comparisons are the Attic grave stele from the Piraeus in the National Archaeological Museum in Athens (inv. 726; **Fig. 187**)[168] and the stele of Mnesarete in Munich.[169]

The Colonna Artemis moves forward with a measured, not hasty step; she probably held her bow in her left hand and, given the position of her right hand, may have just shot an arrow.[170] The proper right side of the statue reveals the forward motion best (**Fig. 166**); both legs are clearly visible, and the parallel folds falling between the legs and to the rear of her proper right leg emphasize the mildly forward-sloping diagonal of her body. Her front leg serves, if the expression has any meaning in this case, as the "standing" leg;[171] the rear leg is slightly bent at the knee. As is the case with the diskobolos attributed to Naukydes discussed above, it is difficult to describe the most logical vantage point from which to look at the statue. In the case of Artemis, there is an arc of about 100 degrees, with the front of the chest as its midpoint; this results in a slightly oblique view of the legs, arms, and head which provides a good sense of her motion and the action of having released an arrow. Of course the context is not at all clear: at whom has she shot an arrow? Artemis is, of course, a huntress and is so represented on vases,[172] but she is also a punishing goddess, as is well known from her treatment of Aktaion, the Niobids, and others.[173] Given that here and most often in the fourth century she wears a long peplos, her role as huntress appears to be secondary to her role as avenger. I imagine she has just dispatched a miscreant.

Another widely copied and adapted Artemis type is named after its most complete version, in Dresden (**Fig. 170**).[174] This Artemis stands firmly on her proper left leg, with her proper right leg drawn back and the foot turned outward, and she wears a peplos with long, unbelted overfold and a quiver hung behind her right shoulder on a strap that crosses her chest. Her left arm is held down and must have held her bow, particularly if

[165] Linfert, in Beck, Bol, and Bückling, *Polyklet*, p. 614, commentary to no. 139 (Paris, Louvre Ma 2190), draws a convincing comparison with the diskobolos often attributed to Naukydes; see note 79 above.

[166] An interesting later parallel helps support the early date, the pedestal relief from the Artemiseion of Ephesos in London, BM 1200, right side: Rügler, *Columnae caelatae*, pl. 1.2; Ridgway, *Hellenistic Sculpture*, vol. 1, pl. 6 (here, **Fig. 40**). Here too there is a mixture of opaque cloth and semitransparency over the legs, but the plasticity of the cloth builds masses rather than just lines.

[167] Vienna, Gemäldegalerie der bildenden Künste Wien, Glyptothek: Borbein, *JdI* 88 (1973) 129–31, figs. 49–51; Kabus-Jahn, *Frauenfiguren* (note 125 above) 60–65; Lygkopoulos, *Untersuchungen*, 123–25, 129, 130; *LIMC*, s.v. Hera no. 106; Filges, *Standbilder* (note 130 above) 21, 40; Todisco, *Scultura greca*, no. 22; Bol, *Bildhauerkunst*, vol. 2, 284, figs. 239a–c (W. Geominy).

[168] Kaltsas, *SNAMA*, 126, no. 321*; Diepolder, *Grabreliefs*, pl. 26.

[169] Munich, Glyptothek 491: B. Vierneisel-Schlörb, *Glyptothek München, Katalog der Skulpturen*, vol. 3, *Klassische Grabdenkmäler und Votivreliefs* (Munich 1988) 19–25, no. 4, pls. 6–10; Diepolder, *Grabreliefs*, pl. 27.

[170] Bieber, *Ancient Copies*, fig. 359 (the Vatican version restored as described).

[171] This is difficult to see in the published photographs; the views published by Bieber, *Ancient Copies*, figs. 357, 363, 365, are all taken from too far back; the best view is from about a three-quarter position.

[172] *LIMC*, s.v. Artemis nos. 171*–75* (L. Kahil).

[173] L. Kahil, in *LIMC*, vol. 2 (Zurich 1984) s.v. Artemis, commentary, p. 750, III.6.

[174] Dresden, SKD Herrmann 117: F. Brommer, "Zur Dresdner Artemis," *MarbWPr*, 1950/51, 3–12, pls. 1, 2; Bieber, *Ancient Copies*, 86–87, figs. 332–34; *LIMC*, s.v. Artemis no. 137* (L. Kahil); Todisco, *Scultura greca*, no. 105; Bol, *Bildhauerkunst*, vol. 2, 285–86, figs. 241a–c (W. Geominy); Martinez, *Praxitèle*, 324–25, no. 79*; Knoll, Vorster, and Woelk, *Katalog Dresden*, 183–89, no. 15 (W. Geominy). A variant in Munich, Glyptothek 227, represents well the large number of other variants: Vierneisel-Schlörb, *Klassische Skulpturen*, 293–301, no. 28, figs. 140–43; *LIMC*, s.v. Artemis no. 142*; Todisco, no. 107.

the right arm is correctly rendered as held up high with the forearm bent back to draw an arrow from the quiver.[175] Artemis prepares to shoot at something, but there is only a slight hint of context; since she again wears a long garment, she is unlikely to be at the hunt. The date of the statue is controversial, ranging from the second quarter to the end of the third quarter of the fourth century. Perhaps the most distinctive trait of the statue type is the drapery: even in the harsher copies in which the fold furrows are blunt troughs and the folds doughy (Kassel Sk 16)[176] the material resolves into bunches and planes, which are best seen in the examples of the statue in Berlin and Antakya.[177] At the earliest she must be later than the Colonna type.

The next Artemis, found at Gabii and now in the Louvre, is a more complex and more beautiful statue (**Figs. 137, 138**).[178] She wears her long chiton tucked up so that it does not impede her legs, thus suggesting her realm of the hunt, even though she is engaged in a quite different activity—pinning a garment over her proper right shoulder. She has been thought to be a copy of the statue of Artemis made by Praxiteles for the sanctuary of Artemis Brauronia on the Athenian Acropolis.[179] But the principal reason for this suggestion is her gesture of pinning a robe around her, since the dedication of robes to Artemis Brauronia by women was part of the cult, and these robes were hung and placed on the statues at Brauron.[180] Completely apart from the precise identification of the statue, the gesture of Artemis identifies an aspect of her cult, as do the statues of her reaching for an arrow in her quiver (Dresden type) or having released an arrow (Colonna type). But here the sharp turn of the head to concentrate on the gesture of her two hands fastening the garment over her proper right shoulder changes the nature of the image totally. The banal act of pinning the garment is an important aspect of the cult, but the choice of theme humanizes the image and relates this statue to the strigil-cleaner in Vienna, both in the type of moment chosen and in the creation of space in front of the body by the positioning of the arms. Indeed, the body describes a spiral: from the viewer's point of view the right leg is set well back, while the arms and head turn strongly to the viewer's left.

[175] Brommer, "Dresdner Artemis" (note 174 above) 5, 7–8, has argued that the arm must have been held more to the front and therefore had nothing to do with the quiver, but Vierneisel-Schlörb, *Klassische Skulpturen*, 295, convincingly defends the gesture of the Dresden example.

[176] Gercke and Zimmermann-Elseify, *Bestandskatalog Kassel*, 87–88, no. 17*.

[177] Berlin, Staatl. Mus. Sk 60: Blümel, *Katalog Skulpturen Berlin*, vol. 5 (note 56 above) 26–27, no. K 242, pl. 58; Antakya, Hatay Museum 1230: R. Stillwell, ed., *Antioch-on-the-Orontes*, vol. 2, *The Excavations, 1933–1936* (Princeton 1938) 173, no. 160, pl. 12; J. Meischner, "Die Skulpturen des Hatay Museums von Antakya," *JdI* 118 (2003) 287–88, no. 1, pl. 1.1–3.

[178] Paris, Louvre Ma 529: Rolley, *Sculpture grecque*, 262, figs. 265, 266; Lygkopoulos, *Untersuchungen*, 133–36; Bieber, *Ancient Copies*, figs. 269–72; Ridgway, *Fourth-Century Styles*, 329, pl. 77; *LIMC*, s.v. Artemis no. 190* (L. Kahil); Todisco, *Scultura greca*, no. 116; Boardman, *GS-LCP*, figs. 86.1, 86.2; Bol, *Bildhauerkunst*, vol. 2, 364–65, figs. 327a–h (C. Maderna).

[179] T. Linders, *Studies in the Treasure Records of Artemis Brauronia Found in Athens*, Skrifter Utgivna av Svenska Institutet i Athen, 4°, 19 (Stockholm 1972) 15–16; G. Despinis, "Neues zu einem alten Fund," *AM* 109 (1994) 193, note 74. Despinis (pp. 173–98, pls. 31–45) argues that the head, Acrop. 1352, belonged to a colossal acrolithic statue of Artemis by Praxiteles. He later examined fragments of several colossal statues found at Brauron from which he reconstructed a colossal seated acrolithic statue of the fourth century, among others: "Die Kultstatuen der Artemis in Brauron," *AM* 119 (2004) 216–315, pls. 64–75.

[180] Linders, *Treasure Records of Artemis Brauronia* (note 179 above) passim; I. B. Romano, "Early Greek Cult Images" (Ph.D. diss., University of Pennsylvania, 1980) 89–92; Romano, "Early Greek Cult Images and Cult Practices," in *Early Greek Cult Practice: Proceedings of the Fifth International Symposium at the Swedish Institute at Athens, 26–29 June, 1986*, Skrifter Utgivna av Svenska Institutet i Athen, 4°, 38, ed. R. Hägg, N. Marinatos, and G. C. Nordqvist (Stockholm 1988) 131–32; L. Kahil, in *LIMC*, vol. 2, s.v. Artemis, commentary, pp. 751–52, III.7; W. Burkert, *Greek Religion*, trans. J. Raffan (Cambridge, MA, 1985) 151. *IG* II² 1514, lines 41–43, states that the garment dedicated is περὶ τῶι ἀγάλμ[α]τι τῶι ὀρθῶι. See Linders (above) p. 15.

Instead of the traditional image of the huntress, the Artemis from Gabii is the protector of women, from whom she receives garments. Her chiton falls from her proper left shoulder, as it does on the east frieze of the Parthenon, emphasizing her character here as a divinity of fertility.[181] At the same time she is active, with her garment tucked up so that she can run, which may remind the viewer of the "little bears" and their races in honor of Artemis. The full plasticity of the mantle which Artemis pins around herself goes beyond the modeling of the Dresden type and, as Timotheos Lygkopoulos has pointed out, approaches the sensitive rendition of cloth on the drum from the Artemiseion of Ephesos in the British Museum (**Fig. 39**).[182] The date of the Artemiseion sculptures is much debated; Axel Rügler proposes a range from 340 to 310;[183] he places the large drum fragment in London latest, around 320–310.[184] The contrast of the mantle and chiton of the female figure (often called Alkestis) on the Ephesian drum certainly resembles that of our Artemis; the sense of modeling in volumes together with a convincing portrayal of texture is depicted better on the drum, but of course it is an original.

Three statues of Athena deserve mention at this point. The earliest is most likely the Athena in the Piraeus, which I consider an original (**Figs. 75, 77, 78**).[185] Here is a rather heavy-set woman in a thick peplos with heavy overfold. The overfold hanging down in front is askew, far longer on the statue's proper left. This is a complex arrangement because the overfold is created by the pinning of the material of the peplos at the shoulders, which normally makes the overfold hang at an equal length around the figure. In this case, Athena has folded the back part of the overfold up behind her proper left shoulder. To do so, she has pulled the front around to her proper left so that the corner that should be over her right thigh is over her left thigh. It is a bit difficult to visualize precisely how the overfold functions at the back (**Fig. 78**) since it seems that there is simply too much cloth there, but the radical pulling of the front cloth around to the back must explain this phenomenon. An interesting consequence is that the belt of the peplos is visible only at her back just below the complex arrangement of the overfold there. In her proper left hand she probably held both spear and shield. A trace of the spear remains in a lead mass in her hand, which probably also held the top rim of a shield. A shield with inlaid decoration of racing chariots was found nearby; if it belonged to the Athena, it must have rested on the ground. It has, however, not yet been published. Athena also held out something in her proper right hand; as in the case of the Marathon boy, the object was attached to the palm, but here also to the thumb. Its shape was clearly irregular and it was therefore probably not a phiale. Athena cocks her head slightly to her right and looks out beyond the hand. She is rather static, just a little pompous, and her drapery is in control of the overall impression she conveys.

The close copy of the Piraeus Athena in the Louvre, the Mattei Athena, has been discussed in chapter 3 above (**Figs. 76, 79**).[186] Since Michaela Fuchs has suggested that it is a more authoritative version of the statue type, it is worth examining its stance here. On a compositional level the Mattei Athena roughly follows the Vescovali and Rospigliosi Athenas (**Figs. 145, 146, 168, 169**), to be discussed further below (pp. 130–32), in the placement of her hand on her hip. If we restore the Mattei Athena's left hand to hold a

[181] Brommer, *Parthenonfries*, pl. 179.

[182] Lygkopoulos, *Untersuchungen*, 135. Artemiseion drum: London, BM 1206: Rügler, *Columnae caelatae*, pl. 13.2; Ridgway, *Hellenistic Sculpture*, vol. 1, pl. 5; Boardman, *GS-LCP*, fig. 23.2.

[183] Rügler, *Columnae caelatae*, 68–89.

[184] Ibid., 72–73, 87.

[185] Piraeus 4646; on the controversy over her status, see chap. 3, pp. 75–76 above.

[186] Paris, Louvre Ma 530: see chap. 3, p. 76 above with note 166.

shield and spear instead of the ambiguous gesture of questioning or indecision conveyed by the modern left hand, the impression of the statue becomes only slightly less vague. But what is immediately striking is that the vagueness is precisely the impression conveyed by the Vescovali and Rospigliosi Athenas, whereas the Piraeus Athena reflects the far more assertive poses of fifth-century Athenas, such as the Velletri and Giustiniani types.

Although not a major issue in the literature, the manner in which the overfold of the Piraeus Athena is arranged is peculiar and must have some iconographic importance; it is certainly unusual. There are three statues that reflect something of the basic pattern in the fifth century: a small bronze in Paris,[187] the Berlin-Frankfurt peplophoros type,[188] and the well-known fleeing Niobid in Copenhagen who lifts her apoptygma with both hands as though to protect herself from the arrows of Apollo and Artemis.[189] In the first two, one end of the apoptygma is brought forward over the proper right shoulder and hangs down in front. But the pattern of the Boiotian grave stele of Polyxena in Berlin is more relevant to understanding the pattern of the Piraeus Athens: Polyxena stands frontally and pulls her apoptygma up over her head.[190] There is a hole for the attachment of a metal object in her proper right hand; Blümel suggests that it may have been for a key and that Polyxena is a priestess; the covering of her head could very likely have to do with her sacred office. Clearly there are several situations in which a woman might use her apoptygma to cover her head, though protection, as in the case of the Copenhagen Niobid, suits the Piraeus Athena least. Practically, the slight forward lean of the Mattei Athena seems to respond to the swath of the overfold she has pulled up on the back of her shoulders, though the manner in which her proper right arm angles slightly to the back is not obviously consonant with trying to keep a pile of drapery thrown up behind her. The most likely suggestion is that of Karl Schefold: Athena is caught in an intimate moment associated with sacrifice, and she has just cast off the overfold from her head, but it has not yet fallen back into position.[191] Athena is depicted in a somewhat disheveled state, a moment in the course of an activity that, to the modern viewer, is not clear. If this is the case, then the sculptor of the Mattei Athena has misunderstood the situation and has adjusted the pose to accommodate the cloth on the back, whereas it was very likely meant to be falling back into its natural position. On two counts, then, the statue is important: she represents an intimate moment of undefined consequence, and the position of the overfold on her back indicates a temporal process. Athena is not static but is caught betwixt and between.

Various dates have been proposed for the Piraeus statue, from the second through the third quarter of the fourth century; my observations above point to an earlier rather than a later date: the second quarter of the century. Although the statue has a strong matronly

[187] Paris, Louvre Br 297: K. Vierneisel, "Ein griechische Peplos-Statue in Berlin," JBerlMus 15 (1973) 25, note 6, figs. 20, 21; R. Tölle-Kastenbein, Frühklassische Peplosfiguren, Originale (Mainz 1980) 227 (e), pl. 154, pp. 225–26, 228.

[188] Berlin, Staatl. Mus. 1971.1; Frankfurt, Liebieghaus 383: Vierneisel, JBerlMus 15 (1973) 5–37; R. Tölle-Kastenbein, "Frühklassisch Peplosfiguren: Typen und Repliken," AntP 20 (1986) 70–71, pls. 64–67; P. C. Bol, ed., Antike Bildwerke, Liebieghaus-Museum Alter Plastik, vol. 1, Bildwerke aus Stein und aus Stuck von archiascher Zeit bis zur Spätantike (Melsungen 1983) 50–55, no. 15*.

[189] Copenhagen, NCG 520: Poulsen, Catalogue, 267–69, no. 398; Moltesen, Classical Period, 43–45, no. 1*.

[190] Blümel, Klassisch Skulpturen Berlin, 17–18, no. 6, fig. 12; W. Schild-Xenidou, Boiotische Grab und Weihreliefs archaischer und klassischer Zeit (Munich 1972) 30–32, no. 32; Bieber, Griechische Kleidung (note 164 above) 34, pl. 3.2; K. Schefold, "Die Athena des Piräus," AntK 14 (1971) 38.

[191] Schefold, AntK 14 (1971) 38–39. One slight objection to this otherwise convincing suggestion is that the tail of the helmet crest lies on top of the cloth of the overfold, whereas it should be covered by it. The Mattei Athena avoids the problem: it has no crest on the helmet.

character, she is also caught in a casual moment. Above all, her military aspect is subsidiary, as it is very much in the two Athenas to be discussed next, the Vescovali and Rospigliosi types.

Athena of the Vescovali type is known from a number of Roman copies (**Figs. 145, 146**).[192] After a period of confusion, it was realized by Ina E. Altripp that the head types of the Athena Vescovali and the Athena Rospigliosi types (**Figs. 168, 169**) had become interchanged.[193] Athena wears a peplos and himation, the latter folded into a narrow band covering her body from knees to breasts and fully enveloping her proper left arm. Her aegis is somewhat casually pushed to her left side, where it is partially covered by the mantle. On her head, finally, is the traditional Corinthian helmet. As already remarked, the Athena Vescovali is a close mirror image of one of the Muses on the Mantineia base (**Fig. 98**, center); the only significant differences are that the Vescovali Athena raises her head as she turns to her left, and, though uncertain in detail, her right arm must have been held slightly away from the body. The figures also differ in the pronounced narrowing of the upper torso of the Muse; the Athena Vescovali is a more robust woman. Indeed, instead of seeming to slouch a little, this Athena appears more active and alert. This is conveyed by the raised hip and shoulder of her left side over the free leg, a reversal of classical contrapposto motivated by incipient body movement as opposed to rest. She is just beginning to move, since her left arm is still in a position of relaxation, and her right arm was held down in a position similar to that of the proper left arm of the bronze Athena in the Piraeus. Wolfgang Schürmann observes the important detail that the plinths of the various Athena Vescovali statues are so small that it is unlikely that she held a spear with its butt resting on the ground,[194] so one imagines that the right arm is free and hints at the beginning of a rotating motion. The pose of the Muse on the Mantineia base is static and a little stiff; she is the central axis of the block to whom her companions on either side turn. The composition of the other slab with three Muses (Athens, National Archaeological Museum 216; **Fig. 97**) is much the same. By contrast, the Athena Vescovali has an agreeably open and incipient active pose. Of course there is no indication of why her head is raised; Borbein considers it a matter of a stylistic preference of the period. This is probably true, but the Muses of the Mantineia base do not share it; it is probably an iconographic sign whose meaning remains obscure. The portrait heads of Alexander the Great also turn rather sharply and look up, as does the head of the sandal-binding Hermes (**Figs. 188, 189**).[195] Coupled with the incipient movement of the Athena Vescovali, the upward glance suggests the stimulus to begin movement. Perhaps the meaning of the upturned head is no more than an indication of alertness and the beginning of activity. Certainly the uncertain interpretation of the pose is no different from that of the statues, both male and female, discussed above; the emphasis is not on doing something but on being alive and to some degree active. The alteration of the proper right arm and position of the head in the variant of the Vescovali statue type, seen best in a small bronze from Arezzo, suggests a very different interpretation of the figure, but it was found in many pieces and is so largely

[192] Schürmann, *AntP* 27 (2000) 37–90, pls. 20–49; Kabus-Jahn, *Frauenfiguren* (note 125 above) 88–92; *LIMC*, s.v. Athena/Minerva no. 156* (F. Canciani); I. E. Altripp, "Small Athenas: Some Remarks on Late Classical and Hellenistic Statues," in Deacy and Villing, *Athena in the Classical World* (note 26 above) 184–85, pl. 8; Todisco, *Scultura greca*, no. 123.

[193] Altripp, *AA*, 1996, 83–94.

[194] Schürmann, *AntP* 27 (2000) 71.

[195] See Borbein, *MarbWPr*, 1970, 31, note 13, 39, note 54, on the uncertain meaning of Alexander's upward glance.

restored that its value is simply to underscore the real interest of the type.[196] The Arezzo statuette's head faces front, and she does not look upward; her proper right arm, a modern restoration, is held out to the front with the hand open, as though she were arguing over the price of fish.

The date of the Athena Vescovali is uncertain; dates range from 360 to 330–320.[197] Since no other sculpture from this period has a firm date, the field is quite open. Comparisons with grave reliefs have little meaning because the statue type is so much more complex than any figure found on the reliefs, though a figure somewhat like the Athena Vescovali does appear on a fragmentary votive relief to Dionysos.[198] Part of the difficulty lies in the novelty of the pose of the Vescovali type. This is also true of another Athena type, the Rospigliosi (**Figs. 168, 169**).[199] The statue in Berlin, including the head, appears to be the most reliable of the different examples of the type.[200] However, the other well-known example, in Florence, preserves an important variant considered to be more authoritative: the short chiton that is not visible below the himation.[201] Although the head on the statue in Florence is actually of the Vescovali type and is set so that it looks up at a far too steep and very awkward angle, the bare lower legs function much better than the dense drapery of the Berlin example to enhance the impression of an active young women at rest.

The Rospigliosi type of Athena is remarkably slim, the Berlin example more so than the others, and in this one regard the contrast with the Vescovali type could not be clearer. In this she resembles a popular type of Kore/Persephone, such as the statue in Vienna restored as a Muse,[202] which contrasts with the heavier-set, matronly female figures of the general run of female statues and women on grave stelai. The stance and the position of the proper left arm wrapped in the himation also resemble the statues of Sophokles in the Vatican[203] and Aischines in Naples (**Fig. 283**).[204] They are usually dated around 340 and 310, respectively, on vague historical grounds. The Sophokles statue is connected with the Lykourgan rebuilding of the Theater of Dionysos in Athens, when,

[196] Florence, MAN 248: Schürmann, *AntP* 27 (2000) 80–82, no. U1, pl. 46a–c; Rizzo, *Prassitele*, 93, 118, pls. 139–41. The modern heads that are not turned up on the versions in Liverpool (formerly in Ince Blundell Hall), Castle Howard, and Oxford, completely change the meaning of the statue: Schürmann, *AntP* 27 (2000) pls. 24, 26, 30.

[197] Todisco, *Scultura greca*, no. 123 (= 360–340); Ridgway, *Fourth-Century Styles*, 325 (= 340); Kabus-Jahn, *Frauenfiguren* (note 125 above) 92 (= 340–330); Schürmann, *AntP* 27 (2000) 75–76 (= 330–320).

[198] Athens, NAM 1440: Kaltsas, *SNAMA*, 222, no. 462*. The type appears in a figure identified as Hera on a pelike by the Marsyas/Eleusinian Painter in Saint Petersburg, St. 1792: *ARV*² 1476.1; *Beazley Addenda*² 381; E. Simon, "Eleusis in Athenian Vase-Painting: New Literature and Some Suggestions," in *Athenian Potters and Painters*, ed. J. H. Oakley, W. D. E. Coulson, and O. Palagia (Oxford 1997) 105–6, fig. 14.

[199] Borbein, *MarbWPr*, 1970, 29–43, pls. 6–8; O. Waldhauer, "The Date of the Athena Rospigliosi Type," *JHS* 43 (1923) 176–82, pls. 7, 8; Schlörb, *Timotheos*, 60–63; G. B. Waywell, "Athena Mattei," *BSA* 66 (1971) 377–78, 381, no. 2, pl. 71b; *LIMC*, s.v. Athena/Minerva no. 155* (F. Canciani); Altripp, *AA*, 1996, 83–94; Ridgway, *Fourth-Century Styles*, 325–26, pl. 76; Todisco, *Scultura greca*, no. 299.

[200] Berlin, Staatl. Mus. Sk 73: Blümel, *Katalog Skulpturen Berlin*, vol. 5 (note 56 above) 25, no. K 239, pls. 53–55; Borbein, *MarbWPr*, 1970, pl. 8, left; Altripp, *AA*, 1996, 89–91, 94, figs. 12–14.

[201] Florence, Uffizi 185: Mansuelli, *Uffizi*, 56–57, no. 33*; Borbein, *MarbWPr*, 1970, pls. 6, 7; Todisco, *Scultura greca*, no. 299; Ridgway, *Fourth-Century Styles*, pl. 76.

[202] Vienna, KHM I 157: Filges, *Standbilder* (note 130 above) 280, no. 178*; Todisco, *Scultura greca*, no. 290.

[203] Vatican, Museo Gregoriano Profano ex Lateranense 9973: C. Vorster, *Vatikanische Museen, Museo Gregoriano Profano ex Lateranense: Katalog der Skulpturen*, vol. 2, *Römische Skulpturen des späten Hellenismus und der Kaiserzeit* (Mainz 1993) 154–59, no. 67, figs. 297–308; Helbig⁴, vol. 1, no. 1066 (H. von Heinze); Todisco, *Scultura greca*, no. 292.

[204] Naples, MAN 6018: F. Hiller, "Zum Neapler Aeschines," *MarbWPr*, 1962, 53–60, pls. 12–14; G. M. A. Richter, *The Portraits of the Greeks* (London 1965–72) vol. 2, 213, no. 6, fig. 1369; Ridgway, *Hellenistic Sculpture*, vol. 1, 226, pl. 109; Todisco, *Scultura greca*, no. 300.

according to pseudo-Plutarch (*Lives of the Ten Orators, Lykourgos* 10), statues of the three great tragedians of the fifth century—Aischylos, Sophokles, and Euripides—were set up, and statues of the three were indeed seen by Pausanias (1.21.1).[205] Aischines died on Samos in 310 B.C. For our purposes it is perhaps enough to accept that both the Vescovali and Rospigliosi Athenas belong in the last third of the fourth century, represented symbolically as 330 to 310 B.C.[206]

A convincing interpretation of the Rospigliosi Athena type is difficult: the stance is ambiguous. The strong diagonals of the himation create a powerful movement up to the viewer's right, which is also the direction of the statue's upward-tilted head. The effect is more emphatic than that of the statue of Aischines because the folds of his himation are straight and roughly parallel; on the Rospigliosi Athena the folds are curved and a little chaotic. The bare legs, the angled foot position, and the proper right arm held away from the body also add to the sense of movement, as opposed to the far more static Aischines. Borbein suggested that the new depiction of Athena in the Rospigliosi type might be interpreted as a more philosophical or cultural image, in contrast to the solid and military qualities of earlier Athenas.[207] Ridgway suggests, to the contrary, that the short chiton and manner of wearing the himation have male connotations.[208] My own reaction to the figure is that it is an agile and youthful goddess; the short chiton reminds me of the growing popularity of images of Artemis in a chitoniskos, for example, the Versailles type of the early third century (**Fig. 240**).[209] The slimness recalls the Kore/Persephone type in Vienna, as already mentioned.[210] I am tempted to go so far as to suggest that the Rospigliosi Athena may be all things to all people: she has spear and helmet; she is able to be active in her short chiton; she resembles Persephone; she is young. The upturned head, shared with the Vescovali Athena, may again be compared to the portraits of Alexander and perhaps even the sandal-binding Hermes and suggest not only activity but also otherworldliness. Is she perhaps the ideal of the intellectual and the active, the two traits of Athena that are usually kept quite separate?

Near the end of the fourth century, a new style, but one related to that of the Athena Rospigliosi and the Kore/Persephone in Vienna, appears; it is characterized by closely clinging, though not transparent, drapery. The most important monument in this style is the Column of the Dancers at Delphi, also known as the Acanthus Column (**Figs. 99, 100**).[211] Although its date has been much debated—partly because of the similarity of its

[205] Overbeck, *Schriftquellen*, nos. 1411, 1409. B. Hintzen-Bohlen, *Die Kulturpolitik des Eubulos und des Lykurg: Die Denkmäler- und Bauprojekte in Athen zwischen 355 und 322 v. Chr.* (Berlin 1997) 29–31.

[206] In this I follow Borbein, *MarbWPr*, 1970, 36, note 38, i.e., the Vescovali before the Rospigliosi, which he dates ca. 310 (p. 36), and close to the Sophokles, which he dates 340–330 (p. 35). Himmelmann, *Ideale Nacktheit*, 98–100, suggests but does not argue an early-fourth-century date for the Rospigliosi type; Altripp, *AA*, 1996, 83, note 4, 94, reviews the extensive literature on the early and late dates.

[207] Borbein, *MarbWPr*, 1970, 36–37, 40–43.

[208] *Fourth-Century Styles*, 325.

[209] Paris, Louvre Ma 589: *LIMC*, s.v. Artemis/Diana no. 27* (E. Simon); Rolley, *Sculpture grecque*, 292–93, fig. 302; Todisco, *Scultura greca*, no. 228.

[210] See note 202 above.

[211] J. Pouilloux and G. Roux, *Énigmes à Delphes* (Paris 1963) 123–49, pls. XXIII–XXVIII; J. Bousquet, "Delphes et les Aglaurides d'Athènes," *BCH* 88 (1964) 655–75; G. Roux, "Problèmes delphiques d'architecture et d'épigraphie," *RA*, 1969, 37–46; Borbein, *JdI* 88 (1973) 202–12, figs. 96, 97; J. Marcadé, "Les bras des danseuses," in *Mélanges helléniques offerts à Georges Daux* (Paris 1974) 239–54, repr. in J. Marcadé, *Études de sculpture et d'iconographie antiques: Scripta varia, 1941–1991* (Paris 1993) 153–68; Ridgway, *Hellenistic Sculpture*, vol. 1, 22–26, pl. 4; Picard, *Delphes: Le musée*, 84–90, figs. 46–48; J.-L. Martinez, "La colonne des danseuses de Delphes," *CRAI*, 1997, 35–46; Rolley, *Sculpture grecque*, 381–83, figs. 402–4; Todisco, *Scultura greca*, no. 305; Bol, *Bildhauerkunst*, vol. 2, 371–72, figs. 338a–f (C. Maderna).

style to the Rich Style and partly because of Claude Vatin's controversial reading of faint traces of inscriptions on the base of the column[212]—the present consensus places the column in the last third of the fourth century.[213] The grave stele of Hieron and Lysippe from Rhamnous bridges the style of the Athena Rospigliosi and the Muse in Vienna and that of the Delphi "dancers."[214] A tall acanthus stem rises 8.8 meters, and three women stand or possibly dance on its top; each of them wears a polos and a short chiton that barely reaches the knee, and raises her arms to support a tripod crowned with an omphalos; the whole monument reaches a height of about 13 meters.[215] The chitons are belted just below the breasts, and the cloth, which is thin but not transparent, clings to the figures so that the navels are apparent, though a fine web of fold lines covers all the surfaces. The arcing folds of the lower chiton behind the thighs suggest strong movement, which might indicate a dance. The feet of all three figures are missing, but they were certainly suspended well above the acanthus plant below them. Perhaps the viewer looking up from well below the figures saw the feet as though resting on the acanthus; if the feet actually stood on it, they would certainly have been hidden.

Closely related to the Delphi "dancers" is the statuette of a raving mainad in Dresden (**Fig. 190**).[216] The movement here is totally different: the mainad twists in frenzy, her head cast back at an almost impossible angle, and her short, belted garment is pulled back, exposing almost completely her proper left side. But it is her drapery that resembles that of the "dancers" of the Acanthus Column: it is not transparent, but it is thin and clings to the body with exactly the same minor fold ridges, and, where the material pulls away from the body, it creates long soft arcs of cloth almost without mass. An obvious comparison to the pose of the Dresden Mainad is the recently discovered bronze satyr in Mazara del Vallo discussed above, thought by some to be an original of the late fourth century and possibly even by Praxiteles.[217] The comparison is not easy, because the arms of the mainad are missing, but the body and legs allow some cautionary observations. Although the head of the mainad is thrown back in a manner similar to that of the satyr, the body is far less twisted and has a clear frontal view perpendicular to the torso, whereas the satyr's principal view is, as Andreae points out, from three-quarters right.[218] Of equal importance is that the mainad's

[212] C. Vatin, "Les danseuses de Delphes," *CRAI*, 1983, 26–40; Pouilloux, *FdD* 3.4, 139–40, no. 462; J. Bousquet, "Inscriptions de Delphes," *BCH* 108 (1984) 696; A. Corso, *Prassitele: Fonti epigrafiche e letterarie; Vita e opere*, vol. 1, *Fonti epigrafiche; Fonti litterarie dall'età dello scultore al medio impero (IV sec. a.C.–circa 175 d.C.)* (Rome 1988) 15–17, no. A1. Martinez, *CRAI*, 1997, 44, note 27, rejects Vatin's readings most strongly. See chap. 2, pp. 44–45 above with note 172.

[213] J. Frel, "Le sculpteur des danseuses," *GettyMusJ* 6–7 (1978–79) 75–82; J. Hicks, "Acanthus and the Date of the Acanthus Column at Delphi," *AJA* 84 (1980) 213; Despinis, *AM* 109 (1994) 184–85; H. Knell, "Überlegungen zur öffentlichen Architektur des IV. Jahrhunderts in Athen," in *Die athenische Demokratie im 4. Jahrhundert v. Chr.: Vollendung oder Verfall einer Verfassungsform? Akten eines Symposiums, 3.–7. August 1992, Bellagio*, ed. W. Eder (Stuttgart 1995) 486, fig. 15; Hintzen-Bohlen, *Kulturpolitik des Eubulos* (note 205 above) 66–67; Boardman, *GS-LCP*, fig. 15.

[214] Athens, NAM 833: Kaltsas, *SNAMA*, 204, no. 409*; Diepolder, *Grabreliefs*, 54, 56, pl. 54; Clairmont, *CAT*, 2.480; Himmelmann, *Attische Grabreliefs*, 129–36, figs. 51, 52. Diepolder compared the stele to the record relief of 318/17, which underscores the late date of the new style.

[215] Martinez, *CRAI*, 1997, 35–46.

[216] Dresden, SKD Herrmann 133 (ZV 1941): Stewart, *Skopas*, 91–93, pl. 32; Stewart, *Greek Sculpture*, 184, fig. 547; Ridgway, *Fourth-Century Styles*, 255–57, ills. 21a–d, pl. 61; Knoll et al., *Antiken im Albertinum*, 28, no. 12; Todisco, *Scultura greca*, no. 138; Boardman, *GS-LCP*, fig. 33; Bol, *Bildhauerkunst*, vol. 2, 335–36, figs. 306a–g (C. Maderna); Knoll, Vorster, and Woelk, *Katalog Dresden*, 890–97*, no. 212 (C. Vorster); B. Barr-Sharrar, "The Dresden Maenad and Skopas of Paros," in Katsonopoulou and Stewart, *Skopas of Paros* (note 102 above) 321–36.

[217] See chap. 2, pp. 36–37 above. The comparison is made by P. Moreno, "Satiro di Prassitele," in *Il Satiro danzante*, ed. R. Petriaggi (Milan 2003) 103, fig. 11 on p. 104.

[218] Andreae, *Tanzende Satyr* (note 113 above) 13–14, fig. 1.

legs (insofar as preserved) are close together and the lower legs are not flung out, as is one of the satyr's. In both these aspects the Dresden Mainad reflects more closely the mainads of the Neo-Attic reliefs and the mainads of the Derveni krater.[219] Since I am inclined to date the Dresden Mainad in the last third of the fourth century, based primarily on the rendition of drapery, I submit that the pose of the originals of the Neo-Attic mainads was still alive in the later fourth century when the original of the Dresden Mainad was made. But in the Classical period it is impossible to name a single figure either in relief or in the round that has the flamboyance of the Mazara satyr, which leads me to doubt its attribution to the fourth century. One can, of course, advance the hypothesis that an immensely creative artist, such as Praxiteles, ventured well beyond structural forms of his time, but if he or some other artist did, it had no resonance for a century or more.

Somewhat less closely related to the Delphi "dancers" and Dresden Mainad is the impressive female torso in the Athenian Agora variously identified as Themis or Tyche (**Fig. 80**).[220] The cloth of the statue's chiton is rendered as a similarly thin fabric, but now with a web of tiny folds that nonetheless allow the navel to appear through it; the belt is high under the breasts. This figure, though, wears a heavy himation over her proper left shoulder and slung across the lower abdomen and over the projecting proper left forearm.[221] The noticeably thin drapery with very light folds also appears on the Themis of Rhamnous signed by Chairestratos (**Fig. 191**).[222] The relationship of the style to that of the "dancers" in Delphi led Jiří Frel to posit that Chairestratos was the sculptor of the Acanthus Column, but Olga Palagia is correct to suggest that the Themis of Rhamnous is a rather poor, eclectic work based on the colossal statue in the Athenian Agora.[223] Closer to the style of the Delphi "dancers" of the Acanthus Column is the statue, perhaps of an Aura, in Copenhagen (**Fig. 45**).[224] Although Mette Moltesen suggests a date around 400, Vagn Poulsen correctly concluded that the narrow shoulders and high belt suggest a date in the Hellenistic period. Since Poulsen, like so many others, begins the Hellenistic period in 320, his date for the Aura could be at the end of the fourth century,[225] though I am inclined to feel that the statue is much later. Her very narrow shoulders and the slim body suggest a date in the late second century B.C.[226] The style of thin, semitransparent

[219] Barr-Sharrar, *Derveni Krater*, 123–48. W. Geominy, "Looking for a New Skopaic Maenad," in Katsonopoulou and Stewart, *Skopas of Paros* (note 102 above) 371–77, suggests that the Berlin dancer (Sk 208) is a more likely choice for the mainad of Skopas.

[220] Athens, Agora S 2370: T. L. Shear, Jr., "The Athenian Agora: Excavations of 1970," *Hesperia* 40 (1971) 270–71, pl. 56; E. B. Harrison, "The Shoulder-Cord of Themis," in *Festschrift für Frank Brommer*, ed. U. Höckmann and A. Krug (Mainz 1977) 155–61, pl. 43.2–3; O. Palagia, "A Colossal Statue of a Personification from the Agora of Athens," *Hesperia* 51 (1982) 99–113, pls. 29, 30; Palagia, "No Demokratia," in *The Archaeology of Athens and Attica under the Democracy*, ed. W. D. E. Coulson and O. Palagia (Oxford 1994) 113–22; Ridgway, *Hellenistic Sculpture*, vol. 1, 54–55, pl. 29; Smith, *Polis and Personification*, 148 no. S 10; Todisco, *Scultura greca*, no. 304; Boardman, *GS-LCP*, fig. 51; Bol, *Bildhauerkunst*, vol. 2, 370–71, fig. 337 (C. Maderna).

[221] The torso of a female statue in Frankfurt, Liebieghaus 80, resembles the Themis/Tyche of the Agora except that the drapery is heavier, though still clinging: Bol, *Bildwerke aus Stein und aus Stuck* (note 188 above) 96–99, no. 26*.

[222] Athens, NAM 231: Kaltsas, *SNAMA*, 272, no. 568*; Ridgway, *Hellenistic Sculpture*, vol. 1, 55–57, pl. 31.

[223] Palagia, *Hesperia* 51 (1982) 105–6, pl. 33d, e.

[224] Copenhagen, NCG 2432: Poulsen, *Catalogue*, no. 397a; Moltesen, *Classical Period*, 60–61, no. 9*; Schlörb, *Timotheos*, 79–80, fig. 57; Danner, *Griechische Akrotere*, 26, no. 161; Todisco, *Scultura greca*, no. 21; Bol, *Bildhauerkunst*, vol. 2, 276–77, figs. 226a, 226b (W. Geominy).

[225] Poulsen, *Catalogue*, 15; Geominy, in Bol, *Bildhauerkunst*, vol. 2, 277, dates the statue parallel to the pediments of the Temple of Asklepios at Epidauros, that is, ca. 380–370.

[226] Compare Boston, MFA 97.286: Comstock and Vermeule, *Sculpture in Stone*, 58–59, no. 91*; Ridgway, *Hellenistic Sculpture*, vol. 2, 157–58, pl. 50.

drapery is very rare in the grave reliefs[227] and, as far as I can see, nonexistent in the record reliefs.[228] The dating of this stylistic phase therefore has no solid foundation, but the last third or quarter of the fourth century seems reasonable, since the style continues down into the third century.

<p style="text-align:center">* * *</p>

Sculpture of the fourth century has a series of diverse elements of style, composition, and subject matter that all focus on creating a coherent, though not necessarily harmonious, image of spatial and temporal aliveness—figures breathe and move in real space and time. There is also a strong element of implication beyond simple illusionistic imagery: there is on the most basic level an allusion to character, as on Attic grave monuments or the statues of the Maussolleion or the Daochos Monument. Equally important is the allusion to a situation that is not merely an event or an action. The Eirene and Ploutos, the Perseus/Paris/ballplayer, and the Resting Satyr each describes a person in a situation that is representative, even characteristic, yet is so primarily by alluding to something that is not directly represented. Though the excesses of the Rich Style die out in the first half of the century, its primary features continue into its "plain" successor in which line and texture are tamed but still used to expand the descriptive possibilities of images by adding character in the abstract guise of style and composition. The conscious recognition of style as the expressive medium of art is the heart of the novelty of art in the fourth century and will occupy pride of place in a later chapter. But much of my commentary has had to be built on the foundation of uncertain Roman "copies." In the following section of this chapter originals are almost the only subject of our inquiry.

VASE PAINTING AND MONUMENTAL PAINTING

If there are relatively few original sculptures of the fourth century, there are even fewer original monumental paintings and no preserved panel paintings. The discovery of painted grave stelai and the elaborate Macedonian tombs of the second half of the century, as well as the barbarian chieftain's tomb at Kazanlǎk in modern Bulgaria, provide a bare minimum of material to discuss an art form that occupies a large position in the later Roman accounts of the art of the late fifth and fourth centuries.[229] The possibility that some extant Roman wall paintings reflect Greek works of the fourth century was discussed briefly in the last chapter, but the evidence is often very weak and generally more controversial than the proposition that Roman statues reflect Greek originals more

[227] Athens, NAM 817: Kaltsas, *SNAMA*, 202, no. 405*. It is interesting to compare the earlier relief, apparently of a dancer, Athens, NAM 1896 (Kaltsas, 188, no. 370*), in which the drapery covering the standing woman holding krotala is diaphanous and largely smooth. B. Schmaltz, "Typus und Stil im historischen Umfeld," *JdI* 112 (1997) 90–99, discusses a partially similar phenomenon of the breasts of women on Attic stelai that are clearly revealed through their drapery; on p. 94, note 63, he lists six such stelai later than the Rich Style. He concludes that they represent young brides or mothers.

[228] Meyer, *Urkundenreliefs*, 77, observes with respect to the latter that "die Gewänder der Grabrelieffiguren eignen sich wegen der Verschiedenheit der Motive, der stärkeren Plastizität der Figuren und des größeren Formats der Reliefs weniger zum Vergleich."

[229] The most recent treatment of the Macedonian tombs is Brecoulaki, *Peinture funéraire*, with excellent color plates. S. G. Miller gives a brief review of recent discoveries and publications: "Macedonian Painting: Discovery and Research," in *International Congress Alexander the Great: From Macedonia to the Oikoumene, Veria, 27–31/5/1998*, ed. A. Vlazakis (Veroia 1999) 75–88. The texts are gathered by A. Reinach, *Recueil Milliet: Textes grecs et latins relatifs à l'histoire de la peinture ancienne* (Paris 1921); most also appear in Overbeck, *Schriftquellen*, 187–216, 310–70, and some are translated by Pollitt, *Art of Greece*, 95–112, 154–82.

or less accurately.[230] For the preceding Late Archaic and Classical periods, scholars have used Attic vases combined with descriptions of paintings, especially by Pausanias, to reconstruct some sense of the wall paintings, particularly those at Athens.[231] At least here the vases are contemporary originals that, as shown by the descriptions of the lost wall paintings, share some of their characteristics, such as compositional principles and, in the case of white-ground vessels, color. For the pre-classical and classical works there is ample evidence in Etruscan and West Greek tombs,[232] though these and the paintings found at Elmalı in northern Lykia in Asia Minor[233] represent a special context, the tomb. However, the painted wooden plaques of Pitsa, of the end of the sixth century, indicate that there was little difference between panel and tomb paintings.[234]

It seems very unlikely, however, that Greek paintings on walls were made in the same manner as the preserved (Greek or non-Greek) tomb paintings. The fact that Pausanias in the later second century A.D. saw several original wall paintings of the fifth century B.C. in buildings that either were certainly or with great probability extensively or wholly rebuilt between the time of their original decoration with paintings and Pausanias's day suggests rather forcefully that their walls were decorated with wooden panels that could be removed.[235] In any case, the walls were not painted in fresco, that is, on moist plaster to which the pigments bonded indissolubly, a procedure that appears to have developed in Greece only during the course of the fourth century.[236] Accordingly, classical Greek paintings were not applied over vast areas, but consisted of juxtaposed, separate, portable sections.[237] How large they may have been is open to speculation.

Two important characteristics of Greek painting as it developed in the fifth century were the mastery of foreshortening and color. The illusionistic rendering of volumes began in the late sixth century in vase painting and sculpture with the simple technique of foreshortening. This concentrated on the discrete forms of elements of the human body, of horses, and perhaps of ships' sails. By the beginning of the fifth century it was fully understood and re-

[230] See chap. 3, pp. 90–94 above.

[231] C. Robert, "Die Nekyia des Polygnot," *HallWPr* 16 (1892); Robert, "Die Iliupersis des Polygnot," *HallWPr* 17 (1893); Robert, "Die Marathonschlacht in der Poikile und Weiteres über Polygnot," *HallWPr* 18 (1895); E. Simon, "Polygnotan Painting and the Niobid Painter," *AJA* 67 (1963) 43–62; M. D. Stansbury-O'Donnell, "Polygnotos's *Iliupersis*: A New Reconstruction," *AJA* 93 (1989) 203–15; Stansbury-O'Donnell, "Polygnotos's *Nekyia*: A Reconstruction and Analysis," *AJA* 94 (1990) 213–35; S. B. Matheson, *Polygnotos and Vase Painting in Classical Athens* (Madison, WI, 1995).

[232] M. Napoli, *La tomba del tuffatore* (Bari 1970); A. Rouveret, "La tombe du Plongeur et les fresques étrusques: Témoinages sur la peinture grecque," *RA*, 1974, 15–32.

[233] M. J. Mellink, R. A. Bridges, and F. C. di Vignale, *Kızılbel: An Archaic Painted Tomb Chamber in Northern Lycia*, Bryn Mawr College Archaeological Monographs (Philadelphia 1998).

[234] The well-preserved plaque A is widely published: E. Walter-Karydi, "Prinzipien der archaischen Farbgebung," in *Studien zur klassischen Archäologie: Friedrich Hiller zu seinem 60. Geburtstag*, ed. K. Braun and A. Furtwängler (Saarbrucken 1986) 25–28, figs. 1–3; N. J. Koch, *De Picturae Initiis: Die Anfänge der griechischen Malerei im 7. Jahrhundert v. Chr.* (Munich 1996) 7–8, figs. 1, 2; Neumann, *Weihreliefs*, 27, pl. 12a; J. Charbonneaux, R. Martin, and F. Villard, *Archaic Greek Art (620–480 B.C.)* (New York 1971) 312, fig. 357. For the fragmentary plaques B–D, see most recently J. A. Papapostolou, "Color in Archaic Painting," in *Color in Ancient Greece: The Role of Color in Ancient Greek Art and Architecture, 700–31 B.C.; Proceedings of the Conference Held in Thessaloniki, 12th–16th April, 2000*, ed. M. A. Tiverios and D. S. Tsiafakis (Thessaloniki 2002) 61–62, pl. 12, figs. 7–9.

[235] At Vergina a frieze on the exterior facade of the Tomb of the Prince was done on a perishable ground and suffered the expected fate: Andronikos, *Royal Tombs*, 199, fig. 160.

[236] L. Vlad Borelli, "Nota sulla tecnica nella pittore parietale etrusca," in *Ricerche di pittura ellenistica: Lettura e interpretazione della produzione pittorica dal IV secolo a.C. all'ellenismo* (Rome 1985) 89–90. Brecoulaki, *Peinture funéraire*, 439, states that all the Macedonian painted tombs she treats were painted in *fresco secco*.

[237] Bruno, *Form and Color*, 107–9; H. A. Thompson and R. E. Wycherley, *The Athenian Agora*, vol. 14, *The Agora of Athens: The History, Shape and Uses of an Ancient City Center* (Princeton 1972) 90–91; Scheibler, *Griechische Malerei*, 95; Pouilloux, *FdD* 2.C.2.

placed the archaic principle of juxtaposed characteristic views of each element of the body. Linear perspective, that is, the apparent convergence of parallel lines in recession, was clearly known in the second half of the fifth century, but was never applied consistently as a system.[238] The technical term for it, *skenographia* (scene painting), indicates a connection with the theater, and indeed the painter who gained fame for its development, Agatharchos, is reported to have painted a stage set for Aischylos and/or Sophokles.[239] Since linear perspective is based on principles of geometry, it is not surprising that two philosophers, Demokritos and Anaxagoras, are said in the sources to have written treatises on the subject, which suggests that a theory of perspective was understood in the fifth century B.C.[240] Yet the fact that Roman paintings of the first century B.C. are hardly more systematic in their use of linear perspective than the late-fifth-century vase paintings has elicited various explanations. Erwin Panofsky correctly deduced from this that the principles of rigid linear perspective as developed in western Europe during the Renaissance did not effectively describe the Graeco-Roman experience of space.[241] Bernhard Schweitzer's formulation of the principle of body or object perspective (*Körperperspektive*), that is, the general coherence of three-dimensional relationships within the confines of discreet objects, whether human bodies or tables, describes well the Greek use of perspective, whether foreshortening or rudimentary linear perspective.[242] The concept of space as a homogenous continuum was not formulated. Finally, Angès Rouveret has produced a convincing synthesis of these observations, whose basis is that the surface of the painting, whether wall or panel, does not serve as a window into a coherent space beyond, but is a real surface on which the elements of a picture are assembled.[243] The issue of a coherent spatial continuum does not arise because the construction is not purely geometric but relies on an intuitive arrangement of the various elements comprising the image.[244]

The issue of color in Greek painting is similar. The earliest examples of large-scale painting in the sixth century B.C. reveal that figures were painted in outline on a white ground and that unmodulated colors filled the outlines as appropriate.[245] This is the technique of early Etruscan tomb paintings, the painted tombs of Paestum, and the painted wooden plaques from Pitsa in Achaia. The technique continued well down into the fifth century

[238] By far the most sensitive study is that of R. Delbrück, *Beiträge zur Kenntnis der Linienperspektive in der griechischen Kunst* (Bonn 1899); some additions and particularly images were added by J. White, *Perspective in Ancient Drawing and Painting*, Society for the Promotion of Hellenic Studies, Supplementary Paper 7 (London 1956); G. M. A. Richter, *Perspective in Greek and Roman Art* (London and New York 1970); E. Keuls, *Plato and Greek Painting*, Columbia Studies in the Classical Tradition 5 (Leiden 1978) 63–66, 110–15.

[239] Vitruvius 7 praef. 10; Aristotle, *Poetics* 4.1449a 18. See generally Rouveret, *Histoire et imaginaire*, 106–15.

[240] Rouveret, *Histoire et imaginaire*, 100–106.

[241] E. Panofsky, *Perspective as Symbolic Form*, trans. C. S. Wood (New York 1991); originally published as "Die Perspektive als symbolische Form," in *Vorträge der Bibliothek Warburg, 1924–1925* (Leipzig and Berlin 1927) 258–330. Keuls, *Plato and Greek Painting* (note 238 above) 65, does not agree.

[242] B. Schweitzer, *Vom Sinn der Perspektive* (Tübingen 1953) 13–15. E. Walter-Karydi, "Der Naiskos des Hermon: Ein spätklassisches Grabgemälde," in *Festschrift Ernst Berger* (note 14 above) 336, objects that Schweitzer proposes a "Raumperspektive" after 460 B.C., which indeed he does, but in such a manner that it so closely resembles "Körperperspektive," that the difference is minimal. See also J. Borchhardt, "Zur Darstellung von Objekte in der Entfernung: Beobachtungen zu den Anfängen der griechische Landschaftsmalerei," in *Tainia: Roland Hampe zum 70. Geburtstag am 2. Dezember 1978*, ed. H. A. Cahn and E. Simon (Mainz 1980) 257–67, who argues unconvincingly that perspectival diminution to convincingly represent relative distance within a scene was practiced from the late sixth century on.

[243] Rouveret, *Histoire et imaginaire*, 96–98. Her analysis (pp. 65–127) is based on a minute examination of the literary references.

[244] Ibid., 93–95.

[245] Walter-Karydi, "Prinzipien der archaischen Farbgebung" (note 234 above) 26–41.

until Apollodoros, an Athenian, began to explore an increasingly nuanced use of color to indicate modeling, to which the term *skiagraphia* was applied.[246] Apollodoros's dates are not certain; Pliny (*NH* 35.60) gives the ninety-third Olympiad (408–405 B.C.) for his *floruit*. However, the first movement away from the simple application of unmodulated color begins much earlier on white-ground vases; the use of darker hues of a local color to render folds first occurs around the middle of the fifth century.[247] Shortly afterward, the white-ground lekythos painters abandoned all elements of the previous part-ceramic fired painting and even began to apply preliminary sketches in matt tempera colors.[248] In the last third of the fifth century, some painters applied several unmixed, superimposed colors directly on the white kaolin surface to give local color to folds in drapery and reveal the structure of the body beneath drapery.[249] A more radical and rarer technique is the application of different colors next to each other in the hair of some figures and occasionally also for rocky seats; highlights in the hair are added in white (**Fig. 192**).[250] Near the very end of the century, painters in and around Group R, and particularly the painters of the Group of the Huge Lekythoi, begin to apply hatched shading to male figures (**Fig. 193**).[251] It can hardly be a controversial assumption that the white-ground lekythoi faithfully reflect contemporary developments of the great panel painters, and it is precisely at the end of the fifth century that Apollodoros is said by Pliny to have revolutionized the art of painting.[252] Plutarch is somewhat more informative in that he records that Apollodoros was "the first to mix colors and to grade shadows."[253] Dionysios of Halikarnassos (*De Isaeo* 4) summarizes the situation very clearly, though he mentions no names:

> There are some old paintings which are worked in simple colors without any subtle blending of tints but clear in their outline, and thereby possessing great charm; whereas the later paintings are less well-drawn but contain greater detail and a subtle interplay of light and shade, and are more effective because of the many nuances of color which they contain. (Trans. S. Usher, Loeb edition)

One has only to recall that this was the period of the Rich Style in sculpture and of red-figure vase painting to see how monumental painting must have paralleled the other plastic arts of the period.[254]

The word *skiagraphia* is used by both Plato and Aristotle to describe contemporary painting, and there has been some debate about its precise meaning. The root clearly means "shadow" painting. It is coupled with the similar word *skenographia*, which, as we

[246] The precise meaning of *skiagraphia* is much debated: Pollitt, *Ancient View*, 247–54; Bruno, *Form and Color*, 27–28, 37; Keuls, *Plato and Greek Painting* (note 238 above) 38–39, 59–87; Rouveret, *Histoire et imaginaire*, 11–63.

[247] E. Walter-Karydi, "Color in Classical Painting," in Tiverios and Tsiafakis, *Color in Ancient Greece* (note 234 above) 77, pl. 15.1.

[248] Koch-Brinkmann, *Polychrome Bilder*, 49–51; I. Wehgartner, "Color on Classical Vases," in Tiverios and Tsiafakis, *Color in Ancient Greece* (note 234 above) 93–94.

[249] Koch-Brinkmann, *Polychrome Bilder*, 71–74.

[250] Athens, Kerameikos 3146: ibid., 74–76, figs. 95–97, 106, 107, 110.

[251] Berlin, Staatl. Mus. F 2685: Koch-Brinkmann, *Polychrome Bilder*, 88, figs. 133–35, and generally 76–79, figs. 126–44.

[252] Overbeck, *Schriftquellen*, nos. 1641–46. Rouveret, *Histoire et imaginaire*, 59–63, observes that the epithet σκια-γράφος applied to Apollodoros by a late scholiast on *Odyssey* 10.265 is probably somewhat misleading because in the Late Imperial period *skiagraphos* appears to be a synonym for *zōgraphos*.

[253] *Moralia* 346a (*De Gloria Athen.* 2 = Overbeck, *Schriftquellen*, no. 1645). My translation is based on Rouveret, *Histoire et imaginaire*, 40–41, 45–46; cf. Pollitt, *Ancient View of Greek Art*, 251.

[254] Koch-Brinkmann, *Polychrome Bilder*, 54–55.

have seen above, literally means "scene painting" and designated the ancient equivalent of perspective. Although various precise meanings for each of these terms has been proposed by scholars over the past one hundred years, it seems clear from the ancient texts that the terms had a somewhat fluid meaning depending on the context and the period. Rouveret, on the basis of a close reading of the texts, has suggested a broader interpretation of the original technical meaning of both terms in the later Classical period. She equates *skiagraphia* with the general sense of illusionistic painting, while *skenographia*, she argues logically and convincingly, can be considered a subset of *skiagraphia*, since the production of a convincing representation of a building with any pretense of three-dimensionality must include some modulation of light and shadows.[255]

The development of both *skenographia* and *skiagraphia* in the second half of the fifth century is completely logical and clearly justifies the belief of later commentators such as Pliny that painting was revolutionized, not to say invented, in that period. Indeed, these developments allow painting to vie with sculpture, since the dioramic statues discussed above, such as the Aphrodite of Knidos, the Resting Satyr, or the Apollo Sauroktonos, demand that the viewer create a scene that is not actually depicted at all but intimated by stance, gesture, and a prop or two. The view widely held today that painting became the dominant art form of the fourth century is probably misleading, but it was new, and it presented a more obvious demonstration of the new trends of the fourth century than sculpture.

Apollodoros begins the list of painters revered by later writers, and his contributions to the development of painting are slightly better described. Primary among these painters are Zeuxis and Parrhasios. Again the dates of both men are uncertain, though they must have died no later than the early fourth century.[256] Zeuxis is said to have come from Herakleia, which was probably the city in Lucania on the Gulf of Taranto, but he visited Athens, as both Plato (*Protagoras* 318b) and Xenophon (*Symposion* 4.63) attest, and probably worked there. Parrhasios came from Ephesos in East Greece, though he appears to have been resident in Athens most of his life. The two painters represent for classical antiquity roughly the modern opposition of Rubens and Poussin: the first a practitioner of coloristic effects and shading, a true pupil of Apollodoros, as we are told Zeuxis was, and the second the master of outline.[257] Pliny has little to say about Zeuxis other than giving the usual list of works and a few adjectives to describe his style, but his observations on Parrhasios are particularly interesting because they constitute one of the longest and most subjective evaluations of the style of an artist. Pliny cites both Antigonos of Karistos and Xenokrates at the end of the passage, which strongly suggests that they are the origin of this passage. I quote it in full, since its very nature will occupy us repeatedly (*NH* 35.67–68):

> . . . it is admitted by artists that he [Parrhasios] won the palm in the drawing of outlines. This in painting is the high-water mark of refinement; to paint bulk and the surface within the outlines, though no doubt a great achievement, is one in which many have won distinction, but to give the contour of the figures, and make a satisfactory boundary where the painting within finishes, is rarely attained in successful artistry. For the contour ought to round itself off and so terminate as to suggest the presence of other parts behind it also, and disclose even what it hides. This is the distinction conceded to

[255] Rouveret, *Histoire et imaginaire*, 114–15.

[256] Gschwantler, *Zeuxis und Parrhasios*, 65–70.

[257] A major source on the two artists is Pliny, *NH* 35.60–72. In general, see Gschwantler, *Zeuxis und Parrhasios*, passim; V. L. Brüschweiler-Mooser, *Ausgewählte Künstleranekdoten: Eine Quellenuntersuchung* (Bern 1969) 90–99.

Parrhasios by Antigonos and Xenokrates who have written on the art of painting, and they do not merely admit it but actually advertise it. And there are many other pen-sketches still extant among his panels and parchments, from which it is said that artists derive profit. Nevertheless he seems to fall below his own level in giving expression to the surface of the body inside the outline. (Trans. H. Rackham, Loeb edition)

And, in fact, the coloristic style already discussed is paralleled by a style of elegant line in a number of white-ground lekythoi of the end of the fifth century. The two manners are rarely to be considered mutually exclusive, except perhaps in the Huge Lekythoi. The Painter of Munich 2335[258] and the Woman Painter[259] may give some idea of the combination of line and color in the manner of Parrhasios (**Figs. 194, 195**). Two lekythoi by the R Group are among the finest examples of linear virtuosity. On the example in London a woman sits in three-quarter pose at a grave monument, her legs covered by her blue mantle (**Fig. 196**);[260] the other vase, in Vienna, delineates the torso of a young man seated on a grave monument in three-quarter view with extraordinary elegance.[261]

The new developments of monumental painting, both perspective and coloristic effects, were clearly inimical to traditional vase painting. The white-ground lekythoi disappear around 400 B.C., and red-figure vases begin a fitful decline. The curved surfaces of vases demanded restraint in spatial effects, and the black ground of the Attic red-figure technique was most effectively coupled with light figures defined by lines rather than modeled masses. Nonetheless, the new developments of monumental painting did affect vase painters, who tried to incorporate aspects of both perspective and coloristic effects. The increased use of white is noticeable; it was often covered with a light wash of glaze to produce a rich yellow-golden effect.[262] Indeed, gold foil was applied to areas of raised relief (**Fig. 197**),[263] and near the end of the century blue and pink colors were occasionally used on otherwise red-figure vases. One of the most elaborate of these vases is a pelike depicting the Judgment of Paris: Athena's aegis is covered in gold foil, and she wears a green peplos; Paris is in blue (**Fig. 198**).[264]

Painted pottery in Greece was almost a monopoly of Athens from the late sixth century on. Near the end of the fifth century, excellent red-figure vases began to be made in the Greek areas of Italy and Sicily, probably by migrant Attic painters driven out by the rigors

[258] New York, MMA 09.221.44: D. C. Kurtz, *Athenian White Lekythoi: Patterns and Painters*, Oxford Monographs on Classical Archaeology (Oxford 1975) 218, pl. 42.1.

[259] Athens, NAM 1956: Kurtz, *Athenian White Lekythoi* (note 258 above) 219, pl. 44.1; Koch-Brinkmann, *Polychrome Bilder*, 58–61, figs. 60–62.

[260] London, BM D 71: *ARV²* 1384.15; Koch-Brinkmann, *Polychrome Bilder*, figs. 78–80.

[261] Vienna, KHM IV 143: *ARV²* 1383.1; Koch-Brinkmann, *Polychrome Bilder*, figs. 83–87.

[262] Wehgartner, "Color on Classical Vases" (note 248 above) 90–91.

[263] Saint Petersburg, Hermitage P 1837.2: *Paralipomena* 488; L. Stephani, *Die Vasen: Sammlung der Kaiserlichen Ermitage* (Saint Petersburg 1869) vol. 2, 310–16, no. 1790; F. Courby, *Les vases grecs à reliefs* (Paris 1922) 129–30, no. 3; E. A. Zervoudaki, "Attische polychrome Reliefkeramik des späten 5. und des 4. Jahrhunderts v. Chr.," *AM* 83 (1968) 26, no. 35; M. Tiverios, "Die von Xenophantos Athenaios signierte große Lekythos aus Pantikapaion: Alte Funde neu betrachtet," in *Athenian Potters and Painters* (note 198 above) 269–84*; M. Miller, "Art, Myth and Reality: Xenophantos' Lekythos Re-examined," in *Poetry, Theory, Praxis: The Social Life of Myth, Word and Image in Ancient Greece; Essays in Honour of William J. Slater*, ed. E. Csapo and M. Miller (Oxford 2003) 19–47*; B. Cohen, *The Colors of Clay: Special Techniques in Athenian Vases*, exh. cat. (Los Angeles 2006) 141–42, no. 37*. See generally B. Cohen, "Added Clay and Gilding in Athenian Vase-Painting," in Cohen, *Colors of Clay*, 106–17; Courby, *Vases grecs à reliefs*, 189–91; R. Lullies, *Vergoldete Terrakotten-Appliken aus Tarent*, RM-EH 7 (Heidelberg 1962) 39–42.

[264] Malibu, Getty 83.AE.10: D. A. Scott and Y. Taniguchi, "Archaeological Chemistry: A Case Study of a Greek Polychrome Pelike," in Tiverios and Tsiafakis, *Color in Ancient Greece* (note 234 above) 235–44, pls. 46, 47; Cohen, *Colors of Clay*, 324, 337–38, no. 104* (K. Lapatin), attributed to the Painter of the Wedding Procession.

of the Peloponnesian War.[265] The purposes for which painted terracotta vessels were made must have been quite diverse, but the extensive export of Attic vases to Italy and the Black Sea area in the fourth century means that the majority of complete vases preserved in modern museums ended up abroad and in some cases were certainly made for foreigners. It has long been thought that the painted ceramic vases served a similar function as modern china, but this has been challenged, in part convincingly, by Michael Vickers,[266] though the appearance of fine decorated pottery in the few domestic contexts excavated thus far demonstrates that painted pots were indeed also used in the private houses of both rich and poor.[267] It appears likely that some terracotta vessels served specific and limited functions and were made for special celebrations, such as the choes for the Anthesteria.[268] Placement in tombs was another major function of vases, both in Greece and abroad.[269] The Athenian vases of the fourth century are of great interest stylistically because they are the only evidence we have for mainland Greek painting until the appearance of the great Macedonian tombs in the second half of the century. It is nonetheless worth repeating the observation of Henri Metzger that there is a certain monotony in the production of Athenian painted pottery of the fourth century, but with a small number of brilliant exceptions.[270]

The evolution of Attic red-figure vase painting from the late fifth into the fourth century is traditionally divided into two groups, the progressive and the traditional. The clearest distinction between the two groups is the frequent use by the progressives of what has been called bird's-eye perspective. This involves simply the arrangement of the picture surface as a more or less steeply inclined plane, as though seen from a high vantage point; over this apparently sloping surface figures and objects are distributed as though in depth. Each object or figure is, however, seen from a normal horizontal vantage point, rather than from above, as if from a raised position commensurate with the view of the surface on which they stand. It is thought that the wall painter Polygnotos developed or used this schema extensively somewhere before the middle of the fifth century, and modern scholarship has attached his name to the technique. One of the most famous and early examples on pottery is the Niobid Painter's name vase, a calyx-krater in Paris dated around 460.[271] There are two other ways of dealing with the relatively large surface of kraters or other large vases: placing large figures on a horizontal band that serves as a groundline, or dividing the surface into two friezes in which the smaller figures are again firmly planted on a groundline. The Niobid Painter used all three principles of composition.[272]

[265] M. Robertson, *The Art of Vase-Painting in Classical Athens* (Cambridge 1992) 235–36. On other small centers of fabrication in Corinth and Boiotia, see chap. 2, p. 52 above with note 236.

[266] See chap. 2, p. 47 above with note 191.

[267] D. M. Pritchard, "Fool's Gold and Silver: Reflections on the Evidentiary Status of Finely Painted Attic Pottery," *Antichthon* 33 (1999) 1–27; I. Scheibler, *Griechische Töpferkunst: Herstellung, Handel und Gebrauch der antiken Tongefässe*, Beck's Archäologische Bibliothek (Munich 1983) 44–58. The finds of painted pottery in both wealthy and poor Athenian houses is summarized by Pritchard, pp. 13–21. The domestic finds of fine painted pottery at Olynthos are analyzed by F. Fless, *Rotfigurige Keramik als Handelsware: Erwerb und Gebrauch attischer Vasen im mediterranen und pontischen Raum während des 4. Jhs. v.Chr.*, Internationale Archäologie 71 (Rahden, Westphalia, 2002) 34–40.

[268] R. Hamilton, *Choes and Anthesteria: Athenian Iconography and Ritual* (Ann Arbor 1992).

[269] Metzger, *Représentations*, 407–8, 409–13; T. B. L. Webster, *Potter and Painter in Classical Athens* (London 1972) 270–300.

[270] Metzger, *Représentations*, 414.

[271] Paris, Louvre G 341: *ARV*[2] 601.22; *Beazley Addenda*[2] 266; M. Prange, *Der Niobidenmaler und sein Werkstatt: Untersuchungen zu einer Vasenwerkstatt frühklassischer Zeit* (Frankfurt am Main 1989); M. Denoyelle, *Le cratère des Niobides*, Collection Solo 7 (Paris 1997); Boardman, *ARFV-CP*, figs. 4.1, 4.2.

[272] Boardman, *ARFV-CP*, figs. 2, 5, 6.

The Eretria Painter is an excellent example of the progressive group. He painted from about 440 to about 415, spanning the end of the High Classic style and the beginning of the Rich Style.[273] His squat lekythos formerly in Berlin (now lost) depicts Dionysos surrounded by mainads scattered over the surface of the frieze zone with gay abandon (**Fig. 199**).[274] As with the Niobid Painter earlier, the use of bird's-eye perspective is not the painter's only way of seeing: his epinetron in Athens has two simple bands of figures on either side that are firmly planted on a groundline (**Fig. 200**).[275] Yet here too the broad figure panels appear to represent a real sense of space; at least the Ionic column on the right side appears to hold up the egg-and-dart band above as though it were an architrave, and the figures appear to be enclosed in a structure. The table next to Alkestis and the cabinet behind him on the extreme right of the scene are rendered in divergent but very recognizable linear perspective. The fine linear patterns of the rich drapery of the women is distinctive of the painter and the progressive school.

The Eretria Painter's principal follower is the Meidias Painter, who worked approximately from 420 to 400 B.C.[276] He carries the rich and lively drapery of his predecessor to new heights that parallel but never equal the mannerisms of contemporary sculptures (**Fig. 201**).[277] He and the circle of painters around and after him have been judged severely by Beazley and most other students of Attic vase painting until very recently,[278] a confirmation, if one was needed, that the style of vases and sculpture develop along closely similar patterns that elicit very similar reactions in modern scholarship. The quality of draftsmanship in the Meidian group remains high, but the painters do depart from the old principle of Attic red-figure vase painting described above, that the figures should predominate in creating illusions of space. Yet there is already an ambiguity in this statement, since it was the Polygnotan group of painters, such as the Niobid Painter, who introduced bird's-eye perspective.

A second group of painters, represented by the Kleophon Painter and the Dinos Painter, appears to belong in a more conservative tradition and prefer more monumental and solid forms.[279] These painters too develop out of the Polygnotan group, but they choose to emphasize the figure style rather than the open spatial compositions of the progressives. The Dinos Painter himself "probably worked well into the last quarter of the century."[280] His best-known vase is a stamnos in Naples depicting mainads celebrating around a post-and-mask representation of Dionysos.[281] The figures occupy very nearly the whole height of the picture band, and there is little overlapping. A more ambitious and interesting vase is his calyx-krater in Bologna that shows the preparations for the foot race between Hippomenes

[273] A. Lezzi-Hafter, *Der Eretria-Maler: Werke und Weggefährten*, Forschungen zur antiken Keramik, Reihe 2, Kerameus 6 (Mainz 1988) 23; Robertson, *Vase-Painting*, 230–32.

[274] Formerly Berlin, Staatl. Mus. F 2471 (lost): *ARV²* 1247.1; Lezzi-Hafter, *Eretria-Maler* (note 273 above) no. 234, pls. 143d–145; Boardman, *ARFV-CP*, fig. 229.

[275] Athens, NAM 1629: *ARV²* 1250.34; Lezzi-Hafter, *Eretria-Maler* (note 273 above) no. 257, pls. 168, 169; E. Simon, *Die griechischen Vasen*, 2nd ed. (Munich 1981) pl. 216; Boardman, *ARFV-CP*, fig. 235.

[276] Burn, *Meidias Painter*, 7–11; Robertson, *Vase-Painting*, 237–42.

[277] Cleveland Museum of Art 82.142: Burn, *Meidias Painter*, 21, 99, no. M 20, pls. 11, 12a, 12b.

[278] Ibid., 2–3.

[279] Robertson, *Vase-Painting*, 242–47; W. Real, *Studien zur Entwicklung der Vasenmalerei im ausgehenden 5. Jahrhundert v. Chr.*, Orbus Antiquus 28 (Münster 1973); W. Hahland, *Vasen um Meidias*, Bilder griechischer Vasen 1 (Berlin 1930).

[280] Boardman, *ARFV-CP*, 167.

[281] Naples, MAN 2419: *ARV²* 1151.2; Robertson, *Vase-Painting*, 243, figs. 246, 247; Boardman, *ARFV-CP*, fig. 177.

and Atalanta (**Fig. 202**).[282] The composition is more open, and the figures are not glued to the groundline; overlapping is almost totally avoided. The Dinos Painter's later contemporary is the Nikias Painter,[283] whose solid and independent figures on their groundline can be contrasted with the turbulent floating figures of the gigantomachy painted by the Suessula Painter on his progressive amphora in Paris.[284]

Although these two groups are recognizable as representing different but parallel traditions, painters cross the boundaries and use elements of both. John Boardman notes particularly Aison and Aristophanes,[285] but it is difficult or impossible to find a painter who does not at times use both traditions. Part of the distinction between the two groups is not only style and composition, but the very size of the vessels they choose to paint. There is a tendency toward the end of the fifth century to paint many more small vases associated with the world of women, while the male vases of the symposium, the krater and the kylix, decrease in importance.[286] The former are the preferred vases of the Meidias Painter and his later associates,[287] while the latter are the preferred vases of the conservatives following the Dinos Painter.[288] But here again the distinction is only one of emphasis, not uniform and divergent practice.

The distinction of two separate traditions or groups of painters and workshops is indeed not very easy to maintain using the criteria that are of importance here.[289] The classic tradition of figures clearly separated and arranged on a firm horizontal groundline progressively disappears in favor of a largely new principle of composition: complex groupings with extensive overlapping and foreshortening, in which white paint plays an important role in helping sort out the layers of depth.[290] At times subsidiary figures are raised above the otherwise magnetic groundline, though they hardly create a sense of open space or depth. The placement seems dictated by the desire to fill the surface of the vase, but the old principle is the same: to emphasize the light forms of the figures set in the black ground. The name piece of the Talos Painter is certainly the most impressive and earliest

[282] Bologna, Museo Civico Archeologico 300: *ARV*[2] 1152.7; *Beazley Addenda*[2] 336; E. D. Reeder, *Pandora: Women in Classical Greece*, exh. cat. (Baltimore 1995) 365–68, no. 117*; T. F. Scanlon, *Eros and Greek Athletics* (Oxford 2002) 182–85, fig. 7.3.

[283] Robertson, *Vase-Painting*, 250–51; Boardman, *ARFV-CP*, figs. 319–21.

[284] Paris, Louvre S 1677: *ARV*[2] 1344.1; Robertson, *Vase-Painting*, 258, fig. 261; Boardman, *ARFV-CP*, figs. 329.1–3.

[285] Boardman, *ARFV-CP*, 147.

[286] Burn, *Meidias Painter*, 11. For a detailed study of shapes in this period, see C. Campenon, *La céramique attique à figures rouges, autour de 400 avant J.-C.: Les principales formes, évolution et production* (Paris 1994), especially p. 112.

[287] Meidias: hydriai 6; pelike 1; (krater fragment: Burn, *Meidias Painter*, no. M 8); loutrophoroi 3; oinochoai 3 (+ Burn no. M 15); squat lekythoi 4 (+ Burn no. MM 20); lekanides 4 (+ Burn nos. MM 25–28); pyxis 1 (+ Burn nos. MM 30, 31); (cup, Burn no. MM 32; plates, Burn nos. MM 33, 34); fragments 2 (3?); hydria 1(?). Manner of/circle of: hydriai 1+1+8+4; stamnos 1; fragments 1+16+1; squat lekythoi 1+2+25+3; acorn lekythoi 1+1+3; lekythoi 4; round aryballos 1; panathenaic amphoras 2; pelikai 1+1; calyx-kraters 1+1; calyx- or bell-krater 1; bell-kraters 1+2; oinochoai 3+3+13+6+1+2+3; cups 3+1; stemless cups 4; pyxides 4+8; lebedes gamikoi 2+9; loutrophoroi 1+16; lekanides 15.

[288] Volute-kraters 1; stamnos 1; dinos 4; calyx-kraters 8; bell- or calyx-kraters 3; bell-kraters 22; amphora 1; pelikai 3; loutrophoros 1; fragments 4. Manner of Dinos Painter or near: bell-kraters: 12+2; bell- or calyx-kraters 2+1; bell-krater (special shape) 1; calyx-kraters 4+1; dinos 1; pelikai 4; neck amphora 1; loutrophoros 1; fragment 1. Chrysis Painter: hydriai 8; bell-krater 1. Near the Chrysis Painter (Somzée Painter): pelikai 2; bell-kraters 2. Painter of Louvre G 443: oinochoai 2; hydria 1.

[289] The arguments of Real, *Entwicklung der Vasenmalerei* (note 279 above) 28, criticized by I. McPhee in his review of the book (*AJA* 79 [1975] 164), seem to be based at least in part on the observations made here, which have nothing to do with the technical characteristics of the genealogy of the painters as defined within the system of J. D. Beazley; on the latter, see M. Robertson, "Beazley's Use of Terms," in *Beazley Addenda*[2], pp. xii–xx.

[290] Hahland, *Vasen um Meidias* (note 279 above) 8–9; Robertson, *Vase-Painting*, 255–59.

example of the type (**Fig. 203**).[291] In this and similar works the ambiance of pictorialism, as conceived by the Eretria and Meidias Painters, is still ignored but now in favor of juxtaposed plastic masses; this is the most prominent tendency of vase painting through the first quarter of the fourth century. In the works of the Meleager Painter, in which there is a balance of large pots and cups, elements of the classic tradition continue: the figures on his amphora in Toronto are impressively self-contained as discreet forms, yet they are set both on and above the groundline in a mildly pictorial arrangement (**Fig. 204**).[292] His hydria in New York depicting Poseidon and Amymone could almost be the work of a progressive painter.[293] Similar compositions can be found in the work of the Painter of London F 64[294] and the lone hydria painted by the Jena Painter.[295] Just before the middle of the century such compositions led over the Pourtalès Painter, whose bell-krater in London—probably depicting the initiation of Herakles and the Dioskouroi into the Eleusinian Mysteries—has large foreground figures set on the bottom border of the scene, smaller figures raised to a second tier of space, and at the very top a truncated single column and a set of four truncated columns joined by an architrave (**Fig. 205**).[296] The sense of space is very compressed yet is clearly an interest of the painter as he struggles somewhat unsuccessfully to combine two traditions.

The classic tradition culminates in the work of the Marsyas Painter, whose career begins in the decade 370–360 and whose late phase includes the work formerly attributed to the Marsyas/Eleusinian Painter by Beazley, as Panos Valavanis has so clearly demonstrated.[297] His close relationship to the Pourtalès Painter is visible in his pelike in London depicting Peleus and Thetis; the composition reflects that of the Pourtalès Painter's bell-krater just described: figures occupy the bottom border of the scene, but others rise above it (**Fig. 206**).[298] The Nereid at the upper right is actually seen from behind, fleeing into the background. The more monumental lebes gamikos in Saint Petersburg separates the painter from all his colleagues (**Fig. 207**).[299] Large, indeed monumental, figures all on the groundline occupy the whole surface of the vase from top to bottom; they carry out the

[291] Ruvo, MAN Jatta 36933 (ex 1501): *ARV*[2] 1338.1; Simon, *Griechischen Vasen*[2] (note 275 above) pls. 212–15; Boardman, *ARFV-CP*, fig. 324.1–3.

[292] Toronto, ROM 919.5.35 (388): *ARV*[2] 1411.40; *LIMC*, s.v. Atalanta no. 40* (J. Boardman); K. Kathariou, *Το εργαστήριο του ζώγραφου του Μελεάγρου και η εποχή του· Παρατηρήσεις στην Αττική κεραμεική του πρώτου τετάρτου του 4ου αι. π. Χ.* (Thessaloniki 2002) 212, MEL 3; F. A. G. Beck, *Album of Greek Education* (Sydney 1975) fig. 418; Boardman, *ARFV-CP*, fig. 336.

[293] New York, MMA 56.171.56: *ARV*[2] 1412.46; *Beazley Addenda*[2] 374; *LIMC*, s.v. Amymone no. 60*; Reeder, *Pandora* (note 282 above) 361–63, no. 116*; Kathariou, *Εργαστήριο του Μελεάγρου* (note 292 above) 221, MEL 74, pls. 26, 27.

[294] London, BM 1924.7–16.1: *ARV*[2] 1420.6; Robertson, *Vase-Painting*, 273, fig. 273; Metzger, *Représentations*, pl. 23; Boardman, *ARFV-CP*, fig. 355.

[295] Berlin, Staatl. Mus. 3768: *ARV*[2] 1516.81; Schefold, *KV*, pl. 3b; Schefold, *UKV*, 17–18, no. 145, figs. 27, 28; Metzger, *Représentations*, pl. 38.2; U. Gehrig, A. Greifenhagen, and N. Kunisch, *Führer durch die Antikenabteilung, Staatliche Museen Preussischer Kulturbesitz, Berlin* (Berlin 1968) pl. 68; W.-D. Heilmeyer, L. Giuliani, G. Platz, and G. Zimmer, *Antikenmuseum Berlin: Die ausgestellten Werke* (Berlin 1988) 152–53, no. 3; Boardman, *ARFV-CP*, fig. 362.

[296] London, BM F 68: *ARV*[2] 1446.1; *Beazley Addenda*[2] 378; Metzger, *Représentations*, 245, no. 13, pl. 33.3; H. Metzger, *Imagerie athénienne* (Paris 1965) 39, no. 27; Valavanis, *Παναθηναϊκοί αμφορείς*, 262–63, pls. 92–95; Boardman, *ARFV-CP*, fig. 372; Cohen, *Colors of Clay*, 320, fig. 1.

[297] *Παναθηναϊκοί αμφορείς*, 282–86.

[298] London, BM E 424: *ARV*[2] 1475.4; *Beazley Addenda*[2] 381; K. Schefold, "Die Stilgeschichte der Monumentalmalerei in der Zeit Alexanders des Grossen," in *Proceedings of the 12th International Congress of Classical Archaeology, Athens, 4–10 September 1983*, vol. 1 (Athens 1985) 26–27, pl. 6; Simon, *Griechischen Vasen*[2] (note 275 above) pl. LII (color); Boardman, *ARFV-CP*, fig. 390; Cohen, *Colors of Clay*, 322, fig. 3.

[299] Saint Petersburg, Hermitage P 1906.175 (15592): *ARV*[2] 1475.1; Cohen, *Colors of Clay*, 335–36, no. 103*; Valavanis, *Παναθηναϊκοί αμφορείς*, 269, pls. 102–5; J. H. Oakley and R. H. Sinos, *The Wedding in Ancient Athens* (Madison, WI, 1993) 40, figs. 124–27; Simon, *Griechischen Vasen*[2] (note 275 above) pls. 236–39; Boardman, *ARFVP-CP*, fig. 388; Cohen, *Colors of Clay*, 334–36, no. 103.

preparations for a wedding, attended by numerous fluttering erotes, the only light and frilly aspect of the impressive composition. The tightly packed figures, though they are solid, three-dimensional forms, allow no space around them. A hydria in Munich with the Judgment of Paris by a late follower of the Marsyas Painter continues the compositional principles of the "classic" tradition with a weak hand.[300] The vase comes from Alexandria and therefore belongs to the latest phase of Attic red-figure painting. Similar to the seated figures on late grave reliefs, Paris sits looking out of the scene rather than at the three goddesses, who are distributed around him—Aphrodite to the left and slightly raised above the groundline, Athena even higher up to the right, and Hera on the groundline to the right of Athena. As with the late scenes of the Marsyas/Eleusinian Painter, an initial response is to think that nothing is going on, that the scene is a mere gathering of divinities around Paris.[301] But Paris's lonely stare out into space suggests that he is contemplating weighty matters, and the activity around Aphrodite indicates that here too an event is taking place, perhaps more at an inward, psychological level rather than a chatty, narrative story.

The pictorial tradition of the Meidias Painter also continues, but in modified form, a development that parallels that of the classic tradition. Numerous works that theoretically still use bird's-eye perspective actually present little more than a densely packed composition spread over the whole surface of the scene. The effect is sometimes pictorial (**Fig. 208**),[302] but more often the scene becomes a carpet pattern without any sense of space or depth (**Fig. 209**).[303]

Near the end of the fifth century, an old practice of decorating vases is revived: actual plastic figures and subsidiary forms are attached to the surface of the vases. This is symptomatic of the development of all vase decoration in the early fourth century. The use of applied gold foil, frequently on small buttons of applied clay, was already noted above. The squat lekythos by the Xenophantos Painter in Saint Petersburg is an early (400–390 B.C.) and particularly fine example of the type, with extensive use of molded figures and forms applied to a vase otherwise painted in the red-figure technique (**Fig. 197**).[304] It appears very likely that the new technique reflects an increasing appreciation of metal vessels with relief decoration,[305] which are cited frequently in fourth-century texts as marks of conspicuous consumption by the Athenian nouveaux riches. One of the most impressive examples of the type is the so-called Regina Vasorum in Saint Petersburg (**Figs. 210, 211**).[306]

[300] Munich, Staatliche Antikensammlungen 2439: Robertson, *Vase-Painting*, 287–88, fig. 290; Schefold, *UKV*, 24, 134, no. 188; Metzger, *Représentations*, 271, no. 15; Simon, *Griechischen Vasen*[2] (note 275 above) pl. 240; Boardman, *ARFVP-CP*, fig. 428; Cohen, *Colors of Clay*, 325, fig. 8.

[301] See chap. 6, pp. 247–48 below, and **Fig. 246**.

[302] Oxford, Ashmolean 1917.61; *ARV*[2], 1428.1 (Oxford Grypomachy); *Beazley Addenda*[2] 376; *CVA*, Oxford 1 (Great Britian 3) pls. 24.4, 25.9; *LIMC*, s.v. Amazones no. 569* (R. Devambez and A. Kaufmann-Samaras); Boardman, *ARFV-CP*, fig. 342.

[303] Naples, MAN 2200; *ARV*[2] 1440.1 (Oinomaos Painter); *Beazley Addenda*[2] 377; C. M. Havelock, "The Archaic as Survival versus the Archaistic as a New Style," *AJA* 69 (1965) pl. 74, fig. 10; E. Simon, *Die Götter der Griechen* (Munich 1985) 161, fig. 146; van Straten, *Hierà Kalá*, 269, V408, fig. 42; Boardman, *ARFV-CP*, fig. 351 = A. Furtwängler and K. Reichhold, *Griechische Vasenmalerei: Auswahl hervorragender Vasenbilder*, vol. 3 (Munich 1932) pl. 146.

[304] Saint Petersburg, Hermitage P 1837.2: see p. 140, note 263 above.

[305] Campenon, *Céramique attique à figures rouges* (note 286 above) 114–17, with bibliography.

[306] Saint Petersburg, Hermitage ГР-4593 (Б 1659, St. 525): L. Stephani, *Die Vasen: Sammlung der Kaiserlichen Ermitage* (Saint Petersburg 1869) vol. 1, 268–71, no. 525; Metzger, *Imagerie athénienne* (note 296 above) 40–41, no. 36, pls. 20–22; Zervoudaki, *AM* 83 (1968) 36–37, no. 77; *LIMC*, s.v. Eubouleus no. 10, s.v. Herakles no. 1404, s.v. Dionysos no. 526, s.v. Demeter no. 405*; K. Clinton, *Myth and Cult: The Iconography of the Eleusinian Mysteries; The Martin P. Nilsson Lectures on Greek Religion, Delivered 19–21 November 1990 at the Swedish Institute at Athens*, Skrifter Utgivna av Svenska Institutet i Athen, 8°, 11 (Stockholm 1992) 78–81, 134, no. 5, figs. 17–19; Simon, "Eleusis in Athenian Vase-Painting" (note 198 above) 97, 103–6, figs. 11–13; Cohen, *Colors of Clay*, 115, fig. 9.

The exquisite modeling of the figures combined with the rich coloring and use of gold foil spells the death knell of simple vase painting, which is overwhelmed by the new taste for the display of wealth and elegance. It can hardly be a coincidence that red-figure vase painting goes into a precipitous decline in quality at just this time. The effect of molded figure appliqués is, of course, similar to the effect of the massed, plastically rendered figures of the Talos Painter's volute-krater and the Pourtalès Painter's bell-krater mentioned above, which may explain the new style of painting as a parallel response to the increased use of metal vessels with relief decoration.[307]

The development of the early fourth century is best characterized by the gradual amalgamation of the classic and pictorial traditions of the second half of the fifth century that find mutual ground in the plastic rendition of forms, whether illusionistically, through foreshortening and overlappings, or via the use of actual plastically modeled forms applied to the surface of the vases, creating local but not pictorial space. The figures dominate the compositions. The final product is the figures of the Marsyas Painter, which are illusionistically plastic but sufficiently separated into discreet units to suggest open space without actually representing it, a style that may justly bear the name *megalographia*. I immediately think of the observation of Pliny cited above (*NH* 35.67–68) that Parrhasios could effectively render the full plasticity of a figure by line alone. The relationship between the vase paintings and the works of Parrhasios cannot truly be judged, since none of his paintings are preserved. Nonetheless, it appears that the Meidias Painter and his school of vase painters have much in common with Zeuxis, while the Dinos Painter's classical tradition may have been akin to the work of Parrhasios. But it will be recalled that if one follows the traditional division of vase painting of the end of the fifth and the beginning of the fourth century into two separate workshop traditions, it appears that the actual styles blend. So, for example, the calligraphy of the Meidias Painter may well resemble more closely the style of Parrhasios, and the massive forms and propensity for overlappings heightened by the use of white paint favored by the Talos and Pourtalès Painters may more closely resemble the style of Zeuxis.[308] Probably both propositions are correct and reflect the actual character of monumental painting in the period more accurately than the often too sharply drawn textual accounts. If the megalographic style of the Marsyas Painter is the natural culmination of the traditions in vase painting, it is not remiss to suggest that the painting on the facade of "Philip's Tomb" at Vergina is a natural blending of the two traditions of monumental painting (**Fig. 119**).[309]

Over the past thirty years, the discovery of several Macedonian tombs with well-preserved paintings has substantially changed our understanding of Greek painting in the later fourth century. The tombs all appear to date to the last third of the fourth century and the first quarter of the third century.[310] It is not my purpose to review all these discoveries in detail but to review the evaluation of the technique and composition of the paint-

[307] L. Burn, "A Dinoid Volute-Krater by the Meleager Painter: An Attic Vase in the South Italian Manner," in *Greek Vases in the J. Paul Getty Museum*, vol. 5 (Malibu, CA, 1991) 115–17, suggests that complex monumental vases with plastic decoration, often thought to originate in South Italian workshops, may have their origin in Athens and imitated the metal vessels whose popularity was burgeoning.

[308] Burn, *Meidias Painter*, 8–10.

[309] Andronikos, *Royal Tombs*, figs. 57–71; Saatsoglou-Paliadeli, *Τάφος του Φιλίππου*; Brecoulaki, *Peinture funéraire*, 101–33, pls. 26–46.

[310] The "Tomb of Eurydike" at Vergina is considered the earliest, dating around 340 B.C.: S. Drougou and C. Saatsoglou-Paliadeli, *Vergina: Wandering through the Archaeological Site*, 2nd ed., trans. A. Doumas (Athens 2000) 60–61, figs. 83–85; R. Ginouvès and M. B. Hatzopoulos, eds., *Macedonia: From Philip II to the Roman Conquest* (Princeton 1994) 140, 154–61, figs. 135–37.

ings. In actuality, the main characteristics of the tomb paintings were already revealed by the great tomb of Lefkadia commonly called the Tomb of Judgment after the four large figures painted on either side of the door on its facade: on the left, Hermes and the deceased; on the right, Aiakos and Rhadamanthys, the judges of the dead (**Figs. 117, 118**).[311] Painted on the white plaster covering the facade, the garments of Hermes and the deceased are executed in rather bright blues and red-violets; the garments of Aiakos and Rhadamanthys are done in yellow-browns.[312] The contrasting colors of the first pair create a strong sense of shape but less so of volumes; the volumes of the second pair are emphatic. A similar set of contrasts exists between the frieze of the tomb at Aghios Athanasios near Thessaloniki and the guardian figures below.[313]

Another distinction in the Macedonian tomb paintings is between a linear and a painterly manner of work. There is some confusion here in the observations of the experts. The painting in the Tomb of Persephone at Vergina combines the two approaches in a most effective manner (**Fig. 120**).[314] Totally apart from the preliminary incision in the moist plaster to fix the broad elements of the figures, there is a masterful use of contour lines that is particularly evident in the body of Persephone and, on the south wall, the leftmost seated women. The shading along the lower edge of Persephone's proper right arm is also done with a series of hatched lines.[315] In stark contrast are the heads of Hermes, Hades, Persephone, and the crouching woman on the right of the main scene. Particularly interesting is the head of Hermes, in which blue is used in short brush strokes,[316] reminiscent of the head of Rhadamanthys on the facade of the Tomb of Judgment at Lefkadia.[317] Otherwise the colors of the paintings are principally red-violet, brown, and yellow. As on the Tomb of Judgment, the colors are applied thinly so that the white ground shines through. This effect may be heightened now because the pigments have faded or disappeared, since the technique was *fresco al secco*.[318] Equally, it has been pointed out that the painting may never have been completed.[319]

The hunt frieze on the facade of "Philip's Tomb" at Vergina (**Fig. 119**) differs substantially from the paintings in the Tomb of Persephone.[320] The frieze is 5.56 meters long and 1.16 meters high.[321] There is disagreement on the technique of applying the colors: Chrysoula Saatsoglou-Paliadeli maintains that some color was applied on damp clay, and some paint in a binding substance that was applied dry, but Hariclia Brecoulaki argues

[311] P. M. Petsas, Ὁ τάφος τῶν Λευκαδίων (Athens 1966); Brecoulaki, *Peinture funéraire*, 204–17, pls. 74–76.

[312] Walter-Karydi, "Color in Classical Painting," in Tiverios and Tsiafakis, *Color in Ancient Greece* (note 234 above) 84–85; Bruno, *Form and Color*, 25–26, 80–81, pls. 5b–8.

[313] Koch-Brinkmann, *Polychrome Bilder*, 96–97; Brecoulaki, *Peinture funéraire*, pls. 90–94, 99, 100.

[314] M. Andronikos, *Vergina II: The 'Tomb of Persephone'* (Athens 1994); Andronikos, *Royal Tombs*, 86–95; Brecoulaki, *Peinture funéraire*, 77–100, pls. 11–13; P. Moreno, "Arti figurative: Recenti scoperte," in *La crisi della polis*, vol. 2, *Arte, religione, musica* (Milan 1979) 708–14, pls. 73, 75; Scheibler, *Griechische Malerei*, 90–93, fig. 39, color pl. IV; M. Andronicos, in *Macedonia: From Philip II to the Roman Conquest* (note 310 above) 183–86, figs. 154–56.

[315] Andronikos, *Vergina II*, figs. 21, 24; Brecoulaki, *Peinture funéraire*, pl. 14.1.

[316] H. Brecoulaki, "Eléments de style et de technique sur les peintures funéraires de Macédoine (IV–IIIème s. av. J.-C.)," in *La pittura parietale in Macedonia e Magna Grecia: Atti del Convegno internazionale di studi in ricordo di Mario Napoli (Salerno-Paestum, 1996)*, ed. A. Pontrandolfo (Paestum 2002) 27, pl. II.1; Brecoulaki, *Peinture funéraire*, pl. 18.1.

[317] Bruno, *Form and Color*, pls. 8, 9. Rouveret, *Histoire et imaginaire*, 224–25, remarks that the technique of the head of Hades is also closely similar to the technique at Lefkadia.

[318] Andronikos, *Vergina II*, 70, 76.

[319] Koch-Brinkmann, *Polychrome Bilder*, 93–94. Brecoulaki, *Peinture funéraire*, 92–93, however, attributes the "unfinished" aspect of parts of the painting integral to the style of the painter, although she admits that he might have been "particulièrement pressé de finir la décoration de la tombe."

[320] Saatsoglou-Paliadeli, Τάφος του Φιλίππου, passim; Brecoulaki, *Peinture funéraire*, 103–33, pls. 26–43.

[321] Saatsoglou-Paliadeli, Τάφος του Φιλίππου, 2.

that all color was applied with an organic binding medium.[322] Although the painting has sustained serious deterioration, enough detail is preserved to suggest that the rapid and sometimes sketchy qualities seen in the Tomb of Persephone were absent from or minor on "Philip's Tomb." There is no extensive preliminary incision; it was used only to set the various straight lines of spears, the central pillar monument, and a very few contours of hunter and dogs.[323] The style weds clear delineation of the figures with coloristic modeling. One of the finest examples is the hunter to the right of center (no. 7) swinging an axe behind the lion.[324] The subtle modeling of the skin with tonal gradations and hatched shading, as well as the complex spatial configuration of the man who has drawn back an axe behind him and is about to rotate forward, are stunning. The modeling of the face of the man just to the left (no. 6), who wears the Macedonian cap, the *kausia*, reveals a fully plastic rendition of the lips, cheek, and nose, the cheeks covered by a sparse beard.[325] One of the best-preserved figures of the whole frieze is the hunter no. 9, who is about to throw a spear at the bear above and behind him to the right.[326] His proper right arm is drawn back before launching the spear at the bear and is strongly modeled by light and shadow, as is indeed his whole body and his legs, where preserved. The brown chlamys fastened around his neck and held out to the viewer's right by his proper left arm is modeled by tonal gradations, hatched shading, and dark black lines to mark the deep furrows of the cloth. Finally, from my personal point of view, the most remarkable part of the painting is the lion's foreleg pinning down the head of a dog.[327] The powerful, dark, hairy leg of the lion contrasts with the more softly modeled light fur of the dog, which is hatched with short gray-brown strokes.

When the frieze of "Philip's Tomb" was discovered it was the setting and general spatial characteristics of the painting that elicited the greatest astonishment.[328] This was a reaction to the elements of landscape that serve as a backdrop to the figures. Some of these elements are known in fifth-century vase painting: the rocky ground of the Niobid Painter's name vase in Paris and many white-ground lekythoi with imaginative elements of landscape, such as the Thanatos Painter's in London with a picture of a hare hunt (**Fig. 212**).[329] But the hunt frieze creates for the first time a far more complex setting: rocky outcrops on the extreme left and right, on which, respectively, a deer and a bear appear wounded and in flight; three majestic trees and a grove which separate the four separate episodes of the hunt; and plausibly the outline of hills at some distance in the center background.[330]

[322] Ibid., 33–37; C. Saatsoglou-Paliadeli, "Linear and Painterly: Color and Drawing in Ancient Greek Painting," in Tiverios and Tsiafakis, *Color in Ancient Greece* (note 234 above) 102; Brecoulaki, *Peinture funéraire*, 123.

[323] Saatsoglou-Paliadeli, *Τάφος του Φιλίππου*, 39–40, fig. 8 on pp. 44–45; Brecoulaki, *Peinture funéraire*, 120–21.

[324] Andronikos, *Royal Tombs*, 111, fig. 67 (upper right); Saatsoglou-Paliadeli, *Τάφος του Φιλίππου*, pls. 7a, 15a (right side), 26b; Brecoulaki, *Peinture funéraire*, pls. 31, 32, 35.1.

[325] Saatsoglou-Paliadeli, *Τάφος του Φιλίππου*, pl. 15a; Brecoulaki, *Peinture funéraire*, pls. 31, 32, 35.2 On the *kausia* and possible consequences for lowering the date of the tomb to the last quarter of the fourth century, see A. M. Prestianni Giallombardo, "Recenti testimonianze iconografiche sulla 'kausia' in Macedonia e la datazione del fregio della caccia della II tomba reale di Vergina," *DialHistAnc* 17.1 (1991) 257–304.

[326] Andronikos, *Royal Tombs*, 112–13, figs. 68, 69; Saatsoglou-Paliadeli, *Τάφος του Φιλίππου*, pls. 20c, 21a; Brecoulaki, *Peinture funéraire*, pl. 30 (reversed); Koch-Brinkmann, *Polychrome Bilder*, 94–95.

[327] Saatsoglou-Paliadeli, *Τάφος του Φιλίππου*, pls. 9b, 16a, 16b; Brecoulaki, *Peinture funéraire*, pl. 39.2.

[328] P. H. von Blanckenhagen, "Painting in the Time of Alexander and Later," in Barr-Sharrar and Borza, *Macedonia*, 258.

[329] Niobid Painter: Paris, Louvre G 341: *ARV²* 601.22; Boardman, *ARFV-CP*, figs. 4.1, 4.2. Thanatos Painter: London, BM D 60: *ARV²* 1230.37; Kurtz, *Athenian White Lekythoi* (note 258 above) 211, pl. 32.3; J. H. Oakley, *Picturing Death in Classical Athens: The Evidence of the White Lekythoi* (Cambridge 2004) figs. 136, 137; Boardman, *ARFV-CP*, fig. 272.

[330] Brecoulaki, *Peinture funéraire*, 111–13.

The foreground is a stagelike space scattered with stones of various sizes and a few weedy plants. Perhaps most interesting is the right-hand tree, which has a broad fillet tied around it and a figured plaque hanging on it. To the right of it stands a pillar on top of which are three small figures, statues or statuettes of divinities, one supposes.[331] This can legitimately be construed as the beginning of the sacral-idyllic landscape that already contains all the elements of the Hellenistic votive relief in Munich: tree, pillar with figures of divinities on it, ribbon wound around the tree trunk, and moderately-sized figures.[332]

Space in the painting is not created just by the elements of scenery but also by radical foreshortenings, particularly of figures seen from behind, by cast shadows, and by forms in the background appearing indistinctly in the manner of aerial perspective. The two hunters (nos. 2 and 3) on the left seen from behind are masterful creations.[333] The contour of the head of no. 2 achieves precisely what Pliny (*NH* 35.68) praises in the painting of Parrhasios: "For the contour ought to round itself off and so terminate as to suggest the presence of other parts behind it also, and disclose even what it hides" (trans. H. Rackham, Loeb edition). Cast shadows are not new, since they appear on the Amazon sarcophagus from Tarquinia in Florence.[334] Even though the shadows are thrown consistently, as though there were a light source at the upper left of the picture, there is no sense that the modeling of the figures depends on this source of light.[335] More interesting is the possible sense of a coloristic effect on objects in the background; the color of the deer on the top left is toned down, perhaps to suggest that it is farther back in the composition.[336] What is clearer is that the background behind the trees is rendered in soft colors and is indistinct.[337] On the other hand, the painting does not really break away from the sense of a stage space with a scene painting behind it; space is still expressed principally by the relationships of concrete forms, much as in the Alexander Mosaic (**Fig. 155**), with which the tomb painting shares many traits.

Saatsoglou-Paliadeli has argued that the technique of the hunt frieze is "painterly," in contrast to the linear treatment of the paintings in the Tomb of Persephone.[338] The technique of the two tombs is certainly different, but neither one appears to me to be either predominantly painterly or linear. As Ulrike Koch-Brinkmann has pointed out, the paintings of the Tomb of Persephone may not be finished and therefore any assessment of the intended final product is uncertain.[339] There are, nevertheless, significant differences between the two paintings. First, there is the extensive use of preliminary incisions in the

[331] Andronikos, *Royal Tombs*, 102–3, figs. 58, 59 (whole frieze); Saatsoglou-Paliadeli, *Τάφος του Φιλίππου*, pls. 8, 9a; A. Pekridou-Gorecki, " Zum Jagdfries des sogenannten Philipp-Grabes in Vergina," in *Fremde Zeiten: Festschrift für Jürgen Borchhardt zum sechzigsten Geburtstag am 25. Februar 1996 dargebracht von Kollegen, Schülern und Freunden*, ed. F. Blakolmer et al. (Vienna 1996) 89–103.

[332] Munich, Glyptothek 206: C. M. Havelock, *Hellenistic Art: The Art of the Classical World from the Death of Alexander the Great to the Battle of Actium* (London 1971) 199–200, no. 168*; J. J. Pollitt, *Art in the Hellenistic Age* (Cambridge 1986) 197, fig. 210; B. S. Ridgway, *Hellenistic Sculpture*, vol. 2, *The Styles of ca. 200–100 B.C.* (Madison, WI, 2000) 208–10.

[333] Saatsoglou-Paliadeli, *Τάφος του Φιλίππου*, figs. 10, 11 (pp. 50–51), pls. 11a, 12a, 12b; Brecoulaki, *Peinture funéraire*, pls. 27, 29.

[334] Florence, MAN 5811: Koch-Brinkmann, *Polychrome Bilder*, 85–89, figs. 149–56.

[335] Walter-Karydi, "Color in Classical Painting," in Tiverios and Tsiafakis, *Color in Ancient Greece* (note 234 above) 79–80; Brecoulaki, *Peinture funéraire*, 114.

[336] Walter-Karydi, "Color in Classical Painting," in Tiverios and Tsiafakis, *Color in Ancient Greece* (note 234 above) 81. Brecoulaki, *Peinture funéraire*, 113, notes, however, that the deer is the same size as the dead deer in the left foreground.

[337] Brecoulaki, *Peinture funéraire*, 121–22.

[338] Saatsoglou-Paliadeli, "Linear and Painterly" (note 322 above) 97–105.

[339] Koch-Brinkmann, *Polychrome Bilder*, 93. See note 319 above.

Tomb of Persephone and the very infrequent use of them in the hunt frieze. Secondly, the paint of the hunt frieze is frequently opaque and layered, while in the Tomb of Persephone the white ground "shines" through the thin coloring.[340] This, of course, could simply be a result of the work not being finished. But totally apart from this, both paintings use linear and painterly techniques where appropriate.

Various opinions have been offered on the palette of colors used in the paintings of the tombs at Vergina. Neither uses blue or green extensively, though blue appears in both and green in the hunt frieze.[341] As noted in chapter 3, the four-color palette mentioned by Pliny and Cicero is simply an exaggeration; blue occurs prominently on white-ground lekythoi and in the tomb paintings, and must have been used in the original of the Alexander Mosaic, at least mixed into other colors.[342] Indeed, the chariot frieze of the Tomb of the Prince at Vergina has a dark blue ground,[343] as do the pediment of the Tomb of the Palmettes at Lefkadia[344] and the figured frieze of the tomb at Aghios Athanasios near Thessaloniki.[345] The conclusion seems inevitable that the Romans simplified and idealized the tendency of some Greek paintings to a predominately red-brown palette, in contrast to the predilection of Roman patrons for bright, warm colors, which Pliny (*NH* 35.50) expressly condemns as insensitive.[346] But the Greeks did create works with bright, warm colors, as is attested by the paintings in the tomb at Aghios Athanasios of the early third century.[347]

The mosaics of the private houses at Pella have been mentioned briefly in a previous chapter.[348] They are important to my present discussion in two ways. First, they reflect the characteristics of the contemporary tomb paintings. That is, they hold to an abbreviated palette of essentially four colors, and they reveal a highly sophisticated sense of modeling through color gradations and the balance of light and shade. Unlike most of the tomb paintings, the ground of the scenes is most often dark. The two mosaics in the House of the Abduction of Helen are the most impressive. The huge (8.48 × 2.84 meters) eponymous mosaic is somewhat schematic, and line predominates, even though extensive gray shading models the bodies of the horses (**Fig. 213**).[349] The strong sense of three-dimen-

[340] Andronikos, *Vergina II*, 119.

[341] Andronikos, *Vergina II*, 119; S. E. Filippakis, B. Perdikatsis, and K. Assimenos, "X-Ray Analysis of Pigments from Vergina, Greece (Second Tomb)," *StConserv* 24 (1979) 54–58. Walter-Karydi, "Color in Classical Painting," in Tiverios and Tsiafakis, *Color in Ancient Greece* (note 234 above) 83, incorrectly states that neither blue nor green appear in the hunt frieze.

[342] See chap. 3, pp. 95–96 above.

[343] Andronikos, *Royal Tombs*, 204–5, figs. 166–68; Brecoulaki, *Peinture funéraire*, pls. 50–52; Drougou and Saatsoglou-Paliadeli, *Vergina* (note 310 above) 57, fig. 78; Ginouvès and Hatzopoulos, *Macedonia:* (note 310 above) 172–73, fig. 144.

[344] Brecoulaki, *Peinture funéraire*, 173–204, pls. 64–67; K. Rhomiopoulou and H. Brecoulaki, "Style and Painting Techniques on the Wall Paintings of the 'Tomb of the Palmettes' at Lefkadia," in Tiverios and Tsiafakis, *Color in Ancient Greece* (note 234 above) 107–15, pls. 23, 24; K. Rhomiopoulou, *Lefkadia, Ancient Mieza* (Athens 1997) 30–35, cover ill., fig. 26.

[345] Brecoulaki, *Peinture funéraire*, 263–303, pls. 90–94; M. Tsimbidou-Avloniti, "Revealing a Painted Macedonian Tomb," in Pontrandolfo, *Pittura parietale in Macedonia* (note 316 above) 37–42, pls. VI, VII; Tsimbidou-Avloniti, "The Macedonian Tomb at Aghios Athanasios, Thessaloniki," in *Alexander the Great: Treasures from an Epic Era of Hellenism*, ed. D. Pandermalis (New York 2004) 149–51 (with good color plates).

[346] Bruno, *Form and Color*, 67–87; Rouveret, *Histoire et imaginaire*, 255–70; Koch-Brinkmann, *Polychrome Bilder*, 107, 110–11.

[347] Walter-Karydi, "Color in Classical Painting," in Tiverios and Tsiafakis, *Color in Ancient Greece* (note 234 above) 83–84.

[348] See chap. 2, p. 49 above.

[349] Salzmann, *Kieselmosaiken*, 106–7, cat. 101 (Pella 8), pl. 35.1, 35.2; M. Andronicos, "Pella," in *The Greek Museums* (Athens 1975) 262, no. 5; J. Charbonneaux, R. Martin, and F. Villard, *Hellenistic Art (330–50 B.C.)* (New York 1973) 103, fig. 95; M. Robertson, "Greek Mosaics," *JHS* 85 (1965) 79–80.

sional form is, however, far more apparent in the mosaic, signed by Gnosis, of two young men killing a stag.[350] Since no context other than a rough ground is indicated, there is, of course, no sense of space except that occupied by the figures whose bodies overlap. At least to this modern viewer, the four-color palette and the dark ground, which emphasizes pattern over a complex illusionistic space, seem appropriate for the decoration of floors. If the Greeks thought so too, it appears eminently plausible that there was already a developed sense of the varying requirements of pictorial form in different contexts.

The second importance of the Pella mosaics is to emphasize the invasion of private houses by figured pictures that appear not to have a primary function in the service of ritual or cult. How novel this may be is impossible to say with any assurance. Alkibiades is reported to have imprisoned Agatharchos in his house to paint it; although the account first occurs in the spurious *Alkibiades* (17) attributed to Andokides, it is referred to by Demosthenes (*Against Meidias* 147) and repeated by Plutarch (*Alkibiades* 16.4). What kind of painting was required is unknown. Mosaic floors first appear in Greece around the end of the fifth century, first in public buildings but quickly spreading to the private sphere, as the rich finds at Eretria and Olynthos prove (**Figs. 112–14**).[351]

It is the development of painting and the appearance of mosaics that most clearly make a break with the past. These changes clearly begin in the second half of the fifth century and lead to the unambiguous establishment of the mortal viewer as the primary reference of the painted image. The development of sculpture proceeds along a similar path, demanding an ever greater participation of the viewer. The similar function of the two media is underscored by the report that Praxiteles particularly valued Nikias's painting of his statues (Pliny, *NH* 35.133). Agnès Rouveret advances the reasonable hypothesis that the painter may have helped underscore the illusionistic aliveness of the statues.[352] This brings us to one of the most important aspects of the art of the fourth century—the manner in which it was viewed and experienced. The evidence for this is the subject of the next chapter.

[350] Salzmann, *Kieselmosaiken*, 107–8, cat. 103 (Pella 10), pl. 29, color pls. 101.2–6, 102.1, 102.2; Andronicos, "Pella" (note 349 above) 259, no. 3 (color); Charbonneaux, Martin, and Villard, *Hellenistic Art* (note 349 above) 110–11, figs. 107, 108; Robertson, *JHS* 85 (1965) 81–82, pl. 20.2; Scheibler, *Griechische Malerei*, 118, fig. 52.
[351] See further chap. 7, pp. 264–65 below.
[352] *Histoire et imaginaire*, 32–33.

5A Form and Presentation

Sculpture

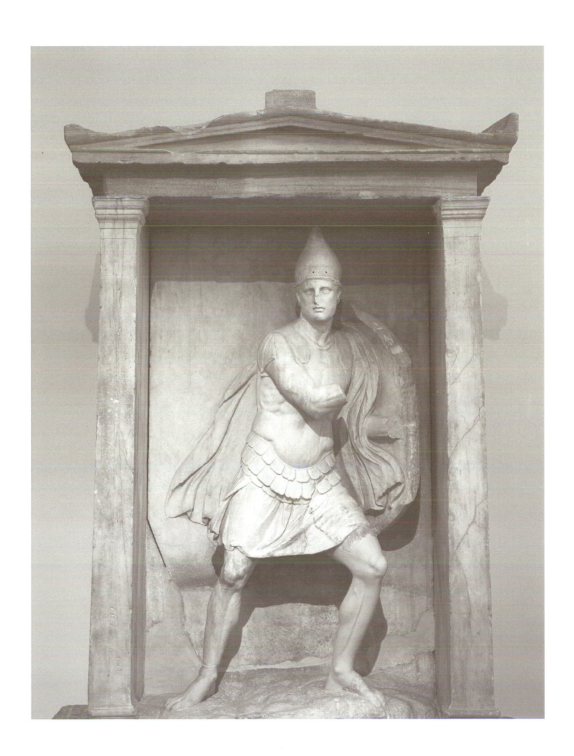

The modern distinction between different classes of Greek sculptural categories is a useful tool of classification but is probably overly strict. The statue of an athletic victor in a sanctuary may not be motivated by the same impulses that produced the more common dedications to divinities, but it is still a votive.[1] The Athenian choregic monuments are not, for the most part, even set up in sanctuaries. Why the Street of the Tripods was chosen as the principal location for them is unknown,[2] but it seems quite clear that the monuments honored Dionysos, the god of the contests. But even the more rudimentary distinction of what was intended for the gods and what for mortals is unclear. On the one hand, public display may emphasize to the modern mind the nonreligious sphere, but the location of almost all major monuments in classical Greek sanctuaries and cemeteries makes it quite clear that they served both mortal pride and reverence for the gods or departed mortals. The early-third-century fourth mime of Herodas gives a little insight into the experience of visiting a sanctuary. Two women, Kokkale and Kynno, enter the sanctuary of Asklepios on Kos to make an offering of a pinax (painted tablet or panel), which Kokkale is directed to put at the right hand of Hygieia, and to sacrifice a rooster. Since the temple is not yet open, they examine their surroundings:

> Kokkale: "What beautiful statues, dear Kynno; what craftsman made this stone statue and who set it up?"
> Kynno: "The children of Praxiteles; do you not see those letters on the base? Euthies the son of Prexon set it up."

While the women continue waiting for the temple to open, they comment on other sculptures, such as a child looking up at an apple, an old man, a boy throttling a goose, etc. On going into the temple they comment on paintings, one by Apelles. The women are apparently of simple background and react strongly to the naturalism of the sculptures and painting, but the tone throughout is casual, with a balance of reverence and touristic wonder.[3]

[1] S. Lattimore, "The Nature of Early Greek Victor Statues," in *Coroebus Triumphs: The Alliance of Sport and the Arts*, ed. S. J. Bandy (San Diego, CA, 1988) 245–56; D. T. Steiner, *Images in Mind: Statues in Archaic and Classical Greek Literature and Thought* (Princeton 2001) 17; N. Himmelmann, *Die private Bildnisweihung bei den Griechen: Zu den Ursprüngen des abendländischen Porträts* (Wiesbaden 2001) 52–53 and especially note 79; Rausa, *Vincitore*, 14–19; Bol, *Antretende Diskobol*, 34.

[2] Travlos, *Pictorial Dictionary*, 566; W. Judeich, *Topgraphie von Athen*, 2nd ed. (Munich 1931; repr. Chicago 1994) 183, 305.

[3] F. Manakidou, *Beschreibung von Kunstwerken in der hellenistischen Dichtung: Ein Beitrag zur hellenistischen Poetik*, Beiträge zur Altertumskunde 36 (Stuttgart 1993) 18–50. For a similar simple admiration of realism, see Theokritos 15, 78–86. On a more sophisticated level, compare the recently discovered papyrus of Poseidippos: K. J. Gutzwiller, "Posidippus on Statuary," in *Il papiro di Posidippo un anno dopo*, ed. G. Bastianini and A. Casanova (Florence 2002) 41–60; A. Stewart, "Posidippus and the Truth in Sculpture," in *The New Posidippus: A Hellenistic Poetry Book*, ed. K. J. Gutzwiller (Oxford 2005) 183–205.

It has generally been assumed that pottery and even most metal vessels were household items and that the representations on these items have a more literary or moralistic purpose than a strictly religious one. Although this may be true, divinities play an important role in the iconography of Attic clay vessels. However, as was discussed briefly in chapter 2, it seems probable that the Attic clay vessels were in fact used primarily for specific festivals or rituals, a conclusion never in doubt for the mass of clay oinochoai produced in the late fifth century for the celebration of the Anthesteria.[4]

All works of Greek art were colored. The recent exhibition shown in Munich, Copenhagen, and Rome has brought this fact home to a wide audience.[5] Indeed, the ancient surface of stone and bronze sculpture is forever lost, so that the perception of the ancient viewer can in many cases only be guessed at. But the importance of color is not just that it must have generally transformed the appearance of all sculptures, but in certain cases it must radically change our perception of specific monuments. Ulrike Koch-Brinkmann has indeed argued convincingly that the rich colors of late white-ground lekythoi play an important role in the composition and interpretation of the scenes depicted, unifying logically separate elements.[6] This is probably also the case for at least two votive reliefs of the fourth century. Paul Hartwig originally proposed that on the famous relief from the Piraeus dedicated to Bendis, now in the British Museum, the great open space to the left of the god must have been painted with some indication of the setting (**Fig. 214**).[7] Semni Karouzou has offered a similar interpretation of a relief in Brauron dedicated to Artemis:[8] she proposes that the large blank space above the votaries might have been filled with the painting of a stoa represented in perspective. Of course, this is all speculation, but Karouzou's point of departure is the observable phenomenon that Greek art normally neither leaves large blank spaces nor favors such unbalanced compositions. So, while the lack of the preservation of painting does affect our perception of most Greek monuments, in the case of the two votive reliefs it may do so very substantially.

In this chapter I examine monuments primarily as visual displays, and arrange the discussion according to the function of the monuments. At least some sporadic inquiry into the content of the monuments is inevitable, but my aim here is to investigate to what extent the visual presentation of a monument or class of monuments may determine how they were experienced by their contemporaries and to what extent the form is important for understanding the content. Since the evidence is at best spotty, I do not make a distinction between clearly private and public monuments, and I follow an order of decreasing evidence.

[4] R. Hamilton, *Choes and Anthesteria: Athenian Iconography and Ritual* (Ann Arbor 1992). See chap. 4, p. 141 above.

[5] Brinkmann and Wünsche, *Bunte Götter* (Munich 2004); the exhibition later appeared in abbreviated form at Harvard University: S. Ebbinghaus, ed., *Gods in Color: Painted Sculpture of Classical Antiquity, Arthur M. Sackler Museum, Sept. 22, 2007–Jan. 20, 2008* (Cambridge, MA, 2007). See also V. Brinkmann, *Die Polychromie der archaischen und frühklassischen Skulptur* (Munich 2003).

[6] Koch-Brinkmann, *Polychrome Bilder*, 56–58.

[7] London, BM 2155: P. Hartwig, *Bendis: Eine archaeologische Untersuchung* (Leipzig 1897) 13–15, pl. 2; van Straten, "Gifts for the Gods," 91, fig. 31; D. Tsiafakis, "The Allure and Repulsion of Thracians in the Art of Classical Athens," in *Not the Classical Ideal: Athens and the Construction of the Other in Greek Art*, ed. B. Cohen (Leiden 2000) 386–87, fig. 14.10.

[8] Brauron 1151: S. Karouzou, "Bemalte attische Weihreliefs," in *Studies in Classical Art and Archaeology: A Tribute to Peter Heinrich von Blanckenhagen*, ed. G. Kopcke and M. B. Moore (Locust Valley, NY, 1979) 112, pl. 33.2; *LIMC*, s.v. Artemis no. 974* (L. Kahil); Neumann, *Weihreliefs*, 63, pl. 40b; A. Comella, *I rilievi votivi greci di periodo arcaico e classico: Diffusione, ideologia, committenza* (Bari 2002) 27, 205, fig. 125 (Brauron no. 1).

The best evidence we have for the placement of sculpture in a controlled context is found in the mostly Attic grave reliefs of the fourth century.[9] Although grave reliefs are now usually set up in museums as individual "works of art,"[10] the modern visitor often finds an entire room or two dedicated to them and can thus imagine their original context, which in many respects was not unlike a prosperous modern cemetery. However, as noted in chapter 2, many of the grandest grave monuments of the fourth century were set up as elaborate displays along major thoroughfares outside a city or town (**Fig. 89**).[11] As is clear from both the streets leading to the Sacred Gate at Athens[12] and the road leading to Rhamnous,[13] the grave monuments were arranged above high retaining walls, often in plots or precincts, so that they could be seen by every passerby but to which access was obviously restricted. A stele was often part of a larger display consisting of multiple stelai of different sorts, marble vases, and occasionally statues. Clearly, display was a primary factor in the appearance of these funerary monuments, and they were vehicles for the families to proclaim their pride.[14] The grave was also a sacred space where the family carried out rituals at least once a year to honor their ancestors, and a question on the location and treatment of the family graves was part of the *dokimasia* of Athenian magistrates according to pseudo-Aristotle (*Ath. Pol.* 55.3) and Xenophon (*Memorabilia* 2.2.13). And, of course, the vast majority of grave reliefs belonged to simple family plots scattered behind the great displays, as can still be experienced in the Athenian Kerameikos.

The inscribing of grave monuments was common, but the content of the inscriptions varies widely, from a simple statement of the name(s) of the figure(s) on the monument, with or without patronymic and demotic, to standardized laments for the deceased, such as that on a stele from the Kerameikos in Athens: "She left grief to her husband, her mother, and the father who begot her, Polyxena, who lies buried here."[15] A somewhat more interesting inscription is that of Aristokles son of Menon, now in London:[16] "After sharing many happy pursuits with companions of my age, grown from the earth I have returned to the earth. And I am Aristokles from the Piraeus, Menon's son." The stele is a simple shaft with horizontal top molding and no side frames. A rider on a rearing horse

[9] For the general bibliography, see chap. 2, note 129 above.

[10] Clairmont, *CAT, Introductory Volume*, 180–82; Schmaltz, *Griechische Grabreliefs*, 4–6, on the Hegeso stele.

[11] Chap. 2, pp. 40–41 above.

[12] See chap. 2, p. 40, note 145 above.

[13] See chap. 2, p. 40, note 146 above.

[14] Bergemann, *Demos und Thanatos*, 7–33; B. Schmaltz, "Verwendung und Funktion attischer Grabmäler," *Marb-WPr*, 1979, 13–37. See also P. Valavanis, "Ἐπὶ κίονος εὖ μάλα ὑψηλοῦ· Κιονωτό ἐπιτύμβιο μνημεῖο στο Ικάριον Αττικής," in *Ἀμύνονα ἔργα· Τιμητικός τόμος γία τον καθηγητή Βασίλη Κ. Λαμπρινουδάκη*, ed. E. Simantoni-Bournia, A. A. Laimou, L. G. Mendoni, and N. Kourou (Athens 2007) 281–96.

[15] Athens, NAM 723: Kaltsas, *SNAMA*, 184, no. 363*; Clairmont, *CAT*, 2.850; *IG* II² 12495; W. Peek, *Greek Verse Inscriptions: Epigrams on Funerary Stelae and Monuments* (Berlin 1955; repr. Chicago 1988) 345; C. Clairmont, *Gravestone and Epigram: Greek Memorials from the Archaic and Classical Period* (Mainz 1970) 126–28, no. 50, pl. 23. More complex examples are cited by R. E. Leader, "In Death Not Divided: Gender, Family, and State on Classical Athenian Grave Stelae," *AJA* 101 (1997) 692–94. A series of inscriptions on the gravestones of fourth-century women is collected by J. Pircher and G. Pfohl, *Das Lob der Frau im vorchristlichen Grabepigramm der Griechen* (Innsbruck 1979) 18–50, nos. 4–16; see also S. Moraw, "Schönheit und Sophrosyne: Zum Verhältnis von weiblicher Nacktheit und bürgerlichem Status in der attischen Vasenmalerei," *JdI* 113 (2003) 39–40.

[16] London, BM 638: *IG* II² 7151; Peek, *Greek Verse Inscriptions* (note 15 above) no. 1702; Clairmont, *Gravestone and Epigram* (note 15 above) 93–95, no. 24 (whence the translation), pl. 12; Clairmont, *CAT*, 2.209a*. G. Daux, "Stèles funéraires et épigrammes," *BCH* 96 (1972) 505–7, notes that there is rarely any relationship between the epigram and the picture of a stele, but in this case there obviously is one.

faces to the right; behind him a figure on foot (groom) in medium-long garment strides to the right holding a staff (spear? lagobolon?) on his left shoulder. The surface is badly worn, which makes a precise reading of the details impossible.

There are numerous examples on which the commentary or eulogy is more extensive, if not materially different. But one inscription stands out, on a simple sunken panel stele of the late fourth century or perhaps the early third (**Fig. 215**). The heading is in Greek and Phoenician, followed by a Greek verse epigram:

> Antipatros, son of Aphrodisios, from Askalon.
> Domsalōs, son of Domanō, the Sidonian, set up the memorial.
> I am ŠMÝ, son of ʿBDʾŠTRT, the Askalonite. (This is) what I erected, DʾMṢLḤ, son of DʾMḤN the Sidonian.
>
> Let no man wonder at the picture here, that on one side of me stretches a lion, on the other a ship's prow. For a hostile lion came to tear my body apart; but friends rescued me and honored me with burial here, (friends) whom I, well-disposed, wished for, coming from their sacred ship. Phoenike was the land I came from; my body is buried in this land.[17]

The picture is, indeed, something to wonder at: a man, presumably Antipatros, lies on a *klinē* with a lion resting its forepaws at the head of the couch, and a nude male leans from the other side over the corpse to push the lion away, while a ship's prow floats behind the scene, sometimes mistakenly taken as forming the head of the nude man (**Fig. 215**). This certainly makes it clear that some grave monuments were carved on demand and at times represented the circumstances of the deceased's end. As is largely the case today, the inscriptions must normally have been intended for family and the casual passerby, who is occasionally addressed.[18]

Among the very earliest large marble grave stelai of classical Attica is the stele of Eupheros, discovered in the Kerameikos in 1964 (**Fig. 216**),[19] which is closely related to the so-called cat stele from Salamis or Aigina.[20] Both are tall and narrow, and neither has side frames. The Eupheros stele has a low pediment with palmette acroteria, while the cat stele has a horizontal anthemion band along the top. A variety of other early stelai have no side frames, though a pedimental crown is common, such as that on the stele in New York of a seated woman holding up an alabastron.[21] The stele of Hegeso, of around 400 B.C., represents the new standard type of stele that will dominate during the fourth century:

[17] Athens, NAM 1488: Kaltsas, *SNAMA*, 190, no. 376*; Clairmont, *CAT*, 3.410; *IG* II² 8388; Peek, *Greek Verse Inscriptions* (note 15 above), 1601; Clairmont, *Gravestone and Epigram* (note 15 above), 114–17, no. 38, pl. 19. The literature is immense, and I cite only the most recent: M. Barbanera, "Ancora sulla stele funeraria di Antipatros di Ascalona: Una messa a punto," *NumAntCl* 21 (1992) 87–103, pls. 1–4; A. Scholl, *Die attischen Bildfeldstelen des 4. Jhs. v. Chr.: Untersuchungen zu den kleinformatigen Grabreliefs im spätklassischen Athen*, AM-BH 17 (Berlin 1996) 272, no. 183 (with full bibliography to that date), pl. 48.1; J. M. S. Stager, "'Let No One Wonder at This Image': A Phoenician Funerary Stele in Athens," *Hesperia* 74 (2005) 427–49. The translation and transcription are from Clairmont, *Gravestone and Epigram*, with slight modifications.

[18] Piraeus 1222: *IG* II² 10435; Peek, *Greek Verse Inscriptions* (note 15 above) 1653; Clairmont, *Gravestone and Epigram* (note 15 above), 122–23, no. 44, pl. 21.

[19] Athens, Kerameikos P 1169: Clairmont, *CAT*, 1.081; Schmaltz, *Griechische Grabreliefs*, 199, pl. 7.2; Himmelmann, *Attische Grabreliefs*, 19; Bol, *Bildhauerkunst*, 233–34, figs. 168a, b (D. Kreikenbom).

[20] Athens, NAM 715: Kaltsas, *SNAMA*, 148, no. 287*; Clairmont, *CAT*, 1.550.

[21] New York, MMA 08.258.42: Richter, *Catalogue*, 50–51, no. 75, pl. LXI; Clairmont, *CAT*, 1, 181; Diepolder, *Grabreliefs*, 15, pl. 7; K. Friis Johansen, *The Attic Grave-Reliefs of the Classical Period: An Essay in Interpretation* (Copenhagen 1951) 155, fig. 77 (p. 153).

flat pilasters, which are carved in one piece with the relief, support a light pediment with palmette acroteria.[22] In the first half of the fourth century, the architectural frame remains shallow, and the seated and standing figures overlap the pilasters (**Figs. 86, 185, 187**). Around the middle of the century the number of figures multiplies and the frame becomes progressively deeper, finally attaining independence as a separate element which fully encloses the figures. More often than not, the framing pilasters are not preserved (**Fig. 220**), presumably because they were reused as ready-made building blocks, but where the whole architectural enclosure is preserved, the monuments are truly impressive, for example, the Aristonautes stele (**Fig. 88**)[23] or the second stele of Demetria and Pamphile (**Fig. 87**).[24]

The naiskos stele is hardly the only form of grave monument. There is a variety of forms of grave monument that still defy convincing explanation: marble lekythoi,[25] loutrophoroi (**Fig. 217**),[26] elaborate reliefs,[27] elaborate vessels carved in imitation of rich metalwork, among which is an impressively hideous griffin cauldron in marble.[28] There also exists a variety of statues of both humans and animals that added to the diversity and impressiveness of grave plots. Examples are the two statues of crouching archers in oriental dress,[29] the mourning women now in Berlin,[30] and the great bull on top of the stele of Dionysios of Kollytos,[31] as well as lions[32] and dogs.[33] The standard iconography of the grave monu-

[22] Athens, NAM 3624: Kaltsas, *SNAMA*, 156, no. 309*; Clairmont, *CAT*, 2.150; Schmaltz, *Griechische Grabreliefs*, 1–23, 105, 126, 142, 145; Friis Johansen, *Attic Grave-Reliefs* (note 21 above) 17–20, fig. 5; Bol, *Bildhauerkunst*, 261–62, fig. 195 (W. Geominy).

[23] Athens, NAM 738: Kaltsas, *SNAMA*, 204, no. 410*; Clairmont, *CAT*, 1.460; A. von Salis, *Das Grabmal des Aristonautes*, *BWPr* 84 (Berlin 1926); Diepolder, *Grabreliefs*, 52–53, pl. 50; B. S. Ridgway, "'Aristonautes' Stele, Athens Nat. Mus. 738," in *Kotinos: Festschrift für Erika Simon*, ed. H. Froning, T. Hölscher, and H. Mielsch (Mainz 1992) 270–75; H. J. Meyer, "Das Grabmal des Aristonautes," *HASB* 8 (1982) 21–26, pls. 10, 11.

[24] Athens, Kerameikos P 687: Clairmont, *CAT*, 2.464; Diepolder, *Grabreliefs*, 53, pl. 51.1; Himmelmann, *Attische Grabreliefs*, pp. 39, 59 note 80, fig. 14; W. Kovacsovics, *Kerameikos: Ergebnisse der Ausgrabungen*, vol. 14, *Die Eckterrasse an der Gräberstrasse des Kerameikos* (Berlin 1990) 80, pl. 17; Bol, *Bildhauerkunst*, 378, fig. 348 (C. Maderna).

[25] B. Schmaltz, *Untersuchungen zu den attischen Marmorlekythen* (Berlin 1970); A. Prukakis-Christodolopoulos, "Einige Marmorlekythen," *AM* 85 (1970) 54–99; A. M. Prukakis, "The Evolution of the Attic Marble Lekythoi and Their Relation to the Problem of Identifying the Dead among the Figures Shown on the Funerary Reliefs" (Ph.D. diss., University of London, 1971).

[26] G. Kokula, *Marmorlutrophoren*, *AM-BH* 10 (Berlin 1984); C. Dehl, "Eine Gruppe früher Lutrophorenstelen aus dem Kerameikos," *AM* 96 (1981) 163–78; J. Bergemann, "Die sogenannte Loutrophoros: Grabmal für unverheiratete Tote?" *AM* 111 (1997) 149–90, pls. 22–32.

[27] E.g., Clairmont, *CAT*, 2.154, 2.710, 3.190. Perhaps the most enigmatic relief shows two bearded men with heavy bodies reclining on a *klinē* with two women seated on the ends next to them and, in the foreground, a ship with four oars and a bearded man seated in it, sometimes identified as Charon: J.-M. Dentzer, *Le motif du banquet couché dans le proche orient et le monde grec du VIIe au IVe siècle avant J.-C.* (Paris 1982), R199, pl. 76, fig. 457; *LIMC*, s.v. Charon no. 57* (C. Sourvinou-Inwood); Knigge, *Kerameikos*, 126 (plot no. 24), but A. Scholl, "Das 'Charonrelief' im Kerameikos," *JdI* 108 (1993) 353–73, pls. 1–3, convincingly identifies the banqueters as *metics* involved in the grain trade; Clairmont, *CAT, Supplement*, 70–72, no. 5.470, photograph on p. 160.

[28] Athens, NAM 3619, 3620: Kaltsas, *SNAMA*, 192, no. 380*; other examples: Kaltsas, *SNAMA*, 200, no. 398*, 203, no. 408*; Kokula, *Marmorlutrophoren* (note 26 above) pls. 38, 39; Boardman, *GS-LCP*, fig. 134.

[29] Athens, NAM 823, 824: Kaltsas, *SNAMA*, 196, no. 390*; Knigge, *Kerameikos*, 125, fig. 122.

[30] Berlin, Staatl. Mus. Sk 498, 499: Blümel, *Klassisch Skulpturen Berlin*, 44–45, no. 45, figs. 62–69.

[31] Athens, NAM 4498: Knigge, *Kerameikos*, 123–26, figs. 119, 120; also the bull in Copenhagen, NCG 1567: Poulsen, *Catalogue*, 180–81, no. 238; Moltesen, *Classical Period*, 77, no. 21*. See generally M. Polojiorghi, "Stiere und Löwen in der attischen Grabkunst," *AM* 119 (2004) 239–59, pls. 55–63.

[32] U. Vedder, *Untersuchungen zur plastischen Ausstattung attischer Grabanlagen des 4. Jhs. v. Chr.* (Frankfurt am Main 1985) 79–88, 117–18; D. Woysch-Méautis, *La représentation des animaux et des êtres fabuleux sur les monuments funéraires grecs de l'époque archaïque à la fin du IVe siècle av. J.-C.* (Lausanne 1982) 73–77; Kaltsas, *SNAMA*, 205, nos. 411–13*.

[33] Vedder, *Ausstattung attischer Grabanlagen* (note 32 above) 88–91; Kaltsas, *SNAMA*, 186, no. 366*; Knigge, *Kerameikos*, 162–63, precinct 65; also the squatting dog in Copenhagen, NCG 2447: Poulsen, *Catalogue*, 181–82, no. 238b; Moltesen, *Classical Period*, 76, no. 20*. Dogs appear frequently on the stelai of hunters and alone: Woysch-Méautis, *Représentation des animaux* (note 32 above) 53–60; M. Zlotogorska, *Darstellungen von Hunden auf griechischen Grabreliefs von der Archaik bis in die römische Kaiserzeit* (Hamburg 1997).

ments depicts the deceased in the company of either a servant or family member or even a number of both. There are minor iconographic themes that represent scenes of the life of the deceased. For women, a very infrequent scene is a seated woman partially reclining and assisted by one or two female attendants; since the seated woman is usually at the center and is often larger than the attendants or occasional mourner, she is believed to be the deceased depicted dying in childbirth.[34] For men the range is greater: foot-soldiers in battle,[35] cavalry engagements,[36] the hunt,[37] and a tiny group depicting males in some activity other than battle or hunt.[38] Figures contemplating theatrical masks are depicted on three monuments—two on normal stelai[39] and one on the rectangular base of a loutrophoros-hydria (**Fig. 217**).[40] On the two stelai the figures contemplating a mask or masks are male. The third figure, who appears to be female, occurs on the base, or *trapeza,* of a loutrophoros-hydria that bears a traditional scene of a bearded man grasping the hand of a woman. Andreas Scholl, however, suggests that the figure on the *trapeza* is in fact a man in the long dress of an actor.[41]

These monuments indicate that the apparent uniformity of Attic grave monuments was not as rigid as is generally believed. The background of the noncanonical themes is largely unclear. The relief depicting Demokleides on the prow of a (mostly painted) ship with his helmet next to him may suggest that he was lost at sea.[42] This probably also applies to the small relief of Demetrios in attack pose, also on the prow of a ship.[43] But why women should be shown dying in childbirth remains obscure since an alternative more in line with conventional patterns was available: an attendant holding a baby out to the deceased mother.[44] Nancy Demand, starting from a suggestion of Christoph Clairmont,

[34] Clairmont, *CAT*, vol. 4, list on p. 88 (twelve examples); U. Vedder, "Frauentod-Kriegertod im Spiegel der attischen Grabkunst des IV. Jhs. v. Chr.," *AM* 103 (1988) 161–91, pls. 21–25; Scholl, *Attischen Bildfeldstelen* (note 17 above), 159–64; J. H. Oakley, "Death and the Child," in *Coming of Age in Ancient Greece: Images of Childhood from the Classical Past*, exh. cat., ed. J. Neils and J. H. Oakley (New Haven, CT, 2003) 185–87, figs. 28, 29.

[35] Clairmont, *CAT*, 1.194, 1.277, 1.361, 1.458, 1.460, 2.192, 2.217, 2.251, 2.251a, 2.393, 2.413; R. Stupperich, *Staatsbegräbnis und Privatgrabmal im klassischen Athen* (Münster 1977) 175–77, 184–90.

[36] Clairmont, *CAT*, 2.130, 2.131, 2.209, 2.213, 2.214a, 2.215, 2.412b, 3.430a, 3.432, 3.433, 4.650 (perhaps); Stupperich, *Staatsbegräbnis* (note 35 above) 177–79; R. Stupperich, "The Iconography of Athenian State Burials in the Classical Period," in *The Archaeology of Athens and Attica Under the Democracy*, ed. W. D. E. Coulson, O. Palagia, et al. (Oxford 1994) 95, on battles on grave monuments in general. Battles had appeared earlier on white-ground lekythoi of the Reed Painter's workshop and earlier still on funerary loutrophoroi: Kurtz, *Athenian White Lekythoi*, 64–65.

[37] Clairmont, *CAT*, 2.214a, 2.372c. The first (Budapest 4744) is very fragmentary and does not show what or whom is being attacked, an animal or a person. Given the poses of the attackers and the probable weapon (club) of the man on foot on the right, a hunt is very probable. Hunters not engaged in hunting but identified as such by holding a lagobolon or perhaps by the presence of a dog or dogs with someone holding a small animal such as a rabbit are more frequent: *CAT*, vol. 4, lists on pp. 120 (hunter) and 126 (lagobolon).

[38] Clairmont, *CAT*, 1.100, 1.302, 1.890, 2.209a, 2.710.

[39] Clairmont, *CAT*, 1.075 (Piraeus), 1.400 (Lyme Hall); for the relief in the Piraeus (ex Salamis) see also N. Slater, "Vanished Players: Two Classical Reliefs and Theater History," *GRBS* 26 (1985) 340–44, pl. 2; G. Steinhauer, *Τα μνημεία και το Αρχαιολογικό Μουσείο του Πειραιά* (Athens 1998) 70, fig. 18; Steinhauer, *Μουσείο Πειραιώς*, no. 447. On the stele in Lyme Hall, see further chap. 7, p. 293 below with note 232.

[40] Athens, NAM 4498: Kaltsas, *SNAMA*, 170, no. 334; Clairmont, *CAT*, 4.270; Kosmopoulou, *Statue Bases*, 223–25, no. 50, fig. 79; A. Scholl, "Nicht Aristophanes sonder Epigenes: Das Lyme-Park-Relief und die Darstellung von Dichtern und Shauspielern," *JdI* 110 (1995) 231, fig. 15.

[41] Scholl, *JdI* 110 (1995) 231.

[42] Athens, NAM 752: Kaltsas, *SNAMA*, 163, no. 320; Clairmont, *CAT*, 1.330; Scholl, *Attischen Bildfeldstelen* (note 17 above) 244–45, no. 70; Stupperich, *Staatsbegräbnis* (note 35 above) 179–80; Stupperich, "Athenian State Burials" (note 36 above) 97, fig. 6.

[43] Munich, Glyptothek 522: B. Vierneisel-Schlörb, *Glyptothek München, Katalog der Skulpturen*, vol. 3, *Klassische Grabdenkmäler und Votivreliefs* (Munich 1988) 59–64, pl. 24; Clairmont, *CAT*, 1.458.

[44] For example, Leiden, Rijksmuseum van Oudheden I 1903/2.1: Clairmont, *CAT*, 2.652; and Athens, NAM 3790: Kaltsas, *SNAMA*, 183, no. 362; Clairmont, *CAT*, 2.780. Vedder, *AM* 103 (1988) 182–84, follows an old interpretation

argues that these stelai may commemorate not the women who died in childbirth, but the profession of the midwives who are depicted on each of the reliefs, attending the women in labor.[45] At first glance this makes some sense, but the mourning figure included on at least two of the stelai is logically to be connected with the suffering woman and not the midwife.[46] Also against the suggestion is that, other than the three poet/actor stelai already mentioned, there are only two other memorials which make a visual reference to the profession of the deceased. One of these certainly belongs to a metic, and the second one may as well. Xanthippos, whose status as citizen is not indicated on his early stele of about 420, is depicted as a shoemaker;[47] the stele of the metic Sosinos of Gortyn shows him as a metalworker.[48] Whichever interpretation one adopts, and the evidence is unclear, the stelai of women in childbirth represent a real contrast both with the mainstream compositions and the alternative scenes.

If one views each naiskos stele as an independent monument, the framing elements have both an iconographic and an aesthetic function. The pedimental form of the tops of the stelai, which are occasionally replaced by an abbreviated lateral view of a tiled roof with antefixes (**Fig. 218**),[49] indicates a building in which the figures are grouped. The designation of this building as a naiskos in the modern literature suggests a sacred structure. If we take the depictions of such buildings on South Italian funerary vases, where they appear in large numbers, as any indication of their nature, they were light and open, much like a garden gazebo.[50] Since the figures in the naiskos were certainly not always all dead at the time the monument was set up,[51] the scenes represent either a view of the deceased before death or a timeless and apparently locationless interaction of the deceased with the still living.[52] On the white-ground lekythoi of the fifth century, the most frequent theme is that of living people bringing offerings to the grave, indicated by a tomb mound and/or a tall, narrow stele (**Fig. 219**).[53] Occasionally one of the figures may represent the deceased next to the stele.[54] These last scenes reflect the East Greek tradition of marble stelai that most prob-

that the depiction of the death of women in childbirth parallels that of the death of warriors in battle and that both are particularly grievous and honorable. She dates the beginning of the theme ca. 370–360 (p. 164); curiously, it is used only on small, rather modest monuments. The child probably died with the mother, while in the case of the stelai that represent a child presented to the seated mother, it may be guessed that the child survived.

[45] A verbal communication to N. Demand, *Birth, Death, and Motherhood in Classical Greece* (Baltimore 1994) 130, a position Demand supports (pp. 121–34, pls. 1–11).

[46] A. Kosmopoulou, "Working Women: Female Professionals on Classical Attic Gravestones," *BSA* 96 (2001) 299–300, accepts that the deceased is the seated woman and notes, for example (p. 287), that nurses are never depicted on their own grave stelai in their professional capacity.

[47] London, BM 628 (1805.7-3.183): Clairmont, *CAT*, 1.630; Diepolder, *Grabreliefs*, 11–12, pl. 4.

[48] Paris, Louvre Ma 769: Hamiaux, *Sculptures grecques*, vol. 1, 146–47, no. 140; Clairmont, *CAT*, 1.202; Himmelmann, *Attische Grabreliefs*, 43, note 64; J. Bergemann, "Lysias: Das Bildnis eines attischen Redners und Metöken," in *Wissenschaft mit Enthusiasmus: Beiträge zu antiken Bildnissen und zur historischen Landeskunde Klaus Fittschen gewidmet*, ed. J. Bergemann (Rahden, Westphalia, 2001) 121–22.

[49] Clairmont, *CAT*, vol. 1, 39–40. Clairmont's claim that the side view of the roof suggests a domestic rather than sacred setting is difficult to support. An arbitrary selection of examples: *CAT*, 0.871, 0.909, 1.202, 1.862 (here **Fig. 218**), 2.909, 3.383c, 3.384c, 3.409, 4.471.

[50] A. D. Trendall and A. Cambitoglou, *The Red-Figured Vases of Apulia*, vol. 1 (Oxford 1978) li–lii, 186.

[51] Bergemann, *Demos und Thanatos*, 25–28; Himmelmann, *Attische Grabreliefs*, 99. For example, the first stele of Demetria and Pamphile, Athens, NAM 2708: Clairmont, *CAT*, 2.426; Kovacsovics, *Kerameikos* 14 (note 24 above), 79, pl. 16; Himmelmann, *Attische Grabreliefs*, fig. 13, pp. 39, 59, note 80.

[52] Schmaltz, *MarbWP*, 1979, 13–21, reviews the long controversy over how the various scenes on the grave monuments are to be read.

[53] New York, MMA 06.1075: Kurtz, *Athenian White Lekythoi*, 51, 216, pl. 39.1. See generally J. H. Oakley, *Picturing Death in Classical Athens: The Evidence of the White Lekythoi* (Cambridge 2004) 145–214.

[54] Oakley, *Picturing Death* (note 53 above) 148, 165–69, 173; Koch-Brinkmann, *Polychrome Bilder auf weissgrundigen Lekythen* (note 6 above) 52–53; J. Bažant, "Entre la croyance et l'expérience: Le mort sur les lécythes à fond

ably depict the deceased seated and receiving offerings from family members.[55] It is eminently reasonable to consider that the iconography of the Attic stelai was under the direct influence of this tradition when the apparent prohibition of elaborate grave monuments in Athens was lifted sometime in the period just before or around 430 B.C.[56] Certainly the white-ground lekythoi provided a firm basis for adopting such a tradition when carved stone monuments were again permitted.[57]

The Attic stelai provide an important insight into the establishment of a pictorial setting for sculpture. The building that forms the frame of the stelai is actually not locationless but is the burial plot where the living communicate with the deceased. Although, unlike on many of the white-ground lekythoi, the living generally do not bring offerings, the presumable context of the scenes on the stelai is the important ritual for the deceased at the grave.[58] The subject of the images, however, is not the ritual,[59] but an ambiguous representation of the deceased as though alive and in some relationship to the living. The gradual enlargement of the number of figures with prominent gestures of mourning creates an increasingly ambiguous image in which there is explicit interaction of the living and the dead beyond a servant standing statically by, having presented a (deceased?) woman with a box into which she reaches or at which she stares, or a relative who observes the deceased (**Figs. 185, 187**). Most common is a handshake between two men or a man and a woman (**Fig. 86**).[60] At times women gesture to each other, bending forward in mournful intimacy while one or more other figures crowd around, some making gestures of mourning (**Fig. 220**).[61] The culmination of the development is the Ilissos stele, on which a bearded and draped man on the right stares intently at a nude youth who does not look back at the old

blanc," in *Iconographie classique et identités régionales: Paris 26 et 27 mai 1983*, ed. L. Kahil, C. Augé, and P. Linant de Bellefonds, *BCH* suppl. 14 (Athens and Paris 1986) 37–44; see also H. A. Shapiro, "The Iconography of Mourning in Athenian Art," *AJA* 95 (1991) 629–56.

[55] H. Hiller, *Ionische Grabreliefs der ersten Hälfte des 5. Jahrhunderts v. Chr.*, IstMitt-BH 12 (Tübingen 1975) 78–82. Himmelmann, *Attische Grabreliefs*, 31, suggests the type had its origin in Attica before the prohibition of luxurious grave monuments ca. 500.

[56] Friis Johansen, *Attic Grave-Reliefs* (note 21 above) 133–48; Himmelmann, *Attische Grabreliefs*, 19; Schmaltz, *Griechische Grabreliefs*, 197–200; Bergemann, *Demos und Thanatos*, 20. K. Stears, "Dead Women's Society: Constructing Female Gender in Classical Athenian Funerary Sculpture," in *Time, Tradition, and Society in Greek Archaeology: Bridging the 'Great Divide,'* ed. N. Spencer (London and New York 1995) 113, argues for an earlier date, ca. 450, which was the opinion of Diepolder, *Grabreliefs*, 13.

[57] A rather special marble lekythos was found in a tomb on the island of Aigina; rather than having sculptured decoration, it is painted: Athens, NAM 3585: Clairmont, *CAT*, 2.052; Prukakis-Christodolopoulos, *AM* 85 (1970) 55, 63, 69–70, fig. 1. Although the foot and part of the neck are missing, the vase measures 0.56 meters high. On one side is painted a stele mounted on two perspectively represented steps and crowned by a pediment. A figure, apparently wrapped in a mantle, is painted on the stele. Two figures frame the stele and appear to decorate it. On the other side five small winged figures float around tall, leafy plants. The vase obviously represents the transition from the iconography of the white-ground lekythoi to the later canonical scenes of family attending the deceased.

[58] R. Garland, *The Greek Way of Death* (Ithaca, NY, 1985) 104–20; D. C. Kurtz and J. Boardman, *Greek Burial Customs* (Ithaca, NY, 1971) 143–48. Bergemann, *Demos und Thanatos*, 10, makes the interesting observation that in one case where the offering place is preserved, in the plot of Dionysios of Kollytos in the Kerameikos, it lay behind the stelai, which therefore did not play a central role in the rituals performed at the grave. Cf. Himmelmann, *Attische Grabreliefs*, 98–99.

[59] Proposed by J. Thimme, "Die Stele der Hegeso als Zeugnis des attischen Grabkultes," *AntK* 7 (1964) 16–29; Thimme, "Bilder, Inschriften und Opfer an attischen Gräbern," *AA*, 1967, 199–213. The thesis has not been accepted by Stupperich, "Athenian State Burials" (note 36 above) 96, and Bergemann, *Demos und Thanatos*, 1, and is unconvincing.

[60] See list of *dexiosis* scenes in Clairmont, *CAT*, vol. 6, p. 99. A convincing interpretation of the character of the images of the stelai is given by Leader, *AJA* 101 (1997) 683–99.

[61] Clairmont, *CAT*, 3.461, 3.461a, 3.465, 3.466.

man but out at the viewer (**Fig. 132**).[62] The nude deceased holds a lagobolon and rests against a stepped monument, presumably his grave, using his mantle as a cushion, while a child sits huddled on the steps of the monument with downcast gaze and a dog sniffs the ground. At first it appears that the ambiguity is lessened and the two realms can be grasped intuitively: the nude youth is an epiphany, while the old man, the child, and the dog are all alive and mourn at the grave monument against which the deceased leans. But my second reaction is to group the nude youth with the child and dog, and separate out the old man as an observer of a touching scene in which the nude youth is eminently real, even to the point of using his mantle as a cushion on the hard, cold marble of, presumably, his own grave monument. The youth also looks at the viewer to engage his attention and, one imagines, commiseration. The viewer and the old man are on a par: they observe the epiphany of the deceased, of which neither the child nor the dog is aware. This is a real scene with spatial relations that at first are understandable; but, on closer inspection, it becomes an illusion in which the viewer is invited to participate, a characteristic phenomenon of the fourth century to which I shall return repeatedly. In some respects, the scene of the Ilissos stele resembles more closely the iconography of the white-ground lekythoi than the mainstream of fourth-century reliefs in which there is an interaction of living and deceased.

The difference between the lekythoi and the grave stelai of the fourth century can perhaps be seen best by comparing the open columnar buildings seen in perspective on several votive reliefs to Herakles (**Fig. 221**)[63] with similar structures on black- and red-figure vases of the Late Archaic period that depict Herakles with Kerberos at the gate of Hades (**Fig. 222**).[64] The architectural elements on the vases simply provide a symbolic setting; on the grave reliefs of the early fourth century the rudimentary architectural elements of a building occupy a real space, not only because of the use of perspective, but also because of their size and placement in relation to the figures. It is not clear what the building is meant to depict; it could be either a small sacred building in a sanctuary of Herakles[65] or the gate of Hades, as on the Late Archaic vases (or both).[66] The fourth-century reliefs are ambiguous primarily because the space in them seems real, but it is in fact still the symbolic quality of the elements that is important in communicating the meaning of the images.

What the naiskos of the grave stelai is meant to depict is unknown, though clearly it is a building that opens a kind of window into the world of the dead and allows the living to interact with the deceased, indeed, akin to the gate of Hades. Since the stelai with pedimental

[62] Athens, NAM 869: Kaltsas, *SNAMA*, 193–94, no. 382*; Clairmont, *CAT*, 2.954; N. Himmelmann-Wildschütz, *Studien zum Ilissos-Relief* (Munich 1956); Bol, *Bildhauerkunst*, 380, figs. 348a, b (C. Maderna).

[63] Athens, NAM 2723: E. Tagalidou, *Weihreliefs an Herakles aus klassischer Zeit*, SIMA-PB 99 (Jonsered 1993) 215–19, no. 21, pl. 12; *LIMC*, s.v. Herakles no. 760*. Venice, MAN 100: Tagalidou, 239–42, no. 39, pl. 16; *LIMC*, s.v. Herakles no. 1375* (here **Figs. 139, 140**). Athens, NAM 1404: Kaltsas, *SNAMA*, 139, no. 266*; Tagalidou, 208–11, no. 18, pl. 10; Süsserott, *Griechische Plastik*, 104, pl. 14.3.

[64] Paris, Louvre F 204: *ARV²* 4.11 (Andokides Painter); *Beazley Addenda²*, 150; *LIMC*, s.v. Herakles no. 2554*; K. Schefold, *Götter- und Heldensagen der Griechen in der spätarchaischen Kunst* (Munich 1978) 122, fig. 152. Boston, MFA 28.46: *ABV* 261, 38; *LIMC*, s.v. Herakles no. 2556* (Manner of the Lysippides Painter).

[65] Tagalidou, *Weihreliefs an Herakles* (note 63 above) 27–49; Himmelmann, *Ausruhende Herakles*, 70–71, 74, 132–34. J. Riethmüller, "Bothros and Tetrastylon: The Heroon of Asklepius in Athens," in *Ancient Greek Hero Cult: Proceedings of the Fifth International Seminar on Ancient Greek Cult, Organized by the Department of Classical Archaeology and Ancient History, Göteborg University, 21–23 April 1995*, ed. R. Hägg (Stockholm 1999) 143–43; Riethmüller, *Asklepios: Heiligtümer und Kulte* (Heidelberg 2005) 271, points to the tetrastylon in the sanctuary of Asklepios on the south slope of the Athenian Acropolis as a parallel; M. Seifert, "'Epi Xenia: Zu Tisch!' Überlegungen zu Weihreliefs in Athen aus klassischer Zeit," *Hephaistos* 25 (2007) 263–64.

[66] J. N. Svoronos, *Das athener Nationalmuseum* (Athens 1908–11) 381–84; O. Walter, "Der Säulenbau des Herakles," *AM* 62 (1937) 41–51, rejected by Tagalidou, *Weihreliefs an Herakles* (note 63 above) 28.

crowns resemble a pylon, or perhaps specifically the Propylaia on the Athenian Acropolis, this suggestion may have several levels of meaning, since the propylon served as the opening into sacred space, both on the Acropolis and elsewhere. In any case, the grave naiskos allows the viewer to look into an ambiguous space in which the living and dead can interact; apart from invoking ambiguities of space and time, its basic function is to make present what is absent—the deceased.[67] Concrete elements of setting play a minor though typical role: the built frame encloses a sacred space in which the deceased is an epiphany, just as Aphrodite is in her temple at Knidos and Praxiteles' Satyr is in the choregic monument mentioned by Pausanias (see pp. 196–97 below). Together with the Ilissos stele, the stele of Aristonautes illustrates this point well (**Fig. 88**): Aristonautes in full battle dress rushes to the attack on a slightly rising piece of naturalistically rendered ground; the viewer is transported into the middle of a battle.[68] It is not difficult to imagine the strong reactions of viewers to either the Ilissos stele or that of Aristonautes: deep sorrow and terror, respectively.

The sheer size and number of medium- to large-size stelai with the traditional motifs of deceased and family member(s) and servant(s) must have rendered the few noncanonical stelai almost invisible. The sometimes baroque decorative crowns of the stelai, along with the elaborate reliefs mentioned above, certainly produced an atmosphere that is not grasped by the modern concept of the "classical" so strongly ingrained in our visual vocabulary over the last two hundred years (**Fig. 218**). The grave plots lining the roads into Athens and elsewhere introduced the visitor to the people of the city or town before arrival. The contrast with fifth-century cemeteries must have been startling: the earlier nonfigural monuments may have constituted an impressive show of reverence for the dead, but the fourth-century cemetery presented a horde of people in ostentatious assemblages filling the visitor's horizon: a marble city of the living, prosperous dead. There must have been a tension between the impressive individual monuments and the great mass of them; I can easily imagine that the move to increasingly deep naiskoi with scenic representations was in part an attempt to assert the individual monument over its neighbors.

STATUE GROUPS

The creation of controlled settings for votive statues is difficult to document because they are almost never mentioned in the ancient sources, and archaeological evidence is largely lacking.[69] The situation is slightly better for statue groups. The presentation of groups of sculpture has a long history. The Geneleos group on Samos demonstrates attention to a monumental setting in the sixth century: each of the six figures—standing, sitting, or reclining—is set frontally and rigidly next to its neighbor on a long, raised, rectangular base.[70] The group was set up along the Sacred Way into the sanctuary along with innumerable

[67] S. I. Johnston, *Restless Dead: Encounters Between the Living and the Dead in Ancient Greece* (Berkeley 1999) reviews the evidence both literary and archaeological for belief in the active intervention of the dead in the world of the living. See also Rouveret, *Histoire et imaginaire*, 20.

[68] W. A. P. Childs, "Platon, les images et l'art grec du IVe siècle avant J.-C.," *RA*, 1994, 52–53. Meyer, *HASB* 8 (1982) 21–26, pls. 10, 11, makes the point that the stele was mounted high up on a retaining wall along the narrow road that ran through the cemetery, which perhaps made the immediacy of the stele less dramatic.

[69] C. Alves, "Weihungen im klassischen Heiligtum," in *Standort: Kontext und Funktion antiker Skulptur*, ed. K. Stemmer (Berlin 1995) 192–95; B. S. Ridgway, "The Setting of Greek Sculpture," *Hesperia* 40 (1971) 336–45. See further pp. 185–89 below.

[70] B. Freyer-Schauenburg, *Samos*, vol. 11, *Bildwerke der archaischen Zeit und des strengen Stils* (Bonn 1974) 106–30, nos. 58–63, pls. 44–53, 73; H. L. Schanz, *Greek Sculptural Groups: Archaic and Classical* (Ph.D. diss., Harvard University, 1969), Outstanding Dissertations in the Fine Arts (New York 1980) 14–18, pls. 5, 6.

other votives.[71] This remained the practice down into the fourth century, as the main entrance to the sanctuary of Apollo at Delphi indicates (**Fig. 236**). From the entrance at the southeast corner of the temenos the rising road was framed by a continuous series of statue groups up to the first hairpin turn at the Treasury of the Siphnians. The visitor's impression must have been closely similar to that of the archaic visitor to the sanctuary of Hera on Samos. There are, however, differences in the manner the groups were constituted, which will be discussed below. The overall display of the groups along both sides of the Sacred Way at Delphi also resembles the way in which grave monuments were displayed along the entrance roads to Athens in the Kerameikos. The difference here resides in the form of the monuments. In each case the content of the display must have been immediately recognizable. As we shall see, the same type of development applies to both types of monument, votive and funerary—the viewer is progressively addressed in a more direct manner.

An Early Classical base on Samos with a lunate shape suggests on the basis of its plan alone a more dynamic relationship among the three figures that stood on it.[72] The group of statues dedicated at Olympia by the Achaians, with sculptures by Onatas depicting the Achaian heroes drawing lots to determine who will fight Hektor (*Iliad* 7.170–83), demonstrates how sensitive and dramatic the presentation of sculptured monuments had become in the fifth century.[73] Pausanias (5.25.8–10) describes it in some detail:

> There are also offerings dedicated by the whole Achaian race in common; they represent those who, when Hektor challenged any Greek to meet him in single combat, dared to cast lots to choose the champion. They stand, armed with spears and shields, near the great temple. Right opposite, on a second pedestal, is a figure of Nestor, who has thrown the lot of each into the helmet. The number of those casting lots to meet Hektor is now only eight, for the ninth, the statue of Odysseus, they say that Nero carried to Rome, but Agamemnon's statue is the only one of the eight to have his name inscribed upon it; the writing is from right to left. (Trans. W. H. S. Jones and H. A. Ormerod, Loeb edition)

The situation of the monument just off the southeast corner of the Temple of Zeus can best be appreciated on a plan of the sanctuary (**Fig. 237**, no. 8).[74] The ancient processional way went right between Nestor and the heroes. The psychological element of the presentation here is unmistakable, though difficult to judge. It is clearly the spatial element that is most remarkable; the modern mind reconstructs a vivid diorama, as though the visitor to the sanctuary were the witness of a real gathering of the heroes. A similar response has been attached to the group of the Tyrannicides in the Athenian Agora: Hipparchos is missing, and the viewer takes his place.[75] But this reaction is really a product of the manner in which the two statues are now displayed back-to-back in the museum in

[71] See the plan of the site in H. Walter, *Das griechische Heiligtum dargestellt am Heraion von Samos* (Stuttgart 1990) fig. 169 on p. 157.

[72] E. Buschor, "Gruppe des Myron," *AM* 68 (1953) 51–62; Schanz, *Sculptural Groups* (note 70 above) 85–88; H. Kyrieleis, *Führer durch das Heraion von Samos* (Athens 1981) 129–30, no. 33, fig. 98.

[73] F. Eckstein, Ἀναθήματα: *Studien zu den Weihgeschenken strengen Stils im Heiligtum von Olympia* (Berlin 1969) 27–32; Schanz, *Sculptural Groups* (note 70 above) 83; C. Ioakimidou, *Die Statuenreihen griechischer Poleis und Bünde aus spätarchaischer und klassischer Zeit* (Munich 1997) 82–87, no. 13, 213–40, pl. 13.2; A. Ajootian, "Heroes and Athletes at Olympia: The Achaean Dedication," *AJA* 106 (2002) 267 (paper abstract).

[74] The plan is after A. Mallwitz, *Olympia und seine Bauten* (Darmstadt 1972).

[75] See S. Brunnsåker, *The Tyrant-Slayers of Kritios and Nesiotes: A Critical Study of the Sources and Restorations*, 2nd ed., Skrifter Utgivna av Svenska Institutet i Athen, 4°, 17 (Stockholm 1971); Schanz, *Sculptural Groups* (note 70 above) 74, and Stewart, *Greek Sculpture*, 136, on the role of the viewer. See also the broad study of the location of the group

Naples. Brunilde Ridgway has stressed that "'the eloquent silhouette' should be the major criterion in the reconstruction of the group."[76] This is clearly underscored by the use of the poses of the two statues for figures of Theseus on late Attic red-figure vases and the friezes of the Hephaisteion.[77] The Diskobolos of Myron is particularly important in this regard: the vertical whirling pattern of the arms is an abstract graphic allusion to the action of a discus thrower; the flattened composition of the statue forces a single vantage point perpendicular to the figure's chest. It is likewise the dramatic gestures of the Tyrannicides that are important, and, of course, their location on or near the spot where Hipparchos was cut down. As Aileen Ajootian points out, the essence of Early Classical sculpture is to suggest the outcome of the representation, as in the east pediment of the Temple of Zeus at Olympia,[78] and that is precisely what the gestures of the Tyrannicides do. It therefore seems likely to me that the Achaian monument at Olympia was less a vivid diorama than it was an evocation of the coming duel, in a manner similar to the static figures of the east pediment of the Temple of Zeus at Olympia.

But a new approach to group sculptures is suggested by Pausanias's description of the dedication of the Spartans at Delphi to commemorate their victory over the Athenians at Aigospotamoi at the end of the fifth century, commonly known as the Lysander Monument. Pausanias describes it thus (10.9.7–11):

> Opposite these are offerings of the Lakedaimonians from spoils of the Athenians: the Dioskouroi, Zeus, Apollo, Artemis, and beside these Poseidon, Lysander, son of Aristokritos, represented as being crowned by Poseidon, Agias, soothsayer to Lysander on the occasion of his victory, and Hermon, who steered his flag-ship. . . . Behind the offerings enumerated are statues of those who, whether Spartans or Spartan allies, assisted Lysander at Aigospotamoi. (Trans. W. H. S. Jones, Loeb edition)

The dedication, located at the very entrance of the sacred precinct at Delphi, has left no trace in that spot, though some of the bases of the group have been found (**Fig. 236**, no. 109).[79] All that can be said of the monument beyond Pausanias's brief description must be derived from the preserved blocks on which the statues stood. There are eleven fragmentary inscribed blocks that must have originally belonged to the monument; more may come to light in the storerooms, since the final publication has not appeared.[80] The most reasonable reconstruction is that proposed by Jean-François Bommelaer: Pausa-

and its visual impact by A. Ajootian, "A Day at the Races: The Tyrannicides in the Fifth-Century Agora," in *Stephanos: Studies in Honor of Brunilde Sismondo Ridgway*, ed. K. Hartswick and M. C. Sturgeon (Philadelphia 1998) 1–13.

[76] B. S. Ridgway, *The Severe Style in Greek Sculpture* (Princeton 1970) 82.

[77] E.g., on the Codrus Painter's kylix, London, BM E 84: ARV^2 1269.4; Boardman, *ARFV-CP*, fig. 240. The figure of Theseus on both friezes of the Hephaisteion also uses the stances of the Tyrannicides: Bockelberg, *AntP* 18 (1979) pls. 24, 42b.

[78] Ajootian, "Day at the Races" (note 75 above) 3.

[79] Bourguet, *FdD* 3.1, vol. 2, 27–41. The dedicatory inscription, a poem by Ion of Samos, has also survived: ibid., 50; J. Pouilloux, *Choix d'inscriptions grecques: Textes, traductions et notes* (Paris 1960) 157–58, no. 46. On the location of the monument and recent additions to the evidence, see J. Pouilloux and G. Roux, *Énigmes à Delphes* (Paris 1963) 16–19, 23, 30–32, 34–35, 55–60; Schanz, *Sculptural Groups* (note 70 above) 62–66; J.-F. Bommelaer, *Lysandre de Sparte: Histoire et traditions*, BÉFAR 240 (Paris 1981) 14–16, 18; C. Habicht, *Pausanias' Guide to Ancient Greece*, 2nd ed. (Berkeley 1998) 71–74; Bommelaer and Laroche, *Delphes: Le site*, 108–10, pls. II and V (no. 109); Bommelaer notes that several blocks of the foundation may be in place; see his pl. II, number 109; Ioakimidou, *Statuenreihen* (note 73 above) 107–15, no. 21, 281–306, pls. 25–29.

[80] J.-F. Bommelaer, "Les navarques et les successeurs de Polyclète à Delphes," *BCH* 95 (1971) 45–64, added several important fragments, with major consequences for the eventual reconstruction. Bourguet, *FdD* 3.1, vol. 2, 40–41, no. 69, does not belong, as demonstrated by Roux, in Pouilloux and Roux, *Énigmes à Delphes* (note 79 above) 47–50.

nias, after noting the monuments on the right of the entrance to the sanctuary, crossed the Sacred Way and recorded from the first line of statues right to left—the gods, Lysander, the pilot, and the seer.[81] He then returned from left to right, enumerating the other Spartan and allied leaders. The statues in the front row were apparently arranged frontally and in a simple row, with only Lysander and Poseidon, who crowns him, turning toward each other. The relationship between Lysander and Poseidon can be visualized through a number of reliefs, perhaps best on two sarcophagi from Xanthos now in the British Museum: on the crest frieze of the Merehi sarcophagus (ca. 400 or very slightly later) a draped male appears to crown a frontal nude youth, while on the short ends of the base of the Payava sarcophagus (about the middle of the fourth century) two similar groups are depicted.[82]

According to Pausanias, twenty-eight statues stood in a second row behind.[83] Some of the bases of these figures are preserved, all apparently belonging to roughly the center of the group. On the basis of the imprints of their feet on the blocks, the statues behind were slightly smaller than the statues of the gods and Lysander.[84] It is not clear how the two rows of figures might have related to each other, but the faces of the bases on which the associates of Lysander stood were inscribed with their names and therefore either stood at some distance behind the first row or were set higher. Pierre de La Coste-Messelière proposed that the front statues may have been divided into two separate groups, with an open space in the center to view the rear line of statues, a proposal partly dependent on his desire to attribute the monument to the stoa on the right side of the Sacred Way.[85] Bommelaer proposes the same composition, though on the left side of the Sacred Way.[86] Since there is no evidence, the question is moot.[87] However, the evidence of the top surfaces of the preserved blocks indicates that the figures were not simply set in a line and equidistant from one another; some were close together, others spread out.[88] The suggestion of Dorothea Arnold that between the sets of figures there were rather large objects—possibly trophies of the victory, such as parts of ships—is almost certainly incorrect.[89] Yet her description of the composition as painterly or pictorial seems accurate, and there was at least one largish object between the statues. In point of fact, the addition of various subsidiary elements in dedications of statue groups was not unusual, but the varied groupings of the figures is new. It is in the latter respect that the Spartan dedication may inaugurate an important tendency of the whole fourth century: the establishment of a suggestive context for statues

[81] Bommelaer, *BCH* 95 (1971) 62–63; cf. Ioakimidou, *Statuenreihen* (note 73 above) 292.

[82] London, BM 950 (Payava), 951 (Merehi): P. Demargne and E. Laroche, *Fouilles de Xanthos*, vol. 5, *Tombes-maisons, tombes rupestres et sarcophages; les épitaphes lyciennes* (Paris 1974) pls. 44.1, 45.1, 52.1. At one end the deceased is dressed in cuirass, at the other he is nude, while the man doing the crowning is in cuirass and in mantle, respectively.

[83] The issue of the number is uncertain: Pausanias's text is corrupt, and the evidence of the bases suggests that the total number was twenty-nine or thirty. See P. de La Coste-Messelière, "Trois notules delphiques," *BCH* 77 (1953) 184–86; J. Bousquet, *BCH* 90 (1966) 438–40; Bommelaer, *BCH* 95 (1971) 60–62 and note 23. Pausanias also missed the herald of block X: Bourguet, *FdD* 3.1, 38 (no. 67).

[84] La Coste-Messelière, "Trois notules" (note 83 above) 187; Pouilloux and Roux, *Énigmes à Delphes* (note 79 above) 55: 1.90 meters versus 1.60 meters. Ioakimidou, *Statuenreihen* (note 73 above) 292–93, proposes that only the gods were large and that all the mortals were small.

[85] La Coste-Messelière, "Trois notules" (note 83 above) 182–89.

[86] Bommelaer, *Lysandre de Sparte* (note 79 above) 15–16; Bommelaer and Laroche, *Delphes: Le site*, 109, pl. V, no. 109.

[87] Pouilloux and Roux, *Énigmes à Delphes* (note 79 above) 55–56, fig. 57 and no. 3 on folding plan at back, proposes a plan in two parallel rows.

[88] Ibid., 55; Bommelaer, *BCH* 95 (1971) 64.

[89] Arnold, *Polykletnachfolge*, 102–7, fig. 40a.

and statue groups such as the Sauroktonos (**Fig. 181**), the Resting Satyr (**Fig. 180**), and the Knidian Aphrodite (**Fig. 147**).[90] On the basis of the evidence of the fifth century, the tendency to such contextualization begins early but also shifts its emphasis sometime before the middle of the fourth century, taking that date as the approximate period of the statues just mentioned. It is also at about this time that the grave stelai begin to depict massed groups and almost dioramic scenes of mourning or action, such as the scenes of intense mourning and intimate interaction of women on the stelai discussed above.

The evidence of the votive reliefs may allow some visualization of the Lysander Monument. At the end of the fifth century the Xenokrateia relief already displays a rich variety in its groupings of the ten women and children framed by Apollo seated on his tripod on the left and the protome of Acheloös and an archaistic female figure, perhaps Hekate, on the right (**Figs. 91, 92**).[91] Xenokrateia dedicated the relief to Kephisos on the founding of his sanctuary. The relief honors Kephisos and the gods who share his altar and participate in the upbringing of Xenokrateia's son, Xeniades. Pairs of goddesses face each other as though in conversation, and two frontal figures—one female, one male—appear self-absorbed. Three smaller figures are in the foreground just to the right of Apollo, partially filling a gap between the figures in the background. Here Kephisos leans over and gestures to a medium-size Xenokrateia, while the infant Xeniades raises up his arm(s?) to him. The figures in the background are quite tightly pressed together, and there is little sense of depth, even though three of the figures are broadly overlapped by figures in front of them. This marvelous assemblage of divinities looks like an informal party to which young Xeniades is being introduced, conveying a clear sense of the ease of communication between the mortal and the divine, not unlike the gesture of Poseidon crowning Lysander on the Spartan monument at Delphi.

The Xenokrateia relief is remarkable for its very shallow carving. A companion piece from the same sanctuary and of about the same date is the amphyglyphon of Echelos and Basile.[92] On side B the three nymphs occupy the right side of the relief. Just left of center are two bearded men; the one on the right has horns and is generally identified as Kephisos; the one on the left is sometimes identified as Ilissos but is more frequently called simply a hero. On the extreme left is an androgynous figure sometimes identified as Artemis, sometimes as Hermes. Although the relief has more space around the figures, so that they appear more plastic than the figures of the Xenokrateia relief, the relationships are very similar, and the figures still occupy a narrow, stagelike space.

The Lysander Monument must have suggested both space and a naturalistic interaction of the figures not only by the stances and groupings, but also by an obvious and simple

[90] See pp. 193–95, and chap. 6, p. 242 below.

[91] Athens, NAM 2756: Kaltsas, *SNAMA*, 257, no. 133*; Mitropoulou, *Votive Reliefs*, 43–44, no. 65, fig. 103; Neumann, *Weihreliefs*, 49, 66, pl. 27a; F. T. van Straten, "Images of Gods and Men in a Changing Society: Self-Identity in Hellenistic Religion," in *Images and Ideologies: Self-Definition in the Hellenistic World*, ed. A. Bulloch, E. S. Gruen, A. A. Long, and A. Stewart (Berkeley 1993) 259–60, fig. 23; Edwards, "Votive Reliefs to Pan," 310–38, no. 3, pl. 2a, b; Güntner, *Göttervereine*, 21, 161, no. G5, pl. 36.2; U. Kron, "Priesthoods, Dedications and Euergetism: What Part Did Religion Play in the Political and Social Status of Greek Women?" in *Religion and Power in the Ancient Greek World: Proceedings of the Uppsala Symposium 1993*, ed. P. Hellström and B. Alroth (Uppsala 1996) 166–68, fig. 17; Bol, *Bildhauerkunst*, 227–28, fig. 166 (D. Kreikenbom).

[92] Athens, NAM 1783: Kaltsas, *SNAMA*, 134, no. 258* (only side A); U. Hausmann, *Griechische Weihreliefs* (Berlin 1960) 37–40, figs. 18, 19 (sides A and B); Mitropoulou, *Votive Reliefs*, no. 128, figs. 185, 186 (sides A and B); Comella, *Rilievi votivi* (note 8 above) 70–71, figs. 61, 62 (sides A and B), 211–12: Falero 1; J.-C. Wulfmeier, *Griechische Doppelreliefs* (Münster 2005) 128–31, cat. WR 19; Ridgway, *Fifth Century Styles*, 131, 133–34, fig. 98 (side A); Bol, *Bildhauerkunst*, 227, fig. 165 (D. Kreikenbom).

iconographic element: clothing in the broadest sense. Although it has been assumed that the statues of the Lakedaimonian dedication at Delphi were all presented in heroic nudity, there is no evidence at all for this assumption.[93] A most important point is that not only the statue of Lysander was of a living man, but so too were the statues of the other men. To speak of portraits may just muddy the waters, since we have no evidence at all on the appearance of the individual figures. However, the debate over the appearance of the statue of Perikles is directly relevant: was he clothed or nude?[94] The evidence does not allow a certain answer, and Nikolaus Himmelmann's suggestion in favor of the statue being clothed clearly underscores the uncertainty.[95] The evidence of the Attic grave and votive reliefs, however, does indicate that contemporary mortals were generally depicted in normal dress. In Attica this also applies to warriors, though not to athletes or most hunters. The representation of male figures in full dress was not unusual even in the Archaic period. Aristion is in full battle dress on his grave stele of the late sixth century;[96] a torso of a warrior on the Athenian Acropolis wears a breastplate and chiton;[97] the figures on the bases of both the "cat and dog base" and the "hockey-players base" are dressed,[98] as are the votaries on the votive relief to Athena on the Acropolis.[99] So nudity is reserved for special contexts and is not universal.[100] But nudity becomes less frequent in the fourth century, at least in Athens. This development underscores the new atmosphere of the sculptural representations, which is visible at least in part in the groupings of statues in the Lysander Monument at Delphi. What it amounts to is not so much a painterly concrete context, as Dorothea Arnold imagined for the Lysander Monument, but a psychological context that goes well beyond the simple depiction of figures interacting.

In the Early Classical period, as already pointed out, the group of the Tyrannicides depicts a scene with a psychological dimension, but it is the graphic gestures that communicate the meaning. Equally, the group of Athena and Marsyas as reconstructed by modern scholarship depicts a dramatic moment with a psychological aspect—the eventual punishment of the satyr—but the figures act out their parts in clear graphic patterns on an essentially two-dimensional stage.[101] In both the Tyrannicides and the Athena-

[93] Arnold, *Polykletnachfolge*, 107–9; see note 82 above.

[94] Richter, *Portraits*, vol. 1, 102–4, figs. 429–41; G. M. A. Richter and R. R. R. Smith, *The Portraits of the Greeks* (Ithaca, NY, 1984) 173–75; E. Voutiras, *Studien zu Interpretation und Stil griechischer Porträts des 5. und frühen 4. Jahrhunderts* (Bonn 1980) 98–109; A. E. Raubitschek, "Zur Periklesstatue des Kresilas," *ArchCl* 25–26 (1973–74) 620–21; T. Hölscher, "Die Aufstellung des Perikles-Bildnisses und ihre Bedeutung," in *Festschrift für Ernst Siegmann zum 60. Geburtstag*, ed. J. Latacz (Würzburg 1975) (= *WürzJbb* 1 [1975]) 187–99, repr. in Fittschen, *Griechische Porträts*, 377–91; C. M. Keesling, *The Votive Statues of the Athenian Acropolis* (Cambridge 2003) 193–95; O. Jaeggi, *Die griechischen Porträts: Antike Repräsentation, moderne Projektion* (Berlin 2008) 55–56, 58–59.

[95] Himmelmann, *Ideale Nacktheit*, 89–101; cf. Voutiras, *Interpretation und Stil griechischer Porträts* (note 94 above) 103; Hölscher, "Aufstellung des Perikles-Bildnisses" (note 94 above) 195–96; C. Houser, "Alexander's Influence on Greek Sculpture as Seen in a Portrait in Athens," in Barr-Sharrar and Borza, *Macedonia,* 233 and note 8 on p. 237.

[96] Athens, NAM 29: Kaltsas, *SNAMA*, 70, no. 100*.

[97] Athens, Acrop. 599: Brouskari, *Acropolis Museum*, 128–29, fig. 246; V. Brinkmann, "Eine Rüstung auf der nackten Haut? Der frühklassische 'Panzertorso' von der Athener Akropolis," in Brinkmann and Wünsche, *Bunte Götter*, 115–19.

[98] Athens, NAM 3476 and 3477: Kaltsas, *SNAMA*, 66–68, nos 95*, 96*.

[99] Athens, Acrop. 581: Brouskari, *Acropolis Museum*, 52–53, fig. 94.

[100] Himmelmann, *Ideale Nacktheit*, 25–28 and passim.

[101] G. Daltrop, *Il gruppo mironiano di Athena e Marsia nei Musei Vaticani* (Vatican City 1980); G. Daltrop and P. C. Bol, *Athena des Myron* (Frankfurt am Main 1983). The theme itself probably expressed social-political values, as Robert Sutton has recently suggested: R. F. Sutton, Jr., "The Good, the Base, and the Ugly: The Drunken Orgy in Attic Vase Painting and the Athenian Self," in *Not the Classical Ideal* (note 7 above) 200–202. The playing of the *aulos* belongs to the more passionate moments of Greek music and was only briefly acceptable for proper members of society: A. L. Ford, *The Origins of Criticism: Literary Culture and Poetic Theory in Classical Greece* (Princeton 2002) 141, 190.

Marsyas group, the stylized gestures illustrate the action in a theatrically dramatic manner. The poses of the Knidian Aphrodite, the Sauroktonos, and the Resting Satyr suggest contexts and actions that are in fact not depicted at all. It is the anecdotal character of the representations that communicates a mood, and the mood conveys the extended content. It seems possible that the varied groupings of the statues of the "navarchs" of the Lysander Monument indicate just such a humanization of the figures, probably in battle dress or other appropriate garb, in a visually convincing scene. The very fact that the statues were arranged in two tiers is perhaps indicative of a certain painterly appearance, as suggested by Dorothea Arnold. The "navarchs" would normally be seen arranged behind Lysander and the gods in "casual" groups suggesting the after-the-battle context of the victorious crowning of Lysander by Poseidon, with the "navarchs" really as spectators of the event. The small figures in the left foreground of the relief of Xenokrateia and her son probably play a similar role: the divinities behind seem to be gathered rather informally for the presentation of Xenokles to Kephisos and to them as co-inhabitants of the sanctuary. The very size of the Lysander Monument, which was probably over 15 meters long and at least 3 meters deep, must have presented a singularly impressive picture, in purposeful contrast to the adjoining much smaller and simpler Athenian dedication commemorating Marathon.

Directly opposite the Lysander Monument was a votive group set up by the Arkadians, probably after their invasion of Lakonia and freeing of Messene, together with the Thebans under Epaminondas, in the winter of 370/69 (**Fig. 236**, no. 105). The base of the monument is almost completely preserved and was found largely still in situ.[102] Its inscriptions follow closely, though not precisely, the text given by Pausanias (10.9.5–6). Although modern descriptions of the composition of the sculptures tend to the romantic and fanciful, it can at least be argued that there were two or three groupings of statues and that several unidentifiable objects stood among them. Apollo stood first on the right, followed by Kallisto and a Nike.[103] Although it is impossible to demonstrate that Kallisto was falling to her knees before Apollo, as Arnold[104] suggests, the two figures are set closely together, move toward each other, and are separated from the heroes by Nike. Beyond Nike is Arkas, who is separated from Apheias by a long, narrow cutting, probably for a small stele.[105] The next two figures are closer together and yet flank an indeterminate object.[106] The last three figures are more widely spaced; Heinrich Bulle suggests that a tree with a bird stood next to Azan, for which there is no evidence at all.[107] It is nonetheless probable that the monument did produce something of a more pictorial appearance, certainly when compared with the monument of the eponymous heroes of Attica set up in

[102] Bommelaer and Laroche, *Delphes: Le site*, 104–6, fig. 35, pls. I and V, no. 105; H. Pomtow, "Studien zu den Weihgeschenken und der Topographie von Delphi," *AM* 31 (1906) 461–92 (with H. Bulle: "Die Standspuren," pp. 483–92); Bourguet, *FdD* 3.1, 4–9; Arnold, *Polykletnachfolge*, 191–93, 194–95, fig. 40b; Pouilloux and Roux, *Énigmes à Delphes* (note 79 above) 24–28; Schanz, *Sculptural Groups* (note 70 above) 55–57; Ioakimidou, *Statuenreihen* (note 73 above) 119–24, no. 23, 322–41, pl. 34.

[103] J. Marcadé, *Recueil des signatures de sculpteurs grecs*, vol. 1 (Paris 1953) 86, gives a photograph of the top of these blocks which differs from the drawings of both Pomtow, "Studien zu den Weihgeschenken" (note 102 above) pl. XXIV, and Arnold, *Polykletnachfolge*, fig. 40b.

[104] Arnold, *Polykletnachfolge*, 191–92.

[105] Bulle, in Pomtow, "Studien zu den Weihgeschenken" (note 102 above) 491; Bommelaer and Laroche, *Delphes: Le site*, 106.

[106] Marcadé, *Signatures* (note 103 above) vol. 1, 6 (photo of blocks); Bulle, in Pomtow, "Studien zu den Weihgeschenken" (note 102 above) 491, suggests a dog.

[107] Bulle, in Pomtow, "Studien zu den Weihgeschenken" (note 102 above) 491.

the Athenian Agora somewhere around the middle of the fourth century, although reusing statues of the earlier monument, which T. Leslie Shear Jr. has dated around 430–425 and placed under the west end of Middle Stoa.[108]

Located just up the Sacred Way from the Arkadian monument (**Fig. 236**, no. 113) is the hemicycle containing the statues of the Argive ancestors of Herakles, dedicated shortly after 369 B.C. and commemorating for Argos the same events that prompted the Arkadian dedication.[109] The evidence of this monument is problematic and at best ambiguous because it seems most likely that it was not finished as originally planned. The single most important aspect of the preserved monument is that the back wall of the hemicycle is high and serves as the retaining wall of the rapidly rising ground of the sanctuary to the north. The floor of the hemicycle is raised well above the level of the Sacred Way, clearly setting the monument off from the space of the viewer; along with the high back wall of the monument, this suggests that the intention was to create a controlled space for the statues. Only half of the semicircle actually received statues, ten in all, beginning precisely at the midpoint with Danaos and moving progressively to the left to the figure of Herakles at the end next to the Sacred Way. Each statue does not appear to have interacted with its neighbors, and all are spaced at regular intervals. Pausanias's account (10.10.5) is so abbreviated that it can neither help us visualize the monument nor guess what he thought of its apparently incomplete state. Whether or not one accepts the suggestion that there was never intended to be a full complement of statues on the base of the hemicycle,[110] the fact that only the uphill half received statues indicates an interesting visual presentation oriented toward the natural position of the visitor to the sanctuary coming up the Sacred Way.

A similar sense of visual order is attested at Olympia by the bases of the *Zanes*, the statues of Zeus paid for by the fines of athletes who cheated in the games (Pausanias 3.21.2–18). These were set up along the retaining wall of the terrace on which the treasuries were built, flanking the stairs of the fourth-century entrance to the stadium (**Fig. 237**, nos. 1 and 2).[111] The first group of statues was set up in 388 (98th Olympiad), and the second in 332 (112th Olympiad) according to Pausanias (3.21.3 and 5). The location had an obvious purpose for those entering the stadium and, like the dedication of the Arkadians at Delphi, constitutes a controlled use of space to convey a visual impression. Ridgway has captured this new quality very accurately when she speaks of the "spectacular."[112] This term applies to grave stelai, statues, and the groups under consideration here. As I shall argue later, this novel aspect of the art of the fourth century is its most character-

[108] T. L. Shear, Jr., "The Monument of the Eponymous Heroes in the Athenian Agora," *Hesperia* 39 (1970) 145–222; U. Kron, *Die zehn attischen Phylenheroen*, AM-BH 5 (Berlin 1976) 228–32; C. C. Mattusch, "The Eponymous Heroes: The Idea of Sculptural Groups," in *The Archaeology of Athens and Attica under the Democracy*, Oxbow Monograph 37, ed. W. D. E. Coulson, O. Palagia, et al. (Oxford 1994) 74–80; Ioakimidou, *Statuenreihen* (note 73 above) 100–106, no. 20, 274–80, pls. 22–24.

[109] Bommelaer and Laroche, *Delphes: Le site*, 114–15, fig. 38, pls. II and V, no. 113; Bourguet, *FdD* 3.1, 41–46, figs. 20, 21; Pouilloux and Roux, *Énigmes à Delphes* (note 79 above) 46–51; F. Salviat, "L'offrande argienne de l'"hémicycle des rois' à Delphes et l'Héraclès Béotien," *BCH* 89 (1965) 307–14; Arnold, *Polykletnachfolge*, 193–94, 195–96, fig. 40b; Schanz, *Sculptural Groups* (note 70 above) 57–60, pl. 19; Ioakimidou, *Statuenreihen* (note 73 above) 115–19, no. 22, 307–21, pls. 30–33.

[110] Roux, in Pouilloux and Roux, *Énigmes à Delphes* (note 79 above) 50, considers the monument incomplete; Salviat, *BCH* 89 (1965) 308, argues the opposite.

[111] E. Kunze and H. Schleif, *II. Bericht über die Ausgrabungen in Olympia, Winter 1937/38*, issued with *JdI* 53 (1938) 42–44 (Die Schatzhaus-Terrassenmauer), pl. 15; H.-V. Herrmann, *Olympia: Heiligtum und Wettkampfstätte* (Munich 1972) 163, 168, note 658, fig. 64; Mallwitz, *Olympia und seine Bauten* (note 74 above) 188–89.

[112] B. S. Ridgway, "The Setting of Greek Sculpture," *Hesperia* 40 (1971) 337.

istic quality and has not just an aesthetic role but also an all-important function as the carrier of meaning.

Another monument that exhibits a similar interest in innovative composition is the Atarbos base, an interesting private dedication on the Athenian Acropolis. It consists of two preserved blocks whose fronts carry reliefs that will be discussed later; on these blocks stood two life-size bronze statues and perhaps a third (**Figs. 223, 224**).[113] The inscription indicates that Atarbos set up the monument to celebrate a victory in the Pyrrhic dance in the archonship of either Kephisodoros or Kephisophon—if the former name is correct, the date is either 366 or 323; if the latter, the date is 329. On stylistic grounds, either of the two later dates is preferable to the earlier one.[114] The cuttings for a statue on the viewer's left indicate that the figure stood in something like the position of the diskobolos attributed to Naukydes (**Fig. 172**) or the Herakles of the Lehnbach type,[115] that is, with both feet flat on the ground and the weight carried on the proper left leg, while the right leg was extended forward. To the right is a square insert with cuttings for two feet facing the front, both feet flat on the ground but now quite close together and set parallel to each other. This figure, to judge by the cuttings for its feet, was smaller than the figure on the left. On the extreme right of the preserved right-hand block are cuttings for two more feet, this time small and slightly splayed out.[116] This figure's proper right foot just intersects the cutting for the left foot of the figure on the left. It appears that the larger statue at the left did not interact with the other two; in fact, it appears to have turned its back on the statues on the right. The base certainly continued with at least one more block on the right end, though there are no clamp cuttings on the right end of the right block, as there are at the join on the top surfaces of the preserved blocks. The varied positions indicated by the preserved cuttings for the three statues suggest a novel composition which must have conveyed a particular, though now obscure, content. Perhaps the *choregos* is the larger figure on the left, and the several small figures on the right were the actual dancers.

The spectacular quality of group dedications is enhanced in the votive group set up at Delphi by Daochos of Thessaly, probably in 334/3 (**Figs. 13–18**; **Fig. 236**, no. 511).[117] Dao-

[113] Athens, Acrop. 1338: Brouskari, *Acropolis Museum*, 20, fig. 5; A. L. Boegehold, "Group and Single Competitions at the Panathenaia," in *Worshipping Athena: Panathenaia and Parthenon*, ed. J. Neils (Madison, WI, 1996) 101–3, figs. 4.1, 4.2; A. Kosmopoulou, "The Relief Base of Atarbos, Acropolis Museum 1338," in *Stephanos: Studies in Honor of Brunilde Sismondo Ridgway*, ed. K. J. Hartswick and M. C. Sturgeon (Philadelphia 1998) 163–72; Kosmopoulou, *Statue Bases*, 204–5, no. 39, fig. 60; C. M. Keesling, "Early Hellenistic Portrait Statues on the Athenian Acropolis," in *Early Hellenistic Portraiture: Image, Style, Context*, ed. P. Schultz and R. von den Hoff (Cambridge 2007) 145–46, fig. 109 (drawing of the top surface), and particularly her detailed discussion in note 34 on p. 158; Wilson, *Khoregia*, 39–40, fig. 2; Bol, *Bildhauerkunst*, 271, fig. 213 (W. Geominy). J. L. Shear, "Atarbos' Base and the Panathenaia," *JHS* 123 (2003) 164–80, argues persuasively that the monument was both changed and enlarged soon after the original dedication.

[114] Davies, *APF*, 74, no. 2679, prefers the earlier date on the basis of historical probability, though he notes that there probably existed an Ata[rbos] in the later fourth or early third century: *IG* II² 4433. W. Geominy, however, also prefers the earlier date on stylistic grounds: Bol, *Bildhauerkunst*, 271. J. Shear, *JHS* 123 (2003) 164, agrees with the later date. See p. 182 below.

[115] Rome, MNR (Palazzo Altemps) 8573: Giuliano, *MNR*, vol. 1, pt. 5 (Rome 1983) 89–90, no. 37* (B. Palma); *LIMC*, s.v. Herakles no. 352* (J. Boardman et al.); Helbig⁴, vol. 3, 273, no. 2351 (H. von Steuben).

[116] Keesling, "Early Hellenistic Portrait Statues" (note 113 above) 158, note 34, suggests that these may constitute a later addition, as does J. Shear, *JHS* 123 (2003) 164–80.

[117] On the range of possible dates, see chap. 2, pp. 28–29, note 23 above. On the monument, see Jacquemin and Laroche, *BCH* 125 (2001) 305–32; Bommelaer and Laroche, *Delphes: Le site*, 200–201, no. 511; Picard, *Delphes: Le musée*, 91–98, figs. 49–56; E. Will, "À propos de la base des Thessaliens à Delphes," *BCH* 62 (1938) 289–304, pls. 30, 31; T. Dohrn, "Die Marmor-Standbilder des Daochos-Weihgeschenks in Delphi," *AntP* 8 (1968) 33–53, pls. 10–37;

chos was a creature of Philip of Macedon and *hieromnēmon* of the Amphyktionic League from approximately 338 to 334; his dedication exalts himself and his family. The location of the group in an enclosure on the steep slopes above and to the east of the Temple of Apollo was badly eroded before excavation, and the nature of the enclosure remains controversial. Recently, Anne Jacquemin and Didier Laroche have proposed that the statue group was set up in an earlier roofed building and not an open enclosed space specifically constructed for it.[118] The sloping bedrock of the site was partly cut away on the northwest, and the southeast side was filled up in the fourth century to allow this and the adjoining monuments to be built along a path that led from an entrance to the sanctuary in the east temenos wall to the terrace of the temple or up to the theater.[119] The building or enclosure of the dedication was built against a terrace wall to the north; Jacquemin and Laroche restore the entrance to their enclosed building on the short, west, side, while the earlier reconstruction of a simple enclosure placed the entrance on the long, south, side.[120] The space enclosed was 12.5 meters long, but its depth is uncertain, probably roughly 7 to 8 meters. Of the original nine statues, eight are preserved in various fragmentary states. At the right end of the 11.54-meter-long rectangular base was a now missing statue, which is generally thought to have been a seated Apollo, though Jacquemin and Laroche propose that the cutting for it is unfinished and that the statue was never made or at least never put in place, because they argue that the whole building and its statues were destroyed by a mudslide before being completed.[121] To the left stood the statues of the ancestors of Daochos in chronological order from Aknonios (**Fig. 16**), tetrarch of Thessaly around 500 B.C., to Sisyphos II, the still-living son of the dedicator (**Fig. 18**). Inscriptions on the base identify the achievements of the various members of the family, living and dead.[122] Each statue is presented in a manner pertinent to the achievements of the person depicted and, according to Wilfred Geominy, in correct historical guise.[123] At the most rudimentary level of clothing, the three athletes, Agias (**Fig. 14**), Agelaos (**Fig. 15**), and Telemachos, are depicted nude; the two statesmen, Aknonios (**Fig. 16**) and Daochos I, wear the Macedonian/Thessalian chlamys; and the one soldier, Sisyphos I, wears a short chiton and strap

E. K. Tsirivakos, "Παρατηρήσεις ἐπὶ τοῦ Μνημείου τοῦ Δαόχου," *ArchEph* (1972) 70–85, pls. 22–29; A. H. Borbein, "Die griechische Statue des 4. Jahrhunderts v. Chr.," *JdI* 88 (1973) 79–84; P. Themelis, "Contribution à l'étude de l'ex-voto delphique de Daochos," *BCH* 103 (1979) 507–19; B. Fehr, *Bewegungsweisen und Verhaltensideale: Physiognomische Deutungsmöglichkeiten der Bewegungdarstellung an griechischen Statuen d. 5. u. 4. Jhs. v. Chr.* (Bad Bramstedt 1979) 59–66, figs. 17–22; K. E. Evans, "The Daochos Monument" (Ph.D. diss., Princeton University, 1996); C. Löhr, *Griechische Familienweihungen: Untersuchungen einer Repräsentationsform von ihren Anfängen bis zum Ende des 4. Jhs. v. Chr.* (Rahden, Westphalia, 2000) 118–23, no. 139; Ridgway, *Hellenistic Sculpture*, vol. 1, 46–50, pls. 22–26; Todisco, *Scultura greca*, nos. 237–42.

[118] Jacquemin and Laroche, *BCH* 125 (2001) 307–21; on the earlier reconstruction, see Pouilloux, *FdD* 2.C.2, 67–80, pls. 33–37, plan 11.

[119] A. Jacquemin, *Offrandes monumentales à Delphes* (Athens and Paris 1999) 248–49. The Attalid stoa and associated structures obliterated the east end of this terrace.

[120] W. Geominy, "The Daochos Monument at Delphi: The Style and Setting of a Family Portrait in Historic Dress," in Schultz and von den Hoff, *Early Hellenistic Portraiture* (note 113 above) 85–88, points out the difficulties of the reconstruction by Jacquemin and Laroche and argues for the earlier version. Since the evidence is either totally lacking or at best ambiguous, I too prefer the earlier reconstruction of a simple enclosure with its entrance on the south side.

[121] Jacquemin and Laroche, *BCH* 125 (2001) 325–27; see Geominy's objection (previous note).

[122] Pouilloux, *FdD* 3.4, 134–38, no. 460; T. Homolle, "Ex-voto trouvés à Delphes, 3: Statues du Thessalien Daochos et de sa famille," *BCH* 21 (1897) 592–98; E. Preuner, *Ein delphisches Weihgeschenk* (Leipzig 1900) 1–39; J. Ebert, "Griechische Epigramme auf Sieger an gymnischen und hippischen Agonen," *AbhLeip* 63, no. 2 (1972) 137–45, nos. 43–45; Löhr, *Familienweihungen*, 120–21.

[123] Geominy, "Daochos Monument," 96.

boots that come up to mid-calf (**Fig. 17**). Beyond dress, the boxer, Agias, is strongly built; the boy runner, Agelaos, is lithe.[124] Finally, the son of the dedicator, Sisyphos II, has no accomplishments to his credit, and the inscription merely gives his name (**Fig. 18**). He leans on an archaistic herm with his chlamys hanging from his left shoulder in a manner reminiscent of several statues of Hermes (**Fig. 174**).[125] The pronounced S-curve of his supple body suggests youth and elegance without defined character. The nude body and the chlamys gathered to one side might even be thought to suggest that he has the option of becoming either an athlete or a statesman.[126]

The nine statues were arranged along the north wall on a base almost a meter high.[127] It is important to note that the building held not only the principal dedication but at least three and probably four other bases made of the same stone and with the same carving technique.[128] Because only three sides of these bases were smoothed and intended to be seen, in Jacquemin's and Laroche's reconstruction they stood along the long south wall opposite the long base or, in the old reconstruction, along the short east and west walls. One of the preserved bases was certainly intended to receive a statue; the tops of the other two or three have no markings that would suggest their function, and none are in-scribed. Jacquemin and Laroche posit that these may have been intended to hold statues of women and children, though there are no ready candidates, and, whatever statues were planned, they were probably never made. The bases nonetheless suggest the intention to create a complex spatial arrangement of Daochos's genealogical gallery that might have seemed a three-dimensional diorama within a contained area, an impression justified by the arrangement and stance of the preserved statues. There are evident differences in size: Agias, Aknonios, Sisyphos I, and Daochos I appear larger than Agelaos and Sisyphos II. The stance and build of the statues varies even more; they move somewhat erratically and appear restless, with forward and backward shifts, turns, arms held up and down, heavy and lithe bodies.[129] Although this is a subjective assessment, the old reconstruction of the building, whether roofed or open, with its entrance on the south side directly from the path along the terrace, is far to be preferred, since such an arrangement is clearly more in

[124] N. Serwint, "Greek Athletic Sculpture from the Fifth and Fourth Centuries B.C.: An Iconographic Study" (Ph.D. diss., Princeton University, 1987) 384–91, distinguishes physical characteristics that reflect the athletic spe-ciality of the individual figures but concludes that they are not emphatic differences. Xenophon, *Symposion* 2.17–18, notes the exaggerated physiques of various specialized athletes.

[125] E.g., Richelieu type, Paris, Louvre Ma 573 (here **Fig. 173**): Todisco, *Scultura greca*, no. 53; Florence, Palazzo Pitti: Todisco, no. 50; and the Hermes from Andros: Karusu, *AM* 84 (1969) 143–57, pls. 66–68.11; Todisco, no. 285; Boardman, *GS-LCP*, fig. 78. On the archaistic herm, see D. Willers, "Zum Hermes Propylaios des Alkamenes," *JdI* 82 (1967) 83, fig. 56; T. Brahms, *Archaismus: Untersuchungen zur Funktion und Bedeutung archaistischer Kunst in der Klas-sik und im Hellenismus* (Frankfurt am Main 1994) 133–34, 306, no 19, fig. 37. O. Palagia and N. Herz, "Investigation of Marbles at Delphi," in *Interdisciplinary Studies on Ancient Stone: Proceedings of the Fifth International Conference of the Association for the Study of Marble and Other Stones in Antiquity, Museum of Fine Arts, Boston, 1998*, ASMOSIA 5 (London 2002) 246–47, reject the statue of Sisyphos II as part of the group, primarily because its marble is Parian while that of the other statues of the group appears to be Pentelic, but also because its Praxitelean style is quite dif-ferent from the rest of the group. Neither argument is compelling, though equally not refutable; Geominy, "Daochos Monument," 94–96, raises pertinent objections to Palagia's thesis.

[126] Themelis, *BCH* 103 (1979) 514, notes that two parallel rings of small drill holes around the head just above the ears indicate the addition of a fillet or, more likely, a crown of some sort, but since whatever it was has no effect on the hair, it must have been a late addition. Both Agias and Agelaos have bands carved in the stone.

[127] Pouilloux, *FdD* 2.C.2, 67–80, pls. 33–37, plan 11; Jacquemin and Laroche, *BCH* 125 (2001) 314, fig. 6, 324, fig. 13.

[128] Jacquemin and Laroche, *BCH* 125 (2001) 327–29; Geominy, "Daochos Monument," 85–88.

[129] H. von Steuben, "Zur Komposition des Daochos-Monumentes," in *Antike Porträts: Zum Gedächtnis von Helga von Heintze*, ed. H. von Steuben (Möhnesee 1999) 35–38.

keeping with the fourth century's strong interest in creating a defined space for the viewing of statue groups.[130]

The pictorial statue group culminates in two monuments for which some, though admittedly slight, evidence is preserved: the lion hunt dedicated by Krateros at Delphi and the Florentine Niobids. The first group is certainly still within our broad time frame, and the second may be. Pliny (*NH* 34.64) merely mentions the monument of Krateros at Delphi, but Plutarch (*Alexander* 40.5) describes the statue group thus: "This hunting-scene Krateros dedicated at Delphi, with bronze figures of the lion, the dogs, the king engaged with the lion, and himself coming to his assistance; some of the figures were molded by Lysippos, and some by Leochares" (trans. B. Perrin, Loeb edition). The monument was located just north of the west end of the Temple of Apollo on a low terrace, actually a large niche or exedra cut into the *ischegaon*, or retaining wall, of the steeply rising ground between the temple and the theater (**Fig. 225**; **Fig. 236**, no. 540).[131] All that can be said is that the terrace measures 15.27 × 6.35 meters. No trace of the base of the monument or any other indication of its disposition is preserved except for the dedicatory inscription, which is placed slightly off center to the left, presumably because a figure or figures of the group would otherwise have hidden it, although its position 3.10 meters above the paving of the exedra would presumably have rendered it unreadable without a ladder, since the letters are only 3.5 centimeters high.[132] The inscription confirms Plutarch's brief account and adds the fact that the monument was dedicated by Krateros's son to complete or fulfill the vow of his father, who died in 320. It reads as follows:

> Krateros the son of Alexander vowed these (statues) to Apollo, an honored and famous man. He bore and left a child in his house, Krateros, who set these up and completed all his father's promises so that the hunt of this bull-killing lion should keep for him everlasting and greedy fame, oh foreigner, which, at that time when he accompanied Alexander, the much-praised King of Asia, and ravaged together (the land) and vanquished utterly, and thus coming to grips with it, killed it at the limits of sheep-pasturing Syria.

The date of the monument in the last years of the fourth century is not in question, though Plutarch's attribution of the figures to Lysippos and Leochares suggests a date closer to 320 rather than the end of the century.[133] Fernand Courby reconstructed a narrow stoa-like enclosure for the monument, but the present view is that it was open to the sky and with-

[130] See the general observations of Borbein, *JdI* 88 (1973) 61–66, 106–7; Schultz, "Argead Portraits," 222–25.

[131] Courby, *FdD* 2.A.2, 237–40, figs. 187–91; Pouilloux, *FdD* 2.C.2, 90–91; Jacquemin, *Offrandes monumentales* (note 119 above) 140, 204–5; Bommelaer and Laroche, *Delphes: Le site*, 225–27, no. 540; T. Hölscher, *Griechische Historienbilder des 5. und 4. Jahrhunderts v. Chr.* (Würzburg 1973) 181–85; Borbein, *JdI* 88 (1973) 91–95; E. Voutiras, "Zur historischen Bedeutung des Krateros-Weihgeschenkes in Delphi," *WürzJbb* 10 (1984) 58–62; H. von Hesberg, "Die Löwenkampfgruppe auf dem Kapitol und ihre Wiederholung in Augsburg," *RM* 94 (1987) 120–24; C. Saatsoglou-Paliadeli, "Το ανάθημα του Κρατερού στους Δελφούς· Μεθοδολόγικα προβλήματα αναπαράστασης" (The Dedication of Krateros at Delphi: Problems of Reconstruction), *Egnatia* 1 (1989) 81–99, pls. 393–97 (English summary on p. 100).

[132] T. Homolle, "Ex-voto trouvés à Delphes, 4: La chasse d'Alexandre," *BCH* 21 (1897) 598–600; Courby, *FdD* 2.A.2, 239; R. Flacelière, *Fouilles de Delphes*, vol. 3, *Épigraphie*, fasc. 4, *Inscriptions de la région nord du sanctuaire*, pt. 2, *Nos. 87 a 275* (Paris 1954) 213–14, no. 137, pl. 23.1–5; W. Peek, "Zur Löwenjagd des Krateros," *Philologus* 105 (1961) 297–98; L. Moretti, *Iscrizioni storiche ellenistiche* (Florence 1967–76) vol. 2, 5–7, no. 73, vol. 3, XXI, no. 73; K. Bringmann and H. von Steuben, eds., *Schenkungen hellenistischer Herrscher an griechische Städte und Heiligtümer* (Berlin 1995) vol. 1, 141–43, no. 90.

[133] Hölscher, *Historienbilder* (note 131 above) 182. The argument in favor of the later date is based on the assumption that the son, only one year old when his father died, could not have been in a position to carry out the vow until his maturity. F. P. Johnson, *Lysippos* (Durham, NC, 1927) 67, also cites the appearance of the inscription. See also Voutiras, *WürzJbb* 10 (1984) 57–59.

out easy access, since the terrace on which it stood was raised roughly 3 meters above the ground surrounding the temple.[134] Indeed, Bommelaer and Laroche suggest that it was best viewed from the platform of the temple to the south.[135] Courby had originally thought that a lower section of the terrace about 3.30 meters wide in front of the main part of the niche was accessible to visitors from the stairs to the west.

The appearance of Krateros's dedication is forever lost, but some impression of it can be gained from roughly contemporary images of lion hunts which can be associated with Alexander. Georg Loeschcke originally suggested that a now famous base in the Louvre from Messene might reflect the composition (**Fig. 226**).[136] Although the relief has suffered since its discovery at the beginning of the nineteenth century, the composition remains clear: on the right a nude man lunges to the left; he swings a double-headed ax with his right arm and has a lion skin twisted around his left arm. A lion faces him but turns its head around to the viewer's left, where a horse and rider gallop up; the rider wears the Macedonian cap, the *kausia*, and once held a spear aimed at the lion. On the right side of the lion a dog stands next to the nude man, and a wounded dog lies under the forepaws of the lion. At the upper left of the block is the tip of a spear, indicating that the scene continued beyond the preserved section of the base. The interpretation of the nude man on the right as Alexander and the rider as Krateros is not difficult to accept. As has been pointed out, the same composition occurs on the painted hunting frieze of Tomb II at Vergina, considered by some to be the tomb of Philip II, the father of Alexander, who died in 336 (**Fig. 119**).[137] Various other hunting scenes of roughly this period show quite different circumstances: on the "Alexander sarcophagus" from Sidon[138] Alexander is on a horse, so there is no connection with the Krateros Monument.[139] It is very uncertain that Tomb II at Vergina belongs to Philip II, so the early date proposed by some need not affect the discussion of a possible relationship with the Krateros Monument. What is striking is that the brief account of Plutarch clearly agrees with the sparse figures of the relief from Messene in the Louvre.

The fact that there are several other figures in the painting at Vergina (two men on foot, two riders, and three dogs) strengthens the impression that the Krateros Monument also included more than the principal protagonists, but the composition of the painted

[134] Courby, *FdD* 2.A.2, fig. 190, gives the height of the niche's floor as 3.25 meters; Pouilloux, *FdD* 2.C.2, 90–91 and plan 14, does not give a precise figure, but from plan 14 the paving of the niche must be between 3.56 and 4.21 meters, since its level was around the middle of the tenth course of the *ischegaon* wall to the east.

[135] Bommelaer and Laroche, *Delphes: Le site*, 226.

[136] Paris, Louvre Ma 858: M. Hamiaux, *Musée du Louvre: Les sculptures grecques*, vol. 2, *La période hellénistique (IIIe–Ier siècles avant J.-C.)* (Paris 1998) 194–95, no. 214*; G. Loeschcke, "Relief aus Messene," *JdI* 3 (1888) 189–93, pl. 7; Hölscher, *Historienbilder* (note 131 above) 183–85, pl. 15.3; R. Vasić, "Das Weihgeschenck des Krateros in Delphi und die Löwenjagd in Pella," *AntK* 22 (1979) 106–9, pl. 32.1; A. Stewart, *Faces of Power: Alexander's Image and Hellenistic Politics* (Berkeley 1993) 276–77; O. Palagia, "Alexander the Great as Lion Hunter: The Fresco of Vergina Tomb II and the Marble Frieze of Messene in the Louvre," *Minerva* 9.4 (1998) 25–28; Palagia, "Hephaestion's Pyre and the Royal Hunt of Alexander," in *Alexander the Great in Fact and Fiction*, ed. A. B. Bosworth and E. J. C. Baynham (Oxford 2000) 202–6, figs. 15–18; Moreno, *Lisippo*, 174, no. 4.22.1*; Rolley, *Sculpture grecque*, 341; Todisco, *Scultura greca*, no. 275; Boardman, *GS-LCP*, 133, fig. 154.

[137] Andronikos, *Royal Tombs*, 103, figs. 58, 59; Saatsoglou-Paliadeli, *Τάφος του Φιλίππου*, pls. 4b, 5a, 8; Brecoulaki, *Peinture funéraire*, pl. 28; Stewart, *Faces of Power* (note 136 above) 274, text fig. 11. See most recently H. M. Franks, *Hunters, Heroes, Kings: The Frieze of Tomb II at Vergina* (Princeton 2012), on the Vergina hunt and its iconographic context.

[138] Istanbul 370: V. von Graeve, *Der Alexandersarkophag und seine Werkstatt*, IstForsch 28 (Berlin 1970) pls. 24, 25, 36–39.

[139] Stewart, *Faces of Power* (note 136 above) 270–77.

scene is striking even within the whole painted frieze: five or six different hunts are depicted, and the lion hunt occupies almost half the space. In the other hunts there is a distinct emphasis on movement into the picture plane: the deer on the extreme left and the bear on the extreme right are in the background and are attacked from the foreground. The boar hunt adjoining the lion hunt on the viewer's left has one figure seen from the back, and the main hunter is depicted behind the head of the beast. In the lion hunt the nude ax-swinging hunter is close behind the head of the lion (only his lower proper left leg is hidden), and the horse of the attacking rider on the viewer's right almost straddles the lion, though it is represented in a partial three-quarter view. A plausible deduction from this and the base from Messene in the Louvre is that the composition of the Krateros Monument was not developed in depth but functioned as a broad and shallow composition to be seen from a distance—as Bommelaer and Laroche have suggested, from the pteroma of the Apollo temple.[140] This is a broadly interesting interpretation, since the issue of real versus apparent depth affects all images of the fourth century. Adolf Borbein demonstrated many years ago how statues of the fourth century create the illusion of true depth by bringing out elements on the sides of figures that would properly not be visible from the front.[141] It is similarly evident in Attic and South Italian vase painting of the fourth century that scenes are not developed in depth but extend laterally, even where individual figures are shown strongly foreshortened. Where depth is implied, it is done by using the old "Polygnotan" bird's-eye perspective through an apparent rising ground on which higher equals further behind (**Fig. 206**).[142]

The plausible suggestion that the lion hunt of the Krateros dedication at Delphi was conceived as a frieze in the round to be seen at distance in the defined space of the raised terrace leads us to the second possible late-fourth-century narrative group, the slaughter of the Niobids. The core of the Niobid group is formed by twelve statues that were found in Rome in 1583 in the area that was once the Horti Lamiani and are now in the Uffizi in Florence (**Figs. 227–29, 231, 232**).[143] They are believed to have originally represented the mother, Niobe; probably seven sons and seven daughters; and a pedagogue. However, of the twelve statues found in Rome, only six sons and three daughters are certainly identifiable as part of the Niobid group.[144] Two statues in Florence traditionally known as Psyche and Narcissus may also have belonged to the group.[145] A fragmentary statue of a Niobid girl in the Vatican must be added to the group; it is a Roman copy of a girl who has already succumbed and leans up against one of the Niobid boys similar to one in Florence (**Fig. 230**).[146] Several copies of some of the statues exist, as well as copies of a number of the

[140] J. J. Pollitt, *Art in the Hellenistic Age* (Cambridge 1986) 49, describes the Krateros and Granikos monuments as "highly theatrical in character, rather like stage sets with the actors turned to bronze."

[141] Borbein, *JdI* 88 (1973) 43–212; see also Geominy, *Niobiden*, 21–22.

[142] Such as the pelike of the Marsyas Painter in London, BM E 424: ARV^2 1475.4; Boardman, *ARFV-CP*, fig. 390; and the pelike by the Eleusinian Painter in Saint Petersburg, Hermitage St. 1858: ARV^2 1475.7, Boardman, *ARFV-CP*, fig. 391.

[143] Mansuelli, *Uffizi*, 101–10; Geominy, *Niobiden*, passim.

[144] Mansuelli, *Uffizi*, 110–21, nos. 70–82. Hereafter in the text references to the statues in Florence are given by the catalogue number in Mansuelli.

[145] Ibid., 122–23, nos. 83, 84.

[146] Vatican 567: W. Amelung, *Die Sculpturen des Vaticanischen Museums*, vol. 2, *Belvedere, Sala degli animali, Galleria delle statue, Sala de' busti, Gabinetto delle maschere, Loggia scoperta* (Berlin 1908; repr. Berlin 1995) 608, no. 401, pl. 57; Helbig[4], vol. 1, no. 139 (W. Fuchs); Geominy, *Niobiden*, 107–17, figs. 107, 115–18; M. Bieber, *The Sculpture of the Hellenistic Age*, 2nd ed. (New York 1961) 75, fig. 255. The Niobid boy against whose leg she leaned is Mansuelli, *Uffizi*, 114–16, no. 74, fig. 74.

heads.[147] How these statues were set up is unknown, but most commentators suggest that they were disposed in the Horti Lamiani in a loose relationship to each other. The plinths of the statues are carved in the form of rough ground.

The date of the group is much debated. At first it was associated with the mention in Pliny (*NH* 36.28) of a group of dying Niobids in the Temple of Apollo Sosianus in Rome, whose authorship he says was disputed and attributed either to Skopas or Praxiteles. In either case, the originals of the group would thus belong in the second half of the fourth century. The quality of the copies differs greatly, and the statues in Florence have been extensively restored and their surfaces much altered in the process. The best-known and most obvious divergence in quality is between one of the Niobid daughters in Florence (M 72; **Fig. 232**) and her parallel in the Vatican known as the Chiaramonti Niobid (**Fig. 233**).[148] The arms of the statue in Florence are modern restorations; nonetheless, the two statues differ significantly in appearance. The Chiaramonti Niobid has justly been compared with works in the "baroque" style of the second century B.C.[149] Many of the characteristics of the example in Florence also belong to this style. In contrast, the drapery and surface of the vigorously lunging pair of youths in Florence (M 79 and M 80; **Fig. 229**) and the duplicate pair of youths on one knee (M 77 and M 78) lack all sense of plasticity and are lifeless. Luckily, a copy of the kneeling type in excellent condition was found in Rome in 1955, and it is in all respects more impressive and convincing: the youthful anatomy is sensitively modeled and the drapery has a sense of mass (**Fig. 234**).[150] The poor quality of surface and modeling is not uniform in the Uffizi statues; the so-called eldest daughter (M 71), heavily restored, is again a lifeless piece, but the pedagogue (M 82; **Fig. 228**) and his young ward (M 75) have fully modeled and lively drapery, as does Niobe herself and the daughter she clutches (M 70; **Fig. 227**).

The group of Niobe and her children, whatever their state of preservation and quality of carving, all share one signal characteristic: they are basically flat and provide the viewer with only a very narrow arc for a satisfactory vantage point. This led Hans Weber to propose in 1960 that the group was not a copy of a late-fourth-century original but a creation of the Late Hellenistic period,[151] an opinion followed by most commentators since.[152] Opposition to this argument has come primarily from Wilfred Geominy in his exhaustive study of 1984, which maintains a date in the late fourth century, between 330 and 320.[153] There is certainly no doubt that the statues belonging to the group are all intended to be

[147] A comprehensive list is given by Geominy, *Niobiden*, 44–157, in his discussion of each figure; various examples will be mentioned in my examination only where specifically relevant.

[148] Vatican, Museo Gregoriano Profano ex Lateranense 1035: C. Vorster, *Vatikanische Museen, Museo Gregoriano Profano ex Lateranense: Katalog der Skulpturen, 2: Römische Skulpturen des späten Hellenismus und der Kaiserzeit, 1: Werke nach Vorlagen und Bildformeln des. 5. und 4. Jahrhunderts v. Chr.*, ed. G. Daltrop and H. Oehler (Mainz 1993) 77–82, no. 29, figs. 137–44; Helbig[4], vol. 1, no. 598 (W. Fuchs); Geominy, *Niobiden*, 44–63, fig. 26; *LIMC*, s.v. Niobidai no. 23c1* (W. Geominy).

[149] E. Bielefeld, "Die Niobide Chiaramonti," *Pantheon* 30 (1972) 357–65.

[150] Rome, Musei Capitolini, Centrale Montemartini (ACEA) MC 3027: Geominy, *Niobiden*, 82, 388, note 251, no. IV, figs. 66, 67; H. Weber, "Zur Zeitbestimmung der Florentiner Niobiden," *JdI* 75 (1960) fig. 1; Helbig[4], vol. 2, no. 1783 (H. von Steuben); *LIMC*, s.v. Niobidai no. 23h3 (W. Geominy).

[151] Weber, *JdI* 75 (1960) 112–32. He was not the first to make the suggestion of an advanced Hellenistic date; see Mansuelli, *Uffizi*, 105–7.

[152] The bibliography is large; Mansuelli, *Uffizi*, 104–5, and Ridgway, *Hellenistic Sculpture*, vol. 1, 82–84, vol. 3, 92–94, review the pertinent literature.

[153] Geominy, *Niobiden*; W. Geominy, in *LIMC*, s.v. Niobidai no. 23, with commentary, vol. 4 (Zurich 1985) 926–27; supported by Vorster, *Museo Gregoriano Profano* (note 148 above) 79; and cautiously by Rolley, *Sculpture grecque*, 279–81.

seen from a single rather narrow area in front, but the probable relief-like appearance of the Krateros Monument at Delphi suggests that a multifigure narrative group of the late fourth century might indeed use flattened figures.

In the previous chapter, stylistic analysis of fourth-century statues, following the arguments of Adolf Borbein,[154] suggested that there was a general emphasis on frontality. The primary statues of the type that are useful for comparison with the Florentine Niobid group are the sandal-binding Hermes (**Figs. 188, 189**)[155] and the Eros stringing his bow (**Figs. 143, 144**).[156] Although Ridgway has argued that the Hermes should be dated to the Late Hellenistic period and the flatness of the Eros is enhanced in the copies of the hypothetical original,[157] the Hermes is really not very flat: his torso is set at an angle in depth, his proper right arm blocks the left from view, and his forearm recedes in depth, while his head turns out toward the viewer. The flatness of the Eros likewise is really only a result of the clear contour of the figure; his legs are strongly bent at the knee, and his proper left arm presses into the flesh of his chest in response to the great pressure he must apply to the bow to string it (if that is what he is doing). With the wings spread behind his back, he in fact fills quite a substantial volume of space.

Many of the Florentine Niobid statues are much flatter than either the Hermes or the Eros: the four boy types (M 74, M 76, M 77 and M 78, M 79 and M 80) are spread out on a narrow plane with almost abstract graphic gestures that create no space in front of them. The lower leg of the kneeling boy does disappear into the background, but it is invisible to the viewer standing in front. The statue of Niobe clutching her young daughter (M 70)[158] and the pedagogue and his accompanying young boy (M 75, M 82) are more three-dimensional and, as noted above, are more plastic in general in both drapery and anatomy.[159] The so-called eldest daughter (M 71) does reach down for her mantle, which has fallen over her thighs, and possibly reaches behind her head with her proper left arm (a modern restoration). The Chiaramonti type is better preserved and certainly has depth: the ends of her mantle flutter out across her waist and behind her shoulders, and she reaches back over her shoulder with her proper right arm (restored in the Florence statue).[160] The supine boy (Florence M 73, Munich 269) is difficult to judge.[161] The left side of the Munich figure's head is more sketchily carved than the right, so the latter must have been the principal side, at least in its Roman version.[162] This means that his proper right arm covered the lower part of his face, and his proper left hand, lying on his abdomen, seems to appear

[154] Borbein, *JdI* 88 (1973) 43–212.

[155] J. Inan, "Der sandalbindende Hermes," *AntP* 22 (1993) 105–16, pls. 34–42; Moreno, *Lisippo*, 236–41.

[156] E.g., Rome, MNR (Palazzo Massimo) 129185 (**Figs. 143, 144**); Rome, Musei Capitolini 410: Todisco, *Scultura greca*, no. 247; Helbig[4], vol. 2, no. 1231 (H. von Steuben). The attribution of this type to Lysippos has no foundation in texts but is based on stylistic analysis: H. Döhl, *Der Eros des Lysipp: Frühhellenistische Eroten* (Göttingen 1968) 5–14, 29–43. For photographs of many of the replicas, see Moreno, *Lisippo*, 111–29.

[157] B. S. Ridgway, "The Date of the So-Called Lysippan Jason," *AJA* 68 (1964) 113–28; Ridgway, *Fourth-Century Styles*, 307–8; Ridgway, *Hellenistic Sculpture*, vol. 1, 82. On the Eros: Ridgway, *Fourth-Century Styles*, 291.

[158] E. Künzl, *Frühhellenistische Gruppen* (Cologne 1968) 32–36.

[159] An excellent but fragmentary torso of the pedagogue was recently found in Rome: Rome, MNR (Palazzo Massimo) 380382: D. Candilio, "Statua di pedagogo dagli Horti Sallustiani," *Bollettino di Archeologia* 1–2 (1990) 206–11, figs. 89, 90; *LIMC*, s.v. Niobidai no. 23b2 (W. Geominy).

[160] Vorster, *Museo Gregoriano Profano* (note 148 above) no. 29, figs. 137–44; Geominy, *Niobiden*, 44–63, figs. 15–39; *LIMC*, s.v. Niobidai no. 23c1* (W. Geominy).

[161] Munich, Glyptothek 269: Vierneisel-Schlörb, *Klassische Skulpturen*, 472–86, figs. 233–36; Geominy, *Niobiden*, 147–57, figs. 162–80.

[162] Vierneisel-Schlörb, *Klassische Skulpturen*, 472–73, figs. 234, 236.

from nowhere. Finally, though not universally accepted as part of the original group, the two statues known as Psyche and Narcissus (M 82, M 83) have a great deal more depth.

The criticism of many of the Uffizi statues as inordinately flat is largely justified. Three statues sometimes associated with the Florentine Niobid group are revealing in their differences. First, the so-called Ilioneus in Munich depicts a crouching youth with his proper right arm raised and the left brought across his chest.[163] No matter the point of view, he does not qualify as flat in any way. This is equally true of a statue in the John Paul Getty Museum of a youth kneeling on a rocky plinth with his garment fallen about his knees.[164] The third statue is known as the youth from Subiaco (**Fig. 235**).[165] Here everything is different. This is a flat statue; indeed so flat that the figure is pressed into a narrow plane with its arms and legs serving merely as graphic lines with no depth of any sort. The proper right arm is raised, the left extended forward and slightly downward. As Geominy concludes, this statue has nothing to do with the Florentine Niobids.[166] In fact, it is quite clear that none of these three statues does—the Ilioneus and the statue in the Getty are fully three-dimensional creations that probably belong in the third century; the youth from Subiaco is generally dated in the first century B.C.

Perhaps the most caustic comment about the Niobid statues is that they are elegantly decorative.[167] This is particularly true of the four boys. The steeply lunging pair in Florence (M 79, M 80; **Fig. 229**) lean at a 50-degree angle and reach out in a manner reminiscent of the Borghese Warrior in the Louvre,[168] with which they have been compared, although the treatment of the anatomy could not be more different.[169] Such steeply inclined lunging figures are found in the fourth century in relief sculpture, but not in the round. The closest parallel is the fighting Herakles in the Capitoline Museums (now Montemartini Centrale power station; **Fig. 159**), but his torso is not in line with his diagonally placed proper right leg.[170] The two bronze runners from Herculaneum in Naples lean forward, but again the torso is not in line with the diagonal leg.[171] Figures very similar to the Niobids, however, do occur in relief in the Amazonomachy frieze of the Maussolleion: one warrior on slab 1009 of the Maussolleion frieze leans at the same angle as the lunging Nio-

[163] Munich, Glyptothek 270: ibid., 431–34, no. 39, figs. 210–15; see also Geominy, *Niobiden*, 196–201; *LIMC*, s.v. Niobidai no. 59 (W. Geominy).

[164] Malibu, Getty 72.AA.126: C. C. Vermeule and N. Neuerburg, *Catalogue of Ancient Art, The J. Paul Getty Museum: The Larger Statuary, Wall Paintings and Mosaics* (Malibu, CA, 1973) 12–13, no. 22*; C. C. Vermeule, *Greek and Roman Sculpture in America: Masterpieces in Public Collections in the United States and Canada* (Malibu, CA, and Berkeley 1981) 187, no. 154*.

[165] Rome, MNR (Palazzo Massimo) 1075 (here **Fig. 235**): Giuliano, *MNR*, vol. 1, pt. 1, 168–71, no. 114* (L. de Lachenal); Helbig⁴, vol. 3, no. 2277 (H. von Steuben); Bieber, *Sculpture of the Hellenistic Age* (note 146 above) 76, fig. 266; R. R. R. Smith, *Hellenistic Sculpture* (London 1991) fig. 55.

[166] Geominy, *Niobiden*, 201–2.

[167] H. von Steuben, in Helbig⁴, vol. 2, no. 1783.

[168] Paris, Louvre Ma 527: Hamiaux, *Sculpture grecque*, vol. 2 (note 136 above) 50–54, no. 60*; Smith, *Hellenistic Sculpture*, fig. 54; Ridgway, *Hellenistic Sculpture*, vol. 2, 271–73.

[169] Weber, *JdI* 75 (1960) 125–26; Ridgway, *Hellenistic Sculpture*, vol. 1, 83.

[170] Rome, Musei Capitolini, Centrale Montemartini (ACEA) MC 1088: Helbig⁴, vol. 2, no. 1585 (H. von Steuben); BrBr 352; H. Stuart Jones, *The Sculptures of the Palazzo dei Conservatori: A Catalogue of the Ancient Sculptures Preserved in the Municipal Collections of Rome*, vol. 2 (Oxford 1926) 158, no. 7, pl. 58; V. H. Poulsen, "Some Early Fourth Century Sculptures," *ActaArch* 15 (1944) 74, fig. 14; Arnold, *Polykletnachfolge*, 173–74, pls. 21a, 21c, 24c; W. Fuchs, *Die Skulptur der Griechen*, 4th ed. (Munich 1993) 118–20, fig. 111.

[171] Naples, MAN 5626 and 5627: Fuchs, *Skulptur der Griechen* (note 170 above) 363, figs. 404, 405; C. C. Mattusch, *The Villa dei Papiri at Herculaneum: Life and Afterlife of a Sculpture Collection* (Los Angeles 2005) 189–94, figs. 1–13.

bid boys,[172] and another warrior on slab 1014 (**Fig. 8**, right) is even more steeply inclined (45 degrees).[173] The two other Niobid boys (M 74 and M 76) lean at about 60 degrees, the same angle as several figures on the frieze of the Lysikrates Monument (**Fig. 19**).[174] The decorative elegance of the Lysikrates frieze is undeniable. The friezes of both the Maussolleion and Lysikrates Monument avoid any penetration of the background; the figures are confined to a narrow stage.

The drapery of Niobe and the Niobids is difficult to judge. The drapery of the two lunging (M 79 and M 80; **Fig. 229**) and the two kneeling boys (M 77 and M 78) in Florence has been so worked over in modern times that it is essentially characterless. This is also true of the so-called eldest daughter (M 71). On the other hand, the drapery of Niobe herself and of the daughter she holds could easily belong in the late fourth century (**Fig. 227**). The contrast of the daughter's sheer chiton and the mantle fallen around her buttocks might be compared with the drapery of the women of the Acanthus Column in Delphi (**Figs. 99, 100**) and related figures discussed in the previous chapter.[175] The contrast of the chitoniskos and chlamys of Aristonautes also comes close (**Fig. 88**).[176] The drapery of Niobe herself, like that of the pedagogue (**Fig. 228**) and the youngest son who runs with him, is well represented on mainstream Attic grave stelai of the second half of the fourth century.[177] Geominy has also shown that the head forms are very similar to those of statues datable in the area of 330–320.[178]

The evidence reviewed thus far appears to speak almost unambiguously for a dating of the Niobid group in the late fourth century, supporting the once traditional assessment. But there are two factors that Hans Weber has advanced as strong counterarguments. The first is that there was a strong revival of interest in classical forms in the first century B.C. Indeed, without that period's passion for copies of classical Greek sculpture our knowledge of the originals would be greatly impoverished, as discussed in chapter 3. The distinction of copy from variant or new ideal sculpture is, as we have seen, often difficult and must be based principally on internal divergences of style. In the case of the Niobids, Weber claims that this is precisely what we have: good fourth-century forms wedded to excessively flat compositions. He even accepts that the head forms are best located in the period 330–320.[179] We must grant that there is a discrepancy between the apparent fourth-century style of drapery and heads and the extreme flatness of the composition.

The second important issue is that no one has yet been able to propose a convincing arrangement for the Niobid group. Weber remarks that there is a disturbing imbalance of eight figures moving to the right: Niobe (M 70; **Fig. 227**), the "eldest" daughter (M 71), the Chiaramonti type M 72 (**Fig. 233**), the group of the boy M 74 plus Vatican girl (**Figs. 230, 231**), the boy M 75, the kneeling boys (M 78 and M 79: **Fig. 234**), and the lunging boys (M 80 and M 81; **Fig. 229**).[180] Only the pedagogue and youngest son move to the left (**Fig. 228**). The dead boy (M 73; Munich) is impossible to fit into a convincing composition with the

[172] Cook, *Relief Sculpture of the Mausoleum*, pl. 5, no. 2.

[173] Ibid., pl. 9, no. 8.

[174] Ehrhardt, *AntP* 22 (1993) pls. 2b, 3.

[175] See chap. 4, pp. 132–35 above.

[176] See also the Boiotian stele Athens, NAM 817: Kaltsas, *SNAMA*, 202–3, no. 405*.

[177] Athens, NAM 820: Kaltsas, *SNAMA*, 202, no. 404*; Clairmont, *CAT*, 2.390; Diepolder, *Grabreliefs*, pl. 51.2.

[178] Geominy, *Niobiden*, 239–49.

[179] Weber, *JdI* 75 (1960) 127.

[180] Ibid., 112, 126–27, 131–32.

other figures, resulting in awkward arrangements such as tilting him with his head down so that he could be seen better.[181] If the figures of "Psyche" (M 82) and "Narcissus" (M 83) are included in the group, the girl moves to the right and the boy faces frontally, though struck in the back. If the group originally included seven sons and seven daughters, as is commonly assumed, and since there are six boys (seven including Narcissus) and four girls (five including Psyche), there are three to five figures that are potentially missing. Even if the larger number is correct and all the missing figures moved to the left, a perfect symmetry would still be impossible, so the idea should be scrapped. Perhaps more important than the direction of movement is the direction the figures look because in several cases this implies the location of the avenging figures of Apollo and Artemis. One group comprises the following figures: Niobe turns her head slightly to the viewer's left; the so-called eldest daughter appears to have been struck in the back from the left; the Chiaramonti daughter looks and flees to the right, indicating that she is running away from the left; the boy M 76 looks back to the left while moving to the right. A second group consists of the boy M 74 plus the girl in the Vatican, who appear to react to something on the right; the pedagogue and youngest son flee to the left but look to the right; the kneeling boys (M 77 and M 78) look up sharply to the right; and, depending on the version accepted, the lunging boy flees to the right but looks back to the left (**Fig. 229**) or flees to the left and looks out at the viewer.[182] The "Psyche" moves to the right but turns back to the left. Basically, six figures look to the right and five look to the left. Probably the best reconstruction thus far is that of Barbara Vierneisel-Schlörb, which uses the height of the figures to create a roughly pedimental form with Niobe in the center.[183] This achieves a rough balance of movement and the direction in which the figures look, and the varied alternation suggests action and confusion. It is, however, simply a hypothesis with no supporting evidence.

The idea that the Niobids are a coherent group that reflects a single important monument may perhaps best be abandoned. The strongest pointer in this direction is the Chiaramonti type (**Fig. 233**). The style of drapery in both the Vatican and the Uffizi copies is clearly Hellenistic, of the second century, and differs in all aspects from the drapery of the other figures of the group. The supine boy is also very difficult to visualize among the other figures. The two lunging figures that are near but not real duplicates suggests a gratuitous extension of the group, probably for its location in the Horti Lamiani. Such an interpretation may help explain the quandary expressed by Pliny (*NH* 36.28) over the authorship of the statues of dying Niobids in the Temple of Apollo Sosianus in Rome, since, if they are of different dates, their authorship should be in doubt.[184] The existence

[181] Ibid., 115, 119, 124, 127. The tilted pose was first suggested by E. Buschor, "Die Oxforder Niobe," *MüJb* 9 (1914–15) 197–98 (figure on p. 198).

[182] Mansuelli, *Uffizi*, 118–19, nos. 79, 80, figs. 80, 81, notes that the heads, though ancient, do not belong. They are not copies of each other because no. 79 is worked to be seen from behind, while no. 80 is worked to be seen from the front. It is worth noting that depictions of figures seen from behind are known in the second half of the fourth century: Cook, *Relief Sculpture of the Mausoleum*, pls. 24 (Centauromachy slab, BM 1032), 14 and 15 (BM slab 1022), 13 (BM slab 1021). Vergina: Andronikos, *Royal Tombs*, 102–3, figs. 58, 59, second and third human figures from the left; Saatsoglou-Paliadeli, *Τάφος του Φιλίππου*, pls. 4a, 8.1, 8.2; Brecoulaki, *Peinture funéraire*, pls. 27, 29. Buschor, *MüJb* 9 (1914–15) fig. on p. 200, also chooses this view, while Vierneisel-Schlörb, *Klassische Skulpturen*, 476, rejects the two figures as late additions to the group.

[183] Vierneisel-Schlörb, *Klassische Skulpturen*, 482. H. Walter, *Vom Sinnwandel griechischer Mythen* (Waldsassen 1959) 50, fig. 42, actually presents a sketch of a hypothetical pediment, and Mansuelli, *Uffizi*, 101, publishes a drawing by R. Cockerell placing the group in a pediment. Rolley, *Sculpture grecque*, 280–81, does not reject a pedimental composition out of hand.

[184] Vierneisel-Schlörb, *Klassische Skulpturen*, 477.

of copies of some of the figure types, particularly the Cretan Niobe, but also the pedagogue and Soissons version of the youngest boy,[185] in different arrangements also suggests a core group of figures that was excerpted, used either as themselves or for new purposes. This, of course, reflects the basic fact that the Romans used Greek models in any way they chose: mirror reversals, changed gestures, varied styles.

On the other hand, Ernst Künzl has supported the late-fourth-century date for the statue of Niobe and her daughter (**Fig. 227**), comparing her to the group of Leda and the swan (**Fig. 104**).[186] The evidence of the Krateros Monument and accounts of lost narrative groups of the fourth century suggest there may have existed a late-fourth-century group of the slaughter of the Niobids. There is no reason to argue that the flatness of the figures is evidence of their Late Hellenistic date. The only certain evidence we have for the display of sculptural groups in the fourth century is against walls: the dedications along the Sacred Way at the entrance to the sanctuary at Delphi, the Daochos Monument at Delphi, and the group of *Zanes* statues at Olympia which were set against the retaining wall of the terrace that supported the treasuries. Some small argument can also be derived from the development of friezes during the second half of the fourth century. As Uwe Süssenbach has demonstrated, the comprehensive linear and planar patterns of the Maussolleion friezes gradually become more plastic and create a contrast of figure with now permeable ground,[187] ending in the "Alexander sarcophagus" from Sidon now in Istanbul, in which the figures create a dense, plastic pattern raised from the relief ground and emphasized by shadows.[188] The clear compositional patterns of the Maussolleion friezes continue but in attenuated form in the Lysikrates Monument's narrow frieze (**Figs. 19, 20**).[189] A series of reliefs must belong in this general period: the Mantineia base (**Figs. 96–98**), the Atarbos base on the Athenian Acropolis (**Figs. 223, 224**),[190] a relief in Munich,[191] and perhaps the apoxyomenoi relief in the Acropolis Museum in Athens.[192] Movement toward more tightly packed and plastic forms characterizes the Fuggischer Sarcophagus in Vienna, from Soloi on Cyprus (**Figs. 63, 64**),[193] and the fragments of the carved base and column drums of the new Artemiseion in Ephesos (**Figs. 39, 40**).[194] As will be discussed below, an increasing plasticity appears common to almost all of these, and a fragmentation of composition is common to all: figures or groups of figures interact less and become isolated notations. Consequently, I can easily imagine that some part of the Florentine Niobid group and related figures reflects a group of the

[185] Soissons, Musée Municipal (dépôt du Louvre Ma 1339): *LIMC*, s.v. Niobidai no. 23b3–23c3* (W. Geominy); Geominy, *Niobiden*, 129–33, figs. 143, 145, 146; Weber, *JdI* 75 (1960) 117–18, fig. 3.

[186] Künzl, *Frühhellenistische Gruppen* (note 158 above) 32–36.

[187] U. Süssenbach, *Der Frühhellenismus im griechischen Kampf-Relief: Versuch einer Rekonstruktion der Stilentwicklung vom Mausoleum von Halikarnassos bis zum Großen Altarfries von Pergamon* (Bonn 1971) 28–30.

[188] Graeve, *Alexandersarkophag* (note 138 above).

[189] Ehrhardt, *AntP* 22 (1993) 7–67, pls. 1–19.

[190] See p. 171 above.

[191] Munich, Glyptothek 473: Vierneisel-Schlörb, *Klassische Grabdenkmäler* (note 43 above) 158–61, no. 29, pls. 62, 63; Kosmopoulou, *Statue Bases*, 206, no. 40, fig. 61.

[192] Athens, Acrop. 3176 + 5460 + 2635: Brouskari, *Acropolis Museum*, 18–19, fig. 4; F. Rausa, "Due donari agonistici dall'Acropoli," *AM* 113 (1998) 192–205, 232, pls. 34, 35; Kosmopoulou, *Statue Bases*, 208–9, no. 42, fig. 63.

[193] R. Fleischer et al., "Der Wiener Amazonensarkophag," *AntP* 26 (1998) 7–54, pls. 1–18; A. Hermary, "Le sarcophage d'un prince de Soloi," *RDAC* (1987) 231–33, pl. 59; J. Ferron, *Sarcophages de Phénicie: Sarcophages à scènes en relief* (Paris 1993) 319–44, pls. LXVIII–LXXV; Ridgway, *Hellenistic Sculpture*, vol. 1, 45–46, pls. 18–21.

[194] Rügler, *Die Columnae caelatae*.

later fourth century; indeed, I would support Geominy's date of no later than 320, when plasticity disrupts the flattened friezes, as Süssenbach has argued.

One other circumstantial argument for a date for the original Niobid statues is the relatively circumscribed popularity of the theme in vase painting. In the fourth century, thirteen South Italian vases depict the myth, all but one of which are dated ca. 340–330. Niobe is depicted alone eleven times on vases that apparently show her mourning at the tomb of her children.[195] Two Apulian vases of the last third of the century depict the actual slaughter of Niobe's children: a volute-krater by the Baltimore Painter and a hydria by the Arpi Painter.[196] Both show Apollo and Artemis. The figures of the Niobids gesture dramatically, and on the Baltimore Painter's vase in Ruvo the figure of Apollo has a remarkably diagonal pose. The vases could be taken to suggest that the statue group was a creation of Magna Graecia, but this is a gratuitous suggestion. A wooden sarcophagus depicting the slaughter of the Niobids found near Kerch in the Crimea was originally dated by Ludolf Stephani to around 300 B.C.,[197] but recent scholars date it to the end of the first or the beginning of the second century A.D.[198] The figures were rendered in plaster and attached to the wooden sides of the sarcophagus, little of which remained even when it was first uncovered.

It is interesting to note that the subject of the slaughter of the Niobids had earlier been popular in both sculpture and vase painting at roughly the same time. It had served as the subject of the pedimental sculpture of an unknown temple around 440[199] and was represented on the throne of Zeus at Olympia in the 430s.[200] The slightly earlier name piece of the Niobid Painter[201] and five approximately contemporary vases take up the subject in much abbreviated fashion and indicate a brief but strong interest in the subject.[202]

Finally, the apparent lack of the protagonists, the avenging divinities Apollo and Artemis, in the Florentine Niobid group is, as will be discussed below in conjunction both with temple pediments and individual statues, closely related to the strong tendency in the art of the fourth century to imply while not representing explicitly.[203] Indeed, this

[195] A. D. Trendall, "The Mourning Niobe," *RA*, 1972, 309–16, figs. 1–5; *LIMC*, s.v. Niobe nos. 10*–20* (M. Schmidt).

[196] Ruvo, MAN Jatta 424: Trendall and Cambitoglou, *Vases of Apulia* (note 50 above) 365–66, no. 24; H. Sichtermann, *Griechische Vasen in Unteritalien: Aus der Sammlung Jatta in Ruvo*, Bilderhefte des Deutschen Archäologischen Instituts Rom 3–4 (Tübingen 1966) 51, no. K73, pls. 123, 124, 126. Foggia, Museo Civico 132726: Trendall (above) 924, 925, no. 91, pl. 361; E. Lippolis, ed., *Arte e artigianato in Magna Grecia*, exh. cat. (Naples 1996) ill. on p. 405. Neither vase is illustrated in *LIMC*, s.v. Niobidai nos. 10, 11 (W. Geominy).

[197] L. Stephani, "Erklärung einiger im Jahre 1874 im südlichen Russland gefundener Kunstwerke," *CRPétersb*, 1875, 5–15, pl. I; C. Watzinger, *Griechische Holzsarkophage aus der Zeit Alexanders der Grossen* (Leipzig 1905) 54–55, no. 35, figs. 116, 117.

[198] M. Vaulina and A. Wąsowicz, *Bois grecs et romains de l'Ermitage* (Wrocław 1974) 115 (with fig. 62 on p. 117); P. Pinelli and A. Wąsowicz, *Catalogue des bois et stucs grecs et romains provenant de Kertch*, Musée du Louvre (Paris 1986) 52–53, no. 9, figs. 9, 10 (although they note that nothing is left of the figures today). For similar figures in the Louvre: ibid., 59–83, nos. 14–21; *LIMC*, s.v. Niobidai nos. 42a–t (W. Geominy).

[199] *LIMC*, s.v. Niobidai nos. 21, 22 (W. Geominy).

[200] *LIMC*, s.v. Niobidai no. 15* (W. Geominy).

[201] Paris, Louvre G 341: *ARV*² 601.22; *LIMC*, s.v. Niobidai no. 4 (W. Geominy).

[202] *LIMC*, s.v. Niobidai nos. 5–9 (W. Geominy); J. H. Oakley, *The Phiale Painter* (Mainz 1990) 91, no. 154bis, pl. 132a, b, publishes a skyphos by the Phiale Painter omitted from *LIMC*: London, BM E 81: *ARV*² 1024.150.

[203] See particularly P. H. von Blanckenhagen, "Der ergänzende Betrachter: Bemerkungen zu einem Aspekt hellenistischer Kunst," in *Wandlungen: Studien zur antiken und neueren Kunst; Ernst Homann-Wedeking gewidmet* (Waldsassen 1975) 193–201. The statue now in the Montemartini power station (Centrale Montemartini [ACEA] MC 3529), once thought to be Apollo from a Niobid group from one of the pediments of the Temple of Apollo Sosianus in Rome (Helbig⁴, vol. 2, no. 1642 [W. Fuchs]), is now Theseus in the Amazonomachy pediment: E. La Rocca, "Le sculture del tempio di Apollo Sosiano a Roma," in *Archaische und klassische griechische Plastik: Akten des internationalen Kolloquiums vom 22.–25. April 1985 in Athen*, ed. H. Kyrieleis (Mainz 1986) vol. 2, 51–57, pl. 95.

effect of leaving it to the spectator to fill in the setting and to experience instead the extended emotional ambiance of the sculpture permeates even the grave stelai of the fourth century. Instead of lessening the emotional reaction to the slaughter of the children of Niobe, the Florentine group enhances it because the viewer must imagine the avenging divinities, thus engaging with the group rather than simply reading it. The type of hypothetical reconstruction suggested by Vierneisel-Schlörb, as noted above, suggests action and confusion, and, we should add, the all-pervasiveness of the divinities, since direction of flight and direction of countenance crisscross.

The length of the group, which had some sixteen statues, would probably be over 16 meters if all the figures were arranged in a line. This exceeds the length of both the Daochos building and the Krateros niche at Delphi by at least 3 meters. Both Peter von Blanckenhagen and Brunilde Ridgway have expressed the view that the setting of the Florentine group requires an openness to modulating the emotional reaction to the event depicted,[204] and this corresponds with Weber's emphasis on the statues being conceived largely as individual notations rather than as a tightly composed group.[205] However, a densely packed and complex composition seems to me more persuasive. Von Blanckenhagen observes that the Pergamene victory monuments on the Acropolis of Athens must have drawn much of their emotional appeal from their setting, right there where such momentous events had taken place.[206] Whether this required a particular compositional arrangement or was conferred by the location alone is impossible to decide. There is no evidence whatsoever for the location of either the Florentine group of Niobids or the original group from which it may derive, except the rendering of their plinths as rocky ground. Given von Blanckenhagen's observation on location as an element of expression, I am tempted to think of the destruction of Thebes, the home of Niobe, by Alexander in 335 as an instigation for a large group of statues. The refounding of the city by Kassander in 316 (Diod. Sic. 19.53–54.3) might also be considered, although it is a bit late for my sense of a date for the group. Either date would roughly agree with the popularity of the subject on South Italian vases mentioned above.

Totally apart from the vexed question of the Florentine Niobids, it is clear from the evidence of the preserved Daochos base and the disposition of the Krateros niche that statue groups in the late fourth century did not employ complex compositions in depth. Indeed, the discussion of the Krateros Monument strongly suggests that the pictorial character of the lion hunt was limited to a friezelike arrangement whose effect was emphasized by the primary vantage point for viewing the monument being at a distance, something akin to the small frieze of the Lysikrates Monument discussed below. The question of whether one can speak of an illusionistic image similar to the later grave stelai, such that of Aristonautes or the Ilissos stele, is impossible to answer with any conviction (**Figs. 88, 132**). Perhaps a more convincing comparison is with the late stele of Demetria and Pamphile: the two women look out at the viewer from their rather confined space in the deep naiskos (**Fig. 87**).[207] The figures exist in a dramatic isolation that

[204] Von Blanckenhagen, "Ergänzende Betrachter" (note 203 above) 198; B. S. Ridgway, *Hellenistic Sculpture*, vol. 3, *The Styles of ca. 100–31 B.C.* (Madison, WI, 2002) 92.

[205] Weber, *JdI* 75 (1960) 131–32.

[206] Von Blanckenhagen, "Ergänzende Betrachter" (note 203 above) 198.

[207] Van Straten, "Images of Gods and Men" (note 91 above) 252–53, remarks on a similar phenomenon on later fourth-century votive reliefs: divinities turning out to the viewer instead of facing the votaries who approach from one side or the other, usually the right.

conveys a distance rather than the interconnection of the world of the deceased and that of the living—there is a palpable distance between the viewer and the figures of the stele. This impression is once again parallel to the development of frieze composition in the later fourth century, as has already been mentioned and will be treated at greater length in the next chapter.

FREESTANDING STATUES

Specific evidence for the location and manner of setting up single statues in classical Greece is almost totally lacking, in contrast to the evidence for the bases for large groups discussed above, which are preserved in situ at Delphi and occasionally elsewhere. However, we do know that single statues and groups were set up on a variety of bases, both low and moderately high. In the fourth century, the most favored base for single statues was a simple rectangular block of stone between 0.30 and 0.60 meters high, either plain or sculptured.[208] The actual block on which a statue or statues stood was set on a foundation—sometimes approximately flush with the ground, sometimes raised on a step or steps—which could increase the height of the base a further 0.30 to 0.60 meters. Some single statues were mounted on shafts of unknown height.[209] There are exceptions to these guidelines, primarily the Nike of Paionios at Olympia and its counterpart at Delphi, which were mounted on pillars that were triangular in section and over 8 meters high;[210] the Acanthus Column at Delphi, with a total height of 13 meters;[211] and the statues of the eponymous heroes in the Athenian Agora, which were set on a high base, possibly more than 2 meters in height.[212] Bases for special groups of statues, probably with some relationship to cult, often had sculptured relief slabs encasing the structural base.[213]

Bases with carved reliefs appear to have been used for both freestanding sculpture and grave monuments in the late fifth and fourth centuries. In her recent study, Angeliki Kosmopoulou catalogues thirty-one sculptured bases for freestanding monuments of various types[214] and thirteen bases for funerary monuments.[215] Although many are fragmentary, they nonetheless indicate that in many cases statues were not seen in isolation, but that

[208] Jacquemin, *Offrandes monumentales* (note 119 above) 120–38, pls. 9, 10, gives an excellent review of the size and shape of statue bases at Delphi, which is generally applicable; see also M. Jacob-Felsch, *Die Entwicklung griechischer Statuenbasen und die Aufstellung der Statuen* (Waldsassen 1969) 61–76, and catalogues I and II; and, for sculptured bases, Kosmopoulou, *Statue Bases*, 202.

[209] Jacob-Felsch, *Entwicklung griechischer Statuenbasen* (note 208 above) 67–68; O. Walter, "Zur Heraklesbasis von Lamptrai," *MdI* 3 (1950) 139–47; H. A. Thompson, "Excavations in the Athenian Agora: 1952," *Hesperia* 22 (1953) 49–51, fig. 3.

[210] K. Herrmann, "Der Pfeiler der Paionios-Nike in Olympia," *JdI* 87 (1972) 232–57.

[211] Martinez, *CRAI*, 1997, 35–46.

[212] Shear, Jr., *Hesperia* 39 (1970) 145–222; Thompson and Wycherley, *Athenian Agora* 14, 38–41, fig. 11; J. McK. Camp, *The Athenian Agora: A Guide to the Excavation and Museum*, 4th ed. (Athens 1990) 69–72, figs. 33, 34; Kron, *Phylenheroen* (note 108 above).

[213] See generally Kosmopoulou, *Statue Bases*, 236–51, nos. 59–63. Specific examples are a relief slab in Eleusis, 5095: A. Delivorrias, "Doppeldeutigkeiten und Missdeutungen: Über den Widerstand der Monumente in den Denkmöglichkeiten der archäologischen Interpretation und die ursprüngliche Bestimmung eines eleusinischen Reliefs," in *Kotinos: Festschrift für Erika Simon* (note 23 above) 181–87, pls. 37, 39 (just short of 0.60 meters high); and the Mantineia base in Athens, NAM 215–17: Kaltsas, *SNAMA*, 256, no. 513; Kosmopoulou (above) 248–51, no. 63, figs. 105–7 (height 0.97 m), here **Figs. 96–98**.

[214] Kosmopoulou, *Statue Bases*, 175–210, nos. 13–43.

[215] Ibid., 216–35, nos. 46–58.

some sculptural commentary was provided. The commentary was frequently anecdotal, even on sculptured bases of the Archaic period, such as the "cat and dog base,"[216] which has parallels in at least three fourth-century bases.[217] But the most interesting of all the sculptured bases is the base for the posthumous statue of Poulydamas in Olympia, which was seen by Pausanias (6.5.1–7) and attributed by him to Lysippos (**Fig. 95**).[218] On the front, Poulydamas is depicted dispatching one of the three "Immortals" in front of King Darius; on the left side, Poulydamas kills a lion; on the right, unfortunately badly damaged, he sits on the dead lion.[219] Whatever the appearance of the statue and whatever props were associated with it, the base provides a brief and even humorous commentary.

In addition to reliefs there were frequently more or less informative inscriptions on bases, such as that of Agias at Delphi, which indicates indubitably that somebody paid attention to what was written. The inscribed base of a statue of Agias at Pharsalos, now lost, was seen in the nineteenth century and its inscription recorded.[220] It lists among Agias's accomplishments as many (τόσα) victories at Delphi as at Nemea, where he was victorious five times. The inscription on the base for Agias's statue at Delphi, however, has a *rasura* at just this point, and apparently someone replaced the original τόσα of the Delphi inscription with the number three, one assumes as a correction of an exaggerated boast on the base in Agias's hometown.[221]

Equally, inscriptions provided commentary, though the preserved examples tend to be very brief, much as on grave stelai. The rather long inscription of the Krateros Monument, discussed above, says awfully little about the subject of the statuary group, though it at least locates it in time and place.[222] An inscription of the late fourth or early third century from Erythrai on the west coast of Asia Minor refers to the dedicated image, an interesting and not infrequent aspect of inscriptions of the period:[223]

> I, Simo, wife of Zoilos, priestess of Dionysos before the city, daughter of Pankratides, have presented this image as a proof of my beauty and my virtue and wealth, as an eternal memento for the children and the children's children.

A similar inscription on a base of either the first half of the fourth century or the first half of the third century found on the Athenian Acropolis reads:[224]

[216] Athens, NAM 3476: Kaltsas, *SNAMA*, 66–68, no. 95*.

[217] Kosmopoulou, *Statue Bases*, figs. 63 (Athens, Acrop. 3176 + 5460 + 2635), 58 (Paris, Louvre Ma 834), 54 (Volos 17), and probably a fourth example in Munich (no. 473), fig. 61.

[218] Olympia Λ 45: Kosmopoulou, *Statue Bases*, figs. 55–57; A. von Salis, *Löwenkampfbilder des Lysipp*, BWPr 112 (Berlin 1956) 32–36, fig. 19; Todisco, *Scultura greca*, no. 246; Bol, *Bildhauerkunst*, 372–73, fig. 339 (C. Maderna).

[219] J. Marcadé, "A propos de la base de Poulydamas à Olympie," in *Lysippe et son influence: Études de divers savants*, ed. J. Chamay and J.-L. Maier (Geneva 1987) 113–24, pl. 25, figs. 69–71; repr. in J. Marcadé, *Études de sculpture et d'iconographie antiques: Scripta varia, 1941–1991* (Paris 1993) 345–60.

[220] See p. 172 above with note 122.

[221] Marcadé, *Signatures* (note 103 above) vol. 1, no. 68; Pouilloux, *FdD* 3.4, 136.

[222] See p. 174 above.

[223] H. Engelmann and R. Merkelbach, *Die Inschriften von Erythrai und Klazomenai*, vol. 2, *Nr. 201–536*, Inschriften griechischer Städte aus Kleinasien 2 (Bonn 1973) 364–65, no. 210a, pl. XLI, cited and translated by van Straten, "Gifts for the Gods," 76.

[224] Athens, EM 8746 + 10682; *IG* II² 3464: Συῆ[ρις . .]γου ׀ Σ– – – ׀ Λυσ[ιμάχ]ης ׀ διά[κο]νος ׀ ἡ ἐν τ[ῶι ἱε]ρῶι εἰκών με [ἥδε] σαφῆς δηλοῖ ׀ τύπου· ἔ[ργα] δὲ καὶ νοῦς ׀ [νῦν ζ]ῴει παρὰ πᾶσι σαφῆ· ׀ [σε]μνὴ δέ με μοῖρα ׀ [ἥ]γαγεν εἰς ναὸν περικαλλέ[α] ׀ Παλλάδος ἁγνῆς, ׀ [οὗ] πόνον οὐκ ἀκλεᾶ τόνδε ׀ ἐλάτρευσα θεᾶι. ׀ Νικόμαχος ἐπόησεν: E. Reisch, "Die Tempeldienerin des Nikomachos," *ÖJh* 19–20 (1919) 296–98; partially in E. Loewy, *Inschriften griechischer Bildhauer* (Leipzig 1885; repr. Chicago 1976) 58, no. 75; J. B. Connelly, *Portrait of a Priestess: Women and Ritual in Ancient Greece* (Princeton 2007) 131–32. On the date, see D. M. Lewis, "Notes on Attic Inscriptions (II)," *BSA* 50 (1955) 8. Keesling,

Syeris, daughter of ?, the temple servant of Lysimache who was [priestess] in this sanctuary. This fine image shows me clearly and [my] deeds and character live now clearly in the presence of all. A holy lot led me into the beautiful sanctuary of chaste Pallas, where I rendered the goddess not unrenowned service. Nikomachos made it.

Unfortunately, the top of the base is lost, but a possible reference to the statue by Pausanias (1.27.4) indicates that the figure was only one cubit (ca. 50 cm) high and depicted Syeris as an old woman, which inspired Reisch to suggest a small bronze statuette in Vienna as a reflection of the figure.[225] But either of these inscriptions could just as well have been on the base of the generic reverent woman types represented by the "Artemisia" from Halikarnassos in London (**Fig. 5**),[226] though, given the late date of the bases, the more active types of the bronze "Spinner" in Munich[227] or the Anzio girl in Rome[228] might be better choices, or possibly an actual portrait, as I shall discuss in chapter 7. But the basic point is that the isolated statue in a modern museum is not only a fragment in itself but is a fragmentary part of an originally multifaceted display in which information was communicated not only by the statue itself, but also by its subsidiary relief base and/or inscription.

In general, freestanding sculpture was visually accessible to visitors in Late Classical Greek sanctuaries. However, to the best of my knowledge, other than bases for groups, only three or four bases of single statues of the late fifth or fourth century have any claim to having been found in situ. The best evidence is for the base of the statue of a pankratiast found in the sanctuary of Hera on Samos (**Fig. 238**).[229] From the inscription on the base, its date must fall at the very end of the fifth or the early part of the fourth century. The single block on which a marble statue was mounted is relatively high, 0.80 meters, but it stood on a foundation that was flush with the ground. The base stood in the acute angle at the intersection of the main road leading from the north gate of the sanctuary and a ramp up to the area of the East Stoa. Although the surface of the immediate area was raised in the second half of the second century B.C., the excavators argue that the base of the statue remained in situ but was itself also raised. It is unclear how high the wall behind the statue may have stood and what the relationship of the statue to the wall was, but it is certain the statue could only have been seen from the front and sides. It faced into the sanctuary and therefore away from the two main structures near it (gate and stoa).

The location of the base of the statue dedicated by Eurydike in the diminutive sanctuary of Eukleia at Vergina is interesting (**Fig. 11**).[230] It stood a short distance from the west wall of the sanctuary building and was the southernmost in a line of three similar bases. It is 0.48 meters high, and its top measures 0.77 × 0.685 meters. The base is far better preserved than its companions, and the statue that stood on it also survives, though it is uncertain

"Early Hellenistic Portrait Statues" (note 113 above) 158, note 37, believes on autopsy that only the name label above is of the third century and that the main inscription, and therefore the dedication, belongs in the first half of the fourth century. I have not seen the base.

[225] Vienna, KHM VI 2318: J. Bankó, "Bronzestatuette einer alten Frau im Wiener Hofmuseum," *ÖJh* 19–20 (1919) 296–98, pl. VI; Reisch, *ÖJh* 19–20 (1919) 299–316.

[226] London, BM 1001: Todisco, *Scultura greca*, no. 163.

[227] Munich, Glyptothek 444: Todisco, *Scultura greca*, no. 122.

[228] Rome, MNR (Palazzo Massimo) 50170: Giuliano, *MNR*, vol. 1, pt. 1, 186–92, no. 121* (L. de Lachenal).

[229] Jacob-Felsch, *Entwicklung griechischer Statuenbasen* (note 208 above) 170, no. 12; E. Homann-Wedeking, "Samos 1964," *AA*, 1965, col. 440, fig. 10; H. P. Isler and T. E. Kalpaxis, *Samos*, vol. 4, *Das archaische Nordtor und seine Umgebung im Heraion von Samos* (Bonn 1978) 43–45, pls. 31, 32, Beil. 26, 27, plans 1, 6.

[230] See chap. 2, p. 28 above, and bibliography in note 17.

whether it is Eurydike or Eukleia. Although this and the other two statues stood with their backs to the wall of the sanctuary building, space was left between them and the wall. Yet the back of the statue is only rudimentarily worked out, and the back of the base has a rough projection that makes it quite clear that the back was not to be seen.[231]

Two bases in the Altis of Olympia stood up against the south wall of the fourth-century temenos. The base of Telemachos, dated around 300 B.C., flanked what appears to have been the main entrance through the low temenos wall to the southeast of the Temple of Zeus (**Fig. 237**, no. 11).[232] The base of Philonides near the southwest corner of the Altis at Olympia was not found in situ but fitted perfectly a foundation near which it was discovered, and that location agrees with Pausanias's account (**Fig. 237**, no. 14).[233] Its date must also fall very late in the fourth century.

A further piece of evidence is supplied by a base on the Athenian Acropolis. Again not found in situ, the base for statues of Konon and his son Timotheos was found close to a cutting in the bedrock that suits it perfectly.[234] The base is semicircular and was set against the terrace wall along the north side of the foundation of the Parthenon but turned slightly toward the viewer approaching from the Propylaia. Again, it would have had a wall behind it, and the slight turning of the monument to the west may, as Stevens suggests, have been done to enhance the view of it. Another fourth-century semicircular stepped base on the Acropolis, for a statue of the general Kephisodotos by Demetrios of Alopeke, has no certainly known setting.[235] But the curved base indicates very clearly the direction from which the monument is to be viewed, which is clearly from the front. It is worthwhile noting that the round base, which had been moderately popular in the fifth century, almost disappears in the fourth.[236] This suggests that in the fourth century statues may have emphasized viewing from a frontal vantage point, but bases with reliefs in the Archaic period,[237] like those in the fourth century, such as the Poulydamas base at Olympia,[238] are also carved on only three sides, and the back is ignored. Evidence for the fifth century is unfortunately lacking.[239]

[231] Andronikos, *Ergon*, 1990, 83–84, figs. 115, 117; A. Pariente, "Chronique des fouilles et découvertes archéologiques en Grèce en 1990," *BCH* 115 (1991) 901, fig. 92.

[232] W. Dörpfeld, in *Olympia: Die Ergebnisse der von dem Deutschen Reich veranstalteten Ausgrabung*, vol. 1, *Topographie und Geschichte von Olympia* (Berlin 1897) 88, *Karten und Pläne*, Bl. III, VIe; W. Dittenberger and K. Purgold, *Olympia: Die Ergebnisse der von dem Deutschen Reich veranstalteten Ausgrabung*, vol. 5, *Die Inschriften von Olympia* (Berlin 1896) cols. 303–6, no. 177; L. Moretti, *Iscrizioni agonistiche greche*, Studi pubblicati dall'istituto italiano per la storia antica 12 (Rome 1953) 87–89, no. 34; Moretti, "Olympionikai: I vincitori negli antichi agoni Olimpici," *MemLinc*, ser. 8, vol. 8.2 (1957) 135, no. 531, who places the base between dated bases of 292 and 288, therefore a bit later than in his earlier publication; H.-V. Herrmann, "Die Siegerstatuen von Olympia," *Nikephoros* 1 (1988) 132; Mallwitz, *Olympia und seine Bauten* (note 74 above) 121; Pausanias 6.13.11.

[233] Dörpfeld, in *Olympia*, vol. 1 (note 232 above), *Karten und Pläne*, Bl. III, VId; Dittenberger and Purgold, *Olympia*, vol. 5 (note 232 above) 403–4, no. 276; Pausanias 6.16.5.

[234] *IG* II² 3453; G. P. Stevens, "The Northeast Corner of the Parthenon," *Hesperia* 15 (1946) 4–10, figs. 3, 5–9 (the monument is no. 2 on the plan, fig. 3); Jacob-Felsch, *Entwicklung griechischer Statuenbasen* (note 208 above) 66, 185, cat. II, no. 100; J. M. Hurwit, *The Athenian Acropolis: History, Mythology, and Archaeology from the Neolithic Era to the Present* (Cambridge 1999) 250, fig. 203; Löhr, *Familienweihungen*, 76–77, no. 86.

[235] *IG* II² 3828; Hurwit, *Athenian Acropolis* (note 234 above) 251, fig. 204; Xenophon, *Hellenika* 2.1.16, a new general at Aigospotomoi.

[236] Jacob-Felsch, *Entwicklung griechischer Statuenbasen* (note 208 above) 62, lists only two, but the base believed to have held a statue of the priestess Lysimache on the Athenian Acropolis (*IG* II² 3453) was round; E. Berger, "Die Hauptwerke des Basler Antikenmuseums zwischen 460 und 430 v. Chr.," *AntK* 11 (1968) 68–69 and note 63; Hurwit, *Athenian Acropolis* (note 234 above) 251.

[237] Athens, NAM 3476, 3477: Kaltsas, *SNAMA*, 66–68, nos. 95*, 96*.

[238] Note 218 above.

[239] Kosmopoulou, *Statue Bases*, 64.

An equivocal source of information on the setting of single statues is the commentary of Pausanias, principally on his visits to Olympia (5.21–22, 6.1–18)[240] and Delphi (10.9–32.1).[241] These accounts can be compared with the modern archaeological record to provide at least some sense of how statues were set up. At Olympia the sanctuary lies on the flat alluvial soil at the confluence of the Alpheios and Kladeos rivers. The center of the sanctuary was dominated by the Early Classical Temple of Zeus; on the north side stood the old Temple of Hera, the temenos of Pelops, and the Metroön. To the east lay the stadium, which took its present shape along the foot of the Hill of Kronos in the middle of the fifth and the beginning of the fourth century, and the Echo Hall, built in the second half of the fourth century (**Fig. 237**). Statues stood in great profusion in the sanctuary. Pausanias divides his description of the statues in the sanctuary into two sections: first those of Zeus (5.21–27), and then all the others (6.1–18). He begins his account of statues of victorious athletes and other notable people near the Heraion in the north and follows a path southward to the sanctuary wall near the Bouleuterion, where he notes the statue of Telemachos mentioned above, then turns westward, and at the west wall of the sanctuary, where he saw the statue of Philonedes, he returns northeastward, ending at a point just to the east of the great temple. Pausanias himself states at the beginning of his account that he will mention only statues of particularly distinguished athletes or other people or statues that are notable of themselves. According to Hans-Volkmar Herrmann, Pausanias describes 197 statues of victorious athletes.[242] The excavations have found 98 bases of athletic victors, 37 of which were noted by Pausanias.[243] The foundations of several dedications, particularly of larger groups, described by Pausanias have been found in situ and therefore give some structure to his account.[244] The evidence is nonetheless of uncertain value, since Pausanias is writing in the second half of the second century A.D., after major restructuring of the sanctuary had occurred,[245] and it quickly becomes evident that he is interested principally in statues of the fifth and fourth centuries B.C. He has a particular liking for Pythagoras of Rhegion, of the second quarter of the fifth century, and for Naukydes, of the first half of the fourth century. All of this is perhaps immaterial to my present inquiry, since all that can be gleaned from Pausanias and the archaeological evidence is that statues stood cheek by jowl in groups surrounding the Temple of Zeus. It is nonetheless quite clear that many statues were set up to flank the principal paths through the sanctuary and around the areas of cult and public festivities. But this is of little help in visualizing precisely how a statue was seen by a visitor to the sanctuary.

At Delphi the terrain was very different: the sanctuary was built on a steep slope with buildings scattered over its surface (**Fig. 236**). As already discussed, the main entrance to the sanctuary ran along the foot of a high terrace wall to the north and was lined with large public dedications of the fifth and fourth centuries. Pausanias explicitly says that he did not consider it desirable to describe the vast number of private dedications (10.9.1–2).

[240] Herrmann, *Nikephoros* 1 (1988) 119–83; Rausa, *Vincitore*, 39–51; T. Hölscher, "Rituelle Räume und politische Denkmäler im Heiligtum von Olympia," in *Olympia 1875–2000: 125 Jahre Deutsche Ausgrabungen: Internationales Symposion, Berlin 9.–11. November 2000*, ed. H. Kyrieleis (Mainz 2002) 339–43.

[241] Jacquemin, *Offrandes monumentales* (note 119 above); H. Pomtow, "Delphica III: Der Tempelgiro des Pausanias nebst seiner Perigese und der des Plutarch," *BPW* 32, fasc. 37 (1912) cols. 1170–76.

[242] Herrmann, *Nikephoros* 1 (1988) 134–35, 151–76; in his earlier book, *Olympia: Heiligtum und Wettkampfstätte* (1972) 115, 244, note 438, Herrmann had estimated the number to be 203.

[243] Herrmann, *Nikephoros* 1 (1988) 136.

[244] My illustration **Fig. 237** is from Mallwitz, *Olympia und seine Bauten* (note 74 above).

[245] Rausa, *Vincitore*, 40–41.

The only other account preserved is in Plutarch's very sketchy *The Oracles at Delphi No Longer Given in Verse* (2–17 [395a–402b]), written when he was a priest at Delphi at the end of the first and beginning of the second century A.D. But both writers postdate the depredations of Greek sanctuaries by Roman generals (Sulla: Plutarch, *Sulla* 12.5–6) and emperors (Nero: Pausanias 10.7.1, 10.19.2).[246] The recent analysis by Anne Jacquemin indicates that dedications were concentrated along the major passages in the sanctuary, just as was the case at Olympia. Terrace walls also served either as backdrop or support.[247] Jacquemin notes that many particularly important dedications were grouped around the upper terrace on which the Temple of Apollo stood, and she posits that a secondary concentration was around the open space of the Threshing Floor (ἅλως) just slightly to the northeast of the Treasury of the Athenians (marked "AIRE" on the plan, **Fig. 236**).[248] Of all the statues mentioned in the later accounts, only two stand out: the gold statues of Gorgias and Phryne which stood on columns of unknown height (Pausanias 10.15.1, 10.18.7; Plutarch, *The Oracles at Delphi No Longer Given in Verse* 14–15 [401a–e]). It appears that the sheer number of dedications required that all free space was used; the dedication by Rhodopis was seen by Herodotos (2.134–35) somewhere to the east of the middle of the sanctuary and, though it was then gone, Plutarch still knew where it had been (*The Oracles at Delphi No Longer Given in Verse* 14 [400f–401a]).[249]

The scanty evidence of the texts and the archaeological record must be supplemented by an analysis of the preserved statues, both originals and copies. Of particular importance is the development in the late fifth century of specific stances that led to an increasingly sensitive depiction of figures with almost anecdotal character, and, as a consequence, the figures come alive. This new aliveness has important consequences for the manner in which statues are conceived, both by the sculptor and the viewer. This is clearly the case with the statue of Eirene and Ploutos, which translates an abstract concept, the dependence of wealth on peace, into a humanistic image of nurturing (**Fig. 12**).[250] The complexity of the image is difficult to grasp, since the modern viewer tends to see the group as a contrived allegory or proto-allegory constructed of personifications, and therefore an abstraction. Yet to the ancient Greek the distinctions of personification, *daimōn*, and divinity were not absolute, and none was in significant respects different from mortals. The Eirene and Ploutos group clearly focuses on the human concept of nurturing, while at the same time its primary function is religious. From the many representations of worshipers approaching divinities on votive reliefs, it is quite clear that Greeks imagined that they were facing the divinity to whom they brought sacrifice (**Fig. 214**).[251] So it must also have been with the Eirene and Ploutos. The statue has no interest at all from the back: one sees just the mantle falling in a plane relieved only by a stack of catenary folds that reveal absolutely nothing of the figures as seen from the front. Indeed, one should recall the observation of

[246] Jacquemin, *Offrandes monumentales* (note 119 above) 238; E. Champlin, *Nero* (Cambridge, MA, 2003) 133–34.

[247] Jacquemin, *Offrandes monumentales* (note 119 above) 120–22.

[248] Ibid., 32–36; H. Collitz et al., *Sammlung der griechischen Dialekt-Inschriften*, vol. 2 (Göttingen 1899) no. 2101, line 8, no. 2642, line 64.

[249] Bommelaer and Laroche, *Delphes: Le site*, 160. Part of the inscribed base of the dedication was reported to have been found in the modern excavations after World War II by E. Mastrokostas, "Λατύπη δελφικὴ," in *Γέρας Αντώνιου Κεραμοπούλλου* (Athens 1953) 635–42, pl. 31; J. M. Cook and J. Boardman, "Archaeology in Greece, 1953," *JHS* 74 (1954) 154, fig. 10, but only the letters KEN·PO are readable, and the identification has been dropped.

[250] E. Simon, "Eirene und Pax: Friedensgöttinnen in der Antike," *SBFrankfurt* 24 (1988) no. 3, 64, points out that Eirene is not the mother of Ploutos (his mother is Demeter) but the nurse.

[251] E. Vikela, "Attische Weihreliefs und die Kult-Topographie Attikas," *AM* 112 (1997) 169–75; van Straten, "Images of Gods and Men" (note 91 above) 248–53.

Borbein that from the front of this and most statues of the fourth century one sees aspects of the sides and even the back spread out, as opposed to the real three-dimensionality of fifth-century statues, which one can walk around and grasp some important information about from all points of view. The Eirene and Ploutos can be viewed only from the front over a rather small arc of perhaps 100 degrees or a little more.

The statue group of Eirene and Ploutos presents the viewer with an epiphany of the two divinities. It is a pity that we have no information about the actual manner of the presentation of the statue group—what kind and size of base it stood on, etc. This statue is, of course, a special case: it is a cult image, which were, as far as we know, always viewed from the front.[252] Still, the structure of the statue itself does give a useful guide to how it was experienced, and this I shall argue is an essential aspect of understanding the art of the fourth century. The problem of using Roman copies, however, becomes acute because the most interesting types are known only in copies: the resting satyrs, oil-pourers, resting Herakleses, or the Artemises of the Colonna or Gabii type, the Knidian Aphrodites. Let us begin, however, with an undisputed original: the bronze statue of a youth from Antikythera.

The bronze statue from Antikythera was put together from many small fragments and is generally heavily restored (**Figs. 69, 70**).[253] Nonetheless, the broad forms of the anatomy and the stance are genuinely ancient. The statue is usually dated shortly after the middle of the fourth century, around 340–330, and is believed to be a product of the school of Polykleitos.[254] The chronological indicators are the openness of the stance and the small size of the head in relation to the body, which, as we have seen, are characteristics clearly associated with works of the later fourth century. It is the explanation of the stance that must hold our attention. The statue has been identified as Perseus holding up the severed head of the Gorgon Medusa, as Alexandros/Paris presenting the golden apple to Aphrodite, and as a ballplayer.[255] In each case it is the upraised proper right arm that inspires the interpretation. The obvious similarity to the Renaissance statue in Florence by Benvenuto Cellini need not invalidate the interpretation as Perseus. Several South Italian vases of the end of the fifth century and the early fourth century depict Perseus in a pose very similar to that of the Antikythera statue. Typical of the group is a Lucanian volute-krater of about 400 B.C. which depicts Perseus holding up the head of Medusa in his right hand and cradling the *harpē* in his left; a pair of satyrs gyrates on either side.[256] Several other South Italian vases repeat the scene in its essentials. In Athens, only much earlier, vase painters also used the motif of Perseus holding up the head of Medusa: Perseus displays the head to Polydektes, whose lower half is turned to stone.[257] Angelos Delivorrias

[252] The distinction of cult image and votive image is important here only in terms of the manner in which it was seen, not in the manner in which it functioned; see Scheer, *Gottheit*, 130–46.

[253] For bibliography, see chap. 4, p. 112, note 85 above.

[254] Himmelmann, *Ausruhende Herakles*, 186, says the date cannot be later than 360 but does not argue the point.

[255] *LIMC*, s.v. Alexandros no. 1 (R. Hampe); s.v. Perseus no. 65 and commentary, vol. 7 (Zurich 1994) p. 346 (L. J. Roccos). Arnold, *Polykletnachfolge*, 207, note 709, opposes the identification as Paris; Kaltsas, *SNAMA*, 248, no. 518, supports it.

[256] Taranto, Museo Archeologico Nazionale 8263: *LIMC*, s.v. Perseus no. 32*; K. Schauenburg, *Perseus in der Kunst des Altertums* (Bonn 1960) 99, pl. 33; E. Langlotz, *Der triumphierende Perseus*, Arbeitsgemeinschaft für Forschung des Landes Nordrhein-Westfalen, Geisteswissenschaften 69 (Cologne 1960) 17–18, pl. 7.1 (detail); A. D. Trendall, *The Red-Figured Vases of Lucania, Campania and Sicily* (Oxford 1967) 55, no. 280, pl. 24 (details of B).

[257] *LIMC*, s.v. Polydektes nos. 3* 4*, 7; Schauenburg, *Perseus* (note 256 above) pl. 37.2; L. J. Roccos, in *LIMC*, vol. 7 (Zurich 1994) 346. Only two Attic vases of the fourth century depict Perseus at all (*LIMC*, s.v. Perseus nos. 92, 179), while there are several South Italian vases with at least vague similarities to the bronze statue: *LIMC*, s.v. Perseus nos. 33* (Bonn, AKM 2667 [79]), 34* (Taranto, Museo Archeologico Nazionale 124007), 35 (Saint Petersburg, Hermitage St. 1609); *LIMC*, s.v. Polydektes no. 5* (Copenhagen, National Museum of Denmark 3407); Schauenburg, *Perseus*, pls. 32.1, 34.1.

has published a small bronze statuette in Sparta, also of the middle of the fifth century, that resembles the Antikythera statue in pose, and he considers it a reflection of the statue of Perseus by Pythagoras.[258] To the meager number of representations of Perseus with the head of the Gorgon Medusa on the mainland one can add the painting from Roman Italy, discussed in chapter 3, often considered to be based on a Greek prototype, perhaps by the painter Nikias; it depicts Perseus, having killed the dragon, helping Andromeda down from the rock to which she was bound (**Fig. 154**). This is also a modestly popular theme in vase painting.[259] Perseus was quite clearly a mildly popular subject in the fourth century B.C. Accordingly, the identification of the youth from Antikythera as Perseus is possible, though hardly provable. Actually, this interpretation is not necessary for my point (though it is helpful): the youth appears to stand restlessly without specific context though making a very specific gesture, even though we cannot claim to recognize it with certainty. If the statue represents Perseus, the South Italian and Attic vases provide a context because they show either Athena or a satyr or satyrs either staring at or looking down to avoid the effect of the head of Medusa, or Polydektes being turned to stone. If the statue represents Paris, we must then imagine Hermes and the three goddesses around him. In the unlikely case that the statue depicts a ballplayer, there is at least one companion not depicted who interacts with the statue. In any case, though particularly if the statue is Perseus, the content of the statue resembles that of the diskobolos attributed to Naukydes discussed in the last chapter (**Figs. 172, 173**).[260] It also resembles many of the Roman copies of originals which are widely believed to date to the fourth century, such as the resting satyrs, oil-pourers, etc. Although we have yet to look at vase painting, it is important to note here an observation of Henri Metzger on the nature of iconography in the fourth century: there are far fewer heroic mythological scenes on fourth-century Attic pots, and those that do occur appear to have a more general reference to an idea behind the narrative rather than an interest in the narrative itself.[261] I am not sure that this is, in fact, altogether new in Greek mythological iconography, but it is certainly more emphatic in the imagery of the fourth century.

The bronze boy from Marathon Bay, probably an original, belongs in the same sphere as the Perseus/Paris/ballplayer: his gesture suggests a particular context, which is unclear, and he is not totally engrossed in the activity (**Figs. 65–67**).[262] Above all the stance is somewhat disconcerting: he looks as though he should be resting against some object to the viewer's left, but the evidence of his proper right hand indicates that nothing was there.[263] Since the statue is set up in the museum so that one can move around it at a good viewing distance, it quickly becomes apparent that there are good and bad positions to view it, and this is also readily apparent in some of the published photographs. The best positions are from dead center (**Fig. 65**) and from a slight distance to the viewer's left of

[258] A. Delivorrias, "Zum Motiv des triumphierenden Perseus," *AntK* 12 (1969) 22–24, pl. 15.

[259] See the discussion above, chap. 3, pp. 91–92.

[260] Chap. 4, pp. 111–12 above.

[261] Metzger, *Représentations*, 27–29, 37–38, 229–30 (Herakles), 239, 261 (Eleusis), 294, 376–77, 415–16; H. Froning, "Herakles und Dionysos auf einer Schale des 4. Jhs. v. Chr. in Würzburg," *WürzJbb* 1 (1975) 204–8.

[262] For bibliography, see chap. 4, p. 112, note 86 above.

[263] W. H. Schuchhardt, "Der Jüngling von Marathon," *Die Antike* 6 (1930) 338–40. Although Ridgway, *Fourth-Century Styles*, 343, 360, note 39, mentions that the arms could be later replacements, she also notes that P. G. Calligas says that it is mere conjecture that the left hand was altered in the Roman period: O. Tzachou-Alexandri, ed., *Mind and Body: Athletic Contests in Ancient Greece*, exh. cat. (Athens 1989) 72, no. 71. As noted in chap. 4, pp. 112–13 above, the pose of the statue does closely resemble the figure of Hygieia on votive reliefs, where she leans against a tree or other support, so I do not discount the existence of a support to which the statue was simply not attached. For a photographic detail of the hand, see Houser, *Bronze Sculpture*, ills. 14.6, 14.7.

dead center (**Fig. 67**).[264] From right of dead center (**Fig. 66**) the composition becomes more complex but is probably still viable.[265] That is, just as for the Eirene and Ploutos, there is an arc of good vantage points for viewing the statue from the front, but the back becomes incomprehensible. The youth held an object of some size in his proper left hand; the hand and 20 centimeters of the forearm are flattened, and a large round dowel is set into the upturned palm to attach it.[266] One suggestion that would explain the obscure gestures is that the youth's proper left hand held a largish object, to which was attached a fillet that he held up in his proper right hand, since the fingers are slightly parted.[267] Whatever the activity depicted, the stance brings into strong relief the contrast or ambiguity of doing and yet resting: the statue plays with a sense of imbalance and contemplation, and this with an atmosphere of nonchalance. Schuchhardt long ago made the convincing observation that the youth is represented in "a playful, non-activity."[268] In this the statue resembles the Hermes and Dionysos in Olympia, which it also resembles in other respects (**Fig. 133**).[269] Although the position of the head and arm is the same, the legs are reversed, as is the shift of the torso. The internal restlessness of the Olympia Hermes is increased in the Marathon boy; in both cases the whole function of the classic contrapposto stance is so altered as to be negated.[270] The stance and gestures create a sense of ambiguous movements which I am tempted to call a "sort of doing something." The figure is doing something in an absent-minded, contemplative mood.[271] The stance and gestures are open and create an illusionistically real space in which the figure actually is alive, though restrained.

In both the Perseus/Paris/ballplayer and the boy from Marathon the composition is open, the stance and gestures both fill a fully three-dimensional space and imply an extension beyond what is actually depicted. Dorothea Arnold's observation on the diskobolos attributed to Naukydes (**Fig. 172**), cited in the previous chapter, that there is a reflective and reflexive character to the statue, is even stronger in the boy from Marathon Bay.[272] Arnold goes on to describe the statue as on the border of the activity portrayed, which is precisely the same for the Marathon boy.[273] This also describes the Hermes in Olympia well—he is resting while on his mission to deliver the child Dionysos to the nymphs of Nyssa. Arnold's observation applies equally to the resting satyrs and a host of other statues of the fourth century: a banal human moment that is marginal to an often uncertain activity reveals the inner life of a figure. This amounts to creating an illusion of a figure alive in

[264] Schuchhardt, *Die Antike* 6 (1930) pl. 28.

[265] C. Houser and D. Finn, *Greek Monumental Bronze Sculpture* (New York 1983) ill. on p. 104, though the photo was taken from quite far to the right. A vantage point just to the left of this position would avoid obstruction by the object held in the youth's left hand, whatever its size, and would visually separate the two feet.

[266] Schuchhardt, *Die Antike* 6 (1930) 338; Houser, *Bronze Sculpture*, ill. 14.5

[267] Schuchhardt, *Die Antike* 6 (1930) 339, fig. 2; Houser, *Bronze Sculpture*, ills. 14.6, 14.7; Ridgway, *Fourth-Century Styles*, pl. 84b, 84c, gives two reconstructions. Claude Rolley, *Sculpture grecque*, 248, has also suggested that the youth is Hermes holding out the child Dionysos and snapping the fingers of his right hand to attract the child's attention, but whatever was held by the left hand cannot have been very heavy. F. Weege, *Der einschenkende Satyr aus Sammlung Mengarini*, BWPr 89 (Berlin 1929) 29–30, suggests that the boy is a parallel for the pouring satyr type and that he held up a rhyton, but this ignores the flattening of the boy's proper left forearm.

[268] Schuchhardt, *Die Antike* 6 (1930) 353.

[269] For a discussion of this statue, see chap. 3, p. 75, and chap. 4, pp. 112–13 above.

[270] Borbein, *JdI* 88 (1973) 163. B. R. Brown, *Anticlassicism in Greek Sculpture of the Fourth Century B.C.* (New York 1973) 21.

[271] Ridgway, *Fourth-Century Styles*, 344, speaks of the "absent-minded glance."

[272] Arnold, *Polykletnachfolge*, 113, with reference to J. Sieveking, text to BrBr, nos. 682–85, left, p. 4; see chap. 4, p. 112 with note 86 above.

[273] Arnold, *Polykletnachfolge*, 120.

real space and doing something a bit difficult to define. The aliveness and the somewhat banal (though principally uncertain) activity contrasts totally with the simple purposefulness of fifth-century statues.[274]

The marginal context of fourth-century statues is best illustrated through works preserved only as Roman copies. Take, for example, the "Resting Satyr" type (**Fig. 180**).[275] Totally independent of the specific forms of the Roman version, a satyr is depicted leaning heavily on a tree stump, something like the pose of the leaning Aphrodites. The left arm is akimbo, and the back of the left hand rests against his hip. The feet are set one in front of the other. What is the subject? Clearly a satyr who has no possibility of movement without a complex series of preparatory shifts of weight and repositioning of legs and arms. A static satyr. As far as I can tell, the satyr does absolutely nothing in any of the Roman versions. It is actually rather a sad and revolutionary image—a satyr with nothing to do, no hell to raise, no nymph to pursue, etc. But perhaps that is just the point: given the nature of a satyr, the image represents the contrary, but this is probably quite a logical and imaginative extension of the nature of a satyr.[276] On the one hand, he has no pubic hair and thus is not yet at an age to carouse, so his "satyrness" is ambiguous.[277] But this a characteristic of satyrs: they often are depicted without pubic hair even when bearded.[278] Secondly, and perhaps of greatest importance, the satyr does not have an erection.[279] It is also noticeable that in all the preserved copies his hair is full and luxurious. In brief, this is a very human satyr, even a refined human satyr. The tree stump on which he rests suggests a context out in the woods. The apparently anecdotal image of a satyr at rest becomes a rather brilliant image of the nature of a satyr which he himself imagines; his "satyrness" is conveyed not by the traditional iconography of action but simply by the animal skin slung around his shoulder and by his pointed ears, almost hidden in his mop of hair. The statue creates a very realistic image of a banal situation which requires the viewer to engage actively with a novel image of a traditional subject to puzzle out its ambiguities. Part of the novelty resides in a strong temporal element, since it is the imagined past and future that is really the subject. It is such an interpretation I would place on the Perseus/Paris/

[274] Von Blanckenhagen, "Ergänzende Betrachter" (note 203 above) 193–201, broaches the same topic but describes the manner of presentation of the Hellenistic statues, which are his subject, slightly differently. He focuses on the need for the viewer to fill in the essential elements of the sculpture but does not comment on the peripheral—or in my terms here, the banal—subject of so many of the works. The latter may, in fact, apply less to the Hellenistic examples discussed by von Blanckenhagen.

[275] P. Gercke, *Satyrn des Praxiteles* (Hamburg 1968) 22–69; E. Bartman, *Ancient Sculptural Copies in Miniature*, Columbia Studies in the Classical Tradition 19 (Leiden 1992) 193–95, Appendix 2A–B, 3; Martinez, *Praxitèle*, 236–48, 258–59, 260–67, nos. 60–63; Vierneisel-Schlörb, *Klassische Skulpturen*, 353–63, no. 32, figs. 165–79; Todisco, *Scultura greca*, nos. 135, 136; Stewart, *Greek Sculpture*, fig. 510.

[276] Von Blanckenhagen's discussion of the Barberini Faun ("Ergänzende Betrachter" [note 203 above] 197) reveals that figure to be the natural heir of the fourth-century resting satyr. C. Kunze, "Die Konstruktion einer realen Begegnung: Zur Statue des Barberinischen Fauns in München," in *Neue Forschungen zur hellenistischen Plastik: Kolloquium zum 70. Geburtstag von Georg Daltrop*, ed. G. Zimmer (Eichstätt-Ingolstadt 2005) 19–23, makes similar observations on the statue in Munich but contrasts it with the resting satyr.

[277] A. Stewart, *Art, Desire, and the Body in Ancient Greece* (Cambridge and New York 1997) 200–202.

[278] K. Seaman, "Retrieving the Original Aphrodite of Knidos," *RendLinc*, ser. 9, 15 (2004) 553–54. A perusal of the *LIMC* plates, s.v. Silenoi (vol. 8), indicates that satyrs are frequently depicted without pubic hair.

[279] F. Lissarrague, "The Sexual Life of Satyrs," in *Before Sexuality: The Construction of Erotic Experience in the Greek World*, ed. D. M. Halperin, J. J. Winkler, and F. I. Zeitlin (Princeton 1990) 55, 59–61, notes in passing the fact that not all satyrs are depicted with erect penis and discusses "refined" satyrs with bound-up penises. As Lissarrague points out (p. 56), Aristophanes, *Clouds* 1011–14, describes the Athenian sophisticate as having a small penis. Although the resting type is clearly a young satyr, Erika Simon, in *LIMC*, s.v. Silenoi no. 213 (Rome, Musei Capitolini 739), says that he is "erwachsen."

ballplayer, the boy from Marathon Bay, and the Hermes and Dionysos in Olympia. There is a primary sense of being alive and in a real world, a secondary existence as a particular being, and a tertiary, ambiguous, existence as doing something "sort of." In the fifth century, the vast majority of statues appear to be primarily somebody, and secondarily they do something characteristic of who they are. It is not an exaggeration to speak of a new sense of space and context coupled with a subtle temporal element, all of which create a new psychological depth in the statues of the fourth century; there is a strong element of this in many of the works, albeit preserved only in Roman copies. Certainly the element of a psychological dimension links the Plain Style of the fourth century with the Rich Style of the late fifth and early fourth centuries.

Several statues should be mentioned in the present context because they all share the basic characteristics just discussed. The kind of diorama created by the Resting Satyr is easily visible in the Apollo Sauroktonos (**Figs. 181, 182**),[280] the Hermes ("Sandal-binder") fiddling with his sandal (**Figs. 188, 189**),[281] and the Eros stringing his bow (**Figs. 143, 144**).[282] Each is depicted in a situation that appears both intimate and somewhat inconsequential, though in reality each scene is a part of a narrative that is of great religious significance, as opposed to the intimate and banal representations of apoxyomenoi (**Figs. 71, 150**) and oil-pourers (**Figs. 124, 126**), for example, who perform the intimate and subsidiary activities of the athlete. Of course the parallel is much closer than this observation implies because the image of the athlete suggests the whole world of the palaestra, with numerous competitors and judges, as depicted on Panathenaic amphoras (**Fig. 121**), and because athletic success was of great moral and political significance, and statues were set up only to victors.[283] One striking but totally lost quality of these statues is that the originals were of bronze which was generally kept highly polished so that the figures shone, as though athletes covered in gleaming oil and sweat.[284] Color was equally important for marble statues, to judge by Pliny's report that Praxiteles was said to have judged his most important marble statues to be those that were painted by Nikias (*NH* 35.233).[285] The illusion of a natural scene conveyed by the originals was thus much enhanced over the somewhat cold and aloof preserved marble copies.

To return to the narrative, group statues all have a primary area from which they are best viewed, generally an arc of about 100 degrees, with the front of the chest—or, in the case of Hermes "Sandal-binder," the frontal face (**Fig. 188**)—serving as midpoint of the arc. As remarked above, this is typical of fourth-century sculpture. In each case an enclosed space is created by the gesture of the figures, usually by bringing an arm across the chest, or by the relationship of two figures interacting. It is evident that the later statues create a real, three-dimensional space encompassed by their reflexive gestures. This is obvious in the Vatican Apoxyomenos (**Fig. 150**) and the Vienna-Ephesos bronze strigil-cleaner (**Fig. 71**), but it does not apply to the diminutive raving mainad in Dresden

[280] Preisshofen, *AntP* 28 (2002) 41–115, pls. 21–64.

[281] Inan, *AntP* 22 (1993) 105–16, pls. 34–42.

[282] Döhl, *Eros des Lysipp* (note 156 above).

[283] As will be suggested below, the strigil appears to take on symbolic meaning as a sign of purity, though it is probably going too far to suggest that it does so in the statues; see chap. 6, p. 243 below.

[284] R. Wünsche, "Zur Farbigkeit des Münchener Bronzekopfes mit der Siegerbinde," in Brinkmann and Wünsche, *Bunte Götter*, 133–47; D. T. Steiner, "Moving Images: Fifth-Century Victory Monuments and the Athlete's Allure," *ClAnt* 17 (1998) 133, 138. See also chap. 3, p. 69 above.

[285] P. Jockey, "Praxitèle et Nicias, le débat sur la polychromie de la statuaire antique," in Pasquier and Martinez, *Praxitèle*, 62–81.

(**Fig. 190**).[286] Although the rotation of the body, the upward-turned head, and the presumed positions of the arms do produce a real space for the movement of the figure, the impression conveyed is of an unlimited openness which connects the mainad with two other famous statues often dated to the late fourth century, the Apollo Belvedere (**Fig. 239**)[287] and the statue often considered a companion to it, the Artemis of Versailles type (**Fig. 240**).[288] In both types movement is pronounced, and the axis of the head/line of sight is approximately perpendicular to the direction of the figure's movement. The sense of space is not so much concrete but infinite as a consequence of the strong directional movement of the figures and their broad, open gestures.[289] Another observation that leads in the same direction is that neither statue is conceived in the almost theatrical manner of the true fourth-century works discussed above: I can easily imagine the Dresden Mainad, the Apollo Belvedere, and the Artemis of Versailles standing in free space well away from their backdrops. Indeed, all three statues appear to me to demand such an open setting. If any of them belongs in the fourth century, then it could only be at its very end, though an early-third-century date seems more probable to me.

There are just two textual accounts that speak specifically of the setting of statues in the fourth century. One we have already had occasion to mention: Pliny's (*NH* 36.21) description of the shrine at Knidos which housed the Aphrodite by Praxiteles:

> The shrine in which it stands is entirely open so as to allow the image of the goddess to be viewed from every side, and it is believed to have been made in this way with the blessing of the goddess herself. The statue is equally admirable from every angle. (Trans. D. E. Eichholz, Loeb edition)

No great faith has been placed in this account because of the conflicting evidence of other ancient sources,[290] and its description of the open setting of the statue appears to conflict with the strong impression that statues in the fourth century were intended to be seen from a position more or less in front of them, as all the statues discussed above indicate. The diorama-like character of the compositions reinforces this observation. How-

[286] Dresden, SKD Herrmann 133 (ZV 1941): Knoll et al., *Antiken im Albertinum*, 28, no. 12*; Stewart, *Skopas*, 91–93, pl. 32; Ridgway, *Fourth-Century Styles*, 255–57, ill. 21a–d, pl. 61; Todisco, *Scultura greca*, no. 138; Boardman, *GS-LCP*, fig. 33; Bol, *Bildhauerkunst*, 335–36, figs. 306a–g (C. Maderna); Knoll, Vorster, and Woelk, *Katalog Dresden*, 890–96*, no. 212 (C. Vorster).

[287] Vatican, Museo Pio-Clementino 1015: Helbig⁴, vol. 1, no. 226 (W. Fuchs); B. Andreae, ed., *Bildkatalog der Skulpturen des Vatikanischen Museums*, vol. 2, *Museo Pio Clementino, Cortile Ottagono* (Berlin and New York 1998) pls. 49–59, with bibliography on p. 7*; O. Deubner, "Der Gott mit dem Bogen: Das Problem des Apollo im Belvedere," *JdI* 94 (1979) 223–44; N. Himmelmann, "Apoll vom Belvedere," in *Il cortile delle statue: Der Statuenhof des Belvedere im Vatikan; Akten des internationalen Kongresses zu Ehren von Richard Krautheimer, Rom, 21.–23. Oktober 1992*, ed. M. Winner, B. Andreae, and C. Pietrangeli (Mainz 1998) 211–25; *LIMC*, s.v. Apollon no. 79* (V. Lambrinoudakis); Todisco, *Scultura greca*, no. 226; Bol, *Bildhauerkunst*, 341–43, figs. 312a–f (C. Maderna). On very different grounds M. Fuchs, "'Nach allem, was schon über diesen Apoll gesagt worden. . .': Ist der Typus Belvedere für die griechische Kunst noch zu retten?" *BullCom* 105 (2004) 143–44, comes to essentially the same conclusion as here, that the Belvedere Apollo belongs in the early third century. But this agreement does not save the authenticity of the head in a Munich private collection: N. Himmelmann, "Apollon in München," *BullCom* 106 (2005) 161–66.

[288] Paris, Louvre Ma 589: Lippold, *Griechische Plastik*, 270, pl. 98.2; *LIMC*, s.v. Artemis/Diana no. 27* (E. Simon); Rolley, *Sculpture grecque*, 292–93, fig. 302; Ridgway, *Fourth-Century Styles*, 93–94; Todisco, *Scultura greca*, no. 228; Bol, *Bildhauerkunst*, 343–44, figs. 313a–h (C. Maderna).

[289] Borbein, *JdI* 88 (1973) 150–52, comes to the opposite conclusion.

[290] Borbein, *JdI* 88 (1973) 188–94 (Anhang I), and K. Stemmer, ed., *Standorte: Kontext und Funktion antiker Skulptur*, exh. cat. (Berlin 1995) 241–43, no. B79 (D. Damaskos), review the contradictory evidence for the setting of the Knidia. See also Ajootian, "Praxiteles," in *Personal Styles in Greek Sculpture*, YCS 30, ed. O. Palagia and J. J. Pollitt (Cambridge 1996) 102; A. Corso, "The Cnidian Aphrodite," in *Sculptors and Sculpture of Caria and the Dodecanese*, ed. I. Jenkins and G. B. Waywell (London 1997) 95; Corso, "The Cult and Political Background of the Knidian Aphrodite," *Proceedings of the Danish Institute at Athens* 5 (2007) 173, note 2; Stewart, *Art, Desire, and the Body* (note 277 above) 97.

ever, there is one ancient text that might clarify the problem with Pliny's statement about the Knidian Aphrodite's setting. Pausanias (1.20.1) describes a choregic monument for which Praxiteles made a statue thus:

> Leading from the Prytaneion is a road called Tripods. The place takes its name from the shrines (ναοί), large enough to hold the tripods which stand upon them, of bronze, but containing very remarkable works of art (μνήμης δὲ ἄξια μάλιστα περιέχοντες εἰργασμένα), one of which is a satyr, of which Praxiteles is said to have been very proud. (Trans. W. H. S. Jones and H. A. Ormerod, Loeb edition [slightly emended])

According to recent studies the Lysikrates Monument might resemble both the type of monument described by Pausanias and the setting of the Knidia described by Pliny because the original plan of the monument had open intercolumniations (which in the end had to be filled to support the heavy superstructure on which the bronze tripod was mounted),[291] and the space inside the columns could easily hold a statue in the manner suggested by Pausanias's description.[292] Although the view that the Knidian Aphrodite might have originally stood in a similar type of open structure is unlikely, the existence of round buildings, such as the tholos in the Marmaria at Delphi, the tholos of Epidauros, and the later Philippeion at Olympia, suggests that she might have stood in the center of a typical tholos,[293] since Pliny's account requires only that the statue be able to be viewed from all sides.[294] In such a case there would be no chronological difficulty with the type and size of the building. But what is really noteworthy here is the fact that the setting of the statue is mentioned at all, and that this concern with presentation is clearly of increasing interest in the fourth century. The remains of the large choregic monuments discovered along the west and south side of the Odeion in Athens indicate that they were significant structures that constitute real displays.[295] The one reasonably well-preserved example is 5 meters wide and 4 meters deep with two columns in antis.[296] The choregic monuments of Nikias and Thrasyllos,[297] both celebrating victories in the year 320/19, were larger by far and together

[291] H. Bauer, "Lysikratesdenkmal: Baubestand und Rekonstruktion," AM 92 (1977) 197–227; P. Amandry, "Monuments chorégiques d'Athènes," BCH 121 (1997) 463–87; Wilson, Khoregia, 222 and note 82, fig. 13 on p. 224.

[292] The round building at Knidos discovered by Iris Love was for a time thought to be the Temple of Aphrodite Euploia in which the statue once stood: I. C. Love, "A Preliminary Report of the Excavations at Knidos, 1969," AJA 74 (1970) 402–4; Love, "A Preliminary Report of the Excavations at Knidos, 1970," AJA 76 (1972) 70–75; Love, "A Preliminary Report of the Excavations at Knidos, 1971," AJA 76 (1972) 154–55. However, the identification is apparently erroneous; according to H. Bankel, "Knidos: Der hellenistische Rundtempel und sein Altar; Vorbericht," AA, 1997, 51–71, the building was dedicated to Athena and built in the third century; accepted by Rolley, Sculpture grecque, 257. However, Schultz, "Argead Portraits," 222 and note 138 on p. 232, accepts the earlier identification without discussion. On monopteroi, or open round structures of the type envisaged by modern commentators as the type of building described by Pliny, see F. Seiler, Die griechische Tholos: Untersuchungen zur Entwicklung, Typologie und Funktion kunstmässiger Rundbauten (Mainz 1986) 135–47.

[293] Seiler, Griechische Tholos (note 292 above) 56–135.

[294] A. Corso, "Praxiteles and the Parian Marble," in Paria Lithos: Parian Quarries, Marble and Workshops of Sculpture: Proceedings of the First International Conference on the Archaeology of Paros and the Cyclades, Paros, 2–5 October 1997, ed. D. U. Schilardi and D. Katsonopoulou (Paroikia 2000) 130, comes to a similar conclusion.

[295] M. Korres, "Περίκλειο Ὠδεῖο καὶ τὰ πλησίον χορηγικὰ μνημεῖα," ArchDelt 35 (1980 [1988]) B′ 1, 14–18; A. Khoremi-Spetsieri, "Η οδός των Τριπόδων καὶ τὰ χορηγικά μνημεία στην αρχαία Αθήνα," in The Archaeology of Athens and Attica under the Democracy, ed. W. D. E. Coulson, O. Palagia, T. L. Shear, Jr., H. A. Shapiro, and F. J. Frost (Oxford 1994) 31–42; and in general Wilson, Khoregia, 209–13.

[296] Korres, ArchDelt 35 (1980 [1988]) B′ 1, 16 (no. 8), plan 4 on p. 17; Wilson, Khoregia, 210, fig. 9, 213 and note 42.

[297] Wilson, Khoregia, 226–34. The Nikias monument was extraordinarily grand; it measured roughly 13 × 16 meters: W. B. Dinsmoor, "The Choregic Monument of Nicias," AJA 14 (1910) 459–84; Travlos, Pictorial Dictionary, 357–60; B. D. Wescoat, "Athens and Macedonian Royalty on Samothrace: The Pentelic Connection," in The Macedonians in Athens, 322–229 B.C., ed. O. Palagia and S. V. Tracy (Oxford 2003) 109–11, figs. 10, 11. On the Thrasyllos

with the Lysikrates Monument show how elaborate such monuments became near the end of the fourth century.[298] If the Knidia did stand in a tholos, perhaps something like the Philippeion at Olympia, the effect would have been dramatic: the statue standing in the center of an enclosed and covered space seen first from the open door. This would have been a truly spectacular presentation.[299] Whatever the case, in the fourth century statues clearly required strong participation on the part of the viewer, which simply means they were meant to be looked at, and they appear to have been set up accordingly.

VOTIVE RELIEFS

The closest comparisons for the images on grave stelai are those of the votive reliefs which parallel the reappearance and development of the funerary reliefs.[300] There are, of course, distinct differences between the two groups of monuments: although the votive reliefs do sometimes have architectural and even natural elements as frames, they do not usually share the naiskos frame of the grave reliefs, and their focus is rarely so concentrated. As mentioned in chapter 2, some votive reliefs were mounted on large pillars that made their generally modest size more impressive visually (**Fig. 91**); such pillars have been recovered from various sanctuaries and are occasionally depicted in the votive reliefs themselves (**Fig. 93**).[301] In the Athenian Agora, the base signed by Bryaxis was set up just where the Sacred Way jogs northward around the back of the Stoa Basileios and just 4 meters from the north wall of the Stoa of Zeus.[302] Homer Thompson notes that the inscription on the base faced to the northwest, that is, toward the road.[303] Obviously, large votive monuments were located so that they could be seen but not obstruct circulation. The suggestion that the profusion of relatively small votive reliefs may indicate that they were inexpensive and reflect some theoretical popular piety is untenable; the examples discussed here are all of marble, and even the smallest and meanest cannot have been inexpensive.[304] How the small reliefs were set up in sanctuaries is unknown, since there is no certain evidence that they were attached to walls or suspended, as is the case for the small terracotta plaques.[305] Rodenwaldt makes

monument: Travlos, 562–65; Amandry, *BCH* 121 (1997) 446–63. In general, see R. F. Townsend, "The Philippeion and Fourth-Century Athenian Architecture," in Palagia and Tracy, *Macedonians in Athens*, 96–98. For the statue that is connected with the monument of Thrasyllos, see chap. 2, p. 35, note 90 above.

[298] Most were of course quite simple: P. Amandry, "Trépieds d'Athènes: II. Thargélies," *BCH* 101 (1977) 165–202.

[299] Schultz, "Argead Portraits," 222–25. Schultz stresses the visibility from all sides as a general rule, but it is clear that this was never the case in the fourth century. In the case of the Philippeion the statues stood barely a meter from the wall behind, and this seems to be the norm in all the preserved cases, such as the Daochos Monument, the *Zanes* at Olympia, and the statues dedicated by Eurydike in the sanctuary of Eukleia at Vergina. The issue is, rather, that the enclosed space created a controlled setting for the statues which became a real space in which they appeared real and alive, dioramas similar to the statues of the Sauroktonos or Resting Satyr.

[300] Neumann, *Weihreliefs*, 47–48; Clairmont, *CAT, Introductory Volume*, 182–84.

[301] Chap. 2, pp. 41–42 above.

[302] H. A. Thompson, "Buildings on the West Side of the Athenian Agora," *Hesperia* 6 (1937) 7, 70; Thompson and Wycherley, *Athenian Agora* 14, 95, 223 and note 29, with earlier bibliography. A cavalry relief was discovered near the same spot in 1970: Athens, Agora I 7167: T. L. Shear, Jr., "The Athenian Agora: Excavations of 1970," *Hesperia* 40 (1971) 271–72, pl. 57c; Tzachou-Alexandri, *Mind and Body* (note 263 above) 335–37, no. 226*; Camp, *Athenian Agora: A Guide* (note 212 above) 204–5, fig. 132.

[303] Thompson, *Hesperia* 6 (1937) 7, note 2.

[304] M. Edelmann, *Menschen auf griechischen Weihreliefs* (Munich 1999) 180–81.

[305] G. Salapata, "Greek Votive Plaques: Manufacture, Display, Disposal," *BABesch* 77 (2002) 26–31; K. Karoglou, *Attic Pinakes: Votive Images in Clay*, BAR International Series 2104 (Oxford 2010) 6–8; J. Boardman, "Painted Votive Plaques and an Early Inscription from Aegina," *BSA* 49 (1954) 183–201.

the logical suggestion that they were placed wherever there was appropriate space, which could be on benches, tables, along walls, etc.[306] Although not usually described in publications of votive reliefs, the manner in which the backs are treated probably indicates several different manners of display. Some, such as the Xenokrateia relief from New Phaleron (**Figs. 91, 92**)[307] and a relief of the early fourth century in Princeton,[308] have rough-picked backs. Others have backs with traces of a fine pointed chisel,[309] and a few have a round hole cut in the back, possibly for attachment.[310] Some have a coarse tenon for insertion either into a raised base or possibly just the ground.[311]

It seems clear that the small size of the vast majority of votive reliefs, the predilection for a horizontal format, and the frequent lack of an architectural frame or the depiction of the side of a pitched roof with antefixes all establish an appearance for the reliefs that triggered immediate recognition of their function by the ancient viewer (**Figs. 141, 214, 242**).[312] Perhaps this observation applies particularly to Attica because a stele from Thebes in Boiotia with a simple pedimental crown is uncertainly interpreted as either votive or funerary (**Fig. 241**).[313] The stele is relatively large, ca. 1.40 meters high and 1.25 meters wide. On the left is a seated woman and, on the right, a seated, bearded man; behind the man is a standing woman; in the middle, a bearded man and a youth. The stele is dated around 400 B.C., and its iconography has nothing to do with the contemporary or later Attic tradition of either grave or votive reliefs. Given its size and format, it nonetheless seems likely that the relief is funerary, which is the consensus of earlier studies, though the function of East Greek reliefs of the first half of the fifth century is at times difficult to determine.[314]

The standard subject of votive reliefs in the fourth century is the depiction of the votary, either alone or in a group, in the presence of a divinity or divinities.[315] The juxtaposition of divinity and worshiper(s) parallels the representation on the grave reliefs of the living and the dead in the same space. Since such an arrangement was already common

[306] G. Rodenwaldt, *Das Relief bei den Griechen* (Berlin 1923) 68–69. See generally F. T. van Straten, "Votives and Votaries in Greek Sanctuaries," in *Le sanctuaire grec: Huit exposés suivis de discussions*, Fondation Hardt: Entretiens sur l'antiquité classique 37, ed. O. Reverdin and B. Grange (Geneva 1992) 247–74. See p. 154 above on Mime 4 of Herodas and the placement of a votive pinax at the right hand of Hygieia.

[307] Athens, NAM 2756; see p. 167 and note 91 above.

[308] Princeton University Art Museum y1978–3: B. S. Ridgway et al., *Greek Sculpture in the Art Museum, Princeton University* (Princeton 1994) 15, no. 3.

[309] Athens, NAM 2490: Mitropoulou, *Votive Reliefs*, 46, no. 68: "traces of fine pointed chisel"; ibid., 47, no. 69, fig. 107 (Delos A 3139).

[310] Athens, Ephoria Γʹ, 5a (storeroom): Mitropoulou, *Votive Reliefs*, 51, no. 86, fig. 135: "lines of fine pointed chisel and a hole (depth 0.07, diameter 0.02)." Athens, NAM 3572: ibid., 54, no. 92, fig. 140: "Traces of fine pointed chisel and a round hole (diameter 0.06, depth 0.04)."

[311] Athens, NAM 1340: Mitropoulou, *Votive Reliefs*, 58, no. 106, fig. 153; the back has "traces of coarse pointed chisel." Athens, NAM 3369: Kaltsas, *SNAMA*, 209–10, no. 425*; Neumann, *Weihreliefs*, 51, 67, pl. 28; *LIMC*, s.v. Amphiaraos no. 63*; Ridgway, *Fourth-Century Styles*, 95–96, pl. 49; Comella, *Rilievi votivi* (note 8 above) 132, no. 134, 216 (Oropos no. 5*); Boardman, *GS-LCP*, fig. 142.

[312] Neumann, *Weihreliefs*, 50–51.

[313] Athens, NAM 1861: Kaltsas, *SNAMA*, 164–65, no. 325*; M. Collignon, "Bas-relief funéraire de Béotie: Musée National d'Athènes," *MonPiot* 3 (1896) 31–37, pl. 3; G. Rodenwaldt, "Thespische Reliefs," *JdI* 28 (1913) 331–32, fig. 9; Picard, *Manuel*, vol. 3.1, 174–75, fig. 51; S. Karouzou, *National Archaeological Museum: Collection of Sculpture; A Catalogue* (Athens 1968) 138; W. Schild-Xenidou, *Boiotische Grab- und Weihreliefs archaischer und klassischer Zeit* (Munich 1972) 37–39, no. 40; Clairmont, *CAT*, 5.650.

[314] N. M. Kontoleon, *Aspects de la Grèce préclassique* (Paris 1970) 23–27; H. Hiller, *Ionische Grabreliefs der ersten Hälfte des 5. Jahrhunderts v. Chr.*, IstMitt-BH 12 (Tübingen 1975) 126, 135; Neumann, *Weihreliefs*, 3. The stele from Ikaria is indeed similar in size and format to the relief from Thebes, having a simple pediment and no side frames: Kontoleon, pl. I.

[315] Edelmann, *Menschen auf griechischen Weihreliefs* (note 304 above).

in the sixth century,[316] and, as just mentioned, in the East Greek reliefs of the earlier fifth century, it is at times difficult to distinguish a grave relief from a votive relief.

In the fourth century, the divinities usually sit or stand on one side of an altar while worshipers laden with the paraphernalia of sacrifice approach from the other side of the altar (**Fig. 141**),[317] though a not insubstantial number of reliefs show a votary close to or even touching the divinity.[318] In most of the reliefs there is little or no indication of locality other than the altar, but in a number of them natural settings and architecture are represented in some detail. There are several notable votive reliefs to Asklepios and Hygieia with setting depicted. In the simplest example Hygieia leans against a tree trunk (**Fig. 242**).[319] On a relief in Copenhagen a man is carried on a litter in front of a tree in which a snake climbs, while one of the litter bearers and a young man on the left throw stones at the snake.[320] The style, and therefore the date, of the relief is difficult to judge, but it may be of the late fifth century.

The very fragmentary stele of Telemachos from the Asklepieion in Athens, reconstructed by Luigi Beschi, has a complex architectural setting represented only in low relief (**Fig. 90**).[321] Beschi presents convincing arguments that the architecture is that of the Asklepieion in Athens itself. The relief dates to the late fifth or early fourth century and is notable because two copies of it were made. Another particularly impressive example is a relief with a fully plastically rendered building next to the scene of sacrifice.[322]

Some votive reliefs have elaborate natural settings. One such example is the well-known fragmentary relief in the Museo Torlonia in Rome: a man leading a horse and followed by a dog on the viewer's right walks toward a rustic altar and a male votary on the left.[323] Behind this scene is a rocky surface on which two seated figures (broken off at the waist and mid-torso, respectively) at the sides face the center; the lower part of a central naiskos is preserved, in which is a figure, probably a statue. The male figure in the foreground is interpreted as a hero, and the seated figures above as divinities. Votive reliefs dedicated to the nymphs almost always have a natural setting, normally a rough cave and hillside with goats, which is the natural place for a cult of the nymphs and indeed is the

[316] The small marble votive relief of a family bringing a sow to Athena (Athens, Acrop. 581) precisely parallels the Late Classical votive reliefs: Brouskari, *Acropolis Museum*, 52–53, fig. 94; Boardman, *GS-AP*, fig. 258. Edelmann, *Menschen auf griechischen Weihreliefs* (note 304 above) 176, states that the Acropolis relief is unique, but the Pitsa painted plaque also shows a family approaching an altar with sacrificial sheep: Neumann, *Weihreliefs*, 27, pl. 12a; J. Charbonneaux, R. Martin, and F. Villard, *Archaic Greek Art (620–480 B.C.)* (New York 1971) 312, fig. 357; admittedly, the divinity is not present here.

[317] Van Straten, "Votives and Votaries" (note 306 above) 274–84; F. T. van Straten, *Hierà Kalá: Images of Animal Sacrifice in Archaic and Classical Greece* (Leiden 1995).

[318] Athens, NAM 1408: Kaltsas, *SNAMA*, 220, no. 457*; see generally van Straten, "Images of Gods and Men" (note 91 above) 250–53, figs. 3, 4, 7.

[319] Athens, NAM 1333: Kaltsas, *SNAMA*, 226, no. 475*.

[320] Copenhagen, NCG 2308: Poulsen, *Catalogue*, 173–75, no. 233a; Moltesen, *Classical Period*, 130, no. 67*; Comella, *Rilievi votivi* (note 8 above) 86–87, 206 (Calcidica no. 1), fig. 80.

[321] L. Beschi, "Il monumento di Telemachos, fondatore dell'Asklepieion ateniese," *ASAtene* 45–46 (1967–68) 382–436; Beschi, "Il rilievo di Telemachos ricompletato," *AAA* 15 (1982) 31–43; *LIMC*, s.v. Asklepios no. 394* (B. Holzmann); B. S. Ridgway, "Painterly and Pictorial in Greek Relief Sculpture," in *Ancient Greek Art and Iconography*, ed. W. G. Moon (Madison, WI, 1983) 199–201, figs. 13.6, 13.7; Rouveret, *Histoire et imaginaire*, 336–42, figs. 18a–c; Güntner, *Göttervereine*, 146–47, no. C53, pl. 25 (drawing); Vikela, *AM* 112 (1997) 170, 190, fig. 3 on p. 191; Stafford, *Worshipping Virtues*, 153–56, 159; Wulfmeier, *Griechische Doppelreliefs* (note 92 above) 141–48, pls. 21, 22.

[322] Athens, NAM 1377: Kaltsas, *SNAMA*, 215, no. 442*; Neumann, *Weihreliefs*, 51, fig. 29.

[323] Rome, Museo Torlonia 433: Mitropoulou, *Votive Reliefs*, 40–41, no. 58, fig. 94; Ridgway, "Painterly and Pictorial" (note 321 above) 202, fig. 13.12; Güntner, *Göttervereine*, 147, no. C54, pl. 26.2; Comella, *Rilievi votivi* (note 8 above) 53–54, 221 (Roma no. 3), fig. 40; Himmelmann, *Ausruhende Herakles*, 53.

most frequent findspot of the preserved examples, the sanctuaries at Vari and on Mount Pentelikon (**Fig. 94**).[324]

Why architecture and natural settings occur in the other votive reliefs in not known. The inclusion of elements of setting had been popular in Attic vase painting at the end of the sixth century and had occurred sporadically on vases of various origins throughout the sixth century.[325] Evelyn Harrison has reconstructed the shield of the Athena Parthenos with an elaborate cityscape surmounting the rocky slopes of the Athenian Acropolis.[326] The reliefs of the fourth century do not depart greatly from the earlier reserve in the depiction of settings, though the intimation of an extension of real rather than conceptual space is new and noticeable. This is particularly clear in the votive reliefs to Herakles discussed above (**Figs. 139, 140, 221**).[327]

If we accept the argument that the reliefs dedicated to Asklepios and Hygieia reflect the architecture of their sanctuary in Athens and that the cave setting of the reliefs dedicated to the nymphs is also a reflection of the rural sanctuaries where the nymphs were worshiped, then the naiskos in the reliefs dedicated to Herakles must also be an element of his cult. There is no obvious explanation of the natural setting of the Torlonia hero relief cited above. The hero and horse motif in Attic votive reliefs of the late fifth century have no indication of setting,[328] and in the fourth century the horse is regularly reduced to a mere protome presented in an architectural frame next to banquet scenes.[329] The motif of a man walking with a horse does appear on Attic marble lekythoi of the fourth century and on a few grave stelai.[330] But of course none of these includes any indication of context. The formal relationship of the man and horse on the grave lekythoi to the figure on the Torlonia relief probably suggests the heroic quality of the lekythoi but fails to address the purpose of the landscape of the relief.

Another relief with hero and indication of setting has been reconstructed by Beschi from fragments in Athens and Aquila, in Italy, and a drawing dating around 1600 of a now lost fragment of the same subject.[331] As with the Telemachos relief, there existed two copies, and one made its way to Italy. The main part of the picture is a warship being rowed at full tilt to the viewer's right, above and to the right of which a large youthful figure sits on rocky ground, accompanied by a dog. Beschi suggests that the youthful figure is Paralos,

[324] W. Fuchs, "Attische Nymphenreliefs," *AM* 77 (1962) 242–49; Edwards, "Votive Reliefs to Pan," 52–63.

[325] W. A. P. Childs, "The Lycian City-Reliefs and Their Mediterranean Traditions" (Ph.D. diss., Princeton University, 1971) 200–365; M. Carroll-Spillecke, *Landscape Depictions in Greek Relief Sculpture: Development and Conventionalization* (Frankfurt am Main and New York 1985).

[326] E. B. Harrison, "Motifs of the City-Siege on the Shield of Athena Parthenos," *AJA* 85 (1981) 281–317, pls. 46–54.

[327] See p. 162 with note 63 above.

[328] Mitropoulou, *Votive Reliefs*, 127–29; Himmelmann, *Ausruhende Herakles*, 48–58.

[329] Dentzer, *Banquet couché* (note 27 above) 490–93; Himmelmann, *Ausruhende Herakles*, 40–41. The impressive Symmachos relief from Pharsalos in the Volos Archaeological Museum, Λ 391, continues the earlier tradition, combining in this case a hero leading a horse next to a seated figure of Hestia, both facing a group of five votaries: H. Biesantz, *Thessalischen Grabreliefs: Studien zur nordgriechischen Kunst* (Mainz 1965) L50, pp. 31, 105, 151, 170, pl. 47; S. G. Miller, "Hestia and Symmachos," *OpRom* 9 (1973) 167–72, figs. 1–4; *LIMC*, s.v. Heros Equitans no. 85 (A. Cermanović-Kuzmanović et al.); Himmelmann, *Ausruhende Herakles*, 53–54.

[330] Woysch-Méautis, *Représentation des animaux* (note 32 above) nos. 29–64a; Clairmont, *CAT*, 1.226, 1.434, 2.220a, 2.331, 2.444, 2.651, 2.710, 2.867a, 3.217, 3.694, 4.219, 4.770.

[331] Athens, Acrop. 1339 plus scattered fragments: L. Beschi, "Rilievi votivi attici ricomposti," *ASAtene* 47–48 (n.s., 31–32) (1969–70) 117–32, figs. 18–24; *LIMC*, suppl. vol. 8, s.v. Paralos no. 3 (A. Johnston); Ridgway, "Painterly and Pictorial" (note 321 above) 202, fig. 13.13 (drawing); Vikela, *AM* 112 (1997) 190, fig. 3.

the reputed inventor of ships, and the ship is the Attic ship of the same name.[332] The rocky ground on which the youthful "hero" sits above the ship could be a promontory, such as the Piraeus or Sounion, from which the "hero" watches over his ship. However uncertain their interpretation may be, it is clear that votive reliefs allow settings, whereas they are studiously avoided in most other sculptural monuments. The settings must be an indication of the nature of the hero or divinity, even if we cannot assign a name or mythology to the figure(s).

Several votive reliefs go beyond a merely rudimentary depiction of setting and create rather complex scenes. For example, an unfortunately very fragmentary relief from the Athenian Asklepieion depicts a complex scene that may be mythological (**Fig. 243**).[333] The lower part of the relief is occupied by a conical mass, probably a mountain. At the bottom left a small nude male figure faces right, where there is a deep depression in the stone in which there is a coiled snake with rearing head; above the depression a dog moves toward the right, which is lost. Above and to the left, partly overlapped by the mountain, stands a woman facing right; she rests one hand on the top of the mountain. At the very top a man sits facing to the right with his mantle wrapped around his lower torso and holding his proper right hand up and to the side; it must have held a vertical staff, very much a traditional motif for a god. The relief has been interpreted as the birth of Asklepios or the image of a healing dream; the latter is a frequent element in votive reliefs to Asklepios.[334] In either case, the setting has a specific reference to an aspect of cult.

A similarly complex but somewhat better preserved relief from Thessaly represents a large seated male with mantle thrown over his legs and a much smaller seated female figure, possibly Dionysos and Ariadne, in a rocky landscape accompanied by three groups of satyrs involved in various activities (**Fig. 244**).[335] The rocky terrain may indicate the wilds in which satyrs dwell and Dionysos reigns, but what the satyrs are up to is unclear. Beneath the divine couple, on the lower right of the relief, a lone satyr with what appears to be a lagobolon tucked under his arm escorts (?) a panther. In the center, a satyr pirouettes next to a rectangular relief (?) on a typical high stand next to a tree; and, at the left, a badly damaged group of figures of different sizes appears to be subduing a rearing animal of uncertain type (a horse?).

What is particularly interesting in all these votive reliefs with architecture or natural setting is the idea that setting conveys an important aspect of the function of the votive. This is not totally new in the fourth century: the sixth-century votive terracotta plaques from Pentaskouphia in the Corinthia depict the kilns in which pots were fired and even laborers in the (clay?) pits.[336] The hypothesis has been advanced that the classical reliefs

[332] *LIMC*, suppl. vol. 8, s.v. Paralos, pp. 941–42 (A. Johnston). An inscription of the second half of the fourth century from the Mahdhia shipwreck cites Paralos and his sanctuary, the Paralion, perhaps at the Piraeus: G. Petzl, "Die griechischen Inschriften," in *Das Wrack: Der antike Schiffsfund von Mahdia*, ed. G. H. Salies, H.-H. von Prittwitz und Gaffron, and G. Bauchhenss (Cologne 1994) vol. 1, 386–89. Paralos is depicted on a vase by the Jena Painter: Paul-Zinserling, *Jena-Maler*, pl. 47.2.

[333] Athens, NAM 1351: Beschi, *ASAtene*, 47–48 (n.s., 31–32) (1969–70) 99, fig. 8; *LIMC*, s.v. Artemis no. 1279* (L. Kahil); Ridgway, "Painterly and Pictorial" (note 321 above) 203–4, fig. 13.15; Ridgway, *Fourth-Century Styles*, 200, pl. 53; Vikela, *AM* 112 (1997) 190–92, pl. 23.2; Comella, *Rilievi votivi* (note 8 above) 102–3 (Atene no. 94), fig. 95.

[334] F. van Straten, "Daikrates' Dream: A Votive Relief from Kos, and Some Other Kat'onar Dedications," *BABesch* 51 (1976) 1–27.

[335] Volos, Archaeological Museum 421: BrBr 785a, 785b, no. V, pp. 22–23, fig. 2 on p. 21 (K. Schefold); Ridgway, "Painterly and Pictorial" (note 321 above) 205, fig. 13.17.

[336] *AntDenk* 1 (1891), pls. 7, 8; *AntDenk* 2 (1898), pls. 23, 24; A. Chatzidemetriou, Παραστάσεις εργαστηρίων και εμπορίου στην εικονογραφία αρχαϊκών και κλασικών χρόνων (Athens 2005) 32–33, pls. 1–3; N. Cuomo di Caprio,

reflect "popular" art like the Pentaskouphia plaques, but this is circular reasoning. Votive plaques, whether "popular" and inexpensive or "elite" and expensive, function in the context of cult and can hardly be subjected to twentieth-century art-historical categories.[337] This is perhaps best demonstrated by a relief from the Amphiareion in Oropos that depicts the act of healing twice within a single framed scene (**Fig. 245**).[338] On the left, the large male figure of the god appears to bandage the upper arm of a smaller young man; on the right, presumably the same young man lies on a bed and a snake bites him at the same place on his arm; on the extreme right of the relief, the young man, depicted for a third time and clearly the votary of the relief, raises his hand in reverence. The complex narrative here has nothing to do with some hypothetical "popular" strain in ancient art. Rather, the votive reliefs with settings reveal a fundamental principle of Greek art of the fourth century: appearance expresses content. The spatial ambiguity is not astonishing because Greek art from its very beginning had embraced interleaved spatial and temporal elements, such as the combined prothesis and ekphora of the Dipylon Painter on the large Late Geometric amphora in Athens (no. 803).[339] The *locus classicus* is the kylix in Boston by the Painter of the Boston Polyphemos[340] with the episode from the *Odyssey* at the palace of Kirke, in which three or four temporal units are depicted together: Kirke turns Odysseus's men into swine; Antilochos rushes off to warn Odysseus; Odysseus rushes in with drawn sword to save his men; and Kirke is depicted naked, probably a reference to the denouement of the event, when she and Odysseus make up in bed.

An overriding impression conveyed by the votive reliefs is that the gods are immanent, present in the sanctuary and at the sacrifice which is so often the subject of the reliefs.[341] Even if this is not a new concept in the fourth century, the intimacy of the interaction of the gods and mortals is forcefully expressed by such details as the figure of Hygieia leaning against a tree or votive pillar. The emphasis on the locative aspects of the cave of the nymphs and probably the naiskos of the reliefs dedicated to Herakles underscores this impression. This is also the probable motivation for the other architectural and landscape elements of the reliefs—the gods are not just anywhere, and particularly not isolated on Mount Olympos, but actually present on earth.

The votive relief clearly did not normally have the impressive quality of a funerary stele, a statue, or a statue group. Focusing on the appearance of a "popular" quality defined by the difference in size and expense avoids the fact that funerary stelai also present increasingly intimate scenes of family members mourning the deceased. Statues and even publicly sponsored statue groups were also adopting a "popular" quality in the fourth century. In the case of the larger groups, this is difficult to demonstrate convincingly, though the event behind the Krateros Monument in Delphi is certainly to be classed as such, if the base in Paris does reflect its basic form. The base of the statue of Poulydamas by Lysippos in Olympia is equally anecdotal. And the repeatedly cited statues of the Resting Satyr, the

"Pottery Kilns on Pinakes from Corinth," in *Ancient Greek and Related Pottery: Proceedings of the International Vase Symposium in Amsterdam, 12–15 April, 1984*, Allard Pierson Series 5, ed. H. A. G. Brijder (Amsterdam 1984) 77–82, figs. 1–18; Charbonneaux, Martin, and Villard, *Archaic Greek Art* (note 316 above) 75, fig. 80.

[337] Karoglou, *Attic Pinakes* (note 305 above) 49–61.

[338] Athens, NAM 3369: see note 311 above.

[339] Athens, NAM 803: B. Schweitzer, *Die geometrische Kunst Griechenlands* (Cologne 1969) fig. 35.

[340] Boston, MFA 99.518: *ABV* 198; *Paralipomena* 80; *Beazley Addenda*[2] 53; Himmelmann, *Reading Greek Art*, 68, fig. 1.

[341] Ridgway, *Fourth-Century Styles*, 196–97, 205.

Apollo Sauroktonos, and the Knidian Aphrodite all qualify as depictions of banal, common, human moments. It is nonetheless true that the votive reliefs convey a more private and intimate relationship with the divine than the funerary stelai do in their own sphere, or the freestanding statues and groups in their sphere. Rather than denigrating them as "popular," it seems to me that they express an intimate relationship with the divine and the heroic. That is, they express reverence and the immanence of the gods more directly.

5B Form and Presentation

Architectural Sculpture

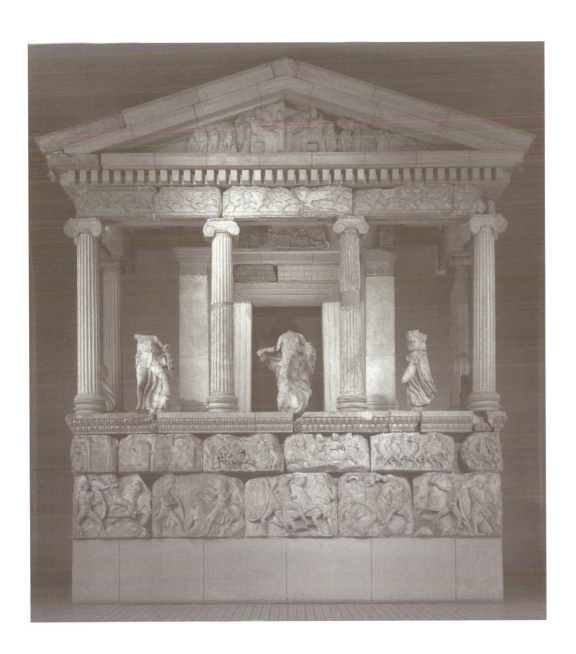

The wealth of architectural ornament in the fourth century, including figural sculpture, is a direct successor of the developments in Athens at the end of the fifth century, specifically, the introduction of the East Greek architectural vocabulary. The Ilissos temple and the Parthenon begin the change, which takes full form in the Temple of Athena Nike and the Erechtheion. This architectural sculpture is just part of a rich embellishment of architecture, not just a continuation or elaboration of earlier forms—the Ionic and then the Corinthian capital and column base, complex moldings of doors, ornate anthemia on gutters (simas), and other moldings.[1] The ornateness of architectural ornament is paralleled both by the development of mosaics and by ornate metalwork and its reflection in stone vessels used for grave monuments. Indeed, the very opulence of freestanding sculpture of the Plain Style in the fourth century is closely analogous.

ARCHITECTURAL FRIEZES

The public monument differs in an important respect from the private dedications in sanctuaries: the monuments stand in the mainstream of the life of the community. While the Lesche of the Knidians at Delphi[2] was set away from the center of the sanctuary, the Stoa Poikile in Athens with its painted scenes occupied a central location.[3] The Stoa of Zeus with its painting by Euphranor continues the tradition down into the fourth century.[4] The later fame of many of the monumental paintings on or in buildings must reflect an original wonder and pride that goes well beyond the religious function of all such ornament. Euripides reflects this unambiguously in *Ion* (184–218), where he has the Athenian chorus enter and exclaim that not only in Athens are there lovely buildings decorated with mythological scenes. The women of the chorus then seem to compete with each other to identify the various subjects of the decoration of the Temple of Apollo at Delphi. Admittedly, in this case the decoration is generally understood to be sculpture, but it certainly need not be, and the subjects identified have little to do with the known sculptural decoration of the old Alkmaionid Temple of Apollo. Whatever the case, it is only architectural sculpture that is preserved today and, with few exceptions, only in fragments. Although nothing can be said of the composition of the Erechtheion frieze of the late fifth century, the use of dark Hymettan marble as a ground on

[1] Tegea 254, 255: Dugas, Berchmans, and Clemmensen, *Sanctuaire d'Aléa Athéna*, pls. 79, 88.C, 95.D; A. A. Stavridou, *Τα γλύπτα του Μουσείου Τεγέας* (Athens 1996) 64, no. 20*.

[2] Bommelaer and Laroche, *Delphes: Le site*, 202–4, no. 605; on the location in the sanctuary, pl. 5, after p. 239 (here **Fig. 236**).

[3] T. L. Shear, Jr., "The Athenian Agora: Excavations of 1980–1982," *Hesperia* 53 (1984) 4–19; J. McK. Camp, *The Athenian Agora: A Guide to the Excavation and Museum*, 4th ed. (Athens 1990) 101–9; Thompson and Wycherley, *Athenian Agora* 14, 90–94.

[4] Pliny, *NH* 35.128; Pausanias 1.3.3–4; Thompson and Wycherley, *Athenian Agora* 14, 96–103.

which white Pentelic marble figures were affixed by dowels gives some idea of the decorative effects sought (**Fig. 3**).[5] The long parapet of the Temple of Athena Nike at the entrance of the Acropolis also indicates that the visual effect was intended to be spectacular (**Fig. 160**).[6] How the metopes of the Temple of Hera at the Argive Heraion may have looked is difficult to judge.[7] The carving was deep, the figures were active.

The best-preserved and best-published sculpture of the Temple of Apollo Epikourios at Bassai indicates both the continuation of rich sculptural decoration and an ornate architectural setting.[8] The interior engaged colonnade of the cella is Ionic except for the earliest known Corinthian capitals, which were used on the central freestanding column and the two framing columns at the rear that carried the internal frieze across the cella at that point to create a small adyton-like space beyond.[9] The temple also had six carved metopes over the pronaos and opisthodomos, four of which are novel in that they appear to have had just one figure.[10]

The interior Ionic frieze was divided unevenly into an Amazonomachy and a Centauromachy (**Figs. 23–25**).[11] The composition of the Amazonomachy contains a few pyramidal groupings but is essentially a series of diverse two- and three-figure groups with slight overlappings. The Centauromachy intersperses Lapiths among a regular sequence of the broad bodies of centaurs (BM 527) or the deer of the chariot of Apollo and Artemis (BM 523) or the broad planes of the scene of rape at the cult statue (BM 524). The occasional use of radical foreshortening,[12] such as the fallen centaur seen from the top of his head (BM 527), and legs disappearing into the background (BM 536), or mild foreshortening, such as the chariot wheel (BM 523) and the rearing horse (BM 534), hardly disturb the otherwise simple projections of the figures. The real plasticity of the figures and the depth of the relief (roughly 12 cm) are far greater in relation to the height of the frieze blocks (64 cm) than those of the great tombs of Asia Minor, such as the Nereid Monument of

[5] Boulter, *AntP* 10 (1970) 7–24, pls. 1–30; L. Shoe, "The Use of Dark Stone in Greek Architecture," in *Commemorative Studies in Honor of Theodore Leslie Shear, Hesperia* suppl. 8 (Baltimore 1949) 347–48.

[6] R. Carpenter, *The Sculpture of the Nike Temple Parapet* (Cambridge, MA, 1929); A. F. Stewart, "History, Myth, and Allegory in the Program of the Temple of Athena Nike, Athens," in *Pictorial Narrative in Antiquity and the Middle Ages*, Studies in the History of Art 16, ed. H. L. Kessler and M. S. Simpson (Washington, DC, 1985) 53–73; T. Hölscher, "Ritual und Bildsprache: Zur Deutung der Reliefs an der Brüstung um das Heiligtum der Athena Nike in Athen," *AM* 112 (1997) 143–66, pls. 18, 19; E. Simon, "An Interpretation of the Nike Temple Parapet," in *The Interpretation of Architectural Sculpture in Greece and Rome*, ed. D. Buitron-Oliver (Washington, DC, 1997) 126–43; P. Schultz, "The Date of the Nike Temple Parapet," *AJA* 106 (2002) 294–95.

[7] C. Waldstein, *The Argive Heraeum*, vol. 1 (Boston 1902) 146–48, pls. 30–35, 39, 40; F. Eichler, "Die Skulpturen des Heraions bei Argos," *ÖJh* 19 (1919) 15–153.

[8] F. A. Cooper, *The Temple of Apollo Bassitas*, vols. 1, 3, and 4, *The Architecture* (Princeton 1996); Madigan, *Apollo Bassitas*; H. Kenner, *Der Fries des Tempels von Bassae-Phigalia* (Vienna 1946); Hofkes-Brukker and Mallwitz, *Bassai-Fries*.

[9] Cooper, *Apollo Bassitas* (note 8 above) vol. 1, 293–95, vol. 3, pls. 68–70, restores only the center column with a Corinthian capital, but only with the greatest difficulty can Ionic capitals be set on the angled engaged columns on either side; see Hofkes-Brukker and Mallwitz, *Bassai-Fries*, 30–33; G. Gruben, *Die Tempel der Griechen*, 4th ed. (Munich 1986) 126 and fig. 115 on p. 125. See most recently D. Scahill, "The Origins of the Corinthian Capital," in *Structure, Image, Ornament: Architectural Sculpture in the Greek World: Proceedings of an International Conference Held at the American School of Classical Studies, 27–28 November 2004*, ed. P. Schultz and R. von den Hoff (Oxford 2009) 40–53.

[10] Madigan, *Apollo Bassitas*, 9–37, pls. 1–35.

[11] According to the reconstruction of Madigan, *Apollo Bassitas*, 77, the Amazonomachy encroached one block on the east long side (BM 535: *Apollo Bassitas*, vol. 4, pls. 58, 60). He also suggests (vol. 2, 70–78) that both the Trojan and Athenian Amazonomachy were represented. The actual presentation of the frieze in the British Museum follows the reconstruction of Peter Corbett and G. U. S. Corbett, for which the evidence currently available is the most convincing: I. Jenkins and D. Williams, "The Arrangement of the Sculptured Frieze from the Temple of Apollo Epikourios at Bassae," in *Sculpture from Arcadia and Laconia*, ed. O. Palagia and W. Coulson (Oxford 1993) 57–77.

[12] Madigan, *Apollo Bassitas*, 95.

Xanthos or the tomb of Maussollos of Karia at Halikarnassos (see below), possibly because of their location in an enclosed space; the larger, exterior, metopes of the tholos at Delphi, of just slightly later date, are closely similar in dimensions, however.[13] Who might enter any temple, and particularly the temple at Bassai on its high mountain ridge, is unknown, but there is ample evidence that many temples were accessible and that prayer to a divinity was thought to be particularly effective if made in the presence of a cult statue,[14] so one need not consider the ornate interiors of temples such as Bassai as only an *agalma* for the god(s).[15] Pausanias (8.41.4) praises the temple for "the beauty of the stone and for its harmony" (τοῦ λίθου τε ἐς κάλλος καὶ τῆς ἁρμονίας ἕνεκα) but does not mention the metopes, the interior Ionic colonnade, or the frieze. This, however, is of no help because Pausanias's reasons for describing something in detail are mostly obscure, for example, his long descriptions of the chest of Kypselos at Olympia, the paintings of the Lesche of the Knidians at Delphi, and the pedimental sculptures at Tegea mentioned above.[16]

The tholos in the Marmaria at Delphi is a little later than the Temple of Apollo at Bassai.[17] Although the final publication is awaited, numerous articles and the display in the museum give a reasonably good impression of this beautiful building. Stylistic analysis suggests a date between 390 and 380. It had eighty carved metopes distributed on the exterior peristyle and around the circular cella building; the latter were smaller (height 42 cm) than the former (height 65 cm), which allows the numerous fragments to be assigned to one series or the other (**Figs. 26, 27**). The relief, like the frieze at Bassai, is very deep (12–13 cm),[18] and most of the figures have been hacked off their backing. On the exterior, the subject was an Amazonomachy and a Centauromachy; the interior series probably depicted the exploits of Herakles and Theseus, though it also had numerous quietly standing figures.[19] Three of the exterior metopes have been largely reconstructed in the museum; one depicts a Greek being beaten down by an Amazon in a lively graphic pattern of parallel and perpendicular diagonals.[20] A similar but even more daring composition depicts a Greek struggling with a rearing horse (**Fig. 26**);[21] again there are crossed and partially parallel diagonals, but the different volumes of the horse and man create an explosive pat-

[13] Nereid Monument, frieze I: height 1.01 m, average depth of relief 8–9 cm; frieze II: height 0.62 m, average depth of relief 7–8 cm. Maussolleion at Halikarnassos: height of Amazonomachy frieze: 0.90 m, average depth of relief 4–5 cm. Ian Jenkins very kindly measured the relief height of the Bassai and Maussolleion friezes for me in December 2005. On the tholos at Delphi, see below.

[14] P. E. Corbett, "Greek Temples and Greek Worshippers: The Literary and Archaeological Evidence," *BICS* 17 (1970) 149–58; Scheer, *Gottheit*, 68.

[15] W. B. Dinsmoor, "The Temple of Apollo at Bassae," *MMS* 4 (1932–33) 212–13.

[16] See chap. 3, pp. 84–85 above.

[17] Charbonneaux, *FdD* 2.B.4.2; G. Roux, "La tholos d'Athéna Pronaia dans son sanctuaire de Delphes," *CRAI*, 1988, 290–309, 835–39; D. Laroche, "La tholos de Delphes: Forme et destination," in *Delphes: Centenaire de la grande fouille réalisée par l'École française d'Athènes, 1892–1903; Actes du colloque Paul Perdrizet, Strasbourg, 6–9 novembre 1991*, ed. J.-F. Bommelaer (Leiden 1992) 207–23; J. Marcadé, "A propos du décor en marbre des monuments de Marmaria," in *Delphes: Centenaire de la grande fouille réalisée par l'École française*, 251–62; J.-F. Bommelaer, *Marmaria: Le sanctuaire d'Athéna à Delphes*, Sites et monuments 16 (Athens and Paris 1997) 59–73.

[18] Delphi 4314.7 + 4314.2 + 4476.11: P. Bernard and J. Marcadé, "Sur une métope de la tholos de Marmaria à Delphes," *BCH* 85 (1961) 450.

[19] Picard, *Delphes: Le musée*, 66–75.

[20] Delphi 4314.7 + 4314.2 + 4476.11: Bernard and Marcadé, *BCH* 85 (1961) 447–73, figs. 1–3, pls. 12, 13; J. Marcadé, "Observations sur les sculptures décoratives de la tholos de Marmaria à Delphes," *AcadBelg-BCBA* ser. 5, 59 (1977) 144, pl. I, fig. 3; Marcadé, "Les métopes mutilées de la tholos de Marmaria à Delphes," *CRAI*, 1979, 165–66.

[21] Delphi 3168: Marcadé, *AcadBelg-BCBA* 59 (1977) 145–46, pl. I, figs. 4, 5; Marcadé, *CRAI*, 1979, 157, 166–68, figs. 1, 16, 17; Marcadé, "Chronique Delphique: La sculpture," *BCH* 105 (1981) 756–57, fig. 76; Marcadé, "Les sculptures décoratives de la tholos de Marmaria à Delphes: État actuel du dossier," in *Archaische und klassische griechische Plastik: Akten des internationalen Kolloquiums vom 22.–25. April 1985 in Athen*, ed. H. Kyrieleis (Mainz 1986) 169–70, pl. 145.

tern that is barely contained by the architectural frame. As so often in these metopes, the motifs are well known from earlier monuments, but the form here is totally new. As Jean Marcadé remarks, the chiastic composition of the man and rearing horse goes back to the metope of the Temple of Zeus at Olympia depicting Herakles and the bull,[22] and it is used in the center of the west frieze of the Parthenon.[23] At Delphi, however, the relationship of the two figures is different: the man is seen from the back and set well to the viewer's left; the balance is at best precarious, and the violent action presses against the frame. The last of the reconstructed metopes is unfortunately badly mutilated—the masses of the forms have been hacked off, leaving only the outlines (**Fig. 27**).[24] On the left it shows a dinos resting on the top of a column; the lower part of the column is largely covered by an indeterminate form, which Marcadé identifies as a fallen figure having taken refuge by the column, marked as a sacred space by the dinos atop it. On the right, a diagonal figure in a long, flowing garment leans to the right, very probably pulling the figure at the column away from it, again a motif that occurs twice in the Amazonomachy of Bassai (though without the column or similar object).[25] As preserved, it looks as if the column on the left stood on a rocky outcrop which extends under the feet of the figure on the right, recalling both the rocky outcrop of the Albani rider relief[26] and the reconstruction of the shield of the Athena Parthenos proposed by Evelyn Harrison.[27]

The energetic poses of many of the fragmentary figures suggest that the Amazonomachy metopes must be later than the Bassai frieze, but the open spaces around the figures of the reconstructed metopes suggest comparison with the metopes of Bassai that present just a single figure. Part of the reason for this open space may be to provide enough room for the energized, flowing drapery to dominate the composition. The importance of flowing, agitated drapery is emphasized by the lower body of an acroterion figure attributed to the tholos at Delphi and the nonjoining torso of either the same figure or another similar figure that once held up her mantle in a manner reminiscent of the Nike of the Temple of Asklepios at Epidauros (**Fig. 32**).[28] Despite the traditional subjects and the frequently traditional compositions of the large metopes of the tholos, Marcadé emphasizes three unusual related characteristics of these metopes: their very deep relief, the elaboration of fluttering garments on the open ground (sometimes carved into the ground), and the inclusion of details of setting.[29] The result is a pictorialism that suggests the metopes are windows into a space beyond their frames. Although the slightly earlier frieze at Bassai has dramatic drapery swirling around the figures and occasionally uses radical foreshortening, as discussed above, the compression of the figures into closely packed masses less-

[22] B. Ashmole, N. Yalouris, and A. Frantz, *Olympia: The Sculptures of the Temple of Zeus* (London 1967) fig. 162.

[23] Brommer, *Parthenonfries*, pl. 23 (West VIII).

[24] Delphi 4226: Bernard and Marcadé, *BCH* 85 (1961) 471, fig. 16; Marcadé, *AcadBelg-BCBA* 59 (1977) 144, pl. I, fig. 2; Marcadé, *CRAI*, 1979, 157–58, fig. 2; Marcadé, "Sculptures décoratives de la tholos" (note 21 above) 169–70.

[25] London, BM 536 (left side): Madigan, *Apollo Bassitas*, pl. 47, no. 145; Hofkes-Brukker and Mallwitz, *Bassai-Fries*, 71 (H 13); Kenner, *Fries des Tempels von Bassae-Phigalia* (note 8 above) pl. 17 (unrestored). London, BM 532: Madigan, pl. 46, no. 141; Hofkes-Brukker and Mallwitz, 83 (H 20); Kenner, pl. 13. At Bassai an approximate parallel occurs in the Centauromachy, BM 524, on which a centaur pulls the mantel from a fallen Lapith woman who grasps at a statue of a female divinity: Madigan, pl. 43, no. 133; Hofkes-Brukker and Mallwitz, 55 (H 4); Kenner, pl. 5.

[26] Rome, Villa Albani 985: Bol, *Villa Albani*, vol. 1, 246–51, no. 80, pls. 140–46 (P. C. Bol); Lullies and Hirmer, *Greek Sculpture*², pls. 179–81; Lippold, *Griechische Plastik*, pl. 96.3.

[27] E. B. Harrison, "Motifs of the City-Siege on the Shield of Athena Parthenos," *AJA* 85 (1981) 281–317, pls. 46–54.

[28] Delphi 4345 + 4352, 8804: Marcadé, *AcadBelg-BCBA* 59 (1977) 150, figs. 17, 18; Picard, *Delphes: Le musée*, 75, fig. 35; Danner, *Griechische Akrotere*, 26, no. 160, pl. 26.

[29] Marcadé, *CRAI*, 1979, 169–70.

ens significantly the effect achieved by the large metopes of the tholos at Delphi.[30] The explosive and elegant drapery of the tholos metopes is a sign of the height of the Rich Style around 380, which quickly recedes as the Plain Style comes to the fore. The pictorialism of the metopes remains of interest in the course of the fourth century, particularly in the private votive reliefs, but also returns in the frieze of the Lysikrates Monument in the 330s, to be discussed below.

The iconographic and compositional dependence of the tholos at Delphi on the Temple of Apollo at Bassai is confirmed by another link: the use of Corinthian capitals for the interior order, this time uniformly for all the columns, which where mounted on a bench that ran around the whole interior. Jean-François Bommelaer has suggested that there was also a second, upper, series of colonnettes, probably of the Ionic order, as at Nemea.[31] The decoration of the tholos also included a leaf molding around the exterior bottom of the cella wall[32] and a gutter with lion-head spouts, acanthus scrolls, and palmette antefixes.[33] With its eighty carved metopes and a marble roof, the building was a jewel in shining Pentelic marble.

The Temple of Athena Alea at Tegea had carved metopes, but they are not sufficiently well preserved to add to our knowledge of architectural decoration.[34] The temple itself is, however, noteworthy. It was Doric on the outside but, like the tholos at Delphi, had engaged Corinthian half-columns on the interior, whose bases were elaborately carved with moldings, as was the crown of the interior cella walls (**Fig. 38**).[35] The sculptured pediments, to be discussed below, and, according to Pausanias, Ionic columns standing outside the temple made for a rich visual experience enhanced, as always, by strong and varied colors which are now gone.

The only building in the sanctuary at Epidauros to receive sculptural decoration after the Temple of Asklepios was the small Temple of Artemis, dated on stylistic grounds to the last quarter of the fourth century.[36] The three preserved acroteria are Nikai, two of which are well preserved (**Fig. 47**).[37] The outer colonnade was Doric, and the inner is restored by Georges Roux as Corinthian.[38] Various textures of stone were used in the construction, but not the strong contrasting colors of the tholos (see below).[39]

[30] Madigan, *Apollo Bassitas*, 75 and note 29, notes the use of irregular groundlines in the Bassai frieze, but again the compression of the composition nullifies any visual effect.

[31] Bommelaer, *Marmaria* (note 17 above) 70. The same reconstruction has been proposed for Tegea, but probably without foundation; see chap. 4, p. 115 with note 104 above.

[32] Charbonneaux, *FdD* 2.B.4.2, figs. 1, 15, 22; Bommelaer, *Marmaria* (note 17 above) 59, fig. 64.

[33] Charbonneaux, *FdD* 2.B.4.2, figs. 8–12; Bommelaer, *Marmaria* (note 17 above) 64, figs. 56, 57.

[34] Dugas, Berchmans, and Clemmensen, *Sanctuaire d'Aléa Athéna*, 102–4; Stewart, *Skopas*, 30–32, 62–66. Two small fragments of carved marble metopes depicting warriors with round shields are associated with the early-fourth-century Temple of Artemis at Kalydon: E. Dyggve, *Das Laphrion: Der Tempelbezirk von Kalydon* (Copenhagen 1948) 123–24, 247–48, figs. 143, 144, pl. XXXI (reconstruction). Since the exterior metopes were poros covered in stucco, Dyggve places the marble metopes over the pronaos. On the date of the temple: ibid., 257–65.

[35] Dugas, Berchmans, and Clemmensen, *Sanctuaire d'Aléa Athéna*, pls. 75, 76, 79. Two blocks of the interior wall of the cella are displayed in the museum and carry the inventory numbers 254 and 255 (here **Fig. 38**).

[36] Burford, *Temple Builders*, 70–73; G. Roux, *L'architecture de l'Argolide aux IVe et IIIe siècles avant J.-C.* (Paris 1961) 201–16.

[37] Athens, NAM 159–61: Kaltsas, *SNAMA*, 179, nos. 355, 356*, 357*; N. Yalouris, "Τὰ ἀκρωτήρια τοῦ ναοῦ τῆς Ἀρτέμιδος," *ArchDelt* 22 (1967) 25–37, pls. 22–38; Gulaki, *Nikedarstellungen*, 89–97, figs. 37–39; Danner, *Griechische Akrotere*, 20, no. 113, pl. 14a–c; Picón, *AntP* 22 (1993) 92, figs. 12–14 (NAM 159); Ridgway, *Hellenistic Sculpture*, vol. 1, 149–50.

[38] Roux, *Architecture de l'Argolide*, 213–14.

[39] Burford, *Temple Builders*, 70.

Three round buildings conclude our discussion: the tholos at Epidauros, probably built just before the middle of the fourth century; the choregic monument of Lysikrates, which celebrated a victory in the dithyrambic contest for boys in 334/3; and the Philippeion at Olympia, begun by Philip of Macedon just after Chaironeia (338) and finished by his son, Alexander the Great.

After the Temple of Asklepios at Epidauros, there was continuous building activity to the end of the fourth century. The date of the tholos at Epidauros is uncertain, but it must have been begun after the Temple of Asklepios and, according to the fragmentary building accounts, took more than twenty-seven years to complete.[40] The exterior was Doric, with metopes decorated only with rosettes;[41] in the cella were freestanding Corinthian columns.[42] The temple was not only richly decorated with elaborate moldings, but dark and light stone was used in its walls.[43] A completely new feature is the interior paving made of alternating black and white slabs cut to form four concentric rows of diamonds.[44] Since mosaic floors were then becoming common, the parallel is inescapable.

The Philippeion at Olympia was both much smaller (13.948 meters in diameter at the stylobate) and in most respects more austere than the tholos at Epidauros, though it had Ionic columns on the exterior and engaged Corinthian columns in the interior.[45] Its most interesting characteristic is a very large door; originally this was thought to have been flanked by two windows on either side, but recent reconstructions have eliminated these.[46] Here the interior space is clearly of importance, and the function of the building—to hold gold and ivory statues of Philip and his immediate family—is obviously paramount.[47] The small building is, in fact, really a sculpture gallery displaying the king of Macedon with familial entourage in his role as victor of Chaironeia. I can only imagine the small, austere monument in the sea of athletic victor statues and votive dedications by triumphant poleis as a new and more spectacular parallel to its neighbors.

The monument of Lysikrates in Athens of roughly the same date as the Philippeion underscores this admittedly subjective reaction. Built by Lysikrates to celebrate the victory of his *phylē*, Akamantis, in the boys' dithyrambic contest,[48] it was set, like statues in sanctuaries, along a major thoroughfare, on the west side of the Street of the Tripods, where it runs more or less north-south on the east side of the Acropolis, and it did not stand alone there. Set on a high basement or podium, the round structure has pseudo-

[40] Roux, *Architecture de l'Argolide*, 171–76; Burford, *Temple Builders*, 63–68

[41] Roux, *Architecture de l'Argolide*, 138–42, pls. 42, 43.

[42] Ibid., 153–56, pls. 47–50.

[43] Ibid., 149, pl. 44.

[44] Burford, *Temple Builders*, 63–64, fig. 8; Roux, *Architecture de l'Argolide*, 160, fig. 36; A.-M. Guimier-Sorbets, "Mosaïques et dallages dans le monde grec aux époques classique et hellénistique," in *Fifth International Colloquium on Ancient Mosaics Held at Bath, England, on September 5–12, 1987*, JRA suppl. 9, ed. P. Johnson, R. Ling, and D. J. Smith (Ann Arbor 1994) vol. 1, 13, fig. 1 (on p. 15).

[45] H. Schleif and W. Zschietzschmann, "Das Philippeion," in OlForsch 1 (Berlin 1944) 1–52; A. Mallwitz, *Olympia und seine Bauten* (Darmstadt 1972) 128–33; S. G. Miller, "The Philippeion and Macedonian Hellenistic Architecture," AM 88 (1973) 189–218; R. F. Townsend, "The Philippeion and Fourth-Century Athenian Architecture," in *The Macedonians in Athens, 322–229 B.C.*, ed. O. Palagia and S. V. Tracy (Oxford 2003) 93–101.

[46] Schleif and Zschietzschmann, "Philippeion" (note 45 above) 22, fig. 4, pl. 12. For the new elevation, see Schultz, "Argead Portraits," 207, fig. 131.

[47] Borbein, JdI 88 (1973) 66–67; Löhr, *Familienweihungen*, 115–17, no. 137; Schultz, "Argead Portraits," 222; P. Schulz, "Divine Images and Royal Ideology in the Philippeion at Olympia," in *Aspects of Ancient Greek Cult: Context, Ritual and Iconography*, ed. J. T. Jensen, G. Hinge, P. Schultz, and B. Wickkiser, Aarhus Studies in Mediterranean Antiquity (Aahrus 2009) 129–93.

[48] Wilson, *Khoregia*, 219–26; Bauer, AM 92 (1977) 197–227; Amandry, BCH 100 (1976) 71–79.

engaged Corinthian columns which support an Ionic architrave and a sculptured frieze, surmounted in turn by a richly carved cornice, roof, central acanthus finial, and, finally, presumably a bronze tripod. The Ionic frieze depicts the story of Dionysos carried off by pirates and his revenge, as related in the *Homeric Hymn to Dionysos* (**Figs. 19, 20**).[49] In one respect the frieze follows the schematic, almost abstract, pattern first seen in the Amazonomachy of the Maussolleion: lunging figures describe strong diagonals (**Figs. 7, 8**). Here, however, there is a lot of space around each figure; in one case a silenos is depicted in three-quarter back view (**Fig. 20**), a pose suggesting depth, like a similar figure on the left of the boar hunt in the painted frieze of "Philip's Tomb" at Vergina (**Fig. 119**). There are also numerous elements of setting—tree, tree stump, rippling water, rocky ground, and a krater—recalling the large metopes of the tholos at Delphi. These pictorial elements recall even more clearly the painterly friezes of the heroon of Trysa (modern Gölbaşı) (see below). On the frieze of the Lysikrates Monument, however, the abbreviated nature of the elements of setting imply the setting without actually depicting it in any detail. Even so, the sense of a narrative in a setting is very strong and recalls to me the sense of implied settings in sculpture in the round, such as the Resting Satyr, Apollo Sauroktonos, or Knidian Aphrodite. However, it is undeniable that there is a tension between narrative representation and the ornamental appearance of the frieze on the small, richly articulated structure. It is highly probable that the structure held a statue in its small interior, and this clearly recalls the Philippeion and underscores the fourth-century interest in the spectacular presentation.

Temples continued to be built in East Greece during the fourth century. Two examples are particularly representative: the immense Temple of Artemis at Ephesos and the small Temple of Athena Polias at Priene. The Temple of Artemis at Ephesos is notable for the present inquiry primarily for its column drums and pedestals carved in relief, following the pattern of its archaic predecessor (**Figs. 39, 40**).[50] The temple was colossal, measuring 137.80 × 72.96 meters.[51] According to Pliny (*NH* 36.21.95), thirty-six of the columns bore carved reliefs. These must have been the three rows of eight columns across the front, the eight columns of the pronaos, and two columns on either side of the front antae. According to Rügler's convincing reconstruction, the carved column drums stood on the square pedestals.[52] The height of each element was 1.84 meters, giving a total height of 3.68 meters for the combined sculptured "bases." The maximum depth of the relief on the pedestals is about 25 centimeters, that of the superimposed drum—for example, block BM 1206—is 11 centimeters at the proper left knee of Hermes.[53] The preserved pedestals all depict active scenes: labors of Herakles, Centauromachy, Europa, and possibly Nikai leading animals to sacrifice.[54] The subject of the reliefs of the column drums, apart from the well-known scene of Hermes, Thanatos, and Alkestis, is uncertain, but all appear to represent people standing and seated in quiet poses, presumably because the mostly draped figures made a harmonious visual transition to the fluted column shafts.[55] The immensity of the Temple of Artemis

[49] Ehrhardt, *AntP* 22 (1993) 7–67, pls. 1–19.

[50] Rügler, *Columnae caelatae*; Ridgway, *Hellenistic Sculpture*, vol. 1, 28–30.

[51] Rügler, *Columnae caelatae*, 40–44.

[52] Ibid., 28–34.

[53] Very kindly measured for me by Dr. Ian Jenkins in May 2006.

[54] Rügler, *Columnae caelatae*, 47–64.

[55] Rügler, *Columnae caelatae*, 30–31, reconstructs the fluted columns sitting on the carved drums with no intervening molding.

and the extraordinarily rich sculptural decoration on its facade distinguish it from the vast majority of its contemporary structures, particularly those on the mainland.

At the time of its discovery the Temple of Athena Polias at Priene was one of the most completely preserved temples in East Greece.[56] Of primary interest here are the large ceiling coffers of the pteron, which were capped with relief sculptures whose style is close to that of the acroteria of the Temple of Artemis at Epidauros (**Fig. 47**).[57] The date of construction appears to be in the lifetime of Alexander, but the building was apparently not completed until the second century B.C. The extraordinary plasticity of the carved figures was complemented by most elaborate coffer frames[58] that reaffirm the signal decorative character of East Greek architecture and sculpture since the sixth century.

TEMPLE PEDIMENTS

The sculpture of temple pediments in the fourth century is a difficult subject to treat because the remains are exceedingly fragmentary. In the sixth and fifth centuries, sculptured temple pediments presented the epiphany of the resident divinity in various contexts, and the Parthenon pediments are chronologically the direct predecessors of the buildings to be discussed next. The pediments of the Parthenon depict the birth of Athena on the east and the contest of Athena with Poseidon to win hegemony over Attica on the west.[59] Although some fragments have been assigned to the pedimental sculptures of the Hephaisteion next to the Athenian Agora and the Temple of Athena Nike at the entrance of the Acropolis, in neither case is there sufficient evidence to recover a useful picture of the subjects and compositions.[60] This is also true of the very fragmentary sculptures from the temple at Mazi.[61]

Both pediments of the Temple of Asklepios at Epidauros, now generally dated around 380 B.C., are, though fragmentary, well enough preserved to allow us to determine both the subject and the general composition.[62] On the west was an Amazonomachy; Nikolas Yalouris believes it to be the Trojan episode, with Penthesileia on a rampant horse in the center

[56] W. Koenigs, "Der Athenatempel von Priene: Bericht über die 1977–82 durchgeführten Untersuchungen," *IstMitt* 33 (1983) 134–75; Koenigs, "The Temple of Athena Polias at Priene: Doric Architecture in the Guise of Ionic?" in *Appearance and Essence: Refinements of Classical Architecture—Curvature; Proceedings of the Second Williams Symposium on Classical Architecture Held at the University of Pennsylvania, Philadelphia, April 2–4, 1993* (Philadelphia 1999) 139–53.

[57] J. C. Carter, *The Sculpture of the Sanctuary of Athena Polias at Priene*, Reports of the Research Committee of the Society of Antiquaries of London 42 (London 1983); the similarity of the drapery and legs of a goddess (pl. XII.d, e) with Athens, NAM 159 and 161 (Kaltsas, *SNAMA*, 179, nos. 356*, 357*), is remarkable. The coffers have also been dated to the second phase of construction, in the second century: P. Higgs, "Back to the Second Century B.C.: New Thoughts on the Date of the Sculptured Coffers from the Temple of Athena Polias, Priene," in Schultz and von den Hoff, *Structure, Image, Ornament* (note 9 above) 13–29.

[58] Koenigs, *IstMitt* 33 (1983) 157–58, pls. 35–39.

[59] Brommer, *Giebel*.

[60] Hephaisteion: H. A. Thompson, "The Sculptural Adornment of the Hephaisteion," *AJA* 66 (1962) 339–47, pls. 91, 92. Nike temple: G. Despinis, "Τὰ γλυπτὰ τῶν ἀετωμάτων τοῦ ναοῦ τῆς Ἀθήνας Νίκης," *ArchDelt* 29 (1974) pt. A, Meletemata, 1–24, pls. 1–24; M. Brouskari, "Aus dem Giebelschmuck des Athena-Nike-Tempels," in *Festschrift für Nikolaus Himmelmann: Beiträge zur Ikonographie und Hermeneutik*, ed. H.-U. Cain, H. Gabelmann, and D. Salzmann (Mainz 1989) 115–18, pl. 20; W. Erhardt, "Der Torso Wien I 328 und der Westgiebel des Athena-Nike-Tempels auf der Akropolis," in *Festschrift für Nikolaus Himmelmann* (above) 119–27. On the acroteria of the temple, see P. Schultz, "The Akroteria of the Temple of Athena Nike," *Hesperia* 69 (2001) 1–47.

[61] I. Trianti, "Ο γλυπτός διάκοσμος του ναού στο Μάζι της Ηλείας," in *Archaische und klassische griechische Plastik* (note 21 above) 155–68, pls. 136–44.

[62] Yalouris, *AntP* 21 (1992) with earlier bibliography; Bol, *Bildhauerkunst*, 272–77, figs. 214–25 (W. Geominy).

(**Fig. 28**). On the east was the Ilioupersis; in Yalouris's reconstruction the rape of Kassandra is at the left of center, and Neoptolemos killing Priam at the right. According to Yalouris, the figures once identified as Neoptolemos struggling with Priam, which had formerly been thought to occupy the center of the east pediment,[63] belong to the central acroterion and represent Apollo and Koronis.[64] The corner acroteria on the east are two Nikai (**Fig. 31**).[65] On the west, two Aurai form the corner acroteria (**Fig. 33**), and a woman with a bird, probably also a Nike, the central one (**Fig. 32**).[66] Neither pediment appears to have contained a divine figure; this is as good as certain on the west (Amazonomachy) and very likely on the east (Ilioupersis).[67] Etienne Lapalus remarks that this is a characteristic of temples in the fourth century, with the notable exception of the Temple of Apollo at Delphi.[68]

Of some importance for the overall effect of the pediments of the Temple of Asklepios at Epidauros is their very small size; the Amazon on a rearing horse in the center of the west pediment is only 0.90 meters high,[69] and the best-preserved Nike acroterion is only 0.85 meters high.[70] In each case the restored compositions are quite open, with space around the figures though with much overlapping. There is not a great deal of torsion; one can even say that where there is torsion it is awkward, for example, the Amazon falling off her horse in the west pediment,[71] though the two dead Greeks at the corners of the west pediment are twisted masses and convincing corpses (**Fig. 29**).[72] Most of the figures display frontal chests above legs in different positions, mostly in profile. Perhaps the most daring pose is that of a kneeling Greek that Yalouris places directly under the rearing horse of the central Amazon (**Fig. 28**).[73] The knees are splayed out to right and left, and the torso leans to the viewer's left with (now lost) arms down and out to the sides. Another interesting composition is the kneeling Greek who pulls a kneeling Amazon by the hair; his torso is turned slightly to the viewer's right, while the Amazon is turned in more than three-quarter view to the left.[74] The arms of the two figures close the open space between the diagonals of the splayed-out bodies. But other than the beautiful figure of the Amazon on a rearing horse in the middle of the west pediment (**Fig. 28**), the sculptures are rather tame. Indeed, the stylistic distinction between the two pediments is often exaggerated in modern commentaries. The style of the east pediment has strong elements of the Rich Style: the female figure sometimes identified as Kassandra has transparent drapery (**Fig. 30**),[75] and that of another fragmentary figure displays a strong contrast of sharp fold ridges and flat areas between, a hallmark of the Rich Style.[76] But other fragments—such as the

[63] Picard, *Manuel*, vol. 3.1, 352, fig. 138, cautiously accepted the figure in the east pediment; Schlörb, *Timotheos*, 10, pl. 1, accepted it; Delivorrias, *Attische Giebelskulpturen*, 193–94, rejected the placement of the figure in the pediment.

[64] Yalouris, *AntP* 21 (1992) 17–19, cat. no. 1, 63, fig. 1, pls. 1, 2.

[65] Ibid., 19–20, cat. nos. 2–4, pls. 3–7.

[66] Ibid., 30–33, cat. nos. 25–27, pls. 24–31.

[67] Ibid., 65; Schlörb, *Timotheos*, 9.

[68] E. Lapalus, *Le fronton sculpté en Grèce, des origines à la fin du IVe siècle* (Paris 1947) 203–19. One of the pediments of the temple at Mazi appears to have had a divine figure (see note 61 above).

[69] Yalouris, *AntP* 21 (1992) 35, cat. no. 34, pl. 40.

[70] Ibid., 30, cat. no. 25, pls. 24–26.

[71] Ibid., 42, cat. no. 37, pl. 46a, b.

[72] Ibid., 33, 44, cat. nos. 28 and 40, pls. 33, 51. A far better photograph of the latter: Schlörb, *Timotheos*, pl. 6.

[73] Yalouris, *AntP* 21 (1992) 35, no. 33, pls. 38, 39, fig. 27 (drawing of reconstruction).

[74] Ibid., 42–44, cat. no. 39, pls. 48, 49.

[75] Ibid., 21–22, cat. no. 7, pl. 9.

[76] Ibid., 25, cat. no. 14, pl. 15.

female chest,[77] the female hip and thigh,[78] and the pair of women, one crouching[79]—suggest that the style has been tamed. The style of the west pediment is more uniformly based in the new Plain Style, though here the Amazon falling from her horse leaves no doubt about her Rich Style ancestry.[80] The acroteria, both Nikai and Aurai, are clearly the strongest representatives of the end of the Rich Style (**Figs. 31–33**).

The style of the pedimental sculptures of the Temple of Asklepios has been a focus of attention for two principal reasons: first, the largely preserved building accounts give the (partially preserved) names of the sculptors who contracted for the pedimental groups and acroteria; and, second, the two styles described above represent the Rich Style of the period after 420 and the Plain Style of the middle and second half of the fourth century. The inscribed building accounts indicate that the architect, Theodotos, was paid for four and a half years plus seventy days, or roughly four years and eight months,[81] so the two styles of the temple's sculpture are contemporary. One of the sculptors named in the building accounts is Timotheos, who is listed in the building accounts as responsible for controversial *tupoi* and the acroteria of one side of the temple;[82] he is otherwise cited only three times in two extant texts, twice in Pliny and once in Pausanias.[83] Clearly the style of the acroteria and therefore of Timotheos is the advanced Rich Style of the early fourth century; Peter Schultz has argued that the disparity in the payments for the acroteria and the pediments indicates that the former sculptors were considered particularly notable masters and were thus paid more than the sculptors of the pediments.[84] There is no absolutely certain original or copy of a free-standing statue of Timotheos known, and we do not know which of the acroteria of the Asklepios temple he made, which makes the task of building an oeuvre of the artist very difficult, though this has been attempted.[85] The most popular attribution is a series of copies of the group of Leda and the swan (**Fig. 104**).[86] The attribution of this type to Timotheos is based solely on its purported resemblance to the sculptures of the east pediment of the Temple of Asklepios at Epidauros, that is, the sculptures with strong residual elements of the Rich Style, but the name of one of the sculptors of the pediments is missing in the inscriptions, and the attribution of this pediment to Timotheos is questionable.[87]

The other preserved pedimental sculptures come from the Temple of Athena Alea at Tegea (**Figs. 34, 35**).[88] The remains are even far more fragmentary than the pediments

[77] Ibid., 22, cat. no. 9, pl. 10e.

[78] Ibid., 24–25, cat. no. 12, pl. 13d–f.

[79] Ibid., 28, cat. no. 19, pls. 18c, 18d, 19c, 19d.

[80] Ibid., 42, cat. no. 37, pl. 46a, 47b.

[81] *IG* IV², I, 102: Roux, *Architecture de l'Argolide*, 84–89, 424–32 (translation); Burford, *Temple Builders*, 54–59, 207, 212–20 (translation).

[82] *IG* IV², I, 102, face A, col. 1, lines 36–37; face B, col. 1, lines 90–92.

[83] Overbeck, *Schriftquellen*, 1328–30: Pliny, *NH* 34.91, 36.32; Pausanias 2.34.4.

[84] P. Schultz, "Accounting for Agency at Epidauros: A Note on *IG* IV² 102 A1–B1 and the Economies of Style," in Schultz and von den Hoff, *Structure, Image, Ornament* (note 9 above) 75–76.

[85] Schlörb, *Timotheos*.

[86] A. Rieche, "Die Kopien des 'Leda des Timotheos,'" *AntP* 17 (1978) 21–55, pls. 10–34.

[87] *IG* IV², I, 102, face B, col. 1, lines 96–97; F. Winter, "Zu den Skulpturen von Epidauros," *AM* 19 (1894) 160; W. Amelung, *Die Basis des Praxiteles aus Mantinea: Archäologische Studien* (Munich 1895) 70–71; Schlörb, *Timotheos*, 51–56.

[88] Dugas, Berchmans, and Clemmensen, *Sanctuaire d'Aléa Athéna*; Stewart, *Skopas*, 5–84; Bol, *Bildhauerkunst*, 331–35, figs. 301–5 (C. Maderna); G. Mostratos, "The Pedimental Compositions and the Akroteria of the Skopaic Temple of Athena Alea at Tegea," in *Skopas of Paros and His World: Proceedings of the Third International Conference on the Archaeology of Paros and the Cyclades, Paroikia, Paros, 11–14 June 2010*, ed. D. Katsonopoulou and A. F. Stewart (Athens 2013) 191–210.

of Epidauros, and the date is uncertain and much disputed. Part of the reason that these sculptures have drawn a disproportionate interest in relationship to their number and condition is that Pausanias (8.45.4–7) describes the temple thus:

> The ancient sanctuary of Athena Alea was made for the Tegeans by Aleus. Later on the Tegeans set up for the goddess a large temple, worth seeing. The sanctuary was utterly destroyed by a fire which suddenly broke out when Diophantos was archon at Athens, in the second year of the ninety-sixth Olympiad (395 B.C.), at which Eupolemus of Elis won the foot race. The modern temple is far superior to all other temples in the Peloponnesus on many grounds, especially for its size. Its first row of columns is Doric, and the next to it Corinthian; also, outside the temple, stand columns of the Ionic order. I discovered that its architect was Scopas the Parian, who made images in many places of ancient Greece, and some besides in Ionia and Caria. On the front gable is the hunting of the Calydonian boar. The boar stands right in the center. On one side are Atalanta, Meleager, Theseus, Telamon, Peleus, Polydeuces, Iolaüs, the partner in most of the labors of Heracles, and also the sons of Thestius, the brothers of Althaea, Prothoüs and Cometes. On the other side of the boar is Epochus supporting Ancaiüs who is now wounded and has dropped his axe; by his side is Castor, with Amphiaraüs, the son of Oïkles, next to whom is Hippothoüs, the son of Cercyon, son of Agamedes, son of Stymphalus. The last figure is Peirithoüs. On the gable at the back is a representation of Telephus fighting Achilles on the plain of the Caïkus. (Trans. W. H. S. Jones, Loeb edition)

The extraordinary detail of the account of the Kaledonian boar hunt stands in stark contrast to the briefest mention of the subject of the other pediment; the reason for this is obscure but may be the importance of the subject as part of the earlier history of Greece.[89] Skopas is said by Pliny (*NH* 36.30) to have participated in the carving of the friezes of the Maussolleion at Halikarnassos, which must have been built from the 350s into the 340s.[90] The temple at Tegea could have been either an earlier or a later work. Contemporary opinion favors the latter, placing the temple and its sculptures around 340.[91] This conclusion is supported both by the style of the fragmentary acroteria figures of women with high-belted chitons (**Figs. 36, 37**) and by the discovery at Tegea of a relief dedicated to Zeus Stratios by Ada and Idrieos, the sister and brother of Maussollos.[92] Geoffrey Waywell's suggestion that the relief is the top of a decree is very attractive; it allows the hypothesis that Ada and Idrieos contributed to the building of the temple whose predecessor had been destroyed some fifty years earlier, as Pausanias relates.[93] The connection with Skopas is probably fortuitous, since statues of Ada and Idrieos were set up at Delphi by the Milesians, almost certainly to mark a signal benefaction.[94]

[89] See chap. 3, pp. 84–85 above.

[90] See chap. 2, p. 115 above.

[91] On the architecture: N. J. Norman, "The Temple of Athena Alea at Tegea," *AJA* 88 (1984) 169–94. On the date of the sculpture: Stewart, *Greek Sculpture*, 182; Rolley, *Sculpture grecque*, vol. 2, 269.

[92] W. B. Waywell, "The Ada, Zeus and Idreus Relief from Tegea in the British Museum," in Palagia and Coulson, *Sculpture from Arcadia* (note 11 above) 79–86.

[93] D. W. Tandy, "Skopas of Paros and the Fourth Century B.C.," in Katsonopoulou and Stewart, *Skopas of Paros* (note 88 above) 85. Rolley, *Sculpture grecque*, vol. 2, 269, does not accept Waywell's interpretation.

[94] Waywell, "Ada, Zeus and Idreus Relief" (note 92 above) 83, suggests that the Milesians acted as diplomatic facilitators between the Karian rulers and Delphi, but a more economical hypothesis is that Ada and Idrieos were significant benefactors of the Milesians.

Pausanias does not mention any divine figures in the pediments other than Kastor; in the east pediment with the Kalydonian boar he places nine figures on one side (the left side in the reconstruction given by Andrew Stewart) and only six figures on the other side (presumably the right). The preserved fragments are not adequate to judge the composition beyond the rudimentary sketch offered by Stewart. The number of figures in the east pediment agrees roughly with the number of figures in the two pediments at Epidauros, which suggests that the composition was similarly open.

The final important fourth-century temple with partially preserved pedimental sculpture is the Temple of Apollo at Delphi. Construction of the temple had been interrupted by the Sacred War from 356 to 346, when the Phokaians occupied and pillaged the sanctuary.[95] Building only got under way again in the 330s and was completed by 327. Although the pedimental sculptures are very fragmentary, two things are clear: (1) Apollo occupied the center of the east pediment (**Fig. 21**), and Dionysos the center of the west (**Fig. 22**); (2) the figures stood or sat side-by-side with no appreciable interaction.[96] Indeed, toward the center of each pediment, as reconstructed by Francis Croissant, the majority of the figures are presented frontally, and in this they resemble the strictly frontal figures of the east pediment of the Alkmaionid sixth-century temple

The static epiphanies of the pediments of the Temple of Apollo at Delphi clearly share formal qualities with some late-fourth-century grave stelai, such as the second stele of Demetria and Pamphile (**Fig. 87**),[97] and similar hieratic monuments, such as the Muses on the Mantineia base (**Figs. 97, 98**).[98] But on the surface their compositional principles seem contrary to the earlier narrative pediments of Epidauros and Tegea and, in theory at least, to the Krateros Monument at Delphi. These comparisons and contrasts are, however, probably only partially valid. The second grave stele of Demetria and Pamphile is roughly contemporary with the stele of Aristonautes (**Fig. 88**), and they do share a pronounced plastic frontality, but Aristonautes' active pose and the rough ground on which he strides project an illusionistic image of the living, active warrior, a motif that goes back to the late-fifth-century grave reliefs of Mnason and Rhynchon.[99] Similarly, the Ilissos stele (**Fig. 132**) may convey an atmosphere of deep sorrow elicited by the static figures grouped around the epiphany of the deceased, but it does so with pictorial and spatial elements that are rare in Attic grave reliefs. It too cannot be distant in date from the other monuments under consideration here. Finally, in vase painting the tendency to compose static scenes with weighty figures parallels the examples of sculpture discussed above, particularly the scenes of the Eleusinian divinities by the Eleusinian Painter, who is the late Marsyas Painter (**Fig. 246**).[100] We can conclude that the subject defines the presentation, but in all cases there is a clear emphasis on plastic forms that are only implicitly intercon-

[95] See chap. 1, p. 10 above; for bibliography, chap. 2, p. 30, note 31.

[96] Croissant, *FdD* 4.7; A. F. Stewart, "Dionysos at Delphi: The Pediments of the Sixth Temple of Apollo and Religious Reform in the Age of Alexander," in Barr-Sharrar and Borza, *Macedonia*, 205–27.

[97] See chap. 5A, pp. 184–85 above.

[98] See chap. 2, pp. 43–44, note 169 above.

[99] K. Demakopoulou and D. Konsola, *Archaeological Museum of Thebes: Guide* (Athens 1981) 74–75, nos. 54, 55, pl. 39 (Mnason); W. Schild-Xenidou, *Boiotische Grab- und Weihreliefs archaischer und klassischer Zeit* (Munich 1972) 41–42, nos. 43, 44; E. Pfuhl, *Malerei und Zeichnung der Griechen* (Munich 1923) pls. 633, 634; J. Charbonneaux, R. Martin, and F. Villard, *Classical Greek Art (480–330 B.C.)* (New York 1972) fig. 307, p. 269 (Mnason); Himmelmann, *Ideale Nacktheit*, 60, fig. 26 (Rhynchon).

[100] Saint Petersburg, Hermitage St. 1792 and St. 1793: Valavanis, Παναθηναϊκοί αμφορείς, 282, pls. 122–25; Boardman, *ARFV-CP*, figs. 392, 393; K. Clinton, *Myth and Cult: The Iconography of the Eleusinian Mysteries; The Martin P. Nilsson Lectures on Greek Religion, Delivered 19–21 November 1990 at the Swedish Institute at Athens* (Stockholm

nected; in fact, each exists as an independent notation. Friezes appear to follow a similar pattern, as Uwe Süssenbach has demonstrated.[101]

Although I find no single characteristic that describes the architectural sculpture of fourth-century temples, the sculpture does appear to become increasingly integrated into the overall rich ornament. This is particularly true of the friezes of the Maussolleion and the Lysikrates Monument. The few and poorly preserved pedimental sculptures do not appear to differ appreciably from their fifth-century predecessors, with the exception of the Temple of Apollo at Delphi, which clearly adopts the static frontality of roughly contemporary grave stelai and vase paintings. Certainly the majority of buildings appear to emphasize the richness of their ornament. The coloristic effects of the masonry of the temples at Epidauros should, however, not be overemphasized because buildings had always been painted more or less elaborately.

SPECTACULAR TOMBS

The great tombs of the fourth century in Asia Minor are a local phenomenon but with important ramifications in the Greek world. There appear to be three parallel traditions that come together in the fourth century. The oldest is the carved sarcophagus; the earliest known example is the sarcophagus of Ahiram from Byblos, of around 1000 B.C.;[102] the next examples come from the Troad (the Polyxena sarcophagus[103]) and Cyprus (the Amathous sarcophagus[104]) in the late sixth and early fifth century, respectively. These are followed closely by a sarcophagus of around the middle of the fifth century from Golgoi on Cyprus.[105] All these carved sarcophagi have the shape of a chest. An East Greek sarcophagus of the late sixth century from Samos has Ionic columns in relief on its interior in imitation of architecture forms, though it is plain on the outside. This intimation of the relationship of a sarcophagus to a building rather than a chest reflects a second tradition, that of large rock-cut tombs with complex architectural facades in Asia Minor, principally in Karia.[106] Numerous tombs were also built in Asia Minor in this period. A small sculptured pediment of the second half of the fifth century found at Sardis is associated with a hypothetical built tomb because of the banquet scene depicted on it.[107] A pyramidal

1992) figs. 20, 21 (St. 1792); E. Simon, "Eleusis in Athenian Vase-Painting: New Literature and Some Suggestions," in *Athenian Potters and Painters*, ed. J. H. Oakley, W. D. E. Coulson, and O. Palagia (Oxford 1997) 97–108.

[101] See chap. 5A, p. 182 above with note 187.

[102] Beirut, National Museum: E. Porada, "Notes on the Sarcophagus of Ahiram," *JANES* 5 (1973) 355–72; R. Fleischer, *Der Klagefrauensarkophag aus Sidon*, IstForsch 34 (Tübingen 1983) 42, pl. 44.3, 44.4; I. Hitzl, *Die griechischen Sarkophage der archaischen und klassischen Zeit* (Jonsered 1991) 170–71, no. 10, figs. 3–5; J. Ferron, *Sarcophages de Phénicie: Sarcophages à scènes en relief* (Paris 1993) 95–99, fig. 8, pls. II–XVI, color pls. LXXVII–LXXIX.

[103] N. Sevinç, "A New Sarcophagus of Polyxena from the Salvage Excavations at Gümüşçay," *StTroica* 6 (1996) 151–64; N. Sevinç, C. B. Rose, D. Strahan, and B. Tekkök-Biçken, "The Dedetepe Tumulus," *StTroica* 8 (1998) 314–16, figs. 15–19; D. Steuernagel, "Ein spätarchaischer sarkophag aus Gümüşçay im Museum von Çanakkale: Ikonographische Beobachtungen," in *Archäologische Studien in Kontaktzonen der antiken Welt*, ed. R. Rolle and K. Schmidt (Göttingen 1998) 165–77; Steuernagel (p. 167) allows a range for the date into the early fifth century.

[104] New York, MMA 74.51.2453 (Myres 1365): V. Karageorghis, J. R. Mertens, and M. E. Rose, *Ancient Art from Cyprus: The Cesnola Collection in the Metropolitan Museum of Art* (New York 2000) 201–4, no. 330; Ferron, *Sarcophages de Phénicie* (note 102 above) 99–102, pls. XVII–XX; A. Hermary and J. R. Mertens, *The Cesnola Collection of Cypriot Art: Stone Sculpture* (New York 2014) 353–63, no. 490.

[105] New York, MMA 74.51.2451 (Myres 1364): Karageorghis et al., *Cesnola Collection* (note 104 above) 204–6, no. 331; Ferron, *Sarcophages de Phénicie* (note 102 above) 103–7, pls. XXI–XXIV; Hermary and Mertens, *Cesnola Collection* (note 104 above) 363–70, no. 491.

[106] C. H. E. Haspels, *The Highlands of Phrygia: Sites and Monuments* (Princeton 1971) 112–38.

[107] G. M. A. Hanfmann, "A Pediment of the Persian Era from Sardis," in *Mansel'e Armağan/Mélanges Mansel* (Ankara 1974) vol. 1, 289–302, pls. 99–104; Hanfmann, *From Croesus to Constantine: The Cities of Western Asia Minor and*

structure at Sardis has also been interpreted as a tomb of the late fifth century.[108] There is also a tradition of large painted tombs, two of which on the Elmalı plateau between Pamphylia and Lykia are superbly preserved.[109] They date to the end of the sixth and the early fifth century. The third tradition is the decoration of buildings with multiple friezes; here again the evidence comes principally from Sardis: a small altar carved with Ionic columns with two or three tiers of friezes between them.[110] A similar stacking of friezes occurs on the stelai of the early fifth century from Daskyleion,[111] and, of course, the painted tombs of Elmalı have multiple friezes one on top of the other.

The elaborate carved pillar tombs and sarcophagi of Lykia at the southwest corner of Asia Minor do not directly relate to the present inquiry,[112] since they inspired no imitations in Greece proper, though the great sarcophagi of the royal cemetery at Sidon are indubitably closely related to them.[113] There is at least one wooden sarcophagus from south Russia, dated to the end of the fifth or beginning of the fourth century, which has carved figures of Greek divinities.[114] Others have various carved appliqués, such as winged animals,[115] and one has Nereids bringing weapons to Achilles.[116] A batik cloth decorated with mythological figures, found in 1875 in the sixth tomb of the "Seven Brothers Barrow" on the Taman Peninsula across the straight from Kerch, is thought to have served as the cover for a sarcophagus (**Fig. 266**).[117]

But in the rich tradition of decorated tombs of Asia Minor and the eastern Mediterranean it is the great temple-like tombs that are the most spectacular. The Nereid Monument of Xanthos is the first monumental product of all three traditions just enumerated. Probably built in the decade 390–380 B.C., it is an Ionic peripteral temple-like building

Their Arts in Greek and Roman Times (Ann Arbor 1975) 18–19, fig. 42; G. M. A. Hanfmann and P. Erhart, "Pedimental Reliefs from a Mausoleum of the Persian Era at Sardis: A Funerary Meal," in *Studies in Ancient Egypt, the Aegean, and the Sudan: Essays in Honor of Dows Dunham on the Occasion of His 90th Birthday, June 1, 1980*, ed. W. K. Simpson and W. M. Davis (Boston 1981) 82–90.

[108] Hanfmann, *Croesus to Constantine* (note 107 above) 15, fig. 37.

[109] M. J. Mellink, R. A. Bridges, and F. C. di Vignale, *Kızılbel: An Archaic Painted Tomb Chamber in Northern Lycia*, Bryn Mawr College Archaeological Monographs (Philadelphia 1998); M. J. Mellink, "Notes on Anatolian Wall Painting," in *Mansel'e Armağan/Mélanges Mansel* (Ankara 1974) vol. 1, 537–47; Mellink, "Local, Phrygian, and Greek Traits in Northern Lycia," *RA*, 1976, 21–34; Mellink, "Mural Painting in Lycian Tombs," in *Proceedings of the Xth International Congress of Classical Archaeology, 1973* (Ankara 1978) vol. 2, 805–9; Mellink, "Fouilles d'Elmalı en Lycie du nord: Découvertes préhistoriques et tombes à fresques," *CRAI*, 1980, 476–96.

[110] Hanfmann, *Croesus to Constantine* (note 107 above) 12, figs. 23–26.

[111] J. Borchhardt, "Epichorische, gräko-persisch beinflusste Reliefs in Kilikien," *IstMitt* 18 (1968) 192–99, pls. 40, 41, 44.2, 48, 50; see also pls. 52–53.1 (reliefs from Ödemiş and Çavuşköy).

[112] P. Demargne, *Fouilles de Xanthos*, vol. 1, *Les piliers funéraires* (Paris 1958); P. Demargne and E. Laroche, *Fouilles de Xanthos*, vol. 5, *Tombes-maisons, tombes rupestres et sarcophages; Les épitaphes lyciennes* (Paris 1974); J. Zahle, "Lykische Felsgräber mit Reliefs aus dem 4. Jahrhundert v. Chr.: Neue und alte Funde," *JdI* 94 (1979) 247–346; C. Bruns-Özgan, *Lykische Grabreliefs des 5. und 4. Jahrhunderts v. Chr.*, IstMitt-BH 33 (Tübingen 1987).

[113] Other than the Mourning Women Sarcophagus discussed below and the "Alexander sarcophagus" already discussed (chap. 5A, pp. 175, 182 above), the two other richly carved examples are the Lykian Sarcophagus and the Satrap Sarcophagus: I. Kleemann, *Der Satrapen-Sarkophag aus Sidon*, IstForsch 20 (Berlin 1958); B. Schmidt-Dounas, *Der lykische Sarkophag aus Sidon*, IstMitt-BH 30 (Tübingen 1985). On the chronology of these, see H. Gabelmann, "Zur Chronologie der Königsnekropole von Sidon," *AA*, 1979, 163–77.

[114] S. Reinach, *Antiquités du Bosphore Cimmérien (1854) rééditées avec un commentaire nouveau et un index général des comptes rendus* (Paris 1892) 126, pls. LXXXI.6, 7, LXXXII; M. Vaulina and A. Wąsowicz, *Bois grecs et romains de l'Ermitage*, trans. M. Drojecka (Wrocław 1974) 52–58, no. 2, pls. XII–XXV, especially pls. XVI, XVII; P. Pinelli and A. Wąsowicz, *Catalogue des bois et stucs grecs et romains provenant de Kertch*, Musée du Louvre (Paris 1986) 32–37, figs. 4, 5. The height of the carved panels is given as 0.25–0.27 meters.

[115] Vaulina and Wąsowicz, *Bois grecs et romains* (note 114 above) 71–74, no. 5, pls. 42, 43.

[116] Ibid., 87–94, no. 12, pls. 63–83.

[117] D. Gerziger, "Eine Decke aus dem sechsten Grab der 'Sieben Brüder,'" *AntK* 18 (1975) 51–55, pls. 21–24; see further chap. 7, pp. 267–68 below.

of four by six columns on a platform or podium measuring 10.17 × 6.8 meters at its base (**Fig. 49**).[118] Built at the edge of a steep declivity with a main road into the city running along its bottom, it was meant to be an impressive sight (**Fig. 48**). Two friezes encircled the top of the podium below an ornate projecting cornice. Three statues probably stood between the columns on each of the two short sides (east and west). Along the long north side were five more statues of swiftly moving women; under some of their feet various marine creatures are preserved: a dolphin, a crab, a bird, a fish (**Figs. 50, 51**).[119] The style of these statues is very Greek, and they were early recognized as Nereids, from which the tomb received its modern name. There were also two fragmentary statues that do not belong with the Nereids and probably represent the deceased dynast and his wife.[120]

The upper part of the tomb is richly carved with a figured frieze on the architrave and another around the top of the cella wall. Both pediments were sculptured, and there were three figural acroteria at either end. Formal analysis indicates that a Greek and a local workshop participated in the carving of the sculpture program, and the iconography consists of both very Greek and very oriental themes, though both were produced by both workshops. The Greek workshop is distinguished by its flamboyant Rich Style drapery: long sinuous folds of cloth separated by almost moist areas clinging to the bodies beneath (**Fig. 55**). The local workshop generally produces a flatter relief with figures in multiple repetitions that suggests a close relationship with Achaemenid palatial reliefs (**Fig. 52**). The theme of a procession of tribute bearers on the cella frieze underscores this connection,[121] while the theme of city siege on the smaller podium frieze points to a Levantine tradition inherited from the great Assyrian palace reliefs of the ninth to seventh century (**Fig. 54**).

The large podium frieze depicts a generalized battle in which some figures wear oriental dress, some are nude, and some wear various clothing ranging from light chitons to full battle armor (**Figs. 52, 55**). Reconstruction of the original sequence of blocks has not been possible, so the composition of this frieze cannot be recovered.[122] The two combatant groups are not always clearly distinguished from each other, though an occasional figure in Persian dress, always male, may point to a local myth. The subject of the small podium frieze, a series of city sieges, permits at least a partial reconstruction of the sequence of blocks because some scenes run over two or more blocks (**Figs. 53, 54**).[123] The long south side has a symmetrical composition with a city in the center and attackers on either end. It is possible that the east side depicted movement across its entirety, from right to left. The west frieze may have had two juxtaposed scenes of a city and a parley with an oriental dynast. The long north side again had a city, but the details of the composition are lost.

The height of the relief is moderate in both friezes. Many details were added in metal and paint. Although the small frieze is narrative, even probably historical, the only pictorial element is the rendition of several of the cities in perspective. The influence of an archaic or oriental manner of composition is evident in the rows of marching soldiers, primarily products of the presumably local workshop (**Fig. 53**), as opposed to the blocks worked by the "imported Greek" sculptors. The large frieze presents simply a series of pat-

[118] P. Demargne and P. Coupel, *Fouilles de Xanthos*, vol. 3, *Le monument des Néréides: L'architecture* (Paris 1969); W. A. P. Childs and P. Demargne, *Fouilles de Xanthos*, vol. 8, *Le monument des Néréides: Le décor sculpté* (Paris 1989).

[119] Childs and Demargne, *FdX* 8 (note 118 above) 167–69.

[120] Ibid., 183–84, British Museum cat. nos. 940, 942, pls. 112–14.

[121] Ibid., pls. 124, 125.

[122] Ibid., pls. 9–33, LXXVI–LXXIX.

[123] Ibid., pls. 40–69, LXXVI–LXXIX.

terns without an overriding compositional principle, with the reservation that we do not know the original sequence of blocks. There are pyramidal three-figure groups and simple oppositions of standing warriors (**Fig. 55**). The occasional horse may have played a role in a larger compositional scheme, perhaps like the Centauromachy of the Temple of Apollo at Bassai, but this is only a hypothesis. There does not appear to have been any relationship between the composition of either frieze and the architecture above.

The reconstructions of the two narrow friezes of the architrave[124] and cella[125] are generally more reliable. The short sides of the architrave frieze appear to have had a central focus—the horse on the west, the rider attacking the boar on the east. This may also have been true of the long south side, where a pair of confronted warriors on rearing horses marks the center. On the north side, the procession of tribute bearers appears to have had a single direction, from right to left. The relief is low, and there is much space around the figures, with little overlapping, even in the battle and hunt friezes.

The fourth, cella, frieze is somewhat more crowded. The east, west, and north friezes have a central focus, with some figures in each frieze moving toward the center. On the north frieze, the center is emphasized by a reclining, bearded, frontal figure holding up a rhyton, who must be the dynast.[126] On the west frieze, an altar is at the center; on the east frieze, it is likely that the figures moved from both left and right, but not enough is preserved to describe the composition precisely, which is also the case for the south side.

The large podium frieze and the acroteria appear to have mythological themes. One of the acroteria may depict Peleus wrestling with Thetis.[127] The interpretation of the central mythological theme of the Nereids is most likely based on the Greek epic tradition that Thetis came to Troy upon the death of her son, Achilles, and, with her sisters, the Nereids, carried off his body to lodge him, resurrected, in the heroic paradise of the Isles of the Blessed.[128] The likelihood of this interpretation is underscored by the earlier traditions of tomb art in Asia Minor and Cyprus. The sarcophagus in the Troad depicts the sacrifice of Polyxena at the tomb of Achilles; the painted tomb at Elmalı depicts Pegasos and Chrysaor rising from the severed neck of Medusa,[129] a theme that also appears on the Golgoi sarcophagus from Cyprus. It seems clear that in the eastern Mediterranean and Cyprus Greek mythology played an early role in tomb iconography, with specific reference to resurrection.

The appropriation of Greek mythology is far more emphatic in another tomb in Lykia that is slightly later than the Nereid Monument; originally at the ancient site of Trysa, near the modern village of Gölbaşı, the tomb itself is now in Vienna.[130] Its walled temenos lies at the eastern end of a high spur overlooking a steep precipice on the north and a steep but manageable slope on the south (**Fig. 56**). The walls on either side of the entrance are sculptured with two superimposed frieze bands, as were all four interior walls.

[124] Ibid., pls. 115–29, LXXXVII–LXXXVIII.

[125] Ibid., pls. 130–39, LXXXIX.

[126] Ibid., pl. 133.1, 2.

[127] Ibid., 301–6, pls. 147–49. See also E. B. Harrison, "New Light on a Nereid Monument Akroterion," in *Kotinos: Festschrift für Erika Simon*, ed. H. Froning, T. Hölscher, and H. Mielsch (Mainz 1992) 204–10.

[128] Childs and Demargne, *FdX* 8 (note 118 above) 270–77; see also T. Robinson, "The Nereid Monument of Xanthos or the Eliyana Monument of Arñna," *OJA* 14 (1995) 355–60.

[129] Mellink, Bridges, and di Vignale, *Kızılbel* (note 109 above) 57–58, pl. 35, color pl. XXVII.

[130] O. Benndorf and G. Niemann, *Das Heroon von Gjölbaschi-Trysa* (Vienna 1889), also serialized in the *Jahrbuch der kunsthistorischen Sammlungen des Allerhöchsten Kaiserhauses* 9 (1889) 1–134, 11 (1890) 1–52, 12 (1891) 5–68; F. Eichler, *Die Reliefs des Heroon von Gjölbaschi-Trysa* (Vienna 1950); W. A. P. Childs, "Prolegomena to a Lycian Chronology, II: The Heroön from Trysa," *RA*, 1976, 281–316; W. Oberleitner, *Das Heroon von Trysa: Ein lykisches Fürstengrab des 4. Jahrhunderts v. Chr.*, AntW 25, Sondernummer (Mainz 1994).

A sarcophagus of traditional Lykian shape was erected off-center within the temenos, and a small enclosure occupied the southeast corner. The ridge was occupied by several other traditional Lykian above-ground tombs. The iconography of all the reliefs appears to be Greek: Amazonomachy (**Fig. 57**), Centauromachy, the Seven against Thebes, Odysseus and the suitors, the rape of the daughters of Leukippos, the adventures of Theseus, etc. In three places the normal pattern of two frieze bands is abandoned in favor of a single scene embracing both bands: twice in the battle on the west wall (**Fig. 58**) and the rape of the Leukippidai on the north wall.[131] In each case, as on the small podium frieze of the Nereid Monument, perspective is applied to architecture in a most pictorial manner. Even in the case where the two superimposed frieze bands are visually distinct, the subject above and below is the same: the battle before a city on the interior west wall, the adjoining Amazonomachy, and the adjoining rape of the Leukippidai on the north wall.[132] None of the friezes appears to have repetitive compositional units. Many of the subjects reflect scenes from Attic pottery, and the painterly quality of parts of the friezes also suggests painting as their inspiration. Indeed, the unusual form of the heroon may reflect the influence of the Theseion in Athens, which had paintings around its interior walls, as Pausanias records (1.17.2–6).[133] It seems probable that the tradition of painted tombs, such as those at Elmalı, has here been manifested in stone.

A second temple-like tomb in Lykia is the heroic tomb of the local dynast Periklä, or Perikles, at Limyra.[134] The foundation course measures roughly 10 × 7 meters, approximately the same as the Nereid Monument. Although the architecture of the tomb has not yet been published in detail, its rich sculpture has. Four caryatids, variants of those of the Erechtheion in Athens, stood at either end of a low podium.[135] Two large friezes decorated the exterior sides of the cella/tomb chamber (**Fig. 60**).[136] A group of Perseus and Medusa crowned one end of the roof with, as on the Nereid Monument, a single female figure facing inward at either corner (**Fig. 59**).[137] The architrave was decorated with rosettes. Both friezes depict processions leading toward the south entrance of the building, each led by a chariot, followed by a trumpeter and various figures in petasoi, cavalry and infantry. As on the Parthenon frieze, the procession has a visual depth created by a second and even a third file of figures, but here they are stacked in lines one above the other. The effect is most impressive in the infantry: between and above the first line of soldiers are heads of two more ranks. Although the first impression is of a real spatial extent in depth, in reality the composition follows the pattern of "Polygnotan" space which uses a rising ground to reveal what is beyond the front plane.

The location of the heroon high up on the side of a moderately steep and rocky incline meant that the monument was visible at some distance and probably had a grand view of the valley, if a defensive wall did not cut it off.[138] In this case, however, the visibility from

[131] Oberleitner, *Heroon von Trysa*, 36, fig. 67, 39–40, figs. 74–76, 42, fig. 81, 46–47, figs. 91, 94; W. A. P. Childs, *The City-Reliefs of Lycia* (Princeton 1978) figs. 13.2–17.

[132] Oberleitner, *Heroon von Trysa*, 35, figs. 64–66, 42–43, figs. 82, 85, 45–46, figs. 90, 92.

[133] H. A. Thompson, "Activity in the Athenian Agora 1960–1965," *Hesperia* 35 (1966) 42, note 8, 47, originally made this suggestion; Childs, *RA*, 1976, 295, note 1.

[134] Borchhardt, *Limyra*; J. Borchhardt, *Die Steine von Zemuri* (Vienna 1993) 45–52.

[135] Borchhardt, *Limyra*, 27–48, pls. 2–17

[136] Ibid., 49–80, pls. 20–26, 37.

[137] Ibid., 81–97, pls. 38–47.

[138] Ibid., 21, fig. 1, pl. 1; T. Marksteiner, *Die befestigte Siedlung von Limyra: Studien zur vorrömischen Wehrarchitektur und Siedlungsentwicklung in Lykien unter besonderer Berücksichtigung der klassischen Periode*, Forschungen in Limyra 1 (Vienna 1997) 31–32, 55, figs. 1–4, folding plans 1 and 2.

below is marginal compared to that of the Nereid Monument by its location directly above a main road into town.

The Mourning Women Sarcophagus from the royal cemetery at Sidon clearly follows the tradition of the two great Lykian temple-tombs of Xanthos and Limyra (**Figs. 61, 62**).[139] The sarcophagus imitates an Ionic temple except that there are antae at the corners. Six mourning women stand frontally or in three-quarter view in the intercolumniations on both long sides, with three on each short side. The "building" is raised on a low podium, like the podiums of the Nereid Monument and the tomb of Periklä at Limyra, around which runs a small frieze depicting hunts. On either long side of the lid is a procession which might be thought of as an outsized gutter. Unlike the tomb of Periklä, the processions do not mirror each other but encircle the lid. The pediments are carved in low relief, each with a seated mourning woman at the center framed by two reclining women. Above the pediment is an acanthus acroterion, with a sphinx at each corner. The short returns of the "gutter" friezes are also carved, this time with a pair of male figures seated or bent forward to fit the confined space.

The procession friezes on the lid have none of the spatial qualities of the friezes at Limyra.[140] Both have a pair of horses led in the Persian manner at the front, followed by a chariot, a wagon with a covered load (presumably the sarcophagus or at least a receptacle for the deceased), and finally a single horse without attendant. There is space around each unit of the procession. The small frieze of the podium is very different.[141] On the long sides the basic compositional unit is a pyramid with concentric sides extending out on either side of the central unit (**Fig. 62**). The animal and opposed attacker form the central unit, with three hunters on either side leaning in toward the central axis. The short sides are somewhat freely composed, with most figures moving in a single direction.

The culmination of the spectacular tomb, approximately at midcentury, is the tomb of Maussollos of Karia at Halikarnassos.[142] The Maussolleion stood in a temenos located in the heart of the new city by the sea completely rebuilt by Maussollos as his capital. Most like the Nereid Monument because of its central location, it obviously raised the bar on what might be called spectacular. Although its location has none of the Lykian scenic drama, it is larger and more elaborately covered in sculpture and became one of the wonders of the ancient world. It sat, as the Nereid Monument did, on a tall podium, in this case measuring about 38 × 32 meters at its base, with an Ionic superstructure of 11 × 9 columns surmounted by a pyramidal roof. Large, over-life-size groups of freestanding sculpture adorned two or possibly three steps around the lower part of the podium;[143] a frieze depicting an Amazonomachy (**Figs. 7–10**) encircled the top of the podium; statues

[139] Istanbul 368: Fleischer, *Klagefrauensarkophag* (note 102 above); Hamdy Bey and Reinach, *Nécropole royale,* 238–71, pls. 4–11; G. Mendel, *Musées impériaux ottomanes: Catalogue des sculptures grecques, romaines et byzantines* (Constantinople 1912) vol. 1, 48, no. 10; Hitzl, *Griechischen Sarkophage* (note 102 above) 179–80, no. 18, figs. 64, 65; Ferron, *Sarcophages de Phénicie* (note 102 above) 125–44, pls. XLV–LIX; Bol, *Bildhauerkunst,* 489–91, figs. 470a–g (M. Maaß).

[140] Fleischer, *Klagefrauensarkophag* (note 102 above) pls. 36–39.

[141] Ibid., pls. 12–17.

[142] The literature is immense, so I cite only the principal recent publications: K. Jeppesen, "Tot operum opus: Ergebnisse der dänischen Forschungen zum Maussolleion von Halikarnass seit 1966," *JdI* 107 (1992) 59–102; Jeppesen, *The Maussolleion at Halikarnassos: Reports of the Danish Archaeological Expedition to Bodrum,* vol. 5, *The Superstructure: A Comparative Analysis of the Architectural, Sculptural, and Literary Evidence* (Aarhus 2002).

[143] Two steps are proposed by Jeppesen; three steps by Waywell: Jeppesen, *JdI* 107 (1992) 82–85, pls. 24–32; Jeppesen, *Maussolleion,* vol. 5 (note 142 above) 176, fig. 18.6; Waywell, *Free-Standing Sculptures,* 56–57, figs. 8, 9.

stood in the intercolumniations (**Figs. 5, 6**); and a frieze of racing chariots was in an unknown location. The location of a frieze depicting a Centauromachy, formerly attributed to the podium under the Amazonomachy, is unknown, but it may have ringed the base of a chariot group at the apex of the roof, in which, Pliny tells us, stood statues of Maussollos and his wife, Artemisia (*NH* 36.4.31). Lions stood around the lower perimeter of the roof. The statues encircling the stepped podium depicted hunts and battles. The statues in the intercolumniations probably represented Maussollos's ancestors.

The only patently mythological themes are the Amazonomachy and Centauromachy, two themes that were combined on Greek buildings—the painting of the Theseion in Athens, the metopes of the Parthenon, and the interior frieze of the Temple of Apollo Epikourios at Bassai, and the large metopes of the tholos in the Marmaria at Delphi. It is not difficult to see these themes gradually changing from the basic message of Greeks triumphant over barbarians to the general triumph of good over evil, life over death, a subject to which I shall return later in the treatment of fourth-century iconography.

The Maussolleion is today particularly famous because both Pliny (*NH* 36.4.30) and Vitruvius (7 praef. 12–13) tell us that at least four renowned sculptors worked on it: Skopas, Timotheos, Leochares, and Bryaxis. Since quite a number of frieze slabs are preserved in good condition, it has been a major interest of scholars over the past century to attribute slabs to the four sculptors and thereby gain some insight into their individual styles.[144] Brian Cook has, however, noted that every slab has been attributed at one time or another to each of the four sculptors, from which it is evident that this line of inquiry has led nowhere.[145] However, in contrast to the anonymity of the sculptors of the Nereid Monument, major Greek sculptors worked on the Maussolleion, and that fact apparently had important repercussions for the Greek mainland.

In 1968, roadwork at Kallithea between Athens and the Piraeus uncovered a major building with rich sculptural decoration (**Fig. 247**).[146] This turned out to be a tomb analogous to the Nereid Monument and the Maussolleion, though much smaller and less richly decorated with sculpture. An inscription informs us that the tomb belonged to Nikeratos of Istria and his son Polyxenos, assuredly *metics*. The structure consisted of a high but shallow podium with a frieze of an Amazonomachy running along the top of the front and turning the corners on both sides (beyond which no further frieze slabs are preserved). Above a strongly projecting cornice rose three steps on which stands what can best be described as a huge funerary stele flanked by two Ionic prostyle columns supporting an Ionic entablature and perhaps a low roof. Within the projecting antae there are three approximately life-size statues, each standing frontally: Nikeratos, wrapped in a mantle and on the viewer's left, is largest; Polyxenos, nude and somewhat smaller, is in the middle; and on the right is a third, slightly smaller, nude male with a mantle thrown over his proper left shoulder. Since the monument has yet to be published beyond the early reports of its discovery, the above description is based on the magnificent re-creation of the monument in the Piraeus Museum.

[144] Cook, *Relief Sculpture of the Mausoleum.*

[145] Ibid., 19–22.

[146] E. Tsirivakos, "Εἰδήσιες ἐκ Καλλιθέας," *AAA* 1 (1968) 35–36, fig. 1, 108–9, figs. 1–3, 212 (inscription); Tsirivakos, "Kallithea: Ergebnisse der Ausgrabung," *AAA* 4 (1971) 108–10, figs. 1, 2; G. Daux, "Chroniques des fouilles," *BCH* 92 (1968) 749, 753 (inscription); G. Steinhauer, *Τα μνημεία και το Αρχαιολογικό Μουσείο Πειραιά* (Athens 1998) 83–84, pls. 24–26; Steinhauer, *Μουσείο Πειραιώς,* figs. 458–65; Schmaltz, *Griechische Grabreliefs,* 141–42; Ridgway, *Hellenistic Sculpture,* vol. 1, 31–32.

The principal element of the Nikeratos monument at Kallithea that goes beyond anything hitherto known in Attic grave monuments is the Amazonomachy frieze on the high podium. Of course, the high freestanding podium is itself also a novelty, but the graves of the Kerameikos in Athens and at Rhamnous were located above high walls lining the streets that ran through the two cemeteries, giving much the same impression as the independent podium of the Kallithea monument. It is, however, both the podium and the frieze that make the monument, which must date around 340–320, so important. The figures all stand frontally; the stance of Polyxenos resembles that of Agias in the Daochos Monument at Delphi, of the 330s. These were almost regal displays that far outshine the very large and impressive grave stelai, such as the Ilissos stele (**Fig. 132**) or even the monument to which the two women in New York may have belonged, which was probably a large, deep naiskos.[147]

A single block of an Amazonomachy long known in the National Archaeological Museum in Athens (**Fig. 248**)[148] was logically thought to be connected with the Kallithea monument, but it does not belong and thus may be attributed to another great tomb of the later fourth century.[149] Literary references to at least two magnificent tombs also suggest that the Kallithea tomb was hardly unique, though again the two best-attested examples belonged to foreigners: the tomb of Theodektes of Phaselis and the cenotaph of Pythionike, the mistress of Harpalos, who died in 326/5.[150] Moreover, other large grave monuments are reported to exist in the area of Kallithea where the Nikeratos monument was found, suggesting that near the end of the fourth century truly spectacular grave monuments were not infrequent, although those of citizens did have to maintain some moderation that was not required of foreigners.[151]

The evidence of architectural sculpture, whether figural or decorative, is underscored by metalwork and mosaics. Indeed, both share the combination of figures and ornament, as do painted terracotta vases. A brief description of these classes of object was given in chapter 2, so I need here only to emphasize the points that are most important for the present discussion. On one end of the spectrum, the sheer refined elegance of small metal, largely silver, vessels is breathtaking (**Fig. 107**). On the other extreme, the great bronze krater from tomb B at Derveni combines elegance, strong ornament, plastic figures, and relief scenes (**Figs. 110, 111**). The closest parallels that come to mind are the sculptured pedestals and column drums of the Temple of Artemis at Ephesos (**Figs. 39, 40**). Mosaics also present rich ornament surrounding their figural panels. Indeed, Martin Robertson has drawn attention to the similarities of the fantastic scrollwork decoration of the stag hunt mosaic in Building II at Pella, the geison decoration on the facade of the tomb at Lefkadia (**Fig. 117**), and metalwork.[152] It immediately becomes evident that such luxurious decoration is rarely, if ever, found on public monuments in Athens. But there are exceptions, for example, the great tomb, discussed above, of Nikeratos and Polyxenos,

[147] New York, MMA 44.11.2, 44.11.3: Richter, *Catalogue*, 62–64, no. 93, pls. 76, 77; Clairmont, *CAT*, 1.971

[148] Athens, NAM 3614: Kaltsas, *SNAMA*, 254, no. 531*; G. I. Despinis, "Αττικοί επιτύμβιοι ναΐσκοι του 4ου αι. II.X.· Μια πρώτη προσέγγιση," in *Αρχαία Ελληνική γλυπτική· Αφιέρωμα στη μνήμη του γλύπτη Στέλιου Τριάντη*, ed. D. Damaskos (Athens 2002) 216, fig. 14; Ridgway, *Hellenistic Sculpture*, vol. 1, 32–33.

[149] Tsirivakos, *AAA* 4 (1971) 110.

[150] A. Scholl, "Πολυτάλαντα μνημεῖα: Zur literarischen und monumentalen Überlieferung aufwendiger Grabmäler im spätklassischen Athen," *JdI* 109 (1994) 252–61.

[151] The very elaborate family tomb precinct of one famous Athenian—Isokrates, who died in 338—is described in the later literary sources. According to [Plutarch], *Moralia* 838b–d, there was a high column surmounted by a siren and a *trapeza* that depicted Gorgias, Isokrates, and others. See further chap. 7, p. 286 below.

[152] M. Robertson, "Early Greek Mosaics," in Barr-Sharrar and Borza, *Macedonia*, 243–44.

metics from Istria on the Black Sea. Since there may have been other similarly ostentatious tombs around Athens, it is better not to argue that this tomb could only have belonged to *metics*. After all, the Lysikrates Monument is almost as ostentatious, and, though Lysikrates' father was a freedman, the family had been wealthy and powerful from the early fourth century.[153] Outside of Athens, but probably an Athenian dedication, the Acanthus Column at Delphi is a good example of the combination of strong ornament and human figures (**Figs. 99, 100**), particularly in the recent reconstruction with the "dancers" holding the omphalos and a metal tripod above their heads.[154] Finally, though the large grave plots did not usually contain highly decorative monuments, they were nonetheless stunningly ostentatious in the profusion of stone monuments of different sorts. Nonetheless, some grave monuments, even though relatively small, are indeed almost Victorian in their profusion of decorative elements.[155] Then there are a relatively limited number of marble vases that copy metal prototypes with the most elaborate and intricate ornament. In this category, pride of place belongs to the griffin cauldron mounted on an acanthus shaft in Athens.[156] So, though Athens tends to be more austere, there is ample proof that its residents, citizens as well as *metics*, sometimes favored lavish decorative monuments. If the dates proposed for the grave monuments have any validity, this interest was not limited to the later fourth century.

Comparison of the preserved monuments of the fourth century with the historical record sketched briefly in chapter 1 is informative. Although wars and internecine political strife characterize the political/military record of the century, the old opinion that the construction of temples and other public buildings decreased in the fourth century is simply not accurate.[157] Part of the skewed picture derives from the Athenocentric view of earlier generations of scholars. In Athens there were few major projects of public building until the great stone Theater of Dionysos under Lykourgos and the arsenal at Piraeus, also completed under Lykourgos. But the sanctuary of Asklepios at Epidauros was almost totally a creation of the fourth century. Many of the buildings of the fourth century were small, like the tholos at Delphi, which was richly decorated with sculpture, as was the Temple of Apollo at Bassai and the Temple of Asklepios at Epidauros. But not all the new temples were small. The Temple of Zeus at Nemea and the Temple of Athena Alea at Tegea rank with all but the largest temples of the fifth century. The change in the proportions of temples and the invention of the Corinthian order do mark clear breaks with the more austere buildings of the fifth century. The frequently shorter length of the temples in relation to their width corresponds to the abandonment of the opisthodomos, which may be a practical change related to cult practice, but the increased height of the columns relative to their lower diameter is purely a change in style, as is the greater amount of carved orna-

[153] Davies, *APF*, 356–57, no. 9461.

[154] J.-L. Martinez, "La colonne des danseuses de Delphes," *CRAI*, 1997, 35–46.

[155] Piraeus 220: A. Conze, *Die attischen Grabreliefs*, vol. 3, pt. 1 (Berlin 1906) 294, no. 1354, pl. 284; G. A. S. Snijder, "Une représentation eschatologique sur une stèle attique due IVe siècle," *RA* 20 (1924) 32–45, pl. 3 left; A. B. Cook, *Zeus: A Study in Ancient Religion*, vol. 3, pt. 1 (Cambridge 1940) 385, fig. 250; G. Kokula, *Marmorlutrophoren*, AM-BH 10 (Berlin 1984) 202, no. O 41. Athens, Kerameikos P 280: Clairmont, *CAT*, 2.154; Kokula, *Marmorlutrophoren*, 166, no. G 4, pl. 10.1; U. Knigge, *Der Kerameikos von Athen: Führung durch Ausgrabungen und Geschichte* (Athens 1988) 154, fig. 151a. Athens, NAM 884: Kaltsas, *SNAMA*, 170–71, no. 335*; Clairmont, *CAT*, 2.710; Knigge, *Kerameikos*, 154, fig. 154b.

[156] Athens, NAM 3619, 3620: Kaltsas, *SNAMA*, 192, no. 380; see also ibid., 200, no. 398, 203, no. 408.

[157] W. B. Dinsmoor, *The Architecture of Ancient Greece: An Account of Its Historic Development* (London 1950; repr. New York 1973) 216, states that "during this century the architecture of the mainland is to be traced only in comparatively minor structures."

ment. Since increased relative height is also found in pottery and sculpture, this appears to be a fundamental element of the aesthetic sense of the fourth century. Indeed, it seems that elegance and ornament are the two features that stand out in the above inquiry. A third feature of great importance is the volume of production. This applies to grave reliefs in general as well as to the multiplication of grave monuments in individual plots or precincts. The same is true of the vast number of marble votive reliefs found in sanctuaries. This third characteristic is, of course, partly dependent on increased wealth—a practical response to outside forces—and partly on the fact that it is a subcategory of ornament: the juxtaposition of numerous objects is a parallel of the juxtaposition of numerous ornamental elements on metal vases, mosaic floors, and architectural moldings.

Although this chapter has focused on the presentation of the monuments of the fourth century, that is, their physical appearance in the broadest sense, the purpose has not been simply to characterize the period as obsessed with spectacular displays. The monuments of the fourth century continue to serve the same functions as their fifth-century predecessors: the religious, political, and social needs of the community. The broadly formal presentation of the monuments informs the content to which I now wish to turn.

6 Iconography

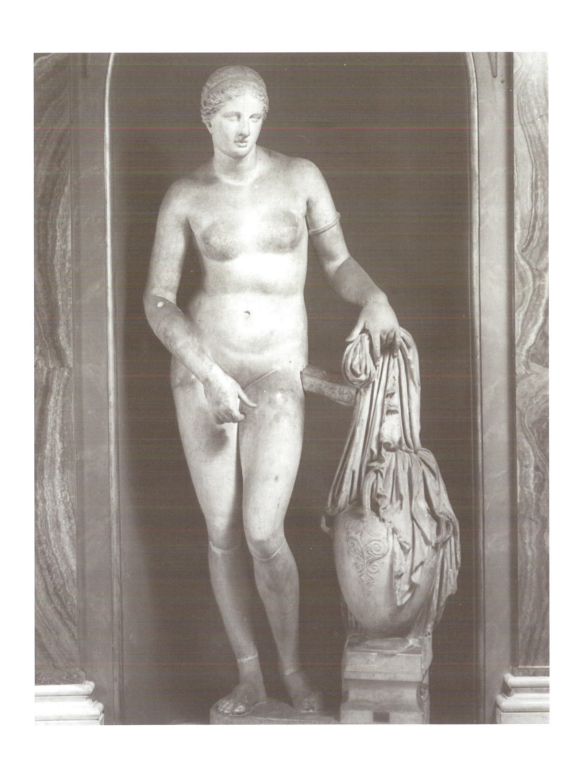

The changes in the iconography of the fourth century B.C. alluded to in the previous chapters permeate all aspects of fourth-century imagery, and at first glance they appear to constitute a virtual revolution. Everyone is aware of the stunning, even shocking, image of the completely nude Aphrodite created by Praxiteles (**Fig. 147**). The story of its acquisition by the city of Knidos, at the southwest corner of Asia Minor, underscores that the ancients, or at least the Late Hellenistic and Early Imperial commentators,[1] also felt surprise and wonderment at this novel and apparently revolutionary creation, similar to modern scholarly assessments. As we have seen, Pliny relates the story that Praxiteles made two statues of Aphrodite—one clothed, the other, famous, one nude—and presented them to the people of Kos to choose between; the Koans were shocked at the nude statue and took the clothed one. In choosing the nude, the Knidians made their city forever famous.[2] Modern scholarship has generally accepted the outlines of the story and made much of the novelty of the completely nude female statue. Yet we have already had occasion to allude to the passage in Pliny (*NH* 36.4.26) which states that Skopas made a nude Aphrodite either before or, far less likely based on the text, better than that of Praxiteles. Indeed, Nikolaus Himmelmann has traced the evolution of nude Aphrodites and her associates, particularly Helen, in the late fifth and early fourth centuries.[3] It is also important to remember the tradition of nude female figures in the seventh century based on oriental traditions, as stressed by Christoph Blinkenberg.[4] We should also recall the formal changes which occurred in the last third of the fifth century that slowly prepared the new image: the increasing transparency of drapery discussed earlier emphasizes the sexual and voluptuous aspect of various divine figures—Aphrodite, of course, but also Athena in the west pediment of the Parthenon, Artemis on the east frieze of the Parthenon, the Nike of Paionios, the "Sandal-binder" of the Nike parapet (**Fig. 160**), and Persephone of Eleusis.[5] Two grave stelai of the early fourth

<hr />

[1] A. Corso, "The Cult and Political Background of the Knidian Aphrodite," *Proceedings of the Danish Institute at Athens* 5 (2007) 181, 189–92, claims that the epigrams of the *Palatine Anthology* assigned to Plato, even if not by him, at least belong in Plato's circle, but this runs counter to the prevailing date of the epigrams between the Late Hellenistic period and the early Empire: D. L. Page, *Further Greek Epigrams: Epigrams before A.D. 50 from the Greek Anthology and Other Sources, Not Included in Hellenistic Epigrams or The Garland of Philip* (Cambridge 1981) 82, 83–84, no. V, 180–81, no. XXIII, and 385, no. LXXXII; the latter he considers the earliest and Hellenistic. Havelock, *Aphrodite of Knidos*, 3, 22–23, 62–63, follows Page.

[2] Cited in full, chap. 3, p. 85 above.

[3] N. Himmelmann-Wildschütz, "Zur Knidischen Aphrodite I," *MarbWPr*, 1957, 11–16, translated in Himmelmann, *Reading Greek Art*, 187–98.

[4] C. S. Blinkenberg, *Knidia: Beiträge zur Kenntnis der Praxitelischen Aphrodite* (Copenhagen 1933) 36–44; S. Böhm, *Die 'Nackte Göttin': Zur Ikonographie und Deutung unbekleideter weiblicher Figuren in der frühgriechischen Kunst* (Mainz 1990).

[5] Steiner, *Images in Mind*, 240–45, discusses the textual background to the attractive image of Nike. Bentz, *Preisamphoren*, 170, 172–73, nos. 4.025, 4.027, 4.052, pls. 110, 112, lists three Panathenaics with a Nike with nude torso. M. Bentz, "Die Preisamphoren aus dem Mosaikenhaus in Eretria," *AntK* 44 (2001) 7–8, pls. 1.4, 4.2, publishes two fragments of Panathenaics with wingless women with nude torsos. Bentz surmises that they might be Charites or

century even use the motif of drapery falling from the shoulder for mortal women, though they do not go so far as to bare the breasts (**Fig. 249**).[6] In the case of the later stele, any doubt about the meaning of the motif and voluptuousness in general is dispelled; as Christos Karousos has emphasized, it represents the seated woman in the thinly veiled guise of a goddess.

The voluptuousness of goddesses indicates their power. This is, of course, the power of generation and a whole range of other powers, since Parmenides and Empedokles had long before explained the forces of the universe in terms of Eros or Aphrodite,[7] a position in accord with the Hesiodic theogony, which made Eros the primordial force that aided Chaos in becoming differentiated.[8] A later but parallel view of Aphrodite and Eros as essential to the functioning of life in broadest terms is most fully elaborated by Plato in the lengthy eulogies of Love in the *Symposion*.[9] But independent of the orientalizing tradition of the seventh-century terracotta figurines, a variety of women in Greek vase painting had been represented either totally or partially nude from the first half of the sixth century on, and in a variety of contexts. The relationship of these earlier iconographic traditions to the new developments of sensuousness in the late fifth century is broadly ignored or even denied, almost certainly without justification.[10]

There are three main themes in which female nudity is depicted in the Archaic through High Classic periods: scenes of rape, sexual orgies, and apparently domestic scenes of women washing themselves and perhaps clothes. The first group of scenes unambiguously uses nudity to depict feminine vulnerability and the sacrilege of rape. From the sixth century on the motif is connected with scenes of the rape of Kassandra at the palladion of Troy in the Ilioupersis[11] and finds monumental expression in the Centauromachy of the west pediment of the Temple of Zeus at Olympia.[12] A fragmentary nude female torso from one of the lost south metopes of the Parthenon appears to continue the tradition,[13] as does slab BM 524 of the Temple of Apollo Epikourios at Bassai.[14]

Nikai without wings but prefers the interpretation that they are personifications of Panathenaia. For bibliography on the sculptures, see chap. 2, p. 34 with note 76, and chap. 4, pp. 104–6 with note 27. S. Moraw, "Schönheit und Sophrosyne: Zum Verhältnis von weiblicher Nacktheit und bürgerlichem Status in der attischen Vasenmalerei," *JdI* 118 (2003) 30–38, describes well the parallel development of mortal women.

[6] Athens, NAM 3891 and 3716: Kaltsas, *SNAMA*, 154, no. 301*, and 168, no. 333*; Clairmont, *CAT*, 1.182 and 3.284; C. Karusos, "Τηλαυγὲς Μνῆμα: Ein attisches Grabmal im Nationalmuseum, Athen," *MüJb* 20 (1969) 7–32; B. Schmaltz, "Typus und Stil im historischen Umfeld," *JdI* 112 (1997) 90, 92, figs. 7, 8; N. Himmelmann, "Quotations of Images of Gods and Heroes on Attic Grave Reliefs of the Late Classical Period," in *Periplous: Papers on Classical Art and Archaeology Presented to Sir John Boardman*, ed. G. R. Tsetskhladze, A. J. N. W. Prag, and A. Snodgrass (London 2000) 143; Bol, *Bildhauerkunst*, 262–63, fig. 197 (W. Geominy).

[7] W. K. C. Guthrie, *A History of Greek Philosophy*, vol. 2, *The Pre-Socratic Tradition from Parmenides to Democritus* (Cambridge 1965) 61–64, 153–90; G. E. R. Lloyd, *Polarity and Analogy: Two Types of Argumentation in Early Greek Thought* (Cambridge 1966; repr. Indianapolis, IN, 1992), chap. 4: "Metaphor and Imagery in Greek Cosmological Theories," 210–303.

[8] J. Rudhardt, *Le rôle d'Eros et d'Aphrodite dans les cosmogonies grecques* (Paris 1986) 10–17.

[9] Ibid., 18–40.

[10] Moraw, *JdI* 118 (2003) 1–47, does treat most of the types of female nudity from the Archaic through the Late Classical period and demonstrates convincingly that there are several parallel manifestations in which females were represented nude, each aimed at a different audience.

[11] J. B. Connelly, "Narrative and Image in Attic Vase Painting: Ajax and Kassandra at the Trojan Palladion," in *Narrative and Event in Ancient Art*, ed. P. J. Holliday (Cambridge 1993) 88–129; B. Cohen, "The Anatomy of Kassandra's Rape: Female Nudity Comes of Age in Greek Art," *Source* 12.2 (1993) 37–46; M. Mangold, *Kassandra in Athen: Die Eroberung Trojas auf attischen Vasenbildern* (Berlin 2000) 34–62.

[12] B. Ashmole, N. Yalouris, and A. Frantz, *Olympia: The Sculptures of the Temple of Zeus* (London 1967) fig. 127 (figures R and S).

[13] Athens, Acrop. 713: F. Brommer, *Die Metopen des Parthenon* (Mainz 1967) 109, pl. 209.

[14] Madigan, *Apollo Bassitas*, pl. 43, no. 133.

The second group of scenes with naked women, which begins in the late sixth century, represents pornographic depictions of rampant group sex with prostitutes at the symposium, with the prostitutes sometimes depicted as old hags.[15] But there are variations, such as nude women dancers or acrobats, who are thought, however, to double as prostitutes at the symposium.[16] All of these scenes dwindle in number toward the middle of the fifth century and then largely disappear. Because of their purported profession and low social rank, modern society wishes to discount these nude women as direct precursors of nude Aphrodite and Helen. But this cannot have been the ancient view.[17] After all, prostitutes served Aphrodite, though the social distinction between them and citizen-women was clearly drawn.[18]

The third, moderately large, group of scenes with naked women also appears at the end of the sixth century. They occur on various vase shapes—particularly vases that might be considered for the use of women, but also on kraters and cups—and show youngish and attractive women gathered primarily at a louterion but also occasionally at a fountain house with lion-head spout. Some of the women wash themselves; some have bundles of clothes which one can surmise they are about to wash, though they are never shown actually doing so. A recent exhaustive book by Ulla Kreilinger obviates the need to dwell on these vases, since her general conclusions approximate my own and follow the growing consensus that many of the scenes of nude women on classical pots do not depict prostitutes.[19] Nonetheless, a brief review of the evidence is useful and leads me to a conclusion slightly different from that of Kreilinger. These vase scenes become more numerous near

[15] I. Peschel, *Die Hetäre bei Symposion und Komos in der attisch-rotfigurigen Vasenmalerei des 6.–4. Jahrh. v. Chr.* (Frankfurt am Main 1987); C. Reinsberg, *Ehe, Hetärentum und Knabenliebe im antiken Griechenland*, Beck's Archäologische Bibliothek (Munich 1989) figs. 49–51.

[16] E.g., F. A. G. Beck, *Album of Greek Education* (Sydney 1975) nos. 376, 387, 389, 390, 395a, and especially no. 381, Copenhagen, National Museum of Denmark 1942: *ARV*² 1020.88 (Phiale Painter); J. H. Oakley, *The Phiale Painter* (Mainz 1990) 37, no. 188, pl. 109. S. Schmidt, *Rhetorische Bilder auf attischen Vasen: Visuelle Kommunikation im 5. Jahrhundert v. Chr.* (Berlin 2005) 254–56, fig. 126, counters that dancing was an element of women's education and therefore the vase scenes do not have to depict *hetairai*, an opinion seconded by Moraw, *JdI* 118 (2003) 19–21.

[17] E. E. Cohen, "'Whoring under Contract': The Legal Context of Prostitutes in Fourth-Century Athens," in *Law and Social Status in Classical Athens*, ed. V. Hunter and J. E. Edmondson (Oxford 2000) 112–47, especially pp. 130–32; see also the review by M. Gagarin, *BMCR* 2001.10.3; Reinsberg, *Ehe, Hetärentum* (note 15 above) 156–62. The general review of female nudity by Moraw, *JdI* 118 (2003) 1–47, suggests that there is a continuous tradition from the Late Archaic period down through the Classical of emphasis of the feminine physical beauty of free Athenian women, which is only partially related to the depictions of *hetairai*.

[18] Reinsberg, *Ehe, Hetärentum* (note 15 above) 153–55; V. Pirenne-Delforge, *L'Aphrodite grecque: Contributions à l'étude de ses cultes et de sa peronnalité dans le panthéon archaïque et classique*, Kernos suppl. 4 (Athens and Liège 1994) 428–30. See generally S. B. Aleshire, "The Economics of Dedications at the Athenian Asklepieion," in *Economics of Cult in the Ancient Greek World: Proceedings of the Uppsala Symposium 1990*, Boreas: Uppsala Studies in Ancient Mediterranean and Near Eastern Civilizations 21, ed. T. Linders and B. Alroth (Uppsala 1992) 84–99, on modern interpretations of how to recognize prostitutes in the ancient sources. The recent narrative of the life of the prostitute Neaira by D. Hamel, *Trying Neaira: The True Story of a Courtesan's Scandalous Life in Ancient Greece* (New Haven, CT, 2003), illuminates the position of a prostitute in Greek society of the fourth century.

[19] U. Kreilinger, *Anständige Nacktheit: Körperpflege, Reinigungsriten und das Phänomen weiblicher Nacktheit im archaisch-klassischen Athen* (Rahden, Westphalia, 2007), and her earlier brief treatise "Anwendung der Gender-Forschung: Das Phänomen der Nacktheit in der attischen Vasenmalerei," in *Methodische Perspektiven in der klassischen Archäologie: Akten der Tagung des Deutschen Archäologen-Verbandes am 19. Juni 2004 in Freiburg*, ed. K. Hitzl (Tübingen 2005) 7–16. Even more recent is A. Stähli, "Nackte Frauen," in *Hermeneutik der Bilder: Beiträge zur Ikonographie und Interpretation griechischer Vasenmalerei*, ed. S. Schmidt and J. H. Oakley (Munich 2009) 43–51. Since these appeared long after completion of the present chapter, I have mainly added them to the footnotes and take them into consideration in the text only where differences of interpretation appear significant. Recent but largely superseded works are: S. Lewis, *The Athenian Woman: An Iconographic Handbook* (London 2002); G. Ferrari, *Figures of Speech: Men and Maidens in Ancient Greece* (Chicago 2002) 47–56; S. Pfisterer-Haas, "Mädchen und Frauen am Wasser: Brunnenhaus und Louterion als Orte der Frauengemeinschaft und der möglichen Begegnung mit einem Mann," *JdI* 117 (2002) 1–79; Schmidt, *Rhetorische Bilder* (note 16 above) 271–78.

the middle of the fifth century, just when the scenes of symposium sex dwindle in popularity. They have, of course, been associated with the scenes of group sex,[20] but, curiously, they generally depict only women; some add interesting props such as aryballoi, sponges, and even strigils. Jean-Louis Durand and François Lissarrague have noted the significance of the louterion in both Attic black- and red-figure vase painting and have suggested a range of meanings, primarily within the world of ritual.[21] They point to a number of vases on which a herm is associated with a louterion and others on which men stand symmetrically around a louterion, apparently attending some ritual.[22]

Some related scenes associated with ritual, however, do make sexual references, for example, a pelike by Myson in Syracuse. On one side, a nude woman holds *olisboi* while climbing into a basket full of them. On the other side, another nude woman leans over a bell-krater; behind her a ball of clothing and a pair of boots are on a stool.[23] A pelike in Lausanne by the Geras Painter depicts a phallus-bird perched on a louterion; on the reverse side, a satyr hacks at a fallen herm with an axe.[24] It appears very likely that these vases belong with several others first discussed together by Ludwig Deubner, who connected them with the festival of the Haloa, a festival to celebrate and help propagate vegetation in the Attic month of Poseideion (December–January).[25] Prostitutes were apparently the main participants. Durand and Lissarrague cite a number of kylikes on which the sexual allusions around a louterion are more subtle, though clear.[26] A stamnos by the Siren Painter in the Shelby White and Leon Levy Collection is more difficult to interpret: on one side is a scene of a beardless youth at the left of a louterion leaning over and fondling the breast of a naked woman at the right of the louterion; a second naked woman strides out of the scene to the right.[27] Susanne Pfisterer-Haas interprets this and a few

[20] J. Bažant, *Les citoyens sur les vases athéniens du 6e au 4e siècle av. J.-C.* (Prague 1985) 31; Reinsberg, *Ehe, Hetärentum* (note 15 above) 55; and implicitly Himmelmann, *Ideale Nacktheit*, 27, 47; L. Bonfante, "Nudity as a Costume in Classical Art," *AJA* 93 (1989) 359; N. Salomon, "Making a World of Difference: Gender, Asymmetry, and the Greek Nude," in *Naked Truths: Women, Sexuality, and Gender in Classical Art and Archaeology*, ed. A. O. Koloski-Ostrow and C. L. Lyons (London 1997) 207. T. B. L. Webster, *Potter and Painter in Classical Athens* (London 1972) 242, was, however, doubtful of such a narrow interpretation.

[21] J.-L. Durand and F. Lissarrague, "Un lieu d'image? L'espace du loutérion," *Hephaistos* 2 (1980) 89–106, repr. in *Arts et légendes d'espaces: Figures du voyage et rhétoriques du monde*, ed. C. Jacob and F. Lestringant (Paris 1981) 125–49.

[22] Paris, Bibliothèque Nationale 839: *ARV²* 367.97 (Triptolemos Painter); Durand and Lissarrague, *Hephaistos* 2 (1980) 91, fig. 3; and a cup in the Louvre, C 10994: *ARV²* 824.23; R. Ginouvès, *Balaneutikè: Recherche sur le bain dans l'antiquité grecque* (Paris 1962) pl. 41, no. 134; Durand and Lissarrague, *Hephaistos* 2 (1980) 92, pl. 1b. A particularly graphic example is a pelike by the Eucharides Painter at one time on the market in Freiburg: Galerie Günter Puhze, *Kunst der Antike*, Katalog 11 (Freiburg 1995) no. 192. I am indebted to Michael Padgett for this reference and many others in this discussion. Here a fully dressed woman leans over a louterion, placing her hands in it, while another holds an oinochoe over it. On the reverse side an *aulētēs* and a draped, bearded man stand on either side of a herm in profile. Although the meaning is not clear, it appears likely that the women are engaged at the louterion in some ritual purification associated with the honoring of Hermes on the other side of the vase.

[23] Syracuse, Museo Archeologico Regionale Paolo Orsi 20.065: *ARV²* 238.5; *Paralipomena* 349.5; Ginouvès, *Balaneutikè*, 55, n. 8, pl. 10, no. 32 (B); *CVA*, Syracuse 1 (Italy 17), pl. 7.1, 7.2; Kreilinger, *Anständige Nacktheit* (note 19 above) fig. 31a, b.

[24] Lausanne, Musée Cantonal d'Archéologie et d'Histoire 3250 (G.20A): *Paralipomena* 355; *Beazley Addenda²* 209; C. Bérard, "Une nouvelle pelike du Peintre de Geras," *AntK* 9 (1966) 93–100, pls. 21, 22; Durand and Lissarrague, *Hephaistos* 2 (1980) 101, fig. 19; E. Vermeule, *Aspects of Death in Early Greek Art and Poetry* (Berkeley 1979) 174, fig. 26.

[25] L. Deubner, *Attische Feste* (Berlin 1932; repr. Darmstadt 1966) 65–67; E. Simon, *Festivals of Attica* (Madison, WI, 1983) 35–37; most recently, Kreilinger, *Anständige Nacktheit* (note 19 above) 163–69.

[26] *Hephaistos* 2 (1980) 100–102.

[27] Formerly in the Hunt Collection: *Stamnoi: An Exhibition at the J. Paul Getty Museum* (Malibu, CA, 1980) no. 15; A. Greifenhagen, "Odysseus in Malibu: Leihgabe aus amerikanischem Privatbesitz," *Pantheon* 40 (1982) 215, figs. 6–8; Sotheby's New York, *The Nelson Bunker Hunt Collection*, auction catalogue, 19 June 1990, no. 13; Pfisterer-Haas, *JdI* 117 (2002) 73, no. L 32; Kreilinger, *Anständige Nacktheit* (note 19 above) 76–77, fig. 97; Stähli, "Nackte Frauen" (note 19 above) 46, fig. 7.

other scenes essentially as genre representations: naked women washing were liable to be approached.[28]

René Ginouvès and Heidrun Pimpl have shown that louteria in pretty much the form known from Attic vases have been found both in sanctuaries and in domestic contexts, which suggests that they served both cult and broad functions in the home.[29] Of course, bathing is a ritual act associated with birth, marriage, and death, as well as the general expiation of pollution.[30] The relevance of the scenes of naked women at a louterion to the present inquiry is simply that the Knidian Aphrodite is universally understood as depicting the goddess at her bath, and bathing is clearly the subject of the vases of interest here.

Naked women at a louterion appear in the late sixth century and are sometimes shown washing nude at a fountain house.[31] Most are simply generic scenes, but a subgroup depicts women specifically washing their hair at either a fountain or louterion. These also begin around 500 B.C. and become more numerous around or just after the middle of the fifth century.[32] An early example on a column-krater in Milan is particularly informative:

[28] Pfisterer-Haas, *JdI* 117 (2002) 26–30, 34–36, 45; J. Boardman, "Boy Meets Girl: An Iconographic Encounter," in *Athenian Potters and Painters*, ed. J. H. Oakley, W. D. E. Coulson, and O. Palagia (Oxford 1997) 259–67.

[29] Ginouvès, *Balaneutikè*, 77–99, 174–75; H. Pimpl, *Perirrhanteria und Louteria: Entwicklung und Verwendung grosser Marmor- und Kalksteinbecken auf figürlichem und säulenartigem Untersatz in Griechenland* (Berlin 1997); see also D. A. Amyx, "The Attic Stelai, Part III: Vases and Other Containers," *Hesperia* 27 (1958) 221–28 (no. 3: Louterion); Kreilinger, *Anständige Nacktheit* (note 19 above) 112–17.

[30] R. Parker, *Miasma: Pollution and Purification in Early Greek Religion* (Oxford 1983) 20, 36, 50–51; S. G. Cole, "*Gynaiki ou Themis:* Gender Differences in the Greek *Leges Sacrae,*" *Helios* 19 (1993) 107–8.

[31] Hydria: Berlin, Staatl. Mus. 1966.20: *Paralipomena* 508; *Beazley Addenda*[2] 390; Pfisterer-Haas, *JdI* 117 (2002) 40, 41, fig. 47, 70, no. L 2; Kreilinger, *Anständige Nacktheit* (note 19 above) fig. 65a–c; Greifenhagen, *Pantheon* 40 (1982) 215, fig. 9.

Stamnos fragment: Heidelberg, Archäologisches Institut der Universität E 51: Ginouvès, *Balaneutikè*, 93, 96, pl. 19, fig. 58; Kreilinger, *Anständige Nacktheit*, fig. 287; C. H. E. Haspels, *Attic Black-Figured Lekythoi* (Paris 1936) 106, who believes the vase is Attic and not Etruscan, as W. Kraiker had suggested, *Gnomon* 10 (1934) 326, note 1; J. H. Grossman, "Six's Technique at the Getty," in *Greek Vases in the J. Paul Getty Museum*, vol. 5 (Malibu, CA, 1991) 22, no. 17.

Amphora: Berlin, Staatl. Mus. F 1843: *ABV* 478; *ABL* 220, no. 85; Ginouvès, *Balaneutikè*, 22–25, 220–21; C. Bérard, "L'impossible femme athlète," *AnnArchStorAnt* 8 (1986) 200, fig. 60.2; Kreilinger, *Anständige Nacktheit*, fig. 5. The vase is illustrated by C. Lenormant and J. de Witte, *Élite des monuments céramographiques: Matériaux pour l'histoire des religions et des moeurs de l'antiquité* (Paris 1861) vol. 4, pl. 18, and, on pl. 17, a similar scene on a now lost olpe; Ginouvès, *Balaneutikè*, 25. The motif also appears on the Phineus cup in Würzburg (L 164), where satyrs spy on naked women showering at a fountain house: J. Boardman, *Early Greek Vase Painting: 11th–6th Centuries B.C.* (London 1998) fig. 479.1. See more fully on these vases Pfisterer-Haas, *JdI* 117 (2002) 36–40, figs. 42, 43; Kreilinger, *Anständige Nacktheit*, 175–78.

[32] Pelike: Athens, NAM 1425 (CC 1180): *ARV*[2] 223.6 (akin to the Nikoxenos Painter); Pfisterer-Haas, *JdI* 117 (2002) 38, 39, figs. 46a, 46b, 70, no. RBB 3; *ABL* 223, no. 6; Ginouvès, *Balaneutikè*, 26–27, pl. 2, no. 4; R. Lullies, *Die kauernde Aphrodite* (Munich 1954) 55, fig. 35. A similar scene occurs on a fragment now in the possession of J. Michael Padgett, Lawrenceville, New Jersey.

There is also an archaic gem, dated in the third quarter of the sixth century, with essentially the same subject, a naked woman with her hair down crouching next to a low basin on a stand: New York, MMA 17.49: G. M. A. Richter, *Metropolitan Museum of Art, New York: Catalogue of Engraved Gems; Greek, Etruscan, and Roman* (Rome 1956; repr. Rome 2006) 25, no. 28, pl. 5; Ginouvès, *Balaneutikè*, 98, pl. 23, no. 71; J. Boardman, *Archaic Greek Gems: Schools and Artists in the Sixth and Early Fifth Centuries B.C.* (London 1968) 77, no. 177, pl. 12; V. Paul-Zinserling, *Der Jena-Maler und sein Kreis: Zur Ikonologie einer attischen Schalenwerkstatt um 400 v. Chr.* (Mainz 1994) pl. 65.1.

An Etruscan gem represents Atalanta naked, her name inscribed next to her, crouching with a box in front of her and a staff next to her, from which hang a strigil, aryballos, and sponge plus another object: A. Furtwängler, *Die antiken Gemmen: Geschichte der Steinschneidekunst im klassischen Altertum* (Leipzig and Berlin 1900) vol. 2, 77, vol. 3, 183, fig. 125, pl. 16, no. 21; Boardman, *Archaic Greek Gems*, 111–12, pl. 24, no. 339; *LIMC*, s.v. Atalante no. 61*. Two Etruscan gems are remarkably close to the gem in New York, but the crouching figure next to a louterion/basin is identified as Peleus, and the gems are dated in the second half of the fifth century: *LIMC*, s.v. Peleus nos. 4*–5* (E. Simon).

Stamnos: Munich, Staatliche Antikensammlungen 2411 WAF (J 349): *ARV*[2] 1051.18; M. Tiverios, "Zur Ikonographie der weiblichen Welt im Zeitalter des Perikles," in *Otium: Festschrift für Michael Strocka*, ed. T. Ganschow and M. Steinhart (Rehmshalen 2005) 381–90; Pfisterer-Haas, *JdI* 117 (2002) 42, fig. 51, 75, no. L 64; Kreilinger, *Anständige*

on one side is a louterion around which are gathered three women, two naked and one clothed (**Fig. 250**).[33] A tree on the right indicates an outdoor space.[34] The nude woman on the left of the louterion leans over it and holds up her hair in front of her face while she grasps a comb (?) in her proper right hand. On the reverse of this vase is another louterion, now on the right of the scene, faced by a cow or bull, to the left of which is a draped man. The cow/bull suggests sacrifice and therefore ritual for both sides of the vase. In the last quarter of the fifth century, a pyxis in New York presents a series of scenes that unambiguously represent a woman's preparations for marriage (**Fig. 251**).[35] A pair of columns defines an interior; to the left of this, an Eros pours water from a hydria onto the hair of a crouching nude woman who holds both hands to her head. There is no louterion, though a loutrophoros stands at some distance along the frieze band.[36] This new iconography of washing hair without a louterion, with an attendant pouring water from a hydria on a crouching nude woman, quickly becomes standard in Attic vase painting.[37] That the scenes of women washing at a louterion both precede and are closely allied to the wedding iconography of the New York pyxis is strongly suggested by a column-krater in Dresden which has been convincingly interpreted by Durand and Lissarrague (**Fig. 252**).[38] A nude woman stands behind a louterion, on which is written ΚΑΛΗ, and holds up a narrow band of cloth, which Durand and Lissarrague suggest may represent the belt that the husband unties from his bride on the night of the wedding.[39] It is more plausible, as Michael Padgett points out to me, that it is the mitra or snood that we often see women using to tie up their hair, especially on the pyxis in New York with wedding scenes (**Fig. 251**).[40]

Nacktheit (note 19 above) fig. 75a–d; Lullies, *Kauernde Aphrodite* (note 32 above) 56, fig. 36; Greifenhagen, *Pantheon* 40 (1982) 215, fig. 10. See also Bologna, Museo Civico Archeologico 261, by the Painter of the Louvre Centauromachy: ARV² 1089.28; *Paralipomena* 449; Ginouvès, *Balaneutikè*, 80, 81, 97 n. 6, pl. 17, no. 50; Pfisterer-Haas, *JdI* 117 (2002) 76, no. L 66.

[33] Milan, Banca Intesa Sanpaolo 9: G. S. Chiesa and F. Slavazzi, eds., *Ceramiche attiche e magnogreche: Collezione Banca Intesa; Catalogo ragionato* (Milan 2006) 78–81, cat. no. 9*; Durand and Lissarrague, *Hephaistos* 2 (1980) 96, fig. 12; Kreilinger, *Anständige Nacktheit* (note 19 above) fig. 96; *CVA*, Milan, Collection "H.A." 2 (Italy 51), p. 4, pl. 2 (2273) (listed as H.A. C 316, but so is the following column-krater). The word ΚΑΛΟΣ is written on both louteria.

[34] According to H. Metzger, *Imagerie athénienne* (Paris 1965) 82, and C. Bérard, *Anodoi: Recherches sur l'imagerie des passages chthoniens* (Rome 1974) 118, the tree can also represent a sanctuary.

[35] New York, MMA 1972.118.148: Moraw, *JdI* 118 (2003) 32–34, figs. 8a–d; V. Sabetai, "Aspects of Nuptial and Genre Imagery in Fifth-Century Athens: Issues of Interpretation and Methodology," in Oakley, Coulson, and Palagia, *Athenian Potters and Painters* (note 28 above) 319–36; D. von Bothmer, *Ancient Art from New York Private Collections* (New York 1961) pl. 91, no. 243; J. H. Oakley and R. H. Sinos, *The Wedding in Ancient Athens* (Madison, WI, 1993) 16, 17, figs. 20, 21; Paul-Zinserling, *Jena-Maler*, 117, pl. 63.1; R. F. Sutton, "The Interaction between Men and Women Portrayed on Attic Red-Figure Pottery" (Ph.D. diss., University of North Carolina, Chapel Hill, 1981) 48, fig. 1, pl. 1; Lullies, *Kauernde Aphrodite* (note 32 above) 42, 57, fig. 38; Kreilinger, *Anständige Nacktheit* (note 19 above) fig. 123.

[36] The name of the vase has been called into question by D. C. Kurtz and J. Boardman, *Greek Burial Customs* (Ithaca, NY, 1971) 151–52; and J. Bergemann, "Die sogenannte Loutrophoros: Grabmal für unverheiratete Tote?" *AM* 111 (1997) 163–66. Bergemann also demonstrates that other vase shapes were used for carrying water in wedding rituals.

[37] E.g., Berlin, Staatl. Mus. F 2707: ARV² 1326.70 (Manner of the Meidias Painter); *CVA*, Berlin 8 (Germany 62), pl. 47; Paul-Zinserling, *Jena-Maler*, 118, pl. 65.2; Sabetai, "Nuptial and Genre Imagery" (note 35 above) 320, fig. 2; Kreilinger, *Anständige Nacktheit* (note 19 above) fig. 126a, b.

[38] Dresden, Albertinum 321 (ZV 797): ARV² 1089.29 (Painter of the Louvre Centauromachy); Durand and Lissarrague, *Hephaistos* 2 (1980) 98, fig. 15 (drawing); Kreilinger, *Anständige Nacktheit* (note 19 above) fig. 78.

[39] M. Detienne, *Dionysos mis à mort* (Paris 1977) 85, with references. This might be considered the parallel of the veil of Aphrodite which covered her breast and lent an irresistible attraction to Hera when she seduced Zeus in the *Iliad* (14, 214–21). For the role of Hera as prototype of marriage, see Rudhardt, *Rôle d'Eros* (note 8 above) 29–30, 32. See also Bérard, *Anodoi* (note 34 above) 119–20, on ritual pieces of cloth of very much the type depicted on the Dresden column-krater.

[40] See also a lebes gamikos by the Washing Painter, Athens, NAM 14790: ARV² 1126.4; Sabetai, "Nuptial and Genre Imagery" (note 35 above) 330, fig. 13.

It accordingly seems likely that, in addition to broad rituals of purification, a number of the vases depicting nude women at a louterion represent the ritual bathing of a bride before marriage. The fact that many of these vases are column-kraters and a few other large shapes (amphoras and stamnoi) suggests that they were made for the wedding festivities, perhaps only for women. Women at louteria also appear on kylikes in even larger numbers, but they are mainly dressed, though not always.[41]

The mythological prototype for these scenes is undoubtedly the bath given Aphrodite by the Charites before she approaches Anchises in the *Homeric Hymn to Aphrodite* (5.61–63):[42]

> And there the Charites bathed her with heavenly oil
> Such as blooms upon the bodies of the eternal gods—
> oil divinely sweet, which she had by her, filled with fragrance.
>
> (Trans. H. G. Evelyn-White, Loeb edition)

Beauty is, in fact, connected with *charis* and is described as a gleaming quality, as though one were covered in unguents.[43] These scenes can therefore be understood as celebrating beauty and fecundity. After all, the kraters might have been bought just for women's celebrations at prenuptial gatherings or other related ceremonies, such as the Apatouria.[44] The idea that women had their own celebratory gatherings has already been advanced by Semeli Pingiatoglou on the basis of a series of late black-figure vases, including an amphora, hydria, column-krater, two lekythoi, and a kalpis, which depict only women at what can only be called a ladies' symposium; this has also been convincingly argued by Kreilinger.[45]

The basic iconography of nude women washing in preparation for their weddings is supplemented by a further group of vases that add to the repertory strigils, aryballoi, and sponges.[46] Though one can question whether these utensils have any implications beyond

[41] Draped women: Pfisterer-Haas, *JdI* 117 (2002) nos. L 14, L 21, L 23–L 29, L 36, L 37, L 46, L 52–L 61a, L 61b; nude women: nos. L 3, L 22, L 44, L 45, L 47, L 85, L 88, L 89.

[42] On bathing and beauty, see also Euripides, *Helen* 676–78, and Kallimachos, Hymn 5, *On the Bath of Pallas*; see S. Scheurer and R. Bielfeldt, "Krisis," in *Das griechische Satyrspiel*, ed. R. Krumeich, N. Pechstein, and B. Seidensticker (Darmstadt 1999) 357–59, on the probability that the Kallimachos passage reflects Sophokles' satyr play *Krisis*. A. Brueckner, *Anakalypteria*, BWPr 64 (Berlin 1904) 16–17, placed the Knidia in the context of marriage iconography on vases; this was rejected in W. Helbig, *Führer durch die öffentlichen Sammlungen klassischer Altertümer in Rom*, 3rd ed. (Leipzig 1912) vol. 1, 204, no. 310, and by Blinkenberg, *Knidia* (note 4 above) 56.

[43] B. MacLachlan, *The Age of Grace: Charis in Early Greek Poetry* (Princeton 1993) 34–39; R. Parker, "Pleasing Thighs: Reciprocity in Ancient Greece," in *Reciprocity in Ancient Greece*, ed. C. Gill, N. Postlewaite, and R. Seaford (Oxford 1998) 108–10. On the Charites and the quality of *charis*, see E. Schwarzenberg, *Die Grazien* (Bonn 1966) 29–32; see also A. B. Cook, *Zeus: A Study in Ancient Religion* (Cambridge 1940) vol. 3, pt. 1, 241, on the daughters of Erechtheus: Pandrosos (all-dewy), Herse (dew), and Aglauros (shining one).

[44] Deubner, *Attische Feste* (note 25 above) 232–34; MacLachlan, *Age of Grace* (note 43 above) 44. It should be noted that normally the principal figure is clearly distinguished from her attendants; only one is known to me on which two women have their hair down, a stamnos in Florence by the Troilos Painter: Florence, MAN 3986: *ARV*² 296.9; *CVA*, Florence 2 (Italy 13) pl. 50.1, 2; Pfisterer-Haas, *JdI* 117 (2002) 40–42, no. L 18 (p. 72); Kreilinger, *Anständige Nacktheit* (note 19 above) fig. 74a, b. The reverse has a scene of boxers with a low basin between them on the ground and a referee on the right.

[45] S. Pingiatoglou, "Rituelle Frauengelage auf scharzfigurigen attischen Vasen," *AM* 109 (1994) 39–51, pls. 14–17; Kreilinger, *Anständige Nacktheit* (note 19 above) 30–49; cf. Lewis, *Athenian Woman* (note 19 above) 113–15. Stähli, "Nackte Frauen" (note 19 above) 43–51, argues to the contrary that these vases were made for male enjoyment of the beauty of women and depict imaginary scenes.

[46] Column-krater in Bari, Museo Civico 4979: *ARV*² 236.4, 1638 (Manner of the Göttingen Painter); G. Arrigoni, "Donne e sport nel mondo greco," in *Le donne in Grecia*, ed. G. Arrigoni (Rome 1985) 166–67, pl. 13; Ginouvès,

just washing,[47] occasionally one woman also wears a band around her breasts, though she is otherwise nude.[48] Since active women, such as dancers, are often depicted wearing a brassiere,[49] the bands likely imply the activity of nude women with strigil, etc., at a louterion. This may have an important resonance in the practices of fifth-century Athens, though some commentators have suggested that the women depicted are Spartans.[50]

Balaneutikè, 94–95; C. Bérard et al., *A City of Images: Iconography and Society in Ancient Greece* (Princeton 1989) 94, fig. 127; Kreilinger, *Anständige Nacktheit* (note 19 above) fig. 91.

Amphora in Palermo, Museo Archeologico Regionale 1659: *ARV*² 565.39 (Pig Painter); G. B. Passeri, *Picturae Etruscorum in Vasculis*, vol. 1 (Rome 1767) pls. 30, 31; Pfisterer-Haas, *JdI* 117 (2002) no. L 35; Kreilinger, *Anständige Nacktheit*, fig. 69 (drawing).

Column-krater in Vienna, KHM 2166: *ARV*² 1111.1 (Painter of Tarquinia 707); Ginouvès, *Balaneutikè*, 222, pl. 18, no. 53; Bérard, *AnnArchStorAnt* 8 (1986) 197, 198, 200, fig. 59.2; Paul-Zinserling, *Jena-Maler*, 113, pl. 56.1; Kreilinger, *Anständige Nacktheit*, fig. 92.

Stamnos in Boston, MFA 95.21: *ARV*² 1052.19, 1680 (Group of Polygnotos); B. Philippaki, *The Attic Stamnos*, Oxford Monographs on Classical Archaeology (Oxford 1967) 134, pl. 56.3 (A); S. B. Matheson, *Polygnotos and Vase Painting in Classical Athens* (Madison, WI, 1995) 168, pl. 150, PGU 23 (p. 450); L. D. Caskey, "Greek Marble Vases," *BMFA* 37 (1939) 79, fig. 10; Pfisterer-Haas, *JdI* 117 (2002) 75, no. L 65; Kreilinger, *Anständige Nacktheit*, fig. 93.

Pyxis in the manner of the Meidias Painter in Berlin, Staatl. Mus. 9756 (3403): *ARV*² 1319.1; Pfisterer-Haas, *JdI* 117 (2002) 53–55, fig. 65, no. L 82.

Calyx-krater by the Fabre Painter in Montpellier, Musée Fabre 837.1.1109: *ARV*² 1444.1; Ginouvès, *Balaneutikè*, 172, pl. 29, no. 97 (A); C. Landes and A.-F. Laurens, eds., *Les vases à memoire: Les collections de céramique grecque dans le midi de la France*, exh. cat. (Lattes 1988) 30–31, no. 4, figs. on p. 43 (A and B); Paul-Zinserling, *Jena-Maler*, 114, pl. 56.3 (A); Pfisterer-Haas, *JdI* 117 (2002) no. L 87; Kreilinger, *Anständige Nacktheit*, 81, fig. 142 (A). The main participants on the vase are a naked woman with some ornaments in her hair who holds a strigil and faces the louterion on the viewer's right, and a clothed woman holding an alabastron who stands to the left; at the far right a satyr dances. A crouching youth is in the louterion and appears to hold a strigil in his upraised right hand; his hair is long and he wears a fillet or diadem. One wonders if this figure was meant to be a woman and became a youth by inattention. It is more likely that he was meant to be an Eros, shown similarly in a louterion on a pelike in Saint Petersburg, Hermitage (1905) 15449: Schefold, *UKV*, 53–54, no. 494, fig. 39 (Hesperides Painter); Metzger, *Représentations*, pl. 43.2; Paul-Zinserling, *Jena-Maler*, 114, pl. 57.2; Bérard, *Anodoi* (note 34 above) 120; cf. *LIMC*, s.v. Eros nos. 653, 654*; Kreilinger, *Anständige Nacktheit*, fig. 139. Cambridge, MA, Harvard Art Museums 60.348: *CVA*, Baltimore, The Robinson Collection 3 (U.S.A. 7) (1938), pls. XIV, XV.1 (near the Hippolytos Painter); Pfisterer-Haas, *JdI* 117 (2002) 53, fig. 64, no. L 91 (p. 78); Kreilinger, *Anständige Nacktheit*, fig. 140, has a complex scene consisting in part of a nude woman holding with both hands a long strand of her hair that falls open on her shoulders at a louterion, an Eros fluttering above the latter, and a crouching nude woman with her hair up on the left next to a standing clothed woman with a largish piece of cloth in her hands, as though she were about to give it to the crouching figure.

[47] E. K. Guhl and R. Engelmann, *Leben der Griechen und Römer*, 6th ed. (Berlin 1893) 367, say without reservation that the strigil was used by both sexes for washing. The reference was kindly supplied by Hugo Meyer.

[48] Column-krater formerly in the Lagunillas Collection, Havana: *ARV*² 1166.98; *Paralipomena* 458.98; *Beazley Addenda*² 338; R. Olmos Romera, *Vasos griegos: Collección Condes de Lagunillas* (Zurich 1990) 152–55, no. 43*; Olmos Romera, *Catálogo de los vasos griegos del Museo Nacional de Bellas Artes de La Habana* (Madrid 1993) 186–88, no. 86*; Pfisterer-Haas, *JdI* 117 (2002) 45, fig. 55, 76, no. L 76; Kreilinger, *Anständige Nacktheit* (note 19 above) fig. 95; Paul-Zinserling, *Jena-Maler*, 113, pl. 56.2; A. D. Trendall, "Three Vases in Sydney," in *Charites: Studien zur Altertumswissenschaft (Festschrift E. Langlotz)*, ed. K. Schauenburg (Bonn 1957) 167, pl. 26.1; Ginouvès, *Balaneutikè*, 94, note 2, 221–22, pl. 18, no. 55, incorrectly placed the vase in Sydney.

Kylix tondo: E. C. Keuls, "Attic Vase-Painting and the Home Textile Industry," in *Ancient Greek Art and Iconography*, ed. W. G. Moon (Madison, WI, 1983) 216, fig. 14.15; Keuls, *The Reign of the Phallus: Sexual Politics in Ancient Athens* (New York 1985) 172, fig. 148; Pfisterer-Haas, *JdI* 117 (2002) 77, no. L 85; Münzen und Medaillen AG, *Antike Vasen, Sonderliste R* (December 1977) no. 58, considered close to the Painter of Berlin 2536 (*ARV*² 1286.1).

[49] Brussels, Musées Royaux A 3556: *ARV*² 1021.120; Beck, *Album of Greek Education* (note 16 above) no. 387; Oakley, *Phiale Painter* (note 16 above) 85–86, no. 120, pl. 97.

[50] Arrigoni, "Donne e sport" (note 46 above) 167, 168 (text to plates 13 and 15), a position rejected by Kreilinger, *Anständige Nacktheit* (note 19 above) 114, 160–61, 182–90; Stähli, "Nackte frauen" (note 19 above) 45; Ginouvès, *Balaneutikè*, 222; Bérard, *City of Images* (note 46 above) 92–93, and *AnnArchStorAnt* 8 (1986) 199. J. Boardman, "Atalanta," in *The Art Institute of Chicago Centennial Lectures*, Museum Studies 10 (Chicago 1983) 10–12, says simply "In Classical Athens it is very doubtful whether physical education played any part in the life of ladies...." See most recently Scanlon, *Eros and Greek Athletics*, 121–38; and B. Kratzmüller, "'Frauensport' im alten Athen? Die Darstellungen sich körperlich betätigender Frauen als Abbild der Einstellung einer patriarchalisch geprägten Gesellschaft zum weiblichen Geschlect," in *Transformationen, Kontinuitäten und Veränderungen in der Sportgeschichte*, ed. W. Buss and A. Krüger (Hoya 2002) 173–74.

But Lilly Kahil long ago published three fragmentary Attic red-figure krateriskoi of unique shape in the collection of Herbert A. Cahn in Basel that show both clothed and naked girls running as part of the sacred rituals of the Arktoi in the sanctuaries of Artemis in Attica (**Fig. 253**).[51] As Kahil showed, vases of that unique form, with very fragmentary remains of scenes similar to those on the vases in Basel but in black-figure technique, have been recovered not only at Brauron but at all sanctuaries of Artemis in Attica.[52] These rituals were carried out by young girls between the ages of five and ten years old, therefore not in anticipation of approaching marriage, as is sometimes suggested.[53] But they do demonstrate the connection of nudity, female athletics, and ritual in Attica, and the connection may be more general, since it has been suggested that the female contests at Olympia, the Heraia, were for girls approaching the age for marriage.[54] A further point is made by Claude Bérard: we need not consider the athletics of women in Attica to be parallel to the competitive sports of males, but rather a healthy *divertissement* of the well-born and beautiful.[55] When the chorus of women in Aristophanes' *Lysistrata* (637–47) cites their accomplishments, the wearing of the yellow robe in the Brauronian festivals is mentioned, along with such prestigious honors as being *arrēphoros* and *kanēphoros* as a beautiful young girl (παῖς καλή).[56]

All of this underscores the importance of women in ritual imagery in classical Athens, and this may be supported by the suggestion of Ira Mark that the winged figure next to Hera on the east frieze of the Parthenon is Nike and serves as a symbol of fertility and marriage.[57] Here Hera performs the gesture of anakalypsis and turns to Zeus on her right, away from the arm of the procession that approaches from the south, the direction her body faces. As Mark points out, the symbolic use of Nike in marriage contexts begins in earnest around the middle of the fifth century, just when the vases with probable marriage

[51] Basel, H. A. Cahn Collection HC 501, 502: L. Kahil, "L'Artémis de Brauron: Rites et mystère," *AntK* 20 (1977) 86–98; Kahil, "Le sanctuaire de Brauron et la religion grecque," *CRAI*, 1988, 799–813; Robertson, *Vase-Painting*, 262–63; E. D. Reeder, *Pandora: Women in Classical Greece*, exh. cat. (Baltimore 1995) 321–27, nos. 98*, 99*; Moraw, *JdI* 118 (2003) 17–18, 21, figs. 7a–d.

[52] R. Hamilton, "Alcman and the Athenian Arkteia," *Hesperia* 58 (1989) 449–72, lists all the known/published fragments of such vases; he has questioned aspects of Kahil's thesis, but his conclusion that the vases represent rituals more generally than just the Arkteia does not affect the present discussion. See further Scanlon, *Eros and Greek Athletics*, 139–74, figs 6.1–6.8, and G. Ferrari Pinney, "Fugitive Nudes: The Woman Athlete," *AJA* 99 (1995) 303–4.

[53] P. H. J. Lloyd-Jones, "Artemis and Iphigeneia," *JHS* 103 (1983) 91–95. J.-P. Vernant, *Mortals and Immortals: Collected Essays*, ed. and trans. F. I. Zeitlin (Princeton 1991) 217–19, C. Sourvinou-Inwood, *Studies in Girls' Transitions: Aspects of the Arkteia and Age Representation in Attic Iconography* (Athens 1988), and Ferrari, *Figures of Speech* (note 19 above) 166–76, suggest that, because of the young age of the girls, the rituals pertain not to marriage but to an initial separation from childhood, as Plato outlines in *Laws* 833C–D. For a full discussion of the issue, see Hamilton, *Hesperia* 58 (1989) 449–72; and most recently C. Faraone, "Playing the Bear and the Fawn for Artemis: Female Initiation or Substitute Sacrifice?" in *Initiation in Ancient Greek Rituals and Narratives: New Critical Perspectives*, ed. D. B. Dodd and C. Faraone (London 2003) 43–68.

[54] Scanlon, *Eros and Greek Athletics*, 98–120; N. Serwint, "The Female Athletic Costume at the Heraia and Prenuptial Initiation Rites," *AJA* 97 (1993) 403–22; C. Sourvinou-Inwood, "Altars with Palm-trees, Palm-trees and *Parthenoi*," *BICS* 32 (1985) 125–46; S. G. Miller, *Ancient Greek Athletics* (New Haven, CT, 2004) 150–59.

[55] Bérard, *AnnArchStorAnt* 8 (1986) 199; Bérard, *City of Images* (note 46 above) 92–93; Paul-Zinserling, *Jena-Maler*, 113–14; Kratzmüller, "Frauensport" (note 50 above) 171–73. Aristophanes, *Lysistrata* 551–54, certainly supports the idea that Athenian women were very conscious of their looks. Stähli, "Nackte Frauen" (note 19 above) 43–52, notes that the female nudes reflect the scenes of nude youths, and the addition of sportive objects emphasizes this parallel as part of the general ideal of beauty. This strikes me as correct and is emphasized by the connection I make below with images of nude Atalanta.

[56] M. R. Lefkowitz, "Women in the Panathenaic and Other Festivals," in *Worshipping Athena: Panathenaia and Parthenon*, ed. J. Neils (Madison, WI, 1996) 79–81.

[57] I. S. Mark, "The Gods of the East Frieze of the Parthenon," *Hesperia* 53 (1984) 302–12; J. Neils, *The Parthenon Frieze* (Cambridge 2001) 165–66.

imagery become most popular.[58] In addition, Mark argues that the grouping of Artemis, Aphrodite, and Eros also refers to childbirth and nurturing.[59] It is hardly necessary to recall that in 451/0 Perikles passed a law governing citizenship which required that both the father and the mother be Athenian for a son to be a citizen.[60] Although the law was not consistently enforced until it was passed again at the end of the century, its original passage strongly suggests a new importance for marriage in Athens of the middle of the fifth century. As we shall see, the exclusivity of citizenship remains of high importance during the fourth century, only to weaken as the Hellenistic period progresses, according to J. K. Davies.

It seems to me that there is a further meaning in the references to the athletic qualities of the nude women at louteria. The athletic heroine par excellence is Atalanta. Although most often depicted in the earlier sixth century fully dressed and wrestling Peleus,[61] near the end of the century she is shown with only her breasts bared.[62] Around the 460s, in the tondo of a cup by the Euaion Painter in the Louvre, she wears a brassiere (**Fig. 254**).[63] On a series of related cups by the Aberdeen Painter a woman, who can only be Atalanta, is depicted bare breasted;[64] on two almost identical cups she stands next to a louterion.[65]

These scenes may be related to two other notable representations of nude women: the Priam Painter's amphora in the Villa Giulia (**Fig. 255**)[66] and a peculiar white-ground amphora by the Andokides Painter in the Louvre (**Fig. 256**).[67] On the reverse of the Priam Painter's amphora Dionysos is seated between two treelike vines in which numerous satyrs climb and collect grape clusters; below are three baskets full of grapes. Beazley describes the scene as "satyrs making wine." On the other side, five naked women disport themselves around an outdoor pool indicated by rippled lines at the lower left into which one of the women dives. The location is indicated by two trees that frame the scene; in the middle is a building that could conceivably be a fountain house seen from the back. The women are therefore probably nymphs or mainads belonging to the world of Dionysos.

[58] Mark, *Hesperia* 53 (1984) 309–11.

[59] Ibid., 295–302.

[60] Pseudo-Aristotle, *Ath. Pol.* 26.4; Plutarch, *Perikles* 37.3; P. J. Rhodes, *A Commentary on the Aristotelean Athenaion Politeia* (Oxford 1993) 331–35; J. K. Davies, "Athenian Citizenship: The Descent Group and the Alternatives," *CJ* 73 (1977–78) 105–21; C. Patterson, *Pericles' Citizenship Law of 451–50 B.C.* (New York 1981); M. Ostwald, *From Popular Sovereignty to the Sovereignty of Law: Law, Society, and Politics in Fifth Century Athens* (Berkeley 1986) 182, 507–8.

[61] *LIMC*, s.v. Atalante nos. 62*, 64*, 65*, 67* (the exceptions are nos. 63* and 66*); A. Ley, "Atalante: Von der Athletin zur Liebhaberin; Ein Beitrag zum Rezeptionswandel eines mythologischen Thema des 6.–4. Jhs. v. Chr.," *Nikephoros* 3 (1990) figs. 1, 2, 4, 6, 7.

[62] *LIMC*, s.v. Atalante nos. 63*, 66*, 68 (Peleus no. 15*), 69*–72*; Ley, *Nikephoros* 3 (1990) figs. 5, 8, 9–12. See now Kreilinger, *Anständige Nacktheit* (note 19 above) 105–7.

[63] Paris, Louvre CA 2259: *ARV*² 797.137; *LIMC*, s.v. Atalante no. 60*; Ley, *Nikephoros* 3 (1990) 49, K 17, fig. 14; Paul-Zinserling, *Jena-Maler*, pl. 61.2; Scanlon, *Eros and Greek Athletics*, 193–94, fig. 7.10; Kreilinger, *Anständige Nacktheit* (note 19 above) fig. 364.

[64] Ferrara, Museo Archeologico Nazionale 1340 (T 991): *ARV*² 919.5; *LIMC*, s.v. Atalante no. 86*; Ley, *Nikephoros* 3 (1990) 50, K 18, fig. 15; Paul-Zinserling, *Jena-Maler*, pl. 61.1; Reeder, *Pandora* (note 51 above) 369, no. 118*; Scanlon, *Eros and Greek Athletics*, 194–95, fig. 7.11; Kreilinger, *Anständige Nacktheit* (note 19 above) fig. 363.

[65] Boston, MFA 03.820: *ARV*² 919.3; *LIMC*, s.v. Peleus no. 29*; Ley, *Nikephoros* 3 (1990) 51, K 19, fig. 16; Paul-Zinserling, *Jena-Maler*, 116, n. 1578, pl. 54.3; Kreilinger, *Anständige Nacktheit* (note 19 above) fig. 101. Rome, Villa Giulia 48234: *ARV*² 919.4; *LIMC*, s.v. Atalante no. 85*; Reeder, *Pandora* (note 51 above) 369–71, no. 119;* Boardman, *ARFV-CP*, fig. 88; Kreilinger, *Anständige Nacktheit* (note 19 above) fig. 103.

[66] Rome, Villa Giulia 106463: *Paralipomena* 146.8ter; *Beazley Addenda*² 90; W. G. Moon, "The Priam Painter: Some Iconographic and Stylistic Considerations," in *Ancient Greek Art and Iconography*, ed. W. G. Moon (Madison, WI, 1983) 110–12, figs. 17a–c, 18a–c; Kreilinger, *Anständige Nacktheit* (note 19 above) 68, fig. 3.

[67] Paris, Louvre F 203: *ARV*² 4.13; Ginouvès, *Balaneutikè*, 25–26, 113; K. Schefold, *Götter- und Heldensagen der Griechen in der spätarchaischen Kunst* (Munich 1978) figs. 135, 136; Cohen, *Colors of Clay*, 196–98, no. 51* (A/B); Kreilinger, *Anständige Nacktheit* (note 19 above) 68, fig. 4.

Warren Moon emphasizes the extraordinary painterly aspect of this panel and posits the possibility of some mural prototype while regretting that the subject was so little treated in Greek art. There is indeed a slightly later, very crude, scene on an Attic skyphos from Rhitsona of two naked youths diving into a pool or stream indicated by a wavy black and white surface, above which is a branch or vine.[68] On the Andokides Painter's amphora, one side depicts three Amazons in light attire with a shield leaning against the frame on the left and a helmet on the ground under the central horse. The other side shows four naked women, one of whom clearly swims actively in a pool or stream indicated by fish.[69] To the right is a Doric column indicating some sort of adjoining structure, perhaps in the same vein as the central building of the Priam Painter's scene. Dietrich von Bothmer suggested that these naked women are Amazons, and he has been followed by later commentators.[70] Even if these identifications are correct, they hardly explain the sudden and brief appearance of these scenes of naked women.

It is unlikely to be a mere coincidence that in the late sixth century there appeared nude (or mostly so) depictions of Atalanta, Amazons, and mainads, and scenes of nude women at louteria, an early example of which, the column-krater in Bari, shows a woman scraping herself with a strigil.[71] That a conscious and purposeful parallel was intended may be indicated by a second event in Atalanta's athletic career, her race with Hippomenes for her hand in marriage. She is shown nude on a calyx-krater by the Dinos Painter of about 420 B.C. in Bologna, on which all the names are inscribed (**Fig. 202**).[72] Here she stands frontally next to a louterion, nude and fixing her cap and hair with both hands. To the right, Aphrodite hands the golden apples to Eros, who will give them to Hippomenes, who stands farther to the viewer's right. The known romantic-erotic relationship of Atalanta with Hippomenes appears to at least contribute to the motivation for her nudity. The tondo of a kylix by the Jena Painter in Paris depicts Peleus and Atalanta (both named) but in reversed positions from the Aberdeen Painter's earlier kylikes (**Fig. 257**).[73] A louterion is again on the left, cut off by the frame, but Atalanta now stands next to it completely nude, and Peleus sits on the viewer's right in a pose similar to that of Atalanta on the kylikes in both Boston and Rome but subtly changed to resemble closely the pose of Ares on the east frieze of the Parthenon. Atalanta tosses her head back and reaches her right hand to her hair, a pose that reflects that of Atalanta on the Dinos Painter's krater in Bologna. The gesture is repeated on fragments of a bell-krater in Oxford dated in the decade after 400 B.C. (**Fig. 258**).[74] Here

[68] P. N. Ure, *Sixth and Fifth Century Pottery from Excavations Made at Rhitsona by R.M. Burrows in 1909 and by P. N. Ure and A. D. Ure in 1921 and 1922* (Oxford 1927) 73, no. 18.78, pl. 20.

[69] Bérard, *AnnArchStorAnt* 8 (1986) 198, identifies the fish as dolphins and thus concludes that the scene portrays the sea.

[70] D. von Bothmer, *Amazons in Greek Art*, Oxford Monographs on Classical Archaeology (Oxford 1957) 154; Schefold, *Götter- und Heldensagen* (note 67 above) 116–17; Moon, "Priam Painter" (note 66 above) 110–13.

[71] Kratzmüller, "Frauensport" (note 50 above) 171–76. For the vases in question, see note 48 above.

[72] Bologna, Museo Civico Archeologico 300 (inv. MCAo 17370): *ARV²* 1152.7; *Beazley Addenda²* 336; Ley, *Nikephoros* 3 (1990) 53, K 23, fig. 19; Ginouvès, *Balaneutikè*, 83, 117, pl. 23, no. 68; Matheson, *Polygnotos and Vase Painting* (note 46 above) 156, pl. 137A, D7 (p. 382); Reeder, *Pandora* (note 51 above) 365–68, no. 117*; *LIMC*, s.v. Aphrodite no. 1523*, s.v. Atalante no. 81*; Scanlon, *Eros and Greek Athletics*, 182–85, fig. 7.3; Kreilinger, *Anständige Nacktheit* (note 19 above) fig. 136.

[73] Paris, Bibliothèque Nationale, Cabinet des Médailles 818: *ARV²* 1512.23; *LIMC*, s.v. Atalante no. 87*; Ley, *Nikephoros* 3 (1990) 54, K 25, fig. 20; Paul-Zinserling, *Jena-Maler*, 112, no. 3, pl. 55; Kreilinger, *Anständige Nacktheit* (note 19 above) fig. 99; Metzger, *Représentations*, 345–46 (no. 75); Ginouvès, *Balaneutikè*, 117–18; Durand and Lissarrague, *Hephaistos* 2 (1980) 100, pl. 2a.

[74] Oxford, Ashmolean 1954.270: Paul-Zinserling, *Jena-Maler*, 116, pl. 62.1; Ley, *Nikephoros* 3 (1990) 72, K 26, with earlier bibliography; Scanlon, *Eros and Greek Athletics*, 195–96, fig. 7.12; Kreilinger, *Anständige Nacktheit* (note 19 above) fig. 100.

again a louterion is on the left, with two naked youths (one sitting on its rim) and, on the far right, an Eros, who appears to hold up a mirror for Atalanta. Finally, fragments of a volute-krater in Ferrara with all the figures named show Atalanta next to Hippomenes; she wears a brassiere and cap and has both hands raised to her head in the manner of the scenes just discussed (**Fig. 259**).[75] However, to one side is the top of a racing post and a figure named Amykos with boxing thongs. The fragment does not allow a convincing interpretation of the scene, but it appears that the context is the palaestra and that Hippomenes should be Peleus.[76] If this is the case, then the iconography of the two athletic events in Atalanta's life may have become fused.

These scenes of the late fifth century and the beginning of the fourth reflect a number of vases that depict a bride binding up her hair, a sequel to the washing, one imagines.[77] We may even surmise that the emphasis placed on washing the hair is connected with the practice of the bride cutting a lock of her hair to mark the transition to marriage.[78] The characteristic gesture of raising one or both hands to the head is quite similar to the pose of Atalanta on the Bologna krater, the Paris kylix, and the fragments in Ferrara and Oxford.[79] Marriage iconography subfuses these late scenes of Atalanta.

The most probable explanation of Atalanta's complete nudity on the Paris kylix and her association with Eros on the Oxford fragments is that she is both a powerful heroine and a prospective bride. This interpretation is particularly attractive because the pictures occur around 400 B.C., just at the time that female nudity is taking hold as a sign of divine power; this attribute is shared by Helen, who may be construed as an alter ego of Aphrodite. In one case near the end of the fifth century, Helen is depicted on a lekythos as a bride washing her hair: Eros pours water on her from a hydria as she crouches in the standard pose, and she is accompanied by Aphrodite, Pothos, Euklaia, and probably Peitho.[80] In the case of Helen, it need not be simply her beauty and therefore her close association with Aphrodite that led to her being depicted nude: Isokrates (*Helen* 61–62) attributes extraordinary powers to her, including making both the Dioskouroi and Menelaos immortal.[81] A point made in several different guises in the eulogies of Love (Eros) in Plato's *Symposion* is that love confers immortality.[82] There is also the early and critically important vase, the Boston Polyphemos Painter's kylix of around 550 B.C., depicting Odysseus and Kirke, the latter nude.[83] Here the connotation of nudity is difficult to determine. Is Kirke a wily whore or a

[75] Ferrara, Museo Archeologico Nazionale 2865 (T 404): *ARV*² 1039.9 (Peleus Painter); *Paralipomena* 443; *Beazley Addenda*² 319; *LIMC*, s.v. Atalante no. 73*; Beck, *Album of Greek Education* (note 16 above) no. 419; Ley, *Nikephoros* 3 (1990) 70, K 22, fig. 18; Kreilinger, *Anständige Nacktheit* (note 19 above) fig. 104.

[76] J. D. Beazley, "Some Inscriptions on Vases: III," *AJA* 64 (1960) 221–25, pl. 53.1; J. Boardman, in *LIMC*, vol. 2, pt. 1 (1984) 949; T. Gantz, *Early Greek Myth: A Guide to Literary and Artistic Sources* (Baltimore 1993) 338.

[77] Oakley and Sinos, *Wedding in Ancient Athens* (note 35 above) figs. 21, 23, 24. See note 41 above.

[78] Ibid., 14; Reinsberg, *Ehe, Hetärentum* (note 15 above) 50–51; E. B. Harrison, "Greek Sculptural Coiffures and Ritual Haircuts," in *Early Greek Cult Practice: Proceedings of the Fifth International Symposium at the Swedish Institute at Athens, 26–29 June, 1986*, ed. R. Hägg, N. Marinatos, and G. C. Nordquist (Stockholm 1988) 251.

[79] On the vase in Bologna the gesture is really that of tucking the hair under the athlete's cap, but that is clearly not the case for the other two examples cited.

[80] London, Embirikos Collection: *ARV*² 1326.66ter, 1690, 1705 (in the manner of the Meidias Painter); A. Lezzi-Hafter, *Der Schuwalow-Maler: Eine Kannenwerkstatt der Parthenonzeit* (Mainz 1976) 91–92, 111, no. S 101, pl. 140 (near the Shuvalov Painter); *LIMC*, s.v. Helene no. 77* (L. Kahil, who notes the reading of Helen by R. Guy); Sabetai, "Nuptial and Genre Imagery" (note 35 above) 320; A. C. Smith, "The Politics of Weddings at Athens: An Iconographic Assessment," *Leeds International Classical Studies* 4.1 (2005) 14, note 75.

[81] See M. Nouhaud, *L'utilisation de l'histoire par les orateurs attiques* (Paris 1982) 14–15.

[82] Plato, *Symposion* 179b–180b (Phaidros's speech on Alkestis and Achilles), 207a–209e (Diotima's metaphorical-philosophical speech).

[83] Boston, MFA 99.518: *ABV* 198; *Beazley Addenda*² 53; *LIMC*, s.v. Kirke no. 14*.

powerful *daimōn*?[84] In fact, she is both, since she will make love with Odysseus before she releases his men from her magical transformations (*Odyssey* 10.336–405). Kirke appears nude on at least three other monuments: a kylix in Boston of roughly the same date as the Boston Polyphemos Painter's;[85] a polychrome terracotta altar from Sicily, now in Paris, of the third quarter of the sixth century;[86] and a pseudo-Chalcidian amphora in Vulci of about the same date as the altar.[87]

The athletic implications of the strigil in some of these scenes with women wearing only a brassiere probably depend, at least in part, on the connection with Atalanta, the heroine athlete who prepares to marry. The primary point of contact must be the rituals of running naked as part of the festivals for young girls, which preceded their return to society as marriageable maidens.[88] The connection with Atalanta standing next to a louterion suggests a further level of meaning. On the simplest level, there is the parallel of men washing, almost always associated with exercise in the palaestra.[89] But the louterion plays such a prominent role in the iconography of Atalanta and of nude women washing during the first two-thirds of the fifth century that it may bear a special meaning. Terracotta louteria on stands were dedicated at the mouth of the dromos of the Bronze Age tomb at Menidi, and elsewhere they are known as funeral gifts from the eighth century to the fifth century.[90] Therefore we may surmise that the louterion symbolized the heroic in certain contexts, a concept that can easily be connected with the divine power of goddesses, voluptuousness, and eventually nudity, as seen in the Knidian Aphrodite.

[84] Himmelmann, *Ideale Nacktheit*, 38; W. Childs, in Himmelmann, *Reading Greek Art*, 7–8.

[85] Boston, MFA 99.519: *ABV* 69.1; *Beazley Addenda*[2] 18; O. Touchefeu-Meynier, *Thèmes odysséens dans l'art antique* (Paris 1968) 85–86, no. 170, pl. 14.1; *LIMC*, s.v. Kirke no. 13, s.v. Odysseus no. 139*.

[86] Paris, Louvre CA 5956: P. Devambez, "Une 'arula' sicilienne au Louvre," *MonPiot* 58 (1972) 4, 13–18, pls. 1, 3; *LIMC*, s.v. Kirke no. 4*.

[87] Museo Archeologico Nazionale di Vulci: F. Canciani, "Eine neue Amphora aus Vulci und das Problem der pseudochalkidischen Vasen," *JdI* 95 (1980) 142–46, figs. 1, 3; Canciani, "Circe e Odisseo," in *Tainia: Roland Hampe zum 70. Geburtstag am 2. Dezember 1978*, ed. H. A. Cahn and E. Simon (Mainz 1980) 117–20, pls. 26.1, 27. The use of female nudity to depict special powers in the sixth century is further suggested by a scene of a naked woman on a cup-skyphos by the Amasis Painter in Paris: Paris, Louvre A 479 (MNB 1746): *ABV* 156.80; D. von Bothmer, *The Amasis Painter and His World: Vase-Painting in Sixth-Century B.C. Athens* (Malibu, CA, 1985) 200–203, cat. no. 54. Here in the center of either side is a single naked woman holding up a flower and holding a wreath or necklace. In each case she faces a nude, bearded man who offers her a chicken. Framing the central group on either side is a pair of homosexual lovers offering and receiving gifts. Given the very masculine context, Claude Bérard has suggested that the naked woman could be Atalanta: C. Bérard, "La chasseresse traquée: Cynégétique et érotique," in *Kanon: Festschrift Ernst Berger zum 60. Geburtstag am 26. Februar 1988 gewidmet*, ed. M. Schmidt (Basel 1988) 280–84. The usual interpretation of a prostitute is hardly convincing (*ABV* 156.80 simply notes: "Courting: A, man and girl; men and youths . . ."). The vase is also earlier than the series of sex and symposium scenes, though it could, of course, prefigure them. At this time a naked woman in the world of men is highly unusual, and the scene may link the representations of Kirke with the later black-figure scenes of Atalanta topless wrestling with Peleus.

[88] Curiously, commentators on the textual tradition of Atalanta appear to find no trace of the visual emphasis on her femininity: M. Detienne, *Dionysos mis à mort* (Paris 1977) 99–117; Vernant, *Mortals and Immortals* (note 53 above) 199–200.

[89] Such as a kylix in Bologna, Museo Civico Archeologico 362 (inv. C177): *ARV*[2] 357 (close to Colmar Painter); Beck, *Album of Greek Education* (note 16 above) fig. 163. The interior tondo shows a nude youth at a louterion; the exterior scenes show youths exercising. Note, however, an Attic red-figure hydria by the Leningrad Painter with the washing of a naked youth by three clothed women: Warsaw, National Museum 142290: *ARV*[2] 571.76; Oakley and Sinos, *Wedding in Ancient Athens* (note 35 above) 15, figs. 10–13. For Stähli, "Nackte Frauen" (note 19 above) 43–45, the analogy between the representation of nude male athletes and the women bathing indicates that both serve to depict the respective ideal.

[90] P. Wolters, "Vasen aus Menidi, II," *JdI* 14 (1899) 125–27, 128–34; D. Callipolitis-Feytmans, *Les "louteria" attiques*, Publication de l'Archeologicon Deltion 6 (Athens 1965) 43–65; R. Hägg, "Gifts to the Heroes in Geometric Greece," in *Gifts to the Gods: Proceedings of the Uppsala Symposium 1985*, ed. T. Linders and G. Nordqvist (Uppsala 1987) 96–98.

Finally, the strigil as an attribute in several of the scenes with naked women may have its own metaphorical meaning. Several of these vases have three males on the reverse side, one of whom often holds a strigil, though no athletic context is evident.[91] The holding up of a strigil, frequently oversized, characterizes a number of scenes on late kylikes, many from the workshop of the Jena Painter. In some cases a nude youth faces a draped woman and holds a strigil out or up as though it indicated something other than the palaestra, where women were, in any case, not allowed (**Fig. 260**).[92] The fact that the woman on the example shown clearly holds a fillet with which she will crown the youth transfers the subject into a metaphorical realm. It seems possible that the strigil on these vases, as well as in scenes of naked women, comes to indicate purity, since bathing was the principal manner of removing pollution of all kinds. Thus the strigil in the hands of a woman may indicate her purity, just as the bath itself does. Here the calyx-krater in Montpellier strengthens the argument: both the naked figure in the louterion, whether youth or altered Eros, and the naked woman facing him on the right hold up a large strigil, a composition that strongly suggests that neither the louterion nor the strigil are mere accouterments of hygiene.[93]

Attic iconography of the bath changes quite radically in the fourth century. When scenes of women washing occur on fourth-century Attic vases, it is almost exclusively of the type on the New York pyxis (**Fig. 251**): a naked women crouches to have water poured on her hair from a hydria by an attendant or an Eros (**Fig. 261**).[94] Both the loutro-

[91] E.g., Cracow, University 331 (103, 1053): *ARV²* 1154.32; *CVA*, Cracow 1 (Poland 11), pl. 72; Kreilinger, *Anständige Nacktheit* (note 19 above) fig. 143; Ginouvès, *Balaneutikè*, 115; Paul-Zinserling, *Jena-Maler*, 114, pl. 56.4, who cites the inventory number as 10.331 in note 1535. The reverse-side motif of three draped youths is frequent on fourth-century kraters, particularly those of the Telos Group (*ARV²* pp. 1425–34); Boardman, *ARFV-CP*, fig. 343, by the Retorted Painter, is a typical example. The youth on the right holds up a large strigil.

[92] Boston, MFA 01.8092: *ARV²* 1518.6 (Q Painter); Paul-Zinserling, *Jena-Maler*, 121, no. 28, pl. 83.1, cf. pl. 79.2. B. Sabattini, "Les skyphos du F.B. Group à Spina: Apport chronologique de l'étude stylistique et typologique," in *La céramique attique du IVe siècle en Méditerranée occidentale: Actes du colloque international organisé par le Centre Camille Jullian, Arles, 7–9 décembre 1995*, ed. B. Sabattini (Naples 2000) 47–65, publishes a large series of skyphoi with nude youths holding huge strigils, but in each case they face a draped male. A more proper representation of athlete and woman is a sunken-panel stele in the Kerameikos which shows a bearded man, Bion, wearing a mantle and carrying aryballos and strigil, shaking hands with a seated woman, Euphrosyne: Clairmont, *CAT*, 3.420 (Athens, Kerameikos I 277). The overly large strigils of the late vases should be contrasted with the small strigils in use by two athletes on an oinochoe by the Achilles Painter in Basel, BS 485: P. Blome, *Basel Museum of Ancient Art and Ludwig Collection* (Geneva and Zurich 1999) 91, fig. 121.

[93] For the vase in Montpellier, see note 46 above. Guhl and Engelmann, *Leben der Griechen und Römer* (note 47 above) 368, discuss an Etruscan bronze strigil in the British Museum (fig. 491 on p. 367) that is far too large to be anything but a votive gift: H. B. Walters, *Catalogue of the Bronzes, Greek, Roman, and Etruscan, in the Department of Greek and Roman Antiquities, British Museum* (London 1899) 110, no. 655; I. Jucker, *Der Gestus des Aposkopein: Ein Beitrag zur Gebärdensprache der antiken Kunst* (Zurich 1956) 108, fig. 41. The handle is a nude woman, perhaps Aphrodite. She raises her left hand to her hair and holds a strigil in the other. An Etruscan cista handle in the Helbig Museum in the Ny Carlsberg Glyptotek, Copenhagen (H 243), also represents a naked woman holding a strigil: M. Moltesen and M. Nielsen, *Etruria and Central Italy* (Copenhagen 1996) 240–41*, no. 104 (H.I.N. 180); R. Herbig, "Mancipatio," *MusHelv* 8 (1951) 225, fig. 2; *Bildertafeln des etruskischen Museums (Helbig Museum) der Ny Carlsberg Glyptothek* (Copenhagen 1928) pl. 102, bottom; Jucker, *Gestus des Aposkopein*, 108. The latter references kindly given by Hugo Meyer. These are, however, Hellenistic, by which time female athletics and bathing in public baths had become widespread: Ginouvès, *Balaneutikè*, 222–24.

A parallel phenomenon is the free use of a mirror in grave scenes on white-ground lekythoi of the late fifth century: Koch-Brinkmann, *Polychrome Bilder*, 53–54.

[94] Athens, NAM 1472, and Saint Petersburg, Hermitage St. 1858 (**Fig. 261**): Paul-Zinserling, *Jena-Maler*, 117, pls. 62.2, 63.2a, b; Moraw, *JdI* 118 (2003) 41, fig. 9; Kreilinger, *Anständige Nacktheit* (note 19 above) fig. 118. See also a mirror case of the third quarter of the fourth century in Berlin (Antiquarium 8148): W. Züchner, *Griechische Klappspiegel*, *JdI-EH* 14 (Berlin 1942) KS 59, p. 46, pl. 21. See generally Bažant, *Citoyens sur les vases athéniens* (note 20 above) 31–32; Ginouvès, *Balaneutikè*, 168–69; Paul-Zinserling, *Jena-Maler*, 117–18.

phoros[95] and the louterion[96] become rare. South Italian vases, however, continue the prominent use of the louterion in scenes of hair washing[97] and create a whole new category that Ginouvès has aptly called "rencontres amoureuses."[98] On Attic vases, the multiplication of erotes in all scenes that relate to marriage, such as on the Marsyas Painter's great lebes gamikos in Saint Petersburg (**Fig. 207**),[99] drives out most of the more specific iconography.

It should come as no surprise that the Knidian Aphrodite of Praxiteles was represented standing next to a hydria. The bath, of which the louterion had become the principal symbol in the fifth century, represented marriage, sex, power, and purity. The hydria became the characteristic vessel of bathing scenes in the late fifth century, from the New York pyxis on, so its presence next to Aphrodite establishes the context unambiguously. As remarked above, the scenes of naked women bathing almost certainly contain allusions to the bath of Aphrodite in the *Homeric Hymn to Aphrodite* (5.61–63), where her attendants are the Charites, themselves connected with water, prosperity, and fecundity. However, the pose of the Knidia is interesting because, as already noted, Attic vases of the fourth century had adopted the crouching position for women washing, precisely the prototype for the statue type known as the Crouching Aphrodite.[100] It is also the pose of Thetis, nude, attacked by Peleus on the pelike in London by the Marsyas Painter (**Fig. 206**).[101] The Knidia's pose resembles more closely that of the women around louteria of the fifth century and particularly figures on South Italian vases of the fourth century, such as a pelike in Oxford, which probably depicts Aphrodite (**Fig. 262**).[102] The vase is dated in the second quarter of the fourth century and thus is independent of the statue type. Of course, the greater sense of three-dimensional space in the later vase scenes changes the arrangement of the figures, and it is this change that is reflected in the stance of the Knidia. But a vital point is made by the pose of the Knidia: the goddess has adopted the iconography of mortals.[103] This already occurred on the balustrade of the Nike temple at the end of the fifth century. Here Nikai perform the rituals associated with the cult of victory—the sacrifice of a bull and the setting up of trophies.[104] The latter is a popular subject on vases as well.[105] The very casualness of the Knidia and the apparent banality of the moment chosen are also prefig-

[95] Paris, Louvre CA 2271: Lullies, *Kauernde Aphrodite* (note 32 above) 60, fig. 42; Zervoudaki, *AM* 83 (1968) 34, no. 70, 67, pls. 26.2, 26.3; G. Kopcke, "Attische Reliefkeramik klassischer Zeit," *AA*, 1969, 45–46, 73–74, no. 212, Beil. 35.1–3; *LIMC*, s.v. Aphrodite no. 1181*.

[96] Saint Petersburg, Hermitage St. 1791: *ARV*² 1476.3 (Eleusinian Painter); Oakley and Sinos, *Wedding in Ancient Athens* (note 35 above) 23, figs. 44, 45; Paul-Zinserling, *Jena-Maler*, 115, pl. 58.1, 2

[97] Ruvo, MAN Jatta 654: Paul-Zinserling, *Jena-Maler*, pl. 64; A. D. Trendall and A. Cambitoglou, *The Red-Figured Vases of Apulia*, vol. 3 (Oxford 1978) s.v. lather, lists a stunning number.

[98] Ginouvès, *Balaneutikè*, 118.

[99] Saint Petersburg, Hermitage P 1906.175 (15592): *ARV*² 1475.1; Boardman, *ARVP-CP*, 191, fig. 388; Valavanis, Παναθηναϊκοί αμφορείς, 269, pls. 102–5; Oakley and Sinos, *Wedding in Ancient Athens* (note 35 above) 40, figs. 124–27; see generally S. Moraw, "Unvereinbare Gegensätze? Frauengemachbilder des 4. Jahrhunderts v. Chr. und das Ideal der bürgerlichen Frau," in *Konstruktionen von Wirklichkeit: Bilder im Griechenland des 5. und 4. Jahrhunderts v. Chr.*, ed. R. von den Hoff and S. Schmidt (Stuttgart 2001) 211–23.

[100] Lullies, *Kauernde Aphrodite* (note 32 above) passim; C. Havelock, *Hellenistic Art: The Art of the Classical World from the Death of Alexander the Great to the Battle of Actium* (London 1971) 121, no. 84; J. J. Pollitt, *Art in the Hellenistic Age* (Cambridge 1986) 56–57, fig. 50; Ridgway, *Hellenistic Sculpture*, vol. 1, 230–32, pls. 112, 113.

[101] London, BM E 424: *ARV*² 1475.4; Boardman, *ARFV-CP*, 191, fig. 390.

[102] Oxford, Ashmolean G 269 (V.550): Trendall and Cambitoglou, *Vases of Apulia* (note 97 above) 399, no. 22, pl. 140.1 (Group of Oxford 269); *LIMC*, s.v. Aphrodite no. 385*; Paul-Zinserling, *Jena-Maler*, pl. 64.3; Kreilinger, *Anständige Nacktheit* (note 19 above) fig. 210.

[103] Ginouvès, *Balaneutikè*, 173–74.

[104] N. Himmelmann-Wildschütz, *Zur Eigenart des klassischen Götterbildes* (Munich 1959); slightly revised and translated in Himmelmann, *Reading Greek Art*, 103–29, especially 107, 115–29.

[105] Paul-Zinserling, *Jena-Maler*, 76–80, pl. 39.

ured on the Nike balustrade in the figure of the so-called Sandal-binder (**Fig. 160**). What does her gesture have to do with her divine nature? It seems to me likely that it projects in a new and intimate manner the same qualities expressed by the grand Nike of Paionios at Olympia.[106] Nike is a fickle thing. Even the Eirene and Ploutos (**Fig. 12**) fall into the category of divinities acting like mortals, since Ploutos is depicted as a small child in the arms of his metaphorical mother or nurse; the former subject occurs on at least one Attic grave stele in the sixth century[107] and occasionally in the fourth.[108] All these subjects and their transformation of the image of divinity suggest an overarching iconographic theme in the fourth century: the boundary between the divine and mortal realms is at times so blurred that we can no longer distinguish between them with certainty.[109]

The extension of the erotic as a sign of divine female power to figures that otherwise hardly seem appropriate—such as Athena, Artemis, and Nike—sheds important light on the manner in which the new iconography develops. But there is a hierarchy of eroticism. For example, Athena and Artemis may appear as attractive young girls with suggestively clinging clothes, but they are never depicted naked.[110] Consider for a moment the representation of women wearing a peplos with long overfold. Originally this style of dress indicated a young girl, presumably because the girl's parents were slightly parsimonious and fitted the child with a garment into which she could grow. After the middle of the fifth century Athena often wears her overfold long,[111] a practice Artemis follows near the end of the century.[112] As the fifth century wanes, the motif occurs in representations of an increasing variety of female divinities, and by the middle of the fourth century it is widely used.[113] The only possible deduction is that an essential aspect of the character of goddesses is that they are young. This is certainly true of the Athena Rospigliosi type[114] and somewhat more obviously of Kore in general.[115] This is a parallel development to the increasingly erotic

[106] Lullies and Hirmer, *Greek Sculpture*[2], pl. 178; Borbein, *JdI* 88 (1973) 165–69, figs. 89, 90; T. Hölscher, "Die Nike der Messenier und Naupaktier in Olympia: Kunst und Geschichte im späten 5. Jahrhundert v. Chr.," *JdI* 89 (1974) 70–111.

[107] G. M. A. Richter, *The Archaic Gravestones of Attica* (London 1961; repr. Oak Park, IL, 1988) fig. 152, no. 59.

[108] E.g., the stele of Ampharete, Athens, Kerameikos P 695: Clairmont, *CAT*, 1.660.

[109] One can object that the fifth-century scenes of naked woman around a louterion were understood as parallels for Aphrodite's bath and therefore represent a divine prototype, but none of the vases discussed above ever suggests that the participants could be confused with the goddess.

[110] Himmelmann, *Ideale Nacktheit*, 9, 48–52.

[111] For example, the Parthenos; a good illustration is the comparison of the record relief of 410/9 in Paris (Louvre Ma 831) with the "Mourning Athena," Athens, Acrop. 625: *LIMC*, s.v. Athena nos. 608*, 625*. The long overfold is also found on many of the Athena types thought to date from the time of the Parthenon into the early fourth century: E. Berger, "Eine Athena aus dem späten 5. Jahrhundert v. Chr.," *AntK* 10 (1967) pl. 24; P. Karanastassis, "Untersuchungen zur kaiserzeitlichen Plastik in Griechenland, II: Kopien, Varianten und Umbildungen nach Athena-Typen des 5. Jhs. v. Chr.," *AM* 102 (1987) pls. 41, 45.1, 45.2, 49, 51.

[112] Votive relief in Kassel, MHK Sk 41: Gercke and Zimmermann-Elseify, *Bestandskatalog Kassel*, 292–93, no. 95*; *LIMC*, s.v. Artemis no. 397*. Brauron 1157 (349): *LIMC*, s.v. Artemis no. 621*. In the fourth century the long overfold is found on most of the statues of Artemis (albeit all Roman copies) and on the votive reliefs, such as Brauron 1151 (5): *LIMC*, s.v. Artemis no. 974*.

[113] J. Fink and H. Weber, *Beiträge zur Trachtgeschichte Griechenlands* (Würzburg-Aumühle 1938) 126–27, 138–39; M. Bieber and F. Eckstein, *Die Entwicklungsgeschichte der griechischen Tracht*, 2nd ed. (Berlin 1967) 33; Neumann, *Weihreliefs*, 60; cf. Ridgway, *Fifth-Century Styles*, 123, note 1.

[114] I. E. Altripp, "Small Athenas: Some Remarks on Late Classical and Hellenistic Statues," in *Athena in the Classical World*, ed. S. Deacy and A. Villing (Leiden 2001) 187–90.

[115] The principal example is certainly the Great Eleusinian Relief, on which Persephone is so clearly depicted as a rather attractive young girl, in contrast to the matronly aspect of Demeter (Schneider, *AntP* 12 [1973] 103–24), followed by the so-called Demeter of Eleusis (see chap. 4, pp. 105–6, note 27 above). Closely related to the Athena Rospigliosi type is the statue in Vienna, KHM I 157, that has sometimes been identified as Hygieia and sometimes as

nature of goddesses,[116] and this observation applies particularly to the statue of Hygieia from Epidauros, of the early fourth century.[117] Of course, the same development has long been noted for male heroes and gods, beginning in the Late Archaic period but becoming dominant near the end of the fifth century.[118] Herakles and Dionysos, who lose their beards, are the most obvious exemplars. If we compare the images of Attic burghers on grave stelai, there is little trace of these youthful and sensual trends. Rather the contrary seems to be the case: men are mature, bearded, and somewhat stolid; women are heavily draped and matronly, even when explicitly young; even children seem still to be mainly small adults.[119] In these cases there is a dichotomy between heroic/divine figures and mere mortals that continues and is accentuated in the Hellenistic period.[120] In the divine sphere, the emphasis on youth and the erotic connects directly with Gerhard Rodenwaldt's thesis that the gods are represented in the fourth century as ῥεῖα ζώοντες and are easily distinguished from images of mortals.[121] Before we tackle this assertion and our contrary observation above, let us first enumerate other salient characteristics of fourth-century iconography.

The most notable development is the significant reduction in traditional heroic mythological scenes and the great increase in scenes that can best be described as divine epiphanies. Henri Metzger's work of 1951 remains the most complete source for the iconography of Attic vases of the fourth century, though clearly it can no longer claim automatic authority since so many new vases have turned up in the half century since it was published. However, a rapid overview of his section on heroic myths reveals that by far the most frequent subject is the apotheosis of Herakles (31 examples),[122] often in the form of the old black-figure scenes with Athena and chariot.[123] The next most popular theme is the birth of Helen (13 examples),[124] followed by the Judgment of Paris (10 examples),[125] Herakles in the Garden of the Hesperides (9 examples),[126] and Paris and Helen (8 examples).[127] The only other hero to qualify as popular is Theseus (8

Kore: *LIMC*, s.v. Persephone no. 10* (G. Güntner); W. Fuchs, *Die Skulptur der Griechen* (Munich 1993) 221, fig. 238; Todisco, *Scultura greca*, no. 290.

[116] L. Llewellyn-Jones, "Sexy Athena: The Dress and Erotic Representation of a Virgin War-Goddess," in *Athena in the Classical World* (note 114 above) 254–57, points to the Athena on the east frieze of the Parthenon as a particularly feminine figure. See also my comments above on the fragmentary torso of Athena from the west pediment of the Parthenon, chap. 4, p. 105, and the bibliography in note 26. The change from clothed to nude Charites also belongs to the developments here under discussion: E. Harrison, in *LIMC*, vol. 3 (Zurich 1986) s.v. Charis, Charites, 200–203 ("Commentary").

[117] Athens, NAM 299: Kaltsas, *SNAMA*, 178, no. 353*; *LIMC*, s.v. Hygieia no. 20* (F. Croissant); Boardman, *GS-LCP*, fig. 52; H. Sobel, *Hygieia: Die Göttin der Gesundheit* (Darmstadt 1990) 105, no. 14, pl. 15a, b. The statue of a woman known as the Izmir-Vienna-Munich type may also be Hygieia in a style close to that of the Athena Rospigliosi and the Vienna statue probably of Kore: Todisco, *Scultura greca*, no. 160.

[118] Himmelmann-Wildschütz, *Eigenart des klassischen Götterbildes* (note 104 above) note 5a on pp. 35–36 (Himmelmann, *Reading Greek Art*, 130, n. 7); Himmelmann, *Ideale Nacktheit*, 27, 44–47; H. Froning, "Herakles und Dionysos auf einer Schale des 4. Jhs. v. Chr. in Würzburg," *WürzJbb* 1 (1975) 207–8.

[119] Ridgway, *Fourth-Century Styles*, 369.

[120] P. Zanker, *Eine Kunst für die Sinne: Zur Bilderwelt des Dionysos und der Aphrodite* (Berlin 1998) 107–10.

[121] Rodenwaldt, Θεοὶ ῥεῖα, 22.

[122] Metzger, *Représentations*, 210–24; R. Vollkommer, *Herakles in the Art of Classical Greece* (Oxford 1988) 32–37; *LIMC*, s.v. Herakles nos. 2916–34.

[123] J. Boardman, "Herakles, Peisistratos and Sons," *RA*, 1972, 57–72; *LIMC*, s.v. Herakles nos. 2877–2908 (R. Devambez and A. Kaufmann-Samaras).

[124] Metzger, *Représentations*, 277–79.

[125] Ibid., 269–71.

[126] Ibid., 202–10.

[127] Ibid., 279–81.

examples).[128] Typical of the fourth century is the far greater popularity of a new subject, Arimasps (14 examples).[129]

Divine figures occur with greater frequency, particularly Aphrodite (30 examples) and Eros (39 examples),[130] Adonis (7 examples),[131] Dionysos and Ariadne (27 examples),[132] other Dionysiac scenes (58 examples),[133] Apollo and Marsyas (18 examples, mainly of the late fifth century),[134] other Apolline themes (26 examples),[135] the Eleusinian divinities in congress (15 examples),[136] and finally Poseidon and Amymone (10 examples).[137] Within the divine area also belongs a large number of scenes that Metzger designates "cérémonies religieuses," among which the most popular is the torch race (23 examples).[138]

The precipitous decline in the number of heroic myths on Attic vases of the fourth century contrasts with the relatively large number of divine images. Yet these are mostly not narrative in nature but appear to represent epiphanies. This is obviously true of a large number of the images of Aphrodite that fall into several related categories: Aphrodite on a swan, sailing on a shell, and the terrestrial *anodos*.[139] But the vast majority of the Dionysiac and Apolline scenes belong in the same category. A good example is a bell-krater of the Pronomos Painter once in Berlin on which Dionysos, beardless, is shown seated and surrounded by two mainads at rest, an Eros, and a satyr, also resting.[140] One cannot help but believe they are all exhausted from a tiring thiasos, much like the statue type of the Resting Satyr (**Fig. 180**). Scenes of the Eleusinian divinities fall mainly in the middle third of the fourth century and are particularly impressive in quality and seriousness of mood (**Figs. 210, 211**).[141] Erika Simon aptly suggests that the scenes stress the theme of peace.[142] Indeed, the religious tone, rather than the narrative and literary, is so clear in these images that it can be construed as the thread that runs through a large majority of fourth-century Attic vase paintings. This is not to say that no narrative myth is depicted. Again, Erika Simon has argued convincingly that the two grand pelikai by the Eleusinian Painter in Saint Petersburg do portray narratives from

[128] Ibid., 318–21. Almost all of these fall in the late fifth century, and only one represents a new subject, if it represents Theseus at all: ibid, p. 319, no. 34; F. N. Pryce, "An Illustration of Bacchylides," *JHS* 56 (1936) 77–78, pl. 5. Beazley, *ARV* (1942) 879, attributed the vase to the manner of the Oinomaos Painter but eliminated the vase in the second edition.

[129] Metzger, *Représentations*, 327–32; Beazley, *ARV*[2], vol. 2, pp. 1462–71, brings many of these together in his G (for Griffin) Group; see most recently Paul-Zinserling, *Jena-Maler*, 106–12; *LIMC*, suppl. vol. 8, s.v. Gryps, pp. 609–11 (M. Leventopoulos), which gives only a brief discussion of the figures with references to the earlier entries in which they appear.

[130] Metzger, *Représentations*, 41–58 (Eros), 59–82 (Aphrodite).

[131] Ibid., 92–94.

[132] Ibid., 110–25.

[133] Ibid., 101–10, 125–54.

[134] Ibid., 158–68.

[135] Ibid., 155–58, 168–90.

[136] Ibid., 231–65.

[137] Ibid., 301–6.

[138] Ibid., 351–57; N. Robertson, "Athena's Shrines and Festivals," in *Worshipping Athena: Panathenaia and Parthenon*, ed. J. Neils (Madison, WI, 1996) 63–65; D. G. Kyle, "The Panathenaic Games: Sacred and Civic Activities," in J. Neils, *Goddess and Polis: The Panathenaic Festival in Ancient Athens*, exh. cat. (Princeton 1992) 96, with catalogue nos. 49–51, pp. 177–80.

[139] Metzger, *Représentations*, 59–92; Bérard, *Anodoi* (note 34 above) 117–25, 153–60.

[140] Berlin, Staatl. Mus. F 2642: *ARV*[2] 1336.2; A. Queyrel, "Scènes apolliniennes et dionysiaques du Peintre de Pothos," *BCH* 108 (1984) 152, fig. 26, said to be destroyed: p. 148, n. 42.

[141] K. Clinton, *Myth and Cult: The Iconography of the Eleusinian Mysteries; The Martin P. Nilsson Lectures on Greek Religion* (Stockholm 1992); E. Simon, "Neue Deutung zweier eleusinischer Denkmäler des vierten Jahrhunderts v. Chr.," *AntK* 9 (1966) 72–92; E. Simon, "Eleusis in Athenian Vase-Painting: New Literature and Some Suggestions," in *Athenian Potters and Painters*, ed. J. H. Oakley, W. D. E. Coulson, and O. Palagia (Oxford 1997) 97–108.

[142] Simon, "Eleusis in Athenian Vase-Painting" (note 141 above) 99–102.

divine myths—the persuasion of Zeus to use war to lighten the overpopulation of Earth (St. 1793; **Fig. 246**) and the persuasion of Demeter to accept the compromise with Hades after the abduction of Persephone (St. 1792).[143] The same is true of the images of Herakles (apotheosis and Garden of the Hesperides) and even of Meleager. In the latter case, all but one of the six fourth-century representations depict not the hunt of the Kaledonian boar,[144] but the moment either before setting out or, less probably, after the hunt; all five of these are attributed to the Meleager Painter, in the first quarter of the century (**Fig. 204**).[145] The hunt itself was, of course, represented on the east pediment of the Temple of Athena Alea at Tegea[146] and on the inner south wall of the heroon of Trysa (modern Gölbaşı) in central Lykia on the southwest coast of Asia Minor.[147] A statue of Meleager is also known in several copies.[148] The appearance of the myth in the pediment at Tegea is particularly interesting because of the prominent position of Atalanta, depicted, according to Pausanias, at the head of the boar and possibly actually spearing it.[149] The importance of this compositional arrangement can be gauged by comparing it with the frieze at Trysa, where Atalanta is set at a distance from the boar on the right and aims an arrow from that safe position, much as she is depicted on sixth- and fifth-century vases.[150] The placement of Atalanta close to the boar first appears on the Melian plaques of the middle of the fifth century.[151] Although the Attic vases of the fourth century represent a very different moment, the preparations for the hunt (**Fig. 204**), they nonetheless also give an unusual prominence to Atalanta, which should not be surprising in view of her role as the prototypical heroine, discussed above. The essential composition of the vases presents a seated woman (Atalanta) flanked by two standing or seated men, one of whom is universally thought to be Meleager; the other may be Meleager's brother, Tydeus. On either side of the central trio are a varying number of male hunters, one of whom sometimes carries a club and therefore may be Theseus.[152] Whether or not it is correct to assume that the new Athenian iconography stems from the play *Meleager* by Euripides, performed ca. 416 B.C., the preserved fragments of the play

[143] Saint Petersburg, Hermitage St. 1792 and St. 1793: *ARV*² 1476.1 and 2; Simon, *AntK* 9 (1972) 72–86.

[144] Metzger, *Représentations*, 312–13, nos. 21–26; F. S. Kleiner, "The Kalydonian Hunt: A Reconstruction of a Painting from the Circle of Polygnotos," *AntK* 15 (1972) 10–11, lists nine fourth-century representations (not in Metzger's list) of the actual hunt in various media and from diverse regions (nos. 3–11), but the only Attic red-figure vase (Saint Petersburg, Hermitage B 4528) is in Metzger's list (no. 26).

[145] *ARV*² 1408.1: Vienna, KHM 158; *ARV*² 1410.14: Würzburg H 4643; *ARV*² 1411.39: Athens, NAM 15113; *ARV*² 1411.40: Toronto, ROM 919.5.35 (388); *ARV*² 1412.49: Ruvo, MAN Jatta 36853 (1418); K. Kathariou, *Το εργαστήριο του ζώγραφου του Μελεάγρου και η εποχή του· Παρατηρήσεις στην Αττική κεραμική του πρώτου τετάρτου του 4ου αι. π. X.* (Thessaloniki 2002) 213, MEL 13, ill. 2, pls. 7, 8; 214, MEL 28, pl. 13A; 212, MEL 2, pls. Γ, Δ; 212–13, MEL 3; 221, MEL 77, pl. 30A, and her discussion of the iconography, 48–56.

[146] Dugas, Berchmans, and Clemmensen, *Sanctuaire d'Aléa Athéna*; Stewart, *Skopas*, 50–53, 61–63.

[147] O. Benndorf and G. Niemann, *Das Heroon von Gjölbaschi-Trysa* (Vienna 1889) pl. VII; F. Eichler, *Die Reliefs des Heroon von Gjölbaschi-Trysa* (Vienna 1950) pls. 8, 9; Oberleitner, *Heroon von Trysa*, 33, figs. 58, 59; G. Daltrop, *Die kalydonische Jagd in der Antike* (Hamburg 1966) pl. 16; *LIMC*, s.v. Meleagros no. 29*.

[148] Berlin, Staatl. Mus. Sk 215: Knittlmayer and Heilmeyer, *Antikensammlung Berlin*², 177–78, no. 103. Vatican, Museo Pio-Clementino 490: Lippold, *Griechische Plastik*, 289, pl. 102.4; Stewart, *Greek Sculpture*, 185, fig. 549; *LIMC*, s.v. Meleagros no. 3*.

[149] Stewart, *Skopas*, 61. Pausanias (8.46.1) says the tusks of the boar were carried off from the temple by Augustus and (8.47.2) that the boar's rotten skin itself was still to be seen in the temple.

[150] Daltrop, *Kalydonische Jagd* (note 147 above) pls. 5, 9, 10; *LIMC*, s.v. Meleagros nos. 7*, 8*, 12*, 17*.

[151] *LIMC*, s.v. Meleagros nos. 30 and 31* (s.v. Atalante nos. 16* and 17); P. Jacobsthal, *Die melischen Reliefs* (Berlin 1931) pls. 15.27, 60.103; Daltrop, *Kalydonische Jagd* (note 147 above) pls. 14, 15 (ca. 470–440 B.C.). It seems possible that Atalanta is represented with a spear near the rear end of the boar and next to a bearded hunter in the tondo of a Lakonian cup in Paris (Louvre E 670): Daltrop, p. 19, pl. 11; M. Pipili, *Laconian Iconography of the Sixth Century B.C.*, University of Oxford, Committee for Archaeology, Monograph 12 (Oxford 1987) 22–23.

[152] A. D. Trendall and T. B. L. Webster, *Illustrations of Greek Drama* (London 1971) 98–99.

leave no doubt that the plot turned around Meleager's passion for Atalanta.[153] The inclusion of Eros in two of the depictions on the Attic vases makes it clear that the amorous relationship is also the subject of the vase painters.[154]

This new role of Atalanta, amorous partner of Meleager and in one guise or another triumphant over the Kaledonian boar, fits quite well with the Atalanta we have already met, triumphant in wrestling over Peleus and duped bride of Hippomenes/Melanion. John Boardman saw an interesting point of connection between the two iconographic traditions: on the pelike in Saint Petersburg depicting the actual hunt, Atalanta shoots her bow from a safe distance at the upper left (much as on the frieze at Trysa), but her chiton falls off one shoulder to bare a breast.[155] The seductive, nude Atalanta is the huntress, wrestler, and runner. In the fourth century, it appears that she transcends her tragic destiny and is elevated to a—or even the—principal place in the east pediment of the Temple of Athena Alea at Tegea. As in the case of the Amazons, as we shall see below, Atalanta, the female outsider, becomes a powerful heroine or even *daimōn*. The Melian plaques of the middle of the fifth century prefigure this development.

The shift of meaning evident in the Attic vases of the fourth century almost amounts to the inversion of the visual content of a number of the traditional myths. Such inversions are most marked in the plays of Euripides. In the *Madness of Herakles* the myth is inverted so that the hero returns from Hades, having brought up Kerberos, only to kill his wife and children and to be saved by Theseus, whom he had just rescued from Hades. The normal sequence is that Herakles' labors, of which the bringing up of Kerberos is one of the last, were occasioned by his madness and the slaughter of his family. But consider also the inversion of characters in the *Elektra*: Orestes is a pimply-faced coward who finally stabs Aigisthos in the back during a sacrifice! Neither he nor Elektra are admirable people set on justice, but are sour and mean, dehumanized by their ordeals. When the traditional myths are presented as sordid tales of human depravity, with no redeeming values except those artificially injected at the end of the play by the *dei ex machina*, it is hardly surprising that those myths become far less frequent on fourth-century vases.

The early development of this trend clearly belongs in the fifth century. Take, for example, the story of Herakles that becomes popular in the fourth century: Prodikos's tale of the hero at the crossroads where he is met by Virtue (Ἀρετή) and Vice (Κακία). Prodikos lived in the fifth century, but the tale is transmitted to us by Xenophon (*Memorabilia* 2.1.21–34). Here the hero becomes something of a good bourgeois instead of a drunken brute.[156] The theme is reflected in the late-fifth- and fourth-century vases that focus on Herakles' trip to the Garden of the Hesperides to fetch the golden apples. Instead of using wile or brute force to acquire the apples, he stands or sits complacently while the Hesperids pluck them for him from the tree encircled by the guardian snake.[157] There can be no doubt that the

[153] Ibid., p. 98; L. Séchan, *Études sur la tragédie grecque dans ses rapports avec la céramique* (Paris 1926; repr. Paris 1967) 423–33; Metzger, *Représentations*, 315–18; A. Nauck, *Tragicorum Graecorum Fragmenta, Supplementum*, ed. B. Snell (Hildesheim 1964) 525–31, nos. 515–39.

[154] Würzburg 522: *ARV*[2] 1410.14; Metzger, *Représentations*, 313, no. 24, pl. 39.2; E. Langlotz, *Griechische Vasen, Martin von Wagner-Museum der Universität Würzburg* (Munich 1932) pl. 191. Ruvo, MAN Jatta 36853 (1418): *ARV*[2] 1412.49; Metzger, *Représentations*, 313, no. 25; *LIMC*, s.v. Atalante no. 41c*, s.v. Meleagros no. 38*.

[155] Boardman, "Atalanta" (note 50 above) 7, fig. 5: Saint Petersburg, Hermitage B 4528; Metzger, *Représentations*, 313, no. 26, pl. 41.4; Daltrop, *Kalydonische Jagd* (note 147 above) pl. 21; *LIMC*, s.v. Atalante no. 9*.

[156] This also appears to have been a theme of Antisthenes, who wrote on Herakles: R. Höistad, *Cynic Hero and Cynic King: Studies in the Cynic Conception of Man* (Uppsala 1948) 36–37.

[157] *LIMC*, s.v. Herakles nos. 2703*, 2716–25*; R. Volkommer, *Herakles in the Art of Classical Greece*, University of Oxford, Committee for Archaeology, Monograph 25 (Oxford 1988) 16–19; Himmelmann, *Ideale Nacktheit*, 105–6.

fourth-century statue types follow this interpretation of the hero: almost all are at rest, observing some event (Hope type)[158] or perhaps looking inward (Copenhagen-Dresden type: **Fig. 177**).[159] The Farnese type is more complex, a classic image of the strongman in weary repose but not with the tranquility of the earlier statues (**Fig. 183**).[160] Several more or less divergent variations exist.[161] Although many scholars accept the Farnese statue in Naples as an accurate reflection of the original (generally dated ca. 330), it seems to me too radical a pathetic image of a retired bodybuilder. It is more likely that the intermediate versions, such as the statue in the Antikythera shipwreck[162] and the fragmentary over-life-size statue in Argos,[163] are better candidates.[164] The contrast of strength and imminent death remain, to which the complex swelling musculature of the Farnese statue in Naples adds little or nothing. But whichever version one chooses to consider closest to an original of the late fourth century, the statue type certainly gives full visual expression to the pathetic view of the hero so movingly formulated by Euripides in the late fifth century.[165]

One of the more interesting inversions of late-fifth-century iconography is the creation of a new type of Gorgon Medusa. The old, snaky-haired face with fangs is replaced by a quite ordinary image of a woman or even a young girl.[166] The so-called middle type—a scowling but otherwise quite human face—appears around the beginning of the fifth century and was probably the type Pheidias used for the device of the shield of the Parthenos.[167] The shield also presents another avant-garde, though not new, inverted iconographic feature: Amazons clad in a short chiton or exomis fastened over one shoulder, leaving one breast bare.[168] The novelty lies in the emphasis on the femininity of the Amazons, in contrast to the standard warrior dress of the sixth century or the Persian costume favored from

[158] Malibu, Getty 70.AA.109: Todisco, *Scultura greca*, no. 201; *LIMC*, s.v. Herakles nos. 656–59.

[159] For bibliography, see chap. 4, p. 116, note 107 above.

[160] Naples, MAN 6001: P. Moreno, "Il Farnese ritrovato ed altri tipi di Eracle in riposo," *MÉFRA* 94 (1982) 503–4, no. B3.3, figs. 66, 71, 74, 76, 129; D. Krull, *Der Herakles vom Typ Farnese: Kopienkritische Untersuchungen einer Schöpfung des Lysipp* (Frankfurt am Main 1985) 10–22, no. 1, figs. 20, 21, pls. 1–4; H. U. Cain, "Der Herakles Farnese: Ein müder Heros?" in *Körper/Sprache: Ausdrucksformen der Leiblichkeit in Kunst und Wissenschaft*, ed. A. Corbineau-Hoffmann and P. Nicklas (Hildesheim 2002) 33–61; Himmelmann, *Ausruhende Herakles*; Moreno, *Lisippo*, 244–47, 4.36.4; Todisco, *Scultura greca*, no. 272; Boardman, *GS-LCP*, fig. 37; Bol, *Bildhauerkunst*, 348–51, 366–67, figs. 318a–e (C. Maderna).

[161] Moreno, "Farnese ritrovato" (note 160 above); Krull, *Herakles vom Typ Farnese* (note 160 above); *LIMC*, s.v. Herakles nos. 699–716 (vol. 4, pp. 762–64); Todisco, *Scultura greca*, nos. 269–71.

[162] P. C. Bol, *Die Skulpturen des Schiffsfundes von Antikythera*, AM-BH 2 (Berlin 1972) 48–49, pls. 24.3, 24.4, 25; Moreno, "Farnese ritrovato" (note 160 above) 423, 424, 432, 496–97, no. B.2.1, figs. 40, 42, 54; Krull, *Herakles vom Typ Farnese* (note 160 above) 28–30, no. 3; Todisco, *Scultura greca*, no. 271.

[163] J. Marcadé, "Sculptures argiennes," *BCH* 81 (1957) 408–13, figs. 2–5; Moreno, "Farnese ritrovato" (note 160 above) 418, 419, 493, no. B.1.2, figs. 32, 34; Krull, *Herakles vom Typ Farnese* (note 160 above) 54–57, no. 11; Todisco, *Scultura greca*, no. 268.

[164] Rolley, *Sculpture grecque*, 335–36, fig. 349, prefers the statue in Argos; Stewart, *Greek Sculpture*, 190, appears to consider the Farnese statue in Naples a "'baroque' reworking in the second century." See also Pollitt, *Art in the Hellenistic Age* (note 100 above) 50–51; and Ridgway, *Fourth-Century Styles*, 305–6.

[165] This is hardly present in the slim version from Salamis, Cyprus, now in Lefkosia: V. Karageorghis and C. C. Vermeule, *Sculptures from Salamis* (Nicosia 1964) vol. 1, 17–18, no. 7, pl. XV; Sjöqvist, "Lysippus," 32, fig. 16; Moreno, "Farnese ritrovato" (note 160 above) 421, 494–95 (no. B.1.8), figs. 39, 124; Krull, *Herakles vom Typ Farnese* (note 160 above) 117–19, 317, no. 32.

[166] E. Buschor, *Medusa Rondanini* (Stuttgart 1958) 32–37, pls. 17, 44, 45; J. Floren, *Studien zur Typologie des Gorgoneion* (Münster 1977) 177–217; *LIMC*, s.v. Gorgo, Gorgones nos. 298–306 (I. Krauskopf).

[167] Floren, *Gorgoneion* (note 166 above) 71–174 (on the Parthenos, 153–66, pls. 13.1–14.7); *LIMC*, s.v. Gorgo, Gorgones no. 175 (I. Krauskopf).

[168] Conveniently collected by N. Leipen, *Athena Parthenos: A Reconstruction* (Toronto 1971) pls. 69–72. E. B. Harrison, "The Composition of the Amazonomachy on the Shield of Athena Parthenos," *Hesperia* 35 (1966) 107–33; Harrison, "Motifs of the City-Siege on the Shield of Athena Parthenos," *AJA* 85 (1981) 281–317.

the time of the Persian Wars on.[169] The first monument that prefigures the shield of the Parthenos is a hydria of about 490 by the Berlin Painter that depicts an Amazon in a very short and transparent chiton attacking a fallen Greek.[170] This is followed by a krater in New York by the Painter of the Wooly Satyrs on which one Amazon has an exposed breast (**Fig. 263**).[171] These Amazons develop the type that served as the conceptual image of the statues of Amazons thought to represent the creations of Polykleitos, Pheidias, and Kresilas, and perhaps two other sculptors (Pliny, *NH* 34.19.53).[172] Here the valiant warriors of Attic black-figure vases and the Persianizing figures of the Early Classical vase painters have become weak from wounds and in their weakness are seductive.[173] The drapery falling from the shoulder and revealing one breast must be connected with the similar, though less emphatic, motif discussed above: the power of goddesses expressed in their new eroticism.[174] Although this theme will not outlast the fifth century as a popular type, one aspect of it does: the triumphant Amazon. A link between the seductive and the triumphant Amazon cannot be purely coincidence, since both appear on the hydria by the Berlin Painter and the volute-krater by the Painter of the Wooly Satyrs in New York.[175] In the center of side A of the New York krater, an Amazon on a horse spears a Greek warrior. It is not the simple fact of an Amazon triumphant that startles, but the compositional importance given to the subject. It is, of course, precisely this image that fills the center of the west pediment of the Temple of Asklepios at Epidauros around 380.[176] The composition is the same as that of the reliefs of the cenotaph of Dexileos (**Fig. 4**) and the state monument for the fallen in Corinth in 394/3: a cavalryman on a rearing horse spears a fallen foe.[177]

An important aspect of these images of victory is the representation of the fallen foe. On the krater in New York, the Greek—largely covered by his shield and with his head turned to face into the scene, that is, away from the viewer—is nude. This is also the case on the Albani rider relief, though the fallen man does have a chlamys, which he holds up in a semblance of defense in much the same way as figure 1 on the west frieze of the Hephaisteion,[178] the Dexileos stele, and the state relief of 394/3, but not on the base from

[169] J. H. Blok, *The Early Amazons: Modern and Ancient Perspectives on a Persistent Myth* (Leiden 1994) 422–24.

[170] The hydria was recently sold by Robert Hecht in New York and is now in a private collection (photographs kindly supplied by Michael Padgett).

[171] New York, MMA 07.286.84: *ARV²* 613.1; E. Bielefeld, *Amazonomachia: Beiträge zur Geschichte der Motivwanderung in der antiken Kunst* (Halle 1951) 77, type B, no. 1, and see also pp. 33–34, 77–83; Bothmer, *Amazons* (note 70 above) no. 7, 168, pl. 75. *LIMC*, s.v. Amazones no. 295*; in his commentary (p. 642) P. Devambez remarks that the change of dress appears to be based on stylistic considerations rather than being a meaningful iconographic change, an opinion I do not share. The Penthesileia Painter also depicts Penthesileia in a simple, sheer chitoniskos on his great kylix in Munich, with similar iconographic meaning: Munich, Staatliche Antikensammlungen 2688 (J 370): *ARV²* 879.1; Bothmer, *Amazons*, 143, no. 30, pl. 71.4; Robertson, *Vase-Painting*, 161, fig. 167; *LIMC*, s.v. Amazones no. 178; see also no. 302*, a krater by the Painter of Bologna 279 in Basel: *ARV²* 612.2.

[172] On these statues, see chap. 3, pp. 61–63 above.

[173] *LIMC*, s.v. Amazones nos. 3–89, 232–41, 260–322. R. Fleischer, "Die Amazonen und das Asyl des Artemisions von Ephesos," *JdI* 117 (2002) 185–216, convincingly argues that all the statue types represent wounded Amazons, and that the subject is the protective powers of Artemis as guardian of asylum.

[174] B. Cohen, "Divesting the Female Breast of Clothes in Classical Sculpture," in Koloski Ostrow and Lyons, *Naked Truths* (note 20 above) 66–92.

[175] See notes 170 and 171 above. A volute-krater by the Pan Painter also depicts an Amazon on foot dispatching a Greek in the center of the battle: Basel, Antikensammlung BS 1453: Blome, *Basel Museum of Ancient Art* (note 92 above) 68–69, figs. 85–87.

[176] Yalouris, *AntP* 21 (1992) pls. 40, 41; *LIMC*, s.v. Amazones no. 421*.

[177] Clairmont, *CAT*, 2.209 (Dexileos); D. Woysch-Méautis, *La représentation des animaux et des êtres fabuleux sur les monuments funéraires grecs de l'époque archaïque à la fin du IVe siècle av. J.-C.* (Lausanne 1982) nos. 23, 24, pl. 6.

[178] S. von Bockelberg, "Die Friese des Hephaisteion," *AntP* 18 (1979) pl. 38. For the Albani rider relief, see chap. 5B, p. 209, note 26 above.

the Academy.[179] On two sides of the Academy base the fallen foe is fully draped, while on the third side he sits on his garment. If we are to interpret the nudity of the fallen figures as indicating their vulnerability, then the nude Greek on the krater in New York underscores the revolutionary character of the new iconography.

The extraordinary popularity of Amazons on Attic red-figure vases during the fifth century decreases precipitously at the end of the century, and the subject all but disappears on fourth-century vases, with the notable exception of a large group of vases by the appropriately named Amazon Painter in the third quarter of the century.[180] From the provenance of the majority of these vases, it seems they that were largely made for export to the Black Sea regions, the popular location of Amazons in classical accounts and the home of their cousins, the historical Skyths.

Part of the reason for the decreased representation of Amazons on fourth-century vases is the general trend away from traditional heroic mythology. In the particular case of Amazons, their function in the fifth century as surrogates for the Persians had lost much of its meaning. Taken together, we can surmise that the Persian Wars as a historical event eclipsed the mythological paradigms, if the Attic orators are any guide. In contradiction to the trend on vases, the Amazonomachy appears in architectural sculpture, such as the frieze of the Temple of Apollo Epikourios at Bassai and slightly later in the west pediment of the Temple of Asklepios at Epidauros. It is also the subject of one of the friezes of the Maussolleion at Halikarnassos and of the funerary monument of Nikeratos and Polyxenos found at Kallithea, as well as the monument to which the lone block in the National Museum in Athens belonged.[181] The transformation of the subject, however, had probably begun still earlier in the century on the large frieze of the Nereid Monument of Xanthos, where the battle of Greeks and Persians borrowed many of the motifs from the Amazonomachy and several of the figures have suspiciously large breasts (block 858; **Fig. 55**). The motif migrates to South Italy near the end of the fourth century, where it becomes an extremely popular subject for tomb sculpture at Taras.[182]

Pierre Devambez believed that the transformation of the Amazons into powerful and benign figures was based on a tradition that grew up in Asia Minor around the middle of the fifth century and was transferred to mainland Greece and the west later in the century.[183] For the funerary use of Amazons, this may be correct. Certainly the use of mythology on tombs has a long tradition in Asia Minor and the partially Greek eastern Mediterranean, as discussed in the previous chapter.[184] The link between these sixth-century and early-fifth-century monuments and the great tombs of the fourth century is impossible to delineate with the evidence presently available, but it is difficult to believe that the later monuments forged a new and independent tradition. The broader transformation of the Amazons into benign spirits appears in the feminine traits they begin to acquire before

[179] Woysch-Méautis, *Représentation des animaux* (note 177 above) nos. 21, 23–25, pl. 6. The Academy base: Athens, NAM 3708: Clairmont, *CAT*, 2.213; Kosmopoulou, *Statue Bases*, 218–19, no. 47, figs. 73–75. On the issue of nudity presented by these early-fourth-century reliefs, see J. M. Hurwit, "The Problem with Dexileos: Heroic and Other Nudities in Greek Art," *AJA* 111 (2007) 35–60. See most recently the commentary of N. Arrington, *Ashes, Images and Memories: The Presence of the War Dead in Fifth-Century Athens* (Oxford 2015) 226–33.

[180] *ARV*² 1478–80; Schefold, *KV*, 20–21; Schefold, *UKV*, 134–35, 159; see generally *LIMC*, s.v. Amazones nos. 336–59.

[181] See chap. 5B, pp. 223–25 above.

[182] J. C. Carter, *The Sculpture of Taras*, TAPS, n.s., 65, pt. 7 (Philadelphia 1976) s.v. Amazons in index.

[183] *LIMC*, s.v. Amazones, commentary (vol. 1 [Zurich 1981] pp. 643–49).

[184] See chap. 5B, pp. 221–22 above.

the middle of the fifth century, as discussed above. This transformation parallels the development of the iconography of Atalanta and the Gorgon Medusa. There can, therefore, be no doubt that the metaphorical frame of mind was present in mainland Greece in the fifth century and was very capable of developing its own vocabulary.

The multiplication of the figure of Eros occurs early in the fifth century; they flutter around Aphrodite and generally occasion no comment.[185] As already pointed out, they multiply further in the last third of the fifth century and invade the world apparently of daily life, or at least the appropriate parts of it. When they land on and in a louterion, its meaning can no longer be in doubt; they play the same role as attendants pouring water over crouching nude maidens. If Eros is a divinity that receives a cult, many erotes pose a conceptual problem to the modern mind.[186] Is Eros a god, and are "erotes" therefore personifications? Certainly multiple erotes function as such, and even a single Eros at a louterion serves more as a characteristic of a situation than as a concrete divinity. Since Eros had been the name applied by Empedokles and Parmenides to the force of attraction in the universe, it is clear that divinity and concept were not neatly distinguished.

The same ambiguity of concept and *daimōn* or even divinity appears to be true for a number of other figures the modern mind tends to consider mere concepts.[187] Nike is certainly one. The multiple representation of Nike on the parapet of the Nike temple on the Athenian Acropolis only breaks with earlier traditions in part, since multiple statues of Nikai had served as acroteria sculpture in the sixth century.[188] More relevant to my present inquiry is the representation for the first time in the late fifth century and down through the fourth century of personified concepts that also appear to be divinities. Eirene is a prime example, but the list is quite long. The establishment of a cult of Eirene in Athens in the second quarter of the fourth century has already been discussed as the probable historical background to the statue group of Eirene and Ploutos attributed to the elder Kephisodotos (**Fig. 12**).[189] Eirene appears in conjunction with Dionysos on two Attic vases of the second half of the fifth century.[190] This record might lead one to treat her merely as one of the many personified concepts that appear on Attic vases of the period, but in Hesiod she is a daughter of Zeus and Themis (*Theogony* 901–2). As Karl Reinhardt has pointed out, the welter of personifications that appear in Greek art in the late fifth and fourth centuries are for the most part not new inventions of the intellect, but ancient figures that hover between divinity and *daimōnes*.[191] The ambiguity is similar to that of the cosmic forces to which divine, mythological names were given. A parallel phenomenon is the allegorization of myths, an intellectual development of the fifth century connected

[185] Berlin, Staatl. Mus. F 2291: *ARV*[2] 459.4; A. Greifenhagen, *Griechische Eroten* (Berlin 1957) 22, fig. 51 on p. 67; Himmelmann, *Reading Greek Art*, 107, fig. 24.

[186] Stafford, *Worshipping Virtues*, chap. 1, "Personifications, Allegory and Belief," gives a concise review of the issues.

[187] On *daimōnes*, see particularly Plato, *Symposion* 202d–203a (Diotima); C. Osborne, *Eros Unveiled: Plato and the God of Love* (Oxford 1994) 103–11; R. Hinks, *Myth and Allegory in Ancient Art*, Studies of the Warburg Institute 6 (London 1939; repr. Nendeln [Liechtenstein] 1968) 106–13; and most recently B. E. Borg, *Der Logos des Mythos: Allegorien und Personifikationen in der frühen griechischen Kunst* (Munich 2002) 49–81.

[188] E.g., the treasury at Olympia of the first decade of the fifth century: *LIMC*, s.v. Nike nos. 29, 30, reconstruction drawing on p. 855. See Scheer, *Gottheit*, 134–36.

[189] See chap. 4, pp. 109–10 above.

[190] H. A. Shapiro, *Personifications in Greek Art* (Zurich 1993) 45–47, figs. 7–9; *LIMC*, s.v. Eirene nos. 11*, 12; Smith, *Polis and Personification*, 78; Stafford, *Worshipping Virtues*, 188, figs. 25a, b.

[191] K. Reinhardt, "Personifikation und Allegorie," in *Vermächtnis der Antike: Gesammelte Essays zur Philosophie und Geschichtsschreibung*, 2nd ed. (Göttingen 1966) 7–40 (written in 1937 but not published until 1966).

with Metrodoros of Lampsakos, who reduced heroes and divinities to physical properties.[192] Clearly, theory was in the air. The main point for my present discussion is that figures that appear to have a principal function as abstractions rather than as divinities become exceedingly popular in the second half of the fifth century. I would not classify personifications of place among these because from earliest times places often had a local nymph or *daimōnic* personality.[193] Important new personifications are Demos and Demokrateia, explicitly reflecting political trends of the period.[194] Less clear are figures such as Komos or Kraipale. The latter name means "a drunken headache," and the personification occurs on a single vase in Boston seated between a satyr named Sikinnos (the satyr dancer) and another female called Thymedia (the impassioned) (**Fig. 264**).[195] The fact that most commentators consider Kraipale a mainad and therefore not a personification is irrelevant to the present discussion, since she and her partners on the vase in Boston are clearly abstractions personified.[196] A development that can only cause further confusion is that some of these personified abstractions, such as Eirene, are given cults in the fourth century which are not attested earlier. To resolve some of the ambiguities, it is possible to follow Reinhardt's claim mentioned above that the numerous personifications on Attic vases are no more than the discovery by the painters of ideas that had long been present in religion and literature. Yet the popularity of personifications in the last third of the fifth century signals a dramatic shift in the expressive vocabulary of Greek vase painters. Instead of scenes from narrative myths in which the various "concept" *daimōnes* underscored a particular interpretation, the late-fifth-century personifications are often arrayed for themselves or, as Lucilla Burn points out,[197] as qualities that belong together and may be gathered around an appropriate Olympian divinity, such as Aphrodite, beyond which they do not constitute a coherent vocabulary that expresses a complex idea not present in the individual labeled figures.

The function of personified abstractions varies tremendously, but it primarily allows a direct and simple statement that sidesteps heroic myth, though still couched in traditional mythic terms. The varied genealogies of any given figure found in our literary sources indicate that the abstractions are configured to the specific purpose of the context and are not intended as absolute and immutable. This is particularly clear in the case of Diotima's analysis of Eros in Plato's *Symposion* (203b–204a), in which she makes Eros's parents Poros (Resource) and Penia (Poverty), from which she spins her characterization of the *daimōn* Eros. And Euripides changed traditional myths to their extreme limits, almost to the point that his plots are new inventions.[198] Agathon took the ultimate step, as Aristotle

[192] F. Wehrli, *Zur Geschichte der allegorischen Deutung Homers im Altertum* (Borna [Leipzig] 1928) chap. 4, "Die vorstoische allegorische Deutung Homers," 64–95, especially 92ff.; Borg, *Logos des Mythos* (note 187 above) 42–48, claims both allegory and allegorization as conscious constructs for Homer and archaic Greek literature; cf. N. J. Richardson, "Homeric Professors in the Age of the Sophists," *PCPS* 21 (1975) 68–69; D. Obbink, "Allegory and Exegesis in the Derveni Papyrus: The Origin of Greek Scholarship," in *Metaphor, Allegory, and the Classical Tradition: Ancient Thought and Modern Revisions*, ed. G. R. Boys-Stones (Oxford 2003) 180–81; G. Betegh, *The Derveni Papyrus: Cosmology, Theology and Interpretation* (Cambridge 2004) 185–205.

[193] See Smith, *Polis and Personification*, 102–7, for a brief review of locative personifications.

[194] Ibid., 96–102 (Demos), 124–26 (Demokratia).

[195] Boston, MFA 00.352: *ARV*² 1214.1 (Kraipale Painter), 1687; L. D. Caskey and J. D. Beazley, *Attic Vase Paintings in the Museum of Fine Arts, Boston*, vol. 2 (Oxford 1954) 93–95, pl. 64 above; G. van Hoorn, *Choes and Anthesteria* (Leiden 1951) fig. 116; *LIMC*, s.v. Kraipale no. 1*.

[196] Smith, *Polis and Personification*, 35–39, on mainads functioning as personifications.

[197] Burn, *Meidias Painter*, 32–40.

[198] H. D. F. Kitto, *Greek Tragedy: A Literary Study*, 3rd ed. (London 2011) 208–9, 303.

states, by presenting a play, *Anthos* (*The Flower*), with made-up plot and characters.[199] This, of course, was the pattern of comedy; as such, the play was not a new invention, and the presentation of abstractions on stage in comedy has caused no comment in the modern discussion. But the Meidias Painter's predilection for personifications parallels that of Aristophanes.[200] This cannot be a coincidence. Heroic, epic myth was losing its relevance and popularity, and the invented story and characters provided a whole new world of expression, part of which is explicitly political and social.[201] Plato's use of myths created for his own purposes in his elaboration of the genealogy of Eros in the *Symposion* has already been noted; for a man who criticizes poetry so severely, he makes up a host of most captivating and wild myths.[202]

An important aspect of the similarity of the personifications in plastic art and in literature is that they appear very domestic—not grand and terrifying demons but homely, genre-like figures. This is the same development that affects the Olympian divinities and the epic heroes that are depicted, though the latter appear on vases astonishingly rarely. Thus Aphrodite and her personified attributes look very much like domestic gatherings of mortals.[203] In the second half of the fourth century, the gathered Eleusinian divinities are presented on Attic vases in largely static scenes, sitting and standing, quietly facing the viewer (**Figs. 210, 211, 246**). Even though Erika Simon's narrative interpretation is convincing, Adolf Furtwängler's interpretation of the scenes as hieratic presentations of the divinities is not inaccurate.[204] The compositions convey a quiet gathering of divinities who communicate with each other with restrained gestures and in small groups. Typical of the fourth century is the inclusion of a fluttering Nike or Eros. Of prime interest here is that the quiet, domestic appearance of the scenes is a thin veil over the momentous events referred to, a manner of expression that is perhaps most characteristic of the fourth century.

The inclusion of erotes in scenes of wedding preparations indicates the extent to which the human and divine worlds intersect. So too does the blurring of the human and divine worlds in the general realm of domesticity on fourth-century vases. Votive reliefs underscore the situation. The groups of family members before an altar and divinity seem totally at ease with their animals and sacrificial paraphernalia, as though they were a modern family out for a picnic (**Fig. 242**). The far larger divinity stands or sits observing the earthly scene, often in a casual and welcoming pose. This observation applies particularly to the figure of Hygieia leaning against any handy prop on a number of reliefs from around

[199] Aristotle, *Poetics* 9.1451b.19–26; P. Lévêque, "Agathon," *Annales de l'Université de Lyon*, ser. 3, *Lettres* 26 (Paris 1955) 55, 105–14; J. Machina, "Le tragedie di Agatone," *Dionisio* 18 (1955) 19–41. For the testimonia and fragments, see B. Snell and R. Kannicht, *Tragicorum Graecorum Fragmenta*, vol. 1 (Göttingen 1986) 155–68. I follow Lévêque in believing the name was simply *The Flower* rather than some mythological name; the possibilities depend on the type and placement of the accent. Lévêque's heading, "le drame bourgeois," sums up the meaning of the innovation and the name of the tragedy rather well. Webster's review of fourth-century tragedy stresses the dramatic new interpretation of the traditional myths in the vein of Euripides: Webster, *Art and Literature*, 62–69.

[200] Burn, *Meidias Painter*, 32–40; Stafford, *Worshipping Virtues*, 16, 162–63.

[201] D. Metzler, "Eunomia und Aphrodite: Zur Ikonologie einer attischen Vasengruppe," *Hephaistos* 2 (1980) 74–88; H. A. Shapiro, "Ponos and Aponia," *GRBS* 25 (1984) 107–10.

[202] R. Wright, "How Credible Are Plato's Myths?" in *Arktouros: Hellenic Studies Presented to Bernard M. W. Knox*, ed. G. W. Bowersock et al. (New York 1979) 364–71. As I have observed elsewhere, Plato (*Phaidros* 246A, 257A) states that his myths express what logical argument cannot: Childs, "Stil als Inhalt," 239.

[203] See the vases discussed in the references cited in notes 200 and 201 above.

[204] A. Furtwängler and K. Reichhold, *Griechische Vasenmalerei: Auswahl hervorragender Vasenbilder*, vol. 2 (Munich 1905) 55; so also Metzger, *Représentations*, 261. See p. 247 above.

the middle of the fourth century on,[205] a pose that reminds one of the popularity of the motif in statuary, such as the Apollo Sauroktonos (**Fig. 181**), the boy from Marathon Bay (**Fig. 65**), or the Pothos (if it is indeed a fourth-century work).[206]

The appearance of numerous personified abstractions in Greek art of the later fifth and fourth centuries clearly constitutes an alternate mode of visual expression to the repetition and variation of heroic myths. Allegory is closely allied to and partially overlaps the use of personifications. Although a strict definition of the word allegory is "to say in another manner," this is too broad a meaning for the use of personifications on fifth-century vases. A more meaningful definition of allegory, as Roger Hinks argued, is the presentation of more or less clearly intended personified abstractions in a setting or relationship that induces the viewer to read the figures dynamically and intellectually.[207] The product should be greater than the sum of its parts. Thus, the massed personifications of the attributes of Aphrodite arranged around the goddess do not qualify as an allegory.[208] Equally, the Nikai carrying out the rituals of victory on the parapet reliefs of the Nike temple on the Athenian Acropolis do not qualify.[209] But Alan Shapiro has made a good case that the panel of the Eretria Painter's epinetron in Athens depicting Aphrodite at the wedding preparations is an allegory of Harmonia (**Fig. 200**).[210] Here the massed personifications perform a commentary on marriage, much as they characterize Slander in Apelles' painting described by Lucian (*On Slander* 4–5). Allegorical expression in its strict form as defined above, however, is not particularly popular in the fourth century, and the few major examples are noteworthy for their rarity. One is the statue of Kairos made by Lysippos described in the epigram of Poseidippos (*Greek Anthology* 16.275):

> **A.** Who and whence was the sculptor? **B.** From Sikyon. **A.** And his name? **B.** Lysippos. **A.** And who are you? **B.** Time (Kairos) who subdues all things. **A.** Why do you stand on tip-toe? **B.** I am ever running. **A.** And why do you have a pair of wings on your feet? **B.** I fly with the wind. **A.** And why do you hold a razor in your right hand? **B.** As a sign to men that I am sharper than any sharp edge. **A.** And why does your hair hang over your face? **B.** For him who meets me to take me by the forelock. **A.** And why, in Heaven's name, is the back of your head bald? **B.** Because none whom I have once raced by on my winged feet will now, though he wishes it sore, take hold of me from behind. **A.** Why did the artist fashion you? **B.** For your sake, stranger, and he set me up in the porch as a lesson. (Trans. W. R. Paton, Loeb edition)

[205] For example, Athens, NAM 1330, 1333, 1383, and 2557, and Paris, Louvre 755, all conveniently illustrated in Süsserott, *Griechische Plastik*, pls. 22.1, 22.2, 22.5, 25.3, 25.4, and van Straten, *Hierà Kalá*, figs. 59, 62–63, 70 (R6, R8, R10, R23). See further p. 259 and note 228 below.

[206] H. Bulle, "Zum Pothos des Skopas," *JdI* 56 (1941) 121–50; O. Palagia, "Skopas of Paros and the 'Pothos,'" in *Paria Lithos: Parian Quarries, Marble and Workshops of Sculpture; Proceedings of the First International Conference on the Archaeology of Paros and the Cyclades, Paros, 2–5 October 1997*, ed. D. U. Schilardi and D. Katsonopoulou (Athens 2000) 219–25.

[207] Hinks, *Myth and Allegory* (note 187 above) 18–19, 32, 62. Stafford, *Worshipping Virtues*, 182, uses such a broad meaning for allegory that it encompasses virtually any representation.

[208] A. Shapiro, "The Origins of Allegory in Greek Art," *Boreas* 9 (1986) 11–14.

[209] Although A. Stewart, "History, Myth, and Allegory in the Program of the Temple of Athena Nike, Athens," in *Pictorial Narrative in Antiquity and the Middle Ages*, Studies in the History of Art 16, ed. H. L. Kessler and M. S. Simpson (Washington, DC, 1985) 53–73, suggests the contrary. See also M. H. Jameson, "The Ritual of the Athena Nike Parapet," in *Ritual, Finance, Politics: Athenian Accounts Presented to David Lewis*, ed. R. Osborne and S. Hornblower (Oxford 1994) 307–24; E. Simon, "An Interpretation of the Nike Temple Parapet," in *The Interpretation of Architectural Sculpture in Greece and Rome*, Studies in the History of Art 49, ed. D. Buitron-Oliver (Washington, DC, 1997) 127–43.

[210] Shapiro, *Boreas* 9 (1986) 15–22; Borg, *Logos des Mythos* (note 187 above) 76–79.

Here, of course, the allegory is made up of particular characteristics of a single personi-fication, but it is the dynamic interrelationship of symbolic forms that constitutes the allegory.

Although there is a dispute over the allegorizing tendencies of the Stoics and even the Cynics,[211] the allegorization of traditional themes in art appears incontrovertible.[212] This allegorization must certainly underlie the transformation of the Amazonomachy in monumental and particularly funerary sculpture discussed above. The transformation of the scenes of Herakles in the Garden of the Hesperides on Attic red-figure vases is another example, following in the wake of Prodikos's allegorizing parable.[213] In the same vein, though more a change in symbolism, are the depictions of bathing. In these, both the bath and the strigil become symbols bearing far more meaning than is readily apparent. It is in the ensemble of shifts of meaning—whether real allegory, allegorization, or increased symbolism—that a pervasive character of imagery in the fourth century may be sought. The Dexileos grave relief represents the simplest transformation but a significant one: the deceased is depicted as victorious (**Fig. 4**). The fact that Dexileos is draped and the fallen enemy is naked corresponds to the usual realism of the stelai of the late fifth and fourth centuries. But the ambiguity of the triumphant deceased reveals a new meaning of the representations on the stelai. Himmelmann has pointed out that several stelai paraphrase important statues of divinities which also suggest a hopeful view of the afterlife that is generally thought to be absent from Greek funerary art.[214]

It seems extremely likely that the subtle changes in iconography, particularly the evidently deceptive realism, are intended to mask a deeper meaning. In the case of the Apollo Sauroktonos (**Fig. 181**), the ambiguity of the modern response to the statue (group) is informative. Some scholars believe the statue represents an intellectual skepti-cism toward the inherited religious views of the Olympians.[215] Others, myself included, see it as an almost ironic statement of the vast power of the god: Python, the snake of Gē at Delphi before the arrival of the young Apollo, is no more to the divine child than a lizard to a mortal child.[216] What is so difficult to accept is the broad humanization of the divine statues in the fourth century: Hermes appears to play with the child Dionysos on his mission to Nysa (**Fig. 133**) or is a weary messenger of the gods (**Fig. 188**); Aphrodite takes a bath like any Athenian woman (**Fig. 147**); Athena stands around with hand on hip in slight exasperation (**Fig. 145**) or is a somewhat inwardly turned young girl (**Fig. 168**); Asklepios is a mature citizen resting on his staff. The strangely reflective image of Dionysos in the west pediment of the Temple of Apollo at Delphi (**Fig. 22**) also fits the new genre,[217] just as the Lykeios Apollo type appears an effeminate and slightly tipsy alter ego of Dionysos.

[211] A. A. Long, "Stoic Readings of Homer," in *Homer's Ancient Readers*, ed. R. Lamberton and J. J. Keaney (Prince-ton 1992) 41–66; Richardson, *PCPS* 21 (n.s., 21) (1975) 65–81; see also the long, rambling observations of Wehrli, *Allegorischen Deutung* (note 192 above).

[212] Although Metzger, *Représentations*, does not treat the subject directly, he observes constantly that the scenes on vases have a secondary, symbolic meaning next to the mythological narrative: e.g., 208, 209–10, 229–30, 285, 306, 418–21.

[213] See p. 249 above.

[214] Himmelmann, "Images of Gods and Heroes" (note 6 above) 136–44. See pp. 230–31, 245 above.

[215] J. J. Pollitt, *Art and Experience in Classical Greece* (Cambridge 1972) 154.

[216] W. Childs, "Platon, les images et l'art grec du IVe siècle avant J.-C.," *RA*, 1994, 47 and n. 80.

[217] A. Stewart, "Dionysos at Delphi: The Pediments of the Sixth Temple of Apollo and Religious Reform in the Age of Alexander," in Barr-Sharrar and Borza, *Macedonia*, 205–27; Croissant, *FdD* 4.7, pls. 34–41.

All these statues have been interpreted as depicting the gods as distant and uncon-cerned with the affairs of people. This view was first elaborated by Gerhard Rodenwaldt in his last publication, Θεοὶ ῥεῖα ζώοντες, of 1943.[218] Yet it is precisely the humanity of the divinities that makes them immediately present and recognizable. Furthermore, it is the illusionistic scenes created by the mini-groups and individual statues that create the impression of an accessible epiphany. The argument about the pose of the Knidian Aphrodite illustrates the point well (**Fig. 147**). Many commentators wish to believe that the Knidia is reacting to an intruder on her bath—the gesture of her proper right arm is thus interpreted as an attempt to cover her groin from the view of the intruder.[219] But a comparison of the Munich and Vatican (Colonna) versions clarifies the situation.[220] The Munich Aphrodite has her head up and sharply turned to the viewer's right (**Fig. 149**). Her proper left arm is raised to the level of her upper abdomen and is approximately over her side; she appears to pull up the drapery of her mantle with this hand, creating straight parallel lines to the top of the hydria that rests on the ground. How totally different is the Vatican statue: her proper left hand falls, and the drapery that it holds cascades over the hydria, which is raised up on a base; her hand is held well to the side of her body; her head is turned down, her vision focused on a point on the ground at no great distance. In the Vatican version, Aphrodite is disturbed by no intruder; she is in the process of letting her garment fall on the hydria while she looks down to the place she will crouch to have the water from the hydria poured on her. Her proper right arm is depicted in an easy pose commensurate with the action. It is the later variations on the theme of nude Aphrodite that change the pose and meaning more or less strongly to suggest an intruder and the action of covering her nudity. The "Belvedere" copy in the Vatican storeroom is a step in this direction (**Fig. 148**); the Capitoline type is the most explicit in this regard.[221] The Knidia is totally unaware of the actual human viewer. It is this feature that suggested to Rodenwaldt and others that the gods were distant.[222] But this is standing what one sees on its head. What we in fact see is a series of very human figures doing what mortals do every day. There is no aloof distance, but an immediacy and intimacy that makes the viewer feel completely at ease as a viewer of, not participant in, the scenes created by the statues. These are, after all, epiphanies; were the viewer meant to be actually present before the divinity the result would have been rather dangerous, as Aktaion and others discovered. Although there is no evidence that these statues had architectural frames[223] like those of the Attic grave reliefs that in the course of the fourth century become real enclosures of

[218] G. Rodenwaldt, Θεοὶ ῥεῖα ζώοντες, AbhBerl, 1943, no. 13 (Berlin 1943).

[219] Reviewed briefly by Havelock, *Aphrodite of Knidos*, 27–37, and B. S. Ridgway, "Some Personal Thoughts on the Knidia," in *Second Chance: Greek Sculptural Studies Revisited* (London 2004) 713–25; Ridgway, *Fourth-Century Styles*, 263–65. Cf. Pfrommer, *IstMitt* 35 (1985) 173–80; A. Stewart, *Art, Desire, and the Body in Ancient Greece* (Cambridge and New York 1997) 103. The long commentary of N. Salomon, "Making a World of Difference: Gender, Asymmetry, and the Greek Nude," in Koloski Ostrow and Lyons, *Naked Truths* (note 20 above) 197–242, runs completely counter to the interpretation proposed here.

[220] Munich, Glyptothek 258: Vierneisel-Schlörb, *Klassische Skulpturen*, 349, no. 31, fig. 158; Ridgway, *Fourth-Century Styles*, 264, pl. 67.

[221] Rome, Musei Capitolini 409: Havelock, *Aphrodite of Knidos*, fig. 18; W. Neumer-Pfau, *Studien zur Ikonographie und gesellschaftlichen Funktion hellenistischer Aphroditestatuen*, Habelts Dissertationsdrucke, Reihe klassische Archäologie 18 (Bonn 1982) 62–82, 117–18; *LIMC*, s.v. Aphrodite no. 409* (A. Delivorrias). Seaman, *RendLinc*, ser. 9, 15 (2004) 538–50, considers the issue uncertain but argues that the original gesture was picking up the clothing rather than letting it fall.

[222] Θεοὶ ῥεῖα, 14–15, followed by Borbein, *JdI* 88 (1973) 173–74.

[223] Borbein, *JdI* 88 (1973) 188–94 (Anhang I) reviews the contradictory evidence for the setting of the Knidia.

the reliefs and statues nearly in the round, they nonetheless demonstrate the same concern with making what is absent appear to be present—the gods instead of the deceased. As discussed in chapter 5A, the development of architectural settings for groups of statues may not be a new phenomenon of the fourth century, but the proliferation and increasing importance of such architectural frames for large votive groups enhances precisely the effect described here for the earlier statues—the creation of an almost palpable space in which a divine skit takes place before the very eyes of the mortal viewer. The architectural frames do not create distance but serve the opposite function: they isolate the epiphany in a real space that is parallel to and analogous to that of the viewer.

It is hardly necessary to argue at length the fact that the statues of divinities in the fourth century bear strong religious conviction. How else can one explain the dramatic increase of votive reliefs? They are particularly important as a class of votive because they illustrate mortals facing the divinity or group of divinities to whom the cult is dedicated. This is an ancient formula, going back to the sixth century, but the real genesis of the classical type is the east frieze of the Parthenon, on which the seated gods sit more or less patiently, conversing at times with each other, awaiting the arrival of the procession.[224] The same somewhat casual atmosphere is also evident on the east frieze of the Nike temple.[225] There can be little surprise that the figure types of the divinities on the votive reliefs frequently repeat and probably represent well-known statues of the relevant cult. The reliefs associated with the Pythion of the deme Ikaria in Attica appear to use the figure of Apollo seated on the omphalos from the east pediment of the new temple at Delphi.[226] In the case of Persephone on reliefs from Eleusis (**Fig. 141**) and elsewhere, the type is easily recognized in the Uffizi statue of Kore (**Fig. 142**).[227] Although there is no preserved statue type of the typical figure of Hygieia on the votive reliefs (**Figs. 93, 242**), the almost exact repetition of the figure on several reliefs allows us to assume that a statue was the prototype.[228] The figure of Asklepios leaning on his staff is another obvious statue type for which numerous Roman versions are preserved.[229]

In summary, I would claim that traditional heroic mythology and the transcendental, somewhat erratic behavior of the gods wane as subjects of art in favor of a new spiritualized world in which the everyday and the divine become parallel phenomena and in

[224] J. Kroll, "The Parthenon Frieze as Votive Relief," *AJA* 83 (1979) 349–52; Neils, *Parthenon Frieze* (note 57 above) 214–15, and 61–66 on the "space of the gods."

[225] Neumann, *Weihreliefs*, 64–65.

[226] Voutiras, *AJA* 86 (1982) 229–33, pls. 30–32; Bommelaer and Laroche, *Delphes: Le site*, 78–80.

[227] See chap. 3, pp. 77–78 above.

[228] See pp. 255–56 and note 205 above. U. Hausmann, *Kunst und Heiligtum: Untersuchungen zu den griechischen Asklepiosreliefs* (Potsdam 1948) 177–78 (nos. 142–46), lists five examples of the type on fourth-century votive reliefs. F. Croissant, *LIMC*, s.v. Hygieia nos. 28–34, lists seven, to which can be added two related types of Hygieia in which she leans on something lower (back of chair, post, etc.): nos. 23–27, 35–37. W. Fuchs, "Attische Nymphenreliefs," *AM* 77 (1962) 248, note 33, suggests a statue as the inspiration for the figure leaning against tree or similar support; and O. Palagia, "A Draped Female Torso in the Ashmolean Museum," *JHS* 95 (1975) 180–82, pl. 20, suggests that a battered torso in the Ashmolean (no. 63) may be an original of the fourth century and represent a woman in a closely similar pose. Croissant denies, however, that the type considered here may derive from a statue type (*LIMC*, vol. 5 [Zurich 1990] p. 569). Sobel, *Hygieia* (note 117 above) 22–23, points to the statue groups of Hygieia and Asklepios in Rome (her pl. 3b) and Copenhagen (P. Arndt, *La Glyptothèque Ny Carlsberg: Les monuments antiques* [Munich 1912] 140–42, pl. 96; fig. 77 on p. 141 illustrates the Vatican group) in which Hygieia leans on the back of Asklepios's throne, although she draws no conclusions about the more emphatic pose of Hygieia in question here.

[229] E.g., Athens, NAM 1334 and 1402: van Straten, *Hierà Kalá*, figs. 64, 66 (R9, R19). For the statue type, see M. Meyer, "Zwei Asklepiostypen des 4. Jahrhunderts v. Chr.: Asklepios Giustini und Asklepios Athen-Macerata," *AntP* 23 (1993) 7–55.

which the heroic has a less dramatic face.[230] The contradictory observations made above concerning, on the one hand, the humanization of the gods in the fourth century, and, on the other hand, the clear distinction of divinity and mortal, are resolved only when one realizes that the gods are youthful, erotic, and, as Rodenwaldt clearly realized, ῥεῖα ζώοντες. Mortals, by contrast, are mature. The men are bearded and are clothed both as civilians and, more astonishingly, even as soldiers. As Himmelmann has pointed out, there is a realm for male nudity, the palaestra and the hunt, but otherwise male nudity becomes approximately what it had been for so long for women, a sign of powerlessness.[231] Mortal women become heavily draped matrons on the Attic grave stelai; the "Artemisia" of the Maussolleion at Halikarnassos fits this pattern (**Fig. 5**), as do the mourning women of the eponymous sarcophagus from Sidon now in Istanbul (**Fig. 61**).

The very contrast of divinity and mortal clearly establishes the nature of fourth-century imagery: it is powerfully expressive in its use of two distinctly realistic vocabularies. The youthful elegance of the divine contrasts with the rather blunt statement of the human, an important element of which is the psychological. Here the character of images—their style and iconography—appears to reflect the democratic world of Athens in particular: the heroic is replaced by the life of the citizen.[232] Yet the two realms are interwoven, as the prologues and epilogues of so many of Euripides' plays clearly demonstrate,[233] as do the profusion of personifications that populate scenes of marriage.[234] The two realms may also be connected by an emphasis on the concept of εὐσχήμων. The extraordinary, almost tedious, repetition of family groups on Attic grave stelai suggests a social image of decorum that masks the disastrous interstate warfare of the fourth century with an ideal image of bourgeois prosperity, an image that even *metics* and the lowest elements of society aspire to, as on the stele of the slave Thous from Laurion (**Fig. 265**).[235] In fine, both the gods and mortals occupy decorous worlds, but the gods are distinguished by youthfulness, elegance, and the ease of their existence; mortals are distinguished by an almost harsh realism that extends to psychological concern. Compare, for example, the diskobolos attributed to Naukydes, of the early fourth century (**Fig. 172**), to the Diskobolos of Myron, of the middle of the fifth century. The former contemplates the throw he is about to make with a new intensity, while Myron's statue presents an ideal schema of the effortless act of rotation and throwing.[236] The generalized rhythm of the statue of Diomedes in Naples sometimes attributed to Kresilas[237] can be contrasted with the broken planes and more powerfully modeled musculature of the statues of Meleager in the Vatican and the Ny Carlsberg Glyptotek in Copenhagen.[238] Finally, the Agias of the Daochos Group in Delphi

[230] Stoic belief in both a rational, cosmic god and in the traditional gods as manifestations of the cosmic god seems close to my interpretation of the implicit content of the art of the fourth century; see P. A. Meijer, *Stoic Theology: Proofs for the Existence of the Cosmic God and of the Traditional Gods: Including a Commentary on Cleanthes' Hymn on Zeus* (Delft 2007).

[231] Himmelmann, *Ideale Nacktheit*, 59–71 (warriors, hunters, athletes) 25, 40–41(nudity and powerlessness).

[232] J. Gregory, *Euripides and the Instruction of the Athenians* (Ann Arbor 1991).

[233] Kitto, *Greek Tragedy* (note 198 above) 294–303.

[234] Metzger, *Représentations*, 41–53. See also Osborne, *Eros Unveiled* (note 187 above) 101–11, on the role of Eros as *daimōn*, the intermediary between the divine and mortals.

[235] Athens, NAM 890: Clairmont, *CAT*, 3.922; Himmelmann, *Attische Grabreliefs*, 46, fig. 16.

[236] D. T. Benediktson, *Literature and the Visual Arts in Ancient Greece and Rome* (Norman, OK, 2000) 63, observes that the Diskobolos is "clearly a work of action but not character."

[237] Lippold, *Griechische Plastik*, pl. 48.4; Stewart, *Greek Sculpture*, fig. 439; Todisco, *Scultura greca*, no. 1.

[238] F. Poulsen, *Billedtavler til kataloget over antike kunstvaerker* (Copenhagen 1907) pl. XXV; Poulsen, *Catalogue*, no. 387.

(**Fig. 14**) represents, as Erik Sjöqvist so aptly remarked, "an individual who seems to shiver in a restless idleness."[239] Though the heroes, like the gods, remain nude in the fourth century, they are subject to the strain of mortal existence from which the gods are protected. Perhaps what most clearly distinguishes a divinity from a mortal is the character of intimacy that pervades the divine sphere. It is this characteristic that also forces the interpretation that the gods are immanent. The casual elegance of gods and goddesses may reflect the new ideal—an escape from the heavy burdens of political strife and war. As we shall see in the next chapter, the increase in wealth and the taste for valuable, exotic, and richly decorated objects stands in contrast to the image of uniformity and harsh realism that is communicated by the public display of the grave reliefs.

[239] Sjöqvist, "Lysippus," 15.

7 Style and Meaning

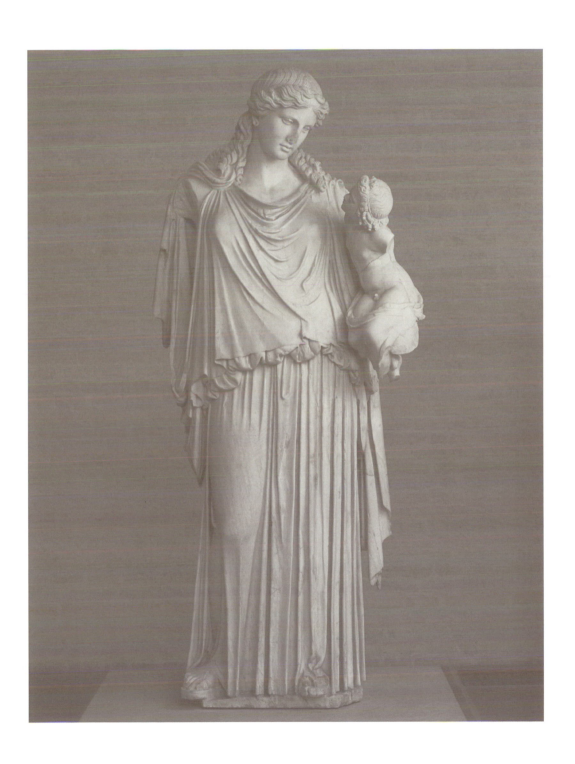

Although I have dealt with general issues of style in chapter 4, there remains a range of issues that were not addressed there. One of these is the extraordinary lavishness and elegance of forms in the fourth century. These characteristics are usually associated only with the Rich Style, from 420 to 380, but in fact they are found throughout the fourth century in specific classes of monuments. It is a bit difficult to grasp the overall effect that must have been a common experience in both public and private spaces. The most obvious elements on public buildings are the rich ornamental moldings with grand vegetal patterns of extraordinary elaborateness, imaginative flourishes, and plasticity, which, we must remember, were also brightly colored. These patterns also occur on metal (**Fig. 110**) and painted vases, and, of course, in the medallions and frames of floor mosaics (**Figs. 113, 114**).[1] The appearance of floor mosaics in private buildings is also an important signal of the rise of private wealth and its physical ostentation which clearly mark off the fourth century from earlier periods. By this I mean to distinguish between the public demonstration of wealth through votive and funerary monuments and the beginning of the ostentatious demonstration of wealth in the private dwelling. The point is made explicitly by Demosthenes (*Third Olynthiac* 25) and is largely confirmed by the inscriptions detailing the selling of the property of the profaners of the Mysteries and the *hermokopidai* in 415, among whom was the definitely wealthy Alkibiades.[2]

The houses in which mosaic floors have been found are mostly modest in size, with the exception of the great palaces of Macedonia and their late-fourth-century counterparts at Pella.[3] An example of a house that is slightly larger, though still modest in size and plan, is the House of the Mosaics at Eretria (**Figs. 112, 113**).[4] Five identifiable Panathenaic amphoras dating to the archonships of Charikleides (363/2) and Kallimedes (360/59), and fragments of two more were found in the house, suggesting an accomplished owner, yet the plan and size of the house differ little from other middle-class

[1] See chap. 2, pp. 47–49 above.

[2] W. K. Pritchett, "The Attic Stelai: Part I," *Hesperia* 22 (1953) 225–311, pls. 67–84; Pritchett, "The Attic Stelai: Part II," *Hesperia* 25 (1956) 178–318; A. Pippin, "The Demioprata of Pollux X," *Hesperia* 25 (1956) 318–28; D. A. Amyx, "The Attic Stelai: Part III: Vases and Other Containers," *Hesperia* 27 (1958) 163–310, pls. 47–54; D. M. Lewis, "After the Profanation of the Mysteries," in *Ancient Society and Institutions: Studies Presented to Victor Ehrenberg on His 75th Birthday* (Oxford 1966) 177–91.

[3] M. Jameson, "Private Space and the Greek City," in *The Greek City from Homer to Alexander*, ed. O. Murray and S. Price (Oxford 1991) 271–95; Y. Grandjean, "La maison grecque du Vème au IVème siècle: Tradition et innovation," in *Le IVe siècle av. J.-C.: Approches historiographiques*, ed. P. Carlier (Nancy 1996) 293–313.

[4] P. Ducrey and I. R. Metzger, "La maison aux mosaïques à Eretrie," *AntK* 22 (1979) 3–21; P. Ducrey, *Eretria*, vol. 8, *Le quartier de la Maison aux mosaïques* (Lausanne 1993); Ducrey, *Eretria: A Guide to the House with the Mosaics* (Athens 1991).

houses known from the late fifth and the fourth century.[5] The mosaic floors are clearly upscale elaborations of the traditional house, but they are not accompanied by greatly expanded plans until much later. One must therefore be a little cautious in taking Demosthenes at his word when he castigates his contemporaries for the egregious luxury of their houses in comparison to the simple modesty of the dwellings of the great men of the fifth century,[6] though the great popularity of mosaic floors certainly is paralleled by other elaborations of the private house, such as the addition of a peristyle to the open central court. The subjects of the mosaic floors of the late fifth and first half of the fourth century are largely not mythological—at most centaurs or Amazons and composite beasts in subsidiary roles.[7] At Olynthos—destroyed, it will be remembered, in 348—the Bellerophon mosaic is one of the earliest large-figured medallion mosaics of the first quarter of the fourth century (**Fig. 114**),[8] followed slightly later by mosaics at Eretria and Sikyon.[9] Finally, near the end of the century, the great mosaics depicting Theseus carrying off Helen (**Fig. 213**), an Amazonomachy, and Dionysos riding a panther appear in the palatial houses of Pella.[10] An obvious difference between the earlier and later pictorial mosaics is that the later examples are designed to be seen best from one principal side, while the earlier mosaics are frequently circular and therefore without a principal axis.[11] The emphasis of the later mosaics is therefore on the picture *qua* picture and not just on the decoration of a space. The development from lavish, largely abstract decoration to mythical picture is noteworthy and must parallel the introduction of painting into the private sphere, both the painting of architecture and in the form of panel paintings.[12] We hear from pseudo-Andokides (*Alkibiades* 17) and Demosthenes (*Against Meidias* 147) of Alkibiades shutting Agatharchos into his house to force him to paint it—with more than whitewash, we assume—and the parallel but more decorous hiring of Zeuxis by King Archelaos of Macedon to paint his new palace at Pella (Aelian, *VH* 14.17).[13] Although there is no evidence of figural wall paintings in domestic contexts until the second century B.C., it seems to me difficult to believe that these earlier projects did not include figures.[14] The Macedonian tombs allow a wide range of possible levels

[5] M. Bentz, "Die Preisamphoren aus dem Mosaikenhaus in Eretria," *AntK* 44 (2001) 3–12, pls. 1–6. Bentz surmises that these were not won by an owner of the house but were purchased on the market in Athens because several other Panathenaics were found in nearby houses at Eretria, and others were found in the domestic area of Olynthos. Since the amphoras in the "House of the Mosaics" were found in the peristyle near the mosaic rooms, Bentz further suggests that they stood there as signs of the athletic ideals of the owners of the house over many generations.

[6] Demosthenes, *Against Aristokrates* 208; pseudo-Demosthenes, *On Organization* (13) 30; Grandjean, "Maison grecque" (note 3 above) 292–93.

[7] Salzmann, *Kieselmosaiken*, 95, 10, 112, cat. 63, 84, 86, 119, pls. 9.1–3, 10.1, 10.2, 11.1–4, 12.2, 12.3, which he dates to the late fifth or early fourth century.

[8] Ibid., 99, cat. 78, pl. 13.

[9] Ibid., 90–91, cat. 37, pls. 26.1–4, 27.1, 111–12, cat. 117, pl. 22.1. Bentz, *AntK* 44 (2001) 10–11, notes, as mentioned earlier (note 5 above), the public presentation of the Panathenaic amphoras in the peristyle of the house, possibly bought for the purpose of display, not won in the games.

[10] Salzmann, *Kieselmosaiken*, 104–5, 108, 106–7, cat. 96, 104, 101, pls. 32.1, 34, 35.

[11] E. Walter-Karydi, *The Greek House: The Rise of Noble Houses in Late Classical Times* (Athens 1998) 58–59.

[12] The mention of painted pinakes in the Attic Stelai listing the private property of the offenders against the mysteries is suggestive but not conclusive: Pippin, *Hesperia* 25 (1956) 326–27 (stele VII, lines 59–62, and Pollux 10.83); Pritchett, *Hesperia* 25 (1956) 250–53.

[13] Gschwantler, *Zeuxis und Parrhasios*, 139–40.

[14] S. G. Miller, *The Tomb of Lyson and Kallikles: A Painted Macedonian Tomb* (Mainz 1993) 98, suggests that similar painting may have existed in contemporary third-century houses; see also V. J. Bruno, *Hellenistic Painting Techniques: The Evidence of the Delos Fragments* (Leiden 1985) 7–8.

for the painting of private dwellings, from simple colored zones (the lower register of the Tomb of Persephone at Vergina [**Fig. 120**]) to narrow figured friezes (Tomb of the Prince, Vergina) to large figures disposed either statically and paratactically on a wall surface (Bella Farm) to narrative scenes such as those presented by the floor mosaics.[15] I suggest that there was just such a sequence of progressively elaborate patterns in the wall paintings of private dwellings.

Although elaborate and costly furniture has been found in the Macedonian tombs,[16] there is no evidence that such furnishings were widely used in Greece.[17] The gilt ivory figures and decorative moldings of the Macedonian tomb furniture indicate the existence of highly skilled workshops that must have included Greek craftsmen and were possibly located in the south.[18] Such workshops have at least been posited for the manufacture of many of the silver and gold vessels found in the northern tombs (**Figs. 107, 108**).[19] The reference by Demosthenes (*Against Meidias* 158) to the ostentatious flaunting of luxurious silver plate in Athens proper confirms that such objects were not unknown among the rich even there, and Euripides lists quantities of silver and gold vessels at the feast in the *Ion* (lines 1165–66, 1175, 1181–82), though these are presumably the treasure of the god.[20]

Another area of luxury is well attested in Athens: elaborately decorated cloth in the form of clothes, rugs, and cushions.[21] Other than the representation of clothes, covers of *klinai*, and cushions on Attic vases of the late fifth and fourth centuries, there is the famous anecdote in Pliny (*NH* 35.62) that Zeuxis "acquired such great wealth that he advertised it at Olympia by displaying his own name in gold lettering on the square medallions (*tessares*) of his robes." This anecdote is framed as merely a criticism of the painter's luxurious ways, but Allan Wace has published a series of scraps of cloth that parallel the descriptions of figured and inscribed garments in the inventories of the sanctuary of Artemis Brauronia.[22] These inscriptions demonstrate conclusively that the type of richly decorated cloth depicted on Attic vases not only existed but that it paralleled the supposedly special luxuriousness of Zeuxis's garment. The interest here is actually twofold: first, the luxurious taste of the Athenians around the year 400 and, second, the fact that this marks a revival, since Vincenz Brinkmann has demonstrated that elaborate clothing came back

[15] See chap. 4, pp. 146–50, above for a discussion of the Macedonian tomb paintings.

[16] Andronikos, *Royal Tombs*, 123–36.

[17] Again, the Attic Stelai of 415 B.C. list only simple furniture: Pritchett, *Hesperia* 25 (1956) 210–33. Lewis, "Profanation of the Mysteries" (note 2 above) 183, notes that only two objects of valuable materials are listed.

[18] D. Harris, *The Treasures of the Parthenon and Erechtheion*, Oxford Monographs on Classical Archaeology (Oxford 1995) 27, 88, 91–94, 110–12, 119–21, 136–38, lists all the furniture in the accounts; an ivory table is the only clearly unusual item. It has been suggested that some of the wooden sarcophagi found along the north coast of the Black Sea were made in Athens, but this seems very unlikely. The Greek cities of Asia Minor are better candidates: M. Vaulina and A. Wąsowicz, *Bois grecs et romains de l'Ermitage*, trans. M. Drojecka (Wrocław 1974) 51, 67–68, 73, 81–82, 92–93.

[19] S. Ebbinghaus, "Between Greece and Persia: Rhyta in Thrace from the Late 5th to the Early 3rd Centuries B.C.," in *Ancient Greeks West and East*, ed. G. R. Tsetskhladze (Leiden 1999) 385–425; she treats a range of other Thracian gold and silver vessels besides the rhyta. See chap. 2, pp. 47–48 above.

[20] T. Linders, "Ritual Display and the Loss of Power," in *Religion and Power in the Ancient Greek World: Proceedings of the Uppsala Symposium 1993*, Acta Universitatis Upsaliensis, Boreas 24, ed. P. Hellström and B. Alroth (Uppsala 1996) 121–24.

[21] See generally E. Buschor, *Beiträge zur Geschichte der griechischen Textilkunst (Die Anfänge und der orientalische Import)* (Munich 1912), particularly 36–50 ("Der orientalische Import").

[22] A. J. B. Wace, "The Cloaks of Zeuxis and Demetrios," *ÖJh* 39 (1952) 111–18; *IG* II² 1514, lines 7–9, and repetitions in 1515 (lines 3ff.) and 1529 (lines 13–14); T. Linders, *Studies in the Treasure Records of Artemis Brauronia Found in Athens*, Skrifter Utgivna av Svenska Institutet i Athen, 4°, 19 (Stockholm 1972) 9.

into fashion after a hiatus during the third quarter of the fifth century, the High Classical period.[23]

One of the best-known descriptions of luxurious cloth is in Euripides' *Ion* 1141–65, where the servant describes the richly decorated cloth of the tent set up at Delphi for the celebratory feast marking Ion's acceptance as Xouthos's son, already mentioned above in reference to the use of gold and silver vessels. The roof was formed by sacred weavings (ὑφάσματ' ἱερά; line 1141) which had been dedicated by Herakles and were spoils from the Amazons (lines 1144–45). On them were depicted Ouranos, Helios, Night, the Pleiades, and other celestial figures (lines 1147–58). Then Ion surrounded the sides with other barbarian weavings (τοίχοισιν δ'ἔτι ἤμπισχεν ἄλλα βαρβάρων ὑφάσματα; lines 1158–59), on which were represented a sea battle against Greeks, composite animals, horsemen hunting deer, and the chase of wild lions (lines 1160–62). Finally, textiles depicting Kekrops and his daughters, the dedicatory gift of some Athenian, were placed at the entrance (lines 1163–65). The origin of the roof material from the Amazons and the unambiguous statement that the side hangings were barbarian has led scholars to suggest that the stimulus for rich figured weavings in Greece came from the Orient. Composite beasts and the hunt were certainly popular in the east and are frequently found in early floor mosaics, which may suggest that they are imitations of oriental carpets.[24]

That richly decorated weavings were popular in the Orient from an early period is not in dispute: the Assyrian palace reliefs depict both figured garments and ornate carpets.[25] The Persians kept this tradition.[26] The relationship between Greek and oriental decorative cloth is demonstrated by the discovery of actual woven cloth in Russia, at Pazyryk and elsewhere.[27] But the Greeks were not just imitators: an embroidered garment found in the Pavlovsky Barrow near Pantikapaion (modern Kerch) in the Crimea represents an Amazonomachy of Greek design.[28] A batik cloth covering a sarcophagus from the sixth tomb of the Seven Brothers Barrows, just across the straights on the Taman Peninsula, depicts a series of labeled Greek myths in a manner reminiscent of Attic red-figure vases: the figures are red on a black ground (**Fig. 266**).[29] Ludolph Stephani suggested that the

[23] V. Brinkmann, "Die nüchterne Farbigkeit der Parthenonskulpturen," in Brinkmann and Wünsche, *Bunte Götter*, 121–25. A. G. Geddes, "Rags and Riches: The Costume of Athenian Men in the Fifth Century," *CQ* 37 (1987) 307–31, gives a good review of textual issues.

[24] F. von Lorentz, "Βαρβάρων ὑφάσματα," *RM* 52 (1937) 165–222.

[25] E.g., E. A. W. Budge, *Assyrian Sculptures in the British Museum: Reign of Ashur-Nasir-Pal, 885–860 B.C.* (London 1914) pls. 49–53 (patterns on garments); A. Paterson, *Assyrian Sculptures: Palace of Sinacherib* (The Hague 1915) pl. 102 (carpet); A. Parrot, *The Arts of Assyria* (New York 1961) figs. 109, 116, 117 (the wall paintings from Til Barsip).

[26] Parrot, *Arts of Assyria* (note 25 above) fig. 247; R. Ghirshman, *The Arts of Ancient Iran* (New York 1964) fig. 190 (both illustrating glazed bricks from Susa in the Louvre).

[27] S. I. Rudenko, *Frozen Tombs of Siberia: The Pazyryk Burials of Iron Age Horsemen* (Berkeley 1970) 205–6, 275, 295–304, pls. 147, 154, 174–77; Ghirshman, *Arts of Ancient Iran* (note 26 above) figs. 466–70; J. Boardman, "Travelling Rugs," *Antiquity* 44 (1970) 143–44; J. Zick-Nissen, "Der Knüpfteppich von Pazyrik und die Frage seiner Datierung," *AA*, 1966, 569–81; P. O. Harper, ed., *From the Lands of the Scythians: Ancient Treasures from the Museums of the U.S.S.R., 3000 B.C.–100 B.C.*, exh. cat. (New York n.d. [1975]) 119, nos. 115, 116, pl. 23.

[28] L. Stephani, "Erklärung einiger Kunstwerke der kaiserlichen Ermitage und anderer Sammlungen," *CRPétersb*, 1878–79, 112–14, pl. III.1–3. A brief description of the barrow and its contents is given by M. I. Artamonov, *The Splendor of Scythian Art: Treasures from Scythian Tombs* (New York 1969) 73, pls. 273–78, with a map following p. 83. Among the finds was a pelike by the Eleusinian Painter (*ARV²* 1476.1); see also Vaulina and Wąsowicz, *Bois grecs et romains* (note 18 above) 75–82, no. 7.

[29] Saint Petersburg, Hermitage VI.16: Stephani, *CRPétersb*, 1878–79, 120–30, pl. IV; D. Gerziger, "Eine Decke aus dem sechsten Grab der 'Sieben Brüder,'" *AntK* 18 (1975) 51–55, pls. 21–24. A brief description of the barrow is given by Artamonov, *Splendor of Scythian Art* (note 28 above) 41–42, with a map following p. 83. A review of the chronology of the barrows is given by K. Schefold, "Der skythische Tierstil in Südrussland," *ESA* 12 (1938) 16–18.

cloth was made in Athens, but most commentators feel that the style is too crude and that a local Black Sea workshop is more likely,[30] though the batik technique makes any stylistic decision uncertain.

Plato mentions weaving often; in the *Republic* (2.369d, 373a–b) he cites weaving as one of the four basic crafts that are necessary in any city, though he clearly means the simple weaving of cloth for clothes. Yet he recognizes in his typically deprecating manner the fine robes preferred in the fourth century (*Republic* 8.557c):

> "All sorts and conditions of men, then, would arise in this state more than in any other?" "Of course." "Possibly," said I, "this is the most beautiful of states; as an himation of many colors, decorated with all kinds of flowers, so this, decorated with every type of character, would appear the most beautiful. And perhaps," said I, "even this the many would judge to be the most beautiful, like boys and women when they see many-colored things."

In *Hippias Minor* (368d), Sokrates chides Hippias on his many claims to expertise, among which he notes "the belt of your chitoniskos, which you wear, is like the Persian ones and most expensive, and you made it yourself." Aristotle (*Meteorologika* 375a–b) comments on the effect of different colors in juxtaposition, citing the different appearance of purple on white and black backgrounds of woven cloth.

Figured textiles are also described, though as usual without satisfactory clarity. Nonetheless, two accounts are illuminating. In the collection of largely ridiculous accounts assembled in the pseudo-Aristotelian *On Marvelous Things Heard* (96.838a1–26) there is a detailed description of a luxurious figured himation made for a Sybarite, Alkimenes. Paul Jacobsthal has argued that the date of the himation must be in the fourth century on the basis of its iconography:[31] "It was purple, fifteen cubits in size, and on either side were woven in small figures, the Susans above, the Persians below; in the center were Zeus, Hera, Themis, Athena, Apollo, and Aphrodite. At either end was Alkimenes, and on either side Sybaris." This hardly gives a clear image of the garment, but it does suggest the very elaborate pictorial nature of woven materials in the fourth century, or simply of Greek weavings, since the fourth-century date cannot be proven. Certainly the clothing, and particularly a robe of Demetrios Poliorketes described by Plutarch (*Demetrios* 41.3–5), emphasizes the incredible luxury of dress that had been developed by the beginning of the Hellenistic period:[32]

> And there was in truth much of the theatrical about Demetrios, who not only had an extravagant array of cloakings and head-gear—double-mitred broad-brimmed hats and purple robes shot with gold, but also equipped his feet with gold-embroidered shoes of the richest purple felt. And there was one cloak which was long in the weaving for him, a magnificent work, on which was represented the world and the heavenly bodies; this was left behind half-finished when the reversal of his fortunes came, and no succeeding king of Macedonia ventured to use it, although not a few of them were given to pomp and luxury. (Trans. B. Perrin, Loeb edition)

The influence of eastern elegance on Greece at the end of the fifth and throughout the fourth century is widespread. Metalwork is perhaps the best parallel for decorated cloth;

[30] Gerziger, *AntK* 18 (1975) 55.
[31] P. Jacobsthal, "A Sybarite Himation," *JHS* 58 (1938) 205–16.
[32] Wace, *ÖJh* 39 (1952) 114–16.

it also influenced the black-glaze vessels with fine vertical ribbing of the end of the fifth through the fourth century[33] and the exquisite series of rhytons that was produced across the Greek world.[34] Ceramic relief vessels were reintroduced near the end of the fifth century after a long hiatus. These richly ornamented and often painted vessels closely parallel contemporary metalwares at a less luxurious level; they are also occasionally remarkable for the subjects they depict.[35] Most interesting is one of a pair of oinochoai painted and signed by Xenophantos the Athenian that was found in the Crimea and is now in Saint Petersburg (**Fig. 197**).[36] The frequent use of gold foil and the increasing tendency to polychromy, which was remarked on above (**Figs. 198, 210, 211**), parallel the appearance of the very elaborate, even exuberant, marble vessels in the Attic cemeteries.[37]

Pretty much all the movable objects discussed thus far are reasonably considered to be particularly luxurious and may be regarded by and large as most suitable for use in cult or in festivals; indeed, such uses are often cited in the texts. The influence of imported oriental cloth has also been posited for the interesting low reliefs on the throne of the priest of Dionysos in the Lykourgan theater in Athens.[38] On the front crossbar of the seat is a representation of a symmetrical pair of kneeling men dressed in oriental fashion and striking at two griffins that face them. Although the date of this throne has been placed as low as the Late Hellenistic period, Michael Maas's arguments for a date in the late fourth century are plausible.[39] A similar monument, though difficult to date convincingly, is a relief slab in Athens that is 0.98 meters high and is divided into two picture panels: above, a bearded man in long-sleeved garment stands between two rampant, winged, and horned lions; below, a lion bites into the back of a fallen deer (**Fig. 267**).[40] The purpose of the relief is uncertain; John Boardman calls it a table support and suggests it may date shortly after 300. Whatever its purpose, the relief suggests, as does a battered torso of a seated figure in oriental dress from the Kerameikos,[41] that foreigners of every conceivable background were not only residents of Athens, as Xenophon so clearly states (*Ways and Means* 2.3),[42]

[33] G. Kopcke, "Golddekorierte attische Schwarzfirniskeramik des vierten Jahrhunderts v. Chr.," *AM* 79 (1964) 22–84, Beil. 8–47; B. B. Shefton, "Persian Gold and Attic Black-Glaze: Achaemenid Influences on Attic Pottery of the 5th and 4th Centuries," in *IX International Congress of Classical Archaeology/IXème Congrès international d'archéologie classique (Damas, 11–20 octobre 1969): Orient, Grèce et Rome* (Damascus 1971) 109–11, pls. 20–22.

[34] M. Pfrommer, "Italien—Makedonien—Kleinasien: Interdependenzen spätklassischer und frühhellenistischer Toreutik," *JdI* 98 (1983) 235–85; Ebbinghaus, "Between Greece and Persia" (note 19 above) 385–425.

[35] E. A. Zervoudaki, "Attische polychrome Reliefkeramik des späten 5. und des 4. Jahrhunderts v. Chr.," *AM* 83 (1968) 1–88, pls. 1–30; G. Kopcke, "Attische Reliefkeramik klassischer Zeit," *AA*, 1969, 545–51; G. Hübner, "Plastischer Dekor an griechischer Keramik: Gestaltungsprinzip und formaler Stellenwert," *JdI* 108 (1993) 321–51; B. B. Shefton, "Metal and Clay: Prototype and Recreation; Zoffany's 'Tribuna' and Lessons from the Malacena Fabric of Hellenistic Volterra (Calyx-Krater, Stamnos, Situla and the Achaemenid Rhyton)," *REA* 100 (1998) 619–62.

[36] For the bibliography, see chap. 4, p. 144, note 304 above.

[37] See chap. 4, pp. 139–40, 145–46, and chap. 5A, p. 158 above.

[38] M. Maas, *Die Prohedrie des Dionysostheaters in Athen* (Munich 1972) 65–68, pls. Ib, IIIa, IIId.

[39] Ibid.; M. Bieber, *The History of the Greek and Roman Theater*, 2nd ed. (Princeton 1961) 70, suggests that the throne, which she dates to the first century B.C., may copy an earlier one.

[40] Athens, NAM 1487: Kaltsas, *SNAMA*, 266, no. 557*; A. D. H. Bivar, "A Persian Monument at Athens and Its Connection with the Achaemenid Seals," in *W. B. Henning Memorial Volume*, ed. M. Boyce and I. Gershevitch (London 1970) 43–61; M. C. Miller, *Athens and Persia in the Fifth Century B.C.: A Study in Cultural Receptivity* (Cambridge 1997) 56, fig. 13; B. Bäbler, *Fleissige Thrakerinnen und wehrhafte Skythen: Nichtgriechen im klassischen Athen und ihre archäologische Hinterlassenschaft* (Stuttgart 1998) 109–11, 233, no. 41; A. D. H. Bivar, *The Personalities of Mithra in Archaeology and Literature* (New York 1998) 75, fig. 38; J. Boardman, *Persia and the West: An Archaeological Investigation of the Genesis of Achaemenid Art* (London 2000) 182–83, fig. 5.64.

[41] Athens, NAM 2728: S. Karouzou, *National Archaeological Museum: Collection of Sculpture; A Catalogue* (Athens 1968) 129; A. Brueckner, *Der Friedhof am Eridanos bei der Hagia Triada zu Athen* (Berlin 1909) 85–86; Bäbler, *Fleissige Thrakerinnen* (note 40 above) 111–13, 233, no. 42, pl. 7.

[42] See chap. 1, p. 16 above.

but enjoyed a certain amount of freedom in having Greek craftsmen produce monuments relevant to their own traditions.[43] Indeed, Balbina Bäbler lists 127 monuments made for non-Greeks in Athens.[44]

In view of the increasingly urgent appeals of orators from Gorgias and Lysias to Isokrates to avenge the Persian attacks on Greece of the fifth century, it may at first appear strange that the Greeks were avid imitators of all luxurious Persian things and were permissive of Persian or Persianizing monuments in their cities. But the fact that Greeks were intimately entwined with Persians and had been for at least a century is too easily forgotten in the face of the political propaganda preserved in the orators.[45] Things foreign were also synonymous with luxury; Aristotle even goes so far as to observe that a sense of foreignness is an admirable trait in speech.[46] Long before, in the days of open hostility between Persia and Greece in the early fifth century, Greek imports into Persian Lykia did not diminish, nor into Persian Cyprus.[47]

However brief this review, I hope it communicates the colorful profusion and lavishness of form of the new or at least newly visible private luxuriousness in fourth-century Greece. Although I cited earlier the architectural ornament of fourth-century buildings as the public parallel of the private sector, it is also important to realize that a very large number of temples were being built, and extensive building programs were being carried out in the great Panhellenic sanctuaries and the impressive stone Theater of Dionysos in Athens with its statues of the fifth-century tragedians.[48] Another notable event in the life of Athenians was the private construction in 321/0 of a bridge over the Kephisos River by Xenokles, who was honored by inscriptions found at Eleusis[49] and in an epigram that was apparently carved on the bridge itself.[50] To some extent, one can claim that, despite the earlier existence of grand sanctuaries with their great stone temples, a somewhat rural, not to say backward and/or dingy, private Greek world was only then making the transition to a respectable urban culture on a par with the great cities of the Near East and the palaces of the Achaemenids. To the latter the Greeks had contributed extensively; they were to conquer all under Alexander. Looking at the material evidence alone, it seems clear that the growth of a cosmopolitan and luxurious culture in Greece over the course of the first half of the fourth century quite adequately prepared the way for the Macedo-

[43] See the Phoenician grave stele cited above, chap. 5A, p. 157, and **Fig. 215**.

[44] Bäbler, *Fleissige Thrakerinnen* (note 40 above) 207–82.

[45] A. D. H. Bivar, "Σύμβολον: A Noteworthy Use for a Persian Gold Phiale," in Tsetskhladze, *Ancient Greeks West and East* (note 19 above) 379–84. Bivar, *Personalities of Mithra* (note 40 above) 67–87, reviews evidence of contacts between Athens and the Achaemenid world starting from the controversial passage in Plato, *Republic* 9.588b–589a, describing the making of a many-headed beast, a lion, and a man encased in the shell of a man, a proposition rejected by E. Lévy, "Platon et le mirage perse: Platon misobarbaros?" in *Le IVe siècle av. J.-C.: Approches historiographiques*, ed. P. Carlier (Nancy 1996) 335–50, with interesting statistics on the frequency of references to Medes, Persians, and barbarians in various fourth-century authors. A. Dihle, *Die Griechen und die Fremden* (Munich 1994) 47–53, reviews the more negative strand of anti-foreign feeling in Greek literature; see also P. Briant, "Histoire et idéologie: Les grecs et la 'décadence perse,'" in *Mélanges Pierre Lévêque*, vol. 2, *Anthropologie et société*, Annales littéraires de l'Université de Besançon 377, ed. E. Geny and M.-M. Mactoux (Paris 1989) 33–47.

[46] *Rhetoric* 3.1404b.10, 36; 1405a.8; 1406a.15; 1414a.27.

[47] W. A. P. Childs, "The Iron Age Kingdom of Marion," *BASOR* 308 (1997) 46.

[48] H. Knell, "Dorische Ringhallentempel in spät- und nachklassischer Zeit," *JdI* 98 (1983) 230, lists twenty-one Doric temples built during the fourth century. On the activity at the Panhellenic sanctuaries, see chap. 1, pp. 18–19, chap. 5B, p. 226 above.

[49] *IG* II² 1191; *SIG* 1048.

[50] *Anth. Pal.* 9.147: A. S. F. Gow and D. L. Page, *The Greek Anthology: Hellenistic Epigrams* (Cambridge 1965) vol. 2, 30–31; P. Veyne, *Bread and Circuses: Historical Sociology and Political Pluralism*, abridged by O. Murray, trans. B. Pearce (London 1990) 87–88.

nian aggression so fervently desired by Greek orators from the end of the fifth century onward.[51] The conquest of the east had, of course, begun much earlier. In Lykian Xanthos, inscriptions bear witness to the presence in the late fifth century of a Greek pedagogue for the local dynastic family,[52] and over the whole of the fourth century first-rate Greek sculptors were producing a grand series of figured sarcophagi for the royal tombs at Sidon (**Figs. 61, 62**).[53] Of course, Greeks had participated in the building of the great Persian palaces in the later sixth century,[54] but the novelty of the fourth century is a sense of less formal and broader contacts and a clear desire to Hellenize local traditions. If the Greeks treated oriental and orientalizing objects as defining luxury, it seems that the orientals had the same reaction in reverse. An interesting view of the Greek experience of the wider world is a series of small terracotta figurines that appear over the course of the fourth century and depict a comic actor all loaded down for travel.[55] The modern traveler may feel sympathetic and recognize the plight of our ancient predecessors.

As so often, the achievement of a world-class sophistication in the fourth century brings with it a certain nostalgia for the "good and simple" past. In the first chapter I had occasion to note that there was a conscious regard for the fifth century as a golden age of politics and literature.[56] Demosthenes remarks on several occasions that his period does not compare favorably with the time of Perikles, and the well-known revival of performances of the tragedies of the great fifth-century poets is another indication of this perception. Equally, in sculpture the influence of the Parthenon and in general the High Classic style of the third quarter of the fifth century remained strong even through the turbulent upheavals of the end of the fifth century and the beginning of the fourth. In statuary, the Athena of the Ince Blundell type is an excellent example from the very end of the fifth century or the beginning of the fourth (**Fig. 268**).[57] She recalls both the type of the Frankfurt Athena attributed to Myron[58] and the Parthenos of Pheidias.[59] The comparison already drawn between the statue of Eirene with the child Ploutos (**Fig. 12**) and the caryatids of the Erechtheion (**Fig. 2**) is just as clear.[60] Stefan Schmidt has also pointed out the almost exact replication of the folds of the apoptygma and kolpos of the Eirene on a statue dedicated on the island of Thasos at the end of the fourth or beginning of the third century.[61] Closely dependent on the caryatids of the Erechtheion are the caryatids of the tomb of the Lykian dynast Periklä of Limyra, dating just before the middle of the

[51] See p. 270 above, on Gorgias, Lysias, and Isokrates.

[52] A. Bourgarel, H. Metzger, A. Davesne, J. Marcadé, J. Bousquet, C. Le Roy, and A. Lemaire, *Fouilles de Xanthos*, vol. 9, *La région nord du Létôon, les sculptures, les inscriptions gréco-lyciennes* (Paris 1992) 155–81.

[53] See chap. 2, p. 33 and chap. 5B, pp. 219, note 113, and 223 above.

[54] C. Nylander, *Ionians in Pasargadae: Studies in Old Persian Architecture* (Uppsala 1970).

[55] W. R. Biers and J. R. Green, "Carrying Baggage," *AntK* 41 (1998) 87–93.

[56] See, chap. 1, p. 2 above.

[57] Liverpool, World Museum, Ince Blundell Collection 8: Karanastassis, *AM* 102 (1987) 360–69, pl. 54.2; M. Mangold, *Athenatypen auf attischen Weihreliefs des 5. und 4. Jhs. v. Chr.* (Bern 1993) 14–19, pl. 1; G. Nick, *Die Athena Parthenos: Studien zum griechischen Kultbild und seiner Rezeption*, AM-BH 19 (Mainz 2002) 180–81; Todisco, *Scultura greca*, no. 9.

[58] Frankfurt, Liebieghaus 195: P. C. Bol, ed., *Antike Bildwerke, Liebieghaus-Museum Alter Plastik*, vol. 1, *Bildwerke aus Stein und aus Stuck von archaischer Zeit bis zur Spätantike* (Melsungen 1983) 55–63, no. 16*; H. F. Eckstein and H. Beck, *Antike Plastik im Liebieghaus* (Frankfurt am Main 1973) nos. 4/5; G. Daltrop and P. C. Bol, *Athena des Myron* (Frankfurt am Main 1983); *LIMC*, s.v. Athena no. 623a* (P. Demargne), s.v. Athena/Minerva no. 423 (F. Canciani).

[59] N. Leipen, *Athena Parthenos: A Reconstruction* (Toronto 1971).

[60] Chap. 4, pp. 109–10 above.

[61] S. Schmidt, "Über den Umgang mit Vorbildern: Bildhauerarbeit im 4. Jahrhundert v. Chr.," *AM* 111 (1997) 214–17, pls. 42, 43.

fourth century.[62] The tomb's caryatid prostyle facade makes it amply clear that the Lykian Periklä wished to link himself to the glory of Athens and used the funerary iconography of the earlier building to convey his own heroic status. Less obvious are clear examples of the repetition of figure motifs on Greek grave stelai drawn from freestanding statues.[63] Carol Benson also demonstrated convincingly that figure types on Attic grave stelai are repeated in rather narrow chronological groups that indicate the changing popularity of certain types.[64] The reflection of divinities in the figure types on Attic grave stelai suggests that the content of the borrowed form was important in the choice.[65]

There are a variety of other revivals that are symptomatic of a broad phenomenon, for example, the revival of old vase shapes; even the technique of molded decoration on vases constitutes a form of revival.[66] The record reliefs are also a specialized area for revivals and quotations from the past, perhaps because of their particular function; they reproduce well-known statue types of divinities in the small reliefs at the top of the official stelai.[67] As I have pointed out in an earlier chapter, votive reliefs borrow figure types from statues known in Roman copies and repeat figures of the divinities honored, which suggests that well-known statues served as the models.[68] In one set of reliefs dedicated to Apollo it is clear that the figure of the god was borrowed from the pedimental sculpture of the temple at Delphi.[69] The conscious pointing to well-known statues was also a feature of the Panathenaic amphoras.[70]

A particularly interesting example of formal quotations from the past are the small, modest statues and statuettes purportedly from Crete, now in Venice,[71] and the statuettes from the sanctuary of Demeter at Kyparissi on Kos.[72] The eleven figures in Venice are stylistically of the end of the fifth century and the first half of the fourth. They are all relatively small, from 0.70 to 1.15 meters high, though the presence of the head in the largest example and its absence from the smallest mean that they were all roughly the same size (the piecing of heads and arms is common). Several reflect more or less vaguely statue types known from Roman statues, such as the earliest, the so-called Abbondanza Grimani (**Fig. 84**),[73] which is a loose adaptation of the Kore Albani (**Fig. 162**);[74] another reflects the

[62] Borchhardt, *Limyra*, 27–48, figs. 4–11.

[63] Schmidt, *AM* 111 (1997) 200–14.

[64] C. A. Benson, "Recurring Figure-Types on Classical Attic Grave Stelai" (Ph.D. diss., Princeton University, 1996).

[65] N. Himmelmann, "Quotations of Images of Gods and Heroes on Attic Grave Reliefs of the Late Classical Period," in *Periplous: Papers on Classical Art and Archaeology Presented to Sir John Boardman*, ed. G. R. Tsetskhladze, A. J. N. W. Prag, and A. Snodgrass (London 2000) 136–44; C. Karusos, "Τηλαυγὴς Μνῆμα: Ein attisches Grabmal im Nationalmuseum, Athen," *MüJb* 20 (1969) 7–32.

[66] M. Robertson, "Europa and Others: Nostalgia in Late Fifth-Century Athenian Vase-Painting," in *Kotinos: Festschrift für Erika Simon*, ed. H. Froning, T. Hölscher, and H. Mielsch (Mainz 1992) 237–40; C. Campenon, *La céramique attique à figures rouges, autour de 400 avant J.-C.: Les principales formes, évolution et production* (Paris 1994) 113.

[67] Meyer, *Urkundenreliefs*, 223–46; Lawton, *Document Reliefs*, 73–77.

[68] See chap. 3, pp. 77–78 above.

[69] Voutiras, *AJA* 86 (1982) 229–33, pls. 30–32. L. J. Roccos, "Athena from a House on the Areopagus," *Hesperia* 60 (1991) 397–410, also proposes a close association of a small statue of Athena found in the Agora excavations (S 2337) with figures of Athena on votive reliefs.

[70] N. Eschbach, *Statuen auf panathenäischen Preisamphoren des 4. Jhs. v. Chr.* (Mainz 1986).

[71] R. Kabus-Jahn, "Die grimanische Figurengruppe in Venedig," *AntP* 11 (1972); Traversari, *Sculture del V°–IV° secolo*, 52–70, nos. 20–26; Favaretto et al., *Museo Archeologico Nazionale di Venezia*, 26–33, nos. I.1–I.8; Todisco, *Scultura greca*, nos. 23–28, 93–95.

[72] R. Kabus-Preisshofen, "Statuettengruppe aus dem Demeterheiligtum bei Kyparissi auf Kos," *AntP* 15 (1975) 31–65, pls. 11–28; Todisco, *Scultura greca*, nos. 118, 119.

[73] Venice, MAN 106: Kabus-Jahn, *AntP* 11 (1972) 13–21, pls. 1–9; Baumer, *Vorbilder*, 165–66, cat. K 24, pl. 50.1–5; Todisco, *Scultura greca*, no. 24.

[74] Maderna-Lauter, in Bol, *Villa Albani*, vol. 4, 215; for full reference and further bibliography, see chap. 4, pp. 105–6 above with note 27.

Demeter in the Musei Capitolini in Rome;[75] a third (**Fig. 82**) has a close variant in a statuette of almost exactly the same size in Vienna (**Fig. 83**);[76] one is a very loose reflection of the caryatids of the Erechtheion.[77] Finally, a small statue of Athena (**Fig. 85**), which was not part of the Grimani collection but may have originally belonged to the same group, has a close mirror variant on the Athenian Acropolis that was discussed above as a possible original (**Fig. 129**).[78]

The Grimani statuettes are variously draped—chiton and mantle, peplos and mantle, peplos and back mantle—a good reflection of the possible variations known in Roman statues thought to imitate statues of the fourth century. The most interesting example is a Rich Style figure with wonderfully lively and sinuous kolpos folds and a pair of long sinuous folds down her back mantle that are similar to the folds on the back of one of the Nereids from the Nereid Monument of Xanthos (London, BM 909).[79] Also notable are inv. 164A, with a rather plain mantle wrapped around the figure which reveals the shape of the heavy-set body (**Fig. 274**);[80] inv. 41A, with peplos and long belted overfold;[81] and inv. 36, with chiton and mantle.[82]

The seven statuettes on Kos seem to begin near the middle of the fourth century and run into the third century; six are women, and one a man. They are small, in the range of one meter high, though in every case the head is preserved. Similar to the figures in Venice, there is common use of piecing for projecting arms, though not for all the heads. Some of them again appear to reflect somewhat loosely Roman statues and figures on votive reliefs.[83] Three of the female figures wear a peplos with kolpos and overfold.[84] One has her mantle pulled across her front (**Fig. 269**) in a manner similar to the statuette in Venice (inv. 164A; **Fig. 274**).[85] Only one statuette presents a lively image: the woman, Persephone, holds out a torch in each hand (**Fig. 270**).[86] She is dressed in chiton, with her mantle across her lower body and a bunched role along its top border; the pattern re-

[75] Venice, MAN 15: Traversari, *Sculture del V°–IV° secolo*, 52–53, no. 20*; Kabus-Jahn, *AntP* 11 (1972) 23–27, inv. 15, pls. 10–13; Baumer, *Vorbilder*, 162–63, cat. K 19, pl. 47.4–6; Todisco, *Scultura greca*, no. 23. Demeter in the Musei Capitolini, inv. 642: Helbig⁴, vol. 2, no. 1387 (H. von Steuben); Kabus-Jahn, *AntP* 11 (1972) fig. 2; W.-H. Schuchhardt, *Alkamenes*, BWPr 126 (Berlin 1977) 11–13, fig. 9 (p. 15).

[76] Venice, MAN 21: Favaretto et al., *Museo Archeologico Nazionale di Venezia*, 32, no. I.6*; Kabus-Jahn, *AntP* 11 (1972) 51–59, inv. 21, pls. 28–32; Baumer, *Vorbilder*, 59–60, 163, cat. K 20, pl. 48.1–5; Todisco, *Scultura greca*, no. 95; Bol, *Bildwerke aus Stein und aus Stuck* (note 58 above) 93–94, text to no. 25. Vienna, KHM I 1245: Kabus-Jahn, *AntP* 11 (1972) 57–58, figs. 10, 11, pls. 33–35; Baumer, *Vorbilder*, 167, cat. K 26, pl. 51.1–5; Schmidt, *AM* 111 (1997) 195–96.

[77] Venice, MAN 116A: Traversari, *Sculture del V°–IV° secolo*, 57, no. 22*; Favaretto et al., *Museo Archeologico Nazionale di Venezia*, 27, no. I.1c*; Kabus-Jahn, *AntP* 11 (1972) 29–34, inv. 116A, pls. 14–16; Baumer, *Vorbilder*, 166–67, cat. K 25, pl. 50.6; Todisco, *Scultura greca*, no. 26.

[78] Venice, MAN 260A: Traversari, *Sculture del V°–IV° secolo*, 66–67, no. 25*; Favaretto et al., *Museo Archeologico Nazionale di Venezia*, 29, no. I.3*; Kabus-Jahn, *AntP* 11 (1972) 87–98, inv. 260A, pls. 52–56. For the statue on the Athenian Acropolis (Acrop. 1336), see chap. 3, p. 68 above, and **Fig. 129**.

[79] Grimani statuette: Venice, MAN 71: Traversari, *Sculture del V°–IV° secolo*, 68–70, no. 26*; Favaretto et al., *Museo Archeologico Nazionale di Venezia*, 28, no. I.2*; Kabus-Jahn, *AntP* 11 (1972) 61–67, inv. 71, pls. 36–40. Nereid: London, BM 909; view of back, Childs and Demargne, *FdX* 8, pt. 2, pl. 92.

[80] Venice, MAN 164A: Kabus-Jahn, *AntP* 11 (1972) 69–73, pls. 41–44; *LIMC*, s.v. Persephone no. 16*.

[81] Venice, MAN 41A: Kabus-Jahn, *AntP* 11 (1972) 75–79, pls. 45–48.

[82] Venice, MAN 36: Favaretto et al., *Museo Archeologico Nazionale di Venezia*, 33, no. I.7*; Kabus-Jahn, *AntP* 11 (1972) 81–86, pls. 49–51; Baumer, *Vorbilder*, 163–64, cat. K 21, pl. 49.1; Todisco, *Scultura greca*, no. 27.

[83] Kabus-Preisshofen, *AntP* 15 (1975) 33.

[84] Ibid., figures A, D, F, and pls. 11, 19, 25.

[85] Ibid., figure B, 39–42, pls. 13–15 (Kora of Lykourgis). On p. 42 Kabus-Preisshofen calls the style East Greek, a descendant of the Lykian Sarcophagus from Sidon in Istanbul, and dates the figure to the second half of the fourth century, a point of some importance in determining a date for the Tribune of Eshmoun from Sidon now in Beirut; see p. 276 below.

[86] Ibid., figure C, 43–46, pls. 16–18.

sembles that of the well-known statue of Persephone in Florence (**Fig. 142**).[87] The rather beautiful head and the forearms were pieced.

The statuettes in Venice and on Kos provide a rich variety of female figures of modest craft. The fact that several of them are reflections of types identifiable from Roman statues and Greek votive reliefs is a useful confirmation of our knowledge of clothing and drapery patterns in the fourth century and, perhaps more than anything else, underscores that certain types were popular in the fourth century, in contrast to the impression of infinite creativity and individuality in the period that is often conveyed by modern commentaries. The observations of Wilfred Geominy, however, caution against too strong a reaction against this traditional view.[88] He points out that the reuse of popular motifs rarely goes as far as precise copying but usually produces a general, recognizable reflection, which certainly holds true for the Athena of the Ince Blundell type and the relationship of the Eirene and the caryatids of the Erechtheion.

So far, the discussion of revivals has focused on formal types, that is, figures whose stance and drapery are revived. But there is another rather different class of revivals that appears to be largely or exclusively stylistic and without reference to a specific earlier formal type. The most problematic for me is the Derveni bronze krater (**Figs. 110, 111**).[89] Early accounts placed it in the first half of the fourth century because the style of the exuberant drapery is clearly that of the Rich Style: many fine, arcing curves and the bunching of cloth with pronounced omega-ended folds. The best comparison is with the Nikai bringing a bull to sacrifice on the north side of the parapet reliefs of the Nike bastion of the late fifth century.[90] Equally close are the various Roman copies of the ecstatic mainads associated with the name of the sculptor Kallimachos.[91] Finally, the frieze of the Temple of Apollo Epikourios at Bassai belongs to this group (**Figs. 23–25**).[92] And the poses of the figures on the Derveni krater and on the various reliefs just cited do not differ appreciably: most figures are represented in profile with mild twists of the torso. Only Ariadne is depicted seated with completely frontal torso and legs slightly askew. If one maintained the later fourth-century date for the krater, it would represent a strong stylistic revival together with figure types typical of the late fifth century. Beryl Barr-Sharrar, in her recent book on the krater, rejects this view—and there is in fact no other convincing evidence for so complete and coherent a revival—though her date around 370 B.C. seems to me a bit late.[93]

The so-called Tribune of Eshmoun from Sidon, now in Beirut, is also perplexing stylistically (**Figs. 271, 272**).[94] It is also somewhat disconcerting to realize how small the monu-

[87] Florence, Uffizi 120; for bibliography, see chap. 3, pp. 77–78 above with note 181.

[88] W. Geominy, "Das Schiffsfund von Mahdia und seine Bedeutung für die antike Kunstgeschichte," in *Das Wrack: Der antike Schiffsfund von Mahdia*, ed. G. H. Salies, H.-H. von Prittwitz und Gaffron, and G. Bauchhenss (Cologne 1994) vol. 2, 932–33.

[89] See chap. 2, pp. 48–49 above with note 202.

[90] Athens, Acrop. 973; for bibliography, see chap. 4, p. 104 above with note 14.

[91] L. A. Touchette, *The Dancing Maenad Reliefs: Continuity and Change in Roman Copies*, BICS suppl. 62 (London 1995); W. Fuchs, *Die Vorbilder der neuattischen Reliefs*, JdI-EH 20 (Berlin 1959) 72–91.

[92] Especially slabs 531 and 535: Hofkes-Brukker and Mallwitz, *Bassai-Fries*, 73–74, 77–78; Madigan, *Apollo Bassitas*, pl. 45, no. 140 (BM 531), pl. 47, no. 144 (BM 535).

[93] Barr-Sharrar, *Derveni Krater*, 44–46, 112–14, and chaps. 5–7.

[94] Beirut, National Museum 2080: Stucky, *Tribune d'Echmoun*; Edwards, "Votive Reliefs to Pan," 242–55, pl. 75; J. Ferron, *Sarcophages de Phénicie: Sarcophages à scènes en relief* (Paris 1993) 352–57, figs. 84, 86–88 (poor drawings); J. Boardman, *The Diffusion of Classical Art in Antiquity*, The A. W. Mellon Lectures in the Fine Arts 1993 (Princeton 1994) 57–58, fig. 3.11; Rolley, *Sculpture grecque*, 394–95, fig. 418; M. Torelli, "Il 'Trono Ludovisi' da Erice all'Oriente," in Ἀμύμονα ἔργα· Τιμητικὸς τόμος για τον καθηγητή Βασίλη Κ. Λαμπρινουδάκη, ed. E. Simantoni-Bournia, A. A. Laimou, L.G. Mendoni, and N. Kourou (Athens 2007) 341–48, repr. in M. Torelli, Σημαίνειν/Significare: Scritti vari di ermeneutica archeologica, ed. A. Sciarma (Pisa 2012) 463–70.

ment is, since photographs of it make it look very large; the length at the plinth is 2.135 meters, the depth 1.25 meters, and the height 1.15 meters, though the marble block on which the friezes are carved was set on a built podium which gave a total height of 2.17 meters. It has two superimposed friezes, with figures that are 0.38 meters high in the lower band and 0.41 to 0.43 meters high in the upper band.[95] It is made of white marble, carved principally on three sides, though there is a single figure at either side of the back of the upper frieze, framing a rectangular open space that makes the upper frieze appear almost as a parapet.[96]

The upper frieze represents an assembly of the gods, with a chariot driven by a long-robed figure on either short side, in each case facing away from the front. The central point of this frieze is framed by Apollo with lyre on the viewer's left and Athena carrying her helmet in her right hand on the right. The lower frieze depicts seventeen dancing women, one woman playing a lyre, another a flute, and one satyr (the second figure from the left on the left short side).[97] The function of the monument and the meaning of its iconography has thus far eluded commentators, though the style is remarkably Greek, as are the figure types. A strong initial response to the style of the dancing women is that they reflect the drapery and poses of the dancing mainads thought to date to the late fifth century, precisely the best comparison for the women of the Derveni krater (**Figs. 110, 111**). This impression, however, is rapidly dispelled by looking at the divine figures of the upper frieze,[98] most of which seem far more comfortable in the Plain Style of the fourth century. The three completely frontal figures look as though they had been adapted from the Eirene and Ploutos attributed to Kephisodotos (**Fig. 12**).[99]

The dancing figures of the bottom frieze do have parallels in the three nymphs of a votive relief found in their sanctuary on Mount Parnes in Attica which cannot be dated earlier than the Early Hellenistic period and is frequently dated in the first century B.C. (**Fig. 273**).[100] A related votive relief to the nymphs from the Peloponnesos,[101] possibly of the late fourth century, displays a far more restrained drapery that has none of the nervous flutters evident in the relief from Mount Parnes and the dancing women of the lower right frieze of the Tribune of Eshmoun. Another late-fourth-century relief from Mount Parnes also confirms that the late votive reliefs to the nymphs did not indulge in highly plastic and fluttering drapery.[102] The Neo-Attic copies of fourth-century votive reliefs to the nymphs show some resemblance to the dancing figures of the Eshmoun monument, but the contrasts

[95] Stucky, *Tribune d'Echmoun*, 10.

[96] Ibid., pls. 1, 3.2.

[97] Ibid., pls. 4, 5. W. Fuchs, "Zentrale und provinzielle Elemente in der spätklassischen Kunst," in *Kanon: Festschrift Ernst Berger zum 60. Geburtstag am 26. Februar 1988 gewidmet*, ed. M. Schmidt (Basel 1988) 158, also identifies one figure as Dionysos and therefore considers the dancing women to be mainads.

[98] Stucky, *Tribune d'Echmoun*, figs. 3, 6, 16 (numbers given on folding plate at back of book), pls. 2.1, 2.2, 3.1, 4.1, 7.1, 9.1.

[99] The statue of Eurydike recently found at Vergina (see chap. 2, p. 27 above with note 17 and **Fig. 11**) closely resembles the frontally standing goddess number 6 of the left side of the upper frieze. The date of the statue of Eurydike is not certain, but it has been dated to the mid-fourth century or later. Schultz, "Argead Portraits," 216, notes that its "stylistic traits provided for the formal armature for an iconography of heroization." I am inclined to date the statue of Eurydike earlier but still see it as old-fashioned.

[100] Athens, NAM 1879: Kaltsas, *SNAMA*, 214, no. 439; Güntner, *Göttervereine*, 127, no. A 50, pl. 10.2; Edwards, "Votive Reliefs to Pan," 725–35, no. 76; R. M. Gais, "Some Problems of River-God Iconography," *AJA* 82 (1978) 359–60, fig. 9. Kaltsas dates the relief "about the middle of the fourth century," but Gais reviews the widely divergent dates proposed by various scholars and comes down in favor of the Hellenistic period, with which Edwards and I clearly concur. Güntner dates the relief in the third century.

[101] Athens, NAM 1449: Kaltsas, *SNAMA*, 219, no. 454*; Güntner, *Göttervereine*, 118–19, no. A9, pl. 2.1; Edwards, "Votive Reliefs to Pan," 777–83, no. 86.

[102] Athens, NAM 1859; see chap. 2, p. 42, note 159 above.

of their smooth surfaces and fluttering, curvilinear folds do not really reflect the more even surface treatment of the dancers on the Tribune.[103] A fragmentary relief slab, probably part of a statue base, in the Acropolis Museum in Athens comes far closer, though the long doughy folds have none of the firmer texture of the Eshmoun figures (**Fig. 275**).[104]

In the end, the extreme eclecticism of the Tribune of Eshmoun is difficult to pin down to a specific period; Stucky's date in the mid-fourth century seems to me more likely than a date in the Late Hellenistic period, argued by Charles Edwards,[105] but neither date is completely convincing. Notable details are the following: (1) The manner in which the mantle clings to the slightly stocky body of the draped woman on the extreme right of the lower front frieze closely resembles both one of the statuettes in Venice purportedly from Crete and another on Kos (**Figs. 274, 269**).[106] The way the clothing clings to the body without being flat or transparent is also not unlike the Athena Rospigliosi (**Figs. 168, 169**). (2) The seated goddess on the left of the upper front frieze resembles the figure of a seated woman on a fragmentary Attic grave stele of the late fourth century[107] (the figure just right of center on the bottom register is in pure profile, a rare phenomenon).[108] (3) The general sense of the frieze composition resembles that of the Amazon sarcophagus from Cyprus, now in Vienna (**Figs. 63, 64**). Accordingly, the most likely date for the Tribune of Eshmoun is in the period around 320.[109] But whatever date one decides on for the Tribune, it presents an eclectic borrowing of styles and figure types from the late fifth and all of the fourth century. Stucky provides a very good parallel in his review of the Greek elements in the sculpture of the sarcophagi from the royal cemetery at Sidon; he suggests that the Greek sculptors must have used pattern books of some type, at least in part, while certain simple and standard motifs could have been drawn from memory.[110] This could easily explain the great disparity of styles evident in the Tribune of Eshmoun. In this case, the various figures correspond in style to the type of figure used as prototypes, which broadly confirms that style and figure type correspond.

The evidence for the consciousness of style as the conveyor of particular meaning is best seen in that most interesting and typically controversial monument of the fourth century, the original group of statues dedicated by the Thessalian Daochos at Delphi in the 330s (**Figs. 14–18**).[111] As we have seen earlier, inscriptions on the base identify each member of the family and list his accomplishments. Each statue is presented in a style pertinent to the achievements of the figure depicted: the three athletes, Agias (**Fig. 14**), Agelaos (**Fig. 15**), and Telemachos, are depicted nude; the two statesmen, Aknonios (**Fig.**

[103] Fuchs, *Vorbilder* (note 91 above) 39–40, pl. 7.

[104] Athens, Acrop. 3363 + 3365 + 3366: Kosmopoulou, *Statue Bases*, 207–8, no. 41, fig. 62; Stucky, *Tribune d'Echmoun*, 38, pl. 18.4; Fuchs, *Vorbilder* (note 91 above) 40, note 100. Kosmopoulou dates the relief to the late fourth century; Fuchs and Stucky date it to the early third century, which must be correct.

[105] Stucky, *Tribune d'Echmoun*, 29–42; Edwards, "Votive Reliefs to Pan," 242–55.

[106] See pp. 273–74 above and Kabus-Preisshofen's evaluation of and date for the statuette in Kos in note 85.

[107] Athens, NAM 1957: Clairmont, *CAT*, 3.457; Lygkopoulos, *Untersuchungen*, 67, no. 36; Diepolder, *Grabreliefs*, 53, pl. 52.2.

[108] A nude warrior is so represented on the "Alexander sarcophagus" from Sidon, now in Istanbul: V. von Graeve, *Der Alexandersarkophag und seine Werkstatt*, IstForsch 28 (Berlin 1970) pls. 30, 47.1, figure A 13, as is one of the apoxyomenoi of the base in the Acropolis Museum (3176 + 5460 + 2635), of the late fourth century: Brouskari, *Acropolis Museum*, 18–19, fig. 4; Kosmopoulou, *Statue Bases*, 208–9, no. 42, fig. 63.

[109] Rolley, *Sculpture grecque*, 395, dates the Tribune in the second half of the fourth century; Fuchs, "Zentrale und provinzielle Elemente" (note 97 above) 158, opts for 340–330; A. Linfert, in his review of Stucky, *Tribune d'Echmoun*, in *BJb* 185 (1985) 602, proposes the second half of the fourth or the early third century.

[110] Stucky, *Tribune d'Echmoun*, 31–37.

[111] See chap. 2, pp. 28–29 and note 23 above on the date, and chap. 5A, pp. 171–74.

16) and Daochos I, and the one soldier, Sisyphos I (**Fig. 17**), are draped. Although this assessment is very subjective, it seems reasonable to recognize some distinction in the physical types depicted: the boxer, Agias, is strongly built; the boy runner, Agelaos, is lithe. Finally, the son of the dedicator, Sisyphos II, has no accomplishments to his credit, and the inscription merely gives his name (**Fig. 18**). He leans on an archaistic herm; the pronounced S-curve of his supple body suggests youth and elegance without pronounced character. The nude body and the chlamys gathered to one side might even be thought to suggest that he has the option of becoming either an athlete or a statesman.

Beyond the iconographic differentiation of the figures of the Daochos Monument is the patent variation in the style of the statues. According to modern scholarly consensus, the statues of the best-preserved of the athletes, Agias and Agelaos (**Figs. 14, 15**), are to be associated with Lysippos. The third athlete, Telemachos, preserved only as a torso, could belong with the first two; all three reflect the style of the school of Polykleitos at some distance.[112] The stocky statue of Sisyphos I, the most obviously Polykleitan figure of the group, is connected with the other two preserved draped figures, Aknonios and Daochos I, and assigned to another workshop with which Tobias Dohrn associated the names of Euthykrates (a student of Lysippos), Euphranor, and Leochares.[113] Finally, the statue of Sisyphos II reflects the style of Praxiteles. Wilfred Geominy also proposes that the actual dates of the various ancestors of Daochos are reflected in the styles the figures.[114]

The rather firm connection of the monument with the name of Lysippos is based on a lost and very fragmentary inscription from Pharsalos in Thessaly, the hometown of Daochos, which was on the base of a statue of Agias signed by Lysippos.[115] The inscription on the base of the statue of Agias at Delphi is almost the same but differs in the number of victories Agias won at Delphi, a difference explained by the need to be accurate at Delphi, where a false boast could have been and indeed was checked, since the line with the variant reading was erased and recarved with the corrected number.[116] Since Lysippos made a statue of Agias at Pharsalos, it is at least plausible to consider the statue in Delphi to be a more or less contemporary copy. Since we have seen above that there is ample evidence that copies or slight variants of statues were produced in the Classical period, this supposition is even likely.[117] To this evidence we can add the brief notice of Pliny (*NH* 35.153) that Lysippos's brother Lysistratos "was the first person who modelled a likeness in plaster of a human being from the living face itself and established the method of pouring wax into this plaster mold and then making corrections on the wax cast...."[118] This testimony at least suggests that an interest in accurate copies may have existed in the circle of Lysippos and provides a plausible background for the duplication at Delphi of a statue in Pharsalos.

The inscription from Pharsalos has been variously interpreted as having belonged either to a single statue or to a group.[119] In the latter case, the whole Daochos Monu-

[112] Arnold, *Polykletnachfolge*, 210–13.

[113] Dohrn, *AntP* 8 (1968) 49.

[114] W. Geominy, "The Daochos Monument at Delphi: The Style and Setting of a Family Portrait in Historic Dress," in *Early Hellenistic Portraiture: Image, Style, Context*, ed. P. Schultz and R. von den Hoff (Cambridge 2007) 96.

[115] E. Preuner, *Ein delphisches Weihgeschenk* (Leipzig 1900) 17–24.

[116] See chap. 5A, p. 186 above.

[117] See chap. 3, pp. 79–80 above and p. 282 below.

[118] Trans. H. Rackham, Loeb edition; Todisco, *Scultura greca*, 131.

[119] K. E. Evans, "The Daochos Monument" (Ph.D. diss., Princeton University, 1996) 104–13; W. Geominy, "Zum Daochos-Weihgeschenk," *Klio* 80 (1998) 379–82. Geominy, "Daochos Monument," 96, argues in favor of a single statue of Agias in Pharsalos.

ment might have existed in a duplicate at Pharsalos. Since Lysippos worked in bronze, the group at Delphi would then be a translation into marble, rather than a simple copy. Olivier Picard suggests that the Pharsalos group could have been much earlier than the Delphi monument, around 360–350, and thus represent an early phase of Lysippos's career, agreeing with the assessment that Lysippos is said to have made of his own work, i.e., that he was greatly influenced by Polykleitos.[120] If this were the case, the statue of Sisyphos II, Daochos II's son, would probably have been added to the Delphi group, since he is portrayed as still young and without accomplishments. This would explain the rather different character of the statue and its Praxitelian style. But a more economical hypothesis is that the stylistic variations of the statues of the Daochos Monument speak strongly for multiple sources for the statues, that is, they are an eclectic set of figures representing different current, popular styles, and the workshop was in all likelihood Thessalian, as Kirsten Evans has convincingly argued.[121] In this case, the statue of Agias may well be a copy or adaptation of the statue by Lysippos in Pharsalos, while the other figures of the group are conscious variations on other contemporary styles. In broad terms, the style of each statue reflects the general characteristics of the person represented as defined by the inscription on the base.

In the examples of revivals discussed thus far there is a general sense that the past was admirable, in fact, classic. However, the revivals are generalized and somewhat sporadic. But the revival of one style—the archaistic style that begins in the second half of the fifth century—seems to have had a very specific purpose.[122] The earliest appearance of the style is associated with two works by the sculptor Alkamenes: a Hermes Propylaios[123] and a Hekate Epipyrgidia.[124] Both are known from a number of late copies and adaptations. The dates of these figures are uncertain but probably fall in the last quarter of the fifth century.[125] The style becomes a recognizable phenomenon by the end of the fifth

[120] Picard, *Delphes: Le musée*, 97.

[121] Evans, "Daochos Monument" (note 119 above) 120–22. In strong support of her assessment is the analysis by S. G. Miller of the eclectic character of the Philippeion built by Philip II at Olympia after the battle of Chaironeia in 338, essentially contemporary with the Daochos dedication: "The Philippeion and Macedonian Hellenistic Architecture," *AM* 88 (1973) 189–218.

[122] A. Leibundgut, *Künstlerische Form und konservative Tendenzen nach Perikles* (Mainz 1989) 19–20; D. Willers, *Zu den Anfängen der archaistischen Plastik in Griechenland*, AM-BH 4 (Berlin 1975), and review by E. B. Harrison in *Gnomon* 53 (1981) 496–98; E. B. Harrison, *The Athenian Agora*, vol. 11, *Archaic and Archaistic Sculpture* (Princeton 1965) 50–67; C. M. Havelock, "The Archaic as Survival versus the Archaistic as a New Style," *AJA* 69 (1965) 331–40.

[123] Harrison, *Agora* 11 (note 122 above) 122–24; D. Willers, "Zum Hermes Propylaios des Alkamenes," *JdI* 82 (1967) 37–109; Willers, *Anfängen der archaistischen Plastik* (note 122 above) 33–47; Schuchhardt, *Alkamenes* (note 75 above) 30–33; T. Brahms, *Archaismus: Untersuchungen zur Funktion und Bedeutung archaistischer Kunst in der Klassik und im Hellenisimus* (Frankfurt am Main 1994) 113–33.

[124] Harrison, *Agora* 11 (note 122 above) 86–88; Willers, *Anfängen der archaistischen Plastik* (note 122 above) 48–52; Schuchhardt, *Alkamenes* (note 75 above) 27–30; Brahms, *Archaismus* (note 123 above) 156–71. W. Fuchs, "Zur Hekate des Alkamenes," *Boreas* 1 (1978) 32–35, pls. 5, 6, published a fragmentary statue of three-bodied Hekate in the storerooms of Hadrian's Villa, Tivoli (inv. 473.576.729), the original of which he dates to 450–440 and relates to the Prokne of the Acropolis and the Cherchel-Ostia Athena. He believes that the latter is a reflection of the Athena Hephaisteia of Alkamenes. Accordingly, the archaistic Hekate may have no connection with Alkamenes. Brahms, *Archaismus* (note 123 above) 162, rejects the connection completely.

[125] Harrison, *Agora* 11 (note 122 above) 61–67; W. Fuchs, "Zum Begin der archaistischen Stiles," *Boreas* 7 (1984) 79–81. Willers, *Anfängen der archaistischen Plastik* (note 122 above) 34, 49–50, 51; Schuchhardt, *Alkamenes* (note 75 above) 30; and Brahms, *Archaismus* (note 123 above) 120–21, 124–25, push the date of the archaistic Hermes Propylaios attributed to Alkamenes back to just after the middle of the fifth century, for which the evidence is ambiguous at best. Havelock, *AJA* 69 (1965) 335–36, begins the style in the Early Classical period. Of course, the mannerist vase painters, such as the Pan Painter, continue to use archaic patterns, and the distinction between this "sub-archaic" style and a conscious revival is perhaps so slight as to be negligible.

century, to judge from a very fragmented round altar from Brauron[126] and a red-figure sherd from the Athenian Agora.[127] It seems no coincidence that only statues of divinities are represented in this style: a small divine figure, almost certainly representing the statue of Athena grasped by Kassandra, on one of the metopes of the Argive Heraion,[128] the cult statue in the Bassai frieze around which the Lapith women take refuge from the onslaught of the centaurs,[129] and the statue of Athena grasped by Kassandra in the west pediment of the Temple of Asklepios at Epidauros.[130] Since the figures of Athena on the Panathenaic amphoras of the period continue to be represented in the old-fashioned black-figure technique, and once again in archaic dress, in the course of the second quarter of the fourth century (**Fig. 121**),[131] it is not difficult to accept that the function of the old-fashioned style was to designate particular religious reverence.[132] The occasional use of archaistic forms for figures on the decree reliefs underscores this interpretation.[133] Near the end of the century, the style is used for the string of women on the frieze of the Hieron on Samothrace,[134] and it crops up in slightly simplified manner on a votive relief to the nymphs in New York.[135]

The idea that there is an appropriate style for the particular function of a monument has been around for a long time.[136] As discussed above, the majority of original sculpture preserved from the fourth century consists of grave and votive reliefs, most of which come from Attica. The repetitive appearance of both groups of monuments has led to an unspoken pejorative evaluation of them. But it is the very repetitive character that deserves our special attention. Even if the romantic assessment of Greek art as a coherent series of individual masterpieces is erroneous, the narrow range of expressive elements in the grave and votive reliefs is unexpected. Precisely the reverse of portrait statues, in which individuals are subsumed in types (see pp. 287–91 below), on the grave and votive reliefs types hide the individuals proclaimed in the accompanying inscriptions. Although using politics to explain artistic patterns is more often than not a mirage, in the case of the funerary and votive reliefs it does seem that the democratic ideology of Athens is the most reasonable explanation of this phenomenon.[137] The desire, on the one hand, to proclaim

[126] W. Fuchs and E. Vikelas, "Zum Rundaltar mit archaistischem Götterzug für Dionysos in Brauron," *Boreas* 8 (1985) 41–48, pls. 2–5; *LIMC*, s.v. Eirene no. 10* (E. Simon); Boardman, *GS-LCP*, 16, fig. 3 (detail); Smith, *Polis and Personification*, 142–43, no. R 2, fig. 7.1; H. A. Shapiro, *Personifications in Greek Art: The Representation of Abstract Concepts, 600–400 B.C.* (Zurich 1993) 47, fig. 10 on p. 48 (drawing), 232, no. 10.

[127] Harrison, *Agora* 11 (note 122 above) 52, 53, 62, 63, 99, pl. 63b.

[128] C. Waldstein, *The Argive Heraeum* (Boston 1902) vol. 1, 149–50, fig. 76; F. Eichler, "Die Skulpturen des Heraions bei Argos," *ÖJh* 19 (1919) 30–31, fig. 23.

[129] Hofkes-Brukker and Mallwitz, *Bassai-Fries*, 55 (BM 524); Madigan, *Apollo Bassitas*, pl. 43.

[130] Yalouris, *AntP* 21 (1992) pl. 14.

[131] J. D. Beazley, *The Development of Attic Black-Figure*, 2nd ed., ed. D. von Bothmer and M. Moore (Berkeley 1986) 90–92, pls. 100–104; Valavanis, Παναθηναϊκοί αμφορείς, 71–79; Brahms, *Archaismus* (note 123 above) 84–86; Bentz, *Preisamphoren*, 60.

[132] Steiner, *Images in Mind*, 91–95. Even a Gorgon could buck the trend to looking appealing on a fourth-century basket-handled krateriskos now in Thessaloniki (no. 5124): K. Rhomaiopoulou, A. Herrmann, and C. C. Vermeule, eds., *The Search for Alexander*, exh. cat. (Boston 1980) 159, no. 116*.

[133] Lawton, *Document Reliefs*, 75, nos. 28 and 52, pls. 15, 27; Meyer, *Urkundenreliefs*, A 68, pl. 22.1, A 127.

[134] P. W. Lehmann and D. Spittle, *Samothrace*, vol. 5, *The Temenos* (Princeton 1982) 172–262; Harrison, *Agora* 11 (note 122 above) 54, 64; Ridgway, *Fourth-Century Styles*, 142–43.

[135] See p. 281 and note 147 below.

[136] B. Schweitzer and U. Hausmann, "Typik und Gattung," in *Allgemeine Grundlagen der Archäologie*, ed. U. Hausmann (Munich 1969) 179–80.

[137] H. S. Versnel, "Religion and Democracy," in *Die athenische Demokratie im 4. Jahrhundert v. Chr.: Vollendung oder Verfall einer Verfassungsform? Akten eines Symposiums, 3.–7. August 1992, Bellagio*, ed. W. Eder (Stuttgart 1995)

one's wealth through a large and conspicuously expensive grave monument or votive dedication to the gods is balanced on the other hand by a tedious uniformity of appearance. It is notable that the stele of the slave Thous from Laurion, if not noteworthy in size and cost, nonetheless portrays the deceased as a typical Athenian (**Fig. 265**).[138] It is again precisely in the general uniformity that every deviation stands out; the numerous monuments that display not only conspicuous wealth but also pretensions to special status have yet to be collected and analyzed, but two notable examples are the large relief in Athens dubbed the "τηλαυγής μνῆμα" by Christos Karousos (**Fig. 249**)[139] and the relief in New York formerly and incorrectly known as the Sostrate stele (**Fig. 276**).[140] In the first, the deceased woman appears in the guise of Hera; in the second, the deceased male in the guise of Zeus. Other grave stelai borrow divine figure types, which also must have served as none-too-subtle markers for contemporary Athenians that certain families had aspirations to special status.[141]

The background of the uniformity is relatively clear: the concept of "good form" (εὔσχημος) is elaborated by Plato in *Republic* 2.400e–401a: "But this you are able to determine: that good form (εὐσχημοσύνη) and bad form (ἀσχημοσύνη) follow from good rhythm and the bad." Sokrates goes on to say that the terms apply to all the crafts, such as painting, embroidery, architecture, etc. The translation I have used, "good form," could just as easily be "graceful" or "seemly"; the latter is the translation chosen by Paul Shorey in the Loeb edition. It is clear that the vast majority of grave stelai and votive reliefs represent the people of Athens as good, solid citizens. In contrast to the archaic reliefs and stelai, the monuments of the fourth century have a very limited repertory of references to the individual status or personal accomplishments of the deceased or votary. In the grave reliefs, the main exceptional types are warrior, hunter, and athlete. As pointed out earlier, craftsmen are hardly ever identified iconographically as such, even when they are *metics*.[142] The votive reliefs also avoid such differentiation except in a few cases such as *apobatēs*, charioteer, rider, and two battle reliefs.[143] The noticeable rarity of the crinkly, thin, and somewhat clinging drapery on women in grave reliefs may be understandable if the desire in these monuments is to represent matrons, which is certainly the impression conveyed even when a mother and daughter are represented together (**Fig. 220**).[144] The two exceptions referred to above apparently represent a dancer and a poet.[145]

It is usually not difficult to recognize divinities on votive reliefs. First, they are larger than their votaries (**Figs. 139, 141, 214**). Second, they tend to be depicted casually stand-

367–87, comes to the conclusion that democratic politics had little or no discernible effect on religion in the fifth and fourth centuries, but, as I suggest below, the strong statement of divine immanence in the fourth century belies this interpretation.

[138] Athens, NAM 890: Clairmont, *CAT*, 3.922; Himmelmann, *Attische Grabreliefs*, 46, fig. 16. See chap. 6, p. 260 above. The so-called Old Oligarch (1.10) remarks with unhappiness that slaves and *metics* are indistinguishable from Athenian citizens in their dress. See in general Bergemann, *Demos und Thanatos*, 148–49.

[139] Athens, NAM 3716: Kaltsas, *SNAMA*, 168–69, no. 333*; Karusos, *MüJb* 20 (1969) 7–32; Clairmont, *CAT*, 3.284. See chap. 6, pp. 229–230 above with note 6.

[140] New York, MMA 11.100.2: Richter, *Catalogue*, 56–57, no. 83, pls. 67, 68a–d; Diepolder, *Grabreliefs*, 35, pl. 30; Clairmont, *CAT*, 3.846; Bol, *Bildhauerkunst*, 265, 268–69, fig. 203 (W. Geominy).

[141] Himmelmann, "Images of Gods and Heroes" (note 65 above) 136–44.

[142] See chap. 5A, p. 160 above.

[143] M. Edelmann, *Menschen auf griechischen Weihreliefs* (Munich 1999) 40–41, 167–73, 176.

[144] Himmelmann, *Attische Grabreliefs*, 50–52. Contrast the figures of Demeter and Persephone on the Great Eleusinian Relief: Boardman, *GS-CP*, fig. 144.

[145] Chap. 4, p. 135, note 227, chap. 5A, p. 159 with note 39, and p. 293 with note 232.

ing or seated, or, as Hygieia, very casually leaning against a tree or other support (**Figs. 93, 242**). Third, they are sometimes stylistically distinct: as opposed to the matronly women of the grave reliefs, goddesses often are young and thinly draped. There is, finally, a fourth distinctive characteristic that applies primarily to the nymphs: on the votive reliefs they are frequently depicted in a dance around an altar or *eschara* in a cave, where their cult was frequently located (**Figs. 94, 273**).[146] Because of the motion, their drapery most often clings somewhat to their bodies and describes curvilinear lines over and next to the figures. This is hardly the same stylistic trait as thin, clinging drapery, but several of the late reliefs also take on some of the linear characteristics of the archaizing style.[147] Together with the distinctive drapery patterns of their dancing movement, the linear and almost archaizing style allows immediate recognition of the sacred scene.

Although the Charites receive very little attention in the fourth century, their close association with the nymphs means they share many characteristics.[148] Principal of these is a prosperous benignity—a charm, grace, and beauty—characteristics that are emphasized by both Plato and Aristotle.[149] These are distinctly not normal characteristics of the mortals of the votive reliefs and the people of the funerary stelai. I submit that just as archaism indicates divine status, thin and lively drapery indicates a special status that might be described as charm. Simon Goldhill has pointed out how important the word "χάρις" is in the meeting of Sokrates and the *hetaira* Theodote in Xenophon's *Memorabilia* (3.11).[150] The erotic and the divine are closely linked in the iconography of Aphrodite and her associates, Helen and the young female divinities discussed above.[151] The women of the Acanthus Column at Delphi may be represented with this type of drapery both because they are dancers and because they are divine or semidivine (**Figs. 99, 100**).[152] Finally, since the identity of the torso from the Athenian Agora is uncertain (**Fig. 80**), the reason for representing her with crinkly and clinging drapery is undeterminable, though the suggestion that she is Themis would connect her with the similarly clothed statue from Rhamnous (**Fig. 191**).[153] It seems extremely likely that the divine power expressed by the thin and clinging drapery of goddesses in the later fifth century and the beginning of the fourth century is here revived, and this clarifies how the Acanthus Column could have been dated in the early fourth century.[154] But it is equally clear that thin, semitransparent drapery is not the exclusive manner of rendering the divine power of goddesses in the fourth century. In chapter 4 we discussed the innumerable statues of Artemis (**Figs. 137**,

[146] Athens, NAM 2011: chap. 2, p. 42, note 158 above; Athens, NAM 1859: chap. 2, p. 42, note 159 above; Athens, NAM 1879: p. 275, note 100 above.

[147] E.g., New York, MMA 25.78.59: Richter, *Catalogue*, 80–81, no. 143, pl. 105a; Edwards, "Votive Reliefs to Pan," 653–60, no. 62, pl. 29; Güntner, *Göttervereine*, 122, no. A 29, pl. 5. See also Athens, NAM 1448: W. Fuchs, "Attische Nymphenreliefs," *AM* 77 (1962) pl. 65.2; Edwards, 618–24, no. 54; Güntner, *Göttervereine*, 125, no. A 44, pl. 9.1.

[148] *LIMC*, s.v. Charis, Charites nos. 191–93, 200–203 (E. B. Harrison); E. Schwarzenberg, *Die Grazien* (Bonn 1966) 29–32; J. H. Oliver, *Demokratia, the Gods, and the Free World* (Baltimore 1960) 110–17.

[149] Oliver, *Demokratia* (note 148 above) 42–55.

[150] S. Goldhill, "The Seductions of the Gaze: Socrates and His Girlfriends," in *Kosmos: Essays in Order, Conflict and Community in Classical Athens*, ed. P. Cartledge, P. Millett, and S. von Reden (Cambridge 1998) 115. On the broad meaning of *charis*, see B. MacLachlan, *The Age of Grace: Charis in Early Greek Poetry* (Princeton 1993).

[151] See chap. 6, p. 241 above.

[152] See chap. 4, pp. 132–33 above.

[153] See chap. 4, p. 134 above.

[154] On the early date: Picard, *Manuel*, vol. 3.1, 75–78, dates the column in the 370s; Ginouvès, *Balaneutikè*, 92, gives the date as 380; Adam, *Technique*, 66, notes that the running drill was used and therefore the date must be post-370/350.

138, 165, 166, 170), Athena (**Figs. 145, 146, 168, 169**), Hygieia, and even Persephone (**Fig. 142**) that are attired quite normally, though only rarely are they matronly in appearance, as, for example, the Piraeus bronze Athena (**Fig. 75**).[155]

It seems clear that during the fourth century a range of expressive tools developed that are particularly noteworthy because they appear to be conscious efforts to produce a reasoned relationship between style and content. The past is a source for stylistic emulations that are attached to specific categories of representation and therefore the expression of a particular content. This idea is closely allied to the development of rhetoric in the late fifth and fourth centuries. Antisthenes apparently linked style of speaking and manner of dress with character,[156] and both Plato and Aristotle argued that presentation must be appropriate to the content of the message. As I have suggested elsewhere, the recognition that style and content are separate but interdependent concepts is immensely important because it allows precisely the development we have been observing: varying style to suit different subjects or different interpretations of a subject.[157] Plato's ambiguity on the value of poetry and the plastic arts is a product of this recognition—poetry and the plastic arts can be beautiful, but they can convey unacceptable content.[158] But for society at large the opposite reaction is obvious: the recognition of the expressive value of style allows an infinite range of interpretations of content. Archaism has its beginning in a period when naturalistic representation of mortals was becoming the norm—citizens dressed as citizens as opposed to nude like heroes: Aphrodite may be nude, and Helen partly so; other divine women, such as Artemis and even Athena, are often revealingly dressed and attractive, though the style depends on the intended manifestation: the Vescovali (**Fig. 145**) versus the Rospigliosi types of Athena (**Figs. 168, 169**), for example.

The predilection for stylistic revivals and repetitive figure types in the late fifth and fourth centuries are part of the conscious objectification of style. Stefan Schmidt has suggested that the repetition of figure types was largely a common procedure intended to reduce the workload of always having to create a new type,[159] but the use of the archaistic style, the lively linear style, the references to statues on votive and decree reliefs, and the miniature depictions of statues on Panathenaic amphoras (**Fig. 122**) all suggest that recognition of the origins of figure types also played an important role in the procedure. This must also be true of the use of divine figure types on grave stelai. Since the stylistic character of an archaistic representation of a divinity would make the content immediately recognizable as a sacred image, the appropriateness of style to content becomes a given. At the same time, the use of an archaizing or a classicizing style must have been recognized for what it was, and this would have been a visual parallel of the orators' view of the past as a "golden age." This has, in fact, been suggested for the Farnese Euripides portrait head in Naples that many think derives from the statue set up by Lykourgos in the Theater of Dionysos in the 330s (**Fig. 281**).[160] In a slightly different vein, the inclusion of orientalizing figures in mosaics may have suggested imported luxury, underscoring the

[155] See chap. 4, pp. 128–30 above.

[156] N. B. Worman, *The Cast of Character: Style in Greek Literature* (Austin, TX, 2002) 189.

[157] Childs, "Stil als Inhalt," 235–41.

[158] C. Cavarnos, "Plato's Teaching on Fine Art," *Philosophy and Phenomenological Research* 13 (1953) 487–98; R. W. Hall, "Art and Morality in Plato: A Reappraisal," *Journal of Aesthetic Education* 24.3 (1990) 5–13.

[159] Schmidt, AM 111 (1997) 217–20.

[160] Naples, MAN 6135: Richter, *Portraits*, vol. 1, 135, no. 13, figs. 717–19; G. M. A. Richter and R. R. R. Smith, *The Portraits of the Greeks* (Ithaca, NY, 1984) 121, fig. 82; K. Fittschen, "Griechische Porträts: Zur Stand der Forschung," in Fittschen, *Griechische Porträts*, 24, pls. 73–75; Bol, *Bildhauerkunst*, vol. 2, figs. 399a–b.

function of the mosaic as a statement of wealth. None of this is totally new; the plastic arts had always functioned in this manner. What is new is the disparate purposes of the new signs, and a major factor in all these considerations is that the formal presentation is of great importance, and it is not passive. The viewer is guided by style to an interpretation of content that is not static.

On a simple level, the style functions as an indicator of the nature of the content; this is self-evident in the languid images of nude youths (**Figs. 65, 180, 181**). At the other end of the scale are the burly, beefy athletic figures, such as the Herakles in the Musei Capitolini (**Fig. 159**)[161] or any of the statues of Herakles attributed to the fourth century, such as the Copenhagen-Dresden type (**Fig. 177**)[162] or the Farnese type (**Fig. 183**).[163] This may at first seem self-evident, but clearly neither the archaic nor the Early Classical styles conform, since in the vast majority of cases an overriding ideal of the athletic *kalos k'agathos* obviated the desirability of differentiation. Yet the number of easily identifiable types in the fifth and fourth centuries is not as great as in the Archaic period,[164] which is surprising in light of the two literary descriptions of character types: the *Characters* of Theophrastos, which consists of a series of brief literary descriptions of people representing various human frailties, and the *Physiognomics*, a work included in the Aristotelian corpus that sets out to describe physical characteristics of various human types or states.[165] Both emphasize the typological as opposed to the individual, but both also emphasize the rich diversity of people, and it is perhaps here that we should seek the reason for the diminished number of iconographic types in the fourth century. It is generally recognized that the preserved Roman copies of Greek classical sculpture include a number of representations of historically important people of the fifth and fourth centuries B.C., that is, portraits that differ from each other in subtle ways. We have already seen that the various figures of the Daochos group at Delphi are distinguished according to their achievements by dress (or lack of it), stance, and quite possibly by physique, achieving a modest level of individuality.[166] Since all but two figures, Daochos II and his son Sisyphos II, were long dead when the monument was set up in the 330s, and only the feet of Daochos II are preserved and Sisyphos has no head, no further evidence of individualization is ascertainable.

[161] Rome, Musei Capitolini, Centrale Montemartini (ACEA) MC 1088: for bibliography, see chap. 5A, p. 179, note 170 above.

[162] See chap. 4, p. 116, note 107 above.

[163] See chap. 6, p. 250, note 160 above.

[164] Himmelmann, *Realistische Themen*, 65; N. Himmelmann, *Die private Bildnisweihung bei den Griechen: Zu den Ursprüngen des abendländischen Porträts* (Wiesbaden 2001) 42. N. Himmelmann, "Das realistische Porträt als Gattungserscheinung in der griechischen Kunst," in *Das Porträt vor der Erfindung des Porträts*, ed. M. Büchsel and P. Schmidt (Mainz 2003) 22–23, has remarked on the large and varied number of archaic types—scribe, warrior, athlete—and M. Stieber, *The Poetics of Appearance in the Attic Korai* (Austin, TX, 2004), has drawn attention to the varied physiognomies of the archaic korai on the Athenian Acropolis. The variations both of types and physiognomies of archaic sculpture already speak strongly of the tension of individual and type in Greek art of all periods. The fragment of Aischylos's *Theoroi* also points to the recognition of actual figures/people in the art of his time: M. Stieber, "Aeschylus' *Theoroi* and Realism in Greek Art," *TAPA* 124 (1994) 85–119.

[165] S. Vogt, in *Aristoteles Werke in deutscher Übersetzung*, vol. 18, *Opuscula*, pt. 6, *Physiognomica*, ed. H. Flashar (Berlin 1999) 73–107, gives an excellent commentary; see also E. C. Evans, *Physiognomics in the Ancient World*, *TAPS*, n.s., 59, pt. 5 (Philadelphia 1969); G. Misener, "Iconistic Portraits," *CP* 19 (1924) 104–12; A. MacC. Armstrong, "The Methods of Greek Physiognomists," *GaR* 5 (1958) 52–56. W. Raeck, "Rolle und Individuum im frühen griechischen Porträt," in Büchsel and Schmidt, *Porträt vor der Erfindung des Porträts* (note 164 above) 37, points out all the inconsistencies in using the physiognomic texts to interpret portrait statues, but this hardly diminishes their role in suggesting interest in creating convincing images of different types of people.

[166] See chap. 5A, pp. 172–73 above.

The important issue of portraiture in the present context is the longstanding dispute over whether the Roman copies of identifiable Greek portraits and the larger number of unidentifiable examples depict some likeness of the person depicted or are subtle variations of types that represent the profession or general group to which the person belonged and at most seek to convey the character of the person without the reference to actual physiological accuracy. Does individuality (or the appearance of it) substitute for the earlier wealth of typological variety? The issue has probably been best examined by Ernst Gombrich as a general question irrespective of historical period.[167] Until photography, the concept of a "true likeness" was unthinkable; images of individuals were meant to convey their excellence or capacity in socially definable terms. This, however, does not clarify why "portraits" have specific features. (In the case of the Roman copies of Greek portraits, these are confined largely to the head/face, since the bodies, always part of the original, were rarely reproduced.)

The issue of a true likeness of the person depicted is, of course, impossible to assess and is perhaps not central to the issue of ancient portraits. Even today, it is pointless to argue that there is such a thing as an absolutely "true" portrait, since time and vantage point of necessity play an important role in how somebody is perceived. Indeed, the portrait photographs of Josef Karsh present readily recognizable famous people, while at the same time it is generally possible to distinguish a Karsh portrait photograph from one by another known photographer. Even more important is to try to establish why or perhaps whether a recognizable portrait was of any interest. Here, at least, contemporary texts suggest that it was. Aristotle (*Poetics* 15.1454b) points out that part of the purpose of a portrait is to grasp both the likeness and the character of a person: "Since tragedy is the mimesis of people better than us, it is necessary to imitate good portrait painters (τοὺς ἀγαθοὺς εἰκονογράφους). For, rendering the characteristic appearance of people and making them similar (τὴν οἰκείαν μορφὴν ὁμοίους ποιοῦντες), they too paint them more beautiful than they are."[168] I suspect Karsh would agree.

It is also clear from contemporary texts that statues of individuals were recognized as an important phenomenon in the fourth century. The earliest mention of a statue of an individual other than the Tyrannicides occurs in a speech of Andokides delivered in 399 (*On the Mysteries* 38), in which he says that at the time of the *hermokopidai* in 415 there was a bronze statue of an unspecified general (ὁ στρατηγός ἐστιν ὁ χαλκοῦς) close to the Theater of Dionysos.[169] In 352, Demosthenes (*Against Aristokrates* 197) mentions the recent habit of the state of setting up bronze statues (τιμὴ τῆς χαλκῆς εἰκόνος) of its successful generals, a subject repeated in pseudo-Demosthenes' *On Organization* ([13] 21) at about the same period (οὐ χαλκοῦς ἵστασαν). Demosthenes, in fact, provides a date for the beginning of the practice (*Against Leptines* 70; delivered in 355): he states that the bronze statue (χαλκῆν

[167] E. H. Gombrich, *The Image and the Eye: Further Studies in the Psychology of Pictorial Representation* (Oxford 1982), especially chap. 5: "The Mask and the Face: The Perception of Physiognomic Likeness in Life and Art," 105–36. My thanks to Robert Bagley for bringing this book to my attention. O. Jaeggi, *Die griechischen Porträts: Antike Repräsentation, moderne Projektion* (Berlin 2008) fairly beats the subject to death but with many useful insights.

[168] A brief statement by Plato, *Republic* 2.377e, parallels this, and Plutarch in the second century A.D. assumes that character is the most laudable aspect of a portrait: *Life of Kimon* 2.2–3. G. Zanker, "Aristotle's Poetics and the Painters," *AJP* 121 (2000) 232–34 and generally 225–35, argues for a primarily social interpretation of this passage in the *Poetics*, rather than a primarily or exclusively moral one. Cf. E. Voutiras, *Studien zu Interpretation und Stil griechischer Porträts des 5. und frühen 4. Jahrhunderts* (Bonn 1980) 30, 33–34.

[169] See generally on this and other references G. Dontas, "Bemerkungen über einige attische Strategenbildnisse der klassischen Zeit," in *Festschrift für Frank Brommer*, ed. U. Höckmann and A. Krug (Mainz 1977) 86–88.

εἰκόνα) of Konon was the first of an (historical) figure to be set up since those of Harmodios and Aristogeiton (ὥσπερ Ἁρμοδίου καὶ Ἀριστογείτονος, ἐστήσαν πρώτου). Aischines, in his speech *Against Ktesiphon* (243), delivered in 330, mentions statues (εἰκόνας) voted for Chabrias, Iphikrates, and Timotheus. In the same year Lykourgos (*Against Leokrates* 51) boasts that in Athens only statues of great generals and the slayers of the tyrants have been set up in the Agora, while in the agoras of other cities are statues of victorious athletes (εὑρήσετε δὲ παρὰ μὲν τοῖς ἄλλοις ἐν ταῖς ἀγοραῖς ἀθλητὰς ἀνακειμένους, παρ᾽ ὑμῖν δὲ στρατηγοὺς ἀγαθούς, καὶ τοὺς τὸν τύραννον ἀποκτείναντας).[170] We know that statues of Konon and his son Timotheos were set up both on the Acropolis and in the Agora of Athens.[171] Lykourgos had statues of the great tragedians of the fifth century made for in his new stone Theater of Dionysos.[172] A recent tabulation of the epigraphic and textual evidence for state-decreed honorific statues in Athens indicates a dramatic increase in the course of the fourth century.[173]

All of these are statues that were set up by the state, some of them of contemporary or near contemporary people, others, such as the tragedians in the Theater of Dionysos, long dead. Statues of individuals were also set up privately as votives in sanctuaries and on tombs. This tradition goes back to the beginning of Greek monumental sculpture in the seventh century but becomes important to the present discussion when the statues—or, rather, Roman copies, mainly busts—suggest that some manner of individualization of the person depicted was intended. It is also worth noting that the habit of setting up private votive statues of individuals was still common in the late fifth and fourth centuries and in fact probably increased in popularity.[174] We know of two statues of Gorgias: one at Olympia, which was seen there by Pausanias (6.17.7–9), and the base of which still exists,[175] and a second, gilt, statue, at Delphi, as well as one of Phryne, both of which still existed at Delphi in the days of Pausanias (10.18.7, 10.15.1). Perhaps most telling is the record of Aristotle's will (Diogenes Laertius 5.15–16), in which he designates that statues of five family members, including one of his mother, be made and set up in sanctuaries, apparently when some of the people depicted were still alive.

Although the evidence is slight, it seems that statues were also set up on the increasingly elaborate tombs of the later fourth century. Bernhard Schmaltz has noted several possible examples, such as a small statue of a nude youth of the early fourth century found in the Piraeus, among others.[176] But in a vein similar to the monument found at Kallithea,

[170] Euripides, *Elektra* 387–88, makes a similarly disparaging remark about statues of athletes in the Agora (αἱ δὲ σάρκες αἱ κεναὶ φρενῶν | ἀγάλματ᾽ ἀγορᾶς εἰσιν), which suggests Lykourgos's observation had early and wide support in Athens.

[171] See chap. 5A, p. 188 above.

[172] See chap. 1, p. 19 above.

[173] G. J. Oliver, "Space and Visualization of Power in the Greek Polis: The Award of Portrait Statues in Decrees from Athens," in Schultz and von den Hoff, *Early Hellenistic Portraiture* (note 114 above) 184–85; also commented on by Himmelmann, *Realistische Themen*, 84–85; S. Dillon, *Ancient Greek Portrait Sculpture: Contexts, Subjects, and Styles* (Cambridge 2006) 102–4.

[174] Dillon, *Portrait Sculpture* (note 173 above) 6, 105–6; C. M. Keesling, *The Votive Statues of the Athenian Acropolis* (Cambridge 2003) 192; cf. Himmelmann, *Realistische Themen*, 84–85.

[175] Löhr, *Familienweihungen*, 83–85, no. 96; Himmelmann, *Private Bildnisweihung* (note 164 above) 14–20, figs. 3–5 (photos and drawing of top); Richter, *Portraits*, vol. 1, 120, no. 1. D. Metzler, *Porträt und Gesellschaft: Über die Entstehung des griechischen Porträts in der Klassik* (Münster 1971) 284–85, discusses both the base in Olympia and the statue in Delphi. See also K. A. Morgan, "Socrates and Gorgias at Delphi and Olympia: *Phaedrus* 235d6–236b4," *CQ* 44 (1994) 375–86.

[176] B. Schmaltz, "Zu einer attischen Grabmalbasis des 4. Jahrhunderts v. Chr.," *AM* 93 (1978) 94 and note 33. For bibliography on the statue, see chap. 2, p. 34, note 77 above.

the rhetor and tragedian Theodektes of Phaselis had an elaborate tomb on the road to Eleusis which, according to pseudo-Plutarch, in the life of Isokrates (*Moralia* 837d), was graced with statues "of the famous poets along with his own. . . (ἔνθα καὶ τοὺς ἐνδόξους τῶν ποιητῶν ἀνέστησαν σὺν αὐτῷ. . .)."[177] The sentence is elliptical but must indicate a portrait, just as the same source notes that Isokrates' tomb had a *trapeza* with the images of earlier intellectuals and notably Gorgias, together with Isokrates himself (*Moralia* 838d).[178]

The earliest Greek sculptures that are generally identified as known historical figures occur in the second quarter of the fifth century, though they survive only in Roman copies: the tyrannicides Harmodios and Aristogeiton (though statues of them were originally set up in the late sixth century),[179] the Themistokles from Ostia,[180] and the head of Pindar preserved in several copies and only recently identified on the basis of the inscribed tondo bust from a Roman building at Aphrodisias.[181] The depiction of the two tyrannicides, though clearly distinguishing their different ages, in all other respects conforms to contemporary sixth-century norms. The features of the heads of Themistokles and Pindar are, on the contrary, sufficiently different from other heads of the period to be easily recognizable as distinct individuals. In an art of generalized types the individual stands out rather starkly and runs the danger, as some scholars have observed, of appearing ugly[182] or, perhaps more importantly, as a deviate. Since the former would almost certainly not be the case, the reason for a deviant image must be addressed. Of course, even in the Archaic period certain deviations from the contemporary ideal schema had been tolerated for mortals, for example, to depict extreme old age, as in the case of Priam on numerous Attic black- and red-figure vases.[183] In the period approximately contemporary with the statues of Themistokles and Pindar, there is the sculpture of the old seer with balding head and flabby chest in the east pediment of the Temple of Zeus at Olympia.[184] In both cases, the deviation from the norm signals a special, respected status which appears to be grounded in part in the fact of advanced age[185] but also clearly in rank (king) and profession (seer). It seems legitimate to conclude that extreme old age was regarded as worthy

[177] Scholl, *JdI* 109 (1994) 252–54; Scholl, *JdI* 110 (1995) 229.

[178] Scholl, *JdI* 109 (1994) 240–52.

[179] S. Brunnsåker, *The Tyrant-Slayers of Kritios and Nesiotes: A Critical Study of the Sources and Restorations*, 2nd ed., Skrifter Utgivna av Svenska Institutet i Athen, 4°, 17 (Stockholm 1971).

[180] H. Sichtermann, "Der Themistokles von Ostia," *Gymnasium* 71 (1964) 248–81, repr. in Fittschen, *Griechische Porträts*, 302–36; Richter, *Portraits*, vol. 1, 98, no. 1, figs. 405–8; Metzler, *Porträt und Gesellschaft* (note 175 above) 182–213, fig. 15; Voutiras, *Interpretation und Stil* (note 168 above) 46–53, figs. 12, 13; Himmelmann, *Realistische Themen*, 66–69, figs. 26, 27; Jaeggi, *Griechischen Porträts* (note 167 above) 52–55, 57–58; R. Krumeich, *Bildnisse griechischer Herrscher und Staatsmänner im 5. Jahrhundert v. Chr.* (Munich 1997) 71–89; Boardman, *GS-CP*, fig. 246.

[181] R. R. R. Smith, "Late Roman Philosopher Portraits from Aphrodisias," *JRS* 80 (1990) 132–35, no. 1, pls. VI, VII; Richter and Smith, *Portraits*, 177, fig. 39; J. Bergemann, "Pindar: Das Bildnis eines konservativen Dichters," *AM* 106 (1991) 157–89, pls. 29–38; Himmelmann, *Realistische Themen*, 69–74, figs. 28–30.

[182] B. Schweitzer, *Studien zur Entstehung des Porträts bei den Griechen*, AbhLeip 91.4 (Leipzig 1939 [1940]), repr. in Schweitzer, *Zur Kunst der Antike: Ausgewählte Schriften*, ed. U. Hausmann (Tübingen 1963) vol. 2, 138–48; L. Giuliani, review of Himmelmann, *Realistische Themen*, in Gnomon 70 (1998) 628–29, 636–37; S. Vogt, *Aristoteles Werke in deutscher Übersetzung*, vol. 18, *Opuscula*, pt. 6, *Physiognomica*, ed. H. Flashar (Berlin 1999) 62; Raeck, "Rolle und Individuum" (note 165 above) 36, 39.

[183] E. Pfuhl, *Die Anfänge der griechischen Bildniskunst: Ein Beitrag zur Geschichte der Individualität* (Munich 1927) 16, 18–21, repr. in Fittschen, *Griechische Porträts*, 232, 240–42; Beazley, *Development of Attic Black-Figure* (note 131 above) pls. 22.1, 85.4, 86.2; J. Boardman, *Athenian Red Figure Vases: The Archaic Period* (London 1975) figs. 33.1, 245.1, 245.2.

[184] B. Ashmole, N. Yalouris, and A. Frantz, *Olympia: The Sculptures of the Temple of Zeus* (London 1967) pls. 31–38; Boardman, *GS-CP*, fig. 20.4

[185] Raeck, "Rolle und Individuum" (note 165 above) 39; B. E. Richardson, *Old Age among the Ancient Greeks: The Greeks Portrayal of Old Age in Literature, Art, and Inscriptions* (Baltimore 1933) 16–23, 82–104.

of respect and that kings and seers make claim to such respect by being represented as balding, flabby-chested men.

There are, of course, other deviant images in the period, such as those of laborers (*banausoi*) that strike the modern viewer as very uncomplimentary.[186] However, these images more likely express pride in the work involved, and they constitute a rare alternative to the otherwise dominant more or less abstract ideal images associated with the elite of Greek society; they may possibly reflect the rise of what one can only call a middle class under Peisistratos and then the budding democracy of the late sixth and early fifth centuries.[187] In addition, there are clearly caricatures of uncertain meaning but, to the modern eye, probably to be interpreted as comic figures associated with folk traditions.[188] As such, they would be a phenomenon parallel to the coarse representations of *banausoi*. They can also be conceived of as paralleling the depiction of imaginative beings, such as satyrs, silenoi, and, not least, centaurs, Gorgons, and even erotes. One might also include Amazons, since they are deviant women.

It does not require much imagination to suspect that deviant appearance carries with it a special and, at times, powerful status. To both the modern and ancient mind, Pindar and Themistokles could claim such special, elevated status. It is equally clear that there are generalized features that classify the heads as types,[189] but their individual traits, that is, those deviant from the contemporary norm, must be considered primary: even if one could not recognize the individual, it must have been eminently clear that one stood before the statue of an important personage.[190] In the case of Pindar, the elegant and perhaps professional reference of the beard must have given a hint to the type of person depicted; in the case of the Themistokles, the rugged, blocklike head must have suggested a tough man, even if not specifically recalling Herakles, as some have suggested.

If we search the contemporary literary evidence we quickly discover that the production of portrait statues is paralleled by a similarly new interest in the literary description of people, that is, biography. Few will forget the marvelous passage in Herodotos in which he describes the meeting between Solon and Kroisos of Lydia (1.30–33). In answer to Kroisos's question about the most blessed (ὀλβιώτατος) person Solon knew of, Solon lists in first place Tellos of Athens, who had seen his grandchildren raised in good state, and then he died valiantly in battle. But a real interest in the person is missing, though Herodotos is among the first Greek writers to show interest in people apart from their

[186] Himmelmann, *Realistische Themen*, 23–48.

[187] Ibid., 9–17; Giuliani, *Gnomon* 70 (1998) 631–33; A. H. Borbein, "Tendenzen der Stilgeschichte der bildenden Kunst und politisch-soziale Entwicklungen zwischen Kleisthenes und Perikles," in *Demokratie und Architektur der hippodamische Städtebau und die Enstehung der Demokratie* (Munich 1989) 91–106.

[188] A. G. Mitchell, *Greek Vase-Painting and the Origins of Visual Humour* (Cambridge 2009) 244–48; P. Zanker, *Die Maske des Sokrates: Das Bild des Intellektuellen in der antiken Kunst* (Munich 1995) 38–40, figs. 19, 20; L. Giuliani, "Il ritratto," in *I greci: Storia, cultura, arte, società*, vol. 2, *Una storia greca*, pt. 2, *Definizione*, ed. S. Settis (Turin 1998) 988–90; Pfuhl, *Anfänge der griechischen Bildniskunst* (note 183 above), elides these caricatures with the deviant representation of old age, as does Metzler, *Porträt und Gesellschaft* (note 175 above) 96–108, but they appear to fit better with the grotesques discussed by Himmelmann, *Realistische Themen*, 89–122, especially his observations on p. 101.

[189] L. Giuliani, *Bildnis und Botschaft: Hermeneutische Untersuchungen zur Bildniskunst der römischen Republik* (Frankfurt am Main 1986) 130–31; Himmelmann, *Realistische Themen*, 81; Himmelmann, *Attische Grabreliefs*, 42–43; Raeck, "Rolle und Individuum" (note 165 above) 29–42.

[190] Giuliani, *Gnomon* 70 (1998) 636–37, recognizes that a deviation from the norm need not be negative, though his insistence that the deviations in portraits are actual reflections of the physical appearance of the person depicted is perhaps exaggerated. For observations similar to mine, see Raeck, "Rolle und Individuum" (note 165 above) 39, 42. Schweitzer, *Entstehung des Porträts* (note 182 above) 144–47, points to the centaurs of the south metopes of the Parthenon as the turning point from ugliness as bad to ugliness as expressive, but the above observations strongly suggest that this had already happened in the sixth century.

noteworthy deeds.[191] But it is a passage of Ion of Chios that stands out as a harbinger of so much of later Greek literature:

> I met Sophocles the poet when he stopped at Chios on his way to command the fleet against Lesbos, and he showed himself to be an amusing and sophisticated man (*paidiōdei kai dexiōi*). At a party hosted by Hermesilaus, his friend and the political connection for Athenians on Chios, the boy pouring wine was standing before the fire; when he bade Sophocles, "Enjoy your wine," Sophocles replied, "I shall—if you take your time in serving me." As the boy blushed yet more furiously, Sophocles turned to the man reclining beside him and said, "How finely Phrynicus spoke in the poem where he said, 'On his purple cheek (*parēisin*) there shone the light of love.'" To this the man, who was a letter-teacher from Eretria, replied, "You are doubtless wise about poetry, Sophocles, yet I am bound to say Phrynicus did not speak well when he called the fair boy's cheeks (*gnathous*) purple. For if a painter were to daub purple pigment on this boy's cheeks, he would not appear fair. It is quite unfair to liken (*eikazein*) what is fair to what is obviously unfair."[192]
>
> At this Sophocles laughed aloud and said to the Eretrian, "I presume then, my good man, that you also disapprove of Simonides' saying—'the maiden sending voice forth from purple mouth'—though it has quite a reputation among the Greeks as being well said, and of the poet when he said, 'Apollo of the golden hair,' on the grounds that a painter who made the god's hair gold rather than black would produce a contemptible picture. Nor does the one who said 'rosy-fingered' meet your approval, for if someone were to dip her fingers in red dye, the result would be a dyer-maid's hands and not those of a fair lady." Everyone laughed and the Eretrian was silenced by the riposte. (Trans. A. L. Ford)

The passage is from Ion's work called the *Epidēmia*, or *Visits*, in which he recorded interesting conversations with various prominent people of the middle of the fifth century.[193] The tone reminds me most clearly of the dialogues of Plato that share the subject of the casual meetings of intellectuals,[194] though Plato uses the medium to expound on a defined topic at great length. Xenophon picks up more of the diverse character of Ion's work in his so-called *Memorabilia*, and in his *Agesilaos* he separates the deeds from his general encomium of the great Spartan king.[195] But the striking thing in all these writings is the interest in the apparently inconsequential minor details of the behavior of the individuals who participate in the discussions; the reply of Sophokles to the Eretrian is in no way dissimilar to the ironic and often hilariously disparaging observations Plato puts into the mouth of Sokrates. There is a comfortable element of banality that reveals the character

[191] H. Homeyer, "Zu den Anfängen der griechischen Biographie," *Philologus* 106 (1962) 75–85; A. Momigliano, *The Development of Greek Biography* (Cambridge, MA, 1993) 34–35.

[192] Athenaeus 13.603e–604f; *FGrHist* 392 F 6; the translation is from Ford, *Origins of Criticism*, 191.

[193] Stesimbrotos is not an equivalent because of the political purposes of his descriptions: F. Schachermeyr, "Stesimbrotos und seine Schrift über die Staatsmänner," *SBWien* 247, no. 5 (1965); Momigliano, *Greek Biography* (note 191 above) 30.

[194] R. Blondell, *The Play of Character in Plato's Dialogues* (Cambridge 2002); D. Nails, *The People of Plato: A Prosopography of Plato and Other Socratics* (Indianapolis, IN, 2002); T. B. L. Webster, *Art and Literature in Fourth-Century Athens* (London 1956) 19–23, 91–92. I. Bruns, *Das literarische Porträt der Griechen im fünften und vierten Jahrhundert vor Christi Geburt* (Berlin 1896; repr. Hildesheim 1961), gives a lengthy and sensitive discussion of the development of characterization in Greek literature.

[195] Momigliano, *Greek Biography* (note 191 above) 50–51; F. Pownall, *Lessons from the Past: The Moral Use of History in Fourth-Century Prose* (Ann Arbor 2004) 33–35.

of the people depicted without making the point too obvious. But there is no physical description of the participants.

In all the preserved literature there is very little description of the physical appearance of people. In the parts of the Hippocratic corpus ascribed to the end of the fifth century, the effect of climate is associated with physical conditions, and this is generally recognized as the beginning of the serious study of physiognomics.[196] Indeed, there is only a single historical figure whose literary descriptions allow convincing comparison with a preserved portrait type: Sokrates. This description is associated in later literature with an early physiognomicist, Zopyros.[197] Sokrates is described by Plato (*Theaitetos* 143e; *Symposion* 215a–b) and Xenophon (*Symposion* 2.19), both of whom knew him well, as an ugly man with snub nose and bulging eyes—somewhat like a silenos or satyr—and a paunch.[198] Two types are preserved in the Roman portraits of Sokrates, and both do resemble a silenos or satyr.[199] The earlier type is widely believed to have been privately commissioned soon after Sokrates' death in 399, possibly coincident with the founding of Plato's Academy sometime after 387.[200] The head is clearly related to that of a silenos or satyr and is remarkable for its divergence from the classical ideal. A small statuette in the British Museum (**Fig. 277**) represents the second type, less emphatically silenos-like, probably of the later fourth century and attributed by some to Lysippos, on the authority of Diogenes Laertius (2.43); the coarse features of the earlier type are here made milder, but the figure is still evocative of the mythical prototype.[201] Just as in the case of the Themistokles and Pindar heads, it seems reasonable to understand the Sokrates portraits both as obvious deviations from the norm to mark the special status of the person and as containing actual characteristics of the individual.[202]

An extremely interesting seated statue in Copenhagen has been identified as possibly a portrait of Sokrates (**Fig. 278**); the head is missing, but an etching by Johannes Preisler

[196] Misener, *CP* 19 (1924) 104; Evans, *Physiognomics* (note 165 above) 18–20.

[197] N. Yalouris, "Die Anfänge der griechischen Porträtkunst und der Physiognomon Zopyros," *AntK* 29 (1986) 5–7; L. Giuliani, "Das älteste Sokrates-Bildnis: Ein physiognomisches Porträt wider die Physiognomiker," in *Der exzentrische Blick: Gespräch über Physiognomik*, ed. C. Schmölders (Berlin 1996) 19–42.

[198] Vogt, *Physiognomica* (note 182 above) 77–79; I. Scheibler, *Sokrates in der griechischen Bildniskunst: 12. Juli bis 24. September 1989, Glyptothek München* (Munich 1989); Scheibler, "Das älteste Sokratesporträt," *MüJb* 40 (1989) 25–28.

[199] Richter, *Portraits*, vol. 1, 109–19, figs. 456–573; Richter and Smith, *Portraits*, 198–204; Voutiras, *Interpretation und Stil* (note 168 above) 172–93; Scheibler, *Sokrates in der griechischen Bildniskunst* (note 198 above); Schiebler, *MüJb* 40 (1989) 7–33; Schiebler, "Sokrates und kein Ende: Die Statuen," in *Antike Porträts: Zum Gedächtnis von Helga von Heintze*, ed. H. von Steuben (Möhnesee 1999) 1–13; Giuliani, "Älteste Sokrates-Bildnis" (note 197 above) 19–42; Zanker, *Maske des Sokrates* (note 188 above) 38–45.

[200] Scheibler, *MüJb* 40 (1989) 10, 21–22; Scheibler, "Sokrates und kein Ende" (note 199 above) 11–12. The date of ca. 380 for the portrait of type A is widely accepted, though Voutiras, *Interpretation und Stil* (note 180 above) 188–93, and "Sokrates in der Akademie: Die früheste bezeugte Philosophenstatue," *AM* 109 (1994) 157–60, reverses the chronology of the two types.

[201] London, BM 1925,1118.1: Richter, *Portraits*, vol. 1, 116, figs. 560–62; Richter and Smith, *Portraits*, 203, fig. 164; Voutiras, *Interpretation und Stil* (note 168 above) 187–92; Zanker, *Maske des Sokrates* (note 188 above) 62–66, fig. 33; Todisco, *Scultura greca*, no. 279; Bol, *Bildhauerkunst*, figs. 393a–d. Voutiras, *AM* 109 (1994) 137ff., deals in detail with the passage of Diogenes Laertius and all its inconsistencies.

[202] Giuliani, "Älteste Sokrates Bildnis" (note 197 above) 25–27. Giuliani, "Ritratto" (note 188 above) 1003, has pointed out that the descriptions by Plato and Xenophon postdate the supposed date of the earlier portrait type and might therefore be dependent on it. Although this is a possibility, it seems more likely that there may have been unanimity of opinion about Sokrates between the early sculptor and Sokrates' prize students. Giuliani, "Älteste Sokrates-Bildnis," 36, suggests that the nonconformist, indeed, ugly appearance of the portraits of Sokrates would have been interpreted as indicative of his bad character in accordance with the tenets of physiognomic analyses that were then being developed, but this seems to me misleading because the very otherness of the portraits must have placed them very much in the category of a special, indeed, powerful status.

published in 1732 almost certainly shows the same statue with a head of Sokrates of the later type.[203] Recent analysis rejects the head of Sokrates as pertinent and down-dates the statue to the third or second century, though the arguments put forward are not totally persuasive.[204] The elderly, flabby-chested man leans slightly forward, his left leg extended, the right leg pulled back under his seat. His mantle rests on his left shoulder and is held out and to the side by his left arm, creating a fluttering pattern along the whole left side of the figure. The figure, whether Sokrates or not, is clearly marked as old and flabby, and therefore of special status. Although I long accepted the identification as Sokrates, the arguments supporting a later date and an identification as an indeterminate intellectual now make this view unlikely. But perhaps the most important characteristic of the statue is that the figure appears to be rising from his seat and causing his mantle to flutter around him, one of the most convincing representations of motion in an ancient statue, which is hard or impossible to parallel in the fourth century.[205] The motion is probably intended to reflect a characteristic of the person depicted or of his intellectual concerns, neither of which seem appropriate for Sokrates.

The portraits of Themistokles, Pindar, and Sokrates were all private dedications. Whether they depict their subjects accurately is difficult or impossible to ascertain, but it is clear that they are notable, that is, special, people. The suggestion by Nikolaus Himmelmann that there is a religious subtext here provides a possible further insight into the appearance of the portrait: these statues were private dedications in sanctuaries, that is, votives, and the individualized statues may suggest the qualities for which the votive was made, not unlike the early inscribed votives that give the name of the votary, probably to make it clear to the divinity who has recognized the divine debt or requires attention.[206] On the other hand, the normative representation of the tyrannicides, a state dedication, probably reflects the socio-political desire to deemphasize the individual in favor of the citizen. Although the portrait of Perikles was almost certainly a private dedication set up around the time of his death in 429, and said to have been made by Kresilas,[207] Perikles' position in the state almost certainly required that he also depict himself as a generalized ideal figure. Some scholars even suggest that the statue presented him in idealized nudity, though there is regrettably no evidence on that point.[208] It is accordingly evident that the statue of a person, even a private dedication, need not even attempt a physical likeness. In the case of Perikles, the democratic desire to minimize individuality certainly must have

[203] Copenhagen, NCG 2812: Poulsen, *Catalogue*, 291–92, no. 415c; F. Poulsen and M. S. Elo, "Reconstruction of the Lysippian Socrates," in *From the Collections of the Ny Carlsberg Glyptothek*, vol. 2 (Copenhagen 1939) 169–82; Richter, *Portraits*, vol. 1, 110, 116, figs. 556–59; Richter and Smith, *Portraits*, 203, fig. 163; Giuliano, *MNR*, vol. 1, pt. 6, 38–42, no. II.12a* (L. de Lachenal); Scheibler, *Sokrates in der griechischen Bildniskunst* (note 198 above) 48*; Scheibler, "Sokrates und kein Ende" (note 199 above) 1–13, pl. 2.1, 2.2; Dillon, *Portrait Sculpture* (note 173 above) 123, fig. 168.

[204] K. Schefold, *Bildnisse der antiken Dichter, Redner und Denker* (Basel 1943) 210; V. Poulsen, *Les portraits grecs* (Copenhagen 1954) 79–80, no. 54; P. Mangazzini, "Su alcuni ritratti di Socrate," *RendPontAcc* 43 (1970–71) 47–54; B. Frischer, "On Reconstructing the Portrait of Epicurus and Identifying the Socrates of Lysippus," *ClAnt* 12 (1979) 143–46; F. Johansen, *Greek Portraits: Ny Carlsberg Glyptotek* (Copenhagen 1992) 142–43*; Dillon, *Portrait Sculpture* (note 173 above) 207, note 192. The most recent full treatment of the issues is given by Scheibler, "Sokrates und kein Ende" (note 199 above) 1–13, who cautiously rejects the seated statue in Copenhagen as a representation of Sokrates.

[205] Cf. Dillon, *Portrait Sculpture* (note 173 above) 93, on the convincing sense of motion in the seated statue of Poseidippos.

[206] Himmelmann, *Realistische Themen*, 74, 79–80; Himmelmann, *Private Bildnisweihung* (note 164 above) 64–69; Himmelmann, "Realistische Porträt" (note 164 above) 24–25.

[207] See chap. 5A, p. 168, note 94 above.

[208] See chap. 5A, p. 168, and note 95 above.

played an important role, and it may also have distinguished many of the state-decreed statues from the private votives.[209] This distinction may have diminished greatly in the second half of the fourth century and into the third, to judge primarily from the statues, in this case complete, of Aischines (**Fig. 283**)[210] and Demosthenes (**Fig. 284**).[211]

Other than Sokrates, we have no sufficiently accurate literary descriptions of people to compare with the preserved Roman portrait heads. But comparison of the heads identified as Plato and Aristotle is most instructive (**Figs. 279, 280**).[212] The head of Plato is thought to derive from a statue set up in the Academy; Diogenes Laertius (3.25) records that a certain Mithridates had a statue of Plato by Silanion set up, very likely after Plato's death in 348/7.[213] The head of Aristotle almost certainly also dates after his death in 322. Both are philosophers, and they look quite similar. The real distinctions are in the hair, particularly on the forehead, and the form of the eyebrows. Comparison of the portrait head of Euripides (**Fig. 281**)[214] to that of Aristotle shows the hair to be quite similar, even on the forehead,[215] but their eyes and eyebrows differ. Not too far from the front hair of both Euripides and Aristotle is that of the bronze head from the Porticello shipwreck, dated by the cargo of the vessel prior to 385 and usually dated around 450 to 440.[216] Its long and abundant beard is similar to the beard of Sokrates and other fifth-century personalities, such as the long-dead Miltiades.[217] Ridgway has argued that the Porticello head depicts a centaur, such as the wise Chi-

[209] F. Studniczka, "Die Anfänge der griechischen Bildniskunst," *Zeitschrift für bildende Kunst* 62 (1928–29) 125–26, repr. in Fittschen, *Griechische Porträts*, 258; Voutiras, *Interpretation und Stil* (note 168 above) 33; Fittschen, "Stand der Forschung" (note 160 above) 15–16, 17–18; Himmelmann, *Realistische Themen*, 54–55, 79. On pages 82–87 Himmelmann points out, however, that many of the officially decreed statues were fantasy portraits of the long deceased and yet those existing in Roman copies show the same formal characteristics of the private portraits, so the distinction official/private has far less weight than generally thought. Cf. Dillon, *Portrait Sculpture* (note 173 above) 104–5. Jaeggi, *Griechischen Porträts* (note 167 above) 46–52, stresses the variable interpretations of both the terms "realistic" and "idealistic."

[210] Naples, MAN 6018: Richter, *Portraits*, vol. 2, 213, no. 6, figs. 1369–71; F. Hiller, "Zum Neapler Aeschines," *MarbWPr*, 1962, 53–60, pl. 12; Ridgway, *Hellenistic Sculpture*, vol. 1, 226, pl. 109; Todisco, *Scultura greca*, no. 300.

[211] Copenhagen, NCG 2782: Richter, *Portraits*, vol. 2, 219, no. 32, figs. 1398–1402, and, generally, 212–15, figs. 1369–96, 215–23, figs. 1397–1513; Richter and Smith, *Portraits*, 73–75, 108–13; Johansen, *Greek Portraits* (note 204 above) 84–87, no. 33*.

[212] Plato: Munich, Glyptothek 548, formerly in the Boehringer collection: K. Vierneisel, "Ein Platon Bildnis für die Glyptothek," in *Jahresgabe des Vereins der Freunde und Förderer der Glyptothek* (Munich 1987) 11–26; J. Dörig, *Art antique: Collections privées de Suisse Romande*, exh. cat. (Mainz 1975) no. 264*; Richter, *Portraits*, vol. 2, 167, no. 18, figs. 942–44. Aristotle: Vienna, KHM I 246: Richter, *Portraits*, 173, no. 7, figs. 976–78, 985. See generally Richter, *Portraits*, 164–70, figs. 903–60, 170–75, figs. 976–1014; Richter and Smith, *Portraits*, 95–99, 181–86; Himmelmann, *Realistische Themen*, 51–53, fig. 21; Himmelmann, "Realistische Porträt" (note 164 above) 19–20, fig. 6.

[213] Richter, *Portraits*, vol. 2, 165, 169; Richter and Smith, *Portraits*, 182; K. Vierneisel, "Wie groß war Platons Statue in der Akademie?" in von Steuben, *Antike Porträts* (note 199 above) 15–26; Bäbler, *Fleissige Thrakerinnen* (note 40 above) 104; Bivar, *Personalities of Mithra* (note 40 above) 74.

[214] Naples, MAN 6135: see p. 282, note 160 above.

[215] The pattern of the hair has a long tradition, as Studniczka, "Anfänge der griechischen Bildniskunst" (note 209 above) 263, has shown, and there are differences between the renderings in the portrait heads, but the set type seems paramount.

[216] E. Paribeni, "Le statue bronzee di Porticello," *BdA* 24 (1984) 1–14; C. J. Eisenman and B. S. Ridgway, *The Porticello Shipwreck: A Mediterranean Merchant Vessel of 415–385 B.C.* (College Station, TX, 1987); B. S. Ridgway, "The Sculptures from the Porticello Wreck," in *Archaische und klassische griechische Plastik: Akten des internationalen Kolloquiums vom 22.–25. April 1985 in Athen*, ed. H. Kyrieleis (Mainz 1986) 59–69, pls. 100, 101; C. C. Mattusch, *Greek Bronze Statuary: From the Beginnings through the Fifth Century B.C.* (Ithaca, NY, 1988) 198–200; Fittschen, "Stand der Forschung" (note 160 above) 19–20; Himmelmann, *Realistische Themen*, 74–79, figs. 31a, b. J. Bergemann, "Lysias: Das Bildnis eines attischen Redners und Metöken," in *Wissenschaft mit Enthusiasmus: Beiträge zu antiken Bildnissen und zur historischen Landeskunde Klaus Fittschen gewidmet*, ed. J. Bergemann (Rahden, Westphalia, 2001) 114 and note 54, prefers a date ca. 400.

[217] Richter, *Portraits*, vol. 1, figs. 381–89; Richter and Smith, *Portraits*, figs. 166–69.

ron, while others prefer to identify it as a portrait.[218] But it is certainly intended to depict a special figure whose age indicates wisdom and probably power in some realm. More closely related to the portrait of Euripides is that of Antisthenes (**Fig. 282**),[219] though the distinctive arcing of his eyebrows and the deep wrinkles over the bridge of the nose make him easy to recognize.[220] Whether any of the features that make each of these heads recognizable are accurate reflections of actual features of the person depicted is, of course, unknowable, and actually of only passing interest, though if both Plato (*Republic* 2.377e) and Aristotle (*Poetics* 1454b) can talk of recognizable images of people, we must not be too skeptical. The fact is that the heads are distinguishable and yet all belong to a quite narrow type, which one might call the intellectual.[221] Though the reality of such a type has been disputed by Paul Zanker, who claims that the philosopher or intellectual type does not differ from that of the elder citizen,[222] there are characteristics that distinguish the heads identified as philosophers and poets from those of the grave reliefs.[223] Johannes Bergemann's study of the male figures on Attic grave stelai of the fourth century reveals a basic typology for males of adult and advanced age, within which there are distinct variations that he categorizes as schemata.[224] The vast majority of adult males have voluminous hair and full beards; the faces can be quite plain and smoothly modeled, but some are distinguished by more or less sunken cheeks, creases at the sides of the nose, and rumpled brow.[225] A small number of aged men are depicted in various stages of baldness.[226] Only very few of these heads resemble any of the portrait heads of statues: one resembles at some distance the portrait of Plato,[227] another is perhaps comparable to the head of Aristotle,[228] and one—a recut stele in the Piraeus on which the central seated figure has been changed from a woman to an old man—depicts a face with remarkably sensitive features.[229] Bernhard Schmaltz has proposed that some grave stelai may present actual portraits of the deceased,[230] which

[218] Stewart, *Greek Sculpture*, 173; Himmelmann, *Realistische Themen*, 74–79.

[219] Vatican, Museo Pio-Clementino 288: Richter, *Portraits*, vol. 2, 180, no. 1, figs. 1037–39, and see generally ibid., 179–81, figs. 1037–56; Richter and Smith, *Portraits*, 121–24; C. A. Picón and S. Hemingway, eds., *Pergamon and the Hellenistic Kingdoms of the Ancient World,* exh. cat. (New York 2016) 63, 141–42, no. 48.

[220] The portrait of Antisthenes is now thought to be a Hellenistic creation in the style of Late Classical portraits. This simply emphasizes the point that the idiosyncratic elements of portraits are meant to reveal a specific character within a type. See most recently R. von den Hoff, *Philosophenporträts des Früh- und Hochhellenismus* (Munich 1994) 136–50; Picón and Hemingway, *Pergamon* (note 219 above) 63, 141–42.

[221] Giuliani, *Bildnis und Botschaft* (note 189 above) 134–37.

[222] Zanker, *Maske des Sokrates* (note 188 above) 46–49.

[223] Dillon, *Portrait Sculpture* (note 173 above) 79–80, 98, 100; she uses caution in defining readily identifiable types and proposes (p. 110) just two main groups: men of action and men of thought, with some overlapping.

[224] Bergemann, *Demos und Thanatos*, 100–105; J. Bergemann, "Die bürgerliche Identität der Athener im Spiegel der attischen Grabreliefs," in *Griechische Klassik: Vorträge bei der interdisziplinären Tagung des Deutschen Archäologen-verbandes und der Mommsengesellschaft vom 24.–27. 10. 1991 in Blaubeuren,* ed. E. Pöhlmann and W. Gauer (Nürnberg 1994) 283–93; Bergemann, "Attic Grave Reliefs and Portrait Sculpture in Fourth Century Athens," in Schultz and von den Hoff, *Early Hellenistic Portraiture* (note 114 above) 34–46; paraphrased by Dillon, *Portrait Sculpture* (note 173 above) 67–73.

[225] Bergemann, *Demos und Thanatos*, pls. 67–85, 98–105.

[226] Ibid., 104–5, pls. 106–8.

[227] Copenhagen, NCG 1957: Poulsen, *Catalogue*, no. 212; Moltesen, *Classical Period*, 97, no. 39*; Bergemann, *Demos und Thanatos*, pl. 69.3, 69.4; Dillon, *Portrait Sculpture* (note 173 above) 69.

[228] Athens, NAM 730: Clairmont, *CAT*, 2.930; Bergemann, *Demos und Thanatos*, pl. 101.1–2.

[229] Piraeus 3577: B. Schmaltz, "Zur Weiter- und Wiederverwendung klassischer Grabreliefs Attikas," *AM* 113 (1998) 182–85, pl. 33.1–3.

[230] B. Schmaltz, "Bildnisse attischer Grabreliefs des späten 4. Jhs.," in von Steuben, *Antike Porträts* (note 199 above) 27–33; Schmaltz, "Griechische Grabreliefs klassischer Zeit: Beobachtungen zum Menschenbild des 4. Jhs.,"

292 CHAPTER 7

certainly might be the case in a very few cases, though unprovable. A good candidate is the head of an old man, separated from its stele, that resembles the head of Demosthenes.[231]

Perhaps what separates the vast majority of the heads on grave stelai from the portrait statues is that the latter depict variations in age but very rarely suggest any real character. Even on the "lamentation" stele in Athens, though the gestures indicate clearly the sadness of death, the faces of the figures are essentially blank (**Fig. 220**). In the rare case where a specific profession is indicated, such as the fragmentary stele of a comic poet in Lyme Hall,[232] the head of the poet (though it was reworked in the early third century, as Andreas Scholl and others have noticed) does suggest troubled emotion and may be influenced by the intellectual portrait type; but clearly the figures on grave stelai normally belong to broad types or vary them with a narrow range of schemata to suggest degrees of age.[233] A reasonable conclusion is that the portrait heads of identifiable poets and philosophers all carry some of the characteristics of the ideal citizen depicted on the grave stelai but contain signal features of shape of head, brow, forehead, and hair that allow an identification as a deviant type in which age as a sign of special status is coupled with idiosyncratic features that may reflect the particular individual's actual appearance.[234]

The very nature of portraits as signs of special status is evident in the statue from the Maussolleion at Halikarnassos, now in London and commonly called Maussollos (**Fig. 6**), which represents a totally different type that can be grouped with the heads of satraps and other local dynasts of Asia Minor on coins of the fourth century.[235] The bronze head of an athlete, usually called a boxer, from Olympia must similarly represent a type and perhaps some individual features of the man depicted.[236] Another group of similar but easily distinguishable figures are the Attic orators best represented by Aischines and Demosthenes

in *Images of Ancestors*, Aarhus Studies in Mediterranean Antiquity 5, ed. J. M. Høtje (Aarhus 2002) 49–58; not accepted by Himmelmann, "Realistische Porträt" (note 164 above) 20–21, *Realistische Themen*, 53–54.

[231] Athens, NAM 3483: Dillon, *Portrait Sculpture* (note 173 above) 8, fig. 7 on p. 9.

[232] Clairmont, *CAT*, 1.400; A. Scholl, *Die antiken Skulpturen in Farnborough Hall sowie in Althorp House, Blenheim Palace, Lyme Park und Penrice Castle*, Monumenta Artis Romanae 23, CSIR Great Britain, vol. 3, fasc. 7 (Mainz 1995) 86–89, no. L3, pls. 71–73; Scholl, "Nicht Aristophanes sonder Epigenes: Das Lyme-Park-Relief und die Darstellung von Dichtern und Shauspielern," *JdI* 110 (1995) 215–22, figs. 1–6; T. B. L. Webster, "Grave Relief of an Athenian Poet," in *Studies Presented to David Moore Robinson on his Seventieth Birthday*, ed. G. E. Mylonas (St. Louis, MO, 1951) vol. 1, 590–93, pl. 55; Webster, *Art and Literature in Fourth-Century Athens*, 17–18, 90, pl. 1; N. Himmelmann, "Grabstele eines Dichters der Mittleren Komödie in Lyme Hall," in *Kotinos: Festschrift für Erika Simon*, ed. H. Froning, T. Hölscher, and H. Mielsch (Mainz 1992) 267–69, pls. 57, 58.1; Himmelmann, *Realistische Themen*, 135–36, 142, figs. 73–77 on pp. 143–44; Vogt, *Physiognomica* (note 182 above) 86, pl. 12.2; S. Schmidt, "Fashion and Meaning: Beardless Portraits of Artists and Literati in the Early Hellenistic Period," in Schultz and von den Hoff, *Early Hellenistic Portraiture* (note 114 above) 110–11, fig. 85. Scholl, *JdI* 110 (1995) 220–26, stresses that the head of the seated poet has been reworked, probably in the early third century, to remove the original beard, which had become unfashionable.

[233] Bergemann, *Demos und Thanatos*, 106–16.

[234] Bergemann, "Attic Grave Reliefs" (note 224 above) 37–38, outlines the position well. Richardson, *Old Age* (note 185 above) 215–24, gives a list of 128 people known from literary sources to have been "outstanding examples of longevity." A significant number of these were poets, philosophers, and related intellectuals, from which she concludes "In Greece it appears that those who have attained to length of years have taken time to cultivate their more human tastes. . . ." (p. 223).

[235] Metzler, *Porträt und Gesellschaft* (note 175 above) 252–57; W. Schwabacher, "Satrapenbildnisse: Zum neuen Münzporträt des Tissaphernes," in *Charites: Studien zur Altertumswissenschaft*, ed. K. Schauenburg (Bonn 1957) 27–32, and "Lycian Coin Portraits," in *Essays in Greek Coinage, Presented to Stanley Robinson*, ed. C. M. Kraay and G. K. Jenkins (Oxford 1968) 111–24, both reprinted in Fittschen, *Griechische Porträts*, 279–85, 337–50. See also in general G. Le Rider, *La naissance de la monnaie: Pratiques monétaires de l'Orient ancien* (Paris 2001) 207–37; P. Debord, *L'Asie Mineure au IVe siècle (412–323 a.C.): Pouvoirs et jeux politiques* (Bordeaux 1999) 50–65; J. Borchhardt, "Die Bedeutung der lykischen Königshöfe für die Enstehung des Porträts," in von Steuben, *Antike Porträts* (note 199 above) 53–84.

[236] See chap. 2, p. 38, note 126 above, for bibliography.

(**Figs. 283, 284**), which contrast with the idealized heads of Alexander (**Fig. 285**) with their leonine *anastolē*, Heraklean brow, upturned glance, etc., as discussed in the pseudo-Aristotelian *Physiognomics*.[237]

One point needs to be stressed: the heads just discussed once belonged to statues before they were excerpted to become herms. The body types must have contributed greatly to the individual characterization of the figures, as comparison of the statues of Aischines in Naples and Demosthenes in Copenhagen and the Vatican reveals. Antisthenes apparently linked style of speaking and manner of dress with character (see p. 282 above), and Xenophon specifically has Sokrates, on his visit to the workshop of Parrhasios, mention stance as a signal characteristic of the character of a figure (*Memorabilia* 3.10.5). Indeed, stance was recognized as an important part of the convincing delivery of speeches.[238] In addition, some statues had more or less lengthy inscriptions and even subsidiary reliefs, for example, the Poulydamas base at Olympia (**Fig. 95**) or the statue and base of the hipparch Simon mentioned by Xenophon (*On the Art of Horsemanship* 1.1).[239] Pausanias (1.2.4) mentions a host of other statues "of such as had some title to fame, both men and women" (ὅσοις τι ὑπῆρχεν ἐς δόξαν) along his way from the Pompeion to the Agora but does not stop to comment on any of them. As we have seen earlier, Pausanias was not an indiscriminate recorder of everything there was to see,[240] and the importance or function of many commemorative statues must have been limited. I wonder if the profusion of statues in a city became a sign of prestige rather than primarily religious reverence or particular political pride. In the case of Demosthenes' statue in the Agora, his fame as an orator and freedom fighter obviously endured. One could plausibly imagine the Athenian Agora and many other public spaces in Pausanias's day looking something like the Vatican Museums, with renowned works standing among a welter of indifferent sculptures. And, just as today, even the well-schooled visitor had to read labels to make sense of the vast majority of sculptures.

<p style="text-align:center">* * *</p>

On contemplating the art of the fourth century, three salient points stand out: first, there is a sense of relaxed banality in diorama-like scenes; and, second, there is an implicit sense of motion—but not explicit, dramatic motion—that reappears only in the next century. Both characteristics contrast with a staid formality and a sense of frozen eternity in the statues of the High Classical style of the fifth century. Both of these qualities of the High Classic gradually evaporate in the course of the last two or three decades of the fifth century, a development basically synonymous with the Rich Style. The third and perhaps most important characteristic of the art of the fourth century is its recognition of style as a tool to convey and nuance content. This includes the exploration of individuality, since

[237] Paris, Louvre Ma 436 (Azara Herm): Richter, *Portraits*, vol. 3, 255, no. 1a, figs. 1733–35; T. Hölscher, *Ideal und Wirklichkeit in den Bildnissen Alexanders des Grossen*, AbhHeid, Jahrg. 1971, Abh. 2 (Heidelberg 1971).

[238] W. W. Fortenbaugh, "Theophrastus on Delivery," in *Theophrastus of Eresus: On His Life and Work*, ed. W. W. Fortenbaugh et al. (New Brunswick, NJ, 1985) 269–88. See also Zanker, *Maske des Sokrates* (note 188 above) 52–55, and Dillon, *Portrait Sculpture* (note 173 above) 61–62, on the exchange of Aischines and Demosthenes on the statue of Solon on Salamis and the proper stance for addressing the public.

[239] This may be the same monument mentioned by Pliny, *NH* 34.76, where he speaks of *equitem Simonem*, whereas Xenophon's text reads ἵππον χαλκοῦν ἀνέθεκε. See T. Hölscher, "Die Aufstellung des Perikles-Bildnisses und ihre Bedeutung," in *Festschrift für Ernst Siegmann zum 60. Geburtstag*, ed. J. Latacz (Würzburg 1975) (= *WürzJbb* 1 [1975]) 193–94, repr. in Fittschen, *Griechische Porträts*, 381–82; Krumeich, *Bildnisse griechischer Herrscher* (note 180 above) 144–46.

[240] See chap. 3, pp. 83–85 above.

it is here that the purpose of the development of the naturalistic image becomes clear. As pointed out above, the number of iconographic types in the Archaic period far exceeds those of the Classical and Late Classical periods. The iconographic type as a formula for diversity has not totally disappeared but has been transformed by the tool of naturalism to depict a wide variety of human character, the explicit interest in which is more than amply underscored by the treatise of Theophrastos. But, as we have just seen, the diversity manifests itself within broadly defined types, and these are the naturalistic successors of the archaic iconographic types. Admittedly, the types are not so explicit that we can claim to recognize with certainty the group to which every portrait head may belong, though there are frequently distinctions in the fourth-century and later portraits that strongly suggest broad types, such as intellectual or man of action. Each type, of course, is varied to produce a sense of an individual with an inner life that is not precisely the same for all members of the type. But in general one can claim that it is possible to distinguish a portrait head from other classes of monument. This is obviously a subtle distinction on occasion but not terribly different from the more or less automatic distinction that can be made between votive and funerary reliefs.

Perhaps the most important conclusion from the investigation of Greek portraits of the fourth century is that the preserved evidence indicates that portraits belong within the mainstream of the art of the period. As both Sheila Dillon and Othmar Jaeggi have emphasized, the purpose of Greek portraits is to convey character,[241] and this is a fair summation of the aims of all classes of Greek art in the fourth century. We must next investigate whether this aim was consciously recognized in the fourth century by examining whether the monuments correspond by and large with the rather frequent contemporary textual commentaries.

[241] Dillon, *Portrait Sculpture* (note 173 above) 10–11; Jaeggi, *Griechischen Porträts* (note 167 above) 61–65.

8 Reception

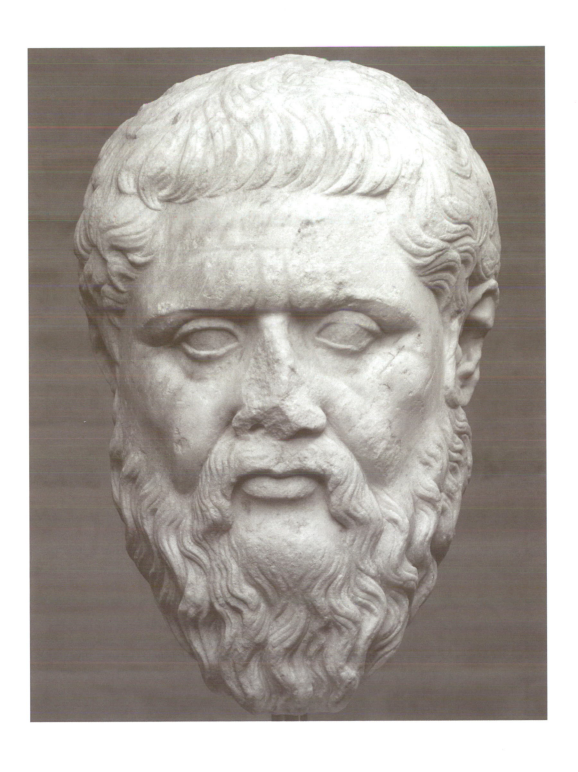

The previous chapters have sketched the extraordinary range and diversity of the art of the fourth century, but it remains to examine the manner in which images were experienced. The writer who most frequently discusses images and their qualities is Plato. The often extreme antagonism of scholars in the twentieth century to Plato's views on art contrasts dramatically with the attitude of poets in the eighteenth and nineteenth centuries.[1] Recently the current orthodox criticism of Plato as a philistine has begun to crack, and suggestions are being made that he actually makes some positive contribution to the discussion of art.[2] For my purposes, Plato's arguments over the validity of poetry, music, and the plastic arts are not of central importance because his observations, taken without his ironic and mildly antagonistic manner, demonstrate more clearly than any other source the accomplishments and expectations of the plastic arts in the first half of the fourth century (he died in 347). For the most part, there is little to surprise in the observations Plato makes on the plastic arts: in sculpture, proportions are varied to adjust to particular angles from which an object will be seen, particularly large statues or those set high up (*Sophist* 235e–236c);[3] painters vary colors according to light and shade and apply paint so that forms may appear solid from a distance but evaporate on close inspection (*Theaitetos* 208e); figures at a distance appear smaller than objects close at hand (*Philebos* 41e–42a; *Protagoras* 356c; *Republic* 602c); water distorts forms (*Republic* 602c). These observations all correspond almost exactly with the evidence of sculpture and painting in the fourth century, as discussed above.

In addition, Plato mentions on various occasions qualities that are highly regarded in images, though, as usual, he depreciates them. In *Phaidon* 100c–d he states: "If anyone tells me that what makes a thing beautiful is its lovely color, or its shape or anything else of the sort, I let all that go, for all those things confuse me. . . ." (ἀλλ᾽ ἐάν τίς μοι λέγῃ δι᾽

[1] R. Jenkyns, *The Victorians and Ancient Greece* (Cambridge, MA, 1980) 227–63 (chap. 10, "Plato"); J. E. Hogle, *Shelley's Progress: Radical Transference and the Development of His Major Works* (Oxford 1988) 266–68. The eulogy of Plato's aesthetics by Walter Pater succinctly conveys the attitude of his predecessors just as it was changing: W. Pater, *Plato and Platonism: A Series of Lectures*, 4th ed. (London 1893; repr. 1925) 267–83.

[2] The earliest protest is R. G. Collingwood, "Plato's Philosophy of Art," *Mind* 34 (1925) 154–72; and Collingwood, *Principles of Art* (Oxford 1938; repr. 1958) 46–52, which had no sequel until G. Sörbom, *Mimesis and Art: Studies in the Origin and Early Development of an Aesthetic Vocabulary* (Uppsala 1966) 106–16; Rouveret, *Histoire et imaginaire*, 117; W. Childs, "Platon, les images et l'art grec du IVe siècle avant J.-C.," *RA*, 1994, 33–56; C. Janaway, *Images of Excellence: Plato's Critique of the Arts* (Oxford 1995); W. G. Leszl, "Plato's Attitude to Poetry and the Fine Arts and the Origins of Aesthetics," *Études platoniciennes* 1 (2004) 113–97. See most recently the broad treatment of the appreciation of "art" in antiquity by M. Muller-Dufeu, *Créer du vivant: Sculpteurs et artistes dans l'antiquité grecque* (Villeneuve-d'Ascq 2011).

[3] Ridgway, *Fourth-Century Styles*, 132, suggests that the proportions of the woman on the slab of the Centauromachy frieze of the Maussolleion in the British Museum (1032) may be elongated because of its probable location high on the monument, under the chariot at its peak: Cook, *Relief Sculpture of the Mausoleum*, pl. 24, no. 182. See also generally L. A. Schneider, *Asymmetrie griechischer Köpfe vom 5. Jh. bis zum Hellenismus* (Wiesbaden 1973).

ὅτι καλόν ἐστιν ὁτιοῦν, ἢ χρῶμα εὐανθὲς ἔχον ἢ σχῆμα ἢ ἄλλο ὁτιοῦν τῶν τοιούτων, τὰ μὲν ἄλλα χαίρειν ἐῶ, ταράττομαι γὰρ ἐν τοῖς ἄλλοις πᾶσι. . . .). In *Phaidros* 251a he notes that there can be a strong physical reaction to seeing beauty which enters through the eyes. Finally, in *Hippias Major* (297e–298a) we read "[H]ow would it help us towards our goal if we were to say that that is beautiful which makes us feel joy; I do not mean all pleasures, but that which makes us feel joy through hearing and sight? For surely beautiful human beings, Hippias, and all decorations and paintings and works of sculpture which are beautiful, delight us when we see them."[4]

But Plato makes three further points about images that address more precisely how images were or could be experienced. On the one hand, Plato emphasizes over and over again the deceptive quality of images, which simply means that images were experienced as marvelously realistic. The clearest statement of this comes in the *Kratylos* (432b–c), in which Sokrates asks about the nature of an image of Kratylos that is the equivalent of its model: there would then not be an image and original, but two originals. Most telling in this regard is the observation in *Phaidros* (261e–262b) that deception is best achieved by the closest similarity between the real and the simulacrum. Finally, in *Sophist* (233d–234b) and *Republic* (10.596d–e) he questions the validity of someone who claims "by virtue of a single art to make all things." Plato returns to the issue of accuracy and recognizability on several occasions, which reinforces the strong feeling that his contemporaries demanded these qualities.[5] This is also indicated by the anecdote of the contest between Zeuxis and Parrhasios to create the ultimately illusionistic work, which Parrhasios wins because he dupes Zeuxis,[6] and by the two women in Herodas's fourth mime who comment repeatedly on the realism of the statues and painting they see in the sanctuary of Asklepios on Kos at the beginning of the third century.

It is clear that the relationship between the image and the object represented is of great importance, and this has been the focus of a vast literature that attempts to clarify what Plato and other classical writers mean by the word μίμησις (*mimēsis* or imitation).[7] For my purposes, however, the issue of greater importance is to investigate what Plato and his colleagues understood to be the manner in which images function. For example, a telling and complex issue is raised by Plato in *Phaidon* (73d–e), in which he examines the associative quality of objects and images:

> "Then do we agree to this also, that when knowledge comes in such a way, it is recollection? What I mean is this: If a man, when he has heard or seen or in any other way perceived a thing, knows not only that thing, but also has a perception of some other thing, the knowledge of which is not the same, but different, are we not right in saying that he recollects the thing of which he has the perception?"
>
> "What do you mean?"

[4] . . . εἰ ὃ ἂν χαίρειν ἡμᾶς ποιῇ, μήτι πάσας τὰς ἡδονάς, ἀλλ᾿ ὃ ἂν διὰ τῆς ἀκοῆς καὶ τῆς ὄψεως, τοῦτο φαῖμεν εἶναι καλόν, πῶς τι ἄρ᾿ ἂν ἀγωνιζοίμεθα; οἵ τέ γέ που καλοὶ ἄνθρωποι, ὦ Ἱππία, καὶ τὰ ποικίλματα πάντα καὶ τὰ ζωγραφήματα καὶ τὰ πλάσματα τέρπει ἡμᾶς ὁρῶντας, ἃ ἂν καλὰ ᾖ. The translation is by F. N. Fowler (Loeb edition). See also *Gorgias* 474d.

[5] See also *Republic* 2.377e, 6.484d; *Kritias* 107b–d.

[6] Pliny, *NH* 35.65; P.-M. Schuhl, *Platon et l'art de son temps (arts plastiques)* (Paris 1952) 86–87; V. L. Brüschweiler-Mooser, *Ausgewählte Künstleranekdoten: Eine Quellenuntersuchung* (Bern 1969) 90–99; Gschwantler, *Zeuxis und Parrhasios*, 133–35.

[7] For a full review of the issue, see most recently S. Halliwell, *The Aesthetics of Mimesis: Ancient Texts and Modern Problems* (Princeton 2002).

"Let me give an example. Knowledge of a man is different from knowledge of a lyre."

"Of course."

"Well, you know that a lover, when he sees a lyre or a cloak or anything else which his beloved is wont to use, perceives the lyre and in his mind receives an image of the boy to whom the lyre belongs, do you not? But this is recollection, just as when one sees Simmias, one often remembers Cebes, and I could cite countless such examples."

"To be sure you could," said Simmias.

"Now," said he, "is that sort of thing a kind of recollection? Especially when it takes place with regard to things which have already been forgotten through time and inattention?"

"Certainly," he replied.

"Well, then," said Socrates, "can a person on seeing a picture of a horse or of a lyre be reminded of a man, or on seeing a picture of Simmias be reminded of Cebes?"

"Surely."

"And on seeing a picture of Simmias he can be reminded of Simmias himself?"

"Yes," said he.

"All these examples show, then, that recollection is caused by like things and also by unlike things, do they not?" (Trans. H. N. Fowler, Loeb edition)

This issue of recollection has a specific function in Plato's theory of knowledge but is obviously closely related to the function of images in general. Equally, Plato notes that people have mental images. In *Republic* (6.484d) he speaks of a mental image of perfection that the craftsman tries to emulate. In *Philebos* (39b–c) the issue is generalized:

When a man receives from sight or some other sense the opinions and utterances of the moment and afterward beholds in his own mind the images of those opinions and utterances.

Ὅταν ἀπ' ὄψεως ἤ τινος ἄλλης αἰσθήσεως τὰ τότε δοξαζόμενα καὶ λεγόμενα ἀπαγαγών τις τὰς τῶν δοξασθέντων καὶ λεχθέντων εἰκόνας ἐν αὑτῷ ὁρᾷ πως.

For the first time that we know of, Plato clearly elaborates a complex understanding of the manner in which people objectify and process images.[8] To his horror, perhaps, there are intimations of his views in Gorgias's *Defense of Helen* (16–17), where Gorgias touches on the power of sight and the resulting mental image (§ 17.20–22):[9]

In this way the sight engraves upon the mind images of things which have been seen. And many frightening impressions linger, and what lingers is exactly analogous to <what is> spoken. (Trans G. Kennedy)

One further point Plato raises is not new with him but derives from a critical tradition of great age: images are silent and cannot respond to being questioned (*Phaidros* 275d).[10] Given Plato's fundamental inquiry into epistemology and ethics, his expressed

[8] E. E. Pender, "Plato on Metaphors and Models," in *Metaphor, Allegory, and the Classical Tradition: Ancient Thought and Modern Revisions*, ed. G. R. Boys-Stones (Oxford 2003) 55–81, discusses the role of *eikon* and *paradeigma* in Plato, with similar conclusions.

[9] Diels-Kranz, *Vorsokr.*, 82 B 11; the translation is from R. K. Sprague, ed., *The Older Sophists* (Columbia, SC, 1972) 54, commented on by Worman, *Cast of Character*, 164–65.

[10] Steiner, *Images in Mind*, 140–43; Ford, *Origins of Criticism*, 98–99, 119–30. A roughly contemporary statement is Alkidamas, *On the Writers of Written Discourses or On the Sophists* 27–28.

opinions on the plastic arts are mostly critical and often hilarious—since one can imagine the violent reaction of his artistically inclined audience or reader—and at times he can be somewhat tedious. But his observations do instruct us on what was expected of images by his contemporaries.

Although a sensitive tabulation of Plato's comments on the plastic arts may not produce a tightly reasoned philosophy of art, it is nonetheless evident that the plastic arts were a topic of discussion among the intellectuals of Late Classical Athens.[11] Another Athenian who does not qualify as a certified aesthete is Xenophon, yet he too provides a valuable insight into the manner in which the plastic arts were experienced in the first half of the fourth century. Of particular importance is Xenophon's treatment of the relationship between appearance and character in his account of Sokrates' visit to the workshop of Parrhasios, where Sokrates remarks that the character (τῆς ψυχῆς ἦθος; *Memorabilia* 3.10.3) or emotion of a person is "reflected in the face and in the stance whether still or in motion" (3.10.5).[12] The quality of aliveness as a complement to character that is emphasized in Sokrates' discussion with the sculptor Kleiton (3.10.6) begins to describe the expectations of a viewer of representations in the fourth century.[13] A third discussion, with the armorer Pistias, reaches the conclusion (3.10.11) that a breastplate that is good fits well and is well-proportioned (ὁ ἁρμόττων γάρ ἐστιν εὔρυθμος). Sokrates points out that these are not absolute qualities but are relative to the user or wearer (3.10.13–15). The fourth and final discussion is with the *hetaira* Theodote, which is longer than the three preceding accounts and occupies all of section 11 of book 3.[14] We learn that Theodote is the model for a painter and that she is evidently wealthy, though she owns no property. It is difficult not to compare Theodote to the badly-fitting but good-looking breastplate that Pistias and Sokrates disparage at 3.10.14. But we learn that Theodote's success is not based just on her intrinsic beauty but also, or primarily, on her manner of dealing with her "friends." This is her soul (3.11.10). So the series of discussions sets out a very clear proposition of what is important in an image (we must remember that Theodote is a favored model for painters [3.11.1]): an image must express character through expression and stance; it must appear alive; it must be appropriate to its function and not just decorative; it must be beautiful and have a good soul. If these encounters of Sokrates do indeed reflect what educated people might have considered important elements of images in the early fourth century, the idea of images functioning beyond prescribed religious, social, and political spheres is clearly in the air. It is also no coincidence that the characteristics cited by Xenophon in a positive manner are also those cited by Plato in his, to me, ironic and confrontational manner.

The third principal writer on the plastic arts in the fourth century is Aristotle. Like Plato, he uses the plastic arts as analogies for various philosophical expositions, but he also makes more focused statements on how he conceives the plastic arts to function. Basi-

[11] S. Halliwell, "Plato and Painting," in *Word and Image in Ancient Greece*, ed. N. K. Rutter and B. A. Sparkes (Edinburgh 2000) 99–116.

[12] F. Preisshofen, "Sokrates im Gespräch mit Parrhasios und Kleiton," in *Studia Platonica: Festschrift für Hermann Gundert zu seinem 65. Geburtstag am 30.4.1974*, ed. K. Döring and W. Kullmann (Amsterdam 1974) 21–40; Gschwantler, *Zeuxis und Parrhasios*, 83–92. Stance was recognized as an important component of rhetoric: W. W. Fortenbaugh, "Theophrastus on Delivery," in *Theophrastus of Eresus: On His Life and Work*, ed. W. W. Fortenbaugh et al. (New Brunswick, NJ, 1985) 269–88.

[13] Stewart, *Greek Sculpture*, 83, followed by D. T. Benediktson, *Literature and the Visual Arts in Ancient Greece and Rome* (Norman, OK, 2000) 67–68, makes a qualitative distinction between painting and sculpture on the basis of this passage, which I find unjustified.

[14] S. Goldhill, "The Seductions of the Gaze: Socrates and His Girlfriends," in *Kosmos: Essays in Order, Conflict and Community in Classical Athens*, ed. P. Cartledge (Cambridge 1998) 113–24.

cally, Aristotle is quite tolerant and even in favor of the plastic arts and poetry. He rather stuns us when he writes in *Poetics* (4.1448b):

> To imitate (μιμεῖσθαι) is innate to people from childhood and differentiates us from the other animals as the most imitative, and our first learning is made through imitation, and everyone takes pleasure in imitations. A conclusive indication of this is that those things we see with discomfort, we enjoy seeing most accurate images of, such as the most awful animals or corpses. The reason for this is that it is not only agreeable for philosophers to learn but for others also, though they share little in it. For this reason they take pleasure in looking at pictures, because they learn by looking and puzzle out something, such as this is that person.

Although everyone in the fourth century, including Plato, would agree that learning comes through the senses and primarily through sight, Aristotle's position is more straightforward and, in a closely parallel passage in *Rhetoric* (1.11.23), includes the plastic arts and poetry as sources of learning:

> And since learning and admiring are pleasant, all things connected with them must also be pleasant; for instance, a work of imitation, such as painting, sculpture, poetry, and all that is well imitated (πᾶν ὅ ἄν εὖ μεμιμημένον), even if the object of imitation is not pleasant; for it is not this that causes pleasure or the reverse, but the inference that the imitation and the object imitated are identical (ἀλλὰ συλλογισμός ἐστιν ὅτι τοῦτο ἐκεῖνο), so that the result is that we learn something. The same may be said of sudden changes and narrow escapes from danger; for all these things excite wonder. (Trans. J. H. Freese, Loeb edition)

Gerald Else and others have argued that the learning of the passage in *Poetics* concerns universal realities, while Andrew Ford proposes that the learning is about the structure of poetics.[15] Curiously, neither cites the parallel passage in *Rhetoric*. Whatever the case, Aristotle's proposition is based not only on the philosopher's response but equally on common experience, and his view is far less exclusive than Plato's. Nonetheless, Aristotle does not mention the appearance of the images except in the *Rhetoric*, where he uses the phrase "all that is well imitated," suggesting purely an evaluation of craft, which, we shall see, is certainly the manner in which Aristotle meant the phrase to be read.

Aesthetic appreciation in Aristotle is no more evident than it is in Plato's observations on images, though, whereas Plato's pronouncements tend to be somewhat haphazard and sometimes contradictory, Aristotle is true to his reputation as the ultimate systematizer. Andrew Ford even argues that Isokrates' and Aristotle's classification of literary genres served as a major impetus to the recognition of the importance of style in the quality of a work, that is, that style can be distinguished from content in the effect and effectiveness of an oral or written composition.[16] The emphasis that both Plato and Aristotle put on the appropriateness of presentation to the subject involved amounts to much the same thing. Indeed, the dispute between the authors of written texts (Isokrates) and the supporters of extemporaneous speaking (Alkidamas) hinges purely on the style of presentation.[17] In

[15] G. Else, *Aristotle's Poetics: The Argument* (Cambridge, MA, 1963) 128–32; Benediktson, *Literature and the Visual Arts* (note 13 above) 70–72; Ford, *Origins of Criticism*, 266–69.

[16] Ford, *Origins of Criticism*, 250–71; see also, in a slightly different vein, Preisshofen, "Sokrates im Gespräch" (note 12 above) 39.

[17] N. O'Sullivan, *Alcidamas, Aristophanes, and the Beginnings of Greek Stylistic Theory*, Hermes Einzelschriften 60 (Stuttgart 1992) 23–62.

terms of physical appearance, the same disjunction is first raised by Euripides, who often expresses the wish that a person's appearance might reflect their character.[18] The fact that character in an ethical sense was considered to have a physiological manifestation was apparently maintained by Antisthenes around the turn of the fifth to the fourth century[19] and is explicit in the earlier descriptions of vice and virtue in Prodikos's tale of Herakles at the crossroads, as related by Xenophon (*Memorabilia* 2.1.20–34).[20] In the fourth century, however, the situation is clearly different. Isokrates appears to make a distinction between character and physical appearance at the end of his encomium on Evagoras (73–76), where he makes a sharp contrast between the mere physical beauty of a statue of a king and the more profound assessment of the king through his writing, and Aristotle makes clear the distinction of character and appearance as different things,[21] which indicates that the old association of beautiful body and noble character (*kalos k'agathos*) was dead.

Aristotle's great interest in the definition of style is the central point of his contribution to our understanding of how images may have been experienced in the fourth century. Like Plato, he criticizes elaborate spectacle (*Poetics* 26.1461b–1462a)[22] and emphasizes the need for appropriateness of style and content as well as appropriateness of style to the intended audience (*Rhetoric* 2.13.6, 3.7.1–5).[23] But it is his discussion of expressive techniques that provides the most interesting insight into the world of Late Classical imagery. Metaphor, though not understood in precisely modern terms ("the figure of speech in which a name is transferred to some object to which it is not properly applicable": *OED*), is particularly relevant to my inquiry.[24] At one level Aristotle considers a metaphor a simple transferal of meaning between related words (stand, lie; thousand, many), but he adds a proportional metaphor for which he gives the following example (*Poetics* 21.1457b): "[T]he cup is to Dionysos what the shield is to Ares; one may then speak of the cup as the shield of Dionysos, or of the shield as the cup of Ares." Although not the same as Plato's discussion of an object or image that alludes to something associated with it, Aristotle's metaphor clearly suggests that an object may play a complex role of referring to something other than itself.[25]

A final subject that Aristotle discusses is *phantasia* (φαντασία). The precise meaning, if there is only one, is difficult to grasp, but at least it means unambiguously a mental image similar to the proposition of Plato.[26] The root of *phantasia* is the verb *phaino/phainesthai*, "to appear"; there are a variety of similarly derived words, such as the adjective *phantastikos* and the noun *phantasma*, all of which are at least related to the English words fantastic and fantasy. The principal passage of concern to me here is in *On the Soul*

[18] E.g., *Medea* 519; *Hekuba* 379; *Herakles* 659; *Elektra* 368–69. See Worman, *Cast of Character*, 32–33.

[19] Worman, *Cast of Character*, 33.

[20] See chap. 6, pp. 249, 257 and chap. 7, p. 282 above; Worman, *Cast of Character*, 35–37.

[21] Worman, *Cast of Character*, 33–35.

[22] Janaway, *Images of Excellence* (note 2 above) 53; Worman, *Cast of Character*, 151–54. Plato's views on excessive display are amply expressed in *Ion*. Benediktson, *Literature and the Visual Arts* (note 13 above) 80–81, remarks that the imagery and display of the theater may have been particularly attractive to Aristotle. The issue is therefore not display as such but excessive emphasis on it.

[23] J. Sprute, "Aristotle and the Legitimacy of Rhetoric," in *Aristotle's Rhetoric: Philosophical Essays*, ed. D. J. Furley and A. Nehamas (Princeton 1994) 117–28; D. C. Innes, "Theophrastus and the Theory of Style," in Fortenbaugh et al., *Theophrastus of Eresus* (note 12 above) 254.

[24] A. Laks, "Substitution et connaissance: Une interprétation unitaire (ou presque) de la théorie aristotélicienne de la métaphore," in Furley and Nehamas, *Aristotle's Rhetoric* (note 23 above) 283–305; Innes, "Theophrastus and the Theory of Style" (note 23 above) 252.

[25] In *Rhetoric* 3.2.10 1405a Aristotle again discusses metaphor but with no greater precision than in the *Poetics*, though he includes euphemisms and thereby adds appreciably to the sense of images as points of reference for what is not explicit. See also *Topics* 1, 17 108a.

[26] G. Watson, *Phantasia in Classical Thought* (Galway 1988) 16–37; Rouveret, *Histoire et imaginaire*, 385–92.

(3.3). Aristotle begins by stating that the two special characteristics of the soul are movement in space and "thinking, judging, and perceiving" (νοεῖν, κρίνειν, αἰσθάνεσθαι: 427a 19). Passing from the truth of perception to the possible error of thinking, Aristotle considers *phantasia*, which is often translated "imagination"[27] (427b 16–27):[28]

> [F]or imagination is different from both perception and thought; imagination always implies perception, and is itself implied by judgment. But clearly imagination and judgment are different modes of thought. For the former is an affection which lies in our power whenever we choose (for it is possible to call up mental pictures, as those do who employ images in arranging their ideas under a mnemonic system), but it is not in our power to form opinions as we will; for we must either hold a false opinion or a true one. Again, when we form an opinion that something is threatening or frightening, we are immediately affected by it, and the same is true of our opinion of something that inspires courage; but in imagination we are like spectators looking at something dreadful or encouraging in a picture (ὥσπερ ἂν οἱ θεώμενοι ἐν γραφῇ τὰ δεινὰ ἢ θαρραλέα). Judgment itself, too, has various forms—knowledge, opinion, prudence, and their opposites, but their differences must be the subject of another discussion.[29]

Aristotle goes on to discuss the images people have in dreams and then addresses the nature of such mental images (428a 12–19):

> Nor do we say "I imagine that it is a man" when our sense is functioning accurately with regard to its object, but only when we do not perceive distinctly. And, as we have said before, visions are seen by men even with their eyes shut (φαίνεται καὶ μύουσιν ὁράματα). Nor is imagination any one of the faculties which are always right, such as knowledge or intelligence; for imagination may be false. It remains, then, to consider whether it is opinion; for opinion may be either true or false.

Aristotle concludes that it is not opinion but, like opinion, it can be true or false because interpretation intervenes between perception and cognition.[30]

It is clear from these observations that Aristotle recognizes a high degree of complexity in the function of images, both those created by plastic artists, that is, painting and sculpture, and by the mind, whether in dreams or otherwise. It seems clear to me that he has a highly sophisticated understanding of images, and one might therefore be tempted to suspect that he may have recognized the added value a craftsman could give to an image, something like our modern understanding of what art is. The very beginning of the *Nikomachean Ethics* (1.1.2) encourages this view:

> In some cases the activity of practicing the craft (*technē*) is the end, but in others the end is some product; in those whose ends are things beside the activity, the products are better (βελτίω) than the activity.

[27] M. Schofield, "Aristotle on the Imagination," in *Aristotle on Mind and the Senses: Proceedings of the Seventh Symposium Aristotelicum*, ed. G. E. R. Lloyd and G. E. L. Owen (Cambridge 1978) 99–140.

[28] The two following translations are by W. S. Hett in the Loeb edition.

[29] It need hardly be pointed out that Aristotle is here leaning heavily on Gorgias's *Defense of Helen* 17–18, and even Plato is too.

[30] K. Lycos, "Aristotle and Plato on 'Appearing,'" *Mind* 73 (1964) 496–514; A. Silverman, "Plato on Phantasia," *ClAnt* 10 (1991) 136–37.

The end of medicine, he goes on to point out, is health, of shipbuilding, a ship. Aristotle unfortunately lists only crafts that have little claim to art in any modern sense. And later in the same work (6.7.9–12) he actually denies such value added by sculptors:

> The term wisdom is employed in the arts (*technai*) to denote those men who are the most accomplished masters of their craft (also *technē*), such as Pheidias as a wise sculptor of stone (λιθουργὸν σοφὸν) and Polykleitos as a maker of statues (ἀνδριαντοποιόν), indicating in this sense nothing more than excellence in the craft (*technē*). But we also think that some people are wise in a general and not in a particular sense.

The reasonable interpretation is that a good craftsman is just that and no more; in this respect, Aristotle is little different from Plato.[31] But there seems to be an almost perceptible conscious denial of some greater quality to craft; in the *Rhetoric* (3.2.10), Aristotle says that "some call actors flatterers of Dionysos, while they call themselves *technites*." In the Loeb edition, J. H. Freese translates *technites* as "artists" in quotation marks. This seems correct because Aristotle continues: "Both these names are metaphors, but the one is a term of abuse, the other the contrary." In *Metaphysics* (1.1.3–17), Aristotle examines the difference between experience and "art" (*technē*). He says that the reason for the difference is that "experience is knowledge of particulars," while *technē* concerns itself with the totality or universals. He sums up the long inquiry thus (1.1.17):

> The reason for our present discussion is that it is generally assumed that what is called wisdom (*sophia*) is concerned with the primary causes and principles, so that, as has been already stated, the man of experience is held to be wiser than the mere possessors of any power of sensation, the artist (*technites*) than the man of experience, the master builder than the artisan (χειροτέχνου δὲ ἀρχιτέκτων); and the speculative sciences to be more learned than the productive (αἱ δὲ θεωρητικαὶ τῶν ποιητικῶν μᾶλλον). Thus it is clear that wisdom is knowledge of certain principles and causes. (Trans. H. Tredennick, Loeb edition)

Instead of "master craftsman," Tredennick's translation of the Greek *architektōn*, I have used the more accurate translation "master builder," since the word usually implies the measured work of the builder, rather than the imitative aims of the sculptor or painter. Here the hierarchy is spelled out, clearly awarding greater admiration to the more abstract profession and thus closely related to the famous passage in *Poetics* (9.1451b 5–7) which states that "poetry is more philosophical and more serious than history; poetry deals with general truths, history with particulars."[32] Poets are able to be socially useful and not mere entertainers, and at times plastic artists also seem included in this category, which is clearly what they were laying claim to in the fourth century.

It is obvious that distinctions between types of craftsmen were made. The best-known statement to this effect is the observation of Isokrates in *Antidosis* (310.2) that it would "be bold to call Pheidias, who made our statue of Athena, a coroplast, or to say that Zeuxis and Parrhasios practiced the same profession as the painters of little tablets (*pinakia*)." Isokrates also makes an essential distinction in *Panegyrikos* (§ 40) between the *technai*

[31] B. Schweitzer, "Mimesis und Phantasia," *Philologus* 89 (1934) 291.

[32] διὸ καὶ φιλοσοφώτερον καὶ σπουδαιότερον ποίησις ἱστορίας ἐστίν· ἡ μὲν γὰρ ποίησις μᾶλλον τὰ καθόλου, ἡ δ᾽ ἱστορία τὰ καθ᾽ ἕκαστον λέγει. R. Kannicht, *The Ancient Quarrel between Poetry and Philosophy: Aspects of the Greek Conception of Literature*, Fifth Broadhead Memorial Lecture (Christchurch, New Zealand, 1988) 31–34.

that produce the necessities of life and those that give pleasure.[33] Later (§ 45) he speaks of spectacles highly esteemed with respect to their crafts (θεάματα... τὰ δὲ κατὰ τὰς τέχνας εὐδοκιμοῦντα). So the issue is clearly not that beautiful things—that is, specifically paintings and statues—were not appreciated by Plato, Xenophon, Aristotle, or Isokrates. Indeed, the one astounding aspect of almost all the references to objects in the entire literature of the fourth century is the almost uniform appreciation for the beauty of paintings and statues. On closer inspection, it is equally clear that each writer is always stating that whatever he does not practice, whether written or extemporaneous speeches, philosophical compositions or dialogues, is less admirable than what he does practice. What is astonishing, then, is that painting and sculpture are frequently the real measures of excellence and beauty which the author, whoever it is, sets as a lesser achievement than his own discipline. Quite clearly, every author has to denigrate the plastic arts to demonstrate his own discipline's excellence. My conclusion, therefore, is that the audience of the writers of the fourth century held the inverse opinion.

It may be possible to clarify why the criticism of the plastic arts became a standard motif of fourth-century literature. The issue of the relationship of perception to the physical world had become a frequent topic of the pre-Socratics, and pretty much the whole discussion of perception in the fourth century began from Protagoras's relativistic thesis that "man is the measure of all things."[34] This stated succinctly that each individual had a personal and irrefutable experience of his surroundings.[35] Ernst Cassirer remarked that

> To rational science . . . skepticism is always a purely negative and destructive principle. But it is quite otherwise the moment we turn to the sphere of feeling and of pure value judgments. For all value judgments as such are concerned not with the thing itself and its absolute nature but rather with a certain relation existing between the objects and ourselves as perceiving, feeling, and judging subjects.[36]

Quite obviously, Protagoras had discovered the realm of value judgments that propagated the private, subjective evaluation of experience and particularly visual perception. Not only were the days of the *kalos k'agathos* numbered, but its formal expression in the High Classic's archaic idealism was equally without foundation. The new breed of thinkers who followed in the wake of Protagoras, the sophists, were so thoroughly lampooned by Plato as to turn the name into a blanket term of condemnation. But they were a group of very different types and played an essential role in the Greek enlightenment of the fourth century.[37] The fact that the sophists heavily influenced Euripides is indicative. The wonderful soliloquy of Helen in the *Troades* (914–65) when she is confronted by Menelaos after the fall of Troy is equal in every respect to the *Defense of Helen* by Gorgias of Leontinoi.[38] The fact that Aristophanes, in the *Clouds,* lumps Sokrates together with sophists like Gorgias as purveyors of gobbledygook is instructive, since both are in fact changing the

[33] Aristotle, *Metaphysics* 1.1.15–16, makes the same distinction.

[34] Diels-Kranz, *Vorsokr.*, 80 B 1, cited by Plato, *Theaitetos* 152a: "Man is the measure of all things, of the existence of the things that are and the non-existence of the things that are not."

[35] A. T. Cole, "The Relativism of Protagoras," *YCS* 22 (1972) 19–45.

[36] E. Cassirer, *The Philosophy of the Enlightenment* (Princeton 1951) 306.

[37] J. de Romilly, *The Great Sophists in Periclean Athens*, trans. J. Lloyd (Oxford 1992); R. W. Wallace, "The Sophists in Athens," in *Democracy, Empire, and the Arts in Fifth-Century Athens*, ed. D. Boedeker and K. A. Raaflaub (Cambridge, MA, 1998) 203–22.

[38] Diels-Kranz, *Vorsokr.*, K 82 B 11; L. Radermacher, *Artium Scriptores: Reste der voraristotelischen Rhetorik*, SBWien 227, no. 3 (Vienna 1951) 52–57, no. 39; G. Kennedy, in Sprague, *Older Sophists* (note 9 above) 50–54.

whole discourse about what reality is. Sokrates, according to the image of him that Plato has left us, was intent on establishing new objective assessments of human experience, while Gorgias, like Protagoras, was intent on demonstrating that there is no such thing.[39] Perhaps the most revealing preserved treatise is the *Dissoi Logoi*, generally dated around the year 400.[40] The anonymous author runs through a series of propositions demonstrating that each can be considered good or bad, depending on one's point of view. Although Gorgias and Plato agreed that the senses, particularly sight, are not reliable (what one sees is not necessarily real), they disagreed totally on what to make of this. The fourth century witnesses the struggle between these two opposed points of view and arrives at a compromise in the works of Aristotle and his immediate successors at the end of the century. In the *Metaphysics* (4.4.32–38) he states his position unequivocally:

> If then that which has more the nature of something is nearer to that something, there will be some truth to which the more true is nearer. And even if there is not, still there is now something more certain and true, and we shall be freed from the undiluted doctrine which precludes any mental determination. (Trans. H. Tredennick, Loeb edition)

The development of rhetoric clearly parallels the skepticism of the pre-Socratics; it was encouraged at Athens by the increasing use of law courts to settle all manner of disputes. Speeches by Antiphon, Andokides, and Lysias are preserved. Most interesting is that Antiphon by choice and Lysias because he was a *metic* were *logographers*, word-smiths, that is, they did not deliver their speeches themselves but wrote them to be delivered by their clients. A novel twist to the composition of speeches for others to deliver was Isokrates' practice of writing treatises as speeches that were never intended to be delivered but rather circulated as manuscripts to be read. But the central development was the art of rhetoric that appears to have begun in the learned circles outside of Athens and to have been imported there in the second half of the fifth century.[41] The novelty was not the development of the genre of convincing speeches but the systematization, that is, the conscious objectification, of the principles of convincing speech.[42] Implicit in the need for convincing speech, of course, is the idea that what is said is not obvious, indeed may be the opposite of obvious or may even be untrue.[43] Lysias, in the defense of Euphiletos for the murder of Eratosthenes, tries hard to suggest that what seems damning premeditation was mere chance. The important issue is twofold: rhetoric systematizes what had previously been common property, and rhetoric introduces the relativization of experience. For my purposes here, rhetoric and sophistry amount to the same thing, to which Plato (*Gorgias* 520a) agrees.

The very multiplicity of styles that spring up in the late fifth century is precisely a product of the subjectivity of experience and therefore reflects the discovery of varied

[39] Diels-Kranz, *Vorsokr.*, 82 B1, 3; Kennedy, in Sprague, *Older Sophists* (note 9 above) 42–46. S. Consigny, *Gorgias: Sophist and Artist* (Columbia, SC, 2001) 89–92, concludes that Gorgias is not backing a purely individual assessment of truth but truth established by a community.

[40] Diels-Kranz, *Vorsokr.*, 90; T. M. Robinson, *Contrasting Arguments: An Edition of the Dissoi Logoi* (New York 1979); Sprague, in *Older Sophists* (note 9 above) 279–93.

[41] W. K. C. Guthrie, *A History of Greek Philosophy*, vol. 3, *The Fifth-Century Enlightenment* (Cambridge 1969) 178–81; T. Cole, *The Origins of Rhetoric in Ancient Greece* (Baltimore 1991); H. Yunis, "The Constraints of Democracy and the Rise of the Art of Rhetoric," in Boedeker and Raaflaub, *Democracy, Empire, and the Arts* (note 37 above) 223–40.

[42] K. J. Dover, *Lysias and the Corpus Lysiacum*, Sather Classical Lectures 39 (Berkeley 1968) 176–80.

[43] Aristotle, *Rhetoric* 3.1.5–6, expressly addresses this issue. Sprute, "Aristotle and the Legitimacy of Rhetoric" (note 23 above) 123–25. Plato, *Phaidros* 272e, makes the point that a good speech "must aim at probability, paying no attention to truth."

modes of expression. It is almost certainly not an exaggeration to draw a parallel with modern developments of the nineteenth and early twentieth centuries, insofar as the fall of the old monarchies and the weakening of the aristocracy was paralleled by the rise of impressionism and then the welter of late-nineteenth- and early-twentieth-century styles, particularly in painting. It seems to me that what Aristotle is denying the sculptors Pheidias and Polykleitos is exactly what the sculptors and painters of the fourth century were claiming for themselves: the wisdom of insight into the human condition that made their plastic statements every bit the equal competitors of the speeches and treatises of the elite exponents of language. The upstart *banausoi* were demanding to be recognized as artists.

The evidence for this is, first of all, the discovery of style as a concept of expression that could be and was manipulated to create persuasive statements, discourses, and treatises, as described by Andrew Ford.[44] The relationship Antisthenes drew between language, dress, and character is an early example of the explicit recognition of the force of style.[45] A second body of evidence, though difficult to consider authoritative, is the anecdotes recorded by the Roman commentators. A particularly famous anecdote is recorded by Pliny (*NH* 35.81–82) of Apelles' unannounced visit to the studio of Protogenes on Rhodes. Protogenes is not present, but a painting of his stood in the studio; Apelles painted an extremely fine line on the panel and then left. When Protogenes returned, he recognized the line as the mark or, better, the personal style of Apelles. Finally, a third and most persuasive, though totally subjective, argument is provided by the Amazonomachy frieze of the Maussolleion at Halikarnassos (**Figs. 7–10**). Brian Cook has documented the amusing fact that every single block of the preserved frieze has been attributed to each of the four or five sculptors named by Pliny (*NH* 36.30) and Vitruvius (7 praef. 13) as having worked on the monument.[46] Nonetheless, even cursory examination of the frieze slabs in the British Museum indicates that there are different individual styles within a framework of an overriding compositional schema. Since the subject of all the blocks is the same, the differences in style must represent the irrepressible individual styles of the various sculptors. This is in stark contrast to the frieze of the Parthenon, where different hands are detectable, as well as the evolution of style, but detecting such distinctions requires concentrated study of the frieze slabs.[47] It is equally important to note that the first elements of the sculptural decoration of the Parthenon, the metopes, or at least the well-preserved south metopes, display a wide variety of styles which are most reasonably explained as the styles of the different sculptors who were brought together on short notice, probably from several different places, and whose styles were different both because of geographic diversity but also because some of the sculptors were very simply inexperienced, not to say downright mediocre and worse. The individual styles of the sculptors of the Parthenon were quickly brought into harmony so that only the scholarly eye can distinguish their idiosyncrasies.

These last observations are strongly contradicted by the final sculptures completed for the Parthenon, the pediments. As is well known, in the east pediment there are radically contrasting differences between the statues identified by the letters E, F, and G on the left side[48] and the statues K, L, and M on the right.[49] There are two possible explanations of

[44] Ford, *Origins of Criticism*, 229–49.
[45] See chap. 7, p. 282 above.
[46] See chap. 4, p. 115 and chap. 5B, p. 224 above. Vitruvius adds Praxiteles as a fifth member of the group.
[47] E. Homann-Wedeking, "Anonymi am Parthenon," *AM* 76 (1961) 107–14.
[48] Brommer, *Giebel*, pls. 33–41; Boardman, *GS-CP*, fig. 80.2.
[49] Brommer, *Giebel*, pls. 45–49; Boardman, *GS-CP*, fig. 80.3.

this: (1) two sculptors with very different styles were assigned the pediment; (2) the subjects of the two groups of sculptures required two different styles to adequately express their character. Although the first scenario might strike one as preposterous, the building inscriptions of the Temple of Asklepios at Epidauros state that the commission for one half of a pediment was awarded to Hektoridas in year three, and then the other half in year four; an unknown sculptor received the contract for the whole other pediment at one time.[50] However, neither in the case of the Parthenon pediments nor in the case of the temple at Epidauros can a lapse of time be a consideration in the evaluation of style, since we know from the respective building inscriptions that in each case the work was completed in just a few years. Given the earlier homogenization of the style of the very diverse sculptors of the Parthenon metopes, the only logical explanation of the different styles of the east pediment is that they express the different content or character of the figures depicted. Indeed, E, F, and G are usually identified as Demeter, Persephone, and perhaps Artemis, while K, L, and M are usually identified as perhaps Hestia, Dione, and Aphrodite.[51]

It is quite clear from the issues cited by Plato, Xenophon, and Aristotle that if images are to function as they describe, a significant degree of interpretation on the part of the viewer is required. This is particularly true of painting, especially if it uses "impressionist" technique, but it is equally true of sculptural distortions. This emphasis on the role of the viewer as interpreter of images is not totally new, though the nature of the interpretation has changed. Previously, a set type with set gestures and set props allowed an unambiguous identification of subject, and interpretation was confined to nuanced meaning. But context and process were normally not indicated. In the fourth century, almost everything is different: figures exist in contexts and particular situations. This is in part what Lysippos may have meant if he ever actually uttered the comment recorded by Pliny (NH 34.65) that "whereas his predecessors had made men as they really were, he made them as they appeared to be." "Appearance" is clearly not simply the external form but also the inner life or character; the art of the fourth century aims to render appearances that suggest the complex spatial and temporal nature of a figure, a comprehensive aliveness of the human subject. Again, nothing fundamental has changed in the objective of Greek art from its very beginnings, since "aliveness" was demonstrably the objective of Late Geometric painters and sculptors, as Nikolaus Himmelmann has shown.[52] Only the vocabulary of expression has changed to suit the changing expectations of what constitutes "aliveness."

The principal issue is therefore to determine what representations in the late fifth and fourth centuries actually communicated. The change from the mainstream archaic vocabulary of kore and kouros to figures that relax or act with vigor obviously allows a broader range of physical states in which the human figure is presented. But it is clear that the statues of the fifth century, even when they exhibit dramatic gestures, are frozen, three-dimensional forms that occupy a narrowly defined space, as though enclosed in protective glass cases. The Rich Style adds expressive qualities of clothing to strengthen the impression of movement and to expand the possible range of states. Take, for example, the

[50] IG IV², I, 102, lines 89–90, 111–12, 98–99; Roux, Architecture de l'Argolide, 84–89, 424–32 (translation); Burford, Temple Builders, 54–59, 207, 212–20 (translation).

[51] B. Ashmole, Architect and Sculptor in Classical Greece (London 1972) 111, 115.

[52] N. Himmelmann-Wildschütz, Bemerkungen zur geometrischen Plastik (Berlin 1964); Himmelmann, Erzählung und Figur in der archaischen Kunst, AbhMainz, Jahrg. 1967, no. 2 (Mainz 1967) 73–97; Himmelmann, Über bildende Kunst in der homerischen Gesellschaft, AbhMainz, Jahrg. 1969, no. 7 (Mainz 1969) 177–223. The last two are translated into English as "Narrative and Figure in Archaic Art," and "The Plastic Arts in Homeric Society," in Himmelmann, Reading Greek Art, 67–102 (trans. H. A. Shapiro) and 25–66 (trans. W. Childs).

sandal-binding Nike of the parapet reliefs of the Temple of Athena Nike on the Athenian Acropolis, whose nervous, unstable balance goes well beyond simple ponderation as it had been developed in the Early and High Classical styles (**Fig. 160**). This is a new state, since the warrior falling backward on the east pediment of the Temple of Aphaia on Aigina[53] is merely falling, that is, he presents a simple graphic pattern of motion, much like the Zeus from Cape Artemision[54] or the Diskobolos of Myron.[55] These are all graphic patterns, not approximations, of real motion: the sandal-binding Nike is unstable—she is caught in a balance with unresolved future, and the gesture/stance is not immediately interpreted as essential to her character. The use of linear patterns of drapery also helps depict the special state of swooning in the figures of the Bassai frieze (**Figs. 23, 24**). Process is an integral element of the subject. But drapery is clearly an unsatisfactory tool for all but a few situations, and the forms of the Rich Style were at times highly artificial. If, as suggested above, the nervous drapery patterns on grave reliefs were intended to suggest the aliveness of the figures depicted (**Fig. 185**), particularly the deceased, the effect is hardly successful, particularly in comparison to such pictorial epiphanies as the Ilissos stele (**Fig. 132**). The introduction of the Plain Style was clearly in direct opposition to the excesses of the preceding period. But does the Plain Style expand the expressive possibilities of art, or is it just a reaction against excess? Certainly one must be impressed by the naturalism of drapery throughout the new style, though, as pointed out above, it can tend to an expressive opulence, as in the case of the "Artemisia" of the Maussolleion at Halikarnassos (**Fig. 5**) and several other related statues. But it is the allusion to context and the suggestion of temporal process that utterly change the nature of images in the period of the Plain Style.

How are allusion and implication expressed? Gesture and stance certainly play major roles, but the decisive element is the temporal moment of the subject chosen. The gestures of the Knidia suggest certain responses, as does her stance (**Fig. 147**). It seems to me that the interpretation that she is reacting defensively to the intrusion of the viewer is based on modern sensitivities, since a natural reaction of the ancient viewer must have been awe and even fear at the repercussions of seeing Aphrodite at her bath.[56] Indeed, the whole idea of a divine image is totally negated by the slightly perverse modern response. The fact that Aphrodite does not notice the viewer is a great relief; her gestures reinforce the peaceful character of the scene. But the critical element of the statue is the moment chosen: Aphrodite bends forward and, even in her tight niche in the Vatican's Gabinetto delle Maschere, appears to move forward. Her proper left leg is bent at the knee, not in the symbolic Polykleitan motif of potential motion but in real forward motion, as she prepares, I surmise, to crouch by the basin which is integral to bathing scenes on vases of the Classical period.[57] Aphrodite prepares to bathe; she does not bathe; the reason for bathing is not indicated, so the sequel appears indeterminate to the modern viewer. But in fact the sequel is rather tightly circumscribed—bathing is an act of purification, normally prior

[53] D. Ohly, *Die Aegineten: Die Marmorskulpturen des Tempels der Aphaia auf Aegina; Ein Katalog der Glyptothek München*, vol. 1, *Die Ostgiebelgruppe* (Munich 1976) pl. 19; B. S. Ridgway, *The Severe Style in Greek Sculpture* (Princeton 1970) fig. 8.

[54] Boardman, *GS-CP*, fig. 35.

[55] Boardman, *GS-CP*, fig. 60.

[56] Scheer, *Gottheit*, 96–108, investigates the relationship of statue to divinity; the statue is at the same time a divinity and only a statue; religious reverence and reality are clearly distinguished and not considered mutually exclusive. For example, Plato, *Laws* 11.930e–931a, observes that "some of the gods whom we honor we see clearly, but of others we set up statues as images, and we believe that when we worship these, lifeless though they be, the living gods beyond feel great good-will towards us and gratitude" (trans. R. G. Bury, Loeb edition).

[57] See chap. 6, p. 234 above, and **Fig. 251**.

to rituals, of which marriage and intercourse are important ones for women and Aphrodite par excellence, as described in the *Homeric Hymn to Aphrodite* (V.61–63).[58] The same observations pertain to the Resting Satyr type (**Fig. 180**). Here the pose is static, and the lack of any identifiable gesture defines his state of rest. Yet his rest is a strong statement of his prior and future actions, since he is a satyr. In both cases, though, it is the allusion to a context and a non-depicted narrative that constitutes the real thrust of the statues: Aphrodite is surrounded by her attendants, who bathe and oil her; the satyr is in the woods with frolicking companions and probably mainads or nymphs. Although not quite as obvious to the modern viewer, the apoxyomenoi (**Figs. 71, 150**) and oil-pourers (**Figs. 124, 126**) also bring vividly to the mind of the viewer the noise and smell of the palaestra and only allude to athletic victory through the logical fact that a statue is not raised to a failed athlete.[59]

Martha Weber has objected, arguing that statues of nude youths or young men that do not have some concrete prop to indicate they are victors are generalized statues of athletic excellence.[60] It is true that the statues of Agias and Agelaos of the Daochos Monument at Delphi have carved fillets in their hair (**Figs. 14, 15**), and the bronze victorious youth in the Getty Museum, probably of the early third century, reaches up to the wreath in his hair.[61] It is therefore open to question whether the various Roman statues of athletes without wreaths or fillets were intended to represent specific victorious athletes. Among Roman copies, this category is very large and includes all of the most famous examples, such as Myron's Diskobolos, the diskobolos attributed to Naukydes (**Fig. 172**), the runners in the Conservatori, the Vatican Apoxyomenos (**Figs. 150–53**), the Ephesos-Vienna strigil-cleaner (**Figs. 71, 72**), etc. The first three of these are, of course, depicted in action and have theoretically not yet triumphed, though this is probably a misleading modern demand for consistency that is so rarely central in ancient art. On Attic grave stelai, nude youths holding a strigil only very rarely have a fillet in their hair or gesture to their heads as though they might be putting on or pointing to a wreath.[62] It remains uncertain, however, whether the Roman statues were copied from generic statues of athletes or were made generic by the copyists. Since all original victor statues have fillets or wreaths, the latter is probable. However, if Weber is correct that statues of athletes such as the Vatican Apoxyomenos (**Fig. 150**) or the Munich Oil-Pourer (**Fig. 124**) were originally generic and were set up as moral and social models for young Greek athletes, it is interesting that banal, intimate moments in the life of the athletes were chosen instead of a specific athletic activity, such as throwing a discus, running, or wrestling. Attic grave stelai only very rarely depict an athletic event or, as we have seen, almost any activity at all except battle and hunt.[63] But if one accepts Weber's thesis, it could be construed as another effect of Athenian democratic distaste for special status; the statues might then be parallels of the

[58] See chap. 6, p. 235 above.

[59] W. H. Gross, *Quas iconicas vocant: Zum Porträtcharakter der Statuen dreimaliger olympischer Sieger*, NAkG, Jahrg. 1969, no. 3 (Göttingen 1969) 69, repr. in Fittschen, *Griechische Porträts*, 365, remarks on the fact that generic post-contest images such as the apoxyomenoi first appear in the late fifth and the fourth century. See Rausa, *Vincitore*, 106, 124, 135, 152, 206, no. 20; Rausa, *AM* 113 (1998) 202, for a list of Pliny's references to apoxyomenoi and statues.

[60] M. Weber, "Zum griechischen Athletenbild: Zum Typus und zur Gattung des Originals der Apoxyomenosstatue im Vatikan," *RM* 103 (1996) 31–49.

[61] J. Frel, *The Getty Bronze*, J. Paul Getty Museum Publication 9 (Malibu, CA, 1978); C. Rolley, *Greek Bronzes*, trans. R. Howell (London 1986) no. 210, fig. 23; Moreno, *Lisippo*, 71–73, no. 4.10.1*; C. C. Mattusch, *The Victorious Youth* (Los Angeles 1997).

[62] Nude youth with strigil and fillet: Clairmont, *CAT*, 1.1081, 1.201, 1.875; gesture to head: *CAT*, 1.825, 1.983.

[63] Chap. 5A, p. 259 above. Other examples of athletes: Clairmont, *CAT*, 1.100 (boxer, pankratiast?), 1.875 (javelin), 1.984 (torch).

generic figures on grave stelai—they represent the social norm since, as in the case of portraits, any deviation represents a special status. But the thesis is not persuasive.

According to preserved inscriptions, some athletic sculptures actually showed the athlete in at least a characteristic pose of the event in which he was victorious, though these tend to belong at the very end of our period and only take real hold in the third century and later.[64] But the phenomenon is not new: the Diskobolos of Myron is in mid-throw; the stele of the pankratiast Agakles of the later fifth century is a rare parallel in funerary reliefs, showing the athlete in action with raised arms;[65] the diskobolos attributed to Naukydes is depicted as he prepares to throw, the composition suggesting the spinning motion and the psychological and physical tension of the victorious athlete (**Fig. 172**).[66] Even the "Praying Youth" (*Betender Knabe*) in Berlin may belong in this series.[67] W. H. Gross makes the extremely enticing suggestion that the statues which represent a specific athletic event were accorded athletes with multiple victories as a sign of their special status, as indicated by Pliny's observation (*NH* 34.16) that the statues of three-time victors "were modeled in the likeness of their limbs (stance), which are called *iconices* (likenesses) (ex membris ipsorum similitudine expressa, quas iconicas vocant)."[68] In all of these examples and many others the effective element of the allusions is the element of time—the moment chosen. In Early Classical statues, the so-called pregnant moment was always one of a critical moment in an action that was central to the theme of the representation. The most characteristic theme of the fourth century is not so much the action pose, of which we have only a few examples before the end of the century, but a moment of private and intimate gesture that is implicit in the real subject but is not the real subject itself: strigil cleaning (**Fig. 71**) is ancillary to athletic victory; dropping one's garment (**Fig. 147**) is ancillary to bathing; leaning on a tree stump (**Fig. 180**) is almost irrelevant to the carousing of satyrs. The Piraeus bronze Athena is one of the most subtle examples (**Figs. 75, 77, 78**): the overfold of her mantle stacked on her upper back suggests, as Karl Schefold proposed, that it covered her head and is falling back after, like a priestess, she has made a sacrifice.[69]

An essential feature of all the statues just mentioned is the moment chosen; each is immensely characteristic while not being central to the action depicted. A frequent observation made in a wide variety of fourth-century commentaries on just about any subject is the importance of *kairos*, the appropriate moment,[70] a concept actually turned into a novel representation by Lysippos that is described in the epigram of Poseidippos

[64] J. Ebert, *Griechische Epigramme auf Sieger an gymnischen und hippischen Agonen*, AbhLeip 63.2 (Berlin 1972) 166–69, 169–72, nos. 55, 56, both dated ca. 300; Bol, *Antretende Diskobol*, 37–40.

[65] Athens, NAM 2004: Kaltsas, *SNAMA*, 152, no. 298; Clairmont, *CAT*, 1.100; O. Tzachou-Alexandri, ed., *Mind and Body: Athletic Contests in Ancient Greece*, exh. cat. (Athens 1989) 335–36, no. 225*.

[66] See chap. 4, pp. 111–12 above.

[67] S. Lehmann, "Der 'Betende Knabe': Zur kunsthistorischen Einordnung und Deutung eines frühhellenistischen Siegerbildes," *ÖJh* 66 (1997) 127, figs. 11, 12, suggests that the statue depicts a young victorious athlete holding up his arms in triumph, and he reconstructs the arms with laced gloves; perhaps the athlete was shown in a position of his contest, as the inscriptions cited above (note 64) state that some lost statues were.

[68] Gross, *Quas iconicas vocant* (note 59 above) 62–76, repr. in Fittschen, *Griechische Porträts*, 359–74. See also S. Vogt, *Aristoteles Werke in deutscher Übersetzung*, vol. 18, *Opuscula*, pt. 6, *Physiognomica*, ed. H. Flashar (Berlin 1999) 60; D. T. Steiner, "Moving Images: Fifth-Century Victory Monuments and the Athlete's Allure," *ClAnt* 17 (1998) 125; Steiner, *Images in Mind*, 229; Himmelmann, *Realistische Themen*, 86.

[69] See chap. 4, p. 129 above.

[70] E. V. Haskins, *Logos and Power in Isocrates and Aristotle* (Columbia, SC, 2004) 66–68. Gorgias appears to have been particularly concerned with *kairos*, which underscores its importance for the artistic developments of the fourth century: Consigny, *Sophist and Artist* (note 39 above) 43–48.

(*Greek Anthology* 16.275) discussed above.[71] Perhaps the most obvious characteristic of the principal statues of the fourth century copied by the Romans is the inconsequential moment described above. The banality or inconsequential aspect of the moment is terribly important because it catches the narrative flow of the subject. The Apollo Sauroktonos (**Fig. 181**) contemplates the lizard in such a manner as to cause modern commentators untold discomfort in trying to explain his stance and gesture. The sculptor has caught the fleeting moment in which an idea is conceived but no motion is yet in process. Plato focuses on just such an issue in *Parmenides* 156d–e: Sokrates tries to pin down the instant (τὸ ἐξαίφνης) between rest and motion. Consider too the Hermes and Dionysos in Olympia (**Fig. 133**): Hermes raises his proper right hand and Dionysos begins to reach for the grapes that Hermes must have held. The moment is in between the idea and the realization of it. This is also true of the Piraeus bronze Athena and its counterpart in Paris (**Figs. 75–79**).

A good and less subjective example of the moment chosen to describe a figure or action is the main scene of the Mantineia base, which depicts Marsyas vigorously playing his flutes while Apollo, seated with his great kithara, looks on (**Fig. 96**). But the most important figure here, almost marking the center axis of the relief block, is the Skythian servant of Apollo who seems to sidle up to Marsyas and tap the fateful knife against his thigh in nervous anticipation. The time chosen is not very precise—Marsyas has not finished his performance; Apollo waits; the Skythian is nervously expectant; the Muses of the other two slabs are mostly idle and unfocused (**Figs. 97, 98**). Eric Csapo and Margaret Miller have emphasized the introduction of linear time in images of the later fifth and fourth centuries.[72] This applies to the current discussion insofar as the images under consideration here, by the choice of a very uncritical or open moment in the temporal unraveling of the event, force the viewer to fill in or create the whole point of the representation: Aphrodite's tryst with Anchises, a satyr's revelry, the death of a reptile, the slaking of a grabby baby's thirst, Marsyas's cruel end. It is precisely the need for the viewer to actively engage with the images of the fourth century that constitutes their real novelty. We have already seen that both Plato and Aristotle are aware of the power of inference,[73] but it is in the account by Demetrios (*On Style* 222) of the observation of Theophrastos that this is made eminently clear.[74] Theophrastos is reported as saying that an orator

> should not elaborate on everything in punctilious detail but should omit some points for the listener to infer and work out for himself. For when he infers what you have omitted, he is not just listening to you but he becomes your witness and reacts more favorably to you. For he is made aware of his own intelligence through you, who have given him the opportunity to be intelligent. To tell your listener every detail as though he were a fool seems to judge him one. (Trans. D. C. Innes, Loeb edition)

The old criticism that statues (and, one must presume, paintings too) were silent and static is utterly negated in these new dynamic compositions that do not rely on simple graphic forms but create whole living dioramas filled with the implied movements and

[71] See chap. 6, p. 256 above.

[72] E. Csapo and M. Miller, "Democracy, Empire, and Art: Toward a Politics of Time and Narrative," in Boedeker and Raaflaub, *Democracy, Empire, and the Arts* (note 37 above) 100–10. See also W. Raeck, "Zur Erzählweise archaischer und klassischer Mythenbilder," *JdI* 99 (1984) 1–25.

[73] G. E. R. Lloyd, *Polarity and Analogy: Two Types of Argumentation in Early Greek Thought* (Cambridge 1966; repr. Indianapolis, IN, 1992) 384–420.

[74] Innes, "Theophrastus and the Theory of Style" (note 23 above) 252–53.

additional participants and their chatter. In the fourth mime of Herodas there is a totally silent slave who accompanies Kokkale and Kynno into the sanctuary of Asklepios on Kos. Kynno orders her to go fetch the warden of the sanctuary, but she doesn't reply, and Kokkale defends her. In this lively scene the nameless slave is thus a strong but silent presence, known only through the observation of others. In its basic form of commenting on the setting in a sanctuary, the mime of Herodas follows an old tradition that goes back well into the fifth century, beginning with Epicharmos, who Athenaios (8.362b) reports wrote a *Thearoi* in which visitors marvel at dedications in Delphi.[75] Aischylos's *Theoroi*, may also belong to the tradition,[76] which is more clearly represented by Euripides' *Ion* (184–218), where the chorus of Attic servants of Kreusa express their amazement that the Temple of Apollo is so like the ones they know in Athens bearing mythological scenes. As Froma Zeitlin has pointed out, Euripides often uses evocative descriptions of setting as backdrops for the human action.[77] Clearly, next to the old tradition of ignoring the setting of human activity there is a subcurrent of interest which increases at the end of the fifth century and through the fourth. Even Plato falls prey to giving an evocative description of the natural setting along the banks of the Ilissos where he portrays Sokrates walking in *Phaidros* 229a–c.[78] Attic vase painting does not participate in this development. However, the fully formed natural setting in the hunt frieze of the "Tomb of Philip" at Vergina, probably of the early third century (**Fig. 119**), does suggest that some attention must have been paid to settings earlier, most likely in panel painting.

The complaints that both Plato and Aristotle make about excessive spectacle in the public presentation of speech or poetic display is easily understood in view of the increasingly grand nature of spectacular displays of sculpture discussed in chapter 5A. To the modern eye, much of their criticism must be directed at allusions to spectacular setting, but there is another element of display that has less to do with grand visual spectacle but still with the effect of spectacle: the psychological character of the event and the moment of the event chosen for representation. The account of the contest of Zeuxis and Parrhasios is clearly related to an anecdote recorded by Aelian (*VH* 2.44) about the painter Theron of Samos, who had the covering of his painting of a hoplite advancing into battle dramatically pulled off as a trumpeter sounded the signal for the charge.[79] Gorgias notes in his *Defense of Helen* (16) that "When belligerents in war buckle on their warlike accouterments of bronze and steel, . . . if the sight sees this, immediately it is alarmed and it alarms the soul, so that often men flee, panic-stricken, from future danger <as though it were> present."[80] The addition of sound to the visual effect clearly constitutes an early example of the multimedia presentation. But the primary point of interest is that there was a conscious attempt to create real scenes of spectacular and dramatic nature that must have appeared supremely realistic, as Plato complained. The grave relief of Aristonautes displays all these qualities (**Fig. 88**). Obviously, emotion is the basic ingredient of these

[75] P. Groeneboom, *Les mimiambes d'Hérodas* (Groningen 1922) 122–23.

[76] M. Stieber, "Aeschylus' *Theoroi* and Realism in Greek Art," *TAPA* 124 (1994) 85–119.

[77] F. Zeitlin, "The Artful Eye: Vision, Ecphrasis and Spectacle in Euripidean Theater," in *Art and Text in Ancient Greek Culture*, ed. S. Goldhill and R. Osborne (Cambridge 1994) 138–96; see also Benediktson, *Literature and the Visual Arts* (note 13 above) 80–81.

[78] Plato, more than his contemporaries, uses the imperative ἰδὲ (look) to direct attention to a new subject. Normally the logical translation is simply "consider," but in *Republic* 7.514a2 and b4, where the image of the cave is presented, the verb takes on a clear sense of "look at the picture I am describing."

[79] Childs, *RA*, 1994, 52–53.

[80] Diels-Kranz, *Vorsokr.*, 82 B11; trans. G. Kennedy, in Sprague, *Older Sophists* (note 9 above) 53.

images, and the topic was of interest to both Plato and Aristotle.[81] To Plato, the rousing of emotions was a cheap shot, to Aristotle, an important part of rhetorical delivery, and the emotional appeal of many images in the fourth century needs no commentary.

The choice of less than obvious moments for the subject of many statues in the fourth century is paralleled in the vase paintings that depict an odd moment in the heroic myth selected, such as the preparation for the hunt in representations of Meleager and Atalanta (**Fig. 204**).[82] Instead of the iconic killing of the boar, the artist chooses an open and undefined moment in the story that has no obvious or inevitable sequel. Henri Metzger convincingly described the new iconographic tendencies of the fourth century as emphasizing general themes rather than mythological events.[83] Even when the protagonists are identifiable in a specific mythological situation—such as Dionysos and Ariadne or Poseidon and Amymone—it is a secondary, generalized theme of epiphany or apotheosis that takes precedence over the narrative of the event.

It seems quite clear that all the above observations pertain to the sphere of the representation of psychological states rather than of actions. It is here that one gains a useful insight into the issue of fourth-century portrait sculpture. Xenophon (*Memorabilia* 3.10.3) specifically has Sokrates ask the painter Parrhasios whether one can represent (ἀπομιμεῖσθε) the character of the soul (τῆς ψυχῆς ἦθος). Parrhasios says one cannot, but Sokrates points out that emotions are evident in the face and thus can be represented, to which Parrhasios agrees. In the fifth century this could be done only by rather crude and simple means, as in the portraits of Themistokles and Pindar.[84] In the fourth century, the tool of naturalism allowed the Greek artist, for such he must now be called, to define the subtle qualities of an individual, though clearly within the confines of broad types. Admittedly, the Aristotelean *Physiognomika* does not constitute a reliable guide to the interpretation of fourth-century portraits, but it does indicate that character was a broad and important topic of concern in the fourth century; indeed, it was already of concern to Euripides at the end of the fifth century in his laments that people's character was not stamped on their appearance like the value of a coin. In some respects, the *Characters* of Theophrastos gives the best clue to the objectives of portrait sculptors and painters.

Just as the stylistic character of the Rich Style does not suddenly appear out of nowhere, so the new psychology evolves rather than is discovered. Alan Shapiro has convincingly demonstrated that personifications gradually invade mythological scenes as commentaries on the event depicted.[85] Old Comedy also used generalized, meaningful names for its cast of characters, though Agathon's introduction of the same practice into tragedy failed to win a following.[86] Admittedly, Euripides' characters had already diverged so greatly from the standard mythical paradigms as to be all but unrecognizable and were really new creations. Attacks on traditional mythology had begun in the sixth century, but in the fifth century there was a movement to reinterpret the traditional myths as veiled perceptions of a different, morally and intellectually more comprehensible, world. The best-preserved

[81] W. W. Fortenbaugh, *Aristotle on Emotion: A Contribution to Philosophical Psychology, Rhetoric, Poetics, Politics, and Ethics* (New York 1975) 9–44; Fortenbaugh, "Theophrastus on Emotion," in Fortenbaugh et al., *Theophrastus of Eresus* (note 12 above) 209–29.

[82] See chap. 6, p. 248 above.

[83] Metzger, *Représentations*, 416–21. Webster, *Art and Literature*, 70, notes that the proportion of traditional mythological comedies falls dramatically in the second half of the fourth century.

[84] See chap. 7, pp. 286–87 above.

[85] Shapiro, *Boreas* 9 (1986) 4–23; see also Webster, *Art and Literature*, 38–43.

[86] See chap. 6, pp. 254–55 and note 199 above.

example is the tale that Xenophon reports was told by Prodikos of Keos, in the third quarter of the fifth century, of Herakles at the crossroads, where he meets Virtue and Vice.[87] But the allegorization of mythology was not unusual in the fifth century.[88] Diogenes of Apollonia equated Zeus, or simply god, with air,[89] and Metrodoros of Lampsakos proposed a variety of allegorical interpretations of divinities.[90] Herodoros and Palaiphatos continued the approach but in pseudohistorical modes.[91] Just as personifications enter the pictorial vocabulary of red-figure vase painting in the last third of the fifth century to clarify an increasingly complex message, so scholars had to clarify the hidden meaning of literary myth.[92] If my suggestion in chapter 6 is correct, inanimate objects such as strigils can take on new meaning and profoundly alter the purport of an image. Apoxyomenoi may not be just athletic victors. Clearly, profound changes are taking place in all aspects of Greek culture. Even the forms of Plato are similar because the concrete world of perception points to the hidden absolute reality to be grasped only by thought.

Given the climate of skepticism and relativity in the second half of the fifth century and throughout the fourth, the search for new solid values exemplified in the debates of the leading literary and philosophical circles is easy to understand. Although the preserved sculpture and painting relate quite clearly to elements of these debates and the understanding they provide of the principal issues of the contemporary plastic arts, there remains a large gap between the subjects and the actual manner in which the figures are represented and the evidence of the texts. The statues may express "aliveness" and a psychological depth, but how are we to understand why Aphrodite was shown preparing to bathe or a satyr contemplating his future rowdy revels? Why does Apollo prepare to kill a harmless lizard or Nike adjust her sandal? The list should, in fact, include all the statues discussed earlier. To these we can add at least the reported subjects of the famous panel paintings listed in our late sources: Perseus helping Andromeda down from her perch after he killed the dragon, the sacrifice of Iphigeneia at Aulis, and the centaur family.

An important part of the answer to the question of the choice of subjects for the sculptures must lie in the fact that those that depict gods depict a new form of epiphany. Rodenwaldt formulated the category as "gods living at ease" (θεοὶ ῥεῖα ζώοντες). This describes precisely the casualness of the figures in whatever activity they are represented. The contrast with earlier divine images is stark: Deborah Steiner emphasizes the large size and the elaborate materials of divine statues of the Archaic and Classical periods.[93] Not only were a number of cult statues chryselephantine, that is, made of gold and ivory, but glass was also used to create a glittering, other-worldly aura.[94] This contrasts with the relatively small size and the simple materials—marble and bronze—of most of the fourth-century

[87] See chap. 6, p. 249 above.

[88] See chap. 6, pp. 253–54 above.

[89] Diels-Kranz, *Vorsokr.*, 64 A8, B5.

[90] Diels-Kranz, *Vorsokr.*, 61 3–4.

[91] W. Nestle, *Vom Mythos zum Logos: Die Selbstentfaltung des griechischen Denkens von Homer bis auf die Sophistik und Sokrates* (Stuttgart 1942; repr. New York 1978) 146–52; *FGrHist*, vol. 1, no. 31: 215–28, 502–9; no. 44: 266–68, 523–24.

[92] D. Metzler, "Eunomia und Aphrodite: Zur Ikonologie einer attischen Vasengruppe," *Hephaistos* 2 (1980) 74–88; H. A. Shapiro, "Ponos and Aponia," *GRBS* 25 (1984) 107–10; and generally H. A. Shapiro, *Personifications in Greek Art: The Representation of Abstract Concepts, 600–400 B.C.* (Zurich 1993).

[93] Steiner, *Images in Mind*, 95–104.

[94] W. Schiering, *Die Werkstatt des Pheidias in Olympia*, vol. 2, *Werkstattfunde*, OlForsch 18 (Berlin 1991) 130–56, figs. 53a, b; Schiering, "Glas für eine Göttin: Zum Gewand einer klassischen Kolossalstatue (Nike?) in Olympia," *AntW* 30 (1999) 39–48; H.-V. Herrmann, *Olympia: Heiligtum und Wettkampfstätte* (Munich 1972) 158, pl. 58b, c.

statues of which we have any record. An obvious exception in size is the Apollo Patroos in the Athenian Agora, which is 2.54 meters high without its head (**Fig. 73**). Are we therefore to consider the Knidia or the Apollo Sauroktonos to have been votives? According to the ancient accounts of the Knidia this does not seem likely.[95] For the Apollo, on the other hand, this is quite a reasonable assumption, which would also apply to the Eros stringing his bow (**Fig. 143**) and very likely to the original of the Hermes and Dionysos in Olympia, though the group is 2.13 meters tall (**Fig. 133**); the original of the Apollo Lykeios was also probably well over 2 meters tall. But these are not the colossal proportions of several of the fifth-century divine images, such as the Athena Parthenos or the Zeus in Olympia. The Athena Velletri is over 3 meters tall, which is half again as large as the fourth-century statues just mentioned.

The interpretation of divine statues of the fourth century must lie in the fact that they are not just epiphanies but are approachable, that is, immanent. Although most commentators in the past have come to the opposite conclusion,[96] the interpretation offered here agrees far better with the prominent sense of divine immanence presented in Plato's *Timaios*[97] and the cosmology of the Stoics.[98] This philosophy is a product of the fourth century and agrees with the evidence of the profusion of offerings, such as the marble votive reliefs discussed above, which attest unequivocally to the piety of the period.[99] However, it is not just piety that the votive reliefs proclaim but also the immanence of the gods. The traditional format of depicting the dedicators facing the divinity goes back to the early fifth century with the relief on the Athenian Acropolis of a family bringing a sow to be sacrificed to Athena.[100] The craftsman on an Early Classical votive relief on the Acropolis appears to place an offering in Athena's hand.[101] In the fourth century, a similar level of intimacy between mortals and divinities on votive reliefs is not only maintained but increased.[102] Indeed, the imagery is most impressive; on the fifth-century votive reliefs the divinity stands formally facing the votary. On the fourth-century votive reliefs it is the gods who on occasion react to the votaries: on several votive reliefs dedicated to Asklepios, the god is depicted personally tending the ill votary (**Fig. 245**);[103] on the great votive relief from New Phaleron, Kephisos leans over to interact directly with Xenokrateia and her son (**Fig. 92**).[104] The Xenokrateia relief even demonstrates that the gods are in some respects indistinguishable from mortals: they are gathered around the presenta-

[95] See chap. 3, pp. 85–86 above.

[96] E.g., Rodenwaldt, Θεοὶ ῥεῖα, 6–7; H. Meyer, "Zum Götterbild in der griechische Religion und Kulturgeschichte," *Orthodoxes Forum* 1 (1987) 158.

[97] F. M. Cornford, *Plato's Cosmology: The Timaeus of Plato Translated with a Running Commentary* (New York 1937; repr. New York 1952; repr. Indianapolis, IN, 1997) 38–39, 137 39.

[98] M. P. Nilsson, *Geschichte der griechischen Religion*, vol. 2, *Die hellenistische und römische Zeit*, 2nd ed. (Munich 1961) 257–59; A. A. Long and D. N. Sedley, *The Hellenistic Philosophers*, vol. 1, *Translations of the Principal Sources, with Philosophical Commentary* (Cambridge 1987) 278–79. The description of the beliefs of the early Stoics by Cicero (*De natura deorum* 1.15.39–41) is particularly relevant.

[99] Vikela, *AM* 112 (1997) 169, 170–71, overemphasizes the marble reliefs as special signs of piety; Theophrastos made the point that the attitude of the sacrificer was more important than the value of the offering: van Straten, "Gifts for the Gods," 68. In his fourth mime, Herodas portrays two simple women who can afford to bring only a cock to Asklepios and remark on their lack of wealth, but the sacrifice is accepted.

[100] Athens, Acrop. 581: Brouskari, *Acropolis Museum*, 52–53, fig. 94; Mitropoulou, *Votive Reliefs*, 22–28, no. 21, fig. 39; Boardman, *GS-AP*, fig. 258.

[101] Athens, Acrop. 577: Mitropoulou, *Votive Reliefs*, 39–40, no. 29, fig. 48; Boardman, *GS-CP*, fig. 42.

[102] Van Straten, "Images of Gods and Men," 249–52.

[103] Athens, NAM 3369: Kaltsas, *SNAMA*, 209–10, no. 425*. See also Piraeus 405: van Straten, "Gifts for the Gods," 98, fig. 41; Vikela, *AM* 112 (1997) 237, pl. 31.3

[104] See chap. 5A, p. 167 above.

tion of Xenokrateia's son, Xeniades, to Kephisos as though at a twentieth-century cocktail party. Since the inscription indicates that the dedication is to Kephisos ξυνβώμοις τε θεοὶς, the image of a modern cocktail party is very appropriate and underscores to what extent the context or background of an event, whether depicted or not, is part of the subject.[105] In a similar vein, the votive reliefs to the nymphs depict the rural setting in which the cult was frequently celebrated (**Fig. 94**).[106] Thus, totally apart from the religious and even philosophical matrix, the monuments speak for themselves. What is new in the images of the gods is the casual and banal context in which they are depicted. A similar casualness or intimacy is visible in the Attic grave stelai discussed above; the stelai present pictures of the deceased somehow in communication with the living, and the naiskos appears to be a magic gate that allows this real communication to take place. Consequently, the stelai present the dead as present, just as the statues of divinities are present epiphanies. The aliveness of statues and figures on grave stelai points directly to the reality of the observation of Plato: artists were claiming to re-create reality in all its aspects. This does not mean a literal likeness in the sense of a physical re-creation, but a characterization that convincingly grasped the real nature of the person; the image of Kratylos was so close to the real character of Kratylos as to be (almost) indistinguishable from its model. It can only have been a most disconcerting experience.

[105] On the identification of the divinities, see Edwards, "Votive Reliefs to Pan," 318–23.

[106] W. Fuchs, "Attische Nymphenreliefs," *AM* 77 (1962) 242–49, Beil. 64–69. A. Klöckner, "Menschlicher Gott und göttlicher Mensch? Zu einigen Weihreliefs für Asklepios und die Nymphen," in *Konstruktionen von Wirklichkeit: Bilder im Griechenland des 5. und 4. Jahrhunderts v. Chr.*, ed. R. von den Hoff and S. Schmidt (Stuttgart 2001) 128–29, observes the unusual familiarity of Agathemeros and Hermes on his votive relief to the nymphs from their sanctuary on Pentelikon, Athens, NAM 4466: Kaltsas, *SNAMA*, 221, no. 459*.

9 Conclusion

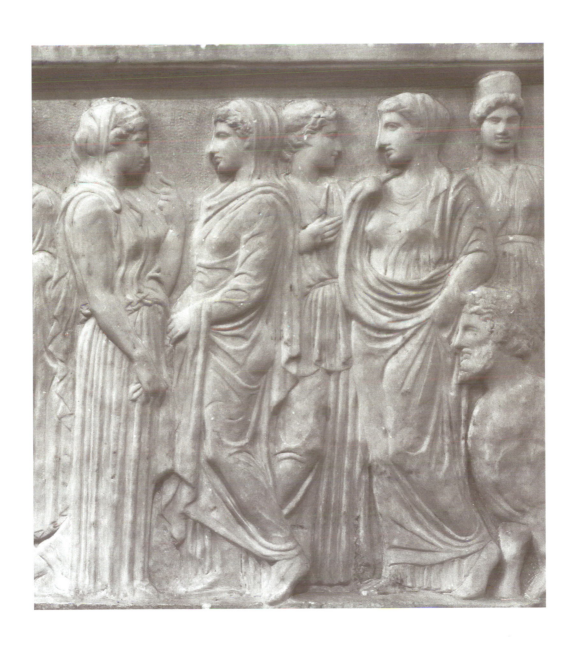

Forms are statements that respond to the concerns of a society. The reason that the modern world since about the beginning of the twentieth century has had a dwindling interest in classical antiquity is that, as the contemporary Danish sculptor Morten Stræde has pointed out, the issues addressed by ancient art are no longer those of the modern world.[1] As the preceding chapters have indicated, this assertion is not entirely true, and it is also contradicted by the popularity of travel to the ancient sites of the Mediterranean basin and even the number of visitors to the ancient galleries of European and American museums.[2] Each phase of classical antiquity has enjoyed a bout of popularity over the past two hundred years, and it is the late fifth and fourth centuries that have been the center of attention for the last few decades. This strongly suggests a modern sympathy for that troubled yet vibrant century.

The foregoing inquiry suggests that the fourth century is a natural continuation of the fifth century with no significant hiatus caused, as some have erroneously surmised, by the shock of the Peloponnesian War. Indeed, almost all the characteristic forms of the art of the fourth century have their origin around or even before the middle of the fifth century.[3] The name commonly given to the period after 370, the Late Classical, is therefore very accurate and forms a logical trio with the Early Classical and the High Classical styles. The period is not one of decline but exactly the contrary—a period of vigorous intellectual and artistic expansion and discovery. To me the most striking aspect of the fourth century is how rich and energetic it is and how stiff and awkward the previous art appears in contrast. Taking a broad historical perspective, it is in the fourth century B.C. that Greek art and culture are for the first time definable in their own terms and not as variants of the art and cultures of the ancient Near East and Egypt. It is equally clear that there is a seamless transition to the art of the Hellenistic period, which varies and elaborates the vocabulary and syntax of the Late Classical.

The brief historical review given in chapter 1 indicates the extent to which war and suffering marked the whole fourth century. These wars were mostly between Greek-speaking peoples. Yet neither the wars nor the great expedition of Alexander of Macedon against Persia from 334 until his death in Babylon in 323 seem to have affected the plastic arts directly. The political and social background does, however, suggest that the plastic arts of the fourth century define a degree of escapism not dissimilar to the period between World

[1] M. Stræde, "Between Scylla and Charybdis: Concerning the Artist's Perception of Antiquity," in J. Fejfer, T. Fischer-Hansen, and A. Rathj, eds., *The Rediscovery of Antiquity: The Role of the Artist*, Acta Hyperborea 10 (Copenhagen 2003) 23–36.

[2] N. Himmelmann, *Utopische Vergangenheit: Archäologie und moderne Kultur* (Berlin 1976), part of which appeared in an English translation by D. Dietrich: "The Utopian Past: Archaeology and Modern Culture," in Himmelmann, *Reading Greek Art*, 237–98.

[3] Metzger, *Représentations*, 13, 369–70.

Wars I and II. Domesticity on the one hand and luxury on the other—two apparently mutually exclusive concerns operate side by side. Though foreign influences are occasionally evident in the art of mainland Greece in the fifth century, they invade almost all private areas of Greek life in the fourth century, while the Greek formal vocabulary reciprocates on the art of the eastern Mediterranean. Alexander was no more than a footnote in the development of the art of the fourth century.

If Greek art of the fourth century is not obviously and directly influenced by the contemporary military turmoil, what of the political situation? There is at least some evidence that a reflection of the development of Athenian democracy can be seen in the uniformity and bourgeois prosperity of the Attic grave and votive reliefs. It is equally clear that those grave reliefs that do differ signally in content, and perhaps also in size and elaborateness, reflect the existence of some families that wished to make a statement of their elite status and therefore superiority to the masses. Since the size and elaborateness of grave monuments do appear to increase toward the end of the fourth century, it is reasonable to conjecture that Demetrios of Phaleron's sumptuary laws were aimed at curtailing such assertions. But the vast majority of grave and votive monuments throughout the fourth century maintain a relatively stable balance of modest to moderate size.

Of course, we lack almost all the statues dedicated in the innumerable sanctuaries, both small local ones and the great Panhellenic ones of Delphi and Olympia. The appearance of these latter, with great shining bronze statues and chariot groups and elaborately painted marble statues, must have been a daunting and gay sight. It is in this context that the diorama-like scenes of the Apollo Sauroktonos and leaning satyr are to be imagined. The modern viewer in a museum or visitor to an ancient site tends to forget that the whole configuration was religious, and not just in the casual modern manner. My assumption is of a lively, colorful jumble; one must try to remember that not only statues and reliefs were dedicated, but numerous other objects as well, including terracotta vases, furniture, and the tools of craftsmen. Small tablets were hung all around the place, as is expressly stated in the fourth mime of Herodas (19–20), composed in the third century B.C.[4] A major difference from the appearance of sixth- and fifth-century sanctuaries was the very aliveness of the statues and groups, very much in the same vein as the displays of apparently intimate family grave reliefs along the roads into Athens and other sites such as Rhamnous (**Fig. 89**).

As in the modern world, in the fourth century there is a conflict evident between diversity and a desired homogeneity. This is perhaps best illustrated by the role of Tyche, Chance, who is a personification, *daimōn*, and divinity. Demetrios of Phaleron, for whom the concept was particularly pertinent, wrote a treatise on Tyche,[5] and in Menander's *Aspis* she introduces the plot, ending with the comment "Finally it remains to tell my name, who I am, the mistress to judge and manage all these things: Tyche."[6] Lysippos's student Eutychides carved a statue of Tyche, known in a number of Roman copies, for the newly founded city of Antiocheia.[7] T. B. L. Webster makes the apt observation that

[4] Cicero, *De natura deorum* 3.89, relates an anecdote about the visit of Diagoras, whose nickname he says was "the Atheist," to the Sanctuary of the Great Gods at Samothrace in the late fifth century: Diagoras was asked how he could maintain that "the gods disregarded men's affairs" in view of "all the votive pictures that prove how many persons have escaped the violence of the storm, and come safe to port, by dint of vows to the gods" (trans. H. Rackham, Loeb edition).

[5] W. W. Fortenbaugh and E. Schütrumpf, eds., *Demetrius of Phalerum: Text, Translation, and Discussion*, Rutgers University Studies in Classical Humanities 9 (New Brunswick, NJ, 2000) 146–51, nos. 82a, 82b, 83.

[6] Menander, *Aspis* 146–48 (trans. W. G. Arnott, Loeb edition, vol. 1 [Cambridge, MA, and London 1979]).

[7] LIMC, s.v. Antiocheia, vol. 1, pp. 840–51 (J. C. Balty).

Tyche is "a sign of a shift of interest from the typical to the individual because Tyche is the unique combination of circumstances which at a particular time and place is the decisive environment for a particular person."[8] In this regard, portrait statues could with little exaggeration be considered votives to Tyche; the individualized type on view in public commemorates success in the face of a volatile world. Lysippos's own statue of Kairos—the fleeting, decisive moment—is also a trenchant statement of the instability that dominates the fourth century behind the facade of homogeneous, bourgeois prosperity, to be overcome only by personal achievement and chance.[9]

Even if one can argue that the political situation does to some extent characterize the monuments of the fourth century, it nevertheless remains true that almost all our evidence derives from the religious sphere. There is no decrease in piety in the fourth century; rather the opposite is probably the case, to judge from the monuments. One aspect of the preserved monuments that has been touched on only in passing needs stronger emphasis: the social changes that more than anything else probably characterize the fourth century or differentiate it from the preceding centuries. On the one hand, the display of wealth of a broad public is remarkable, but even more remarkable is the new position of women. The fact that women play an important iconographic role on the Attic grave stelai is interesting, but it has been noted that the names of women do not play an equally important role in funerary inscriptions.[10] Nonetheless, the number of stelai on which women figure prominently is remarkable; they appear alone with a female servant or with a standing man or in large familial groups. In each case the image is intimate, presenting to the broad public a view of domesticity, which supposedly was jealously guarded.[11] The same is true of the votive reliefs that predominantly show whole families coming to sacrifice—men, women, and children. From at least the middle of the fourth century women play an increasingly important role in family dedications, such as the ancestor gallery dedicated by Philip of Macedon in the Philippeion at Olympia,[12] which contrasts with the all-male ancestors of the Daochos Monument. But even in the later fifth century women dedicate significant structures and monuments on their own, a trend that becomes increasingly important in the Hellenistic period.[13] To be sure, even when women did make individual dedications or were even benefactors of whole sanctuaries, the iconography of votive reliefs mostly depicts them as dependents of their male family members.[14] The contradictory evidence is underscored by the fact that Plato advocated the education of

[8] Webster, *Art and Literature*, 110; T. B. L. Webster, *Studies in Menander*, 2nd ed. (Manchester 1960) 198–201.

[9] See chap. 6, p. 256, and chap. 8, pp. 312–13 above.

[10] S. C. Humphreys, "Family Tombs and Tomb Cult in Ancient Athens: Tradition or Traditionalism?" *JHS* 100 (1980) 96–126; K. Stears, "Dead Women's Society: Constructing Female Gender in Classical Athenian Funerary Sculpture," in *Time, Tradition, and Society in Greek Archaeology: Bridging the 'Great Divide,'* ed. N. Spencer (London and New York 1995) 114–15. Bergemann, *Demos und Thanatos*, 28–33, 129–30, suggests that the stelai and the inscribed names were important documents of family relationships and of citizenship. See also S. C. Humphreys, *The Family, Women and Death: Comparative Studies*, 2nd ed. (Ann Arbor 1993) 61–66.

[11] R. E. Leader, "In Death Not Divided: Gender, Family, and State on Classical Athenian Grave Stelae," *AJA* 101 (1997) 686–90, 692–99.

[12] Löhr, *Familienweihungen*, 115–17, no. 137.

[13] U. Kron, "Priesthoods, Dedications and Euergetism: What Part Did Religion Play in the Political and Social Status of Greek Women?" in *Religion and Power in the Ancient Greek World: Proceedings of the Uppsala Symposium 1993*, ed. P. Hellström and B. Alroth (Uppsala 1996) 139–82.

[14] F. van Straten, "Votives and Votaries in Greek Sanctuaries," in *Le sanctuaire grec: Huit exposés suivis de discussions*, Fondation Hardt, Entretiens sur l'antiquité classique 37, ed. O. Reverdin and B. Grange (Geneva 1992) 274–77. This is, of course, not the case for Xenokrateia. J. P. Gould, "Law, Custom, and Myth: Aspects of the Social Position of Women in Classical Athens," *JHS* 100 (1980) 38–59, makes an excellent attempt to balance the contradictory evidence on the position of women in classical Athens but curiously omits discussion of the epigraphic evidence.

women,[15] while at the same time he makes fun of them on at least two occasions. The first (*Republic* 8.557c) has already been quoted above, but more interesting is a second passage in *Laws* (10.909e–910a) because it deals with the broad issue of votive offerings:

> It is no easy task to found temples and gods, and to do this rightly needs much deliberation; yet it is customary for all women especially, and for sick folk everywhere, and those in peril and in distress (whatever the nature of the distress), and conversely for those who have had a slice of good fortune, to dedicate whatever happens to be at hand at the moment, and to vow sacrifices and promise the founding of shrines to gods and demi-gods and children of gods; and through terrors caused by waking visions or by dreams, and in like manner as they recall many visions and try to provide remedies for each of them, they are wont to found altars and shrines, and to fill with them every house and every village, and open places too, and every spot which was the scene of such experiences. (Trans. R. G. Bury, Loeb edition)

Plato's criticism must reflect a real situation in the fourth century that fostered public statements of private piety, just as his comments on art are statements of contemporary understanding of images. Indeed, Plato is, as usual, right on the mark; the vast religious constructions and the dedications of immense statue groups is nascent in the fourth century. On a parallel track, the sheer beauty of the elegant ladies represented by the Tanagra figurines presages the elaboration of the impressive female statues of the Hellenistic period (**Fig. 105**). Plato is almost certainly ironic in his criticism of publicly exhibited piety and the role of women; his observations are too accurate to be simply antagonistic.

The increasing importance of women in Greek art of the fourth century is closely related to the whole character of the period. The image of the heroic male warrior recedes and is replaced with inwardly turned athletes, such as the diskobolos attributed to Naukydes (**Fig. 172**), the Agias of the Daochos group (**Fig. 14**), and the Apoxyomenos in the Vatican (**Fig. 150**). I know of no fourth-century parallels for the Riace bronzes. The intimacy of god and mortal on the Xenokrateia relief (**Fig. 92**) reminds one of the explicit statements of affection and grief both in the inscriptions on grave reliefs and in the images themselves. This intimacy colors almost all aspects of the divine in the fourth century and is expressed by the casualness and banality of the majority of images of the divine. The very subjects of the preserved votive reliefs and the Roman copies of statues—youthful divinities, healing divinities—underscore this social-religious character; all are immanent and rarely threatening. On the one hand, these images appear as flights into denial of the realities of political upheaval and constant war; on the other hand, they prefigure the gradual blending of mortal and divine in the move to consider powerful living people gods. What precisely such divinization meant to the Greeks is partially recoverable in the explanation of euhemerism: the gods are simply people of the distant past "who have made some discovery of special utility for civilization" (Cicero, *De natura deorum* 1.38). Equally, the Stoic belief in the divine fire permeating all aspects of the experienced world promotes a sense of intimate communion with the divine.

If there is then an all-embracing characterization of the art of the fourth century, it is the expression of intimacy both mortal and divine. Simply put, this means that there is a pervasive sense of emotion in figures and of meaningfulness in the simplicity of human existence as opposed to the political and military chaos of the period. And beyond the

[15] *Republic* 5.451e–452a.

ostensible subject of a representation there is a new and rich world of subjective sensitivity. What is portrayed is a sign of another world, in many respects a parallel in the plastic arts to allegorization in literature. Female nudity is not just sexuality but the power of creation; Herakles' strength is not just muscular but, as Prodikos clearly indicated, moral and ethical. The Apollo Sauroktonos is not just a mischievous youth on a hot summer day but a powerful god who replaces the dark past with light. The personifications on vases and even Lysippos's Kairos are not intellectual conceits but explicit statements of reality behind the perceived. Plato, in fine, answers Euripides' lament that the character of people is not evident in their appearance by elaborating the proposition that there is a higher, purer realm in which true reality is to be found. The artists of the fourth century evidently agreed. But the new and unsettling issue was to define the nature of this true reality; inevitably, this was a subjective call, and Plato's pure, abstract forms had to contend with an increasing myriad of other views. Rodenwaldt grasped the basic nature of the polyvalence of the art of the fourth century: the unease with which the modern world has contemplated the fourth century is the surest recognition of the real character of the century and its sympathetic resonance in our world.

Bibliography

The bibliography contains only works cited several times in widely separated passages in the text. Abbreviations of periodicals and series are those used by the *American Journal of Archaeology* (www.ajaonline.org/submissions/abbreviations) whenever they exist.

Adam, S., *The Technique of Greek Sculpture in the Archaic and Classical Periods*, British School of Archaeology at Athens Supplementary Volume 3 (London 1966).

Ajootian, A., "Praxiteles," in *Personal Styles in Greek Sculpture*, YCS 30, ed. O. Palagia and J. J. Pollitt (Cambridge 1996) 91–129.

Altripp, I. E., "Zu den Athenatypen Rospigliosi und Vescovali: Die Geschichte einer Verwechslung," *AA*, 1996, 83–94.

Amandry, P., "A propos de Polyclète: Statues d'olympioniques et carrière de sculpteurs," in *Charites: Studien zur Altertumswissenschaft*, ed. K. Schauenburg (Bonn 1957) 63–87.

———, "Trépieds d'Athènes: I. Dionysies," *BCH* 100 (1976) 15–93.

Amelung, W., *Die Sculpturen des Vaticanischen Museums*, vol. 2, *Belvedere, Sala degli animali, Galleria delle statue, Sala de' busti, Gabinetto delle maschere, Loggia scoperta* (Berlin 1908; repr. Berlin 1995).

Andreae, B., *Der Alexandermosaik aus Pompeji* (Recklinghausen 1977).

———, "Il Satiro danzante di Mazara del Vallo, copia o originale?" in *Il Satiro danzante di Mazara del Vallo: Il restauro e l'immagine; Atti del convegno, Roma, 3–4 giugno 2003*, ed. R. Petriaggi (Naples 2005) 141–44.

———, *Der tanzende Satyr von Mazara del Vallo und Praxiteles*, AbhMainz, Jahrg. 2009, no. 2 (Mainz 2009).

Andreae, B., ed., *Bildkatalog der Skulpturen des Vatikanischen Museums*, vol. 2, *Museo Pio Clementino: Cortile Ottagono* (Berlin 1998).

Andronikos, M., *Vergina: The Royal Tombs* (Athens 1987).

———, *Vergina II: The 'Tomb of Persephone,'* Bibliothiki tis en Athenais Archaiologikis Hetaireias 142 (Athens 1994).

Arnold, D., *Die Polykletnachfolge: Untersuchungen zur Kunst von Argos und Sikyon zwischen Polyklet und Lysipp*, JdI-EH 25 (Berlin 1969).

Arrigoni, G., "Donne e sport nel mondo greco," in *Le donne in Grecia*, ed. G. Arrigoni (Rome and Bari 1985) 55–201.

Artamonov, M. I., *The Splendor of Scythian Art* (New York 1969).

Ashmole, B., "Solvitur Disputando," in *Festschrift für Frank Brommer*, ed. U. Höckmann and A. Krug (Mainz 1977) 13–20.

Austin, M. M., and P. Vidal-Naquet, eds., *Economic and Social History of Ancient Greece: An Introduction* (Berkeley 1977).

Bäbler, B., *Fleissige Thrakerinnen und wehrhafte Skythen: Nichtgriechen im klassischen Athen und ihre archäologische Hinterlassenschaft*, Beiträge zur Altertumskunde 108 (Stuttgart 1998).

Barr-Sharrar, B., *The Derveni Krater: Masterpiece of Classical Greek Metalwork*, Ancient Art and Architecture in Context 1 (Princeton 2008).

Bartman, E., "Sculptural Display and Collecting in the Private Realm," in *Roman Art in the Private Sphere: New Perspectives on the Architecture and Decor of the Domus, Villa, and Insula*, ed. E. K. Gazda (Ann Arbor 1991) 71–88.

Bauer, H., "Lysikratesdenkmal: Baubestand und Rekonstruktion," *AM* 92 (1977) 197–227.

Baumer, L. E., *Vorbilder und Vorlagen: Studien zu klassischen Frauenstatuen und ihrer Verwendung für Reliefs und Statuetten des 5. und 4. Jahrhunderts vor Christus*, Acta Bernensia 12 (Bern 1997).

Bažant, J., *Les citoyens sur les vases athéniens du 6e au 4e siècle av. J.-C.*, Rozpravy Československé Akademie Věd Řada Společenských věd, Ročnik 95, Sešit 2 (Prague 1985).

Beazley, J. D., *Attic Red-Figure Vase-Painters*, 2nd ed. (Oxford 1963).

———, *The Development of Attic Black-Figure*, 2nd ed., ed. D. von Bothmer and M. Moore (Berkeley 1986).

———, *Paralipomena: Additions to Attic Black-Figure Vase-Painters and to Attic Red-Figure Vase-Painters* (Oxford 1971).

Beck, F. A. G., *Album of Greek Education* (Sydney 1975).

Beck, H., P. C. Bol, and M. Bückling, eds., *Polyklet: Der Bildhauer der griechischen Klassik; Ausstellung im Liebieghaus, Museum alter Plastik, Frankfurt am Main*, exh. cat. (Mainz 1990).

Benediktson, D. T., *Literature and the Visual Arts in Ancient Greece and Rome* (Norman, OK, 2000).

Benndorf, O., "Der Hermes des Praxiteles," *Kunstchronik* 13.49 (1878) cols. 777–85.

Benndorf, O., and G. Niemann, *Das Heroon von Gjölbaschi-Trysa* (Vienna 1889) = O. Benndorf and G. Niemann, "Das Heroon von Gjölbaschi-Trysa," *Jahrbuch der kunsthistorischen Sammlungen des Allerhöchsten Kaiserhauses* 9 (1889) 1–134, 11 (1890) 1–52, 12 (1891) 5–68.

Bentz, M., *Panathenaische Preisamphoren*, AntK-BH 18 (Basel 1998).

———, "Die Preisamphoren aus dem Mosaikenhaus in Eretria," *AntK* 44 (2001) 3–12, pls. 1–6.

Bérard, C., *Anodoi: Recherches sur l'imagerie des passages chthoniens*, Bibliotheca Helvetica Romana 13 (Rome 1974).

Bérard, C., et al., eds., *A City of Images: Iconography and Society in Ancient Greece* (Princeton 1989).

Bergemann, J., *Demos und Thanatos: Untersuchungen zum Wertsystem der Polis im Spiegel der attischen Grabreliefs des 4. Jahrhunderts v. Chr. und zur Funktion der gleichzeitigen Grabbauten* (Munich 1997).

Bergmann, B., "Greek Masterpieces and Roman Recreative Fictions," *HSCP* 97 (1995) 79–120.

Bernard, P., and J. Marcadé, "Sur une métope de la tholos de Marmaria à Delphes," *BCH* 85 (1961) 447–73, pls. XII–XIV.

Beschi, L., "Il monumento di Telemachos, fondatore dell'Asklepieion ateniese," *ASAtene* 45–46 (n.s., 29–30) (1967–68) 381–436.

———, "Rilievi votivi attici ricomposti," *ASAtene* 47–48 (n.s., 31–32) (1969–70) 85–132.

Bieber, M., *Ancient Copies: Contributions to the History of Greek and Roman Art* (New York 1977).

———, *Griechische Kleidung* (Berlin and Leipzig 1928).

———, *The Sculpture of the Hellenistic Age*, 2nd ed. (New York 1961).

Bivar, A. D. H., *The Personalities of Mithra in Archaeology and Literature*, Biennial Yarshater Lecture Series 1 (New York 1998).

Blanckenhagen, P. H. von, "Der ergänzende Betrachter: Bemerkungen zu einem Aspekt hellenistischer Kunst," in *Wandlungen: Studien zur antiken und neueren Kunst; Ernst Homann-Wedeking gewidmet*, ed. Institut für Klassische Archäologie der Universität München (Waldsassen 1975) 193–201.

———, "Painting in the Time of Alexander and Later," in *Macedonia and Greece in Late Classical and Early Hellenistic Times*, Studies in the History of Art 10, Symposium series 1, ed. B. Barr-Sharrar and E. N. Borza (Washington, DC, 1982) 251–60.

Blinkenberg, C., *Knidia: Beiträge zur Kenntnis der Praxitelischen Aphrodite* (Copenhagen 1933).

Blome, P., *Basel Museum of Ancient Art and Ludwig Collection*, Swiss Museums (Geneva and Zurich 1999).

Blümel, C., *Griechische Bildhauerarbeit*, JdI-EH 11 (Berlin 1927).

———, *Der Hermes eines Praxiteles* (Baden-Baden 1948).

———, *Die klassisch griechischen Skulpturen der Staatlichen Museen zu Berlin*, AbhBerl, Klasse für Sprachen, Literatur und Kunst, Jahrg. 1966, no. 2 (Berlin 1966).

——, *Staatliche Museen zu Berlin: Katalog der Sammlung antiker Skulpturen*, vol. 5, *Römische Kopien griechischer Skulpturen des vierten Jahrhunderts v. Chr.* (Berlin 1938).

Boardman, J., "Atalanta," in *The Art Institute of Chicago Centennial Lectures*, Museum Studies 10 (Chicago 1983) 3–19.

——, *Athenian Red Figure Vases: The Archaic Period* (London 1975).

——, *Athenian Red Figure Vases: The Classical Period* (London 1989).

——, *Greek Sculpture: The Classical Period* (London 1985).

——, *Greek Sculpture: The Late Classical Period* (London 1995).

Bol, P. C., *Der antretende Diskobol*, Liebieghaus Monographie 17 (Mainz 1996).

——, *Großplastik aus Bronze in Olympia*, OlForsch 9 (Berlin 1978).

Bol, P. C., ed., *Antike Bildwerke, Liebieghaus-Museum Alter Plastik*, vol. 1, *Bildwerke aus Stein und aus Stuck von archaischer Zeit bis zur Spätantike* (Melsungen 1983).

——, *Forschungen zur Villa Albani: Katalog der antiken Bildwerke*, vol. 1, *Bildwerke im Treppenaufgang und im Piano nobile des Casino* (Berlin 1989); vol. 4, *Bildwerke im Kaffeehaus* (Berlin 1994).

Bol, P. C., et al., *Die Geschichte der antiken Bildhauerkunst*, vol. 2, *Klassische Plastik*, Schriften des Liebieghauses (Mainz 2004).

Bol, R., *Amazones Volneratae: Untersuchungen zu den Ephesischen Amazonenstatuen* (Mainz 1998).

Bommelaer, J.-F., *Lysandre de Sparte: Histoire et traditions*, BÉFAR 240 (Paris 1981).

Bommelaer, J.-F., and D. Laroche, *Guide de Delphes: Le site*, École française d'Athènes, Sites et monuments 7 (Paris 1991).

Borbein, A. H., "Die griechische Statue des 4. Jahrhunderts v. Chr.," *JdI* 88 (1973) 43–212.

Borchhardt, J., *Die Bauskulptur des Heroons von Limyra: Das Grabmal des lykischen Königs Perikles*, IstForsch 32 (Berlin 1976).

Borg, B. E., *Der Logos des Mythos: Allegorien und Personifikationen in der frühen griechischen Kunst* (Munich 2002).

Bothmer, D. von, *Amazons in Greek Art*, Oxford Monographs on Classical Archaeology (Oxford 1957).

Boulter, P. N., "The Frieze of the Erechtheion," *AntP* 10 (1970) 7–28.

Bourguet, É., *Fouilles de Delphes*, vol. 3, *Épigraphie*, fasc. 1, *Inscriptions de l'entrée du sanctuaire au trésor d'Athènes*, 2 vols. (Paris 1911–29).

Brahms, T., *Archaismus: Untersuchungen zur Funktion und Bedeutung archaistischer Kunst in der Klassik und im Hellenismus* (Frankfurt am Main 1994).

Brecoulaki, H., *La peinture funéraire de Macédoine: Emplois et fonctions de la couleur, IVe–IIe s. av. J.-C.*, Centre de Recherches de l'Antiquité Grecque et Romaine (Athènes), Meletemata 48 (Athens 2006).

Brinkmann, V., *Die Polychromie der archaischen und frühklassischen Skulptur*, Studien zur antiken Malerei und Farbgebung 5 (Munich 2003).

Brinkmann, V., and R. Wünsche, eds., *Bunte Götter: Die Farbigkeit antiker Skulptur; Eine Ausstellung der Staatlichen Antikensammlungen und Glyptothek München in Zusammenarbeit mit der Ny Carlsberg Glyptotek Kopenhagen und den Vatikanischen Museen, Rom*, exh. cat., 2nd ed. (Munich 2004).

Brommer, F., *Die Giebel des Parthenon: Eine Einführung* (Mainz 1959).

——, *Die Metopen des Parthenon: Katalog und Untersuchung* (Mainz 1967).

——, *Der Parthenonfries: Katalog und Untersuchung* (Mainz 1977).

Brouskari, M. S., *The Acropolis Museum: A Descriptive Catalog*, trans. J. Binder (Athens 1974).

Brown, B., *Anticlassicism in Greek Sculpture of the Fourth Century B.C.*, Monographs on Archaeology and the Fine Arts Sponsored by the Archaeological Institute of America and the College Art Association of America 26 (New York 1973).

Brueckner, A., *Der Friedhof am Eridanos bei der Hagia Triada zu Athen* (Berlin 1909).

Bruneau, P., *La mosaïque antique* (Paris 1987).

Bruno, V. J., *Form and Color in Greek Painting* (New York 1977).

——, *Hellenistic Painting Techniques: The Evidence of the Delos Fragments*, Columbia Studies in the Classical Tradition 11 (Leiden 1985).

Brüschweiler-Mooser, V. L., *Ausgewählte Künstleranekdoten: Eine Quellenuntersuchung* (Bern 1969).

Burford, A., *The Greek Temple Builders at Epidauros: A Social and Economic Study of Building in the Asklepian Sanctuary, during the Fourth and Early Third Centuries B.C.*, Liverpool Monographs in Archaeology and Oriental Studies (Liverpool 1969).

Burn, L., *The Meidias Painter*, Oxford Monographs on Classical Archaeology (Oxford 1987).

Camp, J. McK., *The Athenian Agora: A Guide to the Excavation and Museum*, 4th ed. (Athens 1990).

Campenon, C., *La céramique attique à figures rouges autour de 400 avant J.C.: Les principales formes, évolution et production* (Paris 1994).

Carey, S., *Pliny's Catalogue of Culture: Art and Empire in the Natural History*, Oxford Studies in Ancient Culture and Representation (Oxford 2003).

Carpenter, R., *Greek Sculpture: A Critical Review* (Chicago 1960).

Charbonneaux, J., R. Martin, and F. Villard, *Classical Greek Art (480–330 B.C.)*, Arts of Mankind 16 (New York 1972).

Charbonneaux, J., R. Martin, and F. Villard, *Hellenistic Art (330–50 B.C.)*, Arts of Mankind 18 (New York 1973).

Childs, W. A. P., "Platon, les images et l'art grec du IVe siècle avant J.-C," *RA*, 1994, 33–56.

——, "Stil als Inhalt statt als Künstlersignatur," in *Meisterwerke: Internationales Symposion anläßlich des 150. Geburtstages von Adolf Furtwängler, Freiburg im Breisgau, 30. Juni–3. Juli 2003*, ed. V. M. Strocka (Munich 2005) 235–41.

Childs, W. A. P., and P. Demargne, *Fouilles de Xanthos*, vol. 8, *Le monument des Néréides: Le décor sculpté*, 2 vols. (Paris 1989).

Clairmont, C. W., *Classical Attic Tombstones*, 8 vols. (Kilchberg 1993).

——, *Gravestone and Epigram: Greek Memorials from the Archaic and Classical Period* (Mainz 1970).

Clinton, K., *Myth and Cult: The Iconography of the Eleusinian Mysteries; The Martin P. Nilsson Lectures on Greek Religion, Delivered 19–21 November 1990 at the Swedish Institute at Athens*, Skrifter Utgivna av Svenska Institutet i Athen, 8°, 11 (Stockholm 1992).

Cohen, A., *The Alexander Mosaic: Stories of Victory and Defeat*, Cambridge Studies in Classical Art and Iconography (Cambridge 1997).

Cohen, B., *The Colors of Clay: Special Techniques in Athenian Vases*, exh. cat. (Los Angeles 2006).

Cohen, E. E., *Athenian Economy and Society: A Banking Perspective* (Princeton 1992).

Comella, A., *I rilievi votivi greci di periodo arcaico e classico: Diffusione, ideologia, committenza*, Bibliotheca Archaeologica 11 (Bari 2002).

Comstock, M. B., and C. C. Vermeule, *Sculpture in Stone: The Greek, Roman and Etruscan Collections of the Museum of Fine Arts, Boston* (Boston 1976).

Cook, B. F., *Relief Sculpture of the Mausoleum at Halicarnassus*, Oxford Monographs on Classical Archaeology (Oxford 2005).

Cook, M. L., "Timokrates' 50 Talents and the Cost of Ancient Warfare," *Eranos* 88 (1990) 69–97.

Cooper, F. A., *The Temple of Apollo Bassitas*, vols. 1 and 3, *The Architecture* (Princeton 1996).

Corso, A., "The Cnidian Aphrodite," in *Sculptors and Sculpture of Caria and the Dodecanese*, ed. I. Jenkins and G. B. Waywell (London 1997) 91–98.

——, "The Hermes of Praxiteles," *NumAntCl* 25 (1996) 131–53.

Courby, F., *Fouilles de Delphes*, vol. 2, *Topographie et architecture*, pt. A, *Le sanctuaire d'Apollon*, fasc. 2, *La terrasse du temple* (Paris 1927).

Curtius, L., *Die Wandmalerei Pompejis* (Cologne 1929; repr. Darmstadt 1960).

Daehner, J. M., and K. Lapatin, eds., *Power and Pathos: Bronze Sculpture of the Hellenistic World*, exh. cat. (Los Angeles 2015).

Daltrop, G., *Die kalydonische Jagd in der Antike* (Hamburg 1966).

Daltrop, G., and P. C. Bol, *Athena des Myron*, Liebieghaus Monographie 8 (Frankfurt am Main 1983).

Danner, P., *Griechische Akrotere der archaischen und klassischen Zeit*, RdA suppl. 5 (Rome 1989).

Davies, J. K., *Athenian Propertied Families, 600–300 B.C.* (Oxford 1971).

——, *Wealth and the Power of Wealth in Classical Athens* (New York 1981).

Delivorrias, A., *Attische Giebelskulpturen und Akrotere des fünften Jahrhunderts*, Tübinger Studien zur Archäologie und Kunstgeschichte 1 (Tübingen 1974).

———, "*Disiecta Membra*: The Remarkable History of Some Sculptures from an Unknown Temple," in *Marble: Art Historical and Scientific Perspectives on Ancient Sculpture*, ed. M. True and J. Podany (Malibu, CA, 1990) 11–46.

Demargne, P., and P. Coupel, *Fouilles de Xanthos*, vol. 3, *Le monument des Néréides: L'architecture* (Paris 1969).

Dentzer, J.-M., *Le motif du banquet couché dans le proche orient et le monde grec du VIIe au IVe siècle avant J.-C.*, BÉFAR 246 (Paris 1982).

Deubner, L., *Attische Feste*, 2nd ed., ed. B. Doer (Darmstadt 1966).

Diepolder, H., *Die attischen Grabreliefs des 5. und 4. Jahrhunderts v. Chr.* (Berlin 1931; repr. Darmstadt 1965).

Dillon, S., *Ancient Greek Portrait Sculpture: Contexts, Subjects, and Styles* (Cambridge 2006).

Döhl, H., *Der Eros des Lysipp: Frühhellenistische Eroten* (Göttingen 1968).

Dohrn, T., "Die Marmor-Standbilder des Daochos-Weihgeschenks in Delphi," *AntP* 8 (1968) 33–53, pls. 10–37.

Drougou, S., and C. Saatsoglou-Paliadeli, *Vergina: Wandering through the Archaeological Site*, 2nd ed., trans. A. Doumas (Athens 2000).

Dugas, C., J. Berchmans, and M. Clemmensen, *Le sanctuaire d'Aléa Athéna à Tégée au IVe siècle* (Paris 1924).

Durand, J.-L., and F. Lissarrague, "Un lieu d'image? L'espace du loutérion," *Hephaistos* 2 (1980) 89–106; repr. in *Arts et légendes d'espaces: Figures du voyage et rhétoriques du monde*, ed. C. Jacob and F. Lestringant (Paris 1981) 125–49.

Ebbinghaus, S., "Between Greece and Persia: Rhyta in Thrace from the Late 5th to the Early 3rd Centuries B.C.," in *Ancient Greeks West and East*, Mnemosyne: Bibliotheca Classica Batava, Supplement 196, ed. G. R. Tsetskhladze (Leiden 1999) 385–425.

Edelmann, M., *Menschen auf griechischen Weihreliefs*, Quellen und Forschungen zur antiken Welt 33 (Munich 1999).

Eder, W., ed., *Die athenische Demokratie im 4. Jahrhundert v. Chr.: Vollendung oder Verfall einer Verfassungsform? Akten eines Symposiums, 3.–7. August 1992, Bellagio* (Stuttgart 1995).

Edwards, C. M., "Greek Votive Reliefs to Pan and the Nymphs" (Ph.D. diss., New York University, 1985).

Ehrhardt, W., "Der Fries des Lysikratesmonument," *AntP* 22 (1993) 7–67, pls. 1–19.

Eichler, F., *Die Reliefs des Heroon von Gjölbaschi-Trysa* (Vienna 1950).

———, "Die Skulpturen des Heraions bei Argos," *ÖJh* 19 (1919) 15–153.

Eschbach, N., *Statuen auf panathenäischen Preisamphoren des 4. Jhs. v. Chr.* (Mainz 1986).

Evans, K. E., "The Daochos Monument" (Ph.D. diss., Princeton University, 1996).

Favaretto, I., M. De Poli, and M. C. Dossi, eds., *Museo Archeologico Nazionale di Venezia* (Milan 2004).

Felten, F., *Griechische tektonische Friese archaischer und klassischer Zeit*, Schriften aus dem Athenaion der klassischen Archäologie Salzburg 4 (Waldsassen 1984).

Ferrari, G., *Figures of Speech: Men and Maidens in Ancient Greece* (Chicago 2002).

Ferron, J., *Sarcophages de Phénicie: Sarcophages à scènes en relief*, Collection Cahiers de Byrsa, Série monographies 3 (Paris 1993).

Feyel, C., *Les artisans dans les sanctuaires grecs aux époques classique et hellénistique à travers la documentation financière en Grèce*, BÉFAR 318 (Athens and Paris 2006).

Filges, A., *Standbilder jugendlicher Göttinnen: Klassische und frühhellenistische Gewandstatuen mit Brustwulst und ihre kaiserzeitliche Rezeption*, Arbeiten zur Archäologie (Cologne 1997).

Flashar, M., *Apollon Kitharodos: Statuarische Typen des musischen Apollon*, Arbeiten zur Archäologie (Cologne 1992).

Floren, J., *Studien zur Typologie des Gorgoneion*, Orbus Antiquus 29 (Münster 1977).

Ford, A. L., *The Origins of Criticism: Literary Culture and Poetic Theory in Classical Greece* (Princeton 2002).

Franks, H. M., *Hunters, Heroes, Kings: The Frieze of Tomb II at Vergina*, Ancient Art and Architecture in Context 3 (Princeton 2012).

Fuchs, W., "Attische Nymphenreliefs," *AM* 77 (1962) 242–49, Beil. 64–69.

———, *Die Skulptur der Griechen*, 4th ed. (Munich 1993).

———, *Die Vorbilder der neuattischen Reliefs*, JdI-EH 20 (Berlin 1959).

Fuhrmann, H., *Philoxenos von Eretria: Archäologische Untersuchungen über zwei Alexandermosaike* (Göttingen 1931).

Furtwängler, A., *Masterpieces of Greek Sculpture: A Series of Essays on the History of Art*, trans. E. Sellers (New York 1895); repr. with omissions, ed. A. N. Oikonomides (Chicago 1964).

———, *Meisterwerke der griechischen Plastik* (Leipzig 1893).

Garland, R., *Introducing New Gods: The Politics of Athenian Religion* (London 1992).

Gazda, E. K., "Roman Sculpture and the Ethos of Emulation: Reconsidering Repetition," *HSCP* 97 (1995) 121–56.

Gazda, E. K., ed., *The Ancient Art of Emulation: Studies in Artistic Originality and Tradition from the Present to Classical Antiquity*, MAAR Supplementary Volume 1 (Ann Arbor 2002).

Geominy, W., "The Daochos Monument at Delphi: The Style and Setting of a Family Portrait in Historic Dress," in *Early Hellenistic Portraiture: Image, Style, Context*, ed. P. Schultz and R. von den Hoff (Cambridge 2007) 84–98.

———, *Die florentiner Niobiden*, 2 vols. (Bonn 1984).

Gercke, P., and N. Zimmermann-Elseify, *Antike Steinskulpturen und neuzeitliche Nachbildungen in Kassel: Bestandskatalog* (Mainz 2007).

Gerziger, D., "Eine Decke aus dem sechsten Grab der 'Sieben Brüder,'" *AntK* 18 (1975) 51–55, pls. 21–24.

Ginouvès, R., *Balaneutikè: Recherche sur le bain dans l'antiquité grecque*, BÉFAR 200 (Paris 1962).

Giouri (Youri), E., *Ὁ κρατήρας τοῦ Δερβενίου*, Bibliothiki tis en Athenais Archaiologikis Hetaireias 89 (Athens 1978).

Giuliani, L., "Das älteste Sokrates-Bildnis: Ein physiognomisches Porträt wider die Physiognomiker," in *Der exzentrische Blick: Gespräch über Physiognomik*, ed. C. Schmölders (Berlin 1996) 19–42.

———, "Il ritratto," in *I greci: Storia, cultura, arte, società*, vol. 2, *Una storia greca*, pt. 2, *Definizione*, ed. S. Settis (Turin 1998) 983–1011.

Giuliano, A., ed., *Museo Nazionale Romano: Le sculture*, 13 vols. (Rome 1979–95).

Gomme, A. W., "The End of the City-State," in A. W. Gomme, *Essays in Greek History and Literature* (Oxford 1937) 204–48.

Graeve, V. von, *Der Alexandersarkophag und seine Werkstatt*, IstForsch 28 (Berlin 1970).

Greifenhagen, A., "Odysseus in Malibu: Leihgabe aus amerikanischem Privatbesitz," *Pantheon* 40 (1982) 211–17.

Gschwantler, K., *Zeuxis und Parrhasios: Ein Beitrag zur antiken Künstlerbiographie*, Dissertationen der Universität Graz 29 (Vienna 1975).

Guhl, E. K., *Leben der Griechen und Römer*, 6th ed., ed. R. Engelmann (Berlin 1893).

Gulaki, A., *Klassische und klassizistische Nikedarstellungen: Untersuchungen zur Typologie und zum Bedeutungswandel* (Bonn 1981).

Güntner, G., *Göttervereine und Götterversammlungen auf attischer Weihreliefs: Untersuchung zur Typologie und Bedeutung*, Beiträge zur Archäologie 21 (Würzburg 1994).

Habicht, C., *Pausanias' Guide to Ancient Greece*, 2nd ed. (Berkeley 1998).

Hahland, H., *Vasen um Meidias*, Forschungen zur antiken Keramik 1 (Mainz 1976).

Hamdy Bey, O., and T. Reinach, *Une nécropole royale à Sidon: Fouilles de Hamdy Bey* (Paris 1892).

Hamiaux, M., *Les sculptures grecques*, vol. 1, *Des origines à la fin du IVe siècle avant J.-C.*, Musée du Louvre, Département des antiquités grecques, étrusques et romaines (Paris 1992).

———, *Les sculptures grecques*, vol. 2, *La période hellénistique (IIIe–Ier siècles avant J.-C.)*, Musée du Louvre, Département des antiquités grecques, étrusques et romaines (Paris 1998).

Harrison, E. B., "Alkamenes' Sculptures for the Hephaisteion: Part I, The Cult Statues," *AJA* 81 (1977) 137–78.

———, *The Athenian Agora: Results of Excavations Conducted by the American School of Classical Studies at Athens*, vol. 11, *Archaic and Archaistic Sculpture* (Princeton 1965).

———, "Style Phases in Greek Sculpture from 450 to 370 B.C.," in *Proceedings of the 12th International Congress of Classical Archaeology, Athens, 4–10 September, 1983*, vol. 3 (Athens 1988) 99–105.

———, "Two Pheidian Heads: Nike and Amazon," in *The Eye of Greece: Studies in the Art of Athens*, ed. D. Kurtz and B. Sparkes (Cambridge 1982) 53–88.

Hartswick, K. J., "The Ares Borghese Reconsidered," *RA* (1990) 227–83.

Haskell, F., and N. Penny, *Taste and the Antique: The Lure of Classical Sculpture, 1500–1900* (New Haven, CT, 1981).

Haspels, C. H. E., *Attic Black-Figured Lekythoi* (Paris 1936).

Havelock, C. M., *The Aphrodite of Knidos and Her Successors: A Historical Review of the Female Nude in Greek Art* (Ann Arbor 1995).

———, *Hellenistic Art: The Art of the Classical World from the Death of Alexander the Great to the Battle of Actium* (London 1971).

Havelock, E. A., *The Literate Revolution in Greece and Its Cultural Consequences* (Princeton 1982).

Herrmann, H.-V., *Olympia: Heiligtum und Wettkampfstätte* (Munich 1972).

———, "Die Siegerstatuen von Olympia," *Nikephoros* 1 (1988) 119–83.

Higgins, R. A., *Greek Terracottas*, Methuen's Handbooks of Archaeology (London 1967).

Himmelmann, N., *Attische Grabreliefs*, Nordrhein-Westfälische Akademie der Wissenschaften, Geisteswissenschaften, Vorträge G 357 (Opladen 1999).

———, *Der ausruhende Herakles*, Nordrhein-Westfälische Akademie der Wissenschaften und der Künste, Geisteswissenschaften, Vorträge G 420 (Paderborn 2009).

———, *Ideale Nacktheit in der griechischen Kunst*, JdI-EH 26 (Berlin 1990).

———, *Die private Bildnisweihung bei den Griechen: Zu den Ursprüngen des abendländischen Porträts*, Nordrhein-Westfälische Akademie der Wissenschaften, Geisteswissenschaften, Vorträge G 373 (Wiesbaden 2001).

———, "Quotations of Images of Gods and Heroes on Attic Grave Reliefs of the Late Classical Period," in *Periplous: Papers on Classical Art and Archaeology Presented to Sir John Boardman*, ed. G. R. Tsetskhladze, A. J. N. W. Prag, and A. M. Snodgrass (London 1990) 136–44.

———, *Reading Greek Art: Essays by Nikolaus Himmelmann*, ed. W. A. P. Childs and H. Meyer (Princeton 1998).

———, "Das realistische Porträt als Gattungserscheinung in der griechischen Kunst," in *Das Porträt vor der Erfindung des Porträts*, ed. M. Büchsel and P. Schmidt (Mainz 2003) 19–27.

———, *Realistische Themen in der griechischen Kunst der archaischen und klassischen Zeit*, JdI-EH 28 (Berlin 1994).

Himmelmann-Wildschütz, N., *Studien zum Ilissos-Relief* (Munich 1956).

———, *Zur Eigenart des klassischen Götterbildes* (Munich 1959).

Hinks, R., *Myth and Allegory in Ancient Art*, Studies of the Warburg Institute 6 (London 1939).

Hintzen-Bohlen, B., *Die Kulturpolitik des Eubulos und des Lykurg: Die Denkmäler- und Bauprojekte in Athen zwischen 355 und 322 v. Chr.* (Berlin 1997).

Hofkes-Brukker, C., and A. Mallwitz, *Der Bassai-Fries* (Munich 1975).

Hölscher, T., "Die Aufstellung des Perikles-Bildnisses und ihre Bedeutung," in *Festschrift für Ernst Siegmann zum 60. Geburtstag* (= *WürzJbb* 1 [1975]), ed. J. Latacz (Würzburg 1975) 187–99; repr. in *Griechische Porträts*, ed. T. Hölscher (Darmstadt 1988) 377–91.

———, *Griechische Historienbilder des 5. und 4. Jahrhunderts v. Chr.*, Beiträge zur Archäologie 6 (Würzburg 1973).

Hornblower, S., *Mausolus* (Oxford 1982).

Houser, C., *Greek Monumental Bronze Sculpture of the Fifth and Fourth Centuries B.C.* (New York 1987).

Houser, C., and D. Finn, *Greek Monumental Bronze Sculpture* (New York and Paris 1983).

Humphreys, S. C., "Economy and Society in Classical Athens," *AnnPisa* 39 (1970) 1–26.

Inan, J., *Roman Sculpture in Side* (Ankara 1975).

Inan, J., "Der sandalbindende Hermes," *AntP* 22 (1993) 105–16.

Innes, D. C., "Theophrastus and the Theory of Style," in *Theophrastus of Eresus: On His Life and Work*, ed. W. W. Fortenbaugh et al., Rutgers University Studies in Classical Humanities (New Brunswick, NJ, 1985) 251–67.

Ioakimidou, C., *Die Statuenreihen griechischer Poleis und Bünde aus spätarchaischer und klassischer Zeit*, Quellen und Forschungen zur antiken Welt 23 (Munich 1997).

Jacob-Felsch, M., *Die Entwicklung griechischer Statuenbasen und die Aufstellung der Statuen* (Waldsassen 1969).

Jacquemin, A., *Offrandes monumentales à Delphes*, BÉFAR 304 (Athens and Paris 1999).

Jacquemin, A., and D. Laroche, "Le monument de Daochos ou le trésor des Thessaliens," *BCH* 125 (2001) 305–22.

Jaeggi, O., *Die griechischen Porträts: Antike Repräsentation, moderne Projektion* (Berlin 2008).

Janaway, C., *Images of Excellence: Plato's Critique of the Arts* (Oxford 1995).

Johansen, K. Friis, *The Attic Grave-Reliefs of the Classical Period: An Essay in Interpretation* (Copenhagen 1951).

Junius, Franciscus, *The Literature of Classical Art*, vol. 1, *The Painting of the Ancients: De Pictura Veterum Libri Tres*, ed. K. Aldrich, P. Fehl, and R. Fehl, California Studies in the History of Art 22 (Berkeley 1991).

Kabus-Jahn, R., "Die grimanische Figurengruppe in Venedig," *AntP* 11 (1972) 7–97.

——, *Studien zu Frauenfiguren des vierten Jahrhunderts vor Christus* (Darmstadt 1963).

Kabus-Preisshofen, R., *Die hellenistische Plastik der Insel Kos*, AM-BH 14 (Berlin 1989).

——, "Statuettengruppe aus dem Demeterheiligtum bei Kyparissi auf Kos," *AntP* 15 (1975) 31–65, pls. 11–28.

Kaltsas, N., *Sculpture in the National Archaeological Museum, Athens*, trans. D. Hardy (Los Angeles 2002).

Kansteiner, S., *Herakles: Die Darstellungen in der Großplastik der Antike* (Cologne 2000).

Karanastassis, P., "Untersuchungen zur kaiserzeitlichen Plastik in Griechenland, II: Kopien, Varianten und Umbildungen nach Athena-Typen des 5. Jhs. v. Chr.," *AM* 102 (1987) 323–428.

Karoglou, K., *Attic Pinakes: Votive Images in Clay*, BAR International Series 2104 (Oxford 2010).

Karouzou, S., *National Archaeological Museum: Collection of Sculpture; A Catalogue*, trans. H. Wace (Athens 1968).

Karusos, C., "Τηλαυγὴς Μνῆμα: Ein attisches Grabmal im Nationalmuseum, Athen," *MüJb* 20 (1969) 7–32.

Kathariou, K., *Το εργαστήριο του ζώγραφου του Μελεάγρου και η εποχή του· Παρατηρήσεις στην Αττική κεραμεική του πρώτου τετάρτου του 4ου αι. π. Χ.* (Thessaloniki 2002).

Katsonopoulou, D., and A. Stewart, eds., *Skopas and His World: Proceedings of the Third International Conference on the Archaeology of Paros and the Cyclades, Paroikia, Paros, 11–14 June 2010*, Paros 3 (Athens 2013).

Kitto, H. D. F., *Greek Tragedy: A Literary Study* (New York, n.d.).

Kleiner, G., *Tanagrafiguren: Untersuchungen zur hellenistichen Kunst und Geschichte*, JdI-EH 15 (Berlin 1942).

Knell, H., *Athen im 4. Jahrhundert v. Chr., eine Stadt verändert ihr Gesicht: Archäologisch-kulturgeschichtliche Betrachtungen* (Darmstadt 2000).

Knigge, U., *Der Kerameikos von Athen: Führung durch Ausgrabungen und Geschichte* (Athens 1988).

Knittlmayer, B., and W.-D. Heilmeyer, eds., *Die Antikensammlung: Altes Museum, Pergamonmuseum, Staatliche Museen zu Berlin*, 2nd ed. (Mainz 1998).

Knoll, K., et al., *Die Antiken im Albertinum: Staatliche Kunstsammlungen Dresden; Skulpturensammlung*, Zaberns Bildbände zur Archäologie 13 (Mainz 1993).

Knoll, K., C. Vorster, and M. Woelk, *Staatliche Kunstsammlungen Dresden, Skulpturensammlung: Katalog der antiken Bildwerke*, vol. 2, pt. 1, *Idealskulptur der römischen Kaiserzeit* (Munich 2011).

Koch-Brinkmann, U., *Polychrome Bilder auf weissgrundigen Lekythen: Zeugen der klassischen griechischen Malerei*, Studien zur antiken Malerei und Farbgebung 4 (Munich 1999).

Kokula, G., *Marmorlutrophoren*, AM-BH 10 (Berlin 1984).

Kopcke, G., "Attische Reliefkeramik klassischer Zeit," *AA*, 1969, 545–51.

Kosmopoulou, A., *The Iconography of Sculptured Statue Bases in the Archaic and Classical Periods* (Madison, WI, 2002).

Kratzmüller, B., "'Frauensport' im alten Athen? Die Darstellungen sich körperlich betätigender Frauen als Abbild der Einstellung einer patriarchalisch geprägten Gesellschaft zum weiblichen Geschlect," in *Transformationen, Kontinuitäten und Veränderungen in der Sportgeschichte*, ed. W. Buss and A. Krüger (Hoya 2002) 171–81.

Kreikenbom, D., *Bildwerke nach Polyklet: Kopienkritische Untersuchungen zu den männlichen statuarischen Typen nach polykletischen Vorbildern; 'Diskophoros,' Hermes, Doryphoros, Herakles, Diadumenos* (Berlin 1990).

Kreilinger, U., *Anständige Nacktheit: Körperpflege, Reinigungsriten und das Phänomen weiblicher Nacktheit im archaisch-klassischen Athen*, Tübinger archäologische Forschungen 2 (Rahden, Westphalia, 2007).

——, "Τὰ ἀξιολογώτατα τοῦ Παυσανίου: Die Kunstauswahlkriterien des Pausanias," *Hermes* 125 (1997) 470–91.

——, "Anwendung der Gender-Forschung: Das Phänomen der Nacktheit in der attischen Vasen-malerei," in *Methodische Perspektiven in der klassischen Archäologie: Akten der Tagung des Deutschen Archäologen-Verbandes am 19. Juni 2004 in Freiburg*, Schriften des Deutschen Archäologen-Verbandes 16, ed. K. Hitzl (Tübingen 2005) 7–16.

Kreuzer, A., "Der Hermes von Olympia," *JdI* 58 (1943) 131–53.

Kron, U., "Priesthoods, Dedications and Euergetism: What Part Did Religion Play in the Political and Social Status of Greek Women?" in *Religion and Power in the Ancient Greek World: Proceedings of the Uppsala Symposium 1993*, Acta Universitatis Upsaliensis, Boreas 24, ed. P. Hellström and B. Alroth (Uppsala 1996) 139–82.

——, *Die zehn attischen Phylenheroen*, AM-BH 5 (Berlin 1976).

Krull, D., *Der Herakles vom Typ Farnese: Kopienkritische Untersuchungen einer Schöpfung des Lysipp* (Frankfurt am Main 1985).

Krumeich, R., *Bildnisse griechischer Herrscher und Staatsmänner im 5. Jahrhundert v. Chr.* (Munich 1997).

Künzl, E., *Frühhellenistische Gruppen* (Cologne 1968).

Kurtz, D. C., *Athenian White Lekythoi: Patterns and Painters*, Oxford Monographs on Classical Archaeology (Oxford 1975).

Kurtz, D. C., and J. Boardman, *Greek Burial Customs* (Ithaca, NY, 1971).

Kyrieleis, H., ed., *Archaische und klassische griechische Plastik: Akten des internationalen Kolloquiums vom 22.–25. April, 1985 in Athen* (Mainz 1986).

Landwehr, C., *Die antiken Gipsabgüsse aus Baiae: Griechische Bronzestatuen in Abgüssen römischer Zeit*, AF 14 (Berlin 1985).

Lawton, C. L., *Attic Document Reliefs: Art and Politics in Ancient Athens*, Oxford Monographs on Classical Archaeology (Oxford 1995).

Leader, R. E., "In Death Not Divided: Gender, Family, and State on Classical Athenian Grave Stelae," *AJA* 101 (1997) 683–99.

Leibundgut, A., *Künstlerische Form und konservative Tendenzen nach Perikles: Ein Stilpluralismus im 5. Jahrhundert v. Chr.?* Trierer Winckelmannsprogramme 10 (Mainz 1991).

Ley, A., "Atalante: Von der Athletin zur Liebhaberin; Ein Beitrag zum Rezeptionswandel eines mythologischen Thema des 6.–4. Jhs. v. Chr.," *Nikephoros* 3 (1990) 31–72.

Lezzi-Hafter, A., *Der Eretria-Maler: Werke und Weggefährten*, Forschungen zur antiken Keramik, Reihe 2, Kerameus 6 (Mainz 1988).

Linfert, A., "Die Schule des Polyklets," in *Polyklet: Der Bildhauer der griechischen Klassik; Ausstellung im Liebieghaus, Museum alter Plastik, Frankfurt am Main*, exh. cat., ed. H. Beck, P. C. Bol, and M. Bückling (Mainz 1990) 240–97.

Linfert-Reich, I., *Musen- und Dichterfiguren des vierten und frühen dritten Jahrhunderts* (Freiburg 1969).

Ling, R., *Roman Painting* (Cambridge 1991).

Lippold, G., *Die griechische Plastik, Handbuch der Archäologie*, vol. 3, pt. 1 (Munich 1950).

Löhr, C., *Griechische Familienweihungen: Untersuchungen einer Repräsentationsform von ihren Anfängen bis zum Ende des 4. Jhs. v. Chr.*, Internationale Archäologie 54 (Rahden, Westphalia, 2000).

Lullies, R., *Die kauernde Aphrodite* (Munich-Pasing 1954).

Lullies, R., and M. Hirmer, *Greek Sculpture*, 2nd ed. (New York 1960).

Lygkopoulos, T., *Untersuchungen zur Chronologie der Plastik des 4. Jhs. v. Chr.*, Dissertation, Rheinische-Friedrich-Wilhelms-Universität zu Bonn, 1982 (Bonn 1983).

Madigan, B. C., *The Temple of Apollo Bassitas*, vol. 2, *The Sculpture*, ed. F. A. Cooper (Princeton 1992).

Mallwitz, A., *Olympia und seine Bauten* (Darmstadt 1972).

Mangold, M., *Weihreliefs des 5. und 4. Jhs. v. Chr.*, Hefte des Archäologischen Seminars der Universität Bern (HASB) 2 (Bern 1993).

Mansuelli, G. A., *Galleria degli Uffizi: Le sculture*, vol. 1, Cataloghi dei musei e gallerie d'Italia (Rome 1958).

Marcadé, J., "Les métopes mutilées de la Tholos de Marmaria à Delphes," *CRAI*, 1979, 151–70; repr. in J. Marcadé, *Études de sculpture et d'iconographie antiques: Scripta varia, 1941–1991* (Paris 1993) 207–26.

⸻, "Observations sur les sculptures décoratives de la Tholos de Marmaria à Delphes," *Acad-Belg-BCBA* 59 (1977) 142–51.

⸻, *Recueil des signatures de sculpteurs grecs*, 2 vols. (Paris 1953–57).

⸻, "Les sculptures décoratives de la Tholos de Marmaria à Delphes: État actuel du dossier," in *Archaische und klassische griechische Plastik: Akten des internationalen Kolloquiums vom 22.–25. April 1985 in Athen*, ed. H. Kyrieleis (Mainz 1986) vol. 2, 169–73, pls. 145–48; repr. in J. Marcadé, *Etudes de sculpture et d'iconographie antiques: Scripta varia, 1941–1991* (Paris 1993) 227–42.

McKechnie, P., *Outsiders in the Greek Cities of the Fourth Century B.C.* (London 1989).

Metzger, H., *Recherches sur l'imagerie athénienne*, Publications de la Biblothèque Salomon Reinach 2 (Paris 1965).

⸻, *Les représentations dans la céramique attique du IVe siècle*, BÉFAR 172 (Paris 1951).

Metzler, D., *Porträt und Gesellschaft: Über die Entstehung des griechischen Porträts in der Klassik* (Münster 1971).

Meyer, M., *Die griechischen Urkundenreliefs*, AM-BH 13 (Berlin 1989).

Milleker, E. J., "The Statue of Apollo Lykeios in Athens" (Ph.D. diss., New York University, 1986).

Miller, S. G., *Ancient Greek Athletics* (New Haven, CT, 2004).

Mitropoulou, E., *Corpus I, Attic Votive Reliefs of the 6th and 5th Centuries B.C.* (Athens 1977).

Moltesen, M., et al., *Greece in the Classical Period: Ny Carlsberg Glyptotek* (Copenhagen 1995).

Momigliano, A., *The Development of Greek Biography*, 2nd ed. (Cambridge, MA, 1993).

Moon, W. G., ed., *Ancient Greek Art and Iconography*, Wisconsin Studies in Classics (Madison, WI, 1983).

Moraw, S., "Schönheit und Sophrosyne: Zum Verhältnis von weiblicher Nacktheit und bürgerlichem Status in der attischen Vasenmalerei," *JdI* 118 (2003) 1–47.

Moreno, P., "Il Farnese ritrovato ed altri tipi di Eracle in riposo," *MÉFRA* 94 (1982) 379–526.

⸻, "La pittura tra classicità e ellenismo," in *La crisi della polis*, vol. 2, *Arte, religione, musica*, Storia e civiltà dei greci, ed. R. Bianchi Bandinelli, vol. 6 (Milan 1979) 459–520.

⸻, "Satiro di Prassitele," in *Il Satiro danzante*, ed. R. Petriaggi (Milan 2003) 102–13.

⸻, "Satiro in estasi di Praxiteles," in *Il Satiro danzante di Mazara del Vallo: Il restauro e l'immagine; Atti del convegno, Roma, 3–4 giugno 2003*, ed. R. Petriaggi (Naples 2005) 198–227.

Moreno, P., ed., *Lisippo: L'arte e la fortuna*, exh. cat. (Rome 1995).

Morgan, C. H., "The Drapery of the Hermes of Praxiteles," *ArchEph* (1937) 61–68.

Moser von Filseck, K., *Der Apoxyomenos des Lysipp und das Phänomen von Zeit und Raum in der Plastik des 5. und 4. Jhs. v. Chr.*, Habelts Dissertationsdrucke, Reihe klassische Archäologie 27 (Bonn 1988).

Mossé, C., *Athens in Decline, 404–86 B.C.*, trans. J. Stewart (London and Boston 1973).

Neumann, G., *Probleme des griechischen Weihreliefs*, Tübinger Studien zur Archäologie und Kunstgeschichte 3 (Tübingen 1979).

Oakley, J. H., *The Phiale Painter*, Forschung zur antiken Keramik, Reihe 2, Kerameus 8 (Mainz 1990).

———, *Picturing Death in Classical Athens: The Evidence of the White Lekythoi*, Cambridge Studies in Classical Art and Iconography (Cambridge 2004).

Oakley, J. H., and R. H. Sinos, *The Wedding in Ancient Athens*, Wisconsin Studies in Classics (Madison, WI, 1993).

Ober, J., *Mass and Elite in Democratic Athens: Rhetoric, Ideology, and the Power of the People* (Princeton 1989).

Oberleitner, W., *Das Heroon von Trysa: Ein lykisches Fürstengrab des 4. Jahrhunderts v. Chr.*, AntW 25, Sondernummer (Mainz 1994).

Osborne, C., *Eros Unveiled: Plato and the God of Love* (Oxford 1994).

O'Sullivan, N., *Alcidamas, Aristophanes, and the Beginnings of Greek Stylistic Theory*, Hermes Einzelschriften 60 (Stuttgart 1992).

Overbeck, J., *Die antiken Schriftquellen zur Geschichte der bildenden Künste bei den Griechen* (Leipzig 1868; repr. Hildesheim 1971).

Palagia, O., "A Colossal Statue of a Personification from the Agora of Athens," *Hesperia* 51 (1982) 99–113.

———, *Euphranor*, Monumenta Graeca et Romana 3 (Leiden 1980).

———, "No Demokratia," in *The Archaeology of Athens and Attica under the Democracy*, Oxbow Monograph 37, ed. W. D. E. Coulson et al. (Oxford 1994) 113–22.

———, "Reflections on the Piraeus Bronzes," in *Greek Offerings: Essays on Greek Art in Honour of John Boardman*, Oxbow Monograph 89, ed. O. Palagia (Oxford 1997) 177–95.

Palagia, O., and J. J. Pollitt, eds., *Personal Styles in Greek Sculpture*, YCS 30 (Cambridge 1996).

Parker, R., *Athenian Religion: A History* (Oxford 1996).

Pasquier, A., and J.-L. Martinez, eds., *Praxitèle*, exh. cat. (Paris 2007).

Paul-Zinserling, V., *Der Jena-Maler und sein Kreis: Zur Ikonologie einer attischen Schalenwerkstatt um 400 v. Chr.* (Mainz 1994).

Pečírka, J., "The Crisis of the Athenian Polis in the Fourth Century B.C.," *Eirene* 9 (1976) 5–29.

Perry, E., *The Aesthetics of Emulation in the Visual Arts of Ancient Rome* (Cambridge 2005).

Petriaggi, P., ed., *Il Satiro danzante di Mazara del Vallo: Il restauro e l'immagine; Atti del convegno, Roma, 3–4 giugno 2003* (Naples 2005).

Pfisterer-Haas, S., "Mädchen und Frauen am Wasser: Brunnenhaus und Louterion als Orte der Frauengemeinschaft und der möglichen Begegnung mit einem Mann," *JdI* 117 (2002) 1–79.

Pfrommer, M., "Zur Venus Colonna: Ein späthellenistische Redaktion der knidischen Aphrodite," *IstMitt* 35 (1985) 173–80.

Phillips, K. M., "Perseus and Andromeda," *AJA* 72 (1968) 1–23.

Picard, C., *L'Acropole, L'enceinte, l'entrée, le bastion d'Athéna Niké, les propylées* (Paris 1929).

———, *Manuel d'archéologie grecque: La sculpture*, vol. 3, *Période classique, IVe siècle*, pt. 1 (Paris 1948); vol. 4, *Période classique, IVe siècle*, pt. 2 (Paris 1954–63).

Picard, O., ed., *Guide de Delphes: Le musée*, École française d'Athènes, Sites et monuments 6 (Paris 1991).

Picón, C. A., "The Oxford Maenad," *AntP* 22 (1993) 84–104, pls. 28–33.

Pinelli, P., and A. Wąsowicz, *Catalogue des bois et stucs grecs et romains provenant de Kertch*, Musée du Louvre (Paris 1986).

Pollitt, J. J., *The Ancient View of Greek Art: Criticism, History, and Terminology* (New Haven, CT, 1974).

———, *Art in the Hellenistic Age* (Cambridge 1986).

———, *The Art of Greece, 1400–31 B.C.*, Sources and Documents in the History of Art (Englewood Cliffs, NJ, 1965).

———, "The Impact of Greek Art on Rome," *TAPA* 108 (1978) 155–74.

Pouilloux, J., *Choix d'inscriptions grecques: Textes, traductions et notes*, Bibliothèque de la Faculté des Lettres de Lyon 4 (Paris 1960).

Pouilloux, J., *Fouilles de Delphes*, vol. 2, *Topographie et architecture*, pt. C, *Divers*, fasc. 2, *La région nord du sanctuaire, de l'époque archaïque à la fin du sanctuaire* (Paris 1960).

——, *Fouilles de Delphes*, vol. 3, *Épigraphie*, fasc. 4, *Les inscriptions de la terrasse du temple et de la région nord du sanctuaire: Nos. 351 à 516* (Paris 1976).

Pouilloux, J., and G. Roux, *Énigmes à Delphes* (Paris 1963).

Poulsen, F., *Catalogue of Ancient Sculpture in the Ny Carlsberg Glyptotek* (Copenhagen 1951).

Preisshofen, R., "Der Apollon Sauroktonos des Praxiteles," *AntP* 28 (2002) 41–115, pls. 21–64.

Pritchett, W. K., "The Attic Stelai: Part II," *Hesperia* 25 (1956) 178–318.

Raeck, W., "Rolle und Individuum im frühen griechischen Porträt," in *Das Porträt vor der Erfindung des Porträts*, ed. M. Büchsel and P. Schmidt (Mainz 2003) 29–42.

Rausa, F., *L'immagine del vincitore: L'atleta nella statuaria greca dall'età arcaica all'ellenismo*, Ludica 2 (Treviso and Rome 1994).

Reeder, E. D., *Pandora: Women in Classical Greece*, exh. cat. (Baltimore 1995).

Reinsberg, C., *Ehe, Hetärentum und Knabenliebe im antiken Griechenland,* Beck's Archäologische Bibliothek (Munich 1989).

Religion and Power in the Ancient Greek World, Proceedings of the Uppsala Symposium 1993, Acta Universitatis Upsaliensis, Boreas 24, ed. P. Hellström and B. Alroth (Uppsala 1996) 139–82.

Reuterswärd, P., *Studien zur Polychromie der Plastik*, vol. 2, *Griechenland und Rom* (Stockholm 1960).

Rhodes, P. J., and R. Osborne, *Greek Historical Inscriptions, 404–323 BC* (Oxford 2003).

Rhomiopoulou, K., A. Herrmann, and C. C. Vermeule, eds., *The Search for Alexander: An Exhibition*, exh. cat. (Boston 1980).

Richter, G. M. A., *Catalogue of Greek Sculptures (Metropolitan Museum of Art)* (Cambridge, MA, 1954).

——, *The Portraits of the Greeks*, 3 vols. (London 1965–72).

Richter, G. M. A., and R. R. R. Smith, *The Portraits of the Greeks* (Ithaca, NY, 1984).

Ridgway, B. S., *Fifth Century Styles in Greek Sculpture* (Princeton 1981).

——, *Fourth-Century Styles in Greek Sculpture*, Wisconsin Studies in Classics (Madison, WI, 1997).

——, *Hellenistic Sculpture*, Wisconsin Studies in Classics, vol. 1, *The Styles of ca. 331–200 B.C.* (Madison, WI, 1990); vol. 2, *The Styles of ca. 200–100 B.C.* (Madison, WI, 2000); vol. 3, *The Styles of ca. 100–31 B.C.* (Madison, WI, 2002).

——, "Notes on the Development of the Greek Frieze," *Hesperia* 35 (1966) 188–204.

——, "*Paene ad Exemplum*: Polykleitos' Other Works," in *Polykleitos, the Doryphoros, and Tradition,* ed. W. G. Moon, Wisconsin Studies in Classics (Madison, WI, 1995) 177–99.

——, "Painterly and Pictorial in Greek Relief Sculpture," in *Ancient Greek Art and Iconography,* ed. W. G. Moon, Wisconsin Studies in Classics (Madison, WI, 1983) 193–208.

——, *Roman Copies of Greek Sculpture: The Problem of the Originals,* Jerome Lectures, 15th series (Ann Arbor 1984).

——, "The Setting of Greek Sculpture," *Hesperia* 40 (1971) 336–56.

——, "A Story of Five Amazons," *AJA* 78 (1974) 1–17.

Rizzo, G. E., *Prassitele* (Milan 1932).

Robertson, M., *The Art of Vase-Painting in Classical Athens* (Cambridge 1992).

Rodenwaldt, G., Θεοὶ ῥεῖα ζώοντες, AbhBerl, Jahrg. 1943, no. 13 (Berlin 1943).

Rolley, C., *Greek Bronzes*, trans. R. Howell (London 1986).

——, *La sculpture grecque*, vol. 2, *La période classique* (Paris 1999).

Rouveret, A., *Histoire et imaginaire de la peinture ancienne: Ve siècle av. J.C.–Ier siècle ap. J.C.,* BÉFAR 274 (Rome 1989).

Roux, G., *L'amphictionie, Delphes et le temple d'Apollon au IVe siècle*, Collection de la Maison de l'Orient Méditerranéen 8 (Lyon and Paris 1979).

——, *L'architecture de l'Argolide aux IVe et IIIe siècles avant J.-C.* (Paris 1961).

——, "Problèmes delphiques d'architecture et d'épigraphie," *RA* (1969) 29–56.

Rudhardt, J., *Le rôle d'Eros et d'Aphrodite dans les cosmogonies grecques*, Essais et Conférences 0756-3884, Collège de France (Paris 1986).

Rügler, A., *Die Columnae caelatae des jüngeren Artemisions von Ephesos, IstMitt-BH* 34 (Tübingen 1988).

Saatsoglou-Paliadeli, C., "Linear and Painterly: Color and Drawing in Ancient Greek Painting," in *Color in Ancient Greece: The Role of Color in Ancient Greek Art and Architecture, 700–31 B.C.; Proceedings of the Conference Held in Thessaloniki, 12th–16th April, 2000*, ed. M. A. Tiverios and D. S. Tsiafakis (Thessaloniki 2002) 97–105, pls. 20–22.

——, *Βεργίνα· Ο τάφος του Φιλίππου· Η τοιχογραφία με το κυνήγι*, Bibliothiki tis en Athenais Archaiologikis Hetaireias 231 (Athens 2004).

Sabetai, V., "Aspects of Nuptial and Genre Imagery in Fifth-Century Athens: Issues of Interpretation and Methodology," in *Athenian Potters and Painters: The Conference Proceedings*, Oxbow Monograph 67, ed. J. H. Oakley, W. D. E. Coulson, and O. Palagia (Oxford 1997) 319–36.

Salzmann, D., *Untersuchungen zu den antiken Kieselmosaiken: Von den Anfängen bis zum Beginn der Tesseratechnik, AF* 10 (Berlin 1982).

Scanlon, T. F., *Eros and Greek Athletics* (Oxford 2002).

Schanz, H. L., *Greek Sculptural Groups: Archaic and Classical* (Ph.D. diss., Harvard University, 1969), Outstanding Dissertations in the Fine Arts (New York 1980).

Scheer, T. S., *Die Gottheit und ihr Bild: Untersuchungen zur Funktion griechischer Kultbilder in Religion und Politik*, Zetemata 105 (Munich 2000).

Schefold, K., "Die Athena des Piräus," *AntK* 14 (1971) 37–42, 133, pls. 15, 16.

——, *Götter- und Heldensagen der Griechen in der spätarchaischen Kunst* (Munich 1978).

——, *Kertscher Vasen*, Bilder griechischer Vasen 3 (Berlin 1930).

——, *Meisterwerke griechischer Kunst*, 2nd ed. (Basel 1960).

——, *Untersuchungen zu den kertscher Vasen*, Archäologische Mitteilungen aus russischen Sammlungen 4 (Berlin 1934).

Scheibler, I., "Das älteste Sokratesporträt," *MüJb* 40 (1989) 7–33.

——, *Griechische Malerei der Antike* (Munich 1994).

——, "Zum Koloritstil der griechischen Malerei," *Pantheon* 36 (1978) 299–307.

——, *Sokrates in der griechischen Bildniskunst: 12. Juli bis 24. September 1989, Glyptothek München*, exh. cat. (Munich 1989).

——, "Sokrates und kein Ende: Die Statuen," in *Antike Porträts: Zum Gedächtnis von Helga von Heintze*, ed. H. von Steuben (Möhnesee 1999) 1–13.

——, "Die 'Vier Farben' der griechischen Malerei," *AntK* 17 (1974) 92–102.

Schild-Xenidou, W., *Boiotische Grab- und Weihreliefs archaischer und klassischer Zeit*, Dissertation, Ludwig-Maximilians-Universität, 1969 (Munich 1972).

Schlörb, B., *Timotheos, JdI-EH* 22 (Berlin 1965).

Schmaltz, B., "Andromeda—Ein campanisches Wandbild," *JdI* 104 (1989) 259–81.

——, *Griechische Grabreliefs*, Erträge der Forschung 192 (Darmstadt 1983).

——, "Typus und Stil im historischen Umfeld," *JdI* 112 (1997) 77–107.

——, "Verwendung und Funktion attischer Grabmäler," *MarbWPr*, 1979, 13–37.

Schmidt, S., *Rhetorische Bilder auf attischen Vasen: Visuelle Kommunikation im 5. Jahrhundert v. Chr.* (Berlin 2005).

——, "Über den Umgang mit Vorbildern: Bildhauerarbeit im 4. Jahrhundert v. Chr.," *AM* 111 (1997) 191–223, pls. 33–44.

Schneider, L., "Das grosse Eleusinische Relief und seine Kopien," *AntP* 12 (1973) 103–24.

Scholl, A., *Die attischen Bildfeldstelen des 4. Jhs. v. Chr.: Untersuchungen zu den kleinformatigen Grab-reliefs im spätklassischen Athen, AM-BH* 17 (Berlin 1996).

Schuchhardt, W.-H., *Alkamenes, BWPr* 126 (Berlin 1977).

Schultz, P., "Leochares' Argead Portraits in the Philippeion," in *Early Hellenistic Portraiture: Image, Style, Context*, ed. P. Schultz and R. von den Hoff (Cambridge 2007) 205–33.

Schürmann, W., "Der Typus der Athena Vescovali und seine Umbildungen," *AntP* 27 (2000) 37–90, pls. 20–49.

Schweitzer, B., *Xenokrates von Athen: Beiträge zur Geschichte der antiken Kunstforschung und Kunst-anschauung*, Schriften der Königsberger Gelehrten Gesellschaft, Geisteswissenschaftliche Klasse 9, 1 (Halle 1932); repr. in B. Schweitzer, *Zur Kunst der Antike: Ausgewählte Schriften*, ed. U. Hausmann and H.-V. Herrmann (Tübingen 1963) vol. 1, 105–64.

Seaman, K., "Retrieving the Original Aphrodite of Knidos," *RendLinc*, ser. 9, 15 (2004) 531–69.

Shapiro, H. A., "The Origins of Allegory in Greek Art," *Boreas* 9 (1986) 4–23.

——, *Personifications in Greek Art: The Representation of Abstract Concepts, 600–400 B.C.* (Zurich 1993).

Shear, Jr., T. L., "The Monument of the Eponymous Heroes in the Athenian Agora," *Hesperia* 39 (1970) 145–222.

Simon, E., "Eirene und Pax: Friedensgöttinnen in der Antike," *SBFrankfurt* 24, no. 3 (1988) 55–80, pls. 1–14.

——, "Eleusis in Athenian Vase-Painting: New Literature and Some Suggestions," in *Athenian Potters and Painters: The Conference Proceedings*, Oxbow Monograph 67, ed. J. H. Oakley, W. D. E. Coulson, and O. Palagia (Oxford 1997) 97–108.

——, *Die griechischen Vasen*, 2nd ed. (Munich 1981).

——, "Neue Deutung zweier eleusinischer Denkmäler des vierten Jahrhunderts v. Chr.," *AntK* 9 (1966) 72–92.

Sjöqvist, E., "Lysippus: I, Lysippus' Career Reconsidered; II, Some Aspects of Lysippus' Art," in *Lectures in Memory of Louise Taft Semple, Second Series*, ed. C. G. Boulter et al., University of Cincinnati Classical Studies 2 (Norman, OK, 1973) 1–50.

Small, J. P., "Time in Space: Narrative in Classical Art," *ArtB* 81 (1999) 562–75.

Smith, A. C., *Polis and Personification in Classical Athenian Art*, Monumenta Graeca et Romana 19 (Leiden, 2011).

Smith, R. R. R., *Hellenistic Sculpture* (London 1991).

Sobel, H., *Hygieia: Die Göttin der Gesundheit* (Darmstadt 1990).

Sprague, R. K., ed., *The Older Sophists* (Columbia, SC, 1972).

Sprute, J., "Aristotle and the Legitimacy of Rhetoric," in *Aristotle's Rhetoric: Philosophical Essays*, ed. D. J. Furley and A. Nehamas (Princeton 1994) 117–28.

Spyropoulos, G., *Drei Meisterwerke der griechischen Plastik aus der Villa des Herodes Atticus zu Eva/ Loukou* (Frankfurt am Main 2001).

Stafford, E., *Worshipping Virtues: Personification and the Divine in Ancient Greece* (London 2000).

Stähler, K., *Griechische Geschichtsbilder klassischer Zeit*, Eikon: Beiträge zur antiken Bildersprache 1 (Münster 1992).

Stähli, A., "Nackte Frauen," in *Hermeneutik der Bilder: Beiträge zur Ikonographie und Interpretation griechischer Vasenmalerei*, ed. S. Schmidt and J. H. Oakley (Munich 2009) 43–51.

Stavridou, A. A., Τα γλύπτα του Μουσείου Τεγέας (Athens 1996).

Stears, K., "Dead Women's Society: Constructing Female Gender in Classical Athenian Funerary Sculpture," in *Time, Tradition, and Society in Greek Archaeology: Bridging the 'Great Divide,'* ed. N. Spencer (London 1995) 109–31.

Steiner, D. T., *Images in Mind: Statues in Archaic and Classical Greek Literature and Thought* (Princeton 2001).

——, "Moving Images: Fifth-Century Victory Monuments and the Athlete's Allure," *ClAnt* 17 (1998) 123–49.

Steinhauer, G., Το Αρχαιλοκιγικό Μουσείο Πειραιώς (Athens 2001).

Stewart, A. F., *Art, Desire, and the Body in Ancient Greece* (Cambridge 1997).

——, *Faces of Power: Alexander's Image and Hellenistic Politics* (Berkeley 1993).

——, *Greek Sculpture: An Exploration* (New Haven, CT, 1990).

——, "Lysippan Studies 2: Agias and Oilpourer," *AJA* 82 (1978) 301–13.

——, *Skopas of Paros* (Park Ridge, NJ, 1977).

Strocka, V. M., *Forschungen in Ephesos*, vol. 8, pt. 1, *Die Wandmalerei der Hanghäuser in Ephesos* (Vienna 1977).

Stucky, R. A., *Tribune d'Echmoun: Ein griechischer Reliefzyklus des 4. Jahrhunderts v. Chr. in Sidon*, *AntK-BH* 13 (Basel 1984).

Stupperich, R., "The Iconography of Athenian State Burials in the Classical Period," in *The Ar-chaeology of Athens and Attica under the Democracy*, Oxbow Monograph 37, ed. W. D. E. Coulson et al. (Oxford 1994) 93–103.

———, *Staatsbegräbnis und Privatgrabmal im klassischen Athen* (Münster 1977).

Süssenbach, U., *Der Frühhellenismus im griechischen Kampf-Relief: Versuch einer Rekonstruktion der Stilentwicklung vom Mausoleum von Halikarnassos bis zum Großen Altarfries von Pergamon*, Abhandlungen zur Kunst-, Musik- und Literaturwissenschaft 105 (Bonn 1971).

Süsserott, H. K., *Griechische Plastik des 4. Jahrhunderts vor Christus: Untersuchungen und Zeitbestim-mung* (Frankfurt 1938).

Svoronos, J. N., *Das athener Nationalmuseum*, 3 vols. (Athens 1908–37).

Tagalidou, E., *Weihreliefs an Herakles aus klassischer Zeit*, Studies in Mediterranean Archaeology and Literature, Pocket-book 99 (Jonsered 1993).

Thompson, H. A., and R. E. Wycherley, *The Athenian Agora: Results of Excavations Conducted by the American School of Classical Studies at Athens*, vol. 14, *The Agora of Athens: The History, Shape and Uses of an Ancient City Center* (Princeton 1972).

Todisco, L., *Scultura greca del IV secolo: Maestri e scuole di statuaria tra classicità ed ellenismo*, Re-pertori fotografici Longanesi 8 (Milan 1993).

Traversari, G., *Sculture del V°–IV° secolo A.C. del Museo archeologico di Venezia*, Collezioni e musei archeologici del Veneto (Venice 1973).

Travlos, J., *Pictorial Dictionary of Ancient Athens* (New York 1971).

Trendall, A. D., and A. Cambitoglou, *The Red-Figured Vases of Apulia*, 6 vols. (Oxford 1978–92).

Trianti, I., *Το Μουσείο Ακροπόλεως* (Athens 1998).

Tzachou-Alexandri, O., ed., *Mind and Body: Athletic Contests in Ancient Greece*, exh. cat. (Athens 1989).

Valavanis, P., *Παναθηναϊκοί αμφορείς από την Ερέτρια· Συμβολή στην Αττική αγγειογραφία του 4ου π.Χ. αι.* (Athens 1991).

van Straten, F. T., "Gifts for the Gods," in *Faith, Hope and Worship: Aspects of Religious Mentality in the Ancient World*, ed. H. S. Versnel, Studies in Greek and Roman Religion (Leiden 1981) 65–151.

———, *Hierà Kalá: Images of Animal Sacrifice in Archaic and Classical Greece* (Leiden 1995).

———, "Images of Gods and Men in a Changing Society: Self-Identity in Hellenistic Religion," in *Images and Ideologies: Self-Definition in the Hellenistic World*, ed. A. Bulloch et al. (Berkeley 1993) 248–64.

———, "Votives and Votaries in Greek Sanctuaries," in *Le sanctuaire grec: Huit exposés suivis de dis-cussions*, Entretiens sur l'Antiquité classique 37, ed. O. Reverdin and B. Grange (Geneva 1992) 247–84.

Vaulina, M., and A. Wąsowicz, *Bois grecs et romains de l'Ermitage*, trans. M. Drojecka (Wrocław 1974).

Vedder, U., "Frauentod-Kriegertod im Spiegel der attischen Grabkunst des IV. Jhs. v. Chr.," *AM* 103 (1988) 161–91, pls. 21–25.

———, *Untersuchungen zur plastischen Ausstattung attischer Grabanlagen des 4. Jhs. v. Chr.*, Disserta-tion, Friedrich-Wilhelms-Universität (Bonn 1984).

Venedikov, I., and T. Gerasimov, *Thracian Art Treasures*, 2nd ed. (Sofia 1979).

Vermeule, C. C., *Greek and Roman Sculpture in America: Masterpieces in Public Collections in the United States and Canada* (Malibu, CA, and Berkeley 1981).

Vermeule, C. C., and A. Brauer, *Stone Sculptures: The Greek, Roman, and Etruscan Collections of the Harvard University Art Museums* (Cambridge, MA, 1990).

Vermeule, C. C., and M. B. Comstock, *Sculpture in Stone and Bronze: Additions to the Collections of Greek, Etruscan and Roman Art, 1971–1988* (Boston 1988).

Vermeule, C. C., and N. Neuerburg, *Catalogue of Ancient Art in the J. Paul Getty Museum: The Larger Statuary, Wall Paintings and Mosaics* (Malibu, CA, 1973).

Vernant, J.-P., *Mortals and Immortals: Collected Essays*, ed. and trans. F. I. Zeitlin (Princeton 1991).

Vierneisel-Schlörb, B., *Glyptothek München, Katalog der Skulpturen*, vol. 2, *Klassische Skulpturen* (Munich 1979).

Vierneisel-Schlörb, B., *Glyptothek München, Katalog der Skulpturen*, vol. 3, *Klassische Grabdenk-mäler und Votiv-reliefs* (Munich 1988).

Vikela, E., "Attische Weihreliefs und die Kult-Topographie Attikas," *AM* 112 (1997) 167–246, pls. 20–31.

Vogt, S., *Aristoteles Werke in deutscher Übersetzung*, vol. 18, *Opuscula*, pt. 6, *Physiognomica*, ed. H. Flashar (Berlin 1999).

Vollkommer, R., *Herakles in the Art of Classical Greece*, Oxford Monographs in Archaeology 25 (Oxford 1988).

Vorster, C., *Vatikanische Museen, Museo Gregoriano Profano ex Lateranense: Katalog der Skulpturen*, vol. 2, *Römische Skulpturen des späten Hellenismus und der Kaiserzeit* (Mainz 1993).

Voutiras, E., "A Dedication of the *Hebdomastai* to the Pythian Apollo," *AJA* 86 (1982) 229–33.

———, *Studien zu Interpretation und Stil griechischer Porträts des 5. und frühen 4. Jahrhunderts* (Bonn 1980).

Wace, A. J. B., "The Cloaks of Zeuxis and Demetrius," *ÖJh* 39 (1952) 111–18.

Walter-Karydi, E., "Color in Classical Painting," in *Color in Ancient Greece: The Role of Color in Ancient Greek Art and Architecture, 700–31 B.C.; Proceedings of the Conference Held in Thessaloniki, 12th–16th April, 2000*, ed. M. A. Tiverios and D. S. Tsiafakis (Thessaloniki 2002) 75–88, pls. 15–17.

Watzinger, C., *Griechische Holzsarkophage aus der Zeit Alexanders der Grossen*, Ausgrabungen der Deutschen Orient-Gesellschaft in Abusir, 1902–1904 (Leipzig 1905).

Waywell, G. B., *The Free-Standing Sculptures of the Mausoleum at Halicarnassus in the British Museum* (London 1978).

Weber, H., "Zur Zeitbestimmung des Florentiner Niobiden," *JdI* 75 (1960) 112–32.

Webster, T. B. L., *Art and Literature in Fourth-Century Athens* (London 1956).

———, *Potter and Painter in Classical Athens* (London 1972).

Wehgartner, I., "Color on Classical Vases," in *Color in Ancient Greece: The Role of Color in Ancient Greek Art and Architecture, 700–31 B.C.; Proceedings of the Conference Held in Thessaloniki, 12th–16th April, 2000*, ed. M. A. Tiverios and D. S. Tsiafakis (Thessaloniki 2002) 89–96, pls. 18, 19.

Wesenberg, B., "Zur Io des Nikias in den pompejanischen Wandbildern," in *Kanon: Festschrift Ernst Berger zum 60. Geburtstag am 26. Februar 1988 gewidmet*, ed. M. Schmidt (Basel 1988) 344–50.

Whitehead, D., *The Ideology of the Athenian Metic*, Proceedings of the Cambridge Philological Society, Supplementary Volume 4 (Cambridge 1977).

Willers, D., *Zu den Anfängen der archaistischen Plastik in Griechenland*, AM-BH 4 (Berlin 1975).

Wilson, P., *The Athenian Institution of the Khoregia: The Chorus, the City, and the Stage* (Cambridge 2000).

Worman, N. B., *The Cast of Character: Style in Greek Literature* (Austin, TX, 2002).

Woysch-Méautis, D., *La représentation des animaux et des êtres fabuleux sur les monuments funé-raires grecs de l'époque archaïque à la fin du IVe siècle av. J.-C.*, Cahiers d'archéologie romande 21 (Lausanne 1982).

Wünsche, R., "Der Jungling vom Magdalensberg: Studie zur römischen Idealplastik," in *Festschrift Luitpold Dussler: 28 Studien zur Archäologie und Kunstgeschichte*, ed. J. A. Schmoll, M. Restle, and H. Weiermann (Munich 1972) 45–80.

Yalouris, N., "Die Skulpturen des Asklepiostempels in Epidauros," *AntP* 21 (1992) 1–93.

Zanker, P., *Klassizistische Statuen: Studien zur Veränderung des Kunstgeschmacks in der römischen Kaiserzeit* (Mainz 1974).

———, *Die Maske des Sokrates: Das Bild des Intellektuellen in der antiken Kunst* (Munich 1995).

Zervoudaki, E. A., "Attische polychrome Reliefkeramik des späten 5. und des 4. Jahrhunderts v. Chr.," *AM* 83 (1968) 1–88.

Index of Subjects

For objects in museums, consult the separate index of museums. For citations of ancient texts and inscriptions, consult the separate index locorum.

Aphrodite, Fréjus-Naples type, 110

Aphrodite, Knidian type (Figs. 147, 148), 77, 96, 110, 118, 119, 139, 167, 169, 191, 198, 204, 212, 230, 234, 310; attribution to Praxiteles, 85; Belvedere type (Fig. 148), 86–89, 258; Braschi variant in Munich (Fig. 149), 87, 258; Colonna type (Fig. 147), 86–89, 258; as an epiphany, 258; immediate and intimate view of, 258; intruder and, 87, 258, 310; Lucian on, 86; Pliny on, 85; power and voluptuousness of, 242; resemblance to women in bathing scenes, 244; setting of on Knidos, 196–97

Aphrodite, leaning types, 80, 111, 194; multiple Greek versions of, 66, 80

Aphrodite, Olympias type, 66

Apollo: in Arkadian votive group at Delphi, 169; and Artemis, 129; in Daochos Monument, 172; and Marsyas on Mantineia base, 44, 120; in pediment of Temple of Apollo at Delphi, 217, 259, 272; in slaughter of Niobids depictions, 183; on Tribune of Eshmoun, 275; on votive relief of Xenokrateia, 167

Apollo, Belvedere type (Fig. 239), 196; possible Baiae plaster cast of, 59

Apollo, Kitharoidos type, 32n56, 66

Apollo, Lykeios type, 79, 114, 257, 317; copies of, 79

Apollo Patroos, statue in Athenian Agora (Figs. 73, 74), 34, 66, 67, 69, 84; copy in Vatican, 66; polished surfaces of, 69; sandal of, 66

Apollo Sauroktonos (Figs. 181, 182), 75, 77, 96, 120, 139, 167, 169, 198n299, 204, 212, 321; copies of, 79; dioramic quality of, 139, 195, 321; focused gaze of, 118; fragmentary bronze statue in Cleveland (Fig. 182), 35–36; leaning on tree, 256; meaning of, 257, 313, 324; Pliny's description of, 90; as possible votive, 317

Apollodoros, Athenian painter, 138, 139

apoxyomenoi, 311, 316; on relief on Athenian Acropolis, 182

apoxyomenos (strigil-cleaner), bronze statue from Ephesos (Figs. 71, 72), 34, 89, 90, 118, 127, 195, 311–12

Apoxyomenos in Vatican (Figs. 150–53), 43, 77, 98, 117–18, 120, 195, 311, 323; attribution to Lysippos, 85, 89–90

Apulian vases: Arpi Painter, slaughter of Niobids, 183; Baltimore Painter, slaughter of Niobids, 183

archaistic style, 8, 60, 278–79, 280, 281, 282; Athena in west pediment of Temple of Asklepios at Epidauros, 279; Athena on Panathenaic amphoras, 279; frieze of Hieron on Samothrace, 279; revealing the sacred, 281; round altar from Brauron, 279; votive relief to nymphs in New York, 279, 281

Ares, Borghese type, 96, 98, 111, 112

Argive Heraion, 30; metopes, 207, 279

Aristophanes, comedian, 255; and aesthetics, 5; and continuity of fifth and fourth centuries, 9; influenced by sophists, 306; on luxury vessels, 47

Aristotle, 2, 9, 11, 16, 17, 20, 22, 52, 137, 156, 254, 267, 270; on benignity, 281; on characteristics of human types or states, 283; and complexity in function of

images, 304; definition of style, 303; on democracies and oligarchies, 21; evaluation of craft, 302; on expression, 5, 7–8, 315; insight into human condition, 308; on learning through sight, 302; on metaphor, 303–5; on phantasia, 303–4; portrait of (Fig. 280), 291; portrait statues designated in will of, 285; on portraits, 284; on presentation and content, 282; on recognizable images of people, 292; on value added by craftsmen, 304–5

Artemis, 122, 281–82; in chitoniskos, 132; restored as Tyche, 57

Artemis, Colonna type (Figs. 165, 166), 108, 125–26, 127, 191

Artemis, Dresden type (Fig. 170), 68, 126–27; in Antakya, 127; in Kassel, use of drill on, 68

Artemis, Gabii type (Figs. 137, 138), 73, 92, 127–28, 191; treatment of drapery, 73

Artemis, Versailles type (Fig. 240), 132, 196

artists: and craftsmen, 21–22; individual styles of, 7, 308

Asia Minor, Greek, 11, 52, 53

Asklepios: Giustini statue type on votive reliefs, 78; as mature citizen, 257; statue in Eleusis dedicated by Epikrates, 35

Asklepios and Hygieia, votive reliefs to, 42, 113, 200–202

Atalanta, 143, 239–42, 242n87, 248–49; arranging hair, 240–41; bare breasted, 239; and Eros, 240–41; and Hippomenes, 142–43, 240, 241; lack of textual tradition of nude, 242n88; on Lakonian cup, 248n151; at louterion, 239, 240, 242; marriage of, 240; and Meleager on Attic vases, 249; on Melian plaques, 248, 249; nude with Peleus, 240; as seductive huntress, wrestler, and runner, 249; tragic destiny of, 249; transformation of into benign spirit, 252; wearing brassiere, 239; as woman athlete par excellence, 239

Atarbos monument (Figs. 223, 224), 43, 111n81, 171, 182; Pyrrhic dance on, 171

Athena: dress of, 245, 279, 282, 312; on east frieze of Parthenon, 246n116; statue on Athenian Acropolis (1336) (Fig. 129), 68, 273; statuette in Venice (Fig. 85), 273; in west pediment of Parthenon, 105, 108, 246n116

Athena and Marsyas group, 168–69

Athena, Hephaisteia type, 78

Athena, Ince Blundell type (Fig. 268), 28, 80, 271, 274

Athena, Mattei type (Figs. 76, 79), 57–58, 75–76, 80, 128–29

Athena, Parthenos type, 80, 245n111; reflected in Roman statue in Argos, 58; rocky setting of shield relief, 209, 250, 251; shield of, 201

Athena, Piraeus bronze statue (Figs. 75, 77, 78), 35, 57–58, 75–76, 128–29, 282, 312

Athena, Rospigliosi type (Figs. 168, 169), 108, 125, 128, 129, 130, 131, 132, 245n115, 246n117, 276, 282; head interchanged with Vescovali type, 130; young, 245

Athena, Velletri type, 78, 108–9, 317; Baiae plaster cast, 59, 78

Athena, Vescovali type (Figs. 145, 146), 108, 125, 128, 129–31; copies of (Figs. 145, 146), 79; depicted on

votive relief to Dionysos, 131; head interchanged with Rospigliosi type, 130; small bronze in Arezzo, 130–31; statue in Florence with head of Rospigliosi type, 131; versus Rospigliosi type, 282

Athens, Acropolis, 15: copies of sculpture from, 77, 127; display of sculpture on, 4; marble torso of warrior with breastplate, 168; sculpture and bases (Figs. 129, 275), 38, 65, 68, 80, 127n179, 168, 171, 182, 186–87, 188, 276, 285. *See also* Atarbos monument

Athens, Agora: base of Bryaxis, 42, 44, 198, 285; copies of sculpture from, 77; description by Pausanias, 84; gilded statue of Demetrios Poliorketes, 35; monument of the eponymous heroes, 169–70, 185; Nereid on dolphin acroterion (Fig. 42), 31, 106; Nike acroterion (Fig. 41), 31, 106; statues in, 285, 294; torso of Tyche or Themis (Fig. 80), 35, 134, 281; votive pillar of shoemaker, 41–42. *See also* Apollo Patroos; Eirene and Ploutos statue group; Tyrannicides group

Athens, choregic monuments, 6, 10, 21, 42–43, 154, 163, 197; of Nikias, 197–98; of Thrasyllos, 35n90, 197. *See also* Lysikrates Monument

Athens, Erechtheion: building accounts, 16, 22n129; caryatids (Fig. 2), 27, 64, 65, 109–10; copies of caryatids, 64–65n72, 65, 67, 78–79, 222, 271–72; dating of sculpture, 27; frieze (Fig. 3), 105, 206–7

Athens, Hephaisteion (Theseion), 165; friezes, 103, 213, 251; paintings in, 224; Theseus in poses of Harmodios and Aristogeiton in frieze, 80–81

Athens, Kerameikos cemetery. *See* Kerameikos cemetery, Athens

Athens, Stoa of Zeus, 206; paintings by Euphranor in, 206

Athens, Street of the Tripods, 10, 154, 211

Athens, Temple of Athena Nike, 26, 206, 213; frieze (Fig. 1), 102–3, 104n18; parapet reliefs (Fig. 160), 68, 104–5, 112, 122, 230, 245, 310, 316; Nikai performing mortal rituals on parapet reliefs, 244, 253, 256. *See also* "Sandal-binder"

Athens, Theater of Dionysos 19, 226; portrait statues of tragedians, 19, 131–32, 282, 285; throne of priest of Dionysos, 269

athletes: inwardly-turned statues of replacing heroic males, 323; victor votives of, 18–19, 34, 97, 154, 186, 189, 195, 211, 285, 311–12, 316

Attic (Praxitelean) school of sculpture, 114

Attic red-figure vase painters. *See names of individual painters*

Attic red-figure vase painting, 91, 92; large figures on ground line in, 141; progressive and conservative groups of, 141; polychrome, 140; and reconstruction of monumental painting, 51; resemblance to silver vessels, 48; small figures in field in, 141;

Attic red-figure vases: plastic additions to, 140, 145; export of, 141; made for foreigners, 141

Augustus of Prima Porta, 58, 99; coloration of, 69

"Aura Palatina" (Fig. 43), 31, 67; statue from villa of Herodes Atticus at Loukou, 31

Aura, statue in Copenhagen (Fig. 45), 32, 134

Azara Herm (Alexander the Great) (Fig. 285), 294

Baiae, plaster casts from, 58–59, 67, 78, 79, 109

baldness depicted on grave stelai, 292

banal, intimate moment, 193–94, 195, 204, 244–45, 311, 313, 318, 323

bases, statue. *See* statue bases

Bassai (Phigalia), Temple of Apollo Epikourios, 122, 226, 252; composition of Centauromachy frieze, 221; Corinthian capital, 207, 210; depth of relief of friezes, 207; friezes (Figs. 23–25), 30–31, 106, 207, 209, 224, 274, 310; Ionic order, 207; metopes, 207; pyramidal groupings in friezes, 207; reconstructions of friezes, 207n11

bathing: of Aphrodite, 87, 118, 236, 242n89, 244, 258, 310; hydria as characteristic vessel for, 244; as ritual, 234, 236, 243, 310–11; of women, 232–36, 257. *See also* louterion

Baumgarten, Alexander Gottlieb, 4

Bendis: cult of, 15; votive relief to (Fig. 214), 155

Beschi, Luigi, 200, 201–2

biography, and portrait statues, 287–89

Blümel, Carl, 119, 129

Borghese Warrior, 179

boy from Marathon bay. *See* Marathon boy

Brauron, sanctuary of Artemis, 38; archaistic altar, 279; dedication of clothing at, 266; krateriskoi from, 238; "little bears" at, 38; votive relief to Artemis, 155

Brecoulaki, Hariclia, 147–48

Brinkmann, Vincenz, 266–67

Bryaxis, sculptor, 115, 198, 224; statue base in Athenian Agora by, 42, 44, 198

building programs in Panhellenic sanctuaries, 18, 29, 270

caricature, 287

caryatids, Erechtheion (Fig. 2), 27, 64, 65, 109–10; copies of, 64–65n72, 65, 67, 78–79, 222, 272–72; statuette reflecting type, 273

Cassirer, Ernst, 306

"cat and dog base," 186; clothed figures on, 168

cat stele from Salamis or Aigina, 157; polish of, 69

Chairestratos, sculptor, 134

Chaironeia, battle of, 11, 21, 23, 39, 211

Chalkis, statue of seated woman, 37

Charites, 230–31n5, 236, 244, 246n116, 281

choregic monuments, 6, 10, 42–43, 154, 197. *See also* Athens, choregic monuments

Cicero: as art collector, 99; attitude toward Greek art, 58

city sieges, 220

classic, meaning of, 9

cloth, decorated, 49, 266, 267; barbarian weavings, 267; batik from "Seven Brothers Barrow" (Fig. 266), 219, 267; himation made for Sybarite Alkimenes, 268; imported from east, 267; from Pavlovsky Barrow, 267; from Pazyryk, 267; Plato on, 268

clothing: dedication of at Brauron, 266; style of as carrier of content, 122–23. *See also* drapery; peplos

ing, 190; Kephisodotos identified as sculptor by Pausanias, 84; on Panathenaic amphora (Fig. 122), 109

elegance and ornament, 227

Eleusinian divinities, 217, 247, 255

Eleusinian Painter, 131n198, 144, 176n142, 217, 244n96, 247–48, 267n28; red-figure pelike in Saint Petersburg (Fig. 246), 217

Eleusis: statue of Asklepios, 35; statue of Persephone, 34, 106, 230; votive relief with figure of Persephone (Fig. 141), 77, 259. *See also* Great Eleusinian Relief

Elmalı, painted tomb, 136, 219; Perseus and Medusa in, 221

emotion, 8, 183–84, 292, 301, 314–15, 323–24

Empedokles, 231, 253

Ephesos, Amazon sculpture contest at, 61–63

Ephesos, Temple of Artemis, carved column drums and pedestals (Figs. 39, 40), 30, 126n166, 182, 212–13, 225; drapery of "Alkestis," 72–73, 128

Epidauros, Temple of Artemis, 31; acroteria (Fig. 47), 33, 124, 210–11, 213–14

Epidauros, Temple of Asklepios, 9–10, 30, 31, 32, 67, 115, 211, 226, 251, 252; acroteria (Figs. 31–33), 124, 209; pediments (Figs. 28–30), 9, 213–15, 217; sculptors of, 215, 309; sculptures, 106–8

Epidauros, tholos, 197, 211

Eretria, House of the Mosaics (Figs. 112, 113), 264–65

Eretria Painter: red-figure epinetron in Athens (Fig. 200), 142, 256; red-figure lekythos formerly in Berlin (lost) (Fig. 199), 142

Eros: analysis of by Diotima, 241n82, 253n187, 254; in bathing scenes, 241, 243; bronze statue in Thespiai by Lysippos, 81; marble statue in Thespiai by Praxiteles, 81; multiplication of in fourth century, 244, 253; nature of, 253, 254, 255; in wedding scenes, 145, 235, 244, 255

Eros, Centocelle type (Fig. 175), 113

Eros stringing his bow (Figs. 143, 144), 178, 195, 317; attribution to Lysippos, 178n156; copies, 79; types, 81

eroticism: and the divine, 281; in images of Athena, Artemis, and Nike, 245; in nature of goddesses, 245–46; as sign of female divine power, 245

Erythrai (Asia Minor), inscription on portrait statue base of Simo, 186

escapism, 261, 320–21

Etruscan tombs, 136, 137

Euaion Painter, red-figure stemless kylix in Paris (Fig. 254), 239

euhemerism, 323

Euphranor, painter, 206

Euphranor, sculptor, 66, 277

Euripides, 11, 254, 260, 324; on appearance and character, 303; *Elektra*, 249, 285n170, 387–88; influenced by sophists, 306; inversion of traditional content, 249; *Ion*, 206, 267; on Meleager's passion for Atalanta, 248–49; portrait of (Fig. 281), 282, 291, 292

Eurydike, wife of Amyntas III, statue of in Vergina (Fig. 11), 28, 187–88, 198n299, 275n99

Euthykrates, sculptor, 277

Fabre Painter, calyx-krater in Montpellier, 237n46

figurines, 6, 10, 45–46, 271; bronze, 46–47; of oil-pourer type, 64; as reflections of monumental sculpture, 45–46, 61n32; of "strategoi," 61n32; Tanagra, 46, 47n191, 323; terracotta, 10, 45–46, 64, 271

flatness as trait of fourth-century statues, 178, 179, 182

foreign influences, 2, 49, 267–70, 321

foreigners in Athens, 16, 269–70

foreshortening, 95, 136, 137, 149, 209; in Alexander Mosaic, 93, 94; dramatic, in painting of Achilles and Briseis, 94; in frieze of Temple of Apollo Epikourios at Bassai, 207, 209–10; in hunt frieze of tomb II at Vergina, 93, 94–95, 149; radical, 207; in vase painting, 143, 146

Formia, Nereids on Hippocamps from, 32

friezes, stacked, 219, 222

Fuggischer Sarcophagus in Vienna (Figs. 63, 64), 33, 182, 218, 276

gaze as fourth-century trait, 118

Geneleos group on Samos, 163–64

"Germanicus," statue in Paris, 72

Gnaios gem in Baltimore, 64

gods: distant and unconcerned, 258; human and immanent, 166, 190, 200, 244, 258, 317; foreign in Attica, 15–16, 53; immanence of, 203; youthful and/or erotic, 128, 245, 260, 281

Golgoi sarcophagus from Cyprus, 218, 221

good form/εὔσχημος, 280

Gorgias (of Leontinoi) 4, 15, 17, 225n151, 270, 286, 306, 307

government, Athenian, 17, 18, 21

grave monuments, 37; elaborate displays of, 37, 41, 156; free-standing sculptures in, 158; griffin cauldron on acanthus shaft, 226; inscriptions on, 156; marble lekythoi, 158, 161n57, 201; marble loutrophoroi, 158, 159

grave rituals, 156, 161; and *dokimasia* of Athenian magistrates, 156

grave stelai, 6, 10, 279, 292–93; architectural frames, 158, 160, 161, 259; dating of, 39–40; influence of East Greek traditions, 160; painted, 49–50

—MONUMENTS: Ampharete, 245n108; Antipatros, son of Aphrodisios, from Ashkalon (Fig. 215), 157; Aristion, 168; Aristokles son of Menon, 156; Aristonautes (Fig. 88), 40, 158, 184, 217, 225; comic poet in Lyme Hall, 159n39, 293; Demetria and Pamphile, first, 39–40, 41, 160n51; Demetria and Pamphile, second (Fig. 87), 39–40, 41, 158, 184, 217; Demetrios on bow of ship, 159; Demokleides on prow of ship, 159; Eukoline, 40; Eupheros (Fig. 216), 157; for the fallen in the Corinthian War of 394/3, 27, 39, 251; Hegeso, 40, 157–58; Hermon (Fig. 116), 50, 95; Hieron and Lysippe from Rhamnous, 133; Korallion from Herakleia (Fig. 86), 39; Ktesileos and Theano (Fig. 185), 122, 310; "lamentation stele" in Athens (Fig. 220), 158, 161, 280, 293; Mnesarete, 126; from Piraeus in Athens (Fig. 187), 125; Polyxena from Boiotia, 129;

grave stelai

—MONUMENTS (*cont.*): Silenis (Fig. 218), 160, 163; Sosinos of Gortyn, metalworker, 160; "Sostrate" in New York (Fig. 276), 280; τηλαυγής μνῆμα (Fig. 249), 280; from Thebes in Boiotia (Fig. 241), 199; Thous, slave from Laurion (Fig. 265), 260, 280; woman holding alabastron in New York (Fig. 276), 157; Xanthippos, shoemaker, 160. *See also* Dexileos, grave stele of; Ilissos stele

—SUBJECTS AND THEMES: absent as present, 258–59; Athenian burghers, 246; bourgeois uniformity, 321; communication of living with dead, 161; craftsmen, 160, 280; depiction of age, 293; elite status, 321; exceptional subjects, 280; figures paraphrasing divinities, 257, 272, 280, 282; horse and man, 201; intimate images of family, 203, 321, 322; location-less space, 160; men in battle or hunt, 159; pictorial space, 161; standard types as democratic, 279–80; theatrical masks, 159; women, 135n227, 156n15, 159–60, 161, 167, 184, 225, 230, 260, 280, 322; women as matrons, 260

Great Eleusinian Relief, 65, 67, 245n115; terracotta copy in Rome, 65

Greeks in the East, 52; pedagogue in Xanthos, 271; sculptors of sarcophagi in Sidon, 271, 276; and Tribune of Eshmoun in Sidon, 275

Grimani statuettes in Venice, ostensibly from Crete (Figs. 82–85, 274), 28, 38, 73, 272–73, 276

Group of the Huge Lekythoi, white-ground lekythos in Berlin (Fig. 193), 138, 140

Group R (white-ground lekythos painters), 138, 140

hair: of Eirene versus Erechtheion caryatids, 109; as feature of deviant portrait types, 293; of Hermes in Olympia, 70, 72, 73, 74; of late-fourth-century male portrait statues, 118; of males on grave stelai, 292; of philosopher portraits, 291; pubic, 112, 114, 119, 194; of satyrs, 194; stacked curls, 121, 121n128, 123; of statue of "Maussollos," 72; of strigil-cleaner from Ephesos, 118; washing of by women on vases, 234, 235, 236–37n44, 241, 243, 243n93, 244

Harrison, Evelyn, 62, 78, 201, 209

Hekate, 167; statue by Alkamenes, 278

Hektoridas, sculptor, 107, 309

Helen, 230, 281, 282; birth of, 246; and divine power, 241; washing hair, 241

Hellenistic period, 9, 11, 26, 60

Hera, 238: Ephesia, 98; and veil of Aphrodite in *Iliad*, 235n39

Hera, Borghese type (Fig. 123), 58, 59, 78, 79; Baiae plaster cast, 59; identification as Aphrodite, 58

Hera from Ephesos in Vienna (Fig. 186), 126

Hera from Samos in Berlin (Fig. 164), 108

Herakles, 102, 249, 324; in action, statue in Rome (Fig. 159), 102, 179, 283; Antisthenes on, 249n156; apotheosis of, 246, 248; and Dioskouroi, 144; Euripides' pathetic view of, 250; in Garden of the Hesperides, 91, 246, 249, 257; and Kerberos at gate of Hades, 162; and parable of Prodikos, 249, 303, 316, 324

Herakles, Copenhagen-Dresden type (Figs. 177, 178), 99, 116–17, 250, 283

Herakles, Farnese type (Fig. 183), 99, 119, 249, 283; statue from Antikythera shipwreck, 250; in Florence, with portrait head of Commodus, 99; over-life-size statue in Argos, 250; from Salamis (Cyprus), 250n165

Herakles, Hope type, 250

Herakles, Lansdowne type (Fig. 176), 114, 116–17

Herakles, resting type, 116–17, 191, 249–50

Herculaneum Women, 73, 92, 125

Hermes, Richelieu type (Fig. 174), 98, 113, 173n125

Hermes "Sandal-binder" (Figs. 188, 189), 130, 132, 178, 195

Hermes and Dionysos statue in Olympia. *See* Olympia, Hermes and child Dionysos statue

Hermon, painted grave stele of (Fig. 116), 50, 95

hero relief in Museo Torlonia, 200, 201

Herodas on visit of women to sanctuary of Asklepios on Kos (fourth mime), 154, 299, 314

Herodotos: on meeting between Solon and Kroisos of Lydia, 287; on selection of most valorous fighters at battle of Salamis, 61

heroic imagery replaced by domestic, 9, 259–60

Hesiod, *Theogony*, 231, 253

hieratic composition, 217, 255

Himmelmann, Nikolaus, 112, 168, 230, 257, 290, 309

"hockey-players base," 168

Homeric Hymn to Aphrodite, 236, 244, 311

Homeric Hymn to Dionysos, 29, 212

human and divine spheres, parallelism of, 255

Hygieia, 122, 282; leaning, on votive reliefs, 42, 192n263, 203, 255–56, 259n228; statue from Epidauros, 34, 246; statue in Vienna, 245n115

Hymettan marble, 206–7

"ideal sculpture," Roman, 3, 96, 97

Idrieos of Karia, 28; dedication of at Tegea, 216; statue of in Delphi, 216

"Ilioneus," statue in Munich, 179

Ilioupersis, 214, 231

Ilissos stele (Fig. 132), 161–62, 163, 217, 310; polish of, 69; treatment of hair in, 72

illusion: of accessible epiphany, 258; in sculpture, 110, 135, 151, 162, 176, 193, 217; spatial, 93, 110, 146, 176, 193; in vase painting, 142, 146; in wall painting, 51, 93, 136

individuality in fourth-century art, 6–8, 52, 274, 284, 287–88, 294–95, 308, 315, 322

interpretation of fourth-century art, 7–9, 122, 130–31, 155, 254–55, 282–83, 304, 315; need for, 309

intimacy: of gods and mortals, 195, 203, 317, 323; on grave stelai, 10, 161, 318, 322; in statues of gods, 129, 195, 258, 261; in statues of mortals, 311, 312

Io and Argos, Pompeian wall painting (Fig. 157), 94

Ion of Chios, *Epidēmia*, 288

Ionic order, 206, 207, 211, 219–20, 223, 224

Isokrates, 15, 225n151, 270, 302, 307; on beauty, 305–6; on character and physical appearance, 303;

on mercenaries, 14; on political situation in Greece, 11–12; tomb of, 225n151, 286; on types of craftsmen, 305–6

Jena Painter, 144, 202n232, 240, 243; workshop of, 243

Judgment of Paris, 48, 140, 145, 246

Kairos, statue by Lysippos, 256, 322, 324

Kallithea, 37; tomb of Nikeratos and Polyxenos (Fig. 247), 41, 224–26, 252

kalos k'agathos, 282, 303

Kassel Apollo, copy of in Building M at Side, 98

Kazanlák, painted tomb, 50, 96, 135

Kephisodotos, sculptor, 22, 96, 253. *See also* Eirene and Ploutos statue group

Kephisos, votive relief to, 167

Kerameikos cemetery, Athens, 39, 40, 85, 156, 164, 225; painted stelai, 50; plot of Agathon from Herakleia, 39; plot of Dionysios of Kollytos, 39, 161n58; plot of Lysimachides, 40. *See also* grave stelai

Kerch Style vases, 26, 91

Kirke, 203; nude, 241–42

Kleophon Painter, 142

Knidos, 230; and Aphrodite statue by Praxiteles, 85, 230; seated statue of Demeter from (Fig. 81), 35

Koch-Brinkmann, Ulrike, 149, 155,

Konon, general, 14, 104n17; statue of, 188, 285

Kore Albani (Fig. 162), 106; replica in Venice (Fig. 82), 106, 108, 272

Kore/Persephone, 122; statue in Vienna restored as Muse, 131, 133; type in Florence (Fig. 142), 78, 125, 274; type in Vienna, 132; young, 245. *See also* Persephone

Kos, sanctuary of Asklepios, sculptures, 154

Kos, sanctuary of Demeter at Kyparissi, statuettes from (Figs. 269, 270), 38, 125, 272–74, 276

Kraipale Painter, red-figure oinochoe in Boston (Fig. 264), 254

Krateros Monument (Fig. 225), 174–76, 178, 182, 203, 217; composition reflected in relief from Messene, 175; friezelike composition of, 184; inscription on, 174, 186; Lysippos and Leochares as sculptors, 174

Kresilas, sculptor, 62, 260, 290

laborers, images of, 287

lead content of bronze sculptures, 37n104

Lecce, copies of Greek statues in theater, 99

Leda and swan, 45, 81, 215

Lefkadia, Tomb of Judgment (Figs. 117, 118), 50, 147, 225; Aiakos and Rhadymanthes depicted in, 147; Hermes depicted in, 95

Lefkadia, Tomb of the Palmettes, 150

Leochares, sculptor, 97, 115, 277

Limyra, tomb of Periklä (Figs. 59, 60), 222–23; caryatids, 271–72

"little bears" at sanctuary of Artemis at Brauron, 128, 238

liturgies, 13, 20, 21

location of monuments, importance of for meaning, 165, 170, 184

louterion, 239, 240, 243, 253; and Atalanta, 242; and

heroes, 242; and purification, 242; rarity of on Attic fourth-century vases, 244; and ritual bathing of bride, 236; and ritual sex, 233; ritual use in festival of the Haloa, 233; in sanctuaries and domestic contexts, 234; on South Italian vases, 244; and women with athletic qualities, 239

Lucian: on Apelles' painting of Slander, 256; on house with copies of Greek statues, 83, 99; on Knidian Aphrodite, 86

Lykourgos, 19, 39, 282, 285; on public statues in Athens, 285; on reverence, 19; and Theater of Dionysos in Athens, 19, 131–32

Lysias, orator, 15, 16, 270, 307

Lysikrates Monument, 29, 42, 43, 120n125, 182, 184, 197, 198, 210, 211, 218, 226; Dionysos and pirates frieze (Figs. 19, 20), 182 212; engaged Corinthian columns, 212; figure depicted in back view, 212; lunging figures, 180, 212; natural settings, 212

Lysippos, sculptor, 22, 81, 97, 98, 115, 186, 203; bronze statue of Eros in Thespiai, 81; identification of works by, 85; influence of Polykleitos on, 278; inscription on base in Pharsalos (lost), 277–78; Kairos statue, 256, 322, 324; Poulydamas base at Olympia, 43, 84, 186, 188, 203; reality versus appearance in works of, 309. *See also* Eros stringing his bow

Macedonian tombs, 141, 146; costly furniture in, 266. *See also* painting in Macedonian tombs

mainad: raving, statue in Dresden (Fig. 190), 133–34, 195–96; torso in Oxford (Fig. 46), 33

mainads, 240; ecstatic, Roman copies after Kallimachos, 274; Neo-Attic, 134

Mantineia base (Figs. 96–98), 43–44, 84, 120, 182, 185n213, 313; Apollo and Marsyas, 120; Muses, 44, 120–21, 124–25, 130, 217, 313; Skythian servant, 120

Marathon boy, bronze statue (Figs. 65–67), 112–13, 119, 128, 192, 193, 194, 195, 256

Marsyas, 98; brief popularity of in vase painting, 80. *See also* Athena and Marsyas group; Mantineia base

Marsyas Painter, 144, 146, 217, 244

Marsyas/Eleusinian Painter. *See* Eleusinian Painter; Marsyas Painter

Mattei Athena. *See* Athena, Mattei type

Maussolleion of Halikarnassos, 27, 33, 135, 218, 224, 252, 293; friezes (Figs. 5–10), 115, 182, 208, 212; head from, 121n128; lunging Amazons in frieze, 179–80; Pliny's description of, 115; sculptors of frieze, 308; statue of "Artemisia" (Fig. 5), 27, 115, 121–23, 187, 260, 310; statue of "Maussollos" (Fig. 6), 27, 68n98, 72, 115, 123n139, 293

Mazara del Vallo, bronze statue of raving satyr. *See* satyr, raving, from Mazara del Vallo

Mazi, Temple of Athena, 30, 213

Medusa, 191, 221, 250; beautiful, 3, 252; middle type on shield of Athena Parthenos, 250; Rondanini, 3. *See also* Perseus: and Medusa

Meidias Painter, 2n1, 105, 142, 143, 146, 255; manner of, pyxis in Berlin, 237n46; squat lekythos in Cleveland (Fig. 201), 105, 142

Meleager: fourth-century statues of, 248, 260; popularity in vase painting, 80

Meleager and Atalanta on Attic vases, 248

Meleager Painter, red-figure amphora in Toronto (Fig. 204), 144, 248, 315

Melian plaques, 248, 249

metal vessels, 10, 47, 53, 145, 225, 264, 266, 268–69; copied by ceramics, 146n307, 269; in Macedonian tombs, 47

metaphor, 303–5

metics, 16–17, 21, 224, 226, 280

Metrodoros of Lampsakos, 254

mimesis/μίμησις, 284, 299

mitra (snood), 235

moldings, ornamental, 49, 206, 210, 211, 227, 264

monumental painting, 49; in Athens, 52, 206, 224; Attic red-figure vase painting as source of reconstructions, 51; in Sikyon, 52

mortals: blurring of boundary with divine, 245; intimacy with gods, 195, 203, 317, 323; languid versus active statues of, 283; viewer as primary reference in painting and sculpture, 151

mosaics, 49, 225, 264; early examples, 151; early nonmythological examples, 265; early nonreligious imagery in private houses, 151; at Eretria, 151, 264–65; at Gordion (Phrygia), 49; narrative myths in, 266; at Olynthos, 49, 151, 265; orientalizing elements in, 282; pebble, 49. *See also* Alexander Mosaic; Pella, mosaics

Mourning Women Sarcophagus (Figs. 61, 62), 33, 122, 219n113, 223, 260

Muses, 122. *See also* Mantineia base

Myron, sculptor, 97, 271. *See also* Diskobolos of Myron

myth: allegorization of, 253; heroic on fourth-century vases, 192; inversion of traditional content, 249

Narkissos statue, so-called (Fig. 171), 110–11; Baiae plaster cast, 59

narrative, 120, 147–48, 195, 212; complex, 203; composition of, 94, 217; groups, 176, 182, implied, 120, 195, 212, 311, 313

Naukydes, sculptor, 111–12, 117, 118, 171, 193, 260, 311, 312, 323

Nemesis of Rhamnous, statue by Agorakritos, 77, 106; copy in Athens (Fig. 128), 66; copy in Copenhagen (Fig. 127), 65–66; fragments excavated by Dilettanti Society, 65, 67–68

Neo-Attic reliefs, 43, 275–76

Nereid: acroterion from Athenian Agora (Fig. 42), 31, 106; pair on Hippocamps from Formia, 32; statue in Burlington House, London (Fig. 44), 31. *See also* Xanthos, Nereid Monument

Nereid Monument, Xanthos. *See* Xanthos, Nereid Monument

New Phaleron, sanctuary at, 41. *See also* Xenokrateia, votive relief of from New Phaleron

Nike: acroteria from Temple of Artemis at Epidauros (Fig. 47), 33, 124, 210–11, 213–14; acroterion from Athenian Agora (Fig. 41), 106; erotic quality in im-

ages of, 245; fickleness of, 245; Hellenistic statue in Basel, use of drill in, 68; in marriage context, 238; of Paionios at Olympia, 61, 185, 245; on pillar at Delphi, 185. *See also* "Sandal-binder"

Nikias, Athenian painter, 91, 92, 143, 151, 192, 195

Niobid group (Figs. 227–34), 176–84; Chiaramonti Niobid in Vatican (Fig. 233), 177, 178, 180, 181; dying Niobids, 77, 177; flatness of statues, 178, 179; fragment of pedagogue recently discovered in Rome, 178n159; lack of antagonists in, 183; restoration and cleaning of surfaces, 180; sculptors identified by Pliny, 177, 181; statue in Copenhagen, 129; statue of Narcissus possibly belonging to, 179, 181; statue of Psyche possibly belonging to, 179, 181; statues lunging at steep angle, 179–80; supine boy in Munich, 178, 180; in Temple of Apollo Sosianus in Rome, 177, 183n203; and Thebes, 184

Niobid Painter, 141, 142, 148, 183

Niobids, 126; on Apulian vases depicting slaughter of Niobids, 183; depicted on throne of Zeus at Olympia, 193; pedimental statues from unknown fifth-century temple, 183; possible early group, 32–33; slaughter of on wooden sarcophagus in Crimea, 183

nostalgia for the past, 271–72, 278

nudity, female, 231–38; and female athletics, 238; of fragmentary torso in lost metope from Parthenon, 231; on large vase shapes, 236; meaning of, 168; and pornography, 232, 233; of running girls in rituals, 242; in scenes of rape, 231, 251; in wedding preparations, 235; of wingless women in Panathenaic amphora fragments, 230–31n5; of woman crouching as Eros pours water on her hair, 235; of women washing clothes, 232; of women washing hair, 234–35, 243, 244; of women washing themselves, 231, 232, 233, 234, 236–37

nudity, male: of citizen soldiers, 52n237; of figures in Daochos Monument, 172–73; on grave reliefs, 162, 168, 311; of heroes, 261; of vanquished foes, 10, 251–52; of youths, 251, 311

nurturing as human concept, 190, 239

Odysseus and Kirke, 203, 241–42

oil-pourer: multiple Greek versions, 80; Munich type (Figs. 124, 125), 98, 311; Myrina terracotta figurine, 64; statues, 63–64, 191, 195, 311

Oinomaos Painter, red-figure bell-krater in Naples (Fig. 209), 145

Olympia, 18, 61; bases of athletic victor statues, 189; classical sculpture at not copied, 77; female athletic contests (Heraia), 238; Pausanias on chest of Kypselos, 84–85, 208; Pausanias on victors' statues and bases, 97; plan of (Fig. 237), 164, 189; Poulydamas base by Lysippos (Fig. 95), 43, 84, 186, 188, 203; statue bases, 188; statues of Achaian heroes by Onatas, 164

Olympia, Hermes and child Dionysos statue (Figs. 133–36), 70–75, 84, 118, 124, 193, 195, 257; carving of hair, 72; polish of, 70–74; recarving of, 71–72;

Plato, 1, 5, 8, 22, 281, 324; on accurate recording of visual effects, 298; antagonism of twentieth-century scholars toward, 298; on associative quality of images, 299–300; on beauty, 298–99; on deceptive quality of images, 299; description of Sokrates, 289; on Eros, 241, 254, 255; on good form, 280; portraits of, 291; on positive qualities of images, 298–99; on presentation appropriate for content, 282; on recognizable images of people, 292; on role of Aphrodite and Eros, 231; on weaving and fine robes, 268

Pliny, 9, 75, 77, 81, 82–83, 99, 107, 212, 223, 251, 308; Antigonos of Karistos as source of, 139; on aura of the original, 85; on Maussolleion of Halikarnassos, 115; on molds and portraits made by Lysistratos, 277; on Parrhasios, 139–40; on Praxiteles' two Aphrodites, 230; on Skopas's nude Aphrodite, 230; on vast number of Greek statues, 97–98; Xenokrates as source of, 139; on Zeuxis, 266

Plutarch: on Apollodoros's painting technique, 138; on dedications at Delphi, 190; on Krateros Monument at Delphi, 174, 175; on robe of Demetrios Poliorketes, 268

polish of sculpture, 68–70, 73, 74, 123; Roman, 73

Polygnotan group, 142

Polygnotos, wall painter, 84, 141

Polykleitos, sculptor: Canon, 17; copies of statues by, 77, 79, 98, 99; and motif of potential motion, 310; school/style of, 97, 110, 114–15, 191, 277, 305, 308. See also Diadoumenos of Polykleitos; Doryphoros of Polykleitos

Pompeii, wall paintings from, 51, 90, 91, 92, 94–95, 99

population of Athens/Attica, 16–17, 22

Porticello shipwreck, bronze head from, 291–92

portrait statues, 322; in Aristotle's will, 285; of "Artemisia" (Fig. 5), 27, 115, 121–23, 187, 260, 310; on elaborate tombs, 285; of Gorgias in Olympia and Delphi, 285; of hipparch Simon, 294; in Krateros Monument, 172–73; of "Maussollos" (Fig. 6), 27, 68n98, 72, 115, 123n139, 293; of Phryne in Delphi, 285; as private votives, 285; of Sophokles, 131–32; of tragedians in Theater of Dionysos, 19, 131–32, 282, 285

portraits, 284–94; and literary descriptions of people, 287–89

—MONUMENTS: Aischines (Fig. 283), 291, 293, 294; Alexander the Great (Azara Herm) (Fig. 285), 294; Antisthenes (Fig. 282), 292, 292n220, 294; Aristotle (Fig. 280), 291; bronze head from Porticello shipwreck, 291–92; bronze head of athlete in Olympia, 293; Demosthenes (Fig. 284), 291, 293, 294; Euripides (Fig. 281), 291; Perikles, 290; Pindar, 286, 287, 289, 290; Plato (Fig. 279), 291; Sokrates (Fig. 277), 289–90; Themistokles, 286, 287, 289, 290

—SUBJECTS AND THEMES: deviant types, 286, 287, 293; individuality, 283, 284, 285, 293, 294; individuals subsumed as types, 279; laborers, 287; old age, 286–87, 293, 293n234; rank and age as special status, 286–87; recognizable images of people, 286, 292; ugliness, 286

Poulydamas base, Olympia (Fig. 95), 43, 84, 186, 188, 203

Pourtalès Painter, red-figure bell-krater in London (Fig. 205), 144, 146

Praxiteles, sculptor, 22, 37, 96, 97, 133, 134, 196, 230; identification of works by, 85; marble statue of Eros in Thespiae, 81; nude Aphrodite, 213; and painter Nikias, 151, 195; as sculptor of Hermes and Dionysos at Olympia, 84; as sculptor of Mantineia base, 44; style of, 114–15, 121. See also Aphrodite, Knidian type

praying boy (Betender Knabe), statue in Berlin, 35, 312

Priam Painter, red-figure amphora in Rome (Fig. 255), 239, 240

Priene, Temple of Athena Polias, 30, 212, 213

private, domestic character of fourth-century art, 9–10, 231, 254–55, 321, 322

Prodikos, parable of Herakles' choice, 257, 303, 324

prosperity in Greece, 2, 6, 21, 52, 270

Protagoras, relativistic theory of, 306, 307

purification rituals, 233n22, 236

Pythagoras of Rhegion, sculptor, 97, 189, 192

Pythion (Attic deme), votive reliefs from, 41, 259

rape of Persephone. See Persephone, rape of

record reliefs, 8, 45, 52, 80, 107, 135, 272; of 318/17, 133n214; of 362/1 (Fig. 102), 107; of 375/4 (?) (Fig. 101), 107; of 377/6 (Fig. 163), 107; of 410/9, 245n111; chronological value of, 27, 45; statue types on, 8, 80, 272

Regina Vasorum, Attic red-figure hydria in Saint Petersburg (Figs. 210, 211), 145–46

Rhamnous, 225, 321; grave monuments at, 40–41, 135, 156, 321; statue of Themis from, 35, 134, 281. See also Nemesis of Rhamnous by Agorakritos

rhetoric, 301n12, 307

Rich Style, 9, 102–6, 135, 138, 142, 214, 215, 220, 264, 273, 274, 294, 309, 310; dating of, 26–27

Ridgway, Brunilde S., 7, 76, 77, 112, 119, 132, 165, 170, 177, 178, 184, 291, 298n3

Rodenwaldt, Gerhardt, 1, 9, 22, 198, 246, 258, 260, 324

Rouveret, Agnès, 137, 139, 151

running drill, 67, 68, 72, 74, 124, 281n154

Saatsoglou-Paliadeli, Chrysoula, 147, 149

Sacred War, 11, 20, 217

sacrifice, concept of, 190

sacrifice of Iphigeneia: painting by Timanthes, 92; Pompeian wall painting, 92

Samos, sanctuary of Hera: base of pankratiast statue, 187; Geneleos group, 163–64; lunate statue base, 164. See also Hera from Samos in Berlin

"Sandal-binder," relief from Temple of Athena Nike, Athens (Fig. 160), 68, 104–5, 122, 230, 245, 309–10

sarcophagi: "Alexander" from Sidon, 33, 96, 175, 182, 219n113, 276n108; Amathous from Cyprus, 218; Fuggischer in Vienna (Figs. 63, 64), 33, 182, 218, 276; Golgoi from Cyprus, 218, 221; Lycian from

Sidon, 33, 219n113; Polyxena from the Troad, 218, 221; from royal cemetery at Sidon, 6, 219, 276; Satrap from Sidon, 33, 219n113; wooden from South Russia, 219. *See also* Mourning Women Sarcophagus

Sardis: altar with stacked friezes, 219; funerary pediment, 33n66, 218; pyramidal structure, tomb (?), 218–19

satyr, pouring type, statue in Dresden (Fig. 68), 80, 113

satyr, raving, from Mazara del Vallo, 36–37, 121, 133, 134

satyr, resting type (Fig. 180), 9, 97, 119, 135, 139, 167, 169, 191, 194, 195, 198n299, 203, 212, 247, 311, 321

satyrs on votive relief from Thessaly, 202

Schweitzer, Bernhard, 137

settings, natural, 42, 200–203, 209, 212

Sicily, 53, 140; polychrome terracotta altar from, 242

Side, Building M, copies of Greek statues in, 98

Sidon, royal cemetery, 52, 122; Greek sculptors of sarcophagi from, 271; sarcophagi from, 6, 219, 276. *See also* Mourning Women Sarcophagus

Sidon, Tribune of Eshmoun (Figs. 271, 272), 33, 274–75; eclecticism of, 276

Silanion, portrait of Plato, 291

silver plate, 47–48, 266; kantharos from Derveni (Fig. 107), 225; rhyton with Judgment of Paris, 48

skenographia, 137, 139

skiagraphia, 138, 139

Skopas, sculptor, 97, 115, 216, 230; statue of nude Aphrodite by, 88

Skopas II, sculptor, 88

slaves, 17n75, 22, 280n138, 314; grave stele of Thous (Fig. 265), 260, 280

Sokrates, 12, 22, 102, 289, 307; and *hetaira* Theodote, 281; portraits of, 289–90; at workshop of Parrhasios, 294, 301, 315

sophists, 2, 5, 22, 306

Sophokles: conservation of reported by Ion of Chios, 288; portrait statues of, 131–32

South Italian vases: depictions of louteria on, 244; funerary, 160; and iconography of Roman painting, 91, 92; "rencontres amoureuses" on, 244

space: Graeco-Roman experience of, 137; public versus private, 264; real versus conceptual, 201

spectacular as quality in fourth-century art, 170, 171, 212, 314

statue bases, 185; by Bryaxis in Athenian Agora, 42, 44, 198; with dancing women on Athenian Acropolis (Fig. 275), 276; of Eurydike in sanctuary of Eukleia at Vergina, 28, 187–88; inscribed, 42, 81–82, 107, 186–87, 198; of Kephisodotos on Athenian Acropolis, 188; of Konon and Timotheos on Athenian Acropolis, 188; lunate on Samos, 164; of pankratiast on Samos (Fig. 238), 187; of Philonides at Olympia, 188; of Poulydamas by Lysippos at Olympia (Fig. 95), 43, 84, 186, 188, 203; with scenes of combat from the Academy, 251–52; of Simo from Erythrai, 186; of Syeris on Athenian Acropolis, 186–87; of Telemachos at Olympia, 188. *See also* Atarbos monument; Mantineia base

statuettes: as copies of statue types, 272; of Demeter, 272–74; of Leda and swan, 45, 81, 215. *See also* figurines; Grimani statuettes in Venice

Stoics, 257, 260n230, 317; belief in divine fire, 323

strigil, 240; as attribute of purity, 242–43; oversized, 243

strigil-cleaner, Vienna-Ephesos (Figs. 71, 72), 34, 89, 90, 118, 127, 195, 311–12

style: expressive value of, 282–83; objectification of, 282

Subiaco, youth from (Fig. 235), 179

subjectivity, 6, 8, 307, 324

Suessula Painter, 143

sumptuary law of Demetrios of Phaleron, 39, 321

swimming depicted on vases, 239, 240

Syeris, inscribed portrait statue base of on Athenian Acropolis, 186–87

Symmachos, votive relief to from Pharsalos, 201n329

symposium: male vases for, 143; prostitutes at, 232; of women, 233, 236

Talos Painter, red-figure volute-krater in Ruvo (Fig. 203), 143–44, 146

Tanagra figurines, 46, 47n191, 323

Tegea, Temple of Athena Alea, 30, 115–17, 226; acroteria (Figs. 36, 37), 33, 123–24; Corinthian order, 120; crown molding of interior cella wall (Fig. 38), 210; metopes, 210; pediments (Figs. 34, 35), 33, 208, 215–17, 248–49; Skopas as sculptor, 216

Telemachos, votive stele from Asklepieion in Athens (Fig. 90), 41, 200, 201

temporality in fourth-century art, 120, 194, 310

Thanatos Painter, white-ground lekythos in London (Fig. 212), 148

theatricality in fourth-century art, 169, 196

Themis or Tyche, torso in Athenian Agora (Fig. 80), 35, 134, 281

Themis, statue from Rhamnous (Fig. 191), 35, 134, 281

Theodektes of Phaselis, tomb of, 225, 286

Theophrastos, *Characters*, 5, 17, 283, 395

Theseus, 246–47, 248

tholos, 197, 198. *See also* Delphi, Marmaria, tholos; Epidauros, tholos

Timotheos, general, 13; statue of, 285

Timotheos, sculptor, 32, 45, 97, 107, 115, 215; Leda and swan attributed to, 45, 81, 182, 215

tombs, built: block with Amazonomachy in Athens (Fig. 248), 225; cenotaph of Pythionike, 225; of Isokrates, 225n151, 286; of Nikeratos and Polyxenos at Kallithea (Fig. 247), 41, 224–26, 252; pyramidal structure at Sardis, 218–19; statues of two women in New York, 37n113, 225; of Theodektes of Phaselis, 225, 286. *See also* Limyra, tomb of Periklä; Maussolleion of Halikarnassos; Trysa, heroon; Xanthos, Nereid Monument

tombs, painted. *See* Elmalı, painted tomb; painting in Macedonian tombs

tragedies, Attic, revival of in fourth century, 19, 271

Tribune of Eshmoun. *See* Sidon, Tribune of Eshmoun

Trysa, heroon (Figs. 56–58), 33, 221–22; Kaledonian Boar Hunt frieze, 248

Tyche, 321–22; of Antioch, 120; torso in Athenian Agora, 35, 134, 281

Tyrannicides group, 77, 78, 168–69, 284, 285, 286, 290; Hipparchos missing from, 164; plaster cast of head of Aristogeiton from Baiae, 59; poses of used for Theseus, 80, 165

vase painters. *See names of individual painters*

vase painting: fewer heroic mythological scenes in fourth century, 192, 246, 247; images of divinities as epiphanies in, 246–47; increased use of white in, 140; most popular divinities in fourth century, 247; polychromy in, 140, 269; use of gold foil in, 140

vases: as household items, 155; use in festivals and rituals, 155. *See also* Apulian vases; Attic red-figure vases; Kerch style vases; South Italian vases; white-ground lekythoi

Vergina (Aigai), sanctuary of Eukleia, 187–88, 198n229

Vergina (Aigai), Tomb of Persephone (Fig. 120), 51, 92, 93, 147, 148, 150, 266; contour lines, 147; possibly incomplete state of, 147, 149; preliminary incision, 147, 149–50; shading, 147

Vergina (Aigai), "Tomb of Philip" (Tomb II) (Figs. 119a, 119b): binding medium, 148; cast shadows, 149; coloristic modeling, 148–49; foreshortening, 149; hunt frieze, 51, 147–50, 175–76, 212; landscape in, 148; Macedonian cap (*kausia*) in, 148

Vergina (Aigai), Tomb of the Prince, 150, 266

votive plaques from Pentaskouphia, 202–3

votive reliefs, 6, 10, 41–42, 198–204, 279; horizontal format, 199; Neo-Attic copies of, 275–76; on pillars, 41, 198, 259; treatment of backs, 199; without architectural frame, 199

—MONUMENTS: Albani Rider relief, 209, 251; to Amphiareios in Oropos (Fig. 245), 203; to Artemis in Brauron, 155; to Asklepios and Hygieia, 42, 113, 200–202; to Asklepios from Asklepieion (Fig. 243), 202; to Bendis from the Piraeus (Fig. 214), 155; to Dionysos and Ariadne (?) from Thessaly (Fig. 244), 202; to Echelos and Basile, 41, 167; with Eleusinian divinities in Naples, 125; to Herakles in Athens (Fig. 221), 42, 162, 201; to Herakles in Venice (Figs. 139, 140), 74, 201; with man on litter in Copenhagen, 200; to the nymphs, 41n152, 200–201, 275, 281; to Persephone in Eleusis, 125; of shoemaker from Athenian Agora, 41–42; to Symmachos from Pharsalos, 201n329; of Telemachos from Asklepieion in Athens (Fig. 90), 41, 200, 201; Torlonia hero relief, 200, 201; of Xenokrateia from New Phaleron (Figs. 91, 92), 41, 169, 199, 317–18, 323

—SUBJECTS AND THEMES: appearance expressing content, 203; architecture, 74, 162, 199, 201, 202–3; bour-

geois uniformity, 321; copies of statues, 77–78, 259, 272; democratic types, 279–80; domesticity, 255–56, 322; horse and man, 201; Hygieia leaning on prop, 42, 192n263, 203, 255–56, 259n228; juxtaposition of divinities and worshipers, 199, 200, 259; natural settings, 42, 200–203; recognizable divinities, 42, 259, 280–81; satyrs, 202; setting and intimacy, 203; warship and youth, 201–2

washing: of hair by women on vases, 234, 235, 236–37n44, 241, 243, 244; ritual, 233; strigils, aryballoi, and sponges in scenes of, 236–37; on vase with woman apoxyomenos, 240

West Greece, 53; tombs in, 136, 137

Westmacott Ephebe, 110; Baiae plaster cast of, 59; statue of type in Dresden, 73

white-ground lekythoi, 136, 155, 161, 162; coloristic effects in, 140; depiction of tomb mound on, 160; painters of, 138, 140, 148; tempera colors in, 138; unmixed superimposed colors on, 138. *See also names of individual painters*

Woman Painter, white-ground lekythos in Athens (Fig. 195), 140

women: accomplishments of in Aristophanes' *Lysistrata*, 238; arranging hair, 241; and athletics, 242–43; dancing, 275; depicted on grave stelai, 135n227, 156n15, 161, 167, 184, 225, 230, 280, 322; erotic images of, 230–31; at louteria, athletic qualities of, 239; as matrons, 131, 246, 260, 280, 281; mourning, 158, 161, 167; new position of in fourth century, 322–23; statues of, 35, 123, 125, 131, 173, 322; symposium of, 233, 236; on vases, 142–43, 231–46; on votive reliefs, 167, 322; washing themselves, 231, 234–41, 243–44

Xanthos: Greek pedagogue at, 271; sarcophagi from, 166

Xanthos, Nereid Monument (Figs. 48–55), 32, 33, 219–21, 252; and Achaemenid palace reliefs, 220; composition of friezes, 221; dynast in frieze, 221; influence of Amazonomachy on battle frieze, 252; mythological subjects of friezes and acroteria, 221; Nereid BM 909, 32, 273; Nereid BM 910, 32, 124; Nereids bringing Achilles to Isle of Blessed, 221; Nereids bringing armor to Achilles, 219; relief depth of friezes, 207–8, 220; tribute bearers in frieze, 220, 221

Xenokrateia, votive relief of from New Phaleron (Figs. 91, 92), 41, 169, 199, 317–18, 323

Xenokrates of Athens, 7, 139; *On Bronze Working*, 17; *On Painting*, 17

Xenophantos Painter, squat lekythos in Saint Petersburg (Fig. 197), 145, 269

Xenophon, 17; on important qualities of images, 301; on Sokrates's visit to craftsmen, 301; on Sokrates's visit to Theodote, 301

youth: kneeling statue in Malibu, 179; nude, statue in Berlin (Fig. 179), 118; victorious, bronze statue in Malibu, 311

youth from Antikythera. *See* Antikythera, bronze statue of youth from

Zeuxis of Herakleia, painter, 22, 139, 146, 266; coloristic style of, 139; contest with Parrhasios, 299; and King Archelaos of Macedon, 265

Zopyros, physiognomicist, 289

Index of Museums

Andros, Archaeological Museum
245, 173n125
Antalya, Archaeological Museum
A3436 (Fig. 59), 222
no inv., frieze from tomb of Periklä (Fig. 60), 222
Astros, Archaeological Museum
356a, 31
Athens, Acropolis Museum
577, 317
581, 168, 200n316, 317
599, 168
625, 245n111
713, 231
973 (Fig. 160), 68, 104–5, 122, 230, 245, 274, 309–10
1336 (Fig. 129), 68, 273
1338 (Figs. 223, 224), 43, 171, 182
1339, 80, 201
1352, 69n106, 127n179
1358 + 2789, 4
3176 + 5460 + 2635, 182, 186n217, 276n108
3363 + 3365 + 3366, 276
6889, 65
6890, 65
Athens, Agora Museum
I 7167, 198n302
I 7396, 41–42
S 37, 35n86
S 182, 31
S 210, 35n86
S 312 (Fig. 41), 31, 106
S 339, 35n86
S 1882, 35n86
S 2091 (Fig. 42), 31n44
S 2154 (Figs. 73, 74), 34, 66, 67, 84
S 2370 (Fig. 80), 35, 134
S 4846, 31n44
Athens, Ephoria Γ΄
5a (storeroom), 199
Athens, Epigraphical Museum
7859 (Fig. 163), 107
8746 + 10682, 186, 186n224, 187
Athens, Kerameikos Museum
3146 (Fig. 192), 138
P 388, 40
P 687 (Fig. 87), 39–41, 158, 184, 217

P 688 (Fig. 86), 39, 161
P 692, 40
P 695, 245n108
P 863, 50
P 1130 (Fig. 4), 10, 27, 39, 251, 257
P 1169 (Fig. 216), 157
P 1535 (Fig. 116), 50, 95
Athens, National Archaeological Museum
29, 168
155 (Fig. 32), 108, 124, 214
156 (Fig. 33), 107–8
159 (Fig. 47), 33, 210
162 (Fig. 31), 107, 124, 214
182, 38n126
215–217 (Figs. 96–98), 43–44, 84, 120–21, 130, 182, 185n213, 217, 313
225, 35
230, 38n118
231 (Fig. 191), 134
299, 34, 246
709, 37n111
715, 69, 157
723, 156
726 (Fig. 187), 126
730, 292
738 (Fig. 88), 40, 158
752, 159
803, 203
820, 180
823, 824, 158
833, 133
869 (Fig. 132), 69, 72, 161–62, 184, 217, 225
870 (Fig. 220), 158, 280, 293
890 (Fig. 265), 260, 280
1330, 113n88, 256
1333 (Fig. 242), 113n88, 200, 256n205
1334, 259n229
1340, 199
1351 (Fig. 243), 202
1377, 42, 200
1383, 256n205
1402, 78n183, 259n229
1404, 42
1408, 200
1425 (CC 1180), 134
1448, 281n147

Index Locorum

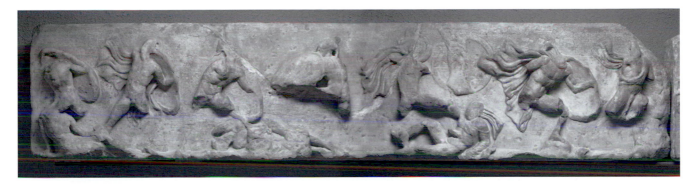

1. Athens, Temple of
Athena Nike, west
frieze, block i. London,
British Museum 421

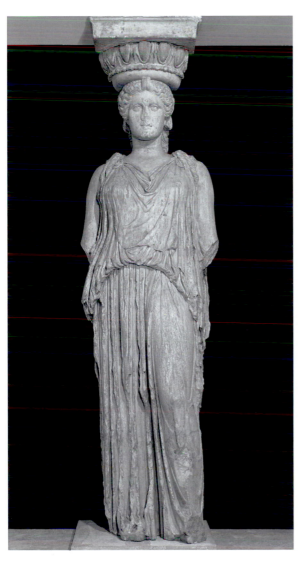

2. Athens, Erechtheion,
caryatid C. London,
British Museum 407

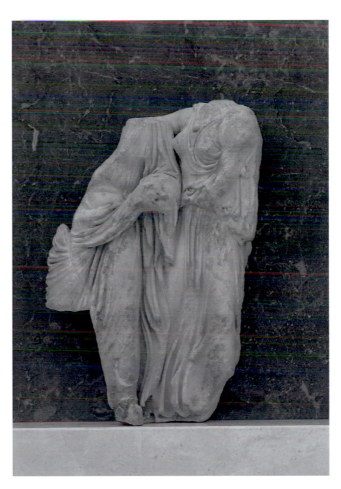

3. Athens, Erechtheion,
frieze. Athens, Acropolis
Museum 1071

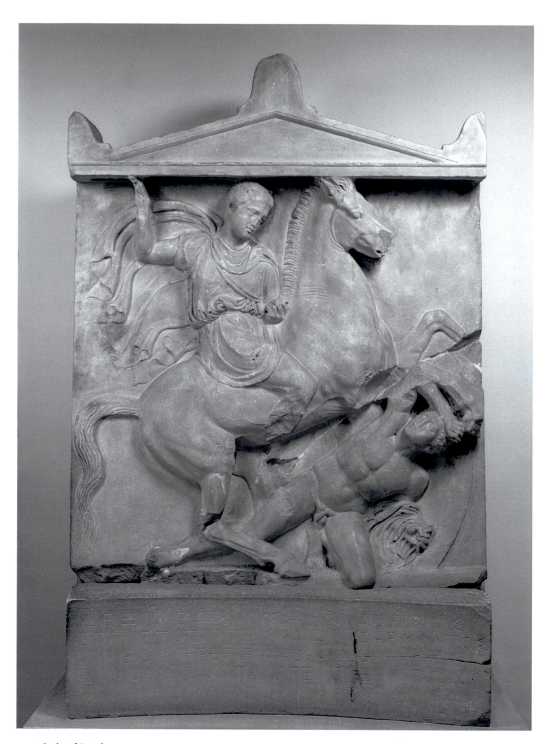

4. Stele of Dexileos.
Athens, Kerameikos
Museum P 1130

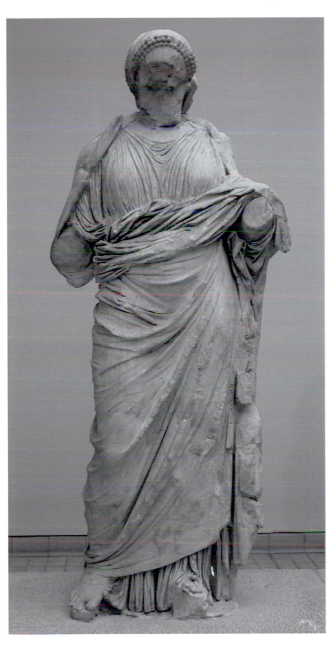

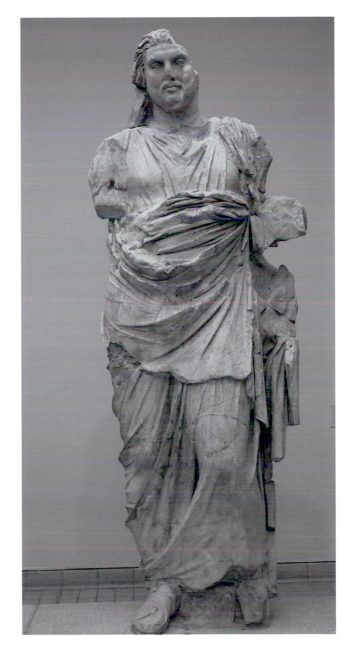

5. Halikarnassos,
"Artemisia." London,
British Museum 1001

6. Halikarnassos,
"Maussollos." London,
British Museum 1000

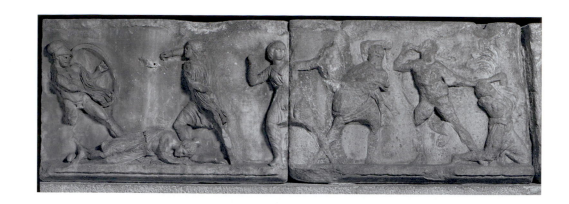

7. Halikarnassos,
Maussolleion frieze,
Amazonomachy.
London, British
Museum 1007 + 1008

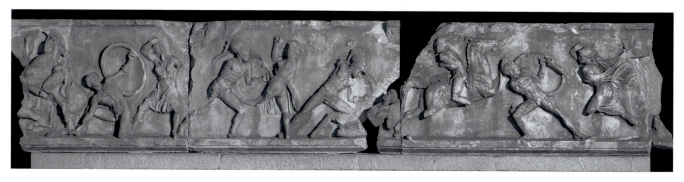

8. Halikarnassos,
Maussolleion frieze,
Amazonomachy.
London, British Museum
1013 + 1014 + 1015

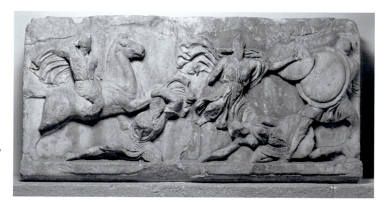

9. Halikarnassos,
Maussolleion frieze,
Amazonomachy.
London, British
Museum 1019

10. Halikarnassos,
Maussolleion frieze,
Amazonomachy. London,
British Museum 1020 + 1021

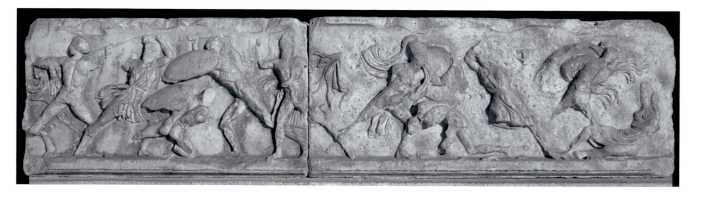

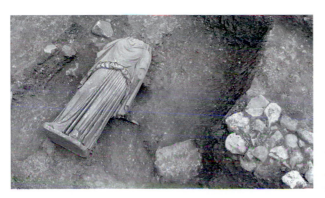

11. Statue dedicated
by Eurydike, wife of
Amyntas III. Vergina,
Archaeological Museum

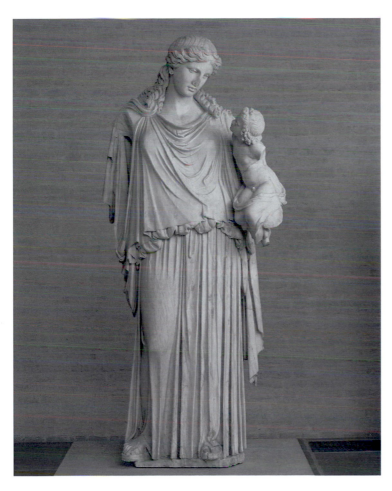

12. Eirene and
Ploutos attributed to
Kephisodotos. Munich,
Glyptothek 219

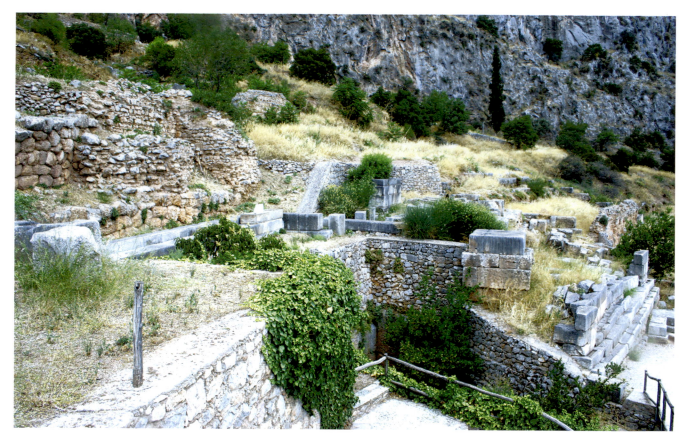

13. Delphi, view
of remains of the
Daochos Monument

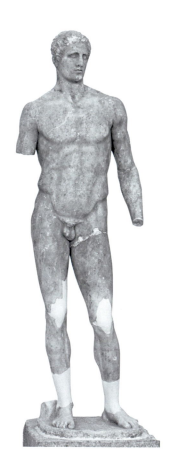

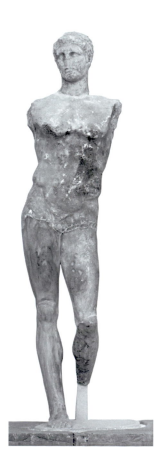

14. Daochos Monument,
Agias. Delphi, Archaeo-
logical Museum 6278

15. (far right) Daochos
Monument, Agelaos.
Delphi, Archaeological
Museum 6277

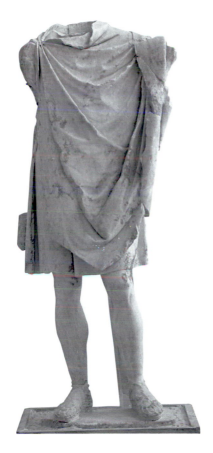

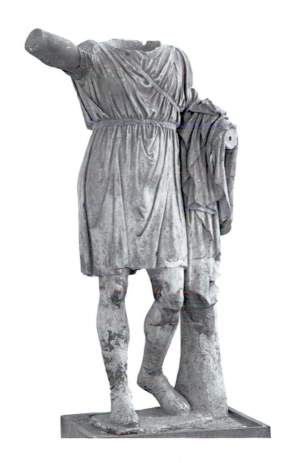

16. (far left) Daochos
Monument, Aknonios.
Delphi, Archaeological
Museum 6279

17. Daochos Monument,
Sisyphos I. Delphi, Archaeo-
logical Museum 6275

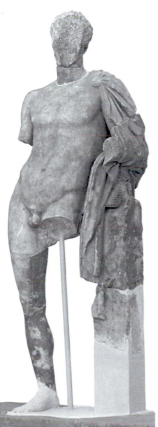

18. Daochos Monument,
Sisyphos II. Delphi,
Archaeological
Museum 6273

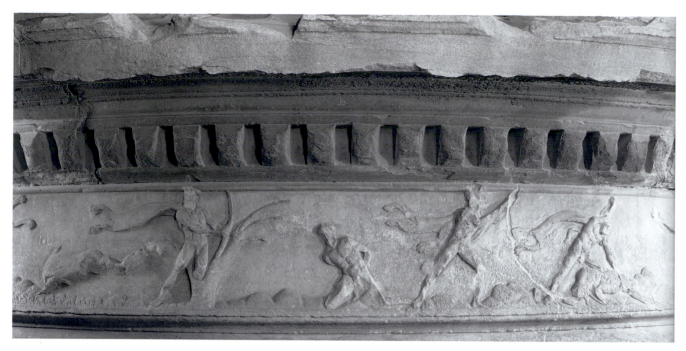

19. Athens, Lysikrates
Monument, south
frieze, Dionysos and
pirates, detail

20. Athens, Lysikrates
Monument, south frieze,
Dionysos and pirates, detail

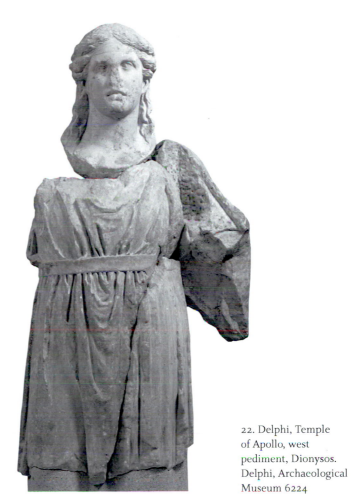

22. Delphi, Temple of Apollo, west pediment, Dionysos. Delphi, Archaeological Museum 6224

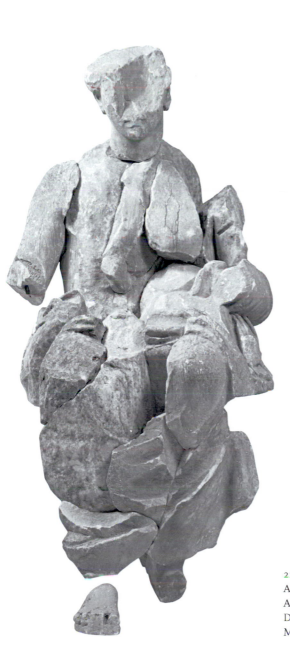

21. Delphi, Temple of Apollo, east pediment, Apollo seated on tripod. Delphi, Archaeological Museum 6223

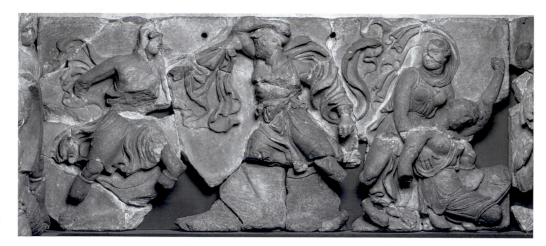

23. Bassai, Temple
of Apollo, frieze,
Amazonomachy. London,
British Museum 531

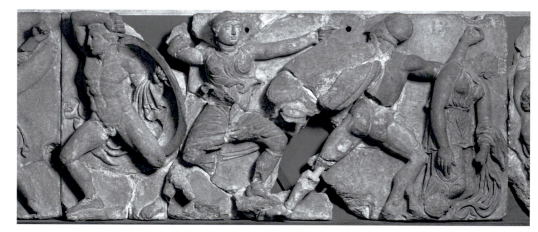

24. Bassai, Temple
of Apollo, frieze,
Amazonomachy. London,
British Museum 533

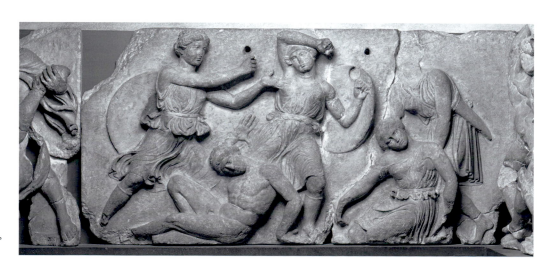

25. Bassai, Temple
of Apollo, frieze,
Amazonomachy. London,
British Museum 542

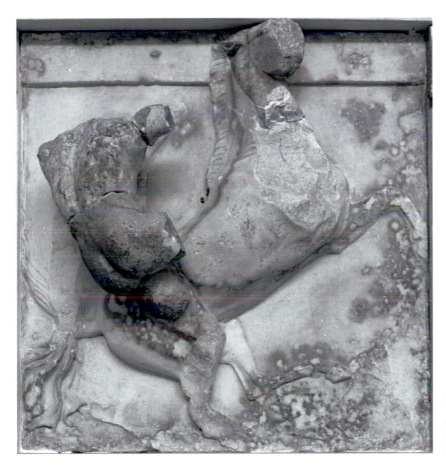

26. Delphi, Marmaria, tholos, metope, large series, Amazonomachy. Delphi, Archaeological Museum 3168

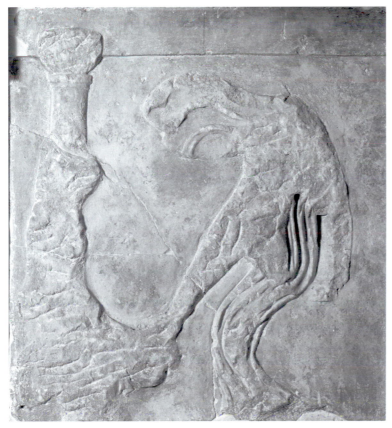

27. Delphi, Marmaria, tholos, metope, large series, Amazonomachy. Delphi, Archaeological Museum 4226

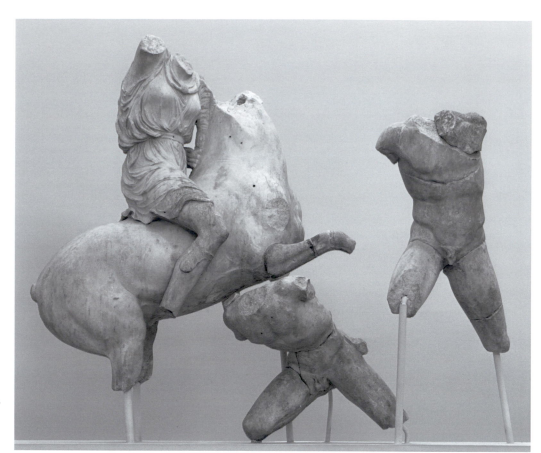

28. Epidauros, Temple of
Asklepios, west pediment,
Amazonomachy. Athens,
National Archaeological
Museum 4757

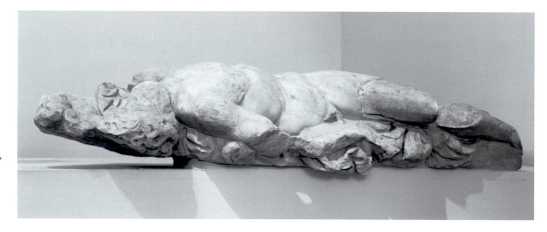

29. Epidauros, Temple of
Asklepios, west pediment,
Amazonomachy,
fallen warrior. Athens,
National Archaeological
Museum 4747

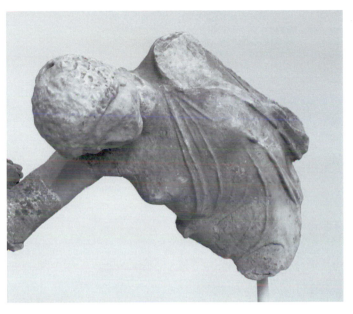

31. Epidauros, Temple of
Asklepios, east acroterion,
Nike. Athens, National
Archaeological Museum 162

30. Epidauros, Temple of
Asklepios, east pediment,
Trojan War, torso of a
woman. Athens, National
Archaeological Museum 4694

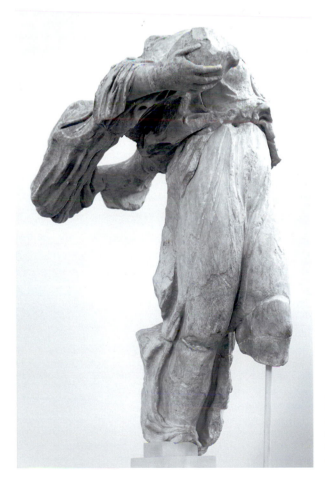

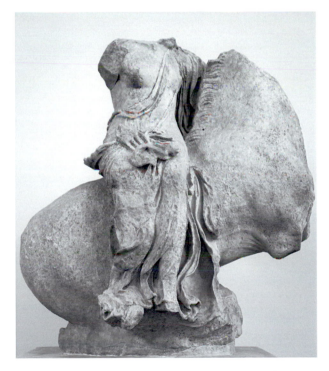

33. Epidauros, Temple
of Asklepios, west
acroterion, "Aura"
riding a horse. Athens,
National Archaeological
Museum 156

32. Epidauros, Temple
of Asklepios, west
acroterion, Nike
with a bird. Athens,
National Archaeological
Museum 155

34. Tegea, Temple of
Athena Alea, male head.
Tegea, Archaeological
Museum 179

35. Tegea, Temple of Athena
Alea, helmeted male head. Tegea,
Archaeological Museum 189

36. Tegea, Temple of
Athena Alea, acroterion,
female torso. Tegea,
Archaeological Museum 59

37. Tegea, Temple of
Athena Alea, acroterion,
female torso. Tegea,
Archaeological
Museum 2288

38. Tegea, Temple of
Athena Alea, crown
molding of interior cella
wall. Tegea, Archaeo-
logical Museum 254 + 255

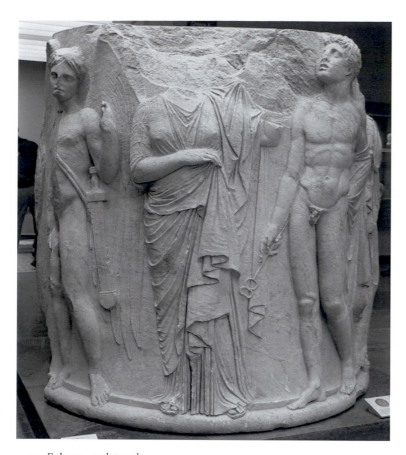

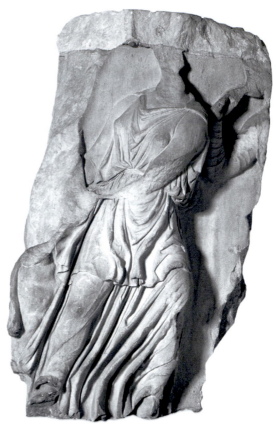

39. Ephesos, sculptured
column drum of
Temple of Artemis,
"Alkestis." London,
British Museum 1206

40. (top right) Ephesos,
sculptured column
base of Temple of
Artemis, woman in
peplos. London, British
Museum 1200

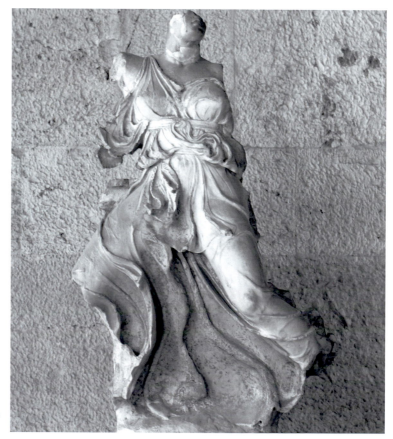

41. Nike, acroterion. Athens,
Agora Museum S 312

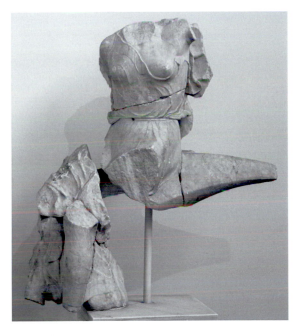

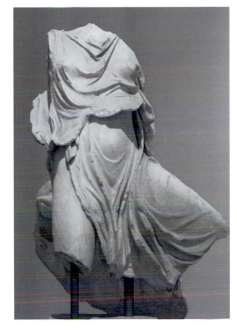

43. "Aura Palatina."
Rome, Museo Nazionale
Romano (Museo
Palatino) 124697

42. Nereid on a dolphin,
acroterion, from the
Athenian Agora. Athens,
National Archaeological
Museum 3397 + 4320 +
4798 + Agora S 2091

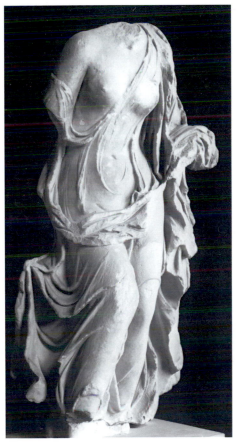

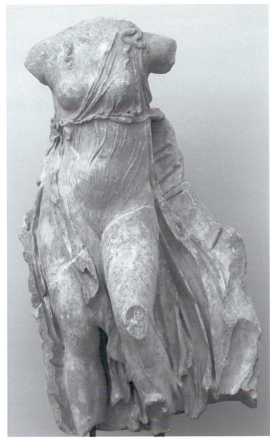

44. (far left) Nereid.
London, Royal Academy,
Burlington House

45. Aura or Nereid.
Copenhagen, Ny
Carlsberg Glyptotek 2432

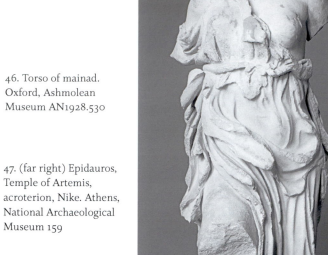

46. Torso of mainad.
Oxford, Ashmolean
Museum AN1928.530

47. (far right) Epidauros,
Temple of Artemis,
acroterion, Nike. Athens,
National Archaeological
Museum 159

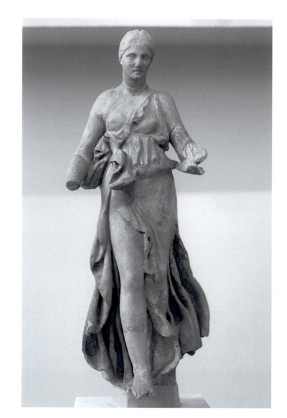

48. Xanthos, view of base
of Nereid Monument
from northwest

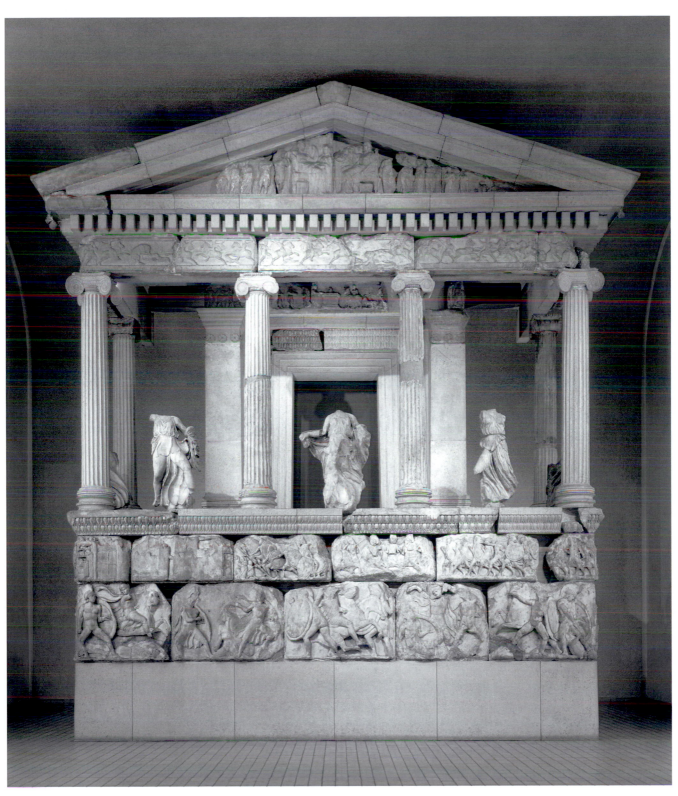

49. Xanthos, recon-
structed east facade
of Nereid Monument.
London, British Museum

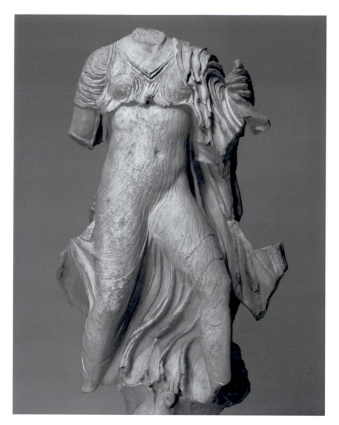

50. Xanthos, Nereid
Monument, Nereid.
London, British
Museum 909

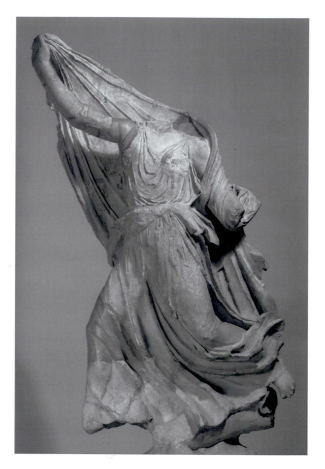

51. Xanthos, Nereid
Monument, Nereid.
London, British
Museum 910

52. Xanthos, Nereid
Monument, large podium
frieze, battle. London,
British Museum 859

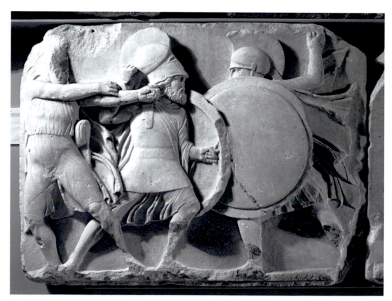

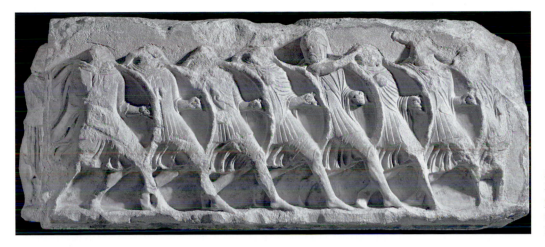

53. Xanthos, Nereid Monument, small podium frieze, marching soldiers. London, British Museum 868L

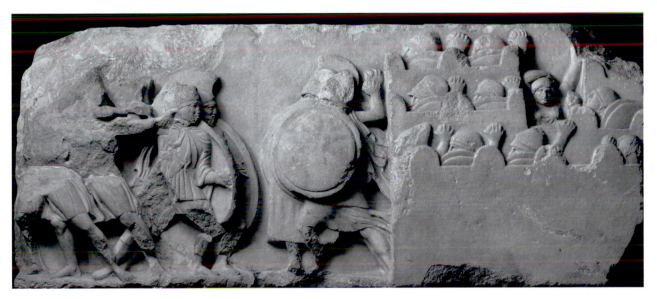

54. Xanthos, Nereid Monument, small podium frieze, city siege. London, British Museum 869

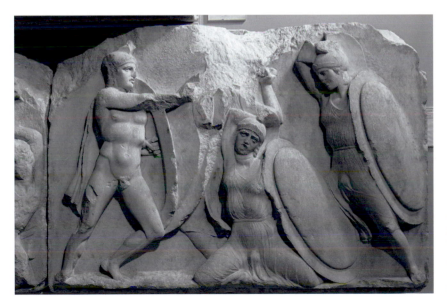

55. Xanthos, Nereid Monument, large podium frieze, battle. London, British Museum 858

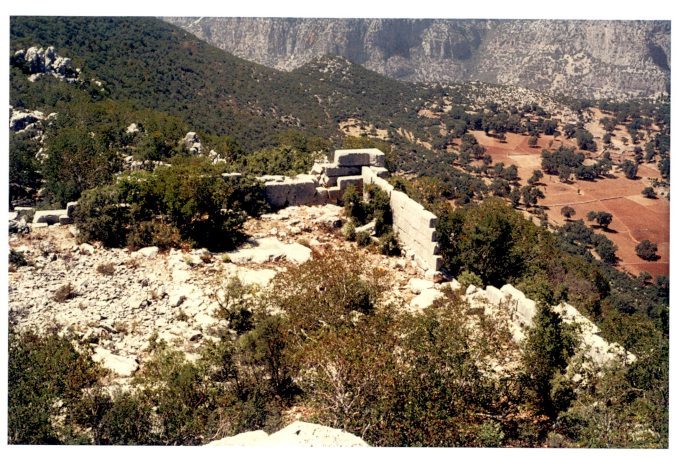

56. Trysa, view of ruins
of heroon from west

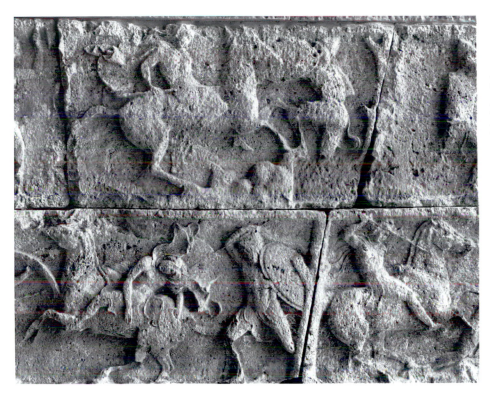

57. Trysa, heroon,
west interior frieze,
Amazonomachy.
Vienna, Kunst-
historisches Museum

58. Trysa, heroon,
west interior frieze,
city siege. Vienna,
Kunsthistorisches
Museum

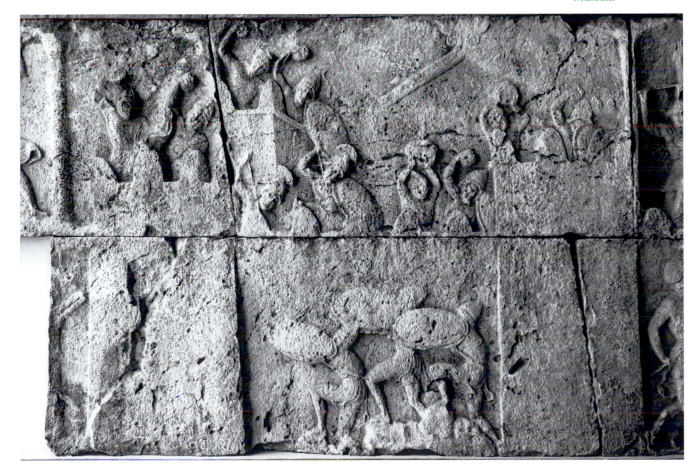

59. Limyra, tomb of
Periklä, acroterion,
Perseus. Antalya,
Archaeological
Museum A3436

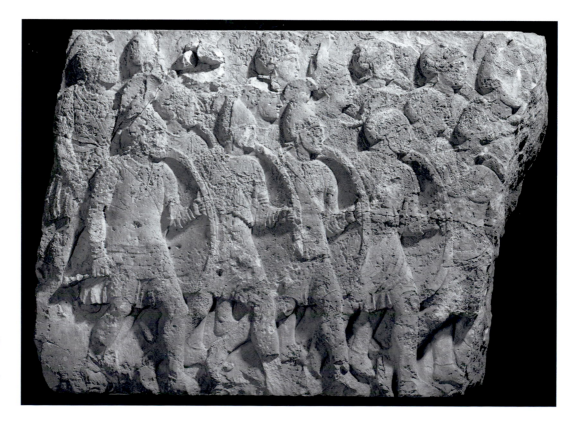

60. Limyra, tomb of
Periklä, west frieze,
procession. Antalya,
Archaeological
Museum

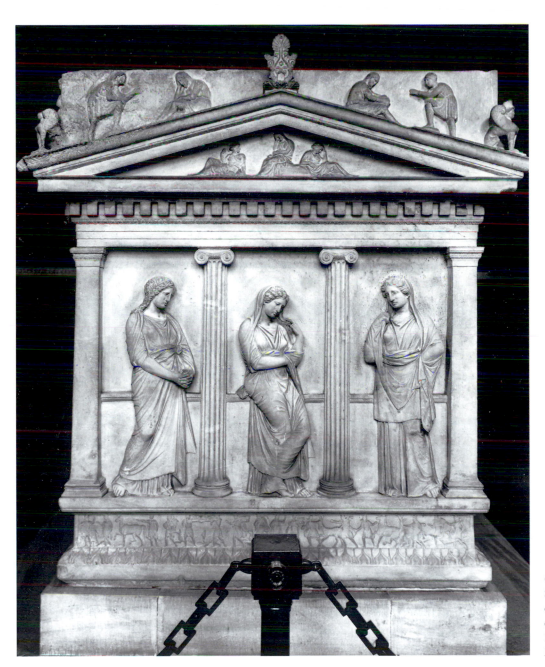

61. Mourning Women
Sarcophagus, short
end, from the royal
cemetery, Sidon.
Istanbul, Archaeological
Museum 368

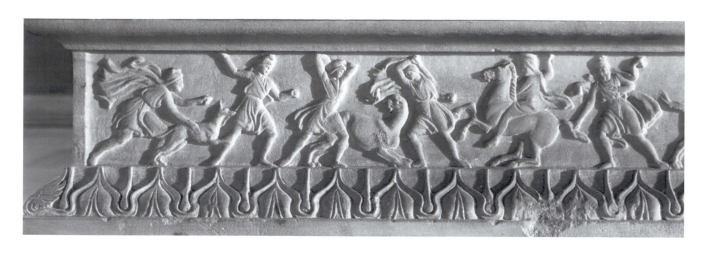

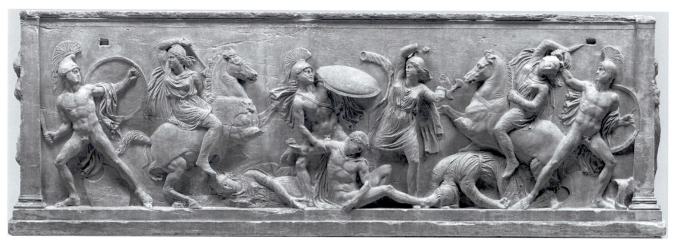

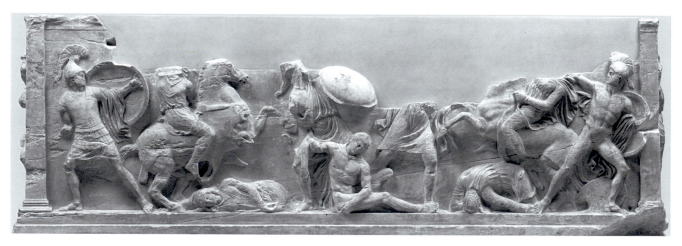

62. (top) Mourning Women Sarcophagus, small podium frieze, B1–B6, from the royal cemetery, Sidon. Istanbul, Archaeological Museum 368

63. (middle) Amazon sarcophagus, side 1, Amazonomachy, from Soloi (Cyprus). Vienna, Kunsthistorisches Museum I 169

64. (bottom) Amazon sarcophagus, side 2, Amazonomachy, from Soloi (Cyprus). Vienna, Kunsthistorisches Museum I 169

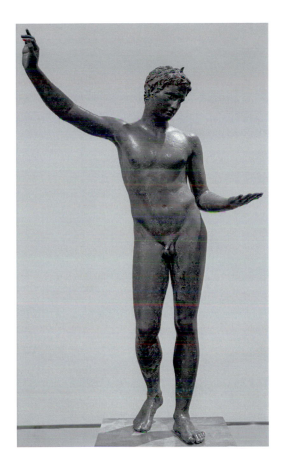

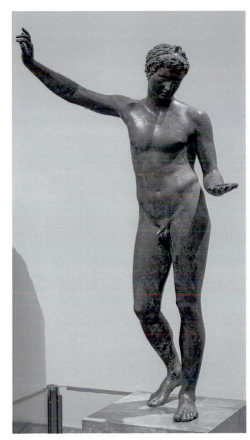

65. (far left) Marathon boy, front. Athens, National Archaeological Museum X 15118

66. Marathon boy, three-quarter right view. Athens, National Archaeological Museum X 15118

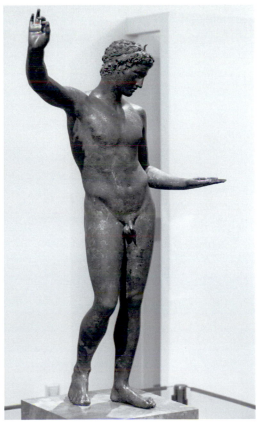

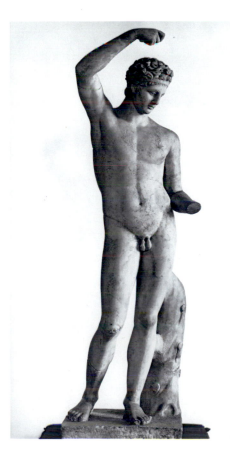

67. (far left) Marathon boy, one-quarter left view. Athens, National Archaeological Museum X 15118

68. Pouring satyr. Dresden, Staatliche Kunstsammlungen, Skulpturensammlung, Herrmann 100

69. Youth from Anti-
kythera, front. Athens,
National Archaeological
Museum X 13396

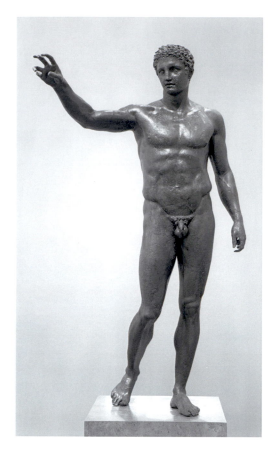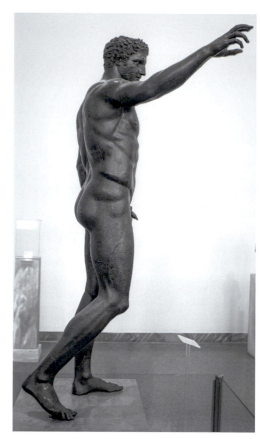

70. (far right) Youth
from Antikythera,
right side. Athens,
National Archaeological
Museum X 13396

71. Strigil-cleaner, from
Ephesos, front. Vienna,
Kunsthistorisches
Museum, Antiken-
sammlung, Ephesos
Museum VI 3168

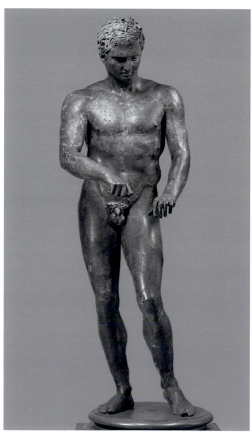

72. (far right) Strigil-
cleaner, from Ephesos,
left side. Vienna,
Kunsthistorisches
Museum, Antiken-
sammlung, Ephesos
Museum VI 3168

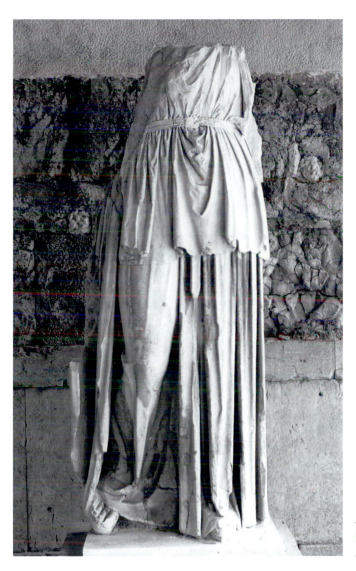

73. Apollo Patroos,
front. Athens, Agora
Museum S 2154

74. Apollo
Patroos, detail
of polished toes.
Athens, Agora
Museum S 2154

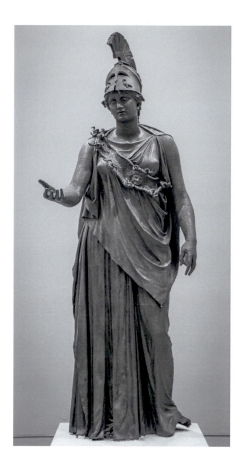

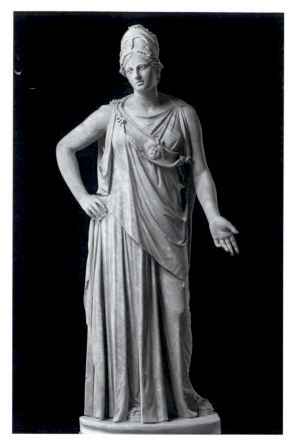

75. Athena from Piraeus,
front. Piraeus, Archaeo-
logical Museum 4646

76. (far right) Athena
Mattei, front. Paris,
Musée du Louvre
Ma 530

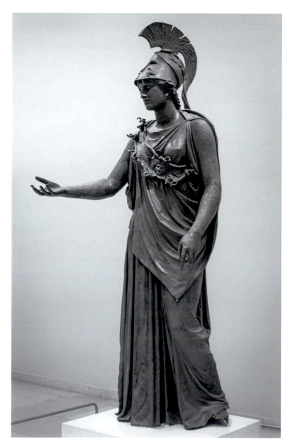

77. Athena from
Piraeus, left side.
Piraeus, Archaeological
Museum 4646

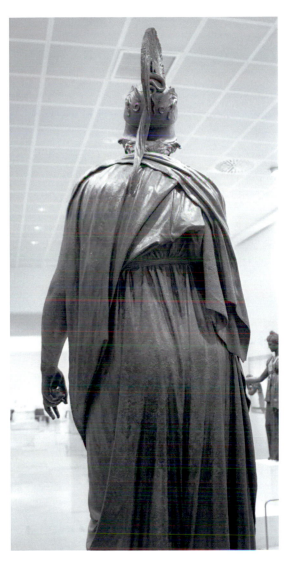

78. Athena from
Piraeus, back of torso.
Piraeus, Archaeological
Museum 4646

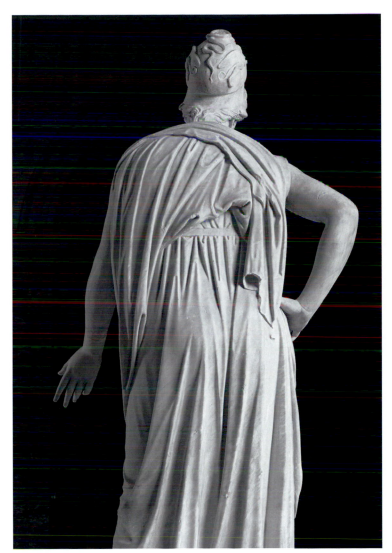

79. Athena Mattei, back
of torso. Paris, Musée
du Louvre Ma 530

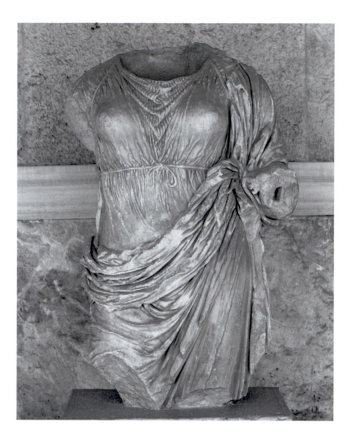

80. Torso of a woman
(Themis or Tyche).
Athens, Agora
Museum S 2370

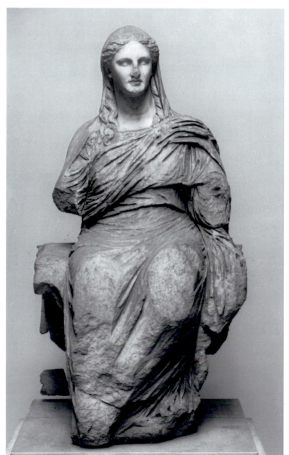

81. Seated Demeter,
from Knidos. London,
British Museum 134

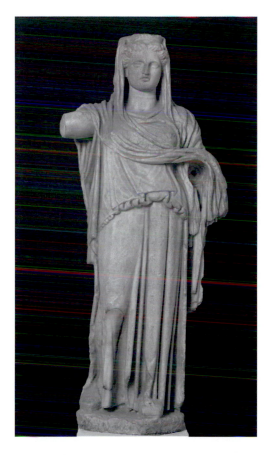

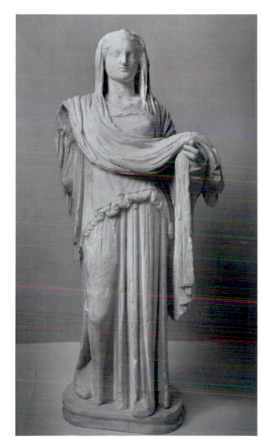

82. (far left) Statuette of Demeter. Venice, Museo Archeologico Nazionale 21

83. Statuette of Demeter. Vienna, Kunsthistorisches Museum 1245

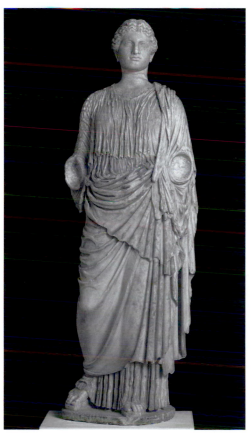

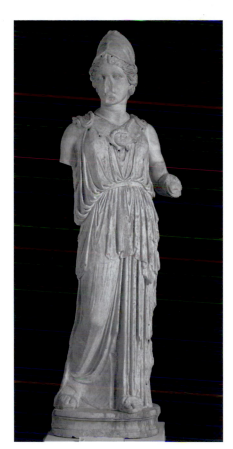

84. (far left) Statuette of draped woman, so-called Abbondanza Grimani. Venice, Museo Archeologico Nazionale 106

85. Statuette of Athena. Venice, Museo Archeologico Nazionale 260A

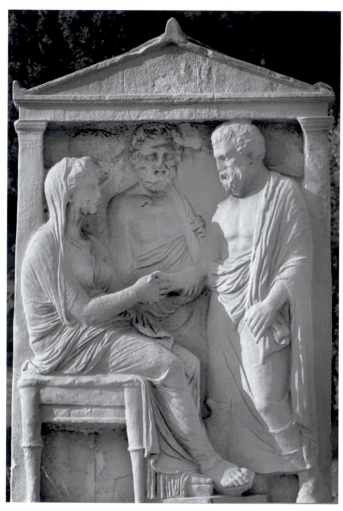

86. Grave stele of Korallion.
Athens, Kerameikos
Museum P 688

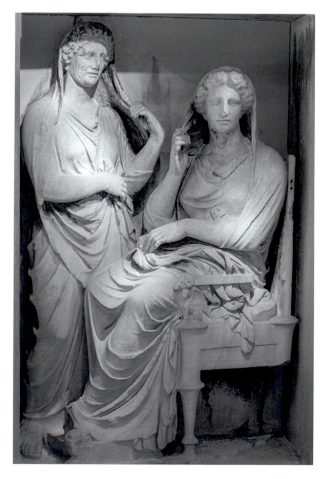

87. Second grave stele of
Demetria and Pamphile.
Athens, Kerameikos
Museum P 687

88. Stele of Aristonautes,
Athens, National
Archaeological
Museum 738

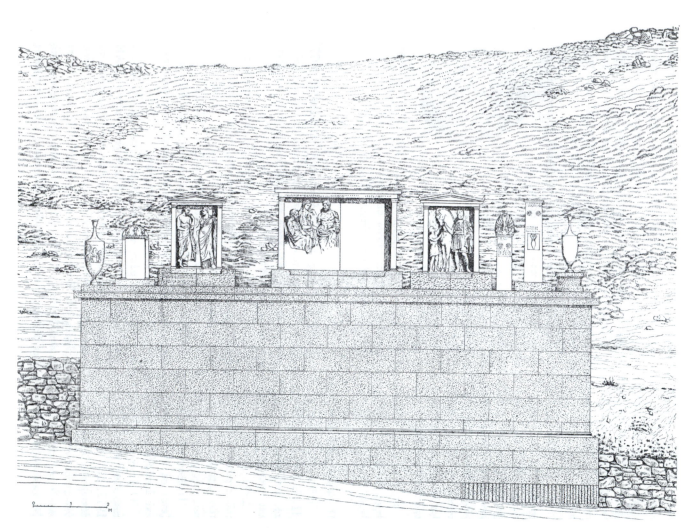

89. Rhamnous, drawing
of funerary plot

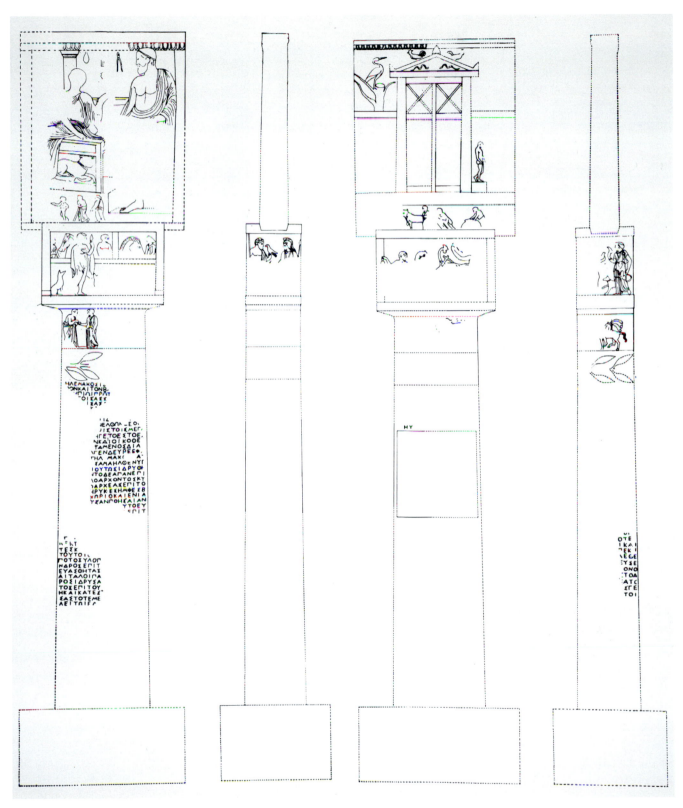

90. Athens, Asklepieion,
reconstruction of
Telemachos stele
by L. Beschi

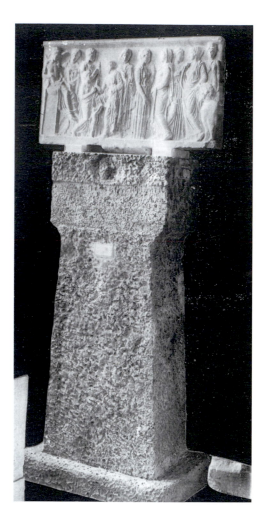

91. Votive relief of Xenokrateia on pillar, from New Phaleron, Attica. Athens, National Archaeological Museum 2756

92. Votive relief of Xenokrateia, from New Phaleron, Attica. Athens, National Archaeological Museum 2756

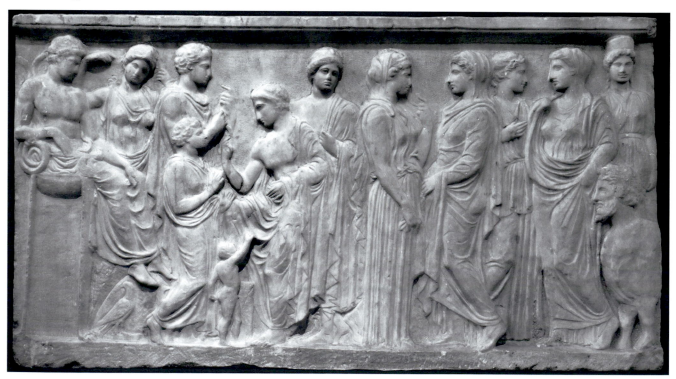

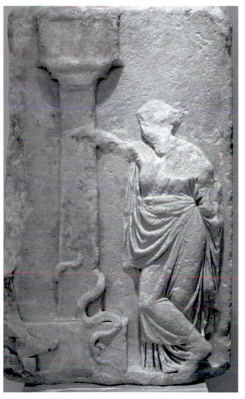

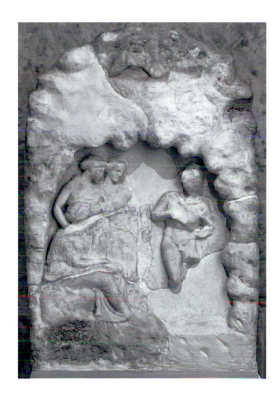

94. Votive relief to the nymphs, from the Vari cave, Attica. Athens, National Archaeological Museum 2011

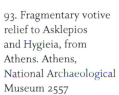

93. Fragmentary votive relief to Asklepios and Hygieia, from Athens. Athens, National Archaeological Museum 2557

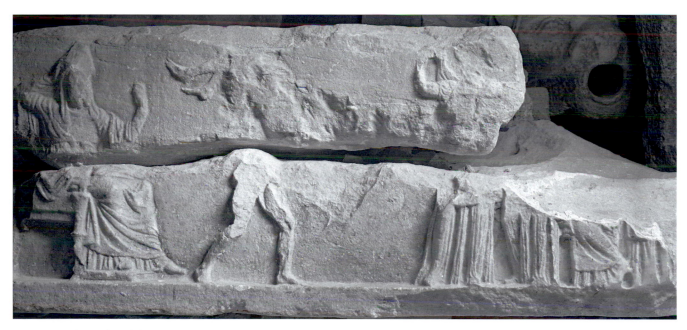

95. Statue base of Poulydamas, Poulydamas holds man aloft before King Darius II. Olympia, Archaeological Museum Λ 45

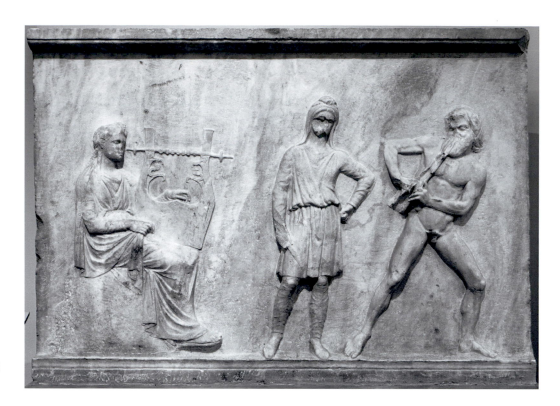

96. Relief slab from
a statue base of Leto,
Apollo, and Artemis,
from Mantineia, Apollo
and Marsyas. Athens,
National Archaeological
Museum 215

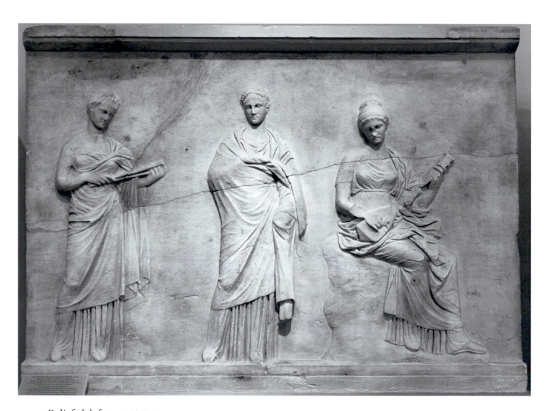

97. Relief slab from a statue
base of Leto, Apollo, and
Artemis, from Mantineia,
three Muses. Athens, National
Archaeological Museum 216

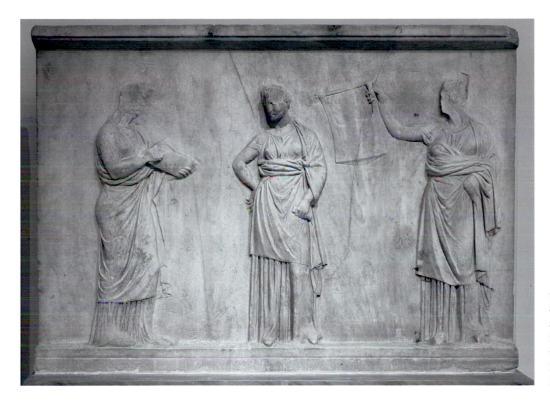

98. Relief slab from a statue base of Leto, Apollo, and Artemis, from Mantineia, three Muses. Athens, National Archaeological Museum 217

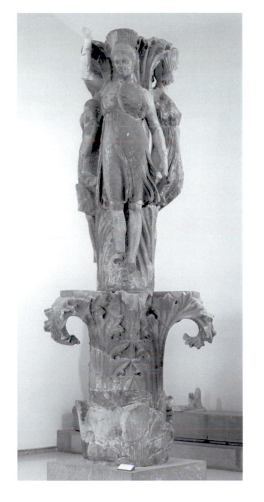

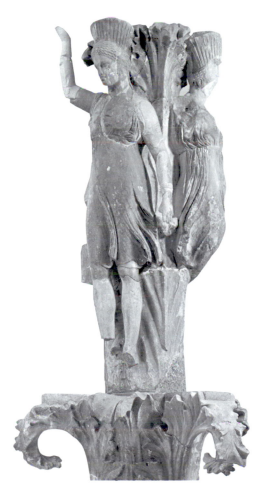

99. (far left) Acanthus Column, top. Delphi, Archaeological Museum 466, 1423, 4851

100. Acanthus Column, detail, dancing women. Delphi, Archaeological Museum 466, 1423, 4851

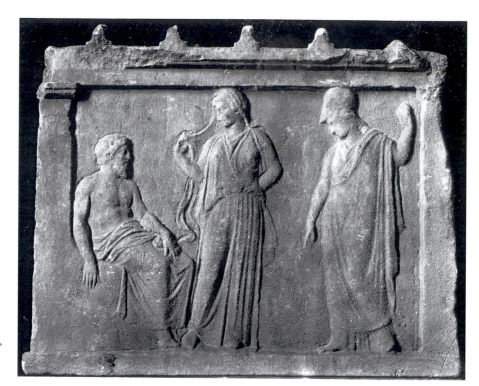

101. Record relief, treaty of Athens and Kerkyra probably in 375/4. Athens, National Archaeological Museum 1467

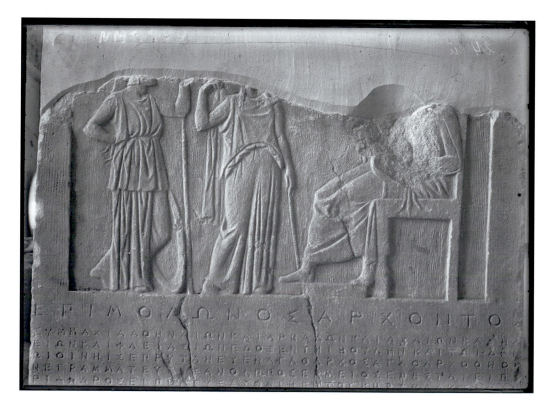

102. Record relief, treaty between Athens and cities in the Peloponnesos in 362/1. Athens, National Archaeological Museum 1481

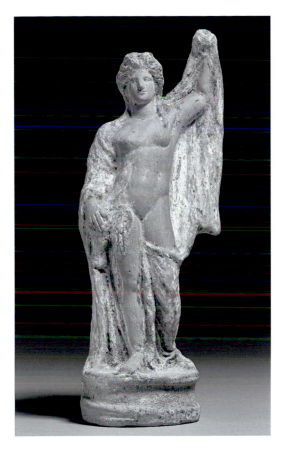

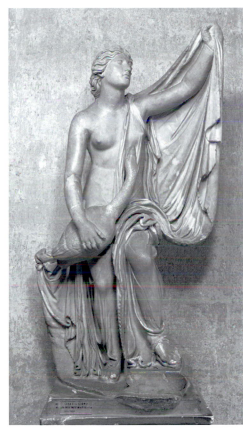

103. (far left) Terracotta statuette of Leda and swan. London, British Museum 1865,7-20.44

104. Leda and swan. Rome, Musei Capitolini 302

105. (far left) Tanagra statuette, fashionable young lady. Boston, Museum of Fine Arts 01.7843

106. Bronze statuette of an athlete. Paris, Musée du Louvre MND 18955

107. Silver kantharos
from Derveni, tomb
B. Thessaloniki,
Archaeological Museum,
Derveni B5

108. Silver-gilt phiale
from Duvanli (Bulgaria),
chariots racing. Plovdiv,
Regional Museum of
Archaeology 1515

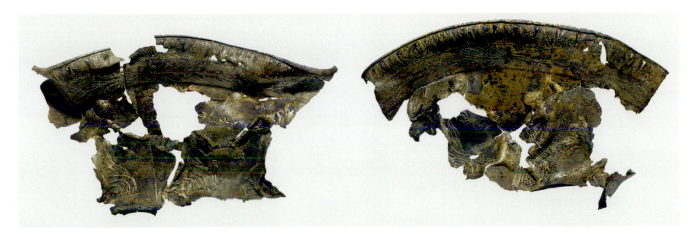

109. Bronze calyx-krater fragment, dancing mainads. Berlin, Staatliche Museen zu Berlin-Preußischer Kulturbesitz (Altes Museum) 30622

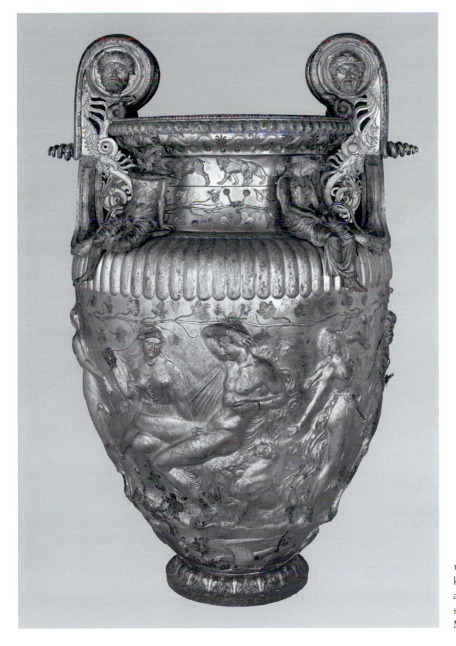

110. Derveni, bronze krater, side A, Dionysos and Ariadne. Thessaloniki, Archaeological Museum Derveni B1

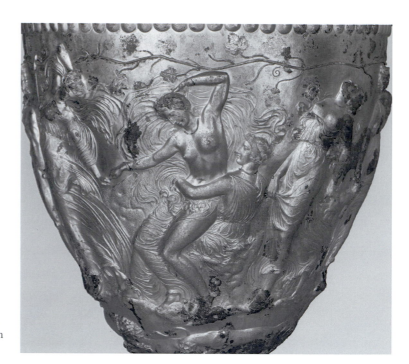

111. Derveni, bronze
krater, side B,
mainads. Thessaloniki,
Archaeological Museum
Derveni B1

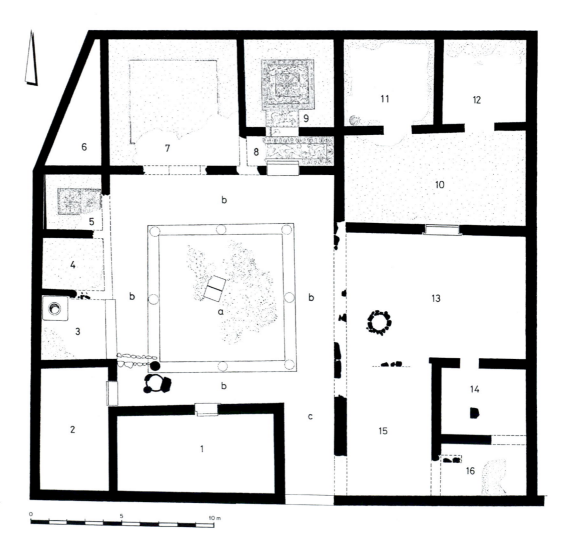

112. Eretria, House of
the Mosaics, plan

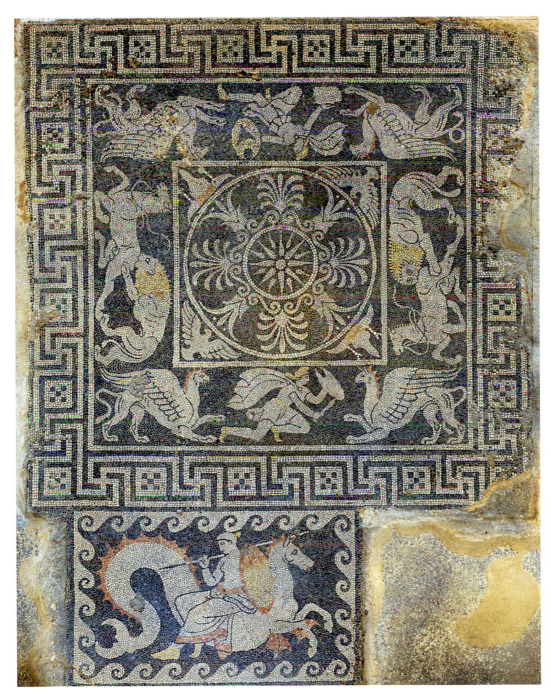

113. Eretria, House of
the Mosaics, mosaic
in andron 9, Arimasps
and griffins

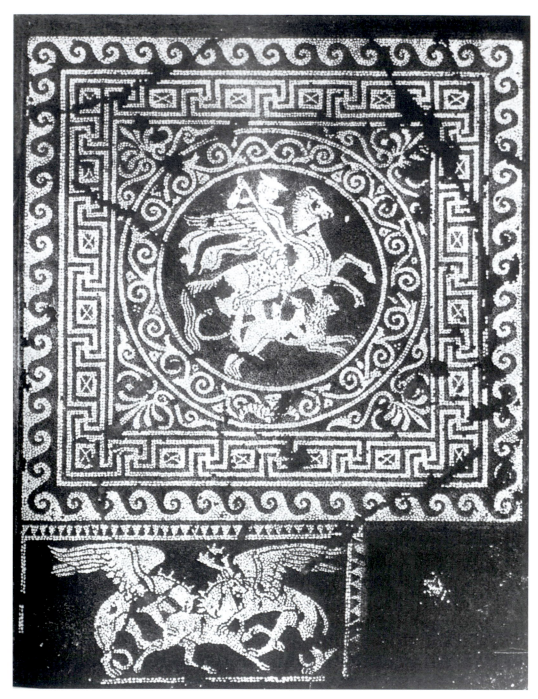

114. Olynthos,
Bellerophon mosaic.
In situ, Olynthos,
House A vi, 3

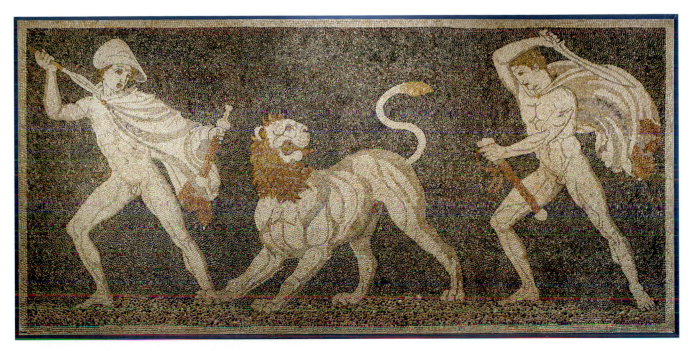

115. Pella, mosaic
of lion hunt from
House 1.1. Pella,
Archaeological Museum

116. Painted grave stele
of Hermon. Athens,
Kerameikos Museum
P 1535 (watercolor)

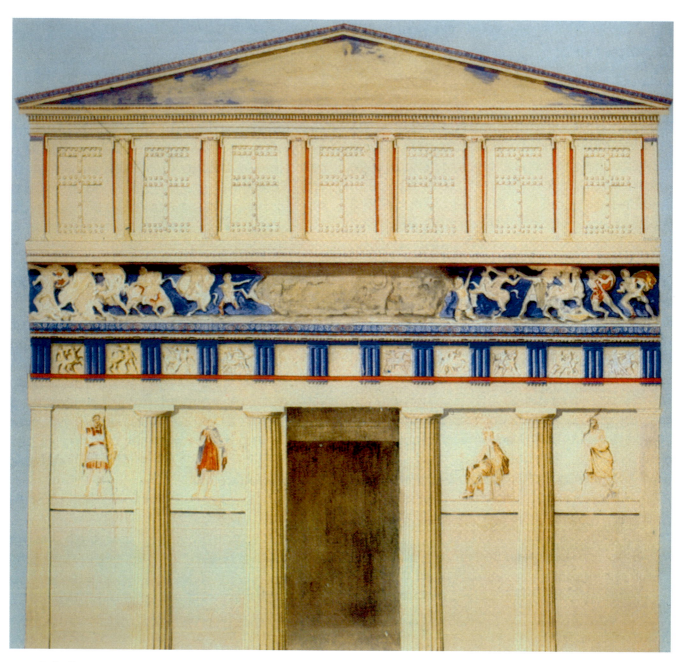

117. Lefkadia,
painted tomb facade,
reconstruction

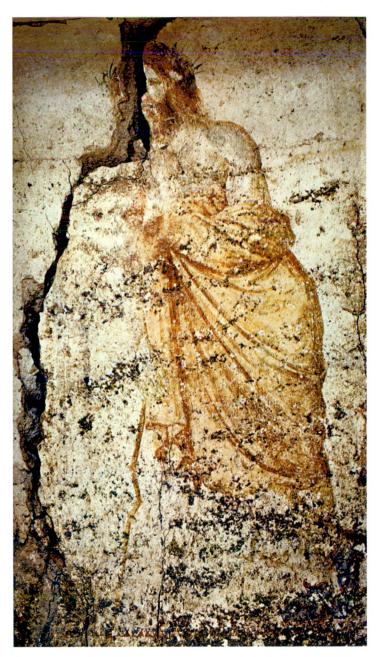

118. Lefkadia, painted
tomb facade, detail,
Rhadamanthys

119a. Vergina, Tomb
II ("Tomb of Philip"),
hunt frieze

119b. Vergina, Tomb
II ("Tomb of Philip"),
hunt frieze, drawing
by Daniel R. Lamp

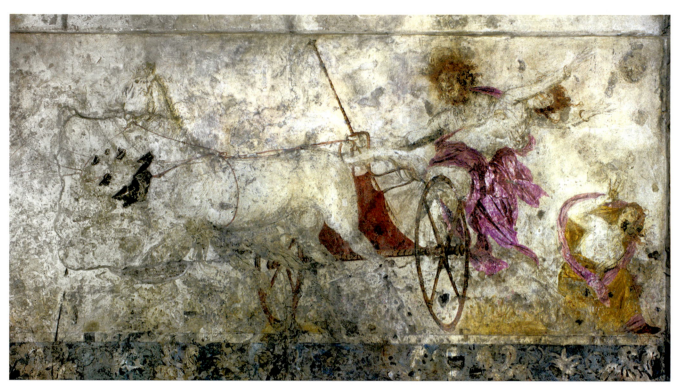

120. Vergina, Tomb I
(Tomb of Persephone),
rape of Persephone, exact
copy by Y. Miltsakakis

121. Panathenaic amphora, archonship of Theophrastos, 340/39 B.C., Athena (side A, left), boxers (side B, right). Cambridge, MA, Harvard Art Museums/Arthur M. Sackler Museum, bequest of Joseph C. Hoppin, 1925.30.124

122. Panathenaic amphora, archonship of Kallimedes, 360/59 B.C. (Kallimedes Painter), detail, Eirene and Ploutos on a column. Athens, National Archaeological Museum 14814

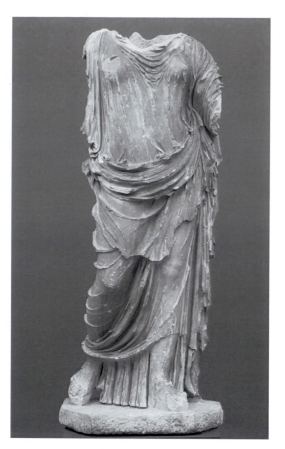

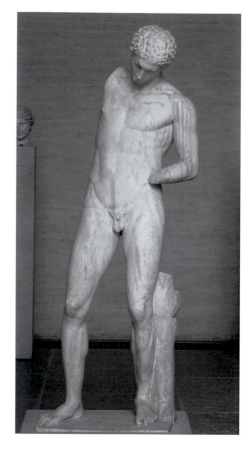

123. Hera Borghese.
Copenhagen, Ny
Carlsberg Glyptotek 1802

124. (far right) Oil-pourer,
Munich type, front.
Munich, Glyptothek 302

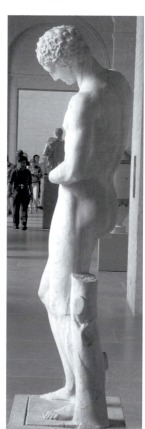

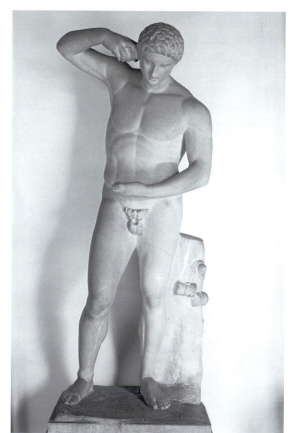

125. Oil-pourer, Munich
type, left side. Munich,
Glyptothek 302

126. (far right) Oil-pourer.
Florence, Palazzo Pitti
128 (Dütschke 22)

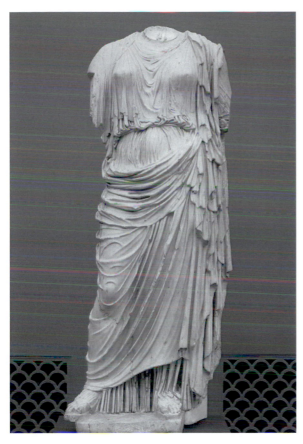

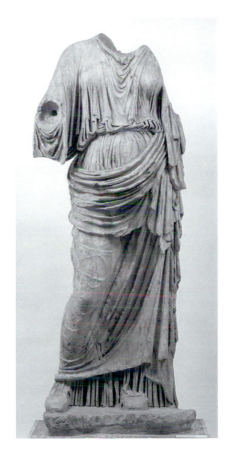

127. (far left) Nemesis of Rhamnous. Copenhagen, Ny Carlsberg Glyptotek 2086

128. Nemesis of Rhamnous. Athens, National Archaeological Museum 3949

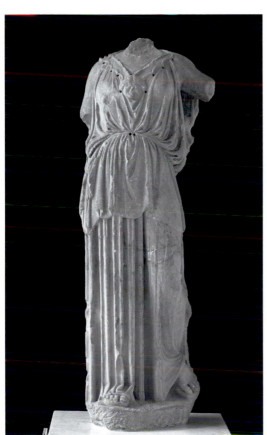

129. Athena. Athens, Acropolis Museum 1336

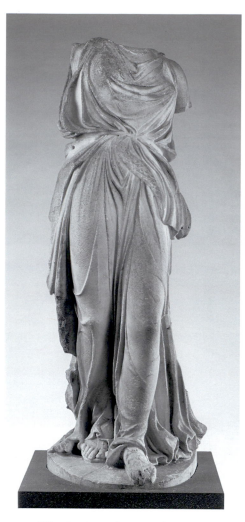

130. Nike. Basel, Antiken-
museum und Sammlung
Ludwig BS 299

131. Nike, detail of bore
marks. Basel, Antiken-
museum und Sammlung
Ludwig BS 299

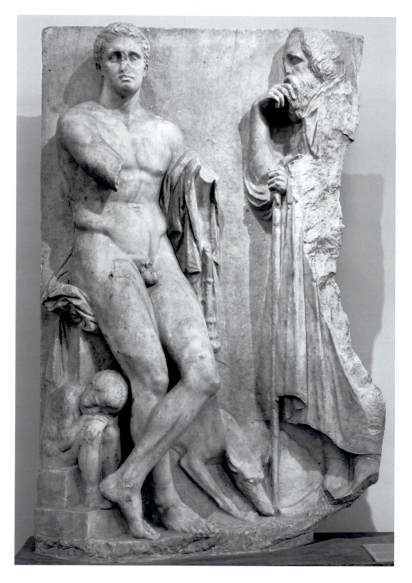

132. Ilissos stele. Athens,
National Archaeological
Museum 869

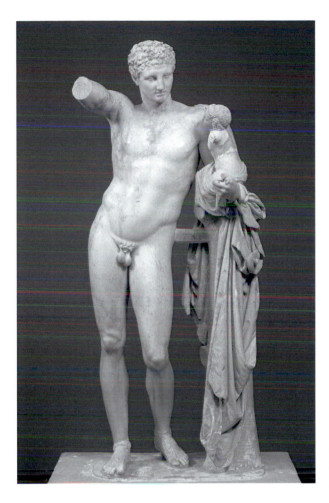

134. Hermes and child Dionysos, detail of front. Olympia, Archaeological Museum

133. Hermes and child Dionysos, front. Olympia, Archaeological Museum

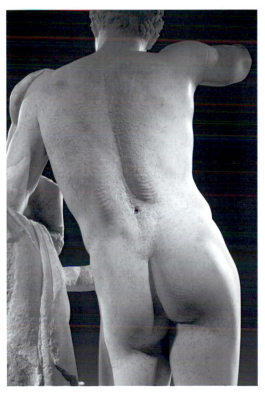

135. (far left) Hermes and child Dionysos, detail of back of torso. Olympia, Archaeological Museum

136. Hermes and child Dionysos, detail of tree trunk and drapery. Olympia, Archaeological Museum

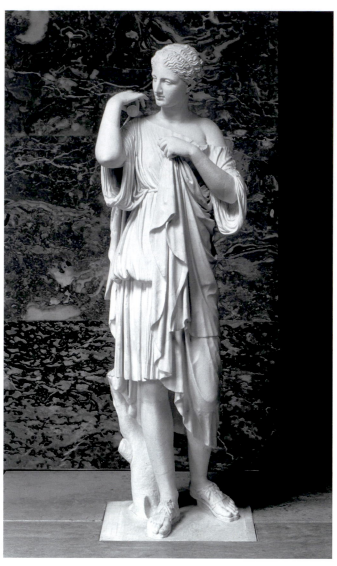

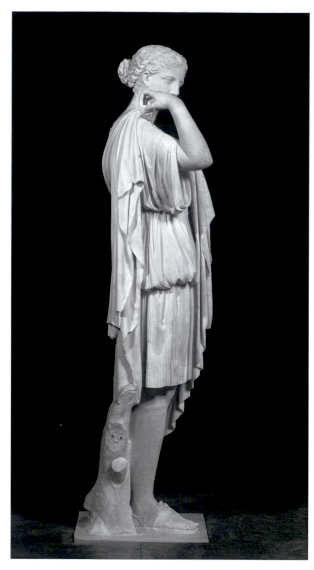

137. Artemis of Gabii,
front. Paris, Musée
du Louvre Ma 529

138. Artemis of Gabii,
right side. Paris, Musée
du Louvre Ma 529

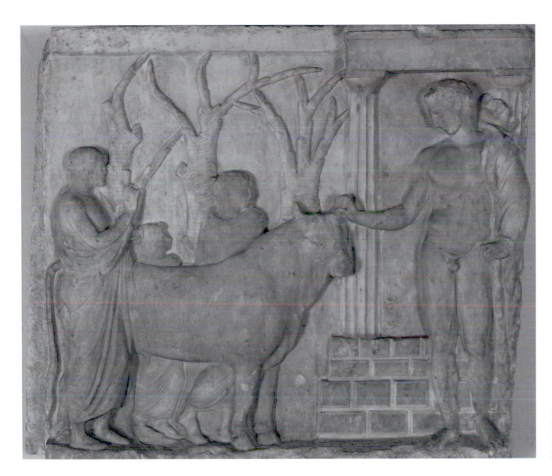

139. Votive relief to
Herakles. Venice,
Museo Archeologico
Nazionale 100

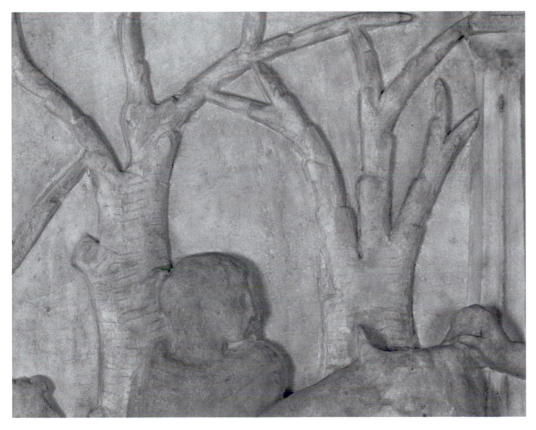

140. Votive relief to
Herakles, detail. Venice,
Museo Archeologico
Nazionale 100

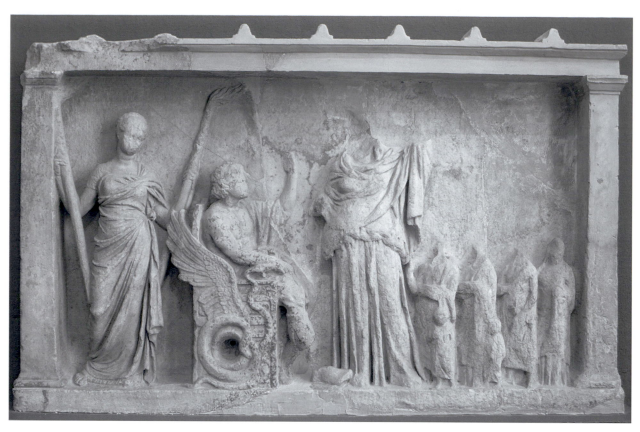

141. Votive relief
to Asklepios and
Hygieia. Eleusis,
Archaeological Museum

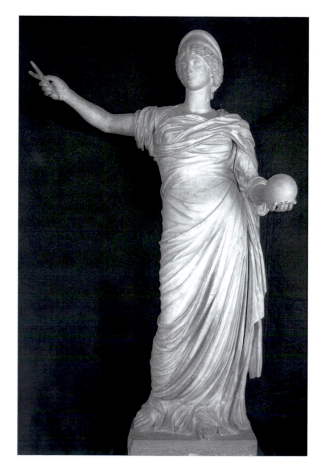

142. Persephone.
Florence, Galleria
degli Uffizi 120

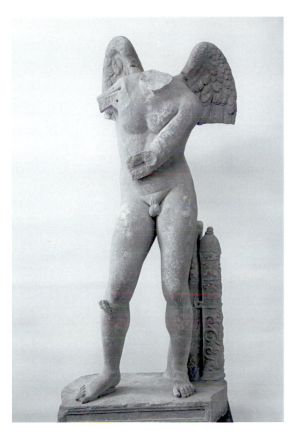

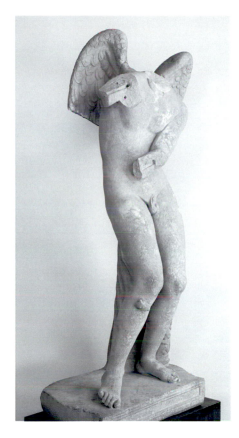

143. (far left) Eros
stringing his bow,
front. Rome, Museo
Nazionale Romano
(Palazzo Massimo) 7430

144. Eros stringing his
bow, right side. Rome,
Museo Nazionale
Romano (Palazzo
Massimo) 7430

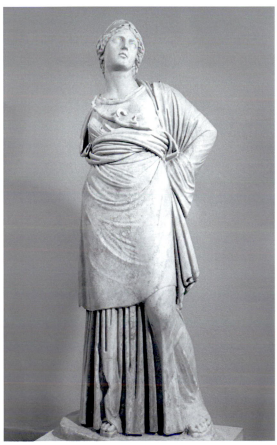

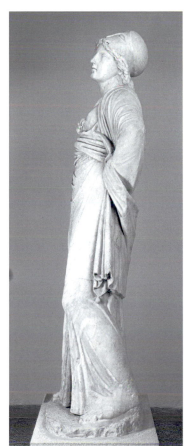

145. (far left) Athena,
Vescovali type, front.
Nikopolis, Archaeo-
logical Museum 6

146. Athena, Vescovali
type, left side. Nikopolis,
Archaeological Museum 6

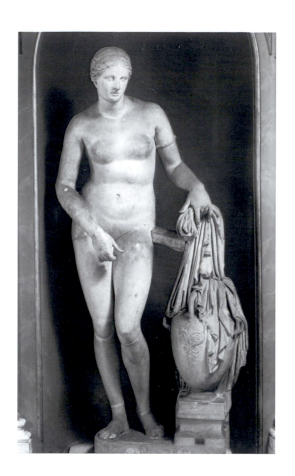

147. Knidian Aphrodite,
Colonna type. Rome,
Musei Vaticani, Museo
Pio-Clementino 812

148. (far right) Knidian
Aphrodite, Belvedere
type. Rome, Musei
Vaticani 4260

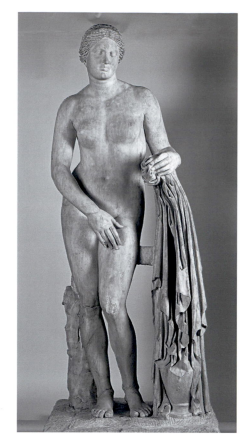

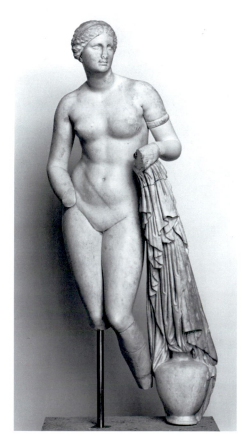

149. Knidian Aphrodite,
Munich variant. Munich,
Glyptothek 258

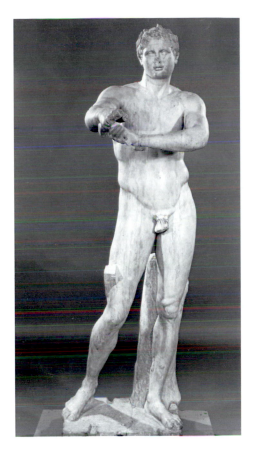

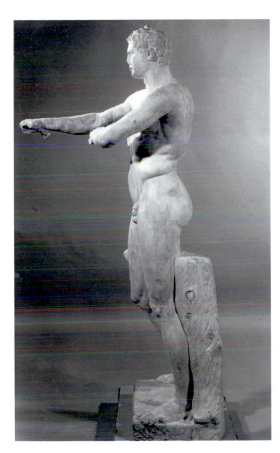

150. (far left) Apoxyo-
menos, front. Rome,
Musei Vaticani, Museo
Pio-Clementino 1185

151. Apoxyomenos,
left side. Rome, Musei
Vaticani, Museo
Pio-Clementino 1185

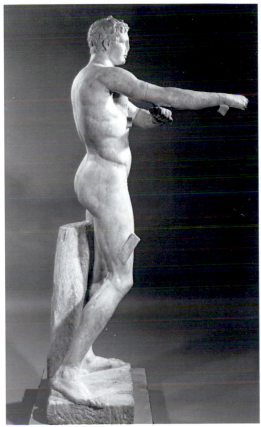

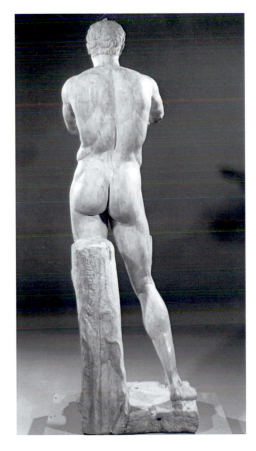

152. (far left) Apoxyo-
menos, right side. Rome,
Musei Vaticani, Museo
Pio-Clementino 1185

153. Apoxyomenos,
back. Rome, Musei
Vaticani, Museo
Pio-Clementino 1185

154. Roman wall painting, Perseus and Andromeda, from the House of the Dioscuri, Pompeii. Naples, Museo Archeologico Nazionale 8998

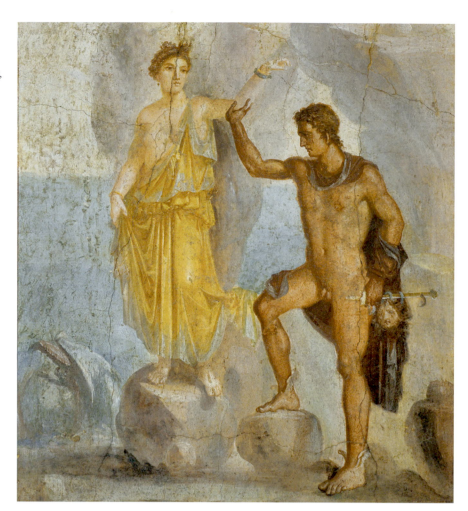

155. Alexander Mosaic, floor mosaic from the House of the Faun, Pompeii. Naples, Museo Archeologico Nazionale 10020

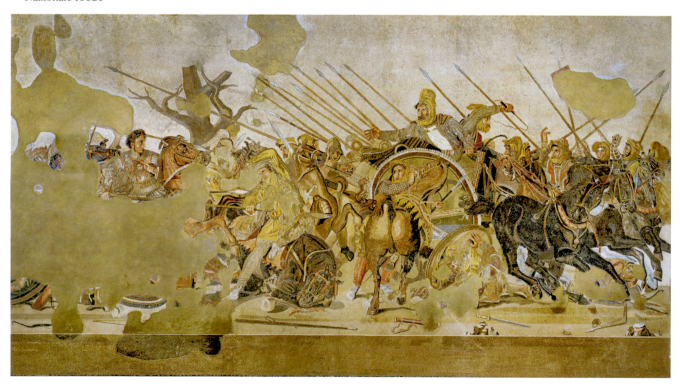

156. Roman wall painting, Alexander Kerau-nophoros. In situ, House of the Vettii, Pompeii

157. Roman wall painting, Io and Argos. In situ, Macellum, Pompeii (VII 9, 4–12)

158. Roman wall
painting, Achilles
and Briseis, from the
House of the Tragic
Poet, Pompeii. Naples,
Museo Archeologico
Nazionale 9105

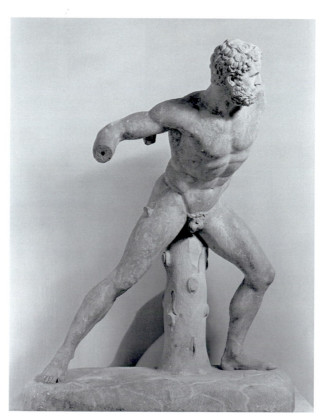

159. Herakles. Rome,
Musei Capitolini,
Centrale Montemartini
(ACEA) MC 1088

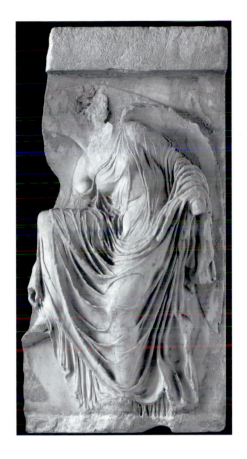

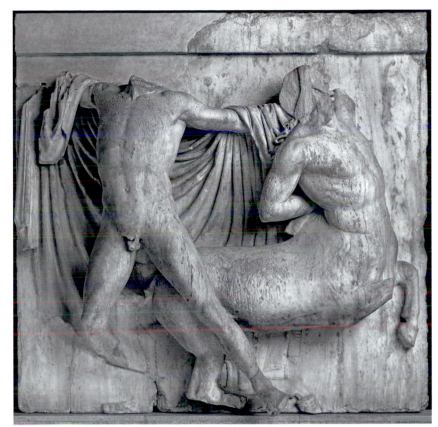

160. (top left) Parapet of the Temple of Athena Nike, "Sandal-binder." Athens, Acropolis Museum 973

161. (above) Parthenon, south metope 27, Centauromachy. London, British Museum 62508

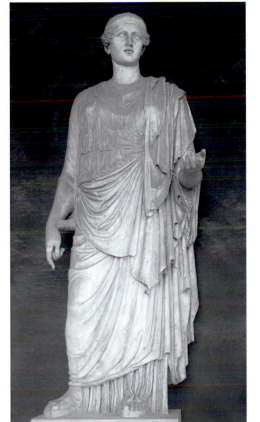

162. (far left) Persephone (Kore Albani). Rome, Villa Albani 749

163. Fragmentary record relief, inventory of the treasurers of Athena, of 377/6, seated Zeus. Athens, Epigraphical Museum 7859

164. "Hera" from Samos. Berlin, Staatliche Museen zu Berlin-Preußischer Kulturbesitz (Pergamon Museum) Sk 1775

165. (far right) Artemis, Colonna type, front. Berlin, Staatliche Museen zu Berlin-Preußischer Kulturbesitz (Pergamon Museum) Sk 59

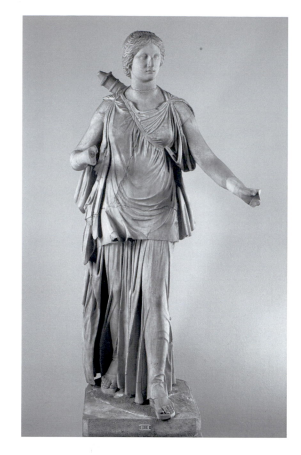

166. Artemis, Colonna type, right side. Berlin, Staatliche Museen zu Berlin-Preußischer Kulturbesitz (Pergamon Museum) Sk 59

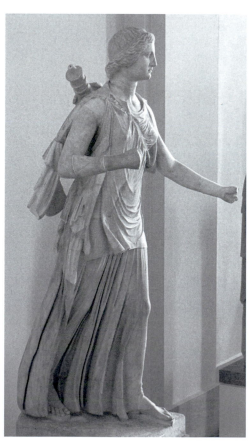

167. (far right) Parthenon, east pediment, Iris or Artemis. London, British Museum 62536

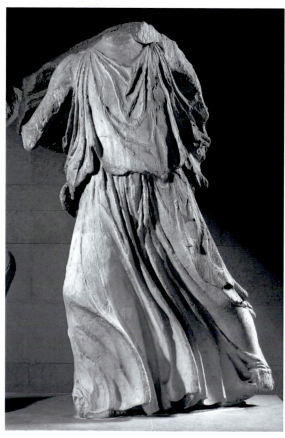

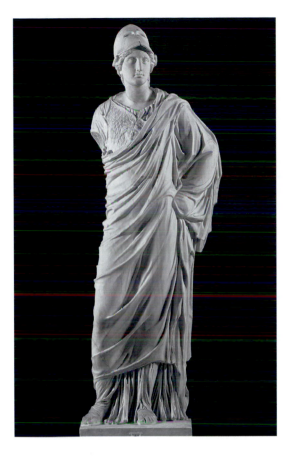

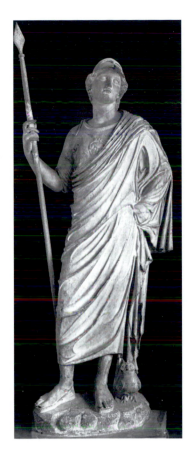

168. (far left) Athena,
Rospigliosi type. Berlin,
Staatliche Museen zu Berlin-
Preußischer Kulturbesitz
(Altes Museum) Sk 73

169. Athena, Rospigliosi
type. Florence, Galleria
degli Uffizi 7019

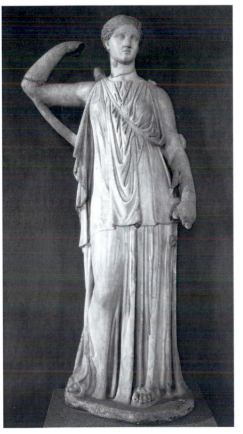

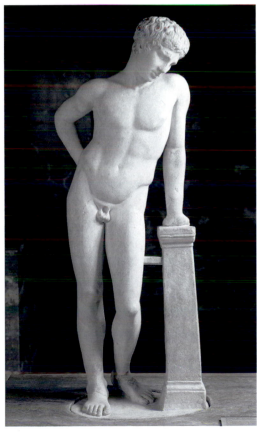

170. (far left) Artemis,
Dresden type.
Dresden, Staatliche
Kunstsammlungen,
Skulpturensammlung,
Herrmann 117

171. Narkissos. Paris,
Musée du Louvre Ma 457

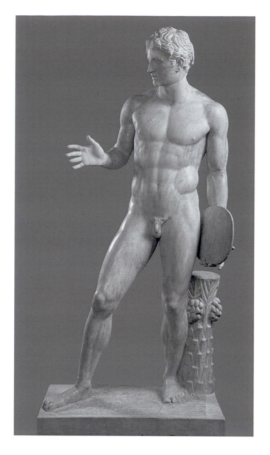
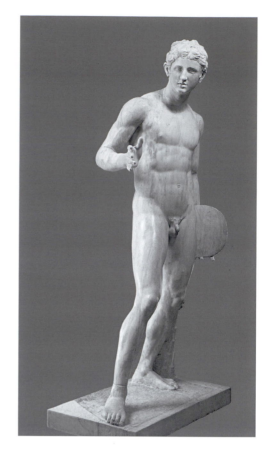

172. Diskobolos
attributed to Naukydes.
Frankfurt am Main,
Liebieghaus Skulpturen-
sammlung 2608

173. (far right) Diskobolos
attributed to Naukydes.
Frankfurt am Main,
Liebieghaus Skulpturen-
sammlung 2608

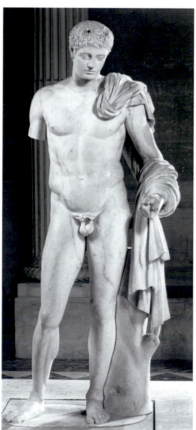
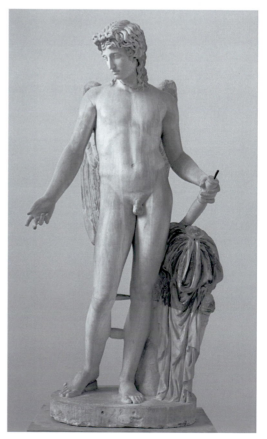

174. Hermes, Richelieu
type. Paris, Musée
du Louvre Ma 573

175. (far right) Eros,
Centocelle type, much
restored. Naples,
Museo Archeologico
Nazionale 6335

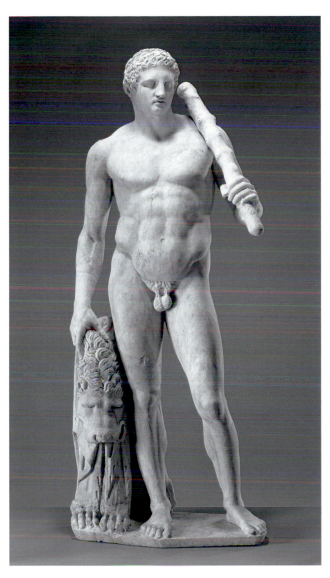

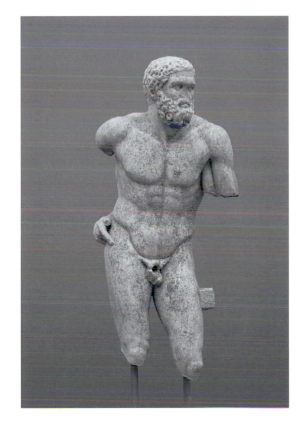

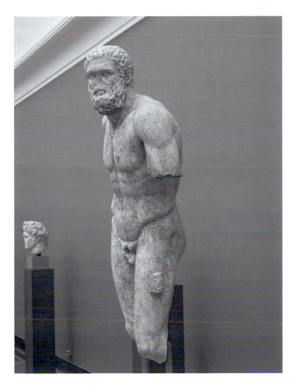

176. Herakles, Lansdowne type. Malibu, J. Paul Getty Museum 70.AA.109

177. (top right) Herakles, Copenhagen-Dresden type, front. Copenhagen, Ny Carlsberg Glyptotek 1720

178. Herakles, Copenhagen-Dresden type, three-quarter right view. Copenhagen, Ny Carlsberg Glyptotek 1720

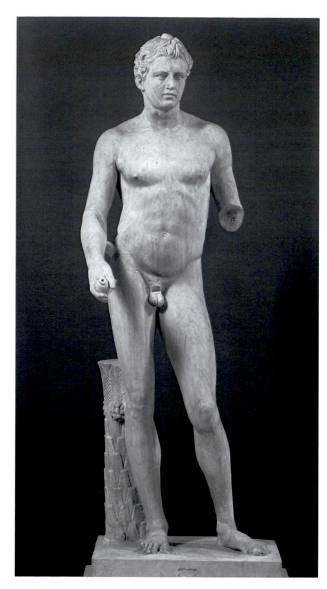

179. Youth. Berlin,
Staatliche Museen zu
Berlin-Preußischer
Kulturbesitz (Pergamon
Museum) Sk 471

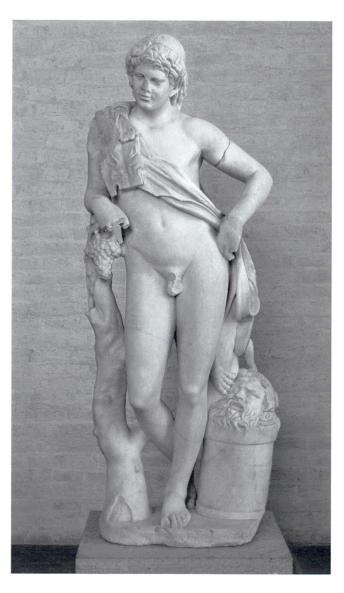

180. Resting satyr.
Munich, Glyptothek 228

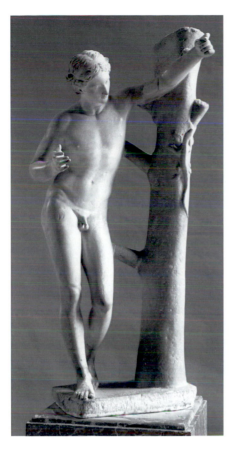

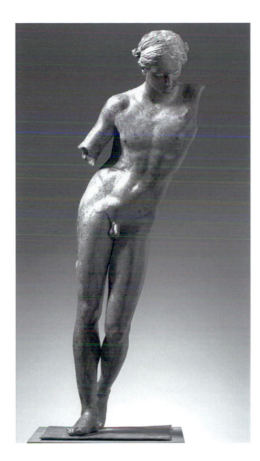

181. (far left) Apollo
Sauroktonos. Paris,
Musée du Louvre Ma 441

182. Bronze Apollo
Sauroktonos. Cleveland
Museum of Art 2004.30.c

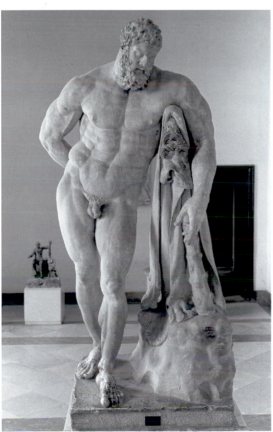

183. Herakles,
Farnese type. Naples,
Museo Archeologico
Nazionale 6001

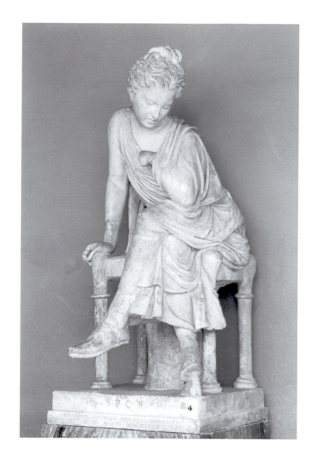

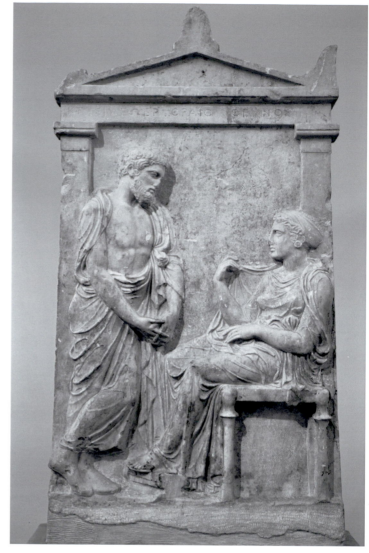

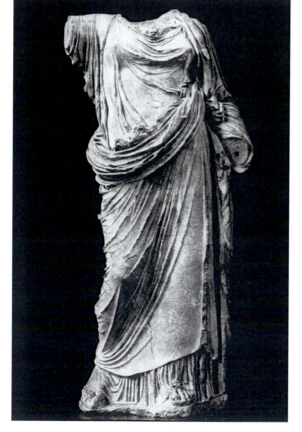

185. Grave stele of
Ktesileos and Theano.
Athens, National
Archaeological
Museum 3472

184. (top left)
Conservatori girl. Rome,
Palazzo dei Conservatori,
Centrale Montemartini
(ACEA) MC 1107

186. Hera from Ephesos.
Vienna, Gemäldegalerie
der Akademie der
bildenden Künste
Wien, Glyptothek

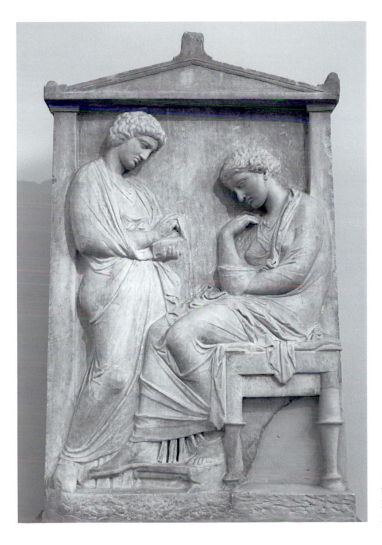

187. Grave stele, from the Piraeus. Athens, National Archaeological Museum 726

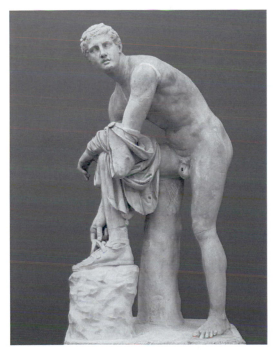

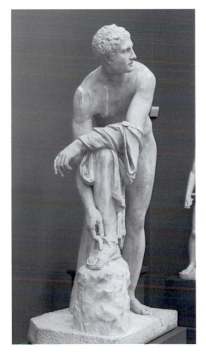

188. (far left) Sandal-binding Hermes, front. Copenhagen, Ny Carlsberg Glyptotek 2798

189. Sandal-binding Hermes, right side. Copenhagen, Ny Carlsberg Glyptotek 2798

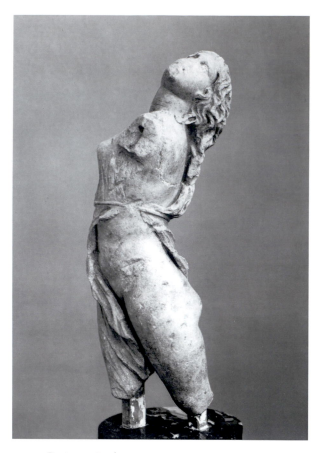

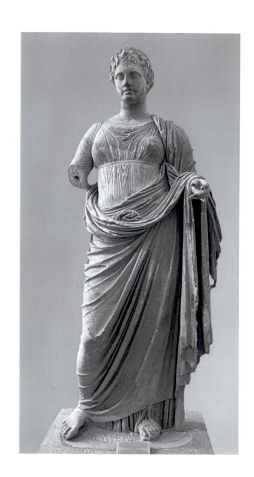

190. Raving mainad
attributed to Skopas.
Dresden, Staatliche
Kunstsammlungen,
Skulpturensammlung,
Herrmann 133 (ZV 1941)

191. (top right) Themis
signed by Chairestratos,
from Rhamnous. Athens,
National Archaeological
Museum 231

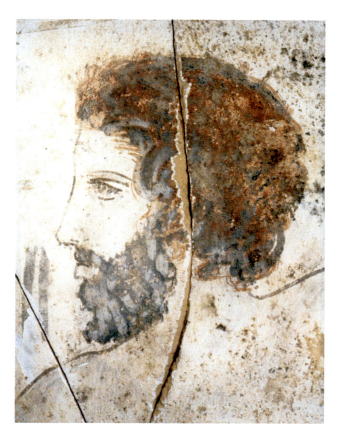

192. Attic white-ground
lekythos, unattributed,
detail of male head.
Athens, Kerameikos
Museum 3146

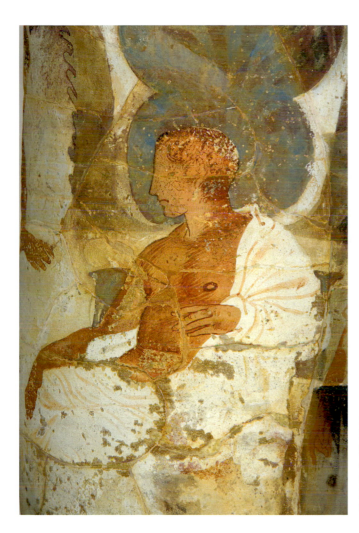

193. Attic white-ground lekythos, Group of the Huge Lekythoi, scene at grave, detail. Berlin, Staatliche Museen zu Berlin-Preußischer Kulturbesitz F 2685

194. Attic white-ground lekythos, Painter of Munich 2335, scene at grave. New York, Metropolitan Museum of Art 09.221.44

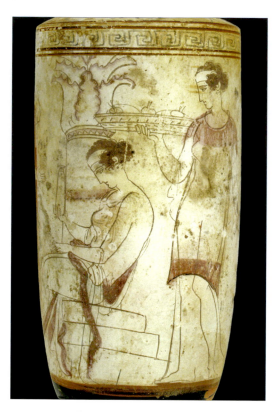

195. Attic white-ground
lekythos, Woman Painter,
scene at grave. Athens,
National Archaeological
Museum 1956

196. (top right) Attic
white-ground lekythos,
Group R, scene at grave.
London, British Museum
D 71 (1852,0302.1)

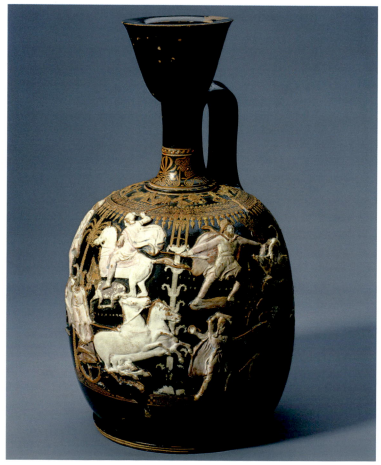

197. Lekythos with
red-figured and plastic
decoration, Xenophantos
Painter, oriental hunt. Saint
Petersburg, Hermitage P
1837.2 (St. 1790 + 107)

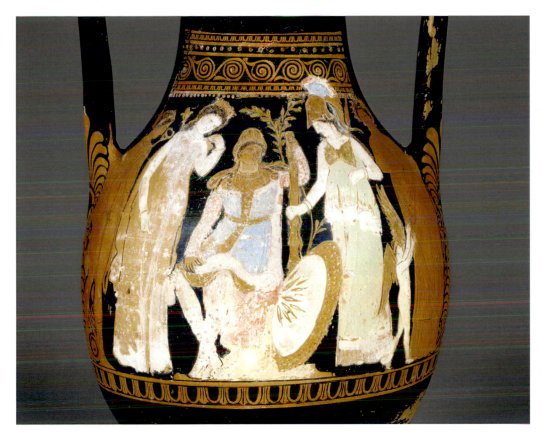

198. Attic red-figure
pelike, Painter of the
Wedding Procession,
Judgment of Paris.
Malibu, J. Paul Getty
Museum 83.AE.10

199. Attic red-figure
lekythos, Eretria Painter,
mainads. Formerly
Berlin, Staatliche Museen
zu Berlin-Preußischer
Kulturbesitz F 2471 (lost)

200. Attic red-figure
epinetron, Eretria
Painter, preparations
for the wedding of
Harmonia. Athens,
National Archaeological
Museum 1629

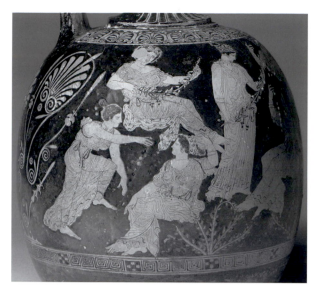

201. Attic red-figure
squat lekythos, Meidias
Painter, attendants of
Aphrodite. Cleveland
Museum of Art 82.142

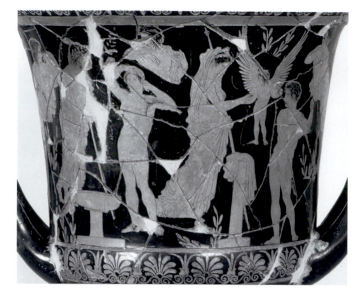

202. Attic red-figure
calyx-krater, Dinos
Painter, preparations for
the foot race between
Hippomenes and
Atalanta. Bologna, Museo
Civico Archeologico 300

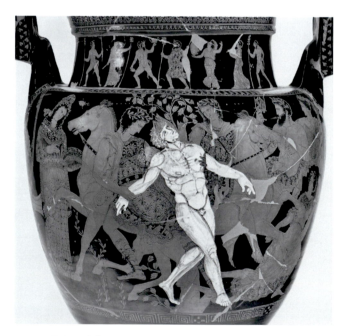

203. Attic red-figure
volute-krater, Talos
Painter, death of Talos.
Ruvo, Museo Archeologico
Nazionale Jatta 36933
(1501)

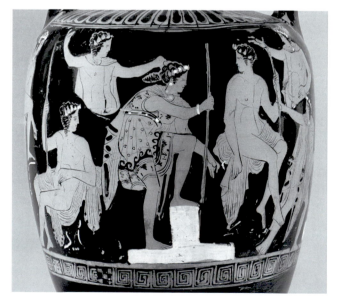

204. Attic red-figure
amphora, Meleager Painter,
Atalanta and Meleager.
Toronto, Royal Ontario
Museum 919.5.35 (388)

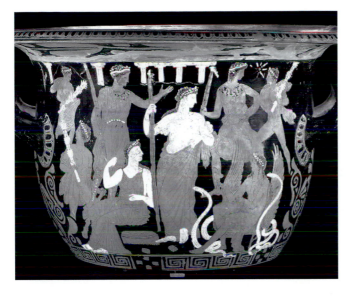

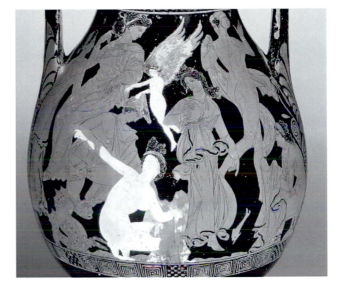

205. (top left) Attic red-figure bell-krater, Pourtalès Painter, initiation of Herakles and the Dioskouroi into the Eleusinian Mysteries. London, British Museum F 68 (1865,0103.14)

206. Attic red-figure pelike, Marsyas Painter, Peleus and Thetis. London, British Museum E 424

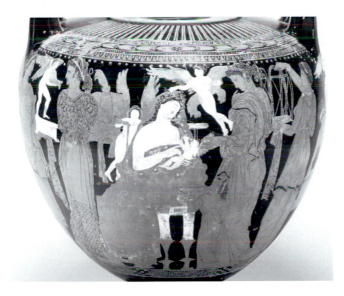

207. Attic red-figure lebes gamikos, Marsyas Painter, seated bride with erotes and women. Saint Petersburg, Hermitage P 1906.175 (15592)

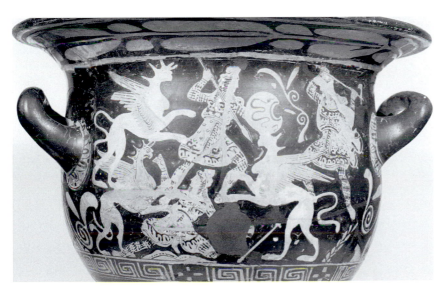

208. Attic red-figure bell-krater, Painter of the Oxford Grypomachy, Amazons and griffins. Oxford, Ashmolean Museum 1917.61

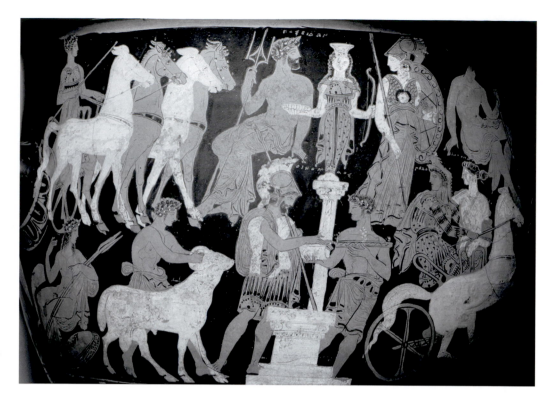

209. Attic red-figure
bell-krater, Oinomaos
Painter, Oinomaos
sacrificing before the
race with Pelops. Naples,
Museo Archeologico
Nazionale 2200

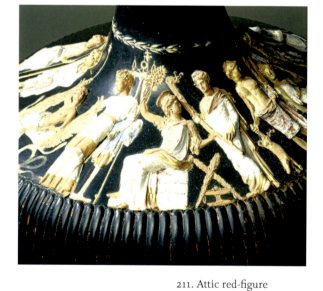

211. Attic red-figure
hydria, unattributed
(Regina Vasorum), detail,
Eleusinian divinities.
Saint Petersburg,
Hermitage ГР-4593
(Б 1659, St. 525)

210. Attic red-figure
hydria, unattributed
(Regina Vasorum),
Eleusinian divinities.
Saint Petersburg,
Hermitage ГР-4593
(Б 1659, St. 525)

212. Attic white-ground
lekythos, Thanatos
Painter, hare hunt and
grave stele. London,
British Museum D 60

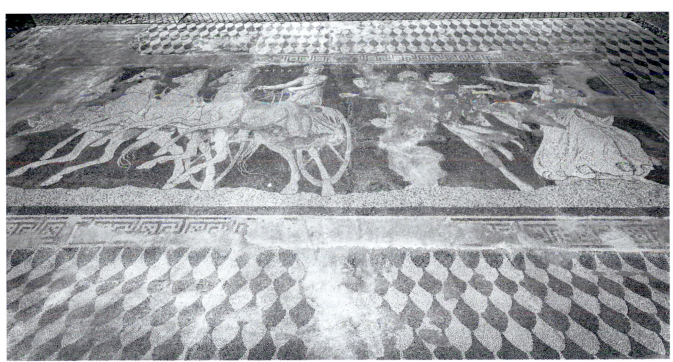

213. Pella, abduction
of Helen mosaic. In
situ, Pella, House of the
Abduction of Helen

214. Votive relief
to Bendis, from the
Piraeus. London,
British Museum 2155

215. Grave stele of Anti-
patros, son of Aphrodisios
of Askalon. Athens,
National Archaeological
Museum 1488

216. Grave stele of
Eupheros. Athens, Kera-
meikos Museum P 1169

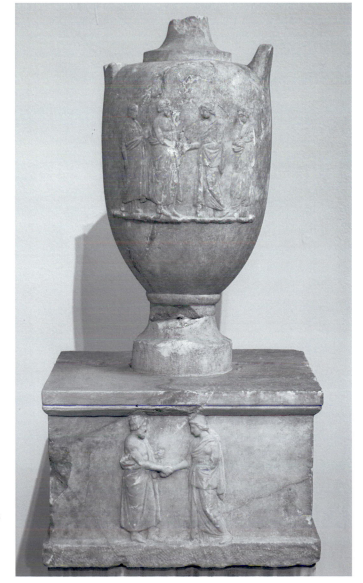

217. Attic funerary
loutrophoros-hydria with
sculptured base; on the right
side of the base a woman
holds a theatrical mask.
Athens, National Archaeo-
logical Museum 4498

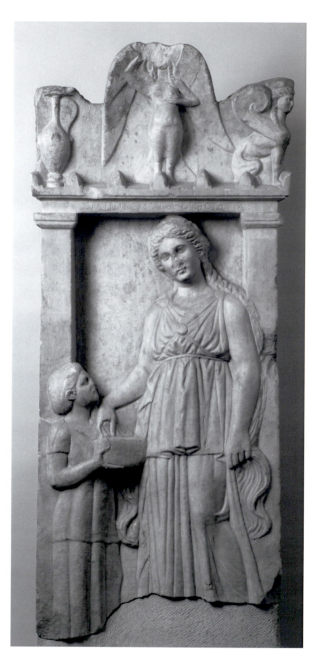

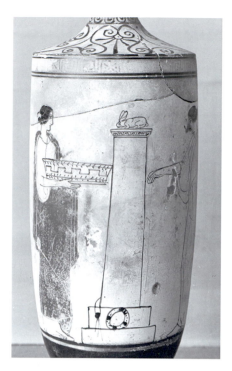

219. Attic white-ground lekythos, mourners at grave monument. New York, Metropolitan Museum of Art 06.1075

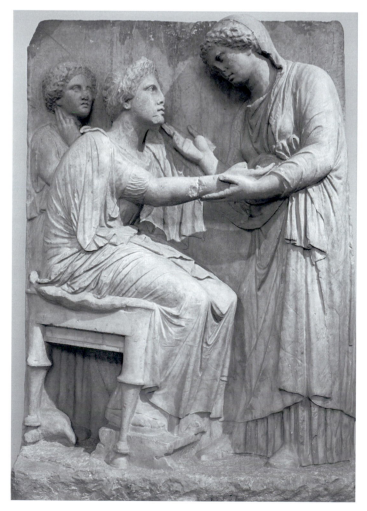

218. Grave stele of Silenis. Berlin, Staatliche Museen zu Berlin-Preußischer Kulturbesitz (Pergamon Museum) Sk 1492

220. Lamentation stele. Athens, National Archaeological Museum 870

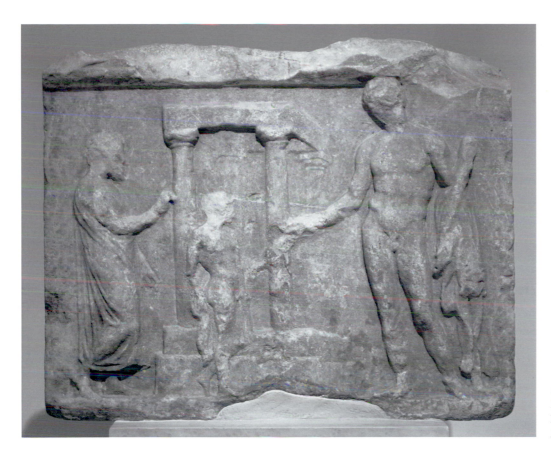

221. Votive relief to Herakles. Athens, National Archaeological Museum 2723

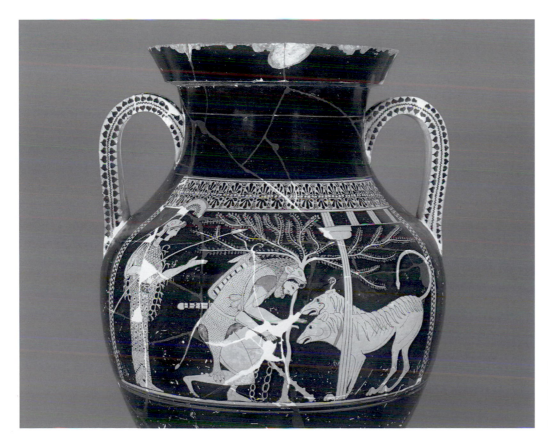

222. Attic red-figure amphora, Andokides Painter, Herakles and Kerberos. Paris, Musée du Louvre F 204

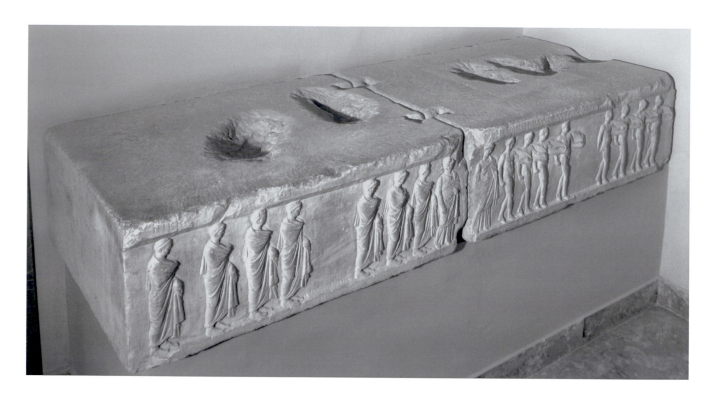

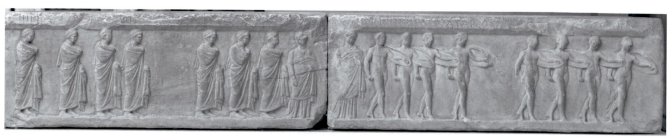

223. (top) Votive
monument of Atarbos,
top. Athens, Acropolis
Museum 1338

224. (below) Votive
monument of Atarbos,
front. Athens, Acropolis
Museum 1338

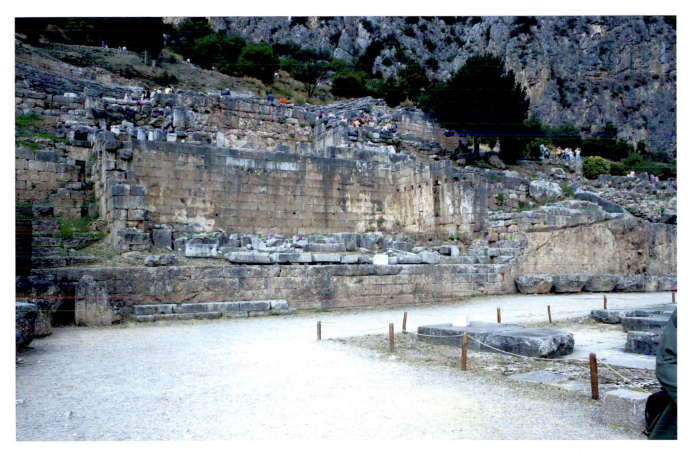

225. Delphi, view of
the Krateros exedra
in the ischegaon

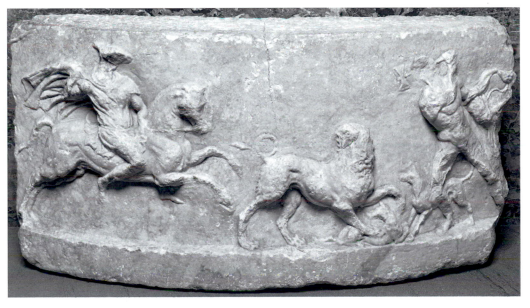

226. Fragment of large
circular base with lion
hunt, from Messene. Paris,
Musée du Louvre Ma 858

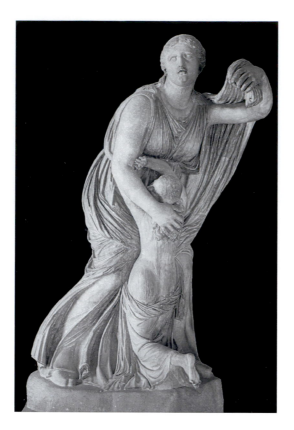

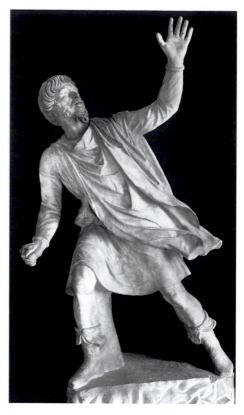

227. Niobid group, Niobe and daughter. Florence, Galleria degli Uffizi 294

228. (far right) Niobid group, pedagogue. Florence, Galleria degli Uffizi 301

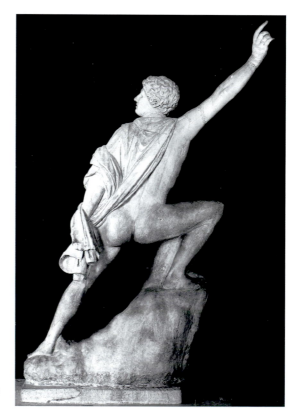

229. Niobid group, lunging Niobid. Florence, Galleria degli Uffizi 306

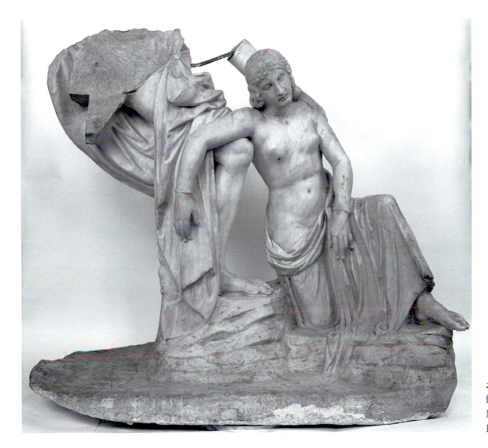

230. Niobid group,
fallen Niobid girl. Rome,
Musei Vaticani, Museo
Pio-Clementino 567

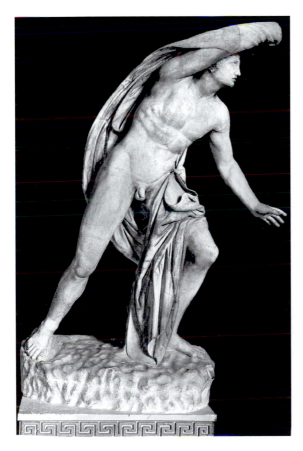

231. Niobid group, older
Niobid boy. Florence,
Galleria degli Uffizi 302

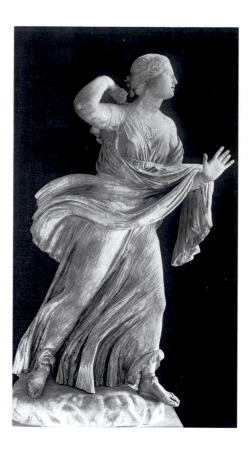

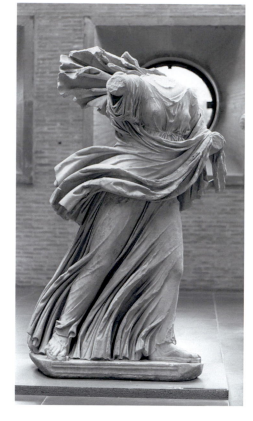

232. Niobid group, fleeing
Niobid girl. Florence,
Galleria degli Uffizi 300

233. (far right) Niobid
group, fleeing Niobid girl
(Chiaramonti Niobid).
Rome, Musei Vaticani,
Lateran Collection 1035

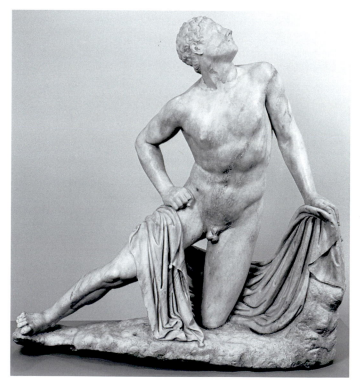

234. Niobid group, fallen
Niobid boy. Rome, Musei Capi-
tolini, Centrale Montemartini
(ACEA) MC 3027

235. Subiaco youth.
Museo Nazionale
Romano (Palazzo
Massimo) 1075

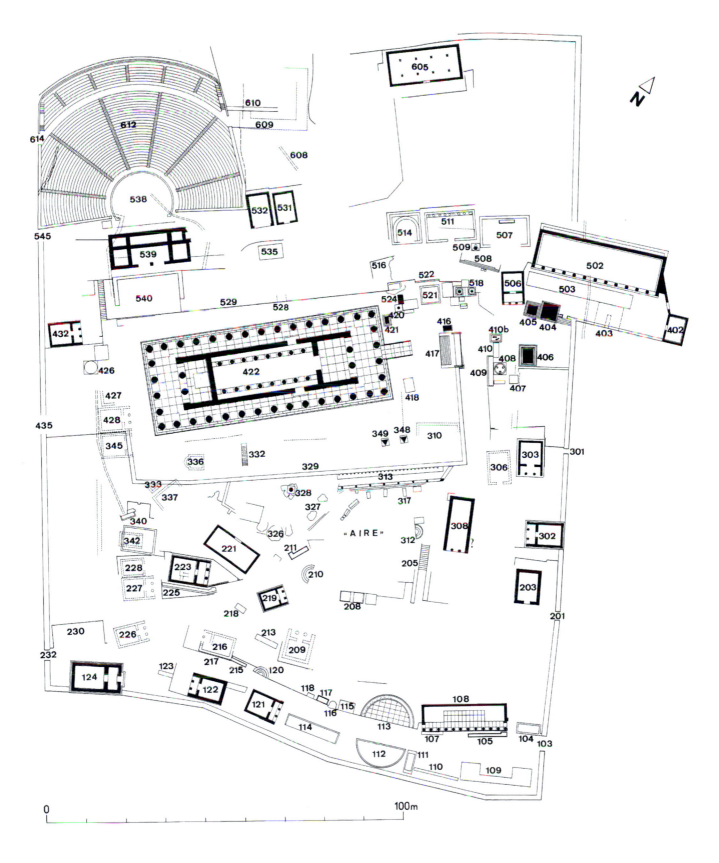

236. Delphi, plan
of sanctuary

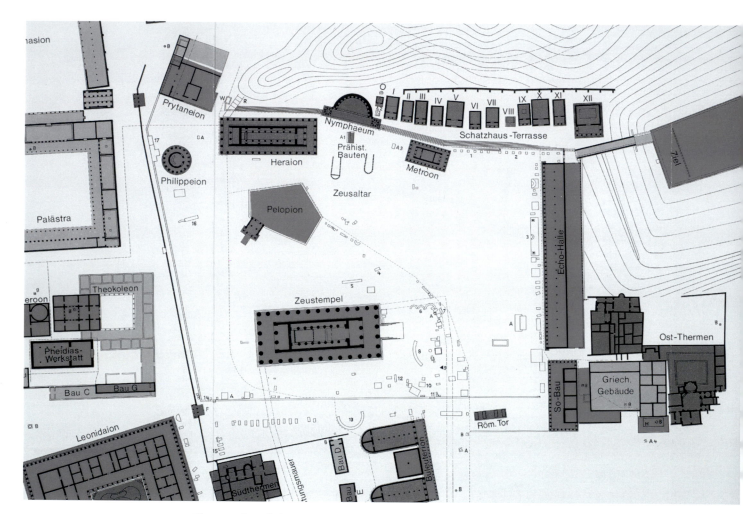

237. Olympia, plan of Altis

238. (opposite page)
Samos, plan of sanctuary
of Hera showing location
of base of a pankratiast

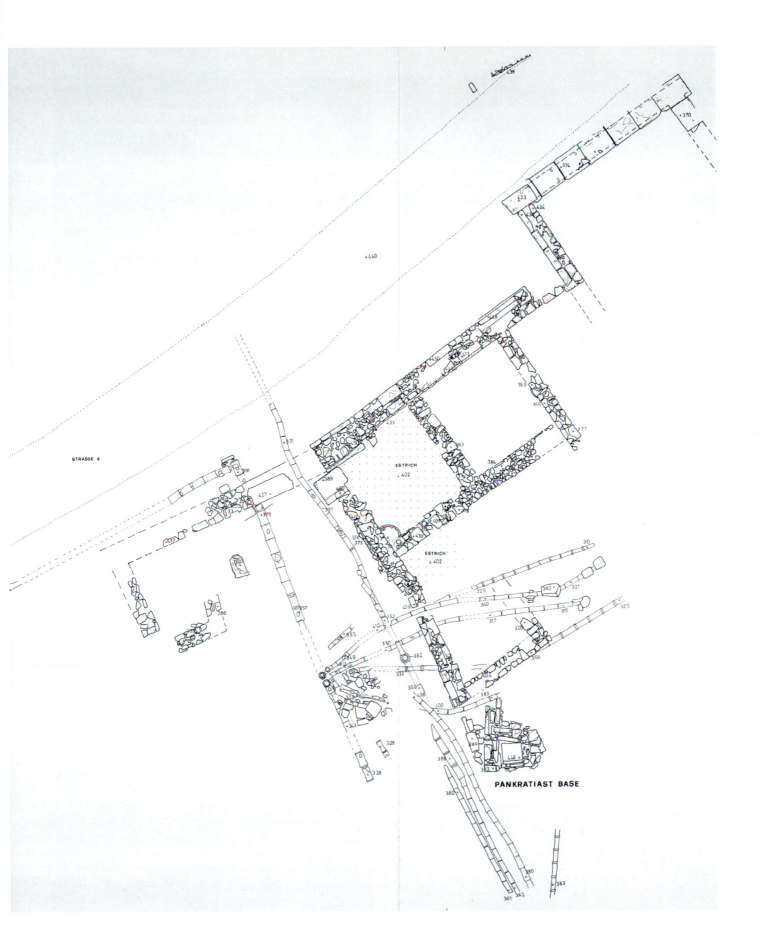

STRASSE 6

ESTRICH
+ 402

ESTRICH
+ 402

PANKRATIAST BASE

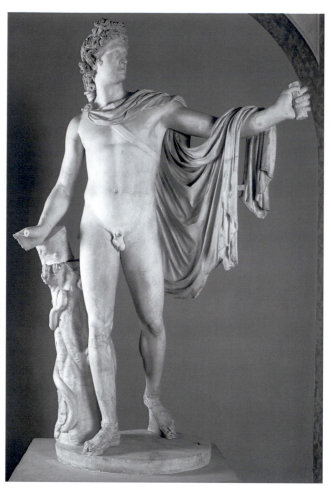

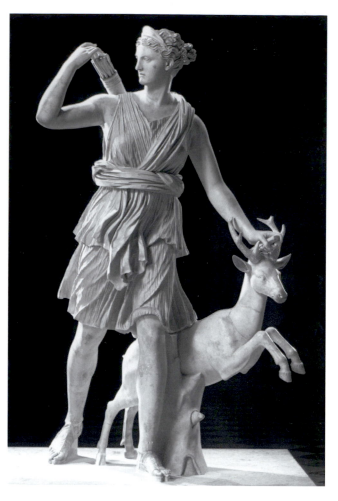

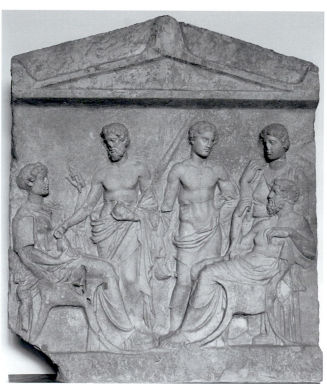

239. Apollo Belvedere.
Rome, Musei
Vaticani, Museo
Pio-Clementino 1015

240. (top right) Artemis
of Versailles. Paris, Musée
du Louvre Ma 589

241. Boiotian grave stele,
from Thebes. Athens,
National Archaeological
Museum 1861

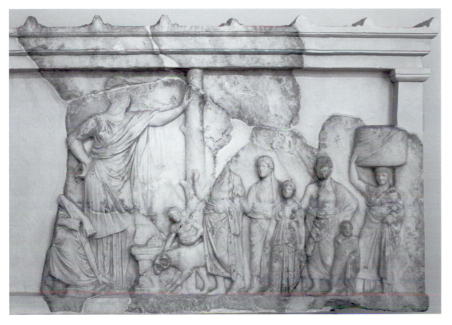

242. Votive relief to
Asklepios and Hygieia.
Athens, National
Archaeological
Museum 1333

243. Fragmentary Attic
votive relief from the
Athenian Asklepicion.
Athens, National Archaeo-
logical Museum 1351

244. (below) Thessalian
votive relief probably to
Dionysos and Ariadne. Volos,
Archaeological Museum 421

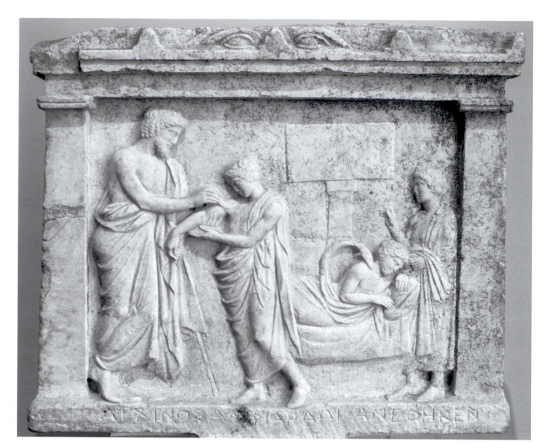

245. Attic votive relief to Amphiaraos dedicated by Archinos of Oropos. Athens, National Archaeological Museum 3369

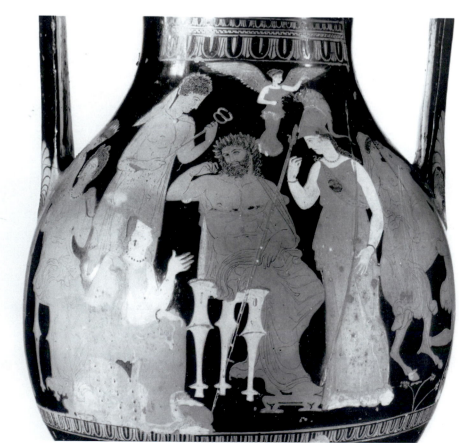

246. Attic red-figure pelike, Eleusinian Painter, side B, Zeus and Themis before the Trojan War. Saint Petersburg, Hermitage St. 1793

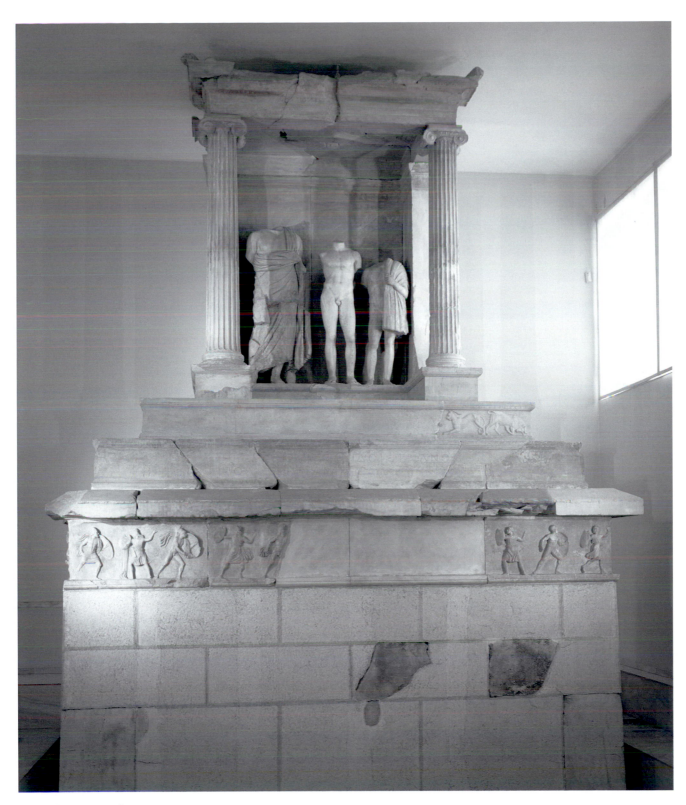

247. Reconstructed
tomb of Nikeratos
of Istria and his son
Polyxenos, from Kallithea.
Piraeus, Archaeological
Museum 2413–529

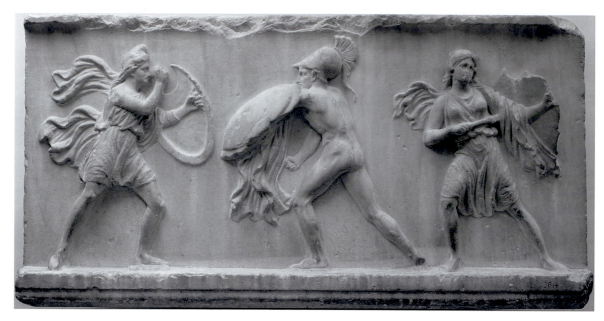

248. Architectural
relief slab from an
unknown building,
Amazonomachy. Athens,
National Archaeological
Museum 3614

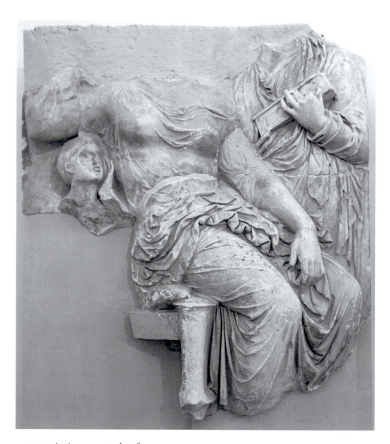

249. Attic grave stele of
a woman (τηλαυγὴς
μνῆμα). Athens,
National Archaeological
Museum 3716

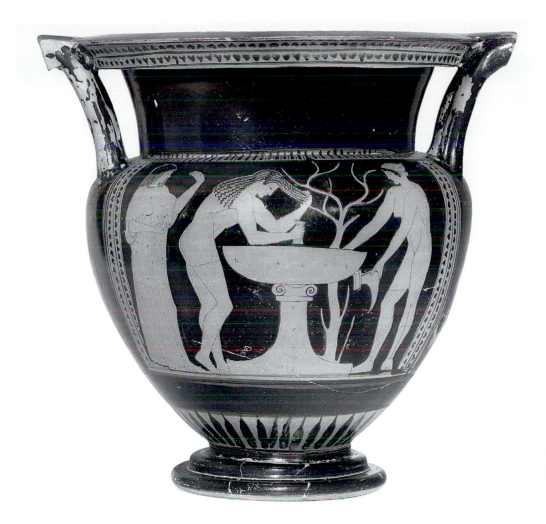

250. Attic red-figure
column-krater, woman
washing her hair at a
louterion. Milan, Banca
Intesa Sanpaolo 9

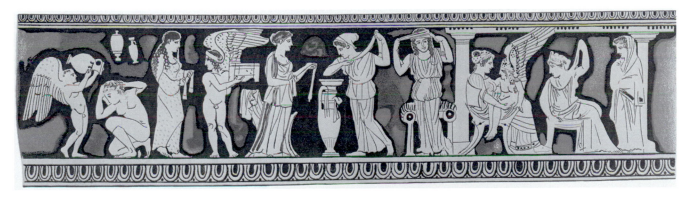

251. Attic red-figure pyxis,
wedding preparations.
New York, Metropolitan
Museum of Art
1972.118.148 (drawing)

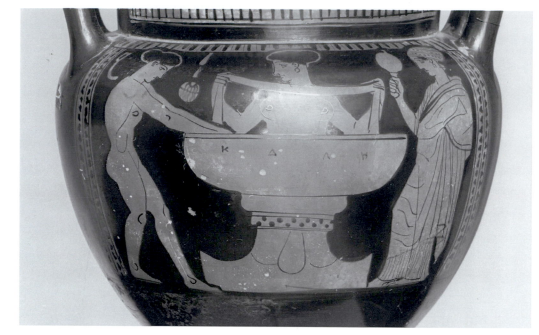

252. Attic red-figure
column-krater, Painter of
the Louvre Centauromachy,
three women at a louterion.
Dresden, Staatliche
Kunstsammlungen,
Albertinum 321 (ZV797)

253. Attic red-figure
krateriskos fragments, nude
running girls. Basel, Herbert
A. Cahn Collection, HC 502

254. Attic red-figure stemless kylix, Euaion Painter, Atalanta in shorts, brassiere, and cap. Paris, Musée du Louvre CA 2259

255. Attic black-figure amphora, Priam Painter, nude women bathing. Rome, Museo Nazionale Etrusco di Villa Giulia 106463

256. Attic white-ground amphora, Andokides Painter, nude women bathing. Paris, Musée du Louvre F 203

257. Attic red-figure kylix,
Jena Painter, Peleus and
Atalanta nude. Paris,
Bibliothèque Nationale,
Cabinet des Médailles 818

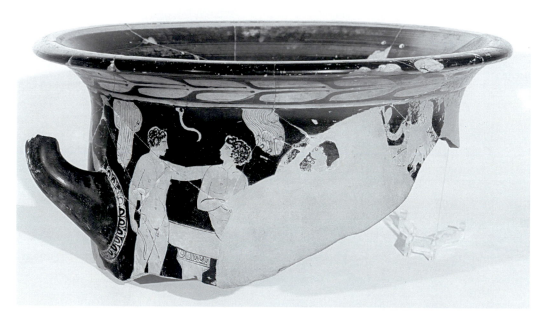

258. Fragmentary Attic
red-figure bell-krater,
Atalanta with nude youths.
Oxford, Ashmolean
Museum 1954.270

259. Fragmentary Attic
red-figure volute-krater,
Peleus Painter, Atalanta
in cap and brassiere with
Hippomenes. Ferrara,
Museo Archeologico
Nazionale 2865 (T 404)

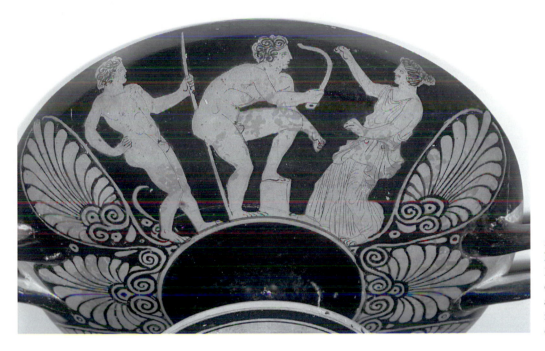

260. Attic red-figure kylix, related to the Jena Painter, two nude youths, one with large strigil, and draped woman with fillet. Boston, Museum of Fine Arts 01.8092

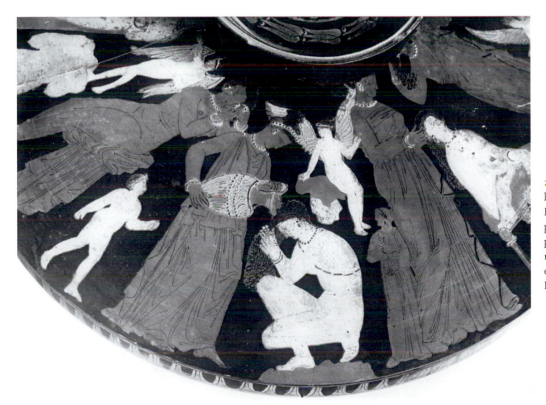

261. Attic red-figure lekanis lid, Marsyas Painter, draped woman pouring water from a pitcher on a crouching nude woman with erotes. Saint Petersburg, Hermitage St. 1858

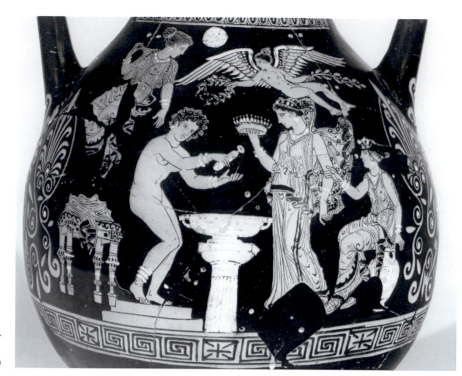

262. Apulian pelike, Group of Oxford G 269, Aphrodite and attendants at louterion. Oxford, Ashmolean Museum G 269 (V.550)

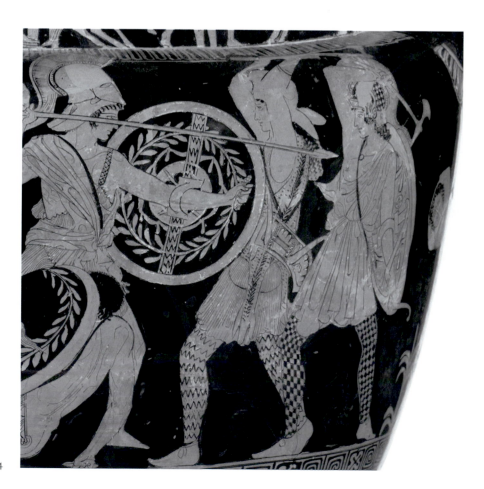

263. Attic red-figure volute-krater, Painter of the Wooly Satyrs, Amazonomachy, detail. New York, Metropolitan Museum of Art 07.286.84

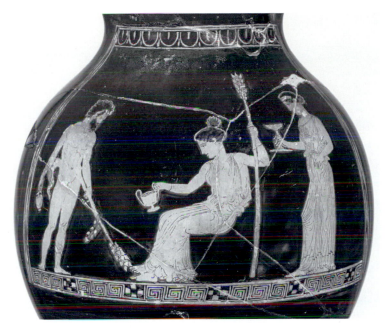

264. Attic red-figure
oinochoe, Kraipale Painter,
seated mainad (Kraipale)
with satyr (Sikinnos)
and mainad (Thymedia).
Boston, Museum of
Fine Arts 00.352

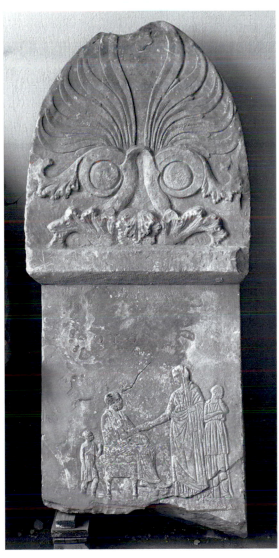

265. Grave stele of
the slave Thous, from
Laurion. Athens,
National Archaeological
Museum 890

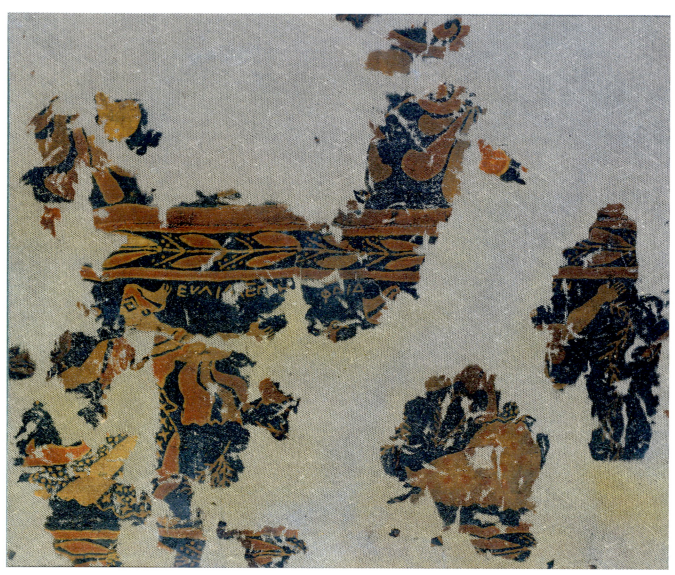

266. Batik cloth with Greek
mythological scenes, from the
"Seven Brothers Barrows,"
Cimmerian Bosporus. Saint
Petersburg, Hermitage VI.16

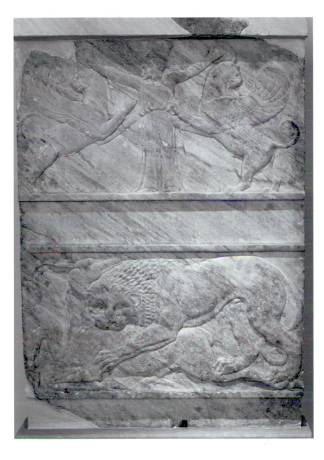

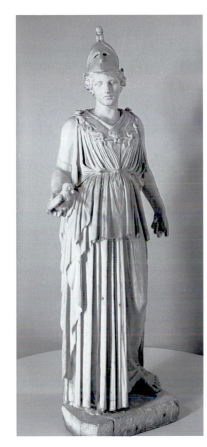

267. (far left) Attic Persianizing relief slab. Athens, National Archaeological Museum 1487

268. Athena, Ince Blundell type, much restored. Liverpool, World Museum, Ince Blundell Hall Collection 8

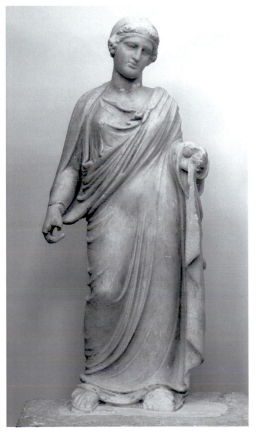

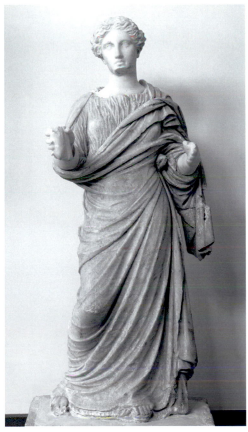

269. (far left) Statuette of Kore, from the sanctuary of Demeter at Kyparissi on Kos, figure B, Kora of Lykourgis. Kos, Archaeological Museum

270. Statuette of Persephone holding two torches, from the sanctuary of Demeter at Kyparissi on Kos, figure C. Kos, Archaeological Museum

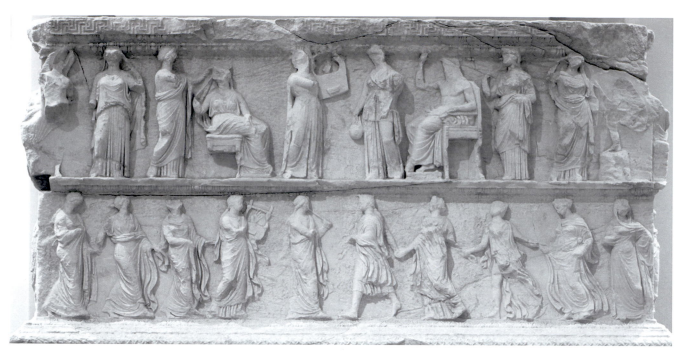

271. Sidon, Tribune
of Eshmoun, long
side. Beirut, National
Museum 2080

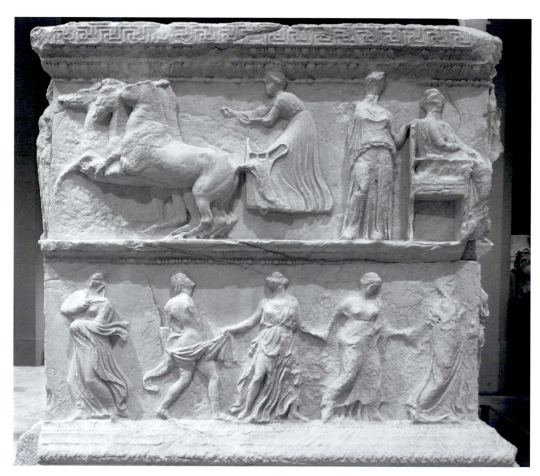

272. Sidon, Tribune
of Eshmoun, right
side. Beirut, National
Museum 2080

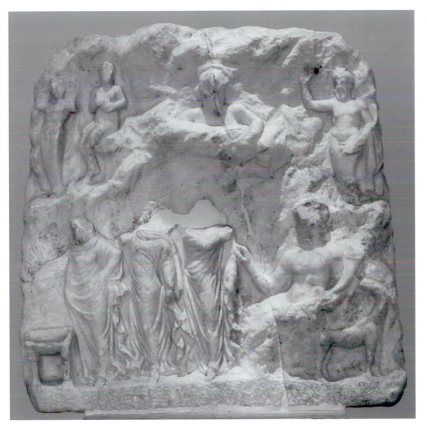

273. Votive relief to
the nymphs. Athens,
National Archaeological
Museum 1879

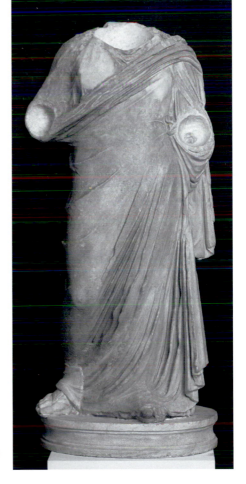

274. Demeter,
purportedly from
Crete. Venice,
Museo Archeologico
Nazionale 164A

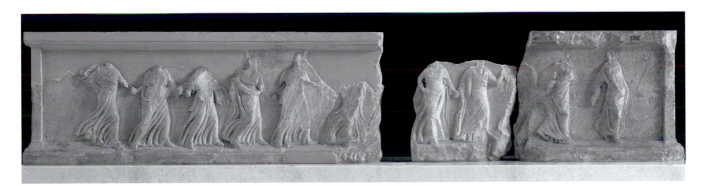

275. Relief slab, probably
part of a statue base,
dancing women. Athens,
Acropolis Museum 3363

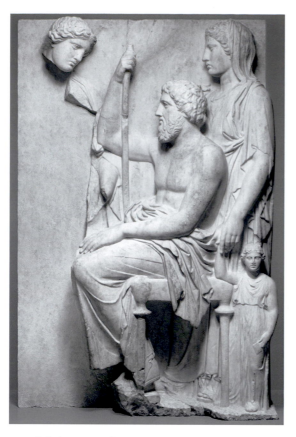

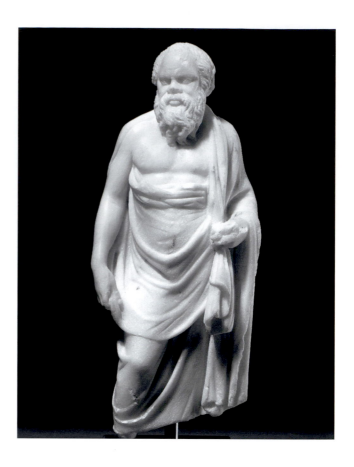

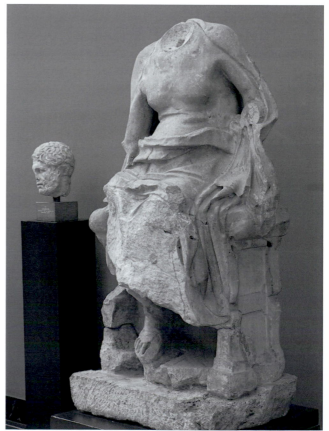

276. Attic grave stele,
so-called Sostrate stele.
New York, Metropolitan
Museum of Art 11.100.2

277. (top right) Portrait
statuette of Sokrates,
type B. London, British
Museum 1925,1118.1

278. Seated portrait of
a philosopher, perhaps
Sokrates. Copenhagen, Ny
Carlsberg Glyptotek 2812

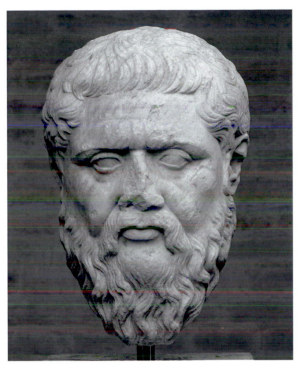

279. Portrait head of
Plato (Boehringer head).
Munich, Glyptothek 548

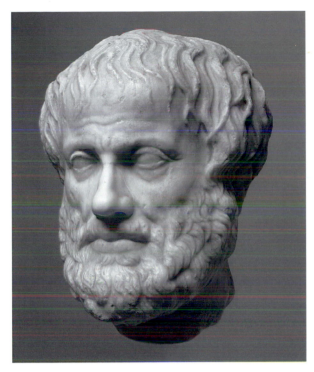

280. Portrait head of Aris-
totle. Vienna, Kunsthis-
torisches Museum I 246

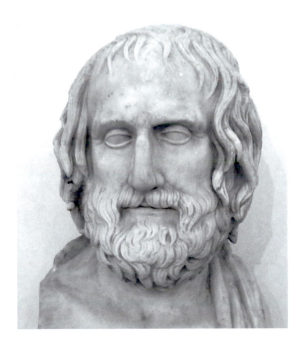

281. Portrait head of
Euripides (Farnese
Euripides). Naples,
Museo Archeologico
Nazionale 6135

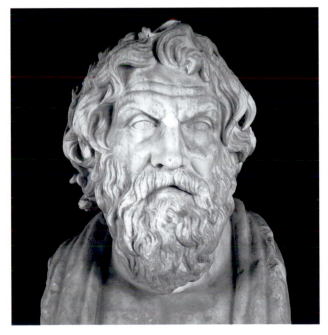

282. Portrait head of
Antisthenes. Rome,
Musei Vaticani, Museo
Pio-Clementino 288

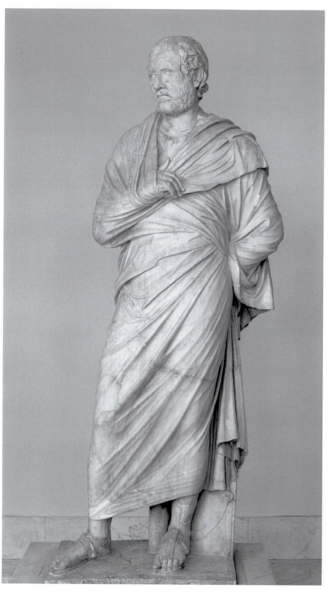

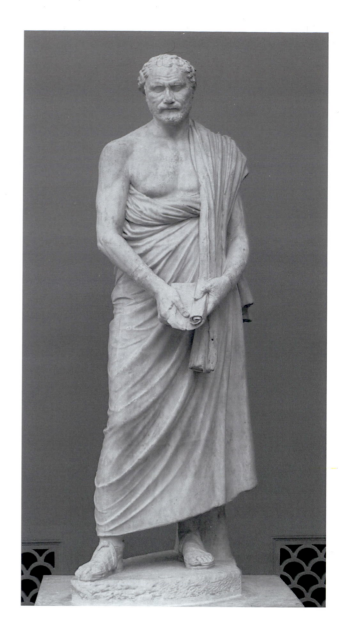

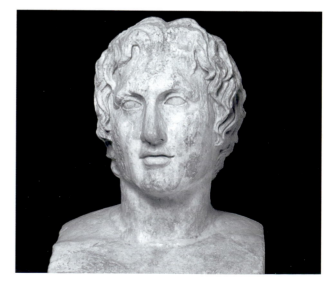

283. Portrait statue
of Aischines. Naples,
Museo Archeologico
Nazionale 6018

284. (top right) Portrait
statue of Demosthenes.
Copenhagen, Ny
Carlsberg Glyptotek 2782

285. Portrait head of
Alexander the Great (Azara
Herm). Paris, Musée
du Louvre Ma 436